Thomas Eakins
Rediscovered

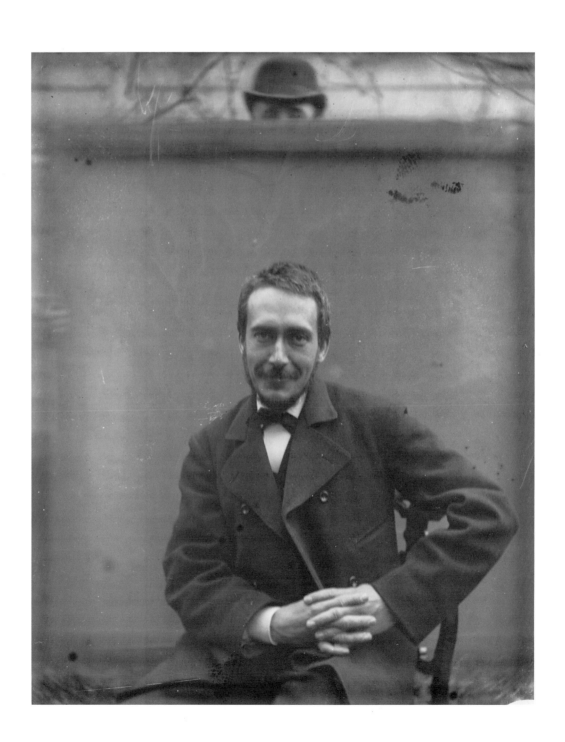

Thomas Eakins
Rediscovered

Charles Bregler's
Thomas Eakins Collection
at the Pennsylvania
Academy of the Fine Arts

Kathleen A. Foster

With contributions by

MARK BOCKRATH

CATHERINE KIMOCK

CHERYL LEIBOLD

JEANETTE TOOHEY

PENNSYLVANIA ACADEMY
of the FINE ARTS, *Philadelphia*

YALE UNIVERSITY PRESS
New Haven and London

PUBLISHED WITH THE ASSISTANCE OF THE GETTY GRANT
PROGRAM AND THE DIETRICH FOUNDATION.

Unless otherwise noted, all images are by Thomas Eakins, courtesy of
the Pennsylvania Academy of the Fine Arts (PAFA), Charles Bregler's
Thomas Eakins Collection, purchased with the partial support of the
Pew Memorial Trust, the John S. Phillips Fund, the Henry S. McNeil
Fund, and the Henry C. Gibson Fund.

Designed by Frank Tierney.
Set in Adobe Caslon type by Highwood Typographic Services,
Hamden, Connecticut.

Printed in the United States of America by Thomson Shore, Inc.

Library of Congress Cataloging-in-Publication Data
Foster, Kathleen A.
Thomas Eakins rediscovered: Charles Bregler's Thomas Eakins collec-
tion at the Pennsylvania Academy of the Fine Arts / Kathleen A.
Foster; with contributions by Mark Bockrath . . . [et al.].
 p. cm.
Includes bibliographical references and index.
ISBN 0-300-06174-9 (alk. paper)
1. Eakins, Thomas, 1844–1916—Catalogs. 2. Eakins, Thomas,
1844–1916—Criticism and interpretation. 3. Bregler, Charles—Art
collections—Catalogs. 4. Art—Private collections—Pennsylvania—
Phildelphia—Catalogs. 5. Art—Pennsylvania—Philadelphia—Catalogs.
6. Pennsylvania Academy of the Fine Arts—Catalogs. I. Bockrath, Mark.
II. Title.
N6537.E3A4 1997
709'.2—dc21 97-8253
 CIP

A catalogue record for this book is available from the British Library.

The paper in this book meets the guidelines for permanence and dura-
bility of the Committee on Production Guidelines for Book Longevity
of the Council on Library Resources.

10 9 8 7 6 5 4 3 2 1

Frontispiece: Photographer unknown, *Thomas Eakins in a Heavy Wool
Jacket*, c. 1879–1884, modern print from 4 × 5 in. dry-plate negative,
1985.68.2.845.

For Henry

Contents

vii

This is a study of dedication: of Thomas Eakins to the detail of his work; of the artist's widow, Susan Macdowell Eakins, and his onetime student, Charles Bregler, to the artist's legacy; and of a group of contemporary scholars, in particular Kathleen A. Foster, to the interpretation of one of the most complex and influential artistic minds in the history of American art. This study is inspired by the remarkable story of how Bregler formed this collection, consisting of 333 drawings, 21 oils, 10 sculptures, 300 glass negatives and positives, more than 500 photographs, and hundreds of personal papers that were acquired by the Pennsylvania Academy of the Fine Arts in 1985. It was the work left behind, literally scattered on the floor after the contents of the Eakins house had been removed following the death of the artist's widow in 1938. The presumed detritus of Eakins' life and work has proved to be rich ore. This is the third publication to derive from this collection, following *Writing about Eakins,* a catalogue of Eakins' manuscripts in the Bregler collection, published in 1989 by Foster and Cheryl Leibold, archivist at the Academy; and *Eakins and the Photograph* (1994), written by Leibold and Susan Danly, a former curator here.

Thomas Eakins Rediscovered is the culmination of this enterprise and what is sure to be a point of departure for the reevaluation of Eakins' work and his contribution to the history of American art. It is also likely to influence the discipline of art history, and the healthy debate about its methods and prerogatives, for it looks not to the major monuments so much as to the incidental work, which was not made to be exhibited: "small things that meant study" in the words of Susan Eakins, which collectively contribute to the ambitious example of Eakins' achievement. Though not a collection of great monuments, it is a collection unique in its comprehensiveness, and, as the author reminds us, the last major unstudied component of Eakins' oeuvre.

No artist has exercised a greater influence on the modern character of the Pennsylvania Academy of the Fine Arts than has Eakins, who was a student from 1862–66 before leaving for Paris to study in Gérôme's studio. He became a professor of drawing and painting in 1879 and director of the school from 1882. He was forced to resign in 1886 because of the ostensible conflict between the artist's devotion to the uncensored study of the human nude and the Board of Directors' standards of propriety at that time. Eakins' ignominious departure from the Academy deprived the institution of its most gifted teacher, and unquestionably deprived it of any opportunity to become a significant repository of more than a handful of his major artistic achievements. His legacy as a teacher, however, and his devotion to the study of the human figure, continue to influence pedagogy at the Academy even today, and they lend significance to the placement of the Bregler collection here. For as much as the Academy is the home of one of the world's foremost museums of American art, it is also home to one of this country's foremost schools of the fine arts. The marriage of exhibiting and collecting with the educational mission of the institution—specifically,

though not exclusively, the training of artists—defines the unique nature of the Academy, which legitimately claims its role as the first art school and museum in this country, founded in 1805 by Charles Willson Peale. This marriage is perfectly reflected in its 1876 neo-Gothic building designed by George Hewitt and Frank Furness, the home of both museum and school, and the venue in which Eakins taught. Today those studios are informally called the Eakins Studios, acknowledging his lasting influence on this institution's identity. Charles Bregler's Thomas Eakins Collection is in this regard well placed, for although it does not represent the summits of Eakins' artistic achievement, it reveals much about artists' *work*, as a process as well as a product.

Charles Bregler's Thomas Eakins Collection was acquired with the partial support of the Pew Memorial Trust, the Henry S. McNeil Fund, the John S. Phillips Fund, and the Henry C. Gibson Fund. Very generous grants from the Dietrich Foundation and the Getty Foundation have supported this ambitious publication. The pursuit of this collection took place over more than twenty years, involving many past directors and board members at the Academy, but special acknowledgment should be made of Frank H. Goodyear's efforts, first as curator, then as director of the museum, and then as president of the Pennsylvania Academy, resulting in Mary Bregler's decision to place the collection here. The prelude to this publication was the exhibition *Thomas Eakins Rediscovered: At Home, At Work, At School,* which appeared at the Academy in 1991–92, with the collaboration of the co-curators, Inez S. Wollins, then director of museum education at the Academy, and Jeanette Toohey, assistant curator. Linda Bantel, then director of the museum, oversaw this important exhibition and was instrumental in her guidance and support for this and the two preceding

publications on the Bregler collection. Conservation of the collection and exhibition planning were supported by grants from the National Endowment for the Humanities, the National Endowment for the Arts, the Institute for Museum Services, the Henry Luce Foundation, and the J. Paul Getty Trust. Additional support for the exhibition and public programs were generously provided by AT&T, ADVANTA Corp., the Annenberg Foundation, Mrs. Henry W. Breyer, the Brickman Group, Ltd., the Connelly Foundation, Miss Maude T. de Schauensee, Mrs. Elliott R. Detchon, the Dietrich Foundation, Mr. and Mrs. Frank H. Goodyear, Jr. (in honor of Mrs. Robert E. Thomas, Jr., and in memory of Seymour Adelman), the Grundy Foundation, Mrs. Roberts Harrison, Mrs. Robert A. Hauslohner, Mr. and Mrs. H. Gates Lloyd III (in memory of Seymour Adelman), Pennsylvania Historical and Museum Commission, Mr. and Mrs. J. Permar Richards, Jr., Mrs. Adolph G. Rosengarten, Jr., Mr. and Mrs. Stanley C. Tuttleman, Wawa Inc., Dr. and Mrs. William Wolgin, Mr. and Mrs. William P. Wood, Mrs. Charles H. Woodward, and an anonymous donor.

All of us at the Academy congratulate Kathleen Foster and her contributors to this volume: Mark Bockrath, Catherine Kimock, Cheryl Leibold, and Jeanette Toohey. Their hard work and dedication have resulted in a major "rediscovery" of a native son of the Academy, and one of this country's greatest artists. It is also an important belated acknowledgment of Eakins' singular influence upon the soul of this Academy.

Daniel Rosenfeld
Edna S. Tuttleman Director of
the Museum of American Art, of the
Pennsylvania Academy of the Fine Arts

ACKNOWLEDGMENTS

This adventure began in the spring of 1983, as Lily Milroy and I nervously stood on the front steps of a South Philadelphia rowhouse, wondering whether Mary Bregler would let us in. I acknowledge, with thanks and a persistent sense of disbelief, the thrill of the welcome that we received that day. Two years later the collection that Mrs. Bregler had so carefully safeguarded came to the Pennsylvania Academy, and the groundwork commenced that would lead to three separate catalogues detailing Charles Bregler's Thomas Eakins Collection. I am grateful to those who assisted me in the preparation of this third volume, documenting the art work by Eakins in the collection. This book was conceived as an introduction to the Bregler collection and a record of the exhibition, *Thomas Eakins Rediscovered: At Home, At Work, At School,* which appeared at the Academy in 1991–92. The exhibition held only a small percentage of the total collection, however, and the need for a complete catalogue gradually altered the scale and focus of this book, pulling it onto another, slower path. The objects, ideas, and even the organizing structure of the exhibition are published here, but they appear within the more detailed framework of a comprehensive catalogue and alongside an analytical text that draws from all parts of the collection.

In preparing this book, my first debt is owed to the staff of the Pennsylvania Academy of the Fine Arts, colleagues for many years who continued to support me after my departure for Indiana University. Elizabeth Milroy, my partner in approaching Mary Bregler, came to work at the Academy when the collection was first received, and she prepared the first inventory of the entire collection. Jeanette Toohey later arrived as assistant curator to help supervise the cataloguing of the collection and then heroically carry out the many details of the exhibition in 1991–92, while I meddled from afar; her management of these invisible but invaluable services has earned her a place on the title page of this book. Cynthia Haveson Veloric and Catherine Kimock also helped us catalogue, and Helen Mangelsdorf lent everyone a hand while overseeing the rehousing and conservation of the collection. The Academy's archivist, Cheryl Leibold, answered many calls for help even while she was preparing a separate catalogue on the Bregler collection photographs. Gale Rawson, the Academy's registrar, suffered the problems of collection storage and a major loan exhibition with her remarkable poise. Over the years, curatorial advice and support came willingly from Mary Mullen Cunningham, Susan Danly, Nancy Fresella-Lee, Susan James-Gadzinski, Ann Monahan, and Judith Stein. From the education department, I enjoyed the creative assistance of Elizabeth Kolowrat and later Inez S. Wolins, who also served, with Toohey, as co-curator of the exhibition. Rick Echelmeyer skillfully photographed all the objects in the Bregler collection. Other past and present staff members who deserve thanks for their assistance in the Bregler project include Joyce Adelman, Joseph Amarotico, Jodie Borie, Marietta Bushnell, Randy Cleaver, Janice Dockery, Tim Gilfillan, Robert A. Harman, Elyssa

Kane, Fred Kelley, Marcella de Keyser, Judy Hayman Moore, Jacolyn Mott, Karen Quinn, Elizabeth Romanella, Catherine Stover, and Roman Tybinko. Many faculty members from the school contributed to the exhibition program, including the director, Frederick S. Osborne, Jr., and Linda Brenner, Moe Brooker, Arthur de Costa, Al Gury, Jim Lueders, Dan Miller, Edith Neff, Peter Paone, Glenn Rudderow, Pat Traub, Tony Visco, and Steve Weiss. My students at the University of Pennsylvania helped with the cataloging; thanks to David R. Brigham, Kathleen James, David Steinberg, Joseph C. Thompson, Michele Taylor, Robert Torchia, Andrew Weinstein, Robin Williams, and Sylvia Yount, whose particular contributions are enumerated in the Guide to the Catalogue. Frank H. Goodyear, Jr., as director of the museum and then president of the Academy, and Linda Bantel, subsequent director of the museum, oversaw all this work and helped make it possible.

Eakins scholars all acknowledge the work of Theodor Siegl, the Philadelphia Museum of Art's late conservator, who demonstrated the power of sympathetic scientific and artistic investigation into Eakins' technique. I learned much from Siegl's writings and his conservation files, and from the work of those working in the same paths, such as Claire Barry and Christina Currie. Special thanks are due, however, to the consulting conservators who worked on the Bregler collection and offered many insights: Virginia Norton Naudé, Debbie Hess Norris, Elizabeth Schulte, and the Academy's paintings conservator, Mark Bockrath, whose careful observations are included in the appendix of this volume.

Beyond the Academy, I was helped by many scholars. Closest to the project were the consultants sponsored by our National Endowment for the Humanities planning grant for the exhibition: Kenneth Finkel, William I. Homer, Elizabeth Johns, Ellwood C. Parry III, and especially Darrel Sewell, who generously shared the research files at the Philadelphia Museum of Art and made the many loans from its collection possible. The other great collection of Eakins study material at the Hirshhorn Museum, much of it also from Charles Bregler, was likewise generous, and I am especially grateful to Phyllis Rosenzweig and Judith Zilczer for their help. After this manuscript was completed, I was invited by the Amon Carter Museum to contribute to the catalogue of their exhibition, *Thomas Eakins and the Swimming Picture,* and I am grateful to the team that collaborated on this project for many fruitful exchanges, particularly with Doreen Bolger, Sarah Cash, Fronia and Marc Simpson, and Nancy Stevens. Over the years, other wise friends and helpful colleagues also contributed advice, assistance, or support: my thanks to Henry Adams, Seymour Adelman, Jane E. Allen, Penny Balkin Bach, Martin Berger, Simon Bronner, Jay E. Cantor, Susan P. Casteras, Maria Chamberlin-Hellman,

Irene D. Coffey, Whitney Davis, Douglas Druick, Stephen R. Edidin, Robert J. Elowitch, Diana Fane, Doris Fanelli, Stuart P. Feld, Linda Ferber, Lawrence A. Fleischman, Martha Fleischman, Michael Fried, Jane Mork Gibson, Lloyd Goodrich, Gilbert Gonzales, Jennifer Hardin, Kurt Harmon, David Henry, Hyman Horn, John K. Howat, Bill Howze, Alain Joyaux, Franklin Kelly, William J. Kelly, Peter M. Kenny, Mary S. Leahy, David Lubin, Barbara MacAdam, John McCoubrey, Ellen G. Miles, Pinkney Near, Paul J. O'Pecko, Mary Panzer, Gerald E. Parsons, Douglass Paschall, Ann Percy, Paul Provost, Jules D. Prown, William R. Rasmussen, Henry Reed, Ira Spanierman, Theodore E. Stebbins, Jr., James Tanis, David Taylor, Peggy Walters Thomas, Carol Troyen, Evan Turner, Jim Voirol, H. Barbara Weinberg, Amy Werbel, Lucy Fowler Williams, Jerome G. Wilson, John Wilmerding, Barbara Wolanin, and Gretchen Worden.

This project was transplanted in mid-development by my move to Indiana, and I am grateful to my colleagues and friends at the Indiana University Art Museum who supported this work, particularly the museum's director, Adelheid Gealt, and Linda Baden, Adriana Calinescu, Nanette Esseck Brewer, Margaret Contompasis, Mary Forrest, Brian Garvey, Kathy Henline, Nancy Krueger, Ed Maxedon, Diane Pelrine, and Danae Thimme. Graduate student assistants Cynthia Empen, Lauren Lessing, Caelan Mys, and Kathleen Spies all helped with research details and the preparation of the manuscript. Sent on to Yale University Press, this massive stack of pages and pictures was guided to publication by Judy Metro and Heidi Downey, whose patient and friendly editing deserves special thanks. Their work was underwritten by generous grants from the Getty Foundation and the Dietrich Foundation that have made this publication possible.

First and last, however, has been the support of my family and friends. In addition to comrades at the Pennsylvania Academy and the Indiana University Art Museum, I wish to acknowledge the friendship of Karen Duffy, Polly and Allen Grimshaw, Mary Beth Hannah and Bill Hansen, Deb Bowman and John McGuigan, John and Mona Pearson, Warren and Barbara Roberts, and Greg Schrempp. Special thanks to Betsy and Henry H. Glassie, Sr., who is much missed, Judy and Bill Friis, my six brothers and sisters and their families, and my heroic mother, Isabella, who made me feel at home in museums. My daughter Ellen Adair, who has grown up with Thomas Eakins around the house, has offered delight and joy. Most important of all has been my husband, Henry, who gave advice and support while daily offering a model of discipline and vision for our own scholarly art. He began by teaching me about folklore and has now shown me how to be an art historian. This book is for Henry, with love.

INTRODUCTION "Small Things That
Meant Study"

*Mr. Eakins generally flung aside small things that meant study to
him for various subjects. So they may look careless, but they are all
interesting to me.*

—Susan Macdowell Eakins, 1933

Thomas Eakins died in 1916, with most of his life's work still
in the house at 1729 Mount Vernon Street in Philadelphia,
where he had lived for almost sixty years. His estate fell into
the custody of his widow, Susan Macdowell Eakins (fig. 1),
and her companion, Mary Adeline Williams, for the next
twenty-two years. These women placed key works in major
institutions and helped Lloyd Goodrich write a book, pub-
lished in 1933, that would establish Eakins as a hero in the
history of American art.[1] His legend won recognition slowly.
When Susan Eakins died in December 1938, the bulk of her
husband's work was still in the house. In the months after
her death, Charles Bregler, once a student and ever a devoted
admirer of Eakins, stepped in to conserve and inventory the
contents of the art collection before it was dispersed to heirs
and agents. On a sentimental last visit to the house after it
had been emptied for sale, Bregler encountered the "most
tragic and pitiful sight I ever saw. Every room was cluttered
with debris as all the contents of the various drawers, closets
etc were thrown upon the floor as they removed the furni-
ture. All the life casts were smashed," he wrote. "I never want
to see anything like this again."[2] Bregler gathered up this
"rubbish"—which included oil sketches, plasters, drawings,
photographs, letters, diaries, and memorabilia—and took it
home to add to the small collection of material given to him
by Mrs. Eakins over the years. In this simple act of rescue lies
the story of Charles Bregler's Thomas Eakins Collection and
the reason for its remarkable character.

In comparing the contents of Eakins' house in 1916 with
the group of objects found almost seventy years later in the
home of Bregler's widow, it appears that three major win-
nowings reduced the artist's holdings to produce the distinc-
tive texture of Bregler's final collection. The first took place
in the 1920s as Susan Eakins set about constructing a niche
for her husband in the pantheon of American art history.
"My hope is to gather together all of Mr. Eakins' small pic-
tures, to form a collection with some of his larger canvases,
hoping before I die, that I may be able to so place them that
they will always be accessible and useful to serious students,"
she wrote to a friend in 1917.[3] Her hopes were realized in the
creation of the memorial gallery at the Philadelphia Museum
of Art (PMA), established by gifts that she and Addie
Williams made in 1929 and 1930. They gave wisely and gen-
erously, donating most of the major paintings and sculptures
in the house, along with many smaller portraits. To this core
group of finished pictures and reliefs was added a selection of
student items and preparatory studies in oil or clay, to give a
sense of Eakins' training and his method. Aside from eight
charcoal studies made in life class, no drawings, photographs,
or manuscripts were included in their gift of fifty-two items.[4]

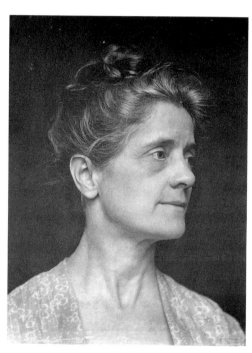

1. Photographer unknown, *Susan Macdowell Eakins
(1851–1938),* c. 1900, platinum print on cream wove
paper, 13¹⁵⁄₁₆ × 11¹⁄₁₆ in., 1985.68.2.85.

Susan Eakins, who managed all gift and sale transactions, wished to represent her husband's work concisely and well, and her selection for the museum reflects on the Bregler collection, which holds—for example—twelve life class drawings (cats. 16–27) very similar to those given away in 1929. In reassembling the whole group we can see that Mrs. Eakins chose to donate the best drawings and most of the complete, full-length figure studies (see fig. 30). There is much to learn, however, from the examples not taken. Although she included a few awkward samples to track Eakins' progress, the typically fragmented character of these student drawings (as in fig. 29) is not well demonstrated by her selection. In re-uniting the two halves of this early portfolio, we gain a subtler sense of Eakins' style and training, a stronger sense of his habits. We can also understand, from the differences between these two groups, the nature of Bregler's collection, with its consistently secondary examples, and the spirit of Susan Eakins' gift, which, like Goodrich's first biography, aimed for uncluttered and heroic effect.

The second major culling of the Eakins house occurred in 1939, following Susan's death. Many fine paintings went to her family in Virginia; other portraits, oil sketches, and a few drawings were sold, usually through the Babcock Gallery in New York. Abandoned as uninteresting or unsalable were the works Bregler claimed, including some oil portraits (mostly unfinished or homely subjects), many slight oil sketches, a few sculptures, and hundreds of drawings, photographs, and manuscripts. The judgment of the heirs and agents was not unwise, for even the best of Eakins' paintings were slow to find purchasers in the 1930s, and such minor work, most of it studio material, held little interest for scholars or collectors.[5] Bregler, however, inherited Susan Eakins' mission and shared her unwavering faith in the future stature of Eakins' work (fig. 2). Reverently, he saved everything that the "Boss" had touched. "These things are all for future students," he told Samuel Murray, another devoted student. "That is the thought and hope that prompts me to care for them."[6]

Bregler's foresight was soon rewarded, for a retrospective exhibition in 1944, marking the centenary of Eakins' birth, revived awareness of his work as it toured to six cities.[7] Bregler, a perennially impoverished artist now approaching the age of eighty, decided to sell the most important parts of his collection, seen in the first two venues of this exhibition. After the show closed in New York most of this material was consigned to Knoedler's gallery; happily, it sold en bloc to Joseph Katz soon after. In 1961, Katz's holdings were acquired by Joseph Hirshhorn, who added them to his museum in Washington, D.C. Enlarged by other items from Samuel Murray's estate, Hirshhorn's Eakins collection offered a foil to the one in the Philadelphia Museum of Art, for it contained many examples of the type of material that Mrs. Eakins had not deemed important: drawings, photographs, oil studies, and memorabilia.[8]

In selecting items from his collection for use in the 1944 exhibition and then later for sale, Bregler—or Henri Marceau,

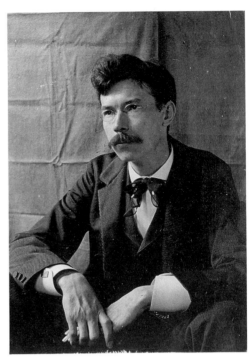

2. *Charles Bregler* (1864–1958), c. 1887, albumen print, 3 9/16 × 2 5/8 in., 1985.68.2.203.

the curator of the show—sifted through the material once again, choosing the largest, most finished examples of a type, or the items in the best condition, or simply the most appealing things, such as Eakins' buckskin cowboy suit. As with Mrs. Eakins' selection, these extracts from the larger collection left related suites of work behind. The most elaborate eight pages from a notebook of costume sketches for *William Rush Carving* were plucked out (see fig. 133), leaving eight pages unchosen (cat. 188a–h); the largest, most splendid high school exercises were taken, while nine smaller, less finished examples (cats. 5–13) remained in the portfolio. Predicting low interest in the illustrations for Eakins' drawing manual, Bregler sold only two out of forty-eight drawings; likewise, only a few representative samples of Eakins' anatomical sketches and perspective drawings were drawn from much larger groups.[9] The resulting division of the collection is sometimes unfortunate, although happily the two parts have themselves remained whole, and the unity of these sets can be quickly comprehended.

Apart from this one large group, Bregler made only a few sales in the 1940s, including groups of photographs (usually his own copy prints) to the Metropolitan Museum and to the collector Mark Lutz (who later gave them to the PMA), and several perspective drawings sold to the PMA and the Cleveland Museum. Generously, he donated a perspective drawing to the Academy (cat. 148) and sent Eakins' portable sketch box, with two studies for *Swimming* inside it, to the Fort Worth Art Association, the owner of the final painting. Bregler also shared parts of his hoard with Seymour

Adelman, a young friend of Susan Eakins' who gradually compiled his own reverent collection of Eakins material, now divided between the collection of Mr. and Mrs. Daniel W. Dietrich II and the Bryn Mawr College Library. Responding to the enthusiasm of George Barker, a student of Eakins' student John Laurie Wallace, Bregler gave him two perspective drawings. These transactions and a few others are documented in Bregler's papers, allowing us to regather the collection he once owned, and that once occupied the cupboards and drawers of Eakins' home.[10]

Bregler spent the last ten years of his life in seclusion, surrounded by the collection that he taught his second wife, Mary Louise Picozzi, to respect and safeguard. After his death in 1958, Mary Bregler moved back to her family's neighborhood in South Philadelphia and anxiously hid away the material, generally rebuffing the stream of scholars, curators, and dealers who came to inquire about her husband's collection. Courted by the Pennsylvania Academy in the 1960s, she came close to an agreement and then changed her mind; likewise, overtures from Sotheby's led to a partial inventory in 1972, but no sale. As a result, when Mary Bregler finally yielded to the Academy's renewed suggestions in 1985, she brought forth material that had been seen by very few people. Other than a few items exhibited in 1944, most of the collection had not been examined since Lloyd Goodrich turned through it in about 1930, when it was still in Eakins' studio. Some items, particularly the most sensitive manuscripts, had evidently been withheld even then; other than Susan Eakins and the Breglers, no one had handled some of these things since Eakins' death. The survival and reappearance of this large, long-awaited and much-speculated-upon collection is the most literal and dramatic "rediscovery" proposed by the title of this book.[11]

The significance of this revelation depends greatly on the size of Bregler's hoard, as well as on its unusual character. The remainders of Eakins' private collection, now thrice culled by knowledgeable persons, are still enormous: 10 sculptures, 21 oils, 333 drawings (including recto and verso images and sketchbook pages), 300 glass negatives and positives, more than 500 photographs, and hundreds of personal papers and artifacts, all from Eakins' hand, plus hundreds of additional items in all these categories by his wife, Bregler, and other artists and friends in his circle. The quality and interest of the collection have been preserved by these statistics, for certain groups are so large and consistent in texture—such as the photographs, the anatomical drawings, and the perspective illustrations and diagrams—that the dispersal of a few examples has hardly diminished their strength. Even the broken sets, such as the life class drawings and the sketchbooks, have sufficient redundancy to make new generalizations possible. In this flood of new material—perhaps twice as many photographs as were previously known, and four times as many drawings—there is a wealth of fresh imagery and information.

A collection of this scale cannot be encompassed in a single volume. The importance of the manuscripts and pho-

tographs, as well as the specialized topics contained in these genres, have inspired separate publications that will serve as companions to this book. *Writing About Eakins* (1989), which I wrote with the Academy's archivist, Cheryl Leibold, analyzes and enumerates the manuscript material published in an accompanying set of microfiche cards. *Eakins and the Photograph,* by Susan Danly (the Academy's former curator), Cheryl Leibold, and others, itemizes and discusses the huge photographic holdings introduced here in Part II. These photographs and manuscripts often insert themselves into this text, but our main concern is the other art in Bregler's hoard: the paintings, drawings, and sculpture. Even within this narrower field there is much to consider: the count of objects is twice the number held in the related collections at the PMA and the Hirshhorn, *including* their photographs and manuscripts.

The provenance of the collection explains the overall character of this new material. With few exceptions, such as the *Spinning* and *Knitting* reliefs (cats. 260, 261), this work was not intended for public display. Earlier winnowing has largely removed the masterworks, the exhibition pieces, the framable and salable items. Initially, we may be drawn to a few choice items that were somehow overlooked or held back during these siftings, such as the oil sketches *Spinning* (cat. 243; plate 3) and *Arcadia* (cat. 251; plate 19), the oil study for *Fifty Years Ago* (cat. 241; plate 5), and Eakins' high school graduation piece, *Thomas Crawford's "Freedom"* (cat. 14).[12] These works are immediately appealing, but their larger significance comes from the qualities they share with the collection as a whole. Mostly private, preparatory, or didactic, these pieces are all "small things that meant study." This realm of study is mapped by repetitious objects showing emphasis and by diverse artifacts illustrating the breadth of Eakins' attack. For with the size of the collection comes range, from speedy notebook jottings to monumental perspective drawings that must have absorbed days of work, from schoolboy caricatures to the portraits of maturity. If not a complete roster, then the present assembly has the appearance of a representative cross-section of "study" of all types, from all periods, in all media.

This large and diverse collection also is the last major unstudied component of Eakins' oeuvre. With the emergence of this material we now likely have almost everything that we ever *will* have, and a new level of analysis of his whole corpus can begin. Many pieces were lost, perhaps destroyed, before Goodrich's accounting in 1933, and many others have scattered since, but the shared pattern of provenance for the bulk of Eakins' work, traced in the line of descent of the Bregler collection, makes it unlikely that much additional material escaped recording, either in Eakins' lifetime or later. Lost items that return to light or unknown pieces that prove authentic will probably not disrupt the sense of Eakins' habits and accomplishments to be gained from extant riches. The possibility of censorship of nude subjects by "well-meaning" friends is considered in chaps. 8 and 11, but from

the examples that survive we can conclude that the respectful husbandry of Susan Eakins and Charles Bregler has saved for us a survey of work that is extraordinarily complete and wide-ranging.

This is a trove for an art historian, and not just for one bent on studying Thomas Eakins, for it offers a spectrum of creativity that includes some of the most humdrum or impenetrably private moments in an artist's repertory. Usually this material is thrown away—by the artist, first, if not by heirs. Few artists are more than momentarily interested in study and preparation pieces; consumed by hopes for progress, they see the faults or the staleness in old work, and, as Susan Eakins said, they fling it aside. A few more self-conscious artists, especially those lionized in their own lifetimes, will harbor preparatory work, bestow it on friends and collectors, sometimes mine it for revisionary inspiration. Michelangelo was pursued for his drawings, and he released them rarely. According to Vasari, he burned many of his drawings shortly before his death "that none might see the labors he had endured, and the trials to which he had subjected his spirit, in his resolve not to fall short of perfection."[13] Eakins, also obsessed by perfection, hid nothing; he cared little for his preparatory work, and his experience of "misunderstanding, persecution and neglect" made him assume that posterity would destroy his work, not clamor for it.[14] In the survival of his studio material, all of his "trials" are exposed, revealing the labor endured for art and the genius that resides in the infinite capacity for taking pains.

In this revelation of work-in-progress, such a collection rises to serve a later generation of Eakins scholars. In 1933, Goodrich sought the broad contours and highlights of Eakins' career; his generalizing, introductory mission had no use for detail. Today, with the structure of Eakins' achievement well established and a demythologizing, contextualizing mood upon the scholarly world, the sense of detail and process in Bregler's material now offers access to a more complex artist, a more three-dimensional human being. The rejoining of the life class portfolio or the sketchbooks represents an encounter of this kind, revealing the foothills rather than the peaks, the ordinary rather than the special, pressing us to enlarge our understanding of previously well-known work. On a second, more interesting level, this, too, is Thomas Eakins rediscovered.

The experience of Bregler's collection, and its meaning, might be represented by a single photograph printed from a glass negative found in a shoebox at the foot of Mary Bregler's basement stairs (frontispiece). In this smiling image, Eakins is recognizable but different; related portraits, some evidently taken on the same day, are known in vintage photographic prints. Most of the extant views give us the official, familiar Eakins, the image he chose to have printed and distributed. Typically, they show the artist in a serious, even brooding mood, presenting a facade that suits the now-mythological Eakins: loner, zealot, martyr (fig. 3). One biographer, Gordon Hendricks, has called the extant photo-

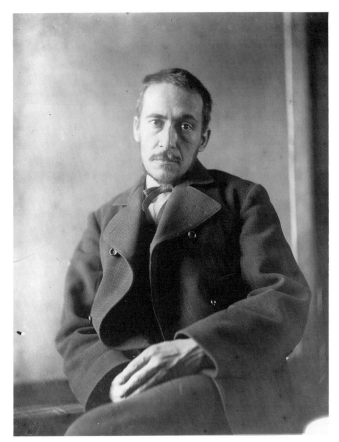

3. Photographer unknown, *Thomas Eakins in a Heavy Wool Jacket,* c. 1879–1884, modern print from 4 × 5 in. dry-plate negative, 1985.68.2.846.

graphic portraits from this moment the "tormented" series.[15] How sunny, by comparison, is the newfound Bregler portrait. Here is an Eakins we know less well, although other evidence confirms such cheerful days as a bohemian student in Paris, as an idolized teacher, as the good-humored companion of the studio or the rail-shooting expedition. Just as novel is the revelation of context. The margins of the negative, usually cropped in the vintage prints to give a tidy, professional finish, here allow us a glimpse of clapboards, bushes, and the comical fingers and head of an obliging friend, who holds a stretched canvas behind Eakins to serve as a backdrop. The backstage business of the photographer of 1880, working outdoors to use the sunlight, lies revealed, and Eakins smiles as if complicit in this slightly ridiculous moment of exposure. As with many photographs in this collection, the photographer and the derby-hatted assistant remain nameless members of a large circle of family, friends, and students who collaborated with Eakins in many of his projects. By its placement within a larger, well-known series and its inclusion of behind-the-scenes information and unidentified collaborators, this portrait encapsulates the principal characteristics of Bregler's collection: surprise within a generally familiar frame, breadth and detail at the margins, revelation of process. Like the cropped margins of a photographic

portrait, the background clutter of the studio can be reassembled to give us a fresh vision of Eakins, in private informal moments: at home, at school, at work.

Such special materials, so rarely saved and so infrequently analyzed, demand an unconventional organization for study. The standard biographical format does not fit, because this collection will not rewrite Eakins' career. New insights from the manuscript collection, detailed in *Writing About Eakins,* prove that the pain of the scandals that shadowed his career from 1886 to 1897 cut deeper than we have imagined; room for a speculative psycho-biography may lie within these papers, but they do not redraw the basic contours of art and life history given in Goodrich's expanded monograph of 1982. Furthermore, most of the material in Bregler's collection comes from the first half of Eakins' career, and it inadequately illustrates his greatest accomplishments. Arrayed chronologically, these objects cannot tell a complete story. On the other hand, if they are isolated by medium in standard catalogue entries they do not show their strength, which emerges from sequences and aggregates. A conventional listing by medium and date is given at the back of this book, and detailed analysis of specific objects occurs throughout, for my enterprise is first and last the catalogue of a collection. But the main text expresses the larger significance of this material: all the meanings of "study" at the core of Eakins' life and work.

My method likewise responds to the special character and opportunity of this collection. I have tried to look at Eakins afresh and to describe his work as an anthropologist might document an alien art and seek its system. I have been lucky to share my life with a folklorist, Henry Glassie, whose study of the world's art has given me a model of patience, discipline, and compassion. Like a scholar of material culture, I have let repetitious objects teach me the logic of materials and processes. As a historian, I have searched for appropriate context to help interpret these objects. The resulting synthesis of method has produced a study as layered and finely detailed as an Eakins painting. Few artists have been so closely scrutinized, yet my own effort only begins to meet the seriousness and thoroughness of Eakins' method.

Unlike a painting, this book is a linear experience that encounters hundreds of separate images, but collectively these objects construct a narrative that tells of the training, the teaching, and the studio practice of a mid-nineteenth-century European-American academic realist. In basic ways, Eakins enacts the culture of his period, so he can represent the education, the attitudes, and the procedures of many artists from this moment whose studios have been lost or dispersed. Bregler's collection also shows Eakins to be different—not just unlike the other artists of his time but different from the artist that he is so often claimed to be: the "honest," straightforward, scientific realist, the sturdy American independent, the "innocent eye."[16] These two perspectives, one seeking the larger, cultural context that unites Eakins with his contemporaries and the other probing for a more subtle,

idiosyncratic identity that sets him apart, have structured my investigation; both yield a fresh sense of Eakins as we consider how he learned to be an artist, how he taught others, and how he made art himself.

With these larger goals, the confusing array of the Bregler collection has here been broken apart and reassembled in three ways—by period, by medium, and by subject—in search of larger patterns of meaning within these odd and disparate objects. To investigate how Eakins became an artist in the first place, I gather the numerous items in the collection made before 1871. They are considered in Part I, which assesses Eakins' family life and the early training in art he received in the Philadelphia public schools, at the Pennsylvania Academy of the Fine Arts from 1862–66, and in Paris, at the Ecole des Beaux-Arts, from 1866–69. From the longer perspective, this student passage follows the course of art education for many artists of the period; from a closer view, it displays sophisticated levels of artifice and abstraction at odds with the notions of "innocence" and American realism so important to Eakins' twentieth-century reputation.

Armed with certain skills and prejudices, Eakins returned to Philadelphia in 1870 and began his professional career. Drawing from his student experience, he spent a dozen years developing a method to make pictures and relief sculptures. The unfolding of this process is charted in Part II, as he sequentially adopted, conquered, revised, and sometimes abandoned different media. First reliant on drawing, his boyhood medium, Eakins slowly learned to paint in oil; once he became competent in oil, he took up watercolor, then sculpture. Gradually, he drew less and less. Photography attracted him in the late 1870s, and eventually the camera supplanted most of the work in pencil that had not already been subsumed by oil. His interest in watercolor, sculpture, and photography endured into the early 1890s but gradually waned as his emphasis settled on oil; in the last fifteen years of his career Eakins narrowed his range and streamlined his method, producing some of the most powerful paintings of his career.

In isolating work by medium in Part II, the skills and values of Eakins' training in Philadelphia and Paris can be clearly traced in his mature work. Eccentricities also emerge: his refusal to produce conventionally beautiful drawings and studies, and his tendency to take his practices (anatomy, perspective) to obsessive extremes. A grouping by medium reflects the hoary artifices of scholarly categorization, but in Eakins' case it usefully reveals a fragmentation of techniques and goals that is key to understanding his work. His attitudes toward medium and method are scrutinized with a view to the sequence of his interests and the special purposes of each type of work within his oeuvre. Now that we have before us almost all of the drawings by Eakins that we probably ever will have, what can be said about his drawing practices, overall? When did Eakins draw? Why? When did he paint? This question of when—or why—again has two levels of focus. His interest in watercolor and photography relates closely to contemporary fashion, showing an alert response to popular

enthusiasm or fresh technology. At a more personal level, the when and why of his choices can be integrated into the progression of his subject preferences and technical challenges: both watercolor and photography were taken up when they were *needed* to accomplish certain personal goals.

The analysis of medium reminds us that there is little of Eakins' finished work in his major medium here, and the usual approach—that is, to begin with the study of his important oils and work backward (or "down") to consider the relationship of preparatory studies—must here be reversed. The wealth of preparatory material suggests instead a vision from the bottom up, and a third consideration of the collection that takes advantage of its strengths. In Part III the objects are assembled into groups devoted to a common theme and aimed at the production of a finished work in painting or sculpture. The final work, and similar or related objects in other collections, have necessarily been gathered into these ensembles to understand the development of a larger project. Ranked chronologically, from his first sporting subjects through his Arcadian and cowboy landscapes and ending with a survey of his portraiture, the sequence of these projects integrates the sense of Parts I and II into a picture of Eakins at work as a mature artist. Individually, these chapters allow a glimpse of the mechanics of creativity, of the development and revision of ideas, and of the discipline of preparation, all rarely studied in depth. Often it has been enough to identify a given work as a "study for" something else, and leave it at that. But what exactly is being gained in each study? What was done first? Last? How did the different media interrelate?

In the intersection of media another pattern emerges over time, demonstrating the progress of Eakins' method over the years as he gradually assimilated new techniques. Never simple, his method grew more complex until, by the 1880s, his work on a certain theme (such as Arcadia) incorporated all the media in his repertory in the service of very complicated and ideologically charged art. The skills and values of his training, and the purposes of the different media, are now seen to flow together, contributing to Eakins' larger intentions. The orchestration of all this work to a particular end helps us understand some very well-known paintings and sculptures in new ways. Attention can then lift to the wider cultural sphere. Why was Eakins interested in four-in-hand coaching? In Arcadia? And we can reconsider Eakins as a realist, now revealed as an academic artist of a quirky and intense order.

The term "academic," used in its popular sense to describe sterile, formulaic work, could not be admitted into the discussion of Eakins' work when it was initially defended as original, uniquely American, and sturdily opposed to the decadent artifices of the European tradition. The influence of his principal teacher, Jean-Léon Gérôme, was disparaged or ignored, and Eakins was seen to have shrugged off four years of experience in France with praiseworthy obtuseness. "So easily did he discard the regulations of his French training, that we forget his masters," wrote Gertrude Vanderbilt Whitney in 1920.[17] More recently, scholars have begun to study the artists Eakins admired—such as Gérôme—finding virtues in the academy and a spectrum of creative possibilities within its realm. Eakins, more than any other American artist of this period, has been recast by evaluations in this new light, and the Bregler collection offers further demonstrations of the quality of his academic spirit.[18]

The sense of Eakins as an academic, developed across all three parts of the text, is recapitulated and concluded in a final section in which I consider the enactment of Eakins' method in his teaching. Again, he appears as both typical of his period and very idiosyncratic. All of his artistic values and practices were systematically put forward in his teaching curriculum, and the Bregler collection displays the range, intensity, and eccentricity of his approach. Not everyone appreciated Eakins' teaching philosophy, and the reaction to his instruction in many ways echoes the period's response to his art. This parallelism can be pursued in considering the artifacts of teaching as emblems of Eakins' artistic method and personality. Already introduced in the sections on drawing, painting, and sculpture, these objects can be assembled now to allow us to consider the legendary Eakins—hero of free speech, maverick, truth-tester—and the idea of "academic" and "realist" art. Spreading Eakins' work out for inspection, from the popular, nostalgic impulses in his subject matter to the arcane, professional techniques of his perspective system, we can see that his method was deeply indebted to the practices instilled by his training and heavily modified by personal imperatives. At last, our twin perspectives on culture and personality must fuse in consideration of the final knot of training, experience, and will that produced a great American artist. To comprehend the whole creative tangle we must begin, however, by sorting out the contributory threads, commencing with the earliest phase of Eakins' artistic life, in Philadelphia, in the 1850s.

Part I Learning To Be
 an Artist

CHAPTER 1 Home Life and Early Training

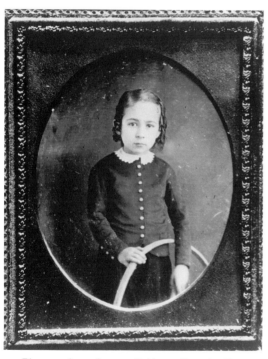

4. Photographer unknown, *Eakins at About Age Six*, c. 1850, cased daguerreotype, 3½ × 2¹³⁄₁₆ in., 1985.68.2.1.

Thomas Eakins enjoyed an exceptionally good American education. His official study of art did not begin until 1862, when he was eighteen, but all of his boyhood training shaped the realistic, hard-working, craftsmanly aspects of his artistic character (fig. 4). Young Tom took complete advantage of the opportunities offered, exploiting the strengths of the educational system and willingly conforming to its values as he pressed to master its content and methods. Evidently the education he received both suited and encouraged his own predilections, confirming skills and attitudes that would remain sturdy for a lifetime. Any failings in the system did not, apparently, cause remorse until after he left Philadelphia in 1866 and first sensed the eccentricity of his own artistic preparation. By that time it was too late to change his already well-formed and stubborn disposition. Although Gérôme and Velázquez would refine and cultivate Eakins' sensibility, the self-confident young artist who sailed for Paris in the fall of 1866 was already on a course that can be projected from the drawings of his youth discovered in the Bregler collection.

These drawings tell us much about Philadelphia, the patterns of American art education, and the environment of Eakins' household. Dominant in all three realms in Eakins' life was his father, Benjamin Eakins (fig. 5), the writing master. Benjamin Eakins was probably his son's first teacher, and his intellectual and emotional support sustained Eakins throughout his youth and maturity. Samples of Mr. Eakins' own work emerge from this collection to illustrate his character: some are incomplete, perhaps discards or interrupted projects, but several illustrate the stream of graduation diplomas and marriage certificates that made every June a crisis in the Eakins household, and at least one (fig. 6) displays the calligrapher's decorative repertory in a text intended for artistic and religious contemplation in the home. The piety, the neatness, the conventional mid-nineteenth-century decorative taste of this prayer all speak for the mood established in Mr. Eakins' household. It was, by all accounts, not an observantly religious home but culturally Protestant, with traces of Quakerism from Benjamin Eakins' in-laws, the Cowperthwaits.[1] *The Lord's Prayer* may never have been intended for Benjamin Eakins' home, but it was a statement made to his community, for his community, a public presentation of himself, signed with a flourish.

The Eakins house, at 179 Mount Vernon Street (fig. 7), where the family moved when Eakins was almost thirteen, enlarges the context of this calligraphy. Until 1939, the house was also "signed" *B. Eakins* on an elegantly engraved silver doorplate (cat. 268).[2] The house, now dedicated to community use as an art center, is dignified and spacious, with four or five upstairs bedrooms and an upstairs rear parlor in addition to the more public spaces on the first floor and the original studio-workshop that occupied the back half of the fourth floor. Almost new when the Eakinses moved there in 1857, this brick house stood at the end of a terrace of other homes, enjoying a double lot with a side yard that opened up the back of the house to sunlight and the more open land-

5. *Benjamin Eakins*, c. 1885, photogravure, 5½ × 3⁹⁄₁₆ in. (image), 1985.68.2.151.

6. Benjamin Eakins, *Our Father Who Art in Heaven* [*The Lord's Prayer*], n.d., pen and ink on cream wove paper, 22⅛ × 17⁹⁄₁₆ in., 1985.68.43.1.

scape north of the city. In the 1850s this house was part of a new neighborhood at the northwest edge of the city's urban core, cut off from the more stylish addresses of old Philadelphia by a belt of trainyards and industrial buildings between Market and Spring Garden streets. As the city grew toward the Schuylkill River, all the neighborhoods west of Broad Street were developed, to be occupied by families like the Eakinses or their middle-class friends and neighbors, the Macdowells, Holmeses, Crowells, and Rothermels (all art-related professionals, or with art-minded children), most of whom were newly genteel offspring of immigrants and tradesmen. Benjamin Eakins' father, Alexander Akens, a weaver, was born in Ireland; Benjamin's wife, Caroline Cowperthwait (see fig. 11), was the daughter of a shoemaker.[3] Benjamin's ascending prosperity is written in this house, four times the size of the home he purchased as a newlywed in 1843; its tall ceilings and plain trim illustrate the Quaker taste of Philadelphia's midcentury middle class: fundamentally unostentatious and conservative, but modern in the desire for large, comfortable, rationalized spaces, with many rooms and hallways for privacy or specialized activity.

The interior of the Eakins home survived almost undisturbed until Susan Eakins' death in 1938. Visitors before this date remember the darkness: sunlight blocked by heavy draperies with Victorian fringes and tassels, "rooms filled with mahogany and rosewood furniture, some old, from the Cowperthwaits, some mid-nineteenth century."[4] Paintings Eakins made in this environment in the 1870s capture the domestic atmosphere, with its overtones of enclosure, security, and stuffy entrapment: *Home Scene* (Brooklyn Museum), *Kathrin* (fig. 8), *Elizabeth Crowell and Her Dog* (San Diego Museum of Art), and, best of all, *The Chess Players* (fig. 9),

7. Eakins' house at 1729 Mount Vernon Street, Philadelphia, c. 1940, photo courtesy of Historical Society of Pennsylvania. The windows of Eakins' first studio, on the fourth floor at the rear of the house, are visible here. His new studio in the front attic, created in 1900, involved raising the original roofline, still visible in the brick pattern of the side wall.

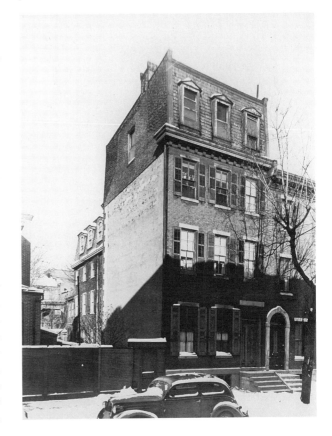

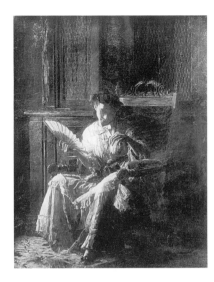

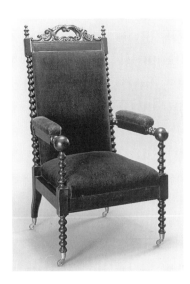

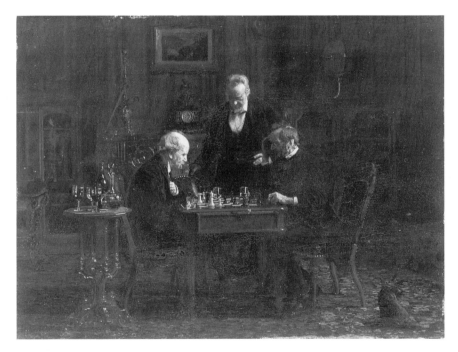

8. *Kathrin,* 1872, oil on canvas, 62¼ × 48¼ in., Yale University Art Gallery, bequest of Stephen C. Clark. Photograph by Charles Bregler, c. 1930, courtesy of PAFA.

9. *The Chess Players,* 1876, oil on wood panel, 11¾ × 16¾ in., Metropolitan Museum of Art, Gift of the artist, 1881.

10. *Carved Victorian Armchair from the Eakins' Family Home* (cat. 263).

where the dust motes are almost visible in the ray of sunlight penetrating the dim, hushed parlor, and the purr of the house cat and the tick of the ornate mantel clock are almost audible in the silence of concentration.

Some of the furniture in these interior scenes is old, like the Queen Anne tilt-top table that figures in *The Zither Player* (Art Institute of Chicago), *Fifty Years Ago* (plate 6) and many of Eakins' perspective diagrams (cats. 105–108, 134–137). Most of it is new, however, probably purchased by the Eakinses after their marriage: the piano in *Home Scene,* the chairs and tables in *The Chess Players,* the upholstered armchair in *Kathrin,* the patterned broadloom wall-to-wall

carpet seen in all. The new furniture shows the eclectic historicism of midcentury, with its appreciation for older styles freely mixed and reinterpreted in contemporary terms: Renaissance Revival, neo-Jacobean. The armchair (fig. 10; cat. 263) that appears in about a dozen of Eakins' paintings throughout his career survives as an eloquent artifact from this environment. Traditional in its references to sixteenth- and seventeenth-century English furniture, it is modern in its fresh combination of these forms, its comfortable proportions and upholstery, its useful casters, its degenerate craftsmanship.[5] The modernity of this chair must remind us of the similar newness and stylishness of the rest of the furnishings,

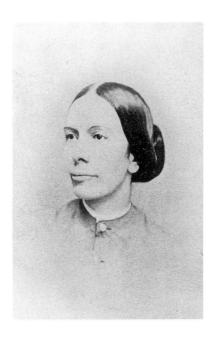

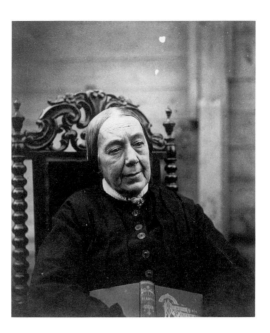

11. A. P. Beecher, *Caroline Cowperthwait Eakins*, 1863–69, albumen carte-de visite, 3¹³⁄₁₆ × 2³⁄₁₆, 1985.68.2.795.

12. *Eliza Cowperthwait*, c. 1885, albumen print, 4⅛ × 3½ in., PAFA, purchased from Gordon Hendricks' collection, with funds donated by the Pennsylvania Academy's Women's Committee, 1988.10.21.

from the rug to the clock, now so quaintly Victorian to our eyes. The thoroughness of Eakins' transcript of such details—banal then, evocative now—may explain the noncommittal receipt of such paintings in the 1870s, when such an interior was ordinary, unremarkable, certainly not picturesque.[6] But considering only the culture of this environment and not Eakins' decision to paint it, the context of Eakins' home is shown to be thoroughly modern and new-made, representing the taste of a recently prosperous and educated family. Forward-looking because they bore little weight from the past (save what they chose to preserve or reinvent), these were classic members of the American bourgeoisie. From such an interior, with its new piano, globe, and framed engraving over the mantel, would come an artist to express the values of this culture, so comfortable with its materialism, so confident about its own progressive and artful civilization.

Within this house lived many people—never fewer than five until 1899, and usually seven or more—plus an assortment of pets. Benjamin Eakins needed such a big house by 1857: he had three children (another would come in 1865) and a selection of his wife's relatives on hand, including his sister-in-law, Eliza Cowperthwait (fig. 12), who lived with the family until her death in 1899.[7] Later, Tom's sister Frances, known as Fanny (fig. 13), brought her husband, Tom's boyhood friend Will Crowell (see fig. 26), to live in her father's house, and three of their children were born there before the family moved to a farm at Avondale in 1877. The youngest daughter, Caroline, known as Caddy, lived there with her husband, Frank Stephens, until the birth of their son in 1886. The Stephenses left, to be immediately replaced by Tom and

his recent bride, Susan Macdowell.[8] This pattern of dense and multigenerational family life, no doubt enriched by one or two domestic servants, lies behind Eakins' entire life, with the exception of his three years abroad and the brief interval when he and Susie set up newlywed quarters in his studio in 1885–86.[9] Eakins was rarely in his life truly "alone" in this system, no matter how scorching the neglect of the art establishment, and accounts of the social life in this house give a picture of hospitality, intellectual liveliness, and neighborhood integration, not hermitage.

Although he was never alone in this house, Eakins was never in charge, either, until the death of his father in 1899. In 1897, Susan Eakins still referred to her home as "Mr. Eakins'" house, and his hegemony must have been recognized by his son, who had a contract with his father to pay rent for room, board, and the use of the fourth-floor studio.[10] Gratitude and guilt are recurrent themes throughout Eakins' letters to his father from Paris; every penny spent was dutifully recorded to his parents, with apologies for his drain on the family's finances and frequent assurances that he would soon return to "earn his own living."[11] But Eakins never earned much from his painting, and he drew a regular salary only during his eight years of teaching at the Academy. For the rest, he depended on Benjamin Eakins' income, which included a comfortable supplement from various investments, including real estate rentals. Benjamin Eakins was evidently unstinting in this support, never grudging or "cranky"; he also subsidized the very large household of his daughter Fanny, at Avondale, when her husband's health forced his early retirement.[12] Such generosity came at a cost for Tom, since it made him permanently dependent and by implica-

13. Frederick Gutekunst, *Frances Eakins*, c. 1868, albumen carte-de-visite, 3¹⁵⁄₁₆ × 2½, PAFA, purchased from Gordon Hendricks' collection, with funds donated by the Pennsylvania Academy's Women's Committee, 1988.10.7.

14. *Margaret Eakins*, c. 1881, albumen print, 3⅜ × 2⅞ in., 1985.68.2.73.

15. Schreiber and Sons, *Caroline Eakins*, 1878, albumen carte-de-visite, 3⁷⁄₁₆ × 2⁵⁄₁₆ in., from Gordon Hendricks' collection; PAFA, purchased with funds donated by the Pennsylvania Academy's Women's Committee, 1988.10.16.

tion immature, perhaps inspiring compensatory manliness and authoritarian manners in other arenas independent of his father's control, such as teaching.[13]

But if unconsciously oppressed by his father, Eakins was more obviously sustained. Benjamin bought his son out of the Civil War lottery draft, financed his lengthy training abroad, and defended him during the scandal caused by Eakins' professional practices in 1886, composing an affidavit of his character and behavior that was circulated to all interested parties.[14] In a deeper sense, he also freed his son to take the impractical, insensitive, or intransigent position that invited this scandal. Thanks to his father's support, Eakins never had to compromise, court favor, or work routinely on other people's projects. Such liberty was Benjamin Eakins' great gift, although the freedom to be principled and professional—or unconventional—also ruined his son's career and brought trouble and division into the very center of the Eakins household.

Benjamin Eakins' support, gladly given and gratefully received, was one part of a respectful and affectionate friendship between father and son. Dour at table (although he enjoyed drinking his homemade wine), "Master Benjamin" was known as a dignified, courtly, but affable man. He was also a great sportsman, companion of the rail-hunting expedition, and indefatigable walker, skater, bicyclist, and swimmer well into the 1890s.[15] Benjamin Eakins must have taught his son to shoot, swim, and sail, and Eakins honored these pastimes and their companionship in *The Artist and His Father Hunting Reed Birds* (plate 10), a painting inscribed (like *The Chess Players*) "Benjamini Eakins filius pinxit" (Benjamin Eakins' son painted this). His father also owned a lathe—the subject

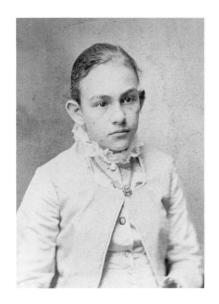

of Tom's most magnificent high-school perspective exercise in 1860—and must have introduced him to the carpentering skills that enabled Eakins to make his own frames and paint-boxes. The fourth-floor workshop where this lathe was installed became Eakins' household studio until 1899. Always a "workshop" and never an "atelier," this room remained infused with the spirit of his father's handcraft.[16]

The women in the Eakins household, always legion, were less authoritative, and the historical record of their influence is thin, although their ministrations on behalf of the darling firstborn child and only son can be imagined from

the image of Tom in a lace-trimmed collar at the age of five or six (see fig. 4). His mother and her sister were frequently addressed in his letters from Paris, but usually on ladylike subjects, such as women's fashions, or in defense of questionable expenditures. Although he spoke as an intellectual peer in his letters to his father, Eakins adopted a tone of affectionate condescension in remarks written to his mother, sisters, and fiancée, revealing assumptions of male superiority and responsibility that would surface later in his teaching.[17] Such attitudes were typical in his day; more surprising and progressive was his willingness to grant opportunity to women: "I do not believe that great painting or sculpture or surgery will ever be done by women," he wrote in 1886, "but good enough work is continually done by them to be well worth the doing."[18]

Eakins was described as "domineering" when he was young, but his relationships with women matured in response to the frailties and talents of his own relatives. His mother's emotional fragility, read in the circumstances of her final illness, which kept the entire family at home prior to her death "from exhaustion from mania" in 1872, may have contributed to his attitude toward women, at once arrogant and unusually compassionate.[19] His sisters also taught him from their strengths: Fanny, very musical and intellectual, supported him staunchly during his trouble in 1886; Maggie (fig. 14), lively and athletic, volunteered to be "manager" of his exhibition entries. Their warm and respectful relations proved a model of close friendship with women that would be repeated with his wife and many students and friends over the years. Among the women in his family, only Caddy (fig. 15), almost twenty-one years younger than her brother, found Eakins' domineering and unconventional ways intolerable. When she turned against him in 1886 to denounce his manners and morals, she found the rest of the family on his side. While the "dainty" Miss Caroline's reaction to her brother's "wolfish looks" and "boorish manners" was described by others as "supersensitive" and inflamed by the malevolence of her husband, her revulsion must have been shared by a portion of the women in Eakins' milieu. His careless grooming and blunt speech seem to have been formed in opposition to genteel, feminine culture—that is, unconsciously if not intentionally calculated to offend those he most despised for their affectation, while testing the tolerance and loyalty of his friends.[20]

Although much of Eakins' social demeanor seems formed in order to challenge "ladies" (and unite, perhaps with suspicious stridency, with manly culture), his earliest art training may well have come from the women in his family, who were most often vested in this period with responsibility for the artistic environment in the home. Like Winslow Homer, Eakins may have been guided by the example or encouragement of his mother, although no record of her influence has survived, perhaps because she died at the outset of Eakins' career, under murky and unhappy circumstances.

Mrs. Caroline Eakins' elusiveness reconfirms, then, the domination of Benjamin Eakins, who was himself an amateur artist and for fifty-one years the writing master at Friends' Central High School in Philadelphia. Certainly he taught his son penmanship and guided his first efforts in drawing, for by the time young Eakins was seventeen he was assisting his father as a calligrapher, and by 1863 he had announced himself as a writing teacher, too.[21] The legacy of this training remained visible in Eakins' handwriting for the rest of his life and in the manifest emphasis on drawing and writing that lay at the foundation of his work.[22] Benjamin Eakins' early encouragement may be read very simply in the retention of all the juvenile sketches and high school projects that, along with Eakins' life class drawings and letters from Paris, ultimately survived to fall into Charles Bregler's custody. Eakins himself was not careful or sentimental about such things; they must have been treasured by his parents as evidence of his talent and bright prospects long before his professional course had been determined.

Other than this demonstration of pride and expectation from his parents, little more is known about Eakins' earliest training or the dawn of his own artistic consciousness. Remembering a pretty girl seen in his boyhood, Eakins remarked in 1874 that even then he was "very noticing and beauty always impressed me very much."[23] No other anecdotes about his early inclinations survive, perhaps because he was never famous enough in his lifetime to draw adulatory interviewers, and the usual family witnesses died well before biographers took an interest. What might be guessed from this silence, and from the other accounts of his youthful accomplishment as a scholar and an athlete, is that Eakins had no early calling as an "artist" but identified himself first as a teacher, like his father.

The horizons of this "very noticing" boy remained open, mostly thanks to Benjamin Eakins but probably with the assistance of his two best friends, both depicted in *The Chess Players*. Bertrand Gardel, seated at left, may have been born in France; he tutored Tom in French and probably encouraged his plans to study in Paris. While he was studying abroad Eakins sent Parisian newspapers and political gossip to Gardel. Evidently a man of wealth and old-fashioned taste, Gardel must have drawn the Eakins family into the plans for his wife's monument in Mount Vernon cemetery, constructed after her death in 1862 (fig. 16). This grand neoclassical pile, inspired by Canova's designs (interpreted by the Philadelphia architect Napoleon Le Brun and the Belgian sculptor Guillaume Geefs), must have seemed glamorous and artistic with its allegorical references to the continents and its classical figures in mourning.[24] Gardel's erudite example as a patron of the arts must have inspired Eakins, who seems to have composed a colossal funerary monument of his own at about this time (cat. 15c). Twenty years later he integrated classical figures of the same type into his own relief sculpture (cats. 204, 262).

Facing Gardel across the table in *The Chess Players* is Benjamin Eakins' other dear friend, George W. Holmes (fig. 17). A landscape painter, Holmes was also a teacher from whom "many young Philadelphians received their first art in-

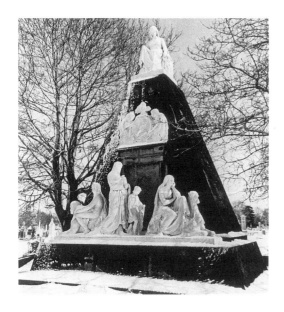

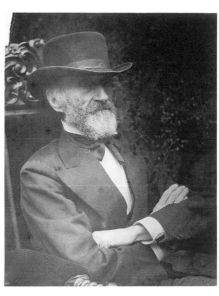

16. Napoleon Le Brun and Guillaume Geefs, *The Gardel Monument*, c. 1862, Mount Vernon Cemetery, Philadelphia, photo courtesy of the Fairmount Park Art Association Archives, Historical Society of Pennsylvania.

17. *George W. Holmes, Seated in Carved Armchair, Facing Right, Arms Folded*, c. 1885, platinum print, 8⅝ × 6⅞ in., 1985.68.2.186.

struction."[25] Mr. Eakins owned a landscape by Holmes, which he lent to the Academy's annual exhibition in 1865, and young Tom donated a painting—*Rail Shooting* (see fig. 122)—to an auction held in January 1878 to benefit Holmes after he became disabled by blindness.[26] Holmes exhibited at the Academy from 1840 until 1876, mostly showing landscape subjects, often in watercolors, from the shores of the Wissahickon, Brandywine, or Delaware Rivers. Susan Eakins remembered that father and son would go on Sunday sketching expeditions with Holmes, perhaps forming, as Goodrich suggested, the picnicking group seen in one of Tom's boyhood drawings (cat. 2), showing his "elders seated under a tree, with a lunch basket and a bottle."[27]

Holmes' fondness for watercolors and waterside industrial sites may lie behind one of the earliest drawings (and one of the few watercolors) in the Bregler collection: *Mill Buildings by a River* (fig. 18; cat. 1). The combination of stipple and wash in this view shows an awareness of midcentury watercolor techniques, although their amateurish and inconsistent application tells us that the artist's knowledge was superficial or new. More remarkable is the choice of subject—a very modern and, to the period, unpicturesque grouping of mill buildings, perhaps from somewhere along the Schuylkill River. Even as a teenager Eakins was alert to unlikely contemporary subjects, painted from life. The disparity of style between the architecture and the landscape evident in this work likewise betrays a pattern that will characterize his later work: already, the components of the scene are being attacked with different pictorial strategies. The different focus on the buildings may indicate that this picture began as a problem in perspective, for the geometric volumes of the mill form the principal challenge of the drawing, while the water surface offers a field for the display of reflections. Although earnest and ambitious, the imprecision of this rendering betrays a level of skill lower than that demonstrated in Eakins'

18. *Landscape Study: Mill Buildings by a River*, c. 1858–62 (cat. 1).

high school drawings from 1859–61 (cats. 5–14). However, the paper used is identical in size and quality to the sheets used for these classroom projects, perhaps indicating that the relative insecurity of this drawing may be a result of the greater complexity and novelty of an outdoor subject, undertaken as a corollary to his first geometric and mechanical drawing exercises.

Holmes may also have been indirectly responsible for a group of landscape drawings that seek to rectify the weakness seen in the foliage of Eakins' watercolor. These four double-sided drawings (cats. 4a–d) are remarkable for their repeated subjects, sometimes neatly labeled ("Ash," "Oak," "Elm") and executed in a conventionalized drawing style, with the occasional decorative monogram ("JDH") in addition to Eakins' signature. These characteristics signal the presence of a model that Holmes surely knew well: *Lessons on Trees*, published in 1850 by James Duffield Harding (1798–1863). A popular English watercolorist known for his picturesque travel

subjects, Harding was the author of "several text books for schools and other highly-regarded works on art subjects."[28] In 1850 the *Art Journal* declared that "no artist of his time has done so much to create a love of landscape painting, and to diffuse a right knowledge of it as Harding," who was described as "emphatically a great teacher."[29] Holmes may have shared this opinion, for in 1841, near the outset of his own exhibition career in Philadelphia, he submitted an item to the Academy entitled "Drawing in lead pencil after J. D. Harding."[30] Although none of his pictures have been located today, the titles of Holmes' exhibition entries at the Academy indicate a bent toward watercolor and landscape views very much in the Harding vein. If, as a family friend, Holmes recommended Harding's work, Eakins could not have failed to respond.

Harding's reputation and the ubiquity of his textbooks could have sufficed, however, to impress any art student in the 1850s. Rembrandt Peale, the painter and author of *Graphics,* the basic drawing manual at Central High in Philadelphia, used texts by Harding to supplement the drawing curriculum he designed for the Philadelphia schools.[31] Perhaps Eakins' drawing teacher at Central, Alexander Jay MacNeill, suggested *Lessons on Trees* for supplementary work outside of school. Whatever the source of his reference, Eakins was not alone in turning to Harding; even John W. Casilear, already a professional engraver and painter by the time *Lessons on Trees* was published, took a turn at copying these plates.[32]

Like many mid-nineteenth-century drawing manuals, Harding's work was organized around a series of plates containing progressively more difficult lessons to be mastered sequentially by the copyist. The earliest plates teach contour and shading conventions for various tree types, offering a graphic "shorthand" to suggest the character of bark and foliage on certain common trees (fig. 19). Eakins practiced these schematic contours in a jumbled fashion (cats. 4a, 4d) and went on to study with greater care the more developed tree motifs presented in Harding's plates 6 through 8 (cats. 4a–c). If extant pages are representative of his course of study, he jumped from here to plate 23 (fig. 20) to make the only completed landscape "scene" in his series (fig. 21; cat. 4d).

This sequence of drawings is instructive in many ways. Because this book, and landscape work in general, were not included in his school curriculum, these exercises demonstrate Eakins' motivation to self-improvement and directed study, perhaps under the supervision or instigation of an adult, perhaps completely alone. Such do-it-yourself instruction manuals, often aimed at children or amateurs without access to formal training, had been growing in popularity throughout the nineteenth century, and nowhere with more enthusiasm than in the United States.[33] Eakins was typical of his class and of the period in turning to a book for self-improvement, but his later patterns of research and independent study make this early course in landscape drawing by way of the library seem especially telling. With typical pre-

19. James Duffield Harding (1798–1863), *Lessons on Trees,* 1850 (plate 2).

meditation, Eakins sought a systematic approach that would equip him with knowledge, skills, and stratagems to control his subject before it was ever confronted. Insecure and prone to overpreparation, Eakins hoped to learn from the conventional wisdom of a seasoned practitioner like Harding before ever stepping out-of-doors. This impulse toward disciplined preparation as opposed to improvisatory confrontation remained consistent through Eakins' life. More confident later about his own skills as an observer, he needed a crutch as a student, and a book offered a comforting, rationalized approach, promising the tools to manage the chaos of nature.

But there were many such books to choose from, and Eakins' use of Harding, in particular, shows his respect for contemporary mainstream taste and the authority of experts. These attitudes would not be remarkable in a teenage boy of this period, except that not all art students show such receptivity, and Eakins, in particular, made homage to expertise a theme in his work for forty years. While it is possible that this book fell into his hands accidentally, it seems more likely that he selected *Lessons on Trees* after considering the alternatives. Compared with other books on landscape sketching, Harding's book had two advantages in addition to its reputability that must have appealed to Eakins: modernity and specificity.[34] Like most art instruction books, *Lessons on Trees* was the product of an older painter, expressing the wisdom of an earlier generation, but it was nonetheless one of the newest books on the subject and one of the most narrowly focused. Eakins' taste for detailed, pertinent study is also revealed in this choice, for he could have picked other books—including

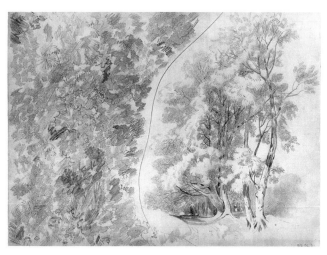

20. James Duffield Harding, *Lessons on Trees*, 1850 (plate 23).

21. Eakins, after Harding, *Tree and Foliage Studies* (cat. 4d).

many by Harding—treating broader issues of landscape art. But, with typical directedness, Eakins did not want to know about "landscape," he wanted to know about *elms* and *oaks*.

Given Eakins' lifetime attention to such detail, it is worth noting the even more up-to-date and more rigorously naturalistic book on landscape art that he did not choose: John Ruskin's *The Elements of Drawing* (1857). Ruskin's art criticism was already well known in the United States, but the popularity of his drawing book would not reach peak until after Eakins' student days, when Ruskin replaced his own teacher, Harding, as art instructor to the millions.[35] If Eakins hesitated over *Elements of Drawing*, perhaps considering it too basic or general, or too new to have been sufficiently tested, he might have turned to Harding on Ruskin's own advice, for Harding's drawings of trees were heartily recommended in the text.[36] Meanwhile, Ruskin's own teachings remained controversial. Even though the native landscape school was gradually turning to a more factual and localized description of the American scene throughout the 1850s, the most zealous Ruskinian painters in the United States remained a small and highly criticized minority. This group, known as the American Pre-Raphaelites, was most active between 1859 and about 1865. The English sources of their style received considerable scrutiny in 1857 and 1858, when a large traveling exhibition of British painting made the rounds of Boston, New York, and Philadelphia.[37] One of Eakins' older colleagues, the painter W. T. Richards, converted to Ruskinism almost overnight in response to the English Pre-Raphaelite pictures in the selection shown at the Pennsylvania Academy. Eakins, however, seems to have been swayed by the more conventional work of the British mainstream that statistically dominated this exhibition. These painters, including Harding, represented the romantic landscape aesthetic that had shaped the Hudson River School and still inspired its painters. In its dependence on picturesque con-

ventions and "recipes" for paint handling, color, and composition, the method of Harding and his contemporaries was profoundly un-Ruskinian, even though Ruskin himself might admire Harding's skillful observation. Harding's graceful record, in becoming a model for students to copy, added a second layer of artifice to the system; *Elements of Drawing*, by contrast, suggested that the student draw immediately from objects at hand, not from illustrations in a book.

Eakins' rapid "graduation" from Harding's manual implies such a Ruskinian critique, though his independent outdoor sketches show a sympathetic grasp of Harding's aesthetic and little of Ruskin's patient practice. From the evidence of extant drawings, Eakins lost interest in the secondhand study of nature rather quickly. Like most students working from this kind of progressive text, he made an earnest show of discipline on the early lessons and then skipped ahead to plate 23, one of the first pages in the section of "much advanced" subjects. Only one such "advanced" study survives, and it may have been the only one he completed, for if the earlier exercises were saved, we can imagine that the more ambitious ones would also have been retained. After this drawing, Eakins apparently moved outdoors, following Harding's intention that the book serve "not so much to supply him with examples for imitation, as through their instrumentality to make him capable of observing Nature truly for himself."[38] The landscape vignettes in Eakins' sketchbook reinvent the compositions in Harding's advanced plates, but from material at hand—tree stumps and fence posts in his own "back yard" (figs. 22, 23).

Two things are apparent in this progression from book to field: Eakins grew bored or dissatisfied with Harding's artifice and hungered for real subjects or a less mannered graphic system; and he could inventively recapitulate from his own experience the picturesque structures of Harding's aesthetic. Eakins' small landscape studies *not* done from

22. James Duffield Harding, *Lessons on Trees*, 1850 (plate 17).

23. *Landscape Studies*, c. 1862–66 (cat. 15i).

Harding show a comprehension of Harding's underlying grammar, if not a graceful command of his surface. Such an ability to work creatively, finding fresh (and sometimes awkward) analogues before him of structures learned from Harding—or Phidias, Velázquez, and Gérôme—would be one of Eakins' greatest strengths, inspiring some of his most innovative "American" work.

The acceptance of these deep structures of the picturesque seems more remarkable, too, when contrasted to the theoretical opposite, represented by the naturalism ascribed to both Eakins and Ruskin. Eakins, cast as the paradigmatic realist, ought to have embraced the religiously descriptive selecting nothing–rejecting nothing manner Ruskin advocated for students. In fact, both men admired Harding; their American followers or apologists would have them be less tolerant, more purist than they really were. Judging from his youthful remarks, Eakins held literal description in low regard at this moment, and perhaps he had also stereotyped Ruskin and rejected his teachings along with most of English art and culture.[39] "A big artist does not sit down monkey like to copy a coal scuttle or an ugly old woman like some Dutch painters,"[40] he wrote to his father in 1868, implying a compa-

rable disdain for contemporary advocates of patient imitation of nature. That Eakins himself would be later lumped with such realists is an irony of art history; such opinions should not restrict our view of the spectrum of realisms contending in the 1860s, embracing actual practice, announced principles, and perceived (or misunderstood) intentions. Within this field of interpretations, Eakins imagined a realism that was different from simple transcription or "re-creation" of nature. Instead, he argued that an artist "steals nature's tools" (light, color, form) for his own use in order to follow a course "parallel to Nature's sailing," not literally in Nature's track.[41] Harding offered such tools second-hand, which Eakins later rejected along with the whole concept of copying other artists' work. But Eakins would continue to seek other useful tools; his struggles as a painter in the 1860s and '70s testify to his conception of the artistic enterprise as essentially contrived, a mustering of rationally derived techniques in service to an illusion of natural effect. His early brush with Harding illustrates this search, reminding us of Eakins' awareness of the fundamental artifices of art-making and his willful construction of a realist technique that was anything but the product of an "innocent" eye.[42]

Central High
School, 1857–1861

The sophistication and artifice of his early training comes to the fore proudly in Eakins' classroom drawing projects from public school in Philadelphia, where he learned skills and habits that shaped his entire career. Disciplined and tightly directed techniques emphasizing neatness and control were instilled early, for two carefully tinted and decorated maps from classes at Zane Street grammar school in 1856–57 show an admirable command of penmanship and watercolor washes by the twelve-year-old Eakins.[1] Proficient at all of his studies, he successfully competed for entrance into Central High School in the summer of 1857. Eakins, who was almost two years younger than most of his classmates, encountered at Central a liberal arts curriculum comparable to that of many colleges of the day. Mathematics and the sciences received special emphasis, and the weekly four hours of drawing instruction, given by A. J. MacNeill, predictably dwelled on the practical or scientific applications of drawing. Geometry, perspective, mechanical drawing, decorative lettering, and ornamental "design" were taught, all with an eye to useful employment in the realms of architecture, engineering, technical illustration, or industrial design. Eakins won high marks all four years in math and science; in drawing, his grades were perfect.[2]

The character of this art training has been deduced from four drawings released by Bregler in the 1940s, all now in the Hirshhorn Museum. Bregler sold the most conventionally "picturesque" of the drawings in his possession—two copies after contemporary prints—and the largest, most elaborate pieces—*Drawing of Gears* and *Perspective of Lathe*, of 1860.[3] An additional ten drawings remained in his portfolios, however, and they now offer a much more complete picture of Eakins' high school art training. The entire group must be close to a complete survey of his course work, and therefore it also serves as a unique illustration of the most advanced art curriculum of the Philadelphia public schools, by one of the system's most proficient students.[4]

Central High School provided one of the most thorough and progressive art instruction programs in American public education. This course of study, thoughtfully reconstructed and analyzed by Elizabeth Johns on the basis of previously known drawings and contemporary records, had a decisive impact on Eakins' artistic method and outlook. As Johns notes, this training "differed considerably in objectives, scope and ideals from art academy instruction of the nineteenth century."[5] To some degree utilitarian, based on hopes for a visually literate and articulate society, the simultaneous, interrelated tuition in writing and drawing at Central also embodied a premise that clarity of draftsmanship would inspire clarity of thinking. This philosophy motivated the artist Rembrandt Peale, who designed the curriculum in the 1840s and wrote the instruction manual *Graphics*, used by all students in their freshman year. For the first two semesters, students practiced basic linear exercises, undertook simple descriptive drawing projects (facial profiles, an egg), and then mastered a succession of ornamental scripts. Two-dimen-

sional sources, such as Peale's book or lithographs of figures and landscapes, dominated the curriculum through the sophomore year, when students copied decorative patterns as well as illusionistic scenes. In the third year (1859–60 for Eakins), three-dimensional subjects were tackled with perspective drawing systems, and the senior year was devoted to the conventions of mechanical drawing (see fig. 24). Each semester was designated by a letter code, from A to H, that sometimes appears on Eakins' drawings. This sequence, spelled out by Johns, can now be correlated to the entire group of drawings as follows:[6]

1857 H Penmanship; Peale's *Graphics*

1858 G Penmanship; Peale's *Graphics*; copy of prints
 [Hirshhorn, cat. 3]

1858 F Penmanship and patterns; copy of prints
 [Hirshhorn, cat. 4]

1859 E Penmanship and solid objects; copy of prints
 [Dietrich, cat. 13]

1859 D Perspective drawing; ornamental writing
 [CBTE, cats. 5–9]

1860 C Perspective drawing; ornamental writing
 [CBTE, cats. 5–9]

1860 B Mechanical drawing; ornamental writing
 [Hirshhorn, cats. 5–6, CBTE, cats. 10–13]

1861 A Mechanical drawing; ornamental writing
 [CBTE, cat. 14]

This sequence shows clearly that all of the newly discovered high school drawings, and now the majority of Eakins' extant work from Central, comes from his last four semesters of study, in 1859 and 1860. Evidently the earlier exercises were mostly penmanship or too elementary to be worth saving, except for the three prints copied in semesters G, F, and E. Given the size, range, and complexity of the drawings surviving from 1859–60 and the limited amount of class time spent each week on these projects, we might assume that these sheets represent most of Eakins' classroom art work during these years, and perhaps a considerable amount of independent time. The only odd thing about the pattern of distribution is the intensity of work in the fall of 1860 (which included the monumental *Lathe*) and the relative emptiness of semester A, the spring of 1861, when he produced only the image of *Thomas Crawford's "Freedom"* (see fig. 27), dated just prior to graduation.[7]

With the number of extant drawings from this period now tripled, a few observations can be made. First, the conclusions reached by Johns in 1980 are substantially confirmed. The breadth of skill she presumed from Eakins' completion of a difficult and extensive examination in September 1862, when he applied for the job of drawing master to succeed his teacher MacNeill, can now be more fully illustrated.[8] Considering the proficiency of these surviving drawings, which, as Goodrich has noted, surpass in competence the work of many mature artists,[9] certain assumptions about Eakins' capability can be reinforced: that he was a master of line and wash, capable of drawing, with patience and delicacy, very complex forms in space. Therefore, the relative impatience and crudeness of drawings made later in his career must be a matter of choice—that is, low investment of care—not incompetence, and the broken, blotty shadows of his watercolors represent intention, not inadvertence, for Eakins could, if he wanted, overlay washes to a perfect blackness (see fig. 27) or seamlessly graduate them from light to dark (fig. 24).

The perfect anonymity of the style learned in school, with its straight edges and cool surfaces, also stands as a reference point for the realism Eakins constructed for himself in the 1870s. Deemed naturalistic and "photographic" later, Eakins' style actually took long strides away from the mechanical, self-effacing manner of his youth to achieve the relatively expressive treatment of light and paint seen in *The Gross Clinic* of 1875 (see fig. 88). His movement away from the mechanical-drafting style of these drawings may have indicated dissatisfaction with its expressive potential but not a rejection of its usefulness, for he readopted the aesthetics of this approach when designing the illustrations for his own drawing manual in the 1880s (cats. 92–144), and the techniques of perspective drawing still informed his last extant drawings (cats. 209–227). Like a foreign language, the style of these schoolboy drawings remained accessible for the occasional, appropriate moment of communication. Like the artificial mode of the Harding drawings, but more pervasive and lasting, this was Eakins' first visual language, and its structure existed whole, for later use as needed, and as a base for the development of a more personal style. Again, we are reminded of the spectrum of realisms available to Eakins and made aware of the self-conscious choices available to a painter with this early command of technique.

The same statement of knowledge, of early experience and then deliberate choice, rises from the materials of these high school drawings. Ten out of the twelve perspective and mechanical drawing studies now known are on excellent paper: five show the watermark of a premier English papermaker (Whatman), and another five (including fig. 25) are on a similar but unmarked medium-weight linen or cotton wove stock.[10] Likewise, all of his drawings made in the Pennsylvania Academy's classes from 1862–66 (e.g., see figs. 29–34) are on classic charcoal paper: handmade, probably French, with prominent chain lines and a recurrent watermark.[11] This good and relatively expensive imported paper may have been stipulated or recommended by his instructors, but whether or not it was his own choice, such paper shows an early acquaintance with the finest drawing materials. Eakins remembered these high standards, always, in his watercolor painting; his exhibition pieces were invariably painted on such good paper. On the other hand, his later failure to use this high-quality

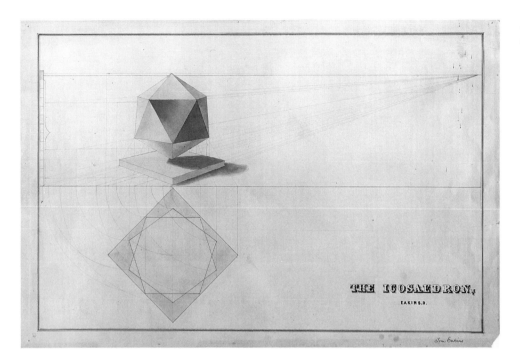

24. *Perspective Drawing: The Icosahedron*, 1859 (cat. 5).

paper for preparatory drawings and sketches could not have been unconscious or ignorant. Economy may have motivated him, but his use of inexpensive, handy papers, such as the backs of Academy fliers, also expresses a sense of his drawings as lesser, private events of only passing importance. The pleasure of fine paper, even as a personal aesthetic indulgence at the moment of drawing, seems to have held no sway with Eakins later. After his student days he rarely sketched on anything but cheap paper, usually ruled foolscap conventionally folded in half and embossed in one corner for use as stationery, or large sheets akin to "butcher paper," probably cut from a roll to match the scale of his paintings. The variety of later paper types has only one pattern: all are inexpensive, household papers, not artist's papers. With perfect consistency, his writing paper also varies according to the nature of the text; official correspondence, such as a letter to the Academy's directors, is on finer paper than most of his sketches.[12] Just as the technical competence of his high school drawings provides a stylistic reference point for Eakins' realism, so their materials offer a benchmark against which later choices can be measured. His later habits may tell us, retrospectively, that these drawing projects were "performances" for the benefit of his teachers, much like the later exhibition watercolors. And, contrasting the classroom projects with the personal sketches of the same period (cats. 4, 15), they reveal a hierarchy of materials as well as of effort, separating the public from the private presentation, even at this early date.

More important than technical finesse or taste in materials, Eakins' schoolboy drawings also reveal habits of mind and method that would endure, as Johns has noted, for a lifetime. These drawings manifest the link between "seeing correctly and thinking profoundly" espoused by Peale's interde-

pendent writing and drawing system, and they also enact a belief in discipline and persistence in accomplishing an incremental, step-by-step mastery of skills or problems.[13] Eakins learned to equate art with hard work and careful preparation at Central, and he embraced the utility of science and mathematics as tools for the construction of an artistic presentation, and as models for artistic problem solving. "All the sciences are done in a simple way," he told his students. "In mathematics the complicated things are reduced to simple things. So it is in painting. You reduce the whole thing to simple factors. You establish these, and work out from there pushing toward one another."[14] The systems were not just analogous to Eakins; they were pleasantly interrelated, mutually reinforcing, aesthetically satisfying. "You ought to take up the study of higher mathematics," he told Bregler. "It is so much like painting."[15]

Eakins' school exercises demonstrate the interpenetration of the beauties of art and mathematics, allowing us to deduce what "art" making entailed at Central, and what it did not. In the relatedness of seeing clearly and thinking clearly proposed by Peale's curriculum, a heavy bias ruled in favor of the conceptual over the perceptual, if Eakins' drawings indeed illustrate the full range of classroom assignments. "Strain your brain more than your eye," said Eakins to his own students later.[16] None of his high school drawings, save perhaps the *Lathe*, depended on observation of the real world, and even the lathe was constructed from a perspective grid, not sketched freehand from nature. The first of his assignments (copies from prints) as well as the very last (Crawford's *Freedom*, probably copied from a photograph or an engraving) evidently responded to sources that were already translated into two dimensions, in black and white. If not

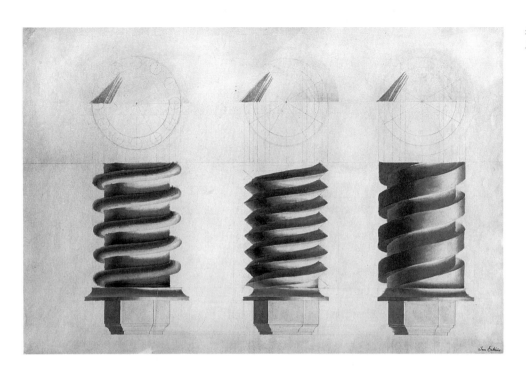

25. *Mechanical Drawing: Three Spirals*, 1860–61 (cat. 13).

also copied from textbook plates, most of the other "objects" depicted in his perspective drawings were imaginary Euclidian solids in a hypothetical space, seen in the mind and geometrically derived rather than observed. These icosahedrons teach faith in measurement and mapping, not vision, which can be faulty or deceived even when most acute. The mechanical drawings from his senior year, such as the worm gears and screws (fig. 25), are even more abstracted. Unlike perspective drawings, which presume a fixed viewer position within sight of the subject, a mechanical drawing exists as if made from a "perfect" vantage point at infinity, so distant that all parallel lines in the object remain parallel in the drawing, rather than converging to a vanishing point. Flat, like an architect's elevation, these renderings depict things as they can never be seen in the world: evenly detailed, uniformly lit, undistorted by viewpoint.

From the beautiful purity, regularity and control of the geometrical world enjoyed in these drawings, we can imagine Eakins' perplexity as he and his graduating class (fig. 26) faced the myriad unknowns and anarchic contingencies of the perceived world. The setback in his skills visible in the landscape and figure drawings done after his graduation from Central measures this transition from conceptual to perceptual work. Forever after in Eakins' drawings the geometric world remains a refuge of steady, ruled lines and clean, confident assertions; the perceived world is tentatively stated as an elusive, ghostly contour or restless skein of lines (cats. 172–173, 191). Always the lord of that mathematical world, he would spend a lifetime struggling to master with equal finality what lay before his eyes. Revelation of the prejudices— and the skill—of his high school training helps us to understand, then, Eakins' habitual conceptualization of his subject,

26. O. H. Willard, *Central High School Group Photograph*, 1861, salted paper print on cream wove paper, 7½ × 5½ in. oval, 1985.68.2.3. Eakins is at 3 o'clock; his friend, Billy Sartain is at noon; Max Schmitt is at 4 o'clock; Will Crowell is at 5.

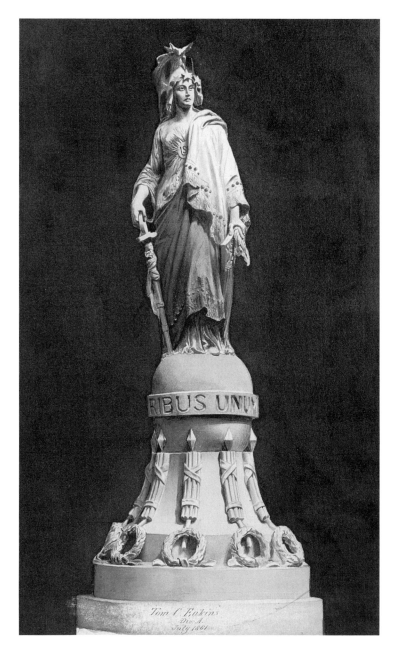

27. *Thomas Crawford's "Freedom,"* 1861 (cat. 14).

prior to painting. According to Bregler, Eakins always had the organization of his picture well in mind before beginning to paint, and he altered the image very little between the initial, thumbnail sketch and the final canvas.[17] First established in space, like a cylinder or a lathe, his figures were then studied from life for characteristic detail. This method, reliant on preconception and geometric underpinnings, grew logically out of the classroom experience at Central High.

Little creativity or personal expression was encouraged in these school "art" projects. Even the liveliest rhetorical image, of Crawford's *Freedom* (fig. 27), seems to have been a twice-removed statement of Northern patriotism at the outbreak of the Civil War, being copied from a reproduction of another man's allegorical figure. Like Benjamin Eakins' *Lord's Prayer,* it is a parlor piece, expressing publicly a perhaps deeply felt but nonetheless conventional opinion, de-

rived from a popularly held source. This kind of copied work, as the height of aspiration in the final semester of art classes, reveals the virtues and limitations of Eakins' standardized, public-school training, with its emphasis on accuracy and lucidity of communication, cleanliness, mastery of craft, and democratic self-effacement. But originality or independence of thought and technique would not have been encouraged, much less taught, at contemporary art academies, where the direction of studies was likely to be just as stilted and narrowly bound to issues of craft and convention. The focus and the exercises were different, however, at a formal art school, and Eakins' enrollment at the Pennsylvania Academy of the Fine Arts in the fall of 1862 must have intentionally sought to redress the omissions of his training at Central with an avowedly "artistic" education.

CHAPTER 3 The Pennsylvania Academy
of the Fine Arts, 1862–1866

Eakins' classes at the Academy began, like most art instruction of the period, with the same kind of exercises he had first undertaken at Central High School. Given his skill, he probably skipped the stage of copying prints, which sometimes occupied beginners at the Academy, to consider models that, although still black and white, were three-dimensional. As their first act following the foundation of the institution in 1805, the Academy's directors had ordered plaster casts of antique and modern sculpture for the instruction of students (fig. 28). Eakins began, like countless others before and since, drawing these casts in charcoal. Like the mathematical procedures he admired, the study of casts reduced a complicated problem—rendering the human figure—into its simplest components. Colorless, motionless, and usually quite smooth, the cast isolated the issues of contour and mass, offering the student a chance to master outline drawing and the modeling of light and shade. It was assumed that the student simultaneously absorbed the principles of classical art vested in the composition, expression, and treatment of detail seen in the sculpture. Even at this earliest moment, then, the Academy's training differed from the curriculum at Central in its paramount emphasis on the description of the human figure and in its attempt to bring the student into a relationship with great historical works of art. Unlike the method at Central, both of these strategies showed a professional orientation specifically addressed to the western tradition of painting and sculpture. This tradition, invented in the Renaissance and codified by European art academies organized from the late sixteenth to the eighteenth centuries, recognized the human figure as the measure of creation, the most noble subject of the artist, and therefore the center of all instruction at the professional art school. It was assumed that if one could draw the human figure well, one could draw anything.[1]

Eakins, the master of imaginary icosahedrons, was clearly rocked back by this shift into three dimensions. The translation of the seen object in space onto the two-dimensional page demanded different hand-eye skills, complicated by the introduction of a new medium, charcoal, that behaved differently from the hard, abstract, graphite and ink line or wash of his high school drawings. The insecurity of this moment is betrayed in two small sketches and a large page of studies discovered in Bregler's collection: sketchbook pencil drawings of a *Son of Niobe* (cat. 15c) and an unidentified *Head in Profile* (cat. 15d), and a sheet filled with five or six fragmentary views in charcoal of the neck and jaw of a sculpture, probably (as Eakins' inscription declares) a Hellenistic or Roman *Hercules* (fig. 29). Eakins may have continued to draw from casts after his promotion to the life class in 1863, and he seems to have been put to work again, very reluctantly, drawing casts at the Ecole des Beaux-Arts in 1866–67, but the cautiousness in *Hercules* makes us assume that this is an early drawing, probably from 1862–63.[2] The short, tight and delicate hatching in this drawing seeks the familiar graduated shadows of his mechanical drawings; Eakins, at this mo-

28. Charles Truscott, Pennsylvania Academy of the Fine Arts, drawing studio, c. 1890, PAFA Archives photo.

29. *Figure Study: Hercules,*
c. 1862–66 (cat. 16).

ment, had not yet learned to exploit the qualities of charcoal. By comparison, his only other surviving charcoal drawing from the antique, *Study of a Warrior's Head,* probably made from the bust *Menelaos* in the Academy's collection, uses charcoal with breadth and bravado. Because of this greater boldness, as well as the presence of a drawing of a nude man on the other side of the sheet, *Menelaos* must have been done later, after his entrance into life class in February 1863.[3]

The progress made between *Hercules* and *Menelaos* is demonstrated many times over in Eakins' life class drawings, although *Hercules* introduces in exaggerated form the qualities of these early figure studies. Typically, Eakins never considered the sculpture as a whole, but only in detail, particularly the zone of the chin and neck, which is depicted repeatedly from different viewpoints. This close examination indicates special interest in the problems of this area, perhaps brought to Eakins' attention by the lectures on "artistic anatomy" that students in the antique class were invited to attend. His tight focus may betray a personal concern then, but it was also typical of elementary art instruction of the period, which urged beginning students to consider fragments in isolation—feet, hands, ears, noses, mouths—and master the difficulties of the figure part by part.[4] Again, this strategy matched Eakins' propensity for breaking complex problems into simple parts, to be methodically solved in sequence and then reassembled into a synthetic solution. The Academy's

cast collection, with its assortment of broken figures taken from larger sculptural groups (such as *Menelaos,* or a son and the head of a daughter from *Niobe and Her Children*), damaged figures (such as the Parthenon pediment sculptures), and fragments (such as *Foot from Canova's "Boxer"*), encouraged this kind of detached study. Indeed, several of the life studies in the Bregler collection (e.g., cats. 19–21 [see fig. 31], 26) could be from casts made from nature, for the collection included life casts of feet and a right knee, as well as hands, torsos, and life masks.[5]

Eakins further fragmented this approach by cropping the face of Hercules in ways that seem to abstract the subject intentionally, heightening the disorienting effects of his unusual viewpoints. In addition, he jumbled his sketches onto the page in a disjointed fashion characteristic of all his preparatory work. Perhaps mindful of the expense of his paper (although he used the back of the sheet only a fifth of the time), Eakins crowded the studies together with no regard for the integrity of any single image or the relationship of the drawings—separately, or as a group—to the borders of the paper. It is as if his interest was so firmly attached to the subject in its illusionistic space that the two-dimensional surface of the page became truly transparent, certainly irrelevant. This focus on the object and disregard for the pictorial surface betray Eakins' prejudices as an old-fashioned realist. Not insensitive to qualities of design and surface in his finished work, his attention to the object at the expense of the pictorial plane remains apparent in all his life drawings and his later preparatory sketches in pencil and oil. The framing edges of his finished paintings would be carefully considered, but the decision was made after the image had been established, not before (cats. 155–156, 172–173, 192–194, 211). Spontaneous sketches almost never interacted with the paper or canvas shape, except perhaps to attach themselves to the upper left-hand corner or left margin (cat. 250). This attitude when sketching matched his indifference toward drawing materials and preparatory pieces in general: purposeful and directed, they were for private investigation, not display; the nicety, even the coherence of the final product mattered little.

These qualities of focus and organization emerge throughout Eakins' life drawings, probably made at the Academy be-

tween late February 1863 and the conclusion of classes in the spring of 1866 (see figs. 30–34). Unity of style and materials suggests that all of Bregler's eleven charcoal figure studies (cats. 17–27) are from this period. Together with the cast drawings, this new group more than doubles the number of extant drawings of this type and period, and their reintegration with previously known examples allows reassessment of the problematic chronology of the entire group. Because none of these drawings are signed or dated by Eakins, scholars have speculatively assigned dates ranging between 1863 and 1876. Goodrich proposed that the drawings were all made in the Academy's life classes between 1863 and 1866; Hendricks suggested that they were from the Academy or the early years at the Ecole in Paris, about 1866–67, and Siegl attributed the weaker examples to the Academy, the better drawings to Paris, and the very best, such as fig. 30, to life classes with the Philadelphia Sketch Club, where Eakins volunteered his services as a visiting critic between 1874 and 1876. The only testimony on the subject came from Susan Eakins, who told Goodrich that she "thought" some were done in Philadelphia, before Eakins left for Paris, and perhaps others were made at the Ecole. Elsewhere she wrote that "only mechanical drawings in india ink and watercolor—and the naked figure of the heavy masked woman are saved from the period before 1866."[6]

Susan Eakins' sense that all the drawings date from before 1866 might be confirmed by the internal evidence of the figures themselves, who wear the hairstyles of the mid-1860s.[7] Their integrity as a group from this period may also be indicated by their common materials. Previously known drawings from this group are on handmade charcoal papers with five different watermarks.[8] The newfound Bregler drawings are all, with one exception (cat. 23, marked "LP"), on paper with an "EB" watermark—like the PMA's drawings 17, 18, and 19—dated by Siegl to 1874–76 on the basis of their greater sophistication. As both Goodrich and Siegl have noted, the availability of imported papers in America makes the watermark useless in determining where the drawings were made, but the common mark at least suggests that all of the "EB" drawings—from the beginner's *Hercules* to the three more advanced studies at the PMA—were made about the same time, or at least in the same place, from a single batch or source of paper.[9] It might be argued that a few identical "EB" sheets were purchased elsewhere or later, or that some were held back and used ten or twelve years on. However, the newfound drawings on the "EB" paper also show qualities of style and competence akin to both early and late groups proposed by Siegl, indicating that the disparity of skill seen in the available drawings may have given a false sense of separate periods. When all these drawings are regathered it appears that the pattern of selection and distribution from the original hoard in Eakins' studio broke the continuities visible in the whole set. This original collection, including at least thirty drawings, was culled twice: first by Susan Eakins, who gave eight charcoals to the Philadelphia Museum of Art

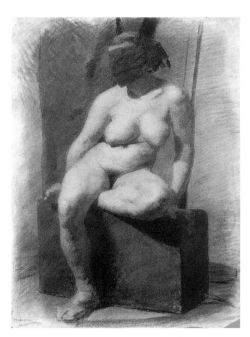

30. *Study of a Seated Nude Woman Wearing a Mask,* c. 1865–66, charcoal on paper, 24¼ × 18⅝ in., Philadelphia Museum of Art, Gift of Mrs. Thomas Eakins and Miss Mary Adeline Williams.

in 1929, and then by the staff of Babcock Gallery, who sold at least four (and perhaps as many as ten) of these drawings after her death in 1938.[10] The best drawings, and those showing complete, full-length figures, naturally were chosen first, so that all of the items remaining in the studio to be claimed by Bregler represented middling work and depicted only partial or unfinished figures.[11]

Following from this segregation of the group, the style of the Bregler drawings falls between the extremes chosen by Mrs. Eakins to exemplify her husband's student work. None of these drawings are as clumsy as *Study of an Arm* (Siegl, cat. 1) or as masterful as the famous *Seated Nude Woman Wearing a Mask*. Most veer toward the tentative style of *Hercules*, showing a short, choppy hatching that lacks the breadth and assurance of the five full-length figure drawings, including the *Seated Nude Woman*, assigned by Siegl to the mid-1870s. Only one, *Nude Man's Right Leg from Rear* (see fig. 34; cat. 27 verso), shows the same free combination of modeling techniques and comfortable sense of space surrounding the figure. Some, like cat. 23, *Knees of a Standing Man*, approach the same sense of form in space; others, such as cat. 20, *Three Knees*, display great delicacy of modeling. Other drawings in this group are flat and aimlessly scribbled (cats. 17, 18) or spatially confused by odd cropping and strongly contrasting, irrational patches of hairlike shadow. On some occasions the unusual viewpoint and cropping, adding to the disjointed incorporation of background elements, make the figure position difficult if not impossible to read (cats. 22, 25, 27). In such drawings there seems to be a will to make the body

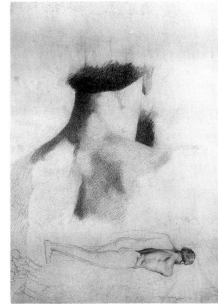

31. *Figure Study: Two Knees,* c. 1863–66 (cat. 21).

32. *Figure Study: Shoulders and Elbow of Seated Man,* c. 1863–66 (cat. 22).

33. *Figure Study: Nude Man's Right Leg from Rear,* c. 1863–66 (cat. 27).

34. *Figure Study: Man's Neck and Upper Back; Standing Nude Man from the Rear,* c. 1863–66 (cat. 24).

strange and the drawing abstract or intentionally puzzling, like the provocative foreshortening of the thighs and buttocks of the young patient on the operating table in *The Gross Clinic*.[12] When two or more such studies share the same page, as in *Hercules*, the visual effect can be both lively and unsettling (figs. 31, 32; cats. 21, 22).

This fragmented approach, characteristic of the beginning levels of study of the figure, must have dominated Eakins' first sessions at the Academy, when most of these drawings were probably made. Such studies were to be superseded, according to academic teaching, by synthetic construction of the entire figure. We might presume, then, that the studies of body parts came early, the full-figure studies late, but the style shared across these subject categories by a few of the drawings (such as fig. 33) suggests that the two

types coexisted at some point, and that the confident style of the full figures closely succeeded the fragments.

The transition from parts to whole could not have been easy for Eakins, as it countered the divide-and-conquer tendencies learned at Central. But, as Boime has pointed out, this change was a wrenching moment for all students of the academic method, who, after years spent pursuing details, suddenly heard their professors exhorting them to squint and seek "wholeness" of effect. Eakins, for one, never overcame this contradiction of strategies. "Model a foot or a head and finish as fine as you can," he told his students, while simultaneously urging them to "think of the big factors." Perhaps recognizing the conflict built into this system of teaching, and hoping to spare others his own confusion, Eakins reduced the time his students spent in class on study of prints,

casts, and drawing. "If I had known what I know now, I would have been a painter in half the time it took me," he said later.[13]

Aside from their relative differences in skill, these drawings are also united by technique, for all of them, from the least competent to the most masterful, employ the same methods and tools. In the early, awkward *Study of an Arm,* like the later *Nude Woman with a Mask,* he lays down broad stripes of charcoal and then rubs them, either with a finger or a rolled-paper "stump," to create smudgy shadows. These broad tones are then lifted up with strokes of a clean stump or perhaps a piece of bread, or overlaid with new, more delicate hatchings with a sharp point (cf. Siegl, cats. 15–17). Some of the Bregler drawings show no use of stump (cats. 20, 24, 25) and only a very fine, cautious overlay of short strokes, as in *Hercules;* perhaps these are all early, before Eakins developed a wider, more suggestive range of effects with the blunt charcoal stick and stump. The standing figure of a man seen in cat. 24 (fig. 33) may summarize the qualities of these early drawings: made with a sharp, hard point (in old-fashioned graphite, unlike the rest)[14] and using a very quiet handling, with linear patterns following the movement of surfaces they describe, this drawing eliminates surrounding context and focuses attention on one section of the body, which is brought into detailed finish. The sketches of vertebrae on the sheet hint at special interest in the spinal column and its form beneath the skin of the neck, perhaps interrelating the life class and the anatomical studies undertaken at this same time.

The smooth surface and sharp contours of this one drawing, so unlike the other full-length drawings with their developed sense of space and range of linear effects, reminds us of the presence of older academic artists in the circle of this life class, whose experience may have given Eakins a model. Although Gérôme worked in this fashion, bringing one section into finish while the rest remained a simple contour, this method contradicted the usual methods of painting and drawing at the Ecole des Beaux-Arts, where students first blocked out the lights and shadows with broad tones before proceeding to such area-by-area finish.[15] The possibility that this one drawing reflects the particular example of Gérôme may be one hint that it comes from Paris, although the figure coexists on a sheet of other charcoal studies bearing all the qualities of early work, and the chances of such an unfinished drawing being saved and returned from Paris seem slim.[16] At the same time, other painters in Philadelphia, notably Peter F. Rothermel and Christian Schussele, could have demonstrated the same academic practice.

Rothermel (fig. 35) had been born and trained in Pennsylvania, aside from a tour of Europe in 1856–59. His outlook seems to have been shaped by the strong legacies of Benjamin West and the English Royal Academy, happily inherited by the Pennsylvania Academy in the early nineteenth century. After beginning as a portrait painter, he turned to figure subjects in the 1840s and soon established himself as the most prominent and energetic history painter in

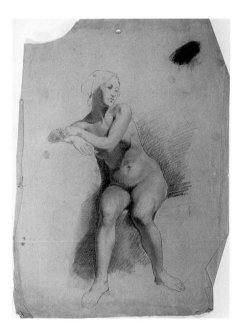

Philadelphia.[17] Made a director of the Pennsylvania Academy in 1846, Rothermel was soon appointed to the committee on instruction for the school, and he took charge of the revitalization of the curriculum in 1854–55, before his departure for Europe.[18] Before he left, or after his return in 1859, Rothermel may have joined the Academy's newly organized life class sessions along with many of Philadelphia's professional artists, who took advantage of the opportunity to draw from the model (fig. 36).

Drawings show that Rothermel worked alongside Christian Schussele, an Alsatian immigrant in Philadelphia who had studied in Paris with Paul Delaroche and Adolphe Yvon

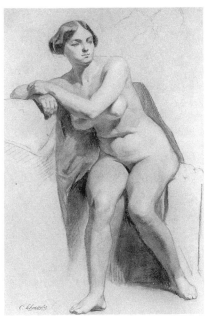

35. Opposite, Photographer unknown, *Peter F. Rothermel* (1812–1895), c. 1885, platinum print, PAFA Archives.

36. Opposite, Peter F. Rothermel, *Figure Study: Nude Woman, Seated, Leaning Left,* c. 1855–65, charcoal on gray wove paper, 23⁹⁄16 × 18⁷⁄16 in., 1985.68.41.6

37. Christian Schussele (1824–1879), *Self Portrait,* c. 1875, oil on fabric, 18 × 15 in., PAFA, Gift of Roger Neidlinger in memory of Jane C. P. Buell Neidlinger, 1990.1.

38. Christian Schussele, *Figure Study: Seated Nude Woman, Resting on Right Arm,* c. 1850–60, charcoal on blue paper, 17⅛ × 11½ in., PAFA, John S. Phillips Collection, 1876.9.578.

Susan Eakins—herself a private student of Schussele in the mid-'70s—insisted that Eakins "did not study under Rothermel or Schussele."[20] However, the proximity of both Rothermel and Schussele made them exemplars of both the technique and subject matter seen in Eakins' life class drawings and his later ventures into subjects from American history and literature.

Many drawings by Rothermel and Schussele in the PAFA's collection, including a new group of thirty-four figure studies by Rothermel found by Bregler in Eakins' studio (such as figs. 36 and 39), demonstrate the tradition Eakins absorbed in these life classes.[21] Almost all the components of his early drawings are available in these examples, which seem to date from the period of Eakins' study, or slightly earlier. Rothermel and Schussele both undertook the disconnected study of body parts or fragmented figures (fig. 39), although both, as seasoned draftsmen, emphasized full-length poses and neither had such a propensity for nearly illegible cropping as Eakins did. Both ignored or eliminated context, except for the occasional studio stand or cushion, or a sometimes lively and erratic halo of shadow attached to the contour of the figure. Eakins, again, created extreme, almost disorienting effects with this same manner. Like Rothermel, who worked more often in charcoal (while the old-fashioned Schussele preferred graphite and crayon), Eakins sought the maximum value contrast possible with his medium, often pushing his shadows into a blackness dark enough to become flat and aggressively antispatial. Rothermel, more experi-

(figs. 37, 38). Schussele earned his living as a lithographer after arriving in the United States in 1848, but by 1851 he was exhibiting figure compositions at the Pennsylvania Academy's annual exhibitions, joining Rothermel with subjects from Shakespeare, the Bible, and American history. Both men were active on the artist's committee, which served as an advisory panel for the life school, and Schussele, before his sojourn in Europe between 1865 and 1868, offered critiques to students in the life and cast drawing classes.[19] Although Eakins claimed to have known Rothermel since childhood, and he had certainly met Schussele by 1862, he does not seem to have availed himself of tutorials from either painter, for

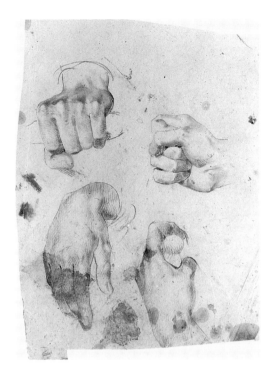

39. Peter F. Rothermel, *Four Hands*, n.d., black chalk on orange paper, 17¼ × 12¹¹⁄₁₆ in., 1985.68.41.25.

enced at this game, typically established his blackest note in a spot apart from the figure, where it functioned as a visual gauge representing the limit of his range, rarely admitted in the figure itself.

Such habits identify the older, more accomplished veteran and make it easy to spot the less practiced hand of the student, particularly among the Bregler collection drawings. Bregler carefully segregated the work of the two artists so that Rothermel's drawings "would not get out and passed off as Eakins," but differences in style confirm his sorting.[22] Predictably, Eakins was much less secure as a draftsman in his early cast drawings and life class fragments, compared to the confidence and fluidity of the older artists. Even in his more assured phases, Eakins never achieved the clean, unhesitating contour lines that both Rothermel and Schussele commanded. Eakins' drawings are "painterly," as Goodrich has remarked; they seek brushlike effects of chiaroscuro and mass.[23] And, unlike Rothermel and Schussele, Eakins sought space in his more mature drawings, placing the figure in a developed context. This feeling for the figure in space could reflect a temperamental difference; the graphic sensibility, however, may be generational. Eakins, a child of the lithographic age, displays a graphic vocabulary learned from the crayon manner of prints by such artists as J. D. Harding. Rothermel and Schussele, at least a generation older, studied first from engravings and learned to emulate the long, steady profiles and hatching of the burin rather than the livelier, more varied handling of the lithographic crayon. Augustus Kollner, a student in the life classes with Eakins, demonstrated an extreme of this aesthetic by choosing to work in pen and ink (fig. 40), proving the diversity of style, technique,

and skill present in the work of the life class participants in this period. Eakins' departure for Paris has led most scholars to conclude that he had surpassed the level of accomplishment in these classes—represented by Kollner's work—but the drawings of Rothermel and Schussele indicate that artists of considerably greater sophistication were on hand. Certainly the frontal nudity of the unmasked models in their drawings also proves that unrestricted sessions were available to Philadelphia's artists in the 1850s and '60s. The smaller numbers of people involved in these classes, and the even smaller number of women students (who were allowed their own life class for the first time in 1860) may explain the untroubled nudity shown in these drawings. The increased participation of amateurs and women, along with the rise of "Victorian" prudishness, may have created a different climate of publicity for Eakins' own classes in the 1870s, but it is clear that Eakins' professional expectations concerning the use of nude models could have been established by precedents in Philadelphia, not just exposure to atelier practices in France.[24] Since it is sometimes assumed that Eakins established an age of enlightenment at the Academy after 1878, bringing the French academic system to provincial Philadelphia with the zeal of a missionary, it is worth considering the notion that he was simply reinstituting, with many improvements, a golden age that had been darkened by the ascendancy of the increasingly disabled and old-fashioned Schussele to the head of the school in 1868, and the complete closing of the Academy for new construction between 1870 and 1876.[25]

If Rothermel and Schussele both enjoyed and promoted the study of the nude, their presence in Eakins' classes seems to have been at best irregular. The life school was "super-

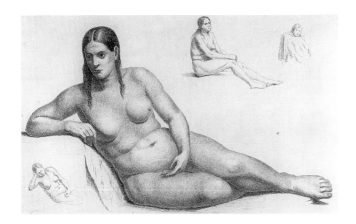

40. Augustus Kollner
(1831–1906), *Reclining Female
Nude and Other Studies*, 1864, pen
and ink on heavy brown laid
paper, 14⁹⁄₁₆ (irr.) × 23¾ (irr.),
PAFA, 1980.4.3.

vised" by an artists' committee, but in practice it was run by the Academy's curator, Robert Wylie (also a painter, just five years older than Eakins) and supported by the students themselves. "No instruction was provided," remembered Eakins' classmate, Earl Shinn, "but the older students assisted their juniors to the best of their ability."[26] Without regular, stringent critiques, Eakins' progress must have been slow. He attended life school three nights a week at most, from October to April; the rest of his time was spent helping his father, teaching, or attending anatomy classes at Jefferson Medical College. Still, over the course of 3 1/2 years of practice, a talented, disciplined, and "noticing" student such as Eakins must have acquired some skill. Certainly the progress seen between the most inexpert of these drawings and the most masterful could have been gained in three years' time, if not sooner. In fact, some of the "progress" read in these drawings may simply be the result of good days and bad days; some of the odd effects may have been the luck of his seating position in the studio, or the harsh overhead lighting of the basement "oubliette," where the life class worked.[27] But however quickly his accomplishment was acquired, Eakins must

have matured sufficiently by the spring of 1866 to contemplate following his classmates Wylie and Shinn to Paris to study at the Ecole des Beaux-Arts. Schussele, himself a product of the Ecole, seems to have encouraged promising Academy students to widen their training in Paris, and he probably counseled Eakins as well.[28] In addition, Eakins' work must have impressed other knowledgeable family advisers, such as Holmes, Gardel, and John Sartain, who surely reinforced the judgment of Benjamin Eakins. Presumably all these gentlemen saw sufficient ability in Eakins' work to justify the time and expense of European study. Likewise, he must have been prepared to offer some demonstration of his skill when he applied for admission to the Ecole, although such an examination, or such a portfolio, is never mentioned in his letters.[29] Can we imagine that, at the age of twenty-two, he (and his father) would entertain the expense of advanced study in Paris without the competence shown in the best of these figure studies? At last, the argument of his age and ambition, added to what we know about his sense of filial responsibility and professional seriousness, must convince us that all of these drawings were made in Philadelphia.

CHAPTER 4 Gérôme and the
Ecole des Beaux-
Arts, 1866–1869

41. Charles Reutlinger, *Jean-Léon Gérôme* (1824–1904), c. 1867–68, albumen carte-de-visite, PAFA Archives.

Fueled by self-confidence and a sense of mission, Eakins barged his way into the Ecole des Beaux-Arts in the fall of 1866, bringing with him five other Americans, some of whom had been waiting six months for admission. Letters in the Bregler Collection reveal Eakins' persistence and resourcefulness in the face of bureaucracy, testifying to his strength of purpose as well as his fluency in French—attributes that none of his colleagues seemed to have shared in equal measure. The determination shown in this month spent "running about, on account of the red tape" demonstrated a stubbornness characteristic of Eakins throughout his life. Other attitudes revealed themselves as well: contempt for the affected and narrow-minded "little vermin" who obstructed his way, reverence for the "big men," such as Gérôme or Count Nieuwerkerke, who graciously and reasonably responded to his suit, and a willingness to push people around in order to gain "justifiable" ends. Later in life these attitudes would create trouble for Eakins; in October 1866 they won him admission to the atelier of Jean-Léon Gérôme (fig. 41).[1]

Eakins was impressed by Gérôme from the moment they met. Interrupted while painting from the model in his lavish private studio, Gérôme listened to Eakins' plea, "hesitated a moment, then put down his paints and wrote" a letter of admission to his atelier to the director of the school.[2] The gratitude won by this courtesy was enlarged over the next three years by feelings of respect and affection as Eakins suffered through Gérôme's critiques and witnessed his teacher's attentive and compassionate direction of the atelier. "He loved and admired his master," remembered his wife, and he kept examples of Gérôme's work prominently displayed in the family's parlor, where a photogravure of *Ave Caesar; Morituri Te Salutant* (fig. 42) held the place of honor over the mantel (as seen in *The Chess Players,* fig. 9), and in his own studio, where a reproduction of *The Two Augurs* (fig. 43) hung on the center of the north wall at least through the early 1880s.[3] The power of Gérôme's pictures can be felt in Eakins' work as late as 1898, as Gerald Ackerman first demonstrated, and Gérôme's values lived on in Eakins' attitudes for a lifetime.[4]

The appeal of Gérôme's paintings had probably registered on Eakins long before he left Philadelphia. In October 1866, when he sat down with the Ecole's secretary, Albert Lenoir, and "we chose Gérôme for my professor," Eakins likely stated a preference, which Lenoir accommodated, predicting Gérôme's liberal reception of such an applicant.[5] Eakins' opinion would have been based on the high estimation of Gérôme's work in the United States: "There are but few French artists of modern times whose works are more known, studied and appreciated in America than those of Léon Gérôme," wrote an admirer in 1877.[6] Within the next decade the majority of Gérôme's most celebrated works would be gathered by American collectors, and American authors would produce the two most lavish and adulatory books ever published on his work. Philadelphia was home to both writers, Earl Shinn (a student of Gérôme, along with Eakins)

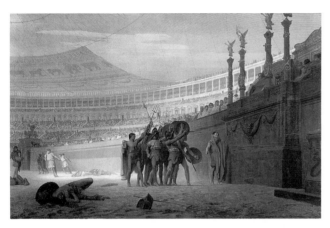

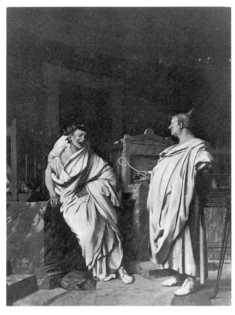

42. Jean-Léon Gérôme, *Hail Caesar! We Who Are About to Die Salute You (Ave Caesar; Morituri Te Salutant)*, 1859, oil on canvas, 36⅜ × 57¼ in., Yale University Art Gallery, Gift of C. Ruxton Love, Jr., B.A. 1925.

43. Jean-Léon Gérôme, *The Two Augurs (Deux Augures n'ont jamais pu se regarder sans rire)*, 1861, oil on canvas, size and location unknown.

and Fanny Field Hering, who spoke for the city's unusually large and enthusiastic band of collectors and admirers of Gérôme's work. Hering acquired the taste from her teacher, Stephen J. Ferris (1835–1915), whose opinion might be measured in the fact that in 1863 he named his son after Gérôme, whom he had yet to meet. Ferris was himself the student and friend of John Sartain, a prime mover in Philadelphia's art circles (and the father of Eakins' friend, the painter William Sartain), whose acquaintance with Albert Lenoir offered Eakins a foot in the door of the Ecole. These overlapping circles of interest make it likely that Eakins was favorably disposed to Gérôme's teaching before he actually crossed the threshold of the Ecole.[7]

Gérôme's best recommendation came from his own work, frequently seen in the United States thanks to the Goupil Gallery affiliate in New York. Most accessible and persuasive was a small painting entitled *Egyptian Recruits Crossing the Desert* (1857), exhibited three times in New York between 1857 and 1864, and at the Pennsylvania Academy's annual exhibition for three years running, 1860–62.[8] Glitter-

ingly detailed and, for Gérôme, unusually full of warmth, atmosphere, and movement, the painting advertised the skills and the exoticism of his work with a becoming modesty. It was the side of Gérôme's work most likely to appeal to Eakins, who must have liked the sense of journalistic authenticity underriding its picturesqueness, and the unaffected manliness in its soldierly, outdoor subject. In comparison with the two other professors at the Ecole—Isidor Pils, older and less well known in America, and Alexandre Cabanel, always viewed with some suspicion in the United States—Gérôme's unpretentious realism must have seemed even more attractive.[9] Eakins' choice was well informed and logical, and it would prove to be good, for Gérôme was entering his most influential period as a painter and teacher.

Gérôme had been an overnight success twenty years earlier at his Salon debut in 1847 when, at the age of thirty-two, he received much praise for his *Young Greeks Setting Cocks to Fight* and won a leadership role among the emerging "Neogrec" school. The spirit of austere classical revival in the artists of this group renewed the tradition of Ingres, bringing a linear, polished effect and a cool, intellectual attitude to their work. Gérôme remained on this path, finding his true metier in 1859, when he sent to the Salon three classical subjects that revealed his talent for historical genre and narrative: *The Dead Caesar, King Candaules,* and *Ave Caesar.* Gérôme soon extended his historical reach to include subjects from antiquity to the contemporary period, ranging across the Mediterranean world from Egypt to France to find inspiration for a steady stream of Salon successes. By the time Eakins arrived at his door in 1866, Gérôme was already a member of the Institut and the Legion of Honor, *hors con-*

cours at the Salon, and entering his fourth year as professor at the Ecole. The following spring a retrospective of eight paintings gathered for display at the Exposition Universelle of 1867—including *Ave Caesar* and *The Two Augurs*—won him a grand medal of honor. At the age of forty-two Gérôme was at the peak of his powers and beginning his greatest decade of critical and popular success. Eakins, quite naturally, was deeply impressed.[10]

Eakins learned many lessons from Gérôme, all absorbed below the surface of his art or manners. Most profoundly, Gérôme taught Eakins how to be an artist, setting an example in his teaching, his painting, and his behavior that demonstrated the rights and responsibilities of his life's work. To some degree a sense of pride and professional mission might have been inhaled from the general atmosphere of the Ecole, where it must have been exhilarating—especially for an American—to stand amid hundreds of colleagues who thought that painting pictures was a reasonable, even an exalted occupation. The tone of the school was hardly reverent, for the competitiveness and anxiety of the students frequently exploded in loud song, coarse talk, and riotousness, but the businesslike dedication to craft, based on an assumption of the importance of the work being done, surely bolstered every student with doubts about what it meant to be an "artist." For Eakins, coming from afar with a more naive notion of the art world than his more cosmopolitan studiomates, the mystique of the Ecole must have been powerful; as with earlier expatriates like Copley or West, the academic tradition was absorbed and then reenacted by him with an idealism that more jaded participants could never muster.[11] This general culture of the Ecole, with its routine insistence on anatomical studies and nude models, and its mood of hardworking informality, forever trained Eakins' expectations. In Philadelphia he tried to reconstruct this ambiance, ignoring the fact that the art community was smaller and less liberal, and—more important—that the presence of women, amateurs, and their interested parents intruded popular manners and morals into the scene.

The professional and masculine mood of the Ecole was borne by most of the students and administrators, but Gérôme was an especially compelling embodiment of this spirit. The boisterousness of the atelier stilled twice each week when "le patron" arrived for his dignified and frequently devastating round of critiques. His first review of Eakins' work was "pretty rough," but Eakins understood and was "glad," even "delighted" by such serious treatment. He immediately bought a photograph to send home. "Gérôme is a young man," he wrote to his family. "He has a beautiful eye and a splendid head. He dresses remarkably plain."[12] Fastidious in his plainness, Gérôme carried himself like a soldier and was quite fond of his green Legion of Honor uniform: "Tall, spare and fiery looking, one would have taken him for the colonel of a crack cavalry regiment rather than a painter," remembered another American student, Edwin Howland Blashfield.[13] His characteristics as a man echoed those of his paintings: tense and precise, knowledgeable and witty, tireless and disciplined. Personally, Eakins was not like Gérôme, and he did not model himself on this pattern. Never so sophisticated nor so restless, Eakins was careless about his appearance and preferred the cluttered ambiance of his "workshop" to the tidy sumptuousness of Gérôme's private studio. Eakins took his sartorial cues from the bohemian style of the Latin Quarter and American Protestant functionalism; Gérôme, who married wealth and was a commercial success, lived in elegant circles but adopted an austere, martial style to indicate—like Eakins—his professional seriousness. Both styles were unconventional and self-conscious; both signaled hard work, integrity, honesty, and alertness to hollower forms of affectation. Notwithstanding his popularity, Gérôme was unswayed by critical opinion or fashionable taste; like Eakins, he was appalled by respectability, conventionalism, and all forms of "chic."[14]

At this deeper level, master and student were more alike, and Eakins' awareness of their similarities may have confirmed some of his oldest habits and convictions. Both men were athletes and outdoorsmen, with the strongly marked masculine personality that attended these interests. Both collected a menagerie of animals that often appeared in their paintings. Both were workaholics, sticklers for detail and procedure. Both were enchanted by cameras. In Gérôme, these traits, small and large, added up to a model modern professional artist, engagingly eccentric but nonetheless well integrated in society. Eakins evidently studied this exemplar well. Such an artist was dedicated, uncompromising, a master of craft and a teacher of students, an aesthete without pretense or effeteness. For his efforts, Gérôme was rewarded with medals and the respect of his colleagues, students, and government. American bankers vied for his work. Eakins must have envisioned some version of this bourgeois respectability for himself when he predicted, in 1868, that he would some day "earn a good living & become even rich" by his paintings.[15] He found it impossible, however, to "be" Gérôme in Philadelphia—to think and act with Gérôme's professional expectations—without a "Legion of Honor" culture for artists and especially without Gérôme's savoir faire. But Eakins tried, in his own unconventional fashion, and perpetually miscalculated his audience in the attempt.

A comparison of the two men reveals great differences in personal style and many shared qualities beneath the surface; the same can be said about their paintings. As Ackerman first noticed, Eakins grasped Gérôme's picturesque subject categories and perceptively discovered American analogues: Schuylkill scullers for Egyptian oarsmen, American chess players and singing cowboys for arnauts, boxers for gladiators.[16] His choice of subject matter was remarked in his own day as peculiar and "American," and indeed his receptiveness to local subject matter has marked him, like Homer, as a native "original." However, his inventiveness was based on an ability to think like Gérôme and find appropriate models to fill the structures of class, race, or exotic locale demanded by

contemporary picturesque convention. Without specific precedent in Gérôme's oeuvre, but generalizing from his example (and the work of numerous French contemporaries), Eakins resourcefully found old-world fisher-folk, bullfighters, and street musicians in Gloucester watermen (see fig. 155), baseball players (see fig. 55), and Philadelphia African Americans (see fig. 68).

Not all of Gérôme's subject categories were acceptable to many viewers, either in Paris or Philadelphia. Gérôme was occasionally reprimanded for having a taste that bordered on immorality, as in his voyeuristic nude subjects (*King Candaules, Phryne Before the Tribunal*) or his bloody gladiators, titillating slave markets, gory assassinations (Caesar, Marechal Ney) and sensational Middle Eastern vignettes (*The Heads of Beys at the Door of the Mosque*), all incidents deemed "in themselves horrible or morally repulsive."[17] A shocked American critic in 1877 condemned the licentious and "unwholesome" paintings Gérôme produced in the 1850s and '60s but reassured his readers that for the last ten years the artist has "kept his pencil within moderate bounds." Nevertheless, he seriously doubted that Gérôme was capable of handling "elevated conceptions."[18] Earl Shinn, with his French training still alive in his memory, was subtle in his defense against such charges: if "voluptuous subjects are treated with a terrible demonstrative coldness," it was because Gérôme "calculated to cast shame on those who go to them for licentious emotion."[19] Gérôme's cynicism, clearly displayed in *The Two Augurs,* and his wit, evident in teasing, erotic subjects like *Phryne,* could not be admitted in words, and Gérôme himself was too smart to enter such debates over the propriety of his subjects. His cool sense of artistic privilege in presenting these paintings to the public speaks for itself, however, providing a model that must be remembered as Eakins put forth his own "questionable" subjects—the nude "society girl" posing in Rush's studio, the surgery of doctors Gross and Agnew—drawing identical charges of impropriety or callousness from American critics.

Eakins also adopted formal compositional structures from Gérôme's repertory: pyramidally organized chess players, standing female nudes seen from the rear, horsemen silhouetted against distant landscape (see figs. 210, 218), figures embraced by amphitheaters.[20] Gérôme did not invent such strategies, but he confirmed them in Eakins' imagination, offering pictorial solutions that could be used in many new contexts. Students at the Ecole were expected to learn composition in this fashion—by the example of their masters, not by practical instruction or theory—and Eakins alertly absorbed many ideas from Gérôme's work at the Salon or the Exposition Universelle, carrying home postcards and photogravures as aides-mémoire.

He also learned from Gérôme's sense of detail, which was a model of academic correctness. Gérôme loved the exotic and insisted on the historically or geographically correct, and his sensuous and scholarly eye marshaled such detail into ensembles in which "disorder itself is orderly." The "archaeo-

logical furor" evidenced in his three Roman subjects at the Salon of 1859 impressed many viewers and even overwhelmed a few; such detail guaranteed that, as another art book from Philadelphia noted, his pictures were "sometimes attractive, sometimes repulsive, but always instructive."[21] Gérôme's careful research, often based on travel as well as museum and library expeditions, set new standards of scholarship at the outset of a period when the reconstruction of historical context would become an end in itself for many in the visual arts. Seeking analogies in French painting and literature, the American critic C. H. Stranahan remarked that if an Eastern subject by Fromentin seemed an "idyl," then Delacroix's version would be an "epic" and Gérôme's, by comparison, would be deemed the "official report."[22]

The cool, detached quality recognized in Gérôme's report of the past was characteristic of the new realism of the 1860s, and it probably appealed to Eakins' wish for unsentimental, unprejudiced observation. Gérôme relied on the seen and the intellectually understood; "He imagines badly, and remembers exceedingly well," wrote Shinn, who might have used the same words to compare Eakins' abandoned imaginary "idyls"—Hiawatha, Columbus, Phidias—to his brilliantly observed local "reports" of the sporting world.[23] Periodically drawn to "poetic" subjects, Eakins always returned to the specific objects and models before him. Study from nature, "to search the truth," was the only "reasonable way," Gérôme reminded Eakins in a letter of 1877. "Other roads carry you to the abyss."[24] Fear of this abyss may have discouraged Eakins' more imaginative compositions, and it led him, when venturing into history, to follow Gérôme's example of research, as in *William Rush Carving* (see chap. 14), which appropriated costume details from period portraits and context from those who remembered the appearance of Rush's workshop. Faulted by Gérôme for his early evenness of handling, Eakins learned to be more selective about detail than Gérôme, more willing to suppress sharpness for the sake of pictorial focus, and less enamored by the display of facts and surface textures for their own sakes.[25] But with his insistence on study from appropriate accessories and costumes he shared Gérôme's fastidiousness, consistent with modern academic standards of ethnographic or historical precision.

It is not clear how, or from whom, Eakins learned the complex sequence of preparatory steps necessary to the planning and execution of an academic painting, for these rituals had been observed by many artists from the time of the Renaissance, and they were not specifically addressed in classes at the Ecole. Eakins' letters indicate that he had seen some of Gérôme's oil sketches and that his teacher "used to get out his *Pollice Verso* to illustrate to me his principles," and perhaps by such informal means Eakins absorbed and then developed a procedure remarkably like Gérôme's own method.[26] This process began with the conceptualization of the image, which was quickly sketched in oil or pencil in order to capture the idea for further work. Research and the assembly of models and properties followed; photographs,

architectural renderings, and perspectives (often supplied by professional draftsmen hired for the work), and location studies were then gathered. A small oil sketch or, rarely, a full-scale cartoon was made to integrate these components and rehearse the final image. Like Gérôme, Eakins did not use all of these steps in every painting, but on occasion he tried them all. He pleasured in the difficulties of perspective, and he did his own work in all instances; had he wanted to hire an assistant he would have found it difficult to find draftsmen in Philadelphia more competent than himself.

Most telling and traditional in this academic method was the practice of conceptualizing the subject in advance rather than working spontaneously from nature. "It was often said of Gérôme that when he sat down to work he knew precisely what he wanted to paint, that the pictorial idea was clearly formed in his mind." As Ackerman has noted, this mental phase, prior to any manual work, was important to sixteenth-century artists because "it made the artist's work an intellectual act, and in short, made artists intellectuals and practitioners of a 'liberal art'—that is, as opposed to a servile art or trade."[27] Bregler, recalling Eakins' habits, stressed this power of conceptualization and remarked the tenaciousness with which Eakins held to his internal image.[28] Ackerman reminds us of Gérôme's imagination and the professional implications of his procedure, both frequently lost in the impressive catalogue of textures and details in his paintings. Bregler, likewise, wished to stress Eakins' imagination, often forgotten in the response to his realistic image. Losing sight of this moment of creativity we can see Gérôme only as an expert stage manager and Eakins as a passive recorder; the recollection of their shared academic procedure reminds us of their traditional aspirations and the willful minds that wed nineteenth-century realism to Renaissance notions of art making.

Eakins eventually parted ways with his teacher on the treatment of detail and on all other aspects of the surface construction of the picture, leading to a difference in overall effect that has obscured their deeper similarities. The differences are important. Eakins never followed Gérôme's painting technique nor emulated his surface; he struggled with the system of painting taught in the atelier and found his own way slowly.[29] This struggle was all the more difficult because Eakins was warring with the training he had received in Philadelphia and with some of the basic premises of Gérôme's work. The locus of Eakins' troubles was in the transition from drawing to painting and in the submission of painting to the crisp and rational aesthetic of academic drawing; for Eakins the first passage was slow, the second impossible.

Draftsmanship was central to Gérôme's paintings, visibly asserting the legacy of Ingres and the values of the French Academy. Depending upon the outlook—and critics certainly took different positions—Gérôme's drawing was found cramped and finicky or exquisite and delicate; sometimes it was agreed to be all these things at once. Both observant and painstaking, Gérôme worked his surfaces to a fine,

smooth finish, achieving a precision of detail that necessarily lost all sense of spontaneity or mystery. "Indefinable hardness is the soul of his work," concluded Henry James, and even Earl Shinn quoted Gérôme as admitting that dryness was a fault that he had not "entirely" defeated.[30]

One might predict that years of linear exercises would prepare Eakins for a smooth transition to Gérôme's style, and indeed Gérôme kept him at charcoal and paper for only five months before promoting him to brush and canvas. But the shock of these new materials disoriented Eakins, who was relatively old (almost twenty-three) to be beginning in oils, and natively inflexible. His problems in mixing color and modeling tones made him bitter about the time he had wasted on drawing from casts, and once he graduated to oils he refused to attend sessions during the "antique week" each month, when the entire class worked from sculpture. "I often wish now that I had never so much as seen a statue antique or modern till after I had been painting for some time," he grumbled.[31] Determined to work only from life, in color, to confront his difficulties at once, Eakins seems to have found the physical properties of paint mysterious, intractable, and compelling. "I made a drawing on my canvass according to Gérôme's directions," he wrote his family in late November 1867, "& then he said not bad, that will do, now I will mix your colors which you will put on. I have not been able to make them gee together & have got a devil of a muss & will get a good scolding tomorrow morning," he concluded morosely, admitting that he was "in the dumps" over his failure.[32] He lost weight and admitted later that "for a long time I did not hardly sleep at nights, but dreamed all the time about color & forms & often nearly always they were crazinesses in their queerness."[33] After Christmas he told the rest of the story: "Gérôme did not scold me that day, you asked me about, but just painted my head right over again & this I take as an insult to my work, and tribute to my perseverance & obedience that week. I had a clean canvas, clean brushes, clean outline, clean everything, but I am sure I would have learned more slathering around."[34]

This wish to "slather around," and Gérôme's offer to prepare the modeling tints on the palette to help his student avoid muddy paint buildup, suggests Eakins' pride and the nature of his difficulties. Also revealed in this anecdote is a different feeling for paint and the construction of form. As he approached the end of his stay in Paris, Eakins was able to assess this difference, and his feelings of isolation, along with his sense of accomplishment.

> Sometimes in my spasmodic efforts to get my tones of color, the paint got thick & [Gérôme] would tell me that it was the thickness of the paint that was hindering me from delicate modelling or delicate changes. How I suffered in my doubtings & would change again, make a fine drawing and rub weak sickly color on it & if my comrades or my teacher told me it was better, it almost drove me crazy. Again I would go back to my old in-

stinct & make frightful work again. It made me doubt of myself, of my intelligence, of everything & yet I thought things looked so beautiful & clean that I could not be mistaken. I think I tried every road possible. Sometimes I took all advice, sometimes I shut my ears & listened to none.[35]

In this same letter Eakins described Gérôme as a "good teacher," in fact "too great to impose much" ("the greater the master, mostly the less he can say"), but concluded that he had learned little from him. Aside from Gérôme's "over-throwing completely the ideas I had got before at home, & then telling me one or two little things in drawing, he has never been able to assist me much & oftener bothered me by mistaking my troubles." Eakins, in his pride, was both right and wrong. His technique did develop independently, more under the star of Couture or Bonnat or Velázquez than in Gérôme's following, and six months later in the Prado he would solemnly pledge in his notebook to "never paint in the manner of the master."[36] But within weeks he would begin a painting based on Gérôme's precedent, and during the next few years he would write to Gérôme frequently, sharing examples of his work and seeking advice.[37] His debts to Gérôme were large, as seen in his approach to pictorial content and organization, his rational, disciplined, and scholarly strategies of art making, and his unswerving sense of personal and professional artistic identity. The substance, if not the "manner" of Gérôme, had been deeply absorbed.

CHAPTER 5 A.-A. Dumont and
Academic Sculpture,
1868–1869

"I got admitted yesterday to the studio of Dumont the sculptor in our school," wrote Eakins to his father on 6 March 1868 (fig. 44). "I am going to model in clay every once in a while. I think I will thus learn faster. When I am tired of painting I will go to the class & be fresh & I will see more models & choose."[1] The idea probably came from Gérôme, who encouraged many of his students to take such advantage of modeling classes at the Ecole. "Painting and sculpture are the same thing," Gérôme was fond of saying, and for the last twenty-five years of his life he proved his point with a succession of polychromed or mixed-media sculptures that recapitulated in three dimensions the themes of his paintings. "I was born to be a sculptor," he exclaimed after his debut in 1878.[2] Eakins, urging his students to "always think of the third dimension," whatever the subject or medium at hand, might have harbored the same thought, or at least drawn courage from Gérôme's declaration, for he took up sculpture with seriousness in the same year.[3]

But in 1868 his interest, like Gérôme's, was strictly that of a painter; he attended Dumont's atelier to learn about mass, the construction of form, the appearance of objects in light and space, about texture and three-dimensional surface. Never intending to become a professional sculptor, Eakins would apply the lessons learned in Paris to only a handful of actual sculpture projects, most of them done long after his return from France. Because these sculptures are rare, and because his teacher has never been recognized as a particularly brilliant or innovative master, Eakins' experience in Dumont's atelier has been given only passing attention. But his education under Dumont—encouraged by Gérôme—significantly shaped his attitude toward sculpture for the duration of his career. His work at the Ecole influenced not only his later approach to clay, wax, plaster, and bronze, but fused integrally with his method of painting and teaching, leading him to insist that all his students undertake the same mixed study.

Augustin-Alexandre Dumont (1801–84) was sixty-seven when Eakins entered his studio; he was a "stout old man," by Eakins' account, "much older than Gérôme."[4] With thirty years of distinguished teaching behind him, he was approaching the end of a long and busy career. A Prix-de-Rome winner forty years earlier, he was the last in a family dynasty of painters and sculptors that stretched back into the seventeenth century, and he wore the responsibility of his inheritance with dignity, austerity, and high moral seriousness. Dumont was the living incarnation of the French Academy, which mourned his death in 1884 with reason, for he was "one of those who best represented its spirit."[5]

Dumont left Paris for Italy in 1823 and remained there seven years as a Prix-de-Rome pensionnaire. After he returned to France, his colossal *Génie de la Liberté* (1833–35) was universally acclaimed when it appeared, in a half-scale model, at the Salon of 1836. Four years later it was installed, at the pleasure of King Louis-Philippe, atop the "July Column" prominently placed in the Place de la Bastille to cele-

44. Frederick Gutekunst, *Thomas Eakins at About Age 24*, c. 1868, albumen carte-de-visite, 3⁹⁄₁₆ × 2⅜ in., 1985.68.2.4.

brate the restoration of the monarchy. Poised on one foot, like Giambologna's *Mercury,* the nude, winged Genius appeared to be alighting on the column, and Dumont accentuated the effect of movement by gilding the figure to make its contours glitter elusively in the sun. Praised for its vivacity, elegance, and truthfulness, *Génie* was judged Dumont's masterpiece, and it made his career. Named to the Legion of Honor in 1836, and a member of the Institute from 1838, he was deluged for the next thirty-five years with official projects for public squares and the facades of governmental buildings.

During this period patronage flowed from institutions seeking legitimacy through lavish public works, and Dumont's mix of allegory and realism, neoclassical dignity and romantic liveliness brought him many commissions. Politically astute and versatile, Dumont knew how to please official clients by "adapting his style to the character of his subjects as well as to the demands of modern taste."[6] He executed figures *Commerce* for the facade of the Bourse and *Justice* for the interior of the Chamber of Deputies; the entire sculptural program for the exterior of the Pavillion Lesdiguières of the Louvre; and in 1863, the figure *Napoléon* atop the restored column in the Place Vendôme. Dumont also supplied many historical portraits to an age fond of commemorating its heroes: St. Louis, Philip-Augustus, Frances I, Poussin, Humboldt. All of these portraits were judged successful for their command of detail, costume, facial expression, and the perfectly seized "trait" of each individual.

The fame of Dumont's nudes, however, surpassed that of his portraiture. After beginning in Rome with copies from the antique, Dumont's neoclassical inventions led to his most famous Salon pieces: *L'Amour tourmenant l'âme* (1827) and *Bacchus enfant élevé par la Nymph Leucothée* (1831), followed by the *Génie de la Liberté.* Received in their own day as charmingly lifelike, these sculptures began to look chilly and overly perfect to the more naturalistic taste of the 1850s, but a retrospective of Dumont's work at the Exposition Universelle of 1855 won him a Grand Medal of Honor and the rank of an officer of the Legion of Honor. Ten years later, when Eakins entered the Ecole, Dumont was still working in the manner he had perfected in the thirties. His studio contained a selection of works typical of his entire career: the bronze portrait *Duc Décazes* (1866), marble busts of Maréchal Davout and the Ecole's secretary, Albert Lenoir (1866), a bronze statue of Pope Urban V (1867), the marble bas-relief *L'Adoration de la Croix* (1868) and, in 1869, the huge bronze monument *La Ville de Mézin offrant une Couronne au Général Tartas.* From this period, too, date the figures done for the Louvre. Such works establish the context of Dumont's teaching and of Eakins' experience in his atelier.[7]

Dumont joined the faculty of the Ecole in 1852. As a teacher, he was as polished and impeccable as his sculpture, and perhaps as cold, although his students, like Gérôme's, protested that his "grave and melancholy" visage masked a "tender soul, a loving heart," and a "compassionate and generous" spirit, ever ready to offer help.[8] Dumont's colleagues admired him as a simple, unassuming, rather modest man and an excellent teacher; his students found him a paternal guardian. "He is like a Father to us," wrote Eakins, anticipating the sentimental tribute of Eugène Guillaume at Dumont's funeral in 1884: "Professor of lofty authority, man of antique rectitude, nothing equalled the goodness of his heart. He had, for us, an inexhaustible benevolence: always ready, even after age had diminished his strength, to come to our studios to advise and encourage us; . . . more than a master, it is a father that we mourn."[9]

Such affectionate veneration was a response to the integrity of Dumont's personal philosophy and teaching method. Following in the footsteps of Etienne-Jules Ramey, he directed the Academy's sculpture classes with unwavering dedication to classical standards. According to Guillaume, the Ramey-Dumont regime at the Ecole sought direction from the "principles and traditions of all sculpture worthy of the name." Learning from the conventions of the past, seeking to maintain "*dignité idéale*," they admired antiquity but respected nature. "Before everything, they were sincere, and they taught that beauty should not be sought without truth."[10] This hope for the assimilation, distillation, and perpetuation of centuries of artistic wisdom, so characteristic of the nineteenth-century mind, was the "academic mandate" to Guillaume, who declared that Dumont bore this duty with "conscience and conviction," with "grave zeal": "He thought that our Company had a certain mission. He held that there was among us a community of principles upon which was based a tradition. He believed that the duty of the Academy is to maintain that tradition, and to resist with its authority every doctrine tending to lower art or even diminish it."[11] From this rigorous and idealistic approach Eakins learned fidelity to nature, respect for the classical past, and traditional academic techniques. All these lessons would endure in his work, along with a more profound sense of the high moral seriousness of the artistic professions. Back in Philadelphia, considering the plight of William Rush or his own difficulties with students and models, Eakins must have steeled his conviction with recollections of Dumont's proud possession of the classical tradition of nude subjects, and his resolute sense of mission. Like Gérôme, Dumont taught by personal example the lifeway of the committed artist and teacher. Dumont's gentler skills—of negotiation, of accommodation to "modern taste"—were not so easily transferred.

Daily activity in the class brought ideology to the level of the practical, and Eakins first responded to his modeling work at the school in relation to its beneficial effect on his painting. "I am learning to work clean and bright and understand some of the niceties of color. My anatomy studies & sculpture, especially the anatomy comes to bear on my work & I construct my men more solid & springy & strong. It makes one catch forms quicker & the slight movements of the model dont hinder or worry me, only show me plainer what I am doing."[12] These studies taught the painter to think

about the three-dimensional qualities of the forms he would later translate onto canvas. The process involved both thought and action, hand and eye, and Dumont continually urged them "to work more with . . . fingers and brains and less with tools."[13] Scale models also helped the painter gauge effects of distance, shadow, and foreshortening while painting. Like many painters since the Renaissance, Gérôme used wax or clay maquettes in staging his compositions, and he may have painted from casts occasionally: Delaborde accused him of using the same plaster foot over and over again in *Ave Caesar*.[14] Eakins' purchase of modeling wax and casts, recorded in his Parisian account book and letters, indicates that he had absorbed this method even as a student, establishing practices that he would revive a decade later in Philadelphia.[15]

Dumont's class taught Eakins how to be a better painter; it also taught him how to be a sculptor. The naturalistic style of the Ecole, reinforced by anatomical lectures and the option of dissection, predictably emerged in Eakins' sculpture as well as his painting, but in a larger sense the Ecole—and particularly Gérôme—validated sculpture as a reasonable pursuit for a painter. Not many artists in this era of specialization displayed ambitions in both two and three-dimensional work: we can list Gérôme, Degas, Renoir, Daumier, Falguière, Carolus-Duran, and Meissonier, all trained in academic circles, and all aware of the Renaissance artist type represented by the Pollaiuolo brothers or Michelangelo. With the exception of William Rimmer (also an anatomist and a teacher), no American painter of the nineteenth century fit as comfortably into this tradition as Eakins, with his small sculptural sketches and reliefs that share the plastic energy of Daumier and Degas, his historical subjects that contain the exactness of Meissonier and Gérôme, and anatomical studies that carry the vitality and studiousness of Géricault. More specifically, the Ecole taught Eakins to value the technique of sculptured relief, exemplified by the work of Phidias and essayed annually by the Prix-de-Rome competitors in sculpture. Never a declared sculptor in Paris, Eakins would return to the naturalistic and neoclassical mode of the French academy when, many years later, interest and opportunity led him into this field.

CHAPTER 6 Bonnat and Spain,
1869–1870

"One terrible anxiety is off my mind," wrote Eakins after two and a half years in Paris: "I will never have to give up painting, for even now I could paint heads good enough to make a living anywhere in America."[1] Suspecting that his career in Philadelphia would be supported by portraiture, Eakins seems to have been preoccupied by competence in "painting heads," and as his studies in Paris drew to a close, he may have been inspired to seek out additional training. After the Ecole's ateliers closed in late July 1869, and before they reopened in September, he joined his friend Billy Sartain for about a month in the private atelier of Léon Bonnat (1833–1922).[2] Although brief, Eakins' experience there was a turning point in his education that has never received adequate study.

Gérôme seems to have encouraged such extracurricular work, recognizing that his own Beaux-Arts atelier could not offer the best training in portraiture. He painted few portraits and "succeeded little in this genre," admitted one of his biographers, as Gérôme himself might have agreed.[3] The problem, however, may have been larger than Gérôme's lack of interest. According to the turn-of-the-century American art historian Samuel Isham, Beaux-Arts training benefited artists in most genres but simply "paralyzed" portraitists. The products of the French school "felt more deeply than the others all the delicacies of modelling, but they had no facile methods of rendering them; a fleeting expression was not to be hastily caught, but rather the bored look of the sitter; even the clothes could not be slighted or hastily done, but required the same deliberate thoroughness. The consequence was much tedium for the sitters and woefully prosaic work."[4]

Admitting his and the Ecole's inadequacies, and realizing that Eakins was nearing the end of his Paris training, Gérôme may have recommended a stint with Bonnat while school was closed for the summer. The two men were good friends ("Il est bien bon garçon," said Gérôme)[5] and mutual supporters: each commonly referred students to the other, and each was heard to say of the other, "There is no better master in Europe."[6] Comparing the two teachers after a month of work, Eakins wrote that "I like Gérôme best I think," but was "very glad to have gone to Bonnat & to have had his criticisms." Of his teaching, Eakins could only remark that he was still young, with "no system."[7]

Bonnat, in fact, was only thirty-six years old in 1869 and had been teaching just two years. Promising and controversial, he had hardly stabilized his *own* method, and, though already a "big man" in Paris art circles, according to Eakins, contradictory currents divided his painting. As Eakins explained,

Bonnat was almost worried to death by his old classic teacher [Madrazo] who wanted him to do the thing his way, & Bonnat couldn't & the reason was—because he saw better than his teacher, although he did such bad work. His teacher told him he would have to stop painting, & then he went to Delaroche who was a very hard master, & took strong likes and dislikes, [who] told him

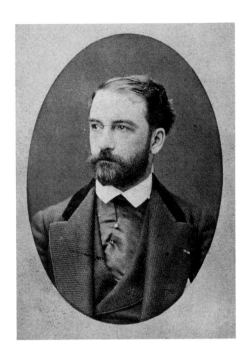

45. Ferdinand Mulnier, *Léon Bonnat* (1833–1922), c. 1867–69, albumen carte-de-visite, Collection of Mr. and Mrs. Daniel W. Dietrich II.

46. Léon Bonnat, *Portrait of a Young Man,* 1860, oil on canvas, 13¼ × 9⅞ in., Snite Museum of Art, University of Notre Dame, on extended loan as a promised gift from Mr. and Mrs. Noah L. Butkin.

to go and be a shoemaker, that was all he was fit for. A few years more & he was as big as the biggest of them. Couture came near giving up painting on account of his masters and his conclusion is the best thing a master can do is to let his pupils alone. Bonnat is still so young, his troubles are fresh in his mind & this is why he has no system.[8]

In 1869 few could have seen in this young liberal the future dean of academic portraitists. Of Bonnat in the nineties—vain, reactionary, glittering with decorations—"it was said that he didn't take off his gloves when he went to bed."[9] But Bonnat the *pompier* was unimagined in the Paris of the sixties; instead, he was hailed as a breath of fresh air, an artist who "turned his back on the artificial and went directly to nature," a radical realist in the tradition of the Spanish Baroque.[10]

The young Bonnat was a maverick academic and, according to Eakins, an unusual man. Both his art and his appearance were dominated by the dark coloring of southern France and Spain. "I will send you Bonnat's photograph," Eakins wrote to his father. "He has a queer shaped head & looks as if he might be anything at all from a philanthropist to a murderer. His forehead is very low but it is very wide & behind his head is high" (fig. 45).[11] Born in Bayonne, he moved with his family to Madrid when he was barely seven. The early lessons learned from Spain, the Prado, and his Spanish masters José and Federico Madrazo were never forgotten; along with Rembrandt, his gods were always Velázquez and Ribera. The Bayonne city fathers sent Bonnat to Léon Cogniet's studio in Paris, where he made his Salon debut in 1857 with three portraits. The same year he received a second-place Prix-de-Rome, which won him renewed

financial support from home and a chance to study in Italy, where he developed a taste for grand figure painting and genre subjects. Returning to Paris in 1861, Bonnat gained the attention of collectors, who admired his portraits and peasant scenes, and critics, who were impressed by his ambitious religious-historical subjects. By 1869 he was well established as one of the young lions of realism in the circle of Manet, Degas, and Gérôme. Elected a Chevalier of the Legion of Honor, he was decorated at the Exposition Universelle of 1867, and, in 1869, he won the Medal of Honor at the Salon.

Bonnat's painting at this time was characterized by the brilliant value contrast, rich color, vigorous brushwork, and solid construction of Velázquez and Ribera, a painting manner that also determined the style and emphasis of his teaching (fig. 46). "His work was loyal, sincere, direct," remembered his student Edwin Howland Blashfield. "He was teaching everything that was sound and solid in painting. His pictured people were round and stood out, they had air to breathe and move in, you could walk behind them. When the caricaturists made their annual tour of the Salon they drew M. Bonnat's figures as stepping out from their frames. Truth and logic were the basis of everything he did. Construction and values, values and construction, how often did the student hear those mysterious words."[12] Stressing breadth and simplicity, Bonnat urged his students to squint in order to seize the major planes of dark and light. "See more simply!" were the watchwords of the studio.[13]

But once the construction of the figure was established, simplicity yielded to a careful, often brutal observation of fact. Here Bonnat's teaching aligned with Gérôme's, and the emphasis shifted to drawing. Aware that the bold, thick stroke of his own painting looked deceptively spontaneous and easy to students, Bonnat sent his slathering pupils to

study the works of Ingres. He himself collected with impeccable taste the works of the greatest draftsmen of all times: Dürer, Rembrandt, Raphael, Leonardo, Michelangelo. "To know how to draw is everything," said Bonnat. "One is never master by way of color, which changes and disappears. One is only master by way of drawing."[14]

Bonnat's passion for the fundamentals of drawing came across each week during the *séances de correction*. Eakins read shyness and uncertainty in Bonnat's brief, terse critiques, and described him with a frankness no Bonnat biographer ever dared: "He is the most timid man I ever saw in my life & has trouble to join three words together. If you ask him the simplest question about what he thinks the best way to do a thing, he won't tell you. He says do it just as you like."[15] Few could criticize this do-as-you-like attitude as restrictive. Of all the teachers at the Ecole, he was known to be the one "who has the least impeded the intellectual development of his students. All agree in recognizing his aesthetic liberalism. . . . While the other professors of the [School of] Fine Arts shaped excellent students who remained faithful to official instruction and perpetuated its wise certitudes, most of the students of Bonnat evolved toward restless research, and strove to find their own path, alone."[16] Perhaps insecure, or convinced that such wandering had its uses, Bonnat insisted that one must not "discourage young people from exploring new paths. Even if they lead to nothing, the true artistic temperaments will end up finding themselves. To lose one's way is not important, as long as one remains oneself. Sooner or later, sincerity in the face of nature and life will bring fertile changes."[17]

Eakins' description of the atelier reveals the rather startling effect of this philosophy in action. "He will never impose any way of working on his boys," he wrote, "so some commence drawing first and some slap on the color first and draw with it afterwards smearing it about, scraping off and plastering it on with a knife or their fingers or small brushes and he never finds fault with the result."[18] If he was surprised then, Eakins later followed this tolerant pattern in his own teaching; he never wished to impose any style or technique on his students as long as they worked earnestly from nature. More immediately, the free-for-all spirit of Bonnat's atelier may have liberated Eakins' own technique, preparing him for the moment, not long after, when he would renounce the technique of Gérôme in favor of the bolder methods of the Spanish school.

In practical terms, Bonnat's portrait style had a more lasting, specific impact on Eakins than did Bonnat's teaching philosophy. Marked by the "powerful originality of his procedure," Bonnat's portraits stood apart; as a critic noted in 1876, even a nonexpert could recognize them at first sight.[19] Characteristically, Bonnat spotlighted his sitters against a uniformly dark, reddish-brown background, making the figures detach themselves from the background and move forward with disconcerting presence, as in the portrait *Victor Hugo* (fig. 47). A complimentary description of a Bonnat

47. Léon Bonnat, *Portrait of Victor Hugo*, 1879, oil on canvas, 138 × 110 cm, © Réunion des Musées Nationaux, Château de Versailles.

portrait typically commended its "firm drawing, solid paint handling, somber coloring heightened by warm browns, and penetrating psychology."[20] A less sympathetic observer described Bonnat's manner as "corrugation," based on Ribera: "It has been justly called an engraver's technic, for while in most hands small strokes would soften the effect, in Bonnat's they increase the hardness. This academic precision is attained at the cost of color and naturally in disregard of atmosphere. Disagreeable as is the work as painting, it has a kind of stark impressiveness, an accentuated truthfulness of character. A celebrity probably would actually look like a Bonnat if congealed in cold storage before the sitting."[21]

If opinion varied on the "disagreeable" quality of Bonnat's surfaces, it was unanimous in regards to likeness. His ability to capture character and facial topography made him one of the most pursued portraitists of his day. "True, historical resemblance has been realized in the most marvelous way," said a Salon reviewer of the stunningly successful *Portrait of A. L. Thiers* in 1877; it was "an event," in fact "an arrival."[22] After the appearance of *Thiers* and *Hugo*, being painted by Bonnat signaled arrival as well. Presidents of the Republic, famous beauties, artists, writers, American millionaires, the elite of the Third Republic all came to Bonnat for their portraits, and paid him very well.

Eakins did not know the Bonnat of this period, though he might have seen the canvases brought home by proud New York bankers and their wives. But he could have learned the rudiments of the style even in the 1860s: the dark, plain backgrounds, the relentless focus on the face and hands of the sitter, the straightforward, unpretentious poses and

everyday clothing, the somber colors and heavy textures (see fig. 239). Bonnat's paint handling remained thicker, looser, less literal than Eakins', but the striking parallels in their work show how completely Eakins joined Bonnat in the camp of French academic realism. Eakins relied on this tradition most heavily when painting commissioned portraits, or in the face of dignified sitters he knew only slightly. As with most painters, the portraits of his family and close friends are warmer, more intense, and more informal. In such cases the conventions seem less obvious because they are less necessary: Eakins' own psychological perceptions (or projections) supported and regulated the structure of the painting. In turn, one must grant a degree of Bonnat's stiffness to the stiffness of his clientele; unlike Eakins, he knew only a fraction of his sitters well.

Portraits of women by Eakins and Bonnat are less similar. Bonnat was famous for his male character studies, but his images of women tend to be effigies. His well-known portrait of an actress, *Madame Pasca* (1874, Musée D'Orsay) is beautifully modeled to give an effect of texture and relief, but it is one of Bonnat's "cold storage" likenesses. Critics teased that her satin dress was invulnerable to even a hatchet blow, that her little finger was strong enough to support the weight of a six-year-old child.[23] Eakins, who liked to paint women in evening dress to reveal their arms and shoulders and to make them more vulnerably feminine, never attempted Bonnat's cold show of luxury and social position. His closest approximations, *The Pathetic Song* (see fig. 96) and the *Concert Singer* (1892, PMA), show a mastery of Bonnat's high-style conventions—shimmeringly painted brocade and beads, the elegant, spotlit silhouette thrown against a void—but they are used only as a foil for the rather ungainly earnestness of the singer. As in Eakins' other portraits of women, the model looks unnaturally dressed up in her fancy clothes, which neither protect nor define her identity but emphasize her tenderness.

Eakins may have learned a few practical matters from Bonnat's portrait method as well, for he set up his model and his easel with the same eccentric exactitude. His instructions to himself, jotted in his pocket notebook in French, outline the procedure also used by Bonnat: "When I work at life size I will always put my canvas as close to the model as possible. Because nature will be more correct than your picture, it would be less foolish to push the canvas farther away than the object being copied. This is the reason why life-size things [in paintings] are usually weak. People like ease when working. One puts the canvas near oneself and loses the grandeur of the sketch, the anatomy, the grand construction and the whole quality of the surface. To copy texture well it is necessary to put the canvas and nature side by side. No other way. If one paints texture any other way, you only make a 'chic' effect."[24]

By standing back, according to Bonnat's portrait method, Eakins introduced larger, more generalized effects into his painting, but at the same time he learned a brand of realism from Bonnat far grittier than Gérôme's. Considered by Zola to be the successor to Courbet, Bonnat was known during the sixties as an uncompromising naturalist, more famous for genre and history than portraiture.[25] His early *Interieur Familiale* (1853) and other domestic topics similar to Eakins' first projects in Philadelphia in the early seventies were followed by Italian peasant subjects undertaken during his stay in Rome. Out of this experience grew an ever-popular sequence of realistic street scenes, urchins, mothers and babies. *The First Steps* (1874) was a great crowd pleaser at the Philadelphia Centennial, where it was deemed "full of the most serious excellences" by Earl Shinn.[26] "Bonnat's supremacy in flesh painting is now uncontested," wrote Shinn; its "truthfulness and . . . solidity" made it "perfect and real." If he admired Bonnat's flesh painting, Eakins could not be so sentimental about proud mothers and beaming toddlers. His pensive *Baby at Play* (coll. Mrs. John Hay Whitney)[27] was less ingratiating, although it followed Bonnat's pattern of life scale, outdoor siting, and naturalistic detail. Eakins' only essay in this genre, it was painted in the year *The First Steps* appeared in Philadelphia.

Bonnat's next genre, the religious paintings, had a more serious impact on Eakins' painting. His series of martyrs—the first was *St. Andrew*, followed by *St. Paul* and *St. Denis*—showcased superb figure painting in the unsettlingly realistic tradition of Ribera. All of these paintings were taken to be so naturalistic that they bordered on the offensive. The year Eakins arrived in Paris, *St. Vincent de Paul Taking the Place of a Galley Slave* drew crowds, praise, and complaints when it appeared at the Salon. Bonnat, it was suspected, hardly cared for the spiritual aspects of the subject and only "seems to have made his painting in order to put some bits of academic figure study in it."[28] Debate increased with the appearance of the medal-winning *Assumption of the Virgin* in 1869, shortly before Eakins entered Bonnat's atelier. The critic J. A. Castagnary found no lightness, no grace, no supernatural aura in the work at all—only the "brutal reality" of a tall, awkward, uncomfortably costumed and theatrically posed artist's model. He felt that the "angels" were too old and too earthy, and he doubted the whole group's ability to ever get off the ground, much less float. "Why bother?" he asked. "Why paint miracles at all?"[29]

If the critics were confused in 1869, they received an unmistakable message from Bonnat's *Le Christ*, painted for the Palais de Justice in Paris. The painting excited interest even before it was exhibited at the Salon of 1874, for the rumor escaped that Bonnat had worked from a cadaver actually nailed to a cross. J. Alden Weir, who was at the Ecole at the time, managed to sneak a look into Bonnat's workroom. It was a "horrid sight," he said, "but it shows how these French artists believe in truth." Of the painting, Weir felt that "as a study of the anatomy of a figure [it] is a marvel, the strongest thing of its kind I have ever seen . . . but a very unpleasing subject."[30] Most Salon viewers agreed. Repulsed by the agonizingly realistic treatment of a traditional subject, they felt that "the sufferings of Christ should not terrify, but touch and

move us. Art does not have the right to alter dogma, even to produce a novel effect."[31] Viewers thought that the realism trivialized, even vulgarized the subject, and they were particularly bothered by the painful, even grotesque catalogue of details: "the long, emaciated arms, the fingers shrivelled like the claws of a crab, the contracted hands, pierced by a nail that pulls on the flesh and the muscles, the bones projecting under the stretched skin, the belly sunken and shadowed . . . , the thighs beaten and blemished, the legs furrowed with bruises."[32] Théophile Gautier, who had understood Bonnat's intentions in his earlier religious subjects, advised viewers "not to look for a particularly profound or intense religious sentiment in these pictures. . . . It is in the study of anatomy, of musculature, that Bonnat's brush triumphs."[33]

Indeed, Bonnat approached the study of the human body with a sentiment equivalent to religious fervor. "The living model! It is Nature, it is life, it is the beautiful, the true!" he exclaimed to William Sartain in an 1877 letter in which he defended the importance of life classes.

It was only by studying and understanding Nature—the living model—that the Greeks arrived at perfection. If they had confined themselves to copying and imitating their predecessors, they would have produced Egyptian or Indian art; and, as *everyone who imitates is always inferior to his model*, they would have produced bad Egyptian or Indian art. . . . Let the student abandon himself to the study of Nature, of the living model. Let him analyze, and measure, and penetrate into its secrets. Let him study anatomy, and understand the causes that swell or diminish the muscles. Let him know that there is beauty only where there is truth. . . . Outside of Nature there is no safety.[34]

Le Christ, an illustration of this philosophy, was destined for the Paris Law Courts, and it was hung over the judges' bench in one of the large courtrooms. At least a few critics saw it as an appropriately chilling lesson to the condemned. Eakins may have absorbed different messages by reading about it, for the picture was exhibited in 1874 at a time when Eakins was in close contact with Paris. Gérôme arranged to show two of his paintings at Goupil's that spring, so Eakins was probably watching the reviews from France, and American accounts of the Salon agreed that Bonnat's work was one of the most "sensational" pictures shown.[35] The Paris correspondent of the *Evening Post* launched his review of the Salon with praise for Bonnat's picture: "The anatomy is perfect, the color has not the repulsive tint of death, and the effect, especially when seen from a distance, is marvelous. It is a perfect representation of human suffering." While wishing for more "nobility" or "divinity" in the figure, the correspondent reminded readers that Bonnat did not seek the ideal, saying of his work to his friends: "Est ce beau ça? il n'est pas idealisé, mais ma foi, c'est la nature."[36]

From such written accounts, if not from the stories of Billy Sartain, who returned to Philadelphia from Bonnat's

studio in 1876, an idea could have been planted in Eakins' mind, where it grew slowly, ripening in 1880, when he painted his own *Crucifixion*, or *Christ on the Cross*.[37] A declared agnostic, Eakins approached the subject with a Bonnat-like intention: it was an old theme to be reworked in a new, more naturalistic way, an opportunity to study anatomy and sunlight in the most serious context. Eakins hammered together a cross and traveled, with his student model J. Laurie Wallace, across the Delaware River to a suitably secluded spot. According to Wallace's account of the undertaking, they had just set up when a party of hunters tramped by and forced them to move. Reestablished, Wallace mounted the cross, donned the crown of thorns Eakins had carefully prepared, and posed while Eakins took a few photographs. The painting itself was executed in the Mount Vernon Street studio, with Wallace suspended from the cross by his hands.[38]

The result was a "lean, lone figure set against a glaring sky—austere, uncouth, and diabolically realistic," according to Eakins' admirer Sadakichi Hartmann.[39] Like Bonnat's painting, it is a "portrait" of a particular body, believably heavy, limp, and awkward, pathetic in its nakedness. There is no drama, little comment; it is impersonal throughout. Unlike Bonnat's crucifixion, there is no theatrical lighting from above, no shock of brutally strained and beaten anatomy, only the tense, curled hands ("like the claws of a crab"), the painfully stretched muscles, and the protruding skeleton. More understated and subtle than the Bonnat, the Eakins sensibility is gentler, less melodramatic. But the motivation and the stark realism are unquestionably linked; written accounts of the two paintings, the two artists' philosophies, and the critical responses to each could easily be exchanged.

A similar interchange of commentaries might be made between the sensation Bonnat created with his *Le Christ* in 1874 and the stir caused by the *Gross Clinic* (see fig. 88), completed in 1876. Here the demands of naturalism alienated the American audience as quickly as Bonnat repulsed the French. "The sense of actuality about it was more than impressive, it was oppressive," remarked Brownell. "But whatever objection a sensitive fastidiousness may find to the subject of this picture," continued the review, "none could be made to the skill with which the scene was rendered." And, though critics argued about the relative merits of Eakins' color and composition, no one could fault the striking accuracy of detail. Brownell called it a "masterpiece of realism in point of technique" that is "equally a masterpiece of dramatic realism in point of art," concluding that "very little in American painting has been done to surpass the power of this drama." Though "many persons thought this canvas . . . both horrible and disgusting, the truth is that it was simply unpoetic." Bonnat, who also favored drama over poetry, had heard similar commentary. As a realist, Eakins, like his teacher, was "distinctly not enamoured of beauty, unless it be considered, as very likely he would contend, that whatever is, is beautiful."[40]

After the manner of his portraiture and the more intense method of his realism, Bonnat gave Eakins a third, less pal-

pable gift: the taste for Spain. The color and surface of Spanish painting appeared in Bonnat's art, the topic was constantly in his conversation, and the works of old and new Spanish masters—Velázquez, Ribera, Murillo, El Greco, Goya, Fortuny, Madrazo—filled his private collection. Sunday mornings he invited his students to his house and then, with the particular problems and interests of each student in mind, he lovingly shared his treasures. Whether this custom had been established in Eakins' time is unclear, and what paintings Bonnat owned by 1869 remains vague, but Bonnat's early enthusiasm for Spanish art can be determined from the evidence of his painting alone. "I was raised in the cult of Velasquez," he once wrote, and from childhood he took inspiration from "Don Diego," a "realist to the utmost, translating everything that he saw, without discrimination, with an implacable rigor. He gave it simplicity, synthesis."[41] Recalling Bonnat's teaching maxims—simplicity and synthesis—it becomes apparent why Velázquez was "son Dieu," why Ribera was his constant guide.

It seems more than coincidental, then, that Eakins left for Spain less than three months after leaving Bonnat's studio. Gérôme was again traveling in the fall of 1869, leaving his atelier in the custody of others, and Eakins was beginning to feel that his "school days were over." "I can construct the human figure now as well as any of Gérôme's boys," he wrote to his father that November.[42] The interminable rain of Paris was undermining his health, the sea voyage home in winter seemed daunting, and plans and stories of southern journeys, including those of his friend Bill Sartain, became too tempting. On 29 November he boarded a train for Madrid, resting there briefly before moving on to Seville, where Sartain and another American student from Gérôme's atelier, Harry Moore, joined him for six months of work and play.[43]

At last in the Prado, Eakins reacted to the paintings of the Spanish masters with an enthusiasm buoyed by long anticipation. From the remarks he jotted in his pocket-sized "Spanish notebook," and from his letters home, it is evident that his personal malaise had been building for months. "I have seen big painting here," he wrote to his father from Madrid. "When I had looked at all the paintings by all the masters I had known I could not help saying to myself all the time, it's very pretty but it's not all yet. It ought to be better, but now I have seen what I always thought ought to have been done & what did not seem to me impossible. O what satisfaction it gave me to see the good Spanish work so good so strong so reasonable so free from every affectation. It stands out like nature itself."[44] Eakins had gone to all the masters in Paris with an eye for technique, for paint handling, for construction. His taste in art reflected this bias, for his favorite painters included only the best technicians and academics. Spanish art, "so free from affectation," appealed to Eakins, who had little patience for the confections, the "smiling, smirking goddesses" and "arsenic green trees" of the Salon favorites. Viewing the Salon of 1868, Eakins could only commend Gérôme, Gustav Doré, and the Spanish painter

Ramon Rodriguez; the rest he dismissed as the "trashiest stuff possible."[45]

A year later, just months before studying with Bonnat and traveling to Spain, Eakins still spoke highly of Gérôme, but his highest accolades went to the man he saw as the contemporary "Phidias of painting & drawing," Thomas Couture (1815–1879). "What a grand talent," he wrote to his sister Fanny on 1 April 1869, shortly after seeing "four little things by Couture" that had the "most beautiful color I ever saw." "Who that ever looked in a girl's eyes or run his fingers through her soft hair or smoothed her cheek with his hand or kissed her lips or their corners that plexus of all that is beautiful in modelling but must love Couture for having shown us nature again & beauty on canvass. In his [Romans of the] Decadence he has far exceeded all other painters. . . . His art & Gérôme's can hardly be compared. They are giants & children each to the other, & are at the head of all art."[46] The sensuous qualities in Couture's art clearly moved Eakins, and we can look to Couture's strong chiaroscuro and his broad and suggestive paint handling for a demonstration of the qualities that would also draw Eakins to Bonnat and Spanish art.

Once in Madrid, Eakins found Velázquez held all the answers. Where Gérôme failed, he succeeded magnificently: light, atmosphere, color, texture, and—especially—sheer handling of paint. Eakins was particularly impressed by his boldness, and he jotted down his own reconstruction of Velázquez's method, which relied on broad construction of forms made subtle by later glazing and scumbling.[47] Bonnat had also described this as painting "du premier coup,"[48] referring to the immediacy and spontaneity of the paint, which was applied to the canvas without preliminary sketchings or underpaintings. Eakins himself used the term *premier coup* with a slightly different emphasis, indicating the method of Bonnat's friend Carolus-Duran or Van Dyck.[49] Theirs was fresh, direct, one-step painting in its own right, but less complex and more opaque than the Spaniard's. It was Velázquez's versatile and masterful overpainting—glazing and scumbling—that impressed Eakins and, more than anything else, broke him from Gérôme. "Besides," he noted to himself, "that is certainly the manner of Bonnat and Fortuny," to which "my own instincts have always carried me, and made me master all my difficulties."

As soon as my things are crudely enough placed, I should seek my largest effects immediately. I should always put in as much light as possible at the outset. Never forget this. This is what confounded me at Bonnat's, where I drew well enough. The spinner of Velasquez, while very impasted, had no ridges to catch the light. He also does this better than Bonnat. So then pile up the paint as much as I want, but never leave ridges. The things of Velasquez are almost made to glaze over. Ribera also works very smoothly, but he leaves folds in the skin of his old people that he refills with the transparent,

colored shadow. Velasquez rubs [*frotte*] a lot with color, completely transparent in the shadows, but the foundation is already solidly painted. Try to construct forms minimally at the outset so that it is possible to paint all of my picture in one day. Work solidly immediately.[50]

Having come to these realizations of his own faults and those of his masters, he decided to follow his own instincts: "I must determine never to paint in the way of my master [Gérôme]. One could hardly hope to be stronger than him, and he is far from painting like the Riberas and Velasquezes."[51]

After his work in Bonnat's studio and his trip to Spain, Eakins reacted even more favorably to painters with a Spanish style who wed careful observation with dazzling technique. Back in Paris in the late spring of 1870, his attention at the Salon was drawn to the work of Henri Regnault (1842–71), who would be described by Earl Shinn as a "sort of later Velasquez."[52] Regnault was only a year older than Eakins when his *Salomé* (Metropolitan Museum of Art) created a sensation at the Salon of 1870. His effect depended on brilliant color, dazzling contrast, and a thick, almost violent execution. Of Regnault's earlier, Prix-de-Rome canvas, Castagnary had exclaimed, "This is not painted, it's thrown," and he greeted the *Salomé* with equal skepticism. Criticizing the pose, the drawing, the detail, and the color, Castagnary concluded that the painter had only one aim: "to make a tour de force, surprise his contemporaries with the richness of his palette and the sureness of his technique." On these terms, Regnault succeeded wonderfully with Eakins, who spent considerable time examining *Salomé* and taking notes on the effect of light, color, and contrast in this painting.[53]

Eakins, Regnault, and Gérôme together admired the work of the Spanish Mariano Fortuny (1838–74), a student of Madrazo after Bonnat. Another wizard of the brush, Fortuny showed more delicacy and finish than Regnault but the same love of bright color and paint. Like Velázquez, Couture, and Bonnat, Fortuny stirred Eakins' sensuous "instincts." Not long after his return to Philadelphia, Eakins was smitten by a painting by Fortuny in a local private collection: "It is the most beautiful thing that I have ever seen," he wrote.[54] Fortuny's glittering effects, particularly in watercolor (see figs. 72, 73), would have a profound effect on Eakins' work later in the decade, when the lessons of Spanish art, old and new, were thoroughly assimilated into his work.

Eakins' developing preference for painterly artists accompanied his rejection of the tight, flat surfaces and local color of Gérôme's style. After three years at the Beaux-Arts, his brief visit to Bonnat's studio was an eye-opener; the atelier ambiance was more liberal, and the studies done there were "entirely different from Gérôme's, much more freedom and color."[55] Once outside the Ecole, in an atmosphere receptive to extra-academic currents, Eakins took to heart the fashionable and unorthodox premier coup method of Carolus-Duran and the bravura effects of Regnault and Fortuny. Premier coup painting seemed shallow to Eakins when he

compared it with Velázquez later, but it was this strategy—drawing with the brush while painting—that Eakins finally adopted for his own use and applied as a teaching method in Philadelphia.

Although strengthened by exposure to the Spanish masters, Eakins felt his newfound conviction crumble beneath the unexpected weight of his own first painting, *A Street Scene in Seville* (plate 1; see cat. 145). "If all the work I have put in my picture could have been straight work I could have had a hundred pictures at least, but I had to change and bother, paint in and out," he wrote to his father. "Picture-making is new to me. There is the sun and gay colors and a hundred things you never see in a studio light, and ever so many botherations that no one out of the trade can guess at."[56] Confused by the proliferation of problems, Eakins fell back on the reassuring method of the Ecole: Gérôme, not Velázquez, guided Eakins' hand. As Ackerman remarked, the precedent Eakins turned to was probably a painting similar to Gérôme's *Pifferari* (1859). Gérôme's peasants were Roman, and his perspective scheme far more complex, but the organization, the picturesque theme of street musicians (described by Eakins as a "*compañia Gymnastica*"), even the viewer-seen-in-a-window motif are the same in both. Carefully observed and literally rendered, Eakins' painting is simpler and less sophisticated than Gérôme's, though its "earnest clumsiness," as Eakins put it, has the appeal of an honest effort.[57] Later that spring, in front of one of Bonnat's Salon entries (*Street in Jerusalem*), Eakins rethought his method and came to some conclusions: "I should have painted my street dance in another way" he noted to himself. First he should have blocked in the wall and the sky, adding only a sunlit form in red to one side, to strike the high note of his palette. The figures could then be painted over this base, as Bonnat had done, and the red keynote painted out. "I would have saved a lot of time and work, and my picture wouldn't have been weak in effect."[58] Eakins regretted not following Bonnat's method, but his influence appears in the painting's large scale and in the rough, small strokes of the brush; Gérôme's *Pifferari*, by contrast, seems photographically smooth.[59]

Before he was bogged down for weeks by the complications of *Street Scene*, Eakins ambitiously projected a bullfight scene and a gypsy subject, neither of which materialized. A few smaller paintings from Spain survive, including another study of his little dancing girl, *Carmelita Requeña* (MMA), which echoes the style of Bonnat's early portraiture, intermingling the solid academic modeling technique and the strong value contrast and color of the Spanish school.[60] Brushy and suggestive, the painting also shows a psychological gentleness unknown to either Gérôme or Bonnat, marking the commencement of a long series of introspective portraits.

Competent and promising, Eakins' work in Spain made no break with either of his painting masters, despite his brave words of independence. Still hesitant and experimental, his style matured rapidly in Philadelphia, following his return in

the summer of 1870. Within a matter of years he developed an independent hybrid of his European sources, combining diverse forms of academic realism into a personal, somewhat eccentric variant suited to his own "instincts." Even then his manner never achieved the fluency or complexity he admired in Velázquez, for "picture-making" would never come easily to him, and he could not pretend otherwise. He depended on the principled and disciplined methods learned in Paris, and he continued to pay homage to his teachers, and their tradition, until the end of his life.

Part II Medium and
Method

Eakins returned from France in the summer of 1870 prepared to launch a career as a painter. The method he had learned in his childhood and elaborated in Europe would mature during the next decade into an idiosyncratic version of academic procedure. He described this strategy in his pocket notebook while standing in the Prado, confirming his own sense of the rightness of his approach: "All the progress that I have made until today," he wrote, "has been the result of discoveries that have allowed me to divide my powers and means of working. Always divide to begin as strongly as possible" (Spanish notebook, 29, CBTE). This divide-and-conquer principle, clear even in his student work, was gradually purified in his work of the 1870s. It is most clearly read when his work is divided by medium, and the separate phases of his method emerge, each with an articulated set of styles and goals. His foundation medium, surely the first he mastered, was drawing in graphite or ink. As his visual and technical vocabulary expanded to include oil, then watercolor, sculpture, and photography, the power of drawing, and its different tasks, dispersed into these new media according to Eakins' interior model of strong and efficient work. Beginning from the substantial body of new material in the Bregler collection, an examination of these media in the order in which Eakins took them up reveals his sense of appropriate means to his specialized ends. Within each medium we can find different types and styles of work expressing purpose and meaning. Step by step, a superbly "academic" and painstaking method emerges, metaphorically akin—as Eakins would agree—to the solution of a complex mathematical problem or the construction of a boat. In understanding this level of craft, we begin to understand Eakins' art.

CHAPTER 7 Drawing

THINKING MADE
VISIBLE

"This artist is the greatest draughtsman in America," de-clared William J. Clark, the art critic for the Philadelphia *Telegraph*, after inspecting Eakins' painting *The Crucifixion* in 1882.[1] Disparaged in his own day for his raw sense of color or unartistic choice of subjects, Eakins won praise for his draw-ing skills even from those critics most annoyed by his work. A century later the compelling merit of his draftmanship has become central to admiration for his art and to the construc-tion of Eakins' identity as a definitively "American" realist. Because it is so important to Eakins' reputation, the role of drawing in his work deserves special scrutiny. When did Eakins draw? What was he trying to accomplish with draw-ing? How many kinds of drawings did he make? What did "drawing" mean to him, in relation to a finished painting like *The Crucifixion*, or in respect to the dozens of drawings found in his studio by Charles Bregler?

Eakins' sense of the term probably matched the defini-tion of the *Telegraph*'s critic, who had stood before *William Rush Carving His Allegorical Figure of the Schuylkill River* (plate 11) four years earlier and explained that the "drawing of the figures in this picture—using the word drawing in its broadest sense to indicate all that goes to the rendering of forms by means of pigments on a flat surface—is exquisitely refined and exquisitely truthful."[2] The influential New York critic Clarence Cook, once the defender of the microscopic focus of the American Pre-Raphaelites, used the same broad sense in complimenting *Negro Boy Dancing* (plate 7) in 1878: "So far as the drawing has to do with the representation of bodily action, and that action the result of thinking and will, drawing here does all that it can ever do," he wrote. "Here is life, and when an artist has this he has all."[3] To Cook, Clark, and no doubt to Eakins, drawing was assumed to be a realist enterprise, bent on the depiction of "life"—that is, the "refined" representation of visual "truth," enlarged by the suggestion of physical and psychological motivation, of past and future time. In such terms it is difficult to distinguish be-tween the goals of painting, drawing, and realist visual art in general; this is Drawing with a capital D, present in every gesture of Eakins' brush.

In a working fashion, Eakins could narrow the ambit of drawing slightly: criticizing his own early rowing paintings, he complained that they were "clumsy & although pretty well drawn [were] wanting in distance & some other qualities."[4] Drawing, in this usage, does not involve effects of atmos-phere, nor by extension areas of sky, nor the broad planes of water, land, or foliage dematerialized by the intervention of "distance." Pure painting, such as it exists for a realist like Eakins, asserts itself in these zones, where the marks of brush or palette knife are broad and the paint surface is sometimes heavy; in watercolor we find this sensibility in nondescriptive patterns of brushwork that establish the background in *Negro Boy Dancing* or *Fifty Years Ago* (see plate 6).

In opposition to the planes of light, shadow, and color that are the realm of painting, a kind of pure, abstract drawing exists subliminally in the geometry of Eakins' perspective

grid. Over time, the scaffold of this construction has some-times grown visible, glimmering through the paint as a ruled horizon line or vertical axis; usually this network can be read only in the edges of furniture or the patterns of the floor. The excellence of this type of drawing lies in its self-effacing cor-rectness: everything looks "right," convincingly set into space. Subtly, and fundamentally, the illusion contrived by perspec-tive contributes to our sense that the subject is "well drawn."

Between these poles of drawing and painting comes a fused drawing-painting dedicated to the "rendering of forms," to the construction of figures and other objects—benches, banjos, details of a landscape or an interior—with brushmarks that reveal directed, descriptive gesture of fingers, wrist, arm. Compared with those used for the surrounding background zones, the brushes here are smaller and the strokes often meld more smoothly, especially where the activity of "drawing" grows most intense, as in the figure of Rush's model or in the delicately painted fishermen along the horizon of *Mending the Net* (plate 17). The fishermen, by contrast to their landscape, express whatever visual distinction Eakins could make be-tween the drawing entailed in painting, and painting alone. Although drawing and painting are necessarily merged in every stroke on the canvas, the balance shifts dramatically be-tween figures and ground. Such a polarization of modes, as seen in *Mending the Net*, is characteristic of Eakins and not typical of all painters. The investment of drawing in the figures, with their resulting pitch of visual interest, expresses quite logically his dedication to figure painting and the prior-ity of Drawing—in the large sense—to this mission.

The articulation of painting and drawing-painting re-veals Eakins' prejudices about subject matter and style, rooted in the art education of this period and shared with most of his contemporaries. But as usual with Eakins, the conventional grew exceptional by a process of exaggeration. The special quality of Eakins' education accounts for many of his later attitudes and habits as a draftsman. As with most children in his culture, his first tool of artistic expression was probably a crayon or a pencil, but his developing skill was di-rected by an unusual Philadelphia public school curriculum that integrated drawing and writing as a central educational experience. This training was followed by four years of evening drawing classes at the Pennsylvania Academy, where he worked exclusively in black and white, on paper. Pro-foundly, redundantly, this training was reinforced through-out these student years by the example of Eakins' father, a writing master, who surely taught his son penmanship along with discipline, rationality, and pride in craftsmanship.

The compounded effect of all this drawing at home and at school, persisting until Eakins was twenty-two, has been frequently remarked but only recently analyzed with care and imagination, by Elizabeth Johns and Michael Fried. Johns' good study of Eakins' training at Central High School has identified a characteristic "ideology" of drawing, based on thorough, systematic method, instilled early and maintained throughout his career.[5] Fried has explored Freudian paths

into *The Gross Clinic* (see fig. 88) and found a constellation of related images in other paintings, all depicting figures bear-ing writing and drawing instruments or tools of investigation and control: pens, pencils, surgical knives, guns. The power of these figures, based on their knowledge, gives them the authority to look, to master, to know yet more. In Fried's model, the lure of knowing, and of control, is represented by the activity of writing-drawing and its metaphorical ana-logues. Fried locates the arena of the "graphic" mentality on the horizontal plane of actual writing, extended into the illu-sionistic space of the picture to bear the artists' reinvention of the real world insofar as he can know and depict it. Coun-tered to this plane of "knowing" is the vertical surface of the canvas itself, representing the purely "pictorial" experience of the painting: its color, texture, and two-dimensional design. To Fried, the unresolved synthesis of these two experiences —of illusion (knowing) and of materialism (seeing)—ac-counts for the tension and enduring interest of Eakins' work.[6] Fried's analysis is useful in its recognition of an interrelated metaphoric system of images and in its revelation of a "family romance" centered on Eakins' relationship with his father; both patterns relate directly to Eakins' elaborate training in drawing and to the depiction of drawing-related activities in his paintings. But Fried does not discuss Eakins' actual draw-ings, their style and content. Do these drawings confirm Fried's model, as well as the disjunction between painting and drawing visible in his finished oils? In coming to terms with Eakins as the "greatest draughtsman" of pre-modern American art, and in discovering his private sense of the meaning and purpose of drawing, we must look harder at the drawings themselves.

In assembling such work for examination we encounter drawing in its more commonly understood form: markings with a point such as crayon, pencil, charcoal, or pen, usually on paper. Some of these drawings incorporate color, usually red or blue ink or pencil, but for the most part they are en-tirely in black and white. Many use ink wash or blurred char-coal for an effect of tone, but the majority are executed with a hard point to produce a crisp line. The overwhelming effect is black and white and linear—like writing.[7]

This much could have been observed from extant draw-ings prior to the emergence of Bregler's collection. But fur-ther generalizations about types and style would have been difficult, for relatively few drawings were known. Goodrich probably saw many drawings in the Eakins house when he visited in the early thirties, but he listed only twenty-six in his catalogue, all of them student figure studies done between 1863 and 1866, or elaborate perspective drawings made be-tween 1872 and 1875. In the fifty years following the publica-tion of his list in 1933, most of these catalogued drawings (then owned by Susan Eakins or given by her and Mary Ade-line Williams to the PMA) moved into public collections, and twice as many more new drawings emerged, for the most part as a result of gifts or sales from Bregler in the decade follow-ing Susan Eakins' death.[8]

The revelation of the 333 drawings remaining in Bregler's collection dramatically enlarges the evidence of Eakins as a draftsman. Altogether, this body of work offers more "news" than any other component of the collection, partly because it is larger than any other category (save photographs) but mostly because the assemblage is four times larger than the previously known corpus. Many possibilities unfold from a group of this size, and one important new question: Is this all? Earlier, the selective survival of some drawings could have been recognized as editorial culling, mostly by Susan Eakins, with the implication of additional examples either lost or not chosen. Now Bregler's collection, mostly composed from the leftovers in Eakins' studio, emerges at last. Assuming that Bregler reverently safeguarded every scrap—as the slightness of some of the drawings suggests—we must consider what might have been destroyed or dispersed prior to his rescue of this material in 1939. We can't possibly have *all* of Eakins' drawings, but is this group likely to be fully representative?

Evidence suggests that the current tally of more than 400 drawings constitutes a high percentage of Eakins' total output. Ensconced in the same large house from boyhood until death, Eakins had no reason to weed his drawings for reasons of space, and photographs of his studio indicate that he was not particularly tidy. Things piled up on tables and in corners, and remained. More important, he was surrounded by devoted family members and students who proudly harbored his childhood drawings and every other relic of a greatness that they felt sure the world would eventually acknowledge. Susan Eakins was especially faithful in this enterprise. Not, by her own admission, a very enthusiastic housekeeper, she guarded Eakins' drawings against his own bitter inclinations. "Why do you keep all that, Susie?" he asked his wife when he found her carefully storing his drawings. "Look how much closet space they take up. They will all be burned after we're gone, anyway—so why not burn them now?"[9] In this curatorial mood, it was probably Susan Eakins who pinned together the related drawings for *A May Morning in the Park* (cats. 197, 198, 200, 202) and *Rail Shooting* (cats. 157, 159–163).

Her task was probably not complicated by the wish to suppress controversial materials. She withheld some of his papers, but ultimately she seems to have destroyed very few manuscripts, allowing painfully detailed documents to survive. It seems unlikely, then, that she destroyed any drawings, if only because the most scandalous episodes of Eakins' life centered on his teaching and his relationships with students, not on the imagery in his work. Nonetheless, the present dearth of figure drawings must be queried from the angle of possible censorship. The legendary bonfire in the back yard of 1729 Mount Vernon Street, interrupted by Seymour Adelman in the spring following Susan Eakins' death in December 1938, may have consumed drawings as well as photographs, destroyed by those eager to bury additional evidence of Eakins' "fetish" of the nude.[10]

Other than this one moment of turmoil in 1939 as Susan Eakins' estate was settled, very few other occasions threatened the hoard of drawings in Eakins' home. The demand was not great. Documents indicate that Mrs. Eakins dispersed fewer than two dozen drawings. Eakins himself is known to have given away his drawings only once: to Leslie W. Miller, who received a set of perspective drawings prepared for the portrait of Mrs. Frishmuth in 1900. Miller, himself a drawing teacher and the author of a manual on perspective, thanked Eakins cordially, but did not keep the drawings.[11]

Speculation must then rest on Eakins' treatment of his drawings, and the possibility that he destroyed many himself. His initial choice of materials does not suggest great esteem for his work, or much thought given to the visual, tactile, or enduring qualities of fine paper. More often selected, it seems, for reasons of economy or expediency, his paper is almost always of a cheap, machine-made variety. A common blue-lined paper of a standard size ("foolscap"), usually folded for use as stationery, recurs frequently, and some of the anatomical drawings are on the back of printed fliers circulated by the Academy to advertise its "Programme of Study of the Living Model" (e.g., cats. 36, 47). His large perspective drawings seem to have been cut from rolls of commercial wrapping paper; these sheets are now very brittle, discolored, and irregular, probably because Bregler trimmed their deteriorating edges. By 1930 some of these drawings had disintegrated beyond repair.[12] Eakins may not have been aware of the self-destructing quality of this paper, but he knew the alternatives, as seen in the fine Whatman paper used in his student drawings or in his watercolors. However, drawings made as personal rather than public expressions received a strikingly lower investment in materials. In private moments the pleasure of fine paper apparently was not important to Eakins, or not worth the cost.

This discrimination between public and private, or quality and convenience, carries through in the condition of Eakins' drawings, which generally suggests a period of very casual ownership prior to the more reverent custody of Susan Eakins and Charles Bregler. Aside from inherent deterioration of the materials, many of the drawings are soiled, creased, and ragged, indicating careless handling. Their shabbiness, added to the evidence of his remarks to his wife, his rare presentation of drawings to others, and the complete absence of sales or exhibition records for this work, all tell a story of low regard for his own drawings. The variety of surviving examples proves, however, that he did not systematically destroy them, perhaps because he always held private plans for revision (ultimately enacted in his late sporting paintings and William Rush subjects) or simply because he didn't care enough to bother. It was easier to let them accumulate until, eventually, someone else took charge.

Under such circumstances, we can expect the loss of drawings by accident or negligence and occasionally by conscious choice. Many obvious lacunae exist: no drawings for

The Gross Clinic have been found, although the spatial and compositional construction of this painting is far more complex than that of the sporting and genre subjects completed about the same time with the aid of elaborate preparatory drawings. Likewise, no perspective for *William Rush Carving* survives, although the many extant preliminary sketches indicate considerable planning for this painting. From the habits seen in the available suites of drawings we might imagine that all of Eakins' figure compositions of the 1870s and most of his full-length portraits were preceded by at least some kind of overall perspective drawing and perhaps detail sketches. An impressive number remains, but such drawings do not exist for every painting. The recognition of this loss can be assuaged, however, by the diversity of the surviving group, which ranges from very large, extremely laborious perspective drawings to notebook sketches of an illegible brevity. The fact that inconsequential jottings and juvenile doodles survive alongside major working drawings encourages the sense of a comprehensive, laissez-faire accumulation over the years, prone to haphazard forces but fundamentally undisturbed by episodes of housecleaning or connoisseurship. It seems unlikely that an entire class of drawings could have disappeared, or, if the lowliest items were saved, that richer examples would have been systematically discarded.

The number and the variety of surviving drawings give us the sensation of a representative cross section of Eakins' drawings, and perhaps an unusually high percentage of his production. Consideration then turns to these extant 400. Although the group is large—and much larger than ever imagined—this suddenly seems like not many drawings for an artist deemed the greatest draftsman of his period. This feeling grows when the group is broken down into types: 15 percent are student drawings from before 1870, 40 percent are brief notebook croquis, and 14 percent are anatomical drawings or dissection studies, matched by an almost identical number of illustrations and diagrams for Eakins' planned drawing manual (fig. 48). Only the remainder—about seventy drawings—bear directly on Eakins' art. Even if the sketchbook pages (about 150 images) are drawn back into the art-related count, this is not a large tally of drawings for four decades of work. Either much more was lost than we have guessed, or Eakins didn't really draw that much.

While we might reexamine the circumstances of Eakins' studio and the provenance of the drawings again, the internal evidence of the drawings tends to encourage and refine this second, somewhat surprising hypothesis. Arranging the entire oeuvre by subject and date, two things become clear: first, 95 percent of the extant drawings from Eakins' maturity actually date from the first fifteen years of his career. Excluding four undated items (cats. 228–231), only twenty of the drawings in the Bregler collection are from after 1886; elsewhere, only five drawings from the post-PAFA years are known. This pattern tells of a dramatic reduction in Eakins' drawing activity after leaving the Academy, and it condenses the available work into a dense network of activity, but still this

48. *Drawing 5 [Viewer Position]*, c. 1884 (cat. 98). An illustration from Eakins' projected drawing manual demonstrating the proper position for a spectator observing Eakins' *Starting Out After Rail*.

would indicate that Eakins made an average of fewer than two dozen drawings annually during this period. The character of this production becomes more interesting and less uselessly "average" in light of a second observation about the drawings overall: as mentioned above, they fall easily into distinct categories of work, each group identified by separate concerns and usually by separate technique and handling. The differences between each genre, often so extreme as to suggest different artists, display a quality of directed purpose in each category, somewhat detached from the draftsmanly endeavors of the next. Each type has a particular mission, sought in the most appropriate and efficient linear terms. The articulation of these different styles and purposes indicates, at the outset, the specialized and function-driven nature of Eakins' drawings, and the precise and rationalized character of his method.

Eakins' multiple drawing styles begin with his handwriting, which can be recognized in three modes, from the stately calligraphy learned from his father and reserved for formal public exchanges (on high-quality paper) to a more rapid penmanship used in letter drafts and casual correspondence (on foolscap) and finally to a swift, boyish scrawl, seen in notebook memoranda or the annotations on his anatomical drawings (made on whatever paper was at hand). Variable, like language, these styles also appear in Eakins' work according to his audience, as his drawing takes on the tone of public declamation, informal conversation, or internal colloquy.

The voice of Eakins' earliest drawings is tentative, revealing the immature skill of his student years. Excluding his high school classroom assignments and some of his life class studies, many of the drawings from before 1866 are united by this insecurity, indicating an incomplete mastery of contemporary drawing conventions. In a process analogous to copying letter forms, he imitated shorthand foliage notations from a drawing manual (see figs. 19–22). The progress seen in the years prior to 1871 ended with the achievement of competence in painting and the nearly total exclusion from his drawings of those subjects most important to his student period: portraits, figure subjects, and landscapes.[13] These topics, the important ones for his art, were almost completely absorbed by painting. After 1870 the tasks delegated to drawing were few and distinct, with each type of work characterized by a different style efficiently adapted to the purpose and the audience at hand.

The most enduring "voice" or handwriting from Eakins' boyhood was the formal public address exemplified by the Spenserian script of his signature (fig. 49) and the style of his high school perspective studies, still present in drawings at the end of his career. This style aspires to the most rigidly conventional, impersonal, and self-consciously artificial kind of writing or drawing, which seeks excellence by perfectly recapitulating a canon that is widely held and thereby retreating into anonymity. Although it might seem odd that an artist's signature, usually an emblem of individualized self-representation, would be expressed in this kind of calligra-

49. *Portrait of Dr. John H. Brinton: Plan and Perspective Study of the Artist's Signature,* 1876 (cat. 176).

phy, the values embedded in this choice are exactly the ones underlying Eakins' artistic identity: close observation of academic norms, mastery of conventional craft, and repression of the self in the service of a realism assumed to be the standard language of serious public art. That this signature is often set into perspective, so as to seem written on the illusionistic plane of the "floor" (cats. 176, 213) only makes an additional witty homage to the canons that Eakins honored.

Logically, the purest expression of this public face in Eakins' drawings appears in the images made for reproduction, as illustrations to the drawing manual he wrote to accompany his own lectures (see figs. 48, 54; cats. 92–138). This sequence of numbered illustrations indicates that Eakins' book, evidently begun in the early eighties after he became professor at the Academy, was nearing completion when it was abandoned, probably some time after his forced resignation in 1886.[14] The style of these drawings expresses the detached scientific and public tone of his teaching mission, as well as the practical necessities of reproduction, although contemporary printing did not require this degree of simplicity. Drawn in ink, with a pen, with very spare detail and modeling, these illustrations use the visual language of maps and geometric diagrams—crisp black and white contrast, evenly ruled or dotted lines, points labeled A, A'—even when human figures are depicted. Such extreme abstraction recurs only in his work on the occasions when Eakins was intentionally drawing for reproduction, as in the sketches made of his own work for use as catalogue illustrations.[15] Although less arbitrary than writing, the lines and forms used here are more in the mode of penmanship than representational drawing. Little effort is made to suggest the quality of visual perception; on a spectrum of representational impact, these drawings are the polar opposite of Eakins' paintings. But then these images are not based on the observation of reality;

they rely on concept, and on the wish to visualize certain principles or relationships in the clearest possible terms. The fundamentally abstract nature of the task directs the quality of the drawing, as does Eakins' wish to invoke the anonymous authority of science.[16] We can gain a glimpse of Eakins' teaching in the rhetoric of this style, for it is deliberately plain and popular and impersonal, seeking a common denominator that is at once extremely accessible and utterly convincing. This style, expressed in words, also emerges from Eakins' text, which is likewise neither chatty nor digressive. Sober and direct, it bluntly asserts the simplicity and the immutability of the "law" of perspective. Text and pictures together suggest the impression made by Eakins' teaching, and his ability to instill the principles of perspective into even the most "artistic" minds. Students learned and remembered concepts taught in this plain style: fifty years later Adam Albright could still hear Eakins say, "Twice as far off, half as big."[17]

Eakins' illustrations seem harshly simplified and mechanical compared with the realistically rendered figures that we associate with his work, but they are only the most extreme statement of a fundamental abstraction that characterizes all of his drawings. Philip Rawson, in his analysis of worldwide drawing types, reminds us that the lines and tones of drawing are never actually seen in nature; drawing is the most "spiritual" and "subjective" of all visual artistic activities in its dependence upon a symbolic language of form. Rawson argues that art is never a record of something "seen," it is always a construct, inspired by habits of vision and based on artificial conventions.[18] A nineteenth-century realist, committed to representation, might seek a relatively more complex, illusionistic rendering of the world in pen or pencil than appears in Eakins' illustrations; Eakins himself did not. Although his other drawings vary in style and purpose, none are "realistic"; all of them accept, even exaggerate, the abstract nature of the drawing enterprise. And, even when most naturalistic, all of Eakins' creations express something of the conceptual aesthetic of these illustrations and perspective drawings. Earl Shinn, reviewing *Starting Out After Rail* (see fig. 65) and *Baseball Players Practicing* (plate 2) in 1881, commented on the "exact, uncompromising, hard, analytic style of Eakins," which "extorted" rather than solicited the spectator's approval. "One thinks of a scientific mind that has made the mistake of taking up art, and wonders whether any better career could have offered itself than the present one of successful instruction."[19]

The teacherly tone of the illustrations grows more informal in the next distinctive subgroup in Eakins' drawings: anatomical studies (fig. 50; cats. 30–81). Although these drawings seem to be record sketches from actual dissections, they have the same abstracted, diagrammatic quality seen in the drawing manual. As Catherine Kimock notes in her introduction to these drawings, the dissection studies isolate and clarify anatomical parts that, to an untrained observer, appear indistinguishably or incoherently united. Like the

50. *Dissection Study: Human [Cross-Section Through Thorax, Shoulder and Upper Arm]*, c. 1878 (cat. 38).

perspective illustrations, they are more informative and "knowing" than a realistic rendering, a photograph, or even the experience of seeing the subject itself, because they make clear relationships latent in structure or space that may be difficult to understand from the observation of surface alone.

Befitting the smaller group that Eakins addressed during a dissection procedure, as well as the need for spontaneous visual analysis or summary in the course of such sessions, these anatomy drawings are more relaxed and rough than the perspective illustrations. Some have been redrawn in pen and ink or colored with red and blue pencils, indicating a secondary phase of work to make the drawing more legible or permanent, perhaps for use in later classes. But even these reworked sketches fall far short of the detail and delicacy of standard anatomical illustrations. Eakins recorded exactly what was necessary for his own purposes, and nothing more. His economy assumed, of course, a rich referential context that included the actual dissection subject, as well as Eakins' own oral commentary, which would have supplied the complete terminology abbreviated on the drawings as well as the three-dimensional complexity of the real form. These drawings, and the anatomical casts sometimes made at the same dissections, survive as the material relics of a communication that included speech, written language, and demonstration. The absence of these other components impoverishes the impact of the drawing but also reminds us of Eakins' tendency to enlist drawing as an extension of text or speech. Like his perspective illustrations, these anatomical drawings are more conceptual than visual, and clearly allied to language.

The anatomical drawings also include a research component that expresses Eakins' use of drawing to advance his own education. The speed and economy demonstrated in these sketches presumes prior experience in dissection; for the most part, Eakins was not learning in the course of producing these sketches so much as he was explaining what he saw or knew to other observers. But occasionally (as in cats. 46, 47) it is clear that his own curiosity was called into play, and the drawings served as memoranda of interesting discoveries.

This quality of investigation dominates a third, more private group of drawings, mostly from pocket sketchbooks (fig. 51). These pages, covered with combinations of writing and drawing, seem to address only the artist himself. Relieved of the responsibility to instruct, they are generally brief, fragmentary, and cryptic. The handling is quick, rough, and decisive, without fine detail or modeling and lacking any sense of the inherent pleasure, interest, or merit of the drawing itself. Like the addresses of models or the train schedules that appear interspersed with the drawings, these sketches are a collection of useful facts jotted down for later reference. Like the other two drawing types, they have a sense of narrowly defined purpose, pursued in the most efficient fashion. Often the mission relates to the correctness of auxiliary details in his paintings. Many of the sketches are costume notes: a collar for *William Rush Carving*, a robe for Christopher Columbus (cat. 189). Much of this information came from other art, such as portraits and genre paintings from Rush's period, but the drawings show that Eakins was interested only in the businesslike recording of detail and not in the larger visual qualities of Gilbert Stuart's work or the likeness of Stuart's sitter. Again, as in the earlier drawing types, the endeavor is not so much about vision as it is about information; the drawings are abstract, not realistic or suggestive. Such fact-oriented drawings disappear after Eakins' acquisition of a camera and the conclusion of his series of historical subjects, both in about 1881.

The foregoing categories—student drawings, illustrations, anatomical studies, sketchbook notations—constitute almost 85 percent of Eakins' drawing oeuvre. The qualities

recognized in this majority, such as an abstraction more affiliated with writing (and speech) than with vision and realistic representation, must be understood as characteristic of Eakins' attitude toward drawing in general. He found drawing useful and appropriate when he was a student (and later, a scholar), and again when he became a teacher; learning—of hand, of eye, of mind—is paramount in these arenas, not art. But a final category of drawings, containing items that relate directly to the construction of his paintings and sculpture, remains to be examined. These drawings come from both ends of Eakins' career, and they are more various and complex than the other types; as a group, they introduce the richest part of Eakins' work as a draftsman.

Within the category of drawings made in preparation for paintings and sculpture, the same efficient division of tasks appears. Gathering together the suite of drawings made in advance of the oil and watercolor versions of *Starting Out After Rail* (see figs. 65, 116), we find a much-folded sheet of stationery with landscape profiles, probably jotted down while sailing (cat. 153); several fact-finding drawings made at a boatyard (cats. 164–167); sketches for the distant sailboat and its skipper (cat. 154); and a perspective of the space, containing only a box representing the position of an invisible boat tilted by wind and water (cat. 152). No drawing recapitulates the information seen in any other; all parts are united only in the final image.

If the research drawings (such as the measured sketches of boats) and the exceedingly rare studies from nature (such as the river profiles) are set aside with the similar sketchbook material, the remaining preparatory drawings are mostly of two types: compositional sketches and perspective drawings. A perspective grid usually organizes both of these types because decisions about perspective preceded and to some degree predetermined the composition of the image and the framing edges. The distinction between these two types is largely a question of sequence—the compositional sketches coming first, followed by the developed perspective drawings—reflected in two very different styles for the figures within the image.

In general, figures—nude or clothed—are rare in Eakins' drawings. The few that exist are mostly from 1870–79, during

the first decade of his career. Their scarcity, given Eakins' dedication to figure subjects, is in itself remarkable. From this pattern we might conclude that Eakins reacted to his long apprenticeship in life drawing classes by gradually rejecting the media associated with them in favor of oils. Convinced that his training had hampered his progress, Eakins may have felt that drawing the figure was retrogressive and time-wasting once he had achieved competency in oil painting. Perhaps for these reasons we find in Eakins' work none of the individual figure studies that are so familiar from the work of other European painters since the Renaissance. Classic examples of this genre by Peter F. Rothermel were found in Eakins' studio (see fig. 36), but after 1870 he evidently had no interest in making such drawings.[20]

The figure drawings that do exist fall into two styles: a fast, loose manner, emphasizing mass, and a tenser, more deliberate style, emphasizing contour. The first style flourishes early, in the fledgling professional drawings in Eakins' Spanish sketchbook, where he planned the composition of *A Street Scene in Seville* (fig. 52; plate 1). The rapid execution of this drawing can be read in the vague, discontinuous, and frequently revised contours, and the scribbled, almost violent hatching. Begun with finer, more tentative outlines, the drawing was reworked in successive passes, with each layer of drawing darker, more decisive and energetic. The restless handling, giving the impression that Eakins hurriedly jumped back and forth across the page in an effort to bring his effect together all at once, may indicate lack of experience in outdoor sketching and the pressure created by having three models before him at once. However, the many changes in the background visible within this drawing and in the alternative solutions seen in a second sketch on the back of the same page (cat. 145d) and in the final painting, also show that Eakins was reacting to—and adapting—his own composition as much as he was depicting a scene in front of his eyes.

Speed or anxiety may enhance the effect of the *Street Scene in Seville* drawings, but the role of imagination probably accounts for the endurance of this style through the midseventies, well past Eakins' student days. Later, when Eakins had no reason to feel insecure or pressured, the loose, overlaid contours and choppy or spiraling gestures of this style may signify indeterminacy—a pose not yet fully established, a model not present. Either or both of these possibilities seem likely for the preliminary perspective drafts and compositional studies that make up the rest of this group (cat. 173 [fig. 57]; cats. 146, 156, 158 [fig. 125]; cats. 192–194 [figs. 145–147]; cats. 206, 207 [fig. 82]; and figs. 58 and 123). All these drawings declare Eakins' sense of the unimportance, even the undesirability, of a crisp contour, and the priority of volume and the large construction of forms in light and dark. Even as a student Eakins shied away from the edges of figures; the contours of his early cast and life drawings are always less secure than the larger masses of light and dark (e.g., cat. 15c). In later, more confident drawings, the multiple contours seem, like the edges of Cézanne's apples, to be charting

52. *A Street Scene in Seville: Compositional Sketch, Window at Center*, 1870, graphite on paper, from the Spanish sketchbook (cat. 145d, verso).

the movement of planes turning in space. In seeking plastic rather than linear qualities in these drawings, Eakins reveals his sculptor's instinct; with his pencil he seems to be feeling, modeling, all around the forms. Such emphasis on volume and the patterns of light and shadow that define mass presents a challenge to any hard, linear drawing tool. The slashing, overall attack of the drawing for *A Street Scene in Seville* employs a pencil to secure a fundamentally painterly effect; such ends obviously could be accomplished more swiftly with brush and paint. Not surprisingly, this type of drawing was doomed as Eakins grew comfortable sketching in oils.

The inevitability of this transition can be read in Eakins' pencil study for the portrait of Kathrin Crowell painted in 1872 (fig. 53; see fig. 8). The sculptural quality of Eakins' approach is obvious in this drawing, probably because the model, later his fiancée, was patiently sitting before him, lending a concreteness to his study that is absent from the other figures drawn in this style. The pose of the sitter anticipates the composition of the final oil closely, and the developed sense of form and chiaroscuro indicates that this drawing probably operated as a preliminary study for the painting in the fashion of his later oil sketches. Details of likeness or of anatomy are never important in such compositional drafts, only the "grand construction" of the body, revealed by light. Oil painting could capture such effects more efficiently, as Eakins began to demonstrate in sketches beginning about 1874; nothing else like the *Kathrin* drawing survives,[21] and all

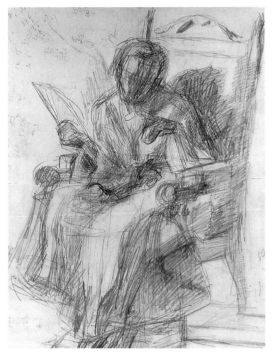

53. *Study for "Girl with a Cat—Kathrin,"* 1872, graphite on paper, 13¹⁄₁₆ × 10⅛ in., Yale University Art Gallery, James W. Fosburgh, B.A. 1933, and Mary C. Fosburgh Collection Fund.

other types of preparatory drawings—save one—become extinct within a decade.

The drawing for *Kathrin*, the many jottings in the Spanish sketchbook, a series of pencil sketches made in 1876 at the Cathedral of Sts. Peter and Paul in Philadelphia,[22] and a few figures drawn from life in his "Washington" sketchbook the next year (see fig. 226) all show that in the first years of his career Eakins occasionally sketched figures and environmental details from life in a pocket notebook or on odd scraps of paper, following the practice of his youth and the habit of most painters of his day. Such observation-based sketching declined steadily in Eakins' drawings between 1870 and 1878, after which it almost disappeared. Like compositional sketching, this work was gathered into photography or painting, which became his arenas of realistic representation.

Meanwhile, the realm of drawing became increasingly abstract, as demonstrated by the second type of figure inhabiting Eakins' preparatory drawings. Although ostensibly more "realistic" than the loosely skeined ghosts in the preliminary compositional drafts for his sporting pictures (see, e.g., figs. 123, 125; cat. 156), the precisely outlined figures in Eakins' large, finished perspective drawings are also not "seen," but copied from other, two-dimensional sources. These figures vary in their substantiveness from the simple pen contour of the banjo player in the drawing for *Negro Boy Dancing* (cat. 191; plate 8) to the strong outline with broad, hatched modeling seen in the drawing for *The Biglin Brothers*

Turning the Stake (see fig. 112) to the outline with ink wash modeling used in the drawing for *John Biglin in a Single Scull* of 1874 (MFA, Boston). All of these figures, no matter how developed, partake of the abstraction of Eakins' illustrations, with their heavy, flattening contours. Outline is "an accident, rather than an essential," said Eakins. "There are no lines in nature."[23] On his own terms, then, all these drawings—like the illustrations—belong in an admittedly artificial world. The hardness, flatness, and absolute security of the outlines around these figures point to the existence of a given source not in nature: earlier studies, usually in oil, certainly from nature, and containing all the surface information absent in the drawing, such as the large oil study of *John Biglin* (Yale University Art Gallery) or *The Banjo Player* (see fig. 70). Like wraiths, the drawn figures hold the place of these more realistic representations; typically, Eakins did not bother to recapitulate that other, more solid image on his drawing. Each preparatory piece had its job, and Eakins did not waste time on redundant effort. Efficiently, he moved between media: preparatory perspective and compositional sketch on paper; individual figure studies in oil; finished, sometimes full-scale perspective on paper; finished oil.

The rationalization of Eakins' method, which gradually drained many responsibilities from drawing and reassigned them to painting, left the activity of drawing reduced and purified. For Eakins, this distilled identity thrived in the maintenance of the task that it had managed from his schoolboy days and would control until the end of his career: linear perspective. The construction of a perspective drawing is a conceptual, not a visual undertaking, as the typical emptiness of Eakins' drawings makes clear. Generally, figures are invisible, their presence indicated by only a footprint on the floor or a reflection on the water. Eakins' procedure did not require life study of models or even furniture until later in the development of the picture; at the beginning, a set of overall measurements "boxing" the depicted object could suffice. This detached process accounts, to a large degree, for the appearance of the ghostly figures that do appear, either in the loose, volumetric style, suggesting work from memory or imagination, or in the sharply outlined, flat style, implying copying from a preexisting, two-dimensional source. A perspective grid precedes the figures in both of these kinds of preparatory drawings, early and late, just as it underlies most of the drawings that relate directly to Eakins' paintings. Such pervasiveness suggests the power of perspective in Eakins' method, and its importance to his sense of the fundamental nature of drawing.

PERSPECTIVE DRAWING

Not a man of words, Eakins cared enough about linear perspective to write a book about the subject. This brief text was designed to accompany his lectures on perspective, mechanical drawing, and the rules of reflection, refraction, and shadows. Although the book was never published, the extant

manuscript and illustrations can now be studied to understand the terms of Eakins' teaching, sometimes whimsically based on his own work (as in fig. 48).[24] His definitions and procedures also give access to his own perspective drawings, allowing us to appreciate the creative choices made in the construction of his paintings and the manipulation of "reality" for artistic purposes that such choices represent.

Linear perspective, discovered or invented during the Renaissance, offers a system for the illusionistic depiction of space and three-dimensional objects on a two-dimensional surface. It is based on the principle that sets of parallel lines will appear to converge and diminish as they move away from the viewer, producing the familiar effect of train tracks that seem to draw closer together in the distance, or the telephone poles that seem to grow shorter as they march toward the horizon. The appearance of convergence or diminution can be represented informally, from observation, but linear perspective provides a method by which changes in scale and contour can be precisely calculated and constructed, almost without recourse to the observed world. Correct operation of this system depends on a fixed relationship between the viewer (or artist), the picture (or drawing), and the objects depicted. Many choices can be made in establishing these positions, but once determined they must be consistently held; if any of these three is altered, the entire image will be affected.

Even from this general description, several qualities of linear perspective reflect upon the character of an artist who faithfully accepts its system. First is the promise of exactness, of geometric, measurable accuracy, an important gift to those, like Eakins, hoping to project the orderliness and truthfulness of science and mathematics onto the endeavor of artistic representation. Second is the necessity for forethought, because many aspects of the picture's appearance will be based on or affected by decisions made before the first mark is drawn on the canvas or paper. The master of perspective is an artist with a strong preliminary visualization of his or her subject, and a patient, even enthusiastic affection for planning. Synthetic perspective "may be described as a thoroughgoing attempt to express an experience of visual reality which is only to be gained by a process of introspection, of asking what it is that is really seen," wrote John White. "Paint with your brain as well as your eye," said Eakins.[25]

To understand the principled relationship between viewer, picture, and depicted object, a few definitions are needed, mostly because Eakins' terms have a precise meaning lost to most modern readers, who generally have no more than a train-tracks-and-telephone-poles grasp of the mechanics of linear perspective. The skill is alive today among architects, set designers, commercial draftsmen, mathematicians, and perceptual psychologists, but even this crowd relies increasingly on computer graphics. Artists now are rarely required to learn perspective in their schools, and most art historians are both uninformed and slightly apprehensive about the subject. Among Eakins scholars, only Theodor Siegl has

ventured more than a wondering appreciation for the manifest complexity of Eakins' preparations. Those readers, like me, who remember high school geometry dimly, will be encouraged to hear from Eakins that the "science of perspective is of great simplicity and of easy comprehension."[26] The explanation of a few terms, often encountered in his text or in the annotations on his drawings, will suffice to introduce the dynamics, if not the mechanics, of this system.[27]

The *picture plane*, often referred to in Eakins' annotations as just the "tableau," is the actual surface of the painting or drawing. In his text and illustrations, Eakins, like many an author of perspective manuals, suggests that the student first imagine this plane as a piece of glass in a window frame (fig. 54). Objects seen through this window might be traced on the glass with a crayon to capture a correct perspective, but—as Eakins notes—if the spectator or the objects move, or if the window is somehow brought closer or pushed farther from the viewer, the tracing will no longer fit the scene and the perspective will no longer seem true. "This shows that a picture once drawn, can be correctly looked at from but one point, where the spectator should have a care to place himself."[28]

This point is established in relation to the picture plane in three ways. First, the *point of sight* is determined—that is, the spot on the picture plane directly opposite the painter's eye. This point can be anywhere on the canvas or paper; usually it is in the center. For Eakins it is always located somewhere on a vertical line drawn down the middle of the picture. "When a picture is made it is a thousand to one that it is on a flat surface, and intended to hang on a vertical; and a person wishing to see it, will stand opposite the middle of it, and look squarely at it" (see fig. 48).[29] The vertical axis, or center line, is the first thing drawn on a perspective or a painting; it corresponds to the center of the field of vision that the artist sees and wishes to depict, and therefore it also represents the direction of the line of sight, from artist to picture, as if drawn on the floor and then continued up the picture plane.

The exact location of the point of sight on this vertical line depends on the height of the artist's eye (the *horizon*), and the distribution of space (or canvas) above or below this viewing position. A landscape seen from a standing position, as in *The Artist and His Father Hunting Reed Birds* (plate 10), will have a horizon at about sixty-three inches, the distance from the ground to the eye level of a man (like Eakins) about 5 feet, 9 inches tall.[30] Any object taller, or higher, than sixty-three inches (a tree, a mountain, or the head of a figure standing on the rear deck of a hunting skiff) will project above this horizon, which rarely coincides with the "natural" horizon, where hills, foliage, or architecture meet the sky. Eakins could have enlarged his canvas to show more sky, or cropped it to include less of the foreground, making the horizon line move in relation to the upper and lower edges of the picture, but the horizon would remain sixty-three inches wherever he placed it on the canvas. For Eakins, choices

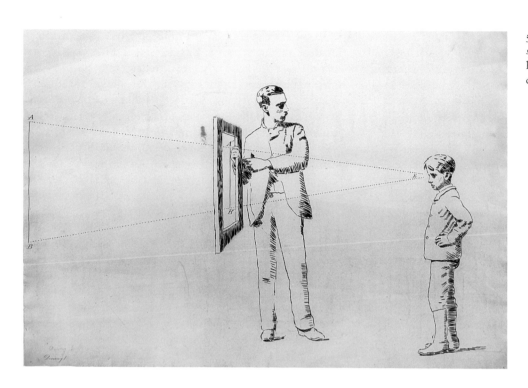

54. *Drawing 1 [The Law of Perspective]*, c. 1884 (cat. 92). An illustration from Eakins' projected drawing manual.

about framing the image and placing the horizon in the design of the picture surface would come later. At the beginning, students must simply place themselves "so as to see [the objects] as you wish to reproduce them"[31] and translate that eye level, reduced if necessary to a manageable scale, on to the vertical line of the drawing.

Eakins found much richness in this choice, as his perspective drawings show. Only rarely did he use the conventional sixty-inch height recommended by textbooks of the period.[32] His viewpoint ranges from 24 inches, crouched across from a hunter or a rower, to nine feet, observing a sailboat (cat. 155); although his portraits are usually based on his own seated or standing position, he would often vary his eye level an inch or two to gain a more effective perspective. The examination of these choices and their expressive impact on a given subject offers a series of small discoveries in Part III, in which particular projects are studied in detail. Overall, the careful calibration of viewing height read in all these subtle variations draws attention to Eakins' studied approach to his subjects, especially his portrait sitters. Remembering that the horizon line expresses the physical embodiment of the artist, his placement in the world, we can remark that Eakins' acute sensitivity to his own position in relation to the other human beings he depicts gives emphasis and particularity to his own presence, as artist, just as it adapts to the specific, idiosyncratic nature of others.

The eye level, once determined strategically, is ticked off on the vertical line and then ruled horizontally across the image from edge to edge. The intersection of the vertical axis, or line of sight, and the horizon line marks the exact point of sight. This point, projected out toward the spectator, represents the spot where all the "visual rays" emitted or reflected by the scene converge upon the lens of the eye, forming the "cone of vision." The same point, projected into the far distance, is the *vanishing point*, where all parallel lines at right angles to the picture plane will seem to converge. This important point, usually close to the center of the painting, never seems to be *exactly* in the center of Eakins' pictures, and usually it is not emphasized; often, as in the portrait of John Hayes Brinton (see fig. 227) it lies obscurely on the back wall of the room, where, according to Eakins' advice, such a spot could be flagged for reference.[33] The evasiveness of this point, which rarely coincides with the image of any meaningful object, demonstrates Eakins' general tendency to obscure the mechanics of his perspective system.

Once the line of sight and the horizon have been drawn, the last variable in the system remains to be determined: the *distance* between the picture plane and the eye. "To fix this last distance you consider how large you want your important objects to be in the picture: if you want it life size in the picture, your drawing must be distant from the eye as far as that object. If you wish any object in the picture half as big as real, you must place your picture plane at half the distance from the eye of that object; if quarter as big, quarter the way, & so on," as shown in fig. 54.[34] Eakins identified the "law of simple proportion" embedded in this instruction as the "one and only law of perspective, the law which solves all questions of perspective asked simply." In short, objects change size in an orderly, mathematical way, according to an easy ratio: "As the distance of the object from the eye is to the distance of the picture plane from the eye, so is the size of the real object to the size of the picture of this object."[35]

As with the choice of horizon, there is much room for play in this ratio. If, for example, Eakins decided that his

figures should be eight inches tall, the ratio of "real object" (say, a sixty-four-inch woman) to image would be 1:8. To maintain this ratio, he might set the distance of the picture at two feet, and place his figures sixteen feet in space. Or the viewing distance could be three feet, in which case the figures would seem to be standing twenty-four feet away. The farther the viewing distance, the more remote the figures—although the image on the picture surface will always be eight inches tall. What changes in this calculation is not the size of the figures but the character of the perspective space around them, and perhaps the quality of color and detail, if a great distance intervenes. The effect of changing positions can be understood by imagining a perspective of space laid out in a checkerboard of one-foot squares, following Eakins' instructions in cat. 100. From such a grid we can see that the squares in the near foreground change size quickly as they recede; beginning from a baseline at ten feet distant, the squares in a typical grid will shrink by half before they are twenty feet away. Objects moved between these two locations will also diminish at this rate, and anything stretched between these points—such as a rowing shell—will change scale at a startling pace. The upsetting and sometimes comical product of this zone of rapid foreshortening is familiar from "trick" photographs of figures lying on the ground with their feet looming close to the camera. A near viewpoint gives this strong sense of space and—if seen from a standing position—a steep slope to the foreground. Unless such effects are deliberately sought, no painter will be advised to place a large, three-dimensional object closer than about ten feet away; usually the object is set back, and the appearance of immediacy is achieved by cropping the canvas.[36]

A different kind of distortion occurs at greater distances, where the reduction from square to square has slowed as the checkerboard rows come in quick succession. From a standing position, objects seen on a level surface beyond about eighty feet away will hardly change size at all when pressed back an additional ten feet. In a distant object or figure made to seem close to the viewer by cropping the foreground (as if seen through a telescope or a telephoto lens), a kind of compressed foreshortening occurs, where the object recedes abruptly without visible diminution, as in *The Pair-Oared Shell* (see fig. 108). This "telescoping" effect can be mitigated by changes in the eye level, as well as by drawing the subject closer to the spectator; as his series of rowing paintings shows, Eakins tested all the variables. Long, awkward objects, like racing shells or four-in-hand coaches, forced Eakins to be ingenious, but the eccentricity and variety of his choices also show pleasure in the manipulation of effects and in the negotiation of different solutions, like variations on a theme or problem in perspective.[37]

The choice of viewing distance also must take into account the size of the intended picture, for obviously the spectator has to stand back to take in a life-size portrait, while a small watercolor will be studied at close range. "There is no mathematical impossibility about making a picture far wider than the eye can see it at one time but a very wide picture so made is very ugly," wrote Eakins.[38] He did not explain why, but the rare intrusion of aesthetic judgment in his prose signals, with typical bluntness, strong disapproval of the illegibility and unnaturalness of effect brought about by excessive width. An optimum viewing distance will bring the entire composition comfortably within the field of vision, and if the viewer is meant to grasp much detail, the picture should be embraced within a 45-degree angle of sight or less. Outside of this wedge human eyesight loses acuity, and other types of distortion in the perspective field become bothersome.[39] To find the viewing distance that brackets the sharp and undistorted center of the visual cone without standing too close, artists and writers of perspective manuals developed various rules of thumb requiring no geometrical expertise. Some advised that the spectator never be closer than the width of the picture; others suggested using the diagonal of the canvas as a yardstick. "I have seen a rule that a picture should not be wider in its diagonal than the picture is distant from the eye," wrote Eakins. "I think this would be the very extreme limit of its greatness."[40] Applying these two tactics, the image will always fall within a 53-degree or a 45-degree angle. A more conservative result could be achieved by following Leonardo's advice to make the viewing distance at least three times longer than the tallest principal feature in the painting—by which calculation a life-size standing portrait would merit a viewing distance of sixteen to eighteen feet, a watercolor of five-inch baseball players would be constructed from a viewing distance of fifteen to twenty inches—or within a visual angle of 22 degrees.[41] The viewing distances for Eakins' pictures fall into this range—never less—but never exactly and repetitiously so, as if by formula. Generally they are much longer than the minimum, sometimes because unusual objects like racing shells required deep placement in space, or because he wished for a very confined visual angle, as seen in the *Portrait of Monsignor James P. Turner* (see fig. 236).

Armed with this set of definitions and the "one and only law of perspective," we can examine a representative suite of drawings, including a previously known sketch and two newly discovered perspective drawings for the watercolor *Baseball Players Practicing* of 1875 (fig. 55; plate 2).[42] This group offers a useful introduction to Eakins' method, and a demonstration of what can be learned from close analysis of such drawings. The conceptual and detached character of the perspective drawing process appears very purely in one of the Bregler drawings (fig. 56), which is completely empty of reference to the material world. Fortunately, Eakins inscribed it "Base Ball," sparing us the work of comparing the spatial coordinates to all the likely paintings of this period. The vertical line and the horizon are sharply drawn and easy to identify; the pattern of diagonal lines gathered at the intersection of these two axes makes the point of sight obvious. These diagonals, representing a system of parallel lines perpendicular to the picture plane (the "orthogonals"), have been crossed by horizontal lines, numbered where they intersect the vertical

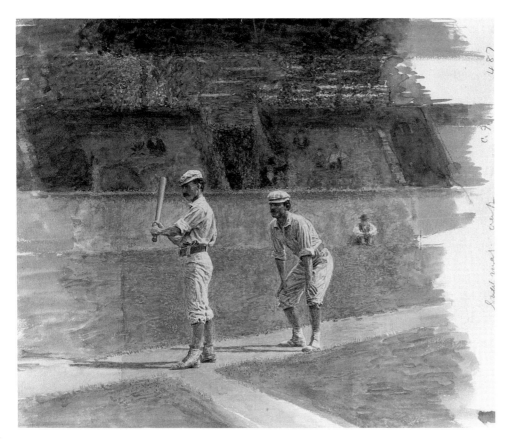

55. *Baseball Players Practicing,* 1875, watercolor on paper, 10⅞ × 12⅞ in., Museum of Art, Rhode Island School of Design, Jesse Metcalf and Walter H. Kimball Funds (plate 2).

56. *Baseball Players Practicing: Perspective Study,* c. 1874–75 (cat. 172).

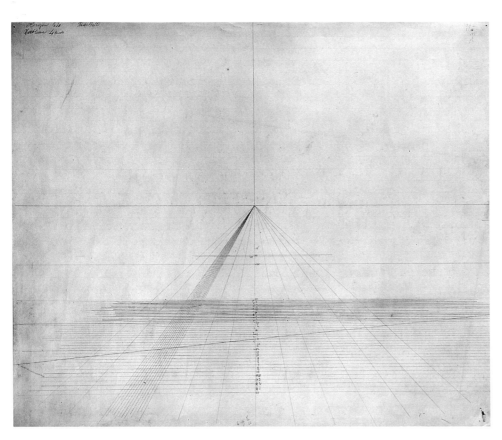

line, from 40 at the bottom up to 175. It is safe to assume that these numbers indicate feet and that the forty-foot baseline in the foreground is likewise divided from side to side at intervals meant to represent feet; the grid that we see is meant to represent a floor of one-foot squares. This presumption is based on convention, but it is reinforced by the subdivision of the fourth "square" to the left into twelve units, certainly representing inches. Typically, this denser set of lines used as an inch scale is set to one side, where it will not overlap other important business. Using calipers, Eakins could quickly measure the apparent size of any object whose dimensions were known, when seen at any place on this grid.[43]

Another area of denser pattern appears in this drawing between sixty-five and eighty feet distant. Without knowing the subject, one could guess that important figures or objects, requiring more refined measuring lines, were destined for this zone, or along the diagonal that runs at a 45-degree angle across the squares between about fifty and sixty-two feet away. Slight tick marks visible along the sixty-four-foot line indicate where Eakins measured out the intervals between his orthogonals. The foot-squares here are three-quarters of an inch wide—an easy unit to measure—indicating a scale of one-sixteenth for objects placed along this line. From this ground line up to the horizon, it is four inches; this distance times the scale factor (4×16) tells us the height of the horizon: sixty-four inches, confirmed by Eakins' inscription at the upper right. Although no figures can be seen, we can imagine that their eye level will be close to the horizon. Eakins' annotations also give us the viewing distance ("Tableau 4 pieds"), but this distance can also be learned from measuring the drawing at a convenient base line (such as sixty-four) and applying the "one law": as the distance of the object from the eye (sixty-four feet) is to the distance of the picture plane from the eye (x), so is the size of the real object to the size of the picture of this object (16:1), or $x/64 = 1/16$, making the viewing distance four feet. Although the drawing is empty and without suggestion of a border, two things can be deduced without prior knowledge of the finished watercolor: that the figures in the shaded zone of the grid will be about four and three-fourths inches tall and that the painting is not large—no larger than four feet across diagonally, and probably, given Eakins' habit of long viewing distances, considerably smaller. While such information is ridiculously vague and redundant when the finished painting is at hand, it can prove useful, as we shall see, if no other related work survives.

The presence of the actual watercolor helps us understand the meaning of the diagonal on the drawing, for a similar graphite line is visible beneath the pale washes of the dirt base path where Wes Fisler and John Clapp stand. This line, and the slightly greater size of the figures (the batter is five inches tall), suggest that the invisible figures on the perspective drawing may have been planned to be seen near the fifty-six-foot line, where the diagonal crosses the vertical axis. The scale here is an odd one-fourteenth of life, assuming a figure about 5 feet, 10 inches tall in real life. This awkward fraction,

set against the tidiness of the image size, suggests that Eakins imagined the five-inch height of his "Athletic boys" first, and then generated the necessary placement in space and their scale, according to the method described in his book.

Looking at the watercolor, it is a surprise to think that the players are fifty-six feet away, and it also seems like four feet is a very long viewing distance for a picture that is only about 9×10 inches when matted. A second drawing in the Bregler collection, cat. 173 (fig. 57), helps us understand that Eakins altered the spatial coordinates of the first perspective before undertaking the final watercolor. This drawing helpfully includes figures, albeit ghostly ones, and the outlines of the grandstand, as well as the same base-path diagonal, but there are no annotations to tell us the horizon, the viewing distance, or the actual distance of anything depicted in this scene. These numbers can all be deduced by measuring the drawing, with the help of information suggested by the earlier perspective. The horizon line is probably close to sixty-four inches again, near Eakins' own eye level and close to the eye of the batter, a first baseman who may have been slightly taller than the artist. Two likely horizon lines appear in the drawing, but from the emphatic, superimposed lines of the grandstand and the level of the railing seen in the watercolor, the lower of the two seems to be the one he used. We can guess that Eakins tested the idea of a higher viewpoint and then dropped it several inches, or else miscalculated the height of the railing and revised it to coincide with the horizon. The height of the batter is again five inches, indicating the same one-fourteenth scale at the spot where he stands. However, these measurements can remain constant while the spatial coordinates shift, so they are of little help in measuring the distance factors. More useful is the base path, which now shows a noticeably steeper slope, more like the one seen in the watercolor. If this diagonal line still cuts across the squares of the grid on a 45-degree angle, as in cat. 172 (fig. 56), this steeper slope indicates a closer viewing distance for the picture and a correspondingly closer placement of the ball players. The assumption of this additional continuity from the other perspective drawing is important, for it allows us to engage another handy rule of thumb, also taught by Leonardo and used by Eakins in his text: "The vanishing points for angles of $45°$, that is, for lines sloping like the diagonals of a square on the floor, two sides parallel with the picture, would be as far to the right or left of the central plane as the picture is forward of the eye." By this geometrical shortcut, the diagonal base path, if continued out beyond the picture space, will intersect the horizon at a point distant from the point of sight equal to the viewing distance of the picture. The vanishing point of the diagonal in this drawing is twenty-four inches from the point of sight, revealing the viewing distance as two feet.[44]

Given this new viewing distance, half the length of the one in the previous drawing, combined with the old scale (1/14), we can calculate the spatial coordinates in the drawing.

57. *Baseball Players Practicing: Perspective Study with Figures,* c. 1874–75 (cat. 173).

The law of perspective, now used to find the distance of the figures ($2/x = 1/14$), will tell us that our boys are twenty-eight feet away. By the same method, the man seated against the stadium wall in the watercolor appears to be about a fiftieth of the height of an actual figure in that pose, so he must be close to one hundred feet away. Moving forward, the lightly drawn line in the foreground of the drawing (also visible in the watercolor), must be twenty-four feet distant, because an easy scale of one foot to one inch (or 1:12) is found here. The lower edge of the watercolor will then fall along a line twenty feet away.

These distances, especially the viewing distance of the picture, make much more sense for a small painting with figures shown in sharp detail. But what did Eakins gain by this revision? For one thing, legibility. By halving the distance between himself and the picture while retaining the size of the figures, he has also halved the distance to the ball players and therefore drawn them forward in his perspective grid. At this closer location, the horizontal lines of the invisible checkerboard beneath their feet come much farther apart than before, making it much easier for the eye to measure the distance between the players on the ground and their relation to each other in space. The recession that occurs between the forward foot of the batter and the rear foot of the catcher—probably less than twenty-four inches of real space—will be compressed into half as much space on paper at fifty-six feet than at twenty-eight, and Clapp will almost seem to stand behind Fisler. The new arrangement also throws the stadium

into a suitably blurry middle distance. The earlier drawing shows the wall at one hundred forty-eight feet, too far to allow any detail in the stands. Considering other alternatives, such as a yet shorter viewing distance of eighteen inches (as close as Eakins would ever stand), the players would be at twenty-one feet, but then the stadium would be about seventy-five feet away, perhaps distractingly close. Furthermore, at this closer range the diagonal movement of the base paths would have grown steeper, broader, and more assertive. In the watercolor, Eakins darkened these paths and narrowed the segment in the foreground by about a third with his final layer of washes, indicating a wish to diminish its presence, even at this distance.

The choice of the viewing distance becomes, then, a calibration of two- and three-dimensional effects that bear directly on the design of the surface and the impact of the subject. From Eakins' choices, we can better understand his intentions and grow conscious of the artistic manipulation of an ostensibly real, observed scene. The main event, of course, is the ball players, and all Eakins' calculations enhance their importance. They are placed in space for maximum legibility of their postures and costumes, recorded with great care and considerable pride. "The moment is just after the batter has taken his bat, before the ball leaves the pitcher's hand," wrote Eakins to his friend Earl Shinn on 30 January, before the watercolor exhibition opened in New York. "They are portraits of Athletic boys, a Philadelphia club. I conceive that they are pretty well drawn."[45] His remarks remind us that the scene

was meant to look like an actual practice, not a staged portrait, although the moment obviously was chosen for convenience in posing as well as its sense of anticipation. Some elements that appear contrived today are in fact documentary: baseball players of this period wore little protective gear, and—although Clapp looks more like a fielder than a catcher—both batting and catching were done from upright positions, as shown. The effect on Shinn, who reviewed the show for *The Nation,* was one of "pure natural force and virility." Shinn found Eakins' handling "a little stiff and labored," but he ranked the baseball players among the best figure paintings in the exhibition: "The selection of themes in itself shows artistic insight, for American sporting-life is the most Olympian, beautiful and genuine side of its civilization from the plastic point of view; the business of the scene, in all three of [Eakins'] pictures, is attended to with the religious fidelity which a Greek sculptor would show in a commemorative athletic statue, and the forms of the youthful ballplayers, indeed, exceed most Greek work we know of in their particular aim of expressing alert strength in a moment of tension."[46]

The players are alert, but the tension stays focused in their figures, because a kind of relaxed energy is reflected from the background, represented by the calm spectator seated against the fence and the scattering of people in the stands, all attentive but motionless. *Scribner's Monthly* remarked the "well-devised background" in this picture, and indeed the mood and placement of the stadium is important to the effect.[47] Formally, it functions as a dark closure to the space; expressively, it returns attention to the foreground and establishes the professional arena of the players. Amphitheater spaces figure significantly elsewhere in Eakins' work: *The Gross Clinic,* begun the same year as this watercolor, and *The Agnew Clinic* both use the same device to fill the background with watchers and engage the spectator. Eakins probably learned to construct such spaces from Gérôme's gladiatorial arenas.[48] In his letter to Shinn, Eakins closed by suggesting that they both go see Gérôme's *Pollice Verso,* and in the next year the image of *Hail Caesar!* would appear within his own painting *The Chess Players* (see figs. 42, 9). The structural parallels between Eakins' athletes in their park and Gérôme's gladiators in the Circus Maximus make obvious the impact of his teacher's imagination, as well as Eakins' typically modern, American transformation of types.

Looking back to the figure drawing we can learn more about this stadium. Posts and braces holding up the roof of the stadium were clearly indicated in the drawing but eliminated in the watercolor wherever they interrupted the grandstand. Perhaps they pressed awareness of the stadium too far forward, or blocked our view of the spectators. The drawing also locates precisely the point of sight, occupied in the watercolor by a dark man standing in the runway leading out of the stadium. This man, and a companion on the other side of this aisle, mirror the poses of the two men seen standing in a similar entrance to the amphitheater in *The Gross Clinic.* All

of the observers in *The Gross Clinic* are portraits; is this true for *Base Ball Players Practicing*? In this mood we might see an image of Benjamin Eakins, seated just above Fisler's bat; is it a coincidence that the red and black jacket on the woman seated next to him is exactly like the one worn by Elizabeth Crowell in *Elizabeth Crowell and Her Dog* (early 1870s; San Diego Museum of Art)? Attention returns to the dark man with the moustache just above the vanishing point. Is this Eakins, literally mirroring himself at the point of sight? This kind of visual play is rare in Eakins' work, although he sometimes included himself in a picture and frequently inserted his family and friends. The suggestiveness of these figures, placed just beyond the point of ready recognition, reiterates the balance between too close and too far struck in all of Eakins' perspective negotiations.

Aware of the deliberate placement of this dark figure, the grandstand, and the players, and conscious of other manipulated components, such as the vanished stadium posts and the shrunken base paths, we must confront the artifice that underlies a painting that seeks to project an impression of realism and authenticity. Where are the players standing? At home? At third? Where are we? Does the relationship between the players and the stands seem right? Isn't Fisler standing behind Clapp, rather than in the line of the pitch? Some of these questions might be resolved by knowledge of the actual playing field the Athletics used, but the evidence of Eakins' drawings suggests that the entire spatial arrangement of this picture has been organized according to the needs of Eakins' design, and not in response to some external reality. This picture is not simply a record of appearances. Such a message often emerges from Eakins' drawings, which demonstrate the persuasive force of the mechanics of perspective—ever encouraging the use of conventional angles, simple fractions, and even numbers—interacting with the creative, arbitrary will of the picture maker.

At a more modest level, knowledge of Eakins' terms and habitual practices in perspective drawing can also illuminate the purpose of vaguely identified items, such as a third baseball drawing previously known and described as possibly "an abandoned first sketch for the subsequent watercolor [or] another picture never carried out" (fig. 58).[49] The sketch style tells us that this is from the preliminary phase of compositional planning, although the figure placement is apparently quite secure. The players assume the poses used in the watercolor, but they are seen from the other side of the "plate," with the diagonal of the base path sloping in the opposite direction. A loosely sketched backdrop hints at a grandstand. The horizon line, according to an annotation, is exactly the same: sixty-four inches. The batter is again about five inches tall. But the spatial coordinates are different: the figures stand between thirty and thirty-two feet distant, and the drawing is annotated "tableau 8 pieds," "Dessin 2 pieds." This inscription indicates that we are looking at a quarter-scale drawing (dessin) for a painting (tableau) to be seen from eight feet away—four times farther than the watercolor.

58. *Perspective Study of Baseball Players*, c. 1874–75, graphite on paper, 13^{15}⁄$_{16}$ × 17^{1}⁄$_{16}$ in., Hirshhorn Museum and Sculpture Garden, Smithsonian Institution, Gift of Joseph H. Hirshhorn, 1966.

From this viewing distance, a standing figure seen at the thirty-two-foot line would be (by the "law" of perspective, $8/32 = 1/x$) one quarter life size, or eighteen inches tall. From the borders suggested by the pencil lines around the composition, we can estimate that Eakins had a picture about 40 × 30 inches in mind. Both the scale of the figures and the size of the entire image indicate that Eakins envisioned a large oil, not a watercolor. "I think I will try to make a baseball picture some day in oil," Eakins remarked to Shinn in his letter of 1875. "It will admit of fine figure painting."[50] Certainly this drawing expresses a developed idea for such a painting, set aside after the commencement of *The Gross Clinic* and eventually abandoned along with all of his sporting subjects, after 1876.

The tentative markings that frame the image in fig. 58, indicating a vertical composition, tell us that Eakins was midway through his planning process and about to confirm the proportions and dimensions of his picture. Early drawings, such as figs. 56 and 57, give no consideration to the edges of the composition, which were determined after the figures had been firmly planted. The border then responds to these internal forms. We rarely have the chance to see these decisions being debated, as in the drawing for *Rail Shooting on the Delaware* (see fig. 123). This method expresses the primacy of the figures and the space, the secondary importance of the picture's edges and its two-dimensional design. The rail-shooting drawing makes us feel the metaphor of the window frame strongly, as if Eakins is simply enlarging or contracting, or moving forward or back, a rectangle that selects for us a felicitous view of the world. Eakins is secure

within his illusionistic space, confident about the correctness of his construction of bodies and volumes, for this is all known and measured; he is less interested in the edges, however, and shows less conviction here, perhaps because there is no obvious right or wrong choice, no "law," only taste. His tentativeness, and a belated moment of fresh decision-making, shows clearly in the watercolor *Baseball Players Practicing*, where two sets of margins are visible. Initially planned as a squarish or horizontal composition, Eakins considered extending the space to the left and then contracted both sides, drawing the right hand margin about one-fourth inch from the elbow of the seated man at the fence and pulling the left margin to within an inch of Fisler's bat, where he signed and dated the picture. Pencil rulings and additional layers of wash along this margin reiterate his choice, and indeed a tighter composition results from this re-matting. Although the framing decision is sometimes seen in Eakins' drawings, it is a task that, as Fried would have it, belongs more properly to the realm of painting—that is, to the sensibility in charge of the picture's two-dimensional surface. Logically, then, this process was transferred into Eakins' oil sketching method, where it became more decisive and subtle, as we shall see in the next section.

Such choices usually had been made by the time Eakins began his final perspective drawing, which represents the most elaborate stage of his preparations and the purest expression of his drawing aesthetic. Bregler's sale or gift of large perspectives to several institutions in the 1940s has already brought nine of these drawings into the public eye, and they have become justly famous as manifestations of Eakins'

exacting, scientific spirit. The reputation created by these drawings may be partly an accident of survival, for such drawings seem to have been rarely saved by artists, even academics like Gérôme, who must have used similar plans. However, it seems safe to assume that few artists—and certainly no other American of this period—devoted such extraordinary energy to such drawings. Eakins himself produced the large and detailed variety for only a few years, from about 1872 to 1876. Most of these were inspired by the challenges of his rowing paintings and other boating subjects, requiring the foreshortening of complex and eccentric forms. The correct rendering of boats became a passion for Eakins, himself a rower and sailor; we sense in the fastidious reconstruction of every oarlock a love affair with the superbly sleek and functional engineering of these modern machines (see fig. 114).

These secondary drawings, made after the general scheme had been confirmed in a perspective sketch, come in two types, sometimes combined on the same page: ground plans and actual perspectives. "A ground plan is a map of a thing drawn to any convenient scale, and should almost always be drawn before putting things into perspective," wrote Eakins in his manual.[51] Sometimes, as in the plan of the four-oared shell (cat. 149), these "maps" can be large and elaborate; more often they appear on the page with the perspective, but pressed to the side and usually at a smaller, less detailed scale. In Fried's scheme, such plans would be the paradigmatic "graphic" representation of space on the plane of writing and drawing; characteristically, Eakins made them often and described them as indispensable. The perspectives based on these plans were sometimes at a smaller scale than the paintings (usually 1/2 or 1/4), but many were full size, so that the design could be transferred to the final canvas or watercolor sheet with pinpricks.

The drawing language used in these plans and perspectives has the impersonal, geometric style of Eakins' public address, although these drawings were surely made for Eakins' benefit alone. The common motivations that underlie this stylistic fraternity are the wish for measured, "scientific" accuracy, and the desire to suppress subjective interpretation or visual guesswork. This style also enacts some of the principles of mechanical drawing, learned at Central High School and taught in his manual; according to Bregler, some of Eakins' pictures were occasionally based on actual boat builders' plans.[52] The use of such borrowed plans, or his own measured drawings, reminds us again that very little—perhaps nothing—in these drawings is done from observation; the space and the most important objects are entirely generated by the geometry of linear perspective and a set of measurements. Lines born out of the logic of this system are firm, unwavering, sometimes emphatically dark, indicating that the conceptual world is the realm of secure knowledge. Natural forms, such as river skylines that appear in the perspective for The Oarsmen (see fig. 114), are drawn more tentatively and vaguely, for they do not come from the system but are instead based on subjective information gained through

perception. The domination of conceptual values is signaled by the coded linear vocabulary that Eakins recommended for these drawings: "To avoid complications, it is well in all extended drawings to use three inks, a blue ink for instance for the square feet marks in the ground plan and for the picture of these square feet in the perspective plan, for the horizon, & middle line, in short, for all the purely perspective scale parts; secondly, a red ink for axes of construction or simpler figures enclosing the complex ones not sought directly, and finally black ink for the finished outlines."[53] In his own drawings, Eakins used red ink rarely (and inconsistently), but the grid of the perspective plan is frequently ruled in blue ink over the original graphite network, partly to keep these lines from blurring in a heavily worked drawing, and partly, as he explained, to avoid confusion with lines—table tops, rugs, wainscoting—seen in the subject itself. (See plates 8, 20.) The artificial character of this layering, which flattens the illusionistic tendencies in the drawing, is often reinforced by the intrusion of annotations, mathematical calculations, and small sketches here and there across the surface, which also assert the plane of the paper as a field for writing, for learning, for ideas.

These small interruptions in the drawing show a lack of concern for the overall integrity of the drawing sheet or even the integrity of the separate images, which sometimes overlap one another, as in fig. 145. The field of the page is treated very differently from that of a canvas; the edges of the sheet have nothing to do with the formation of the image, which usually floats well within, and sometimes extends beyond the page. Physically insignificant in terms of its material qualities, the paper is treated like a convenient, arbitrary fragment of an infinitely large neutral plane, to be written on as well as carved up into small zones, related only by a common vertical axis. As Rawson has noticed, this attitude toward the page is characteristic of sculptors, who build from the center of their subject; painters, by contrast, are more likely to treat the edges of the paper as a given frame.[54]

The pattern of scattered topics coexisting on a single page, like the Fairman Rogers drawings, recurs in the variable focus within a single, spatially unified subject, such as the perspective for The Oarsmen, where attention drops to a level of particularities—an oarlock, a strut, a bolt—wherein some special problem resides. The landscape profiles in this perspective are not attended to because their appropriate arena of study is painting, not perspective drawing, but even within the world of drawing Eakins' attention moves unevenly, bearing down harder on the most complex and difficult forms. By this economy of effort, the end of the oar is mapped, the oarlock is densely described, and the blade is crisply outlined where it cuts the water, but all parts in between are invisible. For all their labor, these drawings contain hardly a "wasted" line.

The values invested in these perspective drawings—faith in science and geometry, dedication to the accurate depiction of the modern world, trust in careful, disciplined planning—

have all been noted by admirers of Eakins' work. But these observations are too simple, considering the use and meaning of perspective in the larger context of Eakins' art. The philosophical implications of the fixed viewing distance, "where a spectator should have a care to place himself," add a particular subtlety to our sense of Eakins as a realist in the European tradition. Linear perspective constructs an illusion of space, suggesting continuity between the spectator (artist) and the pictorial world; used correctly, especially at life scale, it can give an arresting impression of another room extended beyond the frescoed wall of a chapel or a cupola raised above the ceiling of a dome. Since the time of Masaccio and Mantegna, western painters have understood the immediacy and involvement entailed in a deliberately eccentric or localized viewer position, which can enhance the convincing quality of the illusion and also return attention to the skill and coercive power of the artist. When this device is combined with the observation of contemporary life, the painting is twice grounded in the specific, individualized experience of the artist, and—as in many Dutch and Italian Baroque paintings—the picture draws near an extreme of subjectivity and materialism rarely seen in world art. In Eakins' work, drained of the symbolic or metaphoric content often latent in Baroque scenes of everyday life, yet another step is taken in this direction. Eakins was not alone at this pole; it is the home of most late nineteenth-century realist figure painters, who may have used very similar perspective strategies. Eakins, by the evidence of his drawings, proves his self-consciousness of the power vested in his own placement in respect to his subject, which invents a picture as subjectively bound in time and space as any impressionist painting. As Siegl has demonstrated from analyzing the shadow patterns in *The Pair-Oared Shell* (see fig. 108) and its preparatory drawings, the exact time is 7:20 P.M., the exact spot can be pinpointed under the Columbia Bridge, the athletes are particular human beings, the boat is their own pair-oared shell.[55]

Monet was painting the Seine, maybe at the same moment in the summer of 1872, with a similar modern ideology of the located, interactive spectator. His technique differed dramatically, of course, in its denial of the conceptual, drawn component of picture-making in favor of a completely perceptual, painted event. The absence of "drawing" in an arch-impressionist painting, both in the subliminal organization and in the construction of forms, reveals, by contrast, the power of drawing in Eakins' paintings. The *Pair-Oared Shell*, for all its finiteness, is an elaborately contrived fiction of immediacy, constructed over time in a slow and detached fashion that organized the parts like pawns on a chessboard, achieving an effect of naturalness by a very roundabout artifice. This method, with its reliance on concept and drawing, defines the difference between Eakins, a radical academic realist, soon to be a dinosaur in the evolutionary model of art history, and the realist independents, whose even more emphatic subjectivity formed the basis of modernism. For Eakins, so modern in his subject matter and siting, the presence of drawing signaled the old-fashioned "artistic" and intellectual component of his work—the design in space and on the surface, the illusion of reality—the part of his job that made painting more than just craftsmanly documentation. The distancing entailed in his method was important to him, as seen in the degree to which he amplified and multiplied all its components, adding photography and clay modeling to the process, dividing his projects into smaller and smaller units for separate study, to analyze his subject rationally and reconstitute it as art. This detached, manipulative process was the "art" as much as the physical execution of the picture itself.

The triumph of Eakins' art can be read, ultimately, in the degree to which he suppressed awareness of this process, treating linear perspective as yet another pawn in his larger system of making pictures and sculpture. Well aware of the freakish effects that come from perspective systems too consistently applied, Eakins took care to avoid distortion in the foreground or at the edges of his pictures; he also felt free to abandon the viewing distance or the internal consistency of his pictorial space if it became artistically or practically necessary. The viewing distance for *A May Morning in the Park* is, according to the perspective drawings (see fig. 147; cats. 194, 195), eighteen feet, although Eakins surely knew that no one would stand for long at such a distance from a painting that is only 24 × 36 inches in size. This viewing distance is a convenience in the foreshortening of a very long and awkward form—a coach and four—which is convincingly drawn and then, as if seen in a telescope, pulled so close that the lamp brackets on the coach can be examined in detail. Eakins knew, too, that viewers would wander close to his full-length portraits, even though they were constructed from a distance of twelve or fifteen feet; the sitter is conceived simultaneously as a person fixed in perspective, subject to the rules governing figures at that distance, and also as an independent figure, like a real person, literally more detailed as one draws closer. This artistic license extends throughout the canvas, where some things are carefully detailed and others not, according to Eakins' wishes, and where some perspective lines are respected, others deliberately obscured, and some simply overruled, as in the *Portrait of Dr. John H. Brinton* (fig. 227).

These actions serve, like the perspective drawings themselves, to remind us of Eakins' artistic will; master, not hostage, of perspective, he bent his "science" to the authority of art. Always, the perspective system defers to the figures. Having invited spectator involvement with a smooth and convincing continuity of space, the perspective apparatus modestly retreats, avoiding any distraction that will call attention, either by error or bravura display, to its artifice. Other painters, perhaps, will comprehend the professional skill involved; most viewers will simply react to the "direct," "plain," "honest," seemingly uncontrived realism of the figures. This layering of a restrained, self-effacing presentation over a proud and egotistical organization offers a model for Eakins' artistic personality, at once gentle and arrogant, humble in the

face of nature and yet fiercely self-centered and manipulative.

The attitudes expressed in Eakins' perspective drawings give a long view of his approach toward picture-making and the role of drawing; at closer range, the qualities in the perspectives can also be used to characterize and unite all his different styles and types of drawing. Cheap materials, irreverent handling, inattentiveness to the format of the page and the overall unity of the sheet, and a driving sense of efficiency and purpose, all of these visual qualities indicate a draftsman with little interest in the beauty or pleasure of the drawing as an independent artifact. Useful rather than beautiful, these drawings all have work to do: teaching students, teaching Eakins. Most of them are bent on abstracting knowledge—from a dissection, from a historical portrait, from the system of linear perspective. The information stored in the most private of these drawings is a shorthand record of such learning experiences, meaningful to the artist, sometimes dull or inaccessible to others. Sketchbook notations and perspective drawings alike give this sense of research, almost always related to some goal external to the drawing itself—perhaps teaching, perhaps preparation for a painting or sculpture. The extant drawings tell us that Eakins almost never drew except with some predetermined, narrow purpose. There are no "occasional" sketches here, no drawings done for their own sake. "Mr. Eakins is not a sketcher himself, and he appears to have inspired most of his students with his lack of predilection in that direction," commented a Philadelphia newspaper writer in 1881.[56] When he did pick up a pencil or a sketchbook, it was usually on trips away from his studio, when a useful fact appeared before him (costumes of the year 1809, anomalies of the knee, a sailboat in drydock), or at home, when a problem in perspective required solution.[57] Drawing, in all the different roles it undertook, acted as a tool, a means, not an end.

Drawing, in Eakins' practice, remained then an extension of writing—of language, of learning, of conceptualization—and in that capacity it was both master and servant of Eakins' major media, painting and sculpture. As master, it came before the object, offering a field for imagination and construction. As servant, it supplied the scaffold of perspective that supported the illusion of space in a picture or bas-relief, and provided research details. Buried within the activity of painting or modeling, it helped build form. But as an aesthetic object in its own right, the drawing was of negligible interest compared to the media acknowledged by Eakins and most others in his culture as the most exalted vehicles of expression in the visual arts. This hierarchy of prestige is a commonplace of European academic art, but Eakins was unusual in his severe deprecation of the independent artistic value of the individual drawing and in his strict confinement of drawing within a rationalized method, in which each task was delegated to the proper medium and delivered in a style appropriate to the audience and the task.

Over the course of his work in the 1870s, painting gradually took on more and more of the jobs once assigned to or at

least shared by drawing. After 1881, photography assumed some of the responsibilities of composition, detail, and perspective, and after 1886, Eakins drew rarely in pencil or pen. When Mariana Griswold Van Rensselaer approached him for illustrations to an article on his work that she was planning in May 1881, he admitted that "he was so unaccustomed to working in line that he did not know how he should succeed."[58] From this large pattern of work we can conclude that Eakins, a great draftsman, didn't like to draw, didn't approve of spending too much time drawing, or only expended energy on drawing when it really counted: in the perspective layout, or in the final painting, where it was responsible for most of the artistic energy of the picture.

The antipathy or economy expressed in this method was, as the newspaper writer critical of Eakins' teaching practices observed, "opposed to those of the majority of artists."[59] Certainly he did not learn such attitudes from his teachers and mentors. Where did this habit come from? The background may be, as Fried has described it, the "writing/drawing" syndrome formed by his childhood education, which identified the conjoined activity with the search for knowledge and control. All drawing is by nature abstract, but in his compartmentalized way Eakins radically purified this realm, locating all sensual experience—color, mass, texture, the qualities of perception and their representation—in the departments of painting and sculpture. The sensual "pictorial" potential in drawing was suppressed, ignored, drained away in search of the far pole of "graphic," nontactile values. Drawing signified thinking, planning, learning; painting and sculpture involved action, the *doing* of art, working from eye to hand. Battling his own childhood training and his own deliberate contemplative style, Eakins struggled in the 1870s to integrate drawing and painting, thinking and seeing into a single, immediate process. By the end of his life only one kind of drawing had not been assimilated: the irreducible linear and conceptual core, perspective.

Eakins' attitudes also may have come from his identification of drawing with professionalism and work. As the realm of preparation, drawing was not supposed to be frivolous, wasteful, or fun. These drawings, all hard-working, poorly treated servants to his projects, make a show of their disdain for more decorative, ingratiating, self-concerned efforts. Artifacts revealing process, rather than products in their own right, they are not chic displays of technique, vain expressions of personal style. They proclaim, instead, Eakins' self-image as a craftsman in a "workshop," a scientist in a laboratory, a scholar in a library. Perhaps he was self-consciously rejecting the affectation of his contemporaries who styled themselves as "artists," posing in their silk-lined capes in curio-laden ateliers, distracted by the production of self-indulgent drawings. As a student, Charles Sheeler had watched Eakins prepare for his portrait of Leslie W. Miller with elaborate perspective drawings; Sheeler, who watched the work unfold without knowing Eakins' identity, concluded that the "man, whoever he was, could not be a great

artist, for we had learned somewhere that great artists painted only by inspiration, a process akin to magic."[60] Eakins, bent on demystifying this process, identified with anatomists and boat builders more than Whistlerians.

Perhaps, too, he was reacting to Philadelphia and his family circle. Eakins never supported himself but always relied on his father's house and income, and in his earliest letters from Paris we hear him cringing guiltily over his dependence and vowing good behavior. A dutiful son, he returned his father's support with a great display of industry and seriousness, demonstrating that he was not wasting time or money and that the business of painting was honest work. And so there is no luxury in Eakins' preparatory materials, no idleness of effort. He did work hard.

But he also enjoyed himself. Surely, the big perspective drawings were not done merely as professional duty. Did they have to be that large, this complete? There is great pleasure vested in them, but it is a kind of sublimated, Protestant pleasure, overtly disciplined and self-sacrificing, covertly proud of its craftmanship and control. These drawings, like a window into Eakins' mind, are thinking made visible, and their aesthetic abides among the virtues of clear thinking: directness, precision, discipline, authority, all qualities that likewise define excellence within the masculine, scientific, and progressive aesthetic of Eakins' culture. Their presentation is modestly plain, straightforward, unpretentious, clearly utilitarian; beauty is hidden in the experience of the maker. This is a peculiarly American, nineteenth-century, white, Anglo-Saxon Protestant beauty.[61] Like the American beauty Horatio Greenough saw in a clipper ship or Eakins found in a racing shell, it resides in functionalism, in triumphant problem-solving, in the exercise of professional know-how. This pleasure abides in the writing-drawing sphere, where skills and information are learned and applied. Ever curious and experimental, Eakins enjoyed the challenge of inventing a special shutter for his camera, of proving *Gray's Anatomy* wrong. He liked being right, knowing more. His big perspective drawings must have been deeply satisfying as demonstrations of his own competence, his superb control. As such, they serve as emblems of his entire method, which took pride in intellectual as well as craftsmanly preparations, and a grave delight in a job well done.

CHAPTER 8　Oil Painting

THE MATERIAL
WORLD

Eakins was almost twenty-three before he took up a brush and oil paints. His late start, preceded by years devoted to mastering black and white effects in graphite, ink, or charcoal, made his move into paint and color an ordeal. Both training and disposition made him react rationally and deliberately, not intuitively and spontaneously, and he was initially overcome by the simultaneity of problems in painting. He had grown more confident during his three years' work in Gérôme's atelier, but he was set back again by the complexities of his first real "picture" in Seville in 1870 (plate 1). In Spain, Eakins realized that his progress to that point had been built on disassembling problems into small, conquerable components—a method he embraced intellectually and elaborated for more than a decade. But striving against this rational approach, embodied in his drawings, was a will to integrate the sensuous, physical component of art making represented by painting. To Eakins, drawing expressed abstract and analytical thinking; painting meant materiality and synthesis, the tactility of hand and the reality of visual perception, the athletic activity entailed in creation. The sportsman, the cabinetmaker, the sexual being in Eakins was intensely attracted by this physicality, and the artist in him understood that the realm of painting held the integrative power that would make his art most memorable to others. For painting—in its color, texture, and illusion of appearances—also evoked all the nonverbal mysteries of emotion and the unconscious. Raised to affiliate penmanship, drafting, and mathematics, Eakins was at home in the clean, secure world of drawing. He depended on drawing to lend authority to his work, but he was compelled by his wish to master painting and to make painting the master of his rational side. The course of his development in the two decades following his first oil studies in 1867 is the story of that struggle.[1]

The duress of his student days had an immediate effect on his drawing, which grew less frequent and more specialized throughout the 1870s, as we have seen. His attitude was also expressed in words and actions as a teacher, for he rushed his own students through their elementary drawing exercises and promoted them quickly to painting. "I think [a student] should learn to draw with color," he told an interviewer in 1879. "The brush is a more powerful and rapid tool than the point or stump. Very often, practically before the student has had time to get his broadest masses of light and shade with either of these, he has forgotten what he is after. Still the main thing that the brush secures is the instant grasp of the grand construction of a figure. There are no lines in nature, as was found out long before Fortuny exhibited his detestation of them; there are only form and color."[2]

Two years later, Fairman Rogers, the chairman of the Academy's Committee of Instruction, wrote (probably with Eakins' assistance) a manifesto of these principles as enacted in the school's curriculum. "Following the strongly expressed preference of the present professor," wrote Rogers, "the students, almost without exception, paint in the life class, instead of drawing, as usual in most schools." He continued:

Mr. Eakins teaches that the great masses of the body are the first thing that should be put upon the canvas, in preference to the outline, which is, to a certain extent, an accident, rather than an essential; and the students build up their figures from the inside, rather than fill them up after having lined in the outside. . . . It is not believed that the difficulties of painting are either lessened or more quickly surmounted by the substitution of the arbitrary colors, black and white, for the true color; and as a painted study is more like the model than a translation into black and white can be, the comparison with nature is more direct and close, and an error in drawing is more manifest. The materials for drawing on paper, except charcoal, which is dirty and too easily rubbed off, do not admit of the strength, breadth and rapidity of treatment, which are considered important; so that oil paint and clay are the real tools of the school.[3]

Eakins would practice what he preached. His whole-hearted preference for oil on canvas was hardly unconventional, for painting was the most prestigious medium of visual expression in his culture, but his rejection of most drawing in his own work and in his teaching was extremely unusual. Embittered by too many hours misspent in drawing antique sculptures, and savoring his hard-won versatility in oil, Eakins undertook in paint after 1870 many of the tasks that he had previously handled in charcoal or graphite. Most of his compositional sketches, figure studies, outdoor or on-the-spot croquis, even his studies for watercolors were done in oil from this moment until the end of his career.

A wide sampling of these paintings survives, mostly because Eakins sold very little work and saved much of the rest, and because Susan Eakins and Charles Bregler carefully harbored or distributed even the smallest scraps of the collection they inherited. Some things were destroyed, discarded, or overpainted in Eakins' lifetime. Other items were given away, only to disappear: portraits "mislaid" by disapproving families, and sketches poorly labeled and forgotten. "I do not forget your sketch only I haven't got one now that I care to give you," wrote Eakins to a student, perhaps J. L. Wallace, on 2 June 1887. "My best ones were all given away, some to unworthy people. Others were covered up. When I give you a sketch I want it to be good."[4] Despite these patterns of generosity and carelessness, Eakins left a studio full of oil paintings to posterity to demonstrate the range of his work in this medium.

Finished compositions in oil on canvas occupy the center of Eakins' accomplishment as an artist. Such paintings, including his portraits, are the most numerous and complex of his creations, markedly different in scale, treatment, and intention from the preparatory works in oil that preceded them. This type of "exhibition" work is represented in the Bregler collection by only one small and incomplete portrait, *Girl with a Fan: Miss Gutierrez*, cat. 252 (see fig. 220). Remembering the history of Eakins' own collection, which

Susan Eakins culled for important items for sale or donation between 1917 and 1938, and which was sifted again by her heirs in 1939 and once more by Bregler in 1944, it should come as no surprise that the two dozen oils remaining in Bregler's estate were of secondary importance and, at first glance, of minor interest. But these paintings give indirect access to Eakins' larger, richer paintings and afford insights into methods and intentions that can help us "rediscover" some of the most familiar paintings of his career, discussed in Part III.

Eakins' informal oils—that is, paintings made in preparation for these finished, public pictures or undertaken for private study—are better represented by Bregler's group. Like his drawings, Eakins' preparatory oils have not been analyzed as a group, and the new Bregler pieces present an opportunity for an investigation of this whole class, to reveal basic habits and attitudes that have not been remarked in previously known work. These paintings come in many types, but all are characterized by small scale, rough finish, and modest if not downright casual presentation. All mounting, framing, and signing of these pictures seems to have been done later, by others.[5] Eakins' reputation and the provenance of his personal collection assured the survival of a high percentage of such work, but—as with his drawings—there is less, overall, than we might expect of an artist with such a thorough academic training and a predisposition for planning. The numerical predominance of finished work over studies (at a ratio of about 3.5:1) illustrates, to begin with, Eakins' reluctance to waste time or energy on the preparatory phase, or, put another way, his wish to launch work on the final canvas as soon as possible. Although occasionally proud of his own sketches, Eakins had expressed reservations about the value of "wonderful fine" studies even as a student: "I notice those who make such studies seldom make good pictures," he wrote his father in 1869. "To make these wonderful studies, they must make it their special trade, almost must stop learning & pay all their attention to what they are putting on their canvas rather than in their heads." Such studies, made to "show off, to catch a medal, to please a professor or catch the prize of Rome," become an end in themselves, very different from the directed studies of a real painter. "An attractive study is made from experience & calculations," he explained. "The picture maker sets down his grand landmarks & lets them dry and never disturbs them, but the study maker must keep many of his landmarks entirely in his head for he must paint at the first lick & only part at a time & that must be entirely finished at once & so that a wonderful study is an accomplishment & not power. There are enough difficulties in painting itself, without multiplying them without searching what it is useless to vanquish & the best artists never make what is so often thought by the ignorant, to be flashing studies."[6]

Eakins' disdain for such flashing studies may have grown from his own inability to work in this fashion, for he was not naturally facile. However, his admiration for Velázquez and

Fortuny—or Sargent and Chase—indicates that he was not opposed to suggestive handling per se, only the inappropriate application of effort to studies. With consistency, his own oil studies are never as finely finished as his exhibition work. He was supported in this procedure by Gérôme, whose sketches Eakins described as "rough quick things mere notes & daubs."[7] He was not insensitive to the appeal of such work and its merits, as shown by his occasional willingness to exhibit his own informal paintings, such as a few knitting and spinning "studies" that were shown several times between 1881 and 1883. He certainly saved such work, was prepared to submit it to special "sketch exhibitions," and frequently gave "good" examples to sitters or students, such as Wallace, who begged for them as talismans.[8]

The most significant type in this general class of Eakins' painting is the compositional sketch, made in anticipation of more elaborate work in oil or watercolor. In the Bregler collection, a sketch for the painting *Arcadia* (cat. 251; plate 19) and one for the watercolor *Fifty Years Ago* (cat. 241; plate 5) fall into this class, although the latter study demonstrates a special intermediate phase of work undertaken only for the exhibition watercolors discussed in detail in the next section. Such small compositional studies are the most common type of preparatory work in Eakins' extant oeuvre, and they offer important access to his method and preferences as a painter.

First, and following from his rejection of drawing, these sketches show his habit of working directly in oil from the moment his pictorial concept took shape. Perhaps the most remarkable thing about the relation between his finished paintings and the body of preparatory work that came before is the tight correlation between Eakins' first oil sketch of a given subject and the effect of his final canvas. "A most unusual characteristic of Eakins," noted Bregler, "was that when he made a sketch for a painting or portrait he never made any basic change from his first conception that he made in the sketch."[9] The general truth of Bregler's observation is illustrated in pairings like *The Pathetic Song* (plate 9) and its preliminary sketch (fig. 59), or *Monsignor James P. Turner* and its sketch (see fig. 223; plate 22).[10] The faithfulness of each final picture to its sketch demonstrates the importance of this inaugural moment in Eakins' construction of a painting, and the work of imagination that went before it. His most creative moments were in his head; he did not "explore" or "discover" his subject as he worked. With the image set in Eakins' mind, models were posed and painted from life, and the painting developed within the confines of naturalistic description. Few allowances seem to have been made for happy accidents, fresh experimentation, or improvisation. Such planning is consistent with academic method, but it is remarkable in entailing few preparatory drawings (aside from perspective plans) and only a single, sometimes very broad trial sketch; the interior visualization seems to have been complete for the majority of his projects, and most of the work seems to have been done on the finished canvas. Many pictures (usually portraits) were evidently done without any

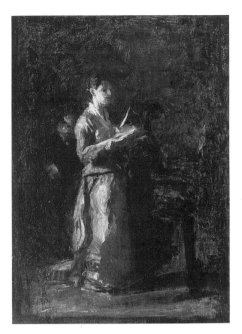

59. *Study for "The Pathetic Song,"* c. 1881, oil on wood, 11⅜ × 8½ in., Hirshhorn Museum and Sculpture Garden, Smithsonian Institution, Gift of Joseph H. Hirshhorn, 1966.

preliminary work, and even complex compositions were sometimes laid out in a single sketch. According to Bregler, the entire *Agnew Clinic* was painted from one 10 × 14 inch sketch and a full-scale study of Dr. Agnew alone.[11] This procedure also reveals qualities of personality demonstrated in Eakins' teaching and personal life: pleasure in forethought, self-confidence, unwavering directness.

The constancy of the image from sketch to finished picture makes variant studies, like *Spinning* (cat. 243; plate 3) and *Arcadia: Sketch* (cat. 251; plate 19), rare and interesting. Only occasionally, and usually in connection with his more complex compositions, such as *William Rush Carving,* will alternate solutions indicate moments of experimentation. *Spinning,* probably made in 1881, shows Eakins' sister Margaret and her setter, Harry, posing in Eakins' studio. This sketch anticipates a watercolor from that year, *Spinning* (fig. 60), of Maggie in a similar pose, but turned to the right rather than the left.[12] The major change in vantage between the Bregler oil and its related watercolor suggests that another more finished oil study, like *Fifty Years Ago* (plate 5), intervened in this series. The Bregler sketch, probably done first, shows Eakins searching for a viewpoint from which one can see both of Maggie's hands without obstruction from the spinning wheel. He found this vantage in the sketch, and it worked well as he constructed the "grand landmarks" of light and shadow in her head and torso, but only as long as the distaff of the spinning wheel was removed or ignored. The whole composition may have been abandoned, however, when the distaff arm, with its large clump of flax, was rein-

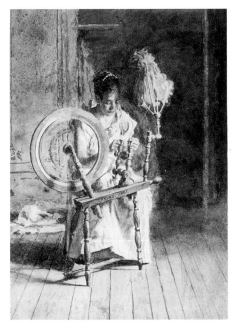

60. *Spinning*, 1881, watercolor on paper, 15⅝ ×
10⅝ in., Estate of Mrs. John Randolph Garrett,
photo courtesy of Christie's.

troduced into the scene. If shown at the size it appears in the watercolor, it would have loomed uncomfortably close to Margaret's head and obscured the curve of her shoulder. Halting as soon as he realized this problem, Eakins never completed the lower part of her figure, which is only suggested by broad strokes indicating the placement of her legs. (Characteristically, he made his sister model with her dress hiked up to reveal her pose clearly.) Without the intrusion of the distaff, the sketch remains a swift and subtle piece of work, good evidence of Eakins' ability to sketch, with a few fluid strokes, a complex form like the spinning wheel, or the fall of light and shadow across the human body. His sense of humor, or personal pleasure, is shown in the inclusion of Harry, who does not appear in either of the finished watercolors. There is pleasure for us, too, in the inspection of Eakins' blunt, decisive brushwork, purposeful rather than "flashing," but lively and strong, the marks of a "picture maker" hard at work.

A second moment of creative decision often appears in these oil sketches, which include (as in the *Turner* sketch) broad strokes with the brush to mark the framing edges of the composition. These borders were marked after the figure was painted, demonstrating Eakins' tendency to generate the edges of his canvases from the inside out, in response to the forms depicted. Like the graphite lines superimposed on his perspective drawings or his rare compositional sketches in pencil (see chap. 7), or the scissored cropping of his photographs (see chap. 11), these secondary decisions underscore the priority given to the forms in space and also remind us

that the two-dimensional existence of the final picture was carefully considered, but at a later time. The subtlety of these choices can be best appreciated in the variety of sizes in Eakins' portraits (see chap. 19). The same diversity of size appears in his landscape and figure compositions of the 1870s, although the proportions of these pictures, whatever their dimensions, repetitively seek a ratio of 2:3.

The long strokes of paint that bracket the figure of Monsignor Turner also signal the irrelevance of the actual margins of Eakins' sketch panel at the moment he was painting. As in his drawings, the physical format of his support seems to have had no influence on Eakins as he sketched his idea in oil. Fixed on the reality of the figures before him, and driven by the desire to establish his interior concept, the two-dimensional extent of his panel mattered little; if anything, Eakins pulled away from the edges of his support (as in the sketch for *The Pathetic Song*) in order to ensure that the format had *no* constraining effect on the composition, which is almost always given a margin of neutral tone within which it can expand or contract according to its needs. As in his drawings, this practice grants first importance to the sculptural existence of the forms and a lesser power to the surface; to remember that a painter can do otherwise we need only recollect Monet's grain stacks, Van Gogh's work at Arles, Homer's late watercolors, or the elaborate price/size fee structure of a portraitist like Thomas Sully.[13]

The tight correlation between the compositional sketch and the final canvas was often the result of the transfer of the image, with the help of a grid of crossed lines (visible in *Fifty Years Ago*, fig. 252, plate 5) as guides for placement or enlargement onto the finished canvas. The figure probably was blocked in on the canvas before the model arrived and then reconfirmed by life sessions, wherein the real people struggled to reachieve or maintain the pose cast on the canvas. In this way the sketch remained a reference point until the final painting was well established.[14]

The oil paintings in the Bregler collection also display Eakins' taste in materials, although these preferences can easily be deduced from other work. The division between his finished canvases and his studies is powerfully reiterated in materials: the paintings are almost all on linen of different weights, stretched and framed. The sketches are on a variety of surfaces, perhaps whatever was inexpensive or handy—and seem to have been framed after Eakins' death, if they are framed at all; some show signs of careless storage when the paint was still wet. The evidence borne in the treatment and materials of his oil sketches immediately tells of their private purpose and their secondary or passing interest to Eakins himself.[15]

For his smallest work Eakins preferred hard surfaces, such as wooden panel, cardboard, or canvasboard. These materials were cheap, easy to acquire and prepare, and could be conveniently carried in the slotted compartments of his painting boxes. The size of these boxes seems to have determined the size of many of his original sketch panels, for

many are about 10 × 14 or 4 × 6.[16] A taste for these stiff panels seems to have been acquired in about 1876, for earlier sketches are usually on canvas (see cats. 232, 233). Practical motives probably lie behind this change, but Eakins could have chosen a more resistant surface for aesthetic reasons, too. He also preferred rather stiff, squared brushes, although he used a variety of sizes and types, even within his smallest, quickest sketches. The combination of a hard panel and a stiff brush invites the characteristic impasto of Eakins' sketches (such as *Spinning*, plate 3), implying the strong, tactile engagement of the entire arm as the paint was pushed across the surfaces. This more athletic and sculptural handling of paint is characteristic of Eakins' work; the predominant use of a soft, round brush and a springier, more absorbent surface, as in Renoir's work, will produce a very different effect.[17]

Many of these panels are naturally tinted—tan wood or gray cardboard, for example—and most were covered with a ground of tan, dark brown, or olive paint, often (as in *Spinning*) applied broadly with a palette knife. These grounds reiterate Eakins' academic training, which taught him to work from dark to light, thinly scrubbing the shadows and building up impasto in the lights, seeking the sculptural quality of forms revealed by value contrast rather than color. This low background tone also establishes the base note of Eakins' palette, which was centered on earth tones—brown, gold, olive—set against paler flesh tints, occasionally relieved by bright red.[18]

Eakins sometimes laid this dark ground tint over an earlier sketch found on a panel that he wished to reuse. Fragments of these buried sketches can often be seen at the margins of the panel (cat. 238; plate 4), or their texture will intrude in the pattern of brush strokes seen on the surface (as in cat. 235). Occasionally X-radiography (see fig. 249; cat. 242) will reveal the character of these undersketches, although sometimes they have been scraped down prior to overpainting and cannot be read.[19] From this evidence we can assume that many of Eakins' early sketches have been, as he admitted, "covered up" by subsequent work. This habit reveals a certain frugality with his materials just as it reiterates the sense that these studies were of only passing importance.

The same Quaker thriftiness may have inspired Eakins to improvise his panels from available materials, to use both sides of every surface, and to crowd several studies onto a single face. These practices also indicate that Eakins had no plans to exhibit or sell such works, and they make obvious the tightly directed focus of each sketch. He sometimes turned the panel when he began a fresh study, in order to suppress his awareness of previous work, but the edges of the panel, or the impinging effect of a neighboring study, bear little on the new scene as it is painted. The autonomy of these sketches has allowed the division of these panels later, usually by Bregler; fortunately, Goodrich's thorough notes allow reconstruction of extant fragments from his collection into their original configurations (see fig. 247).[20] In separating these sketches, Bregler also "completed" them with over-

paint, for most of them originally had the quality of vignettes. Centered on a figure or a landscape form, with a halo of background context that rarely moves out to fill the four corners of a conventional squared format, these sketches sometimes collide raggedly with other studies of a very different subject and scale. These qualities remind us that, for Eakins, the sketch was a first attempt to render a visual effect on a two-dimensional surface, an effort in grand construction, not an essay in picture making. These priorities give Eakins' sketch panels their characteristic inattentiveness to overall decorative organization or finish; investment in either of these areas would have been, to Eakins, misspent.

The small sketches that jostled together on a single panel were not compositional sketches, which always received a fresh and undivided surface. By contrast, the small, ganged studies, often made outdoors (like fig. 247), belong to different types in Eakins' painting repertory. The first group includes traditional academic studies, usually single figures from within a larger composition, or a fragment of a figure, studied in isolation. This method, hallowed by the practice of generations of European painters and consistent with Eakins' earliest art school training, is demonstrated in the study of the upper half of the cowboy-gunman in *"Thar's a New Game Down in Frisco"* (cat. 242), made in preparation for an ink wash illustration, or the study of a horse's leg (cat. 244), one of a series of fragments of Fairman Rogers' team painted prior to work on *A May Morning in the Park* (see figs. 140, 143). Eakins' creation of such individual studies is less surprising than is the scarcity of such works; except for a small group of related horse studies, and a few isolated figures from the Rush series, the Gloucester and Arcadia subjects, and *Between Rounds*, there are fewer of such detail studies than one would expect from an artist with Eakins' training. Their rarity may be exaggerated by overpainting or loss, but the pattern of extant sketches tends to reconfirm Bregler's observation that Eakins went to work straight away on the final canvas, with very few preparatory studies.

Two additional types of oil sketches remain, both somewhat detached from particular painting projects: nude figure studies, and landscape sketches. Neither of these types are common in Eakins' extant oeuvre, and they have not been given much attention as a group. Being unfamiliar, this work offers some of the most unexpected, seemingly uncharacteristic material in the collection. Again, remembering that many of these sketches were passed over in 1930, 1939, and 1944, it is precisely the oddness of these remnants that makes them interesting guides to the byways of Eakins' method in oils.

FIGURE SKETCHES

The three studies of nude models (cats. 238–240; plate 4) do not seem surprising at first, given Eakins' lifelong emphasis on figure painting. But remarkably, classroom or studio exercises by Eakins after 1870 are very rare: these three panels

seem to be the only examples of such work on a small scale. We can imagine that many were destroyed. Bregler, in making an inventory of Susan Eakins' estate, reported that "some sketches were destroyed as I told you by his nieces [Ella and Maggie Crowell] when they studied here." The Crowell girls joined Eakins' classes at the Art Students' League in the early 1890s. Forbidden by their parents from nude modeling, but accepted as students by their uncle with the understanding that all participants in his life classes must be willing to pose, the Crowell girls evidently did model nude for each other, or for their uncle, but were understandably apprehensive about the discovery of such studies by their parents.[21] Other nude studies may have been destroyed in 1939 by a "well-meaning" woman friend who hoped to suppress the possibility of renewed scandal over the "nude posing business," centered on Eakins' use of his women students as models.[22] Notably, the extant nude studies show figures modestly turned away or masked (as in cat. 238), or so broadly painted that their features cannot be recognized.

The environment in all three of these studies seems to be a studio; props are nonexistent, furniture is nondescript, the poses are routine. Their detachment from Eakins' known nude compositions is in itself remarkable, for most of the few surviving nude studies are four times larger, more smoothly finished in their modeling, and directly related to particular projects, usually the various versions of *William Rush Carving* (see chap. 14). The surviving examples seem to tell us—or perhaps intend to give the impression—that Eakins seldom sketched from life for pure "exercise."[23] However, his interest in the nude was keen—as his many photographs reveal—and his opportunities to paint life class models were legion during the years that he taught at the Academy or the Art Students' League. The mask on the model in cat. 238 suggests, in any event, a semi-public event, not a private studio session. But no accounts survive describing Eakins' participation in class alongside his students, nor are there stories about his demonstrating the fine points of painting for his students, as W. M. Chase would do. Moreover, these three sketches are all much smaller and broader than the conventional "academies" produced by students at art schools in this period. Two similar sketches by Eakins' student George Reid, who attended classes at the Academy from late 1882 to 1885, are the only evidence to suggest different practices at the Academy. Perhaps all five are the record of an unusual occasion or the remnants of a much larger class of such work.[24]

LANDSCAPE SKETCHES

The remaining ten oil sketches in the Bregler collection are all landscapes. As a group, they represent one of the least-known aspects of Eakins' work, in part because extant examples have been scattered and effectively lost. The thirty-odd views that can now be gathered for study must awaken us, first, to the presence of landscape in Eakins' work overall. Surprisingly, for an artist with a reputation as a figure painter,

landscape plays a part in almost a third of Eakins' lifetime production. This presence swells between 1871 and 1888, the year he completed his last landscape, *Cowboys in the Badlands*. In the first eighteen years of his career, outdoor subjects, including figures in landscape and pure landscape studies, constituted almost half of Eakins' extant efforts as a painter.[25]

The majority of these landscape paintings collect into two large groups, one from the early 1870s, when he was involved with outdoor sporting subjects (fig. 61; see cats. 232–236, chaps. 12, 13), and another from the early 1880s, when he was painting fishermen and Arcadian nudes (see cats. 247–251, chaps. 16, 17). Smaller clusters of sketches were made in 1878–79, in preparation for *A May Morning in the Park* (see cat. 245, chap. 15) and again in 1887, when Eakins traveled to Dakota Territory (see chap. 18). Like Eakins' figure sketches, most of his informal landscapes seem to have been produced with larger projects in mind, and most of them can be tied directly to particular paintings. Because Eakins rarely seems to have painted outdoors at random, opportunistically, for sheer pleasure or adventure, most of his undated, unidentified landscape sketches can probably be assigned to one of these four moments, when he was on an active campaign to produced finished landscape subjects.

The sources of Eakins' landscape style are mostly French, in the paintings he saw in Paris from 1866 to 1870, when he was first learning to paint. By this time, the naturalism of the Barbizon school had become mainstream, and Eakins could absorb without conscious study the strong value contrast and earthy brown, green, gold, and gray-blue palette seen in the work of Corot, Rousseau, Daubigny, and their followers. These models come to mind in viewing Eakins' landscapes of the early 1870s, such as *Max Schmitt in a Single Scull* (see fig. 107). Passages of rough or scumbled paint, perhaps laid on (to Gérôme's dismay) with a palette knife, and the occasional use of a bright green suggest exposure to Courbet's work.[26] Always generalizing, never botanically detailed, the scrubbed or dry and scratchy foliage typical of Eakins' work seems to willfully reject the early lessons from J. D. Harding's textbook on trees (see cat. 4) and all related Ruskinian practices. His style announces that landscape is "background" to Eakins' figures, which are always rendered with much more precision. The sense that all his plein air studies seek only sufficient information for areas of secondary focus—and no more—betrays Eakins' prejudices as a figure painter; he seems to have had no scientific curiosity about landscape analogous to his desire for information about the human body.

While seeming to turn his back on the British and German sources of the American landscape school, Eakins was not far out of step with his contemporaries in the United States, who were drawing less, painting outdoors more, and tiring of Ruskinian description. His style in *Max Schmitt* can be compared to the dry-brush handling of John F. Kensett or the rapid, scrubbed foliage mannerisms of Albert Bierstadt,

although Eakins' own style tended to a denser and less elabo-rated texture, again in concession to his figures. A transat-lantic sensibility is also seen in his compositional patterns, which favor the banded, horizontal formats or the deep wedge of space used by "luminist" painters in the United States and northern Europe, as well as the early impression-ists. Not drawn to the narrative or picturesque possibilities of changing weather, Eakins also followed the preferences of the luminists in choosing stable and serene conditions, better suited to his layered or fragmented study of a given subject.[27] Eakins' repertory of choices, given these inclinations, emerges from the closer examination of his landscape method in rela-tion to particular projects from 1872 to 1885 (see Part III).

The small sketches made in preparation for these larger landscape compositions come in several types, following the pattern of his figure studies. Rarest, however, are the overall compositional sketches so common to his figure work, such as the study for the entire background of *A May Morning in the Park,* cat. 245 (see fig. 144; plate 13). This sketch is unusual in being finished to the edges of a rectangular shape, clearly corresponding to the edges of the composition of his larger canvas (see fig. 140) and completely unrelated to the shape of the panel. Such a sketch must have been done after the painting was well organized in perspective drawings (cats. 192–194). Studied separately, without Fairman Rogers' team and coach present, it demonstrates the method of segregated study characteristic of Eakins' work overall. Conceptualized and executed as background to the four-in-hand, the land-scape remains a separate world. Eakins' acquisition of a cam-era in about 1881 refined the work of this kind of composi-tional sketch, as the camera took on the job of bracketing the field to be depicted. An oil sketch, made from the same spot as a camera study, was completely freed of the necessity to record detail and accordingly worked to capture effects of color and atmosphere with greater economy and vivacity (see figs. 172, 179, 180; plate 15). The reduction of his own work outdoors in oils in the post-camera days may be expressed in certain brief sketches that are at the far pole from the rela-tively finished *May Morning* study. Not much more than color notes, these late landscape sketches are sometimes (as Bregler noted) "incomprehensible to any one but the artist who made them."[28]

The sense that Eakins usually came to the landscape armed with a perspective drawing, a photograph, or an image determined in his mind's eye pervades the smaller fragmen-tary landscapes in the collection. Several of them can be pre-cisely related to larger paintings, where they were inserted, often at the same scale, as background context (figs. 61, 62; cats. 232, 234, 248). Perhaps sketches collected at random in the field were sorted and considered for such use, then in-serted on his larger canvases wherever they fit. However, a look at the perspective drawings or compositional pho-tographs made in preparation for such paintings as *The Artist and His Father Hunting Reed Birds* (see fig. 119), *Starting Out After Rail* (see fig. 116), and *Shad Fishing at Gloucester* (see

figs. 155, 160) encourages us to conclude that he went out to paint with these broad planes of landscape and the placement of the figures well established in his imagination. The sketches made on this kind of expedition fit neatly into the background edges of his pictures, usually along the horizon line, like fig. 61, cat. 248, or the telegraphic pencil notations of the Delaware River shoreline (cat. 153) that were added to *Starting Out After Rail.* The efficiency of this kind of sketch-ing, which may have produced more than enough material to use but nothing far from the center of his purpose, seems typical of Eakins. Usually, landscape painters of this period spent the warm-weather months outdoors, filling portfolios with drawings and oil sketches that might be worked up into paintings back in the studio. It appears that Eakins rarely painted outdoors with this kind of opportunistic open-end-edness. It seems unlikely that he worked outdoors on his final canvases, as painters began to do with increasing fre-quency in the 1870s. His habits, not surprising in a figure painter and an academic, show us an artist who was not pas-sionately drawn to landscape for its own merits and who treated it as a component of his art to be studied separately, preferably in the smallest isolable unit. Even in his earliest landscape painting (cat. 1) the disjunction between the build-ings and the trees was apparent, and—with typical logic—he rectified his ignorance by turning to a book specifically deal-ing with trees (cat. 4), not a text on the general strategies of landscape painting. His difficulty in grappling with the vari-ables of outdoor painting, recounted in his letters from Seville in 1870 (see chap. 6) or to Gérôme in 1874 (see chap. 13) sprang partly from inexperience and partly from a person-ality that sought controlled analysis, and was uneasy in changing, ungovernable circumstances.

Such generalizations about Eakins' approach to land-scape painting do not mean that he never reacted sponta-neously to an outdoor motif, for a few sketches survive that bear no connection to larger, known works. His letters to his fiancée, Kathrin Crowell, allude to sessions outdoors, such as the note on 19 August 1874 that he had been "down to Gloucester with Hen Schreiber to make a study of splatter-docks in [illegible] Timber Creek."[29] No paintings of splat-terdocks, a species of yellow water lilies, survive to illustrate Eakins' work on this day, although other small shoreline sketches (e.g., cat. 235) may be from similar outings, and the larger sketch, *Ships and Sailboats on the Delaware,* probably records the sailboat race that he and Schreiber encountered on their way home that afternoon (see cat. 232). With his paints at hand, Eakins was able to work from his vantage midstream to capture the color of the river and sky, and the position of a few larger vessels watching the race. Eakins liked the effect and went home to paint two larger oils and a watercolor. Perhaps he was especially charmed by having an idea for a painting thrust on him in this fashion; evidently it did not happen often.

The record of Eakins' small landscape sketches shows that he grew gradually more relaxed and confident during his

61. *Sailboats Racing: Study of the Delaware River*, c. 1874 (cat. 234).

62. *Sailboats (Hikers) Racing on the Delaware*, 1874, oil on canvas, 24 × 36 in., Philadelphia Museum of Art, given by Mrs. Thomas Eakins and Miss Mary Adeline Williams.

principal period of outdoor work, from the early 1870s to the mid-'80s. The progress was subtle, for there was no drastic change in Eakins' style or method, but small differences between sketches attached to projects from the 1870s (such as cats. 232–234) and those clearly from the 1880s (such as cats. 248 and 249) allow a tentative grouping of the remaining undated, unidentified subjects. Like the few extant figure exercises, these "unattached" landscape subjects are difficult to date because there are not many of them, and they seem only to refer to each other; for these reasons Goodrich gathered

them all into a single group of "landscape sketches," "probably" from the early 1880s.[30] They can be ordered, to some degree, by materials, for the dated sketches from the early 1870s are all on canvas (usually mounted, although perhaps later, on cardboard), while the Gloucester vignettes from the '80s are often on harder supports: wood, cardboard, or canvasboard. In between, evidently from the mid-'70s, comes a very small group of oil sketches on paper (figs. 61, 63)—a support Eakins never used again.[31]

The use of canvas or canvasboard in both groups makes

63. *Landscape Study: Field and Tree*, c. 1874 (cat. 236).

visual discrimination necessary, so it can be noted that the Gloucester sketches are generally higher in value, without the strong presence of earth tones in the earlier group, or their characteristic grayness. A comparison between the sketches for *Sailboats Racing* (fig. 61) or *Ships and Sailboats on the Delaware* of 1874 (cat. 232) and the later *Delaware River Scene,* probably from 1881–82 (cat. 250; plate 16), makes this growth clear. Although some of the clumsiness of cat. 232 may be the result of Eakins' unstable perch in a sailboat, *Delaware River Scene* is clearly more confident and suggestive in its handling. The overcast weather and the mid-river viewpoint may have restricted Eakins' palette in the earlier sketches, but the later one finds him seeking opportunities to insert touches of bright, clean color and adding white to all of his tints.[32] The brightness and fluidity of *Delaware River*

Scene show a progressive landscape effect for 1882, indicating a sensibility that had warmed to the idea of working outdoors with no particular end in sight other than the execution of this one small canvas. The same freedom, and the same feeling for the two-dimensional pattern of brushwork and overall composition, seen also in cat. 248 (and notably absent from the earlier, more naturalistic and descriptive sketches), appeared again in an even higher-keyed palette in his few surviving sketches from the Badlands, made in 1887 (see figs. 212, 213). But the turn of events in Eakins' life, recounted in Part III in the context of these landscape paintings from the 1880s, drew him away from such subjects, leaving these few sketches as emblems of a versatility in oil paints that was never fully exploited and, until now, never fully understood.

CHAPTER 9 Watercolor

LESSONS FROM
FRANCE AND
SPAIN

Eakins knew watercolor and ink wash techniques as a boy, but he set them aside when he embarked on his professional art training in 1862. Suddenly, in 1873, he took up watercolors again with surprising ambition. His efforts were soon rewarded with his first sales—in any medium—and his first exhibition prize, a silver medal in 1878 from the exhibition of the Massachusetts Charitable Mechanics' Association in Boston (cat. 269). Before 1879, he was better known and more highly regarded in New York City for his watercolors than for his oils.

Eakins' watercolors are still admired, but news of this early success comes as a surprise to observers a century later who equate watercolor with the spontaneity and plein airism of Winslow Homer and John Singer Sargent. Eakins, with his deliberating method, does not seem well suited to the medium. A closer look at the art world of the 1870s reveals, however, that his work was close to the popular mainstream and, like Homer's, responsive to the most progressive tastes of this period. His involvement in watercolor painting, from 1873 to 1882, corresponds exactly with the swelling of interest in this medium in America; like a barometer of contemporary trends, Eakins' involvement tells of a larger popular movement.[1] To understand why Eakins took up watercolor at just this moment, why his work was so well received, and why he ultimately abandoned the medium, we must attend to this wider phenomenon as well as the technical underpinnings of his success. Although the Bregler collection contains no finished watercolor paintings, a half-dozen drawings and several oil sketches allow us to reconstruct a procedure that was idiosyncratic, like his method in oil painting, and even more complex. Moving between the two vantages—the wider perspective of the watercolor movement and a close view of his preparations—we can "rediscover" much about Eakins that has been long forgotten or never adequately appreciated.

The background of his method and the resulting style lie first in Eakins' childhood, for like many artists of this period he learned to work with watercolors as a boy. His father was an amateur watercolorist, and his father's friend George W. Holmes (see fig. 17) may have offered professional advice. His earliest extant watercolors date from grammar school days, and they show an acquaintance with conventional notions of the picturesque landscape and skill in the handling of pale, clean tints (see fig. 18).[2] By the time he was in high school he could demonstrate an even more expert control of washes to indicate modeling in light and shadow. Because his school assignments (figs. 24–25, 27; cats. 5–14) were basically mechanical drawing exercises, they elicited an astonishing precision of both line and wash that establishes a benchmark of skill, useful in judging the intention of later work departing from this style.

From his early habit of restraint and delicacy would come all of Eakins' later work in watercolor, for while his manner would loosen over the years, it would not expand to include a wider repertory of techniques. Unlike many of his

contemporaries, Eakins seldom used opaque pigments or gouache, and he never tried tinted paper. He rarely adopted any of the trickier scraping, rinsing, blotting, and lifting techniques employed by Homer and many others in this period. Susan Eakins insisted that her husband "never had a lesson or advice in making a watercolor,"[3] and judging from the evidence of his work, the old-fashioned, straightforward techniques of his schoolboy projects, along with the academic habits of preparation he learned for oil painting, gave Eakins everything he needed.

No watercolors survive from the period between 1861, when he produced his high school valedictory piece in ink wash (cat. 14), and 1873, when his first paintings were produced for submission to the seventh annual exhibition of the American Watercolor Society, held early in 1874 (fig. 64). The attractiveness of this exhibition in New York probably awakened his interest in watercolor, for it was one of the few exhibition venues accessible to unknown talent, and it had been winning much favorable publicity. Eakins was at a loss for exhibition opportunities in Philadelphia, where the Academy's annual shows had been suspended during construction of the new building on Cherry Street. After his debut at the Union League's art reception in April 1871, when he exhibited *Max Schmitt in a Single Scull* (see fig. 107), Eakins did not show his work in Philadelphia until the year of the centennial; in New York, his work was refused by the National Academy of Design until 1877.[4] The young and ambitious Eakins naturally noticed the stir created by the American Watercolor Society, a group actively recruiting exhibitors to its shows since its first "annual" in 1867. Marginal artists of every description were welcome, including commercial draftsmen and illustrators, architects and designers, students and amateurs. Older artists seeking a fresh turn to their reputations, such as Winslow Homer, were finding a place for experimental work alongside the entries of younger painters—including many women—seeking patronage and exposure. The artist community in New York had been especially enthusiastic in 1873, when the club mustered an impressive loan exhibition of English watercolors to supplement its own display. United to the annual, the Blackburn Loan Collection took over all the galleries of the National Academy of Design in lieu of the usual winter exhibition, giving New Yorkers the largest survey of contemporary watercolor painting ever seen in the United States. Special gallery decorations, energetic promotion, low prices, and favorable reviews all drew attention to the exhibition. The effect of the show, combined with the proselytizing energy of the Watercolor Society's membership, had dramatic results in 1874, when increased submissions swelled the exhibition by 50 percent. Winslow Homer sent entries for the first time, as did Edwin Austin Abbey, Thomas Hovenden, and a host of illustrators, including F. S. Church and C. S. Reinhart. From abroad came Whistler's work, along with examples by the contemporary Italian-Spanish watercolor school led by Mariano Fortuny. Suddenly, watercolor was fashionable.[5]

64. *John Biglin in a Single Scull*, 1873, 16⅞ × 24 in., Collection of Mr. and Mrs. Paul Mellon, Upperville, Virginia, photo courtesy of Christie's.

In the months after the Blackburn loan exhibition closed, Eakins began to rework in watercolor the rowing and hunting subjects that he had been painting in oils. His progress must have pleased him, for he sent one of these first attempts to Gérôme, who acknowledged receipt of the gift in a letter dated 10 May 1873. "I accept it with pleasure and thank you," wrote Gérôme, who evidently kept this watercolor and offered several comments of praise and criticism in return.[6] Gérôme's remarks indicate that this watercolor, now unlocated, showed a single oarsman, somewhat like *John Biglin in a Single Scull* (fig. 64).[7] The sculler appeared in midstroke, a position Gérôme criticized as motionless. He advised Eakins to select a moment at either extreme of the action, the better to suggest the entire movement. At the same time, he praised the general quality of tone in the picture and described the sky as "firm and light, the background well in its place, and the water done in a charming way, very true, that I do not know how to praise too much." What pleased Gérôme especially was the "construction and foundation joined to honesty that presided over this work" in a fashion that he felt boded well for Eakins' future. "I send you my compliments with my encouragements."[8]

Eakins immediately responded to Gérôme's comments by launching a new series of rowers, revised with his teacher's suggestions in mind and perhaps with a reproduction of Gérôme's own (Egyptian) rowing scene, *The Prisoner* (1863), at hand.[9] Undoubtedly, the major product of this revision was *John Biglin in a Single Scull*, and its replica (MMA). Biglin, a tense knot of color, detail, value contrast and diagonal motion, is locked into the center of the picture by two strong horizontals (the sky line and the scull) and a vertical axis (still visible in pencil) that runs through the oarlock and along the back of his neck. The flat, potentially frozen quality of this composition is relieved by Biglin's move to the top of his stroke, and it is softened by the sky, so "solid yet light,"

the convincing spatial recession, and the "charming" effect of water that Gérôme had admired in the earlier version.

Very cautious in this first year of new work in watercolor, Eakins prepared carefully for *John Biglin* with a perspective drawing (MFA, Boston) and an oil sketch (Yale), both made at twice the scale of the watercolor and with much more detail than usual. The perspective drawing is exceptional in the completeness of the figure modeling, which seems to be based on the effects in the oil; the oil, unlike most of Eakins' preparatory work, is a "study" rather than a sketch, but so complete that it approaches autonomy as a painting. Evenly finished to the edges and densely painted, this oil study captures the effects of sunlight and mass that the drawing renders only schematically. Both the oil and the perspective seem to have been developed simultaneously, however, for the complex pattern of reflections recorded in the oil is based on the structure established in the drawing. The first version of the watercolor, fig. 64, takes this pattern of reflections from the oil, along with the oil's sense of color and form, while using the spatial construction of the drawing. The reduction of both studies by half, to the one-seventh scale of the watercolor, contributes to the miniaturistic intensity of the picture, instilling an effect of largeness beyond its size.[10]

The elaborate preparation undertaken for *John Biglin* relaxed as Eakins grew more confident in watercolor, but similar work always preceded his work in this medium. The unforgiving surface of watercolor paper, which betrays hesitation and change, was never approached until he felt secure about his image. Problems in establishing contour or modeling were attacked in oil, which dried slowly and could be altered easily. All of his watercolors are therefore replicas or translations of work already well resolved in oil or in camera studies; none would have been done outdoors directly from observation, although the addition of detail in the *Biglin* watercolors, not visible in extant studies, may indicate finishing touches from life. But for the most part, these pictures are studio productions, the antithesis of the spontaneous field sketches that formed a large part of contemporary practice in watercolor. Eakins ignored this sketching tradition, instead following the example of the "exhibition watercolor," well established in England since the early nineteenth century, when large, brilliantly colored, and elaborately worked watercolors began to rival the impact of oils. Initially dominated by landscape artists, watercolor eventually attracted figure painters, who had to devise special techniques to manage a medium where a "happy accident" could rarely be turned to advantage, as in landscape work. As one writer noted in 1882, "few American artists have the thorough knowledge of form requisite for direct life-work in watercolor, and so some of them content themselves with simply reproducing their oil paintings. Others again—and this is the better way—prefer to make studies in oil from the model, and to produce work which, while correct in drawing, retains its purity and freshness of color and effect."[11] The survival of such studies by Eakins (e.g., cats. 241,

242) may document a practice shared among American figure painters in watercolor but never seen elsewhere. More remarkable, however, is Eakins' foresight in gauging the impact of the medium on his subject, which, as Sewell noted, luminously "achieved the integration of light, form and color that had been his goal in the rowing paintings."[12] These rowing watercolors, finished in 1873 or early 1874, were the last paintings of this subject that Eakins would complete.

Eakins was satisfied enough with these portraits of rowing and sculling celebrities to send three of them to the Watercolor Society in January 1874. One of them, number 207, *The Pair-Oared Race, John and Barney Biglin Turning the Stake* (unlocated) seems to have been a watercolor version of the oil painting *The Biglin Brothers Turning The Stake* (Cleveland Museum), completed in 1872.[13] The other two rowing pictures were single oarsmen: no. 8, *The Sculler* (now lost), and no. 231, *John Biglin, of New York, The Sculler* (probably fig. 64). C. T. Barney bought *The Sculler* from the exhibition for $80— Eakins' first known sale.[14] In May 1874, after the show closed, Eakins evidently copied no. 231 and sent the original to Gérôme, who acknowledged receipt in a letter dated 10 September 1874. "I have received your pictures and I have found a very great progress; I send you my compliments," wrote Gérôme. "Your watercolor is entirely good, and I am very happy to have in the New World a student like you who does me honor."[15] This praise, and the compliments Gérôme bestowed on the previous version, made Eakins very proud; he fed both letters to Shinn (another Gérôme student and admirer), who quoted their commendations in his review of the Watercolor Society's exhibition for *The Nation* in 1874.[16]

Eakins' correspondence with Gérôme reveals that after three years at home he continued to look to France. If he was not submitting his work to New York, he was sending it to Paris; his oils were shown at Goupil's gallery and at the Salon two years before he had anything accepted at the National Academy of Design.[17] His eagerness to show or present his watercolors to Gérôme provides a starting point for the analysis of these paintings. Their exchanges in 1873–75 reiterate Eakins' many debts to his teacher. Eakins' successful entry into the Salon of 1875 and his introduction to Goupil's probably were sponsored by Gérôme, who was at that time enjoying a position of influence and popularity. Grateful as well as respectful, Eakins must have taken his master's words of advice and encouragement to heart. Gérôme received the first watercolor in 1873 and was delighted above all by a "manner of proceeding that can only lead you to good." He admitted past anxieties concerning Eakins' future as a painter, but was "truly delighted that my advice, although belatedly applied, has finally borne fruit." Gérôme ended this first letter with a request that Eakins keep him "au courant" and consult with him whenever he felt it necessary. "I am very interested in the work of my students," wrote Gérôme, "and yours in particular."[18]

That Gérôme was proud to have such a student in America is no wonder, since Eakins had indeed followed his

specific advice as well as his general procedure with exceptional fidelity. *John Biglin* incorporates Gérôme's suggestions, makes flattering references to Gérôme's own work, and enacts exactly Gérôme's own "manière de procéder," which, logically enough to Gérôme, could only lead to "serious results." The crisp and careful drawing would have pleased him as evidence of rigorous planning: every wave, every cloud has been lightly outlined in pencil. The study of wave motion, reflection patterns, and anatomy surpassed even Gérôme's dedication to scientific accuracy. Eakins' insecurity about his first major watercolors had combined with the natural conscientiousness of his early career to produce a striking effect of precision and forethought. This kind of preparation was the cornerstone of Gérôme's—and the Ecole's—method; naturally Gérôme felt that Eakins was on the "right road."[19] *John Biglin in a Single Scull* makes Eakins' fealty to the academic method obvious—more obvious, in fact, than any of the oils Eakins sent to France. It bore a statement of homage, of sympathetic ideals and procedures, that Gérôme instantly understood.

Evidently this message was not contradicted or confused by the watercolor medium. Gérôme made no comment on Eakins' choice of technique, so we must assume that he found it neither a surprising nor an unacceptable vehicle for painters working in the academic manner. This receptivity opens the possibility that Gérôme's example supported Eakins' interest in watercolor. It might be argued that Eakins sent his master watercolors because, being on paper, they were easy to ship, but it is also unlikely that the first specimen sent by an earnest student to his teacher would be an offbeat, questionable, or insignificant venture. Perhaps Eakins knew full well that Gérôme admired watercolors. This notion seems unlikely because Gérôme's oil paintings show a dense, enamel-like brilliance that would seem antithetical to a watercolor aesthetic. Moreover, watercolor was not taught at the Ecole, and there was no watercolor society or regular watercolor exhibition in Paris before 1878. Nevertheless, at least one unquestioned example of Gérôme's work in watercolor survives to establish his engagement with the medium. This painting, *A Mirmillo Preparing Himself for Combat in a Roman Arena* (priv. coll.), demonstrates how the conscientious academic realist could move gracefully and logically into watercolor. Although finely, almost miraculously finished, with frequent recourse to milky gouache mixtures, this watercolor is surprisingly transparent, showing a just appreciation for the translucency of the medium. Gérôme's discipline and patience are evident throughout; the precision of the drawing and perspective, the quiet assurance of the modeling washes, all show his characteristic brand of realism skillfully translated into watercolor.[20]

Gérôme's rare watercolors may have been provoked by the example of his young friend Mariano Fortuny, a promising Spanish artist contracted to the Goupil-Gérôme family gallery. Fortuny's watercolors, first seen in Paris in 1867, generated much excitement in French art circles during the years of Eakins' study abroad. Particularly active in watercolor around 1868, Fortuny brought his flashing, broken style to maturity in works like *Masquerade* (see fig. 72). Several painters in Gérôme's circle—principally J. G. Vibert—began to experiment with watercolors at this moment, building an interest that culminated in the formation of the Société des Aquarellistes Français in 1878.[21]

Eakins surely responded to this vogue. A provocative entry in his Parisian account book records the purchase of a set of watercolors—perhaps the same box found in Eakins' studio (cat. 264)—in March 1868.[22] No watercolors exist today from this period in Paris, but then Eakins saved few of his French studies. The purchase of these materials confirms the suspicion that *some* work took place in watercolor after 1861 and before 1873, for *John Biglin in a Single Scull* hardly could have been the first, unrehearsed essay in a technique left untried since high school.[23] The renewal of his interest in watercolor, and his sense of the viability of the academic tradition in the medium, may have grown out of his experience in Paris. This possibility does not alter the fact that he waited three years in America before beginning serious work in watercolor, but it does provide a background to explain his receptivity in 1873 and his decision to send Gérôme a watercolor, not an oil, as the first postgraduate sample of his work.

If Eakins, like Gérôme, was stimulated by Fortuny's watercolors in 1868, he responded like Gérôme, too—as an academic, not an imitator. Fortuny's style would emerge in Eakins' work in the late 1870s; at first, his efforts were entirely in the spirit of Gérôme. After a few years devoted to genre scenes and portraits in the dark and painterly style of Bonnat and the Spanish masters he had admired in the Prado, Eakins returned to the manner of Gérôme consistent with his oldest childhood habits. *John Biglin* shows Gérôme's calculated method, fine drawing, and quiet surface, not the glittering, suggestive style of Fortuny or, for that matter, Velázquez.

What Eakins (and Fortuny) captured better than Gérôme, however, is the movement of outdoor light. *John Biglin* is pitched at a higher key than his own or Gérôme's work in oil, but what it loses in saturation it gains in luminosity. Eakins had shown this talent for atmospheric observation earlier, in the first of his rowing pictures: *Max Schmitt in a Single Scull* (see fig. 107), which captures the cool brilliance of autumn just as *John Biglin* recreates the glare of hot and hazy summer. "In a big picture you can see what o'clock it is, afternoon or morning, if it is hot or cold, winter or summer," wrote Eakins, whose sensitivity to American light and weather has earned him part of his reputation as a great national painter.[24] This attentiveness, combined with the relative quietness of his paint handling, links him to the native luminist painters of the 1860s and '70s and to other watercolorists in this period, such as Winslow Homer and William Trost Richards, who were preoccupied by light as a subject. For such artists, watercolor offered the highest possible key and the cleanest, brightest palette for capturing the effects of outdoor light.[25]

For the most part, however, Eakins (like Homer) departed from the luminist mainstream in his interpretation of landscape as a setting for figures, that is, not just the time of day but also "what kind of people are there, and what they are doing, and why they are doing it."[26] As the *Tribune* commented in response to his first watercolors in 1874, Eakins' landscapes were "as much to be enjoyed as the men, with their beautifully ugly muscles."[27] Both Homer and Eakins were exceptional in their openness to the American scene as a unity of place *and* human action; both populated their landscapes in this decade with Americans at work and at leisure—athletes, sportsmen, and fishermen for Eakins; children, farmers, and pretty tourists for Homer. Eakins' best watercolors of outdoor scenes came in 1873–75, when he first began to push his watercolor skill, and as Homer made his first watercolors of similar subjects. Overall, Eakins' work in watercolor coincided exactly with his decade of involvement with outdoor subjects; he all but abandoned the medium at the same moment that he lost interest in landscape, after 1882.[28]

This relation between medium and subject was tight in the first two years of Eakins' work in watercolors. All nine of the major watercolors he completed before January 1875 were devoted to outdoor subjects. His entries at the Centennial exhibition in 1876 expressed his media categories clearly: all four oils depicted interiors, while both watercolors (*Baseball*, plate 2, and *Whistling for Plover*) showed sunlit sporting scenes. His two earliest extant watercolors—*John Biglin* and *Starting Out After Rail* (fig. 65)—began by demonstrating the coordination of landscape subjects, luminist aesthetics, and watercolor.

Starting Out After Rail was shown at the Watercolor Society in 1874 as no. 44, "Harry Young, of Moyamensing, and Sam Helhower, 'The Pusher,' Going Rail Shooting." At $200, it was at least twice as expensive as the two single-sculler pictures, indicating Eakins' own sense of its importance. While the work is only slightly larger than *John Biglin*, the problems of perspective in this subject were considerably more complex, inspiring two full-size oils and a perspective drawing (see figs. 116, 117). The effect of this preparatory work is seen in the absolute sureness and precision of the watercolor. Here, too, Eakins' understanding of watercolor's virtues is made clear. Like *John Biglin*, this watercolor is more transparent and more varied in color than the oils that preceded it. The oils are denser, flatter, more saturated in color and stronger in value contrast; the watercolors are paler, more luminous, more delicate and atmospheric. Eakins turned the lightness of the medium to his advantage in these scenes, where high values were especially appropriate. No body color interrupts the transparency of the pigment; like dazzling sunshine on water, the paper bleaches out the colors and the modeling. A sense of motion and glare also comes from the white paper reserved for highlights. In the water areas, where Eakins' individual strokes rarely overlap, a sparkling margin of white remains around every touch. At-

mospheric softening is also increased by Eakins' discreet use of scraping: the splash of water off the bow, the reflection of the distant sailboat, or the drips running off Biglin's oar are created with tiny scratches that bring up the paper's whiteness as a highlight without drawing attention to the device itself. The shimmer created by these bits of paper, either reserved or scratched, brings air and motion into Eakins' tightly constructed, minutely observed world and gives life to the small, tense figures of Biglin, Young, and Helhower.

The restrained use of techniques like scraping shows that in this early moment Eakins, like Gérôme (and unlike Homer), only cautiously explored the abstract or decorative potential in technique. His effects were gained by careful construction, and when he attempted a looser, more spontaneous effect, results were sometimes mixed. In both *Biglin* and *Starting Out After Rail* the aerial tones were achieved by washes that Eakins allowed to settle unevenly into the pores of the roughly textured paper. The variation in hue is most visible in the sky of the second *John Biglin* (MMA), where very wet washes were allowed to mottle and "cobalt" as they dried. In the first *Biglin* (fig. 64) and *Starting Out After Rail* Eakins rewashed the sky with water to get a more even effect of graduated color and "granulation."[29] This quieter, more regular technique produced a superior sense of deep space and high, North American haze. As usual, Eakins did better with techniques of control rather than surprise.

Eakins' friend Shinn, armed with quotations from Gérôme's letter, made a point of praising these "remarkably original and studious boating scenes" in his review of the AWS exhibition in the *Nation*, but few other critics noticed Eakins' work in 1874, although the *Tribune* found "great merit" in his sculling pictures and, "barring some slight exaggeration, and some signs of timidity," a demonstration of cleverness, spirit, and "thoroughly right intentions." "It is not every year there is so promising a first appearance."[30] Eakins, surely pleased by the sale of his first picture, could feel that he had won a foothold in New York.

Encouraged, Eakins sent new work to the Society's exhibition the following year. Three items were accepted: *No Wind—Race Boats Drifting* (see cat. 233), *Ball Players Practicing* (see fig. 55), and *Negroes Whistling Plover* (Brooklyn Museum).[31] Eakins again wrote to his friend Shinn to describe his entries, stressing the particular circumstances of wind and weather in the sailboat race, the specific individuals shown in the baseball scene, and the effect of luminosity in the hunting subject, which he explained was similar to his (now lost) oil version, *Whistling for Plover*, but "not near as far finished" and "painted in a much higher key with all the light possible."[32] Shinn obligingly responded by featuring Eakins' work in his review in the *Nation*, remarking his affinities with Gérôme and Greek art.[33] Shinn's review was the most enthusiastic and elaborate consideration given to Eakins' watercolors in 1875, but it was not the only notice he received. The *New York Times* described *Ball Players* and *Plover* as "excellent in drawing, attitude and expression."[34] *Scribner's* found

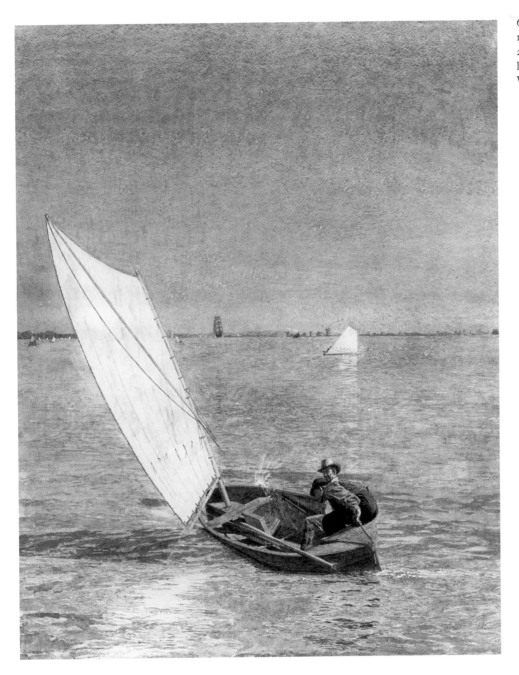

65. *Starting Out After Rail*, 1873–74, watercolor on paper, 25 × 20 in., Roland P. Murdoch Collection, Wichita Art Museum, Wichita, Kansas.

the latter picture "remarkably unconventional, and promises well," though "the clouds in its sky are very bad."[35] Both these reviewers commented on the highly keyed color in *Ball Players*, though *Scribner's* liked its "vigorous contrasts" and brightness, while the *Times* found it simply "crude."

Perhaps Shinn's encouragement was insufficient to counter the mixed reviews (or silence) from other quarters, for Eakins made no appearance at the Society in 1876. His loss of interest seems to have owed less to disaffection, however, than to *The Gross Clinic*, which consumed most of his energies in the latter part of 1875. This painting, in the form of a collotype reproduction, made its debut at the Penn Art Club along with *Whistling for Plover*. The subordination of

all other work at this time to the *Gross Clinic* is demonstrated by the lone watercolor that Eakins completed in 1875, which was a large ink wash replica of the oil, made as a model for the photoengravers in Germany who printed the reproduction (see fig. 88). This copy proves that, despite the gap in his exhibition record, Eakins was keeping his hand in; at the same time, he was teaching watercolor classes at the Philadelphia Sketch Club.[36]

Once *The Gross Clinic* was launched, Eakins returned to watercolor, producing *The Zither Player* (Art Institute of Chicago) in time for the opening exhibition of the new Pennsylvania Academy of the Fine Arts in April 1876.[37] More than a year had elapsed since his last "exhibition piece" in

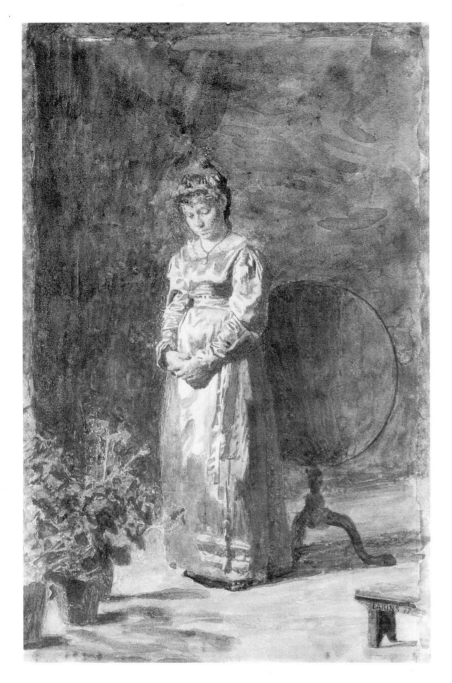

66. *Fifty Years Ago (Young Girl Meditating)*, 1877, watercolor on paper, 8¾ × 5½ in. (22.2 × 13.9), Metropolitan Museum of Art, Fletcher Fund, 1925 (plate 6).

67. *Fifty Years Ago (Young Girl Meditating): Sketch*, 1877, oil on canvas, 8¾ × 6¾ in., Mr. Martin Peretz.

watercolors, and in this time his interest had moved away from outdoor sporting subjects. This shift appears in the major oil that followed the completion of *The Gross Clinic:* the historical genre subject *William Rush Carving His Allegorical Figure of the Schuylkill* (see fig. 129), completed in 1877. The dozen watercolors and wash drawings that Eakins made between 1876 and 1881 all fall into the subject categories seen in *Rush Carving:* quiet figures, frequently dressed in historical costume, set in shadowy interiors.

Fifty Years Ago (figs. 66, 67; plate 6), finished in the same year as *Rush Carving,* demonstrates the tone of this entire group. More recently known as *Young Girl Meditating,* the

watercolor depicts a young woman in a satin dress of about 1830, standing next to an eighteenth-century tilt-top table (familiar from other paintings and drawings) and staring pensively at the floor, or perhaps contemplating some geraniums in a pot at her right.[38] In contrast to the bright sunlight and tense anticipation of the earlier sporting subjects, this new series of watercolors was devoted to dark rooms and more relaxed, introspective activities: music making, spinning, knitting, thinking. Beginning with *The Zither Player,* all the figures in the watercolors begin to bear what Clarence Cook described in 1882 as an "Eakinsish expression." By that time Cook saw Eakins as "our best master" at the art of por-

traying "mere thinking . . . without the aid of gesture or attitude."[39] As the sitters become less active their minds grow more mobile, their souls gain life and ambiguity. The rowers, hunters, and ball players appear as tense, expectant exteriors; they do not think, they wait to act, and the events they anticipate are easily predicted. This "young girl" is instead immersed in less physical and therefore more elusive private activity. The crisp certainty of the earlier subjects is gone; there is less action but more psychological complexity.

This important shift in Eakins' work from physical and outer-directed to spiritual and self-absorbed is visible in every pose and setting from this period, in oils and watercolors alike. His figures all look down, occupied by their work or their thoughts, not at each other or at something beyond the picture space. They are emotionally withdrawn, detached (though not necessarily inaccessible), and set into very closed interiors. Daylight falls on these figures, but windows and doors never appear. *Fifty Years Ago*, like the other watercolors in this group, shows the warm, muffled, slightly mysterious spaces of Eakins' Brown Decades retreat.[40]

The greater confidence of this new series of watercolors can be read in the sequence of surviving preparatory works for *Fifty Years Ago*, which show a more direct method. Working at home, in his own studio, Eakins could bring the subject under his control more easily and simplify some of the procedures he had developed for outdoor work. No perspective drawing is known, but the space is unspecified, uncomplicated, and dark, so such a drawing may not have been necessary. However, because no finished oil preceded this piece (which was evidently, like *John Biglin*, conceived as a watercolor from the start), the subject required its own set of oil studies. Two oil sketches, once joined on the two sides of a single canvasboard panel, record the initial modeling sessions, most likely in Eakins' Mount Vernon Street studio. In the first sketch (fig. 67), the model is seen at three-quarter length, her weight carried on her right leg. With deft strokes Eakins defined the fall of light across her figure, allowing a sense of reverie in the indistinctness of forms. The poetic side of Eakins, imagining a maiden "fifty years ago," was brought closer to earth on the full-length study on the other side of the panel (cat. 241; plate 5). Here he began again with a variant of the same pose, at a slightly smaller scale.[41] The model now stands less gracefully, with her weight evenly distributed—a simple pose for an amateur model, but calculated in its artlessness. Lightly scored with a grid of one-inch squares (subdivided into quarter-inch intervals across the face and hands), this image provided the basis for the watercolor, reduced again by a third. The progress from the dreamy, historical fantasy of the first sketch to the detailed depiction of a particular modern young woman in an old-fashioned dress, obviously posing among studio props, charts the typical chastening effect of observation on Eakins' imaginative flights. A third modeling session must have occurred once the figure was well established on the watercolor paper, for small items not seen in the oil study have been added,

such as her blue necklace and bright red bow, while the pattern of folds and detail in her dress has changed and grown more elaborate. The flat-footed mixture of realism, contrivance, and nostalgia in this picture gives it its special charm today, although modern viewers may not see the anachronisms and the blunt artifice, the complete absence of historical fiction, that must have been apparent to contemporary viewers. As with Winslow Homer's *Fresh Air*, a remarkably similar watercolor concept from the next year showing a "Bo-Peep" on a hillside, the costume subject is just a pretext for an appealing pictorial effect, underwritten by a gentle expression of Eakinsish contemplation.

The method seen in *Fifty Years Ago* required another procedural step when Eakins undertook his largest watercolor, *Negro Boy Dancing* (fig. 68; plate 7), probably painted in December 1877 and January 1878, when it was submitted to the AWS annual in New York as *Study of Negroes*.[42] The subject is a compositional reprise of *The Chess Players* of 1876 (see fig. 9), with a venerable black man replacing Benjamin Eakins as the central judge of two flanking performers, both enraptured by their work. Oil studies also preceded this work (figs. 70, 71), which evidently was conceived from the start as a watercolor; typically, these studies were undertaken separately, at a larger scale, and then integrated on a single perspective drawing (fig. 69). As in the study for *Fifty Years Ago*, each figure was crossed by a grid of lines to facilitate transfer to a uniform, smaller scale.[43] The separate figures must have been studied according to a preliminary compositional sketch, now lost, and a floor plan. He situated his own eye level at 48 inches—his typical viewpoint when seated—so that the horizon skims above the heads of the performers and below the watching eyes of the "grandfather." As in *The Chess Players*, the spectator-artist completes the circle of chairs and benches in the pictorial space, thereby joining the audience of this event.

Once the oil studies were completed, they were knit together on a full-scale perspective drawing, fig. 69, unique in its revelation of Eakins' watercolor method. The figures in the drawing show the ghostly, abstracted style of work copied from another two-dimensional source; the security of the graphite and ink outlines, the flat shadow patterns, and the large chunks of missing information (as in the bodiless dancer) all tell us that the oil studies were at hand when Eakins prepared this drawing.[44] The transfer grid of one-inch squares—drawn in red ink to distinguish it from the blue perspective network and doubled in the complex zones of the faces, hands, and foreshortened banjo—helped Eakins transpose his figures to a new surface (see plate 8). This drawing, made on two overlapped sheets of paper pinned in place, holds an image identical in scale to the watercolor, although—characteristically—the paper's edges have nothing to do with the framing edge of the image, demonstrating the practical and conceptual (nonvisual) nature of this type of preparatory drawing. Numerous pinholes through the paper indicate that Eakins laid this drawing over his watercolor

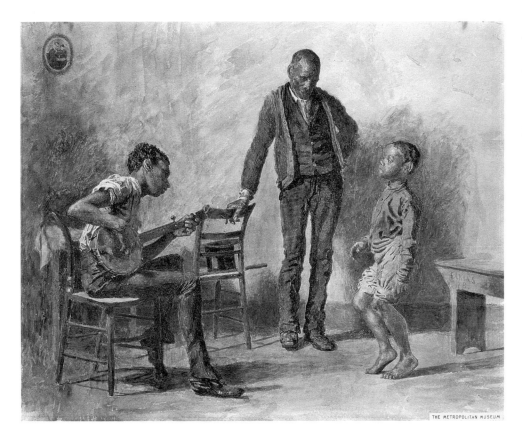

68. *Negro Boy Dancing,* 1878, watercolor on paper, 18⅛ × 22⅝ in., Metropolitan Museum of Art, Fletcher Fund, 1925 (plate 7).

69. *Negro Boy Dancing: Perspective Study,* 1877–78 (cat. 191; plate 8).

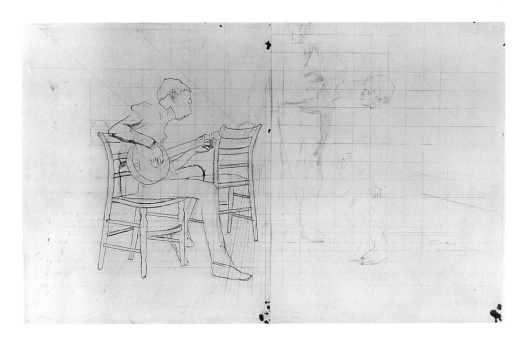

paper and transferred the most important contours to the final sheet with a pattern of tiny prick marks. The figures were probably established on this surface by reference to the oil studies and then developed in detail from new posing sessions, for—as in *Fifty Years Ago*—the final image holds many observations of clothing and accessories not included in the

oils. Finally, Eakins completed the background washes, which establish space and unite the figures.

When the first watercolor in this new series, *The Zither Player,* was exhibited at the Pennsylvania Academy in 1876 it received a long and enthusiastic notice from Eakins' friendliest Philadelphia critic, William Clark of the *Evening Tele-*

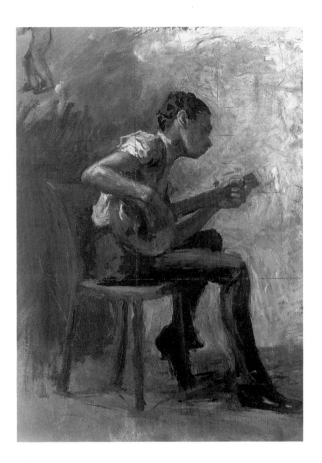

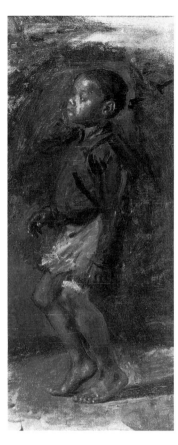

70. *Study for "Negro Boy Danc-
ing": The Banjo Player*, c. 1877–78,
oil on canvas mounted on card-
board, 20 × 15¼ in. (.508 × .387
m), National Gallery of Art,
Washington, Collection of Mr.
and Mrs. Paul Mellon.

71. *Study for "Negro Boy Danc-
ing": The Boy*, c. 1877–78, oil on
canvas, 21 × 9⅛ in. (.533 × .232
m.), National Gallery of Art,
Washington, Collection of Mr.
and Mrs. Paul Mellon.

graph, who hailed it as a "little masterpiece" representing Eakins' best work to date.[45] The New York critics were less responsive when it appeared at the Watercolor Society the following January. No one noticed it at all except Shinn, who remarked only that "Mr. Eakins contributes a 'Zither Player' strong enough to bear the critical neighborhood of a flashing Spanish aquarelle hung above it."[46]

Shinn's quick reference to Eakins' Spanish "neighbors" awakens us to two things about this second phase of Eakins' work: first, these watercolors turn to the warm palette and strong chiaroscuro of his second teacher in Paris, the Spanish painter Léon Bonnat, whose earthy realism grew out of the Spanish Baroque tradition that Eakins especially admired. William Sartain, one of the models for *The Zither Player*, had just returned from his own studies with Bonnat, bringing Eakins fresh news and perhaps fresh inspiration from Paris. Second, Eakins was holding his own, according to Shinn, in an exhibition increasingly populated by contemporary water-colors in the "flashing" style of Fortuny and his Spanish or Italian followers (see figs. 72–74). We know that Eakins saw Fortuny's work in Paris in the late 1860s, but he also had many new opportunities to inspect watercolors from this school once he returned to America. Fortuny made his debut at the American Watercolor Society along with Eakins and Homer in 1874, with several items lent from the collection of John T. Johnston.[47] His works were praised highly, and he quickly assumed a position of celebrity and importance in

American art, particularly after the news of his untimely death in Rome later that year inspired an admiring biography and several lengthy magazine tributes in early 1875.[48] The combined effect of the Baroque and modern Spanish styles on Eakins' watercolors grew after this year, at exactly the time when these two schools reached a new peak of popular-ity among all the young American "Impressionists" returned from Munich and Rome.

The Spanish qualities in this new phase of Eakins' work emerged with clarity in 1877. After *The Zither Player*, finished before April 1876, Eakins did not produce another watercolor until *Fifty Years Ago* and *Seventy Years Ago* (Princeton), which appeared at the Pennsylvania Academy's first loan exhibition of watercolors in December 1877.[49] He forwarded both of these pictures, plus *Study of Negroes*, to the American Water-color Society's exhibition, which opened in early 1878. Like *The Zither Player*, all three subjects show pensive figures in closed interiors; even the music and dancing in *Negroes* pro-ceeds with a kind of detached, almost dreamy concentration. And all three show the palette and style of Spanish realism. The new element in these pictures, shared with contempo-rary Spanish-Italian work, is a distinctive brand of nostalgic picturesqueness. The first two watercolors declare, by their titles, a deliberately retrospective attitude; the last item finds quaintness in the culture of an oppressed minority. All three appealed to a modern sensibility in both the United States and Europe.

The turn to backward-looking subjects by Eakins, Homer, and many other American artists in this decade has been attributed to the mood of patriotic historicism inspired by the Centennial celebration in 1876.[50] Certainly early American motifs became more common immediately after this year. E. W. Perry, who was known for his finely worked domestic genre figures, made the same switch to historical costume subjects in 1877. His watercolor *Spun Out* of 1877, which depicted an old woman asleep behind a flax wheel, was lavishly praised by the conservative critic of the *Independent*, who found that "apart from the artistic merit" of the piece, such work had a "special value as accurate representations of phases of domestic American life of which few memorials remain." The eighteenth-century details in Perry's "thoroughly American production" especially impressed this reviewer; "their great charm is in their absolute veracity."[51] Eakins, whose personal insistence on historical authenticity had already inspired the lengthy researches of the William Rush project, began to feature old-time domestic genre—spinning, knitting, or sewing—at exactly this moment.

The third picture Eakins showed at the Watercolor Society in 1878, *Study of Negroes*, drew on a slightly different type of nostalgia. Like Homer's "wholesome" farm subjects from these years, this picture presented an image of simple pleasures, drawn from picturesque sources in contemporary American life. Much as Europeans looked upon Breton farmers or Scheveningen fisher folk as quaint survivors from bygone days, New Yorkers saw Eakins' Negroes as almost exotic, slightly comic American peasants. The structural similarities between *Study of Negroes* and Eakins' first oil composition, *Street Scene in Seville* (plate 1), imply that Eakins himself saw Philadelphia's blacks as the pictorial equivalents of Spanish street musicians.

The context of the simplest, most "objective" Negro figure subjects from this period can be understood from the response to a watercolor shown in 1882 by Thomas Hovenden, who had—in the words of Clarence Cook—recently "exchanged his Bretons for our darkies."[52] According to the *Herald*, Hovenden's subject (now lost) was "an old, white haired darky, with an expressive and strongly painted face, clad in garments as many colored as those of Joseph," who sat on a table, pipe in hand, with his banjo in a chair beside him, chuckling out "Dem was a good old times."[53] This picture inspired a nostalgic gloss from the *Independent's* critic, who imagined that its "happy go lucky" hero "looks back upon the easy irresponsibility of bondage and cherishes memories of the amenities of slavery, while he forgets its hardships." Such a man was "an exception, but by no means a rare character in the old days, and a figure that will soon have passed out of existence."[54]

As the failures of Reconstruction grew painfully obvious, this sentimental view of black life in the antebellum South gained popularity in the North, bringing minstrel songs, banjos, and Uncle Remus stories into bourgeois parlors, and investing every image of African-American people, no matter how up-to-date, with "old timey" overtones.[55] This spirit explains why Eastman Johnson's *Life in the South* of 1859, a picture of urban back yards in contemporary Washington, D.C., took on the title of Stephen Foster's sentimental ballad "Old Kentucky Home" soon after the Civil War.[56] Similarly, it helps us understand why Eakins' image of urban blacks was immediately read by Earl Shinn as a "comedy of plantation life" rendered with a "quiet intensity that makes every onlooker sympathetic." "The precocious solemnity of the child who is learning to dance, and whose bare legs have absorbed all the liveliness away from his face; the weight of warning in the countenance of his grandfather, who 'pats' for him with the foot, and is ready to pounce on an error; and the serpentine insinuation of the banjo-player, who writhes and twists involuntarily to help on the motion, make up a group of goblin humor so true and intense as to notch a pretty high mark in the degree of comedy."[57]

Shinn's delight in the goblin humor of this work recalls the chuckles elicited by Winslow Homer's kindred subjects, first shown at the American Watercolor Society in 1876.[58] Eakins probably saw these two pictures, *The Busy Bee* and *A Flower for the Teacher*, because they also appeared at the Centennial. The similarities in the two artists' works on this subject are striking, because both share a "quiet intensity" that holds for us today only the gentlest comic undertones. Eakins, as always, seems the subtler and more exacting draftsman, while Homer is—as usual—the more fluent painter, but both artists show a respectful sensitivity to ethnographic detail and a resistance to stereotype unusual at this period. Eakins has carefully observed the posture and expression of a banjo player absorbed in his music, or the lip-biting concentration of a small boy trying to keep in time. The clothes, the new store-bought banjo, the mule-eared chairs, the silk hat, the tiny portrait of Lincoln and his son—all evoke postwar urbanity, not plantation comedy. Such detail makes the subject picturesque and informative, but it also allows the individual figures a complex humanity very different from the good-natured "darkies" in contemporary images by Hovenden and others.[59]

Significantly enough, these subjects were the most popular items Eakins ever produced. Similar items were also important to Homer's breakthrough the following year. After *Study of Negroes* and *Seventy Years Ago* earned Eakins unprecedentedly warm praise in New York, Homer left for a summer in upstate New York and—with typical flair—compounded the appeal of these nostalgic themes by painting shepherdesses both in costume *and* in the countryside. Subjects like *Fresh Air* brought him, as they had Eakins, his first popular success in watercolors. Both artists retained their interest in such modern "peasants," although Eakins, who lived in the midst of the Exposition city, seems to have been infected by Centennial historicism much more than Homer, who dropped the bopeep costumes quickly. Perhaps Eakins' susceptibility can be explained by his admiration for Gérôme's work—with its range of subjects from imperial Rome to Napoleonic France—and by the academic training that made historical genre a familiar mode.

Eakins also might have been encouraged, like Homer, by the watercolor costume pieces of the Fortuny school that, as Henry James noted in 1875, had "lately been thrown in such profusion upon the market" in New York. James grudgingly confessed to liking these "Roman" watercolors, which he described as being full of "ugly women in fantastic arrangements of the costume of the last century."[60] He thought this school silly but "vastly superior" to the "elaborately inane" work by "that multitudinous host of French and Belgian artists who for so many years have been inundating us with solemn representations of beflounced ladies tying their bonnet ribbons." James preferred the new Italian style, with its "half-dowdy" realism and good-humored "deviltry," although in retrospect it seems to us that many of these European painters worked a common, well-tilled ground. The special penchant among the Spanish and Italians for what Earl Shinn deplored as "etiolated rococo folly"[61] evidently followed the lead set by Fortuny in 1864, when he adopted eighteenth-century themes, as in *Masquerade* (fig. 72). Within ten years this genre was well known in New York, as James reveals. In 1874 the *Graphic*'s coverage of the watercolor exhibition featured reproductions of Fortuny's rococo *Mandolin Player* and an expensive work by his only official student, Simonetti, showing a fancy lady daintily fishing in a fountain.[62] This taste among continental artists for subjects dating from before 1820—that is, Eakins' "grandmother's time"—becomes comprehensible in the light of Théophile Gautier's reminder, in 1870, that "rococo" was simply another word for "old-fashioned." In the context of the continental rococo revival, American colonial nostalgia begins to look less like an idiosyncratic expression of nationalism and more like a local manifestation of a widespread yearning in modern, urbanized, Western countries for their collectively old-fashioned, prerevolutionary, pre-industrial days.

If the nostalgic impulse seems too diffuse to credit to any one source, then the method and, in some cases, the specific compositional models for Eakins' figure paintings came from Gérôme, with perhaps a few notions from the historical subjects of Bonnat and Fortuny.[63] *William Rush* (see fig. 129) is remarkably like Fortuny's last major work, *The Choice of a Model* (fig. 73), a painting he worked on for eight years before unveiling it in Paris in 1874.[64] Likewise, Fortuny's etching *The Idyll* (1868) seems strikingly similar to Eakins' Arcadian themes, with their nude pipers in identical poses.[65]

The provocative congruencies between the two artists in the 1870s should come as no surprise, given the high opinion that Eakins had of Fortuny's work. Fortuny, only six years older than Eakins, was making his reputation in Paris while Eakins was a student at the Ecole, and remarks jotted in his Spanish notebook make it clear that Eakins was well acquainted with his work by 1869. Eakins may have returned from Spain in 1870 in time to see Fortuny's much-heralded *Vicaria* (or *Spanish Wedding*) on view at Goupil's that spring. "The name that has been the oftenest spoken for the past

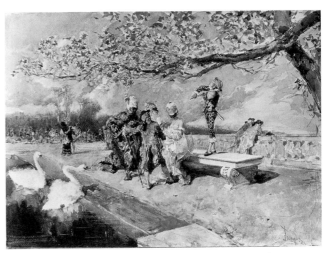

72. Mariano Fortuny (1838–74), *Masquerade*, 1868, watercolor on paper, 17⅝ × 24¾ in., Metropolitan Museum of Art, Bequest of Mary Livingstone Willard, 1926.

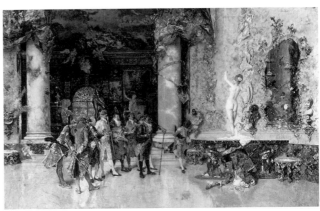

73. Mariano Fortuny, *The Choice of a Model*, 1866–74, oil on panel, 21 × 32½ in., Corcoran Gallery of Art, W. A. Clark Collection.

four months, in the world of art, is surely that of Fortuny," wrote Gautier in a Parisian newspaper on 19 May 1870. "One question never failed, when artists and amateurs met—'Have you seen Fortuny's paintings?'"[66] When Eakins encountered one in Philadelphia, he flatly declared it to be the most beautiful thing he had ever seen.[67]

This praise was echoed a few years later by another of Gérôme's students, J. Alden Weir, after he viewed the paintings by Fortuny in the Paris collection of W. H. Stewart. As a friend of the artist's and his most enthusiastic patron, Stewart at one time owned nineteen of Fortuny's oils and watercolors. A Philadelphian by birth, he cordially received American visitors like Weir, who was especially impressed by the Fortuny watercolors in Stewart's collection. "I must say never in my life have I seen watercolors that could equal his," he wrote after his visit in 1875. "His work although small is broad, and by the side of Meissonier's and Gérôme's looks like life."[68]

A high regard for Fortuny's work seems to have been shared by many of Gérôme's students, perhaps because Gérôme himself declared Fortuny the "greatest master of the technic of painting who has ever appeared."[69] It is no surprise, then, to find that Earl Shinn—also a Gérôme student—shared this opinion and looked to the whole Spanish-Italian school for leadership in watercolor. In his review of the AWS exhibition of 1875, Shinn drew attention to the work of José Villegas, another Spanish painter working in Rome with Fortuny, "to point out the class of art which the more earnest American painters are selecting for standards and criterion." To demonstrate this influence, Shinn pointed to the work of the painter of the "most admirable figure studies" in the exhibition, Thomas Eakins.[70]

Shinn's remarks were made at least a year before Eakins moved into historical genre subjects, indicating that he saw a connection between Eakins and the Spanish-Italian school that was subtler than costume. The initial common ground is realism—that is, the "half-dowdy" look noted by Henry James—and an emphasis on individual character rather than idealized types. More specifically, certain traits of style and composition were shared: both Eakins and the Spanish-Italian watercolorists tended to isolate a detailed single figure against a vague, loosely painted ground. Fortuny himself was fond of this arrangement, as seen in watercolors like *The Mendicant* (c. 1868), *Don Quixote* (1869), or *The Mandolin Player*[71] (lent to the AWS in 1874), a work that differs little in concept and organization from Eakins' *Cowboy Singing*. Fortuny was versatile enough to vary this format as well as his degree of finish. Some of his watercolor figures, like the elegant eighteenth-century connoisseur in *The Rare Vase* (1870), stand in elaborately detailed rococo interiors, while more frequently, as in *Masquerade* or *Street in Tangier* (1869, Walters Art Gallery), densely painted groups appear against broadly painted surroundings. But in every case, Fortuny's handling ranged dramatically from loose washes to tiny chips of color, giving movement, focus, and suggestiveness to the picture. These were the qualities that, in 1877, led Susan N. Carter to mistake Winslow Homer's watercolors for the work of some "newly-dawned" artist of the "French or Roman world."[72] This sensibility also was displayed in Villegas' *Moorish Bazaar*, the picture in the 1875 Watercolor Society exhibition that Earl Shinn offered as a yardstick to earnest students of the art. The *Appleton's* reviewer agreed that the "strongest pictures of the day that we have seen are painted by Spaniards," and also singled out *Moorish Bazaar* as the most brilliant painting in the exhibition. "It is literally crammed with effects of color and contrasts of hard forms with aerial hues," wrote *Appleton's*. "A brawny shoulder, detailed and modeled with the utmost precision and freedom, relieves grandly upon a vague blot of enchanting tints behind it."[73]

These techniques of contrast and massing were controlled (and occasionally overindulged) by a virtuoso like Fortuny, but such devices were quickly reduced to formula by his imitators, who exaggerated these effects into a convention

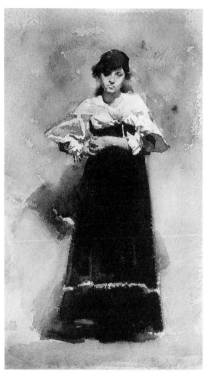

74. John Singer Sargent (1856–1925), *Young Woman with Black Skirt,* c. 1881, watercolor on paper, 14 × 9⅞ in., Metropolitan Museum of Art, Gift of Francis Ormond, 1950.

of extreme figure-ground opposition. When the young John Singer Sargent passed through Spain and Venice he instantly absorbed this stylish effect (fig. 74). The *Scribner's* critic complained in both 1875 and 1876 of the monotonous series of "figures in dress sometimes picturesque, sometimes only supposedly so" from artists in the "Roman School": "They are doled out to us for the most part singly, but also in pairs," wrote *Scribner's* in 1875. "In the former case, their elaborate little persons being projected on a small surface covered with a wash of some suitable neutral color, generally only extending a half-inch or so from the outline."[74] The annoying repetition of this format, with its mannered contrasts and almost nonexistent background, led the same critic to conclude in 1876 that "they all have a passion for isolating a figure, crowding color into it, suppressing the surrounds into extreme sketchiness, and then abandoning the subject to you."[75]

The distinctiveness of this style, and the distaste of the *Scribner's* critic, become more comprehensible in light of the mainstream standards for figure painting in watercolor—that is, the prevailing taste in England, France, and Belgium around 1875. Similar subjects in the hands of such Victorian painters as Fred Walker, Edward Burne-Jones, and Lawrence Alma-Tadema, or popular French watercolorists from the same decade, like J. L. E. Meissonier and Edouard Detaille, were usually finished from edge to edge, prone to hatching or stippling, and reliant on opaque tints. Detail and

color might be concentrated in the figures (who would tend to be conventional types rather than the Spanish-style individualized portraits), but the setting would be clearly, even fastidiously constructed.[76] The *Scribner's* critic, being more partisan than most, clearly demonstrated the division of taste over correct figure-ground relationships, for with consistency the writer disliked Fortuny, despised Villegas, admired the Pre-Raphaelites, and positively doted on young E. A. Abbey.[77]

Eakins' careful figure technique could have offered a lesson to an artist such as Abbey, but his treatment of the background after 1876 favored the vague ambiance of the Spanish school. A loosely defined ground and a wide range of finish appears in all his indoor figure subjects in watercolor after this time, particularly in his last works in this medium, such as *In the Studio, Retrospection,* and especially *Female Nude,*[78] in which the background washes remain very close to the contour of the figure. This shift in technique is especially clear after looking back to the tight, even effect of works before 1876, like *John Biglin* or *Starting Out After Rail.*

In addition, all of these later subjects are single figures. Even in *Negro Boy Dancing,* his largest and most complex composition from this series, Eakins tended to isolate his models both formally and psychologically. As his oil sketches for this picture demonstrate, it was essentially a composite of separate single-figure studies, loosely united by pyramidal organization and directed poses.[79] The feeling of separateness is maintained by the inwardness of the gaze and expression of each face, and the intensification of detail in all the figures, making them islands of interest in a sea of loosely applied strokes. As Shinn noted, "Foreground parts are left in riotous disorder, and parts on the second plane, at which the painter desires to direct the attention, are worked up with sympathy and patience. . . . These telling strokes and sweeps, these foreground forms felt as mere blots of color, these nearer members without outline while farther features are modelled and hardened with all precision, give the system of painting a perspectiveless look when seen close, and a look of pure atmospheric harmony when seen from the proper distance."[80]

The "perspectiveless look" that Shinn described as a product of the subordination of foreground and background has also been interpreted as "photographic," although the focus in all these later works is too inconsistent to be simply a question of narrowing the focal plane, as one might with a camera lens.[81] The selective vision of these pictures, with their detailed figures and shadowy backgrounds, may be a personal version of the more exaggerated manner of contemporary Spanish-Italian watercolor, but it also comes directly out of the artistic conventions of the Baroque masters, especially Velázquez, Ribera, Hals, and Rembrandt, that Eakins (along with Bonnat, Fortuny, Regnault, Manet, Whistler, and other admirers of realism and bravura in the late 1860s) studied intensely. These shared heroes and common sources of inspiration remind us that Eakins was responding *with* his contemporaries as much as to them.

The Spanish school—both Baroque and modern—in-spired Eakins, but he probably understood from his own experience as a painter the advantages of their manner. By laying in the background with large, wet, individually telling strokes, he relieved the finer, brighter areas without draining all motion and interest from the subordinate zones. Freed from literal description, the background gains a life of its own and takes on artistic rather than naturalistic logic. In *Negro Boy Dancing* the shadows swell irrationally and the corner of the room dissolves inexplicably, though these areas make perfect visual sense as they accent the figures and balance the composition. As Homer and Fortuny also knew, these bolder, nondescriptive passages draw attention to the abstract qualities of the medium and the manipulative power of the artist. With Fortuny in particular, the broader areas seem to be flamboyant reminders of how beautiful—and difficult—a watercolor wash can be, and how miraculous, by comparison, are the delicately worked areas nearby. In *Fifty Years Ago* the luster of satin and skin seem all the more astonishing in contrast with the vague, almost clumsy blots of the surrounding zones. Eakins also knew that by capitalizing on deftness and happy accident, this approach promised fresher, more suggestive results.

Earl Shinn understood the "necessity" for Eakins' uneven handling and the pitfalls of insistent finish when he analyzed *Negro Boy Dancing* in 1878. Shinn, who had harped on Winslow Homer's complete lack of finish, found the sketchiness in Eakins' work acceptable because it occurred only in places where further elaboration was either unnecessary or unsafe—that is, risked muddiness. "As it is," wrote Shinn, "there is not the slightest concession to the eye of the conventional spectator demanding evenness of manipulation. . . . The theory of method seems to be that, if a broad, careless stroke has been lucky in defining the form and motion and in imprisoning the color, it is a better thing to leave it," whether consistent in style with the whole picture or not."[82] Shinn's acceptance of Eakins' inconsistency as an alternative to "stirring up mud" in pursuit of greater finish, or making "your color dead by overlaying it" again reveals a bond that, in this critic's eyes, joined Eakins to his Spanish contemporary; three years earlier Shinn had praised Fortuny in almost identical terms.[83]

The range of handling in *Negro Boy Dancing* shows Eakins attempting an alliance of exactness in drawing, as taught by Gérôme, with freshness of surface. Like Fortuny, he tried to combine the "fantastic freedom" of the Spanish painters and and all the "conscientious truthfulness of the French."[84] His efforts to relieve the tightness of Gérôme's manner by learning from the spontaneity of the Spanish painters he admired produced a somewhat homely but effective technique—a compromise that favored conscientious truthfulness over cleverness and freedom. Eakins probably agreed with the "realists of the Bonnat School," who criticized the way Fortuny's broken stroke dematerialized all objects and surfaces indiscriminately, for though Eakins loved to paint the gleam of light off fabric and furniture, he

avoided the bravura that, in Fortuny's last works, made solid objects "too luminous and transparent . . . like sugar candy or glass."[85] Eakins corrected this tendency with a slow-moving manner that rarely matched Fortuny's fluidity or Velázquez's elegance but achieved an affecting sense of truthfulness with similar uses of light, contrast, and selective focus. While studying the clean and simple build-up of tones in Velázquez's work in the Prado, Eakins had noted to himself that such "was truly the manner of Bonnat and Fortuny," in keeping with his own instincts. Eight years later he had drawn these admired styles and his own inclinations together to make himself "master of all my difficulties."[86]

Eakins' personal resolution of Spanish freedom and French exactness was received kindly by Clarence Cook, who admired *Negro Boy Dancing* despite its lack of "skill in handling."[87] That year Cook had begun to tire of the empty displays of virtuosity and elaboration common in contemporary English and French watercolor. After inspecting a work shown at the Society's exhibition by Detaille, the young follower of Meissonier, Cook observed that "this realism has more to do with trick and mechanism than it has to do with art," and he concluded that its worth would be measured quickly "if it could be seen in the same room with a piece by Velasquez, or even one by Regnault."[88] By comparison, Cook pointed to Eakins' work "as a contrast in execution to the drawing by Detaille, since one learns by it how little execution really has to do with producing" artistic results.

> Mr. Eakins, as a scientific draftsman, is just a baby compared to the learned young Frenchman, but he sees as far into human nature and can just as well represent that nature in action. Here are three living human beings, each distinctly marked in character, and each absolutely truthful in the presentment. So far as the drawing has to do with the representation of bodily action, and that action the result of thinking and will, drawing here does all that it can ever do. Other charms may be wanting, beauty of color, skill of handling, but here is life, and when an artist has this he has all.

Cook was not alone in his opinion. When *Negroes* and *Fifty Years Ago* were exhibited at the Massachusetts Charitable Mechanics' Association show later in 1878 they received a silver medal—the first award Eakins ever won in an exhibition, and last one he was given until 1893 (see cat. 269). At the Watercolor Society in New York, Eakins emerged as a celebrity of figure painting. He sold one of his pictures (*Seventy Years Ago*) in the 1878 exhibition, and for the first (and almost the last) time, one of his works (*Study of Negroes*) was featured as an illustration in the catalogue.[89] Crowds of "fair women, in elegant toilets, and men (presumably brave) in street garb" gathered in front of this picture, which hung prominently on the line in the North Gallery; according to the *Independent*, it was "considered by these self-constituted critics (fair and otherwise) the most telling, effective and characteristic figure piece in the North Room. They are

right," added the reviewer: "It is all this and more."[90] Passing into the East Gallery this same critic announced that "what we would most like to possess in this room is Mr. Eakins' *Fifty Years Ago*." After describing this work as "exquisite in conception and color," the writer congratulated Eakins on his progress, "which has more than justified his promise of last year."[91]

No mention of this "promise" had appeared in the *Independent* the year before, so one can only assume that this reviewer adopted the position of retrospective support first struck in 1878 by Clarence Cook. "Mr. Eakins, whose rowing and baseball subjects of several years since awakened an interest that has not slept since, appears this year in great strength," wrote Cook in the *Tribune*, recalling his last enthusiastic review, in 1874.[92] The *Art Journal*, also silent in previous years, made amends by drawing Eakins' work to the top of its review article, using it to demonstrate the principle that "watercolour painting is in its sphere every whit as earnest as oil painting." This critic admired the remarkable "drawing, color and typical quality" of *Negro Boy Dancing*: "His action is finely rendered, and its individuality so marked that we believe its painter to have great possibilities before him."[93]

Eakins capitalized on these possibilities immediately. *Scribner's Monthly* had praised him as one of the best genre painters in the show, and not long after he was commissioned to make two drawings for a Bret Harte story "The Spelling Bee at Angel's," slated for the magazine's November issue.[94] Although the original drawings are lost—or were perhaps destroyed in the course of reproduction—the tonal qualities of the wood engravings make it evident that they were copies from watercolor or ink wash models, like his later illustrations, and like the earlier replica of *The Gross Clinic* made for reproduction in 1875 (see fig. 88). Watercolor was the illustrators' medium in this period, and just as Eakins' skill drew the attention of publishers, he reciprocated with images in the professionally appropriate medium. Even so, his own preparatory studies were in oil, such as the large sketch of the storyteller for the first of his two illustrations (cat. 242). The work on such projects, including perspectives and oil studies, exceeded the preparations for comparable oils, and the pay was low ($40 for both pictures), so we can assume that Eakins, like many another American artist in this decade, was interested in the popular phenomenon of illustration and hoping for exposure in the national press.[95]

Eakins' rising reputation as a watercolorist also brought other, more lucrative "possibilities." Work shown at the watercolor exhibition in New York drew two collectors to his door in 1876, an event that Eakins found remarkable enough to mention to Shinn. "They were strangers to Philadelphia but seemingly less so to N.Y. where they had seen my watercolors," he wrote. "They evidently came to buy."[96] The few patrons who actually did commission work (other than portraits) also favored his watercolors; both James P. Scott and Thomas B. Clarke selected themes from Eakins' watercolors as the basis for new projects in oil and relief sculpture.[97] The

sale of a watercolor from the show in 1878 made the Society Eakins' most encouraging forum in a disappointing period for his oils. Considering the miserable $200 received for *The Gross Clinic* that year and the disputes over the acceptance of the Hayes portrait in 1877, Eakins' watercolors generated a disproportionate share of the praise and a substantial percentage of the income he had earned up to this point.[98]

Despite this pattern of encouragement, Eakins was never able to reachieve the success of 1878. He exhibited only one item with the Society in 1879—*A Quiet Moment* (unlocated)—and nothing in 1880.[99] The hiatus in his work may be worth comparing to Homer's withdrawal, hurt, from the watercolor scene in 1878, for Eakins' absence in New York (at the AWS and the NAD) followed immediately the disastrous reception of *The Gross Clinic* at the Society of American Artists' exhibition in March 1879.[100] This showing did much to fix Eakins' reputation in New York as a realist zealot. "We have had many of Mr. Eakins' pictures exhibited in New York," wrote the *Independent* in 1882, "and they have been very generally and rather roughly criticized by connoisseurs."[101] His increased involvement at the Pennsylvania Academy may further explain his loss of interest in watercolor and his absence in New York. Christian Schussele's death in August 1879 led to Eakins' appointment as professor of drawing and painting, and to a significant increase in his teaching duties. In the spring of 1880 he also began to lecture on perspective, which, when combined with his experiments in photography, left him time for little except his major oil projects, *The Fairman Rogers Four-in-Hand* of 1879 and *The Crucifixion* of 1880 (PMA).

Eakins rallied to watercolor in 1881–82, but his efforts lacked the energy or novelty of his earlier work, and the critical response was commensurately weak. In 1881 he exhibited just one small item at the AWS exhibition, *Spinning* (see fig. 60), a work that revisited the historical genre themes of 1877–78, perhaps in the hopes of renewed critical and financial success. After the mixed response to his major paintings and the strain of two complicated and experimental recent projects in oil, such a dainty and familiar interior subject must have been something of a relief, happily expressed in the air of calm preoccupation that pervades this charming picture.[102] But *Spinning* got a poor hanging at the overcrowded watercolor exhibition and received only passing notice.[103]

Eakins continued to exhibit the spinning watercolors in other exhibitions, and he sent a final selection of work to the Watercolor Society's show the following year, but he painted no more historical genre subjects after 1881. The signs of change are visible in the new spinning subjects, for though the figure was identified by some (like Shinn), as being in period dress, Margaret Eakins was in fact wearing one of the "classical" costumes also seen on the models in Eakins' photographs and Arcadian paintings from the 1880s. This is the first glimpse of the neoclassical idealism that appears in these later landscape and figure compositions, and the first suggestion that Eakins would push beyond specific historical retro-

spection to the more abstract statement of nostalgia expressed by the idea of "Arcadia." Rather than mixing these strains ambiguously (as he did in *Fifty Years Ago*), Eakins began to explore these themes in isolation: pure Golden Age lyricism or unadulterated contemporary realism. These moods united complexly again in oils like *Swimming* (see fig. 181) and the later boxing subjects, but never in the watercolors, which turned resolutely modern.

Perhaps tired of historical themes, Eakins also must have been encouraged by the warmer reception his contemporary genre study *The Pathetic Song* (plate 9) received at the SAA in 1881. "All possible renderings of Italian peasants and colonial damsels and pretty models cannot equal in importance to our growing art one such strong and real and artistic work,"[104] wrote Van Rensselaer in response to this picture. "Of all American artists he is the most typically national, the most devoted to the actual life about him." Although she described his color as "deficient," she praised his brushwork, drawing, insight into character, and management of light, which found art in "three homely figures with ugly clothes in an 'undecorative' interior." Seconding this opinion, Eakins gave the new Metropolitan Museum in New York a painting in a similar vein, *The Chess Players,* an older picture but one that he must have considered representative of his best work. Tellingly, his next genre interior in watercolor was a version of *The Pathetic Song* (MMA).

However, *The Pathetic Song* was the last interior scene in watercolor that Eakins would complete in the next ten years. He never exhibited it, and seems to have painted it largely as a gift to his model, Margaret Harrison.[105] But his return to contemporary subjects also brought renewed interest in landscape painting and fresh topics for watercolor. Along the Delaware River he discovered a modern American version of a well-worn picturesque type: the fisherman. Paintings of fisherfolk were almost as common at this time as images of old-fashioned women, so Eakins (like Homer, who also took up the subject in 1881) was once again engaging popular taste. However, few other artists had chosen American examples or depicted them in such a low-key, unsentimental, and unheroic fashion. These outdoor subjects, discussed at length in Part III, join the tonality of Eakins' earlier "action" watercolors with the quiet, introverted mood of the late '70s. *Mending the Net* (see fig. 173), which was shown by the Watercolor Society in 1882, repeats the structure of *Whistling for Plover* (1874), but with the figures pushed back into the middle plane and turned away. Now their poses express meditation, not tense anticipation.

The revival of landscape in 1881, like the "last hurrah" of spinning subjects, lost energy quickly. These final outdoor watercolors are small in size and, being based on photographs, show lower effort and intensity than his earlier sporting subjects. He chose few outdoor subjects after 1882, other than the generalized Arcadian backdrops of about 1883 and the Dakota views in 1888, and his interest in watercolor dropped off simultaneously. Eakins never exhibited with the

Watercolor Society again, and he completed only one more picture—*Cowboy Singing*—which was painted almost ten years later, after several figure pieces in watercolor had been left unfinished.

The abruptness and relative finality of his departure from the watercolor scene deserves some consideration, for the circumstances and motivations of 1882 reflect back on the reasons Eakins was drawn to the medium in the first place. On the surface, there were specific disruptions that changed the course of his personal life. First came the death of his "favorite" sister, Margaret, in December 1882, when she was only twenty-eight. The numbing effect of this loss may provide the simplest and most immediate reason why Eakins had no work on view in New York the following spring, either at the Watercolor Society or the National Academy. This blow came at the same time that his responsibilities at the Pennsylvania Academy, increasing since Schussele's death in 1879, grew by another degree, for he was made director in the spring of 1882. But rather than taking his new duties in stride and slowly returning to his old interests (as he had in 1880–81), Eakins immersed himself in the administration of the Academy. At the same time, he took on new projects, like the Scott sculpture commission, experiments with motion photography, a manuscript on perspective drawing, and twice-weekly lectures at the Brooklyn Art Association. As Hendricks has remarked, Eakins was sending older work to exhibitions in the early 1880s because he was spending less time painting.[106]

But these particular circumstances only reinforced the larger pattern of Eakins' interests, which led away from watercolor. In 1873 watercolor meant outdoor painting. It evoked France and Spain, it offered limelight and patronage. By 1883 these attractions had weakened. First, his shift away from directly observed landscape undermined the medium's place in his repertory. Meanwhile, photography had supplanted many

of the tasks of outdoor sketching and changed Eakins' habits. The camera offered an alluring solution to the distresses of plein air work, even though—as his final Gloucester watercolors, made from photographs, demonstrate—the glass plates taken back to the studio could not supply the satisfying intensity of field work. With neither the time nor the inclination to recover his methods of the early 1870s, Eakins simply stopped painting landscapes.

He did continue to paint figures in interiors, but at a larger scale and in a darker palette that logically turned to oil paints.[107] Even so, *Cowboy Singing,* of about 1890, maintained the legacy of Gérôme, Fortuny, and Spain. This amalgamated sensibility, so central to his watercolors, remained intact—minus the outdoor component—and was perpetuated in oil until the end of Eakins' career.

While this "Spanish" taste found continuing expression in oils, other topics closely identified with Eakins' success in watercolors—such as rococo subjects or illustration—grew stale. Both of these genres were allied to his hopes for a popular audience, which he found only once, at the American Watercolor Society's exhibitions. After 1882, perhaps embittered by the fickleness of critics and patrons, perhaps emboldened by the security of his new eminence as director of the Academy, Eakins ceased courting public opinion. Like Winslow Homer, he must have felt that he no longer needed the forum of the Watercolor Society or the illustrated press. At the same moment, public opinion tired of watercolors, too. Enthusiasm peaked in 1882 and then dispersed into other fashionable "minor" media—pastels, charcoal, printmaking. A core of committed watercolorists remained, but many other artists, drawn into the movement in the 1870s and critical to its strength, drifted away after 1883.[108] Like Eakins, they had joined for reasons that grew obsolete, and like him, they turned to new projects and new media—in his case, sculpture and photography.

CHAPTER 10 Sculpture

THE LEGACY OF
THE ECOLE

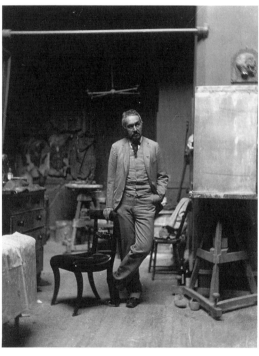

75. Attributed to Samuel Murray, *Thomas Eakins, in Frontal View, in the Chestnut Street Studio*, 1891–92, modern print from 4 × 5 in. dry-plate negative, 1985.68.2.852. Eakins stands next to a covered modeling stand, probably in use by his friends Samuel Murray or William R. O'-Donovan, who were sharing his studio at this time. To his left, and on the rear wall, are plaster anatomical casts.

Eakins' sculpture, like his drawings and paintings, can be sorted and analyzed by style and function to reveal deep principles of art making. Three types of sculpture emerge, all represented in the Bregler collection, all based on the academic practices of the Ecole des Beaux-Arts: anatomical casts, working models, and relief sculptures. The first group, designed for teaching, hardly merits categorization as art, although Eakins' casts from dissection were crisply made and often carefully painted. The second type, modeled in the course of developing a painting, may also reflect school practice, although the maquettes in this group seem to be private artifacts of the studio, intended only for personal study. The third category, including sculpture intended for public display, illustrates Eakins' work in a formal, finished mode. None of these categories are large, for Eakins' total oeuvre in sculpture, catalogued by Goodrich in 1933, contains, in addition to two dozen human and animal casts or anatomical models, only fourteen maquettes for painting or sculpture and eleven relief sculptures, not including the figures for the Witherspoon Building, made in tandem with Samuel Murray.[1] Nonetheless, work in sculpture conditioned Eakins' method and his teaching for thirty years, supporting the strongly plastic effect of his painting and demonstrating a depth of commitment to academic ideals that has not been adequately appreciated.

The sources of Eakins' technique and aesthetic lie in Paris, in the ambiance of the Ecole des Beaux-Arts. Eakins modeled in clay in Dumont's atelier, beginning in 1868, but extant work suggests that he made no sculptures of any kind in Philadelphia until about 1876, when he began to supervise classes at the reopened Pennsylvania Academy. The connection between teaching and sculpture may be significant, as Eakins made only one small portrait relief (*Mary Hallock Greenewalt* in 1905, now lost) after he ceased all teaching and lecturing in 1897. Not surprisingly, then, the first type of sculpture that he took up—casts from dissection—was also his most didactic genre.[2] Like his anatomical drawings, which describe some of the same subjects, these casts were made in a neutral, "scientific" style meant to communicate information with maximum authority and objectivity. Like the "naked series" photos, they were probably done by teams of assistants, under Eakins' direction. Strikingly naturalistic by virtue of their relation to a real human or animal form, they are nonetheless abstracted by fragmentation and by a coloring that seeks to isolate and clarify the parts. Neat labeling in yellow block letters identifies each part with its Latin name and further removes each fragment from the world of living men. Effectively, these are three-dimensional, colored diagrams, abstract in the manner of an illustration from an anatomical textbook.

As chief demonstrator in Dr. W. W. Keen's lectures on artistic anatomy, first delivered to the Academy's students in 1876–77, Eakins undertook or oversaw any dissection procedures for Keen or the students, and he seems to have begun the practice of making casts in the first year of this program.

77. Samuel Murray, *Life Cast of the Right Hand of Thomas Eakins*, c. 1894, painted plaster, 9 × 7½ × 2½ in., 1985.68.1.12.

Keen's report to the board of directors in 1877 mentioned the casts already made of cat and dog sections and asked for authorization to prepare additional plasters of horse and sheep dissections.[3] Two years later Keen gratefully acknowledged the "extremely valuable casts" made by Eakins to record the surfaces as well as the cross sections of a recent dissection of a human cadaver. Accustomed to the examination of the unhealthy, often disfigured specimens unfortunate enough to end up in the city's morgue or charity hospitals, Eakins and his students were astonished by the opportunity to study the body of a young, muscular stevedore killed in an accident, and they "gleefully" hastened to make an extensive permanent record of their subject. This master set was kept at the Academy, and Eakins had his own painted set displayed on the walls of his studio (fig. 75). "As gelatine moulds were made of these casts, they can be furnished very readily & very cheaply to the students many of whom have availed themselves of the opportunity," noted Keen.[4] Sets of these casts were also distributed to local institutions, although none have survived outside of the Academy's present group. In 1939, when Bregler claimed the debris remaining in Eakins' studio, he was horrified to find that "all of the life casts were smashed,"[5] save perhaps the two examples found in his collection. The shoulder section (fig. 76), painted the dark red color of embalmed flesh and informatively labeled in yellow, may be the only surviving example from Eakins' private set of casts; the unpainted left foot (see cat. 259) may illustrate one of the duplicates made for distribution to students.

Plaster casts were also made from undissected subjects or from living models. Sentimentally or instructively, reflecting Eakins' portrait focus, these were usually of the face or hands. Casts of the hands of Eakins' sister Margaret and his nephew William J. Crowell have survived, along with impressions of Eakins' own hand (fig. 77), made by Samuel Murray in about 1894. William R. O'Donovan's plaster portrait relief of Eakins in Bregler's collection, probably dating from the period when he was sharing the Chestnut Street

studio and preparing a full portrait bust of Eakins (1891–92), may also have been based on a life cast. Perhaps at this same time Eakins and O'Donovan acquired Leonard Wells Volk's life mask of Abraham Lincoln of 1860 (also CBTE), as a reference for their collaborative work on the Brooklyn Memorial Arch, completed in 1895.[6] O'Donovan, Eakins, and Murray all produced portraits of Walt Whitman about this time, based on casts of the poet's face, shoulders, and right hand, made by them immediately after Whitman's death in 1892. Two life casts of torsos dated 1890 and an undated female torso similar to one shown in fig. 78, all found in Bregler's collection, were probably made by groups in the Chestnut Street studio or at the Art Students' League, demonstrating that Eakins' students were also busy making life casts. Bregler himself prepared life casts of his grandmother's face and hand in 1890 (CBTE), in preparation for a large portrait exhibited in 1892. All of this activity suggests a revival of inter-

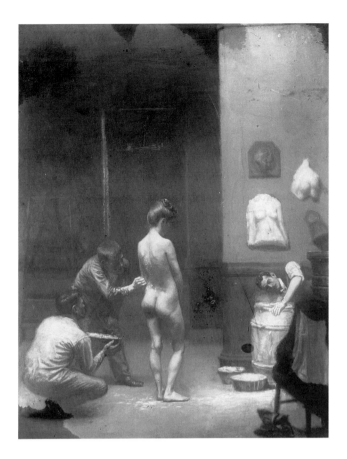

78. Attributed to Thomas
Eakins, *Life Casting in the Chest-*
nut Street Studio, c. 1890–92, oil
on canvas (?), known only from a
gelatin glass negative from the
collection of Eakins' student Ed-
ward Boulton. Philadelphia Mu-
seum of Art, purchased with
funds given by Mr. Seymour
Adelman.

est in life casting exactly when Eakins' most important public commissions in sculpture were under way.[7]

All these casts served multiple purposes. As teaching devices, the anatomical casts supplied life-sized three-dimensional illustrations, useful in lectures to compare to a skeleton, the living model, or another dissection study. On a daily basis, they offered reference for the students: complete sets hung in the Academy's painting studio, the modeling studio, and the dissection room. "While most art students would not be interested to work in anatomy as I have done," said Eakins, "if serious and sometimes puzzled about the meaning of the forms, they can find explanation in these casts."[8] The casts could also serve as models for painting or sculpture, and Eakins encouraged his students to work from such casts, as he himself occasionally did.[9]

Eakins urged this study based on general principles absorbed at the Ecole, confirmed by his own sculptural instincts and refined by his personal practice. He believed that anatomical knowledge was fundamental to artists working in any medium, for it improved their understanding of form, while modeling classes taught construction to painters and sculptors alike. "When Mr. Eakins finds any of his pupils, men or women, painting flat, losing sight of the solidity, weight and roundness of the figure, he sends them across the hall to the modelling room for a few weeks," remarked W. H. Brownell in 1879.[10] "Always think of the third dimen-

sion," Eakins explained. "If you do good modeling, it follows that you will do good painting."[11]

Banned in 1877 from assisting Schussele at the Academy, Eakins turned to the Sketch Club, where he instituted life modeling sessions for *all* students that siphoned attendance from the Academy's more old-fashioned classes, which were for sculptors only, based on the antique, and supervised by Joseph Bailly. When Eakins returned to the Academy in 1878 he replaced Bailly and completely revamped the painting and sculpture programs to follow his own integrated plan. When news of his curriculum reached Paris, Bonnat declared that it was a "most important" experiment that he intended to enact in his new atelier as well.[12] By 1881, when Fairman Rogers prepared his description of the Academy, he could state simply that "oil paint and clay are the real tools of the school."

> It is in accordance with the general theory of the school, that the students should gain accurate information rather than merely acquire the knack of representing something; and nothing increases more rapidly the knowledge of the figure than modelling it. The student studies it from all sides and sees the relation of the parts, and the effect of the pose upon the action of the muscles, much more distinctly than when painting from the one side of a model exposed to him from his fixed position in the painting class. The work is in clay, the figure being usually about 22 inches high, stands and irons for the support of the figures being provided by the Academy. The figure is complete,—not a bas-relief, or a high relief, as in the sculpture class of the Beaux-Arts of Paris.[13]

Eakins must have made such clay figures himself, either for his own satisfaction or in demonstration, but none have survived; like his life class studies in oil, they may have been infrequent, rarely saved, and vulnerable to later censorship.[14]

More often saved, perhaps because they were directly related to particular projects, were models made in wax or clay to serve as mannequins for painting. Evidence of this cate-

79. *George Washington: Study After William Rush,* 1876–77 (cat. 257).

gory of work first appears with the William Rush project of 1876–77, although Eakins had earlier used homemade mannequins, dressed in scraps of colored fabric, to test the effect of sunlight on the costumes of his rowing figures.[15] The wax figures constructed for the Rush painting (fig. 79; cats. 253–257) were more elaborate, however, more obviously based on French academic practice. Launching a project very much in Gérôme's style, Eakins brought forth a wax-modeling technique straight out of Gérôme's repertory, first essayed in Paris almost ten years earlier. Appropriately enough, he turned to Bailly, a French-trained sculptor, to get a recipe for modeling wax tinted with "Spanish Brown."[16]

The construction of small figures in wax or clay had been standard practice since the Renaissance for painters who wished to explore the possibilities of pose and composition, placement in space and the fall of light. Useful in gauging artistic effect, these models also were surrogates for figures, such as Rush's monumental sculpture or Fairman Rogers' trotting horses, that could not be brought into the studio or conveniently frozen in mid-stride. Eakins' many pencil sketches of Rush's *Nymph* (see figs. 136–138; cats. 182–187), installed outdoors near the old Waterworks, helped him consider the best vantage for painting the sculpture within his picture; the wax model allowed him to work more patiently in the studio, where he could refine this choice and actually paint the sculpture in its place.

On one level, these models were studio properties, like old costumes or furniture, that helped support the invention of the painting, and as such they had limited artistic interest. For Eakins, however, the process of modeling was an exploration of form that complemented his two-dimensional work; like his teaching curriculum, these maquettes express the opinion, asserted by Gérôme, that painting and sculpture were "the same thing." For Eakins, the construction of these maquettes also must have helped him understand Rush's sculpture or Rogers' horses in ways that satisfied his own desire for knowledge above and beyond the demands of his picture. Subdued by distance or the darkness of the shop, Rush's sculptures are only dimly seen in the painting; the models do not need to be as lively and detailed as Eakins made them. Although never intended for public display, these maquettes have a plastic energy in their pinched, pulled, and fingerprinted surfaces that betrays Eakins' pleasure in their construction, his unnecessary attention to their independent sculptural effect. In a contradictory fashion, the four horses in *A May Morning in the Park* (see fig. 140) are much more detailed than the wax models made for study.[17] To be really useful as mannequins, the figures should have been more naturalistic, but Eakins arrested his work at an impressionistic moment, when the hand-modeled surface remained assertively, attractively present. Feeling their merit as sculptures, not miniatures, Eakins expressed his kinship with another academic independent, Degas, whose small sculptures strike a very similar note.

Eakins showed his most conservative academic colors in his third category of work, actually intended for public display. He received his first commission, for the *Knitting* and *Spinning* panels for the home of James P. Scott (figs. 80–82; cats. 206, 207, 260, 261), thirteen years after leaving the Ecole, but the principles of Dumont's atelier still shone brightly, and they remained fixed throughout three subsequent public projects: the Brooklyn Memorial Arch, the Trenton Battle Monument, and the Witherspoon Building.

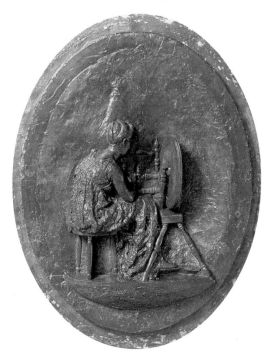

80. *Spinning*, 1882–83 (cat. 261). 81. *Knitting*, 1882–83 (cat. 260).

These large outdoor sculptures, like the smaller *Knitting* and *Spinning* tondos or the three Arcadian panels (see figs. 187, 197), were all done in relief. His impulse to work in relief, perhaps natural to a painter, was not Eakins' only bent, as his wax figures and his constant search for three-dimensionality in painting attest. But the division in Eakins' work suggests that figures in the round were somehow extensions of his teaching activity, explorations of form, vehicles for study and understanding. Relief, by contrast, represented the mode of serious Public Sculpture. To a categorizing mind like Eakins', the separateness of these endeavors was clear: just as a life class "académie" in oil could not be confused with a "picture," so study work in the round differed from relief.

Relief sculpture, much more problematic than work in the round, was analogous to painting in its illusionistic challenge. It "has always been considered the most difficult composition and the one requiring the most learning," he wrote. "The mere geometrical construction of the accessories in a perspective which is not projected on a single plane, but in a variable third dimension, is a puzzle beyond the sculptors whom I know."[18] Eakins seems to have enjoyed this puzzle and to have delighted in teaching others how to solve its difficulties. In his own work he maximized its problems, turning odd objects like a spinning wheel into steeply recessing angles. Like an athlete testing his strength, he was drawn to the arena of his heroes, most notably Phidias, whose Parthenon frieze was always before his eyes in replicas at the Academy. Relief was also the province of the sculpture studios at the Ecole, and the proving ground of the Prix-de-Rome competition in sculpture. The correlation in Eakins' work between his finished, commis-

sioned, public sculpture and the quintessential Beaux-Arts mode may express his sense of the different demands of public (as opposed to private) sculpture; probably it also speaks of his sense of professional responsibility and ambition. To Eakins, relief work required the sculptor's best skills; when he submitted a relief to the public, he offered the height of sculptural art and entered the lists with the greatest sculptors of all time. His accomplishment as a sculptor was finally modest, but it begs consideration in this context; to argue, like some, that to Eakins sculpture "was not an end in itself, but a discipline in understanding the elements of structure and mass which in turn he recreated in his paintings" misapprehends the seriousness with which he engaged the venerable tradition of sculptured relief.[19]

The extent of Eakins' commitment can be read in the sculptures and in his own testimony. He admitted that the work on the Scott panels was "much to my taste," expressing an academic scheme—never welcomed by his patron, evidently—for three separate figure subjects linked by the old-fashioned concept of work and fireside activity (fig. 82; see cat. 206), delivered as a tour-de-force in perspective. The chapter "Sculptured Relief" within Eakins' art-instruction manual (see cats. 133–139) lays out the classical and scientific premises of this work.[20] Based, like other sections of this manual, on Eakins' own projects, this chapter uses as its problem the depiction of a tilt-top table in perspective, much as it appears in *Knitting*. A physical examination of the reliefs confirms his written emphasis on careful preparation. X-radiography reveals that the plaster versions of *Knitting* and *Spinning* in the Bregler collection are composite sculptures,

82. *Spinning and Knitting: Architectural Plan, Interior Elevation, and Sketch of Three Relief Sculptures*, 1882–83 (cat. 206).

not casts from a single, complete clay model. Eakins apparently assembled his relief from separately worked and cast fragments, including the stool, the spinning wheel, and the model in *Spinning,* and the table top and the cat in *Knitting.*[21] Photos of the reliefs taken in Eakins' studio record subtle alterations made just prior to casting (see cats. 260, 261). Such procedures, while previously undocumented, are entirely consistent with his overall problem-solving strategy and his fastidious attention to detail.

For all of their finesse, the Scott panels did not win contemporary approval other than an important word of support from another Paris-trained sculptor, Augustus Saint-Gaudens, one of the few American artists who could appreciate what Eakins was attempting. But Eakins learned from the project, and continued his experiments in three panels, made between 1883 and 1885, based on his Arcadian themes (see chap. 17 and cat. 262). His progress is reflected in these panels and in his writing: to avoid the awkwardness of *Spinning* he chose a figure group with no steeply foreshortened objects or poses, more like the Greek reliefs he admired. "The simple processions of the Greeks viewed in profile or nearly so are exactly suited to reproduce in relief sculpture," he noted in his manual, and he arranged the figures in *Arcadia* (see fig. 187) accordingly.[22] These panels were his only venture into the neoclassical, nude figures that were the stock-in-trade of Dumont and the Ecole. In their small scale

and informal treatment, Eakins expressed his own awareness that such subjects as yet had no public place in American art.

Six years would pass before his friend O'Donovan asked him to collaborate on the equestrian figures of Lincoln and Grant for the Brooklyn Memorial Arch. O'Donovan did the figures and Eakins the horses, no doubt because O'Donovan agreed that "there is probably no man in the country, certainly no artist, who has studied the anatomy of the horse so profoundly as Eakins, or who possesses such intimate knowledge of its every joint and muscle."[23] Eakins may have looked to Gérôme for encouragement in this genre, or to Dumont; both of his masters made naturalistic equestrian figures, although Gérôme was the more enthusiastic horseman. Gérôme, owner of a stable of horses, maintained that "to be a good painter or sculptor of the horse, a man must be something of a horse dealer, and still more of a centaur." Eakins and O'-Donovan followed this advice by carefully shopping for the proper mounts for Lincoln and Grant, and by riding, photographing, and "sketching" the horses in clay to choose appropriate gaits.[24]

The preparation of these reliefs was a model of academic practice, exaggerated by Eakins' demands for a portraitlike naturalism in the horses that matched the individualization of Donovan's riders. Small field sketches in wax were followed by maquettes at one-sixteenth life scale, still extant in the wax *Horse and Rider* and painted wax *Clinker* (both at the Hirshhorn). Quarter-scale models in clay, such as *Billy* (now known only in Eakins' own photograph of the plaster, fig. 83) may have been presented to the Brooklyn Arch committee for approval.[25] The photograph, seen uncropped for the first time in a print from Eakins' own glass negative in Bregler's collection, shows the grid of lines incised in the horse and the backdrop that guided the transfer of the composition to life scale. The full-size sculpture was worked in ten sections in clay over wooden armatures, with the interplay of photographs, sketches, quarter-scale reliefs, and life-modeling sessions. These clay sections were assembled and cast in plaster to create the final model for the bronze foundry. The seams between the sections were still visible when Eakins photographed the plaster *Clinker* in the studio (fig. 84) before shipping it to New York in the spring of 1892 to be joined with O'Donovan's figure of Grant. Both full-size plasters are now lost, making Eakins' photograph the only record of the final stages of a complex process that led to a remarkably integrated final effect.[26]

The fragmented and extended work on the Brooklyn project, including cooperation with another artist and work in sections, after the fashion of his earliest figure drawings or his anatomical casts, illustrates Eakins' academic method and his familiar insistent naturalism. Unusual, however, is the nearly freestanding character of these equestrian figures, who barely engage the back plane of the niche. Goodrich, in remarking this very high relief and the "vitality and largeness of form" expressed within it, speculated that Eakins could have surpassed himself in finished, freestanding sculpture had he

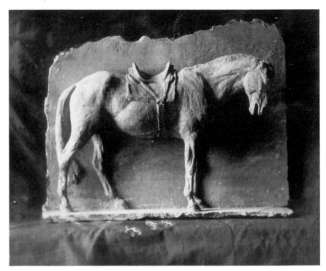

83. *Lincoln's Horse, "Billy": Quarter-Size Model*, c. 1892, view of the c. 25 × 26 in. plaster in Eakins' studio, modern print from 4 × 5 in. dryplate negative, PAFA inv. no. 87.26.55.

continued in this direction.[27] The confines of the commission, predetermined by the niches designed in the arch itself, restrained both O'Donovan and Eakins, who were engaged separately from Frederick MacMonnies, who sculpted the freestanding allegorical piece that crowned the arch. However, Eakins' own "taste" for illusionistically challenging and architecturally "framed" relief may have held his ambitions within this genre, regardless of opportunity. Eakins shared his studio for years with O'Donovan and even longer with Samuel Murray, but he never succumbed to the temptation to try finished work in the round. Perhaps he was amiably conceding this territory to his friends, or perhaps relief simply interested him more.

Eakins' attitude and its contribution to the appearance of the Brooklyn Arch also may have shaped the execution of the ten colossal terra-cotta prophets that Murray made, with Eakins' help, for the Witherspoon Building in Philadelphia in 1895–98. This collaboration between Murray, a sculptor most proficient at freestanding work, and Eakins, the advocate of relief, again produced high-relief figures. Again the commission demanded figures that worked architecturally, and again the principal sculptor turned to Eakins for expertise. The Witherspoon project, which drew upon the traditions of Greece and the Renaissance, followed in the pattern of Dumont's allegorical figures for the exterior of the Louvre. Unfortunately, the deterioration and removal of both Dumont's and Murray's sculptures makes it difficult to compare them except in terms of their conceptual ancestry and ambitions.[28]

Most purely expressing the relief tradition of the Ecole des Beaux-Arts are the two bronze panels for the Trenton Battle Monument, *The Opening of the Fight* and *The Continental Army Crossing the Delaware*.[29] Once again O'Donovan

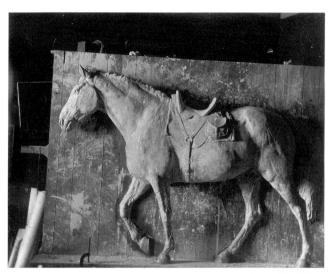

84. *Grant's Horse, "Clinker": Full-Size Model,* c. 1892, view of the life-size plaster in Eakins' studio, modern print from 4 × 5 in. dry-plate negative, PAFA inv. no. 87.26.34.

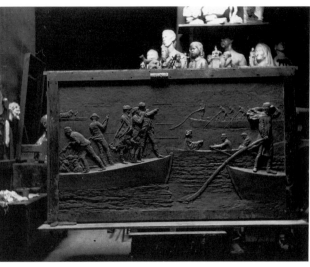

85. *The Continental Army Crossing the Delaware,* c. 1893, view of the clay relief in Eakins' studio; modern print from 4 × 5 in. dry-plate negative, PAFA inv. no. 87.26.40.

drew Eakins into the commission, specifically to prepare reliefs for the sides of a monument that would be crowned by O'Donovan's freestanding figures. A decade after undertaking his last old-fashioned subjects, Eakins revived his scholarly research skills, borrowing costumes and investigating boat types and landscape backgrounds with characteristic zeal. None of this material survives, making an unusual gap in the inventory of Eakins' drawings, photographs, and papers; perhaps, as Goodrich has suggested, he relied upon the archives of a scholar devoted to the history of Trenton.[30] No preliminary studies for the two panels have survived, either, although the compositions are very large (54 1/2 × 94 × 3 7/8 in.) and more complex and finely finished than any earlier work at this scale. Again, this lacuna may indicate loss or perhaps increasing confidence, also demonstrated in his streamlined oil-painting method in this decade, when more work was accomplished on the final canvas, with few preliminary studies. The Bregler collection does contain a new photograph of *Crossing the Delaware,* evidently in clay, probably taken by Eakins in 1893 (fig. 85); small differences in this image—in the coattails of the man at the tiller at right or in the ripples and ice floes around the figure of Washington at the center—indicate that refinements continued to be made before the relief was finally cast in plaster and then in bronze. Sent to the foundry in 1894, the reliefs were installed in 1895, following their exhibition, in bronze or plaster, in Philadelphia and New York.[31]

The Trenton reliefs were the largest sculptures that

Eakins completed entirely on his own, and they demonstrate with finesse the complexities of low relief that had interested Eakins for more than a decade. Much shallower in relief than even the smaller *Knitting* and *Spinning* panels, they are also subtler and more spacious in their use of diagonal forms to suggest recession. Loose, atmospheric, yet finely detailed, they show that Eakins had learned from the problems of the Scott panels and carefully studied classical and modern antecedents. As in much of Eakins' work, the composition of figures is not graceful—although individual figures and groups, such as the three men (Colonel William Washington of Georgia, Alexander Hamilton, and Lieutenant James Monroe) on the prow of the boat in *Crossing the Delaware,* are dramatically effective as well as naturalistically telling.[32] Because they were entirely his own work and completely expressive of Eakins' values, including his desire for historical accuracy and the correct suggestion of perspective in very low relief, it must have pleased him that these panels were well received by critics and by the monument's commissioners.

The onset, at just this moment, of the great age of American public sculpture, so similar to the affluent and rhetorical period that had supported Dumont, did not bring Eakins additional work of this sort, however. Perhaps he was willing and hopeful and therefore disappointed by the lack of patronage, but certainly he must have been satisfied by his demonstration of competence in a genre that few of his countrymen, and certainly no other American painter, had ever mastered so well.

CHAPTER II Photography

SCIENCE AND ART

Photography was the last medium Eakins would draw into his repertory. He was not the first American artist to use the camera either as an aid to work in other media or as an expressive vehicle in its own right, but he was the most important native painter of this period to do both, with a range and intensity of interest that has rarely been rivaled since. This early and inventive photographic work has drawn the attention of many scholars, particularly since the publication of Gordon Hendricks' checklist of about 250 known images in 1972.[1] All studies must begin anew with the revelation of the Bregler collection, which includes more than 1,100 photographic images found in Eakins' household, including dozens of new pictures, in both vintage prints and dry plate negatives, and many complete or superior images previously known only in cropped, blurred or copied prints. The size of this part of the Bregler collection has demanded, like the manuscript trove, a separate catalogue, *Eakins and the Photograph*.[2] To this new study, which looks to the contemporary context of Eakins' photography as well as the personal meaning in his imagery, can be added an examination of the uses of photography within Eakins' larger method of artmaking. In offering a general introduction to the new photographs in the collection I emphasize the aesthetic expressed in this work and the function of photography within Eakins' system of collaborative media. (Part III examines the contribution of his camera studies to specific projects in painting and sculpture, such as *A May Morning in the Park*, the Gloucester and Arcadian landscapes, and the cowboy subjects.)

When one is confronted by these hundreds of images, the most obvious questions arise, some of them so basic as to have been overlooked: Why did Eakins take photographs? Saying that he "used" them for his painting is only a beginning; *how* did he use them? Given a close pairing between a photograph and a painting, what exactly did the photograph contribute? What about the relation between his painting, sculpture, and photographs: Did he have the same goals in each medium? If not, how was photography different? Was the camera simply an adjunct to his other work, or did he use it for independent artistic expression? Is this last question even appropriate to ask, given the context of 1880, when Eakins began to take his own photographs?

Several messages emerge immediately from the materials. The first arises from their general condition, which indicates neglect and low regard. One intact album (fig. 86) and many loose pages from other inexpensive scrapbooks show signs of care, but these books seem to have been composed by Susan Eakins or Charles Bregler. Most of Eakins' own photographs were found unmounted, in keeping with the rarity of their public exhibition in his lifetime. From their condition and from a few period glimpses of his studio (see figs. 75, 106) we can imagine that many photographs were damaged by being tacked to the wall or frequently handled, and others were casually consigned to drawers and cupboards along with his drawings. These photographs, useful in a moment of research or process, seem by their treatment to have

86. *First Page of Eakins' Photo Album, Prior to Conservation.* This album probably was compiled by Susan Macdowell Eakins, with insertions and annotations by Charles Bregler. The image of Eakins, similar to fig. 75, is flanked by portraits of his father-in-law, W. H. Macdowell, his father, Benjamin Eakins, and his mother.

been of passing utility, enjoying secondary, largely private expressive importance. Pushed aside and jumbled, like his drawings, Eakins' photographs survived thanks to the concern of others.[3]

The condition in which the photographs were found tells us of their status and also gives evidence of much loss: broken album pages, mounts with no extant prints, and prints with no surviving negatives. No doubt many images have been lost completely, as illustrated by the two gap-ridden sequences of numbered negatives: the motion studies and the Dakota pictures. From this evidence we can imagine that there was once much more. However, the richness of the Bregler collection, and its tight relationship to other known groups of Eakins' photos, makes it unlikely that a whole category of Eakins' work has been lost completely. Many conclusions about his methods and attitudes can be safely drawn from this material, but, surrounded by signs of loss, it is hard to say "always" or "never."[4]

We can gain courage from sheer statistics, however, for the third message to be drawn from the overall appearance of the collection abides in the staggering number of photographs and in the diversity of imagery, techniques, and dates. The configuration of this material tells us that Eakins was surrounded by photographs, but not continuously throughout his life. We can see a man who grew up with the camera and whose involvement accelerated with every technological advance in the medium. Born five years after the announcement of the first permanent photograph, Eakins

posed for a daguerreotype camera in the 1840s (see fig. 4). His high school graduation photograph of 1861 (see fig. 26) represents the days of salted-paper printing, and his art-student portrait, distributed to friends in Paris in about 1868 (see fig. 44) is an albumen print from the next technological generation, made from a wet collodion plate and mounted in the popular "card photograph" (or *carte-de-visite*) format exchanged and collected with enthusiasm after 1860. The many images of Eakins, his family members, and his future in-laws, the Macdowells, tell us that they were all accustomed to having their pictures taken, and perhaps none was more eager than Eakins himself.[5] It requires some effort to imagine the slowly increasing presence that photography had in the lives of this first generation to mature along with the camera, but the freshness of their experience can be detected in the seriousness assumed for all portraits, even beach-party snapshots. In the uniform sobriety, if not downright glumness, of these portraits, we meet people asking for an eternal image; later generations, more accustomed to the camera and charmed by its instantaneous, fleeting character, will smile and clown more freely.[6]

The gradual acceptance of photography into Eakins' personal and professional life must have been encouraged in France between 1866 and 1870. Within a month of his arrival in Paris he purchased a carte-de-visite photograph of Gérôme (see fig. 41) and then postcard reproductions of his paintings. Not long before leaving Paris he bought a souvenir photo of Ecole students, "4 photographs life studies," some

"photographs from nature," and some from "landscape." Such photos were already a commonplace in Parisian stores carrying artists' supplies, although—given the erotic potential of some of these "nature" studies—they may have been hard to find in America. His purchase may reveal foresight, then, as well as an early sense of the utility of such studies in his work.[7]

Admitting the helpfulness and legitimacy of such photos even while absorbing the method of careful observation from nature instilled at the Ecole, Eakins was taking a middle position in the contemporary controversy over the use of photographs by artists. By the 1860s, painters of widely diverging styles and ideologies had made photographic studies part of their standard practice, although the admission of such use, and the overt emulation of certain photographic effects (particularly fine detail and a smooth finish) had come under critical attack.[8] After warm acceptance by painters in the 1840s, the incursion of photographic aids and photographic effects had produced a confusion between the aims of "art" and the capabilities of the camera, leading some artists to reject, deny, or suppress their photographic sources. The sense that it was improper and unimaginative to rely on such aids colored the debate, leaving an aura of suspicion that still clouds the discovery of photographic sources in the work of a "fine" artist. It seems that Eakins had few qualms about the practice, having developed a philosophy that distinguished his task as an artist from the unselective record of appearances made by the camera, or by unwise painters. The "big artist," he asserted to his father in a letter of 6 March 1868, "does not sit down monkey-like and copy a coal scuttle or an ugly old woman" but instead learns from nature in order to "sail" on a parallel course, following nature's truth and using "her tools," without attempting to re-create nature on canvas.[9] In thus dismissing imitative realism, Eakins aligned himself with the antiphotographic camp even as he cherished carte-de-visite portraits of both Gérôme and Meissonier, two men famous in this period for their detailed painted surfaces and their liberal use of photographs.

To Charles Baudelaire, arguing in this decade for a personally expressive, truly modern art, free from the mechanical qualities of the camera, Gérôme and Meissonier were the enemy, hopelessly enthralled by photographic effects. But like Eakins, or any realist painter in this period with a grain of ambition and self-respect, Gérôme and Meissonier would have claimed a different, better, legitimately modern realist endeavor, one that welcomed the information of the photograph and transcended it. Pledged to avoid "commonplace and indiscriminatory realism"[10] but dedicated to realistic description, such painters sailed uncomfortably close to photographic imagery, and their defense of the art in their work demanded a more refined definition of the differences between painting and photography than the one solicited from artists who avoided a highly detailed surface but surreptitiously borrowed *other* "photographic" qualities—snapshot cropping, polarized values, "distorted" perspective—in search

of a more subjective modern realism. Eakins' embrace of the most aggressive naturalism of the 1860s, exemplified by Bonnat's gruesome martyr subjects, or his (and Bonnat's) identification with the "big" painters of the Spanish Baroque, expressed a wish to reform and refresh academic painting, seen to be foundering in artifice and superficiality. The new spirit in this painting would be shown in the seriousness of its subjects and the discipline of its construction, which employed modern tools and information, implicitly superior to past practice and knowledge. The goal was an art that built on the greatness of the old masters, maintaining tradition while improving upon it. The emulation of photographic surface and details had no part in this reform, although Bonnat's brutal scrutiny of martyred saints or Eakins' *Gross Clinic* inevitably drew accusations of heartless, mechanical insensitivity or dull reportage. However, the contrivances of *The Gross Clinic* as a two-dimensional design, as well as the heavy surface palpable in all of Eakins' oils, must remind us of his intention to "make pictures," not just record appearances. Selective, contrived, and assertively tactile, Eakins' paintings appear "photographic" mostly in photographic reproductions; his separate intentions emerge clearly when his photographs and paintings are placed side by side.

Eakins came back from Paris with study photos in his bags, perhaps prepared by the editorializing of French critics to be discreet in the public display of such materials. Nothing survives from the decade following his return in 1870 to document interaction with photography, although clues and rumors abound. He certainly knew several amateur and professional photographers well: Henry Schreiber may have posed for one of his rowing pictures (see fig. 109), and Frederick Gutekunst made his portrait more than once in this period.[11] One of these two men may have taken the stereographic portrait of Eakins (fig. 87), in an unusual attitude and setting, before 1875. The eccentricity of this picture, and the graphite rulings on the extant print, hint at its use in some planned composition—perhaps even *The Gross Clinic*.[12] If his professional friends could not be asked to cooperate in such projects, there were amateurs to help him make photographs, too: Fairman Rogers had been experimenting with his own camera since the early '70s, and Susan Macdowell claimed to have taken Eakins' picture on 5 September 1880.[13] In Philadelphia, home to the country's oldest photographic society, photographic expertise was readily available, and Eakins could have turned to both commercial and amateur sources.[14]

This accessibility increases the likelihood that photographs informed several projects in the 1870s. Eakins might have used photographic studies for his early rowing subjects to capture difficult poses out on the river; perhaps Henry Schreiber was on both sides of the camera. For *The Gross Clinic*, with its huge cast of busy doctors and students, he used commercial portrait photographs as adjunct information. According to Susan Eakins, who knew Eakins as an instructor at the time, photographic studies were made for *William Rush Carving*, although none have survived. How-

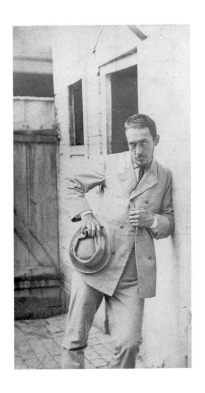

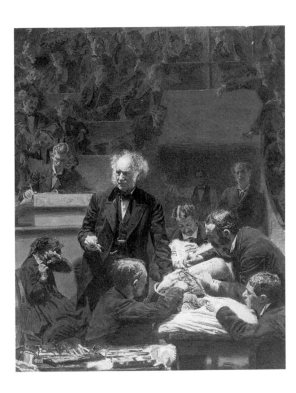

87. Circle of Eakins, *Thomas Eakins Leaning Against a Building*, c. 1870–76, albumen print, 10⁹⁄₁₆ × 5¹⁵⁄₁₆ in., 1985.68.2.33.

88. *The Gross Clinic*, 1875–76, ink wash and pencil on cardboard, 23⅝ × 19⅛ in. Metropolitan Museum of Art, Fletcher Fund, 1923.23.94.

ever, all of these projects before 1878 seem to have relied largely on modeling sessions as a matter of principle, if not necessity. Confronted by a busy or restless sitter like Dr. Gross or President Hayes, Eakins may have turned to available commercial photographs, but without a camera of his own, such aids could only have been peripherally useful.[15]

The small gouache replica of *The Gross Clinic* (fig. 88) that Eakins sent to Adolph Braun and Company in Germany for use in making a photographic reproduction demonstrates a different aspect of Eakins' awareness of the camera in this decade. He made this replica not just because the painting was big and difficult to ship to Alsace, but also because he knew that even the best photographic reproduction in the world—arguably done by Braun's firm—would not read the values in his painting correctly. "My drawing was made with the intention of coming out right in a photograph," he noted in 1881. Photographic negatives were still not equally sensitive to all colors and would not be truly "panchromatic" until past the turn of the century. A photograph of his oil painting, already (and in fact still) difficult to make because of its size and darkness, would have been distorted by readings of color values inconsistent with those perceived by the eye—blues appearing too pale, for example, and reds too dark. To compensate for this effect Eakins correctly translated the color values into black and white himself and sent the monochrome version to Braun. This act reveals his wariness of photographic "lies" as well as his fastidious standards and high hopes for the reproduction, which he no doubt sent to Gérôme and other old friends in Paris, and also displayed at the Penn Art Club and the Pennsylvania Academy in the spring of 1876, when the painting was on its way

to the Centennial exhibition. Five years later, when *The Gross Clinic* was to be reproduced in the *American Art Review,* Eakins again submitted the gouache replica and asked for a good photographic print of it, along with a "light proof" of his image printed "on Whatman's drawing paper than I may work over it with indian ink and bring the tones to what I want, if the first [proof] don't suit me."[16]

A better side of the camera's capability came to Eakins' attention in 1878, with the publication of Eadweard Muybridge's photographs of horses in motion. Fairman Rogers, a wealthy engineer on the Academy's board of directors, had been attempting motion photography himself since the early 1870s, and his enthusiasm for Muybridge's work led directly to Eakins' work on *A May Morning in the Park* (see fig. 140; plate 12), a painting depicting Rogers' four-in-hand rig trotting in Muybridge-correct poses. Eakins and Rogers may have photographed the team in preparation for this painting, although no evidence of such work survives. The lucid depiction of the horses argues for the existence of camera studies, and certainly the criticism of the painting when it was exhibited included unfavorable comparisons to the "frozen," visually unnaturalistic effects of photography. Although enchanted by the accuracy of photographic information, Eakins seems to have admitted that the intrusion of "scientific" effects seen only by the camera disrupted the artistic goals of a painting; he attempted a motion subject only once again (in the diving figure in *Swimming*), and, after toying with the idea of painting cowboys on horseback, instead chose to paint them at rest. With his acquisition of a camera, motion studies fell into the province of the camera, where—if his paintings illustrate his opinion—it more properly belonged.

The investigation sparked by *A May Morning in the Park* may have encouraged Eakins to buy his own camera, although technical breakthroughs in about 1880 probably explain why he waited so long, and then why he acquired one exactly when he did. Experimental dry-plate negatives had been invented in about 1859, allowing photographers to roam without carrying their chemicals to the site, but these plates were much slower than wet collodion plates, and the techniques involved were still messy and complicated. Spurred by the experimentation of amateurs, more sensitive dry plates were introduced into commercial production in about 1880, allowing faster exposures (for more "instantaneous" effects) and simpler processing. These improvements, heralded in May 1881 by *Scribner's Monthly*, were described that August in the same magazine as including the development of small, portable cameras that were both "cheap and simple"; the accessibility of inexpensive, commercially prepared dry plates; and the arrival of a simple printing technology (on ferro-prussiate paper, producing "blue print," or "cyanotype," images) that required only water and a dark room. "All the chemicals and apparatus used in developing dry plates are very cheap, and a small shelf in any closet will answer for a laboratory," claimed *Scribners*. "Any room may be used as a dark room at night, because the plates after exposure can be developed at any time, provided they are kept in the dark. The faculty of taking the pictures and developing the plates can be easily acquired by any boy or girl in two or three lessons, and a person of ordinary intelligence can gain sufficient skill for all business purposes in a week's practice."[17]

By the time this second article appeared, Eakins was the owner of such a camera, and some closet in his house had been converted into a darkroom. His Scovill camera, typical of the type produced to meet the amateur market that boomed following the arrival of more accessible technology, included a carte-de-visite or portrait lens, a "view or landscape tube of long focus," a focusing lens, and three plate holders, all rescued by Bregler and ultimately sold to the Hirshhorn.[18]

Eakins' alacrity in responding to this new technology is characteristic. So is his attentiveness to professional expertise, for he seems to have bought his equipment not long after the Photographic Association of America concluded its trials of the new dry plates in 1881 and issued an enthusiastic endorsement. His sense of timing again suggests contacts in the circle of the Philadelphia Photographic Society, or awareness of the journal *Philadelphia Photographer*, which published reports on recent advances in technology.

The arrival of Eakins' camera announces itself in a flood of prints and negatives from the spring and summer of 1881, indicating the excitement of discovery and experimentation. Negatives made at Gloucester, New Jersey, depicting shad fishermen and the artist's family on the shore of the Delaware River, were found in the Bregler collection in boxes dated April and May 1881 (see chap. 16); nieces and nephews posed at Avondale in May; Academy students in neoclassical dresses danced before the camera in a neighbor's

back yard that June, and beach views at Manasquan, New Jersey, found in a box marked "Squan 1881" (see figs. 94, 95) suggest diverse activity with his new equipment.[19] Within the next four years Eakins would make the bulk of his photographs and discover the various styles, subjects, and purposes characteristic of all his camera work through the turn of the century, when his involvement waned.

Theodor Siegl's categorization of Eakins' photography stands confirmed by the Bregler collection, for though many new images have come to light, most relate to previously known projects, and none reveal a completely unimagined dimension to his work. Unlike Hendricks and Goodrich, Siegl organized the photographs by their use and by the attitudes latent in the imagery rather than by subject: his first group includes family photographs and souvenirs; the second includes pictures taken for the sake of "scientific inquiry"; the third category contains images made in conjunction with specific projects in painting and sculpture; and the last comprises photographs "created as works of art in their own right."[20] These categories are flexible and interpenetrating, but they can be usefully held in the mind when examining the new work found in the Bregler collection, for these groups reiterate the compartmentalized and purposeful style of Eakins' working method. All of these groups reveal Eakins' photographic "aesthetic," although most interest comes, perhaps, from surveying the first three groups for candidates that deserve inclusion in the fourth, "artistic" class. Photography was not generally deemed an art until Eakins' most productive period as a photographer (c. 1881–92) had passed, but the search for artistic expression in his work is more than trolling for harbingers of twentieth-century taste. In this last group, assembled from the images that Eakins felt were important, we see his own sense of the camera's potential as a tool for artists and as an independent, expressive voice of considerable range.

That range began at a pole of objectivity that, to Eakins, had its own buried aesthetic, for "science" was hardly a realm without passion and pleasure for him. But overtly, his purchase of a camera probably was supported by a pragmatic, scientific rationale, not an "artistic" one, for we can expect that Eakins was primarily attracted by its mechanical abilities, not its expressive potential. The photographic record of appearances was first a fact of light and chemistry, not art, and the promise of pure, "scientific" information must have motivated much of Eakins' work with the camera and sustained his exploration of sometimes complex and tedious photographic projects. The camera seen in this spirit of "scientific investigation" satisfied Eakins' own curiosity about human anatomy and animal locomotion, and it could be directly and usefully applied to his teaching. Like the "style-less style" of realism, the aesthetic of this work emerges in its determinedly anti-artistic stance, as if the obvious absence of unnecessary contrivances signaled the appearance of truth.[21]

In this mechanical, informational mode came Eakins' experiments in motion photography alongside Eadweard

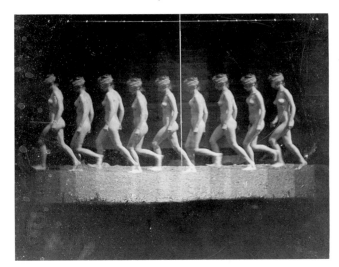

89. *Motion Study: Female Nude, Blindfolded, Walking to Left*, 1885, modern print from 3⅜ × 4⅝ in. dry-plate negative, 1985.68.2.984.

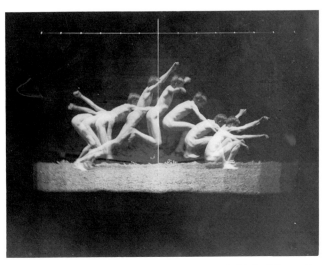

90. *Motion Study: Male Nude, Standing Jump to the Right [History of a Jump]*, 1885, modern print from 3⅝ × 4½ in. dry-plate negative, 1985.68.2.985.

Muybridge at the University of Pennsylvania in 1884 and '85, revealed with new clarity in images found in the Bregler collection (figs. 89–91)[22] and in Eakins' gallery of figure studies known as the "Naked Series," begun in 1883, also seen in many newfound examples (figs. 92, 93; cat. 29).[23] Like a scientist, he undertook this work competitively, seeking to improve Muybridge's results, and collaboratively, working with John Laurie Wallace, Jesse Godley, and Thomas Anshutz, taking his turn in front of the camera and behind it with no inflection in the product (see figs. 91–93). The results of this work, especially the motion studies on a single plate, demonstrate the beauty that Eakins found in the mechanical aptitude of the camera. Innovative and modern, the superbly "photographic" aesthetic expressed in these images grows logically from the academic realism of Eakins' art, with its belief in the innate beauty of the human figure.

Eakins' dedication to the motion photographs can be read in the entries in his account book and in the annotations discovered on the plates, which reveal many months of sometimes frustrating work beginning at the University of Pennsylvania in the spring of 1884. Searching for a way to record precisely the elapsed time between exposures, he developed his own mechanism based on the camera of Etienne-Jules Marey, which produced multiple overlapping images on a single plate, unlike Muybridge's system, which was based on a bank of separate, sequentially triggered cameras. To his improved Marey camera he added a "chronograph" to track the timing of the exposures, designed by Dr. William D. Marks, his colleague on the commission. On 31 August the failure of this first device, built to order that month by a local clockmaker, was memorable enough to receive notice in Susan Eakins' diary. Once the machinery was operating smoothly the effects were spoiled by reflected light fogging the plates, leading Eakins and Anshutz to propose the con-

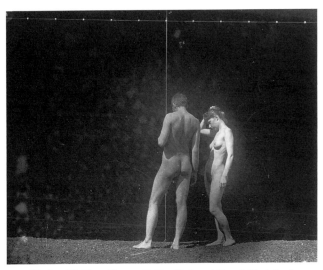

91. Circle of Eakins, *Thomas Eakins Nude and Female Nude in the University of Pennsylvania Photography Shed*, 1885, modern print from 4 × 5 in. dry-plate negative, 1985.68.2.1006.

struction of a shed that would shield the camera and restrict sunlight to a narrow path where the models moved. They received authorization to build this "new house" in October and ran the first tests in it on 5 November but stopped after only two plates were exposed because the weather was too cold for the nude models. Work began again the following year, when ten or more photo sessions between June and August 1885 yielded at least fifty-six plates. The success of this work in 1885 probably inspired Eakins to discard the plates made in 1884; all the newly discovered prints and negatives in the Bregler collection (and apparently most in Hendricks' listing) were made in the new shed, with its exposed strip of sunlit grass between the two halves of the building.[24]

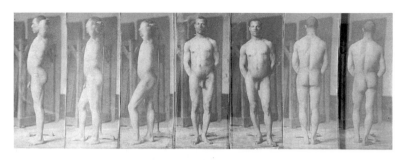

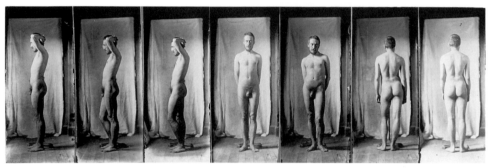

92. *Naked Series: African-American Male, Poses 1–7*, c. 1883, 7 albumen prints mounted on card, 3¹⁄₁₆ × 8⅜ (mount), 1985.68.2.347.

93. Circle of Eakins, *Naked Series: Thomas Eakins, in Front of Cloth Backdrop, Poses 1–7*, c. 1883, modern photograph from seven dry-plate negatives, each c. 4 × 1¹⁄₁₆ in., 1985.68.2.1038, .1029, .1031, .1042, .1044, .1045, .1046.

The commissioners were pleased with Eakins' results, and they published one of his plates (fig. 90) in the report of the project. His camera's superior record of the elapsed time, and therefore of the velocity of the model, suited the doctors at the university, who were seeking documentation of pathological conditions as well as healthy locomotion, and who found Muybridge's separate plates insufficiently precise. The report of Eakins' work, to be presented by the artist in his own section of the published proceedings, was eventually subsumed into the remarks made by Marks, who "regretted that Professor Eakins' admirable work is not yet sufficiently complete for publication as a whole."[25] More work may have been planned, then, although the debacle of Eakins' forced resignation from the Academy in February 1886 must have halted consideration of more nude photography of students, even under the most official circumstances.

Eakins' pride in this work can be read in his display of the *History of a Jump* at the exhibition of the Photographic Society of Philadelphia, held at PAFA in January 1886. His confidence and collegiality led him to offer suggestions to Muybridge (who ignored him), collaborate with Marks on the timing device, and invent a shutter mechanism of his own. As in his anatomical studies, where he was pleased to offer amendments to the record of such authoritative sources as *Gray's Anatomy* (see cat. 44), Eakins pressed forward with his photographic projects, convinced that even as an amateur he could make a contribution. His lecture at the Pennsylvania Academy in 1885 on the results of his new camera, and his presentation before the Academy of Natural Sciences in 1893, when he discussed (with the aid of lantern slides) his research on the dynamic of tendons in the horse's leg (cats. 82–87), illustrate his willingness to come forward with his work and teach from it.[26] Eakins' curiosity, persistence, and ambition

were not unique, for the technological history of photography in the nineteenth century was largely made by the experimentation of such dedicated amateurs, but his investment was rare, especially among a class of persons whose main occupation—realist painting—came confusingly close to the production of the camera.

Part of Eakins' conviction came from his belief in the inherent worth of these scientific projects, apart from their use to him as an artist. His sense of the separate virtues and goals of photography is clearest in the autonomous motion studies or "Naked Series," both of which informed his intelligence as an artist but contributed little to any particular image in his painting or sculpture. The merit of these projects and the straightforwardness of their photographic aesthetic could easily be defended, because the issue of "art" was largely buried by science. But once these easily bracketed groups are set aside, the remainder of Eakins' photographic work shows, in both subject and pictorial effect, many points of overlap with his work in other media, forcing a subtler understanding of Eakins' estimation of his own camera work and his sense of its separate mission.

The development of this more "artistic" photographic aesthetic began with Eakins' earliest camera work in 1881, amid the images in Siegl's first category: souvenirs of family life. These first photographs reflect his newness to the camera in pictures that, in expressing the choices of a beginner, seem by now supremely clichéd; with some effort, we must remember that Eakins' generation discovered these conventions. His pictures in this vein come in the familiar genres that attract and usually content most amateur photographers: family portraits in the back yard, happy picnic groups, pets, vacation landscapes (figs. 94, 95). Then, as now, the initial appeal of these pictures was documentary, but artistic manip-

94. *Margaret Eakins on a Beach, Manasquan, New Jersey (?),* c. 1881, modern print from 4 × 5 in. dry-plate negative, 1985.68.2.858.

95. *Beach with Beach House Hotel in Distance, at Manasquan, New Jersey,* c. 1881, modern print from 4 × 5 in. dry-plate negative, 1985.68.2.971.

ulation appears immediately. Right from the outset Eakins' visual training and characteristic deliberation set his photographs apart from the usual amateur work. He was not, by nature, a spontaneous artist, nor was his so-called "instantaneous" equipment capable of truly spontaneous effects, with the result that even his most "informal" photographs have the air of premeditation, both in the setup of the camera and the obvious preparedness of the sitter. Conventional aesthetic principles prevail in these photos, with an avoidance of distorted or eccentric effects: figures sit or stand, balanced, at the center of the frame, and beach landscapes fall into structures that follow compositional formats familiar from the contemporary paintings of William Trost Richards and Winslow Homer.

No painting projects emerged from these first seaside photographs in 1881; evidently they were experimental exercises with his new camera. Their merit as compositions seems to have been considered, however, as the cropping in the rare extant prints reveals. In his treatment of one view—showing surf, the distant Beach House Hotel, and his own footprints (H 7, almost identical to fig. 95)—surviving prints crop two-thirds of the sky and one-fourth inch from the bottom and left-hand margins of the negative to produce a very horizontal image (H 8), twice as long as wide, in keeping with American luminist beach scenes of the 1870s and Eakins' own oil sketches (see cats. 247–250).[27]

This cropping in his earliest photographs initiates patterns that appear in Eakins' camera work during the next two decades, particularly the exchange of pictorial values between painting and photography, and the importance of these cropping decisions in the creation of his photographic images. The first pattern is hardly surprising, for it is characteristic of most photography in this period with any artistic pretension;

it does, however, contradict the opinion of Charles Bregler (repeated elsewhere in more qualified tones) that Eakins was "absolutely not interested in making artistic photographs."[28] As a visual artist Eakins could not help but impose a selective aesthetic the moment he chose a subject and framed it within the viewing glass of his camera; his secondary decisions, made in the process of printing and cropping the image, intruded his values again. These choices express his opinion of the photographic moment as an event of no final or sacred significance. Rather, it was full of risk and contingency, its results to be necessarily reconsidered and judged later. His dislike of retouching, expressed in writing as well as in the untouched surface of his own prints and negatives, indicates respect for the reality of appearances and the camera's aptitude for an unselective record of detail, but this wish to let the camera do its job, uninterrupted, did not confine his own freedom to reframe the subject, sometimes in several stages, after printing.[29] In this method the negative becomes raw material, like reality, to be bracketed by the realist artist but fundamentally honored; it also reiterates Eakins' habit of drawing and sketching with only peripheral attention to the edges of his supporting surfaces, and his tendency to score the framing edges of a composition after the subject has been internally organized (e.g., cats. 156, 192–194, 203). As in his oil sketches, the edges are generated by the forms within rather than by prior contemplation of the two-dimensional format—his sketchbook, his sketch panel, or the ground glass of his camera. That he was aware of the possibility and the utility of careful framing on the scene is clearly shown in the landscape photographs made in advance of his shad-fishing paintings (see figs. 157, 162, 179), but just as often his impulse was to aim for the figures and worry about the edges later. With this attitude in mind, the many glass negatives in

the Bregler collection that survive without extant prints must be considered open-ended statements about Eakins' interests but not final expressions of his photographic sensibility.

The Gloucester photographs taken in 1881 and 1882 demonstrate Eakins' use of the camera to bracket a picturesque composition for his painting, and also, more predictably, to make figure studies of working men whose actions could never be restaged in the studio (see figs. 156, 161). The number of men involved, their cooperative activity, their complicated tackle—sometimes including horses and windlasses as well as boats and yards of net—all of this had to be studied on the scene from people who could not reasonably be interrupted. The camera was a godsend in such a situation, capturing the interaction of men working in teams in a way that even a more fluent outdoor sketcher than Eakins would find impossible. This dynamic of interrelated poses must have been important to Eakins, as was the record of posture and costume that identified these fishermen and their activity precisely. Throughout the previous decade Eakins had shown intense interest in the revelation of professional identity through gesture, clothing, and accessories, and the camera allowed him to do better, with many figures simultaneously, what he had already done very well. In the same spirit, he would take his camera to Dakota Territory in 1887 to document the details of cowboy life (figs. 203–217). The camera caught the slouch of a cowboy relaxing in the saddle and the cut of a fisherman's well-worn oilskins, and it could grasp the complex outline of such figures. Accustomed to thinking and painting in terms of the "grand construction" of tonal masses, Eakins was not adept at linear contours, and he was impatient in their pursuit. "The least important, the most changeable, the most difficult thing to catch about a figure is the outline," said Eakins.[30] As his studies for *Mending the Net* demonstrate (see figs. 166–169), the camera's outline was sometimes (but remarkably rarely) used unaltered.

The Gloucester work illustrates the invention of a method in 1881–82 that drew upon multiple sources, including many different photos used for different reasons—composition, landscape detail, pose, costume, outline—in conjunction with oil sketches used to establish hue, value, and atmospheric unity. Only occasionally did he rely on a single photographic image for inspiration. Usually the paintings are successful in relation to the complexity of their sources; as with earlier work, such as *William Rush Carving*, the intensity created by a layered, multimedia, academic effort brought the richest effect. And often, when the photograph-to-painting connection is tightest, as in the Gloucester and especially the Arcadian subjects, there is evidence in the final paintings that life study intervened late in the process to alter the information held in the photograph and diminish its contribution. "Eakins only used a photograph, when impossible to get information in the way he preferred, painting from the living, moving model," insisted Susan Eakins. "He disliked working from a photograph, and absolutely refused to do so in a portrait."[31] She must have known, of course, of the hundreds of

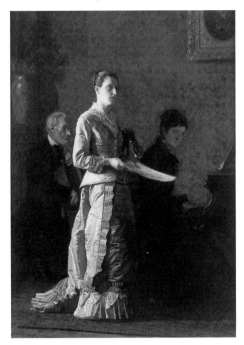

96. *The Pathetic Song*, 1881, oil on canvas, 45¼ × 32½ in., in the collection of the Corcoran Gallery of Art, museum purchase, 19.26 (plate 9).

photographs by her husband in her house, and the study of these pictures in relation to the Gloucester and Arcadian paintings lends irony to our reading of her declaration. The suspicious tone of the antiphotographic rhetoric heard early in Eakins' career may have increased her defensiveness, but the truth of Eakins' actual practice, which usually *did* begin and end with life study, is also revealed in these photographs. And the leeway in her statement is large, for the majority of his photos might be categorized as difficult if not "impossible" information: figures in motion and nudes outdoors.

The pattern of use of photographs as pictorial aids unfolds clearly in a surprising and fascinating series made not long after his acquisition of a camera, as he was preparing *The Pathetic Song* (fig. 96; cat. 203; plate 9). Here, in a familiar Eakinsish darkened interior, one would not predict the use of photographs, because the unmanageable aspects of the multi-figure outdoor scenes were absent or well controlled. Eakins' photos on this occasion may be explained by sheer enthusiasm, then, or curiosity, as he aimed his new camera at every conceivable subject. Perhaps he was told that his principal sitter, Margaret Harrison, could not pose for long. Even more likely, he was overcome by the busyness of her elaborate silk dress but committed, on principle, to documenting every ruffle. Short of having her leave the dress behind for arrangement on the dressmaker's dummy that appears in other views of his studio, these photographs were an excellent record of her costume, which was, like the fisherman's oilskins, a badge of social position. In *The Pathetic Song*, the dress is the single most important accessory in the

97. *Margaret Harrison Posing for "The Pathetic Song," with the Painting Visible at Right,* c. 1881, modern print from 4 × 5 in. dry-plate negative, 1985.68.2.867.

98. *Margaret Harrison Posing for "The Pathetic Song," Half-Length View,* c. 1881, modern print from 4 × 5 in. dry-plate negative, 1985.68.2.874.

painting to establish the context of the event. Eakins may not have had a conscious opinion of this dress: perhaps it simply was what the lady wore for parlor concerts and therefore had to be described. He must have understood, however, that the dress bespoke the values of Victorian society: elaborately artificial, luxurious in its investment of materials and labor, protective of women, who were covered up, bound in and weighted down by such clothing. The clues in this costume were not lost on contemporary viewers, who found the dress and its wearer "commonplace" and "ugly"; Eakins, whether or not he agreed, must have enjoyed constructing a contrast between the stiff, fussy dress and the soft human sentiment that escapes it in song. The intensity of emotion shown was exceptional for this type of subject, for the genre of painting fashionable women in contemporary interiors generally offered nothing more than a sweet and decorative effect. Usually the women depicted are young, pretty, and overdressed, and often they read books or sigh over love letters. As with his entrance into other popular genres—fishermen, Arcadians, old-fashioned figures—Eakins refused to trivialize or glamorize such subjects, painting them all with a kind of earnest, prosaic clumsiness that makes the beauty in the motif, wherever it does emerge, shine with an unpretentious and therefore believable light.[32]

The photographs Eakins made in his studio (figs. 97–99) capture the dress, the pose, and the light much as they appear in the painting. Eleven different negatives in the Bregler collection document this previously unknown session; no vin-

tage prints of any of them survive. To begin with, the photographs are engrossing records of Eakins' studio at the rear of the top floor of the family house, with its dormer windows projecting from a steeply sloping roof.[33] In figs. 97 and 98, Harrison stands in the northwest corner, her back to a west-facing window; the northern windows have been blocked by shutters, and a section of figured fabric has been tacked up behind her head to simulate the parlor wallpaper envisioned

in the painting. She stands next to a chair and a desk that generally echo the stool and piano in the picture, making it clear that the accompanying musicians were already planned, but studied in later, separate sittings. A third of Eakins' canvas, probably on his easel, appears at the right margin, showing the singer's figure blocked in and the left side of the canvas shadowed and otherwise empty. Behind the singer, on the chimney wall, hangs a framed reproduction of Gérôme's painting, *The Two Augurs* (see fig. 43), testifying to Eakins' continuing respect and affection for his master.[34] Carefully lettered on the wall below this picture appears the artist's name: Tom Eakins. Stretchers, canvases, and rolls of paper fill the periphery of the room; books and papers sit on the desk, four chairs (including the shell-carved Chippendale side chair seen frequently in his pictures), a modeling stand, and draped mannequins all appear in these views or in other negatives made after the canvas was removed at the right. This ambiance reconfirms the "workshop" mentality seen in photos of his later studios, and it illustrates the irrelevance of the margins of the negative in such photo studies, for all this studio clutter was supplanted in the painting by additional figures and parlor accessories, none of which are important yet. His use of photography seems highly directed and yet relaxed, without a compunction to construct the entire scene in all its details, and it is fragmented, like the rest of his method, into single-focus units. Perhaps he photographed the other figures, too, or studied them from life, but each seems to have been studied in isolation.

Margaret Harrison was photographed thoroughly, as negatives in the collection illustrate. Five show her at full length, apparently singing, in the pose seen in the painting. Three of these, taken from two different station points, include a portion of the canvas; another two, with the canvas removed and some of the studio paraphernalia rearranged, were taken from slightly closer range. Eakins then moved in to photograph her half-length three times, and then three times at bust length, either standing or seated in his familiar studio chair (fig. 99; cat. 263).[35] These last portrait views, in profile or full face, are reminiscent of the effects in Eakins' photographs of Walt Whitman a decade later, but they are much less expert. Eakins' newness to the camera, as well as his single-minded interest in Harrison, may explain the oddly cropped and blurred negatives in this group. The deliberately restricted interior light also may have slowed his exposure time and shortened the depth of field in his lens, accounting for the blurriness in both foreground and background, and occasionally in the figure. Here, in Eakins' own experience, was exactly the effect of selective focus recognized in Eakins' Gloucester paintings this same year.[36]

The most striking thing about these photographs, however, is that for all the redundancy of negatives and their close relation to Margaret's pose in the paintings, none of them ultimately served Eakins as more than supplementary reference. None of the extant images are repeated in either contour or modeling, suggesting that Eakins completed the

99. *Margaret Harrison in Profile, Sitting in a Carved Armchair,* c. 1881, modern print from 4 × 5 in. glass negative, 1985.68.2.875.

painting from observation, either because the photographs were inadequate or life study was preferred. While it could be argued that the *exact* negatives used were destroyed or accidentally lost, this pattern repeats itself in other important figure paintings with numerous photographic studies, such as the Arcadian paintings (see. chap. 18). Many photographs of piping shepherds have now emerged (see figs. 100, 185, 186), but none are exactly like the piper in the painting or the relief titled *Arcadia*. The welter of photographic studies for the Arcadian works, and the tight interchange between the media, show Eakins' method with the camera and his immediate intentions: to experiment with different preconceived poses and perhaps develop new variants; to use photographic prints to mix and match these poses in the composition of satisfactory figure groups; to preserve individual studies for more exact transfer to the canvas; and then to abandon, refine, or develop these studies in the course of final modeling sessions from life. In this process the photograph functioned as a useful transitional image—reality made flat and black and white, already a two-dimensional, patterned and illusionistic image, midway between real life and painting. Like many of Eakins' academic procedures, the camera put his subject at an aesthetic distance, where it could be professionally, artistically manipulated.[37] Eakins enjoyed this kind of detachment and control, and photographs extended his time for study and deliberation. The impatience or reluctance of women and children, or the sheer difficulty in arranging nude modeling sessions outdoors, also may have motivated him, for Eakins' opportunities for nude study were limited. Given the process and the results, we can understand how the photographs functioned as preliminary study aids, to be tossed into a

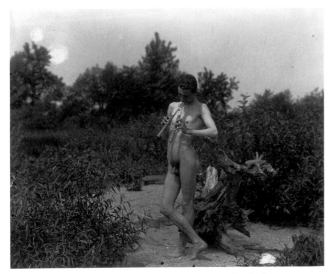

100. *John Laurie Wallace Nude, Playing Pipes, Facing Left*, c. 1883, modern print from 4 × 5 in. dry-plate negative, 1985.68.2.1010.

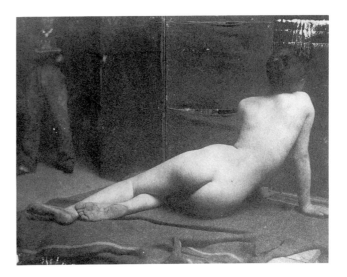

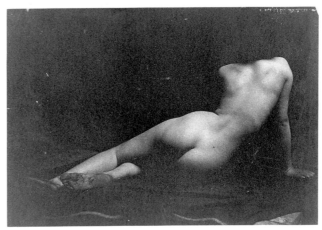

101. Top, *Female Nude, Semi-Reclining, from Rear*, c. 1889, platinum print, 3⅞ × 5¹⁄₁₆ in., 1985.68.2.501.

102. Bottom, *Female Nude, Semi-Reclining, from Rear*, c. 1889, platinum print, 3½ × 5¹⁄₁₆ in., 1985.68.2.506.

drawer once the final pose had been selected or the final modeling sessions were begun.

If this is the case, however, it does not account for the remarkable abundance of these Arcadian and neoclassical images. Some of the multiple views can be explained as experimentation or the usual obsessive overpreparation, but all these multiple printings—in different processes, sizes, mountings, and croppings—seem to demonstrate an affection for these images as photographs, quite apart from their use in painting. The appearance of enlargements in the Arcadian series is in itself interesting, and the repertory of technology is likewise worth study: a few quick cyanotypes, the fastest and cheapest amateur print; more frequent albumen prints, usually contact size (although occasionally enlarged, as in fig. 198); and sometimes the more expensive and complicated platinum prints. The platinum process, with its superior durability and rich range of blacks and grays, became widely known just as Eakins began to work in photography; his early appreciation for its effects is typically sensitive to new technology as well as pictorial advantage. The occasional use of this printing process in his Arcadian photos and related neoclassical figure studies (including the "swimming hole" series) indicates a special investment of both time and money, creating a category of work that, by its choice of materials alone, signals "artistic" consideration. From their large size and multiple printings we can deduce Eakins' favorite pictures: two young women in classical costume, for example (see fig. 195), or the group of young men at the swimming hole (see fig. 182). Although emerging from sessions at least tangentially related to painting and sculpture projects, these images bear only indirectly on the work in other media, and

clearly they enjoyed independent status as satisfying pictorial statements.[38]

The pleasure Eakins took from manipulating his photographs may be read in a series of seven prints, all from the same negative, also surviving in Bregler's collection (figs. 101, 102). The setup is conventional and even less pretentious than many of his neoclassical photographs: the folding screen and the man seen sketching at the left may mean that the model posed at the Art Students' League. The allowance of such detail, as well as the informal arrangement of the blanket she lies upon, are typical of Eakins' disinterest in the margins, and his focus on the figure. In printing and cropping, these distractions were largely eliminated—again rep-

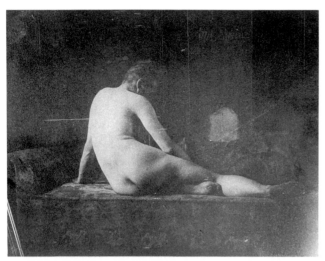

103. Circle of Eakins, *Thomas Eakins Nude, Semireclining on Couch, from Rear,* c. 1883, platinum print, 5⅜ × 7¼ in., 1985.68.2.425.

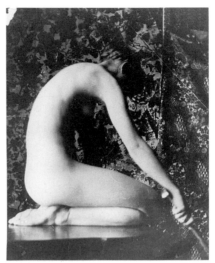

104. *Female Nude Kneeling on Table,* c. 1884, gelatin silver print, 7¾ × 6⁷⁄₁₆ in., 1985.68.2.500.

resenting Eakins' standard practice of secondary "artistic" consideration of his photographic imagery. The first stage, in the studio, involved the contrivance of the pose itself, which is a variant of one seen elsewhere in his photographs and paintings, including one image posed by Eakins himself (fig. 103). Like generations of other painters, he was pleased by the undulating contour of this pose and the long, curving plane of the back.[39] In printing and cropping this image, he explored a range of tonal effects, from bright and crisp to dusky, sometimes obscuring or deleting the background completely. Freed from the mundane studio context, the figure emerges from the shadows as an idealized form.

The experimental mind seen in this remarkable set of prints plays through comparative printing technologies in another, even more contrived image, of a nude woman kneeling on a polished table. Previously known only from a print in Seymour Adelman's collection, three duplicate prints of this image (but no negative) have appeared in Bregler's collection: a contact-size albumen, a slightly larger platinum print, and a much larger gelatin silver print (fig. 104), representing the next generation of photographic printing, available after about 1885.[40] This last print, with its glossy surface, crisp contours and warm darks, makes an interesting contrast to the colder, softer platinum and the paler, harder albumen, creating a difference in tone that Eakins must have appreciated.

The multiple copies of the kneeling or the reclining nude offer opportunities to think about Eakins' treatment of a single image and his feeling for the beauty of the human form, but there are many other models and poses to examine in the collection—some 160 prints and negatives of nude men, women, and children, in addition to the "Naked Series" and the motion photos. About fifty-six images of nude women confirm Eakins' interest in females, disproving (or at least mitigating) the theories that Eakins was more inter-

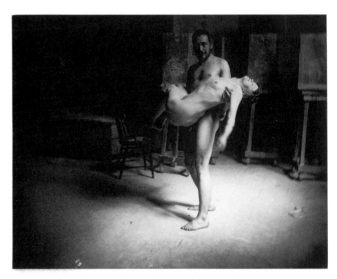

105. Circle of Eakins, *Thomas Eakins, Nude, Holding a Nude Model in His Arms, Looking at Camera,* c. 1885, modern photograph from 4 × 5 in. dry-plate negative, 1985.68.2.848.

ested in men, or that most of such compromising photographs of women were destroyed by a "well-meaning but tragically misguided family friend" not long after Susan Eakins' death.[41] Such a friend might have guessed that the circulation of such photographs, so incendiary in 1886, would still be troublesome in 1939, particularly images of the professor himself posing nude with a woman (fig. 105).[42] Eakins' sense of fun, and his exhibitionistic streak, may stand exposed in this picture, but we can also imagine the rationale behind all of these nude subjects—the same rationale that had justified his purchase of "studies from nature" in Paris: nude models were difficult to find and expensive to hire, and

106. Attributed to Susan Mac-
dowell Eakins, *Samuel Murray,*
Thomas Eakins, and William R.
O'Donovan in the Chestnut Street
Studio (detail), c. 1892, modern
print from 4 × 5 in. dry-plate
negative, 1985.68.2.854.

photographs could capture beautiful figures or transitory poses for future use. "A number of photographs of models used in the Life Classes, were made in cases in which the model was unusually good, or had any peculiarity of form or action which would be instructive," wrote the Academy's Committee on instruction in 1883. "And a collection of these photographs will thus be gradually made for the use of students." No such collection remains at the Academy, leaving only Eakins' personal assembly and—as Goodrich has noted—the portfolio of images given to E. H. Coates as the record of his intentions for such "instructive" material.[43]

Eakins' work in photography was, like his sculpture, deeply attached to his teaching mission, and his interest in the camera fell off after his departure from the Academy early in 1886. It rose again in moments of collective energy, such as the period in the early 1890s when the Art Students' League was prospering and his studio was shared by Samuel Murray and William R. O'Donovan, who collaborated with him on public sculptures in this period. His photography after 1886 shows little alteration in method or attitude, building on the genres of the early '80s: figure and landscape studies in Dakota Territory (see figs. 203–217), following the pattern of his Gloucester work; more motion studies of horses, undertaken as part of his sculpture for the Brooklyn Memorial Arch or in connection with his research on the differential action of equine tendons; more photos of models in neoclassical dress; a few nudes outdoors (see fig. 202); a few figures in difficult action poses, for use in his painting of *Wrestlers* of 1899; and some portraits.[44] He used his camera less after the League closed in 1893, and the last dated activity seems to be in the spring of 1899, for the wrestling picture and other portrait sessions: "Addie [Williams] here and Tom takes more and better photographs," noted Susan Eakins in her diary on 22 January 1899.[45]

Two albumen portraits of Addie have surfaced in Bregler's collection, perhaps representing these last photo studies. Both images were unknown to Hendricks, and both seem unrelated to the two portraits that Eakins painted of her in about 1899 and 1900.[46] Typically, these photographs seem to have been a separate series, undertaken partly for their own interest and partly as trial sessions for an intended painting. As Goodrich has noted, photographic portraits may have suggested certain poses and light effects to Eakins, but the actual oils vary significantly from the photographs, indicating fresh study from life. As Susan Eakins emphasized, Eakins "absolutely" preferred working from life when it came to portraits, and there are no extant examples of a pairing between a photograph and a painting of a living sitter akin to the close correlations in the Gloucester series. Nevertheless, his oeuvre of photographic portraits was large, including some people he never painted and others he painted often, such as his picturesque father-in-law, William H. Macdowell. Some of these portraits are blunt back yard records of appearance, for insertion into the family album; others, of close friends and other artists, are more expressive, showing a fine use of light and shadow to insinuate depth of character and feeling.[47]

Eakins' most famous series of such portraits, made of Walt Whitman, appears in Bregler's collection only in the background of a well-known group photograph of Murray, Eakins, and O'Donovan (fig. 106). This image illustrates the multiple purposes of these portraits and may explain the rarity of vintage prints. Eakins finished his own oil portrait of Whitman in 1888; the photographic portraits were made in Camden in 1891 with the assistance of Murray, who may have visited Whitman on his own. After the poet's death, both Murray and O'Donovan began portrait sculptures, drawing upon photographs made by Eakins, Murray, and others, all of which were tacked on the studio wall for reference. From this constellation of study photos we can see how O'Donovan (whose bust is on the modeling stand) composed his likeness, and how prints by Eakins and Murray were cheerfully mixed together and probably lost in use.[48]

The confusion of Eakins' and Murray's work demonstrated in fig. 106 indicates, again, the low importance Eakins placed on "signature" when it came to his photographs. This

attitude, combined with the maintenance throughout the 1890s of other patterns of use established in the 1880s, would lead us to conclude that Eakins' opinion of his photographs, and their significance, remained consistent to the end of his career. He must have been aware of other attitudes, for Susan Eakins' diary tells us that the Eakins house was full of professional photographers in the 1890s: Eva Watson, Amelia Van Buren, and Frederick von Rapp ("here to print" on 20 April 1899), not to mention the very able resident amateurs, Elizabeth Macdowell and Susan herself. All of these people exhibited at the photography "salons" held at the Pennsylvania Academy between 1898 and 1901, when the "art" photographers of Philadelphia came of age alongside colleagues from the Stieglitz circle in New York and overseas.[49] Eakins did not join them, implicitly stating his own lack of interest or judging his own work as inappropriate.

At the same time, Eakins probably endorsed the ambitions of his wife and his students, Macdowell, Van Buren, and Watson. Perhaps the efforts of these women confirmed his opinion of photography as a lesser but nonetheless interesting artistic endeavor. Like his acceptance of women artists or women surgeons, it may have seemed to be a medium incapable of "greatness" but "well worth the doing."[50] His own camera work he treated a bit like his wife, whom he loved and supported but who always held, by mutual consent, second-class rank in the household. Such attitudes are not unexpected in a man committed, as Eakins was, to traditional, western hierarchies of gender and media, and whose conservatism kept the academic naturalism of the 1860s alive well past the turn of the century. More surprising, then, is the liberalism seen in his defense of equal opportunity in education for women, or the atmosphere of open-minded curiosity that surrounded his own photography and encouraged the work of others in his circle. Significantly, his photographs show a much greater degree of completed, expressive autonomy than his drawings, indicating an impressive incursion of this new medium into the traditional hierarchy. His appreciation of the camera's talents, and his easy incorporation of photography into his method, were a lesson to all who came in contact with his teaching. His prejudices confined most of his own photographs to the studio, but his example liberated the work of his students and foretold the many varieties of a "photographic aesthetic" that matured in the twentieth century.

Strikingly diverse and progressive in its period, Eakins' accomplishment as a photographer looms large in hindsight, although it remained a fundamentally private endeavor that hardly interacted with photography's mainstream. Much richer than his contribution to photography "alone" was Eakins' integration of the camera into a creative process that united and produced work in all media. Always elaborate, this art-making method reached a height of complexity in the early 1880s, after the incorporation of photography expanded his technical repertory to its widest. To understand the development of this working method—its mechanics and its meaning—we now can look at the interplay of media in particular projects and genres, from the early 1870s to the turn of the century.

Part III Projects

CHAPTER 12 The Rowing
 Pictures

"A PASSION FOR
PERSPECTIVE"

Eakins returned to Philadelphia in the summer of 1870, eager to begin making "pictures." He looked to the people around him for inspiration and began producing contemplative portraits of his family and friends—the women indoors, heavily wrapped and artistic, the men outdoors, half-clothed and athletic. The first of these manly, sporting subjects to be finished was exhibited in April 1871: *The Champion, Single Sculls* (fig. 107), a portrait of his high school chum Max Schmitt (see fig. 26), rowing on the Schuylkill. The theme may have been suggested by Gérôme's paintings of oarsmen on the Nile, seen in Paris at a time when Eakins' conversational repertory was restricted, according to Earl Shinn, "pretty much to stories of the Schuylkill boating club." Schmitt's races were also a topic of concern in his letters. "I will be real sorry if he don't win this time," he wrote to his father on 2 July 1869, asking for news of Max's race. "It will break his heart if he don't and it is an ambition that don't wrong others."[1] Schmitt did win, then lost his title, then regained it shortly after Eakins returned from Paris. It was an event worth celebrating among friends, and Gérôme's example was quickly subsumed by the particularities of local landscape, an identifiable champion, and a modern sport that had been only recently embraced in the United States.

Responding to this fashion as well as the opportunity for figure painting, Eakins investigated this novel subject in five more oils and five watercolors, exploring the compositional possibilities of one-, two-, and four-man shells, the oarsman at rest—like Max Schmitt—or ready to race, the space open or confined by bridges, the time noon or sunset. His pursuit of this subject between 1871 and 1874 was impelled by personal knowledge and enthusiasm, for Eakins was an amateur rower himself, quick to appreciate the excellence of his friends and pleased to display his own sturdy image in the distance behind Max. His persistent, almost obsessive interest in the subject also signaled a deeper engagement with pictorial problems that drew him back, repeatedly, seeking more complex or successful effects of space and light. As McHenry noted, "It was not so much a passion for boating . . . as it was this passion for perspective."[2]

The nature of Eakins' passion unfolds in the evidence of his elaborate preparations for these paintings. Energetic, ambitious, and fresh from his academic training, Eakins planned these rowing pictures with a thoroughness that Gérôme himself—who was given two of the watercolors (including fig. 64)—found altogether admirable.[3] Just a few oil studies survive to document this preparation, but eleven fragile perspective drawings have endured, all to the scale of the finished pictures. These drawings were given to Charles Bregler by Susan Eakins; five of them are now in the PAFA collection.[4] Altogether, they make a remarkable set, unique in American art history and unmatched in Eakins' oeuvre. In a lifetime of dedication to perspective, he would never again create a comparable group of drawings. The time and effort banked into this set speak of Eakins' youth and freedom, his love of boats and sportsmen, his obsession with measurement

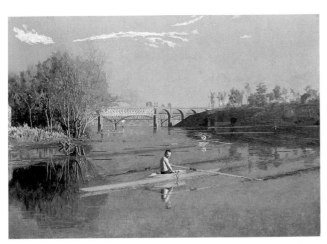

107. *Max Schmitt in a Single Scull* (or, *The Champion, Single Sculls*), 1871, oil on canvas, 32¼ × 46¼ in., Metropolitan Museum of Art, Purchase 1934, Alfred N. Punnett Fund and Gift of George D. Pratt.

and perspective. Together with the earlier-known oil studies, these drawings also tell us much about the methods and concerns underlying a series of paintings that have come to represent, for many, Eakins' "signature" work.

The new Bregler drawings all were made in preparation for two paintings at the end of the rowing series: *The Schreiber Brothers* of 1874 (figs. 109–111; cats. 146–148) and the unfinished *Oarsmen on the Schuylkill*, probably begun that fall (see figs. 114, 115; cats. 149–150). The Schreibers, like the other oarsmen in these pictures, were Eakins' friends. They were amateur rowers, not champions like the athletes who figure in all the rowing pictures prior to 1874.[5] Henry Schreiber was a professional photographer especially known for his animal portraits.[6] Details about his brother—perhaps "Billy," rowing starboard oar, according to the annotations on cat. 147—remain unknown. Their entrance onto the scene introduces a wider cast of models for Eakins, who had painted only Max Schmitt (once) and the Biglin brothers (nine times, together or just John alone) until this moment.

The Schreibers are seen against a pier of the Columbia Bridge, very much like the Biglin brothers in *The Pair-Oared Shell* of 1872 (fig. 108). The drawings for the two paintings are easily confused because of this structural similarity; their differences point to adjustments that Eakins must have undertaken as a dialogue on, if not an outright critique of his earlier pictures. By the spring of 1875 Eakins was no longer exhibiting his Biglin pictures: "They are clumsy & although pretty well drawn are wanting in distance & some other qualities," he explained to Earl Shinn.[7] Reattacking the problem undertaken in one of his earliest Biglin pictures, Eakins set out to address those faults in *The Schreiber Brothers* (fig. 109).

The new canvas was half the size, in square inches, of *The Pair-Oared Shell*, and the figures were diminished by about a third, but the proportions of the composition overall remained consistent despite the change in scale. Both shells move from the right into the left distance, cutting through the dark reflection of the bridge pier. Very subtly shallower, the course of the Schreibers' shell allows us to see the hands of both oarsmen. Other alterations are immediately apparent: the pier behind the Schreibers looms larger, and continues to the right edge of the canvas, blocking the distant view seen in the Biglin picture. Enclosed within this shadowy masonry, the Schreibers are not seen, like the Biglins, against sunlit water. Eakins may have been uncomfortable with the effect of the Biglins placed at the intersection of light and dark, and so pulled the Schreibers well within the gloom of the pier, but positioned so that the sun strikes their figures and brilliantly sets them off against the shadowed stones. The airiness and abstract compositional energy of the larger painting are lost in these changes, but a more dramatic and particular sense of the figures and their motions has been gained. Overall, it would seem that these alterations are small, given the persistence of a given set of forms and spaces, varied only by slight changes in viewer position and angle of light. Eakins has played with the pier and the shell

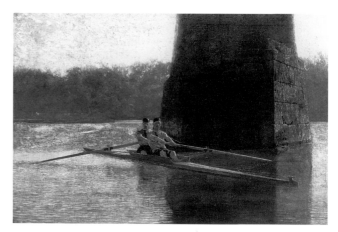

108. *The Pair-Oared Shell,* 1872, oil on canvas, 24 × 36 in., Philadelphia Museum of Art, Given by Mrs. Thomas Eakins and Miss Mary Adeline Williams.

just as Monet considered and reconsidered his grain stacks.

A look at Eakins' drawings tells us that his variations on *The Pair-Oared Shell* were contrived and preconceived, not discovered or improvised. The effect of a much stronger, midafternoon sun may have occurred to Eakins as he stood on the bank of the Schuylkill, but to accomplish the different effects of background and light he did more than simply move his easel to the left in order to catch the pier broadside. A comparison of the drawings made for these two paintings reveals how much fresh calculation went into these changes. Siegl's analysis of *The Pair-Oared Shell* and its two preparatory drawings has shown that the Biglins' boat lies between thirty and sixty feet away from us, and that the picture itself is meant to be viewed from six feet away.[8] The bow oarsman, exactly forty-eight feet away, appears at one-eighth scale, following the ratio that Eakins called the "one and only law of perspective," described above in chap. 7: "As the distance of the object from the eye [forty-eight feet] is to the distance of the picture plane from the eye [six feet], so is the size of the real object to the size of the picture of this object" (see fig. 54). The horizon, or eye level, of *The Pair-Oared Shell* can be determined once this scale is understood by measuring on the drawing from the shell's waterline to the horizon at the forty-eight-foot mark and multiplying by eight to regain the life dimension: thirty-six inches.

Eakins' first draft for *The Schreiber Brothers* (fig. 110), recognized by the ghostly indication of the pier behind the rowers, indicates revision of all these reference points and ratios. Like all of his first-stage perspective drawings, this scheme is entirely in graphite. The "point of sight," at the intersection of the horizon line and the vertical axis of the picture, is easily seen in this drawing. As usual for Eakins' work, the painter and therefore the "ideal" viewer look squarely at a point midway between the vertical framing edges of the picture. Eakins' annotations, borne out in the actual drawing, indicate that the observer stands closer to the painting—five

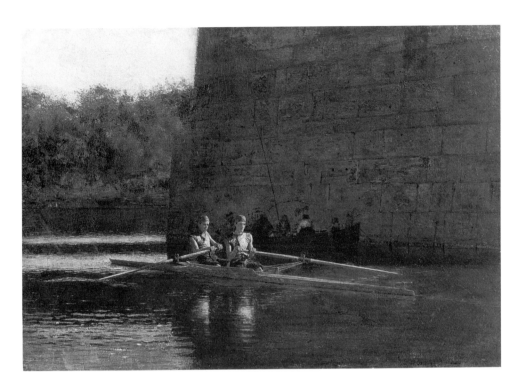

109. *The Oarsmen (The Schreiber Brothers)*, 1874, oil on canvas, 15 × 22 in., Yale University Art Gallery, John Hay Whitney, B.A. 1926, Hon. M.A. 1956, Collection.

110. *The Schreiber Brothers: Perspective Study of Rowers*, c. 1874 (cat. 146).

feet away rather than the six feet needed for *The Pair-Oared Shell*—but farther from the stern of the shell, which is now sixty feet away. The scale at that distance, according to Eakins' "law," is 5/60, or 1/12, life; the figures, at seventy-two feet distant, are a slightly smaller 1/14.5. Even if we did not know the dimensions of the painting Eakins had in mind (which is in fact an inch taller and five inches wider than this drawing, but at the same scale), we could understand from these calculations that Eakins imagined a painting considerably smaller than *The Pair-Oared Shell*.

Eakins played with the scale ratio of viewer distance and figure distance throughout the rowing series. Within the eight extant pictures he repeated himself exactly only once, in the replica of the watercolor sent to Gérôme. Among the remaining seven, only two are the same size, with similar perspective coordinates.[9] The variety of his solutions opens up for us an understanding of the variables at play, and the pleasant challenge of decision-making at the very outset of each picture. The initial choice, for Eakins, lay in his concept of the figures and their size on the canvas. From their scale flowed all the other decisions, such as viewing distance. As he explained in his own perspective manual, the distance between the picture surface and the viewer varies according to "how large you want one of your important objects to be in the picture."[10] Eakins made a different choice for almost every rower in his series: his largest figures are 1/3.5 life (*John Biglin in a Single Scull*, oil sketch and drawing, and *The Biglin Brothers Turning the Stake*); his smallest are the Schreibers at 1/14.5, with others, like *Max Schmitt* or *The Pair-Oared Shell* at 1/8; the watercolor *John Biglin in a Single Scull* (fig. 64) and *The Biglin Brothers Racing* at 1/7. The eccentricity of some of these fractions suggests that, quite sensibly, Eakins first imagined John Biglin as, say, eight inches high and then derived the appropriate scale factor from this size in relation to his real height when seated at the oars.[11]

From this sense of scale followed the establishment of the viewing distance of the picture and the placement of figures in space, according to the "law of perspective." Based on this rule, the figure and the observer are fixed into space on each side of the picture plane at distances that maintain the chosen scale ratio. If the painter draws back from his canvas, the figure must be moved deeper in space; if he steps forward, the figure will come nearer. The viewer's position

should not be too close, however—never less than eighteen inches for a drawing at less than life scale—because the figure will then start to suffer from the distorting effect of rapid scale change in the immediate foreground. Once the figure is pushed to safety (that is, to any spot beyond about fifteen feet distant, where the pace of scale change slows to a less disconcerting speed), artistic negotiation with the viewer's position becomes possible. Within the zone of greatest legibility—between about twenty and thirty feet away—Eakins positioned his figures at every distance. Typically, he placed both the "ideal" viewing position and the figures farther from the picture plane than conventional wisdom might recommend.[12] The Biglins, turning the stake, are thirty-four to thirty-six feet away; in *The Pair-Oared Shell*, they are between forty-two and forty-eight feet from us; the Schreibers, under the bridge, are seventy-two feet distant.

These different placements have visual consequences. At these longer distances we must remember that the orthogonals on the imaginary perspective checkerboard of the river's surface are beginning to converge as the far horizontals pile rapidly together, making the recession of any object not parallel to the picture plane, like the pair-oared shell, occur very swiftly even though the pace of scale change has become very slow. This rapid foreshortening between the bow and stern of a scull without palpable diminution in scale makes for the odd effect of condensed space seen through a telescope or a telephoto camera lens. In both *The Pair-Oared Shell* and *The Schreiber Brothers*, Eakins enhanced this telescopic effect by cropping the foreground so that the first ripples of water seen at the lower edge of the canvas are already sixteen or thirty feet away. The viewer who draws closer to the canvas than the "ideal" distance will be especially struck by the sense of a view seen through binoculars, drawn artificially close by the "telescoping" of the intervening distance.[13] Eakins may have liked this effect, although he criticized the "want of distance" in his pictures. More likely, he accepted it in preference to the distortion of peripheral vision and accelerated scale change that lurked in closer positions.

Perhaps to mitigate the telescopic recession of the Schreibers' boat, Eakins tried lifting the eye level of the observer. Judging from the distance between the horizon and the rowers, we can already guess that the viewing position is much higher in this drawing, but by measuring from a convenient scale baseline (such as the sixty-foot line, where the scale is 1/12) we can know that Eakins imagined an eye level of seventy-two inches above the water, or—as noted at the upper left of the drawing—six feet, twice the viewer's horizon in *The Pair-Oared Shell*.[14] Maybe Eakins was pleased at this moment with the number seventy-two, which is the figure distance, the horizon height and the angle of the boat's recession on the plan. This eye level was the highest viewpoint tested in this series of rowing subjects, which had begun with a conventional sixty inches (for Max Schmitt), dropped to a low of thirty inches (for *John Biglin in a Single Scull*) and also tried thirty-six (*The Biglin Brothers Racing*),

and forty (*The Biglin Brothers Turning the Stake*). The new seventy-two-inch eye level, now much above the rowers, had the advantage of revealing more of the figures and the boat while reducing the telescope effect. As a disadvantage, however, this position gave a much steeper slope to the water's surface, with a corresponding effect on the foreshortening of the boat. The artifice of this vantage may also have bothered Eakins, who usually favored natural viewpoints based on his own eye level while standing or seated. Most of the other rowing pictures are organized as if seen from another boat, with the viewer's eye level close to that of the rowers', giving an exciting and unconventional participant's view to the subject. The seventy-two-inch perspective would be a foot above standard eye level, however, and while it might be explained by the presence of a dock or the deck of another small boat underfoot, Eakins may have felt that this floating vantage was difficult to "explain" with visual clues.

Dissatisfaction with this higher eye level may have caused Eakins to begin again. A later round of efforts, visible in cats. 147 and 148 and in the finished oil of *The Schreiber Brothers*, retained the viewing distance (five feet) and the scale (1/12 at a scale baseline sixty feet distant), but dropped the horizon to forty-eight inches, a comfortable seated position for the artist and about a foot above the eye level of the oarsmen. The next drawing in sequence must have been cat. 147 (fig. 111), which enacts this new eye level while joining the next two phases of Eakins' preparation: plan and detailed perspective rendering. From the annotations as well as the appearance of this drawing, we can see that Eakins has settled down with new coordinates of construction and begun to refine the detail in the boats and reflections. The plan at the upper right of the sheet reveals the shell's new angle of recession: 63 degrees from the picture plane, or a convenient 2:1 slope on the plan (as opposed to the 67-degree angle in the *Pair-Oared Shell*, in which the slope was 2.5:1). He had tried a steeper slope (3:1) in the earlier drawing (cat. 146) to compensate for the higher viewing position; elsewhere in the rowing pictures he used a 1:1 recession (as in *The Biglin Brothers Turning the Stake*) or a near-parallel course (as in *The Biglin Brothers Racing*, at 1:6, or *John Biglin in a Single Scull*). As with the scale decisions, which tend to locate figures near a convenient scale line where fractions are simpler, we can imagine from this pattern of slopes and angles that Eakins first plotted the course of the shell along obvious diagonals on the plan. Thinking geometrically, not visually, he then transferred the plan into perspective to see how it affected the foreshortening of the shell and the alignment of the figures. Eakins must have learned from experience how these diagonals translated into angles on the picture plane, but elements of trial and error or surprise no doubt accompanied these moments of transfer from plan into perspective. This decision, in negotiation with the effects of viewer position and the placement of the figures in depth, was critical to each of the rowing pictures, where the central pictorial challenge involved the situation of an extremely odd object—thirty-six

111. *The Schreiber Brothers: Perspective and Plan*, 1874 (cat. 146).

feet long and fifteen inches wide—in a position that was both interesting and informative.

Once the basic grid was established in space, Eakins confirmed his graphite lines with a system of colored inks described by Eakins in his own drawing manual and reiterated by Bregler in his annotations on cat. 147. Although the inks in this drawing are much faded, making the blue net of the perspective grid difficult to read, Eakins' strong black contours around the principal landscape elements remain telling. Still in graphite are the shadows and reflections, which were sometimes added in wash in his other drawings.

Reflections, especially across choppy water surfaces, held a special fascination for Eakins, and their importance in all his rowing and sailing paintings surely contributed to his persistent interest in these subjects throughout the early 1870s. The drawing for *The Schreiber Brothers* demonstrates the principles of reflection and wave pattern outlined in his drawing book (see cats. 125–128). These forms could be generated geometrically, like the contours of the bridge or the boats; they do not seem to have been studied outdoors, as part of his observation on the scene. Although sketched summarily in the drawing, the reflection appears with greater crispness and detail on paper than in the final painting, where the brushwork deliberately breaks up the contour for a livelier, more naturalistic effect. Likewise the drawing describes the refraction of the oars as they pass under the water, an optical nicety sacrificed to the necessary roughness of the painted water surface in the oil.

The second *Schreiber* drawing also tells us other details about the painting that have been obscured by the darkening of the canvas. The perspective suggests a barge at mid-river, 260 feet away, and clearly depicts a boat moored under the bridge, 120 feet distant. Six figures occupy the boat, including a dog perched alertly in the bow and a fisherman in a white straw hat in the stern. Knowing Eakins' fondness for portraiture, even among the secondary figures in his paintings, it is tempting to identify Benjamin Eakins in his familiar straw boater in the stern and an Eakins family pet in the bow. The drawing also shows that this boat, although largely obscured by shadow or the oarsmen themselves, was as carefully measured in plan and plotted into perspective as the shell. This boat, like the barge in the middle distance, may have been inserted as a spatial marker for the eye to measure the space and increase the sense of distance found "wanting" in the earlier Biglin pictures.

The third drawing for *The Schreiber Brothers* (cat. 148) was made at the same scale as the perspective view (cat. 147) and is dotted with pinholes, probably indicating transfer of the major grid points and contours to the final canvas. No accounts survive to tell us exactly how Eakins accomplished this. Pinholes in his drawings are often just the record of his drafting tools, but sometimes (as in *The Fairman Rogers Four-in-Hand*) the pattern of holes can be matched to pinpricks in the canvas. Evidently these small holes were sufficient to locate the most important or difficult forms,

which were then painted with reference to the drawing. Al-though a graphite sketch is visible beneath some of these oil sketches, such as that of Max Schmitt (see fig. 113), and ruled lines indicating the major axes of the painting can be seen in some finished paintings, Eakins did not recapitulate the per-spective drawing on the canvas, and in fact he used graphite sparingly, if at all, on these finished works. The verso of some drawings, such as cat. 177—of the Chippendale chair seen in *William Rush Carving*—seem to have been rubbed with chalk or graphite to create a pigment surface that could be transferred by tracing. The perspective drawing of *The Biglin Brothers Turning the Stake* (fig. 112) has also been treated in this fashion, which suggests that it was used in the creation of the lost watercolor of this subject, *The Pair-Oared Race.* Slight differences between the oil and the drawing may indicate improvements intended for the watercolor: Eakins sharpened the distinctions in body posture between John, who sits erect and braces his oar to keep it steady as a pivot, and Barney, who leans back, pulling on his oar to turn the scull around the stake. The Biglins' coordination at this tricky moment was a measure of their excellence that Eakins wished to explain clearly. The redrawn contours on the drawing, probably produced in tracing the design in transfer, reiterate his concern while illustrating a technical procedure otherwise invisible in Eakins' work.[15]

Finally, the transfer drawing for *The Schreiber Brothers* indicates the edges of the canvas, rarely shown in drawings from the early stages of work. The determination of exact size and shape came late in his planning in response to the forms within the picture. As a result, Eakins' subject pictures are rarely on a conventional, prestretched canvas, and while round numbers and premeditated proportions sometimes occur (as in *The Pair-Oared Shell*, a neat 24 × 36 in.), eccen-tric sizes are more common (like *The Schreiber Brothers*, an odd 15 × 22 in.).

This last *Schreiber* drawing is almost empty, save for its spidery grid and a few annotations in French that signal the vitality of his Parisian experience and perhaps the impress of perspective classes at the Ecole. This emptiness must have been filled, in the final canvas, with the help of other preparatory work, probably in oil, painted outdoors, to orga-nize general compositional strategy, landscape backgrounds, or tonality. For all the rowing pictures, only three such sketches, including *Sketch of Max Schmitt in a Single Scull* (fig. 113), have survived to represent a class of work that must have been more numerous.[16] Surely many sketches were painted outdoors, using models; others were done from mannequins. "When I came back from Paris," he remembered, "I painted those rowing pictures. I made a little boat out of a cigar box, and rag figures, with the red and white shirts, blue ribbons around the head, and I put them out into the sunlight on the roof and painted them, and tried to get the true tones."[17] Such studies for color and light must have been brought into play once the final perspective grid had been transferred to the canvas and the actual painting commenced.

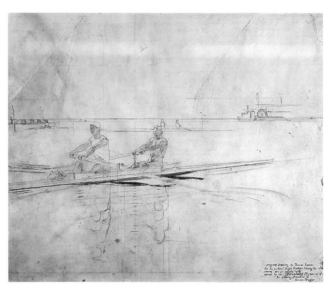

112. *The Biglin Brothers Turning the Stake,* c. 1873, pencil and brown wash on paper, 13$^{15/16}$ × 17 in. (35.5 × 43.1 cm), © Cleveland Museum of Art, 1997, Mr. and Mrs. William H. Marlatt Fund, 42.1066.

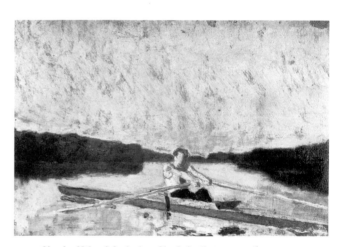

113. *Sketch of Max Schmitt in a Single Scull,* 1871–74, oil on canvas, 10 × 14¼ in., Philadelphia Museum of Art, Given by Mrs. Thomas Eakins and Miss Mary Adeline Williams.

In addition to the sketch plan of the scull seen at the upper right of fig. 111, Eakins probably had a more precise, measured drawing of a pair-oared shell, similar in size and finish to the plan of a four-oared shell seen in cat. 149. Be-cause he had painted pair-oared shells several times by 1874, he may have used an older drawing for *The Schreiber Brothers* or—as Charles Bregler suggested—borrowed drawings from a boatbuilder to ensure the accuracy of his picture. "A boat is the hardest thing I know of to put into perspective," said Eakins. "It is so much like the human figure. There is some-thing alive about it."[18] The boats in his paintings, endowed with this vitality, are all portrait subjects, like the supporting actors and onlookers of his figure compositions. A connois-seur of boats, Eakins found a racing scull particularly fasci-

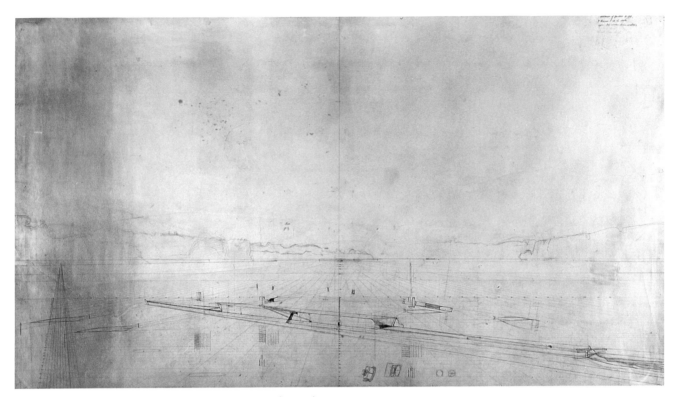

114. *Oarsmen on the Schuylkill: Perspective Drawing*, c. 1874 (cat. 150).

nating, perhaps because of its specialized design, recently "brought so near perfection" by modern engineering as to make rowing "more or less of a science."[19] A New York art critic, reviewing the watercolor exhibition of 1874, praised Eakins' rowers, with their "beautifully ugly muscles," and declared that the "skeleton boats" they rowed were the "only exquisitely artistic production of the American nineteenth-century mind thus far."[20] This streamlined, functional beauty impressed Eakins as well: "It requires a heap of thinking and calculating to build a boat," he said, and it required no less study to paint one correctly.[21] The intensity of this concern, invested into a large perspective drawing like *Oarsmen on the Schuylkill* (fig. 114), indeed gives an eerie life to the empty shell, which floats like an alien spaceship on a wide and vacant reach of the river. The power of this machine on Eakins' imagination, added to the challenge to depict it in space, surely explains his return to this subject so many times in these four years. Most of his perspectives in this period contain boats, and the most amazing drawings in this class, such as *Oarsmen on the Schuylkill*, are always devoted to racing shells.

The perspective of *Oarsmen on the Schuylkill* has been pricked with pinholes, like cat. 148, probably indicating transfer of the design to the canvas of the same scale (fig. 115).[22] Eakins had not painted a four-oared shell before this picture, which may explain the fresh elaboration given to the subject in his drawing. Perhaps he was inspired by the victory of the "Pennsylvania Barge Club Four," which included his

old friend Max Schmitt, in the one-and-a-half-mile straight-away race versus the Quaker City Rowing Club held during the Schuylkill Navy's Fall Regatta, 26 September 1874. According to the *American Rowing Almanac*, the winning crew was Oscar F. West, rowing bow, and Frank Henderson, Max Schmitt, and John Lavens, Jr., at stroke. Max is easily identified, second from the right; the other men, previously unknown, can now be named, although they figure nowhere else in Eakins' work.[23]

The small sketch of Max in a single scull (see fig. 113) seems to have provided the landscape background for *Oarsmen on the Schuylkill*. Tellingly, the pencil contour of the tree line in the perspective drawing breaks in the center, exactly where Max's head interrupts the horizon in the sketch, although the panorama of the river is wider and the eye level slightly higher in the painting. Although the landscape is unfinished in the oil and only summarily outlined in the drawing, this broad reach of the river could have been found only above the Columbia Bridge looking northeast to Laurel Hill. The viewer, although seemingly on the water too, could easily gain this vantage from a seat on the bank of Peters Island.[24] The shell is turning slightly toward the shore at the left, in the direction of the bow oarsman's gaze. The light comes from low in the west—Susan Eakins described it as "sunset"—and the crew seems to be enjoying an early-evening practice. By not showing the actual race and instead featuring a moment of unhurried, almost contemplative teamwork, Eakins returns to the tranquil mood of *The*

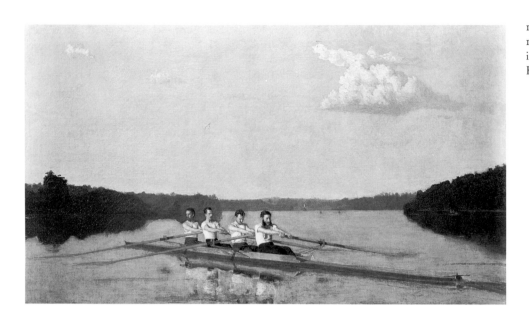

115. *Oarsmen on the Schuylkill*, c.
1874, oil on canvas, 27⅝ × 48¼
in., priv. coll., photo courtesy of
Hirschl and Adler Galleries.

Champion, Single Sculls, which was, like this painting, a celebratory portrait more than a sporting scene.[25]

Although the format of *Oarsmen on the Schuylkill* recapitulates the structure of *The Pair-Oared Shell* and *The Schreiber Brothers* in showing a shell moving diagonally into the left distance, the drawing reveals new "thinking and calculating" as well as a creative reuse of old solutions. The longer shell—about forty-two feet, according to the plan—inspired a larger canvas, wider in relation to its height than any of the others.[26] In keeping with this larger size, the viewing distance is long (six feet, like *The Pair-Oared Shell*), and the viewer's eye level returns to the thirty-six-inch horizon used in that picture. Also like *The Pair-Oared Shell*, the rudder grazes the thirty-foot line in the distance, which puts the feet of John Lavens, rowing stroke, "42 ft. off." Schmitt's torso is therefore about forty-eight feet away, near the one-eighth scale line. He becomes, like the bow oarsman in the two earlier paintings, the artist's easiest and no doubt first reference point among the figures. The most difficult recalibration in this painting seems to have been the angle of recession of the shell, which has been manipulated in order to show the figures linked together as a unit while displaying as much of each individual's pose as possible. The angle of the boat on the plan is 60 degrees, a few degrees shallower than the angle of the earlier shells. This course, unlike the paths of the other boats, does not translate into a tidy slope across the grid of the plan, indicating that for once Eakins had to invent a "customized" trajectory in order to answer the special needs of this composition.

Eakins never finished *Oarsmen on the Schuylkill*, although it was sufficiently complete to sign and give away to the club. As Siegl has noted, the painting lacks detail in its reflections, and—although nothing shown in the drawing has been left undescribed in the oil—there is a certain emptiness in the landscape and water that calls for additional work. As with

many of his portraits, Eakins may have had trouble getting all of his sitters to pose long enough, and—as Siegl has suggested—the prospect (if not the results) of working from photographs chilled his interest in further work on the canvas.[27]

The elegiac air of *Oarsmen* may also express Eakins' mood as he came to the end of this series of rowing pictures. He had tried many variations on the subject, and he was pleased by his progress. Sending his "little picture" (probably *The Schreiber Brothers*, fig. 109) to the NAD's jury in the spring of 1875, he felt confident that it was "better than those Biglin ones," although not without faults. "The picture don't please me altogether," he wrote to Earl Shinn. "I had it too long about I guess. The drawing of the boats & the figures the construction of the thing & and the peculiar swing of the figures rowing pair oared the twist of the starboard oarsman to one the other side & the port to the other on account of the long sweeps are all better expressed than I see any New Yorkers doing but anyhow I am tired of it. I hope it will sell and I'll never see it again."[28]

The picture did not sell. It was returned to Eakins prior to the exhibition's opening, having been rejected by the NAD's jury. Stung, Eakins insisted to Shinn that it was a "much better figure picture than any one in N.Y. can paint." The response of the Academy's jury may have diminished his interest in rowing subjects, however, and soured his appreciation for *The Schreiber Brothers*. At the same time, he was running out of new permutations, having exploited all the most legible and graceful perspective solutions and most of the equipment and personnel at hand. Meanwhile, new projects, most notably *The Gross Clinic*, rose up in 1875 to occupy his time and imagination. Eakins' passion for perspective would never die, but it would never again be so freely indulged; it would not drive his interest in a subject and motivate variants as it did in the four years that produced the great rowing paintings.

CHAPTER 13 "Original and
Studious Boating
Scenes"

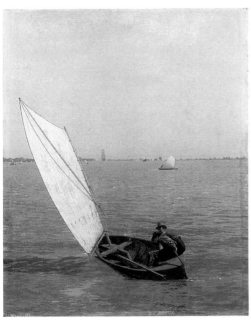

116. *Starting Out After Rail*, c. 1874, oil on canvas, 24 ×
20 in., Charles Henry Hayden Fund, Courtesy of the
Museum of Fine Arts, Boston.

The love of boats expressed in Eakins' rowing paintings extended to other classes of sporting vessels, inspiring a second series of paintings, launched two years after the first rowing picture and carried two years longer, until 1876. The concerns of this new group were related to the earlier series: all offered novel, contemporary figure subjects, required special attention to details of costume, pose, and equipment (especially boats), solved intriguing problems in perspective, and grappled with outdoor light. Eakins' effects in this new group were more diverse, and his efforts—especially in the realm of plein air painting—are more thoroughly documented by material in the Bregler collection. Drawings, oil sketches, and manuscripts together give unusual access to Eakins' process as he went hunting and sailing after artistic material on the Delaware River.

The pursuit began in the fall of 1873. The onset of the rail-hunting season, about the first of September, drew Eakins and his father, as in many years past, to the marshes south of Philadelphia or to wetlands forty miles downstream, where the Cohansey River emptied into Delaware Bay, near Fairton, New Jersey. The family rented or partly owned a "Fish House" near Fairton that served Eakins as a camp for sailing, swimming, fishing, and hunting until he was almost seventy.[1] Susan Eakins remembered that her husband was "a good sailor, managing the small gunning skiff on the Delaware River" for the trip south, often aboard "at four o'clock on the way to the marshy Jersey shores, where he could study the color and character of the scene" and "at times join the gunmen in their shooting."[2]

Eakins made such "color and character" studies on the scene in the late summer and early fall of 1873, until he contracted malaria while hunting. Delirious with fever for two months, he recovered slowly and was not able to take up his arrested projects until late fall. "The doctors believed that I would die," he wrote to Gérôme the following spring. "When I came to myself, the trees no longer had leaves. For a long time I was too weak to work and my mind was also feeble. Finally, I took up my work again from the few studies that I had made and impressions that were no more recent."[3] By January 1874 he had recovered sufficiently to produce his first—and finest—watercolor on sailing, showing the departure for the "Ma'sh": *Harry Young, of Moyamensing, and Sam Helhower, "The Pusher," Going Rail Shooting* (also known as *Starting Out After Rail*, fig. 65), which was exhibited late that month among his entries at the American Watercolor Society's annual show in New York.[4] Because this was Eakins' debut at the watercolor exhibition, his normally cautious preparation must have been additionally fastidious. Most likely, this watercolor followed on the oil of the same size and subject, *Starting Out After Rail* (fig. 116), probably finished late in 1873, and certainly both were based on the same perspective drawing, cat. 152, *Partant Pour La Chasse* (fig. 117).[5]

The pictorial problem developed in these pictures and in the preparatory drawing was one of Eakins' favorite chal-

131

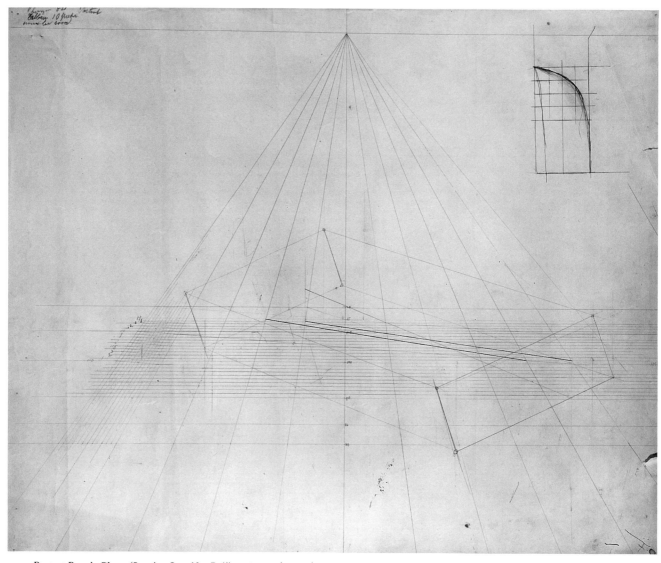

117. *Partant Pour la Chasse (Starting Out After Rail)*, c. 1873–74 (cat. 152).

lenges: "I know of no prettier problem in perspective than to draw a yacht sailing," he wrote a decade later in his perspective manual. "Now it is not possible to prop her up on dry land so as to draw her or photograph her, nor can she be made to hold still in the water in the position of sailing. Her lines, though, that is a mechanical drawing of her, can be had from her owner or her builder, and a draughtsman should be able to put her in perspective exactly."[6] Eakins made his own measured sketches of a boat like the one shown in *Starting Out After Rail* (cats. 164–167), and he probably borrowed more detailed drawings from James C. ("Jim") Wignall, a well-known Philadelphia boatbuilder who received this watercolor from the artist.[7] The boat that Young and Helhower sail is a classic example of a "Delaware ducker," a multipurpose small boat indigenous to the Delaware River basin. Normally about fifteen feet in length and four feet in breadth, the Delaware ducker is a round-bottomed, double-

ended boat, "clinker built," with tightly overlapped "lapstrake" siding. Although its origins are vague, the ducker grew fashionable as a racing boat in the 1860s, reaching a zenith of popularity in the 1880s, when it was a commonplace on the river and in the tidal marshes. A ducker—seen in *Starting Out After Rail* rigged for sail like a catboat, with a centerboard and only a stern deck—could be quickly "unstepped" for use in rail shooting, when its shallow draft and maneuverability adapted it to pushing through shallow water with a gunner standing amidships.[8] Many hours spent in such a hunting skiff and many conversations with boatbuilders like Wignall must have taught Eakins the virtues and idiosyncrasies of the ducker and enlarged his appreciation of it as a distinctively American regional boat type, which had recently developed in response to local needs and conditions. The ducker, like the rowing shell, was an emblem of modern sport and of Eakins' personal and collective

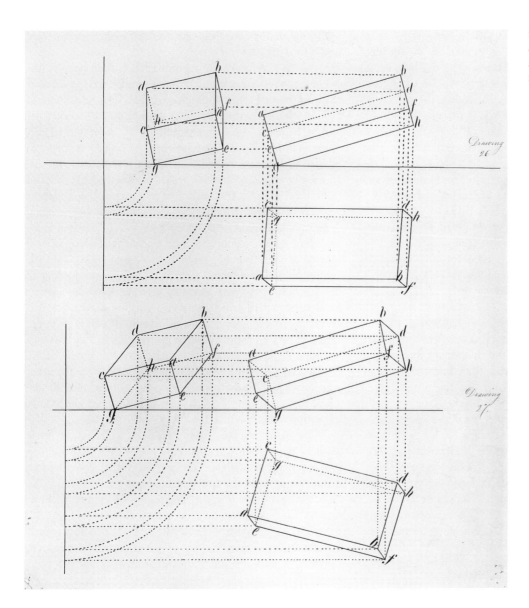

culture. Just as Gérôme's oarsmen on the Nile found an American equivalent on the Schuylkill, the conventionally picturesque boats of European landscape and genre painting found a native equivalent in the Delaware ducker.

The boat type itself, so carefully described, bore an implicit local narrative, but Eakins included accessories to better explain the activity: a shotgun leans against one of the ribs of the skiff, a squarish wooden case (most likely a gunning or cartridge box) lies next to the centerboard trunk, and a pushing pole is tucked under the forward brace, the button-end of its fourteen- or fifteen-foot length extending past the stern. To a knowledgeable observer, these details revealed the men's intentions as clearly as the title.

Eakins' "pretty problem" in perspective then lay in the artful placement of the boat (and the viewer) so that these fine points of construction scenes and gear could be clearly read. Information from the boatbuilder's plans or his own measured

drawings was used to project the boat in perspective, under specific conditions of wind and water. "A vessel sailing will almost certainly have 3 different tilts," continued Eakins' exercise. "She will not likely be sailing in the direct plane of the picture. Then she will be tilted over sideways by the force of the wind, and she will most likely be riding up on a wave or pitching down into the next one. Now the way to draw her is to enclose her in a simple brick-shaped form, to give in mechanical drawing the proper tilts one at a time to the brick form, and finally to put the tilted brick into perspective and lop off the superabounding parts."[9] The ink illustrations accompanying this exercise (fig. 118; cats. 123, 124) seem to have been based on *Starting Out After Rail*. According to McHenry, Eakins "used his own pictures as examples of the exercises on boats," and he may have referred to both the painting and the diagrams in class.[10] The diagrams, in abstracting the problems of the three tilts, demonstrate clearly

the amount of Eakins' calculation in advance of any actual observation. An expert, as Eakins reminds us in his text, "would not have got the tilts by drawing at all, but would have figured them out from trigonometric tables."[11]

Perhaps derived from such calculations, the tilts were nonetheless predetermined by a visual preconception: the wish to have the boat move diagonally up the picture surface at an angle of about 20 degrees, and the need to heel the boat over so that the frame of the boat and its contents are well revealed. The combination of two- and three-dimensional geometries in this painting creates one of Eakins' most abstract and subtle compositions, artfully balanced without obvious organizational schema. The vertical axis of the perspective, for example, is wittily acknowledged with a splash of water, but it remains unobtrusive, and every other compositional line moves evasively away from the corners. The result is austere, contrived, and yet seemingly natural, like the serendipitous gaze of a bystander.

The actual perspective drawing, although less easily read than Eakins' diagrams, tells much about the particular artifices of this composition, such as the level of the horizon line (a very high eighty-four inches), the viewing distance of the painting (a very long ten feet) and the scale of the figures (one-eighth life, on a line eighty feet distant). The unusually high viewing position, about two feet above the eye level of a person standing along the water's edge, allows us to look down into the boat. It also puts the horizon line slightly above the center of the picture and spreads a large and shimmering piece of the river's surface beneath the eye. Eakins probably took this position on a wharf along the Delaware, presumably below Philadelphia near Moyamensing, where Harry Young lived.[12] The men must be heading downstream toward the "Schuylkill flats." Behind them, in the distance, the Gloucester ferry heads west across the river. The strong light off the water and dark shadows on the boat tell us that it is midafternoon. Harry and Sam must be planning to arrive before a late-afternoon high tide in order to enjoy two hours of hunting in the red and gold twilight seen in *The Artist and His Father Hunting Reed Birds in the Cohansey Marshes* (fig. 119; plate 10).

On board for a similar expedition, Eakins sketched on a piece of letter paper the profile of the New Jersey shoreline as they moved south (cat. 153), and the figure of his father, seen in the distant sailboat (cat. 154). Another pencil sketch records cloud forms, with descriptive notes (cat. 171, "sun wrong side looking West"; "These clouds very delicate / hard to see"). A memorandum on the margin of a boat plan (cat. 167) proposes that "when the sun is nearly down / & the whites are oranges & equal in / tone to the sky & flesh is deep red and yellow / in lights & [?] gray in shadow / Make a view looking near north or south." Such ideas and observations on the scene must have been enacted in color sketches in oil (such as fig. 120 and cats. 233–234 from about this time), although none have survived for this particular composition. These details and color notes probably were integrated with

modeling sessions once the perspective had been transferred to the final canvas.

Eakins' careful planning produced a tour de force of linear and aerial perspective, dazzlingly precise in its execution of foreshortened forms and reflected light. The refinement of Eakins' preparation was noted by Earl Shinn, who called attention in his review of the exhibition to "some remarkably original and studious boating scenes" by Eakins, a "new exhibitor, of whom we learn that he is a realist, an anatomist and mathematician; that his perspectives, even of waves and ripples, are protracted according to strict science; and that his teacher, M. Gérôme, praises his execution of water as being done in 'a charming, very strong style which I cannot eulogize too highly.'"[13] Shinn, himself a student of Gérôme, had learned of these remarks from Eakins, who had shared the contents of a letter from Gérôme in 1873. In responding to the gift of a watercolor depicting a rower, Gérôme had offered constructive criticism along with praise.[14] Eakins followed this exchange with a new shipment of paintings in the spring of 1874, including another gift (see fig. 64) and two oils intended for Gérôme's dealer, Goupil's, or the annual Salon. One of these paintings was *Starting Out After Rail;* the other may have been *The Artist and His Father Hunting Reed Birds.*[15] These two pictures probably appeared at the Salon the following spring under the title *Une Chasse aux Etats-Unis.*[16]

The Artist and His Father Hunting makes a narrative pendant to *Starting Out After Rail,* for it shows the hunt in progress many hours later. The artist's father, appearing in a distant vignette in the first painting (with Eakins implicitly on board), now stands in the foreground, his experience honored in the inscription written across the bow of the boat: BENJAMINI EAKINS FILIUS PINXIT. Like the similarly inscribed *Chess Players* (see fig. 9), this picture pays tribute to Benjamin's pastimes and skills, shared with his son since boyhood.

These hunters have gathered in pursuit of the elusive sora rail: "one of the finest game delicacies," rarely seen "except at or near high water." Rail can run swiftly but fly only feebly, so they are flushed out at high tide, when escape on foot is impossible and the bird must rise, "flying slowly with its legs hanging down."[17] Eakins described the hunt itself in the draft of a letter that probably accompanied the shipment of his three paintings to Gérôme in 1874. This text, discovered in the Bregler collection, contains much detail, for Eakins knew Gérôme to be an avid sportsman. Although Eakins' handwriting is cramped, his text much revised with strikeouts, and his French disorientingly free of accents, punctuation, and conventional orthography, a blunt translation of his text gives us access to the fine points of the hunt, and his own care in depicting these same telling moments.

I send you two little paintings and a watercolor. The first shows a fine hunt of my country. It is done in canoes. There are two men in each canoe, the pusher and the hunter. One arranges to leave so that one will arrive at

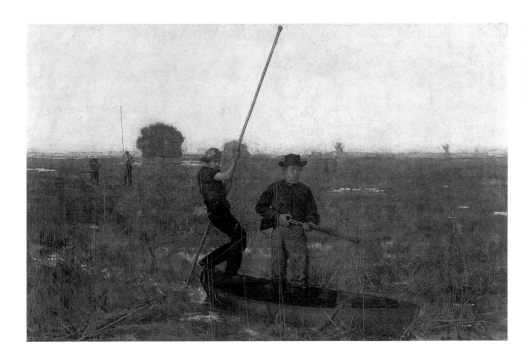

119. *The Artist and His Father Hunting Reed Birds in the Co-hansey Marshes,* c. 1874, oil on canvas, 17⅛ × 26½ in., Virginia Museum, Gift of Paul Mellon (plate 10).

the borders of the marsh two or three hours before high tide. As soon as the water is high enough to float the canoe on the marsh, the men get up and begin the hunt. The pusher climbs up on the deck and the hunter stands in the middle of the boat so that his head will not be hidden, his left foot a bit forward. The pusher pushes the boat among the reeds. The hunter kills the birds that take flight. I show in my first [or main] canoe the move-ment when a bird has just risen. The pusher cries mark and [illegible] on the deck stiffens up and tries to stop the boat or at least hold it more steady. He should not be able to stand upright, because the inertia of the boat makes considerable pressure against his thigh, a pressure that he resists with his weight. The hunter [*sic*] always calls out when he sees the bird because, for the better part of the season when the reeds are still green, he is the one who sees it first because of his higher position on the deck. He sees it often while the hunter sees nothing be-cause the reeds are tall and thick. I have chosen to show my fellows in the season of the cool nights of autumn when the shooting stars have fallen and the reeds have dried. Otherwise one would see nothing but the heads of my fellows. But the pusher calls out anyway [at this sea-son] just from habit. When a bird is killed, the hunter reloads his gun (if it was his second barrel just dis-charged) and then the pusher, having observed the spot where the bird fell, goes there and collects the dead bird by means of his net. Sometimes, while going there, other birds fly up and finally there will be perhaps a dozen birds dead before the pusher is able to pick up one, even though only one bird can be killed at a time. It is principally in remembering well the places that to a novice seem all alike after having once turned the

head, that the good pushers distinguish themselves.

The pusher's pole is fourteen feet long. At the end is a fork to engage the roots and reeds and to prevent the pole from getting broken in the mud. At the other end is a knob, so that the pole won't slip between the pusher's hands. The pusher always looks ahead and plants his pole so that the resistance of the boat will be equal against his two feet. Then the least additional pressure on one or the other foot will turn the bow of the canoe to the opposite side.[18]

Although an incomplete translation of this text has been known, two more pages of notes in French, never before seen, also emerged from Bregler's portfolios. These addi-tional remarks, probably drafted for inclusion in his letter to Gérôme, reveal the special problems of outdoor color and light that Eakins had been struggling with since *A Street Scene in Seville* of 1870. At the top of the page he began with a statement that may, in fact, have been added as his conclu-sion: "One ought to know the place where a picture will be shown before it is begun. In what color [of light], likewise." His further remarks concerning "mes deux tableaux" sound like a comment on the contrasting qualities of light in *Start-ing Out After Rail,* with its blue sky and strong light, and *The Artist and His Father,* with its warm, lowering sun. In each case, the color harmonies were destroyed when the picture was moved into another light.

If I had a blue sky and yellow clouds, the clouds a little more luminous than the sky, and if I had painted it in a warm light, when I carry my study where it will be illu-minated by reflected light from a blue sky, suddenly these same clouds become darker than the sky instead of being more luminous.

Even the impact of a white light mixes up my colors. A day growing very dim illuminates blue long after ceasing to illuminate yellow and red.

I painted my two pictures in a very strong light and a warm enough one, in a reflected light that shone on the houses. A feeble light then darkened my colors, but a blue light destroyed them. I might have been more sensible to have taken a middle road, to have chosen to work on a day neither strong nor weak, with a light completely white.

What is the practice of the best painters? Is there a conventional solution?

This is the rail that takes flight. ~~I remember well I have not forgotten what~~

I have drawn it first in profile. Its thorax is rather short.[19]

Eakins restated this dilemma on the bottom half of the third page of notes:

If I have 3 principal tones. A, B, C.

The first is a place where the sun shines directly. A.

The second is a place where the sun does not shine, but it receives [reflected] light from the sky and illuminated things. B.

The third is a hole where one sees no light. C.

If I fix these three tones correctly in a strong light and then carry my study into a weak light B darkens and grows closer to C and makes a dusky and disagreeable effect.

On the contrary, if I set my three tones in a weak light from memory of the effect seen in sunlight, and if I carry that study into stronger daylight, B draws too close to A and my effect appears weak.

Between these limits, where does one settle? ~~Perhaps one ought to~~[20]

Eakins' description of a picture painted in a weak light, from memory of an effect seen outdoors, suggests the twilight of *The Artist and His Father,* made after his illness using such studies as fig. 120 and the memory of earlier "impressions." This study, although used at the same scale in the painting, was transposed into the darker, redder tonality of the painting, done in the studio. Working in this way, from studies and from memory, he must have felt even more helpless in controlling the effect of a different light on the painting once it was finished. His illness, and the halt in further work outdoors, explained some of his difficulties, but the larger question—of varying light—remained unanswered. Searching for a "middle road" between extremes or a "convention"—a rule-of-thumb used by the "best painters"—Eakins realized that the illumination of the painting could never be controlled or even anticipated unless the installation of the picture could be known in advance. For outdoor subjects, the threat of later exhibition in a darkened (if not gaslit) interior remained inescapable.

The conversation with himself—or Gérôme—implied in this letter was continued more decisively in remarks in his Spanish notebook that suggest the vitality of these issues as early as 1870, or—more likely—the use of this pocket notebook for memoranda as late as 1873 or 1874. Noting the same tendency for halftones to bleach or consolidate in very strong or very weak light, Eakins concluded that to do well he had to commence with the highlights and the flesh tones, fix their relations and then reconcile himself to losing distinctions in the shadows.[21] Observing that his "picture of Max" (probably fig. 107) was "ruined" by exhibition in a very strong light, he determined to key up his paintings, which may explain the bright colors in his outdoor scenes of 1873–74, such as *Baseball Players Practicing* (plate 2) and *Starting Out After Rail* (see figs. 65, 116). His sense of resolution in these notations may explain why Eakins did not mention this dilemma to Gérôme, who offered no advice on the subject when he wrote to Eakins in September 1874. However, in contemplating a letter to Gérôme, Eakins rehearsed in writing an internal monologue that gives us a rare glimpse into his concerns, his problem-solving style, and his wish to control color and light as systematically as he managed form and space.

If frustrated, Eakins was not discouraged. By the following spring he had exhibited another hunting subject in watercolor, *Whistling for Plover,* and completed two related oils for inclusion in his 1875 shipment of paintings to Paris (*Whistling for Plover* and *Pushing for Rail,* fig. 121). An oil sketch of rail birds and two unfinished canvases, *Hunting* and *Landscape with Dog,* are probably from this same period of activity in 1874.[22] All such projects seem to have been halted, like the rowing series, by the commencement of work on *The Gross Clinic* in 1875, but in 1876 Eakins returned to the subject for at least one more essay. Perhaps the onset of the season rekindled his interest: "I have started a new picture of rail shooting & it promises very well," he wrote to his fiancée, Kathrin Crowell, in August 1876. "It is the best I have ever made. Billy Sartain thinks it very fine. Tomorrow morning if sunshiny the nigger comes to pose for me & then Billy and maybe Max Schmitt will be up to dinner & then we will all go sailing in the afternoon if clear."[23] Eakins' pride, and his references to a black model, both point to the painting completed in 1876 and exhibited the following spring at the National Academy of Design as *Rail Shooting on the Delaware.* This painting, currently known as *Will Schuster and Blackman Going Shooting for Rail* (fig. 122), was also known in Eakins' lifetime as *Rail Bird Shooting,* or just *Rail Shooting,* titles that signal its intent as a summary statement of the endeavor, distilled from all his earlier images. Of all the paintings in the series, it has the largest figures (one-sixth life) and the simplest composition, within which the figures take on the quintessential poses of hunter and pusher.[24]

The poses of the two men were chosen, as Goodrich has remarked, from the right-hand pair of hunters in *Pushing for Rail* of 1874, but it is as if the moment rather than the exact compositional idea had been selected for enlargement, be-

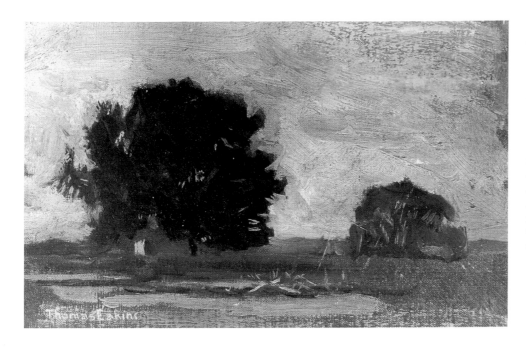

120. *The Artist and His Father Hunting Reed Birds: Marsh Landscape Sketch,* c. 1873 (cat. 232).

121. *Pushing for Rail,* 1874, oil on canvas, 13 × 30¹⁄₁₆ in., Metropolitan Museum of Art, Arthur A. Hearn Fund.

122. *Rail Shooting on the Delaware* [*Will Schuster and Blackman Going Shooting for Rail*], 1876, oil on canvas, 22⅛ × 30¼ in., Yale University Art Gallery, Bequest of Stephen Carlton Clark, B.A. 1903.

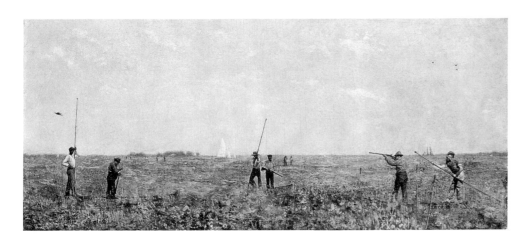

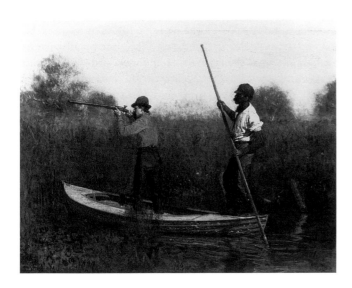

cause the figures are different in many ways.[25] Perhaps responding to Gérôme's preference for the pictures with larger figures among those sent to Paris in 1874 and '75, Eakins pulled this pair of hunters closer to the picture plane and expanded them to ten or eleven inches tall, almost doubling the height of the canvas of his earlier work. The landscape setting was completely revised, maybe because Eakins began this picture at the beginning of the rail-shooting season and wished to capture, for once, the moment described in his letter to Gérôme, when the still-green reeds stood to the shoulders of the gunner, obscuring the view of the distant sportsmen and adding immeasurably to the difficulty of the hunt. To counter this loss of distant perspective, Eakins turned his interest to the foreground, which was enlivened by a wide stretch of water. Here Eakins could indulge himself with an expert display of ripples and reflections, last enjoyed two

years earlier.[26] The emphasis on water, large figures, and a closed landscape also may have been the product of doctor's orders, for as Eakins' letter to Gérôme explained, he had been forbidden new expeditions to the marsh, and this entire picture was probably done closer to home, if not entirely in the studio or back yard at Mount Vernon Street.[27]

His restriction from hunting, added to the difficulties expressed in his letter to Gérôme, may also account for the quality of light in *Rail Shooting*. Brightly lit from a conventional 45-degree angle at the upper right, the scene has a hazy, indeterminate quality of light, unlike the precise and sometimes eccentric daylight of the earlier rowing and hunting pictures. Perhaps, in stressing local color and choosing a balanced, white sunlight, Eakins was consciously choosing *"un chemin moyen,"* hoping to avoid the tonal shifts suffered by his pictures painted in warmer, cooler, or dimmer light when they were moved indoors.

The "ideal" light of this painting matches the spirit of the exhibition titles Eakins used for this picture, which emphasize the generic activity (*Rail Shooting*) and not the participants, but the subtitle on one of his preparatory drawings names the figures—*Schuster and Wright*—and they are indeed respectfully treated as individuals, equals, and experts within the painting. Will Schuster looks like a businessman in sporting clothes, perhaps a friend of the Eakins family and typical of the city-dwelling sportsmen who descended on "The Neck" south of Philadelphia in hunting season. But his posture tells us that Schuster is no novice; rather, he is an experienced hunter, a model rail shooter. Although not a tall man, he commands his shotgun with authority and holds his precarious stance on the floor of a round-bottomed boat with poise. His placement amidships, farther back in the boat than most gunners (compare *Pushing for Rail*), illustrates his superior strength and sense of balance, as well as his excellent relationship with his partner, for this position increases his own difficulty but makes the boat easier to handle for the pusher.[28]

Dave Wright, previously known only as "Blackman" (see cat. 155), is likewise the consummate pusher. From his skill, we can assume that he is one of the many local men who worked as guides during the hunting season.[29] Graceful, almost dance-like in his posture, he holds the boat steady in the manner that Eakins described to Gérôme, his bare toes gripping the deck of the skiff, his eyes attending the outcome of the shot. In this pose, Wright expresses Eakins' verbal account of the two most difficult parts of his job: holding the boat steady while Schuster fires, and spotting the fall of the bird. Tensely alert and, like the gunner, so practiced that he seems almost at ease, Wright offers a model of sympathetic support.

The details of posture and physiognomy in his hunters, obviously studied afresh in 1876, were supported by a reconsideration of all other components of the painting, as two preparatory drawings in Bregler's collection (cats. 155–156) and another perspective drawing in the Dietrich Collection make clear. The initial figure concept was formulated in cat. 156, in graphite. Such drawings are rare, because Eakins preferred to work out figure problems in oil. As seen in his sketches for *Street Scene in Seville* (see fig. 52; cat. 145d), the skein of indecisive line seeks volume and tone, not stable contours. This kind of sketching was useful in exploring the basic placement of the figures and their relation to the horizon and the top of the canvas, indicated by trial lines on the sketch. The figure of Schuster has already taken firm shape, but his pose with the gun to his shoulder could hardly be otherwise unless a different moment in the hunt were chosen. Wright, however, could be shown in a variety of postures, and Eakins' first sketch had him leaning forward with both hands high, more like the model in *Pushing for Rail*. His hands drop in the final pose, but the steep diagonal of his pole, so important to the pyramidal balance of the composition, remains fixed. Incidental figures in the margin of this drawing may have been ideas for the more distant hunters, who were ultimately obscured by the reeds. Closer inspection reveals a comical intent in the figures at the upper right, where a small boy, his gun drooping, looks out in dismay while the pusher behind him smiles and raises his hand as if to slap his knee in delight. These figures appear nowhere in Eakins' paintings, and they may have been done for private amusement, but their humor shows Eakins' graphic expressiveness in "off-duty" moments. McHenry's description of a blackboard kept in the dining room and used by both Tom and Susie for the occasional explanatory diagram or irreverent cartoon makes us imagine that there were other such sketches in Eakins' life.[30]

The figure solution seen in this first drawing remains similar in another preparatory drawing (fig. 123) made to confirm the perspective coordinates. The horizon line has been set at sixty inches, a height that seeks Schuster's eye level and flatters him accordingly. By contrast, Eakins had used a higher viewpoint in *The Artist and His Father Hunting* (sixty-three inches, close to his own eye level) and subtly looked down on Benjamin Eakins. The viewing distance of the new picture (six feet) is longer than that of *The Artist and His Father* (four and a half feet), a revision that also has an impact on the entire perspective. Although larger in size than the Eakinses in their picture, Schuster and Wright are farther from us in space, between thirty-six and forty feet away. This greater distance, in conjunction with the lower horizon, means that we see less of the floor of their boat and follow its foreshortening with less clarity, effects that Eakins evidently desired in order to hold the relief-like processional of the design in tension with a hint of movement into space. A series of experimental lines around the composition illustrate, at the reduced scale of the drawing (which is one-quarter the scale of the painting), Eakins' ideas for the framing edges of the picture. Among all his solutions he chose the image with the longer foreground and the most closely cropped figures, and then he calculated the final size by measuring this shape on the drawing (5 1/2 × 7 1/2 in.) and multiplying by four to achieve the dimensions of his final canvas: 22 × 30, noted at the upper left.[31]

Eakins went on to map the space in greater detail in cat.

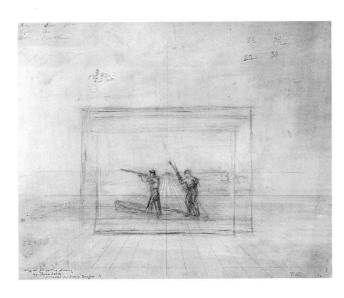

123. *Rail Shooting on the Delaware* [*Will Schuster and Black Man Going Shooting*], 1876, graphite on paper, 13¾ × 17 in., Collection of Mr. and Mrs. Daniel W. Dietrich II.

124. *Rail Shooting: Perspective Study and Plan*, c. 1876 (cat. 155, recto).

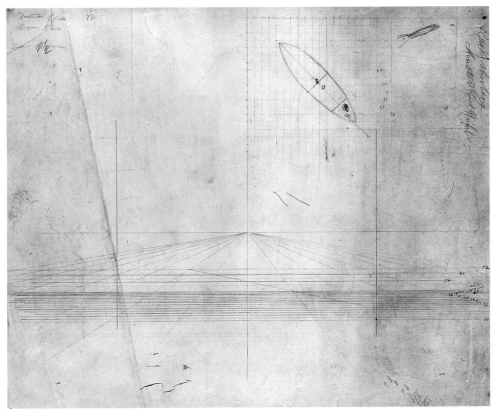

155 (fig. 124) which includes a plan and a perspective drawing. The margins of the canvas are now crisply ruled at left and right, but the top edge remains vaguely determined, and the bottom is only suggested by the commencement of the grid at thirty feet. The boat in the plan, set at a tidy 45-degree angle, does not appear in the drawing. Perhaps Eakins tested the effect of this slope, by projecting it onto the canvas, and found the recession too abrupt or the figures too crowded. As in *Oarsmen on the Schuylkill,* he had to invent a tailor-made path for the boat, more difficult to plot than the 1:1 slope on

this plan or the 2:1 slope of *The Artist and His Father*. His final resolution, which places the skiff on about a 3:2 slope (or at about a 35-degree angle), drew the bow of the boat closer to us, diminishing the speed of the foreshortening, pulling more of the boat's length into view on that side of the composition, and setting the figures slightly more apart. Eakins may have revised the boat on the canvas to accomplish these effects since they did not involve recasting the perspective, but it is more likely that he prepared another drawing, now lost, that planned these changes in detail.

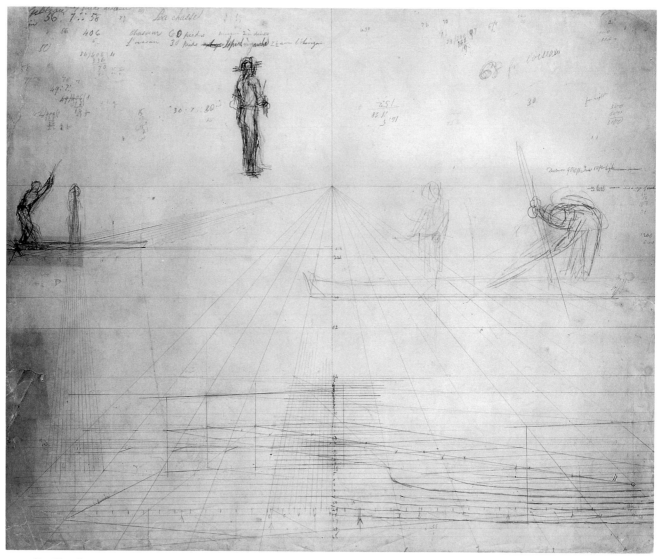

125. *"La Chasse": Perspective Study for "Rail Shooting" [?]* (cat. 158).

Rail Shooting, The Artist and His Father Hunting, and *Pushing for Rail* can all be held in the mind while reading Eakins' letter to Gérôme and while considering a group of unidentified drawings found pinned together in one of Bregler's portfolios. These six drawings (cats. 157, 159–163) and another loose sheet (cat. 158) must have been done at about the same time as the other rail-shooting subjects, for their sketches of boats and hunters have much in common with these three paintings. The most perplexing drawing in this packet is a plan scattered with short diagonal lines (cat. 157) suggesting the placement of many small boats, such as the ten different skiffs seen in *Pushing for Rail.* No configuration in this plan matches the arrangement of boats in any known painting, however, and the simultaneity of two different numbering systems on the grid makes it difficult to separate the different stages of thought that overlap in this drawing. More coherent is a large perspective drawing, cat. 158, helpfully labeled *La Chasse* (fig. 125). Pairs of hunters dot the

space of this drawing, and the foreground bears a flat "brick" in perspective, familiar enough to us from *Starting Out After Rail* to suggest the form of a boat. The diagonal of the foreground boat is likewise a familiar one (a 2:1 slope, as in *The Schreiber Brothers* and *The Artist and His Father Hunting*), while the configuration of distant boats also suggests an early draft of *The Artist and His Father.* However, a comparison of perspective coordinates reveals a lower horizon (fifty-eight inches), longer viewing distance (seven feet), and a much more distant placement of figures in space in *La Chasse,* in which the nearest boat appears between forty-nine and sixty-six feet distant.[32] Annotations tell us that the "chasseur" is sixty feet away, probably just to the right of center, and the ripples on the water at the lower right suggest the placement of a pusher's pole. Given the viewing distance of seven feet, announced in the inscription at the upper left, the pusher will be one-ninth life at that distance, or about eight inches high. The sense that the skiff is being pushed into the distance, not

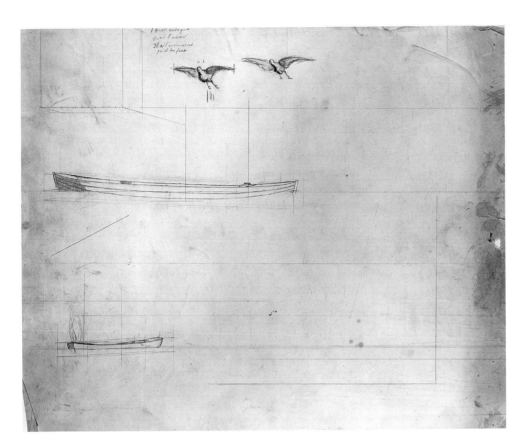

toward the viewer, calls to mind the image of Schuster and Wright, although here too the viewing distance, horizon level, and figure size do not agree (see cats. 155, 156).

Failing to find a painting that matches the configuration in *La Chasse*, we can scrutinize Goodrich's account of a lost painting, catalogued by hearsay in 1933, called *Rail Shooting* or *Gunning for Rail Birds*. Samuel Murray remembered this painting as a vertical composition, about 20 × 16 inches, and similar to *Will Schuster*. It was, he said, "painted in higher key than usual with bright blue sky and shifting feathery clouds indicative of strong wind. The reeds were semi-dry and a light Naples yellow in color. The figures were larger than in most of his gunning pictures; I would say about nine inches in height."[33] Murray recollected that the picture was lent to W. R. O'Donovan about 1892 and never seen again. While Murray's memory of the image forty years later must be allowed some vagueness, the particular format and scale that he described cannot possibly be confused with any other known painting, and the scale of the foreground boat in *La Chasse* indeed indicates figures about eight inches high.

With the lively possibility that this drawing is the key to a lost painting, we can look again at *La Chasse* and try to imagine Eakins' composition. Dropping a hunter and a pusher into place within the brick of the gunning skiff, we can also envision a second boat moving to the left in the middle distance (140 feet away, where the scale is one-twentieth). This hunter holds his gun low while the pusher bends forward, as

if to retrieve a bird—an action not seen in any of the other rail-shooting pictures. The hunter in this skiff is very loosely drawn, perhaps because his figure will be partially blocked by the foreground hunter, whose head will rise slightly above the horizon. At the left, 252 feet away (a convenient one-thirty-sixth scale), a third boat enters the picture space, the pusher energetically at work while the hunter stands alert, looking into the distance. Another figure, drawn out of scale at the top of the page, rehearses the same pose, also seen nowhere else in these paintings. According to Eakins' calculations, the orthogonals of the grid vanish about 9,080 feet away, where 50-foot trees will make a half-inch presence on the horizon. A diagonal marked "*lumière*" moves from the lower left to the upper right, perhaps indicating that "the sun" is behind us to the left, or in front of us to the right.

Other annotations indicate the presence of a bird thirty feet away, "*le pied a gauche 2 1/2 [inches] dessus l'horizon*," a spot midway between the hunter and the viewer, where the bird will appear at one-quarter scale. If this is true, and the figures are arranged as are Schuster and Wright, the hunter in the foreground must be turning to his left and firing at right angles to the boat, over the viewer's left shoulder. This novel idea is confirmed, with alterations, by the packet of drawings of boats and birds found pinned together. Cat. 159 (fig. 126) evidently depicts the two distant boats, not integrated within a single pictorial space but at the same scale used in *La Chasse* (and evidently the scale of the actual paint-

ing). Although both skiffs appear to be empty, they have been drawn with their bows raised, as if responding to the weight of hunters in the stern.[34] Two rail birds (or the same bird sketched twice) soar above the middle-ground boat, their legs characteristically dangling in flight. Further to the left Eakins drafted a *"pied cubique pour l'oiseau"* to box the volume of the bird and show the inclination of its flight. If we imagine the rail flying within this cube and install both boat and bird within the context established by *La Chasse*, the rail will appear exactly over the vanishing point, a rare emphatic coincidence in Eakins' work. Foot markers at the left of the skiff (in fig. 126) indicate, however, that the ducker has been moved: the bow now crosses the line three feet to the right of center, which would place the bird several inches right as well. This configuration must make us reconsider the position of the foreground gunner, who would have to twist almost 180 degrees to make this shot; more likely, the men must be positioned as in *The Artist and His Father Hunting*, although the gunner would now raise his shotgun to aim straight over the viewer's right shoulder. Since the boat brick is slightly more to the right of center in *La Chasse*, we can guess that the hunter's right elbow grazes the center line of the picture. This placement makes sense of Eakins' new arrangement of the middle-ground boat three feet to the right of center, where it will not be overlapped by the hunter's body. The bird, appearing just barely above the horizon, will be bracketed by the bodies of the two gunners. The light, as revealed by the shadow on the ducker, comes from low on the right; the diagonal marked lumière on *La Chasse* can now be understood as the inclination of the sun 25 degrees above the horizon. It must be early morning or late afternoon, producing the bright blue and gold tonality that Murray remembered.

Three more drawings in this group tell us more about the male sora rail (*Porzana carolina*) shown in this picture. Sketched on lined writing paper at life size, the bird flies toward us in cats. 161 and 162, foreshortened and terror-struck, as it would be seen in the painting. The "transparent" view in cat. 162, with the armature of the bird's skeleton revealed, is gridded in inches so that we can see that if the bird's left foot is placed, according to the inscription in *La Chasse*, two and a half inches below the horizon, only the head and the wings will project above the horizon. Cat. 163, showing the same bird from the side, must have been done first, before setting the form into its *"pied cubique."*

The picture we can reconstruct from a composite of these drawings must have carried an unusual effect in perspective, more extreme in the juxtaposition of objects at different distances than any of the rowing pictures. Eakins' brave concept is remarkably akin to Winslow Homer's *Right and Left* of 1909 (National Gallery of Art, Washington), which depicted two ducks in flight in the near foreground, blasted by a hunter in a distant boat.[35] The omission of *Rail Shooting ("La Chasse")* from Eakins' record books, or its confusion in these accounts with other pictures bearing similar

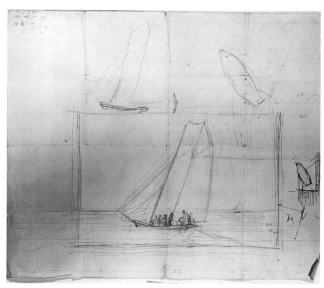

127. *Sailboat [The Vesper?]: Compositional Sketches and Plans*, c. 1874 (cat. 169).

titles, makes it difficult to know if and when it was exhibited, and how contemporary viewers judged its success. Certain clues in Eakins' letter-draft to Gérôme, such as his reference to rail birds ("This is the rail that takes flight. First I have drawn it in profile. Its thorax is rather short."), remind us of his drawings of rail for this picture and hint that this painting was one of the two sent to France in the spring of 1874. Everything in this picture tallies with Eakins' descriptive remarks in this letter, making it possible that *Rail Shooting ("La Chasse")* was one of the paintings shown at the Salon of 1875 as *Une Chasse aux Etats-Unis*.

Rail Shooting ("La Chasse") may not be the only lost painting from this period. A large perspective (fig. 127) and sketches on the back of the Schuster and Wright drawings (fig. 128) demonstrate that at least one more sailing picture was in the works. All three drawings show a double-masted yacht, much longer than the "hikers" depicted in *Sailboats Racing* (see fig. 62), with many figures on board and sometimes others watching from on shore. Eakins' letters to Kathrin Crowell in the summer of 1874 tell of work in progress on such a subject: "Ask Sam [Williams] what days the Lily comes up to town and at what wharf she stops," he wrote to her in Fairton on 22 July. "I am again disappointed in getting my drawings & measurements of the Vesper, as she is gone to Newport. I remember the Lily as being very clean in shape & if I am again disappointed I will probably try to get at the Lily. Ask him if he knows who built her."[36] A month later the *Vesper* had returned, and he tried sketching her, with little satisfaction. "I made another miserable failure with the yacht Vesper," he wrote to Kathrin on 22 August, "but she is here now for good & I am in a way certain to get her at last. My other work is all coming on finely some of it beyond expectations."[37] No further mention of the *Vesper*

128. *Sailboat*, c. 1874–76 (cat. 155, verso).

or the *Lily* appears in what little correspondence survives from this period, and no painting of a yacht is listed in either of Eakins' record books. His "miserable failures" at sketching must have been destroyed or overpainted, and the success of "other work" drew him away. But these three drawings can teach us what Eakins had in mind.

Eakins' quarry, the schooner yacht *Vesper*, 51.8 feet long, was a new boat, built in 1872 at Albertson Brothers Shipyard in Philadelphia. No accounts of the *Vesper*'s racing victories have been discovered, but the boat certainly must have been beautifully "clean in shape" to appeal to Eakins' sensibilities.[38] The largest and most detailed of these three drawings, cat. 169 (fig. 127), includes a fifty-foot boat—perhaps the elusive *Vesper*—on the plan at the upper right. Annotations on the verso imply that Eakins made at least primitive measurements of this yacht. The scale on this drawing may be a clue to the size of the painting Eakins had in mind, for the boat is seen 150 feet away, or at one-one-hundredth scale, given the viewing distance (eighteen inches) prescribed in the annotations at the upper left. If this set of factors remained fixed for the painting, it would have been very small: exactly the size blocked out on the drawing in graphite, about 7 × 11 inches. Within this frame, the image of the boat would have been about six inches across. This miniature scale suggests that Eakins intended to paint this subject in watercolors, although the finished picture would have been even smaller than *Drifting* of 1874, his tiniest finished landscape (see cat. 233).[39]

The two smaller sketches on the verso of cats. 155 (fig. 128) and 156 are less detailed, but their annotations indicate different yachts and new spatial constructions. Cat. 155 has the same horizon level (a very high nine feet) as cat. 169, indicating a viewer standing on a bank or wharf; cat. 156 meddles with an eight-foot horizon and another lower (but unspecified) perspective. The distance of the picture from the viewer is much longer in these two sketches (four and five feet, respectively), also indicating a refigured scale. The sailboat in cat. 155, between 60 and 110 feet distant, must be about 80 feet long; given Eakins' annotations, the scale must be one-twenty-fourth life, which would produce a fairly large image—about thirty inches across rendered in perspective. The yacht in cat. 156 is even larger, more than 100 feet in length, but because the viewing distance is longer (five feet) and the boat sails farther away (between 110 and 180 feet), the scale factor is the same (one twenty-fourth). The image, then, would be only 30 percent larger—about forty inches across. For Eakins, this would entail a major painting, one the size of *The Biglin Brothers Turning the Stake*, which would explain the importance of careful measurement and his wish to know the builder, so as to borrow actual plans. Assuming that a major painting of this size would not go forgotten by Eakins, we can assume only that it was never completed for lack of such details. And, like all of his other outdoor topics in 1875, it was sidelined by *The Gross Clinic* and never taken up again. Eakins continued to sail until the end of his life but he would never again paint boats, or water, with such exactness. Distracted by other challenges, he could also say that he had painted all his favorites—the racing scull, the hiker, the Delaware ducker—and painted them well, from every angle, in many lights, with great thoroughness and affection, and that was enough.

CHAPTER 14 Art and History

WILLIAM RUSH
CARVING HIS
ALLEGORICAL
FIGURE OF THE
SCHUYLKILL RIVER

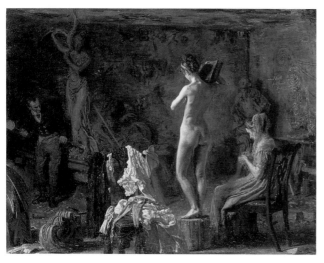

129. *William Rush Carving His Allegorical Figure of the Schuylkill River,*
1877, oil on canvas, 20⅛ × 26½ in., Philadelphia Museum of Art. Given
by Mrs. Thomas Eakins and Miss Mary Adeline Williams (plate 11).

As the American Centennial celebration approached, Eakins
began to compose a painting about William Rush (1756–
1833), a man he described as "one of the earliest and one of
the best American sculptors."[1] Eakins' painting, *William
Rush Carving His Allegorical Figure of the Schuylkill River* (fig.
129; plate 11), perhaps begun as early as 1875 and completed in
1877, was an homage to the work of this earlier Philadel-
phian, and an assertion of the legitimacy of Eakins' own
artistic methods. The picture meant to revive Rush's reputa-
tion and argue for the existence of a tradition of nude study
in the city's artistic community dating back to 1809, when
Rush installed his sculpture of *Water Nymph and Bittern* (see
fig. 135) at the Centre Square water pumping station (fig.
130).[2] The subject of Eakins' painting is Rush, but the center
of attention is the nude model, ostensibly a young woman
from polite society who consented to pose for him. The pri-
mary "Lesson" (as Earl Shinn explained) delivers the "moral"
that "good sculpture, even decorative sculpture, can only be
produced by the most uncompromising, unconventional
study and analysis from life."[3]

 This deep and direct lesson, more controversial during
the succeeding decade of his teachings at the Pennsylvania
Academy than Eakins could ever have imagined in 1877, was
gentled by a historical distance that cast the charm of nostal-
gia and the respectability and remotenesss of age over Rush's
studio practices. This historicism, although invested with
personal polemic, followed conventional academic practice
and popular taste. History painting was the most prestigious
endeavor for an academic artist of this period, and Eakins'
turn to historical themes could be expected from an ambi-
tious young painter who had already conquered modern
genre subjects and heroic contemporary portraiture. At the
same time, the Centennial celebration, bent on tracking the
progress of American culture and the formation of the
American national identity since 1776, had inspired wide-
spread consideration of the country's past. Although not the
first historical subject he completed, *William Rush Carving*
may have been the first one conceived, beginning a string of
"old-fashioned" paintings and sculptures finished between
1876 and 1883.[4]

 By his choice of subject matter Eakins was also follow-
ing in the footsteps of Gérôme, who had brought the idea of
"historical genre" painting to a pinnacle of expertise and pop-
ularity at the time Eakins studied in Paris. Gérôme was the
master of work that brought faraway times and places alive
for mid-nineteenth-century audiences, replacing the grandeur
and breadth of mural scale with a more intimate and illusion-
istic, seemingly journalistic re-creation of events and person-
alities—some famous, others ordinary. Gérôme understood
how to use perspective and scholarly detail to gain convic-
tion, and Eakins, as Shinn noted, was one of the few Ameri-
cans who likewise understood the "apparatus of hiring prop-
erties, arranging incidents, and employing models, by which
conscientious works of art are elaborated."[5] Shinn, who had
studied with Eakins in Gérôme's atelier, recognized *William*

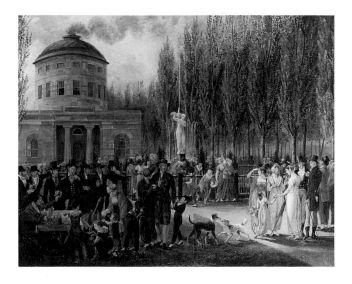

130. John Lewis Krimmel (1786–1821), *Fourth of July in Centre Square*, by 1812, oil on canvas, 22¾ × 29 in., Pennsylvania Academy of the Fine Arts purchase (from the estate of Paul Beck, Jr.).

Rush Carving as a demonstration of academic method at two levels: overtly, a description of an academic artist at work, engrossed in "uncompromising, unconventional study" from life, and covertly, an illustration of that same method, invested in the execution of the actual painting.

On the surface, the analogies to Gérôme's work are obvious: the nude herself is modeled on similar figures by Gérôme, related in pose and identical in their historical distancing.[6] Gérôme freely rummaged through history and across continents in search of plausible pretexts for the depiction of unclothed women; Eakins suffered many more restrictions in the face of an American audience much less tolerant of nudity in art. "I can conceive of few circumstances wherein I would have to make a woman naked," he had written from Paris, correctly anticipating the dearth of opportunities for nude subjects in Philadelphia. Gérôme understood his problem. "As to the question of *nudity*," he wrote to his American biographer, "it is useless to argue about it in your country."[7] In this context, Eakins' Rush subject was a truly inventive stroke, never to be repeated in his work, where figures of nude women appear mostly in studio exercises. The unusual opportunity to paint a nude in *William Rush Carving* makes a rare, direct connection to Gérôme's work, reminding us of Eakins' training and ambition at work within the confinement of his milieu. More profound, however, is the deeper affiliation of spirit between master and pupil revealed in the construction of this painting. In the elaborateness of its preparation, so well documented in drawings and sculpture in the Bregler collection, the painting becomes a manifesto of professional principles, and an homage to Gérôme.

"A subject is an opportunity to read, to teach oneself," said Gérôme. "The painter is like a historian, he ought to speak the truth."[8] In this spirit, Eakins threw himself into research on the Rush theme, tracking down "very old people who still remembered" the sculptor's vanished workshop on Front Street, and borrowing "an original sketchbook of

William Rush preserved by an apprentice and left to another ship carver."[9] Scroll studies, perhaps traced from this sketchbook (cats. 178, 189p) were foreshortened (cat. 179) and transferred to the painting to seem as if drawn in chalk on the back wall of the workshop—a practice Eakins employed in his own studio (see fig. 106). As a carpenter himself, Eakins also must have enjoyed making measured sketches of trestles (cat. 189g) to bear Rush's work. Lacking the actual workshop, he visited other woodcarvers, sketching the detail and ambiance of their environment and adding it to the information gleaned from oral history to construct a plain, plausible space for Rush's work.[10] Finally, eager to make his historical research understood and appreciated, he prepared an explanatory text and a line drawing, with the principal characters and sculptures neatly labeled, for use in the Academy's catalogue in 1881.[11]

No plans or perspective drawings for this space have survived, other than a thumbnail plan in the Washington sketchbook (cat. 189m) that suggests the model's position is eight feet in front of the sculpture of the nymph and sixteen feet forward of Rush's statue of Washington in the far corner of the shop. More elaborate preparatory drawings probably existed, given the internal consistency within the pictorial space as well as what we know about Eakins' method. Changes in scale, from one-fourth life size in the foreground to one-fifth for the model, one-seventh for the figure of Rush, and one-ninth for his sculpture of Washington, allow us to estimate the perspective coordinates established for the construction of this space. Such diminution would occur if the painting were set four feet from the viewer (about twice its width) and the foreground chair depicted as if it were sixteen feet away, with the model at twenty feet, Rush himself at twenty-eight, and the statue of Washington thirty-six feet distant.[12]

The occupants of this space, both human and sculptured, were selected or outfitted to contribute to an early-nineteenth-century historical context. The art from this period became primary source material for Eakins. Rush's

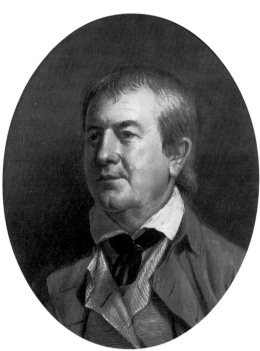

131. *Costume Study: After Rembrandt Peale's "William Rush,"* c. 1877 (cat. 188d).

132. Attributed to Rembrandt Peale (1778–1860), *William Rush,* before 1813, oil on canvas, 23½ × 19½ in. Independence National Historical Park Collection, Philadelphia.

133. *Woman with Parasol (Walking Dress),* 1875–76, pen and ink, pencil and watercolor on paper, 7¼ × 4¹¹⁄₁₆ in., Hirshhorn Museum and Sculpture Garden, Smithsonian Institution, Gift of Joseph H. Hirshhorn, 1966.

appearance and costume were from the sculptor's own self-portrait of 1822, conveniently housed in the Pennsylvania Academy, and a portrait in oils attributed to Rembrandt Peale, probably from about 1800, hanging in the old Peale Museum in Independence Hall (figs. 131, 132).[13] In this painting Rush appears in the collar, tie, and corduroy vest described in Eakins' sketch, although the remainder of his costume had to be supplied from full-length sources nearby, such as Krimmel's *Fourth of July in Centre Square,* also hanging in the Academy's galleries. Krimmel's figures seem to have set the tone for Eakins' costumes for the two women in the painting too, as many of his pocket sketchbook pages show (e.g., cat. 188a). However, many different period sources were consulted—oil portraits by Stuart, Sully, Harding, and others, sculptures by Houdon and W. J. Hubard—including several seen in Washington, D.C., in the late summer of 1877 (see cats. 188b, 189r, s, t, u, y). The model's costume, draped over the chair in the foreground, seems to have been copied from a fashion plate in a magazine of August 1807, sketched in his notebook and carefully annotated (fig. 133): "Walking dress/evening./A plain round/gown of Jaconot/muslin a walking/length with rows of/open hems around/the bottom. A/plain square bosom/sitting close to/the form, laced/up the front/& trimmed/at the edge/with twisted muslin. A/large straw/hat of the/Gypsy [?] form/tied across the/crown with/a silk handkerchief./Deep Vandyke/stock, of lace or needlework. A/black lace or Chinese/shawl, thrown/in irregular negligence/over the shoulders./straw colored kid/gloves & shoes. White/sarsnet parasol, deeply/fringed & painted in/historical devices."[14] Guided by these instructions, Eakins must have assembled a similar wardrobe of real clothing, which he

arranged with artful informality on the chair and painted with wonderful delicacy from life. The result is surely the prettiest still-life in his oeuvre, well calculated to contrast with the forms and textures of the model, whose "undress" becomes, by comparison, all the more palpable and—to some contemporary viewers—"improper."[15]

The costumes and the chalk memorandum written on the wall ("finish scrolls/for S. Girard/Augt. 13th") follow the midsummer atmosphere of Krimmel's painting and atten-

tively adhere to the calendar of Rush's work, which was installed by July 1809.[16] Eakins' inconsistencies in this program are small but notable: the two sculptures at the back of the workshop are from later in Rush's career, and the sculptor's collar, tie, and vest are ten or fifteen years out of date for his jacket and pants. In addition, Rush keeps collar, tie, vest, and jacket *on,* despite the season and his work. As Johns has noted, the curious formality of his dress presents Rush as a gentleman, not a laborer.[17] In ignoring the seasonal clues carefully supplied elsewhere in the picture, Rush's costume becomes additionally symbolic and polite, signaling the artistic quality of his undertaking as well as his respect for the ladies in his shop. It was not a nicety Eakins himself observed, for his habit of walking around the house half-dressed generated malicious gossip a decade later, and his own way of greeting portrait sitters on a hot day—wearing just old "trousers and an undershirt"—lost him at least one female client in the 1890s.[18]

Eakins' costume search must have started before the final canvas was blocked in, and he was still assimilating details in Washington, D.C., in September 1877 (see cat. 189). The actual painting of these details probably came late in the execution of the picture, in the fall of 1877. In between these two phases of work, other supporting elements had to be established, such as the two chairs that bear the chaperone and the model's clothing. These chairs (in fact the same Chippendale chair, borrowed from his friend S. Weir Mitchell, seen twice) each define a box of space that, when accurately set into perspective, offers a convincing illusionistic volume to contain the more complex human form of the chaperone or the half-disclosed, unpredictable shapes of clothing.[19] Eakins' care in setting up this spatial vessel for irregular objects and occupants is illustrated in the full-scale drawing of the chaperone's chair (fig. 134), with the geometric points of its basic construction marked with crosses, probably to facilitate transfer to a perspective grid that existed subliminally on the canvas. The principal contours of this drawing have been broadly rubbed in chalk on the verso of the sheet, perhaps to assist in this transfer process. Laying the drawing on his canvas, Eakins could have retraced the contours or the cross-marks, creating a faint chalk ghost of the chair in his oil composition. Slight alterations between the sketch and the painting, and the observant record of light and shadow on the chair, make it clear that Eakins painted it on the canvas from life once these contours had been correctly established.

The people and objects in the foreground, including the women, the chairs, and all the properties of the still life, could be constructed by this method of research, assembly, perspective organization, and life study, but the more distant items in the workshop, excepting Rush, required a different strategy. Three major objects defining both the space and the character of the shop were life-size sculptures by Rush, all installed permanently in public spaces in Philadelphia. To depict these pieces convincingly within the context of the painting, Eakins began by visiting these sculptures and

134. *William Rush Carving: Study of Chippendale Chair,* c. 1876–77 (cat. 177).

sketching them in situ, getting to know their forms and experimenting with different viewpoints. He sketched the *Allegory of the Waterworks,* installed high over one of the doors to the wheel house at Fairmount, at least three times (cats. 180, 181; Hirshhorn cat. 26.2) and the statue of George Washington at Independence Hall at least once (Hirshhorn cat. 26.1; measurements in the Washington sketchbook, cat. 189j). These few sketches seem to have sufficed in determining the vantage point for each sculpture, for they appear in the painting exactly as positioned in these drawings. In each case the most informative, frontal view was chosen, confirming the principal axis established by Rush.

The *Water Nymph and Bittern* was a more complicated story, however, because the nymph was the centerpiece of his narrative and, unlike the other two sculptures, could be easily studied from all sides. The original *Nymph* had been moved to the new city waterworks at Fairmount and installed in a niche. Nearby, a bronze replica made in 1872 served as a fountain sculpture, as in the old days at Centre Square (fig. 135).[20] Eakins seems to have studied and measured both the wooden original and the replica, although the bronze in the fountain must have been the subject of his clockwise tour of the sculpture in cat. 183 (fig. 136), which shows sequential views from four different vantages 90 degrees apart. Eakins' sense of the "elegance and beauty" of the *Nymph* must have been cultivated by this exercise, which makes the figure dance before us, revealing the succession of graceful contours

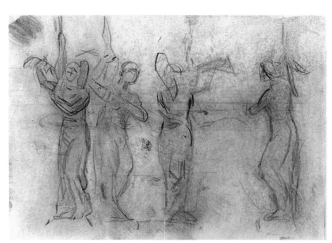

135. William Rush (1756–1833), *Water Nymph and Bittern*, 1809, bronze cast in 1872 from original wooden sculpture, 90¾ in., Fairmount Park Art Commission, Philadelphia.

136. *William Rush's "Water Nymph and Bittern": Four Views*, c. 1876–77 (cat. 183).

assumes a posture quite like the contour of his quick sketch of the sculpture in cat. 183.[22]

Although hardly exhaustive or detailed, this series of figure drawings is unique in Eakins' extant oeuvre. The full-scale *Nymph*, fig. 138, is the most developed graphite study of a figure that survives from Eakins' hand. Because we know he preferred to sketch in oil, the existence of all these pencil studies may be the result of his reluctance to paint in a busy public garden. Overall, the incompleteness of these drawings also suggests their narrow purpose as exploratory tools and their use in conjunction with other studies. What these sketches failed to capture by way of detail may have been made up by photographs, although none have survived;[23] what they lacked in chiaroscuro was supplied by another series of studies, in three dimensions (figs. 79, 139; cats. 253–257).[24]

As a measure of the seriousness of his preparation, Eakins' use of sculptural maquettes signals, again, his intention to muster all the techniques of the complete academic. For his rowing pictures he had constructed small figures to set outdoors, where he could judge the effect of sunlight on their scraps of colored cloth. But he did not undertake real modeling, after the fashion of Gérôme and many other academic painters, until the Rush project. These miniatures offered tiny studies in form that helped him understand Rush's work, and they could be conveniently turned and posed to judge the effect of different vantages. Most important, they could be used as models to paint from, demonstrating the pattern of shadow and highlight in a context quite different from the environment of the actual sculpture. They must have been fun to make, too. Given the murky circumstances depicted in Rush's workshop, Eakins could probably have done a credible job of constructing *Washington* (see fig. 79), the *Allegory of the Waterworks*, and *Rush* without recourse to aids other than his pencil sketches. But he cut no corners, and besides, the recipe for modeling wax, learned from his Academy colleague Joseph Bailly,[25] was easy, and the experience of working the warm wax must have been pleasant and inherently interesting to Eakins.

invented by Rush's composition. Eleven pages of such sketches of the *Nymph* survive (cats. 182–187, 188e, f, g, h; Hirshhorn cat. 26.3), recording many alternate views and details not used in the painting. This variety indicates, like the surfeit of unused costume sketches, the investigative nature of his sketching for this project, which must have helped Eakins teach himself about the form of this sculpture while considering how to position it within the picture. Once the rear-view position of the model had been fixed and Rush placed to her left, only a few positions made sense for the *Nymph*, in terms of logic and legibility. In an early compositional draft in oil (Yale University Art Gallery), the sculpture appears in the position sketched at the far right in fig. 136, echoing the contour of the nude model. Eakins considered this pose again, with more care and a slight change in viewpoint, in cat. 185 (fig. 137). Ultimately he decided on a more frontal view sketched at the far left in cat. 183, and then studied in more detail in cat. 187, at the same scale used in the painting (fig. 138). This vantage describes the sculpture with greater clarity, even though it forces Rush to work on his sculpture at right angles to his view of the model. Occasional photographs of Eakins at work show that he preferred painting or modeling parallel to the plane of the subject he was studying, which may explain the logic of his first orientation of the *Nymph*, although the final arrangement does not seem unconventional or awkward.[21]

As Eakins learned more about the *Nymph*, the model's pose also gained accuracy and grace. The two studies of her figure made in preparation for the oil show an indecisive contrapposto or a huddled left arm; in the final painting, she

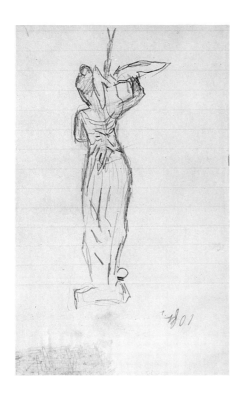

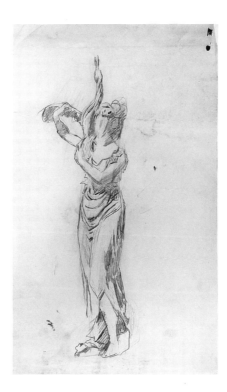

137. *William Rush's "Water Nymph and Bittern": Rear View*, c. 1876–77 (cat. 185).

138. *William Rush's "Water Nymph and Bittern": Frontal View*, c. 1876–77 (cat. 187).

139. *Water Nymph and Bittern: Study After William Rush's "Allegory of the Schuylkill River,"* 1876–77, cast in 1931 (cat. 255).

The full-length models of the three Rush sculptures were all made at a scale of about one-tenth life, although only the *Allegory* could be transferred to the painting at this size. The other two figures were enlarged on the canvas according to their placement in space. The *Water Nymph and Bittern* in the painting can be seen as the product of information in both the full-size sketch (see fig. 138) and the wax model, integrating detail from each source. Neither of these studies carried information about the *Nymph*'s face, however, which was supplied by the contours of a larger, bust-length model (cat. 256). This maquette may have been studied from the wooden version of the sculpture, for the head of the *Nymph* was the best-preserved part of Rush's original figure, even in Eakins' day. Even larger and more detailed was the portrait study of Rush (cat. 254), based on the Peale painting and the Rush self-portrait mentioned above.[26] This study head must have been useful as Eakins painted the foreshortened features of the sculptor, bent over his work.

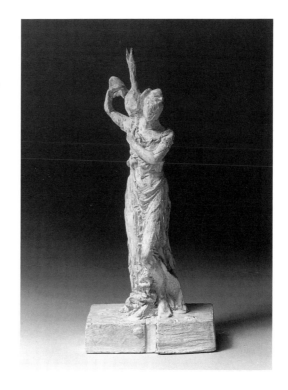

The fine detail in this portrait sculpture, for the most part lost in the diminution of the image and its shadowy context, becomes emblematic of the quality of research and preparation undertaken for the Rush project. Evidently, Eakins knew much more—about Rush's appearance, about his sculptures, about period costumes—than he could ever use in his painting. This kind of overpreparation was never, for Eakins, wasted time. Initially, it allowed him to make choices among the available facts, selecting detail he found most appropriate or interesting. Later, his knowledge gave him the confidence to generalize in places where detail would become distracting. The variable focus in this painting,

which emphasizes the central pyramid of figures and clothing and fades into sketchiness beyond, puts detail in its place. Unlike Gérôme, who was occasionally too fond of an extraneous property, Eakins was the master of his facts, willfully gathering sculptures into the studio that he probably knew dated from later in Rush's career, willfully suppressing detail that detracted from his pictorial effect. As Johns has remarked, the "off-hand effect" of the peripheral zones in this picture "reflect only their place in Eakins' scheme of meanings, not the depth of investigation with which he prepared for the painting."[27] According to Johns, this treatment of detail should remind us of the larger rhetorical fiction of the painting itself, constructed to teach us about artistic values and methods, not lecture on antiquarian "vérité." Although the model resonates with the character of a real woman, studied from life, the painting orchestrates such "realism" into a larger framework of artful picturemaking. Eakins' pleasure in the preparation itself, in research and knowledge, so evident in his drawings and sculptures, marks him as a conscientious academic, an affectionate student of Gérôme. His willingness to abandon this knowledge for the sake of pictorial effect shows him to be the master of this training, too.

CHAPTER 15 Locomotion

*THE FAIRMAN
ROGERS FOUR-IN-
HAND, 1878–1880*

Eakins gathered another medium—photography—into his method in 1878 with the commencement of work on a *A May Morning in the Park*, often known as *The Fairman Rogers Four-in-Hand* (fig. 140; plate 12). Although he may have used photographs incidentally and surreptitiously earlier in the decade, the invention of this painting was clearly inspired by photographs, and its main purpose seems to have been the incorporation of new information on animal locomotion documented in photographs by Eadweard Muybridge.

Eakins and Fairman Rogers (fig. 141), an amateur who had been photographing his own horses in motion since at least 1871, examined with great interest Muybridge's serial images of horses trotting, published in the summer of 1878. On a page of undated notes and sketches discovered in Bregler's collection, which may be the draft of a letter to Rogers in which Eakins expressed his first reaction to these pictures, Eakins commented that it was "pretty to see the sharp & blurred motion in these photographs. They mark so nicely the relative speed of the different parts" to allow for the drawing of trajectories plotting the "center of gravity curve" of the horse as it moved down the track. Sketches of galloping horses and banks of cameras accompanied his remarks, illustrating Eakins' understanding of Muybridge's setup, and ideas for improvement were already put forward. "These are a few things that strike me & you will discover many more," he wrote. "This kind of series photograph certainly opens a big field of movement study. What a fine thing it would be to walk a naked man before a Muybridge apparatus."[1]

It would not be long before Muybridge and Eakins put naked men before their cameras, but in 1878 the photography of horses held their attention. Excited by these pictures, Eakins and Rogers imagined the creation of a painting that would record, for the first time in the history of art, how horses really move. In late 1878 or early 1879, Rogers, a wealthy engineer on the Academy's board of directors, commissioned Eakins to paint a portrait of Rogers' family and his prized coach and four.[2] *A May Morning in the Park* would be first and last a painting concerned with these issues of photography and animal locomotion, but as drawings discovered in Bregler's collection reveal, it is also much more.

Most fundamentally, this painting expresses Eakins' relationship with Fairman Rogers, which has never been adequately understood. Rogers was effectively Eakins' boss from 1878 until 1881—the golden years of his rise to prominence at the Academy. Rogers replaced John Sartain as chairman of the Committee on Instruction in the fall of 1877, and within a few months he had rescinded the order that prevented Eakins from assisting in the classes of the ailing Christian Schussele (see cat. 189 o). Though still a volunteer in the fall of 1878, Eakins was officially appointed Assistant Professor of Painting and Chief Demonstrator of Anatomy, and after Schussele's death in August 1879 Rogers and his two-man committee quickly appointed Eakins full professor, with pay.[3] The painting commission—perhaps Rogers' gentlemanly way of making up for the Academy's inadequate an-

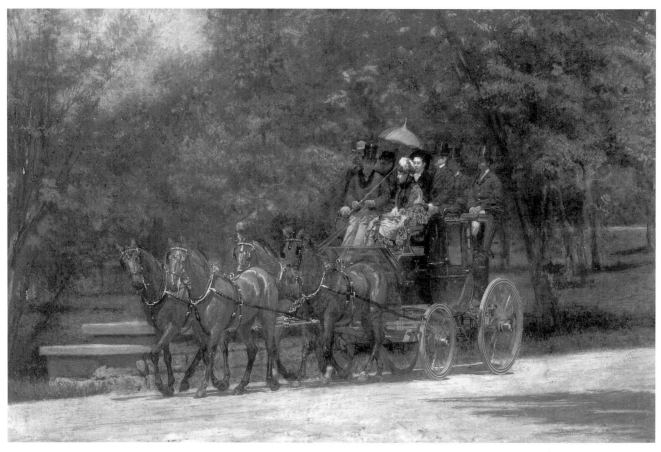

140. *The Fairman Rogers Four-in-Hand* (or, *A May Morning in the Park*), 1879, oil on canvas, 24 × 36 in., Philadelphia Museum of Art, Given by William Alexander Dick (plate 12).

nual salary ($600)—put an additional $500 in Eakins' pocket in 1880, triple the price of most of his paintings.[4] Furthermore, Rogers' support was accompanied by a sympathetic endorsement of Eakins' teaching program, including his controversial emphasis on life class, anatomy studies, and dissection. The descriptive account of the school's curriculum published by Rogers in 1881 voices Eakins' philosophy with a clarity that could have come only from brotherly collaboration.[5]

The solidarity between these two men by 1881 was based on common interests and complementary intellectual styles that bridged major differences in class and personality. Although both men were well educated, enthusiastic sportsmen, and of a scholarly and egalitarian frame of mind, willing to learn from each other gladly, Rogers must have dominated this friendship from the start, and not just because Eakins owed Rogers his job. Eleven years older than Eakins and a man who had both inherited and married wealth, Rogers already was a distinguished professor of engineering at the University of Pennsylvania. Moreover, he was charming and gregarious, with all the social skills that Eakins lacked.[6] His age, class, professional stature, and savoir faire

put Rogers at an advantage, for despite Eakins' self-confidence, he could not have been at ease among the fashionable guests at Rogers' stylish Newport "cottage," Fairholm, where *A May Morning* was first studied. Rogers' initiative may therefore lie behind this project in more ways than simple patronage might imply, leading the young Eakins in directions that he had not previously explored.

Always fond of animals, and ever the anatomist, Eakins had been interested in the depiction of figures in action since undertaking his rowing pictures. Rogers praised his "accurate anatomical knowledge" of horses in 1879 and generously asserted that Eakins "had long been studying the horse from an artistic point of view,"[7] but in fact Eakins had yet to produce a painting of a horse by this date, and surely it was Rogers' own enthusiasm that pressed his interest forward. The Academy had been teaching comparative anatomy as a minor component of Dr. W. W. Keen's lectures on "artistic anatomy," but the importance of the horse seems to have ascended along with Rogers' rise to the chairmanship of the school committee. Horses were a mainstay of the dissection room because their carcasses could be easily acquired, but Rogers energized the program by lending his own prize horses to the school for modeling sessions and offering his stud farm at Springfield, Pennsylvania, for outdoor classes in summer.[8]

PLATE XXXI.

A B C

THE SALUTE.

141. Fairman Rogers demonstrating "The Salute" on the box of his coach, from Rogers, *A Manual of Coaching* (Philadelphia: Lippincott's, 1899), plate 91.

Rogers' favorite mare, Josephine, a horse he described as "nearly as possible perfection in all her points," was one of the first models in this series, and the subject of Eakins' first horse study (and his first sculptural relief), a quarter-scale profile portrait completed in 1878.[9] Predictably (although invisibly to previous scholars), Josephine is front and center in *A May Morning in the Park*, where she appears as Rogers' near-leader (left front horse). Spotlighted by the sun, Josephine reveals the perfection of her points to maximum effect in this prominent position, which probably predetermined the position of the entire coach. Rogers, by comparison, is cast into shadow, but certainly his eyes are on Josephine as he drives, and when considering the painting itself, his affectionate attention must have been drawn always to her gleaming form, rivaled only by the brightly dressed figure of Mrs. Rogers at his left.[10] Josephine served art even in death, for Rogers apparently gave the mare to Eakins and his students to dissect in 1882, when her forms were recorded in an *écorché* relief that became a teaching pendant to the first portrait sculpture.[11] In the time between the discovery of Muybridge's photographs in the fall of 1878 and the exhibition of *A May Morning* two years later, Eakins must have undertaken such anatomical studies with directed purpose, producing many drawings like cats. 69–75. Rogers was full of approval. "The horse enters so largely into the composition of pictures and statuary," he wrote, "especially into works of the higher order, such as historical subjects, and is generally so badly drawn, even by those who profess to have made some study of the animal, that the work seems to be of value."[12]

Eakins' anatomical studies supplemented the information drawn from photographs taken by Muybridge and Rogers. With the introduction of this photographic material,

Eakins, who could have enlightened Rogers on the fine points of dissection, must have listened in turn to his patron's experience. Rogers, known for his mechanical aptitude even as a boy, was quick to appreciate modern technology. He had been experimenting with cameras since the late 1850s, and by 1871 he had designed a special shutter to use for serial photographs of his horses in motion.[13] Eakins knew some professional photographers—Henry Schreiber, Frederick Gutekunst—but he did not own a camera yet, and it seems most likely that he discovered Muybridge's work through Rogers, in a moment of electrifying surprise and delight. He fell to work making diagrams of the trajectories of movement abstracted from these photographs, which he made into lantern slides for use in class. Close study of these photographs probably suggested the idea of illustrating the full cycle of a single gait by depicting each of Rogers' four horses in a different pose taken from Muybridge's sequential photographs of the horse Edgington trotting.[14]

The Muybridge photos served as the models for the four wax sculptures that Eakins probably modeled in 1879, in preparation for this painting. All extant oil sketches and drawings show the horses in the postures they assume in these models, indicating that they were Eakins' first effort in the construction of the painting itself.[15] Typically, these maquettes are a tidy one-eighth scale, easily adapted to the scale of his preparatory drawings.

Eakins left for Newport on 16 June 1879 to stay with Rogers at his summer home, where the sculptures may have been modeled from photographs and with reference to the actual team. The coach was brought out, and he sketched it in oils against the rocky Newport landscape and shoreline, having carefully positioned the horses and the coach, or

142. *Study for "The Fairman Rogers Four-in-Hand,"* c. 1879, oil on panel, 10½ × 14¾ in., Philadelphia Museum of Art, Given by Mrs. Thomas Eakins and Miss Mary Adeline Williams.

143. *The Fairman Rogers Four-in-Hand: Study of a Horse's Leg,* c. 1879, oil on panel (cat. 244).

144. *The Fairman Rogers Four-in-Hand: Landscape Study of Fairmount Park,* c. 1879 (cat. 245; plate 13).

"drag," in advance (fig. 142). As Siegl notes, this composition, which shows the coach proceeding from left to right on a course more parallel to the picture plane, may be an early draft for the final oil or simply a preparatory sketch for a smaller painted fan that Eakins gave to Mrs. Rogers. Considering this second possibility, it is notable that "her" version emphasizes Newport—perhaps the gesture of a grateful houseguest—and eclipses Josephine.[16]

This complete view of the subject was painted on a 10 × 14 inch wooden panel that slipped into the grooved lid of Eakins' painting box. All the oil studies of the horses themselves (such as fig. 143) were on similar panels, perhaps indicating that the individual studies were done "in the field" at about the same time, probably in Newport.[17] The landscape background actually used in the painting was sketched back in Philadelphia, perhaps in the spring or summer of 1879. If actually painted in May, as the title suggests, the two surviving landscape sketches would predate the first trip to Newport, indicating that the Philadelphia setting had already been determined by this time.[18] Both sketches, including the newly discovered landscape in the Bregler collection (fig. 144; plate 13) are on wooden panels sized for Eakins' outdoor painting box. The Bregler sketch surveys the landscape exactly as seen behind the coach, neatly filling the rectangular format rather than leaving (as in his other sketches) the corners incomplete. This tidiness indicates that the framing edges of the canvas and the placement of the coach were already well in mind when Eakins visited the site in Fairmount Park. With typical efficiency, he painted exactly what he needed, altering it only slightly for use in the final canvas. The grass and heavy shadow on the drive in the foreground were eliminated or reduced, but the tonality of bright green foliage and pink road surface was faithfully transferred. Detail seen only in the final painting must indicate that Eakins returned to the site with his large canvas for careful observation of shadows and masonry construction.

In advance of these particular studies of the horses and the landscape, but some time after the formulation of the wax sculptures, came a series of compositional sketches and

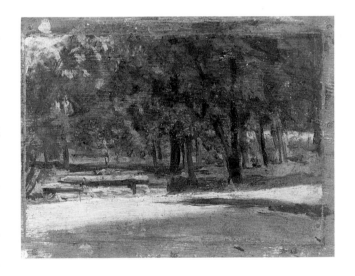

perspective drawings that tell us about the initial phases of Eakins' planning for this painting (cats. 192–196). Most remarkable in these drawings are the elements not seen in the finished painting: a pedestrian with a pack and a dog, a horseman, a Conestoga wagon, and an open landscape with distant hills, somewhat like the Newport view made for Mrs. Rogers' fan. Although it is difficult to establish the order of these drawings, the first may have been cat. 192 (fig. 145), one of the most provocative drawings in the entire collection. Rogers' four-in-hand appears at the center, cropped tightly, but at the same angle as seen in *A May Morning*, with the horses already recognizable by their gaits. A figure walks at the side of the road, to the right, followed by a dog; this same figure, drawn more clearly as a man carrying a bundle on a

145. *The Fairman Rogers Four-in-Hand: Compositional Studies with*
Boats, Horseman and Locomotive, c. 1879 (cat. 192).

147. *The Fairman Rogers Four-in-Hand: Squared Compositional Study,*
c. 1879 (cat. 194).

146. *The Fairman Rogers Four-in-Hand: Compositional Study and
Plan,* c. 1879 (cat. 193).

stick over his shoulder, appears again in the left margin of the
whole sheet. Above this figure, in similar marginal doodles,
comes a parade of transportation: a sailboat, two figures in a
rowboat, a man poling a skiff, a horseman, and one or two
locomotives. Upside down on the page is an architectural
sketch (of Newport?) lightly squared by a grid of graphite
lines, and at the lower right is the pedestal (perhaps) of an
outdoor sculpture.

These items may have been just random jottings, al-
though Eakins never seems to have sketched without pur-
pose, and at least the horseman found a place within the
composition in cat. 193 (fig. 146). This larger drawing devel-
ops the spatial coordinates noted on the margin of cat. 192
and includes a plan that maps the shape of a long rectangle
enclosing the coach and four, moving at an angle of about 66
degrees from the picture plane. This diagonal, like the path
of Schuster and Wright's gunning skiff or the course of the
four-oared shell, is not a conventional slope across the grid,
indicating special maneuvering with this angle as well as the
horizon line (an odd eighty inches, coinciding with the eye
level of none of the participants) to get the particular, advan-
tageous view of the horses and the carriage that Eakins de-
sired. New to this image, in addition to the horseman, is a
groom who raises the coach horn to alert other travelers, and

a Conestoga wagon on the distant hillside, sketched again in
the lower margin with a yoke of oxen. The new horse trots
along in a position similar to that of Josephine, who is now
hidden. This gait has been erased and revised in the next
drawing (fig. 147; cat. 194) to follow the pattern of Williams,
the near-wheeler, indicating that Eakins used his horse ma-
quettes for this new solo horse, too.

The entire composition was rehearsed again in cat. 194,
with many small adjustments. The Conestoga wagon is seen
farther up the hill, so that it is not blocked by the horseman,
Mrs. Rogers joins her husband on the box, and the little dog
draws closer to the walking man, who seems to be set deeper
in space. This figure remains less resolved than the others, in
part because he is not in scale. As his head brushes the hori-
zon line (again confirmed, by annotations, at 80 inches), he
must be a giant or else still somewhat tentatively placed. But
the other aspects of the painting seem resolved.

What happened to the concept seen in these three draw-
ings? Photographic examination of the painting shows re-
painting in the sky and landscape, but no hidden figures, in-
dicating that Eakins abandoned this more complex version
before he began on the final canvas.[19] We can imagine that
the walking man never found a comfortable position in space
and that the rider was eliminated in order to give an uninter-
rupted view of Josephine and the entire outfit. The landscape
background, if sketched in Newport, had to be reinvented by
Eakins once he left Rhode Island. Such piecemeal considera-
tions may have played a part in the demise of this plan, al-
though it seems more likely that he scrapped the whole
scheme at once to concentrate on the streamlined version of
the subject presented in *A May Morning in the Park.* The rea-
sons for this change of heart may be unknowable; more in-
teresting, and more accessible, is the plan that emerges from
these drawings, which shows a narrative ambition quite un-
like any other work from Eakins' hand. To think about the
meaning revealed in even these sketchy drawings we need to
reconsider the context of this commission and look again at
Eakins and Fairman Rogers.

Focused thus far on the movement of the horses, understood through photography or anatomical dissection, our attention must be reorganized by these drawings to consider the coach, surrounded by other forms of locomotion, as an alternate center of meaning for this painting. Cat. 194 teaches us, from its scale relations, that the size of the coach on the surface of the painting was the determining factor as Eakins arranged the objects in perspective. The sparkling machine of the "drag" itself must have inspired Eakins, much like the rowing shell did, to an admiration of its forms. Rogers was surely in love with this carriage, which he ordered in 1872 from the London firm of Barker & Sons, probably because he felt that American coaches were not "smart looking" and were too "ungraceful" in their movements.[20] Such coaches were specialty items, usually custom-made for the client. "A revival of an almost obsolete carriage, 'the four-in-hand coach,' has taken place within a few years," wrote an English observer in 1862. "They are generally built on the model of the best mail and stage coaches of former times, but with a much higher degree of finish. It may appear very easy to the uninitiated to build such a carriage, merely on the lines of former days, but in fact they require such careful and accurate planning of the several parts, individually and combined, that only those who have given much attention to them, and have, to a certain extent, been tutored by gentlemen who drive them, have been successful in turning out carriages of the kind that in most point meet their requirements."[21] Rogers probably had drawings for this coach sent to confirm the customized details of his order, and he published them as illustrations to his book, *A Manual of Coaching,* first published in 1899 (fig. 148). Eakins' access to such drawings may be read in the perfection of his rendering of the coach, right down to the umbrella basket, in the painting and the full-scale perspective drawing (cat. 195) that preceded it.[22]

Rogers' book surveyed the evolution of the two main types of carriages popular among four-in-hand coaching enthusiasts in his day: the lighter "park drag," generally for private use (like his own rig), and the heavier "road coach," traditionally for commercial use.[23] Rogers' historical consciousness might have been tickled, then, by the contrast between his modern drag, built for speed and sporting pleasure, and the lumbering Conestoga wagon, developed to haul great loads of freight in the mid-eighteenth century. Taken together with the pedestrian, who carries his load on his back, and the horseman, these components tell a story of the development of transportation prior to the steam engine. Eakins' sketches of boats in cat. 192 hint at his consideration of shipping, too, a motif perhaps abandoned as too difficult to introduce into this landscape. He ended by emphasizing animal traction, a phenomenon that, in Fairman Rogers' mind, reached a pinnacle of civilization in the activity of four-in-hand coaching.

The anachronistic element in this composition would have been the Conestoga wagon, long since obsolete although probably still familiar to Philadelphians, who lived

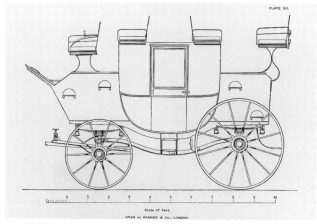

148. Four-in-hand drag by Barker and Sons, from *A Manual of Coaching,* 1899, plate 20.

close to its "birthplace" in Lancaster, Pennsylvania. But the contrast between old and new, rural and urban, work and leisure caught up in this pair of vehicles must not obscure the fact that Rogers' drag was itself a superannuated artifact nostalgically revived by gentlemen of a later day. The whole enterprise of coaching was suffused with a sense of history and artifice, for it was a conscious effort to maintain or re-create the pleasures of the golden age of coaching, acknowledged by aficionados like Rogers to have been the period from about 1820 to 1840.[24] In this period the engineering of the carriage itself came close to its modern perfection, and the "art" of coaching grew naturally out of commerce and daily life, producing teams of men, animals, and equipment that worked efficiently, proudly, professionally. Overtaken by steam power, the stage coach was relegated to remote, usually mountainous areas and replaced by rail or water-borne transport that was faster and more comfortable, albeit much more dangerous.

In 1862 the "crisis" of coaching in England was reached, when the last regular working stagecoach line of the old era died. Coaching clubs, some organized for fun by English gentlemen in the early nineteenth century, found themselves the guardians of the professional lore. In response to the threat of extinction, new clubs rose up, obsolete carriage types were revived by the coach builders, and the "business of the olden time has become the amusement of the present."[25] For gentlemen, the pastime joined appealing aspects of sports and social cachet, as reported by an American text on carriages published in 1878: "The management of a 'team' not only requires great bodily strength, good nerve, and a quick eye, but, being an expensive amusement, is mostly confined to the aristocracy and persons of wealth, with whose habits it is principally associated."[26] In the United States there was only one four-in-hand known in 1860, but according to Rogers, "about 1869 and 1870, at the time of what is usually called the 'Coaching Revival,' amateur coaching increased in England, and has since then spread to America, and to the

continent."[27] The first American group, the New York Coaching Club, was formed in 1875 with Fairman Rogers as the only Philadelphian among its founders.[28] By 1878 it could be said that "the drag . . . has recently created some interest in America, where, under the protection of the New York Coaching Club, it has been the wonder of sporting men and the observed of all observers." Following the institution of excursion trips between New York City and Pelham Bridge by the English Colonel Delancey Kane in May 1876 (see fig. 150), the idea caught on, and "more recently several wealthy individuals have purchased vehicles of the drag class and, aping the European fashion, now drive through our streets in the most approved style with the greatest apparent satisfaction."[29] The phenomenon was very new then, when Eakins and Rogers began to conspire on a painting, and rare almost anywhere in the United States outside of New York City.

The spirit of Rogers and his cronies, mostly young men of wealth and energy, expressed in an affluent fashion a larger mood of nostalgia in this period, often credited to the American Centennial Exhibition. The Centennial, accompanied by its retrospective, nationalistic essays and expositions, drew attention to life in the prerevolutionary period, giving rise to a fashion for pilgrim subjects and "colonial" costume and artifacts.[30] The coaching revival partook of this national historical curiosity, as illustrated by such paintings as *Coaching in New England* (fig. 149) by Albert F. Bellows, shown at the American Watercolor Society's exhibition in 1877. However, the roots of coaching were in a movement begun outside of the United States, and in a context much larger than American Centennial spirit. The four-in-hand revival was distinctly British in its origins; American Anglophiles would probably have taken up coaching in emulation of the English clubs, with or without the Centennial. Similarly, the depiction of coaching in watercolors, oils, and popular prints had already become a staple of British "sporting" art that would inevitably have an American echo in the work of Eakins, Bellows, and—more obviously—the artists employed by Currier and Ives and the illustrated press (fig. 150). But more important, the nostalgia of Rogers and his colleagues overseas shared in the antiquarianism of the entire northern European culture at this moment in modern history. In the simplest sense their nostalgia can be understood as the cyclical fascination with all things "in grandmother's time" (a phrase that Eakins used as the title of a painting completed in 1876), regardless of national anniversaries. In this familiar pattern, one's parents' home seems ordinary, boring, and out of style, while the grandparents' environment appears mysterious, quaint, and old-fashioned. Notably, Eakins did not turn in his own historical reveries to the actual colonial period, but to the early nineteenth century, the period of William Rush and of his own grandparents, whose costumes still lingered in the family attic (seen in cat. 190; plates 6, 11).

But coaching offered a more profound topic for consideration than just grandmother's dress, because the activity proposed a critique of modern life. The nostalgia of the

149. Albert F. Bellows, *Coaching in New England*, c. 1876, watercolor on paper, 24⅞ × 35⅞ in., Brooklyn Museum, Bequest of Caroline H. Polhemus.

coaching revival drew upon a larger mid-nineteenth-century malaise that swept over the industrialized world as the expense and the irrecoverable losses incurred by modernity began to be reckoned. Modern life, from the box of a four-in-hand, seemed too fast, too anaesthetized, and too dangerous while lacking in teamwork, sociability, and opportunities for the display of traditional skills. The romantics of the coaching movement wished to enjoy the ride as much as the destination, to experience the outdoors at a "healthful, delightful and invigorating" pace, to command a complex team of horses and equipment, all endangered pleasures snatched back from oblivion. Rogers, as a model intellectual of his period, lived in a modern Furness and Hewitt home, had the first typewriter in the neighborhood, and tinkered with cameras, but he admitted, in his passion for coaching, deep conservative misgivings.[31]

All of Rogers' possessions—his house, his typewriter, his camera, his coach—tell of his liberal and intellectual style, his affluence, his sensitivity to fashion. Eakins, with his instinct for modernity, must have particularly appreciated the novelty and energy of coaching, which was a recent sport and an exclusive one, if only because of the cost of maintaining a team, a coach, and properly trained and outfitted grooms.[32] This "fashionable and costly but manly form of amusement" was celebrated in an article in June 1878 that Rogers and Eakins surely saw, because it was published in the local *Lippincott's Magazine* and described the members of his club by name.[33] This journalistic attention, in itself a sign of the newsworthiness of the topic, arrived shortly in advance of Muybridge's new photographs, which made the accompanying wood engravings (fig. 150), in the classic flying gallop style, instantly provoking to both Eakins and Rogers. Young's article must have confirmed the sense in both men's minds that a coaching picture, rightly done, was an item of popular as well as personal interest. Eakins' painting may even commemorate an event described in *Lippincott's* article: the historic first outing

150. "Colonel Kane's Coach," from *Lippincott's Magazine,* June 1878.

of the Coaching Club, in which members drove in relay, "on the invitation of a Philadelphia member," from New York to Philadelphia on 4 May and back again on 6 May. "It is customary to assign the last stage to the entertaining member," wrote Rogers, surely meaning that he (as the only Philadelphian in the club, and therefore the host and instigator) would drive his own team on the last stretch through Fairmount and on into center city.[34] This event, surely a weekend worth remembering for Rogers, infuses new meaning into the title *A May Morning in the Park.* In reconstructing an important moment, or just attending to a popular phenomenon, the painting follows Eakins' rowing, rail-shooting, and baseball pictures in presenting a more studied and correct version of a fashionable contemporary sport recorded in popular prints but rarely considered by "fine" artists.[35]

Rogers had a slightly different perspective on the fashionable aspect of coaching, which can be read in the frequent use in his manual of the word "smart" to commend the proper appearance of the coach and its company, or to criticize those effects that were "not smart" (or "common") and therefore to be avoided at all costs. Rogers' deep investment in the correctness of equipment and procedure was not, however, silly or pompous attention to style, although his instructions occasionally have a detail and a Mosaic certitude that has earned his manual a reputation as "the Bible of coaching."[36] Rather, Rogers' concern was scholarly, as a historian; "sporting," as a horseman; and scientific, in the interests of maintaining traditional wisdom. Eakins, who had traipsed through the art museums of Philadelphia and Washington to record the proper cravats of William Rush's day, could respect Rogers' devotion to historical authenticity. As an athlete and outdoorsman, Eakins surely appreciated the driving skill required to manage a four-in-hand. And Eakins must have seconded Rogers' wish to be lucidly "scientific" in his discussion of the best coaching horses, the proper speed of a journey, the suitability of certain coaches to

certain types of terrain, and the rationale for various seemingly ceremonial but in fact functional procedures in driving. "Horsemanship should be reduced to a *science* as far as possible," said Rogers, "or, in other words, that fixed rules, based upon correct principles, should be established, which will enable the instructor to teach and the pupil to understand up to a certain point, beyond which the rider's own genius must be depended upon."[37]

Overarching this historical or athletic or rational spirit came a recognition of the "art" that rose out of the perfect command of skill and the thoughtful consideration of every detail. Visually, there was tremendous satisfaction for Rogers in the appearance of his four-in-hand, the horses well trained, matched, and groomed, the drag elegantly painted and polished, the grooms attired in spotless, color-coordinated liveries. The activity, for the coachmen or the passengers, had another kind of aesthetic thrill. "There is something so exhilarating in the motion behind four horses, through the fresh air," he wrote, "that even stupid people wake up, and for once make themselves agreeable."[38] Most compelling, even intoxicating, however, was the pleasure of Rogers himself, as coachman, in managing the ensemble gracefully, correctly, "smartly." He appears in the painting in model-coachman position (see fig. 141): leaning back on a bolster rather than sitting, both feet planted on the footboard (to avoid being unseated), the whip held—as specified in *A Manual of Coaching*—ten inches from the butt end and at an angle 45 degrees up and 45 degrees forward, where it will not annoy passengers or oncoming traffic.[39] Eakins, as an athlete and an artist, could understand the pleasure in doing things right, the delight in control, requiring physical strength, mental alertness, and long experience. It was a similar excellence celebrated in Will Schuster and Dave Wright, Max Schmitt, and Dr. Samuel Gross: the mastery of an activity that lifts simple craft or physical labor into art. Eakins, in his own coolness in these paintings, in his own respect for detail and correctness, meets these men on their own terms, honoring, by his own show of painterly skill, values of mental and physical discipline, of commitment to "science" and "genius" that matches their art with his own.

Rogers made these parallel aesthetic systems explicit in his own discussion of learning the "art" of coaching. "That man who thinks he can deduce from his 'inner consciousness' all the knowledge which is the result of the long experience, and the accumulated ingenuity of generations of performers, is assuming a great deal," he wrote. "Every art is perfected by the successive inventions of its masters, which, observed by or communicated to one another, are slowly formed into a system much more perfect than it is possible for any one man to create for himself."[40] This philosophy of the accrual of traditional wisdom, science, and "sound principles" was fundamentally academic in a way that echoed Eakins' own methods. In Rogers' attitudes toward art, science, and coaching we can understand the deep harmony of his relationship with Eakins over the curriculum of the Academy's school.

Rogers appreciated the homage paid to his art in *A May Morning in the Park,* despite the criticism of journalists who found Eakins' subject boring and his depiction of motion unconvincing.[41] When his *Manual of Coaching,* many years in the making, was published in 1899, he included a recent photographically derived portrait of his family and the four-in-hand, stationary, and a reproduction of Eakins' painting, now twenty years old. If nothing else, it was a friendly gesture to Eakins; probably it expressed Rogers' genuine affection for this painting and his sense that Eakins had gotten something right about the experience of coaching.

Concerned about the color-correctness of a photographic reproduction made from the original painting, Eakins prepared a black and white replica for Rogers, as he had done for *The Gross Clinic.* The date of this replica is not known; it may have been done not long after the painting, for Rogers' book was in preparation for many years, but surely it was completed before 1899, when the first edition appeared.[42] The publication of this book, or the creation of the replica, seems to have stirred Eakins' memories of this project, prompting him to reconsider the more complex scheme that he had abandoned in 1879. This pattern of retrospection affected much of Eakins' work at the turn of the century, most notably in his return to athletic subjects and his reconsideration of the William Rush story, which he painted again in two new versions in about 1908. The later date of his secondary thoughts about *A May Morning* can be deduced from only one clue within a packet of four provocative drawings (cats. 197, 198, 200, 202) found pinned together in Bregler's portfolios with cat. 196, a study of the wheels of Rogers' drag. Another two drawings found loose in the same portfolio (cats. 199, 201) clearly relate to this group. The theme uniting all these new drawings is the railroad; the clue to the date of the new ruminations comes in the form of a locomotive (cats. 200, 201) that was not invented until 1895.

The railroad idea lurks in the marginal sketches of the earlier drawings (see fig. 145) and looms over the entire program, which features the forms of transportation, like coaching, made obsolete by the ascendancy of the steam locomotive in the 1830s. Eakins excluded the train from all of the compositional sketches, perhaps for reasons of congestion and complexity, and maybe in response to Rogers' own position on the subject of the railroad. Early in his career Rogers had published a paper titled "Roads and Bridges" as part of a report to the Smithsonian Institution. His position in this paper defends the importance of America's "common roads," now being neglected in the enthusiasm for railway building. "While we have covered our country with these iron ways we have the doubtful honor of having the very worst common roads of any civilized country on the globe," wrote Rogers. His sketch of the evolution of the roadway reads like a draft of Eakins' compositional program: "In any country, no matter how new, means of communication between different settlements of men, or between any points of resort, are of the first necessity. Where all traveling is done on foot, as was

the case in our country while occupied by the Indians, simple trails . . . will be sufficient. When beasts of burden are introduced, a wider and smoother path is necessary . . . for the pack horse." The appearance of "sledges and wheeled vehicles, even of the rudest description," demand a yet wider and better-prepared road surface.[43] The lightest and most refined modern carriages require, as noted in *A Manual of Coaching,* the most refined of all roads, such as the "park drives" of Fairmount Park, the site of *A May Morning in the Park.* Fittingly, Eakins shows that Rogers enjoyed the epitome of the coaching experience on these elegant, noncommercial, deliberately aimless pleasure drives.[44] As *Harper's Weekly* noted in 1876, "The old stage routes are to this day the smoothest and best routes to be found" outside of such parks, although the deterioration of highways in general posed many risks for lightweight vehicles, especially those made top-heavy by passengers.[45] The schema in the drawings presents a utopian high road, illustrating Rogers' plea for a road network providing "communication throughout a country" thanks to wide, well-graded surfaces suitable to all kinds of vehicles and including generous pedestrian footpaths. Considered then from the perspective of Rogers' particular concerns, Eakins' early concept can also be imagined as a polemic of the open and well-built road, teeming with Americans on the move. In this argument the railroad had to be deliberately snubbed.

But Eakins must have had another idea, including railroads, signaled by the tantalizingly empty perspective drawing entitled only *Baldwin. Boats* (cat. 197). The title may draw together all the marginal figures left out of the compositional drafts—that is, the locomotives and the boats. "Baldwin," in the context of the three drawings pinned to this perspective, must refer to Philadelphia's Baldwin Locomotive Works, which enjoyed an "overwhelming dominance of the industry," worldwide, between 1860 and 1900.[46] The immense train yards of the Baldwin Works were located on Spring Garden Street between Broad and 18th, just three blocks south of Eakins' home and directly in his path as he walked or cycled to the Academy. Both of the locomotives sketched on these pages were historic Baldwin engines: Old Ironsides, the first construction of the firm's founder, Matthias Baldwin, in 1832 (cats. 199, 200), and the Atlantic type, one of the new generation of larger, faster American passenger locomotives of the 1890s (fig. 151; cats. 200, 201). At the time of its debut in the summer of 1897, a new passenger locomotive of the Atlantic class built by Baldwin for the Philadelphia and Reading Railway (fig. 152), set a record on the 55 1/2-mile Camden to Atlantic City run: an average time of 48 minutes, at an average speed of 69 mph.[47] Eakins, who enjoyed visiting both the beaches and the marshes of south Jersey, as his photographs and paintings show, may have ridden this new high-speed train or learned about it from the attendant publicity that summer. Old Ironsides and this new engine may have vied for a position in his painting—the one locomotive actually invented during the golden age of coach-

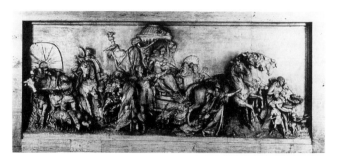

ATLANTIC TYPE LOCOMOTIVE
For Philadelphia and Reading Railway

151. *Locomotives: "Old Ironsides" and Baldwin "Atlantic" Engine,* c. 1899 (cat. 200).

152. "Atlantic"-type Locomotive, Baldwin & Co. brochure, c. 1897.

153. John Gast, *American Progress,* wood engraving from *Crofutt's New Overland Tourist, and Pacific Coast Guide,* c. 1878–79, Lilly Library, Indiana University, Bloomington, Indiana.

154. Karl Bitter (1867–1915), *The Progress of Transportation,* 1895, cast plaster relief, 144 × 360 in., 30th Street Station, Philadelphia, photo courtesy of the Fairmount Park Art Association Archives, Historical Society of Pennsylvania.

ing and a harbinger of change, the other representing the complete victory of the rails by 1897.

Eakins' reconsideration of the theme of transportation may have been fed by the work of other artists as well. Historical and allegorical images of the American empire were certainly on hand, from Leutze's *Westward the Course of Empire Takes Its Way* of 1862, a mural in the Capitol at Washington that Eakins may have seen in 1877 if not later (or in reproduction), to such popular images as Fannie Palmer's *Westward the Star of Empire* of 1868, a chromolithograph featuring the railroad's conquest of the Great Plains. Eakins' travels to Dakota Territory in 1887 could have introduced him to *Crofutt's New Overland Tourist, and Pacific Coast Guide,* with its railroad maps and frontispiece by John Gast, *American Progress* (fig. 153), which allies pedestrians, horsemen, wagons, coaches, and trains in a sweep of civilization across the prairies. This same type of imagination was dis-

played by Karl Bitter, whose cast plaster relief *The Progress of Transportation* (fig. 154) was installed in the Pennsylvania Railroad's old Broad Street Station in 1895.[48] This large frieze, twelve feet high and thirty feet long, decorated the west wall of the station's waiting room, above the information desk. Eakins, who especially prized relief sculpture, must have examined this frieze often as he passed through the station to or from his lectures in New York City. Many of the components of his Fairman Rogers scheme appear in Bitter's composition, which includes a covered wagon hauled by oxen, a horseman, a chariot drawn by four horses, and a group of small children in the vanguard, bearing models of a steamboat, an airship, and a locomotive. Bitter avoided major scale discrepancies by shrinking the largest, most modern inventions to the size of emblematic toys, while Eakins planned the same diminution in a Conestoga wagon by relegating it to the distance. He also seems to have considered a very high viewpoint, not unlike the floating vantage of Gast's *American Progress,* to manage a view of many large, distant objects. The empty perspective grid for *Baldwin. Boats* first stipulates a horizon level at 80 inches, like several of the Fairman Rogers' drawings, but this figure has been altered to indicate 180 and then 240 inches, or 20 feet. This is the height of a balcony, bridge (or railway overpass?), or second-story window, very unusual for Eakins although not uncommon in impressionist paintings of the 1870s. From this height the three diagonal trajectories on the grid (see cat. 197) could be imagined as coaches, boats (as in his planned yacht pictures, cats. 155, 156, and 169, some of which indicate very high

viewer positions), locomotives, or any combination of these vehicles. None of the locomotive sketches are taken from this high vantage, however, indicating that the sketches of trains, evidently made from Baldwin company catalogues (cats. 200, 201), were never developed for placement into such a scheme.

The ambition of such a program, consistent with other historical and sporting themes undertaken by Eakins in the 1870s, throws new light on Eakins' pictorial imagination, and his process from idea to execution. From this same period date other themes with a literary or narrative basis in American history: *William Rush Carving, Hiawatha, Columbus in Prison* (cat. 189), and *The Surrender of Lee to Grant*.[49] Together they indicate a storytelling strain in Eakins' mind, regularly emerging and almost as regularly suppressed, for only the first of these ideas survives in a completed painting. The neglected topics seem more fusty and conventional, less personally relevant than the Rush story, which may be enough to explain their demise. But taken together with the truncation of the Fairman Rogers concept and the similar reduction of a sculpture commission two years later (*Knitting* and *Spinning*, cats. 260, 261), the fate of Eakins' historical visions begins to assume an interesting pattern.

Nothing survives to tell us why the pictures of Columbus, Grant, and Lee were left undone; we know only that he abandoned *Hiawatha* when he judged it sickeningly "poetic." The rejection of *Hiawatha*, like the streamlining of *A May Morning in the Park* or the Scott reliefs, seems to illustrate the chastening that Eakins' grand schemes received from his realist ideology and its academic enactment. Devoted to detail, he must have been uncomfortable reconstructing Columbus from inadequate sources and unhappy with the prospect of painting at least one of the principals at Appomattox from photographs. Realist standards also curtailed his sentimental impulses, clothing the emotional content of his genre subjects in matter-of-fact observation. This approach rendered even the most tender situations—as in *The Courtship* (cat. 190) or *The Pathetic Song* (plate 9)—with an objectivity that drained away superficial charm in order to backhandedly lend credibility to the genuine feelings expressed. Most of the paintings in this flatfooted "poetic" mood were simple pictorial concepts, like *Fifty Years Ago* (plate 6), timeless moments without story or program. His recurrent wish for poetry may have impelled him to adopt these more open and uncomplicated subjects, as if emotional breadth required a simple vehicle.

Formal and technical concerns produced the same reduction of subject in other cases. *Knitting* and *Spinning*, two parts of a projected suite of three interrelated historical panels (see cats. 206, 207), represent just the simplest autonomous components of his initial concept. Hampered in this commission by an unsympathetic patron, Eakins also seems to have succumbed here to the streamlining imperatives of his own elaborate method. Fascinated by details learned from observation, charmed by the challenges of perspective and relief, he pared away complications as he was engrossed by the expanding complexity of the core image. As the spinning wheel or the tilt-top table—or Rogers' coach and horses—grew more enthralling, the intellectual framework faded in importance, along with the emotional potential of the image. Ultimately technical achievement, art for art's sake, dominates the reliefs and *The Fairman Rogers Four-in-Hand*, while the intellectual and emotional inspiration of these projects remains most accessible in the preliminary drawings.

Fairman Rogers' resignation from the Academy's board in 1883 spelled the end of a regime that had encouraged the expansion of Eakins' school program as well as his imagination. Within two years Eakins was mired in rumors about his private studio practices, which involved nude studies that Rogers probably would have understood as professionally acceptable, if socially risky. The new chairman of the Committee on Instruction was not so sympathetic, however, and Eakins eventually lost his job and abandoned, with only a few important exceptions, the type of subjects undertaken during the Fairman Rogers years. "I suppose that you will not be pleased when I tell you that I have resigned from the Board," wrote Rogers to Eakins in November 1883. "I leave the Academy with regret as I have many pleasant associations with my work there—not the least of them the hours spent with you."[50]

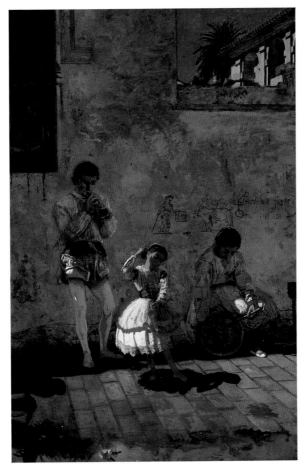

1. *A Street Scene in Seville,* 1870, oil on canvas, 62¾ × 42 cm, Collection of Erving and Joyce Wolfe.

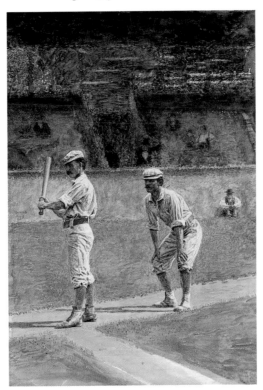

2. *Baseball Players Practicing,* 1875, watercolor on paper, 10⅞ × 12⅞ in., Museum of Art, Rhode Island School of Design, Jesse Metcalf and Walter H. Kimball Funds. Photograph by Cathy Carver.

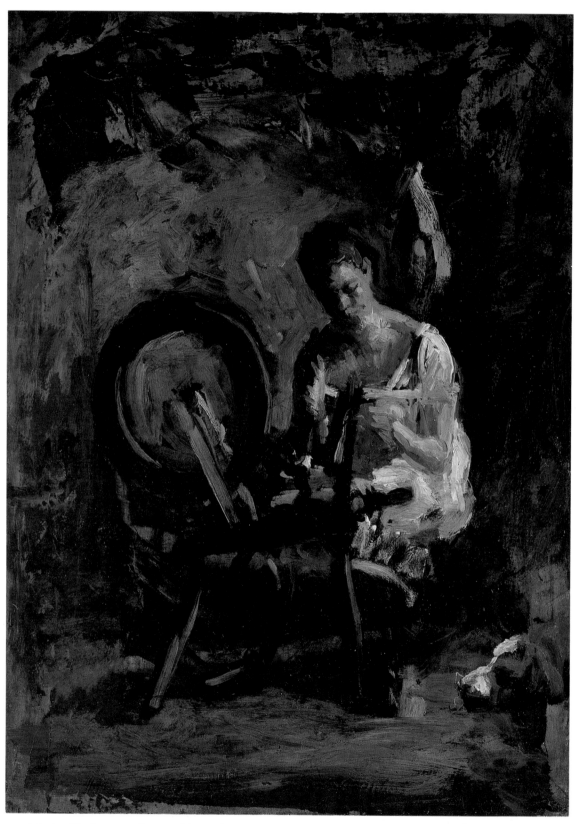

3. *Spinning: Sketch*, c. 1881, oil on panel (cat. 243).

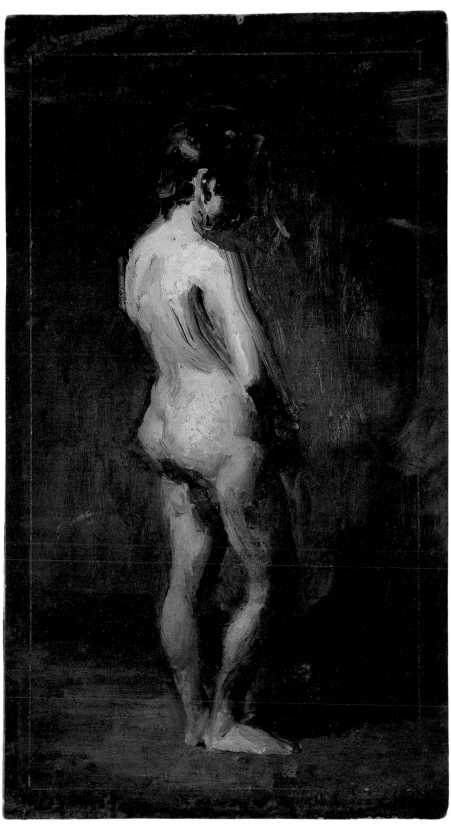

4. *Figure Study: Masked Nude,* c. 1878–85, oil on cardboard (cat. 238).

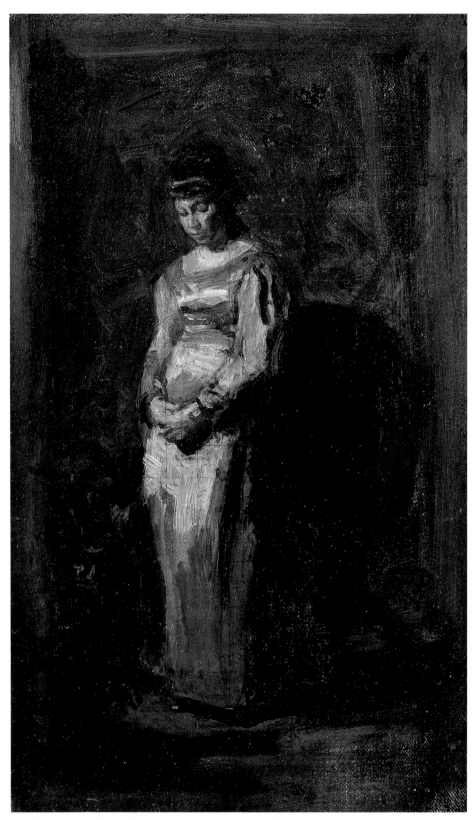

5. *Fifty Years Ago (Young Girl Meditating): Sketch*, c. 1877, oil on canvas (cat. 241).

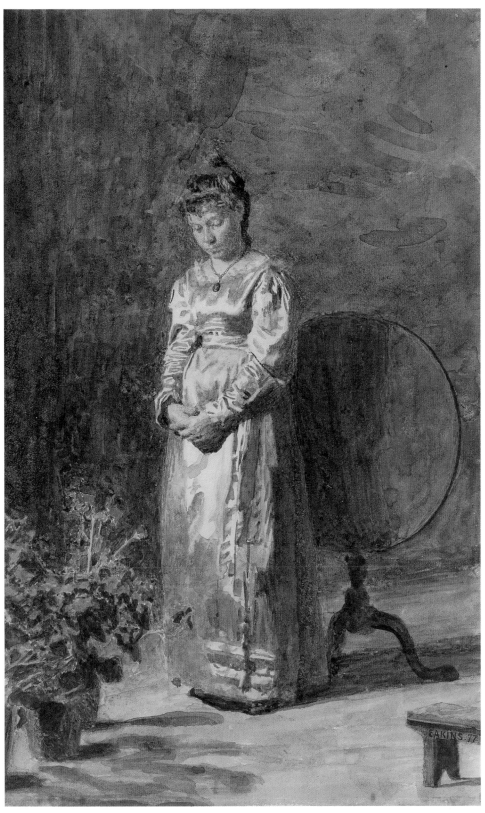

6. *Fifty Years Ago (Young Girl Meditating),* 1877, watercolor on paper, 8¾ × 5½ in. (22.2 × 13.9), Metropolitan Museum of Art, Fletcher Fund, 1925 (25.97.2). Photograph © 1994 The Metropolitan Museum of Art.

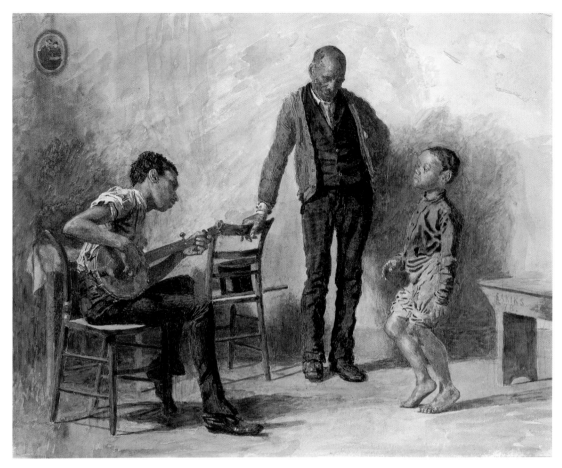

7. *Negro Boy Dancing,* 1878, watercolor on paper, 18⅛ × 22⅝ in., Metropolitan Museum of Art, Fletcher Fund, 1925 (25.97.1). Photograph© 1994 The Metropolitan Museum of Art.

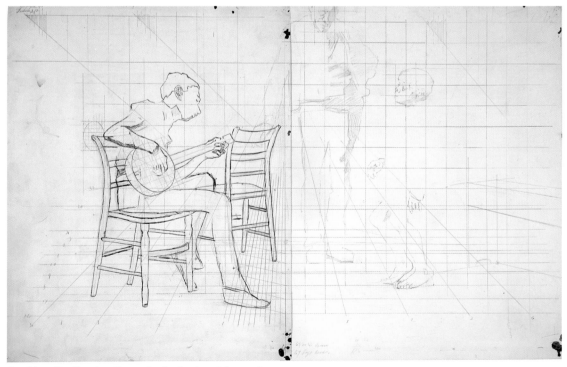

8. *Negro Boy Dancing: Perspective Study,* 1877–78 (cat. 191).

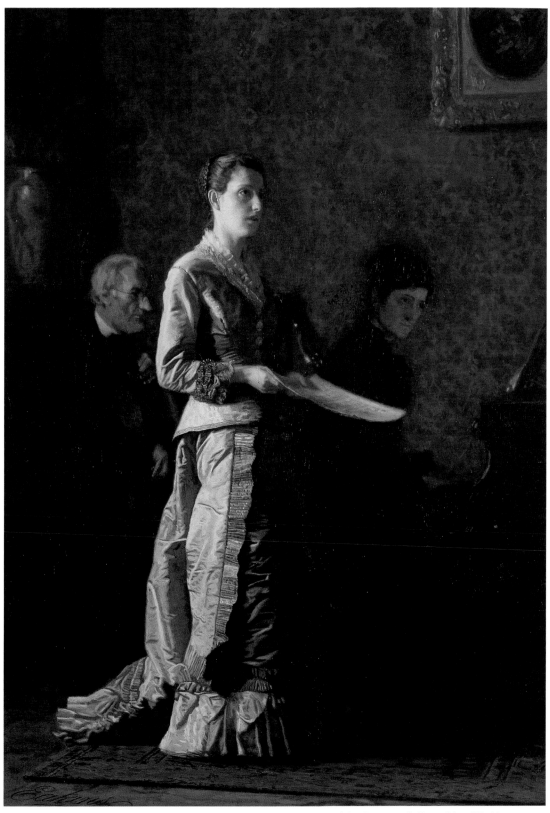

9. *The Pathetic Song*, 1881, oil on canvas, 45¼ × 32½ in., in the collection of the Corcoran Gallery of Art, Washington, D.C. Museum purchase, (19.26), Gallery Fund.

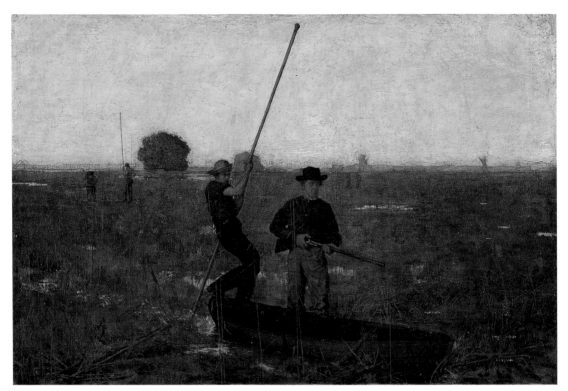

10. *The Artist and His Father Hunting Reed Birds in the Cohansey Marshes*, c. 1874, oil on canvas, 17⅛ × 26½ in., Virginia Museum of Fine Arts, Richmond, the Paul Mellon Collection.© 1997 Virginia Museum of Fine Arts.

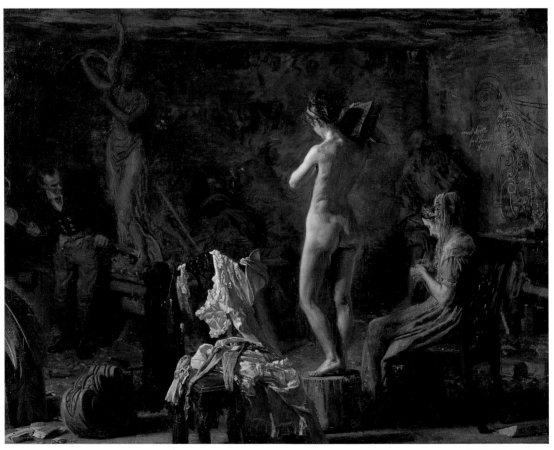

11. *William Rush Carving His Allegorical Figure of the Schuylkill River*, 1877, oil on canvas, 20⅛ × 26½ in., Philadelphia Museum of Art, Given by Mrs. Thomas Eakins and Miss Mary Adeline Williams.

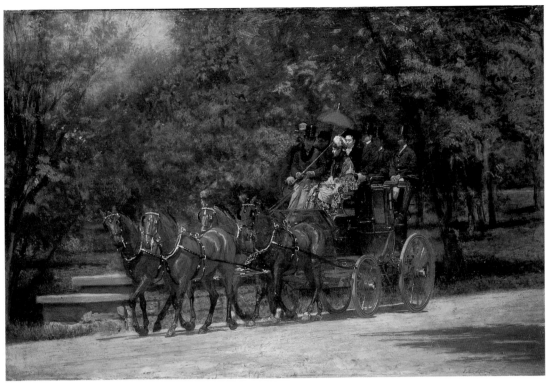

12. *The Fairman Rogers Four-in-Hand* (or, *A May Morning in the Park*), 1879, oil on canvas, 24 × 36 in., Philadelphia Museum of Art, Given by William Alexander Dick.

13. *The Fairman Rogers Four-in-Hand: Landscape Study in Fairmount Park,* c. 1879, oil on panel (cat. 245).

14. *Delaware Riverscape, from Gloucester,* c. 1881, oil on panel (cat. 247).

15. *Shoreline of the Delaware River, with Fishing Nets,* c. 1881, oil on panel (cat. 249, recto).

16. *Delaware River Scene*, c. 1881, oil on canvas (cat. 250).

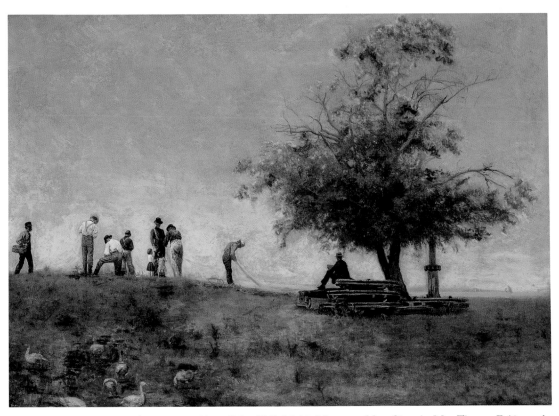

17. *Mending the Net*, 1881, oil on canvas, 32½ × 45¼ in., Philadelphia Museum of Art, Given by Mrs. Thomas Eakins and Miss Mary Adeline Williams.

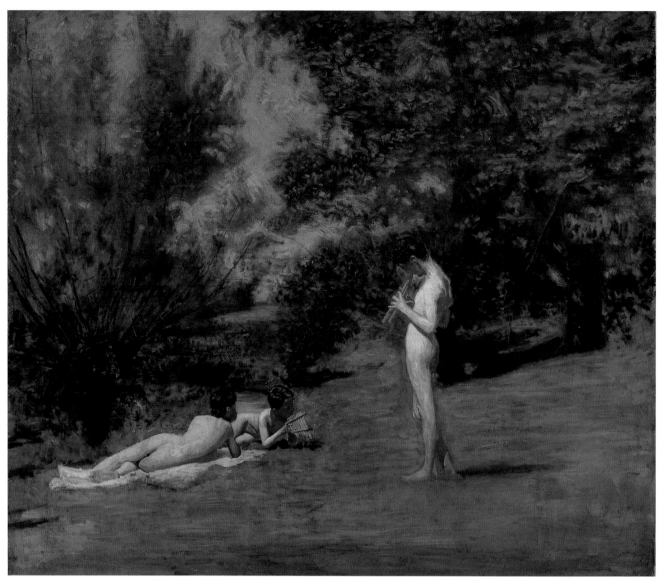

18. *Arcadia,* c. 1883, oil on canvas, 38⅝ × 45 in., Metropolitan Museum of Art, bequest of Miss Adelaide Milton de Groot (1876–1967). (67.187.125). Photograph © 1994 The Metropolitan Museum of Art.

19. *Arcadia: Sketch*, c. 1883–85, oil on canvas (cat. 251).

20. *Portrait of Dr. John H. Brinton: Perspective Study*, 1876 (cat. 175).

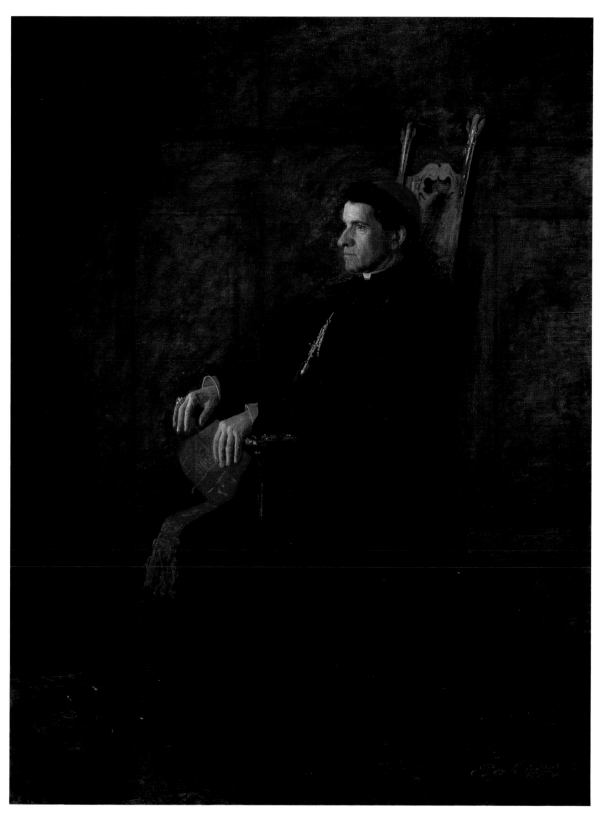

21. *His Eminence Sebastiano Cardinal Martinelli,* 1902, oil on canvas, 78⁵⁄₁₆ × 59¹⁵⁄₁₆ in., Armand Hammer Collection, UCLA, at the Armand Hammer Museum of Art and Cultural Center, Los Angeles.

22. *Monsignor James P. Turner,* c. 1906, oil on canvas, 88 × 42 in., (249.9 × 106.7 cm), Nelson-Atkins Museum of Art, Kansas City, Missouri, Gift of the Enid and Crosby Kemper Foundation.

CHAPTER 16 Gloucester
Landscapes

"CAMERA VISION"

AND

IMPRESSIONISM

The integration of photographic studies into Eakins'
method, begun with his use of Muybridge's work in 1878 for
A May Morning in the Park, reached a more intense and sub-
tle level in the landscape paintings made near Gloucester,
New Jersey, between 1881 and 1883. The impetus behind this
new body of outdoor work—including seven finished paint-
ings depicting shad fishermen, one "pure" landscape, and a
welter of small plein air sketches—seems to have come from
Eakins' acquisition of a camera, probably in the spring of
1881.[1] A shoebox full of glass dry-plate negatives found in
Bregler's collection has yielded sixty-four images relating to
the Gloucester fishing subjects commenced this spring.[2]
These plates testify to a binge of camera work begun in 1881
and maintained through the remaining five years of Eakins'
tenure at the Academy. The character of these photographs,
and their use in tandem with outdoor sketching in oils, reveal
a new phase in the development of Eakins' method, and a
new complexity to the "camera vision" already attributed to
his work in this period.

The Gloucester plates were mostly found in groups of
ten, stored in the manufacturers' cardboard cases, sometimes
labeled and dated. Seven different dates in 1881 and '82, usu-
ally paired on a weekend, are mentioned on these boxes, im-
plying that the photographs were mostly taken on these days
during the shad fishing seasons of 1881 and 1882. These anno-
tations document the first dated photographs that we know
Eakins made himself, with his own camera.[3] While these
dates record a similar pattern of visits in these two years,
most of the Gloucester photographs seem to have been made
in the spring of 1881, because they relate to projects finished
that year or early the next. Most of the strategies and effects
that would become part of his new working method evi-
dently were invented in this first flush of activity.

The concept of a painting based on the shad fisheries
followed the same analogical thinking of his earlier subject
choices, so often inspired by precedents in European con-
temporary work. Like the American rowers, ball players,
chess players, and musicians that followed from the patterns
of Gérôme's Middle Eastern figures, the fishermen were re-
lated to a class of European peasant subjects—often includ-
ing fisherfolk—common in contemporary art. Like Winslow
Homer and a few other native painters, Eakins was able to
see the picturesqueness of American working people, though
even Homer was drawn with the tide of expatriates who pre-
ferred to paint European peasants. At the watercolor exhibi-
tion of 1882, Homer's *Mending Nets,* painted in England,
hung near Eakins' identical American subject (see fig. 173).[4]

The local character of shad fishing, like rail shooting or
sculling, may have been part of its attractiveness to Eakins.
Certainly he had known about the fisheries since his child-
hood, for the annual running of the shad brought delicious
seasonal feasting. Gloucester was only a short ferry ride
across the Delaware River from South Philadelphia, and the
area must have been familiar to him from his many sailing
and hunting expeditions. Weekend visitors from the city en-

155. *Shad Fishing at Gloucester on the Delaware*, 1881, oil on canvas, 12⅛ × 18¼ in., Philadelphia Museum of Art, Given by Mrs. Thomas Eakins and Miss Mary Adeline Williams.

joyed Gloucester's beaches, racetrack, gambling halls, informal restaurants, and—as billboards in the background of Eakins' photographs advertise—shuffleboard facilities.⁵ Despite this tourist activity the farmers and shad fishermen maintained their seasonal preoccupations. Eakins depicted the meeting of these worlds explicitly in one of his first paintings from this group, *Shad Fishing at Gloucester* (fig. 155), in which bourgeois urbanites at their leisure contemplate working-class watermen (often, as the photographs show more clearly, African Americans) at their business. Neither group was judged interesting by the contemporary art press: one critic described the fishermen as "not particularly picturesque creatures at the best," made "utterly dull" in Eakins' treatment, and another found the bystanders to be "very commonplace citizens."⁶ Typically Eakinsish in its attention to modern pastimes—both work and play—much in the fashion of the resort subjects of the impressionists in the late 1860s and '70s, the mood in *Shad Fishing* is luminous and calm, earnest and unglamorous, without the gaiety of French boating parties or the piety and heroism of French peasants depicted in contemporary art. The observers are respectful, surrogates for the painter and models for ourselves.

The emotional flatness in *Shad Fishing,* as well as the marvelous contemporary detail, came in part from Eakins' use of the camera. It was most helpful in recording the appearance of the fishermen, who appear—undisturbed by tourists—in all the other figure subjects in this series. With his camera he could capture characteristic motion and costume without interrupting the men at their work or employing the artificial studio sessions that were necessary to Eakins' hunting pictures. Winslow Homer could sketch such figures rapidly and concisely in pencil and wash out-of-

doors; Eakins' lack of fluency in such a context, added to his preference for oil and his insistence on authenticity, made outdoor group action subjects dauntingly difficult for him. The credibility won from such photographic studies was important to Eakins, and it did not go unremarked. "The mere back view of a series of boatmen's pantaloons, whether of oilcloth or of worn linsey-wolsey, broken into folds that explain a motion, or patched or stained with accidents that explain a toilsome life, are a positive revelation," wrote Earl Shinn in response to *Mending the Net.*⁷

The relatively slow exposure times of Eakins' camera meant that he could not record bodies in motion without some blurring, so he was forced to make repeated exposures in the hopes that at least some of his images would be distinct. Such action photographs were necessarily opportunistic and hopeful; Eakins had no control over the subject other than point of view. Later consideration of the work from such sessions brought ideas for improvement and the germ of an idea for a painting. One early inspiration, the first to yield a product, was the subject *Shad Fishing: Setting the Net* (fig. 156), which recorded a shad boat and a group of bystanders on the beach. The compact massing of the figures on the boat, balanced against a weighty clump of observers, appealed to Eakins. The spare, geometrical organization of the landscape—which he carefully contrived through the lens on a separate occasion (fig. 157)—offered an uncluttered environment, decoratively simple but implying deep space, much like the compositions of Monet and Pissarro. Testing his sense of scale and the geometry of the picture, Eakins also posed just one woman—a figure not seen in the painting—at the edge of the beach, her figure cut by the shoreline exactly like the group in the painting (1985.68.921). In another spot,

156. *Shad Fishing: Setting the Net,* c. 1881, modern print from 4 × 5 in. dry-plate negative, 1985.68.2.886.

157. *Delaware River with Beached Dory,* c. 1881, modern print from 4 × 5 in. dry-plate negative, 1985.68.2.976.

probably on another day, he constructed the entire group of watchers (figs. 158, 159). The figures stand with their backs to the sun so that the angle of light in the first photograph is recapitulated, and they arrange themselves against a diagonal band of grass much like the slope of the shoreline in the painting, which Eakins completed in the summer of 1881.

The bystanders in the painting, while composed and distinctly individualized, remain as anonymous as the fishermen, although we know they are small portraits of Eakins' family. They must have been included for the pleasure of personal reference, so often indulged in Eakins' work, and because family members were easy to push around at will, unlike the fishermen. The party was loosely identified years later by Susan Eakins, who pointed out Benjamin Eakins (at right) and described the group of women as including one of his daughters. The photos allow us to guess that the woman in black is Maggie Eakins, holding the leash of her setter, Harry, who lies near her feet.[8]

Eakins selected elements from these photographs to combine into the image on his canvas: landscape profiles from fig. 157, observers from fig. 159, fishermen from fig. 156, dog from fig. 158. The integration of these elements was not without its problems, some of them unresolved. The photographs show that the horizon line for the family group was lower than the vantage used for the painting and the photo of fishermen, to some degree creating the cutout quality of the bystanders. However, both sets of figures were pushed a good distance into space, making this inconsistency less noticeable. The effect reminds us, however, that there are no surviving perspective drawings for any of these Gloucester subjects, even though much emptier landscapes had been carefully plotted in the 1870s. Now the camera had supplied

an alternate system, and the composite use of sources taken under different circumstances made it impossible to assert a single, unifying viewpoint.

Nonetheless, Eakins established his scale relationships with the same internal consistency seen in his paintings of the 1870s: the family is one-twenty-fourth life, half again larger than the fishermen, at one-thirty-sixth. From this we can conclude that the watermen are half again more distant from us than the family, and, using Eakins' rules of perspective, we can estimate that the two groups may be about 72 and 108 feet distant.[9] The leap in space from the family to the boat does not seem that deep, although Eakins suggested this gap by making the figures on the beach crisp and the ones in the water atmospherically dimmed. His differing treatment of the groups underscores his attachment to the family group as the center of focus in this painting, as well as his understanding of human vision. Two objects at different distances from the eye cannot be painted with equal detail, he reminded his students: "The character of depth is incompatible with that of sharpness."[10] This advice was exaggerated by his photographic sources, for the family group was posed close to the camera while the fishermen were photographed at the distance they seem to occupy in the painting. In the original photograph (fig. 156) the bystanders on the beach are not so different in scale or quality of detail from the fishermen, making the larger scale, nearer placement, and "surprising" detail of the family group in the painting more obvious as a conscious decision on Eakins' part.[11] Perhaps he did this for emphasis or to illustrate atmospheric perspective, or perhaps he wanted to stress the *un*photographic "character of depth" for the human eye, which, unlike the camera, cannot focus simultaneously on different objects.

Although pulled apart in space, the two groups were united by the bright light that falls across them all, noticeably stronger in the painting than in the first photograph. The highlights on the fishermen have all been keyed up, probably from color studies made outdoors, such as the extant oil

158. *Three Women, Man, and Dog near Delaware River,* c. 1881, modern print from 4 × 5 in. dry-plate negative, 1985.68.2.922.

159. *Three Women, Man, and Dog near Delaware River,* c. 1881, modern print from 4 × 5 in. dry-plate negative, 1985.68.2.923.

160. *Shad Fishing at Gloucester on the Delaware,* 1881, oil on canvas, 12 × 18 in. (30.4 × 45.9 cm), Ball State University Art Gallery, Muncie, Indiana. Permanent loan from the Elisabeth Ball Collection, George and Frances Ball Foundation, L83.026.09.

161. *Shad Fishing: Setting the Net,* c. 1881, modern print from 4 × 5 in. dry-plate negative, 1985.68.2.887.

sketch of the head and shoulders of the second woman from the right (cat. 246) and the bright panorama of the Delaware shoreline painted on the same panel (see fig. 257; plate 14).[12] The two groups have also been knit together by the addition of extra figures in the chain of fishermen behind the family (including one man stolen from fig. 175) and by alterations in the poses of two fishermen on the boat, who turn to look at the camera. These two men are made to turn back to their work, completing the mood of absorption in this painting that generates much of its appeal.

Eakins was satisfied with this work, for he sent it to exhibitions in Philadelphia, New York, Cincinnati, and Chicago in 1881 and 1882. Evidently it eclipsed another painting made at the same time, at the same size, and with the same title: *Shad Fishing at Gloucester on the Delaware* (fig. 160), which was sent on a less prestigious but longer tour beginning in September 1881.[13] The composition is a mirror of the other, and composed in much the same way: using both a photograph of men at work (fig. 161) as well as a separate pic-

ture, probably taken on a different day, of the landscape alone (fig. 162).[14] The configuration of the scene adheres closely to that in the photograph of the figures, but the long depth of field in the landscape photo offered details of the far shore, the steamboat pier, and the cluttered beach that Eakins incorporated in his painting. As in the other painting, he suppressed detail along the horizon, eliminating several ships and softening the focus, and he deleted both of the bystanders in conventional street dress, including one who stares boldly at the camera. The boat and the remaining figures appear in a configuration that makes a more convincing and interesting progression into space. Drawn together by their work, they circle around the nets with the professional concentration that Eakins admired in all the athletes, artists, and scholars he painted.

As with the first *Shad Fishing,* outdoor sketching provided the sunny blue and gold tonality that photography

162. *Shoreline of the Delaware River with Boats*, c. 1881, modern print from 4 × 5 in. dry-plate negative, 1985.68.2.926.

163. *Shad Fishing at Gloucester on the Delaware: Delaware River and Gloucester Pier*, c. 1881 (cat. 248).

vania shore seen in this sketch may have contributed to *Shad Fishing*, although it does not correspond exactly to the finished painting, as in cat. 248 (or in other oil sketches, such as cats. 232, 233, 234), mostly because it was painted from a much lower vantage on the beach. Done as a general record of color values and landscape incident, it could have informed more than one of the finished paintings in this group. The narrow, horizontal format of this sketch, as well as its bright and breezy style, also show Eakins working in an unfamiliar mode, here usually associated with pre-impressionist painters like Boudin, or watercolor draftsmen accustomed to the format of a double-page sketchbook.

Several such oil sketches survive for the most important of the shad fishing pictures, *Mending the Net* (fig. 164; plate 17), completed in September 1881 and soon exhibited at two prestigious venues, the Academy's "Special Exhibition of Paintings by American Artists at Home and in Europe" in the fall, and the National Academy of Design's annual exhibition the following spring.[15] This painting, the largest and most ambitious picture of the Gloucester series, also was the most complex composite of photographic studies and plein air painting. Six small figure and landscape sketches in oil and thirty-three glass negatives remain extant, including at least seven photographic images that played a direct part in the appearance of the final canvas.[16] Among these extant plates, the closest thing to an overall photograph of the landscape setting—analogous to the empty beach views used to format the shad fishing paintings—is a picture of the tree and disassembled capstan (fig. 165). This composition establishes the horizon line of the hill, which, continued across to the left, would complete the basic design of the painting. Eakins altered the configuration of the foliage in this photo while assimilating his own oil sketches of the tree, but he may have borrowed the idea of blurred leaves, or of foliage contours eaten away by light, from the halation of the photograph. At the same time, he eliminated much of the low vegetation seen in the photo so that the river could appear in the distance.

A photograph taken at closer range explains the river's presence with greater clarity and introduces the figure of a

could not supply. A tiny scene captured on the corner of what was once a larger panel (fig. 163) was made from the same spot where the photographs were taken, but at a different moment, when a ship was tied up at the pier. Exactly the same size as this passage in the painting, but made with greater speed and less detail, this sketch might have served as the color chord for the entire picture, which, despite its small size, was probably painted in the studio. The appealing simplicity of this sketch, with its strong horizontal banding, flat color zones and broad treatment of detail, draws Whistler's work to mind, suggesting Eakins' grasp of the post-impressionist effects known in American painting as tonalism. The same sketching attitude, and the same stretch of beach, river, and pier, can be seen in cat. 247 (plate 14), perhaps formerly on the verso of the same panel. The detail along the Pennsyl-

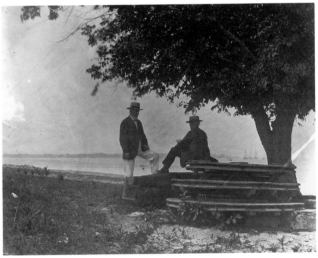

164. *Mending the Net*, 1881, oil on canvas, 32½ × 45¼ in., Philadelphia Museum of Art, Given by Mrs. Thomas Eakins and Miss Mary Adeline Williams (plate 17).

165. *Tree Near the Delaware River*, c. 1881, modern print from 4 × 5 in. dry-plate negative, 1985.68.2.966.

166. *Benjamin Eakins Standing and Man Sitting Under Tree near Delaware River*, c. 1881, modern print from 4 × 5 in. dry-plate negative, 1985.68.2.924.

man seated on the capstan and reading the *Philadelphia Ledger* (fig. 166). This man reappears almost identically in the painting, and from his curly graying hair, small beard, and spectacles, as well as his conversational relationship to Benjamin Eakins, who stands at his left, he may well be Bertrand Gardel, the companion in *The Chess Players*.[17] Unless another, very similar photo once existed without the image of Mr. Eakins, we can assume that the artist manipulated this image too, deleting the figure of his father—perhaps because he was too urbane, too recognizable, or just an unwanted in-

terruption in the looping line of forms along the hill. By his absence, the center of the painting becomes an empty circle of space inscribed by the sweep of the net and the seated man. Eakins also added other small touches, such as the enlarged newspaper, to make the story of the man's preoccupation more legible. However, judging from its artful composition, the photograph itself must have been carefully staged, suggesting that Eakins had his composition well in mind and was orchestrating the family players with a very specific purpose, as in *Shad Fishing*. Like the abandoned pencil sketches

167. *Two Crowell Children, Margaret Eakins, and Frances Eakins Crowell Standing on Roof,* c. 1881, modern print from 4 × 5 in. dry-plate negative, 1985.68.2.863.

168. *Three Fishermen Mending Nets,* c. 1881, modern print from 4 × 5 in. dry-plate negative, 1985.68.2.910.

169. *Two Fishermen Mending Nets,* c. 1881, modern print from 4 × 5 in. dry-plate negative, 1985.68.2.918.

for *A May Morning in the Park,* this photo may reveal to us part of the original plan for this painting.

The other figures in *Mending the Net* seem to have been studied in other locations, with much less control. Most surprising are two negatives of Maggie and Fanny (or perhaps Caddie) Eakins on the roof of a house (probably the Eakins home on Mount Vernon Street) with two small children (probably Fanny's sons Ben and Willie) posed as they appear in the painting (fig. 167).[18] These images have all the hallmarks of an amateur snapshot, with figures blurred and cropped, and a somewhat anxious air of improvisation lent by the proximity of the children to the edge of the roof. However, their relationship to the painting, as well as the rooftop setting, tells us that the figures must have been deliberately posed. Eakins used the roof outside his studio to study the mannequin rowers in the 1870s and his model for the *Crucifixion* in 1881; evidently he did the same thing here, for this spot seems an unlikely venue for family events or spontaneous photographs. The pictures spared the necessity of modeling sessions and added much to the painting. Eakins accomplished a remarkable amount of movement in the procession of his figures by bending the adults and making them kneel or step farther back, but the children added two nice low notes to the musical line along the hill. Their charming, earnest attentiveness also contributes to the spirit of blessed, everyday activity that fills this picture.

The fishermen, by contrast, must have been photographed without contrivance precisely because Eakins wanted them to assume natural, working postures. On principle, Eakins must have wished them to organize themselves; as an artist, he could

capture characteristic moments with his camera and then select the most effective, picturesque postures and groupings. Among the eleven extant plates of net-menders, three figures appear exactly as they do in the painting (figs. 168, 169). The compelling naturalism of the remaining four figures (all at the far left of the composition) suggests that they too were painted with the help of photographs that have not survived.[19]

Much less tractable than the fishermen or even the restless children were the geese in the painting, which were patiently if not desperately stalked in eighteen extant photographic plates. The chase across the Gloucester meadows that can be tracked in this set of plates comically illustrates the technological problems inherent in the slow shutter speed of Eakins' camera. With such wandering subjects, he could only aim, shoot, and hope for the best. At the very least, this series of pictures of geese is a classic display of Eakins' experimental and persevering mind. The pictures also illustrate the "photographic aesthetic" identified by Siegl as characteristic of all the Gloucester paintings. Previously, a

lone vintage print had survived to suggest the existence of others.[20] This one print, taken on the hillside below the tree, seems to have been used in conjunction with other images, such as fig. 170, because none of the extant plates show all the geese configured as they are in the painting. In using blurred images of the geese in the foreground of *Mending the Net*, just as they appear in the photographs, Eakins demonstrates, as Siegl has remarked, his willingness to adopt this kind of "camera vision" within a painting. In this case, it is not just that the geese are too close to be registered within the focal range of the lens, for the plants around them are clearly focused; it is that the geese are moving, and Eakins intentionally depicts them so. This is a photographic style different from the crystalline accuracy of Fairman Rogers' horses, where an instantaneous camera vision was employed; here, the geese are not the main event, and their blurry forms are used only to establish scale in the foreground and set off the sharply detailed figures on the hillside. As a pictorial device, the geese depend on an effect seen only by the camera, but Eakins probably meant to do more than incorporate a novel, mechanical source. He probably intended to reiterate the reality of human vision, with its limited focus, and to press forward principles of visual hierarchy well understood by painters from the days of the Baroque. In *Mending the Net* the techniques of extreme contrast between figure and ground evident in Eakins' watercolors of the late 1870s are now employed in tandem with a deep field. The "Spanish-Italian" pictorial device first noted by Earl Shinn in *Negro Boy Dancing* (see fig. 68; plate 7), whereby "foreground parts are left in riotous disorder, and parts on the second plane, at which the painter desires to direct the attention, are worked up with sympathy and patience," here gained reinforcement from photographic studies.[21]

In knitting together all the images used for *Mending the Net* Eakins again had to abandon the consistency of single-point perspective, because the photographs were taken from different viewpoints. The horizon in the picture as established by the photograph of the tree (and visible as a black ruled line beneath the paint film, nine inches from the lower edge of the canvas) is below the feet of all the figures. The geese were photographed lower still, with the camera sometimes pointing down, perhaps while Eakins was seated or kneeling; the fishermen were taken from tripod height on a flat surface; the children are seen from about their own eye level. All these viewpoints were sewn together in the final composition with little disruption, perhaps because—as in *Shad Fishing*—all the figures are very distant, and many of them bend forward in poses that simulate the effect of a viewer observing them from a slightly lower station point. The light source is nearly the same in all of these photographs too, giving a final effect of unity consolidated by color and shadow studies in oil, made at the same site.

The separate goals of photography and oil sketching in Eakins' method can be learned from examination of the differences between the color sketch of a man's head (fig. 171)

170. *Geese with Tree and Two Men in Background at Gloucester, New Jersey,* 1881, modern print from 4 × 5 in. dry-plate negative, 1985.68.2.947.

and his photograph of the same man (fig. 169), or, even better, by comparing the landscape sketch on the recto of cat. 249 (plate 15) with the photograph made of the same shoreline (fig. 172).[22] Eakins recapitulated in oil the composition seen in his photograph, with the same heaps of shad nets silhouetted against the river, but drew closer to the subject, eliminating the foreground tangle of ropes, floats, and beach grass. Three lonely floats were selected for study, and their swift and brilliantly suggestive modeling generates space throughout the entire scene. The principal goal of this study was not space or detail, however, but color relations and values: the hazy gray-blues of sky and water, the gray-green of the distant shore, the gray-yellow of the beach. More than any of his other landscape sketches, this panel gives a sense of the speed of Eakins' gesture and his sequence of actions with the brush, rapidly scrubbing in the sky and the hints of beach grass, then broadly but more pointedly describing the nets, the floats, and the single sailing ship, caught between sunlight and shadow. To the camera Eakins left the tedious work of recording the maze of ropes and floats that becomes the major pictorial motif of his photograph. Remembering the opposition of painting and drawing in Eakins' work, we can see that the camera has taken the role of drawing: it holds "graphic" knowledge while painting commands the material world of color, texture, and the "real" space of binocular vision.

In these two images Eakins illustrates his grasp of the separate capabilities and aesthetics of the camera's vision. We cannot know whether he made this photograph anticipating its use to him in painting, or simply snapped the shutter because the scene appealed to him, even experimentally, as a photographic study. But if he was interested in the complex texture of the photograph, he never tried to make it into a painting. The image might have served as a two- and three-

171. *Mending the Net: Study of a Fisherman,* c. 1881 (cat. 249, verso).

172. *Shoreline of Delaware River with Fishing Nets,* c. 1881, modern print from 4 × 5 in. dry-plate negative, 1985.68.2.928.

173. *Mending the Net,* 1881–82, watercolor on paper, 10¾ × 16½ in., priv. coll., photo courtesy of Hirschl and Adler Galleries.

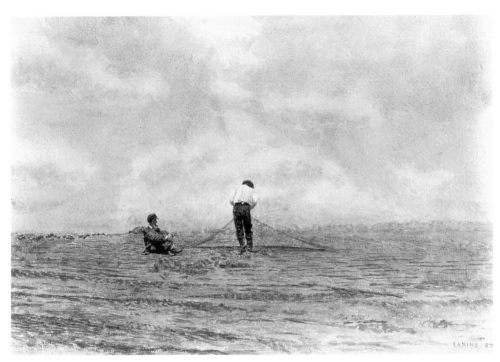

dimensional layout for his watercolor *Mending the Net* of 1882 (fig. 173), wherein the detail of the photograph was completely suppressed.[23] As in his other photographs taken in this formatting mood (see figs. 157, 162), Eakins' geometric organization of the landscape planes made a very avant-garde piece of design. This compositional idea could be carried into another medium, like watercolor, but photographic detail was too intricate and distracting in conjunction with the figures in his oils, so it remained in the realm of the camera.

To painting fell an enhanced sense of painterly surface. Notwithstanding Siegl's argument for a new "photographic vision" in the blurring of detail in the foreground and distance, the landscape in the oil *Mending the Net* remains Barbizon in style, a looser version of Eakins' earliest outdoor

subjects (*Max Schmitt, The Artist and His Father*), all painted in a manner by now typical of many American landscapists, most notably George Inness. Soft and scrubbed, and then layered over with broad brush strokes or palette knife, the background was done in a manner unlike the figures, but it breathes around them comfortably rather than locking them in, or—as in *A May Morning in the Park*—oddly breaking away. The effect of the painting today may be more subdued than it was originally, because Eakins scumbled gray over the sky to diminish its bright blue, perhaps in response to criticism.[24] The final effect of overcast weather is luminous and appropriately unremarkable, befitting the workaday mood. Here, and in *Shad Fishing,* the uneventful sky may also emulate the bright, flat skies in his photographs, which, like most

landscape photographs of this period, could not capture detail in the darks without overexposing the lights.

The accumulation of such lessons from photographs reached a pinnacle of complexity in *Mending the Net.* These included ideas for the entire layout of the canvas, detailed studies for figures, animals, and the tree, and perhaps, as Siegl has suggested, a strategy of "selective focus" along a shallow focal plane. Such a composite method, typical of Eakins' work from his student days, always courted disjunction, but he turned this threat to his advantage here by making the self-containment of the separate figures part of the story of the picture. This effect, observed often by journalists and scholars, has always been appreciated as one of the principal charms of the painting. Ironically, *The Fairman Rogers Four-in-Hand,* made without such direct recourse to photographs, inspired uncomfortable comparisons to camera work; *Mending the Net,* which relied heavily on them, has never been criticized on such terms. Instead, the assembled parts create a mood of quiet, preoccupied industry, wherein the authenticity of the figures and their detachment from the viewer—and from one another—create a sense of the timeless poetry of the everyday.

Contemporary viewers understood this quality but responded to it with different degrees of approval. Earl Shinn was usually a sympathetic critic, and *Mending the Net* elicited from him an almost rapturous response. Describing this painting as Eakins' "latest and probably his best" work, Shinn exclaimed over both the particular effects and the general concept. "The filmy webs of the fishermen form the strangest 'decoration' over the brow of a gentle hill or incline near a river; they rise into the air like Corot exhalations, and festoon the horizon-outlook like gossamer cobwebs, forming a most original 'motif.' Their action, or 'movement,' in artistic language, is produced by a line of fishermen. . . . Every fisherman is a statuette, most realistic, most varied in movement, finished like ivory carving, yet bathed in the misty river-side air." The Philadelphia *Telegraph* likewise praised in two different reviews the "masterly manner" in which Eakins depicted sunlight, and the *New York Times* grudgingly admitted that the figures were skillfully drawn against the sky, "giving more effect of light than he has usually recognized."

The reviews were less friendly when the picture came under the scrutiny of the New York critics at the NAD in the spring of 1882. The *Art Journal*'s critic admired the separate figures but felt that they did not fuse with their landscape or link into a "picture," and the *New York Times* reviewer withdrew the qualified praise issued in 1881, finding "no improvement in the severe, unpoetical, uncompromising style which has characterized work by him of late years. The industry and endeavor to be true are readily acknowledged, but the art is that of the copperplate, dry and unimaginative." Critics at the *New York Tribune* and the *Philadelphia Press* likewise found the subject and pictorial effect perplexingly "commonplace" or of "no value," despite the caliber of the drawing. Against such criticisms flew the opinion of the *New York*

World, whose reviewer praised the "originality of conception and marvellously clever treatment of the figure," as well as the "broad and decided and delightful" handling. Fresh, original, and "thoroughly American," Eakins' work won the highest praise from this critic and also from Mariana Griswold Van Rensselaer. "One of the best and most valuable things in the room is Mr. Eakins' *Mending the Net,*" she wrote. "It was good as painter's work and valuable as a fresh rendering of a distinctly local and unhackneyed theme. There is no one who is doing more than Mr. Eakins to show how our native material, unglossed and unpoeticized, may be made available in artistic work." Such polarization of opinion reveals opposing taste among the critics and the entrenchment of certain stereotypical responses—both disapproving and heroizing—to Eakins' work, even at this relatively early date. But overall, the response was positive, showing an enthusiasm enhanced by surprise: noting Eakins' "very unique individuality," so "apt to astonish and irritate," *Harper's Weekly* seemed relieved and delighted to discover "undoubtedly the most pleasing work that this able but eccentric artist has thus far executed."[25]

Encouraged by the interest in *Mending the Net,* Eakins prepared watercolor variations on the theme for submission to the American Watercolor Society's exhibition early in January 1882: *Mending the Net* (fig. 173), and *Taking Up the Net* (fig. 174), based on a single photograph of fishermen, right down to the framing edges of the negative (fig. 175).[26] *Mending the Net,* like a miniature version of the oil of this title, also isolates the figures deep in space and bathes them in sunlight and meditative silence. Their distance and detachment may be a result of their strangeness to Eakins, for these fishermen were not old friends or paid models. It may also be the result of the intervention of the camera, which distanced Eakins both physically and emotionally from these men, turning them into pictorial subjects even before he set brush to paper or canvas. This alienation, added to the uncanny, sometimes "frozen" naturalness of the postures or gestures of the men in *Taking Up the Net,* may have telegraphed the use of photographs to certain viewers, such as Eakins' friend Leslie W. Miller, who was not pleased by the "depressingly commonplace" results. "These hard, photographic little figures will have to be accepted as 'conscientious,' I suppose, since all the kindly critics will have it so," wrote Miller. "But in their labored feebleness of execution, as well as their singularly inartistic conception, one wonders what relation they can possibly bear to art."[27] Indeed, the kindly critics, especially Van Rensselaer, found virtue in the use of such "real material of a so-called prosaic source," germane to the cultivation of a national sensibility; she praised these two watercolors as "the most capable things in the rooms."[28]

Eakins had heard criticism of his "hard, photographic" realism before, especially since the exhibition of *The Gross Clinic,* but the renewed complaints may have struck him oddly, for these two watercolors (and a final one, *Drawing the Seine,* fig. 176, previously recognized as based explicitly on

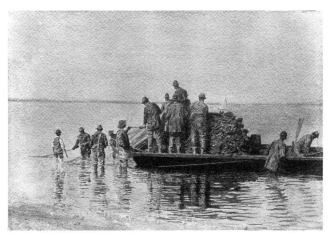

174. *Taking Up the Net,* 1881–82 watercolor on paper, 9½ × 14⅛ in. (24.1 × 25.3 cm), Metropolitan Museum of Art, Fletcher Fund, 1925.

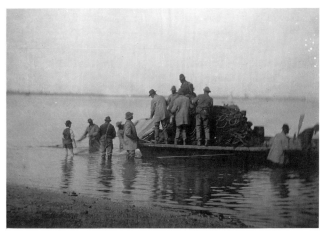

175. *Shad Fishing: Setting the Net,* c. 1881, modern print from 4 × 5 in. dry-plate negative, 1985.68.2.888.

a single photograph, fig. 177) are among the least "photographic" of his works.[29] In fact, the use of photographic aids (or the desire to hide this use) seems to have inspired Eakins to greater largeness and economy of handling. All three of these shad fishing subjects are simpler and less hesitant than his earlier watercolors, and, while this change came at the expense of the engaged, detailed intensity of the 1870s (still favored by some viewers), it was appropriate to a broader landscape perspective.[30] In keeping with contemporary advice on landscape sketching in watercolors, Eakins chose a rougher surface for the paper in *Mending the Net* and *Taking Up the Net,* a paper similar to the one Winslow Homer had used the year before in Gloucester, Massachusetts, with such success. This heavier paper had a pocked surface that trapped pigment or bubbles of air in an irregular pattern, lending atmospheric shimmer to the washes and impeding fine detail. A glance back from these fishing scenes to any earlier watercolor on Eakins' usual smooth paper (such as *Baseball Players,* fig. 55; plate 2) reveals how much more generalizing his touch has become. The new works also look cleaner, partly because there is none of the pencil drawing beneath the tints to create the grainy, "photographic" grayness sometimes seen in the modeling of the earlier watercolors, such as *Negro Boy Dancing* (see fig. 68; plate 7). The new freshness and vigor of his work in watercolor in 1882 "pleasantly" surprised one reviewer accustomed to Eakins' "dreary mannerism"; far from criticizing his photographic hardness, this critic led off his article with praise for Eakins' new look.[31]

Whatever the critical response, the photographic basis of these watercolors seems indisputable, and *Drawing the Seine* provides an opportunity to study exactly how Eakins used the camera in this work. In comparing the watercolor and its camera study, it is clear that Eakins relied heavily on the photograph, though it must be remembered that the photo itself represented considerable artistic forethought and contrivance on Eakins' part. In this respect, the photograph acted much like the oil sketches he had prepared for his ear-

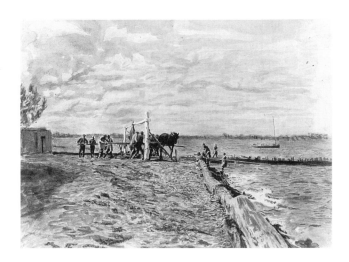

176. *Drawing the Seine,* 1882, watercolor on paper, 11¼ × 16¼ in., Philadelphia Museum of Art, John G. Johnson Collection.

177. *Shad Fishing: Hauling the Net with the Capstan,* c. 1881, modern print from 4 × 5 in. dry-plate negative, 1985.68.2.895.

lier watercolors. But Eakins usually copied his own oil sketches closely, often refining them further, while he selectively studied and freely altered the photograph, probably because it was neither natural nor artistic enough for his taste. Most obviously, color had to be added, and the motion and depth of the sky. The darkening of the sky in the watercolor, enhanced by the lightening of the foreground, completely altered the value structure given by the photograph, throwing more interest on the figures and the windlass, which now became the most brilliant spot in the picture. Siegl has remarked the "photographic" focus of this watercolor, with its sharply detailed middle plane,[32] but this effect was accomplished only by eliminating and blurring details in the foreground that the camera had quite earnestly recorded. The result, then, is more artful and yet appears more natural than the photograph, which seems dramatically abstract (and in some ways more confusing and exciting) by comparison. Ironically, considering Eakins' reliance on memory and camera here, his quick wet touches and dry brush textures are unusually spontaneous, while the empty foreground, bold diagonal recession, and geometric division of the surface recollect the compositional formats of the impressionists.[33]

The relative critical success of these watercolors and the large oil *Mending the Net* inspired another, smaller round of photography in the shad season of 1882, and another set of paintings, although Eakins was close to playing out the subject. Seeking to extend and refresh the series, he undertook the only "pure" landscape in this group and the only large, finished landscape in his oeuvre, *The Meadows, Gloucester* (fig. 178), evidently the last of the paintings based on photographs taken near the fisheries.[34] Like all the second round of Gloucester paintings it was based on a lone photograph (fig. 179); also extant is a bright and fluid oil sketch made from the same spot (fig. 180).[35] As with his landscape study for *A May Morning in the Park* (fig. 144; plate 13), the unusual tidiness of this study in respect to its scored framing edges, and the exact correlation of these edges to the composition of both the photograph and the final canvas, indicate that this oil study was undertaken after the concept of the picture was fixed, and probably after the photograph was made. This tight three-way relationship clearly shows Eakins using the camera like a Claude glass or camera obscura of earlier generations, to select and bracket his subject.

The completeness of the information captured by the oil sketch and photograph also make it very likely that Eakins painted the final picture entirely in his studio. Although he could have easily toted even the largest of these Gloucester paintings across the river to work on the spot, he does not seem to have done so, and his studies certainly made it unnecessary. Four times larger than most of his shad fishing oils, and identical in size to *Mending the Net, The Meadows* was pitched at a grander, "exhibition" scale, and it was probably painted entirely at home, in standard academic fashion, like his two other major canvases of 1881 (*The Crucifixion* and *The Pathetic Song*, also made with the assistance of photographs).

178. *The Meadows, Gloucester,* c. 1882–84, oil on canvas, 32¼ × 45¼ in., Philadelphia Museum of Art, Given by Mrs. Thomas Eakins and Miss Mary Adeline Williams.

This conventional method was matched by contemporary taste in matters of landscape subject, composition, and style. His modern intentions are evident in the deliberate emptiness and banality of the view, which lacks any old-fashioned picturesque construction. This kind of composition signals naturalism and on-the-spot, informal study, as does the heavy paint surface and the palette of bright green, olive, brown, and blue. All of these formal qualities link *The Meadows* with Barbizon landscape painting and particularly Courbet, whose work was surely examined by Eakins in Paris in the 1860s. This memory could have remained or been refreshed by exposure to work by a younger generation adapting Courbet and the Barbizon School to the tastes of Salon juries and American financiers. Eakins would have recently seen, for example, William L. Picknell's salon entry of 1880, *On the Borders of the Marsh*, exhibited at the Philadelphia Society of Artists' show that fall and given to the Pennsylvania Academy early the next year. Picknell's painting depicts an empty, marshy pasture closed in the middle distance by a screen of trees. Informal, minimal, and very big (79 × 59 1/2 in.), Picknell's view of a meadow near Pont-Aven illustrates the mainstream French landscape school that still served as a reference point for Eakins' efforts.[36]

The use of photographs to assist in landscape painting was a commonplace by the 1880s, for French painters since the 1840s had embraced the effortless detail and speed of camera studies, and many American artists had grown accustomed to traveling with cameras or photographers. Eakins' use of photographs in the invention and construction of the Gloucester paintings is not in itself exceptional, then, although the lessons he seems to have drawn from these sources, and the final results, were quite personal and distinctive. Siegl guessed that Eakins had used photographic aids to paint *The Meadows*, largely because the painting displays the selective focus seen in *Mending the Nets*. Siegl was right, but for the wrong reasons, as the appearance of Eakins' crisply

179. *Landscape at Gloucester, New Jersey*, c. 1881–82, modern print from 4 × 5 in. dry-plate negative, 1985.68.2.965.

180. *The Meadows, Gloucester*, c. 1881–82, oil on panel, 10½ × 13¾ in., priv. coll., photo courtesy of Geoffrey Clements.

focused photographic model demonstrates. To Siegl, Eakins' "camera vision" was not a matter of superhuman detail but of the effect of a restricted focal plane wherein objects are sharply defined and set off by blurred objects in the foreground and distance, "as in early photographs."[37] The revelation of Eakins' own negatives in the Bregler collection proves that, indeed, some of Eakins' first photographs have this quality, and the visual novelty of these images may have enhanced the larger strategy of selective focus building in his work throughout the late 1870s. Certainly the range of focus in a picture like *Mending the Net* exceeds that seen in his landscapes prior to 1876, but—more important—it also exceeds the range shown in most of his photographs. Also remarkable is evidence indicating that Eakins did not like this effect in his own photographic prints; in the one vintage print of geese adapted for *Mending the Net*, he cropped the unfocused foreground. And, in translating particular "selectively focused" images into his paintings (as in figs. 166, 168, 169) he edited out most of the blurry margins. From these choices we can begin to understand that selective focus, as a pictorial device, operated freely, without the assistance of particular photographic sources, and that such "camera vision" was, for Eakins, gradually disallowed in his own camera work.

In reconstructing a sense of Eakins' own photographic aesthetic and its use to him in painting, we must remember the categorizing quality of his method and the respectful, scientific quality of his other experimental endeavors. Eakins typically entered other people's technical arenas with sensitivity to the canons of good professional practice, and we might expect him to be alert to contemporary standards in photography as well. According to mainstream aesthetics of 1880, the blurring of the image was usually a "mistake," probably the result of accidental or amateurish misuse of his short-range portrait lens.[38] Notably, such blurred and haloed images do not occur in pictures taken after Eakins' first year

of learning and experimentation. Most of his plain landscape photographs are like fig. 179, with a deep, evenly focused field that records detail from edge to edge and foreground to background, as in standard professional photography of this period. His camera gear included a special landscape lens with a wide angle and long depth of field, well suited to the uniform recording of such sunny, spacious views, and his photograph shows the correct use of this lens for a "good" image, according to the taste of the early 1880s.[39] Like the dangerous foreground and peripheries of a perspective grid (also the by-product of monocular vision), the blurred or distorted zones of the photographic field were politely avoided.

The transformation of this properly crisp, evenly detailed image into the broadly painted, selectively focused painting, which resolves on a brightly lit cow in the middle distance, involves a profoundly anti-photographic mission in terms of the conventional photography of his day. It would have been difficult in 1882 to make a camera "see" the landscape in this fashion, requiring the "wrong" lens (his shorter-range portrait lens), "bad" technique (failure to focus), or the intrusion of manipulative effects (such as greased lenses or retouching) not fashionable in camera work for a decade or more. Such anachronistic practices on Eakins' part are not inconceivable, for he had an experimental mind, and certainly (as the streaked emulsion on many of these early plates, including the one of the meadows, demonstrates) he was guilty of amateurish procedures and capable of learning from them. But if he liked blurry margins in his paintings, he evidently took steps to disallow such effects in his photographs, for neither the streaking nor the wide disparity of focus appear again. A few other landscape photos in the Bregler collection, probably by Eakins but unrelated to known paintings, show a progressive compositional sensibility attuned to the Japanese and impressionist tastes imported into the pictorial photography of the 1890s from painting, but none of these prints have the dramatic range of focus seen in

the Gloucester photos.[40] The progression seen throughout 1881–82, and confirmed by the contrast between *The Meadows* and its companion photograph, is one of increasing articulation of an appropriate style for each medium, consistent with period aesthetics in painting and photography.

The photographic bungles of his first months of camera work may have taught Eakins to extend the range of focus in his paintings, then, but it seems unlikely that he employed this effect just to quote from or re-create a "camera vision" that contemporary photographers deemed faulty. Most likely, he saw the camera's selective focus as a modern and scientific refinement of traditional pictorial wisdom. More speculatively, we might imagine his desire to express recent notions about the nature of human vision, with its extremely limited focal zone. This truth about human sight could only be "seen" or simulated in the record of a selectively focused photograph, because we normally suppress awareness of this effect and compensate for it with the constant motion of our eyes across the visual field. This same scanning movement also makes selective focus in a painting unnecessary, for we read a picture just as we read the rest of the world.[41] Eakins' awareness of these two facts of vision—limited focus and incessant movement—is not known, nor is the extent of his grasp of the larger mechanics of binocular human vision compared with that of the camera. However, his experience with anatomical dissection and his treatise on lenses and diffraction (appended to his drawing manual) indicate unusual sophistication in both areas.[42] His approach to the "truth" of vision might have been only partially informed, or well educated but willfully selective in his use of current theory. But knowing his passion for the interrelationships between science and art, we might imagine his pleasure applying photographic insight to the problem of depicting or reconstructing the quality of human vision in a painting. Like the "science" of Seurat's color theory, the premise of a perfect, fixed eye (also central to Eakins' perspective system) may have offered an intellectual pretext to explore certain pictorial effects that had a purely aesthetic or conceptual appeal.

However intertwined, the goals of painting and photography soon diverged, for the story of Eakins' work in 1881–82 is of increasing distance between the two realms. *The Meadows,* probably his last and largest painting reliant on a single, almost all-inclusive photographic study, is much less "photographic" (in the conventional sense of finely, unselectively detailed) than is work from the previous decade, such as *The Chess Players.* Every year since his introduction to photographic aids his work in landscape had grown broader. Perhaps he was attempting to obscure or distance his sources, or perhaps, in being liberated from detail, he was refining or enhancing what was different about the act and the product of landscape painting. In his finished paintings in this period he attempted effects of color, texture, scale, and form beyond the grasp of either the camera or his own earlier work.[43] Even more striking was the change in his informal outdoor sketching, evident in the many small panels in the Bregler collection (cats. 247, 248, 249, 250). Plein air sketching had been a source of confusion and frustration in the 1870s, as his letter to Gérôme about the hunting paintings makes clear, so it is with surprise that we discover the variety and confidence of his work in 1881 and '82. These small sketches show an aesthetic more progressive than any of his finished oils—a taste in painting analogous to the experimental freshness and modernity of his camera work.

The spontaneous and informal quality of this work is obvious from its size and presentation, often jumbled together on different corners or sides of small wooden panels. The subsequent division or cropping of these panels by Bregler and others has altered their effect, lending a sense of self-containment and importance not entirely in keeping with Eakins' intentions. To say, then, that the thin paint, tonal organization, and flat, banded composition of cat. 248 (fig. 163) recall Whistler's work may be partly to credit Bregler for the construction of a Whistlerian Eakins out of some larger panel. But even if ragged edges are imagined, the effect of this sketch is surprisingly modern, and certainly not photographic in any conventional sense. The breadth shown in this sketch and others such as cats. 247 (plate 14) and 249 (plate 15), indicating both spontaneity and pleasure in the handling of paint, introduces a side of Eakins rarely seen in other work. The effect of these sketches reminds us of the recent return to the United States of many "impressionist" American painters from London, Munich, and Venice, most of them Eakins' colleagues in the exhibitions of the Society of American Artists. However, Eakins' restriction of such work to small paint-box panels also indicates that he understood them to be sketches in the traditional sense, not exhibition pieces. He surely painted them with the same impressionist intentions that inspired his photographs—a desire to catch transitory qualities of movement, color, or atmosphere—but such sketches were not ideologically impressionist, that is, complete and final as works of art. Instead, like the outdoor sketches of many earlier generations of landscape artists, this is fluid preparatory work, impressionist in the older sense of the word.

One painting survives, however, to make a more provoking, less easily categorized statement of this new aesthetic in Eakins' work: *Delaware River Scene* (cat. 250; plate 16). Like the other sketches, it was cropped by Bregler to present a more finished effect, but like his more autonomous preparatory studies (fig. 180; cat. 245), it was alone on its panel. In size, *Delaware River Scene* compares to William Merritt Chase's small oils of the 1880s, J. Alden Weir's similar Whistlerian watercolors of 1881, or William Morris Hunt's talismanic *Gloucester Harbor* (MFA, Boston) of 1877. Their work was also small and simple, lacking in detail, and based on a strong geometry of stripes and diagonals. Quiet and high-valued, these paintings emphasized tonal harmony rather than bright color, although a surprising amount of pink and green appears in Eakins' view. Grown out of Whistler's art and late Barbizon landscape painting, the

tonalism of all these paintings represents a variety of American post-impressionism. Seen among the other painters working in this mood, Eakins appears as a timely, even avant-garde participant in a larger national movement that had yet to win its widest popular following.[44]

Eakins did not remain in the vanguard, choosing for the most part to give up both watercolor painting and plein air landscape work after 1882. His next landscape backgrounds, containing the Arcadian nudes, would be more artificial and academic, less observed or photographed. Apparently, the 1881–82 period brought the most profuse and diverse work of Eakins' career in both landscape sketching and landscape photography, and the most intense interplay of ideas between the two activities. This interchange had its rewards, as in *Mending the Net*, for as Eakins sorted out the capabilities and excellences of his two landscape media he learned to recognize good "painterly" potential within a "bad" photograph. At the same time, he could be misled by his enthusiasm for a good photograph, like fig. 179, or an exciting one, like fig. 177, into a misapprehension of its potential as a painting. The photograph of *Landscape at Gloucester* remains, like the photo of *Hauling the Net*, more interesting than the painting that was based on it. The oil seems too big, too subtle, too empty, perhaps because of the broad suppression of detail and value contrast. It is not without merit, but is not the success of *Mending the Net*, and Eakins knew it. He exhibited the latter painting many times in America and Europe, and won medals with it; *The Meadows* appeared only twice, at exhibitions in 1884 and 1885, and then returned to his studio.[45]

Eakins would paint only one more large, topographical landscape after this year—*Cowboys in the Badlands* of 1888 (see fig. 210)—and in it he returned to the composite use of photographs and oil sketches seen in his first Gloucester paintings. In the intervening years his landscape work turned in a different direction, with larger figures and a diminished emphasis on place. These new paintings, set in an American Arcadia, also perpetuated the composite method developed in the Gloucester series, but they drew on a different wellspring in Eakins' imagination, and a completely new and different photographic oeuvre.

CHAPTER 17 Nudes

THE CAMERA IN
ARCADIA

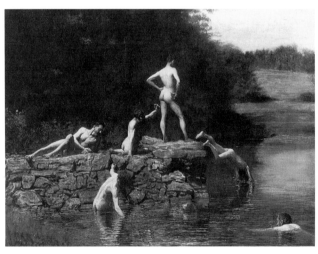

181. *Swimming*, 1885, oil on canvas, 27⅜ × 36⅜ in., Amon Carter Museum, Fort Worth, Texas.

As a student in Paris, Eakins had been able to imagine few circumstances that would allow him the opportunity to paint "naked" figures, but once home, his courage and inventiveness rose along with his professional position. His first essay, undertaken when he was assisting Schussele at the Academy, set his nude safely in the past, in the company of a chaperone (see fig. 129; plate 11). Three years later, in 1880, his second effort—*The Crucifixion*—engaged the most sacred tradition of Western art. This project, aggressively at life scale and abrasively modern in its aesthetic, came just after his succession to Schussele's post as professor of drawing and painting.[1] By 1883, with the confidence of a dozen years' experience at home and the ambition that came from his position as director of the best art school in the country, Eakins was primed to undertake a contemporary nude subject.

Encouragement and patronage came from the Academy itself: Edward Hornor Coates, the young businessman who followed Fairman Rogers as the chairman of the Academy's Committee on Instruction. In 1883, Coates commissioned Eakins to paint a large picture that, by mutual understanding, would some day hang in the Academy's collection. Eakins seized this opportunity to present a manifesto of his beliefs and methods. By August 1884, according to his student and assistant Thomas Anshutz, work was under way on "a picture for Mr. Coates of a party of boys in swimming" (fig. 181).[2] Melding modern camera studies (figs. 182, 183) and plein air sketches, as he had at Gloucester, Eakins produced a painting for Coates that expressed the Pennsylvania Academy's mission as a school and a museum. Profoundly academic in its method as well as its emphasis on the human nude, *Swimming* recovered the spirit of classical art in the beauty of contemporary life.

At about the same time, probably in the summer of 1883, Eakins also began a more private series of paintings and sculptures of an overtly classicizing nature. Never exhibited, probably because they never were finished, these Arcadian works depict figures serenely existing in a summer landscape, nude or clad in antique draperies, listening to or playing music on ancient panpipes and the double flute.[3] The themes and the construction of these Arcadian works, with their references to antiquity, unite with *Swimming* into an assemblage that speaks of Eakins' ambitions as a figure painter and his sense of place within the history of western art. This consciousness seems to have surrounded him at the Pennsylvania Academy between 1883 and 1885, when his authority as director of the schools finally gave him full sway over the curriculum, and his classroom projects, especially in photography, made themselves powerfully felt in his art. Although sometimes deemed uncharacteristic or "experimental," these figure paintings express Eakins' primary identity in these years as a teacher and as an academic, a link in a human chain stretching back to Greece and, through his students, into the future of a correctly modern art.

The myriad sources, ancient and contemporary, that inspired the Arcadian paintings and sculpture have been well

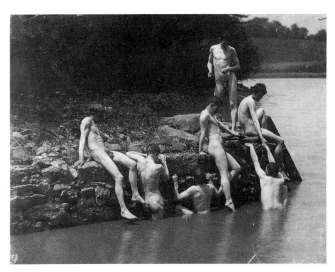

182. Circle of Eakins, *Thomas Eakins and Students, Swimming Nude,* c. 1884, platinum print, 8¹⁵⁄₁₆ × 11¹⁄₁₆ in., 1985.68.2.480.

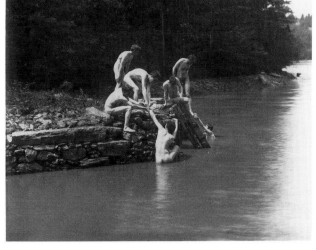

183. Circle of Eakins, *Thomas Eakins and Students, Swimming Nude,* c. 1884, modern print from 4 × 5 in. dry-plate negative, 1985.68.2.1026.

studied, most recently and splendidly by Marc Simpson, who has examined the obvious and subtle forces at play in these works.[4] To this good scholarship the Bregler collection offers several new insights into the construction of these paintings and sculptures, with the revelation of many photographic studies, an oil sketch (cat. 251), a drawing (cat. 203), and the original plaster relief, *An Arcadian* (cat. 262), all of which reopen discussion of Eakins' methods and motives in this series.

The importance of this group is signaled by the size of the largest and most finished painting in the group, *Arcadia* (fig. 184; plate 18), which uses a canvas close to the size of *Mending the Net* and 75 percent larger than *Swimming.* This composition probably began with the small *Arcadia: Sketch* (plate 19), although it is unlike most of Eakins' preliminary compositional sketches in its degree of variation from the final image. The poses of the two figures on the left are different, and the framing edge is less square, cutting much closer to the figures. This format may be the work of a later hand, for the panel has been trimmed on all sides, but the result is pleasantly intimate. This charm is increased by the informal but delicate paint handling, the emerald greens of the landscape, and the strong sense of sunlight and shadow playing across the figures. More than the larger painting, this sketch suggests an environment that truly envelops the bodies in warm air. This quality, and especially the contrast between the seated figures in leafy shade and the standing flute player caught in strong sunlight, may be the result of work done outdoors, when the organization of the painting was taking shape. The flute player appears in this same attitude in the larger oil with only a few changes of posture, as if his pose were already fixed in Eakins' mind by the time of—if not in the process of—this sketch. An oil sketch probably made the same afternoon (Carnegie Museum) supplies these small alterations of hand, shoulder, and knee finally seen in the large oil.[5]

A closely related photograph of a piper in the Hirshhorn Museum and a similar photo of "Johnny" Wallace in the Metropolitan Museum have long since demonstrated the camera's role in this project.[6] The glass plate for this second image (see fig. 100) and new images in prints and negatives in the Bregler collection (figs. 185, 186) extend the variants known to have been made on this same day, reminding us that Eakins himself posed for the figure of the piper several times. Although the painted figure is youthful and slender, Eakins literally enacted this role in front of the camera as well as in his imagination, identifying himself with the artist/musician who enthralls all listeners and—by extension—his students and patrons.[7] Most remarkable, however, is the fact that out of all these poses and duplicate prints, no image corresponds exactly to the piper in the painting, indicating Eakins' ultimate use of modeling sessions in preference to any single or composite photographic solution.[8]

The many duplicate images from these negatives also reveal a new side of Eakins' photographic work, for these redundant prints indicate interest in the images themselves, their enlargement or cropping, and their tonal value as altered by different printings or techniques. Photos from these modeling sessions were put to multiple purposes, for the same piper (clearly Wallace) appears in the relief *Arcadia* (fig. 187) and in the smaller panel *Youth Playing the Pipes* (Hirshhorn), but the redundancy of these images shows an interest in the photographs as an end in themselves. Eakins obviously enjoyed making, owning, and handling these images; the fact that many of them feature his own nude body must also tell us something about the latent narcissism and exhibitionism indulged while the cause of art, science, or practicality was being pursued.[9]

No such redundancy of images accompanies the boy playing the panpipes in *Arcadia,* although an oil sketch and a single photograph (both in the Hirshhorn, and both showing

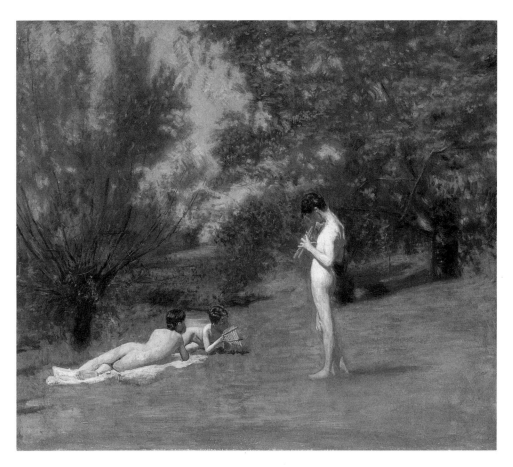

184. *Arcadia,* c. 1883, oil on canvas, 38⅝ × 45 in., Metropolitan Museum of Art, bequest of Miss Adelaide Milton de Groot, 1967 (plate 18).

185. Circle of Eakins, *Thomas Eakins Nude, Playing Pipes, Facing Right,* c. 1883, platinum print, 6⁷⁄₁₆ × 3¹¹⁄₁₆ in., 1985.68.2.487.

186. *John Laurie Wallace Nude, Playing Pipes, Facing Left, in Front of Leafy Background,* c. 1883, platinum print, 3⅜ × 2¹¹⁄₁₆ in., 1985.68.2.492.

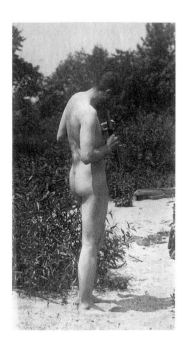

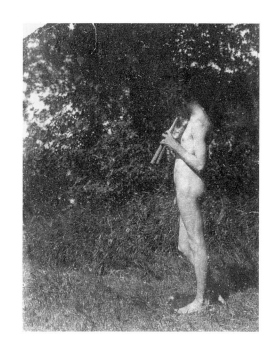

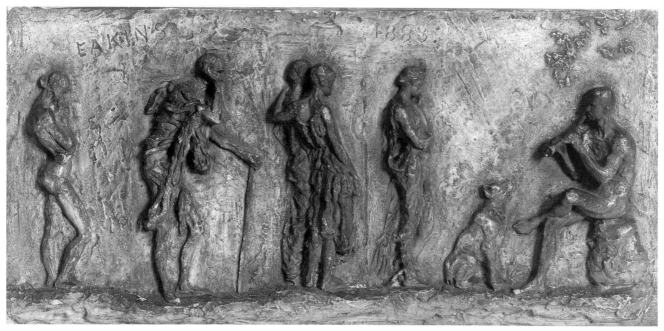

187. *Arcadia*, c. 1883, plaster relief, 11¾ × 24 × 2³⁄₁₆ in., Philadelphia Museum of Art, Purchased: J. Stogdell Stokes Fund.

the boy exactly as he appears in the painting), survive to demonstrate a more truncated version of Eakins' method. One small oil sketch of the woman also remains (Joslyn Art Museum), although she is shown seated and dappled in sunlight, as in the lone extant photo of her known prior to the emergence of the Bregler collection (Hirshhorn).[10] Neither this sketch nor the photograph have been recognized as Arcadian, although the *Arcadia: Sketch* and other newly discovered prints and negatives now make the connection clear. Several photographic variants of the curled-up pose used in the compositional sketch show the model to be Susan Macdowell, then Eakins' fiancée (fig. 188). Seated on a cloth, first one and then the other knee up, she assumes a pyramidal shape that echoes the larger organization of the entire figure group.[11] We know that Eakins (or someone in his circle) liked this photograph, because it was enlarged and mounted on a card, but he rejected all such seated poses in the process of developing the composition of his painting. Searching for a longer, more horizontal shape to stabilize the entire figure group, he experimented with a reclining pose, photographing Susan lying on her stomach (fig. 189) and then on her side (fig. 190). He finally settled on this last pose, with its strongly undulating contour, favored elsewhere in his nude photographic studies (see fig. 103). This decision seems to have come late, for there are no extant oil sketches of this reclining pose, and the woman's figure remains less finished than the standing piper. Like the boy with the panpipes at the center of the group, she seems to have been painted completely from the photograph, right down to the drapery contours, with a resulting flatness and inadequacy that halted further progress on the painting. Susan could not be expected to

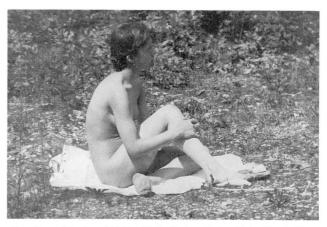

188. *Susan Macdowell Eakins Nude, Sitting, Facing Right, Hands Clasping Right Leg*, c. 1883, albumen print, 5¹⁄₁₆ × 7¹³⁄₁₆ in., 1985.68.2.537.

model nude outdoors on the rooftop outside his studio or in the back yard of the Mount Vernon Street house, and the opportunities for her to venture again to the Crowell farm or the New Jersey dunes may have slipped away. The sense that these many photographic studies of her were taken all at once—on a somewhat daring adventure not easily repeated—may explain the cramped progress on this project, and its ultimate abandonment.

Related photographs of Susan evidently taken on the same spot on the same day contributed to the smaller painting, *An Arcadian* (fig. 191), begun about the same time. An oil sketch for the figure of the woman survives (fig. 192), and two photographic studies of Susan nude (including fig. 193) indi-

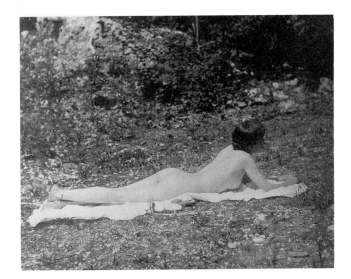

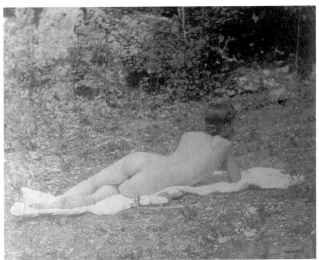

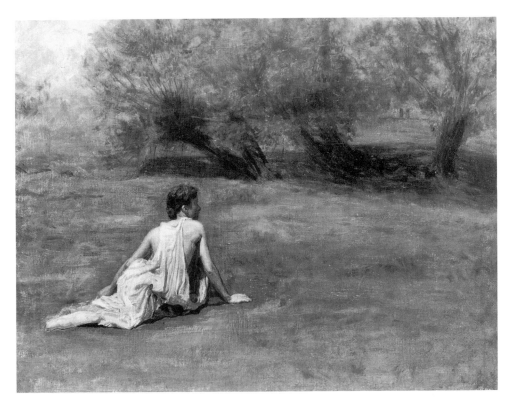

189. *Susan Macdowell Eakins Nude, Lying on Stomach,* c. 1883, cyanotype, 3⅝ × 4⁹/₁₆ in., 1985.68.2.535.

190. *Susan Macdowell Eakins Nude, Reclining on Elbow, from Rear,* c. 1883, albumen print, 3¼ × 4 in., 1985.68.2.542.

191. *An Arcadian,* c. 1883, oil on canvas, 14 × 18 in., Spanierman Galleries.

cate planning for this pose with the camera in advance of his painting.[12] In *An Arcadian,* this figure is draped, and her pose is different in many subtle ways from both extant photographs and the oil sketch, indicating fresh studies from the model as the painting was under way. Although this figure is more resolved than the woman in *Arcadia,* the entire composition was never finished, with the right side of the canvas left bare save for a chalk sketch of a piper, seated in a pose like that of Wallace in one photograph and the relief.[13]

The simultaneity of Eakins' work on both paintings, and his juggling of photographic studies in them, can be read in one small drawing on a piece of letter paper (fig. 194). Sketched figures of the woman, as seen in figs. 188, 189, and 193, are accompanied by measurements in inches and calculations, perhaps for changes in scale. Photographic enlargements could, of course, evade the problem of scale calculation altogether, for instead of adjusting the desirable figure height on the canvas to approach some easy fraction of life size, a photograph could be enlarged to bring the figure to exactly the dimensions needed for the canvas, regardless of neat percentages. The piper in *Arcadia* is about one-fourth scale, but the other figures, evidently more dependent on photographs

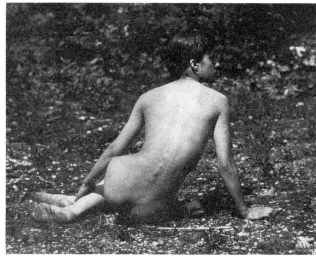

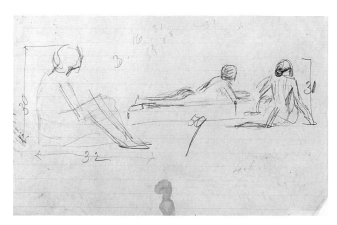

192. *Study for "An Arcadian,"* c.
1883, oil on wood, 8½ × 10⅞ in.
(21.4 × 27.5 cm), Hirshhorn Museum and Sculpture Garden,
Smithsonian Institution, Gift of
Joseph H. Hirshhorn, 1966.

193. *Susan Macdowell Eakins
Nude, Sitting, Looking over Right
Shoulder,* c. 1883, cyanotype, 3½ ×
4⁷⁄₁₆, 1985.68.2.544.

194. *An Arcadian: Three
Sketches,* c. 1883 (cat. 203).

and in more complex poses, may have been sized photographically. This practice may account for some of the very large platinum prints in this series, such as the image of the boy with panpipes, enlarged exactly to the scale of his figure in the painting.[14] The gathering of these three studies on one page suggests, despite the odd scale relationships, a planned composition that somehow united these figures. However, this drawing more likely illustrates Eakins' use of photographs while working out, on a single scrap of paper, the variables for both paintings and the interchangeability of certain figures that may have been considered for either picture. From the welter of photo studies, the incompleteness of the paintings, and the strategic implications of this drawing, we can see that the figures in his photographs had become units, readily enlarged and moved around in a compositional game with endless possibilities.

The Arcadian works remained unfinished, perhaps because the focus of Eakins' attention at this time was distracted by his important commission from Coates. The photographic method used for compositional experimentation was similar, as several well-known studies for *Swimming* have shown, and as a few new prints from Bregler's collection

(fig. 182) and one new image from a glass negative (fig. 183) reiterate. Four different images taken at the site of the swimming hole can now be counted, including three previously catalogued by Hendricks; others may have been taken that have since disappeared. These photographs are remarkable in two ways, the first being the independence of the imagery from the appearance of the final, painted figures (although this may be an accident of survival), and the second being the beauty and importance of the individual pictures, several of which (such as fig. 182) are the largest of Eakins' surviving prints, as well as the most often printed. Both of these factors point to the autonomy of this photographic project as an endeavor related to his painting commission, but with independent results. Contact prints (made the same size as his negatives) in albumen or cyanotype dominate Eakins' working proofs, because these processes were cheap and fast. However, the proliferation of expensive and complicated platinum prints, sometimes seven times larger than the contact prints and with the rich blacks and subtle tonality of this process, show an investment of interest above and beyond the necessities of photographic study aids. Variant croppings also demonstrate Eakins' habit of determining the framing edges

of his pictures in response to the internal organization of the composition, with a correspondingly relaxed concern for the backgrounds and framing edges in the actual photographic plate. As in his paintings, the figure seized attention first and then generated its own borders. With the exception of his landscape studies, where the margins of the negative were obviously well considered as he looked through the lens, Eakins evidently treated his 4 × 5 plates with the same disregard given to the edges of his sketch panels and notebook pages.[15]

The quality of these swimming hole pictures indicates artistic contrivance. Certainly the men knew they were posing, and Eakins (who seems to appear in all of them) or the photographer may have supplied some stage direction. At the same time, there is a measure of informality and improvisation willingly recorded, like the movements of the fishermen at Gloucester, in order to document spontaneous postures and perhaps capture naturally occurring "artistic" moments in everyday life. The final composition of the painting, as many have noted, is much more contrived than any of these photographs; Eakins uses none of the poses exactly as shown. Other, lost photographs may have supplied more direct studies, but from the record of Eakins' account book and the testimony of others, we know that many modeling sessions and wax sculptures also contributed. The higher resolution of this painting, compared to that in the Arcadian pictures, probably is owed to the greater intensity of life study. For Eakins, the amount of finish often seems to be inversely related to his dependence on photographs; the most broadly painted Gloucester landscapes relied heavily on camera studies, while the most carefully worked figure paintings—*Swimming, The Pathetic Song* (see fig. 96)—used photographs only as auxiliaries to life study.

The variations in pose seen in these Arcadian projects—especially *Swimming*, which includes a sequence of figures suggesting movement over time—tie the works into the scientific and classroom-related study undertaken during these years, including motion photographs and the "Naked Series" (see figs. 92, 93; cat. 29).[16] Many of Eakins' students, including the young men seen in photographs lounging around the swimming hole or wrestling in a meadow, also posed for the more scientific nude studies, and occasional overlaps in the repertory of poses—as in the profile contrapposto of the piper in *Arcadia*, who assumes one of the standard positions from the "Naked Series"—demonstrate Eakins' intention to make these research projects come to life in art in his outdoor paintings.[17]

In addition to his desire to illustrate the application of his teaching principles in his work, Eakins had other motives and sources behind these Arcadian works. Noting the contemplative mood, the conventional gestures of mourning, and the suggestion of Attic grave stelae present in the sculptures, Simpson reminds us that the initial inspiration may have been a melancholy one: the surprising death from fever of his favorite sister, Margaret, at Christmas 1882. It may be

Maggie, the sturdy companion of so many outdoor jaunts, whose spirit inhabits these Elysian fields, or perhaps these are her friends, sobered by the knowledge that death comes even to Arcadia.[18]

Given this sad inspiration, Eakins had a wealth of sources from the history of art on which to draw. Primary, of course, was the repertory of forms absorbed as a student at two schools that based their tuition on the study of classical and neoclassical sculpture. Dutiful hours spent drawing from casts in Philadelphia and Paris taught Eakins to hate the practice but to love Greek sculpture; as director of the Academy's schools he diminished the role of charcoal drawing but kept the cast collection, and particularly the frieze of the Parthenon, before the eyes of every student (see fig. 28). Eakins often praised the work of Phidias, "most noble of all." And the pyramidal arrangement of the figures in *Swimming*, posed like a pediment group, or the pacing of the figures in his own relief, *Arcadia*, owes much to the Parthenon sculpture or to other Attic reliefs intimately known from daily encounters in the Academy's studios.[19]

That Eakins enjoyed the contemplation of these sculptures is even more obvious in his photographs, in which students appear artfully posed as Dione and Aphrodite (identified in his day as two of the so-called "Three Fates") from the Parthenon pediment (fig. 195) or as the *Faun with Flute*, visible in fig. 28 and imitated by Wallace in fig. 100.[20] Like the swimming hole photos, these images survive as large platinum prints in several versions, each cropped differently, indicating special interest.[21] These images were made after the relief *Arcadia*, which appears in the background of one of the photographs, although neoclassical costume subjects seem to have been among the first of Eakins' projects with his new camera, if Susan Macdowell correctly remembered 15 June 1881 as the day they had the photos of the "group of infant waist dressed Academy girls taken in Trot's yard."[22] These photo sessions seem to have been motivated by the period's love of "tableaux vivants" as well as by Eakins' desire to confirm the anatomical accuracy of Greek art, or to discover the beauty of the past alive in the present. This spirit must have motivated the many photos of himself and his students nude, outdoors, sometimes wrestling or boxing like the young Spartans evoked by Degas in the 1860s. "The Greeks did not study the antique," Eakins said in 1879. "The draped figures in the Parthenon pediment were modeled from life, undoubtedly. And nature is just as varied and just as beautiful in our day as she was in the time of Phidias."[23]

Another source suggesting the reality of life behind Greek sculpture may have been a set of antique figurines given to the Academy in 1879 by Fairman Rogers (fig. 196). "Everybody is examining [Tanagra figures] nowadays with such novel interest," wrote Earl Shinn in 1881, not long after peasants and archaeologists finished emptying the fourth-century necropolis of Tanagra, north of Athens. Several thousand diminutive terra-cotta figurines were unearthed from this site in the 1870s and rapidly dispersed into collec-

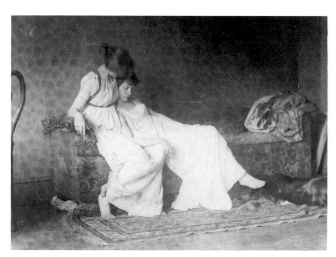

195. *Two Women in Classical Costume, Sitting on Couch,* c. 1883, platinum print, 6⅜ × 8¹³⁄₁₆ in., 1985.68.2.663.

196. *Group of Tanagra Figures,* Greece, 4th century B.C., terra-cotta, PAFA, Gift of Fairman Rogers, 1879.7.1–4.

tions around the world. Most of these statuettes were made from molds in a variety of standard poses, receiving individualized heads, accessories, and paint to represent particular deities, or to act as mourners and companions in the tomb.[24] Eakins, in his mood of Arcadian melancholy, recovered many of the qualities of these small statues in his own reliefs (figs. 187, 197): their intimate scale and quality of hand-modeling in clay, their mourning function, often expressed in conventional gestures (such as raising the hand to the face), their generic figure types, and their redolence of everyday art for ordinary people. Uncommonly lively and graceful, these artifacts are recognizably, accessibly human, despite the passage of time. In turning them over with Rogers or Shinn, Eakins must have been moved, like many other contemporary viewers, to a sense of kinship with the makers and purchasers of these sculptures.

The Tanagra figures also may have taught Eakins the virtues—and the classical legitimacy—of spontaneity and breadth in the surfaces of his own sculpture. As Shinn noted, this lesson of generalized detail appropriate to small sculpture was a valuable one for overly finicky contemporary artists. Eakins, perhaps responding to Saint-Gaudens' friendly criticisms of *Knitting* and *Spinning* in 1883, moved in these Arcadian reliefs to a style that swung more comfortably between individualized characterization and broad, impressionistic handling.[25] The spirit of the Tanagra figures is especially strong in *An Arcadian* (fig. 197; cat. 202), a relief that repeats in isolation the figure of the woman at the right in *Arcadia* (fig. 187) and echoes the "musing pathos" of the graceful women who, "wrapped in a delicious melancholy," so charmed the scholars and collectors of the 1870s.[26]

In this mood of telescoping human history, Eakins may also have absorbed ideas from Renaissance art, some of it in turn inspired by classical sources. A large albumen photograph (fig. 198), known as *The Rock Thrower* from a similar

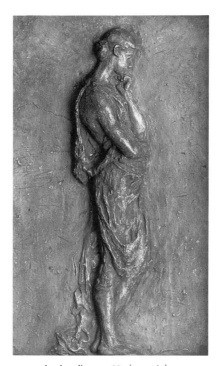

197. *An Arcadian,* c. 1883 (cat. 262).

albumen contact print in Samuel Murray's scrapbook at the Hirshhorn, may have been posed in emulation of a rare Pollaiuolo engraving in the Academy's print collection.[27] A comparison of this photo to the Hirshhorn print shows that Eakins flipped the negative in printing these two images, perhaps with some compositional purpose in mind, or just to create a sense of viewing the pose from all sides. Another source of inspiration near at hand was a complete cast of Ghiberti's gates of the Baptistry in Florence, which offered a model, as Simpson has noted, for figures in *Arcadia*.[28]

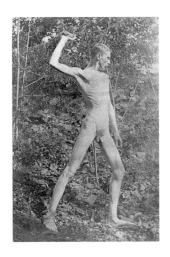

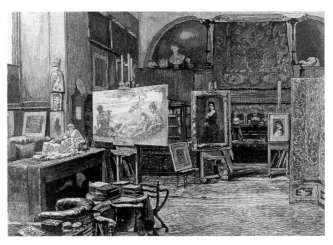

198. *Male Nude, Poised to Throw
Rock, Facing Right, in Wooded
Landscape*, c. 1883, albumen print,
11 × 8⅛ in., 1985.68.2.449.

199. *The Interior of Leighton's
Studio*, from *The Magazine of Art*
4 (1881): 173.

200. Albert Moore, *A Musician*,
c. 1867, oil on canvas, 11¼ × 15¼
in. (28.6 × 38.7 cm), Yale Center
for British Art, Paul Mellon
Fund.

Eakins had earlier opportunities to examine authentic antique and Renaissance art in Europe, although his studies in Paris probably received more powerful shaping from the example of contemporary art based on these classical or neoclassical sources. Throughout the course of the nineteenth century the standards of scholarly correctness in historicizing art had grown more rigorous, keeping pace with new archaeological finds. At the Ecole, Eakins could have attended the "most tiresome and fascinating" lectures by scholars such as Léon Heuzey, a curator at the Louvre who instructed the students on arcane details of costume based on his research. "One week it will be Assyrian dress; the next, Egyptian armor; the third, the Roman Toga, with real togas thrown over painters' undressed models, adjusted in the historic way, and made to imitate the costume of most of the historic statues," remembered Earl Shinn, who may have endured these "dry" but "practical" discourses alongside Eakins in the 1860s.[29]

The utility of these lectures was persuasively demonstrated in the work of Eakins' master, Gérôme, who had been named a Neo-grec in the 1840s. Throughout Eakins' tenure in Paris, Gérôme produced and exhibited a popular series of Greek and Roman historical genre paintings, some of them heroic, others more anecdotal. One of each type— *Ave Caesar* (see fig. 42) and *The Two Augurs* (see fig. 43)—appears in the background of Eakins' work (see figs. 9, 97) more than a decade after his return from France.[30] Although the classical period was only one of Gérôme's pictorial haunts, his reputation was made on such works, which established a standard for archaeological correctness and a taste for everyday detail in the artistic reconstruction of the ancient world. However, Gérôme would be surpassed in the rendering of surfaces and artifacts by others, particularly Lawrence Alma-Tadema, who specialized in antique imagery and took a less dramatic, more extravagantly sensuous approach to the subject. By 1880 the "new classical revival," born in the 1860s, had overtaken all the historical style and subject preferences that had lapped one another with increasing speed and eclectic

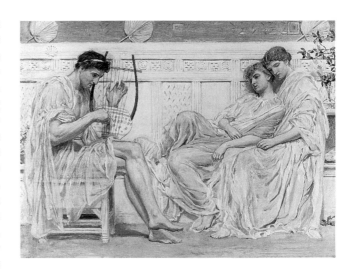

confusion since the dawn of the Romantic period and the demise of the previous Neoclassical era.

Britain excelled all others in this mood, with numerous continentally trained academicians devoted to antique subjects: Alma-Tadema, George F. Watts, E. J. Poynter, Albert Moore, and Frederic Leighton, the president of the Royal Academy.[31] Leighton and Moore, like Eakins, employed piping shepherds and quotations from the Elgin marbles in their work (figs. 199, 200).[32] Moore's good friend Whistler also painted his share of dreamy women in classical draperies, and, like most of these painters—and Thomas Eakins— evoked the languid mood of the Golden Age. Eakins despised English art in his youth, and he avoided the pretentious mythological fictions or anecdotalism of this school, but his photographs in the 1880s capture exactly the quality of sensuousness seen in these painters' work (fig. 201). Spread along a shallow bench like the Roman maidens of Moore, Whistler, or Alma-Tadema, Blanche Gilroy looks directly at the camera, projecting an elegance and seductiveness rare in Eakins' work.[33]

201. *Blanche Gilroy in Classical Costume, Reclining, with Banjo,* c. 1885, albumen print, 2⁷⁄₁₆ × 4⁹⁄₁₆, 1985.68.2.250.

Eakins' paintings and sculptures vary from such photographs in being more French in their breadth, and also more earnest and clumsy, with figures that usually withdraw from the viewer in response to music. As Johns has noted, this musical presence, with its message of savagery soothed and souls transported by the beginnings of art, carries across much of the Arcadian imagery of this period. Titles based on music, invoking visual harmonies analogous to aural ones, or subjects featuring musicians before an audience, were especially frequent among the classicizing British artists and their American or Continental counterparts.[34] Such art is commonly seen as wishful and escapist, a retreat from the ugliness of modern civilization, and Eakins' measure of yearning for simpler, more "natural" times must be weighed against his eager modernity in other realms. Like Fairman Rogers' mix of nostalgic, conservative, and extremely progressive tastes, Eakins' opinions of modern life ranged between disgust and optimism. His Arcadian works show him more alienated than usual, and seeking consolation in old, enduring truths: bodies, sunlight, music. Important to his role as a teacher, this approach offered direction to artists seeking very different stylistic models, from Alma-Tadema to Whistler. From a positive vantage, such an attitude expressed the academy's brave defense of the "western tradition"; seen less cordially, it sponsored much silly, effete, and irrelevant art.

Fearful of affectation, Eakins was not at ease in this mode, even though it appealed to his nobler academic instincts. Typically, he did not press forward the avant-garde aspects of this Arcadian work, although his interest in these themes came well ahead of the peak of popular interest in such subjects in the United States. The Philadelphian Alexander Harrison took up the same concept in his large Salon painting of 1886, *En Arcadie,* which was criticized when it appeared as depicting nothing more than "modern women nude in the open air." The effect was seen as unsettling because Harrison's models looked like women with their clothes off rather than Arcadians comfortable with their nudity. When his painting appeared at the Academy in 1891, the "indelicacy" of certain pictures of this sort inspired a petition of protest. But within this decade such frankly contemporary, sun-dappled nudes would become commonplace in paintings by Childe Hassam, Thomas W. Dewing, Kenyon Cox, W. H. Low, and other hybrid academic-impressionist Americans.[35] Eakins, with typical sensitivity to period taste, sallied forth early on to this field but, with equally typical timing, withdrew well before victory could be enjoyed.

Eakins' retreat from the progressive landscape work done at Gloucester, his cessation of historical costume pieces (both early American and Arcadian), and his declining participation in watercolor and illustration—all fashionable phenomena that were yet to see their widest popularity in the 1880s and '90s—may tell us something about his contrariness, or about his own uneasiness in these genres. The Arcadian paintings are not his strongest work, perhaps because of the poetic artifice involved, or the problems working outdoors with nude models, or the old difficulty in integrating the figures and their background, which works with real success only in his small sketches.[36] But the ambition evident in all these projects, especially the much more resolved *Swimming,* indicates a willingness to engage current international trends with great skill and purpose.

More relevant to Eakins' abandonment of all these outdoor nudes might be the rejection of *Swimming* by its patron in late November 1885, and the trouble brewing at the Academy that broke open in January 1886 and led to Eakins' resignation and disgrace.[37] Coates' polite request to exchange *Swimming* for another "more representative" picture—one better suited to display in the Academy's galleries—could not have been a response to nudity per se, for Coates must have known the concept of the painting in advance, and certainly the Academy had exhibited more salacious imagery, such as Cabanel's famous *Birth of Venus* (sketched by Eakins in 1877; see cat. 189x). Coates' reaction must have been based on the portraitlike realism of the style, which made the figures recognizable as Eakins' students, thereby calling to mind the use of students as models—a practice forbidden by the Acad-

emy's directors within the school's own studios. Privately, Eakins could do as he wished—or so he argued was his professional privilege—but the rumors of similar sessions with women students were already circulating before Christmas 1885, poisoning the air of the Committee on Instruction's interrogation of Eakins the following February. Their investigation was provoked by Eakins' removal of a loincloth from a male model during an anatomy lecture given to women (or men and women) late in January. This act also defied school policy, giving the trustees a specific instance of insubordination seemingly connected to a murkier pattern of intransigence and a much darker suspicion of immorality, kept alive in the minds of the directors by the rumor-mongering of Eakins' enemies.[38] The idea of illicit posing sessions, involving well-bred, middle-class women modeling for each other or for their professor, drew gasps from parents and administrators, and *Swimming* stood as visual confirmation of their speculation about scenes of teacher-student nudity. Eakins might have argued that the innocent honesty of *Swimming* spoke for itself, and he probably sent a portfolio of photographs to Coates to demonstrate the artistic and wholesome character of these nude studies.[39]

Coates' rejection of *Swimming* and the ensuing scandals of 1886 cast a pall over the painting. Eakins exhibited it only twice—in Louisville and Chicago in 1886 and 1887—and then held it back. He painted no more nudes until the turn of the century, when a new series of athletes, some based on classical sculpture (*Wrestlers*, 1899) or in reprise of Gérôme's gladiators (*Salutat*, 1898), showed a resurgence of earlier ambitions. In the interim, the Arcadian ideas had not died, for his monumental relief sculptures in the early 1890s kept the example of Phidias alive. In this period of the Brooklyn Memorial Arch and the Trenton Battle Monument, Eakins prepared a small sketch of *Phidias Studying for the Frieze of the Parthenon* and once again entered the field with Alma-Tadema, whose *Phidias and the Parthenon Frieze* of 1868 attempted a similar reconstruction.[40] Sadakichi Hartmann, one of Eakins' few admirers in the art press of the late 1880s and '90s, was enthusiastic about such ideas and urged him to paint a "big space where horses and men, the naked figures could be moving, and Eakins could follow in the footsteps of Phidias." "[My husband]," said Susan Eakins, "had a great wish for that kind of work."[41] Probably from this same time came a new series of studio photographs of models, most often Weda, Maud, and Catherine Cook, posed in neoclassical draperies alongside casts of antique sculpture. Once again, the sense of confidence won from his position at the head of a supportive band of students (now, at the Art Students' League) seems to have brought forth such idealistic themes. Unchastened by the scandals of 1886, he undertook a new series of outdoor photographs of nudes, again featuring Susan (fig. 202), himself, and his students.[42]

202. *Susan Macdowell Eakins Nude, Left Arm Resting on Neck of Thomas Eakins' Horse, Billy,* c. 1890, platinum print, 6⅜ × 8⅝ in., 1985.68.2.546.

With a gruesome sameness, history repeated itself: in 1895 Eakins removed a loincloth from a model in an anatomy lecture at Drexel and created another outrage. Within two years he was mired in scandal and unhappiness created by two unstable young women—including his niece, Ella Crowell—disturbed by the sexual ambiance of nude study in his classes.[43] Embittered, Eakins gave up teaching completely in 1898. The valiancy of his convictions still shone, however, in a reprise of the William Rush theme made in about 1907, when he produced the boldest nudes of his career, again in homage to Gérôme and as an oblique self-portrait.[44] This resurgent ambition pays homage to the European tradition and displays a tenacious sense of identity within its flow. Uplifted at times of interaction with students and colleagues, this spirit was twice crushed by disastrous confrontations with conventional, very un-Arcadian notions of propriety. Eakins was depressed by these scandals; his output drastically dropped after each one, and his work narrowed. The painting that followed, mostly portraiture, was important, enduring, and heroically traditional in its own way, but we must regret the obstruction of the imagination witnessed in the fate of his Arcadian projects.

In 1887, Eakins found solace by escaping the confines of modern, urban life for Dakota Territory. There he enjoyed an American pastoral idyl, not as a shepherd, but as a cowboy. The final outdoor figures and landscapes in his work reflected this experience of a hard and simple life, and the next musicians he painted would be dressed in buckskins, contemporary rustics distanced in space rather than time. Transformed and only superficially suppressed, the Arcadian wish endured.

CHAPTER 18 "A Little Trip
to the West"

*Cheryl Leibold and
Kathleen A. Foster*

203. *Cowboy Aiming Revolver,* 1887, modern print from 4 × 5 in. dry-plate negative, 1985.68.2.1076.

"I am going to take a little trip to the West," wrote Eakins to John Laurie Wallace in June 1887, just before he set off on an adventure that would both inspire him artistically and rejuvenate his drooping spirits. His ten-week sojourn at the B-T ranch in Dakota Territory, where he lived among the cowboys and participated in the rough ranching life, was prompted by the stress and depression of his dismissal from the Pennsylvania Academy faculty in February 1886.[1] More than a year of dispute and tension followed his departure; by the summer of 1887 he was ready for a change of scene.

The direct inspiration for the ranch visit probably came from Eakins' friend Dr. Horatio C. Wood, a specialist in the treatment of nervous diseases, who owned a share in the B-T ranch. Wood and his colleague Dr. S. Weir Mitchell (also a friend of Eakins) believed in the therapeutic value of the "camp cure"—living outdoors, away from the city—as a basic treatment for a variety of "nervous disorders."[2] Eakins' interest in the West was perhaps aroused in other ways as well. Two of his closest friends, J. L. Wallace and Arthur B. Frost, may have stirred his imagination with pictures and stories. Wallace, one of Eakins' favorite students and a patient model for *The Crucifixion* and the Arcadian subjects, was born in Nebraska, toured the West in 1883–85, and then settled in Chicago. Surely his descriptions of the West were recalled by Eakins, who stopped in Chicago to visit Wallace on his way home from the ranch. Frost, whose friendship with Eakins also began during his studies at the Pennsylvania Academy, had gone on to a successful career as an illustrator. Eakins, who took over Frost's studio at 1330 Chestnut Street when his friend departed for New York in 1883, could hardly have failed to see Frost's illustrations for Theodore Roosevelt's first book of Dakota essays, *Hunting Trips of a Ranchman,* published in a handsome collector's edition in July 1885. Although Frost had no firsthand recollection of the West, Eakins may have been impressed with the book, which was one of the first revelations of the nature of life in Dakota Territory.

Another literary source of inspiration may have been nearby in Camden. Eakins probably met Walt Whitman in the spring of 1887 and began work on a portrait of the poet soon after. In Whitman, Eakins found a sympathetic spirit who may have encouraged his plan to experience the natural life out West. Whitman had himself been West in 1879 and wrote of the trip: "While I know the standard claim is that Yosemite, Niagara Falls, the upper Yellowstone and the like, afford the greatest natural shows, I am not so sure but the prairies and plains, while less stunning at first sight, last longer, fill the esthetic sense fuller, precede all the rest, and make North America's characteristic landscape. Through the whole of this journey, with all its shows and varieties, what most impressed me, and will longest remain with me, are these same prairies."[3] After Eakins' return from Dakota, Whitman commented that Eakins had been "sick, run down, out of sorts; he went right among the cowboys; herded; built up miraculously. . . . It must have done much toward giving

189

204. *Two B-T Ranch Buildings*, 1887, modern print from 4 × 5 in. dry-plate negative, 1985.68.2.1066.

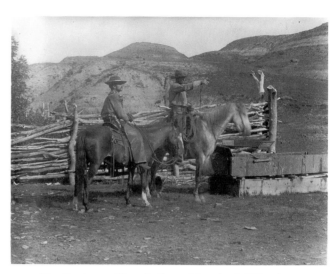

205. *Two Cowboys on Horses in Front of Corral at B-T Ranch*, 1887, modern print from 4 × 5 in. dry-plate negative, 1985.68.2.1094.

him or confirming his theory of painting; he has a sort of cowboy broncho method; he could not have got that wholly or even mainly in the studios of Paris—he needed the converting, confirming, uncompromising touch of the plains."[4]

Trips to the Western wilderness were increasingly popular in the late nineteenth century, and at least two prominent Philadelphians had been impressed by travels West in the years just prior to Eakins' visit. Both returned with stories that could have reached his ears by 1887. Frank Furness, the architect of the Academy's building, filled a room of his home with souvenirs of his Western trips.[5] And Owen Wister, scion of a famous Philadelphia family, first visited a ranch in Wyoming in 1885 at the suggestion of Dr. Mitchell. Like Eakins, Wister was reinvigorated and inspired by his experience.[6]

The letters Eakins wrote to his wife from Dakota Territory reveal that he enjoyed himself thoroughly at the B-T, worked hard, was accepted by the cowboys, joined in the roundup, and even witnessed the capture of a horse thief.[7] He wrote on 11 August 1887: "I am in the best of health; although I have not slept in a bed I have no cold. The living on a round-up is better in quality than in the palace Pullman dining cars. . . . As I became acquainted with all the fellows, I would have trusted any of them without the least fear, but if I had put on any airs I think I would have been hoisted." He seems to have gone into town only a few times. *The Dickinson Press*, a local paper, recorded numerous comings and goings of local folk as well as visitors, but Eakins' name is never mentioned. In turn, his letters consist primarily of descriptions of events he experienced and people he met, although they contain not a single reference to two famous local residents. Theodore Roosevelt, who owned two ranches in the vicinity, was, like Eakins, a well-educated eastern greenhorn who visited Dakota after a personal crisis and proved himself through his integrity and courage. Stories about him, al-

though probably not as colorful as they would later become, must have abounded. Eakins *does* mention meeting a cowboy named Sylvane Ferris, who was Roosevelt's foreman at the Maltese Cross ranch. After the devastating winter of 1886–87 ruined many of the ranchers in the area, Ferris and his partner took over what was left of Roosevelt's herd.[8]

Eakins also must have heard tales of the colorful Marquis de Mores, a Frenchman who came to Dakota Territory in 1883, began buying land and cattle, and at his own expense built the town of Medora. Running afoul of the law when he killed a man, de Mores was subsequently tried and acquitted three times before bankruptcy forced him to return east in 1887.[9] Eakins described his visit to Medora during the roundup in his letter of 31 July: "We came to Medora this morning to breakfast and had a good one. The town is already full of cowboys and in every direction you see the herds of ponies. . . . All day today we expect to loaf around and lots more of cowboys and ponies are coming in. Some few horses are shod, the blacksmith is working and all stores are open. Sunday is unknown to cowboys. Their work is just the same every day."

PHOTOGRAPHY AT THE RANCH

In his letter of 26 September, Eakins wrote: "I saddled up to go photograph a view from a butte 3 miles off." This remark, and a reference to additional photographs made close to the ranch on the following day, constitute the entire discussion of photographic work at the B-T in his letters. However, many images in Bregler's collection indicate much more activity than his letters or previous surviving photographs ever suggested. These pictures demonstrate Eakins' fascination with the ranch life and its characters, and provide a trove of images for historians of art, photography, and the American West.

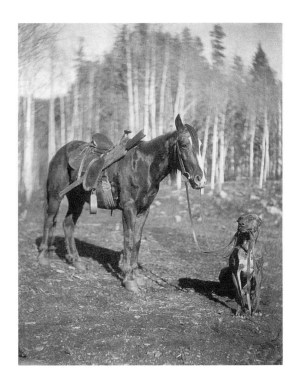

206. *Dog and Pony in Dakota
Territory*, 1887, platinum print,
9⁵⁄₁₆ × 7⁷⁄₁₆ in., 1985.68.2.277.

The Bregler collection contains thirty-six negatives from the Dakota trip, including two landscape views (.1064-.1065), six views of ranch buildings (.1066-.1077), twenty-two cowboy studies (.1078-.1099), and six portraits (.1072-.1077). The only vintage print in the group is a beautiful platinum enlargement (fig. 206) showing a dog holding the reins of a saddled horse in his mouth. Eakins, who loved animals, must have found the subject so delightful that he had it enlarged—a practice he seems to have saved for special or significant images. Three smaller prints of cowboys, none from existing negatives, survive in other collections, indicating a total of at least forty negatives exposed on the trip.[10]

All of the thirty-six surviving negatives are 4 × 5 inch dry plates. Each plate has a number etched into the glass in Eakins' hand, but the numbers are not continuous, ranging between 273 and 408. A few other negatives in the Bregler collection also carry numbers implying some now-lost record system used by Eakins and possibly shared by his wife. This numbering suggests the existence of as many as 135 Dakota negatives—more than three times the number extant today, and a ponderous inventory to imagine carrying west. We know of some lost negatives from extant prints; others must have disappeared without a print, and perhaps some were broken or spoiled and discarded during the trip. Even so, the size of the gaps in the numbering suggests that Eakins' system was irregular by 1887, and the plates that Eakins took to Dakota Territory were remnants of boxes numbered earlier. But even allowing for such inconsistencies and a negligible amount of loss, the surviving work shows a moment of concentrated activity with the camera that would not be seen again in Eakins' career. Bregler's collection confirms that

Eakins took a great many photographs between 1880 and 1887, and far fewer after that date. The Dakota series seems to have been his last intensive photographic effort.[11]

Another intriguing problem presented by the Dakota photographs as a group is the survival of only four prints, and the fact that none of these are from any of the thirty-six extant negatives. Assuming Eakins printed his negatives following his return to Philadelphia, what happened to all these prints? Similarly, only a handful of prints exist from the more than sixty negatives Eakins made of shad fishing at Gloucester. The answer may lie in a detail of the photograph of Eakins, Samuel Murray, and William O'Donovan sometimes called *The Consultation* (see fig. 106). Careful observation reveals that each of the photographs of Walt Whitman tacked to the wall is tightly curled at the edges. Albumen prints were notorious for their tendency to curl into a tight cigarette-shaped tube if not mounted, and Eakins' Dakota and Gloucester prints most likely suffered such a fate. After using them, probably tacked to a wall for reference or inspiration, he found them so badly curled that they had to be discarded. A large number of photographs in the Bregler collection have pinholes in the corners, suggesting that Eakins frequently used this method of study and display. The odd disappearance of the negatives for all four surviving Dakota prints remains a mystery, however. This question, and the puzzling gaps in the etched numbers on the plates, emphasize how little is actually known about Eakins as a photographer, and what a small percentage of his camera work may actually survive.

The photographic images Eakins produced at the ranch, like most of his camera work, were not intended as independent aesthetic statements. Compositions are simple and uncomplicated. Figures pose frontally, unsmiling. Faces either turn away from the camera or stare impassively beyond it. The overall look is straightforward and simple, like the life he experienced and in keeping with his own personal goal. The photographs do not appear to constitute a carefully planned suite but instead seem to have been taken in just two or three sessions, perhaps as his departure approached.

A figure painter at heart, Eakins chose to photograph people far more often than landscapes. The few rather formal

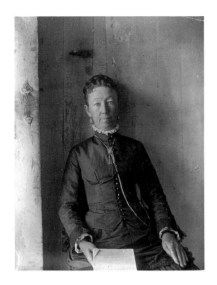

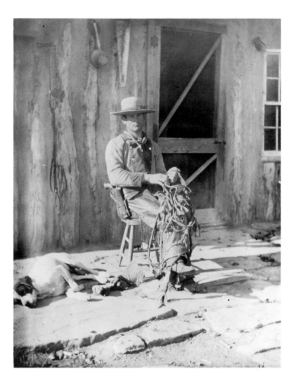

207. *Woman Sitting at B-T Ranch,* 1887, modern print from 4 × 5 in. dry-plate negative, 1985.68.2.1072.

208. *Cowboy Seated in Front of B-T Ranch Building,* 1887, modern print from 4 × 5 in. dry-plate negative, 1985.68.2.1074.

photographs of individuals at close range may be studies for portraits, or simply records of interesting character. The image of a rather dour-looking lady (fig. 207) recalls many of Eakins' other photographic portraits, with its frontal pose, prominent hands, and unsmiling visage. She is one of two Dakota residents already familiar to us through the few copy photographs that Charles Bregler made in the 1940s and gave to the Metropolitan Museum of Art. In the Metropolitan's image (H 136) she is mounted side-saddle on a white horse and wears a different dress. Here she holds a book or journal that we cannot identify, except that it was published by Lippincott's of Philadelphia. Most likely, the sitter is Mrs. Albert Tripp, the ranch manager's wife. In his letter of 28–30 August, Eakins wrote that Mrs. Tripp was leaving for St. Paul, as she was sick of the ranch. The woman's rather elegant garb in her photographs, her tense posture, and her urbane accoutrements, including the book and a lorgnette(?) on an elaborate chain, distinguish her from Eakins' other Dakota sitters. From her appearance, and her wish to be in St. Paul, we can imagine the struggle to maintain a refined, intellectual existence among the cowboys.

The cowboys themselves were occasionally photographed singly, and at close range, although the emphasis rests on their bodies and equipment rather than their faces. One man (fig. 208) presents a striking image of competence, accompanied by all his cowboy gear and the ranch dog, much as Eakins might have posed a scholar with books or scientific instruments. This young man was the most frequently photographed cowboy from the B-T, appearing in six or seven different images, including fig. 203 and (perhaps) an almost comically tidy and severe portrait in his city clothes (.1073).

The cowboys photographed from a greater distance, usually with their horses, seem equally posed and suited up, sometimes in the buckskin outfit that Eakins brought back to Philadelphia. This fringed, embroidered, and studded suit, his saddle, gun, and miscellaneous other gear all returned east to become part of a wardrobe that Eakins used to dress the students who later posed for his cowboy paintings.[12] Like a good academic, Eakins collected such properties to guarantee the authenticity of his details, if not to ornament his studio after the fashion of Gérôme. As Ackerman observed, Eakins visited Dakota Territory much as Gérôme explored Egypt, camera ready and on the lookout for pictorial material; his cowboys singing in the bunkhouse vary from Gérôme's bashi-bazouks singing in the guardroom only in their superficial detail.[13]

Such picturesque props and costumes, and the number of obviously staged figure studies within the group of Dakota photographs, with cowboys repeatedly firing guns, pointing into the distance, shading their eyes against the sun, casually leaning against their horses, or jauntily relaxing in the saddle with one leg thrown over the pommel, remind us of Eakins' mission in the Badlands: "studying cowboy life in order to paint pictures of it."[14] Like Gérôme's photographs of the Middle East, these images must have been partly for the documentation of posture, detail, and mise-en-scène, and partly as compositional trials. It is no surprise, therefore, to find these same poses echoed in the painting that Eakins produced the year following his return: *Cowboys in the Badlands* of 1888 (fig. 210). One of these photographs (fig. 209) was clearly the model for the compositional grouping in the painting; probably, after studying his prints back at home,

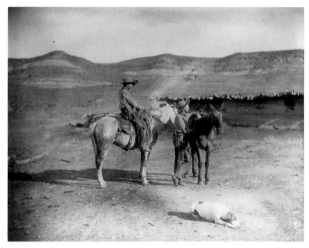

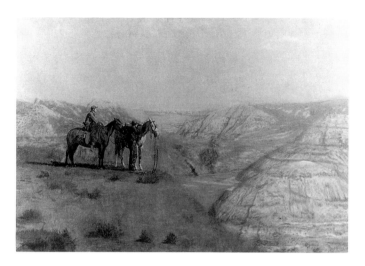

209. *Two Cowboys with Horses in B-T Ranch Yard, Dog in Fore-ground,* 1887, modern print from 4 × 5 in. dry-plate negative, 1985.68.2.1090.

210. *Cowboys in the Badlands,* 1888, oil on canvas, 32½ × 45½ in., priv. coll., photo courtesy of Sotheby Parke-Bernet.

Eakins pulled out this image as promising. He then restaged variants of these poses, using fresh models, for—unless other, more comparable photos have been lost—the positions and accessories of both horses and men were changed in many slight ways for the painting. This habit of using figures to enact his ideas before the camera, and then restudying the poses from life as he painted, follows exactly the method developed in the Gloucester and Arcadian paintings.

As with the fishermen and the Arcadians, Eakins made "background" photographs of the landscape and the ranch buildings. Most of the eight extant landscape photos played no part in his paintings, but they do tell us much about the appearance of a small working cattle ranch in the boom times of the 1880s. Although the main house (referred to as the "shack," see fig. 204), barns, stables, and outbuildings of the B-T were nestled between the creeks and the surrounding hills on some of the very rare flat land in the area, the harsh climate has doomed to oblivion most of such rough sod and log architecture from this period.[15] These photographs may have been taken on 25 September, when Eakins "staid around" the ranch taking pictures, or perhaps on the previous day, when he mentioned carrying his camera to the top of a nearby butte and then stopping "to photograph several things on the way home." From the top of the butte he probably produced fig. 211, a panoramic view that is enough like—without being exactly like—the landscape in *Cowboys in the Badlands* to suggest the loss of other even more closely related negatives.[16]

As at Gloucester and Avondale, Eakins supplemented the camera's broad landscapes and detailed figure studies with outdoor oil sketching, to catch color and tone. "The sun

. . . in the arid country . . . does more things than blister your nose," wrote the painter Frederic Remington of this land-scape. "It is the despair of the painter as it colors the minarets of the Badlands."[17] Eakins translated the harsh light recorded by the camera into pale sage green and cream colors on two panels sized to slide into his paint box (figs. 212, 213). Although one of his companions on the ranch, George Wood, the teenaged son of Horatio Wood, remembered that Eakins was "always busy with his pencil sketching the cowboys and the Badlands and the picturesque costumes," Eakins seems to have painted less than he photographed, or destroyed much of such work, for no pencil drawings and only two landscape panels (with three painted sides) survive.[18] As before, he seems to have sketched on the same sites where he set up his camera, as shown by the pairing of figs. 211 and 212, or 213 and 214. The subject of fig. 213, previously understood as sim-ply "color notations of the rocky landscape," can now be rec-ognized from the photographs as a prairie view on the left and an unrelated sketch on the right of the B-T's double-crib barn (?), with its irregular log walls and sharp wedge of shadow along the interior wall of the runway.[19] Struck by the abstract pattern of this view, Eakins blocked in the shapes broadly and then amused himself by adding the chopping block that, like a float on the beach at Gloucester (cat. 249; plate 15), signals space with two quick dabs of color.

The cowboys in motion were much more difficult to sketch or photograph, although Eakins tried at least twice to paint mounted cowboys at work.[20] Recognizing the limita-tions of his skill, his time, and his photographic equipment, he must have decided on a quieter subject while he was still at the ranch, posing the hands. Perhaps he realized that calmer poses would be possible only at home, with non-cowboy models. The remainder of the extant sketches, and the painting of the final canvas of *Cowboys in the Badlands,* must have been done back in Pennsylvania, probably at the Crowell farm in Avondale.[21]

One small sketch (fig. 215) and a larger oil study (fig. 216) record the method for *Cowboys in the Badlands.* The sketch,

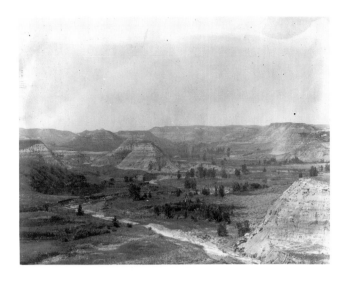

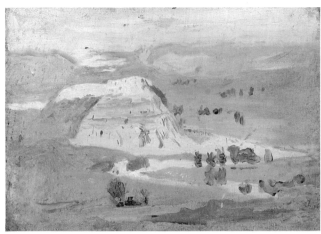

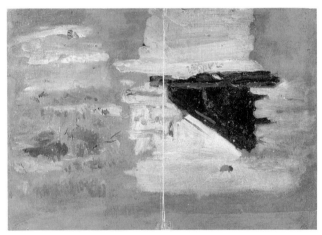

211. *Badlands, Panoramic View*, 1887, modern print from 4 × 5 in. dry-plate negative, 1985.68.2.1064.

212. *Landscape (Sketch for "Cowboys in the Badlands")*, 1887, oil on canvas on cardboard, 10½ × 14½ in., (26.7 × 36.8 cm), Philadelphia Museum of Art, Given by Mrs. Thomas Eakins and Miss Mary Adeline Williams.

213. *Landscape (Sketch for "Cowboys in the Badlands")*, 1887, oil on canvas, 10¼ × 14½ in. (26 × 36.8 cm), Philadelphia Museum of Art, Gift of Seymour Adelman.

214. *B-T Ranch Building, Partial View*, 1887, modern print from 4 × 5 in. dry-plate negative, 1985.68.2.1067.

closely following the poses seen in the final painting and unlike any extant photograph, was probably made in Avondale as the concept crystallized in his mind. The larger study of the right-hand cowboy and his horse may have been done with a photograph, according to Siegl, because the paint handling shows great confidence but none of the dash characteristic of Eakins' sketches from the motif.[22] The relationship to Eakins' negatives is clear (figs. 209, 217), although no

extant photograph is exactly like this figure, and both horse and "cowboy" may have been posed and rephotographed at the farm. The figure in the larger study is one-quarter life scale; crossed with a transfer grid in graphite, he was reconstructed at a smaller scale (one-tenth life) on the final canvas, where a related grid can be read through the thin pigments of the landscape. From the quality of detail and color modeling in both cowboy and horse in the finished picture, it is clear that Eakins worked again from life in completing this painting. Such direct work outdoors in the summer of 1888, under the moist skies of the Delaware Valley, probably accounts for the "surreal" disjunction between the figures and their background, for as many observers have noted, the landscape, although faithfully derived from photographs and color notes, exists in another, drier world.[23]

Notwithstanding Whitman's appreciation for Eakins' "cowboy broncho method," more of the "studios of Paris" lies behind this effect than the "uncompromising touch of the plains." This kind of figure/ground contrast had been a part of Eakins' manner in the Gloucester paintings, and it may have been learned much earlier, from Gérôme's example. As

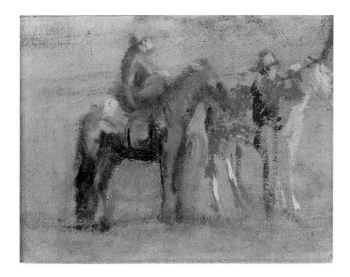

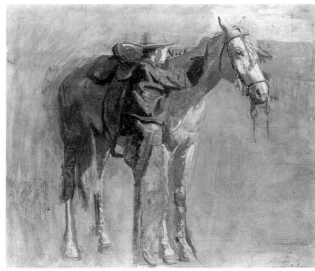

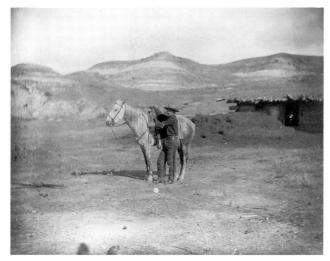

215. *Study for "Cowboys in the Badlands,"* 1888, oil on canvas, 4¾ × 6⅜ in., Albright-Knox Art Gallery, Buffalo, New York, Bequest of Norman E. Boasberg, 1962.

216. *Cowboy (Study for "Cowboys in the Badlands"),* 1887–88, oil on canvas, 20½ × 24¹⁄₁₆ in. (51 × 61.1 cm), Philadelphia Museum of Art, Given by Mrs. Thomas Eakins and Miss Mary Adeline Williams.

217. *Cowboy in Dark Shirt, Standing Next to Dappled Horse,* 1887, modern print from 4 × 5 in. dry-plate negative, 1985.68.2.1080.

218. Jean-Léon Gérôme, *Oedipus: Bonaparte Before the Sphinx,* 1868, oil on canvas, 36 × 54 in. (92.7 × 137 cm), Hearst San Simeon State Historical Monument.

Ackerman was the first to point out, *Cowboys in the Badlands* followed the pattern of such paintings by Gérôme as *A Prayer in the Desert* in placing "solid, clearly-drawn figures against faint background" paled by the intervention of atmosphere.²⁴ Even more direct models can be found in Gérôme's work: *Napoleon Before Cairo* of 1868, or its pendant, *Oedipus: Bonaparte Before the Sphinx* of 1886 (fig. 218), both featuring small

horsemen on a foreground bluff, silhouetted against a hazy distance.²⁵ Gérôme did a better job of integrating landscape and figure, but he made more of the residual disjunction as an adjunct to his meaning, using it to underscore (or perhaps question) Napoleon's ambition in Egypt. Eakins' cowboys invoke no such story, they simply gaze at their hallucinatory landscape with a kind of indeterminate calm. The fact that they are so completely at ease in such an environment may be the understated message of the painting.

Gérôme's formal solutions surely existed subliminally for Eakins, but more consciously he recovered the figure type of the cowboy from Gérôme's repertory of exotic athletes. In Paris in the 1860s Eakins experienced—along with Gérôme, Bonnat, Fortuny, Manet, and many others—a vogue for Spanish art and culture that produced a wave of imagery of toreadors and bullfights, including Gérôme's *Picador* of 1866–70. During his trip to Madrid and Seville in the winter of 1869–70, Eakins had contemplated a "bull fighter picture," but he left Spain without attempting one, and back in Philadelphia the idea must have seemed impossible. Differ-

ent American athletes, the rowers, analogues to Gérôme's oarsman on the Nile, rose up to take their place in his imagination, but the bullfighter was not forgotten, perhaps because Gérôme's *Picador* was nearby in Henry C. Gibson's collection.²⁶ With his eye for American counterparts, Eakins noted in 1875 that "ball players are very fine in their build. They are the same stuff as bull fighters, only bull fighters are older and a trifle stronger perhaps. I think I will try to make a base ball picture some day in oil. It will admit of fine figure painting."²⁷ In Dakota Territory this same figure type appeared, literally as an American picador: the cowboy on horseback. In an appropriate synthesis, Eakins laid an American landscape and American figures over a pictorial structure and a picturesque type, both learned from Gérôme's example of "fine figure painting."

The strength of the cowboy and his characteristic skills play a remarkably small role in Eakins' painting, however, and the passiveness of the figures makes us consider more active alternatives, and why they were rejected. Criticisms of *A May Morning in the Park,* as well as certain of Gérôme's awkwardly frozen dancers and runners, might have taught him caution in essaying movement, especially with horses. If he entertained the idea of depicting a cowboy roping cattle—as suggested by his two extant oil sketches of horsemen in motion—he may have abandoned it as too difficult or problematic, and the camera he brought was not equipped, like the adapted Marey-wheel apparatus he had used for his motion studies, to capture moving figures without blurring. If he tried to photograph the cowboys at work, these plates have been lost. Disdainful of incorrect "flying gallops" and knowing that his time and equipment were both limited, Eakins chose not to attempt an awkward or ill-informed effect of motion.

Dashing effects were conceded to others who, with more opportunity and inclination, had recently moved into this genre, lugging the plates from Muybridge's new *Animal Locomotion.* While working on *Cowboys in the Badlands,* Eakins may have seen Roosevelt's second series of articles on Dakota Territory, this time illustrated not by his friend Frost, but by the young Frederic Remington, who could draw upon personal experience in the Badlands. Eakins may have seen Remington's *Arrest of a Blackfeet Murderer* at the American Watercolor Society's exhibition in 1888, a picture so stirring that *Harper's Weekly* reproduced it twice that year. Like Remington's masterpiece at the NAD the following spring, *A Dash for the Timber* (Amon Carter Museum), this picture showed a company of horsemen at full gallop driving straight toward the viewer.²⁸ Such skill and drama established Remington as the country's king of cowboy artists and fed the popularity of similar detailed action subjects—a popularity that was rising in the 1880s at a rate inversely correlated to the disappearance of cowboy life itself. Sensing this enthusiasm, Eakins wrote to Wallace on 22 October 1888 that he had nearly completed a "little cowboy picture" and hoped to make more. "The cowboy subject is a picturesque one, and it remains only with the public to want pictures."²⁹

Remington was swamped with orders, and returned West to make more studies. Eakins, realizing that his field experience was limited and that his own working method and personal style were ill suited to such subjects, took a quieter, more introspective path, temperamentally closer to the work of the other popular master of Western imagery, Henry Farny. Eakins knew that his photo studies were adequate documents of cowboy posture at rest and that personal recollection, combined with his cowboy suit, could be used to reconstruct the mood and pose seen in the three paintings made in about 1892 of a "cowboy" (actually his student Franklin Schenck) singing at "home ranch." Counterposed to the rough sport of Remington, these musical subjects show Eakins' instinct for cowboy subjects turned on to a more familiar and Eakinsish expressive path. More comfortable with large figures studied from life in a darkened interior, Eakins could build a mood of nostalgia for cowboy life that drew from the contemplative sensibility of his other late portrait studies.³⁰

Eakins found students, like Schenck and Murray, to pose as cowboys when he returned, but he brought real cow ponies home with him to serve as authentic accessories. These two horses are often described in his letters: Baldy, a bay, had a white face and feet, and Billy was a gray with a clear "W" branded on his left flank. Neither horse appears in any Dakota photograph. (A dappled gray horse with a "W" brand does appear in many photographs, but his mottled color shows that he was not the solid-color Billy who posed at Avondale for *Cowboys in the Badlands.*) Horses had been a favorite subject for Eakins as early as the *Fairman Rogers Four-in-Hand* of 1879, and his education alongside Rogers must have made him attentive to the special breeding and training that went into a good cow pony. The wrong kind of horse would be a glaring error in any depiction of cowboy life. "If I can sell any cowboy pictures at all [the horses] will be a good investment for me," he wrote home on 28 August, evidently full of ideas for the use of these horses in his paintings.

The two horses were stabled at the Avondale farm of Eakins' sister, Fanny, and her husband, William J. Crowell. As he had predicted, both animals played roles in Eakins' subsequent photographic and artistic activities, although no cowboy pictures with horses followed *Cowboys in the Badlands.* Billy, the gentle gray, was an especially frequent model for Eakins' projects, appearing in dozens of photographs, many dating from from 1891–94, the period of Eakins' work on the Brooklyn Memorial Arch (see fig. 83), when the horse served as the model for Abraham Lincoln's mount.³¹ Billy also modeled with a provocative series of nudes who, like the cowboys, pose astride or alongside him (see fig. 202). In 1894, Eakins' interests in equine anatomy culminated with a paper on the topic, delivered at Philadelphia's Academy of Natural Sciences. Drawings, photographs, and one lantern slide for this lecture survive in the Bregler collection (cats. 82–87).

The Dakota trip thus fed Eakins' longstanding interest in horses and enriched his series of music-related paintings, also begun in the 1870s. It was not, however, an experience

that produced the string of popular cowboy pictures that Eakins initially imagined. *Cowboys in the Badlands* was his last outdoor subject. His reasons for abandoning the landscape may have been old, for he had struggled since the 1870s with the problems of figures seen outdoors in deep space and the disjunctions created by his rationalized method of separate studies, under different light conditions, concluded by studio work. The effort, and the mixed results, may have ceased to be worth it; that he never exhibited *Cowboys in the Badlands,* choosing instead to send older work to the few shows he entered in the years just after his departure from the Academy, may signal his dissatisfaction or his loss of energy for this old struggle.[32]

Eakins returned from Dakota Territory in great spirits—"built up miraculously," as Whitman said—but his output remained low until the early 1890s, and new setbacks were thrust upon him. His work was rejected three years in a row (1890–92) by the previously adventuresome and supportive Society of American Artists; *The Agnew Clinic,* his major effort after the Dakota trip, was among the works returned, and *Cowboys in the Badlands* was probably rejected, too. Three paintings sent to Paris for the Salon of 1889 were rejected; only one of the group, *The Writing Master,* was accepted for the following year.[33] Although Eakins was sufficiently proud and self-knowing to judge the SAA's jury as the problem, not his paintings, such new wounds must have

hurt his plans for similar work, and he relegated *Cowboys in the Badlands,* like the Arcadian landscapes and *Swimming,* to a dark corner of the studio.

The Agnew Clinic, the most important commission of his career, came in the spring of 1889, not long after the completion of *Cowboys.* The distraction of this enormous and complicated composition probably did much to dilute the memories of ranch life and return Eakins to the studio figure painting that he did best. Other paintings from this period were of students and friends, such as Whitman, in small bust-length formats. A low point seems to have been struck in 1890, when he exhibited only in Chicago and completed only two dated portraits.[34] In 1891, Eakins was rescued from these doldrums by outsiders: E. H. Coates, who became president of the Academy's board in 1890 and reformed the exhibition jury to include only artists, who promptly invited Eakins to contribute new work (he sent six pieces in 1891); and William R. O'Donovan, who sought out Eakins as his collaborator for the Brooklyn Arch reliefs. Both of these efforts to draw Eakins back into the collegial flow of the art community were rewarded by an energetic response, as Eakins—surrounded by students at the League, and busy with new projects—began to scheme again about horses, nude subjects, Phidias, and cowboys, recasting his Dakota experience in musical and nostalgic terms fitted to the "fine figure painting" of his late career.

CHAPTER 19 Portraits

CASE STUDIES
DEFINE A METHOD

219. *Miss Amelia C. Van Buren*, c. 1888–90, oil on canvas, 45 × 32 in. (114.3 × 81.2 cm), Phillips Collection, Washington, D.C.

The careful documentation of costume, posture, gesture, and physiognomy makes every one of Eakins' painted and sculpted figures a portrait in some degree. Such was the habit, Ruskin noted, of many "old and great painters."[1] This attention to details of appearance, enlivened by an even more remarkable ability to depict impalpable expressions of thought and feeling, underlies Eakins' most memorable accomplishments, from his miniaturistic *Chess Players* to his monumental *Gross Clinic*. Many objects in the Bregler collection bear on this talent as a portrait painter, but only indirectly. There are no finished oils to display the subtlety of mood and observation seen in *Miss Amelia C. Van Buren* (fig. 219), no drawings that explain the humane dignity and immediacy of *Professor Leslie W. Miller* (PMA), the taut design and elusive psychological state of *The Thinker: Portrait of Louis N. Kenton* (see fig. 232), or the authority of Eakins' greatest images of surgeons, scientists, athletes, artists. Instead, the view from the Bregler collection is one of preparation and process. We see work in progress that, in its moments of homeliness or mechanical assiduity, gives access, like foothills, to the seemingly mysterious heights of creativity. If, as Oscar Wilde remarked, every great portrait is a picture of the artist, the corpus of Eakins' work in this genre affords another rediscovery of his artistic identity, projected onto the faces and bodies of his contemporaries.

The first message from the range of preparatory drawings, photographs, and oils in the Bregler collection is a reminder of the diversity of Eakins' efforts as a portrait painter, and the variety of his methods. The second lesson is one of repetition, of certain standard procedures and favorite solutions. From these two premises springs an awareness of Eakins' many choices in the invention of his portraits, and of his habitual or preferred practices. Because portraits make up nearly half of his lifetime production, the wealth of repetitive examples opens a wider field for generalization about Eakins' characteristic habits than, say, his rowing pictures. An examination of certain "case studies" emerging from new material in the Bregler collection reveals these traits and introduces the complete sequence of problems and techniques that Eakins mastered in this genre.

The simplest, most direct, and most frequent effect in his repertory can be seen in one of the oils in the collection, *Girl with a Fan: Portrait of Miss Gutierrez* (fig. 220). This painting, among the smallest of Eakins' life-sized portraits, illustrates his favorite head and shoulders format on a canvas size (20 × 16 in.) that he used only rarely before 1902, and thereafter with some frequency.[2] Although beautifully painted in parts, such as the hand and fan, the image of Miss Gutierrez is unfinished. The incomplete modeling of the face leaves us with an overall effect of irresolution; the image lacks the material presence and psychological insight of Eakins' best work. What such a painting can tell us is limited but not without interest, for it demonstrates Eakins' belief in hands as bearers of portrait character, and it shows his working method, in which one part of the figure is brought to com-

220. *Girl with a Fan: Portrait of Miss Gutierrez,* c. 1902–8 (cat. 252).

221. *Jennie Dean Kershaw,* c. 1897, oil on canvas, 40¼ × 30 in., F. M. Hall Collection, Sheldon Memorial Art Gallery, University of Nebraska, Lincoln.

pletion at a time. This system, practiced in Gérôme's atelier and evident in some of Eakins' earliest figure drawings (cat. 24), is dramatically illustrated in his unfinished watercolor *In the Studio* (PMA), in which the figure's nicely finished head and foot are separated by twelve inches of blank paper.

The same focused method can be seen better in the unfinished portrait of Jane Kershaw (fig. 221).[3] Her image, although incomplete, remains compelling, because the face and hands are finished enough to draw us into engagement with this resolute woman, and the vivacious handling of the figure and background show an appealing moment of the artist's work. Such breadth and spontaneity are rare in Eakins' portraits. They contrast with the denser, slower texture of the finished parts, to remind us that the usual range of focus in Eakins' work, even in his most "Spanish" moments (as in figs. 66, 68), was much less flamboyant than the handling of contemporary portraitists like Chase or Sargent. Perhaps his friendship with these two artists at the turn of the century encouraged Eakins to leave the suggestive sections of Kershaw's portrait undisturbed, for beautiful, abstract passages of paint or clever gestures are rarely a part of his surface. Never facile, he disparaged such suggestive effects as "an accomplishment & not power." The power of his own portrait work depended on the patient accumulation of observations. As a result, his unfinished paintings are often,

like *Miss Gutierrez,* disappointing rather than tantalizing.[4]

Knowing Eakins' practice, we can imagine that Miss Gutierrez disappeared before Eakins had the time to bring her portrait into focus. A photograph of Eakins' studio about 1912–13 (fig. 222) shows the painting propped up in full view, evidently awaiting one more session of work.[5] A struggle to get adequate time from busy or impatient sitters lay behind many of his unfinished or unsuccessful portraits, while his very best work was almost always from understanding friends, students, or family members. Both Susan Eakins and Bregler disputed Goodrich's account of lengthy, "exasperating" portrait sessions, arguing that Eakins could seize both truth of character and color quickly: "In an hour he would have enough material, unless he wished to carry the painting to a finish," wrote Mrs. Eakins.[6] However, these finishing sessions could be long; Bregler remembered as one of his "most pleasant memories" sitting "for nearly three hours beside Eakins as he painted the Miss Van Buren portrait, which I think is one of his very best."[7] Implicit in this insistence on life study was also the rejection of photographic aids, which Eakins used only under duress (as seems to be the case in fig. 222).[8]

The investment of time in bust-length portraits, like Miss Gutierrez's, was entirely in the figure, for there was hardly room for background accessories on such a small sur-

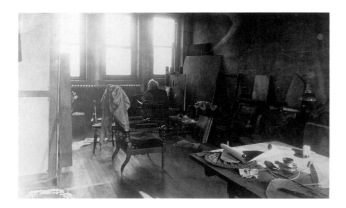

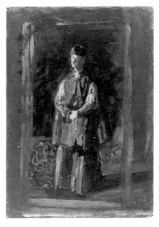

222. *Eakins in His Studio,* 1912–13, photograph, Bryn Mawr College Library, Adelman Collection.

223. *Sketch for the "Portrait of Monsignor James P. Turner,"* c. 1906, oil on cardboard, 14½ × 10½ in. (36.8 × 26.7), Philadelphia Museum of Art, Given by Mrs. Thomas Eakins and Miss Mary Adeline Williams.

224. *Head of a Man (Rutherford B. Hayes?),* 1877? (cat. 237).

face. In this format Eakins began to paint on the final canvas at once, usually at life scale, thereby emphasizing the reality and immediacy of the sitter while avoiding special calculations for reduction.[9] Additional preparatory steps intervened for a larger or more complex portrait. Most often Eakins began full-length portraits with a small oil sketch, usually on a panel close to 14 × 10 inches, with the figure about a sixth to an eighth life size, as in the *Sketch for "Portrait of Monsignor James P. Turner"* (fig. 223) or the *Study for "The Pathetic Song"* (see fig. 59).[10] These sketches were done from life, consolidating an image already well developed in Eakins' mind. Once his idea was confirmed by the sketch, further work simply pressed toward the more perfect realization of this image, slowly drawing reality into reconciliation with concept.[11] The inventive phase of this method is usually lost if not intentionally buried beneath the record of appearances, making it seem that the artist has simply recorded facts like a camera, so consideration must always be given first to the choices made in staging the entire portrait. Why is Turner seen standing at the top of the stairs to the Lady Chapel of the cathedral? Why is Miss Gutierrez clutching a fan? The creative imagination seen elsewhere in his work—in his decision to paint rowers, hunters, ball players, surgeons—reveals itself in the initial choice of posture, lighting, costume, accessories, and in these first small sketches.

The preliminary oil sketch also records Eakins' framing decision, made after the figure was positioned. This practice, consistent in drawings, oils, and photographs, inevitably produced an eccentric size, tailored to exactly one subject. Eakins' portraits larger than the conventional 24 × 20 or 30 × 24 size of a bust-length image are astonishingly various in size, manifesting special consideration.[12] The weight of his framing decision is revealed in these one- and two-inch variations and in the lengths that Eakins would go to correct his own mistakes: for the portrait of *Dr. William Thomson* (see fig. 239) he began on an entirely new canvas when he saw that his first draft needed six more inches of height.

The trial sketch also had a function in the preparation of the final canvas: "Often in starting a portrait he would make

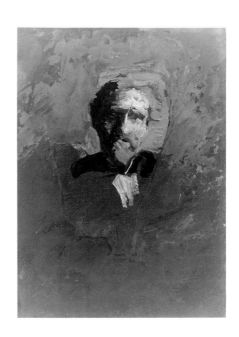

a small sketch of the subject, then with cross lines transfer it to the large canvas—by this means saving time for himself and for the sitter," wrote Mrs. Eakins. "Sometimes the work on the small canvas would be so satisfactory, that the copy of it on the large canvas would be ready for final work."[13] We may get a glimpse of work arrested at this stage in the photograph of the canvas of *The Pathetic Song,* taken when Eakins was pausing in his work to make camera studies of his model (see fig. 97).

Multi-figure portraits may have required additional oil studies of individual participants, such as the doctors and medical students who all posed independently for their portraits in *The Gross Clinic.* Few of these have survived; perhaps Eakins gave them away to the sitters.[14] One tiny vestige of this genre, however, may be the *Head of a Man* (fig. 224), representing Eakins' first impressions of a sitter that he evidently did not have long to paint. Constructed after the fashion of prelimi-

nary studies made by students at the Ecole des Beaux-Arts, the forms are built with simple strokes of a few half-tones, laid down abruptly, without softening or graduation. This portrait is unusual, however, because of its miniature size and its execution on paper, which, when combined with the suggestions of haste, hint that it was not painted in the studio. These clues, taken with the appearance of the sitter, may point to Eakins' lost portrait of President Rutherford B. Hayes, completed in the fall of 1877.[15] If it is Hayes, it joins several small sketches and numerous annotations in his Washington sketchbook (cat. 189) to offer fragmentary insights into Eakins' method for his first known portrait commission.

THE PORTRAIT OF RUTHERFORD B. HAYES: THE DIFFICULTIES OF LIFE STUDY

Eakins' portrait of Hayes has been missing for more than a century, but we do know the exact terms of the commission he received in June 1877 from the Union League of Philadelphia, whose Republican membership desired an image of their newly elected president (fig. 225). "I do not intend to use any photographs," Eakins wrote to his sponsors, "but the president must give me all the sittings I require. I will take a chance to watch him and learn his ways & movements and his disposition," hoping to create a portrait "which may do me credit in my city and which if I may be allowed to exhibit in France may not lessen the esteem I have gained there."[16]

In late September 1877 Eakins traveled to Washington, D.C., bearing a letter of introduction from a member of the League, Colonel Samuel Bell, a small pocket notebook (the Washington sketchbook, cat. 189), and his painting gear. His hopes for standard portrait sittings were soon disappointed. Thirty-five years later, in a letter to Charles Henry Hart, Eakins summarized the circumstances as well as the outcome: "The portrait was far from conventional," he remembered. Hayes "knew nothing of art" and expected Eakins, like several other presidential portraitists who had already trooped through the White House, "to make a rapid sketch for the color and then use the photograph altogether." Hayes was busy; he wanted to get "this business of art" quickly finished. He offered to pose once, after which Eakins had "permission to be in the room with him as he attended affairs of state and received visitors." Such conditions could not have been easy for a painter with Eakins' methods and standards. "The president once posed, I never saw him in the same pose again," he recalled. Hayes "wrote, took notes, stood up, swung his chair around. In short, I had to construct him as I would a little animal."

The thumbnail *Portrait of a Man* may be the product of Hayes' first and only formal portrait sitting. It answered Hayes' expectations of a "rapid sketch for the color" that other portraitists had produced during their allotted sessions and, in keeping with Eakins' description of Hayes' restlessness, it resembles none of the other pencil sketches in Eakins'

225. Mathew Brady, *Rutherford B. Hayes,* c. 1877, photo courtesy of Rutherford B. Hayes Presidential Center, Spiegel Grove, Ohio.

notebook nor the pose chosen for the final portrait, as described in period accounts. Realizing that it was fruitless to wait for Hayes to sit still and look up, Eakins must have soon abandoned any plans for a frontal pose, and he decided to paint the president bending over his desk in a pose that he might be expected to reassume with some regularity. He then launched immediately into the preparation of the final canvas, and by the end of the second session had successfully blocked in the underpainting. "The president gave gave me two sessions," he wrote his fiancée, Kathrin Crowell, on 29 August. "He posed very badly. I have succeeded in the sketch, to which I have given some movement. Tomorrow I will try to get the upper hand in the pose."[17]

Eakins' choice of pose immediately made the portrait unconventional by showing the president absorbed, at work; it was an idea that Eakins liked enough to use again a few years later in the portrait of his father, *The Writing Master.*[18] This workaday view of "the President in his old alpaca office coat, with the stump of a lead pencil in his fingers, and with his sunburned face glistening with summer perspiration" unsettled some viewers, while others found Hayes' features rendered almost unrecognizable by the foreshortened pose and tenebrous setting. But Eakins, in his "severely literal" way, could only hope to draw pictorial possibilities from what lay before him. Patiently, somewhat desperately, Eakins must have camped in the corner of Hayes' sweltering office, waiting for his "little animal" to settle down.

The record of Eakins' two and a half weeks stalking the president was kept in the final pages of his Washington sketchbook, where he noted his schedule of appointments.

This account, listing a total of seventeen hours in Hayes' office on fourteen or fifteen different days, is the only timed account of sittings for an Eakins portrait, although it may not be representative. None of the sessions were long; most of each day must have been spent waiting, sometimes sketching or painting in adjoining White House rooms (see sketchbook page 189t and the small oil, *Sketch of Lafayette Park, Washington, D.C.,* showing the view from a second floor window)[19] or sightseeing in the capital (see sketchbook pages 189r, s, u, y). His notebook implies that the hour or so each day actually spent with the president must have been interesting as a demonstration of presidential business but not conducive to portraiture. Frustration exudes from these diary entries: "Thursday 55 minutes/old man from N.C./got nothing after the/first 10 minutes./Friday 1 hour. Crazy Spiritualist/. . . Monday 2.20–3.30 Gen./Crook +/Ohio Politicians./Tuesday 2.15 to 3.30/N.Y. Bankers./Wednesday 2.15 to 3.15/Bad posing./General Crook./Thursday 2.20. 3.33/Indian Philanthropists/. . . [no date] gave me 10 minutes work. All I had." In accepting the commission Eakins had estimated that a head alone, painted "with the greatest care" (and the full cooperation of the president) could be finished "during a few hours in a week's time." Under the extenuating circumstances, this estimate must have been hopelessly inadequate, especially because Eakins decided on a half-length composition, much larger than the Union League had ordered.

Scattered among his notes, train departure times, and Washington addresses are three quick pencil sketches, perhaps of Hayes in action (see sketchbook pages 189v, w). These figures may represent preliminary ideas for the pose or simply opportunities to sketch Hayes in other attitudes, when work on the oil was impossible. Eakins was not good at this kind of fieldwork; his pencil sketches are neither graceful nor particularly telling. The third sketch (fig. 226), labeled "Mora," showing a standing figure of arguably presidential dignity, may have been drawn from life or sketched out of boredom or despair from a portrait by the New York photographer José Maria Mora (c. 1847–1927). Perhaps fearing that he would never be given adequate opportunities from life, Eakins was driven to the method that the president proposed and began to grasp at information from photographs.[20]

As it turned out, almost nothing from these sketches was used in the final portrait. Ultimately, both pencil and oil studies remained exercises in observation, evidence of Eakins' process of learning "his ways & movements and his disposition" in preparation for making an accurate portrait. The final painting was praised for its "uncompromising truthfulness" and "genuine artistic realism" by art critics but dismissed as a "caricature" by Hayes' friends at the Union League, who also may have been upset by the implications of a flushed complexion on a president known for his teetotalism. After exhibition at Haseltine's Gallery in Philadelphia in December 1877, the painting was duly paid for and installed in the Union League, but not for long. Two years

226. *Sketch of a Man (Rutherford B. Hayes?),* c. 1877 (cat. 189w).

later A. L. Snowden had it replaced (without Eakins' knowledge) with a less troubling portrait by W. Garl Browne. In July 1880, Snowden shipped the offending portrait to Hayes, and the painting fell into oblivion.[21]

The disappearance of the Hayes portrait, added to the disjointed and ambiguous nature of these surviving sketches, leaves us with a fragmentary image of a portrait that Goodrich concluded was "one of Eakins' more original works." We can reconstruct from these shards, however, a useful picture of Eakins' portrait method, representing procedures and attitudes prevalent throughout his career. The present evidence suggests that Eakins obligingly began Hayes' portrait along the route the president expected—a quick oil sketch, a few pencil notes, perhaps photographic aids—and then quickly turned to a life-size oil-on-canvas format, which he insistently worked on "from nature." Clearly the pencil sketches of Hayes illustrate the marginal contribution of such spontaneous drawings to Eakins' portrait method. Following the few drawings of his family from a sketchbook kept during his teenage years (cat. 15), these sketches of Hayes are Eakins' only extant graphic portraits. Evidently he never tried this line of attack again.

The futility of pencil sketching was not the only lesson learned from the Hayes commission. Eakins' hopes for this project had been high: when the portrait appeared in Philadelphia, his friend William Clark noted in the *Evening Telegraph* that the picture was only a "preliminary study" for

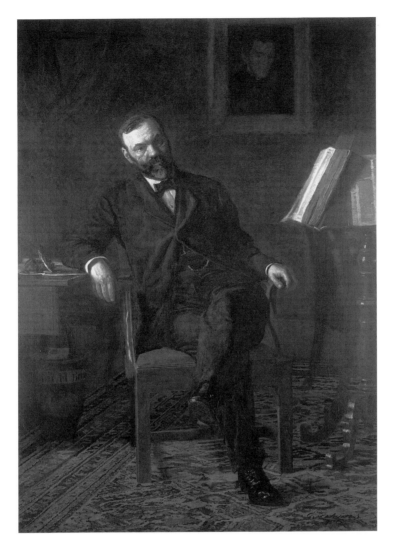

227. *Dr. John H. Brinton*, 1876, oil on canvas, 78⅜ × 57⅛ in., National Gallery of Art, Washington. Lent by National Museum of Health and Medicine of the Armed Forces Institute of Pathology.

a grander, full-length version, curtailed because the artist "was unable to obtain the necessary sittings." If Eakins had, as Clark announced, "expectations of opportunities in the future" to execute this more ambitious version, they were never realized. Such statements, added to the record of frustration in his appointment log, give us a poignant sense of Eakins' thwarted plans. Eager to make good on his first important national commission and to confirm the "esteem" of his friends abroad, Eakins must have been unnerved by the disruption of his usual methodical practices. Until now his sitters had been cooperative family and friends; he had not encountered a subject so impatient with the "business of art" or so famous, so potentially useful to his career. Both the stakes and the level of difficulty rose while Eakins' ability to control the situation fell dramatically.

Inevitably, given the conflict of expectations and the artist's disadvantaged position, the results pleased no one very much. Too "literal" and unconventional for Hayes' friends, the portrait was too compromised to represent the artist's highest aspirations. Eakins valued the picture,

nonetheless, and was upset when he learned, years later, of its disappearance. But he never attempted to borrow the painting for exhibition abroad, nor did he reproduce it, as he had *The Gross Clinic*. And, perhaps learning from the disappointment of this picture, he rarely traveled from his studio to paint portraits, and only then to sitters—such as Professor Benjamin Rowland—who accepted his terms. Hayes was also the only politician Eakins would ever paint. In 1912, Eakins was asked to paint him again. Hayes was still a bad model, ten years dead by this time, and had to be studied from a photograph (see fig. 222).[22]

PORTRAIT OF DR. JOHN H. BRINTON

The year before the Hayes portrait of 1877 Eakins had painted his friend Dr. John H. Brinton (1832–1907), an admired surgeon, under more controlled circumstances, illustrating the type of picture he probably had in mind for Hayes (fig. 227). Three drawings in the Bregler collection (cats. 174–176) illustrate another phase in the preparation of his

228. *Portrait of Dr. John H.
Brinton: Ground Plan*, 1876 (cat.
174).

229. *Portrait of Dr. John H.
Brinton: Perspective Study*, 1876
(cat. 175; plate 20).

large portraits, probably undertaken after the initial sketch had been made and the figures well established. These drawings concern the layout of space in the picture, demonstrating that Eakins had an important role for drawing in his method, but one that hardly touched upon the figure itself. Typically, the sitter is represented only by a broad footprint where his shoe contacts the perspective plane of the floor. The Brinton drawings are the earliest extant set of such perspective plans in Eakins' portrait work, and they make an excellent introduction to the many similar drawings in the collection, and to the problems and choices that Eakins—and most other painters of this period—had to consider when organizing life-size portraits.

Although Brinton would succeed Dr. Samuel Gross as the chief of Jefferson Medical College, Eakins emphasized his sitter's scholarly interests by placing him at home, in his library, with a quill pen and blotter on the drop-leaf desk at

his right. An ancestor's portrait looks down from the wall, and a painted leather fire bucket, neatly lettered "ohn H Brin" serves as a wastebasket under the desk; like the eighteenth-century desk and chairs in the room, these objects tell us of Brinton's family and his historical sensibility. A bright modern bookstand and bold new Turkish carpet tell us of his up-to-date taste and continuing affluence. Eakins borrowed many of these items from Brinton and set them up in his home studio; the doctor himself probably posed in the light from the west window, close to the position occupied by Margaret Harrison when she modeled for *The Pathetic Song* (see fig. 97).[23] Once Eakins had the basic pose and the concept of Brinton's surroundings in his mind's eye, he prepared two drawings: first a plan (fig. 228) and then a perspective of the space (fig. 229; plate 20). Some erasures and secondary lines on the plan may indicate that he pushed the furniture around in his studio a bit before settling on the final arrange-

ment, negotiating the plan to accommodate improvements in the two-dimensional design of the canvas. The plan locates exactly the position of Brinton's chair and bookstand, the edge of the desk he leans on, the axis of the carpet, and the placement of the two more distant Chippendale chairs. These objects, especially the armchair behind the desk, appear again in the perspective with an importance they do not retain in the painting. Contributing little to the major message of the picture, which is carried in Brinton's figure, these two chairs simply hold down or press back the space at the rear of the room, allowing the doctor a coherent foreground. It is enough to imagine them gone to understand their job in the spatial construction.[24]

Several critical decisions were made before undertaking these drawings. First, Eakins established his own position in relation to his subject. As usual, his sitter was placed directly in front of him, in the center of the picture, but asymmetrically arranged. The central, vertical axis of the painting, which Eakins told his students to construct before all else, drops through the highlight on Brinton's lapel, the low point of his watch chain, and the center of his left shoe.[25] Both of Brinton's hands line up along the central, horizontal axis of the canvas. The painter's eye level is not here, however, but at forty-eight inches from the floor (according to his own annotation on the drawing), on a level with Brinton's eyes, indicating Eakins' own position in a chair across from his subject. This four-foot viewing height was comfortable for Eakins, and he used it frequently, because it was both natural and conventional. Subtly, it conveys his own physical and psychological relationship to his sitters: Brinton is met directly, as an equal, while Mrs. Brinton, Amelia Van Buren, and Kathrin Crowell (see figs. 219, 8) are seen from about a foot lower, harbored by the familiar Eakins armchair. The power of this choice is seen in his awareness of its impact, demonstrated in modifications elsewhere: Monsignor Turner (see fig. 236) was raised on steps to give him authority, while Eakins dropped his customary position an inch to meet Cardinal Martinelli (see fig. 235) face to face. The difference made by viewpoint is easily measured by comparing two almost identical full-length portraits: *John J. Borie* (see fig. 230) and *Rev. John J. Fedigan* (cat. 212). Borie, an architect half Eakins' age, was painted almost eye to eye, creating a directness of contact that enhances the informal but elegant tone; Fedigan, older than Eakins, a college president and a priest, is given subtle authority over all subsequent viewers by his position at least eighteen inches above the artist.[26] In the Brinton portrait, this eye level puts the center of sight, or vanishing point of the perspective system, on the rear wall in a space midway between the sitter and his ancestor portrait. Typically, that vanishing point strikes nothing of great significance, as if Eakins wished to suppress awareness of the perspective grid.

Less obvious, but equally important to the appearance of the painting, was Eakins' choice of viewing distance. This is the point from which the perspective space of the picture is calculated, theoretically the spot where the painter stands to consider both his picture and his subject. Ideally, it is the distance a spectator must stand in front of the canvas in order to recover the most natural sense of recession within the pictorial space. Eakins announces this distance on his drawing (fig. 229; plate 20): sixteen feet. It can also be read from the plan, where the axis of the painter's (and the viewer's) sight can be traced from the "o" marked on the scale along the bottom of the drawing up to the spot where Brinton's chair straddles a perpendicular line marked "16" on the vertical axis at the left margin. The same coordinates appear at the left margin of the perspective drawing, confirming Brinton's position "16 ft." distant. Why is he set so far away when he appears life size, and much closer, in the painting? Does this mean the only "correct" viewing position is sixteen feet away?

Eakins knew that viewers would draw closer than sixteen feet to inspect his picture, and certainly he had to paint it from arm's length. The viewing distance established, however, the terms of the basic perspective schema, seen most convincingly from this ideal position and held coherently in the mind from most other distances and angles, because of the naturally compensating intelligence of human vision.[27] The choice of this distance may have had something to do with numerical convenience, for sixteen converts smoothly into fractions and therefore eases the scale reductions from feet to inches needed for the preparation of his drawings.[28] But the real reasons for this long viewing distance were pictorial, and they demonstrate Eakins' mastery of the odd artifices of western painting and linear perspective. Brinton's torso was relatively easy to paint because he appears at the scale of life, as does everything close to him on the sixteen-foot line. More difficult, however, is the convincing illusion of his foreshortened legs, his chair, the bookstand, and the deeper space behind him, all of which depend on the graceful and rational enlargement or diminution of scale. The quality of this "perspective" depends on how far we are standing from the whole ensemble.

Consider the grid of lines that draws together at a vanishing point to make the standard perspective network, as seen in blue ink lines in cat. 175 (plate 20). Objects within this grid will increase in size at a rapidly accelerating speed as they draw into the foreground. Receding objects diminish at a correspondingly slower pace, such that a very distant figure in such a grid must run many feet forward or back before noticeably changing in size. Very small intervals in the foreground will bring, by comparison, drastic alterations. If we pull Brinton too close to us, the speed of scale change from square to square will create uncomfortable visual effects: his foot, for example, will begin to loom grotesquely large in relation to the rest of his body. Van Gogh used this rushing foreground to expressive effect in his paintings of his bedroom in Arles; Ralph Earl, in painting his famous portrait of Roger Sherman (Yale University Art Gallery) pulled his sitter so close to the viewer that he seems to slide forward out of his chair. These effects—so commonplace and tolerable in three-dimensional visual experience—seem distorted and

bizarre when spread across our awareness on the two-dimensional surface of a picture. If Brinton is set a moderate distance away, where the pace of scale change has slowed, this rushing effect calms. Largely for this reason, Eakins always moved past this troublesome foreground to set his life-size, full-length figures between twelve and sixteen distant.[29]

At this range we also can grasp the entire canvas within our field of vision without turning or tilting the head. Sixteen feet is more than adequate for command of even a life-size, full-length portrait, but Eakins seems to have preferred this long viewing distance in preference to an "ugly" closer position that would require using the margins of the visual field where, again, distortions of perspective as well as of focus and color occur. To avoid these distortions, Leonardo recommended that painters step back three times the height of the largest principal object in a picture. Eakins, if he used this rule of thumb, could have multiplied Brinton's size (sixty inches from head to toe) by three to arrive at a viewing distance of fifteen feet. Leonardo knew that, seen from this distance, the main objects in the picture will fall safely within a visual angle of about 20 degrees—well within the frontiers of distortion that begin at 25 or 30 degrees.[30]

This restricted angle seems to have been reckoned in Eakins' portraits with great precision, and even more conservatively than Leonardo advised, for the additional reason that it establishes the exact amount of pictorial space visible to the spectator within the "room" of the painting. Imagine the frame of the canvas as a doorway leading into this room. Standing close to the door, we can see much of the interior space from side to side; as we step back our wedge of sight gradually narrows. The "cone of vision" is not indicated on the Brinton plan (as it is on Cardinal Martinelli's [see fig. 235], or Monsignor Turner's [see fig. 237]), but it can be measured from the spectator's position at sixteen feet to show a visual angle of 17 degrees subtended between the sides of the frame, allowing us to see at most seven and a half feet from side to side at the back of the room. If Eakins were working in a particular architectural space, like the surgical amphitheater at Jefferson Medical College, this measurement allowed him to bracket precisely the amount of the background visible and transfer it convincingly to the picture. In an invented space, like Brinton's, the narrow visual angle worked pictorially, to confine the wandering attention of the viewer. We are not allowed to see too much of Brinton's interior, and are encouraged to return to the sitter in the foreground. For the same reason, Eakins masked the only visible corner in the room with red draperies, obscuring or defeating the very sense of space that he so carefully constructed in the foreground. Eakins avoided the display of corners and ceiling planes with a studiousness that suggests he was taught to do so, probably because odd, "unnatural" effects were likely at these intersections, and they awakened awareness of the artifice of the perspective apparatus—be it right or wrong.

The subversion of his own perspective, and his sense that it was a system to be manipulated according to pictorial convenience, also shows in his treatment of the far wall, which in both drawings appears at a slight angle to the picture plane. In the final painting, however, the Sullyesque ancestor portrait hangs on a plane parallel to the canvas, because it would look odd if it were drawn in perspective. In straightening this picture Eakins breaks allegiance to his plan and implies a very unusual room, but it looks "right," and, after all, the room was his invention all along. His compromise reminds us that Eakins has fabricated this space for Brinton and his picture. An artist, he is neither the prisoner of appearances nor of his own system of perspective.

This manipulation of perspective and its quirks is also seen in Eakins' handling of the paradoxical space that exists between Brinton and the picture plane, a no-man's land that exists only in life-size portraiture, where the viewing distance of the canvas is the same as the imaginary distance of the figure. Conventionally, the point of reckoning viewing distance and scale is the picture plane itself, usually described (as in Eakins' own perspective manual) as a window or pane of glass that cuts through the spectator's visual cone somewhere between the object to be depicted and the viewing point (see fig. 54). If this window frame is held halfway between object and viewer, the image traced on the glass will be half life size. The same image will grow progressively larger as the picture plane is carried back toward the object depicted until, as in a "life-size" portrait, the picture plane coexists with the plane of the sitter and the viewing distance for both picture and subject are identical. In practice, of course, this is impossible, especially with a seated figure such as Brinton, whose left toe projects about three feet in front of his torso. Actually, the entire figure must be situated slightly behind the "glass" of the picture plane, sometimes—as in Brinton's case—several feet back. Either the figure can be pushed back and reduced slightly (as Whistler often did), or the point of life scale can be moved back to a point within the "room" of the painting. However, once inside the pictorial space, the rules of linear perspective come into play. Within this system, space will not stop growing at Brinton's "life-size" position on the sixteen-foot line. Instead, the orthogonals of the grid will keep expanding toward us until they hit the real picture plane, which evidently intersects the floor about thirteen feet from our viewing position. The space visible beneath Brinton, measured from side to side on the plan, is very close to the width of the actual canvas: fifty-seven inches. However, the floor in front of him at the base of the picture plane (the canvas), measures less than four feet of the grid on plan, indicating that the space in the foreground has expanded about 20 percent in the three-foot interval between Brinton and the picture plane. If Brinton were to stand up and walk toward us, he too should grow 20 percent larger than life size.

This odd zone especially plagues the foreground of life-scale portraits where the picture plane drops to the floor. In Eakins' smaller-scale paintings, such as his rowing pictures, the closest visible ground (or water) in the painting is not the location of the picture plane, it is only the first spot visible

over the edge of the painter's "window." Like a view from a window, yards of foreground space have been cropped by the frame.[31] But with a life-size subject on a canvas that seems to rest on the ground, continuity between pictorial space and real space is implied, and the threat of distortion in the foreground must be accommodated. Most painters make an effort to keep this space very shallow. Charles Willson Peale pressed his life-size figures right up against the picture plane, building for them a literal doorframe and a step beneath in his delightful *Staircase Group* of 1795 (PMA).[32] Other painters, such as Caravaggio or David, gave only an impression of immediacy, while actually pushing their figures deep into perspective space, much like Eakins' *Monsignor Turner*, who stands as if quite close to us, poised at the top of a stair that is actually twelve feet away.

Our awareness of this distance, and the problematic foreground space, can be diminished by keeping the floor blank (as in *The Thinker*, fig. 232) or evasive, as in the Turner and Brinton portraits. Geometric floor patterns perpendicular to the picture plane, such as tiles or boards or striped rugs, will express the change in scale with sometimes alarming or distracting explicitness. Renaissance painters liked this centered, zooming space; Eakins did not. In the Brinton portrait, as in every other full-length picture, he set the room and the floor pattern (if there was one) at an angle to the picture plane, demonstrating a practice adhered to with such consistency we can only imagine it was taught to him early. Pictorially, these angles have an enlivening spatial effect that others, like Whistler, deliberately avoided in pursuit of flatness. Eakins wanted to suggest space, but without calling undue attention to the perspective system—as Perugino or Piero might—and the strange zone of the foreground.

Distortion in this space can also be avoided by keeping the floor empty, or at least free of geometric objects or things with a fixed and familiar size that will draw attention to odd changes in scale. This space is not always completely emptied in Eakins' work, and it is interesting to note the objects that Eakins allowed in this zone: indeterminately sized objects, like books; exotic and therefore unfamiliar items, such as the musical instruments and ethnographic art works of Mrs. William D. Frishmuth or Stewart Culin (see fig. 233); the hand of the conductor in *The Concert Singer* (PMA); or his own signature (for *Brinton*, fig. 49; for *An Actress*, cat. 213), which patently exists in a decorative limbo, suggesting illusionistic space and yet clearly part of the two-dimensional identity of the surface.

Finally, the Brinton perspective drawing illustrates the decisiveness of Eakins' framing edges, crisply determined here to produce an eccentric size. An earlier oil sketch probably helped him arrive at the precision shown here. The only details in the drawing that show signs of testing are the placement of the picture frame and the drapery on the back wall, which Eakins moved to several spots before arriving at the balance of the final composition. As usual, these drawings reiterate the irrelevance of the format of his paper and

conversely demonstrate the power of the spatial system invented by his perspective grid and the figures within it, as Eakins carefully organized the framing edges of his composition. As Philip Rawson has noted, this kind of self-contained and self-generating image is characteristic of sculptors' drawings and a strong plastic rather than two-dimensional sensibility.[33]

THE PORTRAIT OF JOHN JOSEPH BORIE III: THE FINAL TOUCHES LEFT UNDONE

The Brinton drawings teach us why Eakins made perspective diagrams, but the moment when he made them, and exactly how he used them, emerges clearly from the perspective and plan for the *Portrait of John Joseph Borie III* (figs. 230, 231), a picture left unfinished at an unusual and revelatory moment in Eakins' process. Young Borie (1869–1925) was an architect and interior designer with the Philadelphia firm Cope and Stewardson from about 1896 to 1899. During these years he designed the gargoyles on the new dormitories at the University of Pennsylvania and befriended Samuel Murray, who modeled a bust of Borie's mother. Murray evidently introduced him to Eakins, who probably painted the portrait before Borie's departure for New York in 1900 and subsequent expatriation to England, after 1905. Most likely, "Dickey" made an elegant portrait subject for Eakins some time around 1896–98, although the painting remained unfinished and was never signed or dated.[34]

The annotations on this drawing are straightforward, indicating that Borie stands twelve and a half feet away, seen from a height of sixty inches—a conventional viewpoint for a standing portrait but slightly lower than Eakins' natural eye level. Like many of Eakins' subjects, Borie may have been posed on a modeling platform that raised him a few inches above the painter. By comparing the painting and the drawing we can locate the vanishing point in the middle of Borie's brilliant white collar, directly beneath his ear. Borie's height on the canvas, even when slouching, is about 5 feet 11, confirming the impression that he was a tall man, but Eakins' artificially lower position flatters Borie's slight advantage in real height to make him seem even taller.

Less comprehensible are the annotations and arrows on the plan: "Window showing building" and "window showing sky." Since no windows appear in the painting, nor are they likely to have been contemplated (since Eakins never put his sitters against a distant prospect and rarely offered any visual escape from the sitter's space), these instructions can be interpreted only literally as the direction of light in the picture from two windows to the left and slightly to the front of Borie. Eakins could have orchestrated such lighting in his home studio by blocking certain windows, but the shadow patterns in the painting are too unfinished to indicate which light source (or if both) prevailed, and the imprecision of his window description may indicate that he was painting in an unfamiliar room. The exact angle of the shadows on the floor

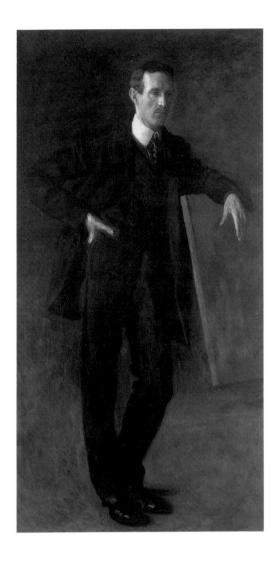

230. *Portrait of John Joseph Borie III*, c. 1896–98, oil on canvas, 80⅜ × 42¼ in. (204.2 × 107.3 cm), Hood Museum of Art, Dartmouth College, Hanover, New Hampshire, Gift of Abby Aldrich Rockefeller.

231. *Portrait of John J. Borie: Perspective Study and Ground Plan*, c. 1896–98 (cat. 209).

could be projected using this drawing, as could the angle of a wall in space behind Borie, or the position of the feet of the drafting table at his left. Eakins did none of these things on this drawing, however, using it only to establish the plane of the drawing board and the position of the horizon line and his sitter's feet in respect to the framing edge. Otherwise, the grid of the perspective remains vacant, even though the painting of the figure on the canvas is fairly resolved.

The halt in the drawing as well as the painting may indicate that the niceties of the perspective of furniture, rear walls, and shadows were to be refined after the figure had been substantially completed, not beforehand as part of a fully developed preparatory scheme. This process of filling-in reminds us of the inherent simplicity of a standing life-size portrait, in which the figure can be established on the canvas at its literal height, without reference to its environment, other than the floor. The interruption of drawing and painting at this moment in Borie's portrait may tell us about Eakins' confident procedures at the age of sixty, or it may reveal a strategy maintained throughout his career but never left exposed until this moment. Probably he worked back and

forth between drawing and painting in all his portraits. From Borie's picture it seems that he first established the horizon line and viewing distance to generate a spare perspective grid that was transferred to the canvas in a few select graphite rulings.[35] Eakins then built the figure at life size on the canvas before returning to his drawings to construct the fine points of the sitter's environment, which were again transferred to the painting and brought into harmony with the figure. The Borie portrait makes us reconsider the Brinton drawings, especially cat. 175, to imagine that the sketchier elements—the left rear chair, the draperies, the picture frame—were all added to his perspective at this second phase in response to the image of Brinton, already near completion on the canvas. These glints of improvisation remind us again of Eakins' imaginative control over a seemingly real world.

The uncluttered quality of Borie's half-finished portrait may have appealed to Eakins, explaining why he left it uncompleted. Many of his later portraits seek this spareness and include only minimal contextual clues. In one of his greatest portraits, *The Thinker* (fig. 232), painted not long after Borie's, Louis Kenton stands in a space defined only by a diagonal

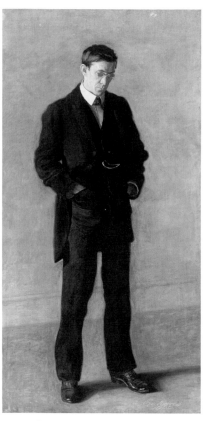

232. *The Thinker: Portrait of Louis N. Kenton*, 1900, oil on canvas, 82 × 42 in., Metropolitan Museum of Art, Kennedy Fund, 1917.

baseboard and his own cast shadow. This environment, enlivened by scrubbed brushwork and the animated contour of Kenton's figure, is hardly empty, needing no reference to books or papers to supplement the expression of pensiveness that emanates from Kenton and preoccupies his space.[36]

PORTRAIT OF STEWART CULIN (THE ARCHAEOLOGIST): THE MEANING OF ACCESSORIES

Eakins took the opposite approach for the portrait of the ethnologist Stewart Culin (1858–1929), cramming the foreground with objects that expressed his friend's intellectual interests. Like the Hayes portrait, Culin's picture has been missing for more than sixty years. In his catalogue of 1933, Goodrich described the portrait from the account of Culin's wife: "Life-size, full-length, seated, the body full face, the head turned half left, various archaeological objects on a table and floor—games, American Indian remains, etc. Dark hair and moustache, canvas, about four or five feet square." The emergence of a lone perspective drawing from Bregler's collection (fig. 233) can teach us more about this important painting of a man whose scholarship continues to inform students of folklore, anthropology, and archaeology.[37]

Eakins painted Culin surrounded by the objects that he collected and studied at the Museum of the University of Pennsylvania, where he was curator of ethnology and later director, from 1892 until 1903. All three protagonists of the three "special collections" at the University Museum were painted by Eakins in 1899 and 1900 in the same fashion: full-length, seated, in the midst of the artifacts they loved. First came Culin,[38] then Mrs. William D. Frishmuth with prized items from her collection of musical instruments, and finally Mrs. Joseph W. Drexel, donor of the museum's international collection of fans.[39] Culin's special expertise was represented in the objects before him, which illustrated his field work among Native Americans and his devotion to the comparative study of games, undertaken with his friend, the anthropologist Frank Hamilton Cushing. Five years earlier Culin had brought Cushing to Eakins' studio, where he was painted with his Zuni artifacts.[40] Echoes of the Cushing portrait linger in Culin's image, perhaps because Culin's monumental *Games of the North American Indians*, a book undertaken with Cushing's encouragement and assistance, was nearing completion when Eakins began the portrait and as Cushing himself slipped toward death. The emblematic importance of these artifacts is signaled by the title Eakins gave to this painting when it was exhibited at the Academy's Annual in 1901: *The Archaeologist: Portrait of Professor Culin*.

The game board in the foreground speaks directly of Culin and Cushing's shared interest: it is a Chinese or Korean chess board, recognizable in its pattern of squares, 8 × 9, with crossed diagonals marking the "palace" of the "general" or king of the two opposing sides. Tiny X's on the intersections of the grid mark the starting positions of the "foot soldiers," according to Chinese play; most likely, Eakins populated this board with authentic markers. Culin had already published two related texts on chess and other Oriental games, openly inviting Cushing's comparative use of his North American data, but Cushing's poor health forced Culin to continue his studies alone. Eakins' use of an Asian chess board shows that he was familiar with Culin's work, although a board of exactly this type does not appear in Culin's writings. Probably it was a particular board from the museum's collection. A chess player himself, Eakins may have been curious about the international variations in chess, and intrigued by Culin's theory that both chess and playing cards derived from rods, sticks, or arrows used for divination and early games of chance. Such sacred arrows appear in Cushing's portrait, and—I hazard to guess—related sticks may have been on the table in Culin's portrait, if not in his hand.[41]

More ambiguous is the cubic form about fifteen inches high seen at the left of the drawing. Following Goodrich's suggestive description, this may be "American Indian remains," contained within the outline of a Northwest Coast bentwood box of a type occasionally used as a cremation chest. Although Culin's own field work, like Cushing's, emphasized southwestern cultures, he traveled widely in North

233. *Portrait of Stewart Culin—*
Perspective Study, c. 1899 (cat. 210).

America and collected five Northwest Coast boxes for the University Museum.[42]

Given Goodrich's description of Culin's pose, we can place him precisely in the space of the perspective drawing, for the chair that he sits on is visible 14.75 feet behind the desk. We can guess that his eye-level, seated, would be about forty-eight inches high, as in the Brinton portrait. Following from this, the top of his head would be (assuming a man of average height) about fifty-two inches from the floor—exactly where a small pencil line cuts the vertical axis next to the annotation "52" in the perspective drawing.

The size of the canvas can also be guessed at from the drawing, with Goodrich's vague "four or five feet square" dimensions in mind. Eakins often let the grid on the picture plane (here laid out in red ink, in three-inch squares, each representing a square foot of the canvas at one-fourth scale) generate the canvas edges as well as the interior space revealed by the "window" of the picture frame. In the case of the Fedigan portrait (cat. 212) Eakins bracketed exactly four feet along the sitter's base line; if he did the same thing here, the frame would crop the box at the lower left and the table at the right, making it unnecessary to describe the turnings of the right-hand table leg, which is indeed unfinished. The lower edge of the canvas is suggested by a darker ink ruling at the thirteen-and-a-half-foot line; the upper edge may be the uppermost pencil grid line, although this seems uncomfortably close to the top of Culin's head. However, the vertical distance of five and a half squares (sixty-six inches) between this line and the thirteen-and-a-half-foot mark establishes a minimum size for a "full-length" view of Culin. Probably the lost painting is no less than 66 × 48. At this size, it would have been the smallest of the triad of museum portraits, but only by six inches in each direction, and it may well have been slightly taller.[43]

The horizon line given in Eakins' annotations is borne out in the drawing: sixty inches. Evidently Eakins stood while painting the seated Culin, a vantage that gave a more informative view of the table top, box, and game board than the eye-to-eye viewpoint of the Brinton portrait, or the seen-from-below viewpoint of Borie or Fedigan. However, placing Culin behind his table, with many objects and surfaces between him and the picture plane, accentuates the problem of the foreground "limbo" in a full-scale portrait. If Culin is "life-size" on the canvas while seen seated 14.75 feet away, what scale are the objects closer to us? According to the drawing, objects at 11 feet (the first pencil line at the bottom of the drawing) will be one-third larger than the same objects seen 14.75 feet distant—that is, one-third larger than life. Eakins evades the distortion of this supernatural foreground by turning the box, table, and game board at angles and cropping their corners, so that the effect of the expanding space will not be easily measured by the eye. Even so, the effect must have been surprising and even more eccentric than the Frishmuth portrait, in which the same kind of exotic jumble was laid out in the foreground but not so insistently pressed

forward. The result may mean to speak to us of Culin's mind, rich and cluttered like a museum basement, packed with artifacts whose interconnectedness awaits discovery through patient description and analysis.

SUMMARY OF THE METHOD: THE CLERICAL PORTRAITS

In the 1890s Eakins befriended several members of the Catholic clergy, especially alumni and faculty of St. Charles Seminary and Villanova College, on the outskirts of Philadelphia. In about 1900 he started to paint bust-length portraits of these men, and by 1902 he had launched an ambitious series of canvases that eventually would include thirteen sitters and six full-length compositions. Eakins was at the top of his form as a portrait painter during these years, and the pictures from this series express the maturity of his method. Three of the largest and most important portraits in this suite are represented by perspective drawings in the Bregler collection: the *Portrait of His Eminence Sebastiano Cardinal Martinelli* (fig. 234; plate 21), the *Portrait of Monsignor James P. Turner* (see fig. 236; plate 22), and the *Portrait of the Very Reverend John J. Fedigan* (cat. 212).[44] Together these paintings can be used to summarize the integrity of the system that we have seen unfold in the "case studies" of this chapter.

Integrity results from the consistent application of a system, at once technical and aesthetic, that makes all these portraits recognizably "Eakins." The same palette appears in all his portraits, regardless of the sitter or setting, giving a characteristic darkness and earth tone, often lit by red. The paint handling is typically heavy, dry, and slow-moving, although not without moments of delicacy; many brush effects are employed, from the fine pink line of a wet eyelid to the sweeping strokes of a shadowed interior. However, the range of texture and focus is not so wide as in contemporary bravura work by such portraitists as Sargent, whose handling seems lively, creamy, and diverse by comparison. Eakins' background is usually very dark, his light source always strong and particular, more often from the left than the right. This light draws the figure into relief and illuminates small details of physiognomy, contributing to the plastic presence of the figure and its particularity. Color, light, and drawing all work to evoke the physical and psychological reality of an individual; we are not fooled that a "real" person stands behind the frame, but we are convinced of the reality of Eakins' witness.

Often described and analyzed, these qualities are only part of what makes Eakins' work distinctive and unified. The regular use of certain procedures, such as the scrubbed darks and impasted lights of Eakins' system of modeling, or the adherence to "laws" of linear perspective, also becomes signature practice. These technical habits can be learned from studying many sets of preparatory sketches and drawings alongside the finished work, as we have done in this book, to learn another kind of general truth residing in the many phases and details of each project. All of Eakins' portraits

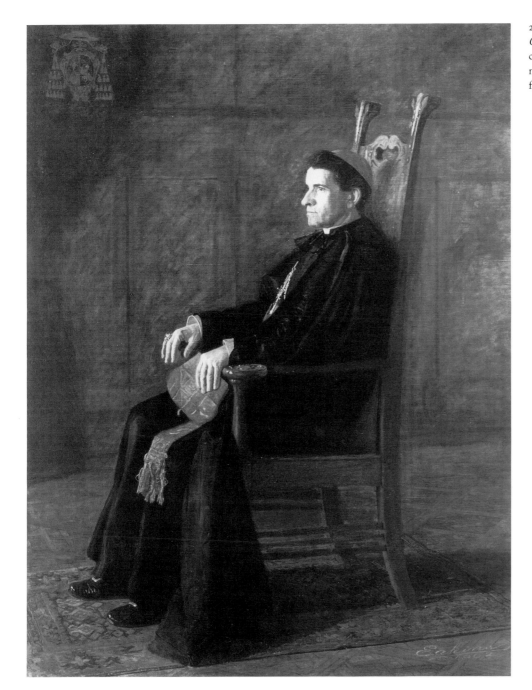

234. *His Eminence Sebastiano Cardinal Martinelli*, 1902, oil on canvas, 78⁵⁄₁₆ × 59¹⁵⁄₁₆ in., Armand Hammer Collection, California (plate 21).

share a sameness, and part of that shared identity is a tendency to explore variations within a tight system. The variety of effect produced from this experimentation is more than the accrued observations that make one sitter look unlike the next; it is a variety of two- and three-dimensional structure. No empty formalism, this practice usually expresses Eakins' opinion of the sitter and his sense of the function of the portrait; it embodies the relationship between Eakins and his subject. Few of Eakins' portraits were commissioned, so this relationship was rarely a business transaction between strangers; usually, both parties volunteered to take on the project. In this agreement—based on Eakins' interest and his

sitter's gift of time—lies a foundation of meaning for the portrait. Knowing details about the sitter and his or her relationship to Eakins offers a key to unlocking the sense in his network of decisions about the image.

The basic terms of realist portraiture are restricted, because the artist has committed to suggesting the illusion of space, the accoutrements of the observed world, and a likeness of the sitter. Life size, full-length portraits usually arrange the sitter in one of only three basic formats—standing, sitting, or reclining—that grant possibilities further limited by the necessity to hold the pose. Linear perspective, with its quirky zones of distortion, also confines the realist

painter: the figure and the viewing distance cannot be too close or too far, the eye level cannot range too high or low, without absurd effects. Within these restrictions Eakins saw an infinity of variations. His diverse solutions show that he enjoyed negotiating the variables, resisting repetition or formula, and insisting on particularity of circumstances. Painting, as he told Bregler, was a lot like mathematics; each portrait was a new equation to balance. Combining his love of problem solving with his dedication to realism, his portraits give the sense that he was striving for a pictorial effect that expressed his sense of the individuality of the sitter and also explored a problem in design that satisfied his need for fresh challenges. In this way the idiosyncrasies of each sitter, and the tailor-made quality of each solution, are bound together in Eakins' artistic identity, making variety another marker of the unity and consistency of his work.

This generality returns us, then, to the importance of detail, of particular context, of technical choices, to the meaning of Eakins' portraits, and the clerical portraits offer rich instances to summarize the exploitation of these variables in his method. Let us begin with the character of these sitters and Eakins' relationship with them. All were high-ranking Catholic clergy, intellectuals as well as administrators and spiritual leaders. At the time, Martinelli (1848–1918) was the highest-ranking prelate in the United States; he was painted at the cardinal's residence in Washington, D.C., in the spring of 1902, just before returning to his duties in Rome. Fedigan (1842–1908) was a leader of the Augustinian order and the president of Villanova College; Turner (1857–1929) was a monsignor, and vicar general of the archdiocese of Philadelphia. Eakins may have been attracted to this group because they were picturesque in their red and black and lace. Perhaps, as he approached the age of sixty, he enjoyed testing his own agnosticism against their faith. Evidently he grew to enjoy their company. Certainly his portraits show that he respected their social and ethical authority, their deep commitment to their work. Despite their traditional vestments, these men are seen as modern, not quaint; they seem wise, dignified, strong. These qualities are conveyed by sober coloring, calm and stable poses, and monumentality. Less obviously, respect is shown in the careful preparation vested in oil sketches (for Turner, see fig. 223) and in extant perspective drawings: three for Martinelli, including cat. 211 (see fig. 235),[45] one for Fedigan (cat. 212), and five for Turner (figs. 237, 238; cats. 215–219).

At first glance, these preparation pieces confirm the obvious: all sitters are squarely placed in the center of the canvas but asymmetrically arranged, according to Eakins' advice as well as his standard practice. In Martinelli's portrait, the lowest, brightest spot on his crucifix is intersected by the vertical axis to become the visual spark of the painting. Turner's missal holds the center of his portrait, while Fedigan, like the architect Borie, steps slightly to the side to balance an image of his life's work, displayed on a drafting board at his left.

Eakins' next decision involved eye level. His annotations on fig. 235 tell us that Martinelli is seen from an odd forty-seven-inch viewpoint, an inch lower than Eakins' more typical eye level when seated. He probably did this as a sign of respect to this small man, so that he would not seem to look down on him. Even so, the horizon line—very near a line drawn on the canvas representing a molding on the rear wall—is an inch above Martinelli's eye level. Fedigan is seen from slightly lower (forty-six inches) to aggrandize his already impressive height. Lower still is the very unusual twenty-eight-and-a-half-inch horizon of the Turner portrait, evidently calculated to make his sitter more imposing, while expressing the actual viewpoint of a parishioner seated in the church transept, three steps (about eighteen inches) below the priest.[46] In all cases, the vanishing point created by the intersection of the vertical axis and the horizon line is not stressed by lines in space or on the surface of the painting. Typically, Eakins wished to reduce consciousness of the spatial system, so it is lost in the paneling behind Martinelli, in the lace of Turner's surplice, or in the folds of Fedigan's habit.

Eakins then placed his figure in space: Fedigan sixteen feet away, Turner fourteen, Martinelli thirteen. These small changes seem to be part of Eakins' play, for in all cases the foreground has been cropped to make the figure seem very close. But for Turner and Martinelli, the closer placement makes the floor around them more legible, and in their portraits the floor is important. The *Martinelli* perspective drawing includes a plan that indicates the placement of Martinelli's chair across the thirteen-foot line, but turned at an 18-degree angle to follow the axis of the prayer rug beneath him as well as the line of the back wall of the room, some five feet away. The rug makes a small island of art and elegance for the priest; perhaps it tells something about his sensibility. The rug is not placed casually; its right-hand edge (at Martinelli's back) is aligned, on plan, with the center point of the back wall; seen in perspective, this edge points to Martinelli's hands. The decision to slant the rug, the back wall, and the sitter adds much to Eakins' difficulties, but the gains are important: a feeling of space and movement to the room that gently activates a potentially static figure; a sense of Martinelli's features in the round; a view of both of the sitter's hands, with his right-hand ring of office significantly profiled. Yet the pose still falls close enough to a perfect profile to retain the qualities of Italian Renaissance portraiture that Eakins must have wished to invoke: timelessness, composure, neoclassical formality.

The plan of Martinelli's space shows a second level of complexity layered into this system: a parquet floor with interior patterns running at 45 degrees to the 18-degree grid of wall and rug. As annotations show, this yielded a secondary pattern running at 63 degrees from the picture plane. Eakins completed one parquet square on the plan, using a scale of "Each 3 spaces [i.e, parquet units] 5 1/2 inches," or, in reality, 5 1/2 feet. Evidently the grid pattern of parquet borders running parallel and at right angles to the wall produced by this first plan seemed too dull and too empty, so he rotated the

235. *Portrait of His Eminence Sebastiano Cardinal Martinelli: Perspective Study and Ground Plan,* c. 1902 (cat. 211).

whole pattern 45 degrees and reduced it by one-third on the final picture. The eighteen-inch-square units on the floor became one foot to a side, and the dominant lines were made to cross under the rug at an angle, forming parquet arrows that point toward Martinelli. Perhaps, as in the portrait of Monsignor Turner (see fig. 236; cats. 215–219), Eakins prepared full-scale drawings of the floor before proceeding. The pattern, as painted, is both precise and subdued, dulled by distance and shadow, adding a context of luxury and geometric refinement to the cardinal's world.

Martinelli's plan also delineates with precision the cone of vision available to a viewer at thirteen feet, given the framing edges of the painting. Exactly five feet of space are depicted from side to side along the line that runs beneath Martinelli's chair. The length of this line, the fictive picture plane, is brought forward in the actual width of the canvas or framing edge (sixty inches) even though this "real" picture plane stands only ten and a half feet away (as shown by a red line on the perspective drawing of the space on the left side

of the sheet). Here, according to the plan, only four feet of floor space are revealed. As in the Brinton portrait, this supernaturally expanded foreground is made as empty and shallow as possible, containing only the ambiguous "reality" of the artist's signature to distract us. Beyond Martinelli our vision opens slightly to include seven feet from side to side at the near point of the back wall. The angle of vision thus inscribed is 22 degrees, well within the scope that can be commanded without unsettling distortion at the edges of the field. Using Leonardo's rule of thumb rather than graph paper and protractor, Eakins may have multiplied his tallest object (Martinelli, at about fifty-two inches) by three, to arrive at the optimal viewing distance to achieve this angle: thirteen feet.

The fourteen-foot viewing distance for Monsignor Turner proposes an even more complex and symbolically laden space for the man who was, significantly, one of Eakins' best friends among this group of clerics. Eakins first painted Turner in about 1900, showing him in an informal,

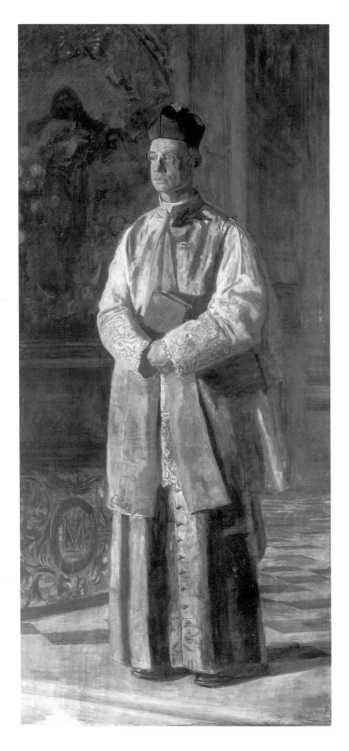

236. *Monsignor James P. Turner,* c. 1906, oil on canvas, 88 × 42 in., (249.9 × 106.7 cm), Nelson-Atkins Museum of Art, Kansas City, Missouri, Gift of the Enid and Crosby Kemper Foundation (plate 22).

tion inspired Eakins to make a grander, public representation in a larger portrait probably finished in 1906 (fig. 236; plate 22). Befitting his secondary authority in the diocese, Turner stands at the top of the steps leading into the Lady Chapel to the left of the main altar of the Cathedral of Saints Peter and Paul in Philadelphia. According to Goodrich, he was officiating at a funeral, although he stands very still, his hands clasped under his missal, with no hint of speech or gesture recently concluded or about to begin. Like Martinelli, Fedigan, and others in Eakins' series of ecclesiastical portraits, Turner simply seems to be posing, but—unlike the rest—he is obviously standing within a religious space.[47]

Eakins knew the cathedral well, for it had been under construction from 1846 to 1864, not far south of his home and only three blocks west of the Pennsylvania Academy. An eclectic design, taken from sources in Italian Renaissance and Baroque architecture, the church was dramatically unlike conventional Protestant churches in Philadelphia, with a cosmopolitan glamour that Eakins must have felt in another of Napoleon Le Brun's designs—the Gardel monument—well known to his family (see fig. 16).[48] When he returned from Europe the ambiance of the cathedral must have seemed even more familiar and attractive as a statement of "Catholic" continental taste, and he undertook his first clerical portrait—of Archbishop James Wood, in 1876—with the idea of portraying his subject standing at the high altar. Wood's illness curtailed the project, and he was ultimately shown seated in the bishop's throne within very vague and dark surroundings.[49] Thirty years later, with a sitter who was young, patient, and influential enough to grant an artist and his painting traps access to the cathedral, Eakins took up again the idea of painting within the church itself. In considering Turner's portrait he took full advantage of the decoration of the building and the qualities of mystery and drama inherent in Le Brun's plan.

Turner's position at the entrance to the Lady Chapel may be explained, as Goodrich suggests, by the occasion of a funeral ceremony, which need not—and usually would not—take place at the main altar. And from this position Eakins could take advantage of the fall of light from windows or doors in the north transept.[50] Farther back in the chapel

bust-length pose that emphasized his qualities as an intellectual. For many years associate editor of the *American Catholic Quarterly,* and then editor from 1898, Turner also took a hand in the administration of the Cathedral parish in Philadelphia, where he served as diocesan secretary to the archbishop. In May 1901, Father Turner was appointed chancellor, and two years later he was made vicar general, second in rank to Archbishop Ryan. By 1905, Turner had won the "title and privileges" of monsignor, and his promo-

there were no sources of natural light. Also important seems to be Turner's position beneath an image of the Virgin Mary, who appears to rise over his right shoulder. At Turner's knee the gate of the communion rail swings open to offer admittance to the Blessed Mother's Altar; in this position, the wrought initial "M" on the gate falls directly beneath the picture of Mary.[51] This emphatic conjunction may tell us something about Turner's religious disposition, better expressed by the image of the Virgin than by that of the crucified Christ, to be seen over the main altar nearby. Certainly Eakins, who made little observance of religion himself, constructed this juxtaposition to comment on Turner's sensibility, not his own. Eakins' care in transposing Mary's image is seen in the punched transfer grid for this section of the painting (cat. 219), which conveyed the slightly raked plane of the picture on to the finished canvas.

Eakins liked to fill the upper corner of his full-length portraits with significant imagery: the cardinal's shield seen in Martinelli's portrait, the Latin inscription considered for Fedigan's, the eye test chart used in Thomson's (see fig. 239). Typically placed in the upper left, the device functions to close off space and return attention to the surface while conveying important information about the sitter. But none of these devices were so large and assertive as this Assumption of the Virgin, nor so obviously religious. The importance of this image is underscored by its contrivance, too, as revealed by an examination of the plan of the Lady Chapel on the left side of the sheet of cat. 215 (fig. 237). This plan represents Turner as a large lozenge standing at the intersection of the visual axis and the fourteen-foot line. He is positioned between two square shapes—probably the posts of the communion rail—with his shoulders parallel to the step in front of him and his back to the chapel altar (marked "wall" on the drawing) some thirty-seven feet behind him to the right, well outside the space of the picture. The plan shows that these angles are geometrically tidy: the step below him runs exactly 30 degrees from the plane of the picture, or 60 degrees from the central visual axis. This axis—the viewer's line of sight—extends over Turner's shoulder to cross the chapel on a diagonal, seeking a distant and empty corner of the church, mysteriously lost in candlelight and shadow, 157 feet away. Such distant prospects are rare in Eakins' portraits, which usually—as in Martinelli's or Fedigan's portrait—do not offer much wandering room. Turner's portrait seeks an extreme of distance and obscurity, perhaps to establish the grandeur of the church as well as the reaches of Turner's intellectual and spiritual life.

The prospect into the chapel is interrupted on the left by the image of the Virgin, although inspection of the plan shows no wall, pier, or other architectural screen appearing at mid-chapel at the odd inclination suggested by the foreshortened frame of this picture. Today a much larger mosaic of the same subject is over the altar at Turner's back, but it is drawn differently and is too large to be this image. However, it is unlikely that any such picture was ever positioned in the center of the chapel at such an odd angle, almost parallel to Eakins' picture plane but unrelated to any architectural feature of the church. If Eakins contrived this arrangement, he did it both rationally and convincingly; the hypothetical placement of such a screen may be indicated by a slight pencil ruling diagonally across the twenty-seven-foot line, where a life-size image of Mary would be conveniently diminished to half-scale. Eakins' willingness to play with the space of the chapel in order to construct the desired juxtaposition of painting and priest underscores the significance of the image of Mary and reminds us, in one dramatic instance, of the manipulative "realism" of his method.[52]

Alerted by this fabrication, we can examine the rest of the background to discover that the right side is also mostly a fiction organized for pictorial rather than documentary purposes. Using the 1862 architect's plan of the church as a guide, it seems that a view of the chapel from this angle would be closed by the north wall of the church, running roughly parallel to the plane of the open gate and at right angles to the "wall" marked in Eakins' plan. However, the barred pattern midway up the canvas on the left cannot be explained in terms of such architecture, nor do these stripes conform to the perspective grid established by the floor and the horizon line. These marks make no descriptive sense; more efficiently, they can be explained as suggestions of dim forms that exist to defeat further exploration into space.

The crisp grid on the surface of the perspective drawing also allows us to anticipate the exact size of the final portrait: $7 \frac{1}{2} \times 3 \frac{1}{2}$ feet. The width of the picture then determines the cone of vision allowed between the framing edges, assuming a viewer fourteen feet away. On his plan, Eakins bracketed the wedge of space interrupted by Turner's figure alone (c. 8 degrees), the wider angle actually allowed by his three-and-a-half-foot wide picture frame (c. 14 degrees), and a third, more open vantage that would have entailed a much larger, square canvas (28 degrees, seven and a half feet wide). This widest angle of vision would have encompassed the corner post of the gate, but it might have introduced some distortion in the tile floor and allowed a distractingly broad view of the back of the chapel, including a corner of the altar. From the evidence of the oil sketch (see fig. 223), which probably preceded all these drawings, the 14-degree angle was close to Eakins' original intention. From the evidence of the plan and the many modifications to the actual background, Eakins also had no wish to give a wider, more explicit view of the chapel. Looking back to other portraits where we have calculated the cone of vision (Brinton, Martinelli), we can appreciate Eakins' negotiations between two-dimensional design and three-dimensional space: his viewing distance establishes the available realm of sight while the framing edges, principally responsible for design, also determine the final angle of the visual cone, and thus control the space as well.

After determining the plan and perspective, Eakins went on to map in detail the tiled floor of Turner's chapel. The

237. *Portrait of Monsignor James P. Turner: Perspective Study and*
Ground Plan, c. 1906 (cat. 215).

care invested in these full-scale drawings indicates that the prospect of these foot-square polychrome tiles, set at an angle to the picture plane, engrossed Eakins much as the parquet floor in Martinelli's portrait had done. One of these drawings (cat. 216) uses a shorter viewing distance (twelve feet) and a lower horizon (twenty-four inches) than seen in all the other drawings and the portrait itself. Evidently this was an experiment or a false start that reveals the presence of a certain amount of play in Eakins' system, even after the figure had been painted. He probably returned to his original, slightly longer viewing distance and slightly higher vantage point in order to increase the legibility of this floor grid,

which, from a lower station, rushes into space too quickly to give an adequate sense of recession.

The other two drawings of the floor, cats. 217 and 218 (fig. 238), are both punched with holes, indicating their use to transfer the floor pattern onto a canvas of the same scale. Black and red, or brown and red wash are used to define the two patterns in the floor in these two drawings. The tiles are more complexly rendered in three tones in cat. 217, which devotes careful attention to the immediate foreground and the left side of the floor; the more distant floor on the right side of the picture especially occupied Eakins in cat. 218. It is not clear why he needed two separate drawings for these two halves of the floor, unless he was experimenting to see which of these two different coloristic patterns looked best from his low eye level. Ultimately, he chose the simpler pattern (cat. 217), with a design so widely spaced that the repeats in the floor are difficult to follow without effort. Again, as in the Martinelli portrait, he did not want to make this pattern too assertive or too interesting—merely credible. Neither plan represents the floor of the chapel as it appears today, nor as it appears in Le Brun's plan, but the many renovations in the church since 1906 may have included replacing the floor. We cannot speculate, then, about the "reality" of the floor, although the presence of two rival designs in his drawings suggests that he organized the tiles, like Martinelli's parquet and like the rest of the chapel, to suit his own purposes and for his own private pleasure.

This tile floor was clearly well considered, and its importance may be underscored by the artist's unwillingness to lay his characteristic perspective signatures across the pattern. In fact, the picture is nowhere signed or dated—uncommon in Eakins' work, particularly in a picture of this size that we know was exhibited immediately.[53] Perhaps, in deference to Turner and the sanctity of the cathedral, he vested his "signature" in the complexity of the perspective scheme and the evocation of a seemingly "real," totally artful space.

Eakins apparently gave Turner's portrait to his family and Fedigan's to Villanova. He likewise donated Martinelli's portrait to the Catholic University of America, in Washington, D.C., although he borrowed it back to exhibit five times between 1902 and 1904—more than any other portrait from this series. Four of these "priestly portraits" were shown at the Pennsylvania Academy's annual in the early spring of 1903, when Eakins' entire series was praised as "a collective work of inestimable historic and artistic value," and Martinelli's picture was singled out for special commendation. "There is a quiet poise about this portrait which makes it a noticeable canvas wherever it is hung," commented the art critic of the *Inquirer.* "It is forceful and dignified, and at the Academy exhibition, surrounded by somewhat more trivial productions, it becomes one of the commanding features of the collection." Another reviewer, writing for the Philadelphia *Record,* commented on the brilliant contrast of red and black in the painting, and the striking depiction of character: "His sharp intelligent face is painted with force and directness and the whole canvas is an artistic document of great value." To this writer, and to many later admirers of Eakins' work, this effect seemed to be based on ingenuousness:

"There is no trickery about this portrait, nor has the artist paid much attention to composition, but painted his subject in the most direct manner possible."[54]

The same might be said of the other clerical portraits, and Eakins probably smiled to know that his preparations accomplished such a sense of naturalness, for we can see that his drawings show considerable attention to composition, and contrivance of a very complicated order. Like an athlete in peak form, he seems to have pleased himself in the covert exercise of his skills. There must have been a deep sense of satisfaction and pride in his own accomplishment, even if it was appreciated by himself alone. Eakins was not a religious man, but if he had a god, this deity existed in such details, in such professional conscientiousness; his god understood the reverence expressed in that parquet floor. For although he was proud, Eakins was also humble in the suppression of his skills to serve the larger purposes of his paintings. A "forceful and dignified" effect, apparently accomplished without artifice, shows respect for a distinguished sitter, and for the art of portraiture.

A LAST PORTRAIT: DR. WILLIAM THOMSON

Eakins finished his last full-length portrait, of Dr. William Thomson, in 1907 (fig. 239). He would not complete another canvas of this size again. True to his religion, he turned from priests back to men of science: half of his male sitters after 1906 were doctors. Eakins must have been comfortable with these people, and especially Dr. Thomson, who was another innovator from the circle of Jefferson Medical College. His gravitation toward these medical men, and his treatment of them pictorially, helps one grasp Eakins' sense of self and place in the world at the age of sixty-three, as his career drew to a close.

William Thomson (1833–1907) was a colleague of Dr. Samuel Gross and likewise a leader in his field, a medical specialist at the time when specialties were just emerging within the structure of medicine as a whole. The doctor's proclivity for experimentation and his mixture of theoretical knowledge and everyday practice were characteristics shared by many of Eakins' sitters, and by Eakins himself. Thomson's special expertise was based on the eye, and his research into the physical limits of visual perception overlapped Eakins' own interest in photography, optics, and perspective. He developed a systematic testing procedure for color-perception in train engineers based on swatches of brightly dyed woolens viewed from varying distances, and was an early advocate of the ophthalmoscope, the now-familiar diagnostic device that Eakins has carefully placed in the right hand of the doctor in the finished portrait.

During the Civil War, Thomson had distinguished himself by creating an advanced system of medical logistics that was adopted throughout the Union armies. He also established a photographic division within the Army Medical Museum, which ultimately grew into the Medical Illustration Service of the Armed Forces Institute of Pathology. It was Thomson's belief in photography's value to medical learning and research that led him to a study of optics and then on to ophthalmology—the study of the eye itself. The conjuncture of Thomson's practical mind, his theoretical work in visual perception, and his fervent belief in the value of the camera must have made the portrait sessions with Eakins a fascinating meeting of like minds.[55]

The construction of Thomson's image comes to life in the series of six drawings (cats. 220–225) that comprise the largest extant suite of related drawings for an Eakins portrait. From the perspective drawing (fig. 240) we can estimate that Eakins' viewpoint was forty-eight inches above the floor. Evidently he was seated while painting Thomson, whose eye level is several inches below the artist's because of his shorter height and slightly slumping posture.[56] Thomson's chair straddles a line twelve feet from Eakins, at the point where all measurements on the canvas are at the scale of life. The foreground of the painting begins about nine and a half feet from the artist. Thomson's left foot, outlined as a footprint on both drawings, rests on the floor about ten feet distant. Against the far wall, sixteen feet away, stands a vertical cabinet carrying an eye test chart. Thomson leans on a table at his left that recedes three and a half feet into space behind him, bearing books and a small lamp or scientific instrument.

The portrait concluded from these drawings was not the first one of Thomson that Eakins attempted. Prior to completing this oil Eakins had painted him on a slightly shorter canvas, in the identical pose (fig. 241). Evidently Eakins was unhappy with this portrait, for he began again on a new canvas six inches taller. In the second version Thomson sits in almost the same place relative to the sides and bottom of the canvas; the additional space gained from the new canvas is mostly overhead. This new height gave more breathing room to the sitter and more room for the eye test chart at the upper left. Because the first version was abandoned before its background details were completed, superficial changes in the second version are few: most notably, the table at the doctor's left has been given a curving edge rather than a squared corner. More fundamental, however, was a slight rise in the horizon line, which seems to have been originally at Thomson's eye level. This change of about three inches explains why the first version couldn't easily be salvaged just by attaching an additional strip of canvas to the top of the picture: Eakins wanted a new canvas because his new viewpoint affected every aspect of the sitter and his space, requiring the complete repainting of the image. The new viewpoint gave a slightly steeper angle of recession to the table, which Eakins masked by trimming back the table edge into a curve—an evasive action analogous to turning the floor grid in the Martinelli and Turner portraits at an angle to the picture plane. He gained, by his addition of three inches of viewing height and six inches of canvas, a longer reach up the back wall of the room to allow hanging the top edge of the eye test chart

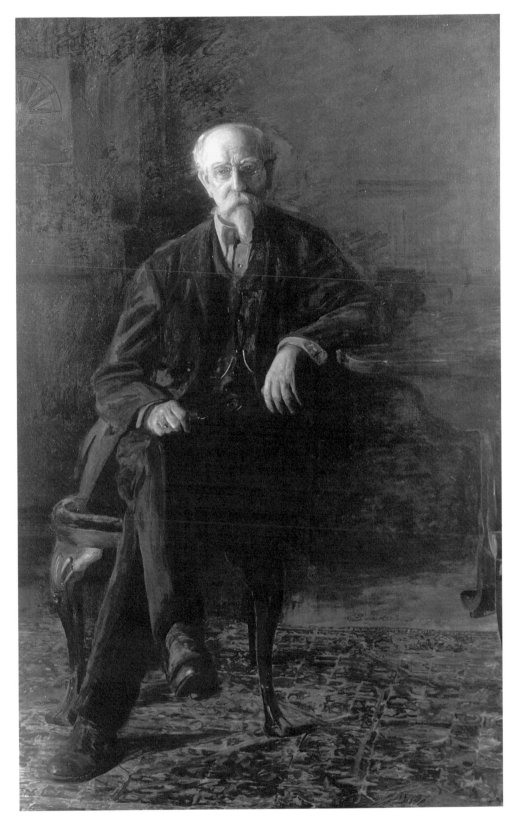

239. *Dr. William Thomson*, 1907, oil on canvas, 73½ × 47½ in., College of Physicians of Philadelphia.

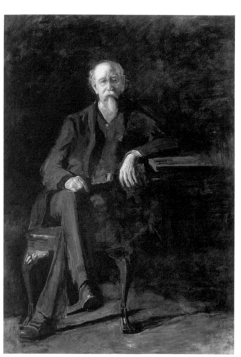

240. *Portrait of Dr. William Thomson: Perspective Study*, c. 1907 (cat. 220).

241. *Portrait of Dr. William Thomson*, c. 1907, oil on canvas, 68 × 48½ in., Hirschl and Adler Galleries.

where it would most likely be installed in Thomson's office: sixty inches above the floor, at "standard" eye level. This placement could not have been effected on the shorter canvas without cropping the chart.[57]

The test card that Eakins worked so hard to include poses its own set of problems, for it is a hybrid object that has not been found in ophthalmic instrument catalogues of this period. Gretchen Worden, director of the Mutter Museum of the College of Physicians of Philadelphia, where Thomson's portrait now hangs, has noticed two oddities in this chart. The upper section, curved and numbered like a clock face, is a typical astigmatic test chart except for the inclusion of single lines between the triple bars that radiate to each numeral (fig. 242). Because astigmatism is measured by the inability to articulate clustered lines, the lone lines serve no purpose other than decoration, which would be inappropriate in a clinical test of this sort. It is surprising to imagine that Eakins, with his own study of camera lenses, misunderstood the purposes of the chart. Also puzzling is the unorthodox combination of this chart with the Snellen visual acuity test below it. The configuration of this lower section, with its diminishing rows of letters, is familiar, but its pairing with half of an astigmatic test chart is unusual. Eakins may have found and copied just such an object, but its odd form suggests that he artistically conflated the two charts into his own efficient new form, neatly circumscribed by the completed lower perimeter of the clock face. The care with which Eakins depicted Thomson's ophthalmoscope, and the trouble that he took to include this chart, encourages us to imagine that there is meaning in this odd test card that awaits further study.[58]

While receiving this chart with ease, the new and larger canvas also gave Eakins the opportunity to refine his delicately asymmetrical composition. The first version must have seemed unbalanced, for he shifted Thomson's head just slightly to the center of the new canvas, bringing the edge of the doctor's left eye (instead of his ear) alongside the vertical axis of the painting, in line with the leg of his Chippendale chair. In this new organization, his left thumb just grazes this same perpendicular, while the index finger of the same hand touches the axis that divides the painting in half horizontally.

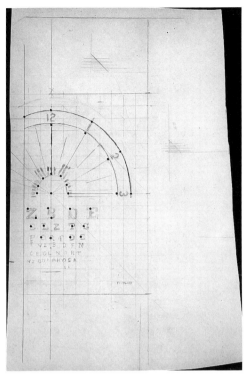

242. *Portrait of Dr. William Thomson: Transfer Pattern for the Eye Chart*, c. 1907 (cat. 224).

In the first version, this horizontal mid-line cut meaninglessly through Thomson's knee; in the second version, with its higher horizon line and taller canvas, the horizontal and vertical midpoint of Eakins' picture now lies emphatically along the line of both hands and the ophthalmoscope that identifies his sitter's expertise. The resulting composition is daringly balanced, considering that the sitter's chair and all of his body except his left arm rest on the left side of the canvas, while the right is principally filled by shadowy space and Oriental carpet. Thomson leans into this space with unquestioning confidence, resting his arm on a table-top cantilevered out from a base made dangerously slender by its extreme foreshortening and cropping. The unexpected tunnel of space beneath this table leads nowhere except to the artist's signature, inscribed in elegant penmanship on the floor. The visual interest and strong sense of movement in space evoked by Thomson's surroundings and his pose, with its projecting crossed leg and many opposed diagonals, adds liveliness to our consideration of the sitter, whose wise, slightly worried look of concern carries the same mixture of calm dignity and restless curiosity felt throughout the painting.[59]

Eakins' abandonment of his first version at a relatively completed state tells us much about his method and his standards at the end of his career. First, the revisions in Thomson's portrait underscore the importance of background artifacts and mise-en-scène to Eakins' work. We can be sure that, having gone to so much trouble to include this eye chart, Eakins felt its presence was extremely significant to both the design and the meaning of his picture. Such effort teaches us to look carefully at the environment of all Eakins' sitters.

The second insight gained from this pair of portraits involves the use and the timing of his drawings. The additional six inches in height and the change in the tabletop seen in the second version make it possible to tie most of the extant drawings (save the ambiguous cat. 225) to the final portrait. Only the plan, cat. 221, could have been used and altered to fit both versions. Maybe Eakins made another set of drawings for the first portrait and none have survived. More likely, all of these extant drawings represent a phase of planning that Eakins had only just begun when he abandoned the first version. Issues of proportion or placement must have been resolved early, in oil sketches or perspective drawings, because problems in these areas would have been apparent soon after he began to work on the figure. Evidently content, he pressed on, bringing the painting to a point where the more distant, peripheral details needed resolution and integration. At this time he returned to his drawing board to consider the exact placement of background furniture and details, still somewhat loosely held in his imagination. Arriving at this moment of planning for the Thomson portrait, Eakins suddenly realized that the eye chart wouldn't fit. His fondness for this kind of emblem in the upper corners of his portraits suggests that he always intended to include it but had made only vague plans to do so. From the problems in the Thomson portrait, added to the evidence of Borie's interrupted image, we might generalize that most of Eakins' full-size perspective studies were done midway through the painting process, not prepared in advance. While this realization in no way diminishes the power of Eakins' preliminary conceptualization and its grip on the painting as it progressed, it does soften the image conveyed by his dauntingly precise perspective drawings. Not everything was obsessively planned; sometimes even Eakins was surprised.

Finally, and most dramatically, comes a revelation of fastidiousness that required a fresh canvas. This kind of revision did not happen often.[60] Usually fixed in his predetermined sense of the final image, Eakins rarely made important changes in pose or format once he was on the final canvas or watercolor sheet. The dissatisfaction he felt when faced with his first, half-finished *Thomson* was unusual, and he responded by starting all over. He was willing to add patches to his drawings, as in cat. 223, but evidently a seamed and scraped-out *canvas* would simply not do. Still, after thirty-five years of painting portraits, Eakins was not improvising or working intuitively, and certainly he was not cutting corners, even if few could appreciate the necessity of his alterations or the improvement gained. The portrait was not a commission (evidently Eakins gave it to the sitter), so he knew no external pressure of time or cost. With only himself to please, he insisted on getting things right. Such "rightness" had both moral and aesthetic value; like a medieval carver finishing the back of a niche sculpture because God

will notice, Eakins prepared his painting to meet the scrutiny of science.

The two Thomson portraits remind us of Eakins' liberty as well as his discipline, and they also expose a vigilant self-criticism not easily documented in finished works. Perhaps all of his art was subject to such testing. Probably he was especially demanding on this occasion because of the sitter. Thomson, of all people, *would* recognize an error in the placement of the test card; surely he and Eakins talked the situation over as new posing sessions became necessary. Thomson's participation may also bear on Eakins' small changes in the vertical axis, the eye level, and the framing edges, and his choice of a viewing distance shared by none of the portraits we have thus far studied: again, Eakins has constructed a technical fingerprint for this portrait. Seeking individuality within a restricted system, he negotiated a unique network of decisions that identifies this portrait as both *Thomson* and *Eakins*. His fastidious standards express professional integrity as well as respect for Thomson, who finds his expertise matched by an equivalent mastery in the "science" of painting.

Thomson's portrait was probably nearing completion by mid-December 1906, when Eakins received a flattering solicitation from the Pennsylvania Academy's new secretary and managing director, John E. D. Trask. The medals awarded to Eakins at three World's Fairs between 1900 and 1904 (see cats. 270–274) had restored him to respectability, and one of his clerical portraits, *Archbishop Elder* (Cincinnati Art Museum), had won the Academy's own Temple Gold Medal in 1904. Younger artists began to vote him on to the juries of major exhibitions, and he was much sought after to judge the Academy's annual. "In view of your Paris medal it is more than ordinarily urgent to take your allotted part in the big movements of American art," begged the previous managing director, Harrison Morris, in 1900.[61] Now hors concours for the juried portion of the show, he could send in whatever he wished. "My dear Mr. Eakins," wrote Trask in 1906, "what are you going to do for our Annual Show? The time for making up our collection lists is now at hand, and, of course, we want you represented by your latest and best work. I have been hoping to get a chance to get up and see you but after all, it would be very presuming of me to suppose that my judgement about your pictures be just as good as your own. Will you not, therefore, fill out and return the enclosed entry cards for two works of your own selection? These, of course, are especially invited and do not go to the jury. We hope therefore, that you will pick out your very best."[62]

The mixed tone of this letter—half fawning and half condescending—may not have eased Eakins' doubts about the Academy's sincerity. "You've got a heap of impudence to give me a medal," he said upon receiving the Temple Prize in 1904.[63] Nonetheless, he sent his latest and best to the 1907 annual: *Portrait of a Clergyman* (James P. Turner, possibly fig. 236), and *Dr. William Thomson*.

In the many reviews of this exhibition saved in the Academy's scrapbook of clippings from this period, no mention is made of either painting. Belatedly honored, he was now ignored. Although he continued to exhibit regularly until 1913, the "big movements in American art" had long since moved on. To younger painters like Robert Henri, who were inventing their own American genealogy, Eakins was already history. By 1907 a new painting had risen that found no use for academic modeling or linear perspective, no meaning in realism. Like Thomson, who would die not long after his portrait was completed, Eakins' tradition was feeble, and his artistic company—never large, even in 1870—was tottering. Was Eakins bitter and lonely? Perhaps bitter, but not abandoned. Correspondence, diaries, and photographs show that the attentions of family and students, and a succession of projects, kept him occupied in the last decade of his life. And the Thomson portrait, like the other late images of thinkers, reminds us that Eakins, in his artistic backwater, was surrounded by inspiring colleagues, none of them painters. Apart from his students, he had only passing friendships with other artists after 1900. Notwithstanding cordial letters or portraits exchanged with Sargent or Chase, he preferred the company of Brinton, Culin, Turner, or Thomson. We can imagine this fraternity in the sparkle in Thomson's eye, telling us of a youthful curiosity and mature intelligence within an old man's body. The same spirit gleams within the aging tradition of Eakins' portraiture. Confronting Thomson, who, as Sylvan Schendler has remarked, looks out at us with the directness of an examining physician, Eakins must have considered his own mortality. In this moment, he chose to reaffirm his pictorial convictions. Confidently leaning out into the darkness beyond them, these two old men talked comfortably together of science.

Conclusion

ARTIST AND TEACHER: THE MEANING OF ACADEMIC REALISM

Charles Bregler's Thomas Eakins Collection is about learning to be an artist, making art, and teaching others to be artists, all in the mode of mid-nineteenth-century realism. Eakins expressed his principles and personality with relentless consistency in all these areas, enacting in his teaching an especially clear illustration of his mind and method. "It is a pleasure to teach what you know to those who want to learn," he wrote in 1874, responding to an invitation that led to his first job: voluntary critiques given to the members of the Philadelphia Sketch Club's new life class.[1] This enthusiasm can be read in the many objects found in his studio—drawings, photographs, plaster casts—that were made for his students at the Pennsylvania Academy, where he taught from 1876 to 1886, or at the Philadelphia Art Students' League, from 1886 to about 1893. Between 1881 and 1899 he used this same material to lecture to students at six other art schools, from Brooklyn to Washington, D.C.[2] Eakins' didactic purpose determined the style and appearance of these objects, for his strongly rational, functional approach necessarily produced a "voice" pitched expressly to a student audience. As we have seen in his anatomical drawings (fig. 243) and casts, the illustrations to his drawing manual, and the "Naked Series" photographs, a "scientific" style was adopted in these works, spare and abstract in the drawings and casts, standardized for maximum neutrality in the photographs. This style was undertaken for its plainness and clarity, for its businesslike directness. The blunt, descriptive record of "fact" in the photos, or the diagrammatic quality of the drawings and casts, both signal seriousness and cool detachment, the proper mood of art study. There is no fun, no wandering, no inflamed inspiration or "art" in these artifacts, just earnest work, understood as necessary to the training of an artist in Eakins' realist mold.

The focus of such study was the human figure, accepted in the western tradition as the centerpiece of creation and therefore the most significant topic for artists. This premise, underlying all art academies in the European mold since the invention of such institutions in the Renaissance, was accepted by Eakins without reservation and enforced with an almost brutal conviction. He organized the instruction at the Pennsylvania Academy to follow, as Susan Eakins said, the practices of "the important schools in Paris."[3] Life class, dedicated to painting the nude, formed the center of the curriculum. Anatomical study, through lecture-demonstrations and dissection, taught students the structure and mechanics of the body that affected the appearance of the skin and conditioned posture and movement. Modeling in clay developed the sense of three-dimensional form and weight-bearing structure. Perspective systems guided the correct placement of figures in an illusionistic space. All these lines of study presumed that descriptive figure subjects, based on the careful observation of real people and their environment, were the mission of the professional artist.[4]

Eakins' study at the Ecole des Beaux-Arts had followed this path; his system in Philadelphia varied mostly in the in-

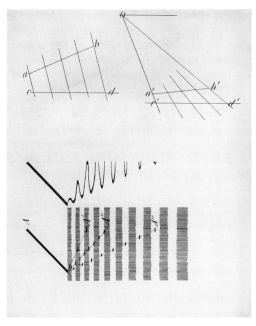

243. *Drawing A4 [Diagram Illustrating Laws of Reflection in Water],* c. 1884 (cat. 128).

tensity of his emphasis on naturalism and plasticity and on the level of his personal involvement in all aspects of the school, which was much smaller than the Ecole. Although his reserved and dignified manner during the twice-weekly classroom critiques followed the practice of Gérôme, Eakins had a much higher profile at the Pennsylvania Academy than any single professor at the Ecole, which was run by a large administrative staff, several faculty members, and student *massiers* (proctors) in every atelier. With his hands on all the classes, Eakins imposed his personal prejudices throughout, particularly in his emphasis on anatomical study, which offered a level of detail usually available only to medical students, and his devotion to perspective, as the foundation of correct spatial construction.[5] Complementing the rational, scientific mood in these studies, Eakins enlisted the camera to compile a dossier of human figure types for comparative study and to record the body in motion.[6] By bringing the camera and the dissection room into the school building, and by insisting on clay modeling sessions for all, Eakins went beyond the practices at the Ecole; characteristically, these innovations were at the service of his brand of "scientific" realism.[7]

The emphases in Eakins' curriculum reveal his sense of what institutional art training could do, and what it could not or should not attempt. He bore down on the components that he felt were the most critical aspects of an artist's education, the most difficult, and the most appropriate to a school. Students could not be expected to master figure subjects without access to nude models and dissection subjects, both of which were expensive or rarely available for private study. Progress would be slow without classroom exchange. Perspective or anatomy might be learned from a book, but it could be taught more efficiently and effectively in lectures designed for their usefulness to artists. For the rest, students were deliberately left on their own. Once set in the "right direction" they were forced to think for themselves, "this having the tendency to strengthen and make the serious student more self-reliant and discourage the frivolous."[8] Dissatisfaction with this policy inspired Fairman Rogers to note in the Academy's descriptive brochure of 1881 the "objection that the school does not sufficiently teach the students picture-making." But "it is hardly within the province of the school to do so," he responded. Picture making "is better learned outside, in private studios, in the fields, from nature, by reading, from a careful study of other pictures, of engravings, of art exhibitions, and in the library, the print room and the exhibitions in the galleries, all freely open to the student; the Academy does as much as it can in this direction."[9] Occasional lecturers spoke to the students on aesthetic issues, but there were no formal classes in art history or theory. Pupils were expected to form their own ideas from other art and from interaction with the world around them; the selection, composition, or treatment of subjects was not deemed teachable. The Ecole des Beaux-Arts offered a richer array of supplementary lectures—on historical costume, or Hippolyte Taine on aesthetics—but the basic philosophy was the same.

Apart from the emphasis given certain aspects of his Ecole experience, Eakins also made several telling omissions, most notably diminishing the time students spent drawing from casts. Very quickly, most were promoted to painting in the life class. His opinion of drawing, read clearly in his own work, carried over into his instruction, but could not overturn a centuries-old tradition. Conceding to conventional practice, he undercut it with words of caution. "Make sketches with charcoal or pencil, the more you do the better," he encouraged his students, then adding that "it won't do you any harm as long as you think of the third dimension."[10] Fearing the harm lurking in the flatness and abstraction of drawing, Eakins reduced its role in the school and enlarged the role of its antidote: clay modeling.

Eakins' reaction to the miserable moments of his own training also inspired him to delete the high-pressure, high-stakes competitions that determined enrollment and class position at the Ecole and eventually built up to the Prix-de-Rome. These competitions suited neither his talent nor his temperament, and he criticized them as educationally useless, distracting, and demoralizing. He could not prevent exhibition prizes for students from proliferating in this period—his own wife won two, and the directors obviously thought they enhanced enrollment—but he disallowed all internal contests as well as the imaginative compositional exercises that crowned the sketch competition at the Ecole.

The rigor of this program discouraged dilettantes, and its narrow focus frustrated those who sought training that might usefully be applied to employment in design or illustration. Such students were advised to look elsewhere. Eakins' curriculum was devoted to the training of professional painters and sculptors. More dangerous complaints could be found within the corps of senior students, where serious and ambitious young artists such as Thomas Anshutz chafed under the restrictiveness of Eakins' regime. These students were interested in landscape, in spontaneous sketching, in "minor" media, in new ideas of impressionism, in the romanticism of the Aesthetic Movement, and in the revival of "poetic" and subjective content.[11] Eakins' Arcadian work shows that he was not immune to this sensibility, but he was not prepared to teach any of these topics in his school, and a certain component of the student body, as well as a board of directors concerned about tuition revenues, gradually formed an alliance against him. His vision of art training was an intense, progressive version of French academic practice in the mid-1860s. Already questionable to many Americans because of its emphasis on nude study, this outlook was outmoded among younger American artists after about 1880, and Eakins' rigidity doomed him to conflict.[12]

The incident that finally inspired the Academy's board to call for his resignation in 1886 has made Eakins a hero to artists and art educators, and a martyr to the forces of Victorian prudery and censorship. By removing the loincloth from a male model in the course of a lecture to an audience of women students (or men and women), Eakins asserted the

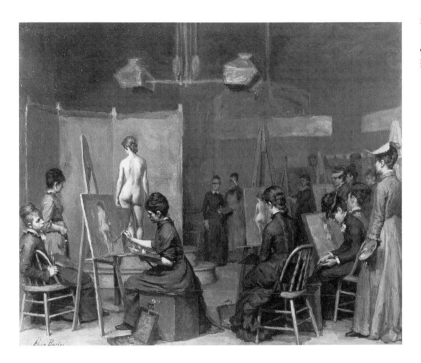

244. Alice Barber Stephens, *The Women's Life Class*, c. 1879, oil grisaille on cardboard, 12 × 14 in., PAFA, Gift of the artist.

necessity for figure study untrammeled by popular morality. In so doing, he expressly overrode the board's policy, laying himself open to charges of insubordination. Previous patterns of obstinacy did not help his case, and the personal resentment of certain students and ex-students, including his own brother-in-law, brought other grievances into play. Newfound manuscripts in the Bregler collection indicate that the loincloth incident simply provided a clear-cut instance of behavior that had provoked the directors and rankled students in the past, offering an occasion for "change in the management of the Schools."[13] However, behind the charges of insubordination teemed a crowd of less explicit allegations pertaining to Eakins' "immoral" use of students as models and his generally coarse behavior, said to range from telling off-color jokes to having incestuous relations with his sister Margaret. All of these rumors spiraled around the topic of nudity, brought forth by Eakins' insistence on featuring nude study at the school (fig. 244) and in his own work, most recently in *Swimming* (see fig. 181), a painting obviously based on student models. The idea of master and pupils consorting together nude, either in private or in a publicly exhibited painting, made Edward Coates uncomfortable enough to exchange *Swimming*, which he had commissioned, for a less controversial image, *The Pathetic Song*. Even less acceptable were tales of women students posing nude for their teacher or for each other, and stories that Eakins had undressed in front of at least one of them, Amelia Van Buren. Eakins argued that these were private, professional moments between consenting adults, and that the Academy's directors had no jurisdiction over the private practices of a figure painter, conducted in his own home or studio. Nonetheless, his reputation was ruined. Whatever his defense, the directors had to

conclude that he was lacking the sound judgment and moral rectitude needed to head a school attended by many young women. At best indiscreet, inflexible, and insensitive to conventional proprieties, at worst deceptive, arrogant, and provocative, Eakins was not well suited to management or to life in the public eye, particularly at the high-water moment of repressive Victorian manners.

To Eakins' credit, most of his men students marched out of the Academy in protest. Led by George Reynolds, they formed the Art Students' League, where Eakins was immediately invited to teach. There, in a self-selected, bohemian, mostly male context, he was spared the "impertinent interference of the ignorant" and enjoyed both the respect and the camaraderie of teaching. He continued lecturing on anatomy and perspective at various art schools for another decade, until a fresh round of scandals relating to his use of nude models demonstrated yet again his difficulties with women students. Never prepared for the hostility of his critics or the sexual confusion of his pupils, while intentionally provoking reactions at every turn, Eakins gradually withdrew into smaller and more private circles.[14]

The confinement and eventual abandonment of his teaching must have been depressing for Eakins, who evidently cared deeply about it. The objects in the Bregler collection hint at the amount of time he spent in the dissection room, in preparing lectures, and in supervising teaching-related photography. Meanwhile, the record of his painting shows a sharp reduction in output with every promotion at the Academy. W. H. Brownell's interview with Eakins in 1879, not long after his rise to the rank of professor, makes evident the satisfaction he derived from taking charge of the school and shaping the curriculum in his own image. He

must have liked to imagine himself as the peer of his masters at the Ecole, bringing the sophistication and professionalism of Paris to students in Philadelphia. To an extent, he did, but his program bore the marks of Eakins' artistic personality; like his own version of academic method, his teaching was based on conventions pressed to an idiosyncratic extreme. The perfect parallelism between his teaching and his art reiterates his identity as a radical academic realist and maverick, for in comparing his work in the Bregler collection to his teaching program, the same large conventions and small idiosyncrasies appear. This redundant pattern helps us understand Eakins as an academic, and a rather odd one.

The large pattern is one of homage to the European figure-painting tradition. Eakins clearly saw himself treading in the footsteps of Velázquez, and he adopted the medium, the subjects, the scale, the palette, and the realist style of such heroes of the Baroque period. He was not alone in this taste, for many others in this century of bourgeois materialism had also rediscovered the realist art of another moment of middle-class, down-to-earth energy in seventeenth-century Holland, Italy, and Spain. But beyond this fashion for old masters appropriate to the age, the academic in Eakins aligned himself with an ancestry of heroic figure artists leading back to the Renaissance and Periclean Athens. Respect for this tradition, and willingness to learn from its precedents, imitate its techniques, and even quote its forms, all mark an academic, and these attitudes were ingrained in Thomas Eakins. In this respect he was, like every academic, a traditionalist, and fundamentally conservative.

The peril of academic art, in any culture, lies in formulas and conventions that gradually lose vitality and meaning through spiritless repetition. To this threat, alive in the insipid salon painting he encountered in Paris, Eakins answered with a kind of born-again academicism, a mission to find the spirit of the old masters again in contemporary subjects. As a fundamentalist, Eakins accepted the hierarchy of media (painting and sculpture), and subjects (figures) absolutely; as a realist reformer, he turned to the world around him for models and subjects and enlisted the improved tools (the camera) and accrued knowledge of his century to improve upon the methods of the past. Again, Eakins was hardly alone in his reaction. The realists of the 1850s had already made an ideology out of the modern, the observed, taking a position that was not so much anti-academic (in the broader sense) as anti-official, anti-conventional. Courbet and his colleagues, attempting to see "innocently" and compose in a self-consciously naive fashion, had already established the path of naturalism.[15] Like Courbet, Eakins dallied with history and literature before devoting himself exclusively to modern subjects; like Courbet and Manet, he sought popular approval and could never understand why his work was not well received. Always identifying himself with the professional mainstream, Eakins did not align himself with the "independents" and never mentioned their work in his letters home. Instead, he sided with Gérôme and especially Bonnat, whose grisly depictions of saints and martyrs in the 1860s attempted reform within the academic tradition, by returning to the examples of the Spanish Baroque and reinventing them with a brutal nineteenth-century detail. Returning to Philadelphia, Eakins launched a career, and a school, bent on similar principles.

Falling in line with a radical academic like Bonnat, and tangentially related to Courbet, Eakins assumed a marginal position in relation to the academic mainstream, although he probably saw himself as defending the most sacred precincts of the tradition. He again parted company from the academic majority, represented by Gérôme, in his development of a method to enact his principles. Most extraordinary was his suppression of the role of drawing. As we have seen, this reluctance to draw may have been a condemnation of his own dreary training, or an affirmation of painting as a superior realm, but in either event there is a remarkable absence in his work of the loving drawings that typically filled the notebooks and portfolios of the artists he admired, such as Gérôme, Couture, and Millet. The meaning of this rejection seems to be entirely in the personal sphere, since it is so much at odds with conventional practice. We can look to the plain, hard-working functionalism of the American Protestant aesthetic or, more likely, to the circumstances of Eakins' family and his personality. Edwin Austin Abbey, seven years younger and also from Quaker, lower-middle-class Philadelphia—and also the patient captive of the Pennsylvania Academy's cast drawing classes—rose to academic celebrity, bearing almost nothing of Eakins' drawing aesthetic.

Drawings also represent the other cardinal quality of an academic: study and preparation. Disliking drawing, or rigidly directing it to certain specific tasks, Eakins made up in other ways the craftsmanly ritual of preparation, turning to clay models, oil studies, and photographs for assistance. In his complex, premeditated method lies the second, deeply academic component of his art, for the dedication to craft—expressed, for example, in an immaculately planned perspective scheme—and the willingness to prepare thoroughly and methodically are traits that Eakins shared with many of his contemporaries with similar training. Often these artists were even more elaborate in their ways than Eakins, who, by impatiently eliminating figure drawing and reducing his oil sketches and studies to a minimum, condensed the phases of sketch, study, and cartoon that others, such as Abbey, Albert Moore (see fig. 200), Frederic Leighton (see fig. 199), or Kenyon Cox clearly enjoyed and extended. Eakins, by comparison, was economical and purposeful in his expenditure of energy, driving directly to his final canvas without wasting time on the objects produced during study. However, he must have spent as much time in preparation as any of his colleagues—if not more—making a show of effort that impressed all witnesses. His boyhood friend and brother-in-law William J. Crowell sent his daughters, Ella and Maggie, to study painting with their uncle Tom in 1890, expressing "small hope indeed that any of our children will ever attain a

mastery of an art requiring such patience, skill and industry."[16]

Such a display of hard work signaled seriousness of purpose as well as the deeper satisfaction that Eakins won from his labors. Denying luxury in the artifacts of preparation, Eakins' pleasure was buried deeper, in the realm of research and knowledge for its own sake, and in the confidence and authority that such knowledge could bring. His friend William Sartain remembered that Eakins was "as interested in study as in producing pictures."[17] Certainly the satisfaction of research and discovery led him into byways of motion photography and anatomy that had little direct bearing on his art. Taken by surprise by Eakins' manner when she met him in 1881, Mariana Griswold Van Rensselaer remarked that he looked like a "clever but most eccentric looking mechanic . . . more like an inventor working ou[t] curious & interesting problems for himself than like an average artist."[18]

Perhaps because he was so easily lured into research and teaching, Eakins applied himself efficiently when the task of picture-making was at hand. All of his surviving studio work can be defended as serious study (such as anatomy) or as directly related to a specific project. Looking back on the work in the Bregler collection, it is remarkable how few variant or trial solutions emerge; either Eakins single-mindedly saved only the artifacts that point to a later accomplishment or he undertook work with an already fixed notion of the finished product. The absence of a sense of exploration, much less wandering, tells us much about Eakins' creative habits; evidently he did not invent spontaneously nor grope toward a desired effect, but instead launched his preparations with a very clear vision of the intended result. The study procedures then become a question of technical competence, information, and observation: Do I know enough about early nineteenth-century costumes? About the anatomy of a figure in this position? About the scale of a figure seen from this distance? Answered one by one, these problems simplified and supported the execution of the most difficult part, the actual painting.

The strategy of divide and conquer, by which the problems in a painting or sculpture were broken down into their smallest components, separately solved, and then reintegrated into a grand solution, characterizes the mechanics of Eakins' academic method. Rational and analytical rather than intuitive or generalizing, this step-by-step method respects traditional wisdom as well as the modern, scientific outlook that Eakins brought to his work. "All the sciences are done in a simple way," he told Bregler. "In mathematics the complicated things are reduced to simple things. So it is in painting. You reduce the whole thing to simple factors. You establish these, then work out from them, pushing them toward one another."[19] In making his work as "scientific" as possible, and anchoring the "simple factors," he kept guesswork and ambiguity to the interstices. Careful procedures built confidence in the outcome and gave the mathematician's pleasure in the construction of a correctly interrelated

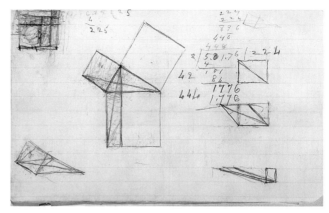

245. *Geometric Shapes and Arithmetical Notations*, c. 1876–78 (cat. 189l, verso).

whole. The beauty of mathematical proof or of geometrical predictability has appealed to many artists; sometimes such certainties have been used to link visual art with universal order, or with the life of the mind, as opposed to the merely material. Eakins clearly believed in a common ground shared by science and art, a faith held by other humanists since the Renaissance. He was extreme, however, in his sense that a revealed truth could justify itself as art, and in the fiercely rational compartmentalization of effort visible in his preparation. All of these traits, characteristically exaggerated out of standard academic method in the direction of naturalism, account for much of the singularity of Eakins' work and the abrasive or uneasy effect of his art on viewers in his lifetime and today.

The fragmentation of Eakins' method descends from the parts-before-whole instruction of his youth; some of it may also be owed to a craftsmanly principle of efficiency. Like the good carpenter that he was, Eakins used the proper tool for each job: perspectives in pencil and ink, color studies in paint. The sense of adventure or challenge demonstrated in, say, Rembrandt's linear pursuit of atmosphere and volume seems to have been disallowed as unproductive, potentially even harmful. In keeping with this craftsmanly discipline was an aesthetic of excellence modestly veiled, apparent to other members of the guild but almost invisible to untutored observers. His peers might recognize the skillful use of perspective, the understanding of anatomy, the mastery of light and shade; others will be impressed mostly by the sense of "directness" and verisimilitude, of uncontrived naturalness. Rapidly, most observers move beyond appreciation for Eakins' skill—for his striking "realism"—to an engagement with his subject matter: individualized humans at specific moments in time. This was Eakins' intention, and its success depended to a large degree on the suppression of the viewer's awareness of the artist and the careful artifices of his work. Apparently direct and immediate but deeply contrived, overtly self-effacing but covertly proud, Eakins' work pronounced his sense of place in the scheme of things, his authority as a "painter" (not

pretentiously an "artist"), and his respectful submissiveness to nature. George Barker, a student of Eakins' student J. L. Wallace, characterized Eakins as a "great anonymous giver," content to abide in the quality of his workmanship. "His pleasure was in doing the thing in the best possible way. . . . I think it was a religion with him . . . to be absolutely honest as far as he could, not pushing himself but pushing the work, the message."[20]

Eakins' method tells of his professional identity, never to his own mind adequately recognized or respected, and of his larger responsibility to the world, as a realist artist. Regarding both his craft tradition and his obligation to depict observed reality, Eakins was beset by a need for control. His method expressed this wish for maximum precision, for the security of science in an endeavor that was laden with subjectivity and ambiguity. Dedicated to the suppression of self and uncertainty, Eakins called forth seemingly impersonal and objective structures to organize his work. Happiest where he was most exact, as in the construction of a perspective grid or the systematic fabrication of reflections on water, and uneasy when things were complex and uncontrollable, as in outdoor painting, Eakins sought a method that evoked, by an artifice that amounted to deceit, the semblance of visual truth. The limitations of the painter's palette, so much more restricted than color-light, and the variables created by different illumination of the picture surface, both required pictorial compromise. These negotiations, expressed in sketches or manuscripts in the Bregler collection, show Eakins coming to grips with the tricks of his trade, the techniques that remove painting from the simple imitation of nature.

Translating visual perception into an illusionistic pattern on a two-dimensional surface is the great artifice of realist painting. In Eakins' work, this process was extended and subdivided in both preparation and execution. He clearly enjoyed rationalizing the process by which the wholeness of experience is rendered into art, effectively maximizing the level of artifice while driving toward an "honest" and natural effect. In this process all the phases of study become not just tools for learning but also tools for the creative transformation of knowledge into a painting or sculpture. Study helps the artist see well, the better to comprehend, select, and render the seen, known world into the forms of realist art. Study in this sense is a necessary distancing device, reducing the world into small, manageable bits, dispassionately subject to the will of science or art. Eakins pressed for, even exaggerated this experience of alienation, by which human beings become cadavers, illustrations of body types, or footprints on a perspective grid. Extremely sensitive to sexuality and all the emotional clues to be read in posture and facial expression, he invented projects and methods that indulged his wish to examine other minds and bodies intensely, while cooling a too-curious, too-penetrating vision. In choosing to become a painter, he selected a job that allowed him close inspection of others, that justified the study he enjoyed. His job also rewarded him with the possession of knowledge, of ownership

of the persons and subjects that he rendered into images. In this light the whole process of study and painting was deeply satisfying, somewhat apart from the pleasure of making a well-constructed, effectively illusionist and decorative object.

The hardest part of the whole academic process, of course, lay in the integration of all the components into an effective picture, joining landscape studies, photographs, clay models, and perspective drawings to support the original concept and the hard work of actual painting. The uneasy combination of these elements threatens Eakins' work, creating the disjunctions of figure and landscape in *A May Morning* or *Cowboys in the Badlands;* the tense unity of the parts also lends, as Michael Fried has noted, an energy that makes Eakins' work perennially interesting. Fried locates this tension in the unreconciled opposition of Eakins' "graphic" sensibility, which sought knowledge of the world and attempted to re-create an illusion of this world in the imaginary space of the picture, and his "pictorial" aesthetic, concerned with the physical presence of the picture's surface.[21] This opposition is a lopsided one, for Eakins' realist creed favored the depicted subject, not the qualities of design and texture of the painting, as an object. His most memorable talents are of the graphic order—the description of form in space, the suggestion of character and emotion in posture and expression—not in the pictorial sphere, for Eakins was not a good colorist, nor always a great designer. But the Bregler collection, while demonstrating the extremities of Eakins' "graphic" obsession, also shows how attentive Eakins was to the two-dimensional pattern of his pictures. Careful decisions about the framing and the manipulation of the background for pictorial effect second the physical impact of his paint surface, which always includes heavy, assertively "painted" passages, and almost no imitative textures. In the presence of these paintings, we are reminded that trompe l'oeil illusionism was not a goal of Eakins' art.

The realism that emerges from these poles of artifice and naturalness, concept and sensuousness, is peculiar to Eakins, but not unique. In league with academic reformers like Bonnat, Eakins took an extreme position in insisting on the inclusion of naturalistic detail that many observers, including other artists, found distractingly specific if not commonplace, ugly, or downright offensive. As Susan Eakins noted, "He thought even in the anatomical work the disposition to make work pleasing to the eye at the expense of accuracy was unfortunate."[22] From the inclusion of wrinkles in skin and clothing, or the bright blood on Dr. Gross' hand, has come Eakins' reputation as an "honest" realist. In this sense, realism accepts the ordinary and the unattractive, even seeks it out, disdaining the pretty, cheerful, and appealing aspects of life that may be the products of idealization, or may be equally "real" but lack the modern taste for novelty, alienation, or shock. Eakins did not unselectively accept everything as material for art; often heroizing or nostalgic, his choices were not far from the mainstream—athletic champions, intellectuals, artists, Arcadian musicians—indicating an

aesthetic of fitness to art that respected conventional categories but filled them with modern American characters, people, and subjects that had never been cast in this light. "That has never been painted before!" he exclaimed with delight to Bregler, revealing his own pleasure in attempting new and difficult subjects, partly to extract that same reaction from others.[23] Eakins' choice was restricted, however, after the figure had been selected and posed; then the appearance of the sitter guided his work, as he searched for the peculiarities that would establish individual identity. At this moment, the rendering of close, generally unflattering detail became a moral necessity. Idealization, ignorance, or inadequate study brought "mutilation"; if depicted carefully and "honestly," nature's creations could not be bad or wrong. Artistically, there is again the desire to astonish the viewer with novelty and specificity; at the very least such realism is confrontational, and—in Eakins' case—the wish to surprise, perhaps to offend, lies buried just beneath an argument for "truth."

The prejudice inherent in this "honesty" is apparent in its directed gaze, which avoids pretty girls, adorable children, sentimental topics, and all conventionally beautiful subjects. Photographs and personal testimony also tell us that Eakins typically exaggerated the rumpled, worn-out, or ungainly aspects of his sitters. If, as Oscar Wilde remarked, all great portraits are effectively self-portraits, the generally introspective and depressed air of Eakins' sitters expresses Eakins' own sensibility as much as his honesty. More subtly, Eakins impresses us as "honest" by his choice of pose and setting, seeming to capture his sitters in natural and characteristic postures. Because he usually painted people and events he knew well, with a success often directly related to the depth of his understanding, Eakins could choose, as a realist, to paint them in "everyday" or typical postures that expressed characteristic or ordinary truths. Looking again at *Fifty Years Ago* or *Amelia Van Buren* or *The Thinker*, it is possible that the models arranged themselves comfortably with a view to a long session of posing, and Eakins simply accepted their posture and centered their image on the canvas or paper. Assuming this laissez-faire attitude on Eakins' part, the art critic in the *New York Tribune* complained in 1881 of his "singular indifference to picture-making," as if reality and not the picture held sway over his choices.[24] However, the choice *not* to intervene actively expresses an aesthetic of naturalism, consciously rather than carelessly accepting of reality. More likely, given the forethought and contrivance seen through-out Eakins' preparatory work, he exerted considerable control over his model, but his intervention sought an effect of naturalness to give the impression of simplicity and minimal "artistic" manipulation. Again, this makes for a studied choice—one opposed to "affectation" but entailing a style of its own, stressing informality or introspection. The term "honesty" has limited if not ironical use, as we consider, overall, the pains that Eakins took to gain an "artless" effect.

The many objects in the Bregler collection teach us that Eakins was concerned with truth—both superficial and deep—available in appearances, and that his attention was generally gathered beyond the plane of the picture, in the real or illusionistic world of figures and space. As a realist painter, he struggled to suggest visual experience on a two-dimensional surface; he did not intend to fool the eye or simulate the perceptual field. As the many "artistic" and technical judgments in his work show, he was not imitating reality or vision, he was making pictures. Pictures had different rules, different priorities from nature's. Eakins, dedicated to science and technology, did not press the most advanced thinking from these realms into his work, for by this logic his paintings and sculptures would have been evenly detailed, like the world, and thus subject to all-over investigation by the movement of the eyes—or radically focused at one point, assuming an instant of vision—or broadly painted overall, like an impressionist canvas, seeking light rather than form. The extremes of focus in his pictures may respond to the suggestion of camera effects, but the work is nowhere uniformly detailed or narrowly focused, exactly as a camera would see. In the same way, the "law" of perspective was observed strictly until it became pictorially awkward, at which point Eakins steered by his own artistic stars.

Both arenas of study—the world and the picture—are felt throughout Eakins' studio materials. The scientific and materialistic impulses of the first arena mark Eakins as a modern; the creative will exhibited in the latter is more old-fashioned, based on the wish to make pictures well. His obsession with science and knowledge has been long recognized, and the Bregler collection demonstrates its breadth and relentlessness. Less familiar, however, has been the sense of creative manipulation of that information in the service of art. Hardly indifferent to picture-making, Eakins proudly, deliberately, professionally assumed his mission as a painter. It is in this revelation of artistic process that Eakins, and his personal version of academic realism, can be rediscovered and understood.

Notes

Introduction

Epigraph: From a letter to Mrs. Hudson, 23 Jan. 1933 (Goodrich, PMA Eakins Archive).

1. Goodrich's pioneering biography and catalogue raisonnée of 1933, *Thomas Eakins: His Life and Work,* established the framework of facts and the nationalistic rhetoric that supported the rise of Eakins' reputation until the emergence of a new generation of monographic studies in the late 1960s. Interest in a subtler or more detailed investigation of Eakins' work inspired Goodrich to revise and greatly expand his earlier work, which appeared in 1982 as *Thomas Eakins.* This two-volume study remains the cornerstone of Eakins scholarship; it also surveys the course of Eakins' reputation and includes a comprehensive bibliography.

2. Draft or copy of a letter from CB to Elizabeth M. Kenton, 21 Sept. 1939 (CBTE, quoted in Foster and Leibold, 14). The provenance of Bregler's manuscript collection is described in detail in the introduction to Foster and Leibold. Since the art work and memorabilia follow the same provenance as the manuscripts, this text can be consulted by those interested in the events and personalities important to the history of the collection. Bregler studied at PAFA from 1883 to 1886 and then with Eakins at the Art Students' League from 1886 to 1890; his life, and his involvement with the Eakinses, is described in Foster and Leibold, 317–337.

3. SME to Horatio C. Wood, 2 Apr. 1917 (CBTE, Foster and Leibold, fiche series II 1/D/9). Writing to the estate's banker, A. C. Morgan, in 1939, Bregler noted that "her whole thought, and which amounted almost to an obsession, was the care and placing of Eakins' pictures in safe and appreciated hands" (IV 4/G/13).

4. The inaugural exhibition of the collection was in the spring of 1930, accompanied by vol. 25 (Mar. 1930) of the *Pennsylvania Museum Bulletin,* which contained essays by Goodrich, Gilbert S. Parker, and Henri Marceau, who appended a catalogue of known work. The history of this gift is given by Evan H. Turner in Siegl, 7–9. The PMA's collection has since attracted many other donations, also described in this useful catalogue, and inspired the survey exhibition of Eakins' work in 1982, accompanied by a catalogue by Darrel Sewell. Another side of this story is told in the correspondence between SME and the first director of the museum, Fiske Kimball, and his curator (later director), Henri Marceau; see Foster and Leibold, 6, 379, 406. SME was also generous with Eakins' students and admirers. In 1939, Bregler was unable to locate "several watercolor studies" and "other sketches and drawings" listed by Goodrich as in SME's possession in 1933. "No doubt they have been given to persons within these last eight years," he concluded (Foster and Leibold, fiche series IV 4/G/4). SME's transactions with students, dealers, curators, and collectors, particularly Bryson Burroughs (at the MMA), Stephen C. Clark, Clarence Cranmer, Carmine Dalesio (of Babcock Galleries), Gilbert Parker (PAFA), and Walter Pach, can also be studied in CBTE.

5. Bregler's inventory of SME's estate listed eighty-five items by Eakins (most included in Goodrich's 1938 catalogue), fifty-five by SME, and twenty-three by other artists. The most important things in his own collection were all items claimed as prior gifts from SME that had remained in the house; these were listed separately. See Foster and Leibold, fiche series IV 13/E/2–8. The general disinterest of scholars might be read in the fact that Burroughs (1924), Marceau (1930), and Goodrich (1933), all of whom had access to the house and had Susan Eakins' full cooperation, cata-

logued very little of the material now found in the Bregler collection. Goodrich's notes show that he saw much of this material but decided not to list it. The dismal financial side of the estate sales is summarized in the report of the Fidelity–Philadelphia Trust Company, prepared by Lillian M. Miedel, 9 Mar. 1967 (copy in PAFA Archives). The critical response to Eakins' work between 1916 and 1940 is documented in Goodrich 1982, II: 273–284, Rosenzweig, 11–12, and Jennifer Hardin, "The Critical Reception of Thomas Eakins's Work, II: Posthumous," in Wilmerding, 195–197.

6. CB to SM (copy), 23 July [1939] (CBTE, Foster and Leibold, 333).

7. The "Thomas Eakins Centennial Exhibition" appeared at the Philadelphia Museum of Art, 8 Apr. to 14 May 1944, accompanied by an issue of the *Philadelphia Museum Bulletin* (vol. 39, May 1944) as a catalogue, with essays by Lloyd Goodrich and Henri Marceau. Versions of this show appeared at Knoedler and Co. in New York from 5 June to 31 July (with an expanded catalogue based on the PMA *Bulletin*); the Wilmington Society of the Fine Arts, Delaware Art Center (1 to 29 Oct.); the Doll and Richards Gallery, Boston (4 to 21 Nov.); the State Art Gallery, Raleigh, N.C. (26 Nov. to 31 Dec.); and the Carnegie Institute, Pittsburgh (26 Apr. to 1 June 1945), where an abridged version of the PMA *Bulletin* was printed. Bregler's many loans to this show are documented in CBTE; see Foster and Leibold, fiche series IV 5/B/7–5/E/12.

8. The history of the Hirshhorn's collection, in many ways identical to the present Bregler collection, is given in the introduction to Rosenzweig, 11–15. Not all of the Eakins material in the museum is included in her excellent book; see also Phyllis D. Rosenzweig, "Problems and Resources in Thomas Eakins' Research: The Hirshhorn Museum's Samuel Murray Collection," *Arts Magazine* (May 1979): 118–120. About half of the Hirshhorn's Eakins collection came from Bregler; with the notable exception of the great portrait *Mrs. Thomas Eakins* (Rosenzweig, *Thomas Eakins Collection,* cat. 92), few of the Bregler items are finished, "exhibition" oils.

9. See Rosenzweig, cats. 26, 31a–c, 56a–b.

10. Seymour Adelman was present during some of Bregler's last visits to the Mount Vernon Street house, which probably explains how he acquired representative drawings, photographs, and manuscripts closely related to Bregler's collection. He also received some gifts from SME and purchased paintings and furniture, such as the famous tilt-top table, at the estate sales in 1939. Adelman wished to save the Eakins house as a memorial site, but he and Bregler were unable to realize such hopes in 1939. Thirty years later Adelman sold much of his collection to the Dietrichs in order to purchase the house, which he then gave to the city of Philadelphia. On Adelman's role, see Foster and Leibold, 13–14. Much of Adelman's collection of art and memorabilia appeared in an exhibition at the PMA (1 Feb. to 18 Mar. 1962), accompanied by a mimeographed brochure, *Eakins in Perspective.* Items from his collection, now owned by the Dietrichs, are more thoroughly catalogued in Avondale/Dietrich. Ann Barton Brown's introduction (43–44) surveys the history of Adelman's material as well as the contributions of the Dietrichs, who have continued Adelman's tradition of dedicated support. Not all the items in their collection are documented in this book, however, and Adelman's large assortment of photographs from Eakins' circle, now at Bryn Mawr, remains to be published. Bregler's other gifts and sales in the period from 1939 to about 1950 are documented in his papers, which are published in the microfiche edition of Foster and Leibold but only loosely indexed; see 326–331.

11. Mary Bregler was already a figure of legend by the time I was in

graduate school in the early 1970s. She must have had many callers, but the only one who ever saw any art work seems to have been James Maroney, then employed by Sotheby's, who told me of many trips to her house in about 1972, the preparation of a two-page checklist of important items, and her eventual change of heart. In 1983, Elizabeth Milroy, who was working at the PMA's Eakins Archive, asked me for information about Mrs. Bregler, and we decided to join forces to approach her. Suspicious and indecisive, Mrs. Bregler was nonetheless very cordial to us; I recounted the story of her custody of the collection and its transfer to the Academy in 1985 in "An Important Eakins Collection," *The Magazine Antiques* 130 (Dec. 1986): 1228–1237, and in Foster and Leibold, 19–22.

12. The inventory of Bregler's estate (copy in PAFA Archives) hints that these oils were personal favorites, for they were displayed in his living room, dining room, and hall. He probably retained the *Knitting* and *Spinning* plasters because Knoedler's already had a set of the bronzes from Samuel Murray's estate; these were shown in the 1944 retrospective and subsequently sold to Joseph Katz.

13. *Lives of the Most Eminent Painters, Sculptors and Architects,* trans. Mrs. Jonathan Foster (London: Bell and Sons, 1883), 5: 335.

14. Eakins' well-known biographical summary, with its bitter synopsis of his "honors," was written to H. S. Morris, 23 Apr. 1894 (PAFA Archives; Foster and Leibold, 347).

15. Hendricks 1972, 12, H 250–252.

16. Goodrich's notion of Eakins' stylistic independence and "innocent eye" was central to his early monograph; see Goodrich 1933, 143–154.

17. "He was exact. He was inevitable. He embodied America's Puritanism, and its intolerance toward evil. Had he lived in other times he would have been considered a reformer or a saint." Quoted by CB in a card to SME, 11 Sept. 1920 (CBTE, Foster and Leibold, 277, fiche series II 2/G/12).

18. The cornerstone of the academic revival has been Boime 1971. For Eakins, such reconsideration began with Ackerman 1969, 235–256. Ackerman's good scholarship inspired my own master's paper at Yale (Foster 1972). The idea of Eakins as a "radical academic" appeared in Sellin. Since then, Weinberg has contributed much to our understanding of how the Ecole shaped several generations of American students; see 1984, 1991. The larger context of this phenomenon has been surveyed by Lois Marie Fink and Joshua C. Taylor in *Academy: The Academic Tradition in American Art* (Washington, D.C.: National Collection of Fine Arts, 1975).

Chapter 1. Home Life and Early Training

1. Goodrich 1982, I: 1–4, on TE's parentage and religious background. Samuel Murray, himself a Catholic, "believed that Eakins never was a Christian"; Bregler described TE as an agnostic. See McHenry, 4, 129, 29, on TE's teasing another child about attending Sunday school, followed by BE's stern reprimand.

2. See also Goodrich 1982, I: 4.

3. Hendricks 1974, 1–5, on TE's genealogy and early residences. Benjamin and Caroline lived at several addresses after their marriage in 1843, all north of Market and west of Tenth. See also Goodrich 1982, I: 4.

4. McHenry, 124; Goodrich 1982, I: 4.

5. This chair was laden with emotion for Bregler and Seymour Adelman; see cat. 263 and Foster and Leibold, xiv.

6. The patrician art critic Mariana Griswold Van Rensselaer described Eakins in 1881 as "not only not a gentleman in the popular acceptance of a 'swell,' but not even a man of tolerably good appearance or breeding. His home & surroundings & family were decidedly the *lower* middle class . . . I used to wonder why he did not put better clothes and furniture into his pictures, but now I wonder how he even managed to see anything so good! His want of a sense of beauty apparent in his pictures is still more so in his surroundings" (quoted in Lois Dinnerstein, "Thomas Eakins' 'Crucifixion' as Perceived by Mariana Griswold Van Rensselaer," *Arts Magazine* [May 1979]: 143; Goodrich 1982, I: 197). Eakins' dedication to the depiction of modern life, which is the principal theme of Johns' excellent book of 1983, unites Eakins with Homer, who was also criticized in this period for wasting his time on uninteresting, unimportant, and "ugly" contemporary subjects. See Foster 1982, 60–61, and the discussion of *The Pathetic Song* in chap. 11 above.

7. TE's letter of 24 Aug. 1873 to Kathrin Crowell indicates that Uncle Emmor, his mother's brother, and Aunt Susan were in residence, although this may have been brief. Eakins' mother was the youngest of ten Cowperthwait siblings who must have been nearby, along with their widowed mother, during Eakins' youth. In the early 1890s at least three Crowell children came to live with their grandfather while they were attending school, and Susan Macdowell's two sisters, Dolly and Lid, were occasional long-term residents. In 1899, Mary Adeline Williams ("Addie"), a childhood friend of Margaret Eakins, joined the household. The tribulations of this extended family are hinted at in SME's diary entries such as that of 7 Jan. 1894, when she notes TE's invention of an electric doormat to signal the departure from her room of the wandering Aunt Eliza (SME, Retrospective diary, CBTE).

8. Foster and Leibold, 72–90.

9. The thirty-five-year tenure of the family's Irish housemaid, Mary Tracy, who "made their place a paradise" from c. 1858 until 1893, is recounted by McHenry, 125. SME's difficulties with later servants are occasionally mentioned in her papers. Such household help does not seem to have been extensive; no mention has been found of a carriage or horses, for example, other than the horses TE kept at his sister's farm.

10. According to McHenry (56), Eakins' agreement with his father was made in 1871 but not formally contracted until 1883. The document itself, once in Bregler's collection, is now in the Hirshhorn; see Rosenzweig, 114–115, and Goodrich 1982, I: 61. It was not until 1900, immediately after his father's death, that Eakins felt free to modify the house to his own liking by building the new fourth floor (front) studio.

11. See Foster and Leibold, 45. TE's letters home from Paris occasionally mention money received from Aunt Eliza, who evidently supported him abroad with her own funds, in addition to those from BE; see, for example, his statement of accounts in his "Spanish notebook," 4 (CBTE, Foster and Leibold, fiche series I 9/E/4).

12. McHenry, 126; Foster and Leibold, 137. To a friend, Henry Huttner, BE described himself as an "old horse in a bark mill going round and round" (CBTE, 29 July 1874, Foster and Leibold, 340). BE seems to have been a benign patron, although his concern over TE's progress in Paris did inspire him to visit France in 1868 and then bring Tom home for several months in the winter of 1868–69; see Foster and Leibold, 53–54.

13. Spared the sobering influence of war, wage-earning, and early marriage, Eakins maintained boyish habits and manners throughout his life; meeting him in 1881, the New York art critic Mariana Gris-

wold Van Rensselaer remarked upon his "untidy" and "ungainly" appearance and his unsophisticated demeanor, "like a big enthusiastic schoolboy." (See n. 6 above and Goodrich 1982, I: 196–198.) A student until the age of twenty-six, Eakins was not engaged until age thirty. Following the death of his fiancée four years later, he remained single until almost the age of forty, when he married Susan Macdowell; see Foster and Leibold, 64–66. TE's Oedipal struggle, as played out in *The Gross Clinic*, is proposed in Fried, 38–40, 68. On compensatory manliness, see David Lubin, *Act of Portrayal: Eakins, Sargent, James* (New Haven: Yale University Press, 1985), 16–17, and Martin A. Berger, "Negotiating Victorian Manhood: Thomas Eakins and the Rowing Works," *Masculinities* 2 (Fall 1994): 1–17.

14. The bounty certificate excluding Eakins from the draft was found among the Bregler papers; see Foster and Leibold, 129, and Milroy 1986, 65 and n. 59 for an analysis of this document. BE's affidavit has disappeared, although it is mentioned in TE's and others' letters of 1886; see Foster and Leibold, 82.

15. McHenry, 125–126; Goodrich 1982, I: 3, 7.

16. "Chase's studio is an atelier: this is a workshop," said Eakins, describing his Chestnut Street Studio (Goodrich 1982, II: 8). His inventory of important possessions, dated 1 July 1911, notes "two good lathes and a forge" (Foster and Leibold, 186). These lathes probably remained in the studio until they were sold by SME in about 1930 (Goodrich, PMA).

17. Hendricks 1974, 23–26; Goodrich 1982, I: 34–36; Foster and Leibold, 45, 64–66.

18. To E. H. Coates, 12 Sept. 1886 (Foster and Leibold, 236). McHenry reported that Tom's early disapproval of higher education for women prevented his sister Frances from attending high school, despite her intellectual and musical talents (29). Evidently such convictions were later overturned, as both younger sisters Margaret and Caroline attended secondary school. And, as his remarks to Coates indicate, Eakins insisted on full access for women to the Academy's program, circumstances precluded at most European art schools of the time.

19. On his "domineering" style, see McHenry, 29; on his mother's death, see Goodrich 1982, I: 76–79; on his relationships with emotionally unstable women, notably Lilian Hammitt and his niece, Ella Crowell, see Foster and Leibold, 95–122. Henry Adams has proposed to me in correspondence a more pathological pattern in Eakins' relationships with women, perhaps stemming from his response to his mother's mental illness.

20. On Caddie's attack in 1886 and the rebuttal of W. J. Crowell, see Foster and Leibold, 84, 228. On his bohemian personal appearance, see nn. 6 and 13 above, and Goodrich 1982, I: 39, 196–198. McHenry alludes to his flirtatiousness as a young man (29), but Eakins described "my sad old face" as "none too pretty" at the venerable age of forty-one; see Foster and Leibold, 139, 214.

21. Goodrich 1982, I: 8.

22. This thesis forms the basis of Fried's *Realism, Writing, Disfiguration* and the departure point for the discussion of Eakins' use of drawing in chap. 7 above.

23. See McHenry, 15, on BE's retention of TE's work. One of the earliest of his high school drawings is inscribed "L'Album de Eakins," indicating that these pieces were once intended for a parlor display book, perhaps begun at the instigation of his parents. See Rosenzweig, 25. TE's quotation is from a letter to Kathrin Crowell, 22 July 1874 (CBTE, Foster and Leibold, fiche series I 3/C/10).

24 See Fairmount Park Art Association, *Sculpture for a City: Philadel-*

phia's Treasures in Bronze and Stone (Philadelphia: FPAA, 1974), 67.

25. Goodrich 1982, I: 8.

26. The painting by Holmes is no. 828, *Study from Nature—Elizabethton, N.J.;* Rutledge/Falk, 101. Since most of Eakins' photographic portraits are from after 1881, they show Holmes blind; see H 197, H 256, and other images in CBTE not recorded by Hendricks, Danly and Leibold, nos. 93, 153–156, 158, 160. He occasionally appears in these photos with Gardel. BE's letter to Henry Huttner in 1874 (see n. 12) also describes the expeditions he and Holmes made every Sunday to Germantown to play chess with Gardel. In his painting and teaching years, Holmes' address was given in the PAFA catalogues as 1711 Filbert Street, but by 1876 he was listed at 1926 Mount Vernon Street, just two blocks from the Eakins house. In the 1890s Holmes may have served as the model for the prophet Isaiah when Eakins and Murray were modeling the sculptures for the Witherspoon building; see Goodrich 1982, I: 106, 165, 326n.

27. Goodrich 1982, I: 8. Goodrich made notes on this drawing and others from the Harding series, cats. 4a–b, in 1930, when they were in SME's custody. Noting the "drawing-masterish" style of these drawings, Goodrich attributed this manner to the influence of Holmes or of TE's high school art teacher, A. J. MacNeill (I: 313).

28. Clement and Hutton, 330.

29. *Art Journal*, n.s. 2 (1850): 181, quoted in Christine Swensen, *Charles Hullmandel and James Duffield Harding: A Study of the English Art of Drawing on Stone* (Northampton, Mass.: Smith College, 1982), 13.

30. Rutledge/Falk, no. 231, p. 101.

31. Harding's most popular titles were *Elementary Art* (1834) and *The Early Drawing Book* (1838), both listed by Rembrandt Peale in his curriculum (see Johns 1980, 142), *The Principles and Practice of Art* (1845), *Lessons on Art* (1849), and *Pencil Drawing* (1850). *Lessons on Trees* was one of Harding's most long-lived titles; see cat. 4. Harding also produced a string of portfolios of landscape subjects in etching and, most frequently, lithography. Eakins' early copies of European views may have been made from the plates in one of these books, although Hendricks' review of this type of literature found no related images; see Hendricks 1974, 10, and Rosenzweig, 24–25.

32. See Child's Gallery, Boston, *Print Annual* 13 (Spring 1991): 29; my thanks to Jeanette Toohey for noticing this Casilear drawing, which copies Lesson 23, plate 6, in *Lessons on Trees*.

33. The explosion of self-instruction manuals in nineteenth-century America is described in Peter C. Marzio, *The Art Crusade: An Analysis of American Drawing Manuals, 1820–1860* (Washington, D.C.: Smithsonian Institution Press, 1976). Because Marzio focuses on the special mission of American "crusaders," he does not treat the sizable bibliography imported from Britain during the same years. The many titles by Harding or the less expensive pocket books published by the English colormakers, evidently for sale in art supply stores, were addressed to the same audience of students and amateurs and expressed similar artistic values and methods. See particularly titles circulated by Winsor and Newton, written by such authors as T. L. Rowbotham and Aaron Penley. Diana Korzenik examines the records of a New England family responding to such art instruction in *Drawn to Art: A Nineteenth Century American Dream* (Hanover, N.H.: New England University Presses, 1985), esp. 50–53, "Self Instruction."

34. TE's admiration for modernity and expertise are premises of Johns 1983. His "great respect for justly deserved authority" is noted by Evan Turner in Siegl, 24.

35. On the teachings in *Elements of Drawing* and the book's reception

in America, see Kathleen A. Foster, "The Pre-Raphaelite Medium: Ruskin, Turner, and American Watercolor," in *The New Path: Ruskin and the Pre-Raphaelites* (Brooklyn, N.Y.: Brooklyn Museum, 1985), 79–107. Readers must be wary of misplaced paragraphs of text on 79–80 and 93.

36. Harding's drawings "are the only works by a modern draughtsman which express in any wise the energy of trees, and the laws of growth," wrote Ruskin in *Elements of Drawing* (London: Smith, Elder, 1857), 158, quoted in Swensen, *Charles Hullmandel and James Duffield Harding,* 43.

37. On this influential exhibition, see Susan P. Casteras, "The 1857–58 Exhibition of English Art in America: Critical Responses to Pre-Raphaelitism," in *The New Path,* 109–139.

38. Harding, *Lessons on Trees,* rev. 12th ed. (London: W. Kent, c. 1868), n.p., sec. 1, part 2.

39. Profoundly, almost viscerally prejudiced against all things English by 1867, when he turned down John Sartain's offer of a trip to London, Eakins relegated Ruskin to the company of his "affected" countrymen and their "inferior" art. In 1868 he asserted that he would take Gérôme's advice on the use of rough sketches "quicker than the work of a writer who knows nothing about painting such as Ruskin." See Foster and Leibold, 51, 129, 209, citing letters from 2 Aug. 1867, c. 30 Nov. 1867, and 29 Oct. 1868, CBTE.

40. Foster and Leibold, 206–207, quoting a letter of 6 Mar. 1868, CBTE. As an example of a "coal scuttle" painter, Eakins added "like Meissonier" but then crossed the name out.

41. Ibid.

42. See Introduction, n. 16.

Chapter 2. Central High School, 1857–1861

1. See Hendricks 1974, 7; these two maps are in the Hirshhorn (see Rosenzweig, 23) and in the collection of Mrs. Peggy Walters Thomas.

2. On TE's high school career, see Goodrich 1982, I: 5–6, and Hendricks 1974, 8–13. On the practical orientation of the CHS curriculum, see Johns 1980, and cat. 13.

3. Rosenzweig, cats. 3–6. Another early drawing in the picturesque mode, probably copied from a lithograph, is the *Camel and Rider* (1859), now in the Dietrich Collection; SME apparently gave this drawing to Seymour Adelman in the 1930s; see Avondale/Dietrich, cat. 13.

4. One "large" and "complicated" drawing seen by Goodrich in the 1930s has since disappeared; see the introductory statement to cats. 5–14.

5. Johns 1980, 139.

6. Ibid., 140–144. See also Hendricks 1974, 8–9. Peale's *Graphics: A Popular System of Drawing and Writing* was first published in 1834.

7. All of the mechanical drawings, cats. 10–13, may be from 1860 or 1861, although they would seem to precede the *Lathe;* see discussion under cat. 10. The missing rendering of a pump (see n. 4) may have been from semester A.

8. Eakins came in second in this competition. The examination questions survive, although the drawings do not; see Johns 1980, 144–146. Although the newly discovered drawings do not recapitulate questions on this test, some of his high school assignments (e.g., cat. 7) are very similar to those demanded by the examiners.

9. Goodrich 1982, I: 5.

10. *Mill Buildings by a River* (cat. 1) is on this same Whatman "Turkey Mill" paper and is close to the size of the finished classroom drawings (11 1/2 × 16 7/8 in.); the largest drawing from this group, the *Lathe,* is the size of a double sheet (22 × 16 5/16). Only cats. 5 and 10, and the three copies from prints of 1858–59, are not on this good paper. In 1881, Eakins specified Whatman paper for a watercolor; see. chap. 11, n. 16.

11. These drawings and their papers are discussed in chap. 3.

12. See Foster and Leibold, 5–6.

13. Johns 1980, 147–149.

14. Bregler I, 384.

15. Ibid. Pages of manuscript outlining advanced problems of geometry and perspective are included as an appendix to Eakins' text on drawing (PMA and PAFA archives). It is not clear whether Eakins intended these as exercises for students or whether he pursued them for his own pleasure.

16. Bregler I, 383.

17. Remembering the planning of *The Agnew Clinic,* Bregler recalled that Eakins "told me exactly how he was going to compose it. The placing of the various figures and his reason for so doing. This before he had made a sketch" (Bregler II, 40; "Thomas Eakins as I knew him," CBTE, Foster and Leibold, 126–127, and fiche series IV 13/D/11–13; and chap. 8 below).

Chapter 3. The Pennsylvania Academy of the Fine Arts, 1862–1866

1. Eakins' admission ticket to the antique class and anatomy lectures at the Academy, dated 7 Oct. 1862, and his undated ticket to life class are both in the Hirshhorn Museum; see Rosenzweig, 28–29. The nature of these classes and Christian Schussele's influence on the curriculum at this time is discussed by Onorato 1977, 87–98, and Chamberlin-Hellman, 53–55. Boime 1971 provides an overview of the humanist values of academic art and the drawing procedures at the Ecole des Beaux-Arts (27–33). On the development of the "academic" curriculum in art schools, beginning with Leonardo's codification of the progression from engravings to casts or sculpture and then to life study, see Boime 1974, 5–13.

2. Eakins had had his fill of cast drawing by the time he reached Paris, where he admitted to cutting class the week the atelier worked from sculptures. In 1868 he mockingly derided the idea of returning to the Academy to "drawey wawey after the nice little busty wustys." When he became a teacher he reduced the time entering students spent drawing from casts, arguing that they should work immediately with paint and color. See Foster and Leibold, 54, 56–57, 317–318, and the discussion of his experience at the Ecole, below. His antipathy makes it unlikely that any of these cast drawings are from later than 1867. In fact, once he took up painting he probably gave up charcoal drawing altogether. As Chamberlin-Hellman has remarked (55), it seems improbable that Eakins would bring cast drawings home from Paris when he was so eager to get beyond such work. No sculpture or cast entitled *Hercules* is listed in the PAFA's inventories in the 1850s, but by 1864 a *Bust of Hercules* had entered the collection; it has since disappeared. See the *Catalogue of the Paintings, Statuary in Marble, Casts in Plaster, etc. . . .* (PAFA, 1864), no. 315.

3. The *Study of a Warrior's Head,* G 18, is identical in size to the other charcoals of this period, although it bears a different watermark; it is owned by the Alex Hillman Family Foundation in New York City. This drawing was first published in Roland McKinney, *Thomas Eakins* (New York: Crown, 1942), 87, where it is dated 1869

and incorrectly described as 22 × 16 in.; it is 24 × 18. Chamberlin-Hellman first identified the subject and proposed its date as 1862 (54), partly based on her discovery of the date of Eakins' graduation to the life class, 23 Feb. 1863 (56). She notes that the *Menelaos* was listed in the Academy's *Catalogue of Paintings, Statuary in Marble, Casts in Plaster, etc. . . .* of 1868, and that it is also listed in the collection catalogue of 1864 (no. 275). It may have been present earlier as "Bust of Ajax" in the 1860 *Art Property Register* (PAFA Archives), 59; the identification of this figure as Ajax in this period is confirmed by its appearance with this title in a catalogue of casts: *Hennecke's Florentine Statuary* (Milwaukee: C. Hennecke, 1887), 80.

4. Boime 1971 describes the venerable tradition of this parts-before-the-whole system and its use by French academics in the nineteenth century (26, 192 n. 15). See also Chamberlin-Hellman, 55–56. Christian Schussele and Peter Rothermel, the supervisors of the Academy's curriculum during this period, knew this system from their own European contacts.

5. Cat. 19, of a knee, is especially suggestive of an *écorché* cast, showing the muscles and tendons exposed. Casts listed in the school's *Art Property Register* of 1860 (58–59) included torsos, feet, hands, arms, and a knee "from nature," and "colossal fragments" of an ear, eye, and nose, perhaps from antique sculpture. Eakins used these life casts in his own teaching, adding new examples to the collection from his own work in dissection; see the *Temporary Catalogue of the Permanent Collection,* 2nd ed. (Philadelphia: PAFA, 1879), 16, which lists thirty life casts in addition to dozens of sculptural fragments. The loss of all but Eakins' own casts (e.g., cats. 258, 259) makes impossible the exact identification of the present drawings with these earlier casts in the collection.

6. SME did not meet TE until 1876, so she admitted that she had "no definite information" (Goodrich 1982, I: 10–11, 314–315; Hendricks 1974, 28–29; Siegl, 48–49, 60–62). Her statement is from "Notes on TE," evidently a draft of a letter to Goodrich from about 1930 (CBTE, Foster and Leibold, fiche series II 4/C/3). In 1881, Eakins told Van Rensselaer that he had "destroyed all his academic studies & since that time he has never worked in black & white" (Goodrich 1982, I: 197). Although clearly an exaggeration, this statement explains the dearth of Parisian material and the rarity of all drawings other than perspective studies after 1870. His shift from drawing to painting, charted in chaps. 7 and 8, also reduces the likelihood that these charcoals are from the mid-'70s.

7. Considering the drawings showing the head or full figure, one (Siegl, cat. 2) is too blurred to be useful, but others (Siegl, cats. 15, 16, 17—all dated by Siegl to the mid-1870s) show women with their hair pulled smoothly back from their foreheads and twisted at the back of the head or nape of the neck, or rolled inside a hairnet to give the "waterfall" effect popular in the mid-1860s. See Elizabeth McClellan, *Historic Dress in America, 1607–1870* (1904–10; rpt., New York: Arno Press, 1977), figs. 140, 168, pp. 274–275. The popularity of this style is documented in Winslow Homer's wood engravings from 1865–67; his images of fashionable women after this year chart the steady movement of the chignon up the back of the head; by the late seventies it rested squarely on the top of the head. Eakins' sisters Fanny and Maggie are last seen in this hairstyle in paintings of c. 1870–71. While men's hairstyles in this period are harder to pinpoint, the man seen in cat. 24 (fig. 34) shows the longer ear-length hair characteristic of the 1860s and earlier; haircuts became shorter after the Civil War. Compare Christian Schussele's *Men of Progress* of 1862 (National Portrait Gallery; see Hendricks 1974, plate 2) with Eakins' *The Gross Clinic* of 1875.

8. See Siegl, 171, for photographs of the three watermarks found on the PMA's drawings, including the "EB," "AM," and "Michallet" papers. Another, more recent PMA accession, not in Siegl's catalogue, is *Nude Man with a Beard* (G 9, PMA 1979.96.14, 23 1/2 × 18 1/4 in.), published in McKinney, *Thomas Eakins,* 86, which carries an "LP" monogram, shared only by cat. 23. The *Warrior's Head* bears a puzzling unidentified monogram not seen elsewhere. The quality of drawing in these last two examples compares to the charcoals that Siegl dated to 1874–76 (on "AM" and "EB" paper). Most of these life and cast drawings are on cream-colored paper, but three are on pink: cat. 17, marked "EB"; *Nude Woman Reclining* (G 15, PMA but not in Siegl; 18 1/4 × 24 in.); and *Nude Woman Reclining, Wearing a Mask* (G 16, not located; 18 × 24 in.). This drawing was seen by Goodrich, who characterized it as full of "bigness" and "delicacy," like G 15 (Goodrich, PMA). One drawing, also unusual for its exotic subject, is on greenish Michallet paper: *Man in a Turban* (G 13, 23 1/8 × 16 7/8 in.; Achenbach Foundation for Graphic Arts). Among all these drawings, this is the one that might have been done in Paris. See Robert F. Johnson, *Master Drawings from the Achenbach Foundation for Graphic Arts* (Geneva: Richard Burton, for the Fine Arts Museums of San Francisco, 1985), 200. In my tally of located drawings, fourteen are "EB" and nine are various other manufacturers; two have not yet been examined.

9. Goodrich 1982, I: 315; Siegl, 61. Only the papers marked Michallet (Siegl, cats. 1–3) have been identified with particular French mills; "LP" may be L. Pelleri, another European papermaker. The "EB" watermark, with the addition of the mill name Tolle et Fils, is also found on an unidentified drawing from the Philadelphia Sketch Club's exhibition portfolio of 1866 (priv. coll.)—another indication that this paper was available in Philadelphia in this decade. The comparable quality of the other examples has encouraged both Goodrich and Siegl to assume that all of these papers are of French manufacture. Siegl himself used the logic of common materials to reinforce his division of the drawings into three groups, for although his dating was based on the relative skill of the drawings, he also divided them into groups sharing the same watermark.

10. Goodrich's catalogue of 1933 listed eighteen charcoal drawings from this period (G 1–18). Of these, five are unlocated (G 10, 12, 14, 16, 17). His more recent reckoning of this group (1982, I: 34) contains some confusion of numbers. None of the twelve drawings in the Bregler collection were catalogued by Goodrich; his notes and sketches from c. 1930 (PMA Archives) indicate that the five currently unlocated items in his catalogue differ from Bregler examples.

11. The fragmented method of Eakins' Academy exercises was already apparent from available drawings, as Chamberlin-Hellman remarked, but the studies in Bregler's trove confirm this tendency and show it to dominate his extant student work by a ratio of 2:1. Of the thirty-eight images (including verso drawings) from this entire group, only thirteen are full-length figures. The selection of thirty known drawings (of which twenty-five have been located) cannot have been Eakins' entire production as a student, but we might imagine that the best, most finished examples were saved.

12. Fried, 59.

13. On the "self-defeating methodology" of the academic method, see Boime 1971, 30–32. Eakins is quoted by Bregler I, 383.

14. Boime 1971, 32, describes the graphite pencil as the preferred drafting tool of the 1830s and '40s; softer effects of crayon, chalk, and charcoal grew popular at midcentury, and after the reforms of 1863, charcoal was habitually used for student drawings at the Ecole. The use of graphite in cat. 24 is unique among these life drawings, but it

follows the practice of the supervisor of these classes, Christian Schussele.

15. Boime 1971, 24–42. See Gérôme's oil *Nude, Study for King Candaules* in Ackerman 1973, 101. Other drawings, revealing Gérôme's habit of focusing on a part of the figure or the drapery to the exclusion of the body, can be found in *Jean Léon Gérôme, 1824–1904* (Vesoul: Musée de Vesoul, 1981). See also Weinberg 1984, 23–33, and 1991, chap. 5, on Gérôme's teaching. The context of nineteenth-century life drawing, remarkably diverse and personalized in style despite the reputed standardization of academic procedures, can be surveyed in Boime 1974 and in Sarah Whitfield, *The Academic Tradition* (Bloomington: Indiana University Art Museum, 1968).

16. On Eakins' destruction of his academic studies, see n. 6. Goodrich surmised that the few oils surviving from Eakins' Paris years were cropped before being brought home to avoid the difficulty of importing nude studies. By this same logic he assumed that full-length nude studies in charcoal, like those at the PMA, would not have been carried home (Goodrich 1982, I: 314). Looking at the fragmentary studies found in Bregler's collection, and remembering Eakins' general lack of interest in his own drawings, one would likewise ask why he would go to the trouble to bring such pages home. More likely, they were absentmindedly retained at home and then later guarded by BE or SME.

17. On Rothermel, see Mark Thistlethwaite, "Peter F. Rothermel: A Forgotten History Painter," *Antiques Magazine* (Nov. 1983): 1016–1022. In 1866–1867, Rothermel was president of the Academy's Council of Academicians. Eakins' affiliation with Rothermel must have been increased by the marriage of Rothermel's daughter, Blanche, to SME's brother, James Macdowell.

18. On Rothermel's role in the revitalization of the school and the relationship of the new curriculum to French academic practice, see Onorato 1977, 51–63. The life school began in the 1855–56 school year, meeting three evenings a week; thirty-six persons attended sessions in the spring of 1856.

19. On Schussele's impact on the Academy's curriculum, see Onorato 1977, 71–103. Earl Shinn, also a student in the early 1860s, recalled that "for a number of years before he assumed positive responsibilities as an instructor [in 1868], he was almost the only artist of Philadelphia who showed any real interest in the Academy's students" ("A Philadelphia Art School," *The Art Amateur* 10 (Jan. 1884): 32, quoted in Sellin, 29).

20. Eakins' remarks on his old friendship and admiration for Rothermel appeared in the Philadelphia *Press* after the older artist's death in 1895; portions are quoted in Thistlethwaite, *Rothermel*, 1022. Thistlethwaite also shared with me additional remarks from this obituary: "Rothermel did not follow his models closely and he took different phases of character from them. I used to drop in at Rothermel's studio very frequently while he was working on his big work, 'Gettysburg' [completed in 1870]. It was stated that it took him eighteen months to paint that, but in reality it took much longer than that. That was his largest commission. Most of his work found a ready sale, and paintings by him can be found in the parlors of most of the old families of Philadelphia." Eakins' remarks also touch on the death of Thomas Hovenden, whom he commended for his teaching, but Rothermel was not mentioned as a teacher. The full text of this article is included in the Hovenden Scrapbooks at the Archives of American Art. Susan Eakins' insistence that her husband had no teacher in Philadelphia fed Goodrich's rhetoric of stylistic independence; see Goodrich 1933,

143, 154; and SME's letters to CB (Feb. 1927) and to Goodrich (n.d. notes, c. 1930) in CBTE, Foster and Leibold, fiche series II 4/B/7.

21. The Schussele drawings are from an album containing more than 190 items, evidently compiled shortly after the artist's death and given to PAFA. The contents of this album are discussed at length in Onorato 1977, chap. 3; and Onorato 1979, 122–125. Other Rothermel drawings at the Academy include many studies, evidently material from the artist's studio, given to PAFA in 1983 by Saul and Ellin Lapp.

22. CB to Samuel Murray, draft, 23 July 1939; Foster and Leibold, 334. The thirty-four Rothermel drawings were found in a portfolio containing only work by artists other than Eakins.

23. Goodrich 1982, I: 12.

24. The use of the mask by the model seems to have been common in Philadelphia, although the practice was always seen as an option, not a rule. Such masks were unusual at the Ecole in Paris, because professional models were readily available, but the appearance of a masked model can only suggest rather than guarantee the venue of any given drawing. On Eakins' opinion of masked models, see cat. 238.

25. Eakins encouraged this vision of his own reforms by insisting that "there were even no life classes in our art schools" in the 1860s (Goodrich 1982, I: 10).

26. Shinn, in Sellin, 28.

27. Ibid., 29.

28. Sellin, 30–31.

29. Allowed entrance by the good graces of the school's secretary, Lenoir, and Gérôme, Eakins never officially matriculated at the Ecole. He apparently competed in the "concours d'admission" or "concours des places" at the Ecole in the spring of 1867, when class ranking was established and the top students were granted admission to the supplemental evening life class, run by Yvon. He did not pass, and he never attempted the concours again; see Milroy 1986, 146–148.

Chapter 4. Gérôme and the Ecole des Beaux-Arts, 1866–1869

1. The admission of foreign students to the Ecole had ceased in 1866 because of overcrowding. The story of Eakins' admittance into Gérôme's atelier, as revealed by new letters in Bregler's collection, is summarized in Foster and Leibold, 48–52, and told in greater detail by Milroy 1986, 88–102. See also Sellin, 31–37, and Weinberg 1984, 101–108.

2. TE to BE, 26 Oct. 1866; CBTE, Foster and Leibold, 197.

3. SME, "Notes on TE" (CBTE, Foster and Leibold, fiche series II 4/A/12). *Ave Caesar* was shown at the Salon of 1859, at Goupil's gallery in New York that same year, and again in Paris at the Universal Exposition of 1867, where Eakins surely saw it. *The Two Augurs*, painted in 1861, was also reexhibited at the exposition of 1867. Both photogravures were purchased in Paris, according to entries in the Spanish notebook. "Photographie—Deux Augures 6.00 [f]" was noted shortly before his departure for home in Dec. 1868 (p. 3); "Photographie—Gladiateur (1) 15.00 [f]," an entry the following March after his return to Paris (p. 5), may record the purchase of the larger print of *Ave Caesar* (CBTE, Foster and Leibold, fiche series I 9/E/6, 8). Although it seems perfectly likely that the Eakins family actually installed *Ave Caesar* in the parlor, as it appears in *The Chess Players*, it is of course possible that Eakins invented its presence over the mantel as a private reference, doubling the

homage to Gérôme contained in the painting, which recapitulates the subject and composition of Gérôme's *Arnauts Playing Chess.* Eakins also brought home postcard reproductions of Gérôme's work, including *The Dance of the Almeh, Prayer on the Rooftops,* and two unidentified Middle Eastern scenes, now in the Dietrich Collection; see Avondale/Dietrich, 66A–D. Ackerman saw others, including *The Prisoner* and *The Chess Players,* in Seymour Adelman's collection (1969, 240). Eakins seems to have had several of these reproductions in hand as he wrote to his sister Fanny in Mar. 1869, enthusiastically describing *Ave Caesar* and others in detail (AAA, Goodrich 1982, I: 45–47). See chap. 17 for the impact of Gérôme's neoclassical work on Eakins in the 1880s.

4. Goodrich's blindness to Gérôme's influence on Eakins, typical of the nationalistic spirit of the 1930s, drew early criticism from Susan Eakins: "When a man cannot understand the greatness of Gérôme I cannot think he understands Eakins," she wrote in 1936 (Foster and Leibold, 308). Defending Eakins' originality and independence, critics as recently as 1964 claimed that it was "difficult to find anything in Eakins' art that he could have learned from Gérôme" (John Canaday, "Thomas Eakins," *Horizon* 6 [Autumn 1964]: 105). The tide turned five years later with Gerald Ackerman's important article recognizing Eakins' many debts to both Gérôme and Bonnat. Ackerman's good observations in 1969 were developed in my own master's thesis (Foster 1972). Since then, the warming of opinion concerning French academic and official art of this period, led by the scholarship of Albert Boime, has revived Gérôme's reputation as both an important artist and teacher. Ackerman's catalogue raisonnée (1986) has allowed fresh appreciation of his work, and Weinberg's studies (1984, 1991) of his impact on American art students, particularly Eakins, has reconstructed his position as one of the greatest teachers of this period. In this more cordial spirit, Eakins' experience with Gérôme is discussed by Chamberlin-Hellman (chap. 2) and Milroy, whose thesis (1986) is devoted to an examination of his Parisian training. See also Foster and Leibold, 54–60.

5. TE to BE, 26 Oct. 1866 (CBTE, Foster and Leibold, 197). Gérôme's liberality filled his atelier with foreign students; a decade later he had to ask his assistant Moreau-Vauthier to reduce their numbers, "Je ne sais combien je puis en recevoir de nouveaux, et il m'en arrive de toutes partes." See Charles Moreau-Vauthier, *Gérôme, peintre et sculpteur* (Paris, 1906), 177.

6. Lucy H. Hooper, "Léon Gérôme," *Art Journal* (New York), n.s. 3 (1877): 26.

7. A list of Gérôme's paintings in American collections prior to 1888 appears in Foster 1972, appendix; Philadelphia collectors included Henry Gibson, Mrs. T. A. Scott, W. P. Wilstach, James Claghorn, Harrison Earl, C. Hutchinson, and James S. Mason. Gérôme's American patronage has since been more systematically documented by Ackerman in his catalogue raisonnée (1986). Weinberg (1984, 1991) surveys Gérôme's forty years of popularity among American students. She notes (88) the timely appearance of Eugene Benson's complimentary assessment of Gérôme in *Galaxy* 1 (1 Aug. 1866): 582, shortly before Eakins' departure for Paris. American monographs on Gérôme include Earl Shinn, *Gérôme: A Collection of the Works of J.-L. Gérôme in 100 Photogravures* (New York: S. L. Hall, 1881), and Fanny Field Hering, *Gérôme: The Life and Works of Jean Léon Gérôme* (New York: Cassell, 1892). Hering's book was based on her article "Gérôme," *Century Magazine* 15 (1889): 483–495, in which she mentions her debt to S. J. Ferris. Jean Leon Gérôme Ferris (1863–1930) later studied in Paris with the

master. Gérôme's popularity in the United States was encouraged by the accessibility of excellent reproductions, such as the ones Eakins purchased in Paris, helpfully published by the firm of Gérôme's father-in-law, Goupil and Co.

8. Ackerman first noted the appearance of this painting at the PAFA, and its likely impact on Eakins (1969, 236–237). Weinberg has published a larger reproduction (1991, 94). A dozen paintings by Gérôme were in circulation in the United States before 1866, including *Ave Caesar, The Two Augurs, The Almeh, The Prayer in the Desert, The Duel after the Masquerade,* and *King Candaules;* see Gerdts and Yarnall, 1399–1401.

9. On Pils, who attracted very few American pupils, see Weinberg 1991, 271. Cabanel won more American students (although not nearly as many as Gérôme) but suffered from the "striking antipathy" of American critics and drew a smaller following from American collectors; see Weinberg 1991, chap. 6, esp. 131.

10. On Gérôme's career, see Ackerman 1972, 1986.

11. Jules Prown has noted this phenomenon in the careers of Copley and especially West, who came from Philadelphia to eventually lead the Royal Academy in England. By the same token, provincial artists (such as Gérôme or Bonnat) often became the most ardent defenders of the French Academy. The boisterousness of the Ecole is frequently described; see, for example, John Milner, *The Studios of Paris: The Capital of Art in the Late Nineteenth Century* (New Haven: Yale University Press, 1988), 21–22. Nonetheless, the supportive "fraternity" of the Parisian environment was recognized as a powerful source of self-respect, even in Eakins' day; see H. T. Tuckerman in *Papers about Paris* (1867), quoted in Weinberg 1991, 70.

12. TE to BE, 11 Nov. 1866 (SME transcript, Goodrich 1982, I: 21).

13. Blashfield, in John C. Van Dyke, *Modern French Masters* (New York, 1896), 47.

14. Bregler II, 383; Dagnan-Bouveret commented on Gérôme's intolerance of conventional or chic work in Charles Moreau-Vauthier, 1906, 183–184; the same biographer also described Gérôme's grim opinion of the painter's métier ("peut-etre le plus dur que je connaisse") and his attempts at discouraging potential artists (16–17, 178). See also Ackerman's description of Gérôme's anticonventional rhetoric (1986, 160–161).

15. TE to BE, 29 Oct. 1868 (CBTE, Foster and Leibold, 208). Remarking the fashionability of another American artist in Paris, E. H. May, Eakins wrote, "If I had no hope of ever earning big money I might be envious" (TE to BE, 7 May 1869, CBTE, Foster and Leibold, fiche series I 3/A/3–4).

16. Ackerman 1969, 239–246. Goodrich treated Gérôme with more sympathy in his revised monograph of 1982, but he still found Eakins' enthusiastic discussion of Gérôme's subject matter (and his silence on his master's "artistic and technical qualities") "surprising." In fact, Eakins did not respond to Gérôme's technique favorably, whereas his subject matter had a lasting effect (Goodrich 1982, I: 44). Weinberg follows Ackerman's lead, noting that in Eakins' transformation of Gérôme's topics, the "narrative and dramatic quotients seem reduced" (1991, 96).

17. Sarah Tytler, quoted in Hering, *Gérôme,* 16.

18. James Stothert, *French and Spanish Painters* (Philadelphia, 1877), 233–235. The rising tide of such commentary in the 1870s, led by Anthony Comstock's campaign against immoral and obscene materials, has been discussed in the context of Eakins' photography by Anne McCauley in Danly and Leibold, 52–47.

19. Shinn, *Gérôme,* 3.

20. Ackerman 1969, 244–246. The record of Gérôme's work exhibited in the United States prior to 1876, listed in Gerdts and Yarnall, 1399–1401, indicates that Eakins' awareness of certain subjects and formats could have been refreshed at home. An image of *King Candaules,* with its centrally posed nude, appeared in the exhibition of the Claghorn collection in Philadelphia in 1874; (Gerdts and Yarnall, 1306); *The Crucifixion* was shown twice in New York in 1875–76 (1399); and *Pollice Verso* seems to have been seen again in 1875 at the home of A. T. Stewart in New York (see TE to Earl Shinn, 30 Jan. 1875, Cadbury Collection, Swarthmore College, quoted in Ackerman 1969, 241–242).

21. Jules Claretie, *Peintres et sculpteurs contemporains* (Paris: Charpentier, 1878), 195; J. A. Castagnary, *Salons: 1857–1879* (Paris: Charpentier, 1892), 1: 97; Louis Viardot, *The Masterpieces of French Art* (Philadelphia, 1883), 6. "It seems almost inconceivable," wrote F. F. Hering, "yet there have been critics of limited perception and faulty education who have ventured to *reproach* Gérôme for his archaeological erudition displayed in many of his pictures" (*Gérôme,* 3).

22. C. C. H. Stranahan, *A History of French Painting* (New York, 1888), 308. Gérôme's own standards improved apace; he was later critical of inaccuracies in *Ave Caesar,* and he felt that his image of the Roman past was much more correct in *Pollice Verso,* a painting he showed to Eakins to demonstrate his principles. See Ackerman 1969, 242; 1972, 69.

23. Shinn, *Gérôme,* text accompanying *Arnauts Playing Chess,* n.p. "Only once [Gérôme] told me that I was going backwards," wrote Eakins to his parents in 1867, "and that time I had made a poetical sort of outline" (12 Mar. 1867, Goodrich transcript, PMA).

24. Gérôme to TE, 22 Feb. 1877 (CBTE, Foster and Leibold, 213).

25. Gérôme's letter of 18 Sept. 1874 criticized Eakins' recent work as a "little equal overall" and urged him to sacrifice "in places to lend greater interest to the principal figures." See Foster and Leibold, no. 144, and Goodrich 1982, I: 116.

26. TE to Earl Shinn, 30 Jan. 1875 (Cadbury Collection, Swarthmore College Library, quoted in Ackerman 1969, 242). Ackerman outlined Gérôme's working procedures (1986, 162–163). TE described Gérôme's oil sketches in a letter to BE, 29 Oct. 1868 (CBTE, Foster and Leibold, 209).

27. Ackerman 1986, 162. "Before you touch your canvas know what you are going to do," said Gérome to his students; see Sellin, 35.

28. See chap. 2, n. 17.

29. The course of Eakins' work at the Ecole has been well documented by Goodrich (1982, I: 17–53), with many citations from letters. The quality and meaning of his training in respect to the Ecole's curriculum has been studied more closely in Foster 1972, Weinberg 1984 and 1991, and Milroy 1986. See also Foster and Leibold, 54–60.

30. James is quoted in Schendler, 83; Gérôme is quoted in Shinn, *Gérôme,* 3. Other American responses to Gérôme's technique are quoted in Foster 1972, 26–27.

31. TE to BE, c. 30 Nov. 1867, Foster and Leibold, no. 33, 56–57; Goodrich 1982, I: 25.

32. Ibid.

33. TE to BE, 29 Nov. 1869 (SME transcript, Goodrich 1982, I: 53).

34. TE to BE, 17 Jan. 1868 (SME transcript, Goodrich 1982, I: 27).

35. TE to BE, 29 Nov. 1869 (SME transcript, Goodrich 1982, I: 53). Among the different strategies Eakins tried may have been the "memory" method of Lecoq de Boisbandran, which probably sharpened Eakins' ability to conceptualize an image. See Foster and Leibold, 56–57.

36. Goodrich 1982, I: 62; and see chap. 6, n. 51.

37. See "Correspondence with Gérôme," Foster and Leibold, 62–64, and discussion in chap. 13 below. SME told Goodrich that Gérôme had written to TE about *The Gross Clinic,* although this letter has not survived. She also noted that Mme. Gérôme sent them a notice of Gérôme's death in 1904 (Goodrich, PMA).

Chapter 5. A.-A. Dumont and Academic Sculpture, 1868–1869

1. CBTE, Foster and Leibold, 208.

2. Wallace Wood, "Chats with Famous Artists," *Century Magazine* 47 (1893): 188; Fanny Field Hering, *Gérôme: The Life and Works of Jean Léon Gérôme* (New York: Cassell, 1892), 223. Gérôme justified his earlier decision in favor of painting as an economic necessity: "I had a large family to support, and sculpture is not remunerative" (R. H. Titherington, "Jean Léon Gérôme," *Munsey's Magazine,* n.d. [c. Jan. 1904]: 286). On Gérôme's sculpture, see Ackerman 1986, 308–333, and Ackerman, *Jean-Léon Gérôme* (Paris: Galerie Tanagra, 1974), 17, cited in Simpson, 81. Most remarkable is Gérôme's reflexive interest in depicting himself as a sculptor in such paintings as *The Artist and Model,* in which he becomes a modern Pygmalion. As Ackerman has noted, these themes are echoed in Eakins' late William Rush subjects, wherein Rush becomes Eakins; see Ackerman 1969, 246–247.

3. Bregler I, 385.

4. TE to BE, 18 Apr. 1868, from Goodrich's transcript of a now-lost letter (Goodrich 1982, I: 27). No record of the length of Eakins' study with Dumont has been found.

5. Eugene Guillaume, "Discours prononcé aux funerailles de M. Dumont," 30 Jan. 1884, in *Discours et Allocutions* (Paris, c. 1900), 103.

6. G. Vattier, *Augustin Dumont: Notes sur sa famille, sa vie, et ses ouvrages* (Paris, 1885), 125 (author's translation).

7. Critical responses to Dumont's work are recited at greater length in Foster 1972, 49–51; see also the bibliography, 148–149. Busy with public commissions and hors concours to the Salon jury, Dumont did not need the Salon and exhibited infrequently, generally arousing little partisan commentary. By the 1840s he had passed on to the jury himself. A précis of Dumont's career, with a list of major works, can be found in Stanislas Lami, *Dictionnaire des Sculpteurs de L'Ecole Française au 19e Siècle* (Paris, 1916), 2: 239–247. The bronze model of the *Génie,* now in the Louvre, is reproduced in Peter Fusco and H. W. Janson, eds., *The Romantics to Rodin: French Nineteenth-Century Sculpture from North American Collections* (New York: Braziller, for the Los Angeles County Museum of Art, 1980), 63. Dumont's sculpture for the exterior of the Louvre is no longer extant; his other Salon pieces, both acquired by the national collection at the Luxembourg palace, have since been distributed to museums in Anvers (Antwerp) and Gênes. Plaster models for most of his works are in the museum at Semur-en-Auxois.

8. Vattier, *Dumont,* 130.

9. TE to BE, 18 Apr. 1868 (Goodrich 1982, I: 27). Vattier, *Dumont,* 128–136. Guillaume (1822–1905), a celebrated official sculptor, held positions at the Ecole from 1863.

10. Guillaume, in Vattier, *Dumont,* 90.

11. Ibid., 103.

12. TE to BE, 8 Sept. 1868 (Goodrich 1982, I: 50).

13. TE to BE, 18 Apr. 1868 (Goodrich 1982, I: 27).

14. Henri Delaborde, from his Salon commentary of 1859, in *Mélanges sur l'art contemporain* (Paris, 1866), 98.

15. Eakins bought modeling wax and tools in the summer of 1869,

when he was working in Bonnat's atelier. That same summer, when he knew that his time in France was ending, he also purchased a plaster cast of a head and a hand, an écorché "anatomical figure," "Houdon's cold girl," and several photographic "life studies." See McHenry, 10–11. See also TE to CEC, 30 Aug. 1869, and Eakins' Spanish notebook, 5–6 (CBTE, Foster and Leibold, 152–153 [letter], and fiche series I 9/E/4 [notebook]). None of these items seems to have survived.

Chapter 6. Bonnat and Spain

1. TE to BE, 24 June 1869 (CBTE, Foster and Leibold, 210).
2. Sartain had come to Paris in Mar. 1869 intending to study with Bonnat. He shared Eakins' studio and must have encouraged Eakins to join the atelier. Sartain's career is discussed in TE's letters to BE of 3 June 1869 and 2 July 1869 (CBTE, Foster and Leibold, nos. 48 and 51), and by Weinberg 1991, 166–168. Earlier letters home indicate that Eakins knew other American painters, Milne Ramsey and E. A. Poole, who were studying with Bonnat; see TE to Eliza Cowperthwait, 27 Dec. 1867 (Dietrich Collection), and Milroy 1986, 256–257. Eakins' tenure in Bonnat's studio is suggested by an entry in his Spanish notebook (CBTE, 8) some time between entries made on 26 July and 12 Aug., when "mois a l'atelier Bonnat 25.00[f]" and "Bienvenue 10.00[f]" indicate the payment of a month's tuition (customarily paid in advance) and the "welcome" treat traditionally offered to other students on the first day of study. No additional payments are recorded in this notebook or in the letter home recapitulating his accounts, TE to CE, 30 Aug. 1869 (CBTE, Foster and Leibold, no. 52). On 8 Sept. he wrote to his father that he had "given up going to Bonnat," who had left for Bayonne (SME transcript, Goodrich 1982, I: 51).
3. Charles Timbal, "Gérôme, étude biographique," *Gazette des Beaux-Arts* 14 (1876): 339. For analysis of Gérôme's portraiture see Foster 1972, 60–61, and Ackerman 1986.
4. Samuel Isham, *American Painting* (New York, 1916), 525–526.
5. Frederic Masson, *L'Orient par J.-L. Gérôme* (Paris, 1910), 5. Bonnat traveled to the Middle East with Gérôme in 1868, a fact recorded by Eakins in a letter to his father, 30 Dec. 1867. "Thus there is mourning in France among students" (CBTE, Foster and Leibold, no. 35).
6. Ackerman 1969, 238, first proposed that Gérôme recommended Bonnat to Eakins as a source for portrait training, citing the experience of E. H. Blashfield, who enjoyed the same team-teaching experience as Eakins. Gérôme sent Blashfield to Bonnat's studio for three months of training before entering the Ecole, and years later Bonnat redirected Blashfield to Gérôme for special consultation. See Blashfield's remarks in John C. Van Dyke, ed., *Modern French Masters* (New York, 1896), 47.
7. TE to BE, 8 Sept. 1869 (SME transcript, Goodrich 1982, I: 51).
8. Ibid. The first three sentences are not published by Goodrich, who shared this transcript with me. Bonnat took over the private atelier of A. A. E. Hébert in 1867.
9. Thadée Natanson, *Peints à leur tour* (Paris, 1948), 172.
10. Blashfield, in Van Dyke, *Modern French Masters*, 49. Bonnat's career has been recently summarized by Anne Clark James in Gabriel P. Weisberg, *The Realist Tradition: French Painting and Drawing, 1830–1900* (Cleveland: Cleveland Museum of Art and Indiana University Press, 1980), 271–273, cats. 139, 151, 152. Bonnat's impact as a teacher has been splendidly surveyed in Weinberg 1991, 155–186. Her discussion of Eakins and Bonnat (168–170) builds on the initial observations of Ackerman (1969, 238, 247–248), Foster (1972, 60–74), and Milroy (1986, 255–265).
11. TE to BE, 8 Sept. 1869 (Goodrich 1982, I: 51). A portrait of Bonnat also appears in Weisberg, *Realist Tradition*, 272. Also see Weinberg 1991, 164, for Degas' portrait of Bonnat.
12. Blashfield, in Van Dyke, *Modern French Masters*, 50.
13. Prince Eugène of Sweden, "Souvenirs sur Léon Bonnat," *Revue de l'art ancien et modern* 45 (Jan. 1924): 22 (author's translation).
14. Marcel Pays, "Léon Bonnat, peintre et collectionneur," *L'Art et les artistes* 4 (1922): 142 (author's translation).
15. TE to BE, 8 Sept. 1869 (Goodrich 1982, I: 51).
16. Pays, "Léon Bonnat," 142. Bonnat gave up his private atelier in 1882 and became professor at the Ecole the following year.
17. Ibid.
18. TE to BE, 8 Sept. 1869 (Goodrich's transcript, 1982, I: 51).
19. Roger Ballu, "Les Peintures de M. Bonnat au Palais de Justice," *L'Art* 4 (1876): 121.
20. Pays, "Léon Bonnat," 133.
21. Frank Jewett Mather, Jr., *Modern Painting* (Garden City, N.Y., 1927), 115.
22. Mario Proth, *Voyage au pays des peintures: Salon de 1877* (Paris, 1877), 115.
23. J. A. Castagnary, *Salons* [1869] (Paris, 1892), I: 143; Mario Proth, *Voyage au pays des peintures: Salon Universel de 1875* (Paris, 1875), 115. *Madame Pasca* was first compared with Eakins' work by Ackerman (1969, 248, fig. 17). The painting is also reproduced in color in Weinberg 1991, plate 178.
24. "Quand je fais grandeur nature je mettrai toujours ma toile aussi près du modele qu'il soit possible. Comme la nature sera plus juste que votre tableau il serait moins bête d'éloigner la toile plus que l'objet que l'on copie. Voilà pourquoi les choses grandeur nature sont faibles d'habitude. On aime son aise quand on travaille. On met la toile pres de soi et l'on perd la grandeur de l'ebauche l'anatomie la grand construction et toute la qualité de surface. Pour bien copier la texture il faut mettre la toile et la nature à côté l'une de l'autre. Pas d'autre moyen. Si l'on fait la texture autrement on fait du chic" (CBTE, Spanish notebook, 41–42). Similar advice was jotted on p. 37: "J'ai dessiné une fois excessivement mal et en me donnais des peines excessives rien que parce que mon chevalet était incliné et du côté ce qui a toute la perspective d'une maniere impossible. Avoir toujours soin que la toile soit perpendiculaire et très juste surtout quand il s'agit de peindre de côté. Cela est très importante et très facile à oublier. Mettre toujours la toile à côté du modèle et regarder de très loin, et surtout au commencement du travail." [Once I drew extremely badly and gave myself excessive troubles, only because my easel was slanted and to one side, making the perspective impossible. Always take care that the canvas be perpendicular and very correct, especially when painting from the side. This is very important and easy to forget. Always put the canvas next to the model and look at it from far away, especially at the beginning of work.] Bonnat's similar method was described by Blashfield in Van Dyke, *Modern French Masters*, 51.
25. Emile Zola, *Salons* (Paris, 1959), 208.
26. Earl Shinn, *Masterpieces of the Centennial International Exhibition: The Art Gallery* (Philadelphia, 1876–78), 354.
27. See Jules Prown, "Eakins' *Baby at Play*," *Studies in the History of Art* 18 (1986): 121–127.
28. Théophile Thoré, *Salons de W. Burger* (Paris, 1870), 2: 290. *St. Vincent* was later installed in the church of St. Nicolas des Champs.
29. Castagnary, *Salons* [1869], I: 341–342; *The Assumption* was painted

for the church of St. Andrew in Bayonne.

30. Dorothy Weir Young, *The Life and Letters of J. Alden Weir* (New Haven: Yale University Press, 1960), 31, 37–38. Ackerman published a longer extract from this letter with an illustration of Bonnat's *Christ,* 1969, 253, 256, as did Weinberg 1991, 158–159. Laws regarding the division of church and state caused the removal of the painting from the Palais de Justice before 1881. It is now in the collection of the Petit Palais.

31. Ballu, "Les Peintures de M. Bonnat," 123–124.

32. Ibid.

33. René Cuzacq, *Bonnat, l'homme et l'artiste* (Mont de Marson, 1940), 18. Within two years of its debut at least one critic had concluded that this painting was the work of an "innovative genius" and ranked it among the great "Crucifixions" of the western tradition; see Th. Veron, *Memorial de l'art et des artistes de mon temps; Le Salon de 1876* (Paris, 1876), 14.

34. G. W. Sheldon, *American Painters,* rev. ed. (New York, 1881), 202, emphasis in original. Sartain had solicited this letter from Bonnat and Eakins had written to Gérôme, each seeking endorsement of their demand for expanded life classes at PAFA in 1876–77. See Milroy 1986, 329–330, for the original French text of this letter, now in the Historical Society of Pennsylvania; and Foster and Leibold, 131, n. 5. Eakins echoed similar sentiments about nature and copying earlier art in 1879; see Brownell, 742.

35. Lucy H. Hooper recalled in 1875 that the two "great successes" of 1874 were Bonnat's *Christ* and Gérôme's *Eminence Grise,* and she described the "sensation" created by Bonnat's work in "The Salon of 1875," *Art Journal* (American ed.) 1 (1875): 188–189. Clarence Cook, in *Art and Artists of Our Time* (New York, 1888), 170, recollected the "storm of controversy" surrounding Bonnat's *Christ,* noting that most artists were united in their admiration of the drawing and the "masterly overcoming of difficulties," but the public was very divided in opinion. Other American responses are excerpted in Clement and Hutton, 75–76.

36. "Bayard" [Taylor?], "The Paris Salon of 1874," correspondence dated 29 May 1874, to the [New York?] *Evening Post;* undated clipping, found in PAFA Salon catalogue.

37. Susan Eakins also referred to this painting as *Ecce Homo,* a phrase that follows Eakins' other Latin titles (e.g., *Salutat*) and the Latin signature and inscription on the painting. See SME to George Corliss, 14 July 1886 (PAFA Archives; Foster and Leibold, 347). On this painting and its context, see Goodrich 1982, I: 190–196, and Elizabeth Milroy, "'Consummatum est . . . ,' A Reassessment of Thomas Eakins' *Crucifixion* of 1880," *Art Bulletin* 72 (June 1989): 269–284.

38. Goodrich's notes from an interview with Wallace in 1938 (AAA, portions in Goodrich 1982, I: 190–191).

39. *A History of American Art* (Boston, 1902), I: 204.

40. W. H. Brownell, "The Younger Painters of America," *Scribner's Monthly* 20 (May 1880): 4, 13.

41. Léon Bonnat, "Velasquez," *Gazette des Beaux-Arts* 1 (1898): 177 (author's translation).

42. TE to BE, 5 Nov. 1869 (CBTE, Foster and Leibold, 210); and "Spain and the Spanish Notebook," 60–61. McHenry (15) first suggested that Gérôme, with his Spanish ancestry and admiration for Spanish art, may have encouraged Eakins' trip, although Gérôme was in Egypt at the time Eakins decided to go to Spain rather than to North Africa. Ackerman first proposed that Bonnat's enthusiasm encouraged Eakins' interest in Spain (1969, 238).

43. Eakins' trip to Spain, and the correspondence and manuscripts from this journey, are extensively described in Goodrich 1982 (I:

59–64). Milroy also examines the meaning of the Spanish trip (1986, 276–313).

44. TE to BE, 2 Dec. 1869 (CBTE, Foster and Leibold, 211).

45. Goodrich 1982, I: 28–29, cites a letter from TE to BE, 9 May 1868 (Dietrich Collection). A subsequent letter fragment, also commenting on the Salon, is TE to BE, undated (late May 1868) (CBTE, Foster and Leibold, no. 40). Goodrich discusses Eakins' opinions of his contemporaries in Paris; see 1982, I: 45–48, 62–63.

46. AAA, Goodrich 1982, I: 46–47. Eakins purchased a photograph of Couture and his "book" (*Entretiens*) in 1868, according to a letter to his father of 17 Mar. (CBTE, Foster and Leibold, no. 39, fiche series I 2/F/4–6).

47. Spanish notebook, 29; Goodrich 1982, I: 62; Foster and Leibold, 61.

48. Bonnat, "Velasquez," 181.

49. E. A. Carolus-Duran (1838–1917), also powerfully moved by the Spanish masters during a sojourn in Spain from 1866–68, was recognized as a "modern emulator of Velasquez" and had an early style affiliated with Bonnat's; he did not begin teaching until the 1870s, when he attracted many American students. On his work, closely identified in this period with the technique described as *premier coup,* see Weinberg 1991, 189–219.

50. "D'ailleurs c'est bien la manière de Bonnat et de Fortuny, c'est là toujours que m'ont portée mes propres instincts et m'ont fait maitre toutes mes difficultes [preceding seven words crossed out]. Aussitot mes choses mises en place assez brutalement je chercherai mon plus grands effets tout de suite. Je mettrai toujours autant de lumière que possible au commencement. Ne jamais oublier ça. C'est ça qui m'a foutu dedans chez Bonnat, ou j'ai dessiné assez bien. La filandière de Velasquez quoique tres empatée n'a point de rugeurs qui accrochent la lumière. Aussi fait il mieux que Bonnat. Empater alors tant que je voudrais mais ne jamais laisser de ruguers. Les choses de Velasquez sont presque faits pour glisser dessus. Ribera aussi fait très lisse mais la dedans il creuse les plis de peaux pour ses vieillards et remplit lex creux de la couleur transperante de l'ombre. Velasquez frotte beaucoup avec des couleurs tout à fait transperantes dans les ombres mais le dessous et deja tres solidement peint" (Spanish notebook, 31). Parts of the first and last sentences of this text are quoted in Goodrich 1982, I: 62. Goodrich translates the words *frottir* and *frotte* as *glaze,* though Eakins' use elsewhere of the term *glisser* makes it more likely that he means *scumble* or *rub.*

51. Spanish notebook, 29 (Goodrich 1982, I: 62).

52. Earl Shinn, *The Nation* 27 (17 Dec. 1874). Regnault, a Prix-de-Rome winner the year Eakins came to Paris, had been in Spain in 1868–69, where he commenced his famous portrait of General Prim (Louvre), which won a medal at the Salon of 1869. Regnault, like Bonnat and Gérôme, essayed extremely naturalistic, bloody subjects, notably *The Execution Without Judgment under the Moorish Kings of Granada,* which—like Eakins' *Gross Clinic*—was said to cause faintness in sensitive viewers. As with Bonnat's *Le Christ* or Gérôme's *The Heads of Beys,* the propriety of exhibiting such a grisly image to the general public was questioned because of a "demoralizing" impact analogous to actually witnessing such an event. It was agreed, however, that artists would appreciate such work as "art." Following some of this logic, *The Gross Clinic* was exhibited at the Centennial in Philadelphia among the medical exhibits, where the audience was assumably prepared to understand it as a representation of a real event, not "art." See S. G. W. Benjamin, *Contemporary Art in Europe* (New York: Harper's, 1877), 102.

53. Castagnary, *Salons* [1870], 398. See Charles Sterling and Margaretta M. Salinger, *French Paintings: A Catalogue of the Collection of the*

Metropolitan Museum of Art (New York: MMA, 1966) 2: 200–204. TE's notes on *Salomé* are in his Spanish notebook, 35; most of his remarks are published in Goodrich 1982, I: 63.

54. Spanish notebook, 42. This remark comes at the end of this book, among remarks entered after the Salon notations in the spring of 1870. The Fortuny painting, seen "chez M. Borie," has not been identified; probably it was *The Gamblers,* owned by Adolphe Borie, who lent it to an exhibition at the Union League in Philadelphia in Oct. 1873; see Gerdts and Yarnall, 1287. In about 1878 Earl Shinn noted that "M. A. Borie" of Philadelphia owned two Fortuny paintings, *The Manola* and *The Breakfast* of 1872; *Chefs d'Oeuvre d'art of the International Exhibition* (Philadelphia: n.d., c. 1879), 81. Eakins painted the younger Adolphe Borie and the architect J. J. Borie c. 1896–98; see cat. 209. An earlier reference to Fortuny (see n. 50) indicates that Eakins was well aware of his work by 1870. His impact on Eakins in the late seventies is discussed in chap. 9.

55. Young, *Life and Letters of J. Alden Weir,* 38.

56. TE to BE, 29 Mar. 1870; Goodrich 1933, 33.

57. Spanish notebook, 57; TE to BE, 28 Apr. 1870 (Goodrich transcript of a lost letter). A tribute to Velázquez may be present, however, in the pose of the drummer, who echoes a foreground figure in *Las Hilanderas.*

58. Spanish notebook, 35–36; Goodrich 1982, I: 63.

59. Ackerman first noted the blend of Gérôme and Bonnat in *Street Scene in Seville* (1969, 239). See also Milroy's analysis (1986, 302–309) and the discussion below in cat. 145.

60. See Spassky, 586–588. Milroy noted the parallels with Couture's work seen in *Carmelita Requeña* (1986, 299–301).

Chapter 7. Drawing: Thinking Made Visible

1. "The Fine Arts," *Philadelphia Evening Telegraph,* 1 Nov. 1882, 4 (PMA Eakins Archive, clipping file).

2. W. J. Clark, Jr., "American Art: A New Departure," *Philadelphia Evening Telegraph,* 13 Mar. 1878, 7 (PMA Eakins Archive, clipping file).

3. "The Water Color Society Exhibition at the Academy," *New York Daily Tribune,* 9 Feb. 1878, 5. Cook's opening review of this exhibition (*Tribune,* 2 Feb. 1878, 5) remarked that "we have very little drawing of the figure equal to" Eakins' work.

4. To Earl Shinn, 24 Mar. 1876 (Goodrich 1982, I: 121). Another passage, describing the virtues of the drawing in *The Schreiber Brothers,* is quoted below in chap. 12.

5. Johns 1980, 147; and see additional discussion in chaps. 1 and 2 above.

6. Fried. Barbara Novak first stated this opposition as "science and sight," noting the unreconciled coexistence of "mathematical" and "visual" interests in Eakins' work. She was also the first to identify the "combining process" so characteristic of Eakins' method. See her important study *American Painting of the Nineteenth Century: Realism, Idealism, and the American Experience* (New York: Praeger, 1969), 191–210.

7. Some of Eakins' drawings are on canvas, but these have mostly been covered by paint and are invisible except by infrared reflectography. Fortunately, the type of drawing sometimes found beneath the paint surface relates directly to extant perspective drawings, which offer easy access to such work. In defining drawing in relation to Eakins' work, I am excluding a special category of drawings made with a brush in ink or watercolor, sometimes included in the

realm of "drawing," in part because the supporting surface is usually paper. Wash and watercolor are distinct in Eakins' work, and more akin to oil painting, although—as in his oils—the quality of drawing is ever present. The distinctiveness of his watercolor method is discussed in chap. 9.

8. During their lifetimes SME and Williams sold only one drawing, a perspective study for *John Biglin,* now in MFA, Boston. They included eight student drawings (G 1–8) in their gifts to the PMA in 1929–30. Henry Marceau added to the PMA's collection by purchasing two perspective drawings from CB in 1944 (Siegl, cats. 8, 9); for himself, he bought the drawing for *Kathrin* (fig. 53). That same year CB sold about forty drawings through Knoedler's gallery; these items are now in the Hirshhorn and constitute the majority of the museum's collection of Eakins' drawings. Only five items published in the Hirshhorn's catalogue came from elsewhere (Samuel Murray's scrapbooks), and of these five, only three seem securely attributed to TE; see Rosenzweig, cats. 119, 122, 123. Two of the three drawings in the Dietrich Collection probably came to Seymour Adelman from CB; the *Will Schuster* drawing (fig. 123) is annotated as a gift, while another label records that SME gave him the camel and rider subject; see Avondale/Dietrich, cats. 12, 13, 14. CB also gave two perspective drawings for the portrait of Cardinal Martinelli to George Barker, a student of J. L. Wallace; these drawings are now in the Joslyn Museum (see chap. 19). The PAFA, MMA, and Cleveland Museum all acquired a perspective drawing from CB in the 1940s, too. Thus, of the seventy-four drawings known prior to 1985, almost 80 percent came from Bregler, with the remainder from SME or Murray. This pattern of provenance, combined with the complete absence of drawings from other sources, tends to diminish the likelihood of outstanding groups of lost drawings. No drawings known to have been sold or given away by Eakins survive.

9. Foster and Leibold, 5. The related provenance of the manuscripts, with speculation about the destruction or survival of additional papers, is discussed (1–27). Seymour Adelman told Susan Casteras that SME admitted to rescuing drawings consigned to the trash by her husband (correspondence from Casteras, Mar. 1992).

10. Foster and Leibold, 111.

11. Eakins' letter to Miller of 1 Feb. 1901 was published in *Kindred Spirits: The E. Maurice Bloch Collection . . . ,* part 2 (Boston: Ars Libri, 1992), no. 161. "I shall take pleasure in showing them to such students as are likely to understand and appreciate the lessons they embody," responded Miller, on 11 Feb. 1901 (PMA); see Siegl, 152. Goodrich corresponded with Miller in 1930, but no mention was made of the perspective drawings at that time. On the dispersal of drawings, see n. 8.

12. Bregler wrote to Carmine Dalesio on 3 Dec. 1939, describing how he had gone over the perspective drawings with SME and found them "in an almost hopeless state of decay, the paper crumbling to pieces as one unrolled them. However, I managed to save a few. Otherwise they would have been destroyed. These were given to me by Mrs. Eakins." In this same draft Bregler noted the loss of the perspective for *The Gross Clinic,* although it is not clear that he ever saw such a drawing (Foster and Leibold, fiche series IV 10/E/11). Bregler told Fiske Kimball that only six of Eakins' perspectives had been saved and mounted: "This was done by me shortly after his death. All others of his perspective drawings were in a state of decay and fell to pieces at the slightest touch" (undated draft, prior to 1938, fiche series IV 1/D/6). Bregler wrote Samuel Murray on 23 July 1939 that SME had given him the perspective

drawings "more than 15 years ago" and that he had mounted "some" and intended to try to save others (Foster and Leibold, 333).

13. Goodrich noted that Eakins made few drawings after his student days and generally "cared little" for drawing as a medium (1982, I: 107). A few sketches of President Hayes, discussed in chap. 19, and a quick drawing of Benjamin Rowland are the only portrait drawings from after 1870; two landscape sketches, of river profiles and cloud forms (cats. 153, 171), seem to have been done on the spur of the moment, when painting materials were not at hand. The scarcity of such landscape drawings throws doubt on the attribution of one large charcoal drawing, cat. 205, that cannot be securely tied to any project. Most of the extant "figure" drawings from after 1870 (outside of the perspective drawings discussed below) are sketches from other painting or sculpture, as in the many drawings of William Rush's work (cats. 180–188) or the sketch of Cabanel's *Venus* (cat. 189x).

14. The manuscript of this book is in the PMA; see introduction to cat. 92. Eakins' reasons for abandoning this book are not known, although his departure from the Academy probably interrupted work on the project and diminished his interest. However, he resumed teaching again soon after, and at least one drawing, cat. 112, is on paper watermarked 1887. Still contemplating publication of the manual for use in tandem with Art Students' League lectures, he may have been discouraged by the appearance of a rival manual, written by Leslie W. Miller, his friend at the School of Industrial Art: *The Essentials of Perspective* (New York: Scribner's, 1887). Miller's dainty, grayed, and anecdotal illustrations offer a useful contrast to Eakins' blunt style.

15. The same pen style appears in his drawing of *William Rush Carving,* made for the catalogue of a PAFA exhibition in 1881 (see Rosenzweig, 75), and a drawing of Dr. Agnew, after *The Agnew Clinic,* probably made about 1889 for some publication (see Siegl, 121). The *Rush* illustration, like an anatomical diagram, includes lettered inscriptions within the image, identifying the figures. Predictably, these drawings usually are on good paper, often the same sort used for his watercolors. Also in this mode are the illustrations to his paper on equine anatomy (cats. 82–86).

16. Philip Rawson, in commenting on the introduction of mechanical drawing machines in the late Middle Ages, notes that such devices allowed the achievement of a "rigid 'optical' accuracy of contour" that expressed assumptions about the "immutably valid formula" of the visual world. "Such science was imported into art, as science always is, for emotional reasons: to induce in the user and his public the satisfying self-confirmation that their activity is part of something irrefutable, durable, far larger than themselves. In fact, a sense of alienation from life, a sterilized reality, is also a result." Rawson also notes the intentional "coolness, thinness and stereotyped air of the diagram" adopted by modern artists to lend the validity of mathematics to their abstract imagery (*Drawing,* 2nd ed. [Philadelphia: University of Pennsylvania Press, 1987], 217, 30).

17. "Memories of Thomas Eakins," *Harper's Bazaar* 81(7) (Aug. 1947): 184, quoted in Siegl, 109. The same phrase was echoed by Thomas Anshutz in a letter to J. L. Wallace in 1884: describing the "usual slow and stately tread" of the school year at PAFA, he notes that "perspective is now the all engrossing topic—twice as far off, twice as far away." Anshutz's misstatement of Eakins' rule may have been intentionally humorous, as both he and Wallace were Eakins' senior assistants (Sellin, in Roanoke, 52). The impact of Eakins' lecturing is described by students in Goodrich 1982, I: 188–189. The accessibility of this style drew "outsiders" to his lectures; "stonecut-

ters who worked on tombstones would come," noted Tommy Eagan (McHenry, 69). Both Eakins' prose and drawing style can be usefully compared with the discursive text and anecdotal drawings in the exactly contemporary manual by Miller.

18. Rawson, *Drawing,* 1: 21–23.

19. Shinn concluded, however, that Eakins was the "only one of all the French pupils who has come home and improved on himself instead of retrograding" ("The Pennsylvania Academy Exhibition," *Art Amateur* 4 [May 1881]: 115). Shinn was more enthusiastic about these pictures when they first appeared, six years earlier; see n. 46 below. Shinn's remarks recall the reaction of M. G. Van Rensselaer, who met Eakins in 1881 and noted that he had the appearance of a "clever but most eccentric-looking mechanic," "much more like an inventor working out curious & interesting problems for himself than like an average artist" (Goodrich 1982, I: 198).

20. Setting aside the life class drawings from his student days, the few figures depicted in his illustrations, and the scattering of thumbnail figure studies (usually drawn from a painting or sculpture) in his sketchbooks, there are only eight drawings known outside the Bregler collection that include figures. Two of these are medium-sized preliminary perspective drawings (figs. 58, 123), and five are larger, more finished perspective drawings: Siegl, cat. 10; G 58 (MFA, Boston); G 69 (priv. coll.); Rosenzweig, cat. 39; and fig. 112. The anomalous drawing for *Kathrin* (fig. 53) is discussed below. The absorption of figure drawing into Eakins' painting also is discussed in chap. 8. Few figure studies exist in oil, as well; Eakins seems to have seen all such preparatory work as potentially digressive.

21. The character of the *Kathrin* drawing bears comparison only with an early charcoal figure study in the PMA, Siegl, cat. 3. Siegl dated this *Study of a Child* to 1866–68, but its bold style and its emphasis on simple volumes may draw it into the period of 1870–72, when Eakins was working on family portraits and domestic genre scenes.

22. Hirshhorn; see Rosenzweig, cat. 23.

23. McHenry, 43; Brownell, 741.

24. References to this manuscript are to the paginated typescript, prepared by Theodor Siegl in the early 1970s. I am grateful to Darrel Sewell for his permission to cite this source. Early drafts of some sections of this text are in CBTE, as are a few advanced exercises that Eakins evidently deleted in his second draft; see Siegl, cat. 56, Foster and Leibold, 122–124, and fiche series I 8/C/3–8/E/9.

25. "For Eakins," wrote McHenry, "the mathematical sciences held a charm of security, a charm of dependability, which they have held for many before him and after. He saw . . . that mathematics is the foundation of all beauty, because mathematics is the science of proportion, and therefore even beauty can be somewhat stated in scientific terms" (22). John White's remark is from his classic study *The Birth and Rebirth of Pictorial Space* (London: Faber and Faber, 1957; rev. ed., 1967), 275. TE's aphorism was quoted by SME in the draft of her letter to Mrs. Lewis R. Dick [n.d., c. 1930] (CBTE, Foster and Leibold, 299; see also Bregler I, 383).

26. TE, PMA typescript, 1.

27. McHenry (22–28) asserted that Eakins made an "original" contribution to artists' perspective, although her analysis is more enthusiastic than it is logical, and I have found Eakins' instruction to be more personalized than innovative. A thorough examination of his methods in the context of French and American practice in this period has not been attempted here, although the topic deserves attention. The bibliography on the history of perspective is large and contentious; the number of teaching manuals is enormous, and their contradictory methods and terms can be confusing. No expert

on this subject, I have tried to use Eakins' terminology, as he intended it, or terms generally understood by nonexperts, aware that I may annoy specialists accustomed to more precise, technical meanings. I have benefited from Margaret A. Hagen, *Varieties of Realism: Geometrics of Representational Art* (Cambridge: Cambridge University Press, 1986), for its introduction to modern theories of perception and the multiple geometries of perspective; her message of cultural relativity, in examining alternate systems in times and places outside of the western tradition, is an important one for art historians, and her bibliography is wide-ranging. Also useful is White, *Birth and Rebirth*; M. H. Pirenne, *Optics, Painting and Photography* (Cambridge: Cambridge University Press, 1970); W. M. Ivins, *Art and Geometry: A Study in Space Intuitions* (New York: Dover, 1964); Fred Dubery and John W. Willats, *Perspective and Other Drawing Systems* (New York: Van Nostrand Reinhold, 1972, 1983); and Michael Kubovy, *The Psychology of Perspective and Renaissance Art* (Cambridge: Cambridge University Press, 1986).

28. TE, PMA typescript, 2.

29. TE, PMA typescript, 4. The vertical line is offset to the left only in Eakins' high school exercises and in his own drawing book illustrations (e.g., cat. 100). For teaching purposes, this may have been done to keep the axis of measurement clear of the depicted object, as well as to make the exercise more challenging, since a regular object offset to the side will not present a symmetrical image.

30. The perspective drawing for this painting, in the collection of Dr. Peter McKinney, is marked with the notation that the horizon is sixty-three. See also chap. 13.

31. TE, PMA typescript, 5.

32. A text used by Eakins at Central High School recommends this standard horizon, probably because this height approximates the eye level of a standing person of average height, and because it can be easily reduced in scale calculations. See William Minifie, *A Text Book of Geometrical Drawing for the Use of Schools . . .* , 2nd ed. (Baltimore: William Minifie & Co., 1850), 86–87.

33. TE, PMA typescript, 5. See also McHenry, 25.

34. Ibid.

35. TE, PMA typescript, 3.

36. The special problem of the foreground in life-size portraits is discussed in chap. 19 of this book. A demonstration of the distortion in objects close to the camera can be seen in Hagen, *Varieties of Realism*, 138. Such joking photographs were also taken by Eakins' students; examples remain in the estate of Mary Bregler and in the Art Gallery of Ontario, from the circle of Eakins' student George A. Reid.

37. McHenry (23) argued that all the boating subjects were motivated by Eakins' interest in a series of "progressively more difficult perspective problems." In her analysis (25–26) the search for an optimum, undistorted angle of vision dominated Eakins' choice of eye level and spectator distance.

38. TE, PMA typescript, 71.

39. On the visual angle, see chap. 19. Human vision remains fairly sharp within a 90-degree angle, but painters are generally advised to work within a 60-degree field, with an angle less than 45 degrees preferred. Citing Wertheim's Curve of optical acuity, Ivins notes that "2–1/2° from the point of greatest sharpness of vision there is a 50% decrease in acuity, and at 45° the acuity has fallen to 2–1/2%" (*Art and Geometry*, 924). Dubery and Willats note that perspective distortions enter the edges of a picture when the angle exceeds 25 degrees (*Perspective and Other Drawing Systems*, 84).

40. TE, PMA typescript, 71. Minifie suggested that the viewing distance never be less than the width of the picture (*Text Book of Geometrical Drawings*, 87). Charles Davies, author of another treatise used at Central High School, advocated a position based on the diagonal of the canvas: "It may be greater, and this is left to the taste of the artist" (*A Treatise on Shades and Shadows, and Linear Perspective*, 2nd ed. [New York: Wiley and Long, 1835], 157). More recently, John White suggested the "normal comfortable range for viewing" as "not less than twice its width" (*Birth and Rebirth*, 194).

41. On Leonardo's advice, see Dubery and Willats, *Perspective and Other Drawing Systems*, 71, 87. Large paintings to be seen by many people at once should be organized with an even longer viewing distance—ten or twenty times the height of the principal objects, advised Leonardo; see Hagen, *Varieties of Realism*, 134. Probably Eakins clinic paintings use such very long viewing distances.

42. Eakins sent this watercolor to the American Watercolor Society's exhibition in late Jan. 1875 as "Ball Players Practising," no. 313, $300; probably the painting and its preparatory drawings were begun in the summer or fall of 1874. On this watercolor (G 86), see Hoopes, 32; Stebbins, 168; Susan P. Carmalt, "Selection I: American Paintings and Watercolors from the Museum's Collection," *Bulletin of the Rhode Island School of Design* 58(4) (Jan. 1972): 18–22; and *A Handbook of the Museum of Art, Rhode Island School of Design* (Providence: The Museum, 1985), no. 199, p. 265, which identifies the batter as the first baseman of the Philadelphia Athletics, Wes Fisler, with the team's catcher, John Clapp. Unlike most of Eakins' watercolors, there are no oil studies preceding this work; the precision in the figures suggests that they once existed.

43. In a more developed perspective drawing Eakins often ruled the inch scale in ink, to increase its precision and durability and to differentiate it from other types of lines in the drawing. See the perspective made for the portrait of John H. Brinton (fig. 229; plate 20). Another type of inch scale appears in some of the perspectives for the rowing subjects; see figs. 111, 114. Eakins describes the construction of an inch scale and its precision up to one thousandth of an inch in his manuscript (11, 19–20). See cats. 100, 101.

44. TE, PMA typescript, 9. The application of this rule allows for the easy location of the horizontal lines on a perspective grid, once the orthogonals have been drawn. Diagonals emanating from this "measuring point," drawn to the foot markings on any baseline, will intersect the orthogonals exactly at the corners of squares on the grid. Once these corner positions have been located, the edges of the squares can be quickly ruled. (See cat. 100 for Eakins' demonstration of this system.) The principle of the measuring point (or "distance point") is a cornerstone of most perspective manuals since the publication of Alberti's *Della Pittura* in 1436. A useful visualization of the geometric principles involved is offered in Dubery and Willats, *Perspective and Other Drawing Systems*, 57.

45. Goodrich 1982, I: 94. The full letter is published in Ackerman 1969, 241.

46. "Fine Arts: The Water-color Society's Exhibition," *The Nation* 20 (18 Feb. 1875): 120. Eakins exhibited two other sporting subjects in this show: *Race Boats Drifting* (see cat. 233) and *Whistling for Plover* (unlocated). Other responses to *Baseball* are cited in chap. 9, nn. 35, 36. For my grasp of nineteenth-century baseball throughout this discussion I am indebted to the helpful observations of my household expert, Henry Glassie.

47. "Culture and Progress: Eighth Exhibition of the Water-Color Society," *Scribner's Monthly* 9 (Apr. 1875): 764.

48. Ackerman (1969) first noted Eakins' "mastery of Gérôme's amphitheater perspective, great circles of rooms which swoop behind the spec-

tator to include him as an observer in the bleachers or as a participant on the sands of the arena," imitated in the clinic pictures and *Between Rounds* (245). Wrote Eakins to Shinn, "Gérôme used to get out his *Pollice Verso* to illustrate to me his principles of painting" (242).

49. Rosenzweig, 56.

50. Ackerman 1969, 241.

51. TE, PMA typescript, 28.

52. "Thomas Eakins as I knew him" (CBTE, Foster and Leibold, fiche series IV 13/13/D).

53. TE, PMA typescript, 18.

54. Rawson, *Drawing,* 54–55. Ackerman publishes no examples of Gérôme's compositional sketches, but he notes that they are often jumbled on a page, surrounded by drawn borders, and executed in a loose style unrelated to his other drawings—all characteristics of Eakins' work as well (1986, 162).

55. In 1912, as the consideration of other geometries (principally the viewpoint at infinity, as used in mechanical drawing and Egyptian or Greek painting) gained attention, Jacques Rivière described perspective as an "accidental" thing, like lightning. "It is the sign, not of a particular moment in time, but of a particular position in space. It indicates not the situation of the objects, but the situation of the spectator. . . . Hence, in the final analysis, perspective is also the sign of an instant, of the instant when a certain man is at a certain point" (quoted in Dubery and Willats, *Perspective and Other Drawing Systems,* 111). The abandonment of this fixed perspective was occasioned, according to Rivière, by a wish to express the consciousness of objects created by movement and accumulated experience, as with actual perception. See Hagen, *Varieties of Realism,* 201, 252–283.

56. "The Fine Arts," *Philadelphia Telegraph,* 19 Nov. 1881 (PMA Eakins Archive). This writer noted that Eakins was "not an opponent" of sketching and that he "candidly admits its worth when pursued under proper auspices," but that he was "anxious that his students shall be firmly grounded in what he deems to be essentials," and, because "his methods of study are so opposed to those of the majority of artists," he did not deprecate out-of-school study, but neither did he encourage it. This article called for an expansion of the Academy's curriculum, voicing criticism that would mount until Eakins' forced resignation in 1886. It is interesting to consider his sudden increase in outdoor sketching in oils in 1881 and 1882 in light of this criticism; see cats. 246–250.

57. Portions of three sketchbooks and one pocket notebook from before 1870 show Eakins' early, conventional practice. After 1870, only two notebooks survive, both from the period of *William Rush Carving,* when Eakins was ranging around Philadelphia in search of background information, and traveling to Washington for the Hayes portrait commission. See cats. 188, 189.

58. Goodrich 1982, I: 197. Eakins told her that he had "destroyed all his academic studies & since that time has never worked in black and white."

59. See n. 56.

60. Goodrich 1982, II: 184–185.

61. Henry Glassie has identified the character of American Protestant folk art in qualities of restrained individualism, overt utilitarianism, and deep pleasure in skillful manipulation of natural materials to very complex artificial ends. My reading of Eakins' "American" aesthetic has been influenced by many conversations with Henry; the core of his argument can be found in *The Spirit of Folk Art* (New York: Abrams, 1989). Much of Eakins' method can be understood as a version of French academic practice, and his "realism" cannot credibly be isolated as an "American" trait. More reason-

ably, however, it could be argued that only in America could one receive this kind of mixed education—part European, part Quaker—with its emphasis on the material and the conceptual, the individual and the collective vision.

Chapter 8. Oil Painting: The Material World

1. An oil study by Charles Fussell, *Young Art Student (Sketch of Thomas Eakins),* probably painted between between 1861 and 1866, shows Eakins at work with palette and brush, indicating some experience with oils prior to the spring of 1867, when Gérôme promoted him to painting (PMA, see Siegl, appendix A, no. 31). The sessions implied by this portrait must have been inconsequential, however, given Eakins' struggles in Paris. SME commented that Eakins may have worked "experimentally" in oils prior to 1867 but that no examples survived (CBTE, Foster and Leibold, fiche series II 4/B/12) Recently, scholars have drawn attention to the physicality of Eakins' paint surfaces; see Sewell, 19, and Johns, 1983, 22.

2. Brownell, 740. Brownell noted the "radical" quality of this opinion.

3. Rogers, 3. McHenry publishes this excerpt (43), and comments that it was "generally believed" that Eakins wrote most of this text.

4. Quoted by CB in a letter to Carmine Dalesio, 3 Dec. 1939 (CBTE, Foster and Leibold, fiche series IV 10/E/10–13). The gift of a study to Wallace is mentioned in a letter of 22 Oct. 1888 (CBTE, Foster and Leibold, 246).

5. "It was not the custom of Eakins to sign sketches," wrote CB to a Mr. Gurevitz on 30 May 1939. "So to insure their authenticity for future generations I have inscribed on the front of them giving title and name of Thomas Eakins" (CBTE, Foster and Leibold, fiche series IV 2/F/5). Bregler's neat printing appears on most of the oil sketches found in his collection, either scratched into the paint surface on the recto or on paper labels glued to the verso. These labels are also seen on items from his collection in the Hirshhorn. I have found no sketches signed by Eakins himself. Some studies in the PMA have been "signed" by SME.

6. TE to BE, undated, late Nov. 1869 (quoted in Goodrich 1982, I: 52). Goodrich listed about 460 oils and finished watercolors from the period beginning with Eakins' return to Philadelphia in 1870. Within this roster, I have counted 90 oil sketches or panels that are 10 × 14 in. or smaller; about 40 are larger. Because work discovered since 1933 tends to be in this study category, the percentage of such studies may approach 30 percent of known paintings. Predictably, more than two-thirds of these oil studies were done between 1873 and 1887, when Eakins was most active outdoors and when his work was most diverse.

7. TE to BE, 29 Oct. 1868 (CBTE, Foster and Leibold, 209). Ackerman describes Gérôme's sketch technique (1986, 162), although no "daubs" of this order are included in his catalogue raisonné. Occasionally Gérôme would "finish up" a sketch for presentation as a gift, which may explain the elaborateness of some existing studies.

8. Eakins sent "Study (Mrs. Perkins Sitting on Dr. M's Chair)" to the Philadelphia Sketch Club's exhibition in Jan. 1882, at a time of rising interest in the more spontaneous and intimate aspects of art. This fascination was expressed in the growth of clubs, such as the American Watercolor Society and the Salmagundi Club, that sponsored special sketch exhibitions or encouraged the submission of such work to their annual shows. This same oil study was sent to Chicago in 1882, and another "Study," lent by Margaret Eakins (perhaps one of the sketches of her spinning, like cat. 243), ap-

peared at PAFA that same year. "A Study" was seen in Detroit in 1883, and "Study of a Girl Spinning (Nannie)" was shown at a sketch exhibition at the American Art Gallery in New York in the fall of 1883. The generic titles make it difficult to identify these paintings exactly, but most likely they were the larger, more finished studies, like *The Spinner (Nannie Williams)* of c. 1878, 30 × 25 in. (Worcester Art Museum). See Milroy, *Lifetime Exhibition Record*. Also, the term "study" in a title can be misleading in this period; often it described finished, independent compositions of a modest size with no narrative structure.

9. CB to Lawrence A. Fleischman, 23 Nov. 1955 (PMA Eakins Archive). This observation is reiterated in other letters in CBTE; see Foster and Leibold, 126–127. The parallels with Gérôme's method are noted in chap. 2, n. 17, and chap. 4, n. 27.

10. The sketch for *The Pathetic Song* is catalogued by Rosenzweig, 93–94. On the Turner portrait, see chap. 19. Many similar compositional sketches are in the PMA and the Hirshhorn.

11. "Thomas Eakins as I knew him" (CBTE, Foster and Leibold, fiche series IV 13/D/13). SME painted the figures of TE and Dr. Fred H. Milliken, at the lower right, from a photograph discovered in CBTE. The other portraits were done directly from life onto the canvas. The large study of Agnew (G 237) is now at the Yale University Art Gallery; the small oil sketch is unlocated.

12. Another panel of the same size, G147 (Yale University Art Gallery), must have been done about the same time. It shows Maggie twice in the same pose but turned 180 degrees, so that she faces away from us. The Yale sketch preceded a different watercolor, *Homespun* of 1881 (MMA). The two watercolors, both sometimes called *Spinning*, are G 144 and 146; see Hoopes, 58–63.

13. Eakins was fond, like Sully, of certain fixed formats in portraiture (see chap. 19). The tendency to shrink from the edge of his sketch panels is a hallmark of Eakins' work; sketches that appear neatly finished to the edge of the support usually have been cropped (e. g., cats. 248, 250) or overpainted (cats. 234, 235) or misattributed.

14. For SME's remarks on the use of these sketches in preparing large portrait canvases, see chap. 19. On Eakins' devices to keep his sitters posed consistently, see chap. 19, n. 60. The transfer method seen in *Fifty Years Ago* is discussed in chap. 9 and in the appendix.

15. Eakins seems to have been conscientious about the materials used in his finished canvases and watercolors, although Bregler remarked that in conserving some of his teacher's deteriorated paintings he had noticed occasional use of a poor quality fabric: "The boss was cheated by Weber [a local art supplier] in selling him canvas" that appeared to be linen but was actually jute, noted CB to Murray (draft, n.d., CBTE, Foster and Leibold, fiche series IV 1/E/6). After fifty years the jute had revealed itself in characteristic brittleness. Bregler did not mention which canvases showed these traits. On Eakins' materials and on the preparation of his panels, see the appendix.

16. The smaller paint box, made by Eakins and still containing two panels, was given by Bregler (via Knoedler's) to the Fort Worth Art Association in about 1944; along with *Swimming*, this box is now in the Amon Carter Museum in Fort Worth. On the panels for this box, see cat. 249. The existence of a larger box has been proposed by Siegl (73), based on Eakins' steady use of c. 10 × 14 panels. A standard commercial panel size, of course, could have determined Eakins' design or purchase of such a box, although Eakins' panels are all slightly irregular, suggesting that they were not commercially made. Many of these panels have been divided or trimmed since 1930, producing a false sense of diverse sizing.

17. Several of Eakins' palettes and brushes are in the Hirshhorn (Rosenzweig, cat. 130), the Dietrich Collection (Avondale/Dietrich, cat. 78), and in the collections of Abram Lerner and Mr. and Mrs. Ben Wolf. Like the palettes and brushes found in Bregler's collection, many of these were used by SME and CB, and it is difficult to sort out their ownership. The brushes in the Dietrich Collection, from Seymour Adelman, have flat ferrules and squared bristles; the trace of 1/4- and 3/8-inch blunt brushes is most obvious in sketches like *Spinning* (plate 3). Also apparent is the use of even smaller, round brushes in the more detailed areas, such as the face of the model in *Fifty Years Ago* (plate 6).

18. On Eakins' palette, see Bockrath in *JAIC*, and his appendix in this volume. See also Bregler II, 38; for Murray's description and Siegl's technical analysis of paints, see Rosenzweig, 227.

19. See Siegl, 173, and other X-radiographic photos in the appendix in this book. In the Prado, Eakins noticed pentimenti emerging through the layers of Velázquez's paint, and he counseled himself in his Spanish notebook (32–33) to always scrape his canvas well when making changes. This precaution was obviously not so important for small studies.

20. The most complex assemblage in the Bregler collection is the group of fragments once united as G 135: see cats. 245–247 and figs. 247, 257. Also once united were cats. 235 and 236.

21. On the circumstances of the Crowell nieces' study, which may have contributed to the mental instability of Ella Crowell, see my essay "Ella Crowell's Suicide," in Foster and Leibold, 105–114. CB's letter to Carmine Dalesio is dated 3 Dec. 1939; see Foster and Leibold, fiche series IV 10/E/10–13.

22. Seymour Adelman often spoke of a bonfire in the yard of 1729 Mount Vernon Street that he interrupted in the spring of 1939. On the good intentions of the censor (probably Elizabeth Macdowell Kenton or Addie Williams) and the background scandal of 1886, see "'Trouble' at the Pennsylvania Academy," in Foster and Leibold, 69–79, and 15, n. 29. Bregler reiterated in other letters that "many of [Eakins'] sketches were destroyed," although he does not comment again on the circumstances (CB to Carmine Dalesio, n.d., CBTE, Foster and Leibold, fiche series IV 1/B/11).

23. Various censors also may have wanted to convey the impression that Eakins was always businesslike and focused in his use of nude models. The majority of the surviving studies of nude women relate to the Rush project, including G 111, 113, 202, 203, 439, 445, 447, 451, 454, and Hirshhorn cat. 114. Most of these are so much larger than the Bregler studies that it is difficult to compare their technique; the one that is most similar in scale, G 113, a careful study of Rush's model (Art Institute of Chicago), is finely finished and therefore different in spirit from the Bregler studies. One other nude woman, G 204, a study in oil for an unfinished watercolor, G 205, is also so much larger in scale that comparison is difficult. See Hoopes, 50–51. The closest similar example is tantalizingly obscure: a seated nude, painted on a cardboard panel very close to the size of the Bregler studies (13 × 8 3/4 in.) is visible from the knees down but otherwise is scraped and covered by a landscape sketch (PMA; Siegl, 96). The landscape sketch, probably from the early 1880s, would offer a terminus date for the nude underneath.

24. Eakins' own life class work from Paris (see Siegl, cats. 4–6) demonstrates this larger scale; see also Weinberg 1984, 29–31, for other examples from the Ecole in the 1870s. Eakins' late full-length nude studies, G 203 (Hirshhorn) and Hirshhorn cat. 114, demonstrate the endurance of this format in his work. The absence of accounts describing Eakins' painting for the benefit of his students implies

the more formal structure of his classroom visits, which seem to have followed the pattern of Gérôme's dignified rounds: occasionally correcting a student's work but never painting with them. In his letter to Coates in 1886, Eakins admitted to sharing the "advantages of my private studio" with his advanced students, with the implication that he allowed them to paint from his model while he was working on his own projects. This may have been the context of these small studies. See TE to Coates, 11 and 12 Sept. 1886 (CBTE, Foster and Leibold, 237–238). Most similar to these sketches, particularly cat. 238, are the two small oil studies of a standing masked nude by the Canadian painter George Reid (1860–1947). Both of Reid's oils are a bit smaller than Eakins' panels but are similar enough in particulars of the background and the model to have been painted on the same day. Reid, who served as an anatomy demonstrator, surely qualified as one of Eakins' advanced pupils. See Christine Boyanoski, *Sympathetic Realism: George A. Reid and the Academic Tradition* (Toronto: Art Gallery of Ontario, 1986), cats. 5, 6. The similarity of Reid's work, which seems slightly drier and more finished than these sketches, raises the possibility that some or all of these panels are by students. Only two pieces by students (an interior by George Reynolds and a life class study by Eakins' sister-in-law, Elizabeth Macdowell Kenton) were found in Bregler's collection, but the scarcity of similar studies and the ambiguous labeling of these three sketches makes attribution difficult. None of these three studies was seen by Goodrich, indicating that Susan Eakins held them back, either because she deemed them insignificant (like other figure drawings not shared) or controversial (like certain manuscripts and photographs). Bregler, usually very assertive about identifying all the work in his possession, positively labeled only one of these sketches as by Eakins (cat. 239) and withheld comment on the other two. Lacking Bregler's guidance, his widow and his estate appraisers listed these two items "Feminine Nude Study," attributed to Eakins (probably cat. 238) and "Feminine Nude Seated," attributed to S. M. Eakins (probably cat. 240). This latter study, the weakest of the group, is not characteristic of SME's extant nude studies, although most of these are from the 1920s and '30s, perhaps fifty years after these sketches were made. However, the speed of these studies, and their small scale, invite clumsy moments that can also be found in Eakins' scribbled figure drawings (e.g., cat. 156). And all three carry the hallmarks of Eakins' other sketches: a rigid panel close to 14 × 10 in size; a dark ground, laid on with a broad brush or a palette knife; a palette of earth tones, forming a pictorial structure of light and dark contrasts; an inattentive use of the surface, with the figure floating in the center of the format, well away from the edges; blunt, rapid work, painted wet-into-wet, with a lively impasto in the lights and without much blending of modeling tints; and a powerful sense of living, weight-bearing, three-dimensional form. Surely Eakins painted all three of these figures.

25. Forty-five percent, or 91 out of 203 paintings in oil and watercolor before 1889, as listed in Goodrich 1933, contain landscape. Of these, 27 were "pure" landscapes or marines, although all but 3 were small sketches, usually made in preparation for or in anticipation of larger work with figures. The lifetime percentage (30 percent) includes 9 drawings made for these paintings. New work discovered in Bregler's collection that was not listed by Goodrich does not change these percentages significantly. The statistics cannot reflect, of course, the work lost in overpainting; many items now listed as figure subjects seem to have been painted over landscapes from the 1870s and '80s. See Foster 1990.

26. Gérôme "feared" that Eakins had begun to use the palette knife when he reviewed his student's submissions to the Salon in 1875; see Goodrich 1982, I: 119. Eakins never mentions Courbet in his letters from Paris, although one of Eakins' students at the Art Students' League, Tommy Eagan, remembered that Eakins liked Courbet's work; McHenry, 70.

27. On Eakins and luminism, see Barbara Novak, "Thomas Eakins, Science and Sight," in *American Painting of the Nineteenth Century: Realism, Idealism, and the American Experience* (New York: Praeger, 1969), 191–196. Novak's understanding of Eakins' method in *Max Schmitt* contributes to a sophisticated analysis of the painting's effect. More recently, see John Wilmerding et al., *American Light: The Luminist Movement, 1850–1876* (Washington, D.C.: National Gallery of Art, 1980). Wilmerding describes Eakins' work as "post-luminist" in its emphasis on figures and human psychology (146–148). In the same book Theodore E. Stebbins, Jr., comments on the "nearly luminist" *Max Schmitt,* which he understands to be closer to the French mainstream (in America) than to luminism (215). Stebbins' essay, "Luminism in Context: A New View," provides an important international perspective on this so-called American style; see 211–234. Carol Troyen made a succinct statement on *Max Schmitt,* its methods and sources, in *A New World: Masterpieces of American Painting, 1860–1910* (Boston: Museum of Fine Arts, 1983), 266. Thorough documentation of *Max Schmitt* can also be found in Spassky, 588–594. Johns argues against the relevance of luminism to *Max Schmitt,* drawing attention to the abstract and expressive qualities of the surface (1983, 21–23).

28. CB to Morgan (?), draft, c. 1939 (CBTE, Foster and Leibold, fiche series IV 4/G/4). This kind of color note is illustrated in *Shore Scene* (G 175, Dietrich Collection); see Avondale/Dietrich, cat. 5.

29. CBTE, Foster and Leibold, fiche series I 3/D/6–7.

30. Goodrich 1933, G 163–177. Some of these panels have been divided (front from back, as G 165) or cut into pieces (as G 170, now CBTE cats. 235, 236). Of this group, two are in the PMA (G 169 [Siegl, 96], and G 166 [not catalogued]); three are in the Dietrich Collection (G 173, Avondale/Dietrich, cat. 2; G 164 and 175, not catalogued); several are in CBTE, including G 167 and 170 (cat. 250), and G 172 (cat. 232). The others are scattered and mostly unlocated, save for G 174, now in the collection of the State University of New York, Buffalo, and G 176, retained by the estate of Mary Bregler.

31. The oil on paper landscapes include G 170 (CBTE cats. 235, 236), G 171 (unlocated), and CBTE cat. 234; see also the small portrait, cat. 237, probably from 1877. All of Eakins' small sketches on canvas have been mounted by Bregler on panel; we do not know whether CB split the original support to make separate pictures, as he did the wooden panels.

32. *Delaware River Scene* is also on a canvas with white priming, whereas the earlier sketches were toned blue-gray before Eakins began to paint (see cat. 232) or were painted over a strongly colored prior sketch (see fig. 61). All of these sketches show signs of another painting beneath the surface, visible in brush patterns or glints of color at the bottom of the image. See fig. 248 for an X-radiographic image of cat. 234. Another of the Gloucester series, cat. 248, is brightened by a yellowish ground.

Chapter 9. Watercolor: Lessons from France and Spain

1. Most of Eakins' watercolors have been published with commentary in Hoopes. Goodrich also discusses this work at some length; see

1982, I: 108–120. Eakins' watercolors were first set against the background of the American watercolor movement in my own study (Foster 1982), which provided the basis for much of the material in this chapter; see esp. 193–262. Research on this topic began at Yale under the supervision of T. E. Stebbins, Jr., who enlisted my help in preparing portions of his book *American Master Drawings and Watercolors*. Stebbins offers an excellent survey of this period, with relevant bibliography (136–173). The nutshell of my own work first appeared in "American Drawings, Watercolors, and Prints," *Metropolitan Museum of Art Bulletin* (Spring 1980): 2–5, plate commentaries, and 39–41. Since 1982 several excellent publications have built on this research, including Susan E. Strickler, ed., *American Traditions in Watercolor: The Worcester Art Museum Collection* (New York: Abbeville, for Worcester Art Museum, 1987), and such studies of Winslow Homer's work as Helen Cooper, *Winslow Homer Watercolors* (New Haven: Yale University Press, 1986), and D. Scott Atkinson and Jochen Wierich, *Winslow Homer in Gloucester* (Chicago: Terra Museum of American Art, 1990).

2. See examples in the Hirshhorn collection (Rosenzweig, cats. 1, 2). On the influence of Benjamin Eakins and G. W. Holmes, see chap. 1 above, nn. 25, 26.

3. Foster and Leibold, fiche series II 4/B/3.

4. See Milroy, *Lifetime Exhibition Record*. Letters indicate that Eakins was refused a showing at the NAD in 1875 and 1876; see Goodrich 1982, I: 121–122, and Hendricks 1974, 82. Goodrich guessed that Eakins' first entries were in 1875, but he may have been rejected earlier. The NAD at this moment was notorious for the self-protectiveness of the older Academicians who ruled the juries and dominated good space "on the line." The attitude of the NAD prompted the June 1877 formation of the Society of American Artists, a group that Eakins immediately joined.

5. See Foster 1982, 19–20, 29–32, on the impact of the 1873 Blackburn Loan Collection.

6. Gérôme's complete letter is quoted and translated by Goodrich 1982, I: 113–114. Hoopes (22) assumes that this watercolor "was presumably returned to Eakins, who may have destroyed it," though the wording of Gérôme's letter makes it clear that he kept it as a gift. Ackerman speculates that Eakins destroyed this watercolor "when Gérôme returned it, for the master suggested some changes." In fact, Eakins was pleased by the praise he received and cited the letter to Earl Shinn. Ackerman quotes this letter but misdates it, thereby confusing his argument (1969, 240).

7. Goodrich includes this vanished watercolor in his 1933 checklist as G 55, *A Rower*, and speculates that it resembled the figure of John Biglin as he appears in the oil *The Biglin Brothers Turning the Stake* (1873, Cleveland Museum of Art [see fig. 112]) (Goodrich 1982, 164). Goodrich guessed that the figure was Biglin by presuming that the watercolor shown eight months later in New York as *The Sculler* (also lost; described in Eakins' notebook as *John Biglin [Single Scull]*) was a replica of the picture sent to Gérôme. See G 56; Goodrich 1933, 164.

8. Goodrich 1982, I: 114.

9. Ackerman 1969, 240. On Eakins' ownership of prints of Gérôme's work, see chap. 4 above, n. 3.

10. The perspective drawing, G 58, is scattered with the usual mathematical calculations and French inscriptions, indicating that the horizon of this picture is 30 inches. The viewing distance of this "grand dessin" is 10 feet; with Biglin seen 35 feet away, the scale of the figure is just under one-fourth life size. The two watercolors made from this drawing, G 56 and 57, are half as large in all dimensions, making a scale of one-eighth, with a viewing distance of 5 feet. On this drawing, see Stebbins, 190–191. The oil study, G 59, shows Biglin at the scale of the perspective drawing, but cropped. This oil is unusual in its completeness to the margin and the dense layering of color in the sky, both of which suggest intentional "finish" if not later reworking. The addition of the bow of the distant shell at the right also seems to be made for the sake of the coherence of the study itself. See also my discussion of this painting in Wilmerding, 70–73. Sewell drew the oil and the drawing together to make an astute discussion of Eakins' method, noting the "tension between observed reality and abstract composition" in this work (18–19). The watercolor *John Biglin*, fig. 64 (G 60), recently emerged from Gérôme's descendants in France and was sold at Christie's, New York, 23 May 1990, lot 69. Signed and dated 1873, unlike the replica at the MMA (G 57), it can be recognized as the first version in its greater fidelity to the drawing and more elaborate detail along the horizon and in the caustics reflected on the shell. Its area is also slightly larger. In preparing his own copy, Eakins respected the crop marks on his first version, improved the smoothness of recession in the water with a daintier, more even stroke, and tried a livelier, clouded effect in the sky. Although the two pictures are remarkably similar, Gérôme's *Biglin* is stronger in color, value contrast, and plasticity, while the MMA version is more delicate and luminous, giving the effect of reflected outdoor light. The emergence of Gérôme's version, correctly predicted by Goodrich to be the precedent for the MMA's *Biglin*, puts to rest much confused speculation about this watercolor (Ackerman 1969, 241–242; Foster 1982, 449).

11. Leslie W. Miller [?], [Watercolor Exhibition Review], *The American* (18 Feb. 1882): 300. Miller's remarks may have been based on his awareness of Eakins' procedures, although Eakins was not mentioned in this review. I have found this method of oil studies advocated in no contemporary manuals of watercolor painting in the U.S., France, or England. Miller commented on the "unusual number of good figure paintings" in this exhibition, the first watercolor display by the Philadelphia Society of Artists, but he did not mention any of Eakins' three entries, *Homespun*, *Shad Fishing at Gloucester* [*Taking Up the Net*] (fig. 174) or *Mending the Net* (fig. 173).

12. Sewell, 19. The full sequence of rowing paintings is examined below, in chap. 12.

13. G 52. The watercolor, G 54, was listed for $200 in the 1874 AWS catalogue; it was one of the most expensive of Eakins' entries that year, indicating (as Goodrich has surmised) an ambitious and detailed piece. This watercolor may have been used for the wood engraving "On the Harlem," which appeared in *Scribner's Monthly* (June 1880): 165. See Parry and Chamberlin-Hellman, 35.

14. *The Sculler* is G 56, titled *John Biglen or The Sculler* by Goodrich, who discovered a marked catalogue indicating the sale to Barney.

15. Gérôme's letter is published with a translation in Goodrich 1982, I: 116.

16. "American Society of Painters in Water Colors," *Nation*, 12 Mar. 1874, 172. Portions of this review are quoted in chap. 13 (see n. 13).

17. On Eakins' submissions to the Salon see chap. 13. Half of the oils sent to France had watercolor versions, and six out of seven watercolors shown at the AWS shows in 1874 and 1875 had finished oil antecedents, indicating how closely these watercolors were bound to the center of Eakins' work.

18. Goodrich 1982, I: 113–114. Gérôme's student-graduates, though scattered, often kept in touch with him, as Eakins did. "Chaque

19. Goodrich 1982, I: 113–114.

20. Ackerman 1991, cat. W-1, 304. At 8 1/2 × 5 in., this painting is similar in scale to Eakins' *Baseball Players Practicing* (fig. 55), which it resembles in theme and arena placement. Ackerman dates it to c. 1877, based on its replication of an oil (no. 260, c. 1877), although the oil and a related pendant (no. 259) may be from as early as 1859, when Gérôme was working on *Ave Caesar*. A watercolor entitled *Prayer at Cairo* appeared at Goupil's in New York in 1866–67, just as Eakins left for Paris; see Gerdts and Yarnall, 1401. Ackerman has found no exhibition records for Gérôme's watercolors, and period documentation for only three. He notes that many excellent watercolors signed "Gérôme" are in circulation; "the good ones seem to be from the studio of Charles Bargue" (1825–83), Gérôme's assistant and close friend (1991, 170, 304).

21. Fortuny is credited with inspiring the formation of the SAF by Oliver Merson, "Aquarellistes Français," *La Grande Encyclopedie* 5 (c. 1885): 468; his exceptional flowering in about 1868 is described in Jean-Charles ("Baron") Davillier, *Fortuny, sa vie, son oeuvre, son correspondence* (Paris, 1875), which was translated into English and published in Philadelphia in 1885 as *Life of Fortuny*, along with *Reminiscences and Notes,* by W. H. Stewart, a collector and friend. Fortuny occupied Gérôme's studio in the winter and spring of 1869–70, while Gérôme was in the Middle East and Eakins was in Europe. Eakins' admiration for Fortuny's work at this time is also discussed in chap. 6.

22. Eakins spent 5f.50 for "watercolors and brushes" (TE to BE, 17 Mar. 1868, CBTE, Foster and Leibold, no. 39, and fiche series I 2/F/5).

23. The tiny watercolor sketch of his father, *Benjamin Eakins* (3 1/2 × 3 1/2 in., priv. coll., Texas), could be from before 1873. Tentative and incomplete, it is difficult to date; perhaps, as Hendricks asserts (1974, 70), it is from around 1870. The anomalous qualities of this work have been noted by Beth Carver, who points out that this is one of Eakins' few watercolors without a related oil; it may represent one of Eakins' few attempts at sketching in watercolor. See "The Watercolors of Thomas Eakins: Their Place in His Oeuvre" (unpublished paper, Williams College Graduate Program in the History of Art, May 1977), p. 7, n. 19.

24. Goodrich 1933, 18.

25. As Siegl has noted, Eakins concluded his work in oil with "final" versions in watercolor because "only in that medium could he properly capture the luminosity of the scene" (59). See, for example, cat. 233. On Eakins and luminism, see Hoopes, 12, and chaps. 8 (n. 27) and 12 below.

26. Goodrich 1933, 18.

27. "Fine Arts: The Water Color Exhibition" (14 Feb. 1874): 7.

28. Lloyd Goodrich, *American Watercolor and Winslow Homer* (Minneapolis: Walker Art Center, 1945), 33; Hoopes, 12.

29. This contemporary term refers to the tendency of cobalt blue—a heavy mineral pigment—to settle quickly and irregularly on the paper, producing surprising (and sometimes disastrous) effects. "Granulation" was a term promoted (and perhaps invented) by the popular watercolor manual writer, Aaron Penley, whose pamphlet, *A System of Water Color Painting* (London: Winsor & Newton, c. 1850) went into its thirty-ninth edition in 1878. Penley advocated this technique for skies because the brushstroke is obliterated by successive rewashings, and the pigment settles gently into the paper's pores to create a grainy, almost subliminal shimmer to the atmospheric tints.

30. Eakins was not mentioned in five other reviews I have located from this year (*Appleton's, Scribner's, Atlantic, Aldine, New York Times*).

31. *Negroes Whistling Plover* was no. 474 at the AWS in 1875, for sale for $300. Goodrich catalogued it as G 71, *Whistling for Plover*. This watercolor was shown later that spring at the Brooklyn Art Association (no. 505). It appeared at the Centennial Exhibition; at the Penn Art Club (Mar. 1876), where it was called *A Negro Whistling Down Plover* (Hendricks 1974, 92); and in an 1877–78 loan exhibition of watercolors, PAFA (no. 10). When this picture appeared at the Boston Art Club in 1880 (as no. 179, *Whistling Plover*), it was owned by S. W. Mitchell. Goodrich (1933, 166) noted that Eakins presented it to Mitchell in the late 1870s. See Hoopes, 26.

32. Letter of 30 Jan. 1875, cited by Hoopes, 26.

33. Shinn's comments in the *Nation* are cited in chap. 7, n. 46.

34. "The Water-Color Exhibition Concluding Notice," *New York Times*, 14 Feb. 1875, 5.

35. "Culture and Progress," *Scribner's* 9 (Apr. 1875): 764. No mention of Eakins' work appeared in reviews this year published in *Atlantic Monthly, Aldine, Independent,* or *Art Journal*.

36. These classes had been instigated at the request of the students—another manifestation of the increasing interest in watercolor at this time. See Hendricks 1974, 85. A watercolor by Susan Macdowell from 1879, *Chaperone* (priv. coll.), testifies to the continuance of Eakins' classes, for the theme (obviously derived from his own work, *Rush Carving* and *Seventy Years Ago*) was given as a project to his students (Hendricks 1974, 111; Casteras, 42).

37. PAFA annual, no. 335. Also shown at PAFA Loan Exhibition of Watercolors, 1877–78, as *The Zitter Player*, no. 59, $150 (G 94; Hoopes, 38).

38. G 116, also exhibited in Eakins' day as *Reminiscence*. Eakins' record books refer to this work as *Fifty Years Ago—Young Lady Admiring a Plant*, although I suspect that this descriptive title was simply for clarification and was not used until the memorial exhibitions of 1917, when the picture was called *Young Woman Looking at Plant*. The modern title dates to Goodrich 1933, 171. Hendricks (1974, 167–168) has confused this work with a painting called *Study* shown at the PAFA annual in 1882. However, *Study* appeared in the oil section of the exhibition, not with the watercolors. *Fifty Years Ago* first appeared at the loan exhibition of watercolors at the PAFA, 1877–78, no. 193; a month after the closing of this show it appeared at the AWS annual. Eakins showed it again in Philadelphia and in Boston, Chicago, St. Louis, New Orleans, and Denver, through 1882; see Milroy, *Lifetime Exhibition Record*.

39. "The Water-Color Society's Exhibition," *Art Amateur* 6 (Mar. 1882): 74.

40. Wanda Corn has discussed this mood as an aspect of Tonalism and commented on a "strong sense of isolation and inwardness" in Eakins' work. See *The Color of Mood: American Tonalism, 1880–1910* (San Francisco: M. H. De Young Museum, 1972), 22, n. 3.

41. The original appearance of this panel, and the annotations made by Bregler after dividing the two sides, are recorded below in cat. 241. The figure in fig. 67 would be about 12 inches tall if complete; the oil study (plate 5) reduces her to about 9 inches; she was reduced again to 6 inches tall in the watercolor. According to SME, the model was Annie King; see SME to LG, 17 June 1930, Goodrich, PMA. Perhaps King was related to "Aunt Sally King," who also modeled for Eakins at this time. Hoopes (42) describes the model as "one of [Eakins'] pupils," and Henry Reed has suggested that

she might be Eakins' student Emily Phillips, later Mrs. A. B. Frost; see Henry M. Reed, *The A. B. Frost Book* (Boston: Wyrick, 1993), 21–28. Another oil study for this watercolor is buried beneath cat. 242; see the X-radiographic image, fig. 249.

42. I presume that this was done in Dec. 1877 or later, because Eakins did not include it in his selection at the PAFA watercolor exhibition that opened on the 3rd of that month. Eakins' record books refer to this picture as "Negro Boy Dancing," although it does not seem to have been exhibited under that title until after his death. It was first exhibited at the 1878 AWS as *Study of Negroes* (no. 92, $290), and later it appeared as *The Dancing Lesson* and *The Negroes.* In 1889, Eakins sent this watercolor, one of his most frequently exhibited paintings, to the Exposition Universelle, as *La Leçon de Danse.* See Milroy, *Lifetime Exhibition Record,* and Goodrich's notebooks, PMA, which list sixteen different exhibition venues between 1878 and 1889 (G 124; see Hoopes, 44).

43. Both of the oil studies—G 125 (the banjo player) and G 125A (the dancer)—were once on the same canvas, as connecting passages of brushwork and scoring show. They had been separated by 1930 and perhaps were divided in Eakins' lifetime, as they followed very different patterns of ownership; according to Goodrich (PMA), the sketch of the dancer was a gift to A. B. Frost, probably before he left Pennsylvania in 1908. Both images have been cropped, so it is difficult to reconstruct the size of the original canvas, but it must have been at least 21 1/8 × 24 1/8. The figures would have faced one another as in the watercolor, but they were painted at different scales. The dancer is about 16 inches high in the oil (one-third life); he was reduced another third, to about 10 1/2 inches, in the watercolor. This reduction is expressed in the grid squares, which are 1 1/2 inches across on the oil and only 1 inch on the perspective drawing, fig. 69, which is at the scale of the watercolor. The banjo player was sketched at a smaller scale and therefore needed only 25 percent reduction: the grid squares on the oil are 1 1/3 inch compared with 1 inch on the perspective. The difference between the two may simply have been the result of different posing sessions, or perhaps Eakins planned to set the banjo player deeper in space and then moved him opposite the dancer. No oil sketch of the old man has survived, although logically it must have preexisted the watercolor, too. The even scale fraction (1/5) and height for the man's figure (about 13 inches) suggest that his size was the starting point in the composition; the odd scale of the other two figures (1/4.5) implies that they were reduced from another scale to fit into this scheme.

44. This type of figure drawing is described in chap. 7.

45. "The Exhibition of the Academy of the Fine Arts," *Philadelphia Evening Telegraph,* 29 Apr. 1876, 5 (quoted in Hendricks 1974, 103–104).

46. Shinn's entire review was unusually brief ("The Water Color Society's Tenth Exhibition," *Nation,* 15 Feb. 1877, 108). Eakins was not mentioned in the eight other reviews of this exhibition that I have located.

47. AWS 1874, no. 172, *Mandolin Player,* reproduced in a pen sketch in the *New York Daily Graphic,* 21 Feb. 1874, 764; no. 269, *St. Gérôme (sic), after Ribera;* no. 366, *Turkish Coffee House;* and no. 373, *A Hall Porter.* Apparently these last two were pen drawings.

48. The most important contemporary source on Fortuny's life and art is Davillier, *Fortuny.* Important obituaries include W. Fol, "Fortuny," *Gazette des Beaux-Arts* (1875): 267–281, 350–364; C. Yriarte, "Fortuny," *L'Art* 1 (1875): 361–372, 384–385. Contemporary opinion is summarized in Clement and Hutton, 263–265. See also the brochure "Fortuny and His Circle," by W. R. Johnston, *Bulletin of*

the Walters Art Gallery 22, no. 7, supplement 2 (Apr. 1970).

49. G 114. *Seventy Years Ago* was framed in with a sheet of the *Philadelphia Ledger* from 3 May 1877, suggesting its completion some time before this date. It was no. 283 at the PAFA's loan exhibition, which included four older watercolors by Eakins as well. In Jan. 1878 it was exhibited at the AWS (no. 237, $150), and later that year it sold to R. D. Worsham for $135 (Goodrich 1933, 171). See Hoopes, 40. A full bibliography appears in Barbara T. Ross, *American Drawings in the Art Museum, Princeton University* (Princeton, 1976), cat. 23, pp. 25–26.

50. Goodrich has expressed this opinion in several publications, e.g., his foreword to Hoopes, 6; see also Hoopes' comment, 40, and Sewell, 59–63. See chapters on *William Rush Carving* and *Fairman Rogers* for examples of this phenomenon. See also William B. Rhoads, *The Colonial Revival,* 2 vols. (New York: Garland, 1977), and Karal Ann Marling, *George Washington Slept Here: Colonial Revivals and Culture, 1876–1986* (Cambridge: Harvard University Press, 1988).

51. "Fine Arts," *Independent,* 1 Mar. 1877, 6.

52. Cook went on to complain that "we hardly know which we like least" (*Art Amateur* [1882]: 73). The Irish-born Hovenden was only four years younger than Eakins. He studied at the NAD during the Civil War and in Paris in the 1870s, a background that explains both his academic figure style and his sense of the picturesque.

53. The title of the picture was *Dem was good old times.* The description comes from the *New York Herald,* 28 Jan. 1882, 5. The painting was illustrated in the AWS 1882 catalogue. An oil of the same title, dated 1882, is in the Chrysler Museum, Norfolk, and an etching of this subject by Hovenden, titled *Dem Was Good Ole Days,* appeared in 1885. See Anne Gregory Terhune et al., *Thomas Hovenden (1840–1895), American Painter of Hearth and Homeland* (Philadelphia: Woodmere Art Museum, 1995), 69, 86.

54. *Independent,* 16 Feb. 1882, 8. Hovenden's African-American subjects and their critical reception have been analyzed by Naurice Frank Woods, Jr., in Terhune, *Thomas Hovenden,* 62–79.

55. As Henry Glassie has told me, this turn of opinion is measured by the remarkable success of Joel Chandler Harris' stories, first published in book form in 1880, and by the subsequent popularity of similar local-color and dialect writings that celebrated the "happy-go-lucky" aspects of African-American life in the "good old times," such as Mrs. L. C. Pyrnelle's *Diddie, Dumps and Tot* (1882) and the stories and novels of Thomas Nelson Page and James Lane Allen. The iconology of African-American figures in American art has been undertaken in modern publications that include discussion of Eakins' work in the context of contemporary attitudes. The largest and most recent study, Guy C. McElroy, *Facing History: The Black Image in American Art, 1710–1940* (Washington, D.C.: Corcoran Gallery of Art, 1990), comments frequently on the "nostalgia for the imagined tranquility of pre-war" life in the South that suffused paintings of the Reconstruction; see 48, 55, 93. McElroy's work builds on the work of Marvin Sadik and Sidney Kaplan in *The Portrayal of the Negro in American Painting* (Brunswick, Maine: Bowdoin College Museum of Art, 1964), which comments on the "lyric" quality of *Negro Boy Dancing* (n.p.); and on Ellwood C. Parry III, *The Image of the Indian and the Black Man in American Art, 1590–1900* (New York: Braziller, 1974). See also Albert Boime's international perspective in *The Art of Exclusion: Representing Blacks in the Nineteenth Century* (Washington, D.C.: Smithsonian Institution Press, 1990), which mentions *Negro Boy Dancing* (102).

56. H. T. Tuckerman uses this new title in *Book of the Artists* (1867); see

Patricia Hills, *Eastman Johnson* (New York: Clarkson Potter, 1972), 30. I am grateful to Henry H. Glassie, Sr., who drew my attention to the identification of *Life in the South* in "The Autobiography of Worthington Whittredge," ed. John I. H. Baur, *Brooklyn Museum Journal* (1942): 55, n. 2.

57. "Eleventh Exhibition of the American Water-Color Society," *Nation*, 26 Feb. 1878, 156–157. Similar but less articulate expressions of appreciation for Eakins' "originality and strength of characterization" can be found in "The Old Cabinet," *Scribner's* 15 (Apr. 1878): 888, and *New York Tribune*, 9 Feb. 1878, 5.

58. Foster 1982, chap. 1 and nn. 89–93.

59. Others submitting Negro subjects to the AWS about this time were Philip Hahs, Alfred Kappes, E. W. Kemble, T. W. Wood, S. G. McCutcheon, and W. L. Sheppard.

60. "On Some Pictures . . . ," *Galaxy* (1875): 91–92. Fortuny's critics disliked his "vulgar" and "trivial" emphasis on the "superficial realities of life" and his "disregard of beauty." Too commonplace, "the faces he paints have no beauty, but they bear upon them faithfully the record that coarse life leaves." J. Carr, in 1875, quoted in Clement and Hutton, 265. Of course, exactly these qualities would have recommended Fortuny's work to Eakins.

61. "Fine Arts: The Water-Color Exhibition III," *Nation*, 4 Mar. 1875, 156.

62. Simonetti's watercolor, *A Figure,* was no. 223 in the catalogue, for sale for $600 from Snedecor's gallery. On Fortuny's watercolor and its reproduction, see n. 47 above.

63. Fortuny's technical influence on Eakins has been noted previously, but his impact on Eakins' subject matter has been disparaged. See Hoopes, 14.

64. This painting is also known as *The Academicians of St. Luke Choosing a Model.* It was once in the Paris collection of the American W. H. Stewart. Douglas Druick first noted this comparison in a graduate seminar at Yale in 1972. The study of these two paintings becomes more interesting when it is learned that Fortuny's painting originally had an older woman seated at the right, at the feet of the nude model. Like the chaperone in *William Rush,* she was knitting and keeping an eye on the artists, who are inspecting the model. The painter Henry Regnault saw *The Choice of a Model* in Fortuny's studio in 1869 and remarked the "inimitable figure of the model's mother, a shrewd and withered beldam like a wicked fairy, sitting knitting near the table on which the girl gesticulates, looking with a calculating eye over her spectacles at the Academicians" (Earl Shinn ["Edward Strahan"], *Chefs-d'Oeuvre d'Art of the International Exhibition, 1878* [Philadelphia, c. 1879], 83). Eakins was in Paris in 1869 (as was Fortuny, who was using Gérôme's studio), but he never mentions seeing the picture. However, the story was recounted in Davillier, *Fortuny*, 65, 158; Shinn evidently learned the anecdote cited above from this source, and Eakins may have known it, too, before launching his *Rush Carving* in 1876.

65. Douglas Druick pointed out this similarity to me in 1972. This etching was reproduced in Yriarte's 1875 article on Fortuny in *L'Art* 1, a periodical well known in America. More important, it was reproduced in *Scribner's Monthly* 18 (Oct. 1879): 825; see Johns 1983, fig. 86. Fortuny's etchings were frequently exhibited in New York and Philadelphia, particularly in the "Black and White" rooms of the American Watercolor Society. Eakins may have had a special familiarity with these prints because of his acquaintance with Stephen J. Ferris, a Philadelphia artist much enamored of both Gérôme and Fortuny. According to Shinn, Ferris owned a piece of the velvet funeral pall used at Fortuny's funeral. Also, according to

a pencil annotation in the copy of Davillier's *Fortuny* at the University of Pennsylvania, Ferris owned "the Coltre (?) brushes for death mask and hand . . . photos . . ." (52). Shinn described Ferris as "the American etcher who has done much to extend Fortuny's fame" (*Chefs-d'Oeuvre,* 82).

66. Quoted in W. H. Stewart, "Reminiscences and Notes," in Davillier, *Fortuny,* 75–76. Gautier's account of the "unexpected revelation" and "sudden explosion" created by this exhibition was also quoted in George Sheldon's *Hours with Art and Artists* (New York: Appleton's, 1882), 39.

67. See chap. 6, n. 54.

68. Dorothy Weir Young, *The Life and Letters of J. Alden Weir* (New Haven: Yale University Press, 1960), 73. Weir was particularly excited by Fortuny in 1875, the year after the artist's death, when popular interest in his work was at its peak. At this time he even considered entering the studio of Raymondo Madrazo, "Fortuny's favorite pupil."

69. Shinn, *Chefs-d'Oeuvre,* 82.

70. *Nation*, 18 Feb. 1875, 119. The following year the *New York Times* review of the Centennial exhibition noted that leadership in watercolor had passed from the English to the Spanish school, which now produced the "finest" watercolors in the world (19 June 1876, 10).

71. The first two watercolors are in the Walters Art Gallery. See Johnston, "Fortuny and His Circle," cats. 4, 8. On the *Mandolin Player,* see n. 47 above.

72. Carter cited the "remarkable force and precision of tones, and subtlety of hues. . . . The contrasts . . . so peculiar and so delicate, and the tints so full of texture." She found the "perfectly free and precise handling, too, as in entire accord with the methods of the best of the foreign aquarellists" ("The Tenth New York Water-Color Exhibition," *Art Journal* [1877]: 95).

73. "The Water-Color Exhibition," *Appleton's,* 20 Feb. 1875: 247. Villegas' painting was also singled out by the *Art Journal* 1 (1875): 91.

74. "Culture and Progress," 763.

75. "Ninth Exhibition of the Water Color Society," *Scribner's* 11 (1876): 902.

76. Many French watercolorists, including Vibert and Detaille, worked in both manners, though often the most extreme demonstration of "rococo folly" and subordinated background came from the French followers of Fortuny's style (e.g., Louis Leloir).

77. See *Scribner's* (1875): 763, and (1876): 901; and Foster 1982, chap. 5.

78. *Retrospection,* of about 1880, is G 141 (Hoopes, 54; Siegl, 90). *Female Nude,* also unfinished, is G 205 (Hoopes, 50; Siegl [as *Nude Woman*], c. 1882, 102). The relationship of this watercolor to fig. 78 may mean that it is from c. 1890, much later than previously suggested. *In the Studio* (G 209) may be as late as 1884, according to Siegl, 112–113; Hoopes, 76; and Foster 1982, 246.

79. See also Hoopes, 44.

80. "Eleventh Exhibition," *Nation,* 156–157.

81. See Hoopes, 38, and Parry and Chamberlin-Hellman, 27. Siegl's discussion of the focus in *The Zither Player,* versus the later oil of the same theme, *Professions at Rehearsal* (1883), demonstrates how Eakins' selective focus becomes more obvious—that is, more artistic and less scientific—in later paintings. Siegl, 105.

82. "Eleventh Exhibition," *Nation,* 156.

83. "Goupil Water-Color Exhibition," *Nation,* 11 Feb. 1875, 101.

84. Théophile Gautier, quoted in Davillier, *Fortuny,* 83.

85. Shinn, *Chefs-d'Oeuvre,* 83; in reference to *The Choice of a Model,* see fig. 73.

86. See chap. 6, n. 50.

87. C. Cook, "Water-Color Society Exhibition," *New York Tribune,* 9 Feb. 1878, 5. Excepting his warm praise for Eakins, Cook's reviews this year were characterized as especially "carnivorous." See "Fine Arts: The Water-Color Society, I," *Independent,* 14 Feb. 1878, 7.

88. See Cook, "Water-Color Society," in reference to Detaille's *Standard Bearer.*

89. *Spinning* was illustrated in the AWS catalogue in 1881. *Seventy Years Ago* sold in 1878 to R. D. Worsham for $135. I conclude that it sold out of the AWS show because it has no later exhibition record, while the other two pictures shown in New York were forwarded to the Boston Charitable Mechanics' exhibition. This watercolor listed for $150 in the catalogue; its sale for $135 tallies with the common practice of marking down catalogue prices to engage buyers, or the payment of a sales commission.

90. *Independent,* 14 Feb. 1878, 7.

91. "Fine Arts: The Water-Color Society, II," *Independent,* 21 Feb. 1878, 7.

92. "Water-Color Society: Private View," *New York Tribune,* 2 Feb. 1878, 5. Cook found *Study of Negroes* a "most admirable piece of character drawing" (14 Feb. 1878, 5), and commented that "we have very little drawing of the figure equal to *Seventy Years Ago.*" Cook made no comment on Eakins between 1874 and 1878. His earlier review of 1874 is cited above, nn. 27 and 30.

93. John Moran, "The American Water-Color Society's Exhibition," *Art Journal* 4 (1878): 91–92. Moran also commented on *Seventy Years Ago* and *Fifty Years Ago.*

94. "The Old Cabinet," 888. *Scribner's* listed "Eakins, Abbey, Reinhart and Pranishnikoff" as best in genre; all save Eakins were regular *Scribner's* illustrators. Eakins' two illustrations, "Thar's a new game down in Frisco" and "The only gent that lived to tell about thet Spellin' Bee," appeared in vol. 17, no. 1, pp. 38 (see cat. 242), 40. Both illustrations are reproduced and discussed in Parry and Chamberlin-Hellman, 25–27.

95. Eakins' experience as an illustrator is surveyed in Parry and Chamberlin-Hellman; on the relation between watercolor and illustration in this period, see Foster 1982, esp. 246–250.

96. This visitation apparently bolstered Eakins' confidence considerably: "The anxiety I once had to sell is diminishing," he wrote in this same letter. "My works are already up to the point where they are worth a good deal and pretty soon the money must come" (to Shinn, 15 Mar. 1876, quoted in Hendricks 1974, 82).

97. Scott's two reliefs were based on *Seventy Years Ago* and *Spinning;* Clarke's oil, *Professionals at Rehearsal* (PMA) was inspired by *The Zither Player.* See Siegl, 100–101.

98. By consulting Eakins' own account books, Goodrich has noted that he earned slightly more than $2,000 from the sale of paintings in the 1870s, including $200 received for *The Gross Clinic.* See Goodrich 1933, 168, 72. On the Hayes commission, see chap. 19. Eakins sold several watercolors at exhibition—which rarely happened with his oils—but their prices were relatively lower than those of oils of a similar size, despite their at least equivalent labor. The economics of this situation eventually may have discouraged watercolorists like Eakins.

99. This lost watercolor, G131, was no. 50 in the AWS 1879 exhibition. Eakins' record books mention ten exhibitions for this work between its debut in 1879 and its last-known appearance, at the Providence Art Club in 1883. Goodrich speculates that the subject in the watercolor duplicates that of the oil sketch, *Sewing,* G 132 (New Britain Museum), in which Mrs. King appears "full length, seated, half-left in a high-back chair" and in contemporary dress (Goodrich 1933, 172, and notebooks, PMA). On the appearance and the response to *A Quiet Moment,* see Foster 1982, 247–248. Eakins began only one other watercolor in the interval between *A Quiet Moment* and his outdoor watercolors of 1881: the unfinished *Retrospection* remarked above, which has been dated to c. 1880 because of the oil, G 140 (Yale), completed that year. However, a photograph of Caroline Eakins in 1881 or 1882, wearing this same dress and striking a similar pose, suggests that the watercolor might have been done slightly later than the oil. As Siegl has remarked (90), the unfinished state of *Retrospection* allows a better view of Eakins' technique, particularly his multiple overlays in the shadowed areas and his tendency to finish certain zones while leaving other areas blank.

100. See Hendricks 1974, 97–100, for the New York response to *The Gross Clinic.* On Homer's response to criticism in 1877, see Foster 1982, 79–81.

101. This reviewer characterized Eakins as a "slave of certain theories" ("Fine Arts: The American Water-Color Society," *Independent* [16 Feb. 1882]: 8).

102. G 144; Hoopes, 62; AWS 1881, no. 83, $100. Illustrated in the catalogue, 8 × 11 in. This watercolor probably appeared at the PAFA annual in the fall of 1882, as *Spinning,* no. 403, $150. The pencil margins beneath the color and the old mat lines are clearly visible in reproduction. A similar subject, also known as *Spinning* (or *Homespun,* G 146), was made at about the same time (Hoopes, 58). This painting probably appeared at the Philadelphia Society of Artists' first watercolor exhibition, in the spring of 1882, as *Homespun.* As with *Spinning,* the margins were ruled by Eakins before the color was laid down. On the oil sketch for *Spinning,* see chap. 8.

103. The exhibition of 1881 was exceptionally crowded, with Homer's late-arriving watercolors hung over doors and along the wainscoting. The *Art Journal* noted that Eakins' work was hung high, and the critic regretted the inability to see it well ("The American Water-Color Society," *Art Journal* 7 [1881]: 85). Earl Shinn praised the "Millet-like breadth of drawing" but could not say much more ("Exhibition of the American Water-Color Society," 4 *Art Amateur* [Feb. 1881]: 46). Van Rensselaer mentioned *Spinning* in her two reviews of this show, "The Water-Color Exhibition—New York," *American Architect and Building News* 9 (19 Mar. 1881): 135, and "The New York Art Season," *Atlantic Monthly* 48 (Aug. 1881): 198. S. G. W. Benjamin also listed Eakins in "Fourteenth Annual Exhibition . . . ," *American Art Review* 2 (1881): 201. He was not mentioned in the seven other reviews of this exhibition that I have located, a silence particularly conspicuous in the *Times* and *Tribune* articles on this show, which are lengthy and exhaustive. The *Times* remained studiously silent on the subject of Eakins' watercolors after 1878. When *Homespun* appeared at the PAFA in 1882, Leslie W. Miller commented that it was "certainly much the best" of his contributions, "though this is not saying as much as one would like to the work of a man who has made so many friends by the seriousness of his purpose and singular faithfulness to his own ideals" ("Water-Color Exhibition at Philadelphia," *American Architect and Building News* 9 [22 Apr. 1882]: 184).

104. Said Van Rensselaer, "The day will come, I believe, when Mr. Eakins will be rated, as he deserves, far above the painters of mere pretty effects" (*Atlantic Monthly* [1881]: 198–199).

105. The watercolor *Pathetic Song* was not catalogued by Goodrich (Hoopes, 68). Unlike all of Eakins' other watercolors (excepting the black and white replicas), *The Pathetic Song* is much smaller

than its oil precedent—only one-ninth the size. This may be explained by its intention as a gift to Margaret Harrison, the singer who posed for the painting. This repeats the practice that Eakins had adopted earlier, of giving (or bartering) watercolors as compensation or tokens of his work. For example, he traded *Starting Out After Rail* for a boat (Hendricks, 79); two scullers were sent to Gérôme; *Drifting* was donated to the Schussele benefit sale; and *Plover* and *Drawing the Seine* were given as thanks to friends (S. W. Mitchell and J. G. Johnson). See Siegl, 85.

106. Hendricks 1974, 215–216.

107. Hoopes, 12. This was not an issue earlier, with works like *The Chess Players*, done on a scale similar to (and occasionally smaller than) his watercolors.

108. The watercolor work of George Inness, for example, follows the same pattern as Eakins'. See Foster 1982 on the course of the watercolor movement and its acme in 1882.

Chapter 10. Sculpture: The Legacy of the Ecole

1. Goodrich 1933, G 498–515. Many of these items exist in multiple versions in wax, plaster, and bronze. Goodrich did not catalogue the anatomical casts and the Witherspoon figures. Most of Eakins' extant sculpture was gathered for consideration in Domit. Domit's list of unlocated work (26) can now be reduced by the discovery of *An Arcadian* (cat. 262) and the small *Clinker*, G 510, now in the Hirshhorn in wax and bronze versions. Still missing in any examples are the small *Billy*, G 512 (fig. 83), and the relief of *Mary Hallock Greenewalt*, G 515. Not listed by Goodrich was the *Horse and Rider* relief "sketch," once in Bregler's collection and now in the Hirshhorn; see Rosenzweig, 142. Eakins also made a wax model for the diving figure in *Swimming*, lost before Goodrich's inventory. Helpful sources of information on Eakins' sculpture include Goodrich 1982 (esp. II: 99–130), Siegl, and Rosenzweig. Also useful will be the forthcoming PAFA, *American Sculpture*, which catalogues work by Eakins as well as his contemporaries. I am grateful to Susan James-Gadzinski, principal author of this catalogue, for her assistance on many aspects of the Bregler collection's sculpture.

2. In addition to the two items in Bregler's collection, cats. 258–259, PAFA owns eighteen variously painted plaster casts of specimens (thirteen human subjects, five animal) and one anatomical model of a horse, *The Mare Josephine (Ecorché)*, given by Eakins to Samuel Murray, who gave them to the Philadelphia School of Design for Women (later Moore College of Art), from whom they were purchased in 1991. See PAFA, *American Sculpture*. Eakins' own set of these casts was used by SME in 1930 to create a series of seventeen human dissection subjects in bronze, now in the PMA; see Siegl, 82–87, for an account of Eakins' manufacture, use, and replication of these casts. The bronze cast of the left foot (replicating cat. 259) was only recently given to the PMA and therefore is not included in Siegl's catalogue. Three of the bronzes at the PMA (Siegl, cats. 36B, D, O) have no surviving plaster version from Eakins' lifetime; all five of the PAFA's animal dissection studies are unique. More on these casts is in McHenry, 30–33; Sewell, 77–79; Chamberlin-Hellman, 155–159, 219–220; and in Virginia Norton Naudé's conservation report on the PAFA plasters, 9 Mar. 1983, PAFA object files, partially published in *JAIC*, 56–60. Casts "from life" had been a part of the PAFA's permanent collection for decades and were used, like the antique sculpture, for drawing models. Eakins' dissatisfaction with these older casts, and with contemporary Euro-

pean ones, may be expressed in his eagerness to make new models, and in Fairman Rogers' comparative remarks (see n. 4 below).

3. 7 Apr. 1877, PAFA Archives, quoted at greater length in Siegl, 87. Keen attributed the cat and dog dissections and casts to Eakins alone. Small-scale reliefs of a horse (*Josephine*, G 499) and horse skeleton (G 500) were made in 1878; see Siegl, 73, and Rosenzweig, 78–79, and chap. 15 below. After Josephine's death, Eakins prepared an écorché relief at the same one-quarter scale, G 502; see PAFA 1991.7.14 and Siegl, 98. Just as the human dissection casts were particularized restatements of Houdon's famous *Ecorché* (also in the PAFA cast collection), the horse studies may show Eakins' engagement with the tradition of Géricault's *Flayed Horse,* said to exist in replica "in every studio" in Paris in 1867. See Peter Fusco and H. W. Janson, eds., *The Romantics to Rodin: French Nineteenth-Century Sculpture from North American Collections* (New York: Braziller, for the Los Angeles County Museum of Art, 1980), 284.

4. See Keen's report to the board, 10 May 1879, PAFA Archives. McHenry describes the "bonanza" of this opportunity, 30–31. J. L. Wallace helped Eakins make this cast of a "big negro"; in 1939 he still "rave[d]" about his beautiful body" (George Barker to CB, Apr. 1939, CBTE, Foster and Leibold, fiche series IV 10/A/3). Many of the extant human casts and anatomical drawings may be from this subject, perhaps from the 1878–79 school year, although some of them are dated earlier (e.g., the right foot at PAFA, dated 1877, 1991.7.7) and some later (the front and back of the male torso, seen on the rear wall in fig. 75, and the right shoulder, all inscribed "1880" on PAFA casts, 1991.7.1, 2, and 4). One other cast at PMA is dated (Siegl, cat. 36O), although the "1880" on all of these may be when they were painted or recast. See Kimock's introduction to the anatomical drawings, cats. 30–91. Fairman Rogers' description of the school in 1881 noted that "there are arrangements in the dissecting rooms for making plaster casts, and a set of anatomical casts have been made, duplicates of which are furnished to students, and to art institutions that desire them, at low prices. They are much superior to the French casts usually sold for the same purpose, having been made from careful dissections by gelatine moulds, possessing all the distinctness of the originals, free from all retouching, and therefore trustworthy" (9). Modeling and casting from equine dissection, evidently at the site of M. L. Shoemaker's factory, are depicted in C. L. Fussell's *Academy Students Dissecting a Horse,* one of the illustrations prepared for Brownell's article in *Scribner's* in 1879; see cat. 30. The view of Eakins in his studio (fig. 75), previously attributed to Susan Eakins, has been credited to Samuel Murray by Douglass Paschall, who discovered a letter from SME to Goodrich (12 April 1931) describing these photos as by Murray (Goodrich, PMA).

5. Foster and Leibold, 14.

6. Masks of Lincoln and Grant were acquired by Eakins and O'Donovan; see Goodrich 1982, II: 114.

7. A bronze hand, said by Murray and SME to be Margaret Eakins', is in the Hirshhorn; see Rosenzweig, 48. She debates the identity of the model and dates the cast to 1871, although it seems more likely that it is from a decade later, when Eakins was more involved with casting. Murray had two of these in 1940; he intended to give one to CB, according to a letter of 9 Apr. 1940 (CBTE, Foster and Leibold, fiche series IV 10/G/14), but such an item was not listed on CB's estate inventory. McHenry (95) noted that the Crowell family owned a bronze. A hand of W. J. Crowell as a child, c. 1885, appeared in Avondale/Dietrich, cat. 67. A cast of Murray's plaster hand of Eakins is also in the Hirshhorn (66.3729); a bronze is in the

PMA (see Siegl, 169, and Goodrich 1982, II: 9). Three plaster casts of hands (two of Margaret Crowell, one of a man) from Eakins' circle are also at PAFA; for this piece and the items mentioned by O'Donovan, Volk, and the life classes, see PAFA, *American Sculpture*. On the unlocated Whitman casts, see McHenry, 85, and Goodrich 1982, II: 38. CB's estate inventory lists many casts, including one of his grandmother's hand, that were not present in his collection in 1985. He perpetuated the tradition by making casts from his second wife's face and hand (CBTE).

8. Quoted by SME in her letter to Mrs. Dick, c. 1930 (Foster and Leibold, 298).

9. Eakins recommended modeling from a cast, as he had done "last summer," noted Bregler in 1887; see Foster and Leibold, fiche series IV 13/B/8, and Bregler I, 384.

10. Brownell, 742.

11. Bregler I, 383, 385.

12. Sellin; Roanoke, 19–21.

13. Rogers, 3, 7.

14. Notably, the only wax maquette to disappear was the study of the nude model made for the William Rush project. Seen by Goodrich in 1930, it was not cast in bronze by SME and had disappeared by the time of Bregler's inventory in 1939.

15. Bregler I, 384. Goodrich 1982, I: 108.

16. On Gérôme's sculpture and Eakins' acquisition of wax and tools in 1869, see chap. 5, n. 15. "Baily's recipe," jotted in Eakins' record book 2, p. 160, says, "Take one pound of yellow wax (beeswax) add to it when melted 1/2 lb. of fecula or starch (as arrowroot etc) in fine powder then add say 3 oz. or so of Venice Turpentine and Spanish Brown [red ochre] as coloring matter. Work it up thoroughly with the hands" (CBTE, Foster and Leibold, fiche series I 10/D/14). McHenry knew of this recipe (43). Hendricks asserts that "Bregler had the recipe," wrongly implying that Eakins received it from him; he also asserts that Eakins painted the sculptures red (1965, 57). On Bailly (1825–83), see PMA, *Three Centuries*, 383. Eakins recommended wax to his students as "more convenient than clay," although such advantages were not elaborated; see Rogers, 7.

17. Bronze casts of the horses are in the PMA; see Siegl, cats. 32A–D. The original wax models and another bronze set are in the collection of Paul Mellon.

18. Goodrich 1933, 64–65.

19. Domit, 12; Simpson, 93.

20. TE to James P. Scott, 18 June 1883 (CBTE, Foster and Leibold, fiche series I 3/F/2–3); Goodrich 1982, I: 216. The "Laws of Sculptured Relief" text is part of Eakins' manuscript in the PMA Eakins Archive. Goodrich cites many sections from this text (1982, I: 212–213).

21. See the published report of conservation by Virginia N. Naudé in *JAIC*, 56–60. More detailed description is available in PAFA files. Naudé and her colleagues gathered the four lifetime sets of plasters for comparison to conclude that the Bregler reliefs are the originals of all known versions.

22. TE, "Laws of Sculptured Relief," PMA typescript, 54. Elsewhere he noted that "the Greeks chose subjects for their reliefs exactly suited to their means of expression" (50). Aside from the Parthenon frieze, small Greek reliefs (probably casts) very similar in spirit to his Arcadian compositions were part of the Academy's collection (see fig. 28). On the development of the "Spinning" and "Knitting" panels, and Saint-Gaudens' response, see cat. 206.

23. Cleveland Moffett, "Grant and Lincoln in Bronze," *McClure's Magazine* 5 (Oct. 1895): 421. Moffett's article is an excellent account

of the work entailed in this project. See also Siegl, 134–136; Rosenzweig, 136–142; Michael Panhorst, "The Equestrian Sculptures for the Brooklyn Memorial Arch," Avondale/Dietrich, 24–26; and Goodrich 1982, II: 110–119, drawing on the unpublished research of Maria Chamberlin-Hellman.

24. McHenry, 27. Gérôme produced a series of small freestanding equestrian sculptures—Napoleon, Caesar, Frederick the Great—in the 1890s, following upon similar subjects in oil that Eakins surely knew, such as fig. 218. Photographs of Eakins and O'Donovan on horseback, as well as related images with nudes, are in CBTE; see Danly and Leibold. Weinberg comments on the similarities between Gérôme's sculpture and Eakins' (1991, 100).

25. Goodrich reproduces a cropped version of this negative from an unidentified source (Seymour Adelman?) (1982, II: 118). A similar variant negative in CBTE is 87.26.33.

26. The recovery of the negative allows a peek at the Chestnut Street studio, with the unframed canvas of *The Red Shawl,* G 256, in the background. Dated by Siegl to 1896–1900, the picture must have been under way, if not completely finished, by the time this photo was taken in the spring of 1892. See Goodrich 1982, II: 117. A cropped print made by Bregler from a similar negative (87.2.e) is in the Hirshhorn; see Rosenzweig, 139. Another glass negative, of Clinker's head and shoulders, is also in CBTE: 87.26.56; see Domit, 50, reproducing a vintage platinum print of this image from Seymour Adelman's collection.

27. Goodrich 1982, II: 118.

28. Eakins' contribution to this commission is not completely understood; see McHenry, 127–128, and Maria Chamberlin-Hellman, "Samuel Murray, Thomas Eakins and the Witherspoon Prophets," *Arts* 53 (1979): 134–139. A letter from TE to Francis Eakins Crowell, 22 Oct. 1895, notes the onset of this commission in the fall of 1895, a year earlier than previously known; see Foster and Leibold, no. 99, p. 113.

29. The Trenton reliefs have been well documented in Zoltan Buki and Suzanne Corlette, eds., "The Trenton Battle Monument: Eakins' Bronzes," *New Jersey State Museum Bulletin* 14 (1973). See also Rosenzweig, 143–145, and Goodrich 1982, II: 119–126.

30. Goodrich 1982, II: 120.

31. Eakins' platinum photographs of the plasters and Bregler's copy prints from these images are in the Hirshhorn; see Rosenzweig, cats. 77a, b. Seymour Adelman owned similar prints. Another set of platinum prints, including a detail of *Crossing the Delaware* (see n. 32), was sent to PAFA by Eakins for use in the 1894 annual exhibition catalogue; these are now in the PAFA Archives. Eakins' glass negatives are in CBTE, 87.26.40 (fig. 85) and 87.26.41 (of the clay) and 87.2.m, 87.2.l, 87.26.42 (of the plaster). A vintage platinum print of the clay model from the glass negative 87.26.40 is 1985.768.2.815. Photographs, perhaps similar to fig. 85, appeared in the brochure published when the monument was dedicated on 19 Oct. 1893; temporary versions cast in "staff" were in place for this ceremony, but the slightly reworked panels in bronze were not installed until spring 1895. The original reliefs are now in the State Museum in Trenton; replicas are now on the monument and in the Hirshhorn. The display of these reliefs at different exhibitions was evidently important to Eakins, who sent nothing else to the Academy's Annual in 1894; see Goodrich 1982, II: 121–124. The panels were best seen in such venues, because their perspective coordinates imply a viewer sharing the horizon line of the principal figures. Occasionally given credit for adjusting these panels to account for their placement on the monument twenty-five feet above most

viewers, Eakins in fact made no perspective concessions to his audience and added far more detail and delicacy than a spectator at that distance can actually appreciate.

32. Eakins liked this grouping, as indicated by the enlarged detail of this section of the *Crossing the Delaware* relief sent to PAFA for possible use as a catalogue photo in 1894. Eakins' annotations on this photo confirm the identity of the three figures; he notes that Hamilton was "afterwards Sec. Treasury" and Monroe was "afterwards President of U.S." Hendricks correctly named these figures (1974, 224); Goodrich's revised identification now must be withdrawn (1982, II: 325).

Chapter 11. Photography: Science and Art

1. The first extended study of Eakins' work in photography appeared in an exhibition and catalogue organized by Gordon Hendricks and PAFA: *Thomas Eakins: His Photographic Works* (Hendricks 1969). Hendricks' pioneering work led to publication of *The Photographs of Thomas Eakins* (Hendricks 1972), which admittedly listed only about 90 percent of known images. Marred at the outset by omissions, errors, and illogical sequencing, this book has since been outdated by reattributions and the emergence of much new material. The appearance of Bregler's collection effectively triples the number of known images from Eakins and his circle, making Hendricks additionally inadequate, although his catalogue numbering (H 1–287) remains the basic reference system for these photographs. Goodrich's revised edition includes extended discussion of Eakins and photography (1982, I: 244–278), with a survey of new research and bibliography through 1982. Of particular note is the appearance of two new groups of work from the estate of Edward H. Coates, introduced in catalogues by the Olympia Galleries. See Olympia 1979, with an introduction by Seymour Adelman, and an analysis and listing (O 1–21) in Onorato 1976, 127–140. This collection was dispersed at Sotheby Parke-Bernet, New York, on 10 Nov. 1977; see their sale catalogue, no. 40448, *Photographs by Thomas Eakins,* with an introduction by Anne Horton. The second Olympia group, containing about sixty items from the Eakins circle, was published in *Photographer Thomas Eakins* (New York: ACA Galleries, Olympia Galleries, 1981), with an introduction by Ellwood C. Parry III. See also Robert McCracken Peck, "Thomas Eakins and Photography: The Means to an End," *Arts* 53 (May 1979): 113–117; Pamela McDonald, "Eakins, the Camera, and the Avondale Photographs," in Avondale/Dietrich, 27–29. William Innes Homer has offered several reattributions in "Who Took Eakins' Photographs?" *Art News* 82 (May 1983): 112–119, and commented on the Whitman portraits in "New Light on Eakins and Whitman in Camden," *Mickle Street Review* (1990): 74–82. Homer has also surveyed the Eakins photographs at the J. Paul Getty Museum, where many new items from the collections of Olympia Galleries, Gordon Hendricks, and the Crowell descendants have been gathered; see "A Group of Photographs by Thomas Eakins," *J. Paul Getty Museum Journal* 13 (1985): 151–156. Also relevant to the study of Eakins' work is Ruth Bowman, "Nature, the Photograph and Thomas Anshutz," *Art Journal* 33 (Fall 1973): 32–40. Individual items in the collection of the Hirshhorn Museum or the PMA can be usefully studied in Rosenzweig, Siegl, and Sewell.

2. See Danly and Leibold, which was developed at the same time as this book and includes much of my research on the photographs, just as this chapter and chap. 18 benefit from the assistance of Cheryl Leibold. The Danly and Leibold volume also contains three excellent essays by scholars expert in the context of nineteenth-century photography and the iconography of Eakins' art; because these texts emerged after the creation of this manuscript, references to their content appear only in the notes. Danly and Leibold publish a topical listing of prints and negatives by Eakins and his immediate circle. To this volume one should turn for details of size, technique, and dating, the identification of sitters and subjects, and the complexities of attribution created by the presence of many photographers within Eakins' ambit, all of whom may have contributed to his projects or left their own prints in his collection. This reckoning of the Bregler collection does not include Charles Bregler's own substantial photographic oeuvre, nor the approximately 200 items by professional photographers—named and unnamed—from about 1850 to 1940, or by other photographers (both amateur and professional) apparently unrelated to Eakins. Of the 600 prints more closely identified with Eakins' circle, 100 are portraits or figure studies of Eakins himself. The remaining images are mostly by Eakins, although work by Susan Macdowell Eakins and other students (Elizabeth Macdowell Kenton, Samuel Murray, Thomas Anshutz, John Laurie Wallace, Amelia Van Buren, Eva Watson, Edmond Quinn) has been identified or suggested, some of it once attributed to Eakins. In addition to these prints, the collection includes 43 glass positives and 270 glass negatives. Most of these positives, and about 200 of the negatives, can be attributed to Eakins. *Eakins and the Photograph* gives the most complete sense of Eakins' work as a photographer, but it must be noted that the Bregler collection is not comprehensive. Approximately one-third of the images listed in Hendricks are not found in CBTE, and other important collections remain to be assimilated, notably Seymour Adelman's material (mostly gleaned from the Eakins house) now in the Bryn Mawr College Library, the substantial Macdowell family collection, still owned by SME's descendants, and important groups of photos in the J. Paul Getty Museum or dispersed from the Olympia Galleries after 1977.

3. The largest Bregler album seems to have been compiled retrospectively, as shown by the range of images on the first page, which includes items from early and late. The priority of images showing Susan Eakins on this opening page may also suggest her participation in the composition of the album. Bregler's annotations appear scattered throughout the album, and photographs by him (of his family) or inserted by him (with cellophane tape) also suggest his later manipulation of the contents. Bregler, as we know, recovered many manuscripts, clippings, and photographs from the floor of the Eakins house, where they had been dumped by the people collecting the furniture for auction. This moment of turmoil may have damaged some items, especially the glass plates, although the general loose, dirty, pinholed, and unmounted condition of the prints must have existed before this upheaval (Foster and Leibold, 1–27). Eakins seems to have exhibited his photographs only twice; Hendricks asserted that the first was at PAFA in 1886 (see fig. 90) (Hendricks 1969, 52; 1972, 8; 1974, 217; Milroy, *Lifetime Exhibition Record,* 25). There were 1,871 items exhibited at the Photographic Society's huge show at the Academy held 11–16 January 1886; see PAFA, *Pictorial Photography,* 6. Two of Eakins' photos (both titled *Bathers,* from the collection of Eva L. Watson-Schutze) were also shown in 1899–1900, among a group by related Philadelphia photographers at the Camera Club in New York; see Goodrich 1982, I: 259, Danly and Leibold, 10, Bolger and Cash, 33, n. 33, and Milroy, *Lifetime Exhibition Record,* 29. On the general condition and con-

256

NOTES TO PAGES 107–109

servation of the CBTE photographs, see Debbie Hess Norris in *JAIC*, 60–62. On the special vulnerability of albumen prints, see chap. 18 below.

4. The pattern of loss in the collection deserves further study, if only to contemplate why some materials have survived and others not. The collection has, for example, many images of Margaret Eakins, but only one of her sister Caroline (1985.68.2.77, H 38), who appears in other known images (H 34–39, 73, and see fig. 15, from Hendricks' collection). Were pictures of her destroyed after she was banned from the household in 1886? Likewise, many of the known Avondale photographs do not appear in Bregler's collection. Were they given to the Crowells, for their interest? Or thrown out when the families were alienated in 1897? There are also no Whitman prints or negatives here; did Samuel Murray claim them all?

5. Two Macdowell daughters—Susan and Elizabeth—were amateur photographers and painters. Their early interest, like Eakins', may have been related to the commercial art involvement of their father, who was an engraver. A remarkable number of photographs of Eakins have survived, perhaps because his heirs were careful curators, and certainly because he was often photographed. Leibold 1991 is a survey of this iconography. Eakins' willingness to appear before the camera gathers additional meaning in his Arcadian subjects; see chap. 17.

6. Hendricks mistakes this seriousness for personality, attributing gloominess to both Eakins' sister Margaret and Susan Macdowell, although both were characterized by their friends as playful and witty (1972, 3, 5). By the turn of the century SME was more relaxed before the camera, as seen in photos of her in the yard with her pets. Few photos show Eakins smiling, either; with typical twentieth-century taste we seize on one (frontispiece) that he discarded in favor of a more dignified image.

7. On his purchase of a photograph of Gérôme, see Goodrich 1982, I: 21; his later purchases are listed in his Spanish notebook (CBTE), including "etudes" (p. 5), "photographie nature" (p. 6), "photographies academies," "femmes turques," and an expensive group of unspecified "photographies" for 29.50f (p. 9). The character of these photos may be implicit in the omission of about half of his notebook entries from the statement of expenditures sent to his parents in a letter of 30 Aug. 1869 (CBTE, Foster and Leibold no. 52, fiche series I 9/E/7–10 and 3/B/1–4). Several of his letters from Paris also discuss photographic reproductions of art, acquired for John Sartain, e.g., TE to BE, 30 Dec. [1867] (Foster and Leibold no. 35, fiche series I 2/D/4–2/E/3). Eakins mentions buying photographs of Thomas Couture, and CBTE contains carte-de-visite images of J. L. E. Meissonier and Rosa Bonheur; the Dietrich Collection has Eakins' photos of Gérôme and his paintings, Bonnat (fig. 45), and other French colleagues, all acquired in Paris. None of the photographs "from nature" acquired in Paris have been precisely identified, although R. M. Peck has proposed that a "Turkish" nude study (H 70) previously attributed to Eakins is, in fact, French (see "Thomas Eakins and Photography," 113–114). Peck may be correct, although the image he discusses is a platinum print, a technique not common until after 1880. On such French nude photos, see Aaron Scharf, *Art and Photography* (London: Penguin, 1968; rev. ed., 1974), 124, 130–134; and Anne McCauley, "'The Most Beautiful of Nature's Works': Thomas Eakins' Photographic Nudes in Their French and American Contexts," in Danly and Leibold, 22–63.

8. On the issues and spokesmen in the debate over photographic aids and effects in this period, see Scharf, *Art and Photography*, esp.

144–166; and Van Deren Coke, *The Painter and the Photograph* (Albuquerque: University of New Mexico, 1964; rev. ed., 1972).

9. Foster and Leibold, 206–208. Recognizing the longevity of the suspicious attitudes born in Eakins' day, Goodrich felt it necessary to reassure his readers that there is nothing "shameful in an artist's using photographs" (1982, I: 258).

10. Gérôme, quoted in Ackerman 1986, 160.

11. Several photographs by the Schreiber firm are in CBTE or other PAFA archival collections. Gutekunst photographed Eakins more than any other professional photographer; CBTE contains eight images by him (in twenty-nine prints, five glass positives, and six negatives) made between 1868 and 1893.

12. Eakins' face, cropped and reversed from this image, appears on his exhibitor's pass to the Centennial, H 244 (Hirshhorn). The location of this picture, from its brick and board architecture, seems to be an alley or stableyard in Philadelphia. Eakins added his self-portrait to *The Gross Clinic* in a pose slightly different from that in fig. 87 but probably taken from a photograph, because he does not look out "at himself," as in most self-portraits. He may have considered including himself in the entrance corridor, in the place of Dr. S. W. Gross, who stands in a similar posture in the background of the painting and shares the horizon line with his father. For the full stereoptic plate, see Foster and Leibold, frontispiece.

13. Goodrich noted that both SME and her sister Elizabeth had a camera in the 1870s (Goodrich 1982, I: 244). Her photo of Eakins, H 247, is dated in her retrospective diary (CBTE). Elsewhere in this diary she noted her own acquisition of a camera (5 June 1882). In a letter of 1929 she was less precise about the dating of this portrait (TE at "about 35") (SME to Carmine Dalesio, Foster and Leibold, no. 20, 273).

14. See Mary Panzer, *Philadelphia Naturalistic Photography, 1865–1906* (New Haven: Yale University Art Gallery, 1982); and Danly and Leibold, 3–10.

15. On the rowing subjects and their "telephoto" foreshortening of space, see chap. 12. The use of photographs in the painting of *The Gross Clinic* was first suggested by Hendricks in "Thomas Eakins' Gross Clinic," *Art Bulletin* (March 1969): 57. On Eakins' photography of Rush's sculpture, for use in painting *William Rush Carving*, see chap. 14 below, n. 21. On the possible use of photographs for the Hayes portrait, see chap. 19 and cat. 189w.

16. On the collotype reproduction, sometimes referred to as an "autotype," see Siegl, 65. Eakins' letter of 13 July 1881 to S. R. Koehler is in *Kindred Spirits: The E. Maurice Bloch Collection . . .*, part 2 (Boston: Ars Libri, 1992), 26–27. The magazine ceased publication before the article and illustration appeared, so it is not known whether Eakins produced additional photo-based gouaches. This technique is demonstrated in a large "light proof" touched by ink wash of *The Christian Martyrs*, by Eakins' friend P. F. Rothermel (PAFA). On the problems of chromatic distortion in early photography, see Beaumont Newhall, *The History of Photography* (New York: Museum of Modern Art, 1964), 92. Eakins had photographs of his paintings made in this period, as shown by glass negatives in the Bregler collection of *The Chess Players, Baby at Play,* and *William Rush Carving*, all paintings completed before he acquired a camera in 1881. The photos may have been taken later, of course, but references to long-awaited "photographer's proofs"—maybe portraits, but perhaps reproductions—in his letters in 1875 tell us that he was patronizing professional photographers. See TE to Earl Shinn, "Good Friday" 1875 and 13 April 1875, Cadbury Collection, Swarthmore College Library. Other glass plates in CBTE,

evidently made by Eakins, record the unfinished appearance of some canvases, such as *Mending the Net* (see chap. 16), *The Pathetic Song* (see n. 33 below), *Between Rounds,* and *Riter Fitzgerald.*

17. "Instantaneous Photography," May 1881, 156; "Recent Progress in Photography," August 1881, 967–58. The first of these articles noted the performance of the new dry plates, outlined their chemistry of preparation and development and mentioned recent literature. The second article also discussed the utility of lantern slides (positive images on glass) and the ease of their production, which Eakins apparently grasped immediately. The artistic potential of photography itself is discussed only in terms of more sophisticated studio setups and retouching. The cost of equipment is also addressed, with a modest camera priced at $10 and 4 × 5 dry negatives listed at $1.15 a dozen—still not cheap for either amateurs or professionals accustomed to reusing homemade plates. On the development of gelatin dry plates, first commercially available in England in 1878 and slowly accepted in the United States, see Robert Taft, *Photography and the American Scene: A Social History, 1839–1889* (New York: Macmillan, 1938; rpt., New York: Dover, 1964), 364–375. The relevance of dry plates to Eakins' interest is noted by Parry in Olympia 1981, n.p.

18. Rosenzweig, cat. 131. According to Eakins' personal memorandum in January 1883 (Dietrich Collection), he also had a trunk to carry his plates, a tripod, and a "solar camera" and accessories. The solar camera was probably an early enlarger, on the model of the one invented by David Woodward in 1857; see Newhall, *History of Photography,* 92. The focusing lens, not mentioned in this inventory, must have been acquired later (see Rosenzweig, 228). The Hirshhorn also has a later camera, c. 1904–7, from Samuel Murray's collection. It may have been used jointly by TE and SM, although no photographs by Eakins have been assigned to this late date, and Murray was working in his own studio by this time. See Rosenzweig, cat. 132; Hendricks 1972, 1. Taft notes that the Scovill Company was the first camera manufacturer to recognize the extent of the amateur market, producing some of the earliest inexpensive, portable cameras available (*Photography and the American Scene,* 376).

19. A group of photographs taken on the Crowell farm on 26 May 1881 appeared in "Eakins at Avondale"; see Avondale/Dietrich, cats. 17, 23, 25. Two photos from this series, *"Bess" with Groom* and *Horse with Groom,* are now in the PAFA collection, from the estate of Gordon Hendricks (1988.10.55, 56). On the dating of the shad fishing negatives, see chap. 16; on SME's recollections of photographs of her mother in Eakins' yard, 26 June 1881, and photos of Academy girls in "infant waist" dresses in "Trot's" yard, see her retrospective diary (CBTE). The *Philadelphia Telegraph* reported on 17 Oct. 1881 that TE had spent part of the summer at "Squan," confirming the date on the box of negatives. These and other photographs, as well as the acquisition of a camera, have been dated to 1880 by Hendricks, evidently based on two photographs of Harry dated "June 1880" (see H 9). A New Jersey beach scene dated "Squan 1880" is also in the J. Paul Getty Museum. These items inspired Danly and Leibold to date fig. 94 and some other Manasquan photos to 1880, with others dated 1881; see 18, n. 16, and 137, 166, 214. However, the absence of additional work until April 1881, particularly in relation to likely projects (such as *The Crucifixion*) completed in 1880, and the burst of activity documented in the spring of 1881 make me believe that Eakins acquired his own camera that year. The "1880" photographs may be by another photographer, made with another camera, or simply misdated. On J. L.

Wallace's recollection of photographs made for *The Crucifixion,* see chap. 6, n. 38.

20. Siegl, 91–92.

21. The seemingly noncommittal record of modern life was a hallmark of realism in literature and the visual arts, although most progressive painters also artfully cultivated the intrinsic properties of the medium. On the "style-less" style, see Linda Nochlin, *Realism* (New York: Penguin, 1971), 13–56. On this aspect of Eakins' work, see Mary Panzer, "Photography, Science, and the Traditional Art of Thomas Eakins," in *Thomas Eakins and the Photograph,* 95–115.

22. The collection includes twenty-nine glass negatives, one glass positive, and fourteen prints taken at the University of Pennsylvania. This tally includes the six prints, four negatives, and one positive made in connection with Eakins' study of the "differential action" of equine tendons (see cats. 82–87). It also includes three "off-duty" photographs of the participants, seen in prints 1985.65.2.495, .532 and .498, and negatives .1005 and .1006 (fig. 91). All of these informal shots, plus six of the negatives (.984, .991, .993, .999, .1002, .1003) and eleven of the prints (.322, .397–.400, .402–.404, .405b, 408, .409) of the motion studies are fresh images. See Danly and Leibold, 203–206. The discovery of the original negatives is rewarding because their annotations allow a partial reconstruction of Eakins' calendar of work, and they offer a crisp view of many images previously known only in Bregler's blurred or reversed copy prints. Vintage prints from this series once owned by Murray are in the Hirshhorn (see Rosenzweig, 118); a group of six albumen prints owned by E. H. Coates is now in the Library Company of Philadelphia. Related drawings are cats. 88–91. SME noted in her retrospective diary (CBTE) that "Tom worked at his moving animal photos with Anshutz and Godley 1885," but little work of this kind has survived, aside from two equestrian subjects (1985.68.2.322 and 1000).

23. CBTE has 107 prints from the "Naked Series," although some of these do not follow the seven conventional poses established for the regular series and therefore may be only peripherally related. Three different series of glass negatives show Eakins himself, in his own studio. The first series, extant in four poses only, shows him against the same figured cloth used in photos for *The Pathetic Song* (see fig. 97). Series 2 and 3 (fig. 93) are complete, and they differ from a fourth series in the Olympia Galleries group (1981, fig. 25) seen in CBTE in albumen prints of poses 6 and 7 only. No other negatives from this series are in CBTE; Eakins gave some to the Franklin Institute (see H 133, 256), and the remainder seem to have been destroyed, except for the plates of himself. The CBTE prints show several models not seen elsewhere, and a variety of presentations, from large albumen sheets with many separate images printed together (1985.68.2.350–.353) to separate figures evidently clipped from such sheets but never mounted. A few, like fig. 92, were found mounted in standard order on blue cards, much like the sets owned by the Coates family and published by Olympia Galleries (.347, .348, .349). See Danly and Leibold, 200–203. On the "Naked Series," see Parry's introduction in Olympia 1981, and Parry. A related drawing, outlining the purposes of these photos, is cat. 29.

24. See Foster and Leibold, SME retrospective diary, 31 Aug. 1884, CBTE. Eakins' work at the University of Pennsylvania was first examined in detail in Homer and Talbot, 194–216. Goodrich gathers information to describe the calendar of this project and Eakins' various technical problems, 1982, I: 268–275. See also McHenry, 73–81; Hendricks 1972, 6–8; Siegl, 110–111. Anshutz revealed the low points in the project by noting to Wallace that "I have no desire to

become an electrician in order to make my own photographs." He also remarked the "clumsy and slow" shutters on Muybridge's lenses, which dissatisfied the "university people," who nonetheless felt they had "gone too far to back out"; see Bowman, "Nature, the Photograph and Thomas Anshutz," 38. Fifty-six exposed plates can be calculated from the numbers and dates on the glass negatives; apparently each day's work was numbered in a fresh series. Known images today account for only three-quarters of this number; the extant negatives represent only half. This destruction of both prints and negatives suggests that more than fifty-six plates were made. The test plates made in November 1884 using the new shed and apparatus may be among the extant examples, although none of the CBTE negatives bear these numbers.

25. Goodrich 1982, I: 297. The University's report, *Animal Locomotion: The Muybridge Work at the University of Pennsylvania: The Method and the Result* (Philadelphia, 1888), printed a wood engraving of Eakins' photograph on p. 14. On Marks' chronograph, and on his role in some of the contradictory claims made in this report, see Goodrich 1982, I: 276–78, and McHenry, 78–80.

26. On his exhibition with the PSP in 1886, see n. 3. Eakins lectured on his new "electrical apparatus" camera to the PSP in Dec. 1883 and at PAFA on 22 May 1885 (SME, Retrospective diary, CBTE; Hendricks 1974, 215–217). On his Academy of Sciences paper, see cats. 82–87.

27. Hendricks remarks the "highly developed framing sense" in these early photos and comments on the cropping of the print of the beach scene (1969, 15; 1972, 2); see also n. 29. This negative (fig. 95) is numbered "11" on the glass; like two Delaware River views numbered "7" and "8" (1985.68.2.967, 968), it may be among his first photographs. Winslow Homer's work comes to mind in the image on glass negative 1985.68.2.977, which shows two distant figures arm in arm on the beach, as in *Promenade on the Beach* (1880, Museum of Fine Arts, Springfield, Mass.). These Manasquan prints are very rare: Hendricks catalogued only six (H 4–8 and 27–28, 7 and 8 being variant croppings of the same image), two of which have negatives in the Bregler collection (H 27, 28; 1985.68.2.860, 857). Another ten negatives showing beach views and figures related to these scenes, but no prints, are in CBTE (1985.68.2.856, .858–59, .969–.975). See Danly and Leibold, 166, 214. As in other sections of the photograph collection, notably the Dakota series, the loss rate of both vintage prints and negatives seems to be very high. One albumen print in the CBTE album (.776), showing many figures splashing in the water alongside boats, does not relate to any other image in the Manasquan group and may well be by another photographer.

28. CB, draft of a letter to Hyatt Mayor, 1 Feb. 1944 (Foster and Leibold, fiche series IV 3/E/11). See also Peck, "Thomas Eakins and Photography." The interplay of painting and photography in the nineteenth century has been shown to be more complex than previously imagined, in Peter Galassi's *Before Photography: Painting and the Invention of Photography* (1981).

29. "Naturally so great an artist with both brush and canvas could be expected to carry over much of his strong sense of composition and chiaroscuro into photography," wrote W. I. Homer ("A Group of Photographs by Thomas Eakins," 153). Homer also comments on variant croppings in photographs of Maggie Eakins in the Getty collection (155). Hendricks, who describes the cropped Manasquan landscape (H 9) as being on a page from a Crowell family album, speculates that Fanny Eakins may have cropped the picture for insertion into the book. This kind of intervention by others, particu-

larly SME, is always a possibility, although the habit of cropping is so widespread in Eakins' work that I feel sure it represents his practice in most cases. Because most of the edges seem to have been cut with scissors, it is impossible to know if any cropping was also done in the enlarging process. Eakins' opinion of retouching can be construed from his remarks in a letter to J. L. Wallace, thanking him for a photograph received in the fall of 1888: "The negative must have been very beautiful before it was retouched." Naturally, it would be useful to know what image inspired the use of the word "beautiful," but no other clues are available; see Foster and Leibold, 246. SME expressed the same opinion in her instructions to a photographer (Gutekunst?) written across an envelope containing a glass negative of an earlier portrait of Eakins: "There seems to be a little retouching on this negative, which I would like removed, if possible, without hurting it" (1985.68.2.831).

30. Brownell, 741. I am grateful to David Brigham for noting the relevance of this remark to Eakins' photography.

31. SME, from the draft of a letter to Mrs. Dick (who owned *The Fairman Rogers Four-in-Hand*), c. 1930 (Foster and Leibold, 299).

32. On *The Pathetic Song*, G 148, see cat. 203 and Goodrich 1982, I: 201–206. The oil sketch (fig. 59) is G 149; see Rosenzweig, 93–94. The watercolor replica given to Miss Harrison in gratitude for her posing was not listed by Goodrich in 1933; it is published in Hoopes, 68–71, who describes it as a "culmination of all his ideas concerning the beauty and expressiveness of women in interiors." Schendler commented on the "deep restrained feeling" in this painting as an affirmation of Eakins' values: "He believes in the highly civilized social order which can produce these sensitive people" (86–87). I commented on the social context described in this picture in "American Drawings, Watercolors, and Prints," Metropolitan Museum of Art *Bulletin* (Spring 1980): 40–41; Johns developed the theme of the painting in the context of Eakins' other musical subjects (1983, 132–135). Contemporary reviews of this painting ranged widely, as usual. Most hostile was Earl Shinn, who declared that "Eakins, for the first time in his history, becomes 'banale,' and gives us a commonplace Constant-Mayer-like woman in the worst-fitting of reach-me-down dresses, executing a song with the fixity and rigidity of taxidermy" ("Exhibition of the S. A. A.," *Art Amateur* 4, no. 6 [May 1881]: 117). Mariana Van Rensselaer agreed by noting the "unpromising material" selected—"three homely figures with ugly clothes in an 'undecorative' interior," but praised the "delightful" result, with its "deep insight into character" and strong national flavor; see her review in *Atlantic Monthly* 48 (Aug. 1881): 198–199. Along the same lines, a reviewer in the *Art Journal* compared *The Pathetic Song* to Bastien-Lepage's *Joan of Arc*, also in the SAA exhibition that spring, noting that both were the result of "an intelligent soul transforming what is popularly considered ugliness into beauty." Eakins' painting was judged by this writer to be one of the best in the show, and one of the best of his works exhibited in New York ("Art Notes," *Art Journal* 7 [May 1881]: 157–158).

33. Charles Bregler drew a sketch map of this studio; see Foster and Leibold, fiche series IV 13/D/1–14. The room can still be visited in the Eakins home. Prior to the discovery of these images, the only period views of this "north" studio were H 14, of Margaret Eakins, H 258 of Eakins (see fig. 103, which shows the same chalk lettering on the wall), and a few costume studies (H 63, 64, 69) that give a fragmentary glimpse of the room.

34. On *The Two Augurs*, see chap. 4, n. 3. The poses and costumes recall the staged photographs of Academy students in classical dress, made in the early 1880s; see H 61 and O 1–3. The painting of *The*

Pathetic Song appears near completion in another negative in the collection (87.26.52), which shows the canvas unsigned and with detail still to be added in the picture frame at upper right, in the sheet of music, and in the figure of SME, which was considerably reworked after this photo was made.

35. Full length: 1985.68.2.867 (fig. 97), .866 and .869; half length: .874 (fig. 98), .871 and .872; bust length .875 (fig. 99), .873 and .876. See Danly and Leibold, 167–168.

36. Siegl, 93. This concept, and a consideration of Eakins' awareness of the differences between human and camera vision, is discussed in chap. 16.

37. Onorato noted the "creative distance" interposed by Eakins' photographic studies that, like mechanical drawing systems or neoclassical costumes, allowed the "greatest possible sense of visual objectivity." The photos, being black and white, were also suggestive of sculpture (1976, 130).

38. Charles Bregler told Hyatt Mayor that SME did some of Eakins' printing; her choices may inflate the pool of duplicates and enlargements. Even so, we can expect that her taste would have seconded her husband's sense of these images. See Onorato 1976, 139, n. 26. Platinum printing may also be a clue to the date of any print, as it dominates the collection after about 1885. Eakins' account book (Dietrich Collection) records expenses for platinum prints on 31 July 1884. However, retrospective printing of favored images, as indicated in TE's letter to J. L. Wallace in 1888 (see chap. 18) may also mean that some of the platinum enlargements were made years after the negative was taken. This practice only reconfirms, however, the significance of these images to Eakins and his pleasure in their existence as photographs.

39. See O 10, and photographs and paintings of SME, chap. 17. The collection includes five other prints of this image of a woman: H 191 (1985.68.2.502–.505, .510) and the glass negative (.1053). Another cropped print is in the MMA; see H 191. A related image, of the same model in a frontal pose, not known to Hendricks, also survives in the collection in four platinum prints (.511–513, .507) and the negative (.1054). See Danly and Leibold, 180.

40. This technique, from a printing-out process distinguished by its "Baryta" layer and glossy surface, is seen less often in the collection, and only in prints dated to the 1890s, such as the photographs of cats by TE or SME. The image published in Goodrich 1982, I: 258, and Sewell, 80, is slightly larger than the CBTE albumen (1985.68.2.675) and platinum print (.499), but the print type is not identified. Although the background has a half-considered quality typical of Eakins' work, showing three different cloths pinned behind the model, the attribution of this photograph—like all the others—rests largely in its emergence from Eakins' studio. Certain oddities about this image, such as the object dangling from a string behind the model, and her gesture with a fencing foil (?) may never be completely understood.

41. Seymour Adelman claimed to have interrupted a bonfire in the back yard of 1729 Mount Vernon Street in the spring or summer of 1939, and he later concluded that the scarcity of nude subjects found in Eakins' house was the result of this destruction, probably instigated by Addie Williams or Elizabeth Macdowell Kenton. Kenton was "family," not friend, but her disapproval of Eakins' use of student models in 1886 may have inspired her to protect Eakins from additional, posthumous scandal. The disappearance of many negatives in this part of the collection, as well as the emergence of plates with no extant prints, points to some loss, although this pattern is apparent throughout the photo collection. My tally of

CBTE includes more photographs of nude men than women at a ratio of about 3:2. This proportion probably reflects the greater availability of men as models, not Eakins' sexual preference, although his intense interest in nudity in general can be underscored. See Olympia 1979, xiv; Goodrich 1982, I: 246; Foster and Leibold, 15, 114–121; Danly and Leibold, 178–205. Sylvia Yount has also remarked to me the androgyny of many of these images, esp. figs. 103 and 104. Elizabeth Johns discusses these currents in Eakins' photographic work in "An Avowal of Artistic Community: Nudity and Fantasy in Thomas Eakins' Photographs," in Danly and Leibold, 77–80. On the male nudes photographed at the "Swimming Hole," see chap. 17 above.

42. Three images in this series survive, showing Eakins' carrying the model (.847, and .848, fig. 105, only extant as negatives), and then lowering her to the floor (.430 and .431, both platinum prints from the same negative, now lost; see Danly and Leibold, 189–190). Goodrich remembered seeing these prints in SME's possession, and he recounts the story of Eakins' friend Mrs. J. M. Dodge, who received, with some surprise and reluctance, "lantern slides" of similar subjects featuring Eakins (Goodrich 1982, II: 96). Eakins' aggressiveness in sharing these images with others suggests a wish to shock or test female friends and acquaintances, a pattern seen elsewhere in his behavior.

43. Parry in Olympia 1981, n.p. (vii); Goodrich 1982, I: 246. Also see chap. 17.

44. On the later motion studies, see cats. 82–91. Many photos of models in neoclassical costume, often posing with casts of sculpture, seem to have been made in the early '90s from Maud, Weda, and Katherine Cook; see 1985.68.2.244–47, .255, .662, .664, .668, .674, .676–77, .1108–9. *The Wrestlers* (G 317, National Academy of Design) was painted from photographs (H 229–231). Oddly, the photograph (H 229) most like the painting and its related sketch (G 313, PMA; see Siegl, 149–150) is not in CBTE; the only extant print came from Murray's collection to the Hirshhorn; see Rosenzweig, 165. The other wrestling images known to Hendricks (H 230, 231) were CB's copy prints from two of his vintage platinotypes, 1985.68.2.434 and .435. Two additional platinum prints, unknown to Hendricks, are also in CBTE: 1985.68.2.432 and .433. See Danly and Leibold, 168–171, 198.

45. Diary for 1899, CBTE. Addie Williams came to live with the Eakinses the following year.

46. These two albumen prints, 1985.68.2.107–108, cannot be precisely dated. See Danly and Leibold, 146. According to Goodrich, the first oil portrait of Addie (G 323, Art Institute of Chicago) was painted about 1899, the second (G 333, PMA; see Siegl, 154) about a year later. McHenry notes a letter from TE to Addie in 1898, inviting her to come to be photographed (133). See also chap. 19 above, n. 6.

47. Goodrich offers an excellent discussion of the late photographic portraits and their relation to Eakins' oils (1982, I: 255–257). He also cites Eakins' refusal to revise a portrait from photographs: "Any attempt on my part to get from mean sources what I may have failed to get from the best would be disastrous" (II: 81). Goodrich notes that Eakins painted eleven portraits entirely from photographs, but only because the sitters were deceased. The corpus of Eakins' photographic work seems to be most vulnerable to attrition by reattribution in the area of portraiture. The photograph of David Wilson Jordan (H 196) has been assigned to Thomas Anshutz; see Ruth Bowman, "The Artist as Model: A Portrait of David Wilson Jordan by Thomas Anshutz," *Register of the Museum of Art* [University

of Kansas] 4, no. 10 (Fall 1973): 5. The so-called *Frank Hamilton Cushing* (H 221) has been found in the Macdowell family collection as *John Reynolds,* perhaps taken by SME or EMK; see 1985.68.2.199, .673. SME and EMK also may have a claim to other images; see Danly and Leibold, and Homer, "Who Took Eakins' Photographs?" Murray's role in the Whitman portraits, also discussed in Homer's article, may lead us to enlarge his role in the photography of his fiancée, Jennie Dean Kershaw; only one image of her (H 224) was found in CBTE. More needs to be known, too, about the early work of Eva Watson and Amelia Van Buren, who were business partners and commercial photographers together in the 1890s. The beautiful series of Van Buren (1985.68.2.702, not in Hendricks, and .712, H 176), showing an environment and an attention to setting not seen in other Eakins' photographs, could well be Watson's work, parallel to equally lovely portraits of Eva Watson in a similarly contrived pose and setting, perhaps by Van Buren (1985.68.2.109–11). A portrait of Louis Kenton, who married Elizabeth Macdowell, is also in CBTE, signed "Van Buren and Watson"; see 1985.68.2.177.

48. The most recent examination of the Whitman photographs discards several of the images attributed to Eakins by Hendricks; see Homer, "Who Took Eakins' Photographs?" 115–119. It is noteworthy that most of the extant prints and all of the seven extant negatives have come from Samuel Murray's collection, now in the Hirshhorn; see Rosenzweig, 67 a–c, and Rosenzweig, "Problems and Resources in Thomas Eakins' Research: The Hirshhorn Museum's "Samuel Murray Collection," *Arts* (1979): 118–120. The PMA's prints are from Mark Lutz, who knew both Bregler and Murray; their technique (silver print) may mean they are later than the only set with a direct provenance from TE: the group of five images solicited by Laurens Maynard for the Whitman Collection at the Boston Public Library. Oddly, this Boston group was not entirely collated into Hendricks' listing. The Boston selection includes H 152 (or a very close variant), published in Small and Maynard's edition of *The Complete Prose Works* (1898), and a near variant of the portrait (H 158) published in the companion volume, *Leaves of Grass.* The library also received from Eakins prints of H 154, 155, and 156, although Homer has identified the first two as by Murray. Maynard's letter to Eakins of Dec. 1896, asking for his photos and a "written statement by yourself of the date and circumstances of the sitting" has come to light in Bregler's collection (Foster and Leibold, no. 185), but unfortunately the library has no such "statement" or any other record of correspondence between Eakins, Maynard, or the then librarian, Herbert Putnam. A letter from Eakins to Maynard late in 1898 asks for the return of the two negatives used for the book illustrations (Dietrich Collection; see Avondale/Dietrich, 74). Maynard's retention of these negatives may explain why Eakins sent variants of these two images to Boston. Many of the photographs on the wall behind O'Donovan's bust (fig. 106) are from the group Homer has attributed to Murray, including the uppermost enlargement (H 154). One print is clearly H 153, but the remainder (excluding those evidently by other photographers) are variants of known prints, indicating the loss of other negatives and prints from this series.

49. See PAFA, *Pictorial;* the wider context of the struggle for the "artistic" status of photography, largely an issue of the 1890s, is surveyed by Newhall, *History of Photography,* 97–109.

50. 11 Sept. 1886 (Foster and Leibold, 236).

Chapter 12. The Rowing Pictures: "A Passion for Perspective"

1. Earl Shinn to Elizabeth Haines, 3 Mar. 1867 (Cadbury Collection, Swarthmore College). TE to BE, 5 July 1869 (CBTE, Foster and Leibold, no. 51, fiche series I 3/A/13–14). On Eakins' knowledge of Gérôme's *The Prisoner* of 1859, seen at the Exposition in 1867, see chap. 4, n. 3, and Ackerman 1969, 240. A similar subject, *Excursion of the Harem,* appeared at the Salon of 1869.

2. McHenry, 23. Johns has enlightened the context of *Max Schmitt,* surveying his career and the American rowing movement in her book (1983, chap. 2). She notes the quality of "the chase" in this series and remarks that Eakins was the first and only painter of his caliber to undertake rowing subjects. Many other scholars have commented on Eakins' rowing paintings; for a summary, see Goodrich 1982, I: 81–122, and Schendler, 33–41. On *The Champion Single Sculls,* G 44, see Spassky, 588–594. The other finished oil paintings on this theme include *The Pair-Oared Shell,* G 49, of 1872 (fig. 108); *The Biglin Brothers Turning the Stake,* G 52, of 1873 (Cleveland Museum of Art); *The Biglin Brothers Racing,* G 61, of c. 1873 (NGA); *The Schreiber Brothers,* G 66, of 1874 (fig. 109); and *Oarsmen on the Schuylkill,* G 63, of c. 1874 (fig. 115). Watercolors include *John Biglin in a Single Scull,* G 57, of c. 1873, and its replica, G 60 (fig. 64). Three watercolors recorded by Goodrich (G 54, 55, 56) are unlocated. The entire series has recently been surveyed by Helen A. Cooper et al. in Yale 1996. A draft of this chapter was shared with Cooper, whose essay reflects much of the information and analysis given here and in my essays on the rowing pictures in Wilmerding, 68–73.

3. On Eakins' rowing subjects in watercolor and Gérôme's response to them, see chap. 9 and fig. 64.

4. Bregler's correspondence is scattered with references to these perspective drawings, e.g., CB to Fiske Kimball, n.d. [1940s] (CBTE, Foster and Leibold, fiche series IV 1/D/6), and notes on SME's estate (IV 4). The perspective drawings in this series *not* in CBTE include G 50 and 51, for *The Pair-Oared Shell* (PMA); G 53, for *The Biglin Brothers Turning the Stake* (Hirshhorn); a drawing not listed by Goodrich but related to G 54, *The Biglin Brothers Turning the Stake* (Cleveland Museum of Art); G 58, for *John Biglin in a Single Scull* (MFA, Boston); and G 62, for *The Biglin Brothers Racing* (Hirschhorn).

5. The Schreibers are not listed in any of the races published in Fred J. Engelhardt, *The American Rowing Almanac and Oarsman's Pocket Companion* (New York: Engelhardt and Bruce, 1874 and 1875 eds.).

6. SME identified this painting as *The Schreiber Brothers,* although she remembered only Henry's first name and his reputation as an animal photographer; see Goodrich 1933, 165. In 1929 she described the rowers as two younger brothers of the photographer; see Foster and Leibold, no. 20, 273, fiche series II 1/C/9. Photos of Eakins' father and sister Caroline stamped or inscribed "Schreiber and Sons" are in the PAFA Archives, from the collection of Gordon Hendricks. Other inscribed Schreiber photos of dogs and horses are in CBTE. See Foster and Leibold, figs. 20, 85.

7. Goodrich 1982, I: 121.

8. No plan for *The Pair-Oared Shell* exists, but Siegl was able to deduce the angle of recession (67 degrees) from his examination of the PMA's perspective drawings. The slope of this line would be 2.5:1 across the plan (see PMA, *Three Centuries,* 392). Siegl's reconstructed plan can be improved by the addition of a line indicating the picture plane, six feet in front of the observer. His text on p. 391

errs in describing the position of the shell, which extends 7 1/2 feet to the left of center. Otherwise, his excellent discussion of this painting and its related drawings is the only extended analysis of Eakins' perspective method in the literature. A condensed version of this text appears in Siegl, 54–56.

9. Both *The Pair-Oared Shell* and *The Biglin Brothers Racing* are 24 × 36 in. The perspective drawing for the latter painting appears to have a viewing distance of six feet, a horizon height of thirty-six inches, and figures at about one-seventh scale.

10. TE, PMA typescript, 5.

11. Typically, the figures are established in relation to an "easy" scale base line nearby, such as the one-half scale along the 20-foot line in the foreground of the drawing for *The Biglin Brothers Turning the Stake* (Hirshhorn).

12. See discussion of the "law of perspective" and Eakins' long viewing distances in chap. 7 above.

13. On the "telescoping" effect, see chap. 7. Siegl described this effect indirectly and somewhat confusingly as the product of an unusually long "point of distance" (the vanishing point of diagonals running 45 degrees from the picture plane). While true, it is easier to remember that the point of distance is the same as the distance from the observer to the picture plane, projected "sideways" left or right along the horizon line from the center point (PMA, *Three Centuries*, 391–394).

14. Additional notations in this corner indicate that he was considering even deeper placement of the shell (at 90, 110[?], and 120 feet) but rejected the idea, perhaps because the figures would become too small or the viewing distance too long for the size of the picture.

15. Hendricks (1974, 335) proposed that this drawing was made as a model for a wood engraving in 1880, with retracings added by Bregler in the twentieth century. The engraving recapitulates the details of the larger oil, however, not the revisions in the figures seen in this drawing. I also find it unlikely that Bregler, in his reverence for Eakins' work, would have heavily redrawn this piece. The wood engraving, by Alice Barber, appeared as *On the Harlem* in *Scribner's Monthly* 20 (June 1880): 165; see Parry and Chamberlin-Hellman, 35. The lost watercolor, G 54, was exhibited as *The Pair-Oared Race—John and Barney Biglin Turning the Stake*, no. 207 in the AWS exhibition in Jan. 1874. As Goodrich notes, it was priced at $200, indicating (for Eakins) a large and detailed piece. If indeed used for transfer, the Cleveland Museum's drawing may give the scale of this lost watercolor. The transfer process that I have proposed would be desirable for watercolor compositions because the pinhole system used for his oils could disfigure the watercolor paper. Valuable new insights into Eakins' transfer method appear in Christina Currie, "Thomas Eakins Under the Microscope: A Technical Analysis of the Rowing Paintings," in Yale 1996, 90–101.

16. The sketch of Max Schmitt, G 64, is catalogued in Siegl, 53. The other extant sketches are *The Oarsman*, G 65 (Portland Art Museum), and the large study *John Biglin in a Single Scull*, G 69 (Yale University Art Gallery). Other oil sketches are evidently buried under the paint of later work; see Siegl, 54, 64, 66, 173.

17. Goodrich 1982, I: 108.

18. See Bregler's annotations on cat. 147. His remarks about Eakins' use of boatbuilders' plans are found in "Thomas Eakins as I Knew Him" (Foster and Leibold, fiche series IV 13/D/5). Other measured boat drawings are cats. 164–170.

19. Engelhardt, *Almanac* (1875), 116–117.

20. "The Watercolor Exhibition," *New York Daily Tribune*, 14 Feb. 1874, 7. "Nature made a blood horse as her masterpiece, and man a skeleton boat as his."

21. See Bregler's annotations on cat. 147.

22. This painting, G 63, was dated "about 1873" by Goodrich, who linked it to the sketch of Max Schmitt, G 64 (fig. 113), presumed to be from about the same time. Siegl argued that the sketch must have been done earlier, however, at the time of *The Champion, Single Sculls,* and therefore he concluded that *The Oarsmen* was also from 1870–71 and may have been the first of Eakins' large rowing pictures. Siegl points to the absence of reflection studies (caustics) in both G 63 and 64 as evidence of the earlier, less scientific phase of this series (Siegl, 53). However, the breadth of the sketch and the incompleteness of the painting may also explain this omission in both.

23. A verso inscription on cat. 149 identifies the subject as "4 oared shell Schmitt." Hendricks was the first to recognize Schmitt and suggest a date of 1874 (1974, 333). Johns suggested this race in 1874 as the pretext for the painting (1983, 41, n.48). She shared her notes with me on the names of the other crew members; this information can be confirmed in Engelhardt, *Almanac* (1875), 73–74. The same crew rowed in the regatta on 17–18 June of that year; see p. 29.

24. See Johns 1983, fig. 28, and Esther M. Klein, *Fairmount Park: A History and a Guidebook* (Bryn Mawr, Pa.: Harcum Junior College Press, 1974), 47, 56–59. Cooper suggests Eakins' position at the tip of Peters Island, although she errs in stating that the boathouses of the Schuylkill Navy are nearby. This error was drawn, however—like much of her analysis of *The Oarsmen*—from an earlier version of this chapter; see Yale 1996, 74.

25. Befitting its commemorative purpose, the painting hung until 1929 on the sun porch of the Pennsylvania Barge Club's boathouse, probably as a gift from the painter. Seymour Adelman said that Eakins, like Schmitt, belonged to this club, although Johns was unable to find his name in the club's records (1983, 24, n. 11). The time of the race is not given in Engelhardt's *Almanac*, although it may have been late in the afternoon, like some of the Biglins' races. Because a straightaway course was rowed, there would have been no 180-degree turns in this race. Race turns are made from port to starboard, anyway, so—notwithstanding Schmitt's show of effort—the shell is not making a racing turn.

26. Engelhardt's *Almanac* gives the standard length of a four-oared shell as forty-one feet, with oars twelve feet, three inches in length. The oars in Eakins' plan, cat. 149, are twelve feet long, like those used for pair-oared shells (1875, 119).

27. Siegl, 53. Siegl was convinced that only the portrait of Schmitt had been painted from life.

28. Goodrich 1982, I: 121, quoting a letter of 26 Mar. 1875.

Chapter 13. "Original and Studious Boating Scenes"

1. McHenry, 131, 141; Goodrich 1982, I:89; Hendricks 1974, 77–78. Eakins probably kept a boat in Fairton; see the photographs by Louis Kenton of Eakins at the "Fish House" (H 284–286).

2. From SME's notes on TE's paintings (Foster and Leibold, 287, fiche series II 4/E/3).

3. TE to J.-L. Gérôme, n.d., c. Mar. 1874, letter draft in French (Foster and Leibold, 56, fiche series I 3/E/4–10). TE's illness was also described in a letter from BE to Henry Huttner, 29 July 1874: "Tom last fall had a serious attack of 'Malarial Fever' which kept him in the house for 10 or 12 weeks, since then he is all right, painting away" (Foster and Leibold, xv, 340).

4. G 79; Hoopes, 28. George P. Tomko, *The Catalogue of the Roland*

P. Murdoch Collection (Wichita: Wichita Art Museum, 1972), 54–57. Tomko finds a change in the inclination of the mast in the watercolor, compared with the oil version, that I do not see. Eakins must have been proud of this watercolor because he exhibited it often: in Louisville in 1879; at Haseltine's gallery in Philadelphia in 1879; in Chicago in 1880; at the Boston Art Club in 1881; at the PAFA Annual in 1881; and at the Academy Art Club in Philadelphia in 1883. At the time of these last two exhibitions, it was owned by the boat-builder James C. Wignall; see Milroy, *Lifetime Exhibition Record*.

5. Two oils are based on this composition: *Sailing*, G 77 (PMA), oil on canvas, 32 × 46 3/8 in. (see Siegl, 63); and *Starting Out After Rail*, G 78 (fig. 116). Goodrich dates both oils and the watercolor to the same year (1874) without commenting on their order of execution, but he mentions that *Sailing* recapitulated "with changes" the composition of the others (1982, I: 108). Hoopes (28) argued that both oils preceded the watercolor, with the larger *Sailing* begun first and only "sketchily painted," followed by the smaller, more finished *Starting Out After Rail*. Siegl, with I believe greater sense, concluded that the two identical oil and watercolor versions came first, while the larger *Sailing* was a "simpler, improved . . . second approach to the same theme." He therefore dates the larger oil to "about 1875," although it could have been made any time after the watercolor was finished in Jan. 1874 (Siegl, 63). The smaller oil was sent to Paris in May 1874 and submitted by Gérôme to the Salon of 1875. This painting remained overseas for about five years, so it was not exhibited often in the United States, perhaps only at the Brooklyn Art Association in 1883. The larger oil was apparently never exhibited (Goodrich 1982, I: 119, 321–322).

6. TE, PMA typescript, 41; Goodrich 1982, I: 102.

7. SME said that it was given to Wignall; some scholars, including Goodrich, have speculated that it was traded for a boat (see Goodrich notebooks [PMA] and Goodrich 1982, I: 87). Wignall's full name and address, at "Warren above Beach" (in Kensington), appear on the verso of G 69, the perspective drawing for *The Artist and His Father Hunting* (coll. Dr. Peter McKinney), which also contains a plan and elevation of the gunning skiff depicted in the painting. Bregler recollected Eakins' practice of borrowing boat plans; see chap. 12, n. 18.

8. Eakins offers a beautiful plan and elevation of a ducker in the perspective drawing cited in the preceding note. Similar contemporary drawings can be found in "A Delaware River 'Ducker,'" *Forest and Stream* (21 Apr. 1887): 286. Hikers (seen in *Sailboats Racing* of 1874; fig. 62), tuck-ups, and duckers, all boats of a similar size "peculiar to the locality and used so far as we know on no other waters," were described and compared in the 24 Feb. 1887 issue (p. 94). The designs in *Forest and Stream*, by W. P. Stephens, were later published in his book *Canoe and Boat Building* (New York: Forest and Stream Publishing, 1889). The classic source for such comparisons of boat types is Howard I. Chapelle, *American Small Sailing Craft: Their Design, Development and Construction* (New York: Norton, 1951); see 216–217 for diagrams and description. The development of the ducker has been documented, with Eakins as an informant, by Benjamin A. G. Fuller in "Delaware Ducker: A Brief History" and "The Ducker in Use," in *Wooden Boat* 48 (Sept.–Oct. 1982): 78–86. Fuller speculates on the origins of the ducker, based on its similarity to an Indian canoe (a term Eakins uses in his letter to Gérôme, cited below), and analyzes the difference between the old-style open model, seen in *The Artist and His Father Hunting*, and the "transitional" type with additional decking depicted in *Starting Out After Rail* and *Rail Shooting* (fig. 122). Although boatbuilders seem

to have been making duckers in the 1850s, the craft caught on in the 1860s, when the first racing records appear. Clubs in north and south Philadelphia were formed in 1872 (in Kensington) and in 1875 (in Southwark) to formalize activities in these boats; see Fuller, "Delaware Ducker," 79, 83. Lance Lee, in "Why the Ducker Today," in the same issue of *Wooden Boat* (86–89), describes the understated beauty of the ducker and her virtues of construction and functional compromise. "The Delaware Ducker, in her heyday, was an intentional marriage of workboat and pleasure craft, and few changes or adaptations to the modern usage can improve or detract from the original mode. It appears that everything, everything, everything was thought out" (88). As an artist and a sportsman, Eakins evidently appreciated such complexity and refinement. Additional photographs of extant duckers can be found in Maynard Bray, *Mystic Seaport Museum, Watercraft* (Mystic, Conn.: The Museum, c. 1979), and Philip C. F. Smith, *Philadelphia on the River* (Philadelphia: University of Pennsylvania Press and the Philadelphia Maritime Museum, 1986), 72–73. The watery activities enjoyed by Philadelphians in this period are also described in Rita Z. Moonsammy, "The Work Cycle of the Meadowlands," and Roger B. Allen, "Sailboats on the Delaware, Yesterday's Playground," both in Tracey L. Bryant and Jonathan R. Pennock, eds., *The Delaware Estuary: Rediscovering a Forgotten Resource* (Newark: University of Delaware, c. 1988). For much help with bibliography and boat-typing, I am indebted to Jane E. Allen, curator of the Philadelphia Maritime Museum; David A. Taylor, folklife specialist, and Gerald Parsons, librarian, of the American Folklife Center at the Library of Congress; and my own resident folklorist, Henry Glassie.

9. TE, PMA typescript, 42; Goodrich 1982, I: 102.

10. McHenry, 68–69. *Starting Out After Rail* also appears in cat. 98 (fig. 48).

11. TE, PMA typescript, 42; Goodrich 1982, I: 102.

12. Eakins owned a sailboat—perhaps a tuck-up or a ducker—that he kept at Cramp's shipyard in Kensington, near Wignall's shop, north of the city center; see Goodrich 1933, 7, and McHenry, 57. McHenry noted that his sailing subjects depicted the river near Kensington and Fishtown, and it is possible that this view looks south from there.

13. "American Society of Painters in Water Colors," *Nation* 18 (12 Mar. 1874): 172. See also chap. 9 above, nn. 8, 16.

14. The exchange of letters with Gérôme is discussed above in chap. 9.

15. G 68. The present title might be corrected to describe their quarry as rail, not reed birds. A description in "A Day in the Ma'sh," an article that Eakins illustrated in 1881, comments that "toward sunset the reed-birds congregate in large flocks and then slaughter is great. . . . Rail-birds are also objects of pursuit in the Ma'sh; but rail-shooting can be enjoyed only at high tide, as the boat must be pushed over the reeds" (*Scribner's Monthly* 22 [July 1881]: 345, 348, 352). A much easier kind of hunting, reed bird shooting was disdained by "high-boat" hunters, and we can imagine that Eakins would have celebrated the more difficult endeavor; see Fuller, "Delaware Ducker," 82. Although the time of day in *The Artist and His Father* does seem to be near sunset, no flocks are to be seen, and the hunter seems poised for the rise of a rail as he is pushed through the marsh at high tide. The illustration accompanying the *Scribner's* text, entitled "Rail Shooting," is a wood engraving of *Will Schuster and Blackman* (fig. 122), showing two figures engaged in the same type of hunting seen in *The Artist and His Father*. Eakins exhibited no painting in his lifetime with "reed birds" in the title; the

present title was first published in the 1917 memorial exhibition catalogue, perhaps based on SME's labels on the verso.

16. Many scholars have speculated about the two paintings Eakins exhibited at the Salon of 1875, and the four other paintings sent that same year and shown at Goupil's gallery in Paris or London. All of these tentative lists are hampered by Eakins' inconsistent record-keeping (he annotated only four items as "shown at Goupil's" or "Paris" in his record books), vague contemporary descriptions, and the threat of missing paintings. Goodrich reformulated his 1933 list to propose that the two Salon paintings were *Starting Out After Rail* (G 78; fig. 116) and *Pushing for Rail* (G 70; fig. 121) (1982, I: 321–22). Alternate formulations are proposed by Ackerman 1969, 253, 255; Siegl, 57–58, 63; and Hendricks, 82. These arguments, as well as the problems posed by the documentation, are summarized in Lois Marie Fink, *American Art at the Nineteenth-Century Paris Salons* (Cambridge: Cambridge University Press and the National Museum of American Art, Smithsonian Institution, 1990), 214–216. All agree that *Starting Out After Rail* was one of the two, but the second picture may never be securely identified. *Pushing for Rail* can probably be eliminated from contention, although it was surely in the second group of four paintings sent to Goupil's in the spring of 1875. Eakins' record book 2 (CBTE) notes that this picture, sold to the MMA, was exhibited in Paris and then in the United States in 1883 and '84, after being returned from Goupil's no earlier than 1879 (Goodrich 1982, I: 322). Known by Eakins as *Shooting Rail on the Schuylkill Flats,* this picture could therefore not have been the one shown at the NAD in 1877 as *Rail Shooting on the Delaware.* Hendricks' misdating of Eakins' letter to Shinn, leading to his mistaken co-identity of these two paintings, makes his speculation about these pictures unhelpful (1974, 82–83); see Goodrich 1982, I: 121–122, for better analysis and dating of these texts. More useful are Eakins' descriptive remarks to Gérôme in the letter that accompanied the first shipment in 1874 (cited below), which tally well with *The Artist and His Father,* and a second letter from 1875 that describes the four new pictures as a "big" painting of water (probably *Sailboats Racing,* G 76, recorded in Eakins' record book 2 as shown at Goupil's), a "drifting race" (probably G 82, *Ships and Sailboats on the Delaware,* PMA), a "nigger" (G 72, *Whistling for Plover,* now unlocated, recorded as exhibited and sold in Paris at Goupil's), and a new rail-shooting picture with "splendid" figures but a composition deemed "too regular" (probably G 70, *Pushing for Rail*). These paintings all arrived too late for submission to the Salon jury, and Gérôme had the two "old ones" at Goupil's sent instead, because "the figures were larger, and Goupil wanted the four new ones for London" (Goodrich 1982, I: 118–119). Exhibition reviews described the two Salon paintings as each containing two hunters in a boat. From these clues it would seem that the two Salon entries were *Starting Out After Rail* (G 78, recorded in record book 2 as sent to Paris) and *The Artist and His Father,* a painting not listed in Eakins' record books. It is also possible that this second Salon piece was the lost *Rail Shooting* (G 105, also not listed in the record books), which also featured larger figures.

17. *A Paradise for Gunners and Anglers* (Philadelphia, Wilmington and Baltimore Railroad Co., 1883), 69–70. "When the law permits [rail] is more mercilessly pursued than perhaps any other game bird." Goodrich mistakenly calls these birds "clapper rail" (1982, I: 90).

18. Foster and Leibold, no. 56, p. 154, fiche series I 3/E/4–10. The verso is covered with calligraphic exercises and dated 10 June 1872. Similar sentences are on the verso of cats. 154 and 161. A translated text, with several omissions and errors, said by Bregler to be the work of Louis Husson, was published by McHenry (39–40). McHenry saw the original draft in French and described its appearance as "very much in the rough in his own handwriting on one side of a sheet of ruled copy paper made up of one piece pasted to the bottom of another, with exercises in Spencerian script on the other side" (56). However, Bregler mislaid this letter later, and Goodrich reprinted McHenry's text in English (1982, I: 319:20). Deletions are indicated; superimposed text appears in italics.

> Je vous envoie deux petits tableaux et une aquarelle. La premier represente une belle chasse de mon pays. Elle se fait avec ~~dans~~ des canots. Il y a deux hommes a chaque canot le pousseur et le chasseur. [~~illegible~~] On arrange de sorte que l'on arrive aux bords du marais deux ou trois heures avant le plus haut de la marée. Aussitot que l'eau est assez haute pour laisser nager le canot sur le marais, les hommes se levent et commencent la chasse. La pousseur monte sur le pont et le chasseur se tient au milieu du bateau pour ne pas enfouir la tete, la pied gauche avance peu [?]. Le pousseur pousse le bateau ~~l'oiseau les oiseaux~~ parmi les roseaux. ~~les oiseaux se sauvent en courant en nageant et en volant. Le chasseur tuer~~ Le chasseur tue les oiseaux qui s'envolent. ~~Dans Aussitot qu'un oiseau J'ai representé~~ Je montre dans mon premier canot le mouvement quand un oiseau vient de sauter. Le pousseur crie voilà (mark) ~~et poussent~~ et [~~illegible~~] sur le champ de pousser *se raidit et* tache d'arrêter le bateau ou au moins de le tenir plus ferme. Il ne devrait [*illegible*] être d'aplomb, car [~~illegible~~] l'inertie du bateau fait une pression considerable contre la cuisse *pression qu'il* resiste avec son poids. Le chasseur [*sic*] crie toujours *en voyant l'oiseau* car *dans [?]* la plus part de la saison ~~c'est lui~~ quand le roseau est *encore* vert c'est lui qui le voit le premier à cause de sa position plus elevé sur le pont. Il le voit souvent et le chasseur ne le voit point, tant le roseau est haut et epais. J'ai choisi *pour montrer mes bonhommes* la saison ou les nuits frais de l'automne et les filants [?] on fait tomber et secher le roseau. *Autrement on ne verrant que les têtes de mes bonhommes.* Mais le chasseur *pousseur* cris tout de même il en a l'habitude. Quand un oiseau est tué le pousseur chargé son fusil si c'est son second canon qu'il vient de décharger et alors le pousseur ayant bien ~~remarquer~~ *dan la tête* l'endroit ou l'oiseau est tombé [~~illegible~~] y va et ramasse l'oiseau mort au moyen de son filet. Quelquefois en ~~y~~ allant *voir [?] l'oiseau morte [?]* il saute d'autres oiseaux et il y aura enfin *peutetre* une douzaine de oiseaux morts avant que le pousseur puisse en ramasser une. ~~C'est là ou les bons~~ quoique on ne puisse *en* tuer ~~ces oiseaux~~ qu'un a la fois. C'est principalement en se rappelant bien les endroits qui aux nouveaux sont tout pareils apres avoir une fois tourné la tête que les bon pousseurs se distinguent. */ Le pousseur plante son baton qui a 14 pieds de / Le pousseur de profession ceux qui en font metier sont /* Le baton de pousseur á 14 pieds de longeur. Au bout il y a une fourche pour s'engager avec les racine et les roseaux et de l'empecher de se defoncer *trop* dans la boue. A l'autre bout il y a un bouton pour que la baton ne se glisse pas d'entre les mains. Le pousseur regarde toujours en avant et plante son baton de sorte que la resistance du bateau soit [~~illegible~~] égal contre ses deux pieds. Alors le moindre pression de plus sur l'un ou *sur* l'autre pied tournera le nez du canot du côté opposée.

19. The French text reads:

> On devrait savoir l'endroit de l'exposition d'un tableau avant

de le commencer. Dans la couleur meme chose. Si j'ai un ciel bleu et des nuages jaunes les nuages un peu plus lumineux que le ciel et si je les peints par une lumiére chaude et quand [?] J'apporte mon etude ou elle sera illuminée par un reflet du ciel bleu ~~tout de suite~~ les mêmes nuages sont tout de suite plus foncés que le ciel au lieu d'etre plus lumineux. [illegible phrase]

La force même d'une lumiere *entierement blanche* dérange mes couleurs. Un jour *devrant tres* faible illumine de bleu enormement longtemps après avoir cessé a illuminer le jaune et le rouge.

J'ai peint mes deux tableaux dans une lumière tres forte et assez chaude dans un reflet de soleil qui donnent sur les maisons. Une lumiere faible ~~les tuent mes~~ *alors noircit* mes couleurs *mais* une lumière bleu les detruit. J'aurais [?] été [?] peuetre plus raisonnable d'avoir ~~peint mon tableau~~ pris un chemin moyen, ~~entre~~ d'avoir choisi pour travailler un~~e~~ jour ni fort ni faible et une lumière tout a fait blanche.

Quelle est l'habitude des meilleurs peintres? Y a t'il un convenance

Ceci est le rail qui vole. Je ~~me suis bien rappelé de n'ai pas oublié ce que~~ Je l'ai dessiné de profils d'abord. Son thorax est assez court.

20. Eakins' text in French reads as follows:

Si j'ai trois tons principaux. A, B, C.

Le premier est un endroit ou le soleil donne directement. A.

La second est un endroit où le soleil ne donne pas mais qui recoit de la lumière du ciel et des choses illuminees. B.

La troisienne est un trou ou l'on ne voit pas de lumière. C.

Si (je fixe ces trois tons) juste (dans une lumière forte) et que j'apporte mon etude dans une lumière faible B noircit et s'approchent trop de C et fait ~~trop~~ un effet noirâtre et désagreable. Au contraire se je fixe mes trois tons dans une lumière faible d'après mon souvenir de l'effet que j'ai vu au soleil et que j'apporte ~~mon~~ cette étude dans un jour plus fort. B s'approchent trop d'A, et mon effet parait faible.

Entre ces limites où rester? ~~On devrait peut etre~~

The top of this third page of notes contains these remarks:

~~J'aurais mieux fait.~~ [*illegible*] *que j'aurais mieux* les details du marais *qui* si j'avais pu finir mes études. En attendant la saison ~~du jaune~~ que j'ai representée *dans mon tableau* ~~je suis~~ j'ai attrapé la malaria en faisant cette même chasse, et la fièvre ma pris très mal. Je restait a lité [?] 8 semaines sans rien savoir la plupart du temps. On croyait *les médécins* que j'allais mourir. Quand je suis revenu à moi même ~~j'etais faible long j'etais~~ *très* ~~faible les feuillage était était~~ les arbres n'avait plus de feuilles[.] J'étais *longtemps* trop faible de traviller et mon intelligence aussi restait faible. Enfin j'ai repris mon travail des *peu* [?] d'études que j'avais faites et d'impressions qui n'était plus récentes. ~~Je suis maintenant bien partant.~~

Un marais a des details ravissants. J aurais gardé mon tableau jusqua l'automne de cette année, mais le medecin me defend de faire la chasse cette annee [~~illegible~~] quoique j'y suis habitué depuis mon enfance. Il me serait [?] dangereux.

Jai fait quelques portraits de genre et quelques portraits d'animaux.

Je ~~pense~~ sens que je vais bientot faire beaucoup mieux. Dans cet espoir j'invite votre critique si vous voyez dans mes tableaux des tendances mauvaises.

An English translation of this page:

I would have made the details of the marsh better if I had been able to finish my studies. While waiting for the season [of yellow] that I represented in my picture I caught malaria pursuing this same hunt, and the fever took me badly. I was bedridden 8 weeks, senseless most of the time. They [the doctors] believed that I would die. When I came to myself the trees no longer had leaves. For a long time I was too weak to work and my mind was also feeble. Finally I took up my work again from the few studies that I had made and impressions that were no more recent.

A marsh has ravishing details. I was going to keep my painting until this fall, but the doctor forbids me to go hunting this year even though I have been used to going there since childhood. It will be dangerous to me.

I have made a few genre portraits and a few portraits of animals.

I feel that I will soon do much better. In this hope I invite your criticism if you see bad tendencies in my paintings.

21. These remarks are excerpted from the last pages of notes in the book (38–42), which follow his remarks on the Salon of 1870. After an interval of blank pages, an "address book" of models, describing their qualities and physical characteristics, concludes this book, indicating that Eakins continued to use it until at least 1880. See Foster and Leibold, fiche series I 9/E/4–10/A/8. The most pertinent notes begin midway down p. 38:

La couleur d'une lumière se fait voir mieux sur les objets blancs. Alors fixer les blancs d'abord [~~illegible~~].

Ce sont les blancs qui mesurent le mieux les deux lumières et les couleurs de ces lumières.

Un tableau qui convient a une lumière quelconque peut se gâter completement par une lumière trop forte.

Proposition: Une lumière blanche trop fort fait avec les couleurs dans un tableau ce que ferait le blanc d'argent. Il detruit la couleur[.] voire le tableau de Max qui est gaté par une forte lumière [~~illegible~~]. Aurait il été mieux de colorier plus fortement mes lumières.

P. 39:

Peut on peindre un tableau de manière qu'il exige telle ou telle lumière.

Quand un tableau est très bas de ton comme chez Rembrandt il est bien dans une assez forte lumière. Dans une faible lumière parait il très colorié et l'on perd beaucoup dans l'ombre.

Une forte lumière detruit-t-elle encore plus vite les couleurs de l'ombre; j'en doute. Peut on exiger du spectateur une faible lumière sur le tableau en faisant gris les noirs.

Au commencement il serait bon de mettre l'ébauche dans le jour le plus défavorable c'est à dire dans celui qui détruit la couleur. Si l'on mettait les couleurs alors, telle quelles devraient etre, on n'aurait jamais de faibles effets de couleurs et je crois qûe l'on pardonne plus facilement au tableau trop de coloration que trop peu . . .

P. 40:

Je place dans mon ébauche la lumière la plus forte et l'ombre la plus foncée. Si j'apporte mon ébauche dans un jour très faible tous les demi teintes s'approchent de l'ombre et paraissent trop noirs mais si je l'apporte dans un grand jour les demi teintes s'approchent trop du point lumineux et fait paraitre commun.

Le vrai principe de faire bon, ça serait peutêtre de faire juste les blancs et les chairs plutôt que tout autre chose et alors il faudrait que les ombres soient plus grises que dans la nature.

Je remarque que Hamilton fait assex gris.

Si je fais justes les plus fortes lumières et que les ombres soient grises mon tableau ne sera pas tant affecté par la couleur du jour.

Comme les differentes lumières dans un tableau sont des variables et que ces lumières font varier tous les tons et que la difference entre les deux lumières principales (marquée sur un blanc ou une chose claire) est generalement plus forte que la difference entre le blanc et le noir[,] on devrait dans l'ébauche ne regarder que ces deux lumières comme chose principale chose qu'il faut fixer tout de suite. Comme on ne peut pas peindre le blanc avec du blanc pur (à cause de ces deux ou trois lumières). Il faut peindre d'abord la première chose coloriée dans la lumière (moins elle sera coloriée plus on peut mettre de lumière dans le tableau). Ayant peint cette chose dans la lumière[,] l'ombre et l'ombre forte, je peindrai dans la lumière la chose la plus foncée (p. 41): en ayant égard à la force de la grande lumière. De ça et de la chose coloriée que j'ai peinte au commencement je fixerai mes blancs. Alors il faut commencer dans l'ombre d'en faire les échos.

Voilà je crois l'ordre qu'il faut suivre pour que chaque ton se trouve sans peine dans sa place, pour que sa place soit bien préparée pour lui d'avance.

Il faut faire l'ébauche très simple d'abord et puis la pousser comme ébauche très pres de la nature.

Translation, p. 38:

The color of a light makes itself seen better on white objects. So establish the whites first.

It is the whites that measure the best the two lights and the colors of these lights.

A painting that allows [?] any light whatsoever can be ruined completely by a light that is too strong.

Proposition: An overly-strong white light has an effect on the colors in a painting similar to the effect of silver white paint. It destroys the color. See the picture of Max which is ruined by a strong light. It would have been better to color my lights more forcibly.

P. 39:

If one could paint a picture in a manner that demanded this or that light.

When a picture is very low in tone, as in a Rembrandt, it is good in a fairly strong light. In a weak light it appears very colored and one loses much in the shadow.

Does a strong light destroy colors in the shadow faster? I doubt it. If one could require of the spectator a feeble light on the picture while making the darks gray.

At the beginning, it would be good to put the sketch in the daylight the least favorable, that is in the light that destroys the color. If one puts the colors on then, the way they ought to be, one will never have a feeble effect of color, and I believe that one pardons more easily too much color in a picture than too little.

P. 40:

I put in my sketch the strongest light and the deepest shadow. If I carry my sketch into weak daylight all the half-tones merge into the shadow and appear too dark, but if I carry it into full daylight the half-tones draw too close to the point of luminosity and are made to appear homogeneous.

The true principle of doing well perhaps will be to make the whites and the flesh correct rather than anything else, and then necessarily the shadows become more gray than in nature.

I notice that [James?] Hamilton works rather gray.

If I make correctly the strongest lights and then my shadows are gray my picture will not be so affected by the color of the daylight.

As the different lights in a picture are variables, and because these lights will make all the tones vary, and because the difference between the two principal lights (shown on a white or clear object) is generally stronger than the difference between white and black, one ought to pay no attention in the sketch to anything but these two lights as the main thing, the thing that must be established immediately. As one cannot paint white with pure white (because of these two or three lights) it is necessary to at first paint the most important colored thing in the light (the less it would be colored, the more one can put light in the picture). Having painted this thing in the light, the shadow, and the strong shadow, I will paint in the light the darkest object in respect to the force of the major light. From that, and from the colored object that I painted at the beginning, I will establish my whites. Then I must begin in the shadow, to make the echoes.

Here is I believe the order that one must follow so that each tone finds itself easily in its place, so that its place is well prepared for it in advance.

One must make the sketch very simple at first and then push it, as a sketch, very close to nature.

22. The watercolor *Whistling for Plover*, G 71 (Brooklyn Museum), was sent to the AWS exhibition in late Jan. 1875, and therefore may have been completed in 1874. The oil version of this subject, G 72, was sold by Goupil's and has not been located. A related composition, *Hunting*, G 73 (Andrew Wyeth), although just 9 1/2 × 11 inches, can be compared to a detailed perspective drawing (not in Goodrich; ex. coll. Seymour Adelman; see Sewell, no. 24) that indicates the painting was carefully planned. An oil sketch of rail, erroneously identified as plover (G 74; see cat. 161) must be from this same time. Because plover are marsh birds, all the plover-hunting studies may be from 1873, before Eakins caught malaria. A larger unfinished canvas, *Landscape with Dog*, G 75 (PMA), was probably begun about this time, too. It may represent the vanished "animal portraits" that Eakins claimed to have made in his letter to Gérôme.

23. Foster and Leibold, no. 57, 19 Aug. 1876, fiche series I 3/D/6–7.

24. According to Eakins' record book entries, this picture was exhibited at the Chicago Interstate Industrial Exposition in the fall of 1877 as *Rail Shooting on the Delaware;* it may have been shown ear-

lier that year under the same title at the NAD. The following October it appeared at PAFA as *Rail Bird Shooting*, lent by G. McCreary, who evidently bought it from the benefit sale for George W. Holmes held in Jan. 1878. In 1881 this image was reproduced in *Scribner's Magazine* based on a gouache replica (Yale University Art Gallery; not in Goodrich). On this composition, see Carol Troyen, *A New World: Masterpieces of American Painting, 1860–1910* (Boston: Museum of Fine Arts, 1983), 269, and Brian T. Allen, "Will Schuster and Blackman Going Shooting," in Wilmerding, 88–89.

25. Goodrich 1982: I: 93.

26. His pleasure in the effects of water in this painting is covertly revealed in his use of the post, reflected in the water, as the basis for an exercise in his drawing manual; see cat. 128.

27. Eakins was still anxious about malaria a year later, when he wrote to his fiancée that he was continuing to dose himself with quinine against the marshy atmosphere of Washington, D.C. See Foster and Leibold, no. 57, 29 Aug. 1877, fiche I 3/D/12–13.

28. "I once asked professional Maurice River guide Ken Camp whether he and the fellows who work for him ever went out without clients and pushed each other just for sport. Mr. Camp said they seldom found the time to do so, but that when they did, the man who was shooting would stand amidships. Moving the gunner back toward the center has the effect of changing the attitude of the boat; it elevates the bow, thus making it easier to push. At the same time, for the gunner to assume this position expresses trust that his colleague on the afterdeck will not brain him with the pushpole. Furthermore, in the middle of the boat, there is nothing for the gunner to brace against; he must remain upright by sheer sense of balance. To stand at that point therefore both requires and demonstrates skill. If in fact Schuster is standing back in the boat, it may conceivably indicate that he is an accomplished railbirder" (Gerald Parsons, American Folklife Center, Library of Congress; from correspondence with author, 10 Dec. 1990). Parsons also quoted contemporary railbird pushers, who now use flat-bottomed, "hard chine" boats, as saying, "I don't know how anybody could stay up in those old round-bottom boats." Parsons' speculation, based on examining the painting, is confirmed by the plan of the skiff in *Rail Shooting* (cat. 155), which shows Schuster's left heel against a rib exactly amidships. The same position is held by Benjamin Eakins, as seen in the plan of *The Artist and His Father Hunting*, although the effect on the bow of the skiff is more apparent in *Rail Shooting*. Camp and Parsons illustrate their point in action on the Maurice River in a photograph in Mary Hufford, *One Space, Many Places: Folklife and Land Use in New Jersey's Pinelands National Reserve* (Washington, D.C.: American Folklife Center, Library of Congress, 1986), 47.

29. See "A Day in the Ma'sh," *Scribner's Monthly* 22 (July 1881): 343–352.

30. McHenry, frontispiece, shows a photo by TE of a sketch by SME on this blackboard.

31. Seen as if thirty-six feet away, on a surface six feet distant from the eye, the figures will be one-sixth life size, as indeed they are on the canvas. The drawing, however, shows them much smaller, at one-twenty-fourth scale. With a viewing distance of eighteen inches, everything in the drawing appears at one-fourth the size Eakins intended for the painting.

32. See text for cat. 158. The perspective drawing for *The Artist and His Father Hunting* (priv. coll.) indicates that the horizon line is sixty-three inches high and the viewing distance of the picture is four and a half feet, giving a scale of one-sixth life to objects at the

twenty-seven-foot line. The two figures, set in space slightly behind this line, are about nine inches tall, or at about one-seventh scale.

33. Goodrich 1933, G 105, 169–170, and his notebooks, PMA.

34. An observation made by Gerald Parsons, in correspondence with the author, 13 Feb. 1991.

35. Murray said that O'Donovan borrowed the painting in about 1892 and presumably took the picture back to his New York studio. Although Homer was rarely in New York in this period, it is conceivable that he saw this picture when visiting O'Donovan, who had been a friend and fellow member of the Tile Club since the 1870s.

36. Foster and Leibold, no. 57, fiche series I 3/C/10–11.

37. Ibid., fiche series I 3/D/2–3.

38. *American Yacht List* (1883), no. 1217, p. 108. The *Vesper* was owned by R. S. Nickerson and others; the owners listed Philadelphia as home port, although they belonged to the Quaker City Yacht Club of Camden, N.J. The club is no longer extant, but its papers are at the Historical Society of Pennsylvania, awaiting examination. The *Lily* was not listed in this register, which was the earliest one that I have found. I am grateful to Jane E. Allen of Philadelphia Maritime Museum for her survey of their records, which yielded only this listing for the *Vesper* and no trace of the *Lily*, although several boats by this name appear in racing records of the 1880s.

39. *Drifting*, on a page 10 3/4 × 16 1/2 in., is marked in graphite to indicate much smaller internal borders; if matted according to Eakins' ruled margins, its dimensions would be about 6 1/2 × 12 inches, close to the size of this sailboat composition. Eakins' preparatory drawings are frequently smaller than his finished composition, often one-quarter of the size of the intended image. Usually his annotations distinguish between the separate viewing distances of the "tableau" and the "dessin," as in cat. 155.

Chapter 14. Art and History:
William Rush Carving His Allegorical Figure of the Schuylkill River

1. See Bantel. Rush was at the head of Eakins' list of Philadelphia artists; see cat. 189k. His statements on Rush, evidently prepared for various exhibition catalogues, are quoted in Goodrich 1982, I: 146, 324–325. The manuscript of his longest text is in the Bregler collection; see Foster and Leibold, 185, and fiche series I 8/F/11–13.

2. The most thorough and enlightening study of the William Rush theme in Eakins' work is in Johns 1983, 82–114. She analyzes Eakins' identification with Rush and the context of the "Old Master in the studio" subject so popular with nineteenth-century artists. Johns also traces the history of Rush's *Nymph* and reveals Eakins' role in the invention of the mythology of Rush's reliance on nude study. Goodrich also finds it unlikely that Rush actually worked from a nude model (1982, I: 145–157). Sewell draws together the many studies for this work (47–57). See also Siegl, 67–72, and Gordon Hendricks, "Eakins' *William Rush Carving His Allegorical Statue of the Schuylkill*," *Art Quarterly* 31 (Winter 1968): 382–404. David Sellin connects Eakins' interest in Rush to the campaign to reinstitute life classes at the new PAFA in the fall of 1876; he notes, however, that Eakins' research on costume seems to have been under way by April 1875 (58–61). Eakins' disputes with the PAFA board over his presence as an assistant to Schussele also coincided with the execution of this project (Siegl, 71), as copied correspondence in his sketchbook (cat. 189o) reiterates.

3. Shinn, "Fine Arts: The Lessons of a Late Exhibition," *The Nation* 26 (11 April 1878): 251, quoted in Sellin, 60–61.

4. The first completed, *In Grandmother's Time* of 1876, was tellingly popular; it sold immediately, unlike most of Eakins' earlier work. See also the drawing for *The Courtship* of 1877 (cat. 190), the oil sketch for *Fifty Years Ago* (cat. 241), and the *Knitting* and *Spinning* sculptures (cats. 260, 261). On this nostalgia for "grandmother's time," see chaps. 9 and 15.

5. Shinn, quoted in Sellin, 60.

6. Ackerman noted the "typical Gérôme stance" of the model in *William Rush Carving* (1969, 246). See also Foster 1972, 96–97, Sellin, 60–61, and Weinberg 1984, 14–15.

7. Goodrich 1982, I: 145; F. F. Hering, "Gérôme," *Century Magazine* 15 (1889): 258.

8. Charles Moreau-Vauthier, *Gérôme, Peintre et Sculpteur* (Paris: 1906), 194.

9. From Eakins' statement, c. 1878–81, CBTE, cited in n. 1. Rush's sketchbook is now lost.

10. See *Interior of a Woodcarver's Shop*, G 112, oil on canvas, 8 5/8 × 13 in. (PMA), and Siegl, 70.

11. The original pen drawing, reproduced in the PAFA catalogue for the exhibition "American Artists at Home and in Europe," 7 Nov. to 26 Dec. 1881, is in the Hirshhorn; see Rosenzweig, cat. 30.

12. This formulation depends on the intervals between the model, Rush, and "Washington" implied in the sketch plan, which is not annotated in any way. Without presuming this pattern, the viewing distance and all other related distances that depend on it could not be precisely determined. See Eakins, *Law of Perspective*, cat. 92. Sellin notes the "startling illusion" of this painting when viewed from "about 3 feet" distant (59).

13. The "Pine-Knot" *Self Portrait* (PAFA) is reproduced in Bantel, 166. The Peale portrait is undated, but was in the Peale museum by 1813; from Rush's costume and appearance, it precedes 1800.

14. Annotated "August, 1807," this drawing (Hirshhorn Museum; Rosenzweig, 63–66) was speculatively identified by Hendricks as from *The Fashions of London and Paris* of that month; see Hendricks, "Eakins' *William Rush Carving*," 384. Although this sketch has been recognized as the source for the costume displayed in the painting, the annotations have not been correctly published, and occasionally Eakins' remarks on the left side of the page (for a different outfit) have been mistakenly used to describe the figure in the sketch. The costume shown in the painting has never been correctly described; it includes most of the items in the sketch. As mentioned in Eakins' notebook, the outfit includes a white cotton dress with a laced and ruffled square-necked bodice; a straw hat tied down with a silk handkerchief; a lace "Van Dyke" collar, tossed over the crest rail of the chair; a "black lace or Chinese shawl," hanging at the left; and yellow kid gloves. A green parasol replaced the white fringed and painted model in the sketch; no shoes are in evidence. To this wardrobe Eakins improvised the addition of a red reticule (?), blue stockings to match the model's hair ribbon, and a provocative jumble of underclothes, probably including a petticoat, chemise, and drawers. As with the surgery in *The Gross Clinic*, Eakins deliberately teases us with the beauty and confusion of these garments, which inspire a voyeuristic curiosity that must account for the sense of "impropriety" felt by some contemporary viewers. That Eakins used particular properties is confirmed by the reappearance of the same dress in *The Courtship* (see cat. 190) of 1877 (Johns 1983, 102).

15. *New York Times*, 13 Mar. 1878, quoted in Goodrich 1982 I: 157.

16. Bantel, 115. Eakins could have seen Rush's invoice to the city, dated 11 Aug. 1809, still preserved in the Philadelphia City Archives. In jest or by coincidence, "August 13th" appears chalked on the wall of Eakins' studio fifteen years later; see fig. 106 and cat. 179.

17. Johns 1983, 100. In an earlier study, G 11 (Yale University Art Gallery), Rush appears in his shirt sleeves—and evidently in 1870s dress, like the chaperone. On Eakins' anachronisms in handling Rush's sculpture, Siegl, 68, Johns 1983, 101, and Hendricks, "Eakins' *William Rush Carving*," 399–400.

18. See Foster and Leibold, 84, and Goodrich 1982, II: 72.

19. This chair also appears in *Seventy Years Ago* of 1877 (Art Museum, Princeton University) and *Retrospection* of c. 1880 (oil, Yale University Art Gallery; watercolor, PMA). It was still in his studio in 1881, when he was working on *The Pathetic Song* (fig. 96). See Goodrich 1982, I: 158. The method of "boxing" complex forms in order to set them easily into space is recommended in Eakins' perspective manual; see cats. 106, 116–118, 123–124.

20. See Bantel, cat. 35, and discussion of CBTE, cat. 182.

21. See, for example, *Eakins at about Fifty with "Billy"* (H 266), c. 1894, *Eakins at Fifty-Six Painting Frank St. John* (H 277), 1900, or the views of Margaret Harrison and the canvas of *The Pathetic Song*, fig. 97, and Eakins' remarks about the placement of his easel, cited in chap. 6.

22. These studies are G 110 (Farnsworth Collection); G 111 (Yale University Art Gallery); and G 113 (Art Institute of Chicago).

23. Susan Eakins mentioned that Eakins had photographed Rush's work, an interesting recollection because it would indicate that he was using a camera three or four years before he is known to have owned one. See Johns 1983, 90, citing SME's letters to William Sartain.

24. Goodrich recorded six figures for the Rush project in 1933 (G 498). By 1939, when SME's estate was inventoried by Bregler, the wax maquette of the model had disappeared, probably the victim of "well-meaning" housecleaning undertaken by Addie Williams or Elizabeth Kenton, who apparently attempted to destroy evidence of Eakins' study of the nude (see Foster and Leibold, 15). SME apparently had misgivings about this nude figure, too, for she did not reproduce it in plaster in 1931, when the other five models were copied; see Siegl, 68.

25. For this recipe, see chap. 10.

26. Siegl, 68.

27. Johns 1983, 90.

Chapter 15. Locomotion: *The Fairman Rogers Four-in-Hand*, 1878–1880

1. See Foster and Leibold, TE, "Notes on Animal Locomotion," fiche series I B/C/1–2. Eakins' concern for precisely measured timing of the photographs emerges in these notes, which argue that it "would have been better, knowing the horse's speed, to have flashed the first camera manually [? text broken] and the others by electric clock work." Muybridge's cameras were tripped by the horse, so that the intervals between pictures could not be recorded. At the University of Pennsylvania in 1884–85, Eakins installed a "chronograph" invented by his colleague, Dr. Marks, to correct this deficiency (see chap. 11 above).

2. The creation of this painting is discussed in Hendricks 1965, 48–64. Eakins' use of Muybridge's photos is analyzed in Homer and Talbot, 194–216. Muybridge's photographs were taken in June 1878, copyrighted in July and August, and rapidly distributed thereafter.

Rogers, who may have known about Muybridge's earlier work for Leland Stanford in 1872, also about horses in motion, might have been among the first to examine the six sets of images published in 1878. By February 1879 Rogers had given a set to PAFA. In February 1879, Muybridge copyrighted the diagrammatic trajectories of each horse's gait; according to Rogers, similar ones had been made by Eakins, probably the previous fall. Eakins' notes, cited above, confirm his early interest in these "curves." Eakins did not contact Muybridge until later in the spring of 1879. Although the dates of Eakins' notes and correspondence and the amount of his work on the trajectories remains speculative, it is clear that both Rogers and Eakins had studied Muybridge's work carefully before the end of 1878. See Hendricks 1965, 49–53; 1974, 214–15. The painting and its studies are discussed in Rosenzweig, 80–85, Siegl, 73–81, Sewell, 64–69, and Goodrich 1982, I: 260–267.

3. Goodrich 1982 I: 172.

4. Eakins listed his sales through 1880 in record book 2, CBTE, 174; see Foster and Leibold, fiche series I 10/D/11. See also Goodrich 1982, I: 326.

5. Rogers, 453–462. Extracts from this article are quoted in Goodrich 1982, I: 173, 181, 184, 186. McHenry (43) and Goodrich (173) speculate that it was written with Eakins. See chap. 8, n. 3 above.

6. Two memoirs supply most of what is known about Rogers' education and interests: Horace Howard Furness, *Fairman Rogers* (Philadelphia: 1903), and Edgar F. Smith, "Biographical Memoir of Fairman Rogers, 1833–1900, Read Before the National Academy of Sciences, Nov. 22, 1906," in *Addresses, Papers, etc . . . of the National Academy of Sciences* (Philadelphia: 1906), 92–107. Rogers was a member of the American Philosophical Society and a founder (in 1863) of the National Academy of Sciences. He taught engineering at the University of Pennsylvania for fifteen years, serving as chairman of the department and ultimately winning an invitation (which he declined) to be president and provost. He became a director of the PAFA in 1871 and, as chairman of the building committee, raised funds for and supervised the construction of the new building at Broad and Cherry Streets.

7. Rogers, in *Art Interchange* (9 July 1879), quoted in Hendricks 1965, 52. Eakins had first studied anatomy and dissection at Jefferson Medical College in 1864–65; see Rosenzweig, 30.

8. Siegl confirmed the existence of Rogers' Springfield farm, previously denied by Hendricks; see Siegl, 73, and Rosenzweig, 78–79. On the use of the horse in classes at PAFA, see Rogers, *Art Interchange*, 7–8.

9. G 499; Siegl, 73. The PMA's bronze cast was made in 1930; the plaster is evidently lost. A skeleton of a horse, G 500, also in relief but at one-eighth scale, was also modeled in 1878; see Rosenzweig, 178–179. A similar cast remains in Mary Bregler's estate. Although the skeleton is said to be Josephine's, the mare was very much alive in 1878. Rogers' abiding admiration for Josephine is illustrated in his *Manual of Coaching* (Philadelphia: Lippincott's, 1899), in which her photograph appears (plate 30) along with Rogers' description of the ideal coaching horse (p. 380). This portrait was not the basis of Eakins' relief (G 499), but the image suggests the existence of other photographic portraits that may have aided his work.

10. Hendricks previously identified Josephine as the off lead (or right front horse) based on her "extensive forelock," a dubious clue because the team is uniformly groomed, with braided manes, and the forelocks are almost invisible. However, lacking better distinctions, Siegl and Rosenzweig followed this lead. More positive evidence appears in cat. 195, where the *other* three horses are all located and

identified: Peacock, the off-leader, who turns obligingly to Josephine; Williams, the near-wheeler, and Chance, the off-wheeler, almost entirely obscured by the other horses. SME insisted that the horses, like the passengers, were all portraits; see Foster and Leibold, 300.

11. G 502, 1882; Siegl, 98–99. A plaster cast of this relief is in the PAFA collection; the PMA's bronze was cast in 1930. Other plaster casts of horse legs in the PAFA may also be from Josephine. A related écorché relief of Josephine, in painted plaster (G 501), is owned by Hirschl and Adler Galleries.

12. Rogers, 7–8.

13. Furness claimed that Rogers was "one of the early photographers, and some of his pictures, taken 45 years ago [i.e., 1858], show very careful manipulation." According to Furness, Rogers was also experimenting with the zoetrope to make an effect of motion pictures (*Fairman Rogers,* 16). Smith, in his *Biographical Memoir of Fairman Rogers,* suggested that Rogers taught Muybridge the concept of the zoetrope, the basis for his later work (106). Hendricks discusses the development of Rogers' special shutter and his early involvement with Muybridge's work (1965, 49–55).

14. Eakins' work on the trajectories was claimed by Fairman Rogers himself in 1879 (see Hendricks 1965, 52–53), although these trajectories were not the ones Muybridge published in 1879, as Hendricks makes more clear in his later book (1974, 214). Homer and Talbot identify the plates Eakins used as models (201, 204). Hendricks' claim that the near-wheeler is walking, not trotting, shows an inattentive examination of Homer and Talbot's research (1965, 58; 1974, 118). However, I do not find convincing their argument that Eakins copied four *particular* consecutive frames (11–14) in the Edgington series. Rather, the photographs find the horse's position repeated exactly every ten frames, with the mirror stance (identical, but on opposite feet) occurring on the fifth frame. Any four sequential frames therefore show the four basic poses recorded by Muybridge's camera. My examination of the profile photographs of Eakins' sculptures (Siegl, 75) and Muybridge's plate seems to indicate that Eakins illustrated one of each of the four "moments" but not any four frames in a row.

15. Siegl, 77. The PMA's bronzes were cast in 1946 from the original waxes, now in the collection of Paul Mellon.

16. G 134; Siegl, 75–76, 80, 173. The fan, not listed in Goodrich, is in the collection of Mrs. Matthews Williams. A color reproduction of it appeared in the Sotheby's sale catalogue no. 3865, 29 April 1976, lot 53. Eakins' departure for Newport is calculated from William Sartain's letter, 14 June 1879, quoted in Siegl, 76. Eakins was in Newport again, from 9 Sept. to early Oct. 1879 (see Siegl, 78), based on TE's letter to SME of 9 Sept. 1879 (Goodrich 1982, II: 334). SME told Mrs. Lewis R. Dick in 1931 that "TE staid with Rogers and did most of the painting there"; see SME's "Notes on TE" (CBTE, Foster and Leibold, fiche series II 4/A/10).

17. Siegl, 78. Many of these studies, like cat. 244, were cut down and split, usually by Bregler. One, G 182, is in the PMA; see Siegl, 78. Others are in the Hirshhorn: G 137 (r. and v., now split), G 201 (v.) and G 199; see Rosenzweig, 80–85. Currently unlocated are G 181, with the forelegs of the near-wheeler on the verso, and the verso of G 165 (now separated from its recto landscape), a full-length study of the off-wheeler.

18. Siegl, 79–80, found a problem in dating the landscape sketch at the PMA (G 62) and the finished painting if the "May" in the title of the painting is taken literally. If done in May 1879 the picture must have been thoroughly composed prior to his Newport visit. How-

ever, if the Newport sketch (fig. 142) is understood as an alternate campaign, the prior work in Fairmount Park ceases to be perplexing. The painting is dated 1879, and, according to Eakins' record book 2, it was finished by Jan. 1880, though it was not exhibited until that fall.

19. Siegl's files at the PMA note the overpainting of the sky and foliage, evidently done in 1880 to counter criticisms that the landscape was not "in keeping." See also Siegl, 81.

20. Rogers, *Manual of Coaching*, 121.

21. Ezra M. Stratton, *The World on Wheels; or Carriages, with Their Historical Associations from the Earliest to the Present Time, Including a Selection from the American Centennial Exhibition* (New York: The author, 1878), 384.

22. Siegl guessed that Eakins must have had such drawings (81). According to Sewell, Bregler remembered that Eakins painted the coach from an "accurate perspective drawing made by its manufacturer" (67). Bregler probably was referring to mechanical drawings like fig. 148, not actual perspectives, for the details of cat. 195 (of the coach) would seem to have been unnecessary if other drawings were in hand. Examination of these drawings and other photos in Rogers' book shows that these coaches had seating cantilevered off the roof on each side, allowing four passengers to fit on each bench. In 1878 Stratton described a drag as ideal for picnics and outings to the racetrack, when it could serve as "a very respectable hotel on wheels . . . capable of seating 14 persons,—four on the inside, eight on the top or roof, and two grooms on the back seat" (*World on Wheels*, 473). "The width of the load on top does undoubtedly detract somewhat from the 'smart' appearance of the coach," admitted Rogers, and it produces the odd effect of unsupported passengers, criticized by Hendricks (1965, 55) as an error on Eakins' part. See "Colonel Kane's Coach," fig. 150, and Rogers, *Manual of Coaching*, 18, 73.

23. Rogers, *Manual of Coaching*, 11–16.

24. Ibid., 304; Jennie J. Young, "The Four-in-Hand, and Glances at the Literature of Coaching," *Lippincott's Magazine* (June 1878): 684, describing the "fond regret" of the "veteran coachees" for the "golden age of the road."

25. Young, "Four-in-Hand," 697–698. This sentiment was paraphrased by Rogers, *Manual of Coaching*, 430.

26. Stratton, *World on Wheels*, 384.

27. Rogers, *Manual of Coaching*, 432. Elizabeth Milroy drew my attention to an excited illustrated account of the fashionable gathering of "The Four-in-Hand Club" in London, in *Harper's Weekly*, 18 Aug. 1873, 732.

28. The formation of the New York Club is described in Young, "Four-in-Hand," 696–699, with a roster of the twenty-one members in 1878. Rogers updates this list in *Manual of Coaching*, 510.

29. Stratton, *World on Wheels*, 481–482.

30. On the colonial revival, see chaps. 9, 14.

31. "Coaching Revival," *Harper's Weekly*, supplement (3 June 1876): 457. The writer contrasted the annoyances of high-speed train travel ("certainly no pleasure") with the delights of coaching: "More genuine, healthful enjoyment can be derived from one ride out to Pelham bridge and back on the top of Colonel Kane's coach than from the whole flying [railway] trip from New York to San Francisco." On Rogers' typewriter, which he had "installed by the inventor," see Smith, 106; his Newport house, Fairholm, was designed by Furness and Hewitt in the mid-1870s.

32. In *Manual of Coaching*, Rogers estimated the cost of a coach at $2,400, "within the limits of a modest establishment," he said (or twice what Eakins was paid annually as director of the school from

1883–86). In contemporary terms, this would equal the cost of a luxury automobile. Much more impressive, however, was the "establishment" necessary to support the horses and personnel, including liveries and other coaching equipment described in detail (128, 420).

33. This article (see n. 24 above) was listed in Rogers' bibliography of coaching literature.

34. Young, "Four-in-Hand," 700; Rogers, *Manual of Coaching*, 486. The seating arrangement on the coach also follows exactly the protocol for the Coaching Club's meets, with the wife of the owner on the box, two men and two ladies on the front roof seat, the hind roof seat folded down, and two grooms in the rumble seat (Rogers, *Manual of Coaching*, 512).

35. Johns 1980 publishes examples of many rowing prints from Eakins' period to show his parallels with popular art; Parry and Chamberlin-Hellman show a chromolithograph of rail shooting from 1866 to suggest a possible linkage (43). In a timely fashion, Currier and Ives had published *Coaching-Four-in-Hand—A Swell Turn Out* in 1876, similar in composition to fig. 150. Even more like Eakins' composition was a wood engraving of *Colonel Kane's Coach on the Road*, by Ivan Pranishnikoff, that accompanied the article in *Harper's Weekly* cited in n. 31. In this image a dog chases the horses and a laborer waves to passengers from the right side of the road. I am grateful to Elizabeth Milroy for drawing this article to my attention.

36. Rogers comments on the "fashionability" of coaching in his manual (389). On "smartness" in coaching, see 73, 93, 121, 304, 420. His manual is claimed to have raised coaching to an art (Furness, *Fairman Rogers*, 17–18).

37. Smith, "Fairman Rogers," 108.

38. Rogers, *Manual of Coaching*, 429, quoted in Furness, *Fairman Rogers*, 19, and Siegl, 76.

39. Rogers, *Manual of Coaching*, 305. Hendricks criticized Rogers' posture and questioned Eakins' correctness, but this passage indicates that Eakins was attending to Rogers well, for the manual was not yet published.

40. Ibid., 349.

41. On the critical response to the painting, see Hendricks 1965, 58–62. Hendricks notes the controversy over whether or not the wheels of the coach should have been blurred as they appear in the painting. Eakins' notes on Muybridge's photos, cited above, confirm that he understood that, in photographs, the "sulky wheels are blurred above and sharp below, because the upper part travels twice as fast as the hub while the lower part is still." In painting the entire wheel blurred, Eakins made a concession to human perception and the visual logic of his art, anticipating that a correctly photographic depiction would look unnatural in his painting.

42. The replica, G 320, is in the St. Louis Art Museum. Ellwood C. Parry III has suggested that it was painted earlier than 1899, by which time photographic film had become more reliably orthochromatic, making the trouble of a replica unnecessary; see "Thomas Eakins and the Everpresence of Photography," *Arts* 51 (June 1977): 115. However, Susan Eakins' retrospective diary for 22 Nov. 1898 notes that Rogers wrote "to ask for a black and white version of coaching picture" (Foster and Leibold, fiche II 6/22 Nov.).

43. "Lectures on Roads and Bridges," *Annual Report of the Board of Regents of the Smithsonian Institution* (Washington, D.C.: Smithsonian, 1861), 123–124.

44. Rogers, *Manual of Coaching*, 16, 427.

45. 3 June 1876, 457.

46. The verso of cat. 193 bears the inscription "Murray's Baldwin," although—like the title *Baldwin. Boats*—no other gloss on this phrase survives. Murray, of course, may be Eakins' student Samuel Murray, who was sharing Eakins' studio in the 1890s. If this is the right Murray, the inscription could have been jotted on the drawing years later, when Eakins was reconsidering this theme, or it may be a clue that all of these more elaborate coaching compositions are from the 1890s. I am grateful to Jeanette Toohey, who first connected the name Baldwin to locomotives, and to Susan Danly, whose work on *The Railroad in the American Landscape: 1850–1950* (Wellesley, Mass.: Wellesley College Museum, 1981) helped me identify the two generations represented in these locomotives. Eakins was an early admirer of these engines; at the Exposition Universelle in Paris in 1867 he proudly noted that the American locomotive was "by far the finest there" (to BE, 31 May 1867, Goodrich 1982, I: 30). On the dominance of the Baldwin Works, see John H. White, Jr., *A History of the American Locomotive and Its Development, 1830–1880* (Baltimore: Johns Hopkins University Press, 1968; rpt., New York: Dover, 1979), 16. The history of the Baldwin company is best detailed in its own publications, including a booklet first published in 1880, revised in 1881, and subsequently reprinted, with extensions, several times, as in *The History of the Baldwin Locomotive Works, 1831–1907* (Philadelphia: Edgell, 1907). See also cats. 200, 201.

47. *History of the Baldwin Locomotive Works* (1907), 86–90. The first version of the Atlantic type engine, with its larger boiler and firebox set behind the driving wheels, was brought out in 1895. Developed out of the popular American type (4–4–0), which overran the country in the 1870s, this new engine gained speed from its compound cylinder (prominent in Eakins' drawing between the first and second set of wheels), also invented at Baldwin by Samuel Vauclain in 1889. The camelback cab seen in Eakins' drawings and in fig. 152 was also a feature of 1890s design; see Fred Westing, *The Locomotives That Baldwin Built* (Seattle: Superior, 1966), 90–101.

48. See Fairmount Park Art Association, *Sculpture of a City: Philadelphia's Treasures in Bronze and Stone* (New York: Walker, 1974), 206. When Broad Street Station was torn down, this relief was moved to 30th Street Station. In this same vein is Asher B. Durand's *Progress* (1853, Warner Collection of Gulf States Paper Corp.), with its sequence of transportation modes, and Thomas Otter's *On the Road* (Nelson-Atkins Museum), shown at PAFA in 1860.

49. Hirshhorn Museum; see Rosenzweig, 55. Another sketch for this painting, showing the other side of the planned composition, remains in Mrs. Bregler's estate. On *Hiawatha*'s fate, see Rosenzweig, 53–54.

50. Goodrich 1982, I: 281.

Chapter 16. Gloucester Landscapes: "Camera Vision" and Impressionism

1. I introduced many of the themes in this chapter in "Realism or Impressionism? The Landscapes of Thomas Eakins," *Studies in the History of Art*, vol. 37 (Washington, D.C.: National Gallery of Art, 1990), 68–69.

2. The collection holds one albumen contact print (1985.68.2.764) and its negative (.906) of men hauling nets onto the beach, and sixty-three other negatives (1985.68.885–.929, .947–.968, .976) of related subjects, all taken near Gloucester. Only three Gloucester images were catalogued by Hendricks (H 29; H 31, now extant in the glass plates .895 and .948; and H 32, with no extant negative). Three ad-

ditional vintage prints of fishermen on the beach, noted by Hendricks but not given numbers, are in the Dietrich Collection. The CBTE images are listed in Danly and Leibold under the topics Gloucester, Landscapes, and Animals.

3. Most of the glass negatives were found still housed in cardboard commercial packages, with the end flaps or backs annotated in several hands and at different times. The plates within did not always match these inscriptions, however, indicating shuffling of the contents over the years. The earliest dated box, containing views of fishermen hauling nets onto the beach (PAFA inventory 87.6, containing 1985.68.2.906–.909, .926, .929, and .944), was inscribed by TE: "Gloucester. Shad[?] / April 21st. / April 23d.1881." A second box (inventory 87.11, containing .900–.905, .921–.923, .925, and .976, all studies for the two paintings titled *Shad Fishing at Gloucester on the Delaware* of 1881), was annotated "Gloucester," 14 and 15 May, at "9 o'clock." A third box (87.12, containing negatives relating to *Drawing the Seine* of 1882, .889–.893, .896–.899) was labeled "Gloucester / fishing / Friday May 24th / 1882," and bore the names of family members and friends ("Will / Frank / Susie / Lizzie / Caddie / Maggie") whose photos may also have been in this box at one time, or who perhaps came on the outing. A fourth box (87.17, with studies for *Shad Fishing* and *Mending the Net*, both of 1881, .863, .886, .910–.920, .924, .962, .966–.967) was inscribed "Gloucester / May 26th, 1882." The latest dated box (inventory 87.7, containing subjects relating to *Mending the Net* of 1881, .885, .912–.917, .927–.928, .961) was labeled "Gloucester / June 7th / 1882."

4. Eakins' entries at the AWS in 1882 included no. 311, *Mending the Net* (probably G 158, fig. 173), and no. 590, *Shad Fishing on the Delaware, at Gloucester* (probably *Taking Up the Net*, G 153, fig. 174). Homer's *Mending Nets*, then known as *Far Away from Billingsgate*, was no. 648. See Foster 1982, 41, 93. Other painters exhibiting similar subjects included Alfred Kappes, whose *Toilers of the Sea* was illustrated in a line cut in the 1878 AWS catalogue, no. 155; from this drawing it seems to have been fishermen hauling nets onto the beach, as in Eakins' work. Granville Perkins, F. A. Silva, and M. F. H. de Haas all exhibited paintings in this period with titles indicating fishing subjects, probably featuring boats and marine views. Far more common were the fishergirls of Brittany and Normandy by Edward Moran, John Singer Sargent, and others, the Italian coastal scenes of Samuel Colman, and the Dutch fisherfolk of George Hitchcock and Harry Chase. See David Sellin and James K. Ballinger, *Americans in Brittany and Normandy, 1860–1910* (Phoenix: Phoenix Art Museum, 1982). Kenneth Finkel told me that shad fishing subjects in watercolor and lithography were produced in Philadelphia by James Queen (1820–1886). The iconography and lore of the Delaware shad fishery is surveyed in Susan A. Popkin and Roger B. Allen, *Gone Fishing! A History of Fishing in River, Bay, and Sea* (Philadelphia: Philadelphia Maritime Museum, 1987), 3–5, 12–19. They reproduce three of Eakins' Gloucester photos once in the collection of Seymour Adelman and now owned by the Maritime Museum.

5. See glass negatives of geese at Gloucester, 1985.68.2.963, .964. For a description of an Eakins family outing to Gloucester for a shad feast, see Goodrich 1982, I: 206–207.

6. Schendler noted the contrast between the group on the beach in "Sunday" clothes and the Negro fishermen on the boat (78). "The Academy of Design," *New York Times*, 30 Apr. 1882; *American Architect and Building News* 10 (31 Dec. 1881): 311–312.

7. Earl Shinn, "Works of American Artists Abroad," *Art Amateur* 6 (Dec. 1881): 6.

8. Goodrich 1933, 174. The photographs, by revealing the slender and graceful form of the woman in black as well as the familiar curve of her cheekbones, put to rest Hendricks' speculation that this figure was a posthumous portrait of Eakins' mother, Caroline (Hendricks 1974, 148–149; Siegl, 94). Goodrich speculated that the group included two daughters (Margaret and Caroline) and a "heavier and probably older woman," perhaps Aunt Eliza Cowperthwait (1982, I: 329, n. 207).

9. Eakins' method of establishing scale is explained in his perspective manuscript; see cat. 100 and chap. 7 above. The exact distances cannot be reckoned without knowing the viewing distance Eakins intended for the painting itself. His other small paintings of this size are usually to be seen from a distance about twice the width of the canvas (or more), which would mean in this case about three feet. From this vantage, figures at one-twenty-fourth scale would be 72 feet distant; those at one-thirty-sixth would be 108 feet away. The telescoping effect, described above in chap. 12, seems to diminish the space between the two groups, suggesting that the viewing distance may be even longer than three feet and the figures even deeper in space.

10. From TE, PMA typescript, quoted in Sewell, 72.

11. These newly revealed photographs of the beach call into question Siegl's thesis that TE's first depiction of the figures showed them cut by a foreground bank (94). Eakins may indeed have invented such a bank, although the visual effect would have been odd. Siegl's observation that the lower halves of all these figures have been painted over the beach layer in a rather different hand cannot be disputed, but it seems more likely that Eakins intended to paint the beach in a lower tone (suggested by the umber primer visible at the margins of the canvas), strewn with shell patterns as seen in these photos. Later, he decided to paint the shore in a single, more high-valued color, but finding it awkward to paint around each figure, he scraped the entire section out, repainted the beach, and then reconstructed the lower parts of each figure over this bright, dense new ground, which now tends to read through the figures. Siegl's analysis of this painting was otherwise prescient, for he noted the "surprising" detail of the family group compared with that of the fishermen, and he attributed this contrast to the interest in variable focus brought about by Eakins' experimentation with the camera. "*Shad Fishing* was probably not based on a single photograph," noted Siegl. "Instead, it would seem to be an arrangement based on various photographs as well as nature studies and possibly, given the presence of the family group, some studio poses" (94). Siegl's notes in the PMA Eakins Archive on the construction of this painting, observed in X-ray photography and in the course of his conservation of this painting, show that Eakins painted it in stages that correspond to his photographs. His underpainting matches the configuration seen in fig. 156, without anticipating the presence of the family group.

12. Another sketch for this painting, catalogued by Goodrich among the unidentified landscape sketches, is on the verso of G 180 (Joslyn Art Museum), a panel from Eakins' small sketch box. The verso includes two color sketches of the Delaware shore, the upper composition exactly like the painting (and the photograph), the lower sketch with a higher horizon line.

13. G 154. The painting appeared in Cincinnati, Brooklyn, Utica, Providence, and finally Chicago, where it may have sold in 1883 (Milroy, *Lifetime Exhibition Record*). These two paintings are distinguished in Eakins' record books by the addition of the word "River" and "(group on sand)" to G 152, and the date "June 1881"

added to G 154. Both were exhibited under variant titles in this period. See Alain G. Joyaux, *The Elisabeth Ball Collection of Paintings, Drawings and Watercolors: The George and Francis Ball Foundation* (Muncie, Ind.: Ball State University Art Gallery, 1984), 16–17.

14. Both glass plates were found in the box dated 21–23 Apr. 1881. Another essay in this same composition, from the same vantage but with the camera pointed slightly down to put the far shoreline near the top of the image, can be seen in 1985.68.2.925. Changes in the tide line and the boats at anchor indicate that it was made at another time; the box it was found in was labeled 14–15 May. This negative is marked "12" on the glass; the box it was in enumerates three exposures (12, 13, and 15) with details of their exposure and development. No other numbered plates from this series have been found. Some of Eakins' negatives from the Dakota trip, and many of his motion studies, are likewise numbered on the plate.

15. G 155; Siegl, 93. Record book 2 notes that it was finished in Sept. 1881. No. 358 in the PAFA catalogue, the entry was accompanied by a crude wood engraving (no. 24) of the image. The extended exhibition history can be traced in Milroy, *Lifetime Exhibition Record*.

16. The oil studies are G 156 (CBTE, cat. 249); G 157, now divided into recto "A," *Tree, Capstan and Lumber* (Leonard Baskin coll.), and verso "B," *The Tree* (unlocated); G 162, now divided into recto "A" (an unrelated subject) and verso "B," *Sketch of the Tree, Lumber Pile and Capstan* (unlocated); G 135, now divided into at least five pieces, of which one is relevant, *Head and Shoulders of Third Fisherman from the Left* (estate of Mary Bregler; see CBTE, cat. 245); and G 195, verso, *Hand of a Fisherman* (Dietrich Collection; see Avondale/Dietrich, cat. 9). The photographic images, including those discussed and reproduced in this chapter, are 1985.68.3.863 and .864 (children); .910–.920 (fishermen); .924 (men under tree); .947–.964 (geese and landscape); and .966 (tree).

17. On Gardel, see chap. 1. Hendricks guessed that the man under the tree was Eakins' friend William Sartain (1974, 148). At least one contemporary viewer thought that this was an artist sketching; see "The Fine Arts," *Philadelphia Telegraph*, 17 Oct. 1881.

18. The other, similar plate is 1985.68.2.864, which was the basis for the pose of the child at the left in the painting. Ben and Willie Crowell were four and two years old in 1881. It is interesting that Eakins discriminated between these two very similar images, choosing a different negative as the source for each child. I am grateful to David Brigham for pointing out that both images were used.

19. The pattern of extant glass plates suggests that an entire group of negatives has disappeared, for although the four net-menders at the right appear in many poses in the extant plates, the three figures at the left appear in none. The man at the far left, whose walking pose would have been difficult to capture from life, seems an especially likely candidate for a photographic study.

20. H 29 (Hirshhorn, but not published in Rosenzweig). Hendricks was the first to suspect the use of photographs throughout the Gloucester paintings (1972, 200). "*Mending the Net* is surely one of the earliest examples of an important American painting based on photographs," wrote Siegl (93). "The vision [in *Mending the Net*] is closer to photography than in almost any other of Eakins' outdoor scenes," wrote Goodrich (1982 I: 207).

21. "Fine Arts: Eleventh Exhibition of the Water-color Society II," *Nation* 26 (28 Feb. 1878): 156. This phenomenon is described above in chap. 9.

22. Another plate made at the same time is 1985.68.2.927. Both show considerable streaking of the emulsion, probably the result of faulty development.

23. G 158; see Hoopes, 72. None of the CBTE negatives or prints duplicate the poses of the two figures in this watercolor, but the similarity to figures seen in *Mending the Net* (especially the standing man, second from the left) must make us imagine that they once existed.

24. See Siegl, 93, and his files on the conservation of this painting, PMA. He notes changes to the painting made after the first varnish coating. A dry plate negative of *Mending the Net*, evidently taken by Eakins while the painting was in his studio, shows the earlier appearance of the canvas (CBTE 87.26.47). Although this image is in black and white, and distorted by non-panchromatic film and foxing on the negative, it is clear that Eakins worked again on both the sky and the foreground, adding another goose to the group at the lower left (the one fourth from the right) and slightly modifying the foliage contours of the tree. Eakins' resolve to paint brightly, read in his notes of c. 1873–74 (cited in chap. 13), changed in the early 1880s, when several highly colored outdoor scenes (including *The Crucifixion*) were grayed with overpaint.

25. Shinn, "Works of American Artists Abroad," 6. His reference to Corot's work is interesting, because the effects that Shinn cites may also have been inspired by Corot's use of photographs; see Van Deren Coke, *The Painter and the Photograph* (Albuquerque: University of New Mexico Press, 1964; rev. ed., 1972), 195. Other comments cited are from "The Fine Arts," *Philadelphia Telegraph*, 17 Oct. 1881 and 19 Nov. 1881; "American Artists," *New York Times*, 6 Nov. 1881; "New York Academy of Design," *Art Journal* (U.S. ed.), June 1882, 190–191; "Academy of Design," *New York Times*, 30 Mar. 1882; "Art in Philadelphia," *New York Tribune*, 25 Nov. 1881; *Philadelphia Press*, 2 Dec. 1881; "Art in Philadelphia," *New York World*, 21 Nov. 1881; M. G. Van Rensselaer, "Picture Exhibitions in Philadelphia," *American Architect and Building News* 10 (31 Dec. 1881): 311–312. Several reviewers, including the *Press*, described the "harsh," "bright" or "imperfect" blue and green palette of this picture when it first appeared; such remarks, especially when couched within a friendly review (e.g., the ones by Van Rensselaer and the *New York World*), may have inspired Eakins to rework the sky later, over his first coat of varnish.

26. AWS 1882: no. 590, *Shad Fishing on the Delaware at Gloucester*, $200; and no. 311, *Mending the Net*, $150. The watercolor *Taking Up the Net*, G 153, is discussed in Hoopes, 64–67.

27. "Water-Color Exhibition at Philadelphia," *American Architect and Building News* 9 (22 Apr. 1882): 185; Hoopes remarked the frozen quality of the poses in *Taking Up the Net* (64). Onorato has commented on the distancing function of Eakins' photographs (1976, 130).

28. "Water-colors in New York," *American Architect and Building News* 11 (8 Apr. 1882): 160.

29. G 159. The photo, H 31, has survived in a vintage contact print once in the collection of Gordon Hendricks. The relationship of this photograph to one used as the basis of an oil, *Hauling the Seine* of 1882 (G 160; see n. 33), may encourage us to assume that both were taken in the spring of 1882. The watercolor was first exhibited in Sept. 1882, at the Cincinnati Industrial Exposition. Hendricks described the pairing of figs. 176 and 177 as "perhaps the most literal example of a transcription from a photograph known in American art" (1974, 151). See also Siegl, 95, Goodrich 1982, I: 175, Hoopes, 74, and Sewell, 73.

30. Another critic described these watercolors as "distinguished by the figure drawing and breadth which finds no sheet of paper too small to admit of the extent of horizon" ("Art Notes," *Art Journal*, n.s. 8 [1882]: 94). Clarence Cook, who had admired Eakins' watercolor figure subjects in the mid-1870s, complained that these new works were too broadly done, with "too much stress laid on the bodies and too little on the heads and faces of his men." Cook felt that the depiction of character and facial expression was one of Eakins' strengths: "When he wants it he knows where to get it" ("The Water Color Society's Exhibition," *Art Amateur* 6 [Mar. 1882]: 75).

31. This review began with the statement, "Thomas Eakins is reckoned among the first of Philadelphia artists. He is at the head of an important art school; but he is the slave of certain theories and his works are characterized by a dreary mannerism. We have had many of Mr. Eakins' pictures in New York, and they have been very generally and rather roughly criticized, by connoisseurs. It is a pleasant variation to be able to speak pleasantly, even warmly of Mr. Eakins' work in the water-color exhibition. His *Shad Fishing on the Delaware* is a vigorous and well-drawn group, with just those telling shades of emphasis on the principal figures that give them character." The critic concluded that "this artist is always a clever draughtsman and his failings as a colorist are less conspicuous in these watercolor pictures than in any of his pictures we have seen" ("Fine Arts," *Independent*, 16 Feb. 1882, 8).

32. Siegl, 94, 105. Hoopes also comments on the "selective" focus in the watercolor (74).

33. The two last fishing pictures were based on photographic images that establish a deep, rushing space measured by a steeply angled foreground bulkhead of boulders and logs. This motif, either paralleling the action of or directing attention to the fishermen, dominates *Drawing the Seine* (fig. 176) and the oil *Drawing the Seine on a Windy Day*, or *Hauling the Seine* (G 160, 1882, priv. coll.), two scenes that look north and south from almost the same spot on the beach at Gloucester, just above the Timber Creek estuary. The photographic source for the oil is lost, but it can be surmised from the existence of a negative (1985.68.2.899) that differs from the painting only in the movement of the fishermen: nets, boats, foreground detail, and all landscape elements are identical. This last shad fishing oil parallels the composition of one from the previous spring, fig. 160, but lacks its interest, perhaps because the figures are too small and too evenly distributed across the picture, or simply because the drama of the rushing foreground in the photograph was an idea that did not carry well into the painting. See Coke, *Painter and the Photograph*, 82–83.

34. G 161; Siegl, 97–98. SME's label on the verso described it as "Landscape, Gloucester N.J. / Country back of the shad fisheries." When first exhibited in 1884 it was entitled *Meadows*.

35. The oil sketch, G 162, is unlocated; see Sotheby's sale catalogue, *American Paintings, Drawings and Sculpture*, New York, 29 Nov. 1990, lot 23. The verso (now separated) has a sketch of the tree and capstan in *Mending the Net*. Fig. 179 was made from a spot also seen in CBTE negatives 1985.68.2.960, .961, and .962, showing geese and cattle near the same tidal marsh at a time of higher water. Siegl's conservation notes (PMA) tell us that the cows in *The Meadows* were painted on top of the completed landscape. No photographic sources for the cows have been found.

36. Nancy Fresella-Lee, *The American Paintings in the Pennsylvania Academy of the Fine Arts: An Illustrated Checklist* (Philadelphia: PAFA, 1989), no. 1057, p. 115. On Picknell, see Sellin and Ballinger, *Americans in Brittany and Normandy*, 148–149. This gift from Joseph E. Temple was the first of a string of Temple Fund Purchases of contemporary art that received wide publicity, as in the *American Art Review*: 1 (1880): 268, and 2 (1881): 214.

37. Siegl, 97–98.
38. Kenneth Finkel has suggested to me that the halolike effect on some of these outdoor views of 1881, including many of the Manasquan beach scenes, may be the result of Eakins' use of a short-focus portrait lens instead of a longer-focus landscape lens. In other cases, such as the Dakota plates, deterioration of the emulsion from exposure to light over time may be a contributing factor. The focus in the study photographs for *The Pathetic Song* (figs. 97–99) is partly the result of a relatively dim interior, which required a wide lens opening and therefore a shallow depth of field. Eakins *liked* blurring in motion photography because it marked the "relative speed of the different parts," and he noted that this nice "distinction will be lost if I take the photographs more quickly." See chap. 15, n. 1.
39. To improve image sharpness he bought a Darlot focusing lens some time after Jan. 1883 (Rosenzweig, 228).
40. See Bregler collection album, 1985.68.2.766, .768, .778. Danly and Leibold (215–16) have dated them to "ca. 1882," though they may be later; they might be by other photographers. The contrast between the photographs in this new pictorial style and the older tradition of Philadelphia photography is demonstrated in PAFA, *Pictorial Photography*.
41. The differences between human and camera vision are well summarized in M. H. Pirenne, *Optics, Painting and Photography* (Cambridge: Cambridge University Press, 1970). "There is no physiological reason," notes Pirenne, "why the marginal parts of [an artist's] canvas should be painted in less sharp detail than the middle of it" (37).
42. Eakins' manuscript (PMA) contains many pages of propositions and calculations on the refraction of light through different types of lenses, evidently part of the search for a combination of camera lenses that would compensate for the natural diffraction of light and produce an undistorted image on the negative. These calculations, as well as his own modifications to the camera used for his motion studies at the University of Pennsylvania in 1884–85, indicate mastery of the mathematical and geometrical concepts of light. Hermann von Helmholtz's influential work on optics, *Handbuch der Physiologischen Optick* (1866), was published in French the following year, when Eakins was in Paris. A related text, *Optisches über Malerei* (from lectures of 1871–73), appeared in French in 1878 as *L'Optique et la Peinture*. An English translation was published by E. Atkinson: "On the Relation of Optics to Painting," in von Helmholtz, *Popular Lectures on Scientific Subjects,* 2nd ser. (New York: D. Appleton, 1881), 75–135. Helmholtz's remarks on the effect of light (104–107) on a painting bear comparison with Eakins' remarks (cited in chap. 13 above). A similar text, "The Recent Progress of the Theory of Vision," translated by Dr. Pye-Smith, was in *Popular Lectures on Scientific Subjects* (New York: Appleton, 1873; 1885 ed.). Helmholtz described the image received by the eye as like a picture, "minutely and elaborately finished at the center, but only roughly sketched at the borders" (213). Helmholtz's emphasis on the role of knowledge and experience in visual perception defines Eakins' attitude as well: "Knowledge of the true relations of surrounding objects of which the artist cannot divest himself, is the greatest difficulty in drawing from nature" (288). Reluctant to guess and eager to measure "true relations," Eakins was not comfortable sketching objects outdoors without guidelines given by perspective or the camera.
43. Perhaps most subtle (and debatable) is Siegl's discovery of a scale of diminishing sharpness from left to right along the row of figures in *Mending the Net*, and from the center of each figure outward to the hat or feet (Siegl, 93). While trusting in Siegl's intimate knowledge of this painting I find this progression difficult to see, although it does correlate with the fall of sunlight and shadow and the corresponding loss of detail in the darks, as recorded by Eakins' camera. If deliberate, such a progression would be an interesting pictorial device reinforcing Eakins' propensity for a left to right compositional reading pattern, but it would again be an example of extending a localized photographic effect into a larger, unphotographic system, for the overall image would not be characteristic, as Siegl suggests, of the "photographs of his day." If anything, it reiterates the limited focal zone of the human eye if fixed at the left margin—an unusual vanishing point for Eakins but not uncommon in Baroque art.
44. Goodrich compared Eakins' rowing subjects of the 1870s to contemporary impressionist work, remarking the shared interest in modern, outdoor, urban life and the common commitment to direct observation. Goodrich noted the differences, too: Eakins' emphasis on light only as it revealed form, and the priority of value structure and drawing over color in his work (1982, I: 98). These distinctions are moot in *Delaware River Scene* even though Eakins' reference point was still not the impressionism of Monet and Renoir but instead the style (called impressionism by Americans in the late '70s) which came from London (Whistler), Munich (Duveneck), and their intersection in Venice, where the influence of Fortuny and his "Spanish-Italian" following in Rome was also felt. The interplay of these sources and late Barbizon painting in France produced tonalism, a style defined by Wanda M. Corn in *The Color of Mood: American Tonalism, 1880–1910* (San Francisco: M. H. de Young Museum, 1972). At the end of the 1880s Theodore Robinson, one of the first Americans to engage in French impressionism, produced landscapes very similar to Eakins' *Delaware River Scene;* remarkably enough, Robinson also used photographic studies as the basis of many of these paintings.
45. At PAFA in the fall of 1884, *Meadows,* no. 62, was listed at a low price, $300, on a par with his watercolors. The previous year his oils had been $1,200. Most of the reviews of this exhibition ignore Eakins' work or dismissed it as "not new" or unimportant. See *Philadelphia Evening Bulletin,* 29 Oct. 1884, 7; "Beta," "The Pennsylvania Academy's Exhibition," *Art Amateur* 12 (Dec. 1884): 7. Only the Philadelphia *Inquirer* bothered to note *The Meadows,* describing it as a "green landscape, wholly commonplace and without feature demanding notice" (30 Oct. 1884, 1). Following the Academy exhibition Eakins had *The Meadows* sent to the Haseltine's gallery in Philadelphia, where it may have been exhibited. See TE to George Corliss, n.d. [Mar. 1885], PAFA Archives. In 1885 the painting appeared at the Inter-State Industrial Exposition in Chicago; Milroy, *Lifetime Exhibition Record,* 25.

Chapter 17. Nudes: The Camera in Arcadia

1. See Elizabeth Milroy, "'Consummatum est . . .': A reassessment of Thomas Eakins' *Crucifixion* of 1880," *Art Bulletin* 71 (2) (June 1989): 269–284. Milroy presents an illuminating analysis of the place of this painting in European tradition, and the contemporary response. She guesses that Eakins used photographs for the painting. J. L. Wallace, who posed for many of the Arcadia photographs, told Goodrich that camera studies were made. See Goodrich's notes from an interview with Wallace in 1938 (AAA, portions in Goodrich 1982, I: 190–191).

2. The exact date of Coates' commission is unknown. The canvas is dated 1883 (according to Goodrich, by SME), although entries in Eakins' account book (Dietrich Collection) indicate that he was hiring models for this project perhaps as early as Dec. 1883 through Aug. 1885. Recent conservation of the painting has concluded that the present date was added after Eakins' death; it was placed over an earlier, nearly illegible "1885." Coates paid him in 1885, shortly after the painting was exhibited at the Academy's fall show. His arrangement with Coates is implied in a letter of 27 Nov. 1885, wherein Coates "confidentially" notes that "as you will recall one of my chief ideas was to have from you a picture which *might* some day become part of the Academy collection" (emphasis in original). Coates cited this plan as the basis for his desire to exchange *Swimming* for another painting that might be "perhaps more acceptable for the purpose which I have always in view" (CBTE, Foster and Leibold, 172, fiche series I 6/D/12–6/E/1). Anshutz's letter to J. L. Wallace is in the Joslyn Art Museum; it is quoted in Goodrich 1982, I: 239–243 and nn., 332. The painting is thoroughly studied in Bolger and Cash.

3. As has been frequently noted, none of these works were shown nor were their titles recorded in Eakins' lifetime. The large *Arcadia* (fig. 184) was given by Eakins to W. M. Chase, and it was sold from his estate in 1917 as *Idyl;* see Spassky, 610. This painting was first referred to as *Arcadia* by Burroughs in his checklist of 1924. Like Marceau and Goodrich, Burroughs must have been given this title by SME. See Goodrich 1982, I: 236.

4. The only dated piece is the plaster relief *Arcadia* (fig. 187), which is incised 1883; see Siegl, 106–108. The photographs used in this series were analyzed by Robert McCracken Peck, "Thomas Eakins and Photography: The Means to an End," *Arts Magazine* 53, no. 9 (May 1979). The entire group was first surveyed as a single topic by John G. Lamb, Jr., "Eakins and the Arcadian Themes," in Avondale/Dietrich, 18–20; in the same book, W. I. Homer suggests that the Crowell farm at Avondale was Eakins' own Arcadia and that the freedom and happiness of this environment inspired these works (11). Goodrich also provides an overview of these projects (1982, I: 230–237). Johns has offered astute formal and contextual analysis of the Arcadian works in reference to Eakins' musical themes (1983, 128–131). Spassky's discussion of the MMA's painting *Arcadia* includes a thorough annotated bibliography citing critical opinions of these works over the years (608–612). Simpson, 71–95, offers the most extensive discussion of the entire corpus of Arcadian work.

5. *Youth Playing Pipes,* G 198, oil on wood, 14 1/2 × 10 1/4 in. Reproduced in Spassky, 611, along with a full discussion of *Arcadia,* G 196, and its related works.

6. H 45 (Rosenzweig, cat. 51); H 46 (MMA). The MMA acquired its photograph directly from Bregler in the 1940s; the Hirshhorn print was also once in his collection.

7. The collection has thirteen prints, two negatives, and one glass positive depicting the piper in six different poses, by two or three models. The images of TE include four prints of H 253 (MMA): 1985.68.2.488–491 and a related pose (fig. 185) not in Hendricks, seen in three prints and a glass negative (.485–.487, .1011). Wallace (addressed as "Johnny" in Eakins' letters, although he signed a letter to Bregler "J. Laurie Wallace") appears as seen in H 46 (MMA) in three prints (.482–.484) and the negative (.1010; fig. 100) and seated as in H 47 (PMA) in two prints (.493–.494). Unique images, not known to Hendricks, show Wallace facing left, standing against a wall of foliage (fig. 186), and a glass positive (.614) with him in the same pose but slightly turned away. (The pose in the

painting is somewhere between these two.) It is possible that this last image was used as a lantern slide in lectures or to enlarge and transfer images. See Danly and Leibold, 195–196. Platinum enlargements of other pipers not recorded in Hendricks or Rosenzweig are in the Murray scrapbooks at the Hirshhorn, including a variant of H 46 (vol. 5, p. 18) and a variant of H 45 with the model seen against a grassy background (vol. 5, p. 13). Hendricks identified Wallace as the model in the Hirshhorn's unique print (H 45), which, along with fig. 186, comes closest to the image in the painting (Hendricks 1969, 93A). He later withdrew this identification (1972, see H 45) and proposed that this model was another student, perhaps the cameraman of H 254, which shows Eakins and Wallace together. However, Wallace's long hair in H 254 indicates that this photo was taken on another day. Even so, the model in H 45 may still be an "unidentified student" or perhaps Eakins himself. Simpson notes the "transformation" of the mature body in the photos to a more adolescent build in *Arcadia* (78).

8. It is of course possible that the precise image did not survive. Assuming, however, that all of his piper studies are before us, it is interesting to observe that Eakins refused exactly the difficult information on contour that the photograph so neatly supplied. By slightly changing the position of the model's right leg in *Arcadia* he altered the entire line of heel and knee. He also turned the figure slightly so that the right arm is visible and the genitals are completely hidden by the curve of the hip, more like the glass positive .614. Although there is much frontal nudity in his photographs, his paintings and sculptures of this period (with the exception of the relief *Youth Playing the Pipes,* Hirshhorn) all observe conventional proprieties.

9. Eakins insisted democratically that "it is not right for one to profit by [nude] study who is unwilling to allow his or her body to be seen" (Foster and Leibold, 113). So it is no surprise to find an equal number of images of Eakins and Wallace as pipers. Overall, however, he appears more frequently than any other model in the outdoor photos. Particularly noteworthy is a series of Eakins alone in long grass, comprising seven poses seen in twelve prints and one glass negative (1985.68.2.462–473, .1013, and other negatives duplicated in prints .1012, .1014; see Danly and Leibold, 192–193). None of these images relate to extant paintings. Excluding the motion studies and the "Naked Series," the category of male nude subjects in the collection includes eighty-nine prints and twenty-three negatives (some not known in extant prints) depicting a total of fifty-seven poses. Eakins appears in twenty-eight of these prints and twelve of the negatives, in twenty-one different poses. Wallace is a distant second in this count (fourteen poses, from thirteen prints and six negatives), followed by Anshutz. The proliferation of duplicates may be explained, perhaps, by Eakins' intention to share prints, as he did with Anshutz, Murray, Watson, and Wallace; his letter to Wallace of 22 Oct. 1888 notes that he "had my negatives out the other day and was printing some. The sight of those old things brought back many a pleasant recollection and made me long to see you again. . . . I send you a print at Mrs. Eakins' suggestion because it is a favorite with us. I think though you have one in platinum" (Foster and Leibold, 246). This kind of retrospective printing, as well as Susan Eakins' "favorites" as she, too, made later prints, must be accounted for in assessing this gallery of nude Eakinses. However, the remarkable number of photographic portraits of Eakins at all ages and in all modes deserves note. See Leibold 1991, 4–9.

10. The oil sketch for the boy, G 199, and the photograph of him, H

48, are catalogued in Rosenzweig (107–108). The sketch of the woman is G 180; her photo is H 19 (not catalogued by Rosenzweig), dated by Hendricks to 1880–82.

11. Susan and Tom were engaged on 27 Sept. 1882. She later told Goodrich that the same model posed for *Arcadia* and *An Arcadian*, without noting her own involvement (1982, I: 235). Eakins' tendency to organize his figures into geometrical shapes has been noted by Hendricks 1972, 2; Onorato 1976, 131–32; and Avondale/Dietrich, 52.

12. See also 1985.68.2.545. The other curled-up poses photographed during this session may have been ideas for this smaller painting as well. A photograph of the landscape in this painting (H 53), probably taken at the Crowell farm at Avondale, shows the same careful framing used in preliminary landscape photos for the Gloucester paintings. Neither this image nor related Arcadian landscape shots survive in the Bregler collection, although many other views of the Crowell farm and family were discovered.

13. H 48, Hirshhorn. Simpson has argued that the painting was completed and then held back while Eakins considered adding another figure, but the asymmetry of the present composition, the woman's expectant gaze, and the thematic priority of the piping man in the other, more complete works, all imply another figure planned for this painting from the beginning. Goodrich described the chalk drawing on the canvas visible when he first visited Susan Eakins in about 1930 (1982, I: 233; Simpson, 76). The neat signature, which Simpson points to as a sign of resolution, may have been added by Mrs. Eakins, who evidently signed *Arcadia;* see Spassky, 610. The relative completeness of the landscape background is no sign of conclusion, either, as Eakins laid the figures in his Gloucester paintings (cf. *The Meadows* and *Shad Fishing*) over landscape. Hendricks argued unconvincingly that the addition of the piper would have forced an error in perspective (1974, 154).

14. This figure, identified by Hendricks as Ben Crowell, is 4 1/2 inches high in a platinum print measuring 5 1/8 × 9 in. in the Hirshhorn (Murray scrapbook V, 14; not catalogued in Rosenzweig, but a duplicate of the image published as no. 50). This print is scored with pencil lines along the ground line of the figure and vertically through the head, shoulder, and arm. No photos of the piper or the woman at full scale have survived, although if such images were used for transfer they are very likely to have been ruined by handling, and discarded.

15. The Bregler collection has one albumen contact print and two platinum enlargements, all of the same image (H 44; fig. 182), also known in an albumen enlargement in the Hirshhorn (Rosenzweig, cat. 46a); a platinum enlargement in the Hirshhorn (Murray scrapbook III, p. 22, 6 5/8 × 9 in., not catalogued by Rosenzweig); a mounted albumen contact print given by TE to Edward Coates about 1886 (O 21); and two unmounted platinum enlargements returned to Mrs. Bregler and now owned by her heirs. Two glass negatives are also in CBTE: fig. 183, unique and unpublished, but closely following the moment seen in H 43; and .1027, of H 43, previously known in a vintage albumen print in the Hirshhorn (Rosenzweig, cat. 46c) and in an albumen contact print given to Coates (O 20; Getty Museum). The fourth image, H 42, is known only in albumen contact prints (Hirshhorn; Rosenzweig, cat. 46b; and O 19, from the Coates set). The spotty survival of the glass negatives again implies the loss of many plates. The proliferation of H 44, which exists in at least six known prints, including three platinum enlargements, indicates a special fondness for this image, although it is by no means assured that Eakins either took this pic-

ture or printed all the duplicates. H 44 and the second most common image, H 43, may be the two "Bathers" owned by Eva Watson and lent to the New York Camera Club show of 1899; see chap. 11, n. 3. Eakins' proprietary pleasure in this image might be concluded from the survival of so many prints—and, in particular, the presentation of three of them to Coates as an illustration of his student figure studies. Onorato usefully speculates about the purposes of these photos but argues for the superiority of the uncropped contact prints in Coates' set (O 19–21) because they exhibit the full margins of the image (1976, 134–135, 139). In contradiction, I think the choices revealed in the variant cropping of the same image show Eakins' aesthetic actively at work, generating a "picture" from the inside out. His disregard for the background can be read in the inadvertent piles of contemporary clothing that occasionally appear on the grass or driftwood behind his Arcadians. On the meaning of these photographs in relation to the painting, see Kathleen A. Foster, "The Making and Meaning of *Swimming*," in Bolger and Cash, 13–35.

16. Simpson notes that the old man photographed in one sequence of the "Naked Series" may have been a model in the *Arcadia* relief (90). He also makes a formal connection between the motion photographs and the friezelike organization of other neoclassical photos and the reliefs (84–86).

17. Other examples can be seen in the photograph of SME standing outdoors (.1048) or TE standing, seen from the rear (.462–.465), as well as many of the outdoor photographs of Wallace and Anshutz from this same group.

18. Simpson, citing Julie Schimmel's paper, "Eakins and Arcadia," presented at the Frick Symposium of 22 Apr. 1977 (91). Schimmel proposed the idea that Margaret's death inspired these works; her thesis, with its reference to Erwin Panofsky's classic study "Et in Arcadia Ego: Poussin and the Elegiac Tradition" (1936) was questioned by Lamb (Avondale/Dietrich, 34) but accepted by Simpson.

19. On the relief *Arcadia*, G 506, see Siegl, 106–107. Lamb notes that this was Eakins' favorite piece from the series, as indicated by the number of period casts (at least four) and its appearance in the background of other paintings and photos (Avondale/Dietrich, 19). See also Johns 1983, 128–131; she notes that the figure at the far right must be a woman, mostly because of the knot of hair at the back of her head. Goodrich, Siegl, and Simpson (84–85) refer to this figure as a "youth." Most interesting as a source of inspiration for this piece is the cast of a Greek grave relief seen on the wall in fig. 28. Contemporary catalogues of the PAFA collection do not list these small reliefs individually, and they are no longer in the collection. SME's retrospective diary (CBTE) notes that on 31 July 1885 "Tom commences to model Godley for panel with Wallace's figure." If true, this would mean that at least one of his two reliefs, G 506 or 508 (both initially based on Wallace's figure), was not completed until 1885, although both are dated 1883. This dating would have a corresponding impact on the date for the photographs (e.g., fig. 195) that include *Arcadia*. See Foster and Leibold, fiche series II 4/D/5. Modeling fees are noted in Eakins' account book for "Panel of Piper" through Dec. 1884; also a mysterious expense for "Swimming relief"—perhaps another, lost relief project. See Siegl, 108, and Dietrich account book.

20. Rosenzweig identified the classical references in the Hirshhorn's photos (105); Simpson gathered Eakins' relevant remarks on Phidias and Greek sculpture and noted the sculptures quoted in his work, such as the flute player (perhaps descended from Lysippos but known in Academy catalogues as *Faun with Flute*) (74). Ono-

rato also discusses the inspiration of sculpture in Eakins' photographs (1976, 128–130). Susan Eakins recollected her husband's enthusiasm for Phidias and encouraged a young friend to visit "the Fates." "Mr. Eakins never went to the Met. Museum without finishing his visit with contemplation of the Fates, the splendid torso of a man [Theseus?], he has not feet or hands but the understanding & modelling was most noble of all to my husband" (SME to George Barker, 9 July 1936, Foster and Leibold, 308). Other references to antique sculpture in Eakins' art will no doubt be discovered, although the search for inspiration in the Academy's cast collection is hampered by the disappearance of many pieces.

21. The CBTE print (fig. 195) is slightly larger than the print, also in platinum, in the Hirshhorn (H 64; Rosenzweig, cat. 54c), and slightly smaller than a less-cropped image in the J. Paul Getty Museum. Another print is in Seymour Adelman's collection at Bryn Mawr College Library, and there is a lantern slide in the Macdowell family collection in Roanoke. The other beautiful image in this series, H 62–63—known in an albumen and a platinum in the Hirshhorn (Rosenzweig, cats. 54a and b), a very large platinum in the MMA (H 63, probably Eakins' largest known photograph, 14 × 10 1/16 in.), and a small platinum print in the Getty—also survives in the Bregler album as a platinum enlargement (.670; 8 5/16 × 5 3/4 in.). The MMA print came from Bregler; the Hirshhorn prints belonged to Samuel Murray. Eighteen other prints of women in classical dress are in CBTE, including prints of H 182, 183, 184, and many unknown to Hendricks. See Danly and Leibold, 168–169.

22. SME's diary of important dates, CBTE. See Hendricks' images H 11, 12, 13, and CBTE 1985.68.2.695 and .639. Trot was probably Mary K. Trotter, an Academy student at this time; see Foster and Leibold, 88, 245. Susan, Mary, and Elizabeth Macdowell figure in these pictures, and logically Trot is the unidentified fourth model. As SME described them, the costumes in these photos are Empire, not classical; they relate to the early-nineteenth-century spinning pictures done in 1881. Also from about this time is the series of Caroline Eakins in similar costume (H 34–39); none of these images of Caroline survive in collections derived from Eakins' own studio.

23. Brownell, 742. Nine images of outdoor wrestling and boxing are now extant, along with seven original negatives. The CBTE holds one albumen contact print (1985.68.2.481, of H 126; its glass negative is in the MMA, from Bregler) and six glass negatives (including H 122–125, .1020, .1023, .1025, .1021, and two new images—.1022 and .1024). Vintage prints from these plates are rare, including only the CBTE albumen and four similar prints given to Coates (Olympia 1977, 506 [H 124], 510, 520 [H 122], 521). The input of others in this series might be surmised from Jesse Godley's relief sculpture *Wrestling Match* of 1886, given to PAFA after his death in 1889 (but no longer in the collection); see *Descriptive Catalogue of the Permanent Collections* (Philadelphia: PAFA, 1892), 87. Godley modeled for *Swimming* and the motion photographs; on Godley and the other models for this series, see Sarah Cash, "'Friendly and Unfriendly': The Swimmers of Dove Lake," in Bolger and Cash, 49–65.

24. Edward Strahan [Earl Shinn], "Greek Terra-cottas from Tanagra and Elsewhere," *Scribner's Monthly* 21 (Apr. 1881): 912. Shinn notes the purchase in 1879 of many figurines from Gaston Feuardent for the Museum of Fine Arts in Boston and for the PAFA (919). According to a clipping in the PAFA files, Rogers purchased the statuettes expressly for the Academy. "They are instinct [*sic*] with life and action, very skilfully worked for their size and material, and nearly always extremely graceful. The feeling of body under the

draperies, and the management of these, are remarkable in many instances" ("Tanagra Figurines," *Philadelphia Evening Telegraph*, 16 Oct. 1879). The appealing domestic quality of these pieces was contrasted with the "lofty" tradition of Greek public art in another clipping, "Tanagra Figurines," *Philadelphia Times*, 15 Nov. 1879. This article noted that, despite the differences in technique and expression between such "toys" and the work of Phidias, a consistency of "popular artistic feeling" united both sculptural traditions, making the figurines of special interest to "the student of art." I am grateful to Susan James-Gadzinski for sharing these clippings from the PAFA files. Popular interest in the Tanagra figures may be deduced from such articles and from a review essay by Thomas Davidson, "The Literature of the Tanagra Figures," *American Art Review* 1 (1880): 37.

25. Shinn, "Greek Terra-cottas," 926. Simpson notes the greater simplicity of format and accessories in these reliefs, compared with those of *Knitting* and *Spinning* (83). On Saint-Gaudens' remarks, see cat. 207.

26. Shinn, "Greek Terra-cottas," 921.

27. Rosenzweig, 104–105. The model appears to be Thomas Anshutz. This pose also paraphrases the classic lunge of warriors in Greek relief sculpture from the fifth to the third centuries B.C. Especially famous examples from the so-called temple of Theseus at Athens would have been known to Eakins from PAFA casts. A better example than Pollaiuolo's print may have come from the same artist's painting of *Hercules and the Hydra* (Uffizi), though it cannot be known how much Eakins knew of this work. Homage to Pollaiuolo would have been appropriate, however, for he was among the first Renaissance artists to study anatomy and undertake dissection. John S. Phillips' print collection, bequeathed to PAFA in 1876, was accessible in large scrapbook-style portfolios in the library, just to the right of the main stair. This collection of perhaps 40,000 prints included many fine reproductive engravings of European masterworks as well as artists' prints, offering a treasury of inspiration to artists. Phillips' European prints have been transferred to the PMA.

28. Rosenzweig, cat. 47b. Simpson, 88–89. These casts were in the PAFA collection by 1855. The *Jacob and Esau* panel that Simpson recognizes as a source appears usefully at eye level on this door.

29. Shinn, "Greek Terra-cottas," 916. This archaeological and theatrical mood is strongest in the series of photographs of Academy students in togas and sandals, dramatically posed before various casts in the PAFA studio. Notably, none of these images survive in the Bregler collection, although they formed part of the set of images given to Coates by Eakins (O 1–7; the first six of these are now in the J. Paul Getty Museum). As with the swimming hole photos, which were not taken by TE but included in this group of samples for Coates' edification, other photographers may have been at work on these images, under Eakins' supervision. The collaborator may be suggested by the presence of duplicates of all these images, excepting O 2 and O 7, in the Thomas Anshutz papers at the Archives of American Art. Anshutz's enduring interest in such subjects is demonstrated twenty years later in *The Tanagra* of 1909 (PAFA); see Nancy Fresella-Lee, *The American Paintings in the Pennsylvania Academy of the Fine Arts: An Illustrated Checklist* (Philadelphia: PAFA, 1989), no. 28.

30. Simpson discusses the impact of Gérôme's neoclassicism on Eakins (71–73). The antireligious humor in *The Two Augurs* may have appealed to Eakins, for it illustrates Cicero's observation that "it is marvelous to see that one augur doesn't laugh when he sees an-

other." Gérôme imagined that, in private, augurs had a good laugh at the expense of their devout public. See Ackerman 1986, no. 133, p. 211. In the 1890s, Gérôme also painted modern "Tanagra" subjects.

31. William Gaunt, *Victorian Olympus* (London: Jonathon Cape, 1952; rev. ed., 1975), 83. The work of these artists was rarely seen at PAFA but very frequently engraved, and a representative display appeared at the Centennial, where Alma-Tadema's work was highly praised; see J. F. Weir, *Official Report of the American Centennial Exhibition*, vol. 1, quoted in Clement and Hutton, 12. Simpson mentions the work of these artists (72).

32. Fig. 199 is taken from Wilfred Meynell, "The Homes of Our Artists. Sir Frederick Leighton's House in Holland Park Road," *Magazine of Art* 4 (1881): 173. It was later reprinted in Wilfred Meynell, ed., *Some Modern Artists and Their Work* (London: Cassell, 1883), 3. The text notes that Leighton had the clay maquette made up by another artist from the oil sketch on his canvas; the sculpture was then used as a model for the final stages of the painting. These English academics were also prodigious users of photographic studies; see Gaunt, *Victorian Olympus*, 105.

33. Analogous poses in Alma-Tadema's work are plentiful; see, for example, *The Women of Amphissa* (1887, Sterling and Francine Clark Art Institute) or *A Reading from Homer* (1885, Philadelphia Museum of Art). See Richard Dorment, *British Painting in the Philadelphia Museum of Art* (Philadelphia: PMA and University of Pennsylvania Press, 1986), 1–8, for a discussion of Alma-Tadema's work and a relevant bibliography. Danly and Leibold (129) have identified the model in this series of photographs as Blanche Gilroy, based on an inscription on an albumen print in the J. Paul Getty Museum. In these pictures Blanche holds or lies near a banjo, probably the same one depicted in *Negro Boy Dancing* (fig. 68). Although its half-lit form sometimes suggests a more historically correct lute or perhaps a tambourine (as seen in Alma-Tadema's *Women of Amphissa*), the banjo reminds us of Eakins' lack of strict archaeological pretense in these studio experiments. The banjo was an African-American instrument only recently invented in its five-string form and popularized after the Civil War.

34. Johns 1983, 128–131. Simpson remarks the spectator/arena model of *Arcadia*, as in *The Gross Clinic* (85). The frequency of the musician-audience structure in the work of Alma-Tadema and his British colleagues of this period is noted in Dorment, *British Painting*, 6.

35. Theodore Child, "American Artists at the Paris Exhibition," *Harper's New Monthly Magazine* 79 (Sept. 1889): 508, quoted in Annette Blaugrund et al., *Paris 1889: American Artists at the Universal Exposition* (New York: Abrams, for PAFA, 1989), 161–164. Johns remarks Harrison's painting but construes it to have been made before 1880 (1983, 128). *En Arcadie* is in the Musée D'Orsay, Paris; it was purchased for the French national collection of contemporary art in 1905. A study for this painting contains variant postures, much more like Eakins' *Arcadia;* see David Sellin and James K. Ballinger, *Americans in Brittany and Normandy, 1860–1910* (Phoenix: Phoenix Art Museum, 1982), no. 36, p. 156. William H. Gerdts surveys the painting of the nude in American art in this period in *The Great American Nude* (New York: Praeger, 1974), esp. 119–124.

36. Van Deren Coke, in *The Painter and the Photograph*, rev. ed. (Albuquerque: University of New Mexico, 1972), 85, has been the harshest critic of these unfinished paintings, pointing to the "stilted poses" and "inconsistent treatment" of figures and landscape. Goodrich, with more gentleness, admitted that *Arcadia* was "not

one of Eakins' strongest works" (1982, I: 251). Gerdts maintained that the awkwardness was deliberate, intentionally in opposition to more conventional, idealized nude figure painting; see *Great American Nude*, 121–122. Spassky surveys other critical responses (610–612).

37. Lamb also concludes that the rejection of *Swimming* explains the abandonment of outdoor nude subjects (Avondale/Dietrich, 20). On the aftermath of this commission, see Bolger and Cash, 25–30, 44–45.

38. See "Trouble at the Pennsylvania Academy," Foster and Leibold, 69–79. On the character of Eakins' "ungentlemanly" behavior, as seen by his accusers (including Thomas Anshutz), see "The Art Club Scandals: Misrepresentations and Foul Lies," Foster and Leibold, 79–90.

39. These photographs came from Coates' descendants, still housed in an envelope addressed to Coates from PAFA. See Olympia 1977; Ellwood C. Parry, in Olympia 1981, introduction; and Goodrich 1982, I: 241. It is by no means clear when Eakins sent these to Coates, or whether Coates simply impounded material found at the Academy that he wished to keep out of circulation. I would propose that they were offered in 1886, perhaps at the time of his final defense to Coates in Sept. (cf. Foster and Leibold, 235–239), as evidence of the pristine motives behind the nude photo sessions with students.

40. G 255; see Goodrich 1982, I: 236–237. Goodrich dated this sketch to c. 1890 and later proposed that it was earlier, from the Arcadian period; see Simpson, 92. Alma-Tadema's painting is now in the Birmingham City Art Gallery; it was first publicly exhibited in 1878.

41. SME to Goodrich; see Goodrich 1982, I: 237.

42. The photo of Susan next to "Billy" (fig. 202) is one of a series of four poses of her either astride or alongside the horse (1985.68.2.546–.553 and glass negative .1047). Eakins brought Billy home from the Dakotas in 1887, but these photos may date from the summer of 1891 through 1894, when Eakins was working at Avondale on his sculptures for the Brooklyn Memorial Arch, and ideas of horse and rider were paramount in his mind. From the same time may be photos of Eakins nude astride Billy (1985.68.2.303–.306, including H 268), and Murray and Schenck astride or alongside Billy and Eakins' other cow pony, Baldy (.313–.314 and .497, all H 180; .496; .829, H 174; and .682, 318–319, all related to H 174). Danly and Leibold date these images to c. 1890 (199–200) or 1893 (209–210). A related image of O'Donovan astride Billy is in the MMA; see Avondale/Dietrich, cats. 66, 39.

43. On these bad times, see "The Nude at Drexel," "The Hammitt Case: A Most Unfortunate Lady," and "Ella Crowell's Suicide," in Foster and Leibold, 93–124.

44. On the late Rush paintings, see Johns 1983, 102–103, 111–114. Ackerman introduced the connection to Gérôme's *Pygmalion* (1969, 244). See also Weinberg 1984, 44, and Sewell, 51. The Pygmalion motif also appears in fig. 78, an image produced about the time of Gérôme's series of self-portraits in the studio, as sculptor.

Chapter 18: "A Little Trip to the West"

1. For more information on the ranch and the letters Eakins wrote to his wife while he was there, and for additional photographs, see Leibold 1988, 2–15, and Foster and Leibold, "Adventures on the Ranch," 90–93, 240–243, and fiche series I 3/C/9–4/E/11. All citations in this text are from letters in CBTE unless otherwise noted. See also Goodrich 1982, II: 16–27.

2. Nancy E. Anderson, "*Cowboys in the Badlands* and the Role of Avondale," in Avondale/Dietrich, 21; Leibold 1988, n. 4.

3. Walt Whitman, *Specimen Days* (Boston: David R. Godine, 1971), 94. Whitman's rambling autobiographical notes, which included his thoughts on his trip to the West, were published in several editions (1882, June 1887, and 1892).

4. Horace Traubel, *With Walt Whitman in Camden, January 21–April 7, 1889* (Philadelphia: University of Pennsylvania Press, 1953), 4: 135.

5. For a photograph of his Western "den," see James F. O'Gorman, *The Architecture of Frank Furness* (Philadelphia: PMA, 1973), fig. 26.

6. See G. Edward White, *The Eastern Establishment and the Western Experience* (Austin: University of Texas Press, 1989), 67–71, for a discussion of Wister's Western trip. Like Frederic Remington and Theodore Roosevelt, Wister continued to visit the West for many years. Although he pursued a law career, he wrote many novels set in the West, including *The Virginian*. Wister and Furness were well acquainted, being related by marriage, and in fact may have traveled West together. See Mark Orlowski, *Frank Furness: Architecture and the Heroic Ideal* (Ph.D. diss., University of Michigan, 1986).

7. See n. 1 for sources giving extensive excerpts and microfiche publication of these letters.

8. See Edmund Morris, *The Rise and Fall of Theodore Roosevelt* (New York: Coward, McCann and Geoghegan, 1979), 615. In his letter of 11 Aug. Eakins writes: "In crossing the Missouri river Silvane of the Maltese Cross wagon was holding up his legs so as to have some fun and commenced pitching and whirling; the feet went down double quick into the stirrups and for about five minutes Silvane looked like the center of a pinwheel." Roosevelt's second set of essays on his experiences in Dakota Territory were published in *The Century Magazine* as "Ranch Life and the Hunting Trail," in six installments between Feb. and Oct. 1888, with illustrations by Frederic Remington. Later published in book form, Roosevelt's 1888 account parallels many of Eakins' descriptions and photographs.

9. See Donald Dresden, *The Marquis of Mores, Emperor of the Badlands* (Norman: University of Oklahoma Press, 1970), 163–172.

10. Danly and Leibold, 220–222. Hendricks catalogued four Dakota images: two were Bregler's modern prints from the glass negatives he owned or from copy negatives (H 134, from 1985.68.2.1074; H 136, from .1075), and a third was a copy print by Bregler (H 138) from the platinum print but with most of the background cropped (.277; fig. 206). The fourth image, an albumen print in the Dietrich Collection (H 135), seems to have survived unique. The Hirshhorn also owns in its archival department one of Bregler's copy prints of H 134. The Bryn Mawr College cowboy portrait, also an albumen print, has not been published; the J. Paul Getty Museum's *Unidentified Man in Dakota Territory* (albumen, 3 7/16 × 4 7/16 in.) is reproduced in William Innes Homer, "A Group of Photographs by Thomas Eakins," *Journal of the J. Paul Getty Museum* 13 (1985): 152. Bregler also mentioned an "Indian photo" given to the University [of Pennsylvania] Museum that is now unlocated; see Leibold 1988, n. 15.

11. The other numbered negatives in CBTE are: eight taken *of* Eakins (possibly by Susan Macdowell) in the backyard at 1729 Mount Vernon Street in the early 1880s, with numbers ranging from 56 to 126; three of Crowell children, numbered 205, 206, and 209; and three landscapes, numbered 7, 8 (or 18), and 11, all probably made at Gloucester or Manasquan, New Jersey, in 1881.

12. The shirt and pants are now in the Hirshhorn, along with a wide-brimmed felt hat, a necktie, and a lariat; see Rosenzweig, cat. 129.

When Bregler lent this costume to Knoedler's gallery in New York in 1944, the outfit included brown chaps, spurs, bridle, cartridge belt, holster, whip, and belt. These additional items are now unlocated. All of these properties can be seen in *Cowboys in the Badlands* or *Home Ranch,* and occasionally the same items appear on cowboys in Eakins' photographs, as in Leibold 1988, figs. 7, 15. Both paintings and photographs also show a pair of fringed gloves (see fig. 203), apparently lost by 1944.

13. Ackerman 1969, 243 and fig. 24. He notes that Eakins owned a postcard reproduction of a painting by Gérôme similar to *Bashi-Bazouk Singing* (Walters Art Gallery) and points to a photograph by Eakins in Seymour Adelman's collection, of a cowboy in the same pose. If this is the print (G 135) now in the Dietrich Collection, the costume and pose are in fact rather different from those in the painting, although Ackerman may have seen another, currently unlocated photograph.

14. H. C. Wood to A. Tripp, n.d. [c. June 1887], Foster and Leibold, no. 166, fiche series I 7/A/14–7/B/2. Quoted in Goodrich 1982, II: 16.

15. On the fate of the B-T and its likely location, see Leibold 1988, 3. The ranchhouse, with glass windows, a porch, and a large chimney, was probably the sod building on the left in fig. 204. The log building at the right may have been a storehouse.

16. Two extant panoramic landscapes, fig. 211 and another (1985.68.2.1065), are numbered on the negative "408" and "406," the highest numbers in Eakins' series. Six extant views of the ranch (including figs. 204 and 214) are numbered 393–395, 397–399. The gaps in this numbering suggest at least one lost negative (407) and perhaps seven or more.

17. Peter Hassrick, *Frederic Remington* (New York: Abrams and the Amon Carter Museum, 1973; concise ed., 1975), 21.

18. Eakins did not habitually sketch in pencil after 1870; Wood may have misremembered the materials. The oil sketches, G 228 and 227, are discussed in Siegl, cats. 65–67, and in Siegl's conservation notes (PMA). Before 1933, Goodrich saw three panels apparently painted in Dakota Territory: G 227–229, all about 10 × 14 in., sized to fit in his paint box. The first two have since been split; the verso of 228 is Siegl, cat. 66, and the verso of 227 was sold at Sotheby Parke-Bernet, New York, 17 Oct. 1980. The third panel, G 229, shows a mounted cowboy herding a steer (?) (PMA; see Siegl, cat. 68). A fourth canvasboard panel, G 225, originally 10 × 18 in., was cut into three pieces some time after 1933. It included a sketch of two cowboys (fig. 215), a saddle (7 × 6 1/4 in.; coll. Chaim Gross) and a stirrup (location unknown). Such studies could have been painted at the B-T or in Pennsylvania, since Eakins took these properties home with him. Two other extant panels of the sketchbox type feature Eakins' student Edward Boulton, so they must have been at least partially painted after Eakins' return. G 230, now divided, shows Boulton on the recto along with various sketches of cowboy gear (Hirschl and Adler galleries); on the verso is the cropped figure of a mounted cowboy in motion, much like G 229, which may well have been painted on the ranch (coll. Henry Reed). G 231, of Boulton in costume, is currently unlocated. Hendricks mentions seeing another sketch of *Cowboys Circling,* "previously unknown to history and now unlocated" (1974, 178). See also Goodrich's notebooks, PMA, and Anderson, in Avondale/Dietrich, 22.

19. Other views of this building (.1068 and .1069) show a window and a stovepipe on one end wall, indicating human occupation on that side.

20. See n. 18 for an account of extant sketches.

21. See Anderson, in Avondale/Dietrich, 21–23. The landscape sketches at the PMA came from the Crowell family, via Seymour Adelman.

22. Siegl, cat. 69, G 226. Most likely, the smaller panel was done at Avondale because the horses seem to be Eakins' own cow ponies, not the horses seen in the photograph (fig. 217).

23. Hendricks commented on the "curious, strangely surrealistic" effect of this painting (1974, 119–120). Siegl (ibid.) described its construction and noted the "inconsistency of light." Goodrich described the "blanched, dreamlike landscape" as contrasting sharply with the fully modeled figures, although he found the effect "not untrue" because of the near placement of the cowboys and the distance of the landscape forms (1982, II: 2–3). The Badlands are, of course, an unusual topographic formation, and Eakins must have wished to convey the exoticism of this landscape and its slightly "unreal" character.

24. Ackerman 1969, 244. He notes that Eakins owned a postcard reproduction of this painting. By 1888 the picture was in the New York collection of Israel Cone; see Foster 1972, appendix.

25. *Napoleon Before Cairo* (Hearst Collection, San Simeon) of 1868 depicts the mounted general in the right foreground, overlooking the city and plains. *Oedipus* was one of Gérôme's personal favorites. Other related compositional structures appear in Gérôme's string of paintings of big cats, such as *The Two Majesties* of 1883 (Milwaukee Art Center), which depicts a lion gazing at the sun from a height overlooking a Badlands-type landscape. See Ackerman 1972, 84; 1986, cats. 173, 175, 529–534.

26. Earl Shinn, "The Private Art Collections of Philadelphia," *Lippincott's Magazine* (May 1872): 575.

27. TE to Earl Shinn, 30 Jan. 1875. Quoted in Goodrich 1982, I: 94. Gérôme's *Picador* (currently unlocated) was exhibited at the Salon of 1870, which Eakins visited immediately after his return from Spain. See Ackerman 1986, no. 177.

28. Muybridge's photographs, based on his work at the University of Pennsylvania in 1883–85, were published in 1887 in eleven volumes; earlier photographs of horses had been available since 1878. These photographs had an electrifying effect on French battle painting in the 1880s, which adopted many of the exciting effects also seen in the Western subjects. Remington's use of photography must be assumed, although it has not been explicitly confirmed; see Hassrick, *Frederic Remington*, 20–224, and plate 12. Hassrick notes Remington's use of photographs in those paintings, although old-style flying gallop poses still appear. Although well established as an illustrator of Western subjects by this time, Remington's reputation as a painter skyrocketed after his successful exhibitions in 1888 and 1889. Earlier on the field with such sensationally energetic subjects was James D. Smillie, whose *Scrub Race on the Western Plain* was a major success at the watercolor exhibition of 1876. Using the same device of horsemen galloping full tilt toward the viewer, this composition was repeated by Smillie in variants, such as *Rough Sport in the Yosemite* (MFA, Boston) of 1883, probably known to both Eakins and Remington. Such cowboy subjects were gaining in popularity in the 1880s, but the real heyday of the genre began with the entrance of artists like Remington and Russell, with extensive personal experience of Western life and photographic knowledge of horses. Typically, Eakins' activity in this genre is a bellwether of rising artistic and public interest.

29. Goodrich 1982, II: 23.

30. *Home Ranch* of 1892, G 248 (PMA; see Siegl, cat. 83); *Cowboy Singing*, G 250 (PMA; see Siegl, cat. 82); the watercolor *Cowboy Singing*, G 249 (MMA); and *Head of a Cowboy*, G 247 (Amherst College Museum), all were painted about the same time, using Franklin Schenck and Samuel Murray as models. On the musical themes of this period, see Johns 1983, 136–137.

31. See chap. 10 on this commission and the sculpture of Billy, G 512. Eakins modeled the horses and William R. O'Donovan did the figures. Eakins' fastidiousness was demonstrated in the research for this project, when he and O'Donovan searched as far as West Point for a "suitable military mount for Ulysses S. Grant." Lincoln, a civilian, was appropriately mounted on Billy, a strong but plain, unpretentious horse; see Goodrich 1982, II: 112.

32. After his resignation in 1886 Eakins did not send work to PAFA for four years, choosing instead to show with the newly organized Art Club (in 1887 and 1889). His work appeared at Louisville (1886), at the SAA (1887), at the NAD (1888), and in Chicago (1887–1889). In 1889 he sent three paintings to the Exposition Universelle in Paris. It appears that of the few items shown between 1886 and 1890, most were from 1886 or earlier. See Milroy, *Lifetime Exhibition Record*.

33. Goodrich 1982, II: 161–162. Three paintings by Eakins were displayed at the Exposition Universelle, although, as Goodrich notes, he was not among the long list of American medalists.

34. The two dated portraits, of Dr. Joseph Leidy (G 292) and Professor George W. Fetter (G 240), were hardly inconsequential, however, and many portraits from this period are listed by Goodrich as "c. 1890." Contributing to the confusion of the year following his return from Dakota Territory was Eakins' student Lilian Hammitt, who wrote him a declaration of love in the spring of 1888. This delicate situation worsened until Hammitt was committed to a mental hospital in the mid-'90s; see "The Hammitt Case: 'A Most Unfortunate Lady,'" Foster and Leibold, 96–104.

Chapter 19. Portraits: Case Studies Define a Method

1. Goodrich offers an excellent survey in his chapter "The Portrait Painter" (1982, II: 52–98). He counted 246 known portraits (80), close to half of Eakins' total roster of paintings. The primacy of portraiture as a reference point for all of Eakins' work is the organizing thesis of Elizabeth Johns' excellent study of 1983. Eakins disliked Ruskin but he would have agreed with his section on portraiture in *Modern Painters* (1846), vol. 2, part 3, sec. 1, chap. 14, para. 14.

2. Eakins usually painted bust-length life-size portraits on 24 × 20 in. canvases. This was his favorite format, accounting for almost a third of his portraits. The 20 × 16 size was used for a pair of family portraits made in about 1871 and then ignored until the last decade of his career, when he employed this tighter format about a dozen times. Goodrich lists dated examples of this size in 1904, 1906, 1907, and 1908; if "circa" dates are also tallied, this size seems to have been most popular with Eakins in the years 1902–4 and 1906–8. Although it may have signaled waning energy, this smaller size was no index of the portrait's merit or importance; Eakins' most moving portrait of his wife was painted on a 20 × 16 in. canvas about 1899–1902 (Hirshhorn; see Rosenzweig, 168–169). Goodrich tallied Eakins' small portraits by decades (see 1982, II: 215).

3. On "Jennie Dean" Kershaw, later Mrs. Samuel Murray, see Goodrich 1982, II: 109. Related photographs are in the Hirshhorn; see Rosenzweig, 157–159. Eakins' emphasis on hands is discussed by Goodrich 1982, II: 59–60. See also the life casts of hands, cats. 362, 367.

4. Eakins' dismissal of studies produced to "show off" is heard in his letters from Paris (chap. 8 above); see Goodrich 1982, I: 52. The portrait of Kershaw, undated but placed at "c. 1899" by Goodrich, was arrested for unknown reasons, perhaps because the asymmetrical placement of the figure made for an unhappy crowding at the left. A more finished version of the head alone is in the Baltimore Museum. The painting, in its half-finished state, reminds us of Eakins' friendship with Chase, who was painted in 1899, and Sargent, who visited Philadelphia in 1903, leaving Eakins with a reproduction, mounted on card, of his *Portrait of Mrs. William White,* signed "to Thomas Eakins / from his admirer / John S. Sargent." See Foster and Leibold, 188, and letters from Sargent (no. 204) and Dr. White (nos. 201, 205) testifying to the circle of friendship. See also Goodrich 1982, II: 222–223.

5. This photograph, H 287, has been dated 1909–10, although the picture must have been taken in 1912–13, when Eakins was working on his second portrait of Rutherford B. Hayes, made from a photograph. In fig. 222 a photograph is indeed pinned to the left margin of the canvas, which appears to be the late Hayes portrait, G 473, now in the collection of Philipse Manor Hall, Yonkers, New York. See Hendricks 1974, 270, fig. 299.

6. The tediousness of Eakins' portrait sittings is a theme reiterated by many of the people Goodrich interviewed in about 1930; see 1933, 145, and 1982, 79. SME's rebuttal is in the draft of a letter to Mrs. Lewis R. Dick, c. 1930 (Foster and Leibold, 299). Her reference was to *The Gross Clinic,* with its many quickly drawn portraits in the background. The principals posed more often, "probably six poses of an hour each time," for Dr. Gross, and "somewhat less time" for the other surgeons. She concluded this letter on Eakins' portrait method with an anecdote about a woman (Mrs. J. W. Drexel) who suggested that her maid pose in her stead, at which point Eakins politely refused to continue. This story is also recounted in Goodrich 1982, II: 179. Bregler disputed the method Goodrich outlined in 1933, arguing for Eakins' ability to work quickly and confidently (see CB to F. A. Sweet, 30 Sept. 1940; Foster and Leibold, fiche series IV 3/D/4; and CB to Goodrich, 30 Oct. 1940, fiche series IV 3/D/9). Other new evidence concerning Eakins' portrait sittings can be gleaned from SME's diary of 1899 (CBTE), which records nine sittings with Addie Williams between 26 Jan. and 7 May, culminating with "two hours on Addie's dress," perhaps the pleated black dress seen in G 323 (Art Institute of Chicago), said to be the first of the two known portraits of her, although the striped and beribboned dress in the second portrait, done "about 1900" (G 333, PMA; see Siegl, 154) would merit the time more. SME also remembered that TE's portrait of J. L. Wallace (G 206), painted during Wallace's visit to Philadelphia in 1885, was completed after four sittings: "Tom calls it done; 1885. Quick work and fine" (Retrospective diary, 17 Aug., CBTE).

7. CB to L. A. Fleischman, 23 Nov. 1955 (PMA Archives).

8. On Eakins' use of photography in portraiture, see chap. 11.

9. Life scale is an obvious, traditional choice because of the ease of one-to-one relationships and the natural scale comprehended by viewers at any distance from the painting. However, other choices are possible, as noted by the portraitist John Collier, who remarked that some artists maintained "that the sitter's head should always be considered to be in some way behind the frame," and accordingly diminished by the laws of perspective. However, the slight reduction looks "meagre and skimpy" to a viewer, wrote Collier, who admitted that he would instead slightly exaggerate the size of the head to give a "more vigorous and striking" effect (*The Art of Por-*

trait Painting [New York: Cassell, 1910], 100–101). By accepting the more "natural" but less "true" perspective system of life-size portraiture, Eakins had to deal with resulting spatial inconsistencies, discussed below in terms of the Brinton portrait.

10. On the Turner sketch, see Siegl, 164.

11. On the importance of the first oil sketch to Eakins' creative method, see chap. 8.

12. Above the conventional portrait size of 30 × 20 in., Eakins' stretcher sizes vary with very little duplication (only 60 × 40, 50 × 40, and 40 × 30 being repeated two or three times). The refinement of choice might be represented by the sequence of portraits all very close to eighty inches high: the earliest, and slenderest, is *The Black Fan* of 1888 (G 259) at forty inches wide; *John J. Borie* (fig. 230) is forty-two inches; *John McClure Hamilton* (G 284) is fifty inches; *Benjamin Rowland* (G 264) is fifty-four inches; and *An Actress* (G 384) is almost 80 × 60 in. *Cardinal Martinelli,* a close variant (fig. 235), is 79 × 60 in. Such variations appear at all sizes, including canvases even smaller than 24 × 20 in., and they are characteristic of his sporting subjects and other genre paintings as well.

13. SME to Mrs. Lewis R. Dick (draft), c. 1930 (Foster and Leibold, 299).

14. Surviving portrait sketches from group compositions are listed in the notes to cat. 237. Similar portraits for *The Agnew Clinic* were made from individual sessions with students and doctors, but these were painted directly on the canvas; see CB to Carmine Dalesio, 3 Dec. 1939 (Foster and Leibold, fiche series IV 10/E/11).

15. For images of Hayes, see also Eakins' later portrait of 1912 (made from a photograph, as seen in fig. 222) and W. Garl Browne's portrait of 1878, which supplanted Eakins' first effort at the Union League; see Hendricks 1974, 270. The National Portrait Gallery owns several images of Hayes, as does the Hayes Presidential Center in Fremont, Ohio. Period images, like Brady's portrait of c. 1877 (fig. 225), all show Hayes' short beard, straight brow, high forehead, and ear-length hair, parted on his left. Hayes' long nose receives varied treatment in these portraits, even though it seems to have been his most distinctive feature. See *The Permanent Collection Illustrated Checklist* (Washington, D.C.: National Portrait Gallery, Smithsonian Institution, 1987), 132.

16. Goodrich 1933, 55, quoting a letter of 13 June 1877 to George D. McCreary (Rutherford B. Hayes Library, Fremont, Ohio); this letter and most of the period commentary on this commission were published, along with a detailed description of the project, in Gordon Hendricks, "The Eakins Portrait of Rutherford B. Hayes," *American Art Journal* 1(1) (Spring 1969): 104–114; and Hendricks' subsequent Letter to the Editor, *American Art Journal* 3(2) (Fall 1971): 103. Condensed, this material appears in Hendricks 1974, 115–118, 270. Goodrich's revised biography incorporated most of Hendricks' material; unless otherwise noted, all quotations in this section can be found in Goodrich 1982, I: 141–144.

17. CBTE, Foster and Leibold, no. 57, fiche series I 3/D/12–13. Eakins' unaccented and irregular French in this letter, verbatim: "Le president m'en donné deux séances. Il a posé très mal. Sourt [?] j'ai reussi dans l'ébauche à l'aquelle j'ai donner assez de mouvement. Demain je vais insister d'avantage sur la pose."

18. G 188 (MMA), 1882. The Hayes portrait joins Eakins' suite of images of pen, pencil, gun, and scalpel-bearing figures analyzed so provocatively by Fried; the metaphoric system embracing writing and drawing that Fried remarks would quite naturally embrace a figure of fatherly authority, such as the president of the United States.

19. G 118 (PMA); see Siegl, 72–73.

20. A search through the photographic collections at the Hayes Center has not yielded a photograph by Mora, or one in this pose. Gilbert Gonzales, curator of this material, nonetheless feels that the sketch on cat. 189w captures "something very characteristic" about Hayes' bearing, his typical gesture and appearance, suggesting that it is indeed the president and may have been done from life. I am grateful for his advice and assistance in conversations on this topic. Other pencil sketches in the Washington sketchbook that may relate to the Hayes portrait include a floor plan and room elevation; see cats. 189i, q.

21. Hendricks, Letter to the Editor, 103. Browne's portrait is reproduced in Hendricks 1974, 270.

22. On the late Hayes portrait, see n. 5.

23. A résumé of Brinton's accomplishments appears in Goodrich 1933, 169 (G 101). He was medical director of Grant's army and later edited the six-volume *Medical and Surgical History of the War of Rebellion* and founded the Army Medical Museum. See also Goodrich 1982, I: 76, 138–140; Hendricks 1974, 111, 115; Avondale/Dietrich, 30, 35. Letters from TE to his fiancée, Kathrin Crowell, dated 19 Aug. 1876 and (by internal reference) 8 Sept. 1876, refer to portrait sittings by Brinton (CBTE; see Foster and Leibold, 154, and fiche series I 3/D/6–7, 10–11).

24. The legs of the left rear chair have been painted over the rug, indicating that they were added at a late moment. The uncharacteristically finished drawing of the chair in cat. 175 (fig. 229; plate 20) may also mean that it was added some time after the perspective was drafted, when Eakins was considering the treatment of this section of the space and the design. Pentimenti also indicate a change in the position of Brinton's right foot, which was once more at an angle, following the footprint on the plan, cat. 175.

25. On Eakins' procedures in setting up the picture plane and determining the point of sight, the vertical and horizontal axes of the composition, and the viewing distance, see cat. 98 and chap. 7.

26. Eakins did not always condescend to his women sitters, as the portraits of *Mrs. Frishmuth* and *The Old-Fashioned Dress* demonstrate. As Jules Prown has suggested to me, the low viewpoint in *Kathrin* (about 36 inches) hints that he was "kneeling" to his future fiancée or (more likely) seated on the floor. The Bregler drawings indicate that Eakins worked both standing and seated, according to the effect he desired. This kind of versatility was necessary, according to the portraitist John Collier, because standing gave the artist a desirable freedom of movement but often caused "impossible" effects of perspective, especially with seated models. To alleviate the "absurdly steep" slope of the floor that occurs when the painter looks down on the sitter, or to mitigate the "unbecoming" foreshortening of the face and neck, Collier advised building stages or small platforms to lift the model to the painter's eye level or slightly above. Some of these uncomfortable effects of perspective can also be reduced by moving away from the sitter, as Eakins often did. See *Art of Portrait Painting*, 82–89.

27. The human ability to comprehend, without distortion, pictures seen from oblique angles is the major premise of M. H. Pirenne, *Optics, Painting and Photography* (Cambridge: Cambridge University Press, 1970).

28. The perspective drawing, cat. 175, is made at one-eighth life scale with a viewing distance likewise reduced to one-eighth of the painting's, or two feet. On this drawing, objects along the sixteen-foot line can be easily calculated, because one foot will be represented there by 1 1/2 inches. People used to working with perspective problems will seek round and versatile numbers (usually divided by four) that convert easily into fractions. Eakins used certain scale reductions frequently (1/4, 1/8, 1/12, 1/24) but not consistently, as witnessed in the viewing distance of Borie (12 1/2 feet), Culin (14 3/4 feet), and Martinelli (13 feet).

29. The power of this scale change can be illustrated by setting Brinton on the eight-foot line in the grid. At this distance, objects twice as far away, or eight feet beyond Brinton, will shrink to half the size of life (according to the "law" of perspective; see cat. 92). However, seen next to Brinton's large figure, they will seem "too small." Eakins avoids this effect by placing Brinton farther away and keeping the interior space shallow. The armchair behind him, for example, is diminished to four-fifths life by the same rule of proportion—not an unsettling reduction. These same devices, of a shallow stage of space and a long viewing distance, were employed by Caravaggio in his *Supper at Emmaus* (c. 1600–10, National Gallery, London), where the viewing distance is about a foot longer than the Brinton portrait. This long vantage allows the disciple seated at Christ's left to throw his arms out in surprise without appreciable change in scale between the distant hand and the near one; although foreshortened, like Brinton's crossed leg, his extended hands remain close to life size, encouraging the sense that the viewer is seated very close to the supper table. See Fred Dubery and John Willats, "Long Spectator Distance and Shallow Field of Focus," in *Perspective and Other Drawing Systems* (New York: Van Nostrand Reinhold, 1972; rev. ed., 1983), 80–81.

30. On Leonardo's rule and on other aspects of visual angle and spectator distance, see the discussion of Eakins' perspective system in chap. 7.

31. The unusual perspective of these outdoor subjects, with their "telescoped" foregrounds, is discussed above in chap. 12. Equally eccentric is the inclusion of foreground conventionally cropped by the frame, as in Manet's *Battle of the Kearsarge and the Alabama, 1864* (John G. Johnson Collection, PMA), in which yards of water are included in the view to give a sense of the painter's actual position on board another ship, watching the battle at sea.

32. On Peale's *Staircase Group*, see Dorinda Evans' discussion in PMA, *Three Centuries*, cat. 137. Collier, in recognizing the special "difficulties" of full-length portraits, noted that some distance was always necessary "so as not to bring the feet too near the edge of the frame"; the figure should therefore be pushed a "yard or so" into space. Such figures ought to be diminished as a result, "but they are not usually so painted." As a compromise, Collier advocated cropping the floor as much as possible and using a long viewing distance (*Art of Portrait Painting*, 101).

33. Philip Rawson, *Drawing* (Oxford: Oxford University Press, 1969; rev. ed., Philadelphia: University of Pennsylvania Press, 1987), 53–54.

34. G 467. This painting has been variously dated in the literature. Burroughs has suggested "1893?" and Marceau placed it between 1892 and 1895. In 1933, Goodrich put it in sequence between 1909 and 1910 without offering a rationale, although he did give biographical details on the sitter. Apparently Goodrich's book inspired a letter from Adolphe Borie, the sitter's cousin and owner of the painting, who called this picture *The Architect* and recollected the date as 1896–1900. This letter, which contains additional biographic background, was shown to me by Barbara MacAdams of the Hood Museum of Art, who generously shared her research file on Borie. From her slender record of Borie's life, gleaned from various libraries in Philadelphia, it might be concluded that the por-

trait could not have been painted earlier than 1896, when he announced himself as a practicing architect; the confidence of his pose as *The Architect*, perhaps flanked by his own design on the drafting table at his left, would seem to announce professional arrival. The portrait probably was begun before 1899, because Borie is not mentioned in SME's diary of that year (PAFA Archives), and his trip to England in the winter of 1898–99 and his move to New York in 1900 may explain its interruption. More recently this portrait has been published in Arthur R. Blumenthal, *Portraits at Dartmouth* (Hanover, N.H.: Dartmouth College Museum and Galleries, 1978), 76, and *Treasures of the Hood Museum of Art* (Hudson Hills, 1985), 160. A sampling of Borie's work on the Cope and Stewardson dormitories, perhaps meant to be alluded to on the drawing board at his left, may be the unattributed drawings in PAFA, *Drawing Toward Building*, 173.

35. The gradual translucency of Eakins' pigments makes these pencil grids more visible over time. The central axis and horizon are especially apparent in some of his watercolors and thinly painted oils, such as *The Cello Player* (fig. 250). Infrared reflectography by Molly Faries has revealed a similar but more complex grid beneath the paint surface of *Monsignor Turner* (fig. 236), corresponding to the full-scale drawings, cats. 216–219.

36. On *The Thinker*, see Goodrich 1982, II: 179–182, and Spassky, 622–626.

37. G 483, p. 207. The painting may have been exhibited at the University of Pennsylvania and then at the Brooklyn Museum, where Culin was curator after 1903. At some point, perhaps after Culin's retirement, the portrait returned to his possession. When Goodrich queried Culin's widow in 1930, she reported that it had been stolen "some years ago." No further trace of the painting has been recorded, although Goodrich copied a sketch of the composition, evidently by Eakins, found on the back of a bank slip (PMA notebooks). Culin's accomplishments have been recently surveyed in Diana Fane, "The Language of Things: Stewart Culin as a Collector," in *Objects of Myth and Memory: American Indian Art at the Brooklyn Museum* (Brooklyn: Brooklyn Museum and University of Washington Press, 1991), 13–27. Fane has kindly shared with me Mrs. Culin's correspondence, in which she notes that "Mr. Culin got up an exhibition for Mr. Eakins, the first he ever had, and was a great enthusiast at a time when his marvelous canvases were laughed at." Alice Culin never met Eakins (she was Culin's second wife); she may be referring to the 1896 Earle Galleries show, or more likely the exhibition held at the Faculty Club of the University of Pennsylvania in 1901; see Milroy, *Lifetime Exhibition Record*. McHenry noted that Eakins, Murray, and Culin were friends who "often went to University faculty dinners together" (114).

38. The Culin portrait, dated "about 1899" by Goodrich, was begun by midsummer 1899; according to a diary entry by SME on 21 July of that year, she went with TE to the university on that day to see the "sketch" for Culin's portrait (CBTE). She may be referring to the roughed-out sketch on the final canvas or to a preparatory sketch that is now lost. The painting was exhibited that fall at the Carnegie Annual.

39. Sarah Frishmuth's portrait, G 338, is dated 1900; 96 × 72 in., PMA (see Siegl, 151–153). Mrs. Drexel's unfinished portrait, G 339, was originally 72 × 53 before being cut down by Bregler to its present dimensions of 47 1/4 × 37 1/4 (Hirshhorn; see Rosenzweig, 172–173). Both the Culin and Frishmuth portraits were exhibited together at PAFA in 1901 but won little notice at an exhibition where *The Thinker* drew most of the praise and attention of the critics.

40. The Cushing portrait, G 273, is now owned by the Gilcrease Insti-

tute, Tulsa (oil on canvas, 90 × 60 in.). It was lent by Eakins to the University Museum where—like Mrs. Frishmuth's portrait—it was hung amid the collections. When Culin moved to Brooklyn, the Cushing portrait moved, too.

41. Mrs. Culin remembered the pose with his "hand on things on table." Culin's comparative study of games was begun in the early 1890s, producing exhibits at the Columbian Exhibition in Chicago in 1894 and at the Atlanta Cotton Exposition the following year. His catalogue of the later exhibition was first published at "Chess and Playing Cards: Catalogue of Games and Implements for Divination . . . ," in *Report of the U.S. National Museum* (Washington, D.C.: Smithsonian Institution, 1896), 665–942. Related diagrams of Chinese and Korean chess boards appear on pp. 864 and 866, although neither illustration shows the proportions of Eakins' board. I am grateful to Lucy Fowler Williams, keeper at the University Museum, who first suggested that this board was Chinese and noted that such chess boards are in the University Museum's Asian collection. Diana Fane, curator at the Brooklyn Museum, has alternatively suggested that the board may be Philippine. Simon Bronner also helpfully brought Culin's publication to my attention. Culin wrote another book, *Korean Games* (Philadelphia: University of Pennsylvania, 1895), including some of this material, although the section on chess was written by W. H. Wilkerson. The preface to a reprint of this book in 1958, published under the title *Games of the Orient*, comments on "the fact that the clue to the origin of both chess and cards was found by Mr. Culin, with the aid given by Mr. Cushing, among the aboriginal people of America." These studies culminated in Culin's epic *Games of the North American Indians*, first published in the *Twenty-Fourth Annual Report of the Bureau of American Ethnology* (Washington, D.C.: Smithsonian Institution, 1902–3).

42. Lucy Fowler Williams confirmed Culin's acquisition of this material for the museum.

43. Burroughs, 332, catalogued the Culin portrait as 48 × 48 in., although his checklist is often vague or incorrect about such things, and Mrs. Culin's memory of it as "about 5 × 5" seems more reliable. If it really was square, it would be the only time Eakins used this format.

44. See Goodrich 1982, II: 186–88. Goodrich describes the Martinelli portrait, G 361, as the best of this early group of clerical subjects. See also W. H. Gerdts, "Thomas Eakins and the Episcopal Portrait: Archbishop William Henry Elder," *Arts* 53 (May 1979): 154–157.

45. The Joslyn Museum in Omaha owns two other drawings for this portrait, not listed in Goodrich 1933 or Hendricks 1974. Both were given by Bregler to George Barker, a student of Eakins' student J. L. Wallace, and they were donated to the museum in 1966 in Barker's memory. These drawings are smaller than cat. 211, empty of figures, and in poor condition; both are difficult to photograph and reproduce. I have not seen them, but I am grateful to Marsha Gallagher and Penelope Smith of the Joslyn Museum for their descriptions in writing and conversation. The first (148.1) is a perspective drawing, like the left side of cat. 211, in graphite and blue and red pencil on a sheet of paper 10 3/4 × 21 1/2 in., with a smaller strip of paper (2 3/4 × 8 1/2 in.) appended to the bottom so that the orthogonals of the grid could be extended. This drawing seems to be exploring the possibilities of a shorter viewing distance (twelve rather than thirteen feet). An annotation suggests that the scale is three inches to the foot (or one-fourth life), although this page is far too small to encompass such a scale; the CBTE drawing, which is larger, is one-sixth life. The second perspective drawing (148.2), in graphite on discolored brown paper, is 19 1/4 × 15 1/2 in. While

difficult to read, the annotations seem to be identical to those on cat. 211, although the horizon line has been noted first as sixty-seven, then changed to forty-seven. Given Martinelli's height, this seems to be Eakins' mistake, corrected, rather than a change in strategy. This drawing also indicates the canvas size as 78 × 60 in.

46. The red pompon on his biretta stands six feet from the floor, indicating his height to be average—about 5 feet 9. The unusual viewer position may indicate that Eakins wished to reinforce the impression made by Turner when officiating, or that he foresaw the installation of this picture in a location where this low horizon line would be effective. Certainly, if the painting were hung above the dado in the galleries of the Pennsylvania Academy (where it may have been exhibited in 1907), the spectator's position would have been correctly established.

47. An outline of Turner's career can be found in his obituary in *Records of the American Catholic Historical Society of Philadelphia* 40 (1929), "Necrology," n.p. Born in Philadelphia and trained at St. Charles Seminary in Overbrook, Turner was ordained in the cathedral in 1885. The first Turner portrait, G 347, is at St. Charles Seminary, where Eakins may have met Turner in the company of Samuel Murray, who also modeled a portrait figure of *Father Turner* in 1903; see Goodrich 1982, II: 192, 194. Goodrich first described the setting as the Cathedral of Saints Peter and Paul, with the high altar in the distance (1933, 203). However, Goodrich's notebooks (PMA) record that Eakins saw Turner officiate at the funeral of Peter Dooner from this place before the Blessed Mother's Altar; Goodrich's source, and Dooner's relationship to Turner or Eakins, are not known.

48. See PAFA, *Drawing Toward Building*, 91–92. Le Brun's plan, c. 1862 (prior to the completion of the church), is reproduced on p. 92.

49. G 107, completed in 1877; 82 × 60 in., St. Charles Borromeo Seminary. The surface of Wood's portrait has been altered by deterioration and restoration; even when Goodrich examined it in about 1930 the background was difficult to read. However, Siegl noted that architectural details from the cathedral, included in the pencil sketches that Eakins made there in 1876, appear in the background of the painting. These drawings, once in Bregler's collection, are now in the Hirshhorn; see Rosenzweig, 57–58.

50. The light comes from in front of Turner and is almost horizontal, as the shadows indicate. Renovations to the church, including the addition of a large twentieth-century chapel along the north wall, have blocked the doors and windows now. Eakins may have had Turner pose in his studio as well. The new studio he built in the front of his house in 1900 had large northern windows that could have reconstructed the transept light; see fig. 222.

51. These decorative gates are no longer present; apparently they were removed in either 1915 or 1957, when substantial renovations and enlargement of the chapel took place and the railing was replaced with a new one, set one step down and toward the transept. Le Brun's plan of 1862, together with Eakins' plan for the painting, suggests the original placement of this railing between the chapel piers, at the top of the third step up from the transept. I am grateful to Jeanette Toohey, who made a preliminary foray to the cathedral to answer my questions, prior to my own visit. An undated visitor's guide published by the cathedral mentions these renovations.

52. Following the death in 1910 of his mentor, Archbishop Ryan, Turner was made rector of the Church of the Nativity of the Blessed Virgin Mary in Philadelphia, an appointment that the iconography of this portrait would suggest as appropriate.

53. Among the full-length clerical portraits, only the image of Diomede Falconio is also unsigned, although it bears a lengthy Latin inscription on the verso. The Turner portrait may have been shown at PAFA in Jan. 1907 as *A Clergyman;* see Rutledge/Falk, 182, no. 433. Before this show closed, a *Portrait of Monsignor Turner* appeared at the Corcoran's first annual exhibition. Another portrait of Turner, *The Vicar General,* was seen at the Corcoran in 1908. The smaller, earlier portrait (G 347) may have been shown at PAFA and at one of these Corcoran annuals; Siegl asserted that the large version appeared first (164). See Milroy, *Lifetime Exhibition Record.*

54. Milroy, *Lifetime Exhibition Record.* See also Goodrich 1982, II: 188. The *Portrait of J. J. Fedigan* (see cat. 212) was also shown at the PAFA in 1903; see Rutledge/Falk, 181–182. The reviews cited are from "The Fine Arts," *The Evening Telegraph,* 17 Jan. 1903; "Brilliant Display of High-Class Art," *Inquirer,* 18 Jan. 1903, 2; untitled clipping, *The Record,* 18 Jan. 1903. All clippings are in the PAFA Archives and were kindly supplied to me by Cheryl Leibold.

55. The biographical introduction was written by Joseph C. Thompson in conjunction with his catalogue discussion; see cats. 223–225. On the emerging specialization of the medical profession in this period, see Paul Starr, *The Social Transformation of American Medicine* (New York: Basic Books, 1982). Thomson was affiliated with Wills Eye Hospital and also taught at the Jefferson Medical College. For discussion of his career and Eakins' portrait, see Goodrich 1933, no. 442; PMA, *The Art of Philadelphia Medicine* (Philadelphia: PMA, 1965), 71; Harold D. Barnshaw, "The Portrait of Dr. William Thomson by Thomas Eakins," *Transactions and Studies of the College of Physicians of Philadelphia,* 4th ser., 38 (July 1970): 40–43; and Julia Berkowitz, *College of Physicians of Philadelphia Portrait Catalogue* (Philadelphia, 1984), 210–213. Berkowitz notes that Thomson was also an amateur artist. Thomson's own ophthalmoscope remains in the collection of the College of Physicians; it is reproduced in Gretchen Worden, "Philadelphia Seen," *Transactions and Studies of the College of Physicians at Philadelphia,* 5th ser., 2 (June 1989): 65–66.

56. The height of the horizon can be calculated from the perspective view, cat. 220, which, like the plan, bears a grid of three-inch squares, each representing one square foot on the canvas at one-quarter scale. The height of the vanishing point can be measured from the twelve-foot baseline (where Thomson sits) to the horizon and then multiplied by four to give the life-scale of the portrait. This vanishing point is one foot from the top of the canvas, in the shadow on Thomson's forehead.

57. Because there are no parallel lines within the image to establish the vanishing point precisely, the relatively lower height of the spectator (and Eakins) in the first version can be gauged only by comparing surfaces that we look down on, such as Thomson's feet, or his foreshortened upper leg, or the recession of the floor in the foreground. Thomson's penetrating gaze also seems to engage us more directly—eye to eye—in the earlier version. The inherently vague nature of my calculations, which are based on measurements taken from photographs, must be confessed before asserting that sixty-four inches of wall are visible in the finished portrait while only about fifty-six inches can be seen in the first version. Eakins could have gained *more* space on this wall by keeping his eye level low while adding canvas to the top of the composition; his decision to raise the eye level must have entailed other factors in addition to including the eye chart, such as the foreshortening of the figure and foreground furniture. The first version, G 443, is catalogued and reproduced in color in the Christie's sale catalogue, *American Paintings, Drawings and Sculpture,* New York, 3 June 1983, lot 105.

58. I am grateful to Gretchen Worden for her examination of the painting and related research, shared with me in correspondence, 7 Jan. 1991. She also notes the elusive identity of the object on the table, in front of the books at Thomson's left. This "mystery object" seems to be more than a highlight on the table, but exactly what it is remains uncertain. The inclusion of the astigmatic test chart, like the Noyes ophthalmoscope, signals Thomson's general area of expertise as well as his particular research and publication on the use of the ophthalmoscope and the diagnosis and treatment of astigmatism; see Berkowitz, *College of Physicians,* 210.

59. See Schendler, 185, for a sympathetic interpretation of the mood and meaning of the Thomson portrait. Berkowitz's analysis of the subtle animation in Thomson's pose, counterposed to the signs of weakness and aging in his body, tells the same story (*College of Physicians,* 212–213).

60. Eakins painted the businessman Robert C. Ogden, seated, at full length, in 1904. The portrait was on a large canvas comparable to Thomson's (72 × 48 in.); an earlier version was undertaken, but it is now lost, so the reasons for Eakins' reconsideration cannot be estimated. The final portrait, G 394 (Hirshhorn; see Rosenzweig, cat. 107, and its related sketch, cat. 108), was painted after perspective drawings of the chair and the "whole composition" were made, according to Eakins' student F. W. Stokes, who allowed Eakins the use of his New York studio for the sittings. Another painter, Gifford Beal, also testified that Eakins made chalk lines on the background tapestry to ensure the consistency of the sitter's position, and that he asked Ogden to keep his eye on a target fixed to another wall, although Bregler, Murray, and Mrs. Eakins all protested to Goodrich that this was not characteristic. See Goodrich, II: 225–232. The only other "false start" in Eakins' work seems to have been for the portrait of *William D. Marks* of 1886 (G 216, 76 × 53 1/2 in.; Washington University Gallery of Art, St. Louis); the first version, G 217 (unlocated), was the same size.

61. On Eakins' late reputation and popularity as a juror, see Goodrich 1982, II: 199–201. On Harrison Morris' letter, see "Manuscripts Pertaining to Thomas Eakins in the Archives of the Pennsylvania Academy, Other than the Bregler Collection," Foster and Leibold, 347–362, including other cordial correspondence between Eakins and PAFA, largely begun with overtures from Morris commencing about 1894.

62. Trask to TE, 17 Dec. 1906 (Foster and Leibold, 357, no. 78). Eakins returned his two entry cards that month (p. 357, no. 79), indicating that his entries were at least close to completion.

63. Goodrich 1982, II: 201.

Conclusion

1. From a letter of 2 Apr. 1874, quoted by Sellin in Roanoke, 54. Eakins' Sketch Club experience is described on 18–19. The club acknowledged his work with the gift of an engraved porte-crayon in 1875 (cat. 265).

2. On Eakins' other lecturing, see Goodrich I: 303–304.

3. SME, "Notes on TE" (CBTE, Foster and Leibold, fiche series II 4/C/12).

4. Much is known about Eakins' curriculum at the Pennsylvania Academy and later, and my overview of his teaching relies on several period sources, including the annual reports of the school and the notes of the Committee on Instruction (PAFA Archives). Eakins was interviewed in 1879 (see Brownell), and two years later the curriculum was described in an article and a brochure "generally believed" to have been cowritten by Eakins himself; see Rogers,

and McHenry, 43. Charles Bregler has been the fountainhead of direct quotations from classroom sessions. "I can almost hear Tom speak," said Susan Eakins, responding to his two articles ("Eakins as a Teacher," *Arts* [1931]: 379). Goodrich interviewed former students and compiled a description of Eakins' teaching in his 1933 monograph (72–95), and in 1982, I: 167–189, 279–309. The relationship between Eakins' Parisian training and his reforms at PAFA are considered in Foster 1972, 104–108. Also useful are Louise Lippincott's description of the Academy's school, "Thomas Eakins and the Academy," in *In This Academy* (Philadelphia: PAFA, 1976), 162–187; Sellin, in Roanoke, 1–44; and Elizabeth Johns, "Thomas Eakins and 'Pure Art Education,'" *Archives of American Art Journal* 23 (3) (1983): 2–5. Maria Chamberlin-Hellman's thorough study "Eakins as a Teacher" (Ph.D. diss., Columbia University, 1981) is slated for publication in 1998 as *Thomas Eakins: Master Teacher* (Washington, D.C.: Smithsonian Institution Press).

5. On the anatomical teaching at PAFA, see Kimock's introduction to cats. 31–98. His instruction in perspective is outlined in chap. 7 and in cats. 99–145.

6. See chap. 11 and cats. 88–91 on motion studies and the "Naked Series."

7. Eakins' other innovation was his liberal policy toward women students, who were given access (albeit segregated) to all parts of his program. Privately doubting that women artists could ever be "great," he nonetheless insisted that their work was good enough to merit top-notch professional support. In this respect, his school was more progressive than any other in Europe or the United States at this date. See chap. 1, n. 18.

8. Bregler II, 33. On Eakins' idea of leaving the student to work independently, as did Gérôme and Bonnat, see Johns, "Pure Art Education," 3.

9. Rogers, 6; McHenry, 45.

10. Bregler I, 385.

11. Johns, "Pure Art Eduction," 2–3; Sellin, in Roanoke, 32–34.

12. Johns, "Pure Art Education," 2–3; Johns 1983, 112.

13. On Eakins' forced resignation, see "Trouble at the Pennsylvania Academy," Foster and Leibold, 69–90.

14. A small oil by Reynolds, evidently owned by Eakins, is in CBTE; it is reproduced, along with information about the artist, in Sarah Cash, "Friendly and Unfriendly," in Bolger and Cash, 119. On these scandals of the 1890s, see "The 'Nude' at Drexel," "The Hammitt Case," "Ella Crowell's Suicide," and "Eakins as a Teacher," in Foster and Leibold, 93–123.

15. On the aesthetics of realism, see chap. 11.

16. Foster and Leibold, 111.

17. Sartain's memoir, written after TE's death, is in CBTE; see Foster and Leibold, fiche series II 4/B/5.

18. "I have met no painter more persistently studious to pursue this fundamental base [i.e., anatomy] of art study"; quoted in Goodrich 1982, I: 198–199.

19. Foster and Leibold, fiche series IV B/D/5.

20. SME noted that Eakins wished to be called a painter, not an artist, in her remarks to Goodrich; see his notes from SME, PMA. Barker's letter to CB of 18 Nov. 1939 is in CBTE, Foster and Leibold, fiche series IV 10/E/3.

21. Fried, 21–41, 74–89.

22. SME, "Notes on TE" (CBTE, Foster and Leibold, fiche series II 4/A/10).

23. Bregler II, 38.

24. 25 Nov. 1881.

Catalogue of
Charles Bregler's
Thomas Eakins
Collection

All items are by Thomas Eakins, unless otherwise noted, and are part of Charles Bregler's Thomas Eakins Collection (CBTE).

Guide to the Catalogue

Titles: Few of the items in Bregler's collection were catalogued by Lloyd Goodrich and given titles based on records of Eakins' usage. As a result, most of the titles have been recently assigned, based on research or description, and the occasional older title (often invented by Bregler) has been regularized to avoid confusion with similar objects. Variant titles are sometimes included in brackets in the main title; more often they are mentioned in the notes.

Measurements: Measurements are given in inches, height preceding width. Centimeter dimensions follow within parentheses; they have been calculated from the inch measurement, so they may be slightly less precise.

Inscriptions: Many objects in this collection have been inscribed or annotated by persons whose handwriting became familiar to the cataloguers. When possible, these writers are identified by initials within parentheses, in advance of the text: Thomas Eakins (TE), Susan Macdowell Eakins (SME), Charles Bregler (CB). Labels and numbers affixed to these objects since the time of Bregler's estate inventory in 1958 have not been recorded here.

Provenance: Unless otherwise noted, all the objects in this collection follow the general provenance described in the introduction: from the home and studio of Thomas Eakins to his estate, under the custody of Mrs. Eakins and Miss Mary Adeline Williams, in 1916; to Charles Bregler in 1939, following the death of Mrs. Eakins in December 1938; to Mary Louise Picozzi Bregler at the time of Bregler's death in 1958; to PAFA in 1985.

Abbreviations: Persons and institutions frequently mentioned in the catalogue have been abbreviated as follows. See also the key to abbreviated bibliographical references on p. 460.

BE	Benjamin Eakins
CBTE	Charles Bregler's Thomas Eakins Collection
EMK	Elizabeth Macdowell Kenton
G	Lloyd Goodrich, catalogue raisonné number (1933)
H	Gordon Hendricks, catalogue of Eakins' photographs (1972)
O	Ronald Onorato, checklist of Olympia Galleries photographs by TE
SM	Samuel Murray
SME	Susan Macdowell Eakins
TE	Thomas Eakins

Institutions and Collections

AAA	Archives of American Art, Smithsonian Institution, Washington, D.C.
Adelman	Seymour Adelman Collection, Bryn Mawr College Library, Bryn Mawr, Pa.
ASL-PH	Art Students' League, Philadelphia
AWS	American Watercolor Society
Carnegie	Carnegie Institute, Pittsburgh
Dietrich	Mr. and Mrs. Daniel W. Dietrich II Collection, Chester Springs, Pa.
Hirshhorn	Hirshhorn Museum and Sculpture Garden, Smithsonian Institution, Washington, D.C.
Knoedler	Knoedler & Co., New York
MMA	Metropolitan Museum of Art, New York
NAD	National Academy of Design, New York
PAFA	Pennsylvania Academy of the Fine Arts, Philadelphia
PMA	Philadelphia Museum of Art
SAA	Society of American Artists, New York

Authors of catalogue entries, in addition to KF (Kathleen Foster)

DB	David R. Brigham, 145
KJ	Kathleen James, 16, 69, 190, 206, 207, 243
CK	Catherine Kimock, 30–90
DS	David Steinberg, 14, 22, 155, 214, 238, 240
MT	Michele Taylor, 177–179, 187
JCT	Joseph C. Thompson, 13, 46, 223, 224, 225, 242
CHV	Cynthia Haveson Veloric, 92, 94–97, 105–106, 109, 120, 123, 125–129, 135, 181
AW	Andrew Weinstein 348, 349
RW	Robin Williams, 105
SY	Sylvia Yount, 156h, 156i

Juvenile Drawings

I

Landscape Study: Mill Buildings by a River (r),
c. 1858–62

Portrait of a Boy (v)

> Watercolor over graphite (r); graphite (v) on cream wove
> paper
>
> Watermark: J WHATMAN TURKEY MILL
>
> $11^{7}/_{16} \times 16^{15}/_{16}$ in. (29.1 × 43 cm)
>
> 1985.68.4.13
>
> Fig. 18

The tentative and stylized watercolor technique in this
view resembles the handling in the small landscape on the
back of Eakins' carte-de-visite in the Hirshhorn Museum,
variously dated 1853–60.[1] Jane Mork Gibson, a historian of
Philadelphia's industrial architecture, has guessed that this
watercolor depicts a textile mill, probably in the German-
town area, where numerous waterpowered mills like this one
existed in this period.[2] (KF)

> 1. Rosenzweig, 22, dated c. 1853. Hendricks also dated this to 1853; see
> 1974, checklist 28. Goodrich, however, placed it in "the late 50s"; see
> correspondence cited in Rosenzweig, 22.
> 2. Correspondence with KF, 31 Aug. 1991.

2

Landscape Studies: Two Men Picnicking; Boulders,
Trees and House (r), c. 1860–62

Landscape Studies: Tree and Rocks; Sleeping Figure;
Riverbank with Trees and Boulders (v)

> Graphite on heavy off-white wove paper
>
> 13 × 19½ in. (33 × 49.5 cm)
>
> 1985.68.4.25
>
> Inscriptions (r): (TE in graphite, b.r.) *T.E.*
>
> Inscriptions (v): (TE in graphite, b.l. of right image) *Wait-*
> *ing till the sketch was finished*

This large sheet of heavy paper has been folded in half to
create four leaves for sketching. Evidently, all the scenes on
this sheet were drawn in the course of an outing along the
banks of a river. Eakins drew while his companions pic-
nicked or napped, "waiting till the sketch was finished."[1]
Eakins' initials are drawn as they appear in the student
sketchbook, cat. 15, page *h*, and on an early figure study
(PMA) made about 1863.[2] (KF)

> 1. Goodrich's text describes this drawing, although it was "where-
> abouts unknown" (1982, I: 8, 313).
> 2. G 6; Siegl, 49. I am grateful to Sylvia Yount for noting the similarity
> in signatures between the landscape sketch and the figure drawing.

2 r

2 v

School, where other instruction manuals by Harding were used. (The influence of his teachers and mentors at this time is discussed along with these drawings in chap. 1). These drawings show greater expertise than do the scenes copied from lithographs in his second and third semesters at Central High School in 1858; more comparable in skill are the drawings in his student sketchbook (cat. 15), also loosely dated to 1862–66.[2] The inclusion of boyish caricatures and doodles (compare page *d*) links these drawings to Eakins' youth, but the relative sophistication of their technique may place them as late as 1866, the year he left Philadelphia for Paris. (KF)

1. The library of the PAFA owns two early copies of *Lessons on Trees,* but one was given in the twentieth century and the other at an unspecified date. A comparison of the 1855 and the 1858 Day and Son editions shows many redrawn plates, although the exercises and their sequence remain the same. By the twelfth edition (1868 or later), all the plates had been redrawn again, giving another indication of the large edition size and popularity of this manual.

2. Hirshhorn; see Rosenzweig, 24–25.

3

Boat, n.d.

Graphite on buff laid paper

Watermark: Irish Linen / [torn]s Ward / [torn] Co

4½ × 7 in. (11.4 × 17.8 cm)

1985.68.4.14

The tiny figure in the bow carrying a staff may indicate that this boat is Noah's ark. The simplicity of the drawing and its subject suggest a youthful moment. (KF)

4

Landscape Sketchbook, c. 1860–66

Graphite on 4 sheets of buff wove paper

9 × 14¾ in. (22.9 × 37.5 cm) sheet size

Inscriptions: All by TE (recorded below)

These four sheets of tree and foliage studies on the same machine-made paper have been grouped together as remnants of a hypothetical sketchbook, in part because of their shared physical description but more significantly because of their common subject. All are based on study of James D. Harding's art instruction manual *Lessons on Trees,* first published in London in 1850 and reissued in at least fourteen editions, some of them "edited and revised" or with redrawn plates. From Eakins' extant studies, it is difficult to determine which edition he used; slight variations between his drawings and Harding's plates may be the product of his own improvisation or a response to variant plates in an edition that I have not seen.[1]

The date of Eakins' course of study cannot be pinpointed, although it surely came some time after 1858, when he was introduced to the art curriculum at Central High

4a

Tree Studies: Elm Foliage (r and v)

8¹⁵⁄₁₆ × 14¾ in. (22.7 × 37.5 cm)

1985.68.4.10

Inscriptions (v): (c.) *elm* / (c.r.) *elm*

On the recto, the central and bottom right foliage groups are based on lessons 13 and 14 (elm foliage) seen on plate 4 of Harding's *Lessons on Trees.* As in many of the other sketches, Eakins' variations from Harding's model seem to be personal combinations of this exercise, although they may indicate his use of a variant plate from another edition after 1858. The conglomerate of foliage studies at the left of the sheet looks like a combination of exercises from lessons 6–12 on plates 2 (see fig. 19), 3, and 4 (elm, ash, and oak). On the verso, the left side of the page is based on lesson 8, plate 2 (foliage contours); the center and right-hand sketches are fragments from lessons 9 or 10, plate 3 (foliage shadows).

4a r

Harding, plate 4.

4b

Tree Studies: Birches (r)

Tree Studies: Elm and Oak (v)

> 9¹⁄₁₆ × 14¾ in. (23 × 37.5 cm)
>
> 1985.68.4.26
>
> Inscriptions (r): (b.c.) *T. Eakins;* (u.l.) *Birch, Beach;* (b.r.) *Birch*
>
> Inscriptions (v): (b.l.) *Elm;* (b.r.) *Oak*
>
> References: Foster 1990, 70

The recto images are similar to Harding's lesson 27, plate 7. Eakins' changes in this study are significant: the trunk and branch forms are similar, but their overlap is altered so that the left-hand trunk is thrown into shadow and the right side is lit by the sun. In the course of this switch, several branches change trunks. This alteration, more than the slight changes seen elsewhere in these sketches, suggests a variant plate from an edition after 1858. Eakins' repetition of this subject on both sides of the page would seem to confirm the presence of a model that was copied twice. The verso images are drawn from lessons 25 (elm) and 26 (oak) on plate 7.

4b r

4b v

Harding, plate 7

4c

Tree Studies: Beech and Ash (r)

Tree Studies: Oak and Beech (v)

> 8¾ × 14¾ in. (22.2 × 37.5 cm)
>
> 1985.68.4.11
>
> Inscriptions (r): (b.l.) *Beech.;* (b.r.) *Ash.*
>
> Inscriptions (v): (b.r.) *T.E.;* (b.l.) *Oak;* (b.r. under tree) *Beech*

The recto study on the left follows lesson 24 (beech), plate 6, or lesson 28, plate 7, which shows the same image more fully modeled. Eakins' drawing falls between these two progressive exercises. On the right side of the page is a free adaptation of lesson 29 (ash), plate 8. On the verso, the left study is from lesson 30 (oak), plate 8; the right is taken from lesson 31 (beech), plate 8. Eakins' study eliminated the more distant trunk and altered the lower branches.

4c r

4c v

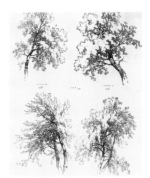

Harding, plate 8

4d

Tree and Foliage Studies (r)

Foliage and Faces (v)

> 9¹⁵⁄₁₆ × 13½ in. (25.2 × 34.3 cm)
>
> 1985.68.4.12
>
> Inscriptions (v): (c.r.) *JDH*
>
> Fig. 21

The foliage shading conventions seen on the left side of the recto are taken from the various exercises on plates 2 (see fig. 19), 3, and 4. The group of trees at right is taken from the right half of lesson 56 (mountain ash), plate 23 (see fig. 20). On the verso, random notations are based on Harding's shorthand schemes for contour and shadow seen in plates 2–4.

Central High School Drawings, 1859–1861

Eakins attended Central High School in Philadelphia from fall 1857 through the spring 1861. The drawing curriculum there, designed by the artist Rembrandt Peale, was a model of the most progressive and sophisticated art instruction of the period. Work began with penmanship exercises in the freshman year and proceeded through the study of decorative patterns, the description of solid objects, perspective and mechanical drawing, and ornamental lettering and "design." These classes were taken in a set order, with each semester designated by a letter from H (for the beginning level) to A (for the most advanced work, done in the spring of the senior year). Knowing this system, we can date most of Eakins' high school drawings by their content (so that all mechanical drawings must be from 1860 or '61, Eakins' B and A semesters) or by the letter code that sometimes appears alongside Eakins' signature (e.g., cats. 5 and 6, both inscribed *D*, must be from fall 1859, four semesters prior to graduation).[1] Most interesting, and unlike any of the other projects in this suite, is the rendering of *Thomas Crawford's "Freedom,"* cat. 14, which is dated July 1861 and therefore represents Eakins' graduation valedictory. (KF)

1. This curriculum is thoroughly described in Johns 1980; a table of this course work, with related extant drawings, is given above in chap. 2. Three early exercises, evidently copies from lithographs made in semesters G and F (1858) are in the Hirshhorn and Dietrich collections; see Rosenzweig, cats. 3–4, and Avondale/Dietrich, cat. 13. More similar to the Bregler drawings are *Drawing of Gears*, c. 1860, and *Drawing of a Lathe*, dated 1860, also in the Hirshhorn; see Rosenzweig, cats. 5–6. Goodrich saw few of these drawings, and he published none of them in 1933. "In 1930 SME owned the three drawings of an icosaedron [cat. 5], of a pump, and of the Crawford statue [cat. 14], on all of which I made notes," he wrote in 1982. Still unlocated is the "complicated pump, perhaps part of the Philadelphia waterworks" (Goodrich 1982, I: 5, 313). Goodrich's notes from 1930 (PMA) describe this drawing as "large" and "marvellously accurate and well done," in ink, unsigned and undated.

5

Perspective Drawing: The Icosaedron [1859]

Pen and ink, wash, and graphite on buff wove paper

11⅜ × 16⅞ in. (28.9 × 42.9 cm)

1985.68.4.4

Inscriptions: (TE in ink, b.r.) *THE ICOSAEDRON, / EAKINS, D. / Tom Eakins*

Exhibitions: PMA, 1944, not listed in catalogue but visible in installation photos, and recorded in PMA loan receipt, 28 Mar. 1944; probably also shown at Knoedler 1944.

Fig. 24

Semester D of Eakins' high school drawing curriculum occurred in fall 1859, when students were taught perspective

drawing and ornamental writing, both demonstrated in this exercise. An icosaedron has twenty triangular faces presenting a six-sided profile and pentagonal points. (KF)

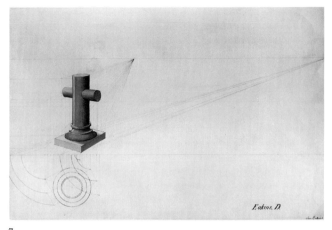

7

6

Perspective Drawing: Icosaedron (r) [1859]
Two Winches (v)

Pen and ink, wash, and graphite on cream wove paper

12¼ × 14⅛ in. (irr.) (31.1 × 35.9 cm)

1985.68.4.7

Very similar to the exercise in cat. 5, this drawing uses the "point of sight" (at left) and the "distance point" (now lost off the page at right) to map the icosaedron. The ruled ink border may indicate that the drawing was finished and signed, like cat. 5. (KF)

6 r

7

Perspective Drawing: Column with Crosspiece [1859]

Pen and ink, wash, and graphite on cream wove paper

Watermark: J WHATMAN TURKEY MILL

11³⁄₁₆ × 16¾ in. (28.4 × 42.6 cm)

1985.68.4.8

Inscriptions: (TE in ink, b.r.) *Eakins. D. / Tom Eakins*

This exercise is similar to cats. 5 and 6. At the upper right two circles, one inscribed within the other, are drawn lightly in pencil, perhaps indicating a false start on the plan. (KF)

8

Perspective Drawing: Geometric Solids [1859–60]

Pen and ink, wash, and graphite on cream wove paper

11⁷⁄₁₆ × 16⅞ in. (29.1 × 42.9 cm)

1985.68.4.6

Inscriptions: (TE in ink, b.r.) *Tom Eakins*

Solid objects were first studied in semester E (spring 1859, for Eakins), although this exercise may illustrate the perspective drawing taught in semesters D and C that fall and in the spring of 1860. Four solids are depicted here: a cylinder topped by a double pyramid, and a hexagonal post topped by a sphere. The upper and lower shapes are precisely divided by the horizon line; the vanishing point lies between left- and right-hand units. As in cats. 5–7, plans of these forms appear below each perspective.

The format Eakins uses here to map the base of the column and then project it into perspective follows the system outlined in William M. Bartholomew's *Linear Perspective Explained,* a textbook used at Central High School in this period. "To represent a circle seen obliquely is more difficult than the drawing of any other form, and it will be well for the pupil to make a careful study of the perspective of this figure before he attempts to represent an object containing curved lines."[1] Eakins, an advanced student, moved beyond Bartholomew's exercise by including two curved solids with careful shading. The problem of curved objects in space remained a delightful challenge to Eakins (as in *The Courtship,* cat. 190, or *The Fairman Rogers Four-in-Hand,* cats. 192–196), and related exercises were included in his own perspective manual (cats. 107–109, 118–119, 120). (KF)

1. *Linear Perspective Explained* (Boston: Shepard, Clark and Brown, 1859), 54–57. Johns 1980, 142.

8

10

9

Perspective Study: Geometric Form [1859–60]

Ink and wash over graphite on cream wove paper

Watermark: J WHATMAN TURKEY MILL

9⅛ × 5/16 in. (23.2 × 8.4 cm)

1985.68.4.2

The odd cropping of this image implies that it was once part of a larger sheet. The forms are similar to those in cats. 5–8. (KF)

10

Mechanical Drawing: Cogwheel and Pinion [1860–61]

Pen and ink over graphite on buff wove paper

16 × 11¼ (irr.) in. (40.6 × 28.6 cm)

1985.68.4.5

Mechanical drawing was studied for two semesters in the senior year. For Eakins, the exercises shown in cats. 10–13 must have been undertaken in fall 1860, though some of the principles of mechanical drawing (such as plans) had been mastered the previous year (cats. 5–9). The gears drawn in cat. 10 may be related to the more polished depiction of a rack and pinion in *Drawing of Gears* in the Hirshhorn, also once in Bregler's collection. Methods for the drawing of such gears were included in one of Eakins' high school manuals, William Minifie's *Textbook of Geometrical Drawing*, although Eakins' exercises vary from the examples in this book.[1] The wheel and pinion, as well as the sketch of the steam engine and the governor mechanism seen in cats. 11–12, are relatively simple exercises; the steam engine looks particularly amateurish and may be among the first of Eakins' projects in the fall of 1860. The more expert screwthreads or spirals drawn in cat. 13 may date from later in the semester, when Eakins produced his masterpiece of perspective, mechanical and ornamental drawing skills: the *Drawing of a Lathe*.[2] (KF)

1. *Textbook of Geometrical Drawing* (Baltimore: William Minifie, 1849; 2nd ed., 1850), pp. 72–74, plates 34–35.
2. Also owned by Bregler, and now in the Hirshhorn.

11

Mechanical Drawing: Steam Engine (r) [1860–61]

Mechanical Drawing: Hexagon and Cube (v)

Graphite on cream wove paper

9⅝ × 12 in. (24.5 × 30.5 cm)

1985.68.4.17

Inscriptions (v): (TE in ink, b.r.) *Tom Eakins;* (in graphite, u.l.) *4 ft 2 ft;* (c.) *a*

The verso drawing illustrates the basic format of mechanical drawing, with the plan and the front and side elevations of a form organized as Eakins specified, twenty-five years later, in his own drawing manual. See cats. 10 and 114. (KF)

11

12

Mechanical Drawing: Governor Mechanism [1860–61]

Pen and ink over graphite on cream wove paper

11⅜ × 16¾ in. (28.9 × 42.6 cm)

1985.68.4.3

Inscriptions (r): (CB? SME? in ink, b.r.) *Tom Eakins;* (in graphite, b.c.) *Unfinished*

Inscriptions (v): (CB? SME? in graphite, u.r.) *(Plaster Casting) / Mr. Aurelius Renzetti / American Statuary Co. / South American & Ionic Sts.- / near Chestnut betw 3rd and 2nd St./ [line] / Roman Bronze Works / 275 Greene St - Brooklyn, N.Y. -*

See cat. 10. Aurelius Renzetti (1897–1975) was a PAFA student employed by American Statuary Co. as early as 1916 and into the 1920s. (KF)

12

13

Mechanical Drawing: Three Spirals [1860–61]

Pen and ink, wash, and graphite on cream wove paper

11 × 16⅜ in. (27.9 × 41.6 cm)

1985.68.4.9

Inscriptions: (TE in ink, b.r.) *Tom Eakins*

Exhibitions: PAFA, *Graphic Arts* 1986, no. 96.

Fig. 25

Hopes for the improvement of the industrial arts often inspired reform of public school art education in the United States and England during Eakins' lifetime. The need for qualified designers and draftsmen surely motivated the mechanical drawing curriculum at Central High School, producing exercises devoted to the gears, lathes, steam engines, and screw threads, as in cat. 13, the finest example of this genre in the Bregler collection. Eakins excelled at this work, but the machinations of his culture are as much in evidence in *Three Spirals* as his own mechanical predilections.

These three so-called screws are better described as three geometrically generated variations on the spiral theme. The figure on the left is a round coil wrapped around a cylinder, much more resembling a spring than a screw. The middle study represents the thread as an isosceles triangle rotating around the core. The figure on the right is a cylinder with a rectangular spiral added. Superimposed above all three are cross sections, or "plans," of each column.

Eakins' drawing may be a classroom variant based on the most advanced problems in his textbooks. In Charles Davies' *Treatise on Shades and Shadows,*[1] "Problem XIX" asks that the student project and correctly shade a screw based on the form of a cylinder with a thread generated by a spiraling isosceles triangle. Eakins' drawing shows such a screw at the center but with a different light source and flanked by other screws based on different geometrical forms, following the format of a similar but unshaded exercise in A. Cornu's *Course of Linear Drawing,*[2] another book used at Central High. The first

challenge in this exercise lies in the generation of the form itself; the second difficulty, as Davies' text makes clear, lies in the precise and delicate description of the "shades and shadows" of the form in light. In this drawing Eakins proves himself the master of both skills.

Even as a school exercise this drawing foretells, by its systematic rigor, investigations into basic underlying structures and laws of construction. Moved by the beauty and revelation of principles in this exercise, Eakins—like Cornu—included a related problem involving the depiction of a spiral staircase in his own perspective classes (cats. 109–112). His understanding of a screw's geometrical and mechanical principles would be matched by his grasp of basic design and variation in the human body. (JCT/KF)

1. *A Treatise on Shades and Shadows, and Linear Perspective,* 2nd ed. (New York: Wiley and Long, 1835), pp. 81–83, plate 11. Davies' exercise also dwells on the cast shadow, not undertaken by Eakins. I have taken the orientation of this drawing to be signaled by Eakins' signature at the bottom right of the page; if inverted, the drawing follows Davies' recommendation for draftsmen of a light source 45 degrees from the left, and the plans would fall below the elevations in a more conventional pattern. On the textbooks used at Central High School, see chap. 2 and Johns 1980, 142.
2. Cornu's *A Course of Linear Drawing* was translated by A. D. Bache, the principal of Central High School (Philadelphia: A. Dobson, 1842). I am grateful to Amy Werbel, who found the copy of this book "lost" in the Library of Congress and shared it with me.

14

Thomas Crawford's "Freedom," 1861

Pen and ink and wash on cream wove paper

Watermark: J WHATMAN/TURKEY MILL

13½ × 10⅜ (irr.) in. (34.3 × 26.4 cm)

1985.68.4.1

Inscriptions (TE in ink, b.c.) Tom C. Eakins/ Div.A./ July 1861

References Goodrich 1982 I: 5, 313.

Fig. 27

This drawing depicts the statue popularly known as *Freedom,* commissioned from Thomas Crawford (1814–57) for the dome of the U.S. Capitol.[1] The nineteen-and-a-half-foot plaster (now in the National Museum of American Art) was completed in Italy shortly before Crawford's death and shipped to the United States in 1858, finally arriving in March 1859. Sometime before 24 May 1860, Clark Mills was commissioned to cast Crawford's statue in bronze.[2] On 15 May 1861, M. C. Meigs, the captain of engineers responsible for the restoration of the Capitol, suspended the project to enable the government to devote its funds to the Civil War effort. Two days later he issued orders to have brought in from

Mills' foundry everything that had been paid for to date.[3] Planning continued, however, for on 31 July 1861, Mills wrote to Meigs that he hoped to make the statue a "masterpiece of casting to equal Europe if possible."[4] Evidently, *Freedom* had not yet been cast in bronze by July 1861, the date of Eakins' drawing.

Short of a trip to Mills' foundry near Bladensburg, Maryland, Eakins could have known the appearance of *Freedom* only from prints or photographs. In 1861 an engraving of the statue was widely available on the first five-dollar demand note, issued in Philadelphia, among other cities.[5] Like Eakins' drawing, this engraving depicts the plaster model from the front, seen against a black background. But the banknote engraving truncates the statue's spherical base below the Latin inscription, while Eakins drew from a source that depicted the entire base "surrounded by wreaths indicative of the rewards Freedom is ready to bestow upon distinction in the Arts and Sciences."[6]

In July 1861 an image of Freedom to decorate the capitol of a country at war with itself could not avoid being rich in association for Americans. If a viewer knew of the model's difficult journey from Rome to Bladensburg, then its image might have suggested the travails that beset the cause of Freedom.[7] The delay in casting, if a viewer were aware of it, could have symbolized the threat that the Civil War posed to Freedom. Reproduced on federal currency, *Freedom* could emblemize hope for the union. Circumscribed by a graphite oval and perhaps produced for display in an oval mat or picture frame, Eakins' *Freedom* may have been intended to serve as a domestic icon.

The drawing is among the last of Eakins' career at Central High School. The signature "Tom C. Eakins" is consistent with the way his name appeared on his school records.[8] In July 1861, the month he dated the drawing, Eakins received his A.B. degree. Because the last semester was known as Semester A, the inscription "Div. A," an abbreviation of Division A, seems to refer to his final, eighth semester.[9] According to the art curriculum, Semester A was devoted to mechanical drawing and designing. We do not know whether Eakins' drawing was a standard class assignment or a culminating and perhaps voluntary honors assignment.[10] The drawing may be seen as the earliest link between Eakins and architectural sculpture, an interest later given expression in several public sculpture projects in the 1890s.

The style of Eakins' drawing confirms that his source was a two-dimensional medium that had already translated the modeling and chiaroscuro of the statue onto a flat black and white surface. His strongly plastic drawing in pen and ink stands in marked contrast to less confidently modeled charcoal drawings of a slightly later date done from the figure (cats. 16–28), which Eakins had to translate himself into two dimensions. He created some of the white areas through scraping the paper, particularly the field on which he signed and dated the work and the highlights of the sculpture inscription and the shield in *Freedom*'s left hand. The deep black areas were achieved through successive layers of wash, revealed most clearly at the left edge, where Eakins apparently taped his drawing to a work board. Perhaps even more surprising than his ability to render such a convincing three-dimensional form at an early age is the fact that he did it *without* a preliminary pencil sketch underneath. The degree of finesse and precision with the loaded brush shows an incredible manual dexterity for one so young and seems linked to early training in calligraphy from his father. (DS)

1. Crawford's first known mention of the statue's subject appears in a letter dated 20 June 1855, which identified it as *Freedom Triumphant in War and Peace*; see Robert L. Gale, *Thomas Crawford, American Sculptor* (Pittsburgh: University of Pittsburgh Press, 1964), 141, n. 183. Later in 1855, Crawford referred to the statue as *Armed Liberty*, and in 1857, he called it *America* (Gale, *Thomas Crawford*, 150, n. 214; 182, n. 79). His letters were all addressed to Captain M. C. Meigs, who in a letter to Crawford dated 10 Apr. 1857 referred to the statue as *Liberty*. *Freedom* is the name of choice for Gale; see also Charles E. Fairman, *Art and Artists of the Capitol of the United States of America* (Washington, 1927); and Michael E. Shapiro, *Bronze Casting and American Sculpture, 1850–1900* (Newark: University of Delaware Press, 1985). Sylvia E. Crane prefers *Armed Liberty (Armed Freedom)*; see *White Silence: Greenough, Powers, and Crawford, American Sculptors in Nineteenth-Century Italy* (Coral Gables: University of Miami Press, 1972), 458.
2. On Mills, see Shapiro, *Bronze Casting*, and Fairman, *Art and Artists*, 201.
3. Fairman, *Art and Artists*, 201.
4. Mills to Meigs, cited in Shapiro, *Bronze Casting*, 43, n. 77.
5. Chester L. Krause and Robert F. Lemke, *Standard Catalogue of United States Paper Money* (Iola, Wis.: Krause, 1981).
6. Crawford to Meigs, 20 June 1855, cited in Crane, *White Silence*, 382, n. 8. See also Gale, *Thomas Crawford*, 141, n. 183.
7. See Fairman, *Art and Artists*, 183; Crane, *White Silence*, 405. The history of the finished bronze was as trouble-ridden as that of the plaster model. According to Crane, "For a year it decorated the grounds east of the Capitol until it was erected at noon on December 2, 1863" (*White Silence*, 406). A nationalistic, allegorical interpretation of the installation appeared in a newspaper article dated 2 Dec. 1863, reprinted in Shapiro, *Bronze Casting*, p. 44, n. 80.
8. Goodrich 1982, I: 312, n. 5.
9. See text preceding cat. 5, and Johns 1980.
10. Goodrich, in his notebook remarks made in 1930, surmised that this was a classroom assignment; see PMA Archives. No mention of such an assignment appears in the published excerpts of the diary of Eakins' classmate Joseph Boggs Beale. See Nicholas B. Wainwright, "Education of an Artist: The Diary of Joseph Boggs Beale, 1856–1862," *Pennsylvania Magazine of History and Biography* 97(4) (Oct. 1973): 485–510.

15

Student Sketchbook, c. 1862–66

Graphite on 9 sheets of cream wove paper

c. 7¹⁄₁₆ × c. 10⅛ in. (17.9 × 25.7 cm)

Only nine pages of drawings survive from this early sketchbook, although several blank pages or fragments attached to these loose sheets testify to a larger book. Because the cover and binding were lost and broken, the order of the drawings within the book cannot be reconstructed. All these pages were found scattered within a single portfolio in Bregler's collection. Their common binding has been deduced by the paper size (for all the pages are 7 or 7¹⁄₁₆ by 10 or 10¹⁄₁₆ in.) and quality (inexpensive machine-made stock with high acidity).

The date of this sketchbook can be established only loosely, for there are no telling annotations or subjects. Overall, the tentative and inexpert drawing reveals Eakins' pre-professional student period, prior to his departure for Paris in the fall of 1866. Most of the landscape sketches show the influence of Eakins' study of J. D. Harding's work and therefore must postdate the drawings in the landscape sketchbook (cat. 4). The presence of cast drawings on pages *c* and *d* imply the use of this sketchbook during his early years of study at PAFA, when he was enrolled (beginning in the fall of 1862) in classes that studied antique sculpture. The fantastic scene on page *c* could, if related to the Gardel monument (fig. 16), also date the use of this sketchbook to 1862. Certain figure drawings, such as the portrait of a girl seen on page *e,* or the woman and child seen on page *b,* suggest a slightly later date if they are indeed Eakins' oldest sister, Frances, his mother, Caroline, and his baby sister, Caddy, born in 1865. (KF)

15a

Landscape Study: "Eaglesfield" and the Girard Avenue Bridge

1985.68.4.15

Eakins made this sketch from the east bank of the Schuylkill, on the grounds of Sedgeley, looking across the river to Eaglesfield, a house half hidden in the trees behind a group of icehouses and the Girard Avenue bridge. This same bridge appears in another sketch, now in the Hirshhorn,[1] and both house and bridge are seen again (from upstream) in the background of *Max Schmitt in a Single Scull* of 1871 (fig. 107). Eaglesfield was torn down shortly before the Centennial; the Philadelphia Zoo now occupies the site of the icehouses. (KF)

1. Rosenzweig, 49, dated 1871.

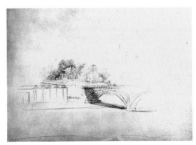

15a

15b

Figure Studies: Heads of Woman and Child

1985.68.4.16

This page of drawings probably displays Eakins' penchant for using his family members as models. At the upper left, a woman's profile—perhaps of his mother, Caroline—shows a bent head with closed eyes; the features are rendered in dark outline, the hair shaded faintly. A delicate, full-face portrait of a baby appears center-left. The child may be Eakins' youngest sister, Caroline ("Caddy," who was born in 1865), the only baby in the Eakins household during his art-student years. (His middle sister, Margaret, was born in 1853.) In fainter outline, a side view of a hand is depicted at center, and even slighter sketches of the baby's face appear at the right. (SY)

15b

15c

Fantastic Monument (r), c. 1862?

Cast Drawing: Nude Man, Crouching; Figure Sketches (v)

1985.68.4.18

The drawing on the verso of this page may date the entire sketchbook to about 1862, when Eakins enrolled in the elementary drawing classes at the Pennsylvania Academy. In October of that year he began to draw from the collection of antique sculpture (mostly copies and plaster casts) that served as studies in anatomy, composition, and chiaroscuro for beginners. This kneeling youth probably was drawn from a marble copy of *Son of Niobe,* owned—along with *Daughter of Niobe*—by PAFA by 1855. Taken from a Roman sculpture of *Niobe and Her Children,* now in the Uffizi Gallery in Florence, this copy was once on permanent display in the Academy's rotunda and became a fixture of the drawing studios in the new building (see fig. 28).[1] The tight, automatic hatching in this drawing and the tentative contour betray Eakins' lack of experience at the outset of his studies. His line would become more confident, but his tendency to create odd, erratic shadow zones would persist.

On the recto, Eakins' design for a monument set within a vast colonnaded hall evokes the spirit of the romantic sublime, showing an unexpected imaginative turn in his youthful

work. The bent and hooded figure at the upper right suggests the classical iconography of mourning and may represent a more detailed study of one of the two flanking figures at the base of the monument itself. Eakins may have copied this scheme from a book illustration or engraving, or perhaps—given the vagueness of detail and colossal scale of the project—invented it himself in a flight of funereal imagination. It is possible that he was responding to the mood, the plans, or the construction of the Gardel monument (fig. 16), erected in Mount Vernon cemetery, Philadelphia, in about 1862, from designs by the architect Napoleon Le Brun (1821–1901), with figures by the Belgian sculptor Guillaume Geefs (1805–83).[2] Bertrand Gardel, the chess-playing companion of Benjamin Eakins and the informal French tutor of young Tom, commissioned this monument to his wife, whose death and commemoration must have been important to the Eakins household. The sophisticated neoclassical references in this monument, which was based on Antonio Canova's work, included seven draped, mourning figures. Geefs' complex allegory, added to the impressive scale of the nearly twenty-four-foot-tall pyramidal superstructure, surely brought the issues of a grand tradition into Eakins' consciousness at a time when his own artistic ambitions were awakening. Following conversations about this project, he may have prepared this drawing as a fantastic proposal of his own. If the figure sketches in this album (pp. b, e) indicate work in 1865, perhaps Eakins was drafting a Lincoln memorial. (KF)

1. PAFA, *Proceedings of the Annual Meeting of the Stockholders, June 4, 1855* (Philadelphia: Collins, 1855), 16. I am grateful to Susan James Gadzinski, who identified this figure and shared this reference; this cast is no longer in the school's collection. The PAFA's cast collection will be discussed in her forthcoming catalogue; see PAFA, *American Sculpture.* See also *Catalogue of the 34th Annual Exhibition of the PAFA* (Philadelphia: Collins, 1858), p. 28, no. 523.
2. See Fairmount Park Art Association, *Sculpture of a City: Philadelphia's Treasures in Bronze and Stone* (New York: Walker, 1974), 67.

15c r

15c v

15d

Cast Drawing: Head in Profile; Sketches of a Sleeping Dog (r)

1985.68.4.19

Lists of the Academy's collection of statuary and casts from about 1860 suggest many sources for this classical profile, although the odd cropping suggests a mask, such as the *Mask of Niobe's Daughter,* acquired in London in 1860.[1] Like the drawing of *Sons of Niobe,* this page of sketches was probably done in 1862–63, when Eakins began cast drawing classes at PAFA. (KF)

1. See "Casts in Plaster," *Art Property Register* (PAFA Archives), 59. This cast is no longer in the school's collection. See cat. 15c, n. 1.

15d

15e

Portrait of a Young Woman [Frances Eakins?]

1985.68.4.20

This portrait appears to be Eakins' sister Frances ("Fanny"), who was born in 1848. Her appearance in this sketch as a young woman helps establish the dates of this sketchbook between 1862 and 1866, particularly if the baby shown on page *b* is Tom's other sister Caddy. For a photograph of Fanny c. 1868, see fig. 13. (KF)

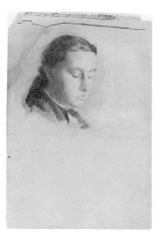

15e

15f

Tree Studies (r and v)

1985.68.4.21

These studies may also illustrate a section of Fairmount Park along the Schuylkill river. The curls and zigzags of the foliage indicate a date after Eakins' study of J. D. Harding's *Lessons on Trees*, although the other landscape drawings in this sketchbook are not so systematic. (KF)

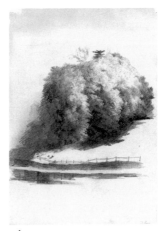

15h

15f

15g

Figure Studies: Child's Head, Facing Left; Woman's Head

1985.68.4.22

As with page *b*, the woman and child sketched here may be Eakins' mother, Caroline, and his youngest sister, Caddy.

15h

Landscape Study: Foliage, Pasture and Fence

1985.68.4.23

Inscriptions: (TE in graphite, b.r.) *T.E*

Another sylvan scene, this study is more elaborate than the others in the sketchbook. It depicts a wooded hill bordered by a rail fence; the slope of the hill terminates in a pond or river. The range of chiaroscuro shading is considerably more pronounced here than in the rest of the sketchbook. It is also the only sketch that is signed. (SY)

15i

Landscape Studies: Fallen Tree; Riverbank [?] and Tree (r)

Landscape Study: Covered Bridge (v)

1985.68.4.24

References: Foster 1990, 72.

Fig. 23

The two sketches on the recto are oriented differently. On the left, a tree has fallen across the corner of a fence, offering a confusing tangle of overlapped forms. On the right, a curve of a bank borders a half-sunken tree trunk. The branches, crooked and ravaged, are handled with great delicacy, using a strong range of values. Both drawings seek an unusual and complex spatial experience from a deliberately difficult vantage. (SY/KF)

Figure Drawings: Pennsylvania Academy of the Fine Arts, Antique and Life Class, 1862–1866

16

Figure Study: Hercules [Man's Jaw and Neck], c. 1862–1866

Charcoal on tan laid paper

Watermark: E B with caduceus in a shield

24 × 18½ in. (61 × 47 cm)

1985.68.35.4

Inscriptions (r): (TE in charcoal, b.c.) *HERCULES*

Fig. 29

This sheet shows a total of six views of a man's neck and jaw. Both the amount of the face shown and the degree of finish of the sketches vary considerably, as does the technique Eakins uses interchangeably to distinguish both figure and ground. The drawing shows its maker simultaneously learning about anatomical form through the use of multiple views and experimenting with methods of modeling form. The *Hercules* can also be assigned an early date because the highly idealized but meticulously observed jaw belongs to a cast rather than to a model.[1] Eakins drew from casts of classical sculpture during his early years at the Pennsylvania Academy, beginning in the fall of 1862, and briefly (and reluctantly) after his arrival in Paris in 1866. The exploratory character of this drawing suggests that it was made in Philadelphia. Multiple pinholes in the corners may indicate several sessions of work. (KJ)

1. Two casts of Hercules, including E34, *Face of Hercules,* and E67, *Young Hercules,* were listed in the first complete catalogue of the school's collection, published about 1877–78; see *Temporary Catalogue of the Permanent Collection of the P.A.F.A.,* 2nd ed. (Philadelphia: PAFA, 1879) 13, 14. It is not known when these casts entered the collection, although they do not appear in the *Art Property Register* of 1860 (PAFA Archives). Neither remains in the collection today.

17

Figure Study: Shoulders and Back of Reclining Nude Woman (r), c. 1863–66

Figure Study: Shoulders (v)

Charcoal on pinkish-buff laid paper

Watermark: E B with caduceus in a shield

24³⁄₁₆ × 18½ in. (irr.) (61.4 × 47 cm)

1985.68.35.1

The study on the verso seems to be of the same model and pose seen on the recto, but from a point more to the left. Eakins turned the paper for this second study to orient the figure across the top of the sheet. His difficulty with this pose can be read in the digressive attention to the background drapery in both attempts. (KF)

17 r

17 v

18

Figure Study: Buttocks of Reclining Nude Woman, c. 1863–66

Charcoal on buff laid paper

Watermark: E B with caduceus in a shield

18¹¹⁄₁₆ × 24 in. (irr.) (47.5 × 61 cm)

1985.68.35.2

This could be the lower half of the model seen in cat. 17. On the verso is a very light life-size sketch of a hand and lower arm(?). (KF)

18

19

Figure Study: Bent Knee, c. 1863–66

Charcoal on buff laid paper

Watermark: E B with caduceus in a shield

18½ × 24 in. (irr.) (47 × 61 cm)

1985.68.35.3

The unusual modeling suggests an *écorché* (skinned) figure, if not Eakins' own attempt to show the muscles and tendons beneath the surface of the model's knee. (KF)

19

20

Figure Study: Three Knees, c. 1863–66

Charcoal on buff laid paper

Watermark: E B with caduceus in a shield

24 × 18½ in. (irr.) (61 × 47 cm)

1985.68.35.5

20

21

Figure Study: Two Knees, c. 1863–66

Charcoal on buff laid paper

Watermark: E B with caduceus in a shield

24 × 18⁹⁄₁₆ in. (irr.) (61 × 47.2 cm)

1985.68.35.6

Fig. 31

22

Figure Study: Shoulders and Elbow of Seated Man, c. 1863–66

Charcoal on buff laid paper

Watermark: E B with caduceus in a shield

24 × 18½ in. (61 × 47 cm)

1985.68.35.7

Inscriptions: (TE in charcoal, b.r.) *12*

Fig. 32

The pose shown in this study resembles the figure in *Study of a Seated Nude Man* (PMA), although that drawing represents the model from a more frontal position and shows the whole figure. Both are on similar paper with the same watermark.[1] The numerous pinholes in the corners of the sheet suggest that Eakins repeatedly fastened it to his drawing board; he probably made the top and bottom studies at different times. (DS)

1. G 4; see Siegl, 61–62, 171 (fig. 1c).

23

Figure Study: Knees of a Standing Man, Facing Left, c. 1863–66

Charcoal on buff laid paper

Watermark: LP Bellow [?]

23⅞ × 18½ in. (irr.) (60.6 × 47 cm)

1985.68.35.8

The slightly heavier, oatmeal surface of this paper, with its ambiguous watermark, is not seen in any other Eakins drawing. (KF)

23

24

Figure Study: Man's Neck and Upper Back; Standing Nude Man from Rear (r), c. 1863–66

Figure Study: Shoulder, with Detail of Spinous Process of Ilium (v)

Charcoal and graphite on buff laid paper

Watermark: E B with caduceus in a shield

24 × 18½ in. (irr.) (61 × 47 cm)

1985.68.35.9

Inscriptions (v): (TE in graphite, u.c.) *P.S. Spinous Pr. of Ilium R.*

Fig. 34 (recto)

The inscription on the verso and the small sketch of vertebrae in the bottom left corner of the recto indicate Eakins' interest in the skeletal construction of this model's neck and back and its impact on the surface of the skin. On the recto, the close-up view of the neck is in charcoal; the smaller, full-length figure is in graphite, a medium not seen elsewhere in these early figure drawings. (KF)

25

Figure Studies: Nude Man's Buttocks (?), Abdomen, Knee, c. 1863–66

Charcoal on buff laid paper

Watermark: E B with caduceus in a shield

24 × 18⁹⁄₁₆ in. (irr.) (61 × 47.2 cm)

1985.68.35.10

25

26

Figure Study: Three Left Feet, c. 1863–66

Charcoal on buff laid paper

Watermark: E B with caduceus in a shield

24 × 18½ in. (61 × 47 cm)

1985.68.35.11

This drawing of the same left foot from three vantages reveals a great range of surface treatment, both in technique and quality. Some areas of highlighted flesh are drawn as a skein of scratchlike marks, made with the charcoal sharpened to a point and delicately worked across the textured surface of the French handmade paper. Other areas, such as the ankle of the upper foot, are defined schematically as distinct patches of shadow, and the handling is somewhat formulaic—even awkward. A certain unevenness in its marking scheme indicates that the primary focus of this drawing essay is something quite different from the usual figure study.

The theme here is not the flesh of the foot, nor the evocation of its structural underpinning, but rather the complex orientation of the foot in a particular space. There is a sense of challenge taken up by these distinct views, which, unlike

many of Eakins' figural studies, are artfully arranged on the sheet, the horizontally placed member arching over two vertically situated studies below. The challenge undertaken is to render the foot, notoriously difficult to draw in isolation, at three purposely strange angles, from which it appears even more odd than it actually is. The top foot is viewed from sole-level and in strict profile. This is not a view common to everyday experience, but on reflection it is quite precisely artful: it implies a pedestal, a model on a studio platform, perhaps, or, more commonly, a raised sculpture. The foot on the lower left is taken from a frontal view, but here it is the arch and bottom of the foot that win Eakins' focus. The lower right version is the most normalized, although its radical foreshortening makes this view strange as well. Arbitrary shadowed areas around the feet, and the odd disjunction of the horizon line in each of the three views, also contribute to the unusual effect. One thinks in respect to this "foot space" of Eakins' admonition to his students, recalled by Bregler: "Get the foot well planted on the floor. . . . If you ever see any photographs of Gerome's works, notice that he gets the foot flat on the floor better than any of them."[1] On this page Eakins has assumed a viewpoint that allows serious investigation of those precise points of spatiality in which the foot gets well planted. (JCT)

1. Bregler I, 383–385.

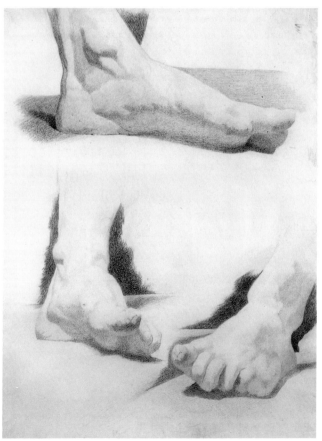

26

27

Figure Study: Nude Man's Lower Leg (r), 1863–66

Figure Study: Nude Man's Right Leg from Rear (v)

Charcoal on buff laid paper

Watermark: E B with caduceus in a shield

24⅛ × 18½ in. (irr.) (61.3 × 47 cm)

1985.68.35.12

Fig. 34 (verso)

On the recto are two less finished studies, in addition to the view of a lower left leg: a foreshortened knee, and the outline of a left foot. On the verso, two slight sketches—of a knee and a reclining figure—adjoin the larger study of the leg. (KF)

27 r

28

Figure Study: Hand with Tools, n.d.

Charcoal on cream laid paper

Watermark: MBM

18¹³⁄₁₆ × 24⅜ in. (47.8 × 61.9 cm)

1985.68.35.13

The style, the subject, and the paper of this drawing are all unique in Eakins' work, making the dating of this sheet difficult. The right hand shown seems to have its fourth finger drawn twice; the gesture, evidently of someone holding a loop of string and a flat stick, has not been identified, and it does not appear elsewhere in Eakins' work. The unidentified form at the right, possibly a wing nut, may relate to the work of the hand. Although the size and quality of the paper are identical to that used in other figure drawings from his classes at the Academy, the MBM watermark is not found on any other drawing from this period, and the style is freer and the modeling less finished, pointing to different purpose and perhaps a different date. (KF)

28

Figure Studies: The "Naked Series"

[Nine Line Drawings of Standing Figures Showing the Axes of Weight and Action], 1883

> Graphite and black ink on blue-lined laid paper
>
> 7¾ × 9¾ in. (19.7 × 24.8 cm)
>
> 1985.68.6.10
>
> Inscriptions: (TE in graphite, b.r.) numbered computations and notations; (b.l.) embossed stationer's stamp: *BATH*

The "Naked Series"

These figure drawings are tracings from the photographs known as the "Naked Series," made by Eakins and his students at the Academy in about 1883.[1] Different models were posed in front of the camera in the same series of seven postures, usually with arms raised above the head or loosely held in front or back of the torso with the body's weight evenly distributed, then shifted to the left and the right legs. From this gallery of body types, including men, women and children, came a catalogue of comparative anatomy of the human figure and—most important—an illustration of the body's axis of weight and motion. This central line, traced in pencil or pen through the spine to the floor, was, as E. C. Parry notes, the "whole purpose of the Naked Series."[2]

Numbering each of these nine figures from left to right, with numbers 1–4 in the top row and 5–9 below, we can correlate most of these tracings to extant photographs. The drawings in the bottom row are based on pictures of Eakins himself.[3] An identical set of tracings was discovered among materials sent to E. H. Coates, chairman of the Academy's Committee on Instruction, with accompanying texts that explain Eakins' purposes:

> The centre lines in red represent the general axes of weight and of action and are deduced from a consideration of the centres of gravity of small horizontal sections of the figure, which centres joined form the continuous lines.
>
> In the thorax this line approaches the back outline rather than the front because first—of the shape of a section of that region and second because of this position of the lungs of but little weight. These lines are maintained throughout their curves by increased action of the muscles on the convex parts of their curves by ligaments or by the resistance of bones only. Such lines form the only simple basis for synthetic construction of the figure. Thomas Eakins.[4]

The four upper tracings are taken from four different models. The second man (no. 2 from the left) seems to be John Laurie Wallace;[5] the woman at the far right (no. 4) resembles the model known as "Brooklyn No. 2."[6] The other two figures have not been related to extant photographs.

The same nine tracings seen in this drawing appear

again, but in jumbled order, in a similar sketch on lined paper, now in the Hirshhorn Museum.[7] From the disorganized order and scale of this drawing, we might conclude that it was a first draft; the CBTE drawing a more orderly revision; and the third version, on tracing paper with annotations, a polished copy for Coates that attempted to explain the purposes of Eakins' unorthodox photographic sessions. (KF)

1. See Ellwood C. Parry II's introduction to Olympia 1981, and Parry.
2. Olympia 1981, viii.
3. Ibid., p. 25, no. 24. A partial set of these photographs is in CBTE; see figs. 92, 93.
4. Collection of Mr. and Mrs. Joseph Seraphin (Olympia 1981, p. 45, no. 45). As in these tracings, the third and sixth figures in the suite of seven photographs are omitted.
5. Olympia 1981, p. 41, no. 41.
6. Detroit Institute of Arts (Olympia 1981, p. 35, no. 35); an adjacent tracing glued to this set of photographs describes the same pose seen in frame no. 1. This same suite is in CBTE, 1985.68.6.10.
7. Parry, p. 73, fig. 24.

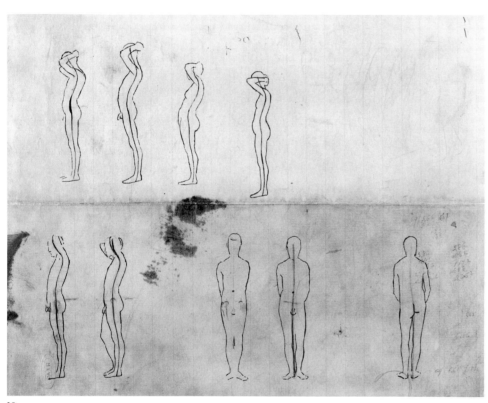

29

Anatomical Drawings

The Bregler collection includes a large group of human and animal anatomical dissection studies and related anatomical drawings, unusual in the work of most artists and fascinating in their revelation of Eakins' methods and concerns. The dissection studies were executed by Eakins in the demonstrations conducted as part of the courses in artistic anatomy given at the Pennsylvania Academy by Dr. William W. Keen. Most of these drawings were done in 1877–79, when Eakins was most involved with this part of the curriculum as Keen's chief demonstrator of anatomical dissections. After fall 1879, when he was promoted to professor of painting and drawing, his senior students—such as Thomas Anshutz—undertook the day-to-day supervision and demonstration of dissection, but Eakins remained the guiding force of this aspect of the school's curriculum.

Dissection was only a part (although as Lloyd Goodrich said, the most radical part) of the Academy's comprehensive art program based on the study of the human figure.[1] Within three years of its establishment in 1876 in the new Furness Building, the program had gained national and international recognition for being the most progressive and thorough course of art studies available anywhere. "It quite takes one's breath away, does it not?" wrote William Brownell in *Scribner's Monthly*. "Exhaustive is a faint word by which to characterize such a course of instruction."[2]

The extraordinary anatomy classes at the Academy achieved the reputation they did for a combination of reasons. Philadelphia's scientists, physicians, and medical colleges were at the forefront of America's tremendous and rapid advances in scientific standards, research, and education throughout the nineteenth century, and they set many of the standards of training, testing, and achievement that were later instituted throughout the country in the twentieth century. Medical education outside the major cities of the East fell several decades behind Philadelphia's example. Educational standards and requirements were low at best, and facilities were often extremely poor. Many medical students were given the status of physician without having ever dissected, and those who were fortunate to have some dissecting practice as part of their studies did so on ill-preserved cadavers.[3] Seen in this light, the anatomy and dissection courses available to the men and women of the Pennsylvania Academy were above the general level of medical education in much of the country. While the intent was never to train surgeons at the Academy, and the art students were not required to dissect or take any exams,[4] the students were being taught by one of the most prominent anatomists in America using the most advanced demonstration techniques available, under the supervision of a painter who was himself rarely qualified in this field.

Eakins was first and foremost an artist, but he was also fully trained in anatomy, a product of the special scientific environment of Philadelphia. By 1876, when he was brought into the newly reopened PAFA schools at Broad and Cherry as an unpaid demonstrator for Keen's classes, he had studied

anatomy and dissection for a dozen years in Philadelphia at Jefferson Medical College, and in Paris.[5]

Keen had been practicing medicine and teaching pathological anatomy for almost ten years at Jefferson, and he was the director of the Philadelphia College of Anatomy, a prestigious private medical school and early research center, the only one of its kind in the country. He had an outstanding career as a clinical surgeon, educator, and writer, with numerous publications and honorary degrees. It was at the Philadelphia School of Anatomy in 1873, when he was thirty-six, that he began to teach artistic anatomy and to develop the courses that he would present at PAFA.[6] His first series of about thirty lectures included "8 on the skeleton, 12½ on the muscles," and the remaining on the eyes, nose, ear, fat and veins, hair, postural expression, and the influence of sex on the development of the body.[7]

Keen brought up-to-date methods to his demonstration lectures, juxtaposing the live model with skeletons, plaster casts of antique sculpture, and a vertically hung cadaver hooked up to galvanized batteries (see accompanying illustration). He described the demonstrations to the Committee on Instruction as follows: "At most of the lectures I have also had an excellent male model and after showing the parts on the skeleton or the subject I have then at once demonstrated them on the living model calling the muscles into play using dumbbells, weights, and rings. . . . When occasion required I have used the galvanic battery to call special muscles into contraction and thus illustrate their function."[8]

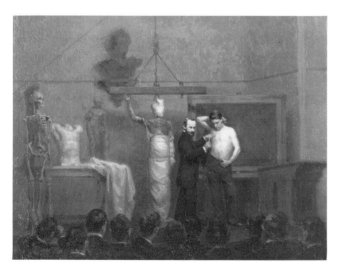

Charles H. Stephens (c. 1855–1933), *Anatomical Lecture by Dr. William Williams Keen*, c. 1879, oil grisaille on cardboard, 12 × 14 in. (21.9 × 27.9 cm), PAFA, Gift of the artist. Illustration for William C. Brownell, "The Art Schools of Philadelphia," *Scribner's Monthly* 18 (Sept. 1879).

Ten years later, in 1887, Keen was selected to edit the new American edition of Henry Gray's *Anatomy, Descriptive and Surgical,* in which he published his essay "On the Systematic Use of the Living Model as a Means of Illustration in Teaching Anatomy." Here, where he could share his

demonstration methods with a large audience, he claimed that his ten-year teaching experience at the Pennsylvania Academy convinced him of the necessity of comparing the dissected subject with the living body in medical anatomy study. He explained the necessity for this full set of props by understatement: "What might be called postural Anatomy is almost impossible in the dead."

> Incidentally, also I may say that I have found it very useful to study the cadaver, not only horizontally, on a rotating table, as we generally do, but in the vertical position. I place two hooks in the skull, just above the ears, and suspend the body from the ceiling by a pulley, also using a cross-piece with cords and self adjusting pulleys, by which the arms can be raised at will and the body easily rotated. The skeleton, cadaver and model are thus all in the same posture, and no mental transposition of relations is necessary in passing from one to the other.[9]

His assessment of this artistic approach to clinical anatomy was that this practice "throws an entirely new light on the practical applications of anatomy to the everyday wants of the doctor, and enlivens what is otherwise . . . a dry subject. No teacher who ever tries it will ever be willing to dispense with it."[10]

Although it was Keen who structured and ran the anatomy lectures, it was Eakins, with his conviction in the value of anatomy study for artists, who brought the first major innovation to the Academy's anatomy lectures within the first year: the art students were permitted to actually dissect. Also in his first year as demonstrator, Eakins dissected a cat, dog, horse, and sheep and made casts of these dissections. Keen did not record any formal lectures on comparative or animal anatomy in his initial report to the board this year, so it seems that Eakins took the initiative in introducing this to the Academy as well. Keen responded by incorporating the comparative anatomy of expression and the different animal anatomies into the course.

Eakins' casts of the dissected human cadaver (cats. 258–259) have been well known through examples already at the Academy and the Philadelphia Museum of Art. Copies of these casts were available to the students for a small fee and were superior, as aids to study, to the anatomically incorrect plaster *écorché* figures to which they had been accustomed.[11] Keen often borrowed animal skeletons from the Academy of Natural Sciences and relied on the University of Pennsylvania to supply the cadavers for the dissection class. In 1880 he requested that the Academy donate complete sets of Eakins' casts, painted and labeled, to these institutions to become part of their growing study collections.[12]

Both Eakins and Keen took the authority for their innovative methods from the other's discipline. Medical students were encouraged to use their eyes to distinguish the surface landmarks of the body, described in Gray's *Anatomy* as those "lines, eminences, and depressions which are guides to, or indications of, deeper seated parts . . . to study the great casts and sculptures, and to study their own bodies to gain a more

complete understanding of their subject, the human body."[13] At the same time, Eakins directed his students to look inside the body, to explore it with their hands and fingers, and to visualize its three-dimensional sections and interior forms when drawing and painting. Keen's interest in advancing the methods of medical anatomy study using techniques most suited to artists was matched only by Eakins' interest in teaching anatomy to artists using the best techniques available to science. There was obviously a mutual professional respect between Keen and Eakins, top professionals in their fields with a common interest. The fact that Eakins could interpret and translate the anatomical terrain of muscles and tendons, contractions and extensions, insertions, origins, and aponeurotic sheathing into the language of form, structure, movement, light, and surface for his students guaranteed the relevance of the program.

Not everything was perfect, however. The academy students didn't always get the best material to work with, and it seems that the men got to the cadavers first. Elizabeth Macdowell requested that the women students have time in the dissecting room reserved exclusively for them, and she described their situation in a letter to Eakins dated 31 January 1882:

> Up to the present the boys have worked on the new subject, while we were at ours, but now, beside that fact that ours is dried up completely, they have cut off the head, arms and scapula so the back, about the freshest part, is about useless. This was done without consulting us, and Miss Roberts and I had just prepared it for study. There are several good girls who are seeing the subject for the first time, and they can get a very poor concept from such a dried up dismantled mass. The boys monopolize the alternate mornings too, leaving us no opportunity to see the new subject. When we have come in contact with them there are some—who are both noisy and rude, making it very unpleasant.[14]

Sometimes second in line for opportunities to dissect, the women students were also confined by a contemporary morality that disapproved of their observation of male genitals under any public circumstances, certainly including art galleries, life classes, anatomy lectures, and dissections. Eakins lost his job in 1886 for removing the loincloth from a male model in an anatomy lecture to women (or a mixed audience of men and women); at least one of the women present was offended and complained. The ensuing investigation of Eakins' practices revealed a similar "modesty" in the dissecting room, evidently enforced by the senior demonstrators (Jesse Godley and, perhaps reluctantly, Mary Searle) against Eakins' will. Although the details of the "dissecting room matter" are not known, it appears that Eakins criticized the castration of a cadaver that was to be used by the women's class: "If there is a place in all the world where seriousness should reign and the little affectations of this life have no place it is there in the dissecting room and the mutilation of the male subject for the false modesty is to me revolting."[15]

The perfect seriousness of the dissecting room, for Eakins, emerges in the many anatomical drawings in the Bregler collection. The group includes forty-nine dissection studies, arranged below in the catalogue by species: human, cat, dog, lion, horse, and sheep. Within each category the drawings are further organized according to the topology—for example, the torso, the leg, the muscles of the back. While many of the drawings are accompanied by detailed remarks and notes that identify the species as well as the anatomical features portrayed, just as many are not so conveniently annotated. These unlabeled drawings either have no identifying inscriptions or are marked only with the initials of the Latin nomenclature for the muscles illustrated. Careful comparison of these drawings to the text and illustrations of the 1901 edition of Gray's *Anatomy* (rpt., Running Press, 1974) aided in their accurate identification. Drawings on which the species is not indicated were identified by careful visual examination and comparison of the subject, media, paper, and style of execution with categorized and identified drawings.

Eighteen of the sketches are studies taken from the dissected human cadaver. This category includes a group of six cross sections of the leg; three from the upper right leg and three from the lower left leg. This group records a complete series of sections taken at intervals on the leg from the groin

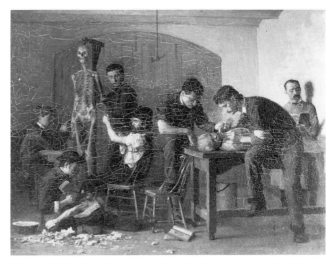

Thomas P. Anshutz (1851–1912), *Dissecting Room*, c. 1879, oil grisaille on cardboard, 10 × 12½ in. (25.4 × 31.8 cm), PAFA, Gift of the artist. Illustration for William C. Brownell, "The Art Schools of Philadelphia," *Scribner's Monthly* 18 (Sept. 1879).

to the ankle, following clinical procedures consistent with those outlined and illustrated in Gray's *Anatomy*. A second set of cross sections thoroughly examines the torso, starting at the neck and continuing to the lower back. Dissection studies of muscles of the shoulder, arm, back, hand, and knee complete the group of human anatomical studies.

Comparative anatomy studies constitute more than half the drawings in this collection. The largest set of drawings in

this category are of the cat (twelve) and the dog (seven). There are two studies of the lion and four of the horse. (See accompanying illustration.) Of interest in this group are Eakins' careful inscriptions, which underscore his interest in the comparative forms and functions of the major muscle groups. Five of the anatomical dissection studies categorized as "unidentified" were probably done on the same occasion from a single animal, most likely the sheep; see cats. 76–80. Three sketches of horses, while not dissection drawings, have been appended to this section because they show a related interest in anatomy and proportion (cats. 73–75). Also representing Eakins' interest in equine anatomy are the illustrations to his paper on the differential action of muscles and tendons in a horse's leg, delivered before the Academy of Natural Sciences in 1894 (cats. 82–87), and his motion studies (cats. 88–91).

What are these drawings, and what can be learned from them? It is obvious what they are not. They are not works of art, anatomical illustrations, or consciously "artistic" renderings. Eakins had no aesthetic pretense about anatomy study. "This whole matter of dissection is not art at all, any more than grammar is poetry. It is work, and hard work, disagreeable work. No one, however, needs to be told that enthusiasm for one's ends operates to lessen the disagreeableness of his patient working toward attainment of it. In itself I have no doubt the pupils consider it less pleasant than copying the frieze of the Parthenon."[16] These drawings are, to an anatomist's eye, direct, clear, and eloquently executed. They have a quality of immediacy and fluency that shows Eakins' own eye, mind, and hand investigating the forms and structures of the body with deceptive ease. The sketchy, schematic, diagrammatic, annotated drawings record the act of dissecting—and Eakins focused within this act. The drawings also can offer us a deeper glimpse into the process and content of anatomy study at PAFA during Eakins' tenure, from 1876 to 1886.

Most of the drawings are loosely and rapidly sketched in graphite, often combined with red and blue pencil with areas overdrawn in black ink. Many sketches are on the common lined foolscap writing paper or on the reverse of printed fliers announcing classes at the Academy. The small size and physical character of these drawings suggest an intimacy and immediacy of response in teaching and learning that would have been possible with the relatively small number of more advanced students who would practice dissection each semester.

In their approach, many drawings are characteristic of regional anatomy as studied in the medical colleges: they show a close and particular observation of interrelated muscles and tendons. Keen, in his first annual report to the board of directors, describes the general procedure of dissection: "When treating the muscles I have dissected the subject and have thus shown the muscular attachments on the bones and their actual appearance on the subject, on one side the muscles were completely dissected for their minuter study while on the other the underlying tissues only were removed and

then their natural relations to the other parts have been demonstrated."[17] The cross sections especially show a broad and lucid comprehension of these relationships in simplified, diagrammatic renditions of what can appear to the untrained eye to be an undifferentiated muscle mass. Eakins' schematic drawing, as in cat. 31, beautifully clarifies and identifies the muscles. Such drawings would have been a valuable teaching tool at the dissection tables or even in the life class. Cross-sectional anatomy was perhaps a less common procedure in the PAFA dissecting room than was the regional anatomy, which uncovers the muscles layer by layer. It is most likely that these sections were "full" lateral sections cut directly through the bone to create thin circular "discs."[18] The sequential cross-sections helped students to observe the changes in shape and adjacency of the muscles as they extend up and down the leg, as well as the changing shape of the leg at the location of the section. One of the section drawings that Eakins identified as "left leg section thickest part of gastrocnemius" (cat. 34) shows where the thick gastrocnemius muscles bulge at the calf and most noticeably influence its form. Eakins instructed students in the life painting classes to "think of the cross-sections of the parts of the body when you are painting."[19] This statement would have little meaning in a less comprehensive course of study, and it demonstrates the consistency and integrity Eakins was able to achieve in his teaching of the figure.

Some of the drawings seem to record "highlights" of special anatomical or medical interest: examples of variations from normal morphology, exemplary subjects, or uncommon procedures. Typical of this group is his drawing of an anomaly of the knee, dated January 1878—which he describes as "the fibres of Sartorius running uncommonly low" (cat. 46). He did several sketches of this subject, including a more finished version in the Hirshhorn. Two of these were sketched in pencil and then redrawn in pen and ink, as if for archival or teaching purposes. This may be an instance in which Keen brought his own surgical-research expertise into the Academy's dissection demonstrations and gained a useful response from Eakins. Three years later, in 1881, Keen published "A Lecture on the Clinical Anatomy of the Lower Extremity and Especially the Knee and Ankle Joints."[20]

This is the same joint, on the horse, that Eakins discussed thirteen years later in his own article, "Differential Action of Certain Muscles Passing More than One Joint." His research of the muscles and tendons as they determine movement and support in the leg was progressive within the field of comparative anatomy. The field had long confined itself to the comparative study of forms and had only recently moved toward investigating function. After reading a study on the subject by a French authority who contradicted everything he knew to be true, Eakins was inspired to set the record straight.[21] The same critical attitude is revealed in his drawing of the scapula (cat. 74) in which he challenges the authority of Gray's *Anatomy* on the basis of his own investigations.[22]

In the middle of the infraspinatus there is a superficial tendon or aponeurosis: the fibres from the spine come down crossing, approaching the deltoid in direction of fibres. The teres major arises principally from the strong aponeurosis covering the infraspinatus, and well over to the inner edge of the scapula. It is not drawn important enough in Gray. It looks too much as if it only had its direct scapular origin whereas its aponeurotic origin is still larger and more important.

In this drawing, as in many others, Eakins calls attention to aponeurotic sheathing, tendonous connections, and muscle origins and insertions. These features create subtle changes in the tension of the skin and add definition to the muscles, and so they are of interest in artistic anatomy, along with the more obvious landmarks of joints and skeletal structure that students of the figure are trained to recognize. Curious enough to pursue his studies beyond Gray, Eakins nonetheless remained focused, for the most part, on the artistic relevance of dissection to his painting and sculpture.

Although sometimes engaged by his own research, Eakins did not forget that the purpose of dissection at the Academy was to teach students to paint realistically. "We turn out no physicians and surgeons," he told Brownell. "For anatomy, as such, we care nothing whatever." "To draw the human figure it is necessary to know as much as possible about its structure and its movements, its bones and muscles, how they are made, and how they act. You don't suppose we pay much attention to the viscera, or study the function of the spleen, I trust."[23] His drawings show us that he certainly *did* care for "anatomy as such," but he understood the larger context of his study and did not expect his students to follow him into realms of pure investigation.

Eakins' comments and observations on the drawings enrich our understanding of his approach to anatomy by giving us clues to what he found significant or extraneous. While some drawings are more didactic than others, their dominant quality is one of active searching, describing, and explaining, and never of overfamiliarity or complacency. The comments are, by nature of the study, analytical. But they are balanced overall with a curiosity and openness to the constant discoveries of difference and individuality that Eakins encountered in the process of dissecting.

Eakins' intellectual abilities, interests, and temperament can be characterized as a "quest of knowledge"[24]—a phrase he used to explain his reasons for undertaking the anatomical investigations of the horse—and by his respect for the processes and products of that quest: the great and intelligent achievements of all time in science and art. In either realm, the quest demanded the same behavior: direct personal experience, alert observation, fearless inquiry. "To study Anatomy out of a book is like learning to paint out of a book," he told his students. "It's a waste of time."[25] (CK)

1. Goodrich 1982, I: 76–77.
2. Brownell, 747.
3. Charles Russell Bardeen, "Anatomy in America," *Bulletin of the University of Wisconsin*, no. 115 (1905): 49.
4. In the Minutes of the Board of Directors, 10 May 1879 (PAFA Archives), Keen suggests the introduction of examinations to reinforce the material presented in the lectures. It is most likely that this practice was never instituted, as it was never mentioned in further reports.
5. See a discussion of Eakins' early scientific education and Philadelphia's role in medical and surgical training in Johns 1984, 46–81.
6. Donald C. Geist, M.D., "William Williams Keen, M.D., and the Teaching of Artistic Anatomy," *Transactions and Studies of the College of Physicians of Philadelphia* 41 (1974): 307–308.
7. Keen, Minutes of the Board of Directors, 7 April 1877, PAFA Archives.
8. Ibid.
9. W. W. Keen, "On the Systematic Use of the Living Model as a Means of Illustration in Teaching Anatomy," in Gray, *Anatomy*, 33–34.
10. Ibid.
11. Keen, Minutes of the Board of Directors, 7 Apr. 1877, PAFA Archives. "The large plaster cast of the muscles after Houdon has been carefully painted from the dissections of the body by Mr. Eakins and some of the students and it will now be a much more useful model than heretofore. This model is in many respects inaccurate and I am gratified to learn that you have already ordered some other more accurate casts from Paris which are expected soon."
12. Keen, Minutes of the Board of Directors, 4 Nov. 1880, PAFA Archives. "The Academy of Natural Sciences again very liberally gave me the use of as many skeletons as I desired for illustrating my lectures on the comparative anatomy of the vertebrate skeleton. . . . As a very appropriate recognition of their repeated courtesy and also the University of Penna. for their kindness in assisting us in obtaining dissecting material, I would suggest that a complete set of the admirable casts made by Mr. Eakins and the Assistant Demonstrators be painted, labelled with the names of the parts presented to the Academy and the University with a suitable [minute?]." Such sets of casts have not been located at these two institutions.
13. Luther Holden, "Landmarks, Medical and Surgical," in Gray, *Anatomy*, 1025–26.
14. Elizabeth Macdowell (Kenton) to TE, 1882, PAFA Archives.
15. TE to E. H. Coates, 15 Feb. 1886; Foster and Leibold, 215. The "dissecting room matter" is discussed in relation to Eakins' forced resignation in " 'Trouble' at the Academy," Foster and Leibold, 76.
16. Goodrich 1982, I: 181, from Brownell, 745.
17. Keen, Minutes of Board of Directors, 7 Apr. 1877, PAFA Archives.
18. While sections made today are approximately one-half cm or less thick, it was only after 1881 that techniques for cutting and freezing thin sections became widely practiced; the tools and methods of chemical preservatives available to Eakins in the 1870s would have produced a thicker section.
19. Bregler I, 383.
20. William W. Keen, *Annals of Anatomy and Surgery*, vol. 3 (1881), 1–20.
21. Eakins' paper was published in the *Proceedings of the Academy of Natural Sciences* 46 (1894): 178–179. He criticized a passage by the French comparative anatomist Chaveau in his *Traité d'anatomie comparée des animaux domestiques*. "I mistrust entirely the accuracy of Chaveau's observation as to the effect of cutting the tendon in

the living horse. The severance of this mighty cord in the dead horse causes instant collapse. I suspect that in Chaveau's experiment the cord was but imperfectly cut, or, it may be, that by an extraordinary co-ordination of muscular effort the poor beast still stood for a short time previous to its final destruction, but it is inconceivable to me that a trained and unprejudiced observer should detect no change in the appearance of the animal upon the destruction of such a great part of the mechanism."

22. Charles Bardeen comments on Gray's dominance in medical study in "Anatomy in America," 40: "Here in America during the last half century Gray became such an authority on gross anatomy that to many the two terms have seemed synonymous and thousands of students lacking confidence in their power to see for themselves have turned away from apparent imperfections actually found in human structure to get what they are sure must be the real truth from Gray."

23. Brownell, 744–45.

24. Elizabeth Johns, "'I, A PAINTER': Thomas Eakins at the Academy of Natural Sciences," *Frontiers, Annual of the Academy of Natural Sciences of Philadelphia* 3 (1981–82): 46.

25. Goodrich 1982, I: 177, quoting Bregler I, 383.

30

Dissection Study: Human [Cross-section of Front of Upper Right Leg]

Graphite on foolscap

7¹³⁄₁₆ × 12⁷⁄₁₆ in. (19.8 × 31.6 cm)

1985.68.5.1

Inscriptions: (TE in graphite throughout) identification of muscles: *Vastus externus; Vast*[us] *Internus; Rectus* [femoris]; *Sart*[orius]; [Adductor] *Longus;* [Adductor] *Brevus; Gracilis; Biceps;* [flexor cruris]; *Magnus; S.*[emi] *T.*[endinosus]; *Tendon Semi membranous; T. Vagi* [sic?] [tensor fascia femoris]; *Pectineus;* (u.r.) *Tendon;* (u.l.) embossed stationers' stamp: building within oval

This drawing is one of a series of cross sections of the human leg, from upper thigh to ankle, seen in cats. 30–36.[1] The date on cat. 36, 1878, may stand for them all. This drawing shows a full circular cross section of the thigh but focuses on the muscle group at the front of the leg, approximately midway between hip and knee. Both this drawing and the next one appear to have been made from full circular (disc-shaped) cross sections of the leg. The clarity of the drawing and the inscribed identifying detail become much weaker at one side of each drawing, cat. 31 showing greater detail of the back of the leg and cat. 30 of the front. This differentiation may reflect how the cross sections were taken from the subject and studied. Eakins' anatomical casts of the leg (e.g., PAFA 1991.7.12) clearly reveal that deep wedge-shape cuts were made, sometimes halfway but never entirely through the limb. It seems more likely that such "half-moon" discs were the actual "seen" subjects of the drawings and that

Eakins "rounded out" the drawing either from memory or from observing a separate cross section. Eakins' cast of the right thigh, leg, and foot, related to this drawing and cats. 31 and 32, was made in 1879.[2] The locations of the cuts on this cast correspond closely to the muscle-section studies of the right leg. The drawings may not have been made from the same cadaver from which the cast was taken, but it is revealing to compare the full cast leg with the drawings to understand the larger context and the approximate location of each section. (CK)

1. For a clinical description of dissection procedure illustrated by Eakins' work, see Gray, *Anatomy*, pp. 427, 428, figs. 255, 256.
2. PMA; Siegl, 86.

30

31

Dissection Study: Human [Cross-section of Back of Upper Right Leg]

Graphite on foolscap

12⁷⁄₁₆ × 7¹³⁄₁₆ in. (31.6 × 19.8 cm)

1985.68.5.2

Inscriptions: (TE in graphite throughout) *S.*[emi] *T*[endinosus]; *S.*[emi] *M*[embranous]; *A.*[dductor] *Mag.*[nus]; *A*[dductor]. *Mag.*[nus]; *Gracilis; Sart*[orius]; *A*[dductor] *Longus; R.*[ectus] *F*[emoris]; *B.*[iceps] *shorthead; B.*[iceps]; (b.r.) embossed stationer's stamp: building within oval

This cross section focuses on the muscles at the back of the thigh and is taken from a point closer to the knee than cat. 30. The overall narrowing of the thigh at this location would create a more oval rather than circular section; the rectus femoris seems smaller and flatter in comparison with cat. 30, as it would be where it terminates in a strong, flattened tendon before inserting into the knee. (See Gray, *Anatomy*, pp. 420, 428; figs. 253, 256.)

31

32

Dissection Study: Human [Cross-section of Upper Right Leg]

Graphite on cream wove paper (printed PAFA circular)

5 × 8 in. (12.7 × 20.5 cm)

1985.68.5.3

Inscriptions (r): (TE in graphite) identification of muscles throughout: *ST, SM, AM, Gracilis, Bicep, Bicep;* (r.c.) *middle section / right Thigh / looking up*

Inscriptions (v): printed text announcing distribution of admission cards to PAFA schools, 1876

The group of muscles labeled in this study are from the back of the leg. See cats. 30, 31, and 36.

33

Dissection Study: Human [Cross-section Below Knee, Right Leg]

Graphite on foolscap

12⁷⁄₁₆ × 7¹³⁄₁₆ in. (31.6 × 19.8 cm)

1985.68.5.4

Inscriptions: (TE in graphite, u.l.) *G* [astrocnemius]; *P* [lantaris or Popliteus?]; *Tendon / Gastrocnum[ius]; Long head Biceps; Tendon Biceps; Short head Biceps; Tendon Popliteus;* (c.) *Fat; Lig* [ament]. *Pat* [ella].; (r.) *Tendon S.* [emi]; *M.* [embranosus]; *Sartorius; Tenon Gracillis;* (b.r.) embossed stationers' stamp: building within oval

The group of muscles labeled in this study are of the back and side of the lower leg. See cat. 30.

34

Dissection Study: Human [Cross-section of Lower Left Leg at Thickest Part of Gastrocnemius]

Graphite on foolscap

12⁷⁄₁₆ × 7¹³⁄₁₆ in. (31.6 × 19.8 cm)

1985.68.5.5

Inscriptions: (TE in graphite, c.) *left leg section thickest part of gastrocnemius;* abbreviated identification of muscles throughout: *G* [astrocnemius]; *S* [olius]; *T.*[ibialis] *P* [osticus]; *T.*[ibials] *A* [nticus]; *E. C. D.* [extensor longus digitorum?]; *P* [eroneus] *L* [ongus]; *P.*[eroneus] *B* [revis]; *F. L. P.* [flexor longus hallucis?]; *E. P. P.* [extensor proprius hallucis?]; (b.r.) embossed stationers' stamp: building within oval

See cat. 30. Eakins' cast of a right leg shows a hemispherical wedge removed from the back of the leg at this same point, the "thickest part of gastrocnemius." The initials "F. L. P" and "E. P. P." in this diagram, identifying certain muscles of the toe and ankle, show a rare divergence from standard terminology in these drawings. Gray's *Anatomy* calls these muscles the flexor longus hallucis and extensor proprius hallucis. With consistency, Eakins labels the same sections in cat. 35 "Prop. Pal." and "Flex Pallicus," instead of proprius hallucis and flexor hallucis, as given by Gray. Eakins may have erred, or invented his own Latin term, based on the confusion created by the interchangeable Latin words for big toe (pollex) and thumb (hallux, or allex). Gray's *Anatomy* (p. 434) and the medical dictionaries of the period debated the etymology and proper usage of these terms, although none cite Eakins' exact spelling. The variations remind us that the field was still somewhat in flux and open to the investigations and contributions of amateurs such as Eakins (compare cats. 82–86.) (CK/KF)

35

Dissection Study: Human [Cross-section of Left Leg above Ankle]

Graphite on foolscap

12⁷⁄₁₆ × 7¹³⁄₁₆ in. (31.6 × 19.8 cm)

1985.68.5.6

Inscriptions: (TE in graphite, u.r.) *G tendon Tib*[ialis]. / *Posticus;* (u.l.) *Prop.*[rius] *Pal.* [Hallucis?]; *Flex.*[or Longus] / *Pallicis.* [Hallucis?]; *Soleus; T.*[endon] *Ach*[illis]; *Fat; Ex* [?] *Com.* [Extensor Longus?] / *& P.*[eroneus] *Ter*[tius]; (b.l.) embossed stationer's stamp: building within oval

See cat. 30 and Gray, *Anatomy,* 285, 433–436. On the irregular term "pallicis," see cat. 34. Eakins' cast of a left leg

(PAFA 1991.7.12) ends above the ankle near the point described in this drawing. (CK)

37

36

Dissection Study: Human [Cross-sections of Muscles of the Right Leg], 1878

Pen and ink over graphite on cream wove paper (printed PAFA circular)

9⁹⁄₁₆ × 6 in. (24.3 × 15.2 cm)

1985.68.5.7

Inscriptions (r): (TE in graphite, u.c.) *Subject 1878. / right leg looking / up;* identification of muscle sections throughout: *Pectineus / Cross section in middle; Sartorius / middle; ILIO PSOAS / just after leaving Pelvis; Rectus femoris / middle; Rect[us] Abdominus.; Ex[ternal] Oblique; Transversalis; Internnal / Oblique*

Inscriptions (v): printed text describing "Study of the Living Model"

See cats. 30 and 32 and a photo of the verso of cat. 47.

37

Dissection Study: Human [Cross-section of the Neck]

Graphite on foolscap

12⁷⁄₁₆ × 7¹³⁄₁₆ in. (31.6 × 19.8 cm)

1985.68.5.8

Inscriptions: (TE in graphite) identification of muscles and fascia throughout: *S.[pinalis] Colli / T.[rachelo] Mastoid? is* ["is" crossed out] *= / small complexus; Biventer cervicis; Rectus Capitas Ant.[icus] Maj.[or]; semi spinalis colli; Scalenus Medius; Longus Colli; S.[plenius] Capitas; Complexus; S.[pinal] Cord; S.[emi]; S.[pinalis]; C.[olli]; S.[terno] C.[leido] M.[astoid]; L.[evator]; A.[nguli]; S.[capulae]; WHOLE / Hole;* (b.r.) embossed stationer's stamp: building within oval

This drawing is one of four possibly sequential studies of cross sections of a human torso from the neck to the region of the lower back, cats. 37–40. See Gray, *Anatomy,* pp. 316, 334, 337; figs. 201, 211, 212. Eakins' suite of drawings of the upper torso may relate to his cast of a neck and part of a shoulder, cat. 258; although this cast is of the front of the torso only, it is cut near the same point as cat. 37. (CK)

38

Dissection Study: Human [Cross-section Through Thorax, Shoulder and Upper Arm]

Graphite on foolscap

7¹³⁄₁₆ × 12½ in. (19.8 × 31.8 cm)

1985.68.5.9

Inscriptions: (TE in graphite, u.l. to u.r.) *Teres Minor / Tricep* [within small sketch indicating relative positions of same] */ A few fibres of teres minor show the cut section having been made / high enough to miss all but a few upper fibres of this muscle.;* (in graphite throughout) *Trape[zius]; Rhomb[oideus]; Serratus Mag[nus]; Subscapularis / Infra / spinatus; Triceps; C.[oraco] B[rachialis]; B[rachialis]; P[ectoralis] Min.[or]; P[ectoralis] Maj[or]; Fat & Vessels; Deltoid;* (b.r.) embossed stationers' stamp: building within oval

Fig. 50

See cat. 37 and cat. 258, Eakins' cast of a neck and part of shoulder. The section described in this drawing is an area that corresponds closely to the cut below the clavicle through the shoulder and chest, along the base of the cast. (CK)

39

Dissection Study: Human [Cross-section of Torso, Thoracic Region]

Graphite on foolscap

7¼ × 11¾ in. (18.4 × 29.8 cm)

1985.68.5.10

Inscriptions: (TE in graphite, b.l. to u.c.) *Aorta / Spinal*

cord / *Spinous process.* / *Bone* / *Bone* / *Trapezius* / *Sacro lumbalis.* / *L.*[atissimus] *Dorsi* / *S.*[erratus] *Mag.*[nus] *P*[ectoralis] *Maj.*[or]; numbers *5–9,* indicating position of these ribs

See cat. 37. This drawing describes the layers of muscle surrounding the spine and rib cage between the fifth and ninth ribs. The encircled numbers indicate the relative position of the lower ribs meeting the sternum at the fifth rib, seen from above. Gray's *Anatomy* describes the dissection procedure that Eakins may have followed to expose these muscles (see pp. 336–337; fig. 212). (CK)

39

40

Dissection Study: Human [Cross-section of Torso, Lumbaric Region]

Graphite on foolscap

12⁷⁄₁₆ × 15⁹⁄₁₆ in. (31.6 × 39.5 cm)

1985.68.5.11

Inscriptions: (TE in graphite, u.c. to b.r.) *S.*[pinal] *Cord.*; *L.*[atissimus] *Dorsi*; *Sacro lumbalis*; *Psoas Magnus*; *Quad.*[ratus] *Lumb.*[orum]; *Lat.*[issimus] *Dorsi*; *Transversalis*; *Internal Oblique*; *External*; *Oblique* (b.l.) embossed stationers' stamp: building within oval

See cat. 37 and Gray, *Anatomy*, p. 364; fig. 221. This drawing is on a full sheet of the ruled writing paper that Eakins usually tore in half, along the fold, to use for these studies. (CK)

41

Dissection Study: Human [Tendons Crossing the Joint of the Little Finger, Left Arm]

Black ink over graphite and blue pencil on foolscap

7¾ × 12⁷⁄₁₆ in. (irr.) (19.7 × 31.6 cm)

1985.68.5.12

Inscriptions: (TE in black ink over graphite, u.l. to c.l.) *a extenseur / anterieur / du metacarpe. / b. ext. anterieur / des phalanges / c. ext. lateral des / phalanges / d. flechisseur / externe du metacarpe / e tendon du / flechisseur interne / du metacarpe;* (b.l.) *extern. aspect of left wrist.;* (u.c.) *The external fibres of tendon / of flexor, tendon intern, met. / join at acute / angle those of / tendon of ext. / lateral des phalanges. / Ex. lateral des phalanges / repond a l'extenseur du / petit doigt chez l'homme;* (in graphite and blue pencil, b.r.) smaller sketch of joint, crossed out; (u.l.) embossed stationers' stamp: building within oval

Eakins' use of French annotations may indicate an early date for this drawing, when the French he used abroad from 1866 to 1870 was still part of his working method. Such annotations appear on many of his perspective drawings from the mid-1870s. Dr. W. W. Keen had also studied in France, and both he and Eakins would have been familiar with French texts and clinical dissection procedures that had established a model for contemporary anatomists. (CK/KF)

41

42

Dissection Study: Human [Back of Left Hand]

Pen and ink over graphite on foolscap

12⁷⁄₁₆ × 7⁵⁄₁₆ in. (31.6 × 18.6 cm)

1985.68.5.13

Inscriptions: (TE in ink over graphite, r.c.) *Back of / left hand / Aponeurotic slip / between index / & middle finger / very thin & high / up. / Between middle / & ring very strong / between ring & / little finger still / stronger;* (u.l.) embossed stationers' mark: building within oval

Eakins' cast of a left hand (PAFA 1991.7.3), does not show exactly the same placement of tendons seen in the drawing, but the sketch is not precisely rendered. In the drawing, the fingers (at the bottom of the page) have been cut below the first or second joint. (CK)

43

Dissection Study: Human [Back, Origin of Latissimus Dorsi]

Pen and ink over graphite on foolscap

12⁷⁄₁₆ × 7⁷⁄₈ in. (31.6 × 20 cm)

1985.68.5.14

Inscriptions: (TE in ink, b.r.) *Origin / Latissimus Dorsi / Man.;* (b.r.) embossed stationers' stamp: building within oval

This drawing may have been taken from the same subject seen in Eakins' cast *Back of a Male Torso* (PAFA 1991.7.2) or from the cast itself. Both expose an area from upper neck to sacrum with flesh left intact over hip and gluteus. Such a cut of flesh shows standard dissection procedure, revealing an inverted triangle from iliac crest to sacrum, with a deep muscle layer cut away to expose the muscle in this drawing on the left side only. In his Report to the Committee on Instruction, 7 April 1877, Dr. Keen noted that "when treating the muscles I have the dissected subject and have thus shown the muscular attachments on the bones and their actual appearance on the subject, on one side the muscles were completely dissected for their minuter study while on the other the underlying tissues only were removed and then natural relations to the other parts have been demonstrated."[1] (CK)

1. PAFA Archives. Another dissection study of the human torso is in the Dietrich Collection (Avondale/Dietrich, cat. 12). See also Gray, *Anatomy*, 337.

Gray's *Anatomy*. More significantly, Eakins' observation shows his explorations beyond the manuals and his willingness to challenge the authority of a reputable text with evidence gained from his own investigations. Eakins' concerns in this drawing are those of an artist, who must learn to recognize and understand origins, insertions, superficial tendons, and joints as the landmarks of the body. However, the critical and scientific spirit demonstrated in this drawing moves Eakins beyond artistic anatomy and into the realm of investigation for its own sake. (CK)

44

44

Dissection Study: Human [Major Muscles Crossing the Scapula]

Pen and ink over graphite on foolscap

12⁷⁄₁₆ × 7⁷⁄₈ in. (31.6 × 20 cm)

1985.68.5.15

Inscriptions: (TE in ink over graphite, b.l. to b.r.) identification of muscles and tendons: *In the middle of the infra spinnatus there is a / superficial tendon or aponeurosis: the fibres from the / spine come down crossing, approaching the deltoid / in direction of fibres. The teres major arises principally / from the strong aponeurosis covering the infra spinatus, / and well over to the inner edge of scapula. It is not / drawn important enough in Gray. It looks too much /* [torn; *as*] *if it only had its direct scapular origin whereas its /* [torn; *apo*] *neurotic origin is still larger and more important;* (u.r.) embossed stationers' stamp: building within oval

Eakins' inscriptions on this drawing confirm that he and his students were using the best dissection manual available:

45

Dissection Study: Human [Left Knee Insertion of Semi-Membranosus]

Pen and ink over graphite on foolscap

12⁷⁄₁₆ × 7⁷⁄₈ in. (31.6 × 20 cm)

1985.68.5.16

Inscriptions: (TE in ink, u.c.) *Man;* (in ink over graphite) *Left knee insertion of / semi-membranous*

See also cats. 46 and 47.

46

Dissection Study: Human [Fibres of Sartorius, Right Knee Bent], 1878

Graphite on foolscap

12⁷⁄₁₆ × 7¾ in. (31.6 × 19.7 cm)

1985.68.5.17

Inscriptions (r): (TE in graphite, b.c.) *Jan. 1878 / The fibres of sartorius running uncommonly / low.;* (b.l.) embossed stationers' stamp: building within oval

Inscriptions (v): (u.l.) *E. L. Courtney artist / 1539 Chestnut*

Cats. 46 and 47, and the more finished Hirshhorn version of the same knee—with its "uncommonly low" sartorius—were all executed in pencil on the same date; two of these sketches were then retraced in pen and ink, as if for archival or teaching purposes. In general, the drafting focuses on connective tissues and the interrelationship of the main fibrous structures. The text points to the exceptional sartorius placement, which evidently stimulated all three drawings.[1]

Dr. W. W. Keen may have brought his own research interests into the Academy's anatomy demonstrations, inspiring a sympathetic response in Eakins. This drawing, as well as cat. 47, examines a joint that Keen discussed in "A Lecture on the Clinical Anatomy of the Lower Extremity and Especially the Knee and Ankle Joints," published in 1881. Eakins developed his own interest in the function of ligaments and muscles in motion across such joints in the paper he read before the Academy of Natural Sciences in 1894: "The Differential Action of Certain Muscles Passing More Than One Joint" of the horse (see cats. 82–87). (JCT/CK)

1. Rosenzweig, p. 76, cat. 31a. The Hirshhorn's drawing, which came from CB, is inscribed "Right Knee. man. 18 Jan. 1878," with more detailed descriptions of aponeurotic slip. It is on the same embossed writing paper.

46

47

Dissection Study: Human [Fibres of Sartorius Running Uncommon(ly) Low], 1878

Pen and ink over graphite on cream wove paper (printed PAFA circular)

9⁹⁄₁₆ × 6 in. (24.3 × 15.2 cm)

1985.68.5.18

Inscriptions (r): (TE in ink over graphite, u.c.) *Subject of Jan. 1878. / Fibres of Sartorius running uncommon / low.;* (b.c.) *A. Hole in ligament between bones / B. Tendon of Adductor Magnus.*

Inscriptions (v): printed text describing "Study of the Living Model"

See cats. 45 and 46.

47 r 47 v

48

Dissection Study: Cat: Pectoral Muscle (r)

Dissection Study: Unidentified (v)

Graphite, red and blue pencil on foolscap (r)

Graphite, pen and ink (v)

7³⁄₁₆ × 11¾ in. (18.3 × 29.8 cm)

1985.68.5.19

Inscriptions: (TE in graphite, u.l.) *c.d & Sterno aponeurotic remove;* (u.r.) *Deep pectoral can be divided into / two parts the front part straight / fibres. The back part with tucking /* [word crossed out] *business;* (b.l. to b.r.) *Sterno aponeurotic runs back as far as end of ripped cartillary* [sic] */ Deep pectoral back to same place or little farther they both seem to run into linea alba. / Deep pectoral is inserted into strong*

aponeurosis inserted into outer edge bicipital groove & into
tendinous arch & into / coracoid process The tendinous arch
gives off expansion which [several words crossed out] *runs*
over the joint.; (u.r.) embossed stationers' stamp: star
with crown in wreath

Eakins' twelve dissection studies of the cat (nos. 48–59)
testify to the importance of this animal in the comparative
anatomy studies of this period. Horace Jayne, who was pro-
fessor of zoology at the University of Pennsylvania and direc-
tor of the Wistar Institute of Anatomy and Biology, particu-
larly recommended the study of the cat in the preface to his
book *Mammalian Anatomy* (1898). Jayne wrote that he had
devised a course of instruction "some years ago" at the uni-
versity "in the belief that a careful and exhaustive study of the
structure of an inferior animal would be an excellent prepara-
tion for the study of human anatomy and would form a foun-
dation broad enough for more extended work in morphol-
ogy." Dr. W. W. Keen reported to the PAFA's board of
directors on 7 April 1877 that Eakins had completed dissec-
tions and casts of the cat; these drawings may be from that
spring's work, although the dissections were probably re-
peated annually. Most of the drawings in this group are on
the same ruled paper with a distinctive blind stamp (a star
with a crown in a wreath), in red and blue pencil over
graphite; these common materials suggest that the drawings
were all done at the same time. Eakins' plaster casts of the cat
are still in the Academy's collection: 1991.7.15, .16, and .17.
(CK)

49

Dissection Study: Cat [Muscles of the Shoulder and
Neck]

Red and blue pencil over graphite on foolscap

7³⁄₁₆ × 11¾ in. (18.3 × 29.8 cm)

1985.68.5.20

Inscriptions: (TE in graphite, u.l.) *cat*; (u.c.) *Section rhom-*
boid. thickest just in front / of spine of scapula opposite
[crossed out] *antea spinatus*; (b.r.) *Natural size section. /*
Seen sideways in drawing / It lies under mastoid humeralis
/ (arising from its under fascia.) & / from the clavicle. The
clavicle seems / to be useful only [crossed out] *in keeping*
these muscles / spread around the front of shoulder; (u.l.)
embossed stationers' stamp: star with crown in wreath

See cat. 48.

50

Dissection Study: Cat [Pectoral Muscle] (r)

Dissection Study: Unidentified (v)

Graphite and blue pencil on foolscap (r)

Pen and ink over graphite (v)

7³⁄₁₆ × 11¾ in. (irr.) (18.3 × 29.8 cm)

1985.68.5.21

Inscriptions: (TE in graphite, b.l. and c.l.) identification of
muscle sections: *C, D*; (b.l.) *Section A*; (c.) *St.*[erno]
Aponeurotic; (b.l.) embossed stationers' stamp: star with
crown in wreath

This sketch describes the origin of the pectoral muscle at
the sternum (in blue pencil) and its insertion on the shaft of
the humerus. See cat. 48. (CK)

51

Dissection Study: Cat [Muscles of the Shoulders and
Back]

Graphite and red and blue pencil on foolscap

7⁵⁄₁₆ × 11¾ in. (18.6 × 29.8 cm)

1985.68.5.22

Inscriptions: (TE in graphite, u.r.) *Cat. right shoulder*
thrown out to / show serratus mag.[nus] *& lev.*[ator] */*
ang.[uli] *scapulae.*; (b.r.) *section of serr.*[atus] *mag*[nus]
and *lev.*[ator] *ang.*[uli] *scapul*[ae] */ showing its thickest*
portions.; (u.l.) embossed stationers' stamp: star with
crown in wreath

See cat. 48.

52

Dissection Study: Cat [Muscles of the Neck, Shoulder
and Thorax]

Graphite with red and blue pencil on foolscap

7³⁄₁₆ × 11¾ in. (18.3 × 29.8 cm)

1985.68.5.23

Inscriptions: (TE in graphite, u.c.) *Cat*; (u.l.) *Latissimus*
Dorsi & Pectoralis / fibres mingle at side of thorax. / The
back fibres A of Deltoid / very thin almost absent / front
part B moderately / heavy.; (u.l.) embossed stationers'
stamp: star with crown in wreath

See cat. 48.

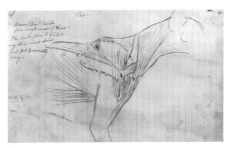

52

53

Dissection Study: Cat [Muscles and Tendons of the Hind Leg and Pelvis]

Red and blue pencil over graphite on foolscap

7¼ × 11¾ in. (18.4 × 29.8 cm)

1985.68.5.24

Inscriptions: (TE in graphite, u.c.) *Cat*; diagram illustrating location of two sections: *A; section; A This muscle / ph. sends off a very thin / tendon runs down behind / femur & finally inserted / into patella. resembling / above part of Gluteus / maximus of man.*; (b.r.) *Gluteus internus. part of fascia of insertion / goes down* [crossed out: *all th*] *gathering itself into a tendon / to reach the* [crossed out: *heel*] *os calcis*; (b.l.) *section of semitendinosus*; (b.l.) *section of gluteus externus / or long vastus*; (b.l.) embossed stationers' stamp: star with crown in wreath

54

Dissection Study: Cat [Major Muscles of the Leg]

Graphite and red and blue pencil on foolscap

7³⁄₁₆ × 11¾ in. (18.3 × 29.8 cm)

1985.68.5.25

Inscriptions: (TE in graphite, c.) *cat / G. Gastrocnemius cut & / pushed aside / P. Perforatus or flexor / sublimis or superficial / of the phalanges. / Pop. Popliteus / S. Soleus without doubt arising from* [crossed out: *pesaner (?)*] *fibula & oblique line of tibia* [crossed out: *by t*]; (u.l.) embossed stationers' stamp: star with crown in wreath

See cat. 48 and the other feline leg studies, cats. 55–58.

55

Dissection Study: Cat [Pelvis and Hind Leg; Muscle Cross-sections]

Graphite and red and blue pencil on cream laid paper

8 × 5⅛ in. (20.3 × 13 cm)

1985.68.5.26

Inscriptions: (TE in graphite, b.r.) *ST / SM / SM* [semitendinosus / semi-membranous]

See cat. 54.

56

Dissection Study: Cat [Muscles and Ligaments Crossing the Pelvis and Hind Leg]

Blue and red pencil over graphite on cream laid paper

8 × 5¼ in. (20.3 × 13.3 cm)

1985.68.5.27

Inscriptions: (TE in graphite, b.l.) *A long muscular / slip goes from sacro– / sciatic ligament to the / tendo-achilles it lies over / & in front of S.*[emi] *T.*[endinosus] *at origin / crosses it at the lower 4th. / & is covered itself by the / gluteus externus*; (u.r.) identifying cross section: *a b c d a b c d; Gluteus externus*

See cat. 54.

57

Dissection Study: Cat [Muscles and Tendons of Hind Leg]

Graphite on foolscap

7³⁄₁₆ × 5⅞ in. (18.3 × 14.9 cm)

1985.68.5.28

Inscriptions: (TE in graphite, u.r. to l.r.) *cat. / D tendon gastrocnemius / E" soleus / G." perforatus. / A. Peroneus longus / arising from / crest of tibia / B. Anterior tendon / of short peroneus / inserted into tendon / of extensor communis*[?] */ C. Posterior tendon of / short peroneus inserted into / base of metatarsals*

See cat. 54.

58

Dissection Study: Cat [Hind Leg and Pelvis]

Graphite and red pencil on foolscap

7¹³⁄₁₆ × 9¹⁵⁄₁₆ in. (19.8 × 25.2 cm)

1985.68.5.29

See cat. 54.

59

Dissection Study: Cat [Muscles of the Head]

Graphite and red and blue pencil on foolscap

7¼ × 11¾ in. (18.4 × 29.8 cm)

1985.68.5.30

Inscriptions: (TE in graphite, u.c.): *cat; section of splennis /
& little complexus.;* (c.) *section of complexus;* (l.c.) *com-
plexus;* (u.l.) *grand and small right / posterior of head.;*
(b.l.) *section grand oblique of head. / little oblique;* (b.l.)
embossed stationers' stamp: star with crown in wreath

See cat. 48.

60

Dissection Study: Dog [Major Muscles of Face and Skull], c. 1878

Pen and black, blue, and red inks over graphite on buff
paper

8 × 10 in. [irr.] (20.3 × 25.4 cm)

1985.68.5.31

Inscriptions: (TE in black ink over graphite, u.l.) *Masseter
muscle Short fibres going down from / external fascia to the
bone;* (c.l.) *A large bunch of fibres of temporal mus- / cle
arise from top of zygomatic / arch;* (u.r.) *section of masseter
muscle* [loss] */ tendinous laminae*[?] [loss] */ top; external /
bottom*

Study of the dog was a regular part of the comparative
anatomy program, sometimes thanks to the cooperation of
the Philadelphia City Dog Pound. Letters to and from the
superintendent of the pound in February 1879 tell that a
"muscular bloodhound" was offered to the PAFA anatomy
classes that month.[1] Some of the seven canine dissection
studies in the collection (e.g., cat. 65) may be of this particu-
lar animal.

This drawing may be from the year before, according to
Keen's report to the board of directors on 2 April 1878: "Not
only was the human body dissected," he wrote, "but when on
the face they prepared for me the muscles of the face in the
horse, the dog and the sheep with illustrative diagrams so
that I was enabled to incorporate the Comparative Anatomy
of Expression into the course."[2] Two years later Keen re-
ported that animal skeletons from the Academy of Natural
Sciences had been borrowed to illustrate his lectures. "The
comparative anatomy of the muscles of the face was as
heretofore illustrated by dissections of the heads of severed
quadrupeds; that of the rest of the body chiefly by drawing."[3]
(CK)

1. Letters of 3 and 18 Feb. 1879, PAFA Archives. See also Onorato
1979, p. 124, n. 32.

2. PAFA Archives. See also drawings of the facial muscles of the
horse, cat. 69, and the sheep [?], cat. 76.
3. 10 May 1879, PAFA Archives.

60

61

Dissection Study: Dog [Muscles of the Shoulder]

Pen and ink over graphite on foolscap

7⅞ × 11 in. (20 × 27.9 cm)

1985.68.5.32

Inscriptions: (TE in ink over graphite, u.r.) *Dog;* (u.c. to
u.r.) *Trapezius* [in graphite only, crossed out: *comes from
ap*] *arises by / pointed extremity in aponeurosis* [in
graphite only, crossed out: *opp*] */ The point is over the
10th. rib.;* (c.r.) *right shoulder / blade;* (b.r. on diagram
twice) *aponeurosis;* (c.) *dog occipital;* (c.l.) *dog; scapula;* (in
graphite, u.l. to b.l.) *rhomboid / Girard 2 muscles cervico
sous scapulaire et dorso sous scapulaire*

This sheet was originally folded in half to carry four sep-
arate drawings of the muscle fibres and tissue surrounding
the scapula. The sketches show the direction and attenuated
form of the fibers as they arise from aponeurotic tissue or at-
tach to the scapula. See also cat. 60. (CK)

62

Dissection Study: Dog [Muscles of the Thorax]

Pen and ink over graphite on foolscap

7¾ × 12⁷⁄₁₆ in. (19.7 × 31.6 cm)

1985.68.5.33

Inscriptions: (TE in ink over graphite, b.c.) *Platysma ¹⁄₁₆
inch / thick except on side / of chest & abdomen / where it is
3/8 inch thick;* (b.r.) *A Latissimus dorsi: the / platysma be-
comes very thin / before vanishing at the / edge. . . . ;* (c.) *A;*

(c.r.) *TRAPEZIUS;* (u.r.) embossed stationers' stamp: building within oval

See cat. 60.

63

Dissection Study: Dog [Pectoral Muscles]

Pen and ink over graphite on foolscap

11 × 7⅞ in. (27.9 × 20 cm)

1985.68.5.34

Inscriptions: (TE in ink over graphite, u.c.) *dog;* (c.) on diagram) *A B C D H;* (u.l.) *8th rib;* (c.) *A. superficial pectoral / B. profound pectoral much larger than super. / C.D. cellular intervals. / H. Humerus. / Fibres of super. pectoral do not tuck in under / like in man & monkey.;* (u.l.) embossed stationers' stamp: cropped

Eakins' annotations reveal that he was also familiar with monkey anatomy, either by dissection or from books. He later kept a monkey as a pet. See also cat. 60. (CK)

64

Dissection Study: Dog [Muscles of Hindquarters]

Pen and blue and red ink over graphite on cream wove paper

8 × 10 in. (20.3 × 25.4 cm)

1985.68.5.35

Inscriptions: (TE in ink, u.c.) *Dog. / Great oblique & Great rectus posterior;* (b.l.) embossed stationers' stamp: coat of arms with crown in wreath / *PARIS*

See cat. 60.

65

Dissection Study: Dog [Muscles of the Hind Leg]

Pen and blue, red, and black ink over graphite on buff paper

10 × 7¹⁵⁄₁₆ in. (irr.) (25.4 × 20.2 cm)

1985.68.5.36

Inscriptions: (TE in black ink, u.c.) *Dog*

This drawing depicts the skeletal structure in blue ink, the muscle fibers in red ink, and the location of dissection incisions (from which cross sections were taken) in black. This muscular dog may be the bloodhound dissected in February 1879; see cat. 60. (CK)

66

Dissection Study: Dog [Panniculus carnosus]

Graphite and red pencil on foolscap

7¼ × 11¾ in. (18.4 × 29.8 cm)

1985.68.5.37

Inscriptions: (TE in ink, u.c.) *Dog ¼th size;* (b.c.) *Panniculus carnosus.;* (in red pencil [effaced]) *pan carnosus;* (b.l.) embossed stationers' stamp: star with crown in wreath

According to *Dorland's Medical Dictionary,* panniculus carnosus is a "thin muscle layer within the superficial fascia of animals with a hairy coat." The external form of the dog, lateral view, is aggressively sketched in graphite. Red pencil is used to indicate the membrane sheath over the greater portion of the dog's torso. See also cat. 60. (CK)

67

Dissection Study: Lion [Deltoid and Biceps], 1885

Pen and ink and blue pencil over graphite on foolscap

7¹³⁄₁₆ × 12½ in. (19.8 × 31.8 cm)

1985.68.5.38

Inscriptions: (TE in ink over graphite, u.c.) *Lion;* (u.r.) *A deltoid / B biceps / The scapula is nearly horizontal / whereas the horse's is nearly perpendicular / The deltoid is developed much more in lion / & resembles man's more. The infra spinatus / is very small compared with horse's but supra / spinatus is much larger. enormous. / The long extensor cubili cannot be separated from / biceps as in horse.;* (c., on diagram) *A; B;* (u.l.) embossed stationers' stamp: building within oval

On 25 November 1885, Eakins reported to PAFA's Committee on Instruction that the cadaver of a lioness that had died at the Zoological Society Gardens had been brought to the Academy for study. A plaster cast of the body was made and later donated to the Academy of Natural Sciences.[1] Two surviving drawings (cats. 67 and 68) record Eakins' dissection of the cadaver, an event memorable enough to gain remark in Susan Eakins' diary.[2]

Compared with Eakins' detailed and procedurally fastidious dissection drawings of the cat, these studies are bold and simplifying, indicating Eakins' long experience as well as his focused interests. His annotations show his interest in animal locomotion and comparative anatomy, particularly human and equine forms. The ideas that he was to present nine years later in his paper "Differential Action" are already evident in his comments on the lion; see cats. 82–87. (CK)

1. PAFA Archives; see also *Minutes of the Committee on Instruction, 1895–1903,* 34.
2. SME's entry for 8 Nov. 1885: "Tom dissects a lioness" (Retrospective diary, CBTE).

68

Dissection Study: Lion [Muscles of Hind Quarters and Leg], 1885

Pen and ink over graphite on foolscap

7¾ × 12⁷⁄₁₆ in. (irr.) (19.7 × 31.6 cm)

1985.68.5.39

Inscriptions: (TE in ink over graphite; the inscriptions in graphite differ slightly from the ink version. Recorded here are the inscriptions in ink.) (u.c.) *Lion;* (u.l.) *The front fibers of it / still very thin & pale / may be called the tensor / vag. femoris but there / is no separation from / gluteus superficialis. / D by its origin looks like / a sartorius but some / of its fibres are / inserted / like rectus directly into / patella but the others are inserted inside knee like / sartorius.;* (b.l.) *Patella; This B is a very powerful / motor of tail & may assist in the / spring & by the weight of the tail in /* [loss] *the exact length of leap after /* [loss] *taken;* (u.r. to b.r.) *A. Pat.*[ella] [losses] */ of Gluteus superficialis arising / from surface of Gluteus / medius. Their lower edge / inserted into very thin / aponeurosis. / B has a strong tendon at its lower / insertion & is inserted principally into / patella some aponeurotic fibres going / to the fibula. This tendon / is covered by C more / fibres of gluteus externus / B is very thick muscle / May probably be considered part of / gluteus like / few fibres / that come / off from / coccyx* [loss] */ m* [loss]; (b.r.) *B natural size section;* (c., on diagram) *A / B / C / D;* (b.l.) embossed stationers' stamp: building within oval

See cat. 67.

68

69

Dissection Study: Horse [Muscles of the Snout]

Pen and ink over graphite on foolscap

7¾ × 12⁷⁄₁₆ in. (19.7 × 31.6 cm)

1985.68.5.40

Inscriptions: (TE in ink over graphite, u.c.) *Lev.*[ator] *Lab.*[ii] *Sup.*[erioris]. */ Alaque nasi;* (c.r.) *tendon of sus maxillo-labial;* (b.r.) embossed stationers' stamp: building within oval

The horse was a subject of special interest for Eakins, who made it a touchstone in the Academy's comparative anatomy curriculum. Four dissection studies and three sketches (cats. 69–75), along with related motion studies and illustrations (cats. 81–89) demonstrate the range of his study. These drawings are part of an investigation in all media, including oil, sculpture, and photography, that occupied Eakins between the late 1870s and the mid-'90s.

The first group of dissection studies and sketches probably dates from 1876–80, when Eakins was actively teaching anatomy and dissection. Charles L. Fussell's painting *Academy Students Dissecting a Horse* (PAFA) illustrates the work that inspired many of these drawings. Some of Eakins' diagrams may have been records of such a dissection; others could have been made as illustrations for Keen's lectures. The study of a horse's snout (cat. 69) may be in preparation for drawings used in Keen's "Comparative Anatomy of Expression" lecture of 1878 along with drawings of the facial muscles of the dog and sheep (see cat. 60).[1]

Eakins' expertise in the realm of equine anatomy must have impressed Fairman Rogers, the chairman of the Academy's Committee on Instruction during these years. Rogers bred horses and had attempted to photograph them in motion; he and Eakins must have had many conversations about both anatomy and locomotion, leading to the commissioning of the painting *The Fairman Rogers Four-in-Hand* (fig. 140, plate 12) in 1878. Some of these drawings, such as cats. 70 and 71, or the quicker sketches (cats. 73–75) may relate to preparations for this painting (see chap. 15).

Eakins' artistic interests are evident in all these drawings, for without exception they examine the visible impact of anatomical structures on the surface of the living horse. Skeletal configurations and especially muscle forms and their origins or insertions preoccupy Eakins in these drawings, for he was interested in the depiction of proper weight-bearing posture and movement. Tendons and aponeurotics, forming the attachment of muscles to the joints, dominate these drawings, as they do in the scholarly paper Eakins presented in 1894, "The Differential Action of Certain Muscles Passing More Than One Joint"; see cats. 82–87. His expertise also brought artistic fruit in this decade, when he worked on two sculptural commissions featuring horses: the Trenton Battle monument, of 1892–93, and the Brooklyn Memorial Arch, begun in 1893. (KJ/CK)

1. A more detailed version of this subject, also from CB's collection and on the same type of paper, is in the Hirshhorn Museum; see Rosenzweig, pp. 76–77, cat. 31c.

69

70

Dissection Study: Horse [Major Muscles of Left Hind Leg]

Graphite and red pencil on foolscap

12⁷⁄₁₆ × 7¹³⁄₁₆ in. (31.6 × 19.8 cm)

1985.68.5.41

Inscriptions: (TE in graphite throughout) letters *a* through *e* corresponding to descriptive inscriptions; (in graphite, u.r. to b.r.) *drawing of / left hind / inner quarter / It represents gracilis / & sartorius with / middle removed. / a sartorius / b. gracilis / c. common tendon / of gracilis & sartorius / d. semimembranosus / e adductors /* [illegible]; (u.r.) embossed stationers' stamp: building within oval

See also cat. 71.

71

Dissection Study: Horse [Right Hind Leg]

Pen and ink over graphite on foolscap

12⁷⁄₁₆ × 7¹³⁄₁₆ in. (31.6 × 19.8 cm)

1985.68.5.42

Inscriptions: (TE in ink over graphite, c.r.) *right hind leg / front aspect.;* (u.l.) embossed stationers' stamp: building within oval

See also cat. 70.

71

72

Dissection Study: Horse [Muscle Insertions on Foreleg]

Pen and black and blue inks over graphite on foolscap

7⅞ × 12⁷⁄₁₆ in. (20 × 31.6 cm)

1985.68.5.43

Inscriptions: (TE in black ink over graphite, on diagram) *A / B / C;* (c.l.) *C. Aponeurotic / radial insertion of / the pectoralis;* (c.r.) *A. Insertion / subscapularis / B. Pectoralis & / Antea spinatus;* (b.l.) embossed stationers' stamp: building within oval

This drawing shows two studies of the upper part of a horse's fore leg, with special attention to the aponeurotic insertions around the joints. The drawing on the left shows scapula, humerus and the olecranon (head of the radius). The shaded portion "C" indicates the sheath-like aponeurotic insertion (or attachment) of the large muscle of the chest, the pectoralis, to the bones of the upper fore leg. The drawing on the right shows the location of the insertion of scapular and pectoral muscles on the humerus.

This sheet is closely related to a drawing at the Hirshhorn which shows the same horse's leg from the other side.[1] See also cat. 69 and related drawings for Eakins' paper on "The Differential Action of Certain Muscles Passing More than One Joint," cats. 82–87. (KJ/CK)

1. Rosenzweig, cats. 31b, 76–77, 84, 136. This drawing, also from CB's collection, is on the same type of foolscap. The inscriptions in the Hirshhorn catalogue occasionally misread Eakins' handwriting; he frequently failed to cross his t's. "Leres" should be read as "teres," "spunstus" as "spinatus."

73

Horse Sketch with Measurements, 1878–80

Graphite on foolscap

8¹⁄₁₆ × 6⁷⁄₁₆ in. (irr.) (20.5 × 16.4 cm)

1985.68.5.44

Inscriptions: (TE in graphite, u.c.) [to height of shoulder blade] *63¼" high;* [to height of rump] *62¾ high;* (u.r.) *17¼ wide shoulder / 22 inches wide rump / 10 in. between middle of heels;* (b.r.) *37 rump / 41¾ shoulder / 10 inches between the heels;* arithmetical notations, *curves rump*

This sketch was attached to 1985.68.5.45 along the upper left margin; see cat. 74. (CK)

73

74

Horse: Rear View, 1878–80

Graphite on foolscap

6⁵⁄₁₆ × 4¹⁄₁₆ in. (irr.) (16 × 10.3 cm)

1985.68.5.45

This sketch was attached to 1985.68.5.44 along the lower edge; see cat. 73 and a similar drawing in the "Washington Sketchbook" of c. 1877, cat. 189e. (KF)

75

Horse: Top View of Hindquarters, 1878–80

Graphite on cream wove paper

7¹⁄₁₆ × 9⁷⁄₈ in. (17.9 × 25.1 cm)

1985.68.5.46

Inscriptions: (TE in graphite, b.l. to b.r.) *Thin horse right angles to back showing the set of pelvis*

75

76

Dissection Studies: Unidentified Animal [Muscles and Cartilage of the Ear]

Pen and ink over graphite on foolscap

12⁷⁄₁₆ × 7¹³⁄₁₆ in. (31.6 × 19.8 cm)

1985.68.5.47

Inscriptions: (TE in black ink over graphite, u.l. to u.r.) *External scuto-auricular is very / flat & thin rotates opening of ear forwards. / Internus a heavy muscle same thickness as / sus maxillo labial.;* (on diagram, u.c.) *Scutiform Cartilage;* (on diagram, c.l.) *Scutiform / natural / size / traced.;* (c.r.) *Under scutiform cartillage / is a strong muscle for / rotating back the opening / of the ear.;* (b.r) *Same drawing / as above / scutiform supposed / to be transparent / showing Scuto / auricularis / internus to / rotate back / opening of the ear;* (b.c. to c.) *lower lip turned back head upside down / mucous membrane removed;* (u.l.) embossed stationers' stamp: building within oval

Five of the six anatomical dissection studies categorized as "Unidentified" (cats. 76–80) can probably be considered a group drawn on the same occasion from a single animal. The first five drawings are all on a blue-lined foolscap sheet with a one-and-three-quarter-inch margin at the top. Four of the five studies are characterized by a loosely handled graphite sketch that is drawn over in heavy black ink. The fifth drawing has, in addition, red and blue pencil traced over in red and blue inks.

Eakins' inscriptions identify one sketch, cat. 76, as a study of an animal's ear. Another study, cat. 79, is clearly a leg and a pelvis, which is compact, sturdy, and with a strong curvature of the femur characteristic of a cow, sheep, or work horse.

Keen's report to the board of directors in 1877 states that Eakins "expects soon to dissect . . . the Horse and the Sheep" and requests that Eakins be authorized to make casts of the dissections, explaining that "they are among the animals most frequently represented in art & the possession of such studies of their muscular systems would be of great use to the students in general & especially as additional means of illustrating my Lecture by a reference to their comparative anatomy."[1] (CK)

1. 7 Apr. 1877, PAFA Archives. Cows were studied by students in PAFA modeling classes, but no reference to the dissection of a cow has been found in Keen's reports.

77

Dissection Study: Unidentified Animal [Insertion of Muscle or Fascia at Joint]

Pen and brown ink over graphite on foolscap

7¾ × 12⁷⁄₁₆ in. (19.7 × 31.6 cm)

1985.68.5.48

Inscriptions: (b.l.) embossed stationers' stamp: building within oval

See cat. 76.

78

Dissection Study: Unidentified Animal [Muscle Insertion]

Pen and ink over graphite on foolscap

12⁷⁄₁₆ × 7⅞ in. (irr.) (31.6 × 20 cm)

1985.68.5.49

Inscriptions: (b.l.) embossed stationers' stamp: building within oval

See cat. 76.

79

Dissection Study: Unidentified Mammal [Muscles of the Hind Leg and Pelvis]

Pen and black, blue, and red ink over graphite and red and blue pencil on foolscap

12⁷⁄₁₆ × 7¹³⁄₁₆ in. (31.6 × 19.8 cm)

1985.68.5.50

Inscriptions: (u.l.) embossed stationers' stamp: building within oval

See cat. 76.

79

80

Dissection Study: Unidentified Animal [Muscles of the Ear]

Pen and ink over graphite on foolscap

12½ × 7¹³⁄₁₆ in. (irr.) (31.8 × 19.8 cm)

1985.68.5.51

Inscriptions: (TE in ink over graphite, u.r.) *scutiform;* (b.l.) embossed stationers' stamp: building within oval

81

Dissection Study [?]: Sections 9–15, 1876–80?

Pen and red and blue ink, and graphite on buff wove paper

31⁷⁄₁₆ × 18¾ in. (irr.) (79.9 × 47.6 cm)

1985.68.33.6

Inscriptions: (TE in graphite, on diagram, u.l. to b.r.) *Section 9; Section 9; Section 10* [?]; *Section 10; Section 11; Section 12; Section 12 / 12; Tacked Under Section; 14; Section 13; 15; 13*

This large and puzzling drawing may be related to Eakins' anatomical studies because of the references to "sections" and the shapes that suggest cross sections similar to his dissection studies—for example, cats. 30–40. The grid lines, marking units of one and a half inches, suggest the life scale of a small animal. However, the identification of the subject is confused by the repetition of numbers within the diagram, and no drawings have been found corresponding to these shapes or annotated with these section numbers. Sets of tack holes in each corner may indicate that Eakins used this as a wall chart during lectures. The paper quality is similar to that of his late perspective drawings, which may mean that this drawing was made two decades after his other anatomical studies. (KF)

81

Eakins presented his paper "Differential Action of Certain Muscles Passing More Than One Joint" before the members of the Academy of Natural Sciences of Philadelphia on 1 May 1894. His text was published in the Academy's *Proceedings* (1894), along with six illustrations. Eakins' original drawings for this publication (cats. 82–86) may have also served him as lantern slides during his lecture, although such plates have not been found.[1] Another drawing, cat. 87, seems to have been a preparatory study for these illustrations.

This paper was the culmination of dissection and motion studies of the horse begun by Eakins in the late 1870s, partly as a result of his response to Eadweard Muybridge's photographs of animal locomotion. Alert to errors in standard anatomical texts (compare the introduction to the anatomical drawings, n. 21, and cat. 44), Eakins was capable of challenging what seemed to be inconsistent or inadequate explanations by conducting his own research. His paper on "Differential Action" proved that "certain muscles" in a horse's leg worked simultaneously, not in alternation, according to conventional wisdom. Much of Eakins' text is quoted or paraphrased in Goodrich 1982, II: 128:30. (KF)

Differential Action Illustrations, 1893–1894

1. According to a note in the *Proceedings* (p. 173), Eakins showed photographs made in 1883 to illustrate his points. Lantern slides from his photographs made in the shed at the University of Pennsylvania in 1885 were also used in this lecture; one remains in the Bregler collection (see Goodrich 1982, II: 129, 326, and PAFA Archives, glass positive 1985.68.2.618). Other photographic prints in the collection from this series are 1985.68.2.405a (H 119), .406, and .407 (H 120), and three pictures not in Hendricks: .405b, .408, .409. Glass negatives in CBTE include 1985.68.2.1004 (H 119), .1001 (H 120 reversed), and two not in Hendricks: .1003 (a variant of H 120) and .1002 (a variant of H 121). See Danly and Leibold, 206.

82

Differential Action: Fig. 1 [Model of Levers and Pulls Approximating Horse's Leg], c. 1894

Pen and ink over graphite on cream wove paper

7¼ × 6⅞ in. (irr.) (18.4 × 17.5 cm)

1985.68.6.1

Inscriptions: (TE in ink, u.l.) *Reduce to ⅓ this size;* (in graphite, b.c.) *Fig. 1;* (u.r.) *7710* [upside down]

References: *Proceedings of the Academy of Natural Sciences* (1894), 173.

82

83

Differential Action: Fig. 2 [Model of Levers and Pulls Approximating Horse's Leg], c. 1894

Pen and ink over graphite on cream wove paper

5½ × 7¾ in. (irr.) (14 × 19.7 cm)

1985.68.6.2

Inscriptions: (TE in ink, u.l.) *2;* (in graphite, b.l.) *Reduce to ⅓;* (in graphite, b.l.) *7710;* (b.c.) *fig. 2*

References: *Proceedings of the Academy of Natural Sciences* (1894), 174.

84

Differential Action: Fig. 3 [Bone Structure of Horse's Front Leg], c. 1894

Pen and ink over graphite on foolscap

11¹³⁄₁₆ × 7¾ in. (30 × 19.7 cm)

1985.68.6.3

Inscriptions: (TE in graphite, u.r.) *Reduce to ⅓;* (in ink, u.r.) *3;* (in graphite, b.l.) *7710;* (b.c.) *Fig. 3*

References: *Proceedings of the Academy of Natural Sciences* (1894), 175.

85

Differential Action: Fig. 4 [Bone Structure of Horse's Hind Leg], c. 1894

Pen and ink on cream wove paper

10⁵⁄₁₆ × 3⅜ in. (irr.) (26.2 × 8.6 cm)

1985.68.6.4

Inscriptions: (TE in graphite, u.l.) *Reduce to ½;* in ink, u.r.) *4;* (in graphite, b.l.) *7710;* (b.c.) *Fig. 4*

References: *Proceedings of the Academy of Natural Sciences* (1894), 175.

85

86

Differential Action: Fig. 5 and Fig. 6 [Tendon Crossing the Knee Joint of the Horse; The Arm of the Horse], c. 1894

Pen and ink on cream wove paper

10¼ × 7⁷⁄₁₆ in. (irr.) (26 × 18.9 cm)

1985.68.6.5

Inscriptions: (TE in graphite, b.r.) *fig. 5;* (b.l.) *fig. 6;* (in ink crossed out in graphite, u.r.) *6;* (u.l.) *5;* (in graphite, u.c.) *Reduce to ½;* (b.l.) *7710*

References: *Proceedings of the Academy of Natural Sciences* (1894), 177, 179.

87

Differential Action: Study of Skeletal Structure of Horse's Hind Leg and Pelvis, c. 1894

Graphite on off-white wove paper (blue-lined on verso)

17 × 14 in. (43.2 × 35.6 cm)

1985.68.6.6

This drawing relates to an illustration of the hind leg of a horse, fig. 4 of Eakins' article (cat. 85), but details suggest that it could be a preliminary anatomical study on which the mechanical model of the leg, illustrated in figs. 1 and 2 (cats. 82, 83), was based. Pinholes are placed through the center of points on the bones of the leg near the joints: at the head of the femur and at the condyle at the base of the femur; at the tarsus bone (connecting the base of the tibia with the metatarsus or lower leg bone; and one each at the first phalanx (joint of the fetlock) and second phalanx (joint of the pastern) of the foot. Ruled lines are drawn connecting these points. The placement of these "hinges" corresponds with Eakins' description of the simple stick and rubber band models he devised to imitate and clearly illustrate the mechanics of muscle leverage in animal locomotion. (CK)

87

Related to Eakins' interest in anatomy are the following twenty-five drawings concerned with animal locomotion. These studies were inspired by Eakins' introduction to the photographs of Eadweard Muybridge, probably in 1877, and were incorporated into his work on *The Fairman Rogers Four-in-Hand* (fig. 140). They relate to a suite of photographs of human subjects in 1884–85 and figures on horseback in the 1890s. His interest in the horse, seen in all the motion studies in the Bregler collection, also produced his own original research on equine anatomy and locomotion; see cats. 82–87. (KF)

Motion Studies

88

Motion Study: Hind Leg of Horse in Three Phases of Gallop, c. 1884?

Pen and ink over graphite on buff wove paper

18¼ × 23⅞ in. (irr.) (46.4 × 60.6 cm)

1985.68.6.7

Inscriptions: (TE in graphite, b.l. to b.r.) numbered diagonal graph 0–60 in increments of 10; (b.r.) arithmetical notations; (u.l.) [numbered diagram 6–60 in increments of 6]; (u.c.) arithmetical notations; (u.r.) *64 12½ in.*

Eakins' drawing shows the hind leg of a horse in three consecutive phases of a gallop, lateral view. The three drawings are placed on a penciled grid of 252 (12 × 21) one-inch squares, each representing 5 inches in life. They detail the skeletal structure at one-fifth scale in graphite within a black ink and graphite contour of the outer form of the horse.

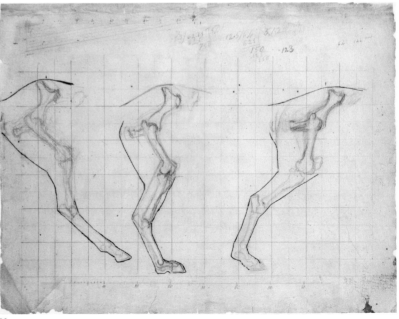

88

This study is probably related to the series of locomotion studies done by Muybridge, or possibly by Eakins and Muybridge at the University of Pennsylvania in 1884.[1] It is clearly of a gallop and not of a slow gait or trot, which rules out any direct relationship of the drawing to *The Fairman Rogers Four-in-Hand.* (CK)

1. See *Animal Locomotion: The Muybridge Work at the University of Pennsylvania. The Method and the Result* (Philadelphia: J.B. Lippincott, 1888), 31, 61, 62; Eadweard Muybridge, *Descriptive Zoopraxography, or the Science of Animal Locomotion Made Popular . . .* (Philadelphia: University of Pennsylvania, 1893), 39.

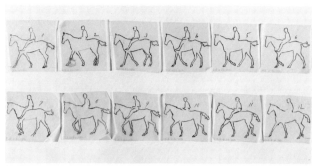

89

89

Motion Studies: Man on Horseback Facing Left (1–12), c. 1887–92

Pen and ink on twelve pieces of tracing paper

Inscriptions: (TE in ink, u.r.) each drawing numbered consecutively, 1–12:

1. 3 × 3 in. (7.6 × 7.6 cm)
2. 3 × 2¹⁵⁄₁₆ in. (7 × 7.5 cm)
3. 3 × 3¹⁄₁₆ in. (7.6 × 7.8 cm)
4. 2⅞ × 3 in. (7.3 × 7.6 cm)
5. 2¹³⁄₁₆ × 3 in. (7.1 × 7.6 cm)
6. 2¾ × 3½ in. (7 × 8.7 cm)
7. 2¾ × 3⅛ in. (7 × 7.9 cm)
8. 2¾ × 3 in. (7 × 7.6 cm)
9. 2¾ × 3 in. (7 × 7.6 cm)
10. 2¾ × 3 in. (7 × 7.6 cm)
11. 2¹³⁄₁₆ × 2¹⁵⁄₁₆ in. (7.1 × 7.5 cm)
12. 2¾ × 3 in. (7 × 7.6 cm)

1985.68.6.8.1–12

These drawings are direct tracings from Eadweard Muybridge's photographs, published in *Animal Locomotion*, vol. 9: *Horses* (Philadelphia: University of Pennsylvania, 1887). The tracings are of the upper set of twelve frames of plate 580, *Annie G. [walking, saddled.]*, and read in sequence from right to left. These tracings may have been done at the same time Eakins was developing his sculptures of horses for the Brooklyn Memorial Arch (1891–92). Muybridge's photos also may have inspired the similar series of images of Eakins on horseback taken in the 1890s; see also cats. 90, 91, and CBTE photographs 1985.68.2.296–310. (CK/KF)

90

Motion Studies: Man on Horseback, Facing Right, c. 1887–92

Pen and ink on twelve pieces of tracing paper

1. 3 × 2¹³⁄₁₆ in. (7.6 × 7.1 cm)
2. 3 × 2¹⁵⁄₁₆ in. (7.6 × 7.5 cm)
3. 3 × 3¹⁄₁₆ in. (7.6 × 7.8 cm)
4. 2⅞ × 3 in. (7.3 × 7.6 cm)
5. 2¹³⁄₁₆ × 3 in. (7.1 × 7.6 cm)
6. 2⅞ × 3⅜ in. (7.3 × 8.6 cm)
7. 2¹³⁄₁₆ × 3⅛ in. (7.1 × 7.9 cm)
8. 2¾ × 3 in. (7 × 7.6 cm)
9. 2¹¹⁄₁₆ × 3 in. (6.8 × 7.6 cm)
10. 2¹³⁄₁₆ × 3 in. (7.1 × 7.6 cm)
11. 2¹³⁄₁₆ × 2¹⁵⁄₁₆ in. (7.1 × 7.5 cm)
12. 2¹³⁄₁₆ × 3 in. (7.1 × 7.6 cm)

1985.68.6.9.1–12

Inscriptions: (TE in ink, u.l.) each drawing numbered consecutively. *1–12*

These tracings are taken from plate 577, *"Clinton" Walking, Mounted, Irregular*, of Muybridge's *Animal Locomotion*, vol. 9: *Horses*. The numbers inscribed on the tracings correspond to the frame numbers on the photographs. This set of tracings is less precise, and more loosely traced than cat. 89. (CK)

91

Motion Studies: Notes and Sketches, c. 1884–85

Graphite on foolscap

11⅛ × 8¼ in. (28.3 × 21 cm)

1985.68.23

Inscriptions: (TE in graphite, u.r.) *The old horse was cer-*

*tainly / entirely clear for an instant / A horse said to be
weak / in the loins, was not clear / at first. Increasing his /
speed he was clear. Lowering / his speed again he was still /
clear & we did not get his first / movement again. / Nettle
in jumping over gate landed / on her fore feet together / or
very, very nearly. / They* [word *horses* inserted above]
were not mounted.; (b.r.) *ft inches / 4.7½ / 2¼ inches /
wider at top / than at bottom / 4 ft 6 in / at bottom / Possi-
ble variation / of 4 inches.;* (b.l.) *black summer[?] red white
/ light / black / shadow / black white / hole light / shade;*
(b.l.): *40 42 / 10 10½*

Eakins' observations of horses jumping must be related
to his interest in motion photography and the study of ani-
mal locomotion. The sketches at the bottom of the page re-
semble a zoetrope, which Eakins used in lectures at the
Academy by 1885.[1] His diagrammatic notes on light, shadow,
and the location of holes may refer to his computations for
the improved Marey wheel camera he developed in 1884–85.[2]
(KF)

1. See the photograph of a zoetrope and a description of Eakins' use
of it in Homer and Talbot, p. 215, fig. 16. Bregler remembered that
"Eakins had made a zoetrope which was on a table in the library at
the Academy. As I remember there was a photo of a horse and a
man on his back. Students would turn this—see the horse gallop-
ing," as in a motion picture (CB to PAFA, 11 May [1953], PAFA
Archives). Eakins' tracings, cats. 89 and 90, may have been made
for use in a zoetrope.

2. Homer and Talbot, 210–212.

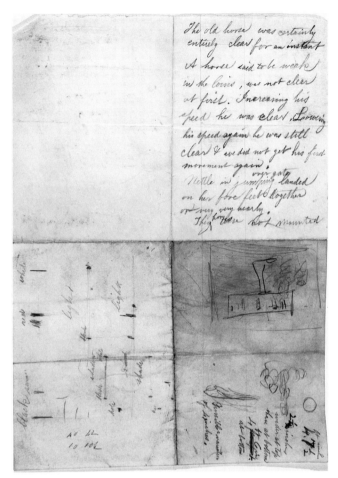

91

Eakins volunteered to teach an informal course in perspective at the Pennsylvania Academy in 1877; in March 1880 he delivered his first official lecture on the topic. Over the next five years he developed a standard series of annual lectures on special drawing techniques. At some point it occurred to him to publish these lectures as a small illustrated handbook. Manuscript drafts of this text, often in duplicate, are in the PMA and PAFA.[1] Siegl has dated the PMA manuscript to about 1884, but the material was certainly developed earlier and worked on while he taught at the Art Students' League, where he continued to deliver these lectures.[2] Bregler's collection now yields the illustrations to this text, most of them finished and ready for photomechanical reproduction, with instructions to the printer included.

The principal sections of this manual cover linear perspective, mechanical and isometric drawing, reflections in water, and sculptural relief, with a brief discussion of shadow. Very long and technical mathematical sections on camera lenses and the refraction of light through lenses are included in the PMA papers, while the PAFA manuscripts include more complicated perspective assignments. No drawings have been found to illustrate this last material, which may have been undertaken more for Eakins' own pleasure than for teaching.

Although the manuscript material is somewhat irregular and disordered, the numbered drawings indicate the sequence Eakins intended for the presentation of his material. Most of the finished drawings are numbered in the same slightly brownish ink, different from the black ink in the drawings, as if he assigned these numbers later.[3] However, the later illustrations are titled only in pencil, with tentative letter-numbers (a^1, a^2, a^3, etc.) indicating some incompleteness at this stage of the manuscript. Many drawings are annotated with instructions to the printer, however, indicating that publication was at hand. It is not known why Eakins abandoned this project, although the upset of his departure from the Academy and the gradual erosion of his student audience after 1886 must have been factors. The style, context, and content of this manual are discussed in chap. 7 (KF)

1. This manuscript, which was once in CB's collection, is catalogued by Siegl, 109. The drafts of Eakins' text at the PMA were typed and edited by Siegl in the early 1970s with a view to their eventual publication. For convenience, this more legible and paginated typescript has been used for reference in the text. I am grateful to Darrel Sewell for permission to cite from this transcript. A coordinated publication uniting Eakins' drawings and his text in a format following his original intentions is planned. The Bregler collection contains an incomplete draft of portions of the more polished text at the PMA. This manuscript material is now in the PAFA Archives; see also Foster and Leibold, 184, and fiche series I 8/C/3–8/D/7. Also at PAFA are CB's notes, taken either from Eakins' lectures or from the manuscript; see Foster and Leibold, 187, and fiche series I 10/E/2–11/E/5. These notes often include small sketches, confirming the relationship of the illustrations to the text.

2. Siegl, 109. Three of the drawings for this manual are on paper with

watermark dates 1881, 1883, and 1887. The latest drawing (cat. 112) may be a belated revision of earlier work, but it proves that Eakins was working on this manuscript after leaving the Academy in 1886.

3. Most of the numbered drawings after *Drawing 13* show a revised numbering system, indicating the insertion of new illustrations and subsequent renumbering; see, e.g., cat. 110.

93

92

Drawing 1 [The Law of Perspective]

Pen and ink over graphite on cream wove paper

Watermark: J WHATMAN 1881

15½ × 22¼ in. (39.4 × 56.5 cm)

1985.68.3.1

Inscriptions: (TE in graphite, b.l.) *Drawing 1* (in black ink, b.l.) *Drawing 1.*; (c.l.) *A / B*; (c.) *A′ / B′*; (c.r.) *E*

References: TE, "Linear Perspective" (PMA typescript), chap. 1, pp. 2–3; CB, notes on linear perspective, PAFA Archives, 4–5.

Fig. 54

This drawing, intended as the first illustration in Eakins' drawing manual, demonstrates the "one and only" scientific law of perspective. A man holds a frame halfway between an upright post (*AB*) and a boy. Straight lines are drawn from points *A* and *B* to the observer's eye at point *E*. The points where the lines intersect the upright frame (*A′B′*) bracket the size the post will appear to be on the picture plane. Because the picture plane is halfway between the post and the boy, the image is exactly half the size of the real post. The mathematical equation underlying this drawing and the diagrams in *Drawing 2 and Drawing 3* (cat. 95) is presented as Eakins' first principle of perspective: "As the distance of the object from the eye is to the distance of the picture plane from the eye so is the size of the real object to the size of the picture of this object." (CHV/KF)

94

[Drawing 1: Study of Boy, with Sight-lines]

Pen and ink over graphite on buff wove paper

16¹⁄₁₆ × 9⁵⁄₁₆ in. (40.8 × 23.7 cm)

1985.68.3.3

Inscriptions: (TE in graphite, b.r.) arithmetical notations

This is a study for the figure of the boy in cat. 92, lightly gridded in pencil for transfer. This sketch appears trimmed at left, where the margin cuts off the dotted lines of vision coming from the boy's eyes. Another section has been cut out of the lower right edge of the paper. (CHV)

93

[Drawing 1: Study of a Boy]

Pen and black and brown ink over graphite on foolscap

14 × 8¼ in. (35.6 × 21 cm)

1985.68.3.2

This is a more heavily shaded drawing of the boy who appears in cats. 92, 94, 126, and 133. Evidently Eakins discarded this crosshatched version in favor of the sparer modeling seen in his final drawings. (KF)

94

95

Drawing 2 and Drawing 3 [Diagrams of the Law of Perspective]

Pen and ink over graphite on cream wove paper

Watermark: Ledger Mills

17¹⁄₁₆ × 22⅛ in. (43.3 × 56.2 cm)

1985.68.3.6

Inscriptions: (TE in graphite, u.r.) *Drawing 3;* (in brown ink, u.r.) *Drawing 3* [2 written over 3 in graphite]; (in graphite, b.r.) *Drawing 2;* (in brown ink, b.r.) *Drawing 2* [3 written over 2 in graphite]; (in ink, on diagrams) various letters, some corrected in graphite

References: TE, "Linear Perspective" (PMA typescript), chap. 1, p. 3; CB, notes on linear perspective, PAFA Archives, 5–6.

These drawings demonstrate the geometric proportions maintained by Eakins' law of perspective, illustrated in cat. 92. Line *AB* represents a post. *E* represents the observer's eye. In *Drawing 2,* line *A′B′* (revised as *ab*) represents the deduced size of the post on a picture plane halfway between the real object and the eye. The constructed triangles offer the mathematical proof of this relationship between the real object and its image. In *Drawing 3,* the picture plane (*A′B′* or *ab*) is one-fourth the distance from the eye to the post, where the image will appear one-fourth the size of life. (CHV/KF)

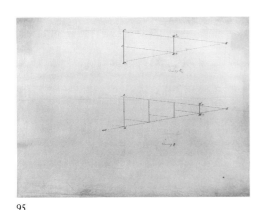

95

96

Drawing 4 [The Law of Perspective]

Pen and ink over graphite on cream wove paper

Watermark: Ledger Mills

17¹⁄₁₆ × 22⅛ in. (43.3 × 56.2 cm)

1985.68.3.9

Inscriptions: (TE in brown ink over graphite, b.c.) *Drawing 4;* (in black ink in diagram, c.l.) *A / B;* (c.) *A′ / B′*

[corrected in graphite: *a b*]

References: TE, "Linear Perspective" (PMA typescript), chap. 1, p. 4; notes on linear perspective, PAFA Archives, 4–5.

This drawing is the same demonstration of scientific perspective as *Drawing 1,* but drawn from a bird's-eye view to show that the rule of proportion holds true for objects horizontally as well as vertically parallel to the picture plane. (CHV)

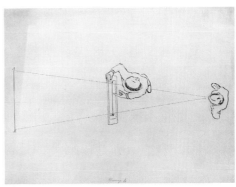

96

97

[Drawing 4: Study of a Boy]

Graphite on off-white paper

Watermark: WESTLOCK

8½ × 7¼ in. (21.6 × 18.4 cm)

1985.68.3.10

This drawing appears to be a study for the boy at right in *Drawing 4,* but with the figure's pose reversed. (CHV)

97

98

Drawing 5 [Viewer Position]

Pen and ink over graphite on cream wove paper

Watermark: Ledger Mills

16 × 7³⁄₁₆ in. (40.6 × 18.3 cm)

1985.68.3.11

Inscriptions: (TE in graphite, b.c.) *Drawing 5.;* (in brown ink, b.c.) *Drawing 5.*

References: TE, "Linear Perspective" (PMA typescript), chap. 2, p. 4; CB, notes on linear perspective, PAFA Archives, 7.

Fig. 48

Eakins stated his "argument" at the beginning of chap. 2: "When a picture is made it is a thousand to one that it is on a flat surface, and intended to hang on a vertical wall; and a person wishing to see it, will stand opposite the middle of it, and look squarely at it." To amuse himself, Eakins drew a sketch of his own *Starting Out After Rail* of c. 1874 (fig. 116) within the frame, although the actual painting is smaller than the one shown here. (KF)

99

Drawing 6 [Measuring]

Pen and ink over graphite on cream wove paper

Watermark: Ledger Mills

13¹³⁄₁₆ × 8⅝ in. (35.1 × 21.9 cm)

1985.68.3.12

Inscriptions: (TE in brown ink, u.r.) *Drawing 6;* (u.l.) *CA / BX;* (in graphite, u.r.) *Reduce to half size / or B = 2 inches*

References: TE, "Linear Perspective" (PMA typescript), chap. 2, p. 6; notes on linear perspective, PAFA Archives, 9.

Drawing 6 demonstrates the plotting of a point X, one foot to the right of the center point *C* and two feet below eye level (*CA*) on a plane twelve feet from the viewer. As depicted on a drawing held one foot from the eye, all relations are one-twelfth the scale of reality. Eakins' annotations instruct the printer to reduce his drawing so that it will be reproduced at exactly this scale. (KF)

99

100

Drawing 7 [Constructing Space in Perspective]

Pen and ink over graphite on buff wove paper

16¾ × 22⁵⁄₁₆ in. (irr.) (42.6 × 56.7 cm)

1985.68.3.13

Inscriptions: (TE in ink, u.r.) *Horizon 60 inches / Picture 2 ft. from eye.;* (b.c.) *Drawing 7;* (in diagram, c.r.) *Perspective of a line sloping 1 sideways to 4 forwards and level / vanishing on horizon 6 inches to right of center / Perspective of line sloping 45° or 1 to 1 vanishing on horizon / of the picture at 2 ft. to the right of center;* (throughout diagram) numbered grid, *0–5, 21–40, a–h;* (in graphite, b.c.) *reduce to* [torn] *or 0 to 4 = 2 inches*

References: TE, "Linear Perspective" (PMA typescript), chap. 3, p. 9; CB, notes on linear perspective, PAFA Archives, 18–21.

This drawing shows the method by which one establishes perspectival space in a picture by building a floor plan, checkerboard fashion. The principal coordinates are established by the center line (at zero), the horizon line (at sixty inches, the average eye level of a standing person), and the distance of the drawing from the eye (two feet). At this viewing distance, objects near the twenty-four-foot-line will be, on paper, one-twelfth natural size. Eakins' actual drawing is made at one-sixth scale (1 foot = 2 inches), partly to make his fine lines and inscriptions crisper and more legible. His instructions to the printer ask that the drawing be reduced to a quarter of its original size, so that the printed illustration will be exactly half the scale of the exercise he dictates in the text. At this new scale (1 foot = ½ inch), the illustration would be about five inches across, small enough to fit on the page of a handbook and easily compared (by doubling all dimensions) to a student's own work.

To construct his checkerboard in space, Eakins begins by locating a convenient distance like the twenty-four-foot-line, "which will give us no fractions" because the scale there is (assuming our two-foot viewing distance) one-twelfth life, where one inch represents one foot. This horizontal line is established by measuring, at scale, down from the horizon line to find the "ground" five inches (or one-twelfth of sixty inches) below. Using the same scale, "feet" are marked off in inches to the left and right of center on this line, and the orthogonals in the checkerboard can be drawn from these points to "vanish" in the distance at the center point.

Beyond the twenty-four-foot line the receding horizontals of the checkerboard are plotted by using a "little device" known to artists since the Renaissance. As Eakins notes in his text, "The vanishing points for angles of 45 degrees, that is for lines sloping like the diagonals of a square on the floor, two sides parallel with the picture, would be as far to the

right or left of the central plane as the picture is forward of the eye." Such a diagonal (*eh*), based on a viewer distance of two feet measured along the horizon line to the right, is inscribed on *Drawing 7*. This diagonal will cross the fan of orthogonals at the intersections of the one-foot grid, indicating the corners and therefore the edges of the floor tiles parallel to the picture plane. Since few drawings are made on paper large enough to include the actual measuring point for this diagonal, Eakins demonstrates a "short cut" method with line *eg*, based on one-fourth the viewing distance (or six inches). Although this line cuts the corner of only every fourth square, it brings the measuring point conveniently within the page. Subdividing this system, a scale of inches can be generated, as seen in the floor tiles just left of center (and in cat. 101). With this grid, Eakins plots the location of two perpendiculars raised at the left, and a rectangular box, *abcd*, to the right. See also cats. 101–103. (KF)

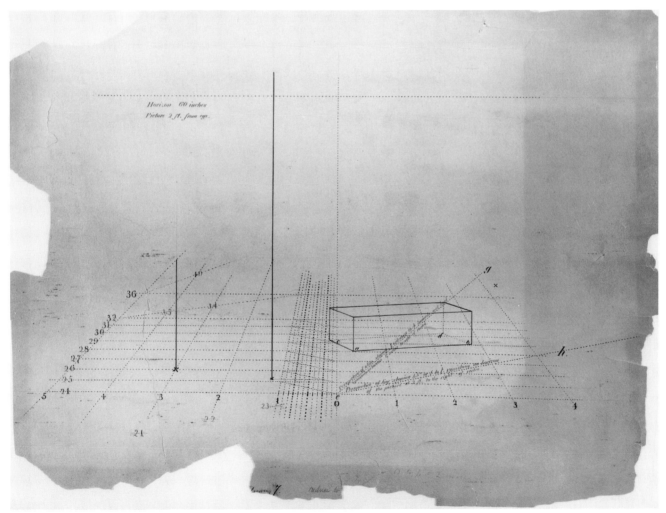

101

Drawing 8 [Inch Scale]

Pen and ink and graphite on buff wove paper

7¼ × 16¹¹⁄₁₆ in. (18.4 × 42.4 cm)

1985.68.3.14

Inscriptions: (TE in brown ink over graphite, c.r.) *Drawing 8.;* (in graphite, b.l. to b.c.) *reduce to ¼ or 0–1 = 1 inch*

References: TE, "Linear Perspective" (PMA typescript), chap. 3, p. 11; CB, notes on linear perspective, PAFA Archives, 21.

Drawing 8 is a plan of the first floor tile left of center in cat. 100. A foot "is a rather coarse measure for fine things," wrote Eakins, "so we had better divide up some of the square feet into inches." Reduced according to his directions, this illustration would have been printed at one-twelfth scale (1 inch = 1 foot). (KF)

101

102

Drawing 9 [Plan of a Box]

Pen and ink over graphite on cream wove paper

Watermark: WESTLOCK

11¹³⁄₁₆ × 17 in. (30 × 43.2 cm)

1985.68.3.15

Inscriptions: (TE in brown ink over graphite, b.c.) *Drawing 9.;* (in graphite, b.r.) *reduce to ¼ th. or 0–2 = 2 in;* (in black ink throughout) numbered grid, *0–2, 28–30, a–d*

References: TE, "Linear Perspective" (PMA typescript), chap. 3, p. 12; CB, notes on linear perspective, PAFA Archives, 23.

Drawing 9 shows the ground plan of the box placed in perspective in cat. 100. (KF)

103

Drawing 10 [Plan of Diagonals]

Pen and ink and graphite on foolscap

6¾ × 14¹⁄₁₆ in. (17.1 × 35.7 cm)

1985.68.3.16

Inscriptions: (TE in brown ink over graphite, c.) *Drawing 10;* (in graphite, c.) *reduce to / ¼th size.;* (in black ink, on diagram) numbered grid, *24–28*

References: TE, "Linear Perspective" (PMA typescript), chap. 3, p. 15; CB, notes on linear perspective, PAFA Archives, 27.

Drawing 10 is a plan of the "little device" suggested in *Drawing 7* (cat. 100) as a shortcut to plotting the scale of feet in a perspective drawing. The line *ef* in both drawings makes a 45-degree angle with the picture plane. It will cross the one-foot-square tiles of the "checkerboard" diagonally, such that the intersections with the orthogonals (shown here in plan as parallel bars) mark the proper feet lines in the floor (25, 26, 27). The line *eg* condenses this device into a 1:4 slope, which will generate every fourth horizontal. (KF)

103

104

[Perspective Grid]

Pen and ink over graphite on cream wove paper

16¾ × 17⅞ in. (42.6 × 45.4 cm)

1985.68.3.23

This may be an illustration that Eakins planned but decided not to include in his manual. Lacking all inscriptions, the drawing is difficult to interpret, although the basic perspective grid and the use of 1:4 diagonals is similar to cat. 100 and the related diagrams that explain its construction (cats. 101–103). (KF)

104

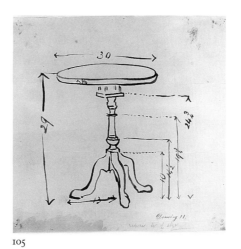

105

105

Drawing 11 [Measured Sketch of Round-top Table]

Brush and brown ink over graphite on cream wove paper

10¾ × 11⅛ in. (27.3 × 28.3 cm)

1985.68.3.17

Inscriptions: (TE in ink, throughout drawing) various dimensions; (in brown ink over graphite, b.r.) *Drawing 11.;* (in graphite, b.r.) *reduce to ¼ size*

References: TE, "Linear Perspective" (PMA typescript), chap. 3, p. 17; CB, notes on linear perspective, PAFA Archives, 31.

Exhibitions: PMA 1944, not in catalogue but seen in installation photos (PMA Eakins Archive) and recorded in PMA loan receipt to CB, 28 Mar. 1944, no. 23. Probably at Knoedler 1944.

Drawing 11 is a sketch of an eighteenth-century tilt-top table that appears in many of Eakins' paintings from the 1870s, such as *The Zither Player* (1876), *Seventy Years Ago* (1877), and *Fifty Years Ago* (1877; fig. 66), and the relief sculpture *Knitting* (1882–83; fig. 81, cat. 261).[1] The table is drawn in accurate perspective later in the manual (see cats. 106–108, 137–138). Here Eakins gives the measurements of the principal parts. The use of brush and ink in a rather loose fashion is unusual in Eakins' oeuvre of perspective drawings. The style signals a preparatory phase of freehand sketching and preliminary measurements. The crude, distorted character of the drawing was deliberately adopted by Eakins to force his readers to follow the cited dimensions in rendering their tables and not merely copy his diagram. "Make an inch division so as to be able to measure accurately and expeditiously, and then make a correct drawing of a round top table of which I give you the sketch (See drawing 11)." (CHV/RW)

1. This table was exhibited at the PMA Eakins centenary exhibition of 1944, on loan from Seymour Adelman. It is now in the Dietrich Collection.

106

Drawing 12 [Plan of Table Top; Section of Curved Table Leg]

Pen and ink over graphite on cream wove paper

Watermark: WESTLOCK

17 × 14 in. (43.2 × 35.6 cm)

1985.68.3.18

Inscriptions: (TE in brown ink over graphite, b.l.) *Drawing 12.*(in black ink, c.r.) *21 ft.;* (c.) *2 ft.;* (in graphite, c.r.) *21 ft.;* (c.) *1 ft* [illegible] *to right.*

References: TE, "Linear Perspective" (PMA typescript), chap. 3, p. 17; CB, notes on linear perspective, PAFA Archives, 32.

Drawing 12 demonstrates how an object like Eakins' tilt-top table can be reduced to simple forms that can be put into perspective easily. The upper diagram represents the table top (a circle) enclosed by a "chess board" of sixty-four squares. The bottom diagram represents a cross section of the table leg. (CHV)

106

107

[Drawing 13: Perspective Study of Tilt-top Table, I]

Pen and ink over graphite on buff wove paper

23³⁄₁₆ × 17¹³⁄₁₆ in. (irr.) (58.9 × 45.2 cm)

1985.68.3.21

Inscriptions: (TE in ink, u.l.) *Distance of Picture / from eye 1½ ft. / Horizon 48 inches. / above the floor.;* (b.l. to b.r.) numbered grid, *0–3, 18–23;* (in graphite, b.l.) *6 ft*

References: TE, "Linear Perspective" (PMA typescript), chap. 3, pp. 15–18; CB, notes on linear perspective, PAFA Archives, 31–33.

This drawing and the next one are variants of *Drawing 13,* known as *Perspective Drawing of a Three-legged Table,* now in the Hirshhorn.[1] All three illustrate an exercise given in Eakins' text, using the tilt-top table measured and planned in earlier drawings (cats. 105–106).

The conditions are given at the upper left: the eye level is forty-eight inches from the floor (an average height for a seated person), and the drawing is to be viewed one and a half feet from the eye. Eakins asked students to first map out the floor from eighteen to twenty-three feet away, then place the table into this grid. At this viewing distance, objects eighteen feet away will appear on the drawing at one-twelfth their real height. Eakins' actual drawing uses a scale of four inches to the foot (or one-third life), but—as the annotations on the Hirshhorn version show—he intended to reduce the entire illustration to bring the printed image to one-twelfth scale.

The instructions in his text ask that the student place the table twenty-one feet, two inches forward of the eye and one foot, five inches to the right of center, as it appears in cats. 107 and 108. Eakins must have reconsidered these coordinates, because the table in the Hirshhorn drawing—evidently his last version—is pushed another foot to the right. This new placement is reflected cat. 106 and in a later drawing based on this same setup (cat. 136), but Eakins' manuscript evidently remained uncorrected when he abandoned the project. It is not clear why Eakins made this change, but it must have been important to him, for it necessitated redrawing most of the parts of the table.

Eakins advised his students to use three inks in such drawings: "a blue ink for instance for the square feet marks in the ground plan and for the picture of these square feet in the perspective plan, for the horizon, & middle line; in short, for all the purely perspective scale parts; secondly a red ink for axes of construction or simple figures enclosing the complex ones not sought directly; and finally black ink for the finished outlines." In illustrations, which have no color, "I make dotted lines, broken lines and full lines."[2]

This system, which Eakins followed in his own project drawings, can be read clearly in cats. 107 and 108. The "blue" lines of the perspective grid are dotted, the "red" lines of the

major axes of construction of the table (i.e., the large, simple planes that contain the shape of the table top and legs) are dashed, and the actual "black" contours of the table are solid lines.

Cat. 108 is similar to cat. 107, although the front table leg has been slightly turned away from us, more like the position seen in the Hirshhorn's *Drawing 13.* The numbering in 108 is much neater and has been set along the center line instead of at the left margin. Few pencil markings are visible in this version, suggesting that it was a more polished draft based on cat. 107. A network of pinholes in 108 not seen in 107 also indicates that it was used for transfer, perhaps to speed Eakins' revisions on the final sheet. (KF)

1. Rosenzweig, 116. Their drawing is 23¾ × 16⁵⁄₁₆ in., or slightly smaller than the two CBTE versions. It has inscriptions not seen on cats. 107 and 108, including instructions to the printer ("reduce to ¼") and the title *Drawing 13* at b.c., in the fashion of the other finished illustrations. Once in Bregler's collection, this drawing must have been chosen for sale because of its similarity to others in his portfolios.
2. PMA typescript, 18, 33.

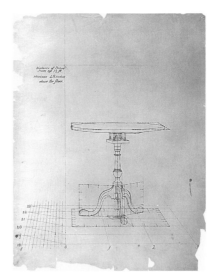

107

108

[Drawing 13: Perspective Study of Tilt-top Table, II]

Pen and ink over graphite on buff wove paper

18¾ × 18 in. (irr.) (47.6 × 45.7 cm)

1985.68.3.22

Inscriptions: (TE in ink, u.l.) *Distance of Picture / from eye 1½ ft. / Horizon 48 inches / above the floor.;* (b.l. to b.r.) numbered grid *0–3, 18–23;* (in graphite, b.l.) *no. 15. reduce to ¼th*

References: TE, "Linear Perspective" (PMA typescript), chap. 3, pp. 15–18; CB, notes on linear perspective,

PAFA Archives, 31–33.

Exhibitions: PMA 1944, not in catalogue but visible in installation photographs (PMA Eakins Archive) and recorded in PMA loan receipt, 28 Mar. 1944, no. 26.

Although this drawing bears the inscription *No. 15* at lower left, it is a draft of *Drawing 13* and should not be confused with *Drawing 15* of a spiral staircase (cat. 110). This annotation may indicate a planned revision of the order of these illustrations. (KF)

109

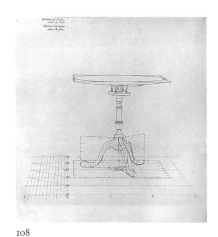

108

109

Drawing 14 [Plan of a Spiral Staircase]

Pen and ink over graphite on cream wove paper

22⁵⁄₁₆ × 15⁹⁄₁₆ in. (56.7 × 39.5 cm)

1985.68.3.24

Inscriptions: (TE in brown ink, b.c.) *Drawing 14;* (in graphite, u.l.) *Horizon* [illegible] / *Picture 1½ ft.;* (b.c.) *Drawing* [erased]; (in black ink, on diagram) numbered grid, *1–13*

References: TE, "Linear Perspective" (PMA typescript), chap. 3, p. 19; CB, notes on linear perspective, PAFA Archives, 34.

Recollecting the spiral staircase exercise in one of his high school textbooks, Cornu's *Course of Linear Study,* Eakins included his own variation on the theme.[1] This drawing represents the plan of a spiral staircase seen in cats. 110–112. The circle is the circumference of the staircase, boxed in a grid of squares, sixteen to a side. The numbered sections represent the twelve steps. (CHV/KF)

1. See cat. 13. Cornu's plate 7 concerns the "Application of the Spiral" to a stair of sixteen steps in each full circle (*Course of Linear Drawing* [Philadelphia, 1842]).

110

Drawing 15 [Perspective of Spiral Staircase]

Pen and ink over graphite on buff wove paper

22⅜ × 17¼ in. (irr.) (56.3 × 43.8 cm)

1985.68.3.25

Inscriptions: (TE in brown ink, b.c.) *Drawing 15;* (in black ink, c.l.) *Horizon 44 inches;* (in black ink, b.l. to b.r.) numbered grid, *0–3, 36–24;* (in graphite, b.c.) *Drawing 13½* [erased]

References: TE, "Linear Perspective" (PMA typescript), chap. 3, p. 19; CB, notes on linear perspective, PAFA Archives, 34–35.

This is a perspective drawing of a spiral staircase shown in plan in cat. 109. According to Eakins' instructions, the eye is forty-four inches from the floor, and the picture is three feet from the eye. From this viewing distance, objects seen thirty-six feet away will be one-twelfth the size of life in the drawing. Eakins' actual scale is two inches to the foot in the foreground (or one-sixth); if reduced by one-half, the drawing would represent the scale in his exercise.

Eakins' specifications describe the project completely: "Let the center of the staircase be 41 ft. 3 inches forward of the eye, o ft. & 7 inches to the right of the middle. The diameter is 7 ft., the round post in the middle is 6 inches thick. There are twelve steps in the circle going up the left like a screw thread, and I give you the ground plan parallel to the picture plane [cat. 109]. You see there is no step parallel with the picture plane, and I give you the ground plan to show you the angle, and I have numbered the steps to show you where to begin. Each step is to be 7 inches high. I have drawn also the axis of the hand rail. Measure how high I have drawn it, & then construct it yourselves." See also cats. 111 and 112 for variants of this drawing. (KF)

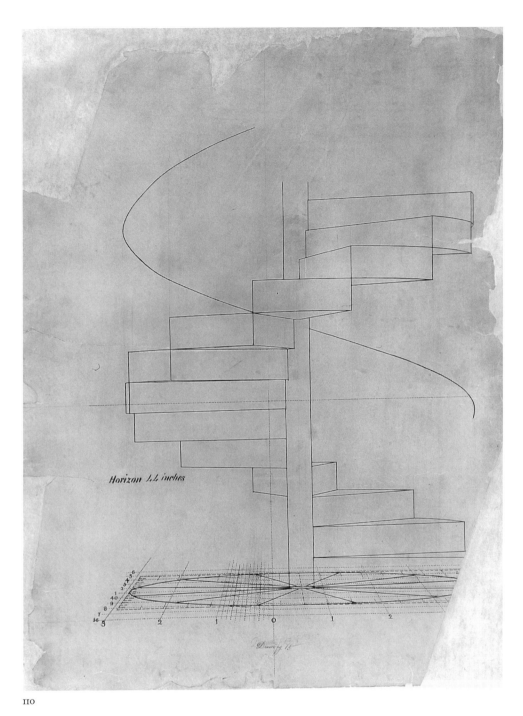

110

III

[Drawing 15: Study of Spiral Staircase and Plan]

Pen and ink over graphite on buff wove paper

22⅜ × 18 in. (56.8 × 45.7 cm)

1985.68.3.52

Inscriptions (r): (TE in graphite, u.l.) [torn] *44 / Picture 3
ft.* [illegible]; (b.c. and c.l.) arithmetical notations

Inscriptions (v): (b.r.) *Perspective work on*

References: TE, "Linear Perspective" (PMA typescript),
chap. 3, p. 19; CB, notes on linear perspective, PAFA
Archives, 34–35.

This drawing seems to be a draft of *Drawing 15* actually
drawn at one-twelfth scale, according to Eakins' text, but
with several variations from the final version. The plan at the

bottom of the drawing centers the stair treads on the axes of the grid, but the perspective rendering twists the plan slightly, setting the stairs off at a different point. This difficulty is complicated by an error in setting the plan into space that generates unequal stair steps, particularly noticeable on stairs 3, 4, 9, and 10 from the bottom. Because the plan is not directly under the perspective, this error may have gone unnoticed until Eakins began to ink in his pencil drawings. (KF)

This a variant of the spiral staircase exercise illustrated in cats. 110 and 111. These two drawings and Eakins' text specify twelve steps to the circle of the stair plan; this variant shows sixteen steps, with resulting differences in the plan and elevation. The placement in space and the viewing distance are identical in all three, although the perspective of the floor at the bottom of cat. 112 (drawn from the same viewer position established at the top of the page) is not seen in the other versions. The entire drawing is also different from the others in the addition of colored inks and shading and the elimination of the handrail mentioned in Eakins' assignment (see cat. 110). Within the whole lot of illustrations, this drawing is unique in being on paper watermarked 1887—from four to six years later than the two other dated papers in the group.[1] The date on this paper may be a clue that all these drawings were made after 1887, or it may indicate that this drawing was done later than the rest, as a revision of the original exercise. (KF)

1. The Hirshhorn *Drawing 13* is on "Whatman 1883"; *Drawing 1* (cat. 92) is on "Whatman 1881."

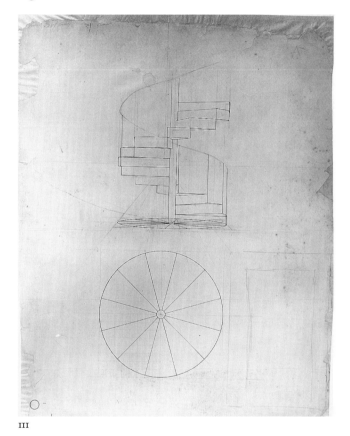

111

112

[Drawing 15: Study of Spiral Staircase with 16 Stairs], c. 1887

Pen and red, black and blue ink over graphite on cream wove paper

18⅞ × 10¾ in. (irr.) (47.9 × 27.3 cm)

Watermark: J Whatman 1887

1985.68.3.26

Inscriptions: (TE in black ink, u.l.) *Picture from eye 3 ft / Horizon. — 44 inches / Centre—41 ft 3 inchs* [sic] *forward / to right 7 inches / Radius 3 ft 6½ inches / 16 steps in circle / rise of steps 7 inches / dia. of Post. 6"*; (in graphite, on stairs) numbered steps *1–17*; (b.l. to b.r.) numbered grid *1–45*

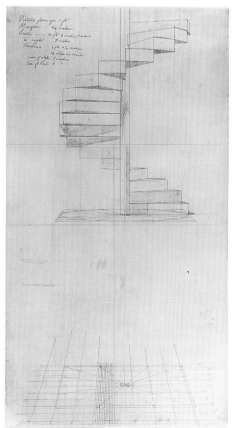

112

113

Drawing 16 [Scale for Measuring Small Parts of an Inch]

Pen and black and brown ink over graphite on cream wove paper

Watermark: Ledger Mills

22⅛ × 16⁵⁄₁₆ in. (56.2 × 41.4 cm)

1985.68.3.27

Inscriptions: (TE in graphite, b.c.) *Drawing 14* [erased] / *reduce 4 times.;* (in black ink over erased inscription, b.c.) *Drawing 16;* (in black ink, throughout diagram) numbered grid, *1–9*

References: TE, "Linear Perspective" (PMA typescript), chap. 3, pp. 19–20.

The diagonal scale that Eakins creates will measure small parts of an inch "to the thousandths of an inch" at any given scale. He recommends drawing one on paper to suit whatever scale is being used in a drawing, and then using calipers or compasses to measure fine distances accurately. The two small circles on his scale bracket a distance of 2.875 inches. This type of diagonal scale was demonstrated in two of the drawing books Eakins used at Central High School more than twenty years earlier.[1] (KF)

1. William Minifie, *A Text Book of Geometrical Drawing,* 2nd ed. (Baltimore: 1850), 29; A. Cornu, *Course of Linear Drawing* (Philadelphia, 1842), plate 3.

113

114

Drawing 17 [Mechanical Drawing: Tea Pot]

Pen and ink over graphite on off-white wove paper

Watermark: WESTLOCK

11⅜ × 14 in. (28.9 × 35.6 cm)

1985.68.3.28

Inscriptions: (TE in brown ink over graphite, b.c.) *Drawing 17;* (in graphite, b.c.) *reduce;* (in brown ink, left margin) *M / N*

References: TE, "Mechanical Drawing" (PMA typescript), 33, 37; (PAFA Archives), 34; CB, notes on mechanical drawing, PAFA Archives, 37, 37a, 37b.

"Mechanical drawing is much simpler than perspective drawing," wrote Eakins, because the scale within the picture never changes to indicate changes of distance from the eye. Parallel lines remain parallel instead of converging, making the shapes and sizes of objects depicted easy to read. "A perspective drawing gives a workman the best notion of the looks of the thing, but he could not measure from a perspective as from a mechanical drawing."

The first two illustrations accompanying Eakins' brief chapter on mechanical drawing show the differences between the American and the French or continental systems of description and layout. *Drawing 17* shows the American treatment of Eakins' "tin tea pot," with the end view (placed at the upper left) taken from the left side of the object. Below the front view comes the plan or bird's-eye view. Important points are linked from view to view with dotted lines. *Drawing 18* (cat. 115) illustrates the French workshop description of the same tea pot. Front view and plan remain arranged as before, but the end view is taken from the right side of the pot, as if generated geometrically from the plan, as shown by the dotted lines. Eakins points out that "there is no essential difference in the two ways of drawing these end views," except the geometrical nicety of the French system. More important, however, is consistency and recognition of conventional practice within any workshop. As an American, he sensibly concludes, "Let us make our end views on the American workshop, rather than on the indeterminate geometry plan, the French plan, the book plan."[1] Bregler's notes include a small sketch illustrating the tea pot from a different viewpoint. This may have been in response to a TE assignment, or just a personal inquiry by CB. (KF)

1. All quotations from TE, "Mechanical Drawing" (PMA typescript), 33. On the differences between mechanical and perspective drawing, see also cat. 122.

114

115

Drawing 18 [Mechanical Drawing: Tea Pot]

Pen and ink over graphite on foolscap

17 × 14 in. (43.2 × 35.6 cm)

1985.68.3.29

Inscriptions: (TE in brown ink, b.c.) *Drawing 18;* (in graphite, b.r.) *reduce*

References: TE, "Mechanical Drawing" (PMA typescript), 33–37; CB, notes on mechanical drawing, PAFA Archives, 37, 27 a, b.

115

116

Drawing 19 and Drawing 20 [Mechanical Drawing: Hoop]

Pen and ink over graphite on cream wove paper

Watermark: WESTLOCK

17 × 14 in. (43.2 × 35.6 cm)

1985.68.3.30

Inscriptions: (TE in brown ink, u.l.) *Drawing 19;* (in graphite) *Drawing 19;* (in brown ink, c.l.) *Drawing 20* (in graphite) *18;* (in graphite, b.l.) *Drawing 18* [8 written over 7]

References: TE, "Mechanical Drawing" (PMA typescript), 34–35, 38; CB, notes on mechanical drawing, PAFA Archives, 38–39.

The project illustrated in cats. 116–118 shows how mechanical drawing strategies can be used to place an oddly tilted object, like a child's hoop turning a corner, properly in the space of a perspective drawing. Eakins' exercise notes that the hoop is tilted 15 degrees on a line running 2:3 from

the picture plane. The hoop touches the ground at a point twenty-six feet, three inches forward of the eye, and one foot, seven inches to the right of the center plane. The terms of the perspective drawing (cat. 117) are given: horizon, sixty-six inches from the floor; viewing distance of the drawing, two feet. These drawings are mechanical drawings of the front, side, and top of the hoop. In *Drawing 21* the plane of the hoop has been gridded and set into perspective. (KF)

116

117

Drawing 21 [Perspective Study: Hoop]

Pen and ink over graphite on cream wove paper

Watermark: WESTLOCK

14 × 17 in. (35.6 × 43.2 cm)

1985.68.3.31

Inscriptions: (TE in graphite, u.l.) *Horizon 66 in. / Distance 4 ft.;* (b.c.) *reduce to ½;* (in ink, u.c.) *Horizon 66 in. / Distance 2 ft.;* (b.c.) *drawing 21;* (on diagram) numbered grid, *24–28,* numbered grid, *0–3,* letters, *a–g*

References: TE, "Mechanical Drawing" (PMA typescript), 34–35, 39; CB, notes on mechanical drawing, PAFA Archives, 40.

See cat. 116.

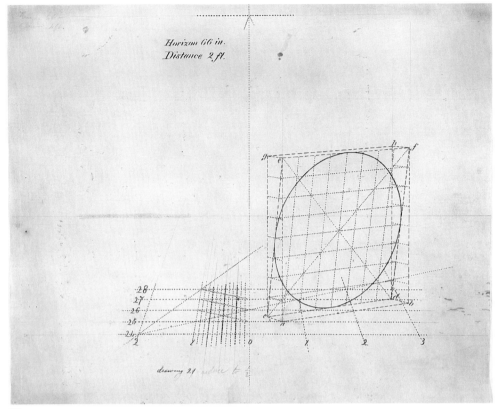

117

118

[Drawing 21: Study of Plan]

Pen and ink over graphite on cream wove paper

Watermark: WESTLOCK

17 × 14 in. (43.2 × 35.6 cm)

1985.68.3.32

Inscriptions: (TE in graphite, c.l.) *26;* (b.l.) numbered grid,
 0 1 2

Evidently this is the plan of the box *abcd* that circum-scribes the hoop drawn in cats. 116–117. The unfinished qual-ity of this drawing may indicate that Eakins made it for his own use or that he decided to eliminate it from the final se-quence of illustrations. (KF)

118

119

Perspective Study: Tilted Hoop

Pen and red ink over graphite on cream wove paper

Watermark: WESTLOCK

17 × 14 in. (43.2 × 35.6 cm)

1985.68.3.33

References: CB, notes on mechanical drawing, PAFA
 Archives, A.

This drawing may be related to the hoop exercise, cats. 117–119, although the angle of the hoop is not the same and the circle has been cut by a grid of sixteen squares instead of the eight used in *Drawing 21.* (KF)

120

Perspective Studies: Tilted Hoop

Graphite on foolscap

12¼ × 7¹¹⁄₁₆ in. (31.1 × 19.5 cm)

1985.68.3.34

Inscriptions: (TE in graphite, c.l.) *top;* (b.r.) arithmetical notations

On this badly torn and folded sheet of paper are a number of fragmentary diagrams and perspective plans. At the lower left is an ellipse enclosed in a gridded-off square; it may relate to the other drawings of hoops (cats. 116–120), although the scale numbers show a placement between seventeen and nineteen feet distant, and an angle unlike the one used in Eakins' exercise. (CHV/KF)

120

121

Drawing 22 [Perspective Study: Falling Hoop]

Pen and ink over graphite on foolscap

10½ × 14¹⁄₁₆ in. (26.7 × 35.7 cm)

1985.68.3.35

Inscriptions: (TE in graphite, c.r.) *Drawing 20;* (in brown ink, b.r.) *Drawing 22;* (in graphite, b.r.) *reduce to ¼th;* (in black ink, on diagrams) *c d e, a–d, a'–e'*

References: TE, "Mechanical Drawing" (PMA typescript), 40; CB, notes on mechanical drawing, PAFA Archives, 41.

Drawing 22 further illustrates how to draw a hoop falling down, using a "geometric device" rather than measuring with calipers. (KF)

122

Drawing 23 [Perspective Versus Mechanical Drawing]

Pen and ink over graphite on cream wove paper

Watermark: WESTLOCK

5¾ × 14 in. (14.6 × 35.6 cm)

1985.68.3.36

Inscriptions: (TE in graphite, c. to c.r.) *Drawing 21 reduce to ½* [erased]; (in brown ink, b.c.) *Drawing 23;* (in black ink, throughout diagram) *A–F, X, Y*

References: TE, "Mechanical Drawing" (PMA typescript), 41; CB, notes on mechanical drawing, PAFA Archives, 41.

"Drawing 23 explains well I think the difference between a mechanical & a perspective drawing," wrote Eakins. *AB* represents an upright line; *CD* and *EF* are picture planes. With the eye at *X,* the image of the line will appear smaller on *CD* and larger on *EF* than it actually is. If the viewer steps back to *Y,* however, the two images will become closer to the real size of the line. Mechanical drawing takes this infinitely distant viewpoint, where "the lines from the eye to the ends of object become more & more nearly parallel." Based on parallel projection, mechanical drawing "is the limit of perspective drawing when the eye is infinitely far away."[1] (KF)

1. TE, "Mechanical Drawing" (PMA typescript), 41.

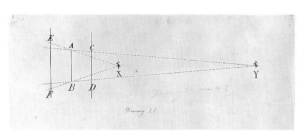

122

123

Drawing 24 and Drawing 25 [Mechanical Drawing: Brick Shapes Enclosing Yachts]

Pen and ink on cream wove paper

Watermark: WESTLOCK

14 × 17¹⁄₁₆ in. (35.6 × 43.3 cm)

1985.68.3.37

Inscriptions: (TE in graphite, u.r.) *Drawing 22* [erased]; (in brown ink, u.r.) *Drawing 24;* (in graphite, b.r.) *Drawing 23* [erased]; (in brown ink, b.r.) *Drawing 25;* (in black ink, throughout diagram) *a–h*

References: TE, "Mechanical Drawing" (PMA typescript), 41–42; CB, notes on mechanical drawing, PAFA Archives, 45.

Two mechanical drawings of brick shapes represent a sailing yacht as it would heel over in the wind. *Drawing 24* is the brick in plan, side, and end elevation, parallel to the picture plane. *Drawing 25* tilts the brick and then deduces the new elevations and plan. Lines that would be hidden by the brick itself are dotted. (CHV)

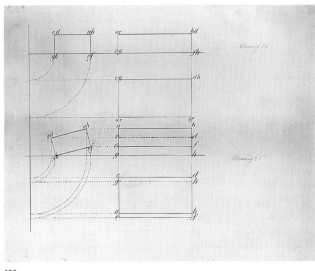

123

124

Drawing 26 and Drawing 27 [Mechanical Drawing: Brick Shapes Enclosing Yachts]

Pen and ink over graphite on cream wove paper
Watermark: WESTLOCK

17 × 14 in. (43.2 × 35.6 cm)

1985.68.3.38

Inscriptions: (TE in brown ink, u.r.) *Drawing 26;* (b.r.) *Drawing 27;* (throughout diagrams) *a–h*

References: TE, "Mechanical Drawing" (PMA typescript), 42–43; CB, notes on mechanical drawing, PAFA Archives, 45.

Exhibitions: PMA 1944, not in catalogue, but listed in PMA loan receipt to CB, 28 Mar. 1994, no. 28; probably at Knoedler 1944.

Fig. 118

In *Drawing 26* the yacht "brick" shown in *Drawing 24* and *25* has been given a second tilt to describe the effect of a boat rising on a swell while heeling over in the wind. In *Drawing 27* a third axis has been added to show the yacht's course away from the picture plane. (KF)

125

Drawing a¹ [Laws of Reflection, with Wharf and Tree]

Pen and brown ink over graphite on cream wove paper
Watermark: Ledger Mills

11⅜ × 17⅛ in. (28.9 × 43.5 cm)

1985.68.3.39

Inscriptions: (TE in graphite, b.c. to b.r.) *Drawing a¹. reduce to convenient size;* (in brown ink, throughout diagram) *A–H, X, R*

References: TE, "Reflections in Water" (PMA typescript), 64; CB, notes on reflections in water, PAFA Archives, 1 and 1a, with sketch.

"There is so much beauty in reflections," wrote Eakins, "that it is generally well worth while to try to get them right."[1] *Drawing a¹* illustrates the law of reflection in water: the angle of reflection equals the angle of incidence. A wharf and a tree and their reflections in the water below are drawn in cross section, with the viewer at *E*. The small inset sketch at the lower right depicts the wharf, tree, and reflection as they would appear from *E*. (CHV)

1. TE, "Reflections in Water" (PMA typescript), 68.

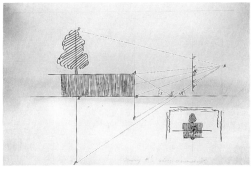

125

126

Drawing a² [Laws of Reflection]

Pen and ink over graphite on buff wove paper

15¹¹⁄₁₆ × 26 in. (irr.) (39.8 × 66 cm)

1985.68.3.4

Inscriptions: (TE in graphite, b.c.) *a²* reduce; (in ink, throughout diagram) *A–F*

References: TE, "Laws of Reflection" (PMA typescript), 65; CB, notes on laws of reflection (PAFA Archives), 2–3, with sketch.

A boy (the same figure seen in cat. 92) is viewing two slanting posts in water. Line *AB* represents a post slanting away from the boy. Line *DE* represents a post slanting to-

ward the boy. Dashed lines *BC* and *EF* represent the posts' reflections in the water. Eakins' drawing demonstrates how the length of the reflection can vary according to the angle of the post or the viewer's position. (CHV)

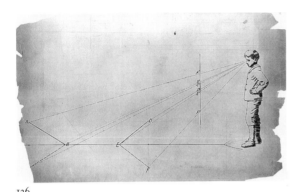

126

127

Drawing a³ [Wave Profiles]

Pen and black ink over graphite on cream wove paper

Watermark: Ledger Mills

13⅞ × 16 in. (35.2 × 40.6 cm)

1985.68.3.40

Inscriptions: (TE in graphite, c. to c.r.) *Drawing a³ reduce*

References: TE, "Reflections in Water" (PMA typescript), 66; CB, notes on laws of reflection, PAFA Archives, 3.

This is a simplified diagram of waves broken into level planes at their top and bottom to demonstrate the various surfaces of reflection on the water. (CHV)

127

128

Drawing a⁴ [Reflection on Moving Water]

Pen and ink over graphite on cream wove paper

Watermark: WESTLOCK

14 × 17 in. (35.6 × 43.2 cm)

1985.68.3.41

Inscriptions: (TE in graphite, b.l.) *a⁴*; (in ink, throughout left diagram) *A / A' / A'' / A'''*; (throughout right diagrams) *a, b, c, d, o / a', b', c', d'*

References: TE, "Reflections in Water" (PMA typescript), 66; CB, notes on laws of reflection, PAFA Archives, 4, B.

Fig. 243

Drawing a⁴ represents a post parallel to the picture plane, but sloping toward the right, and a series of waves in perspective. The top of the post (*A*) is reflected along a curving path created by the waves' surfaces. In the wave troughs, the reflection appears at *A'''*, on the slopes at *A''*, on the wave crests at *A'*. A similar post appears in *Rail Shooting on the Delaware* (fig. 122). The other two diagrams on this sheet represent a ground plan and a perspective view of a line lying obliquely on the floor, as in *Drawing 22* (cat. 121). (CHV)

129

Drawing a⁵ [Refraction: A Ray of Light Hitting Water]

Pen and ink and graphite on cream wove paper

11¼ × 7½ in. (28.6 × 19.1 cm)

1985.68.3.42

Inscriptions: (TE in graphite, b.r.) *a⁵*; (in ink, throughout diagram) *A–F, O, R, S, X*

References: TE, "Reflection in Water" (PMA typescript), 69; CB, notes on laws of reflection, PAFA Archives, 8.

Drawing a⁵ illustrates one of the principal laws of reflection. Line *SO* represents a ray of light hitting the water's surface, line *AB*, and refracted by a ratio of 4:3. (CHV)

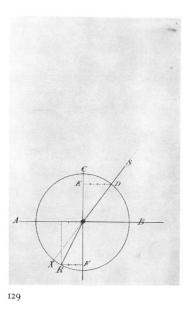

129

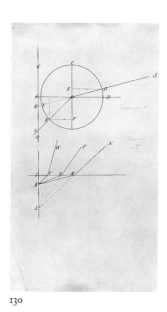

130

130

Drawing a⁶ and Drawing a⁷ [Refraction: A Stick in Water]

Pen and ink over graphite on cream wove paper

Watermark: Ledger Mills

17 1/16 × 9¾ in. (43.3 × 24.8 cm)

1985.68.3.43

Inscriptions: (TE in graphite, u.r.) *Drawing a6;* (c.r.) *Drawing / a7;* (in ink, throughout diagram) letters *B–I, K–S, X*

References: TE, "Reflections in Water" (PMA typescript), 70; CB, notes on laws of reflection, PAFA Archives, 10.

Drawing a⁶ represents a ray of light (LOS) traveling through the water and being refracted in the air. *Drawing a⁷* represents a stick protruding through the water's surface at various positions (*LW, LP, LN*) and the stick's apparent positions to the eye, caused by the refraction of light (*KV, KQ, KM*). Eakins means to show how the water seems shallower or how objects appear closer to the surface because of refraction. (KF)

131

Drawing b¹ [Isometric Drawing: Cube]

Pen and ink over graphite on cream wove paper

9 1/16 × 26¼ in. (23 × 66.7 cm)

1985.68.3.44

Inscriptions: (TE in graphite, b.l.) *drawing b¹ / reduce to convenient size;* (in ink, throughout diagram) letters *a–h*

References: TE, "Isometric drawing" (PMA typescript), 44; CB, notes on isometric drawing, PAFA Archives, 1.

Eakins demonstrates the relationship between a mechanical drawing of a cube, at the left, and an isometric rendering of this cube, at the right. In an isometric projection the cube is tilted 45 degrees so that all its sides are equal, to achieve the outline of a regular hexagon. Foreshortened to the same extent in all directions, the cube is easily measured with a single scale. "As almost all things that folk make are constructed in the rectangular dimensions," wrote Eakins, "isometric drawing has very extended and useful applications."[1] (KF)

1. TE, "Isometric drawing" (PMA typescript), 44.

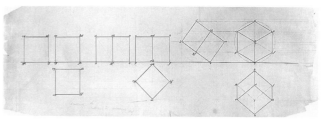

131

132

Drawing b² [Isometric Drawing: Carpenter's Bench]

Pen and ink over graphite on cream wove paper

Watermark: Ledger Mills

16 × 13⁹/₁₆ in. (40.6 × 34.5 cm)

1985.68.3.45

Inscriptions: (TE in graphite, b.l.) *Scale as it stands 1/6 / reduce half;* (b.c.) *b Drawing b* (second *b* crossed out) *2*

References: TE, "Isometric Drawing" (PMA typescript), 45; CB, notes on isometric drawing, PAFA Archives, 2.

This is an isometric projection of a carpenter's bench at two different scales and from two viewpoints. The isometric cube "hexagon" at upper left is included as a one-foot scale and to illustrate the perfect isometric viewpoint that rules the major planes of the rendering. (KF)

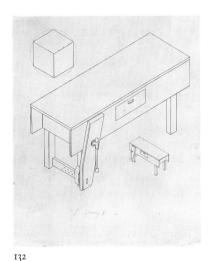

132

133

Drawing C¹ [Types of Relief]

Pen and ink on buff wove paper

16⅜ × 23¹¹/₁₆ in. (41.6 × 60.2 cm)

1985.68.3.5

Inscriptions: (TE in graphite, b.c.) *C drawing 1;* (in ink, on diagram) letters *A–D, a–d, d′–d′, a″–d″*

References: TE, "Sculptured Relief" (PMA typescript), 48; CB, notes on sculptured relief, PAFA Archives, 1.

The same boy seen in cats. 92 and 126 now looks into a hollow box, *ABCD*. Like an image on a picture plane, this box can be represented in perspective in a sculptured relief imagined at any point between the real box and the boy. In such a relief, the principal points must remain on their original sightlines. If the distance between corresponding points (*ab, a′b′, a″b″*) is short, the relief will be low ("basso rilievo," as shown at *a′b′*); if the distance is long, the relief will be high ("alto rilievo," as at *ab* and *a″b″*). As the drawing shows, the entire relief will grow smaller as it draws closer to the eye.

This drawing is very like another, slightly smaller version in the Hirshhorn Museum,¹ in which the boxes are shown in three dimensions to make the compression of the relief more obvious. However, the PAFA version has the advantage of simplicity in its pure cross sections, and its letter coordinates and label correspond exactly to Eakins' description in the text. It is possible that Eakins made the Hirshhorn drawing first and then redrew it to simplify his diagram. More likely, as in the instance of his tilt-top table drawings (cats. 107, 108), he reconsidered the diagram and redrew it but never integrated the new coordinates into his text. (KF)

1. Rosenzweig, 117; 15⁷/₁₆ × 22⁷/₁₆ in., on paper with a watermark J. WHATMAN/1883.

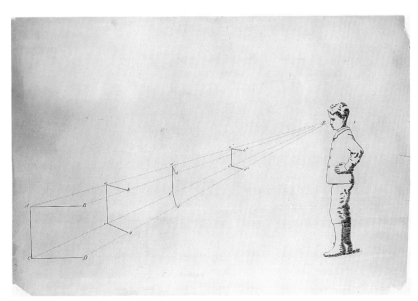

133

134

Drawing C² [Sculptured Relief: Establishing Slope]

Pen and ink over graphite on cream wove paper

7⅝ × 22³⁄₁₆ in. (19.4 × 56.3 cm)

1985.68.3.7

Inscriptions: (TE in graphite, b.c.) *C drawing 2. reduce;* (in ink, b.l. to b.r.) numbered chart, *0–35*, letters *A–J, X, Y*

References: TE, "Sculptured Relief" (PMA typescript), 49; CB, notes on sculptured relief, PAFA Archives, 3–5.

To represent objects in perspective in sculptured relief, as in painting, the viewing distance must be fixed. In addition, the slope of the "floor" or back of the relief must be predetermined and then consistently held. In *Drawing C²* Eakins establishes the floor, the horizon *XY* of a viewer at *X*, and a number of possible slopes, from the most vertical "as in a coin" (*FE*) to the most slanted, as in high relief (*CD*). Once fixed, this slope can receive a perspective scale exactly like a drawing or painting. (KF)

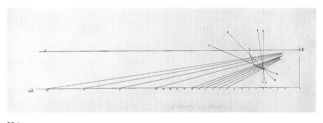

134

135

Diagram C³ [Sculptured Relief: Tilt-top Table Exercise]

Pen and ink over graphite on cream wove paper

8⅞ × 22⅛ in. (22.5 × 56.2 cm)

1985.68.3.8

Inscriptions: (TE in graphite b.c.) *diagram C³;* (b.l.) *reduce to ¼th.* (in ink, c.l.) numbered grid, *18–24;* (u.l.) *xxiv, xviii;* (u.r.) *C–F*

References: TE, "Sculptured Relief" (PMA typescript), 49; CB, notes on sculptured relief, PAFA Archives, 9–11.

This drawing sets up the conditions for a relief of a tilt-top table at one-twelfth scale. *E* is the place of the eye; *18, 19, 20,* and so forth are feet along the floor forward of the eye. Line *CD* represents the picture plane, eighteen inches from the eye, and line *FD* represents the tilted floor of the relief. The roman numerals are the coordinates for the ground plan on the relief. From this preparation, the earlier drawings of a tilt-top table (cats. 105–108) can be applied to the construction of a sculptured relief of the same subject. (CHV)

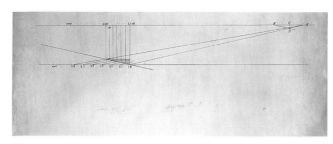

135

136

Drawing C⁴ [Perspective Study: Floor of Relief of Tilt-top Table]

Pen and ink over graphite on cream wove paper

Watermark: LEDGER MILLS

17¹⁄₁₆ × 22⅛ in. (43.3 × 56.2 cm)

1985.68.3.19

Inscriptions: (TE in graphite, b.c.) *C⁴ / reduce to ¼ the size;* (u.l.) *Horizon 48 in / Inclination 18 ft / Distance 1½ ft. / 6 ft.* (in ink, c.l. to b.r.) numbered grid, *0–4, 18–23*

References: TE, "Sculptured Relief" (PMA typescript), 52; CB, notes on laws of relief, PAFA Archives, 12–14.

This is a plan, in perspective, of the floor of a relief sloping at 12.5 degrees, as in cat. 135, showing the placement of the tilt-top table as shown in *Drawing 13* (cat. 107). Eakins placed this table in relief in his own sculpture *Knitting* (cat. 261), although not in this position. (KF)

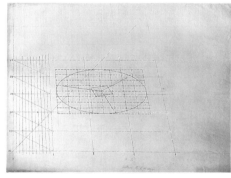

136

137

Drawing C⁵ [Side and Front Elevations of Relief of Tilt-top Table]

Pen and ink over graphite on cream wove paper

17¹⁄₁₆ × 22¹⁄₁₆ in. (43.3 × 56 cm)

1985.68.3.20

Inscriptions: (TE in graphite, b.c.) *drawing C5 / reduce to ¼th size;* (b.l.) *No. 14;* (in ink, in diagram, c.l.) *b a / 22 21 20*

References: TE, "Sculptured relief" (PMA typescript), 53; CB, notes on sculptured relief, PAFA Archives, 12–14.

Exhibitions: PMA 1944, not in catalogue but visible in installation photographs (PMA, Eakins Archive) and listed in PMA receipt to CB, 28 Mar. 1944, no. 25.

This is a drawing of a side elevation of the tilt-top table (at left) and a front elevation (at right) to be consulted while constructing a relief sculpture on the plan of cat. 136. Although unmarked, this drawing seems to be taken from a slightly lower viewpoint than used for other illustrations in this series (see cats. 107, 108, 138). (KF)

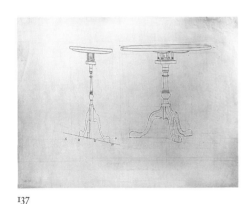

137

138

[Drawing C⁴ or C⁵: Variant Study of Relief of Tilt-top Table]

Pen and ink over graphite on tan wove paper

25⅛ × 18⅝ in. (63.8 × 47.3 cm)

1985.68.3.53

Inscriptions: (TE in graphite, b.l.) arithmetical notations

References: TE, "Sculptured Relief" (PMA typescript), 53; CB, notes on sculptural relief, PAFA Archives, 12–14.

This drawing is a variant combining aspects of the relief floor in *C⁴* (cat. 136) and the elevations of the relief seen in *C⁵* (cat. 137). The terms change throughout these drawings, however. Eakins' exercise specified a slope of 12.5 degrees for the floor of the relief, or "half-life," as shown in cats. 135–137. This third, unlabeled version strikes a steeper slope to produce a shallower relief; both plan and elevations indicate that the floor moves at about a 26-degree angle from the plane of the real floor.

The perspective at the top of the drawing is taken exactly from *Drawing 13* (Hirshhorn; see cats. 107–108), demonstrating Eakins' point that the view of the relief, the

view of a perspective drawing, and a view of the table itself "should all cover each other exactly to the eye of the spectator."[1] (KF)

1. TE, "Sculptured relief" (PMA typescript), 54.

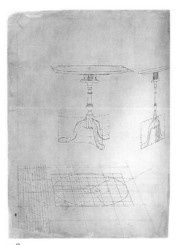

138

139

Perspective Study: Unidentified Subject [Sculptural Relief?]

Pen and ink over graphite on cream wove paper

Watermark: Ledger Mills

12⁵⁄₁₆ × 17¹⁄₁₆ in. (31.3 × 43.3 cm)

1985.68.3.46

This may be an unfinished illustration for the section on sculptured relief, as it seems to study distance points on an inclined plane. (KF)

139

140

Perspective Study: Unidentified Subject [Shadows?]

Pen and ink over graphite on foolscap

14 × 17 in. (35.6 × 43.2 cm)

1985.68.3.47

Inscriptions: (TE in ink, throughout diagram) *A–J*

This drawing of line segments and spheres may relate to Eakins' text on the depiction of shadows. (KF)

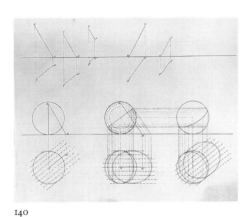

140

141

Perspective Study: Unidentified Subject

Graphite on buff wove paper

11½ × 16⅞ in. (29.2 × 42.9 cm)

1985.68.3.48

Inscriptions: (TE in graphite, u.l in diagrams) *The length of line* [twice]; (u.c.) [illegible] *length;* (u.r.) *required angle* [twice]; (c.) *intersection* [4 times]

The intersecting lines and spheres in this drawing may relate to cat. 140. This drawing and the next three are all on the same paper, and all rely on graphite in a manner unlike the drawing manual illustrations. All three may be from an earlier period, perhaps high school, or they may be by Charles Bregler. (KF)

142

Cycloids

Graphite on buff wove paper

11½ × 16⅞ in. (29.2 × 42.9 cm)

1985.68.3.49

Inscriptions: (TE in graphite, u.l.) *Cycloid curve and tangent / Cycloid;* (u.r.) *Epicycline*[?]; (b.r.) *Evolute*

See cat. 141.

142

143

Geometric Forms

Graphite on buff wove paper

16⅞ × 11⁷⁄₁₆ in. (42.9 × 29.1 cm)

1985.68.3.50

See cat. 141.

143

144

Ellipses

Graphite on buff wove paper

11½ × 17 in. (29.2 × 43.2 cm)

1985.68.3.51

Inscriptions: (TE? in graphite, u.l.) *1/AB = direction / CD = axis / P = focus / M = verben* [?] */ Mnn = parabola* [?] */ EH = radiusvector / PS = parameter / tt = tangent to E;* (u.c.): *2/BC = transverse axis / DE = conjugate axis / EF = foci / BDCD = ellipse / II = tangent / EH = parameter;* (u.r.) *3 / Oval / tangent;* (c.l.) *4 / Oval / & / Tangent;* (c.) *6 / Having 3 / lines and point on / one to construct / ellipse tangent to / them.;* (b.r.) *5*

See cat. 141.

Project Drawings, 1870–1907

145

Spanish Sketchbook, 1869–70

Graphite on thirty-eight sheets of wove paper in various colors (cream, gray-green, tan) bound in a cloth-covered cardboard cover

Watermark: MONTGOLFIER A S^t MARCEL[?] LES-ANNONAY

Pages: 3⁹⁄₁₆ × 6¹⁄₁₆ in. (9 × 15.4 cm)

Cover: 3⁹⁄₁₆ × 6⅛ in. (irr.) (9 × 15.6 cm)

1985.68.34

Inside front cover: (printed paper label) *Chevallets, Boites, Toiles, Panneaux / et / Articles de Peinture / HOSTELLET, Br. te / Rue Laval, PARIS*

Inscriptions: All by TE in graphite, except as noted. The page color is cream, unless otherwise noted. Annotations and remarks are given for each page, following the general commentary.

Before leaving Paris in the fall of 1869, Eakins may have purchased this pocket sketchbook, which carries a label from a local art supply store (recorded above). After three years abroad, he was about to return home, but not before taking a trip south. He wrote to his father that his excursion to Madrid and Seville was to serve aesthetic and recuperative purposes: "I am going to Spain. I have been pretty sick here in spite of my precautions against the weather & feel worn out. I will go straight to Madrid, stay a few days to see the pictures, & then go to Seville."[1]

Eakins arrived in Seville on 4 December 1869 and remained there for about six months. During his first month he painted the bust-length portrait, *Carmelita Requeña*. In a letter to one of his younger sisters, Eakins mentioned his seven-year-old subject: "some candy given to me, I ate a little and then gave the rest to a dear little girl, Carmelita, whom I am painting. . . . She is only seven years old and has to dance in the street every day."[2]

The lists of names, addresses, and descriptions in the sketchbook (as on page *ll*) suggest that Eakins had many models available to him. But he was again drawn to Carmelita Requeña, who appears in his second Spanish painting, *A Street Scene in Seville* (plate 1). In it she is dancing in the street, just as he had described her in his letter home. This picture was much larger and the composition more complex than his initial portrait. Delicately posed in a dance movement, Carmelita stands between Augustín, her father, playing a horn at left, and Angelita, her mother, beating a drum at right. Through an open window in the building behind them a woman and a girl watch the performance. On the wall above Angelita's head someone has drawn a bullfighter confronting a mild-mannered bull, alongside anti-royalist graffiti. At upper right, over a wall, we catch sight of a building and a single palm tree.

The creation of *A Street Scene in Seville*, Eakins' "first

complete composition,"[3] entailed simultaneous exhilaration and frustration. In early 1870 he wrote to his father, relating the challenge that he had newly undertaken:

> My student life is over now & my regular work is commenced. I have started the most difficult kind of picture, making studies in the sunlight. The proprietor of the Hotel gave us permission to work up on top of the roof where we can study right in the sun. Something unforeseen may occur & my pictures may be failures, these first ones. I cannot make a picture fast yet, I want experience in my calculations. Sometimes I do a thing too soon & I have to do it all over again. Sometimes it takes me longer to do a thing than I thought it would & that interferes with something ahead & I have a good many botherations, but I am sure I am on the right road to good work & that is better than being far in a bad road.[4]

His letters home also tell of his continuing struggle with the complications posed by the differences between studio light, in which he had trained, and the outdoor light of his street scene.[5]

Eakins' sketchbook illustrates that, at the outset of his career, he had begun the practice of making a series of preliminary sketches for figures, architecture, landscape, and other elements to be integrated into a completed oil painting, watercolor, or sculpture. His initial concept appears early in the sketchbook, with two very loosely drawn images of the entire composition (page *d*). On the front of this page Eakins depicts the three figures standing in front of the building in the same order as in the oil painting. In this drawing, however, there is a progression from highest to lowest figure from left to right; in the oil painting both parents' heads rise above Carmelita's. The drawing shows windows directly behind and above the horn player; the completed work depicts just one window above and to the left of that figure. In the drawing, the building behind the figures ends just beyond the drummer's shoulder, where curious figures crowd from around the corner of the street. In the painting, Eakins extended the wall of the house to block our view of the distance.

The second sketch of the entire composition, on the verso of page *d* (fig. 52), represents a step toward Eakins' final conception for the picture. Whereas the spatial relationship among the figures is somewhat ambiguous in the first sketch, this one clearly depicts the parents on the same plane as each other, with Carmelita standing forward. Eakins was still experimenting with the number and placement of windows when he made this sketch, but the foreground (vague in the first sketch) now sets the figures back at about the same depth as in the finished work.

Following these overall sketches are studies for each of the picture's components, interspersed with apparently non-related sketches of figures, animals, buildings, and architectural details. Rather than progressing systematically from least to greatest detail for each figure and feature, Eakins moved freely from one aspect of the picture to another. While it is impossible to know the order in which the drawings were made, the diversity of subject matter within the sketchbook shows the range of Eakins' interests and concerns and—in general—the simultaneity of his attack on all the details of the picture.

The sketchbook contains at least three figure studies for the young girl dancing (pages *l*, *p*, and *u*). The first outlines the head, torso, and upper portion of the left arm. As in the completed work, the head slants and the left arm crosses the body. Based on this sketch, it seems that Eakins first considered depicting Carmelita's torso facing left. By the time he completed his second study of the dancer, however, Eakins had shifted her body to a more nearly frontal view. Both sketches merely outline the figure, but the second is more complete in that it includes the girl's raised right arm, wide skirt, and final foot position. Between making this second study and painting the oil, Eakins apparently altered just one detail in the pose: he depicted the right hand raised above Carmelita's ear rather than at chin level, as it is drawn. The shadow of her hand as it falls across her face is studied on page *u*.

At least four sketches concern Angelita Requeña (pages *j*, *o*, and *q*). The first is a drawing of her head, geometrically bisected by a central part in the hair, her face, and the outline of her shoulders. In this simple sketch Eakins confronted the problem of foreshortening the musician's downturned face. The second sketch (page *o*) depicts only the portions of the figure and instrument not drawn in the first—torso, arms, legs, feet, and her drumsticks and drum. The body is more nearly upright in this sketch than in the finished work; Eakins either later decided to represent Angelita slightly more bent over, or he had not yet resolved the problems of foreshortening her torso and left arm. The remaining two studies, both on page *q*, improve the positioning of the hands and the way that the drumsticks are held, and analyze the shadows on the underside of the hand.

Sketches for the third major figure, Augustín Requeña, are more difficult to identify. A loosely drawn figure in short pants, as Augustín is clothed in the painting, appears on page *p* in a pose similar to the musician's, but his identity is obscured by a larger superimposed drawing of his belt. Another sketch that may have been a study for Augustín (page *y*) is a loosely drawn head and body.

At the upper left of *A Street Scene in Seville*, a woman and young girl gaze down on the performers from an open window. Eakins' sketchbook includes a drawing, which seems conceptually related to that corner of the painting, of a single female figure looking down from a window (page *kk*).

Eakins studied local architectural details, making numerous sketches of rooftops, windows, and facades. The preparatory work for the *palacio*[6] (palace) at the upper right appears in a sketch (page *o*) of Roman arches punctuated by rectilinear pilasters. Eakins drew the facade frontally but painted it in perspective. He also recorded characteristic

landscape details, such as the two sketches of palm trees (pages *x* and *y*). Both are free-standing, unlike the one partially blocked from view by the palacio at upper right in the painting, but the first of these drawings is close in shape to the tree in Eakins' finished work.

In choosing to paint street performers Eakins expressed a preference for vernacular subject matter that included documentation of what appears to be a tavern sign surmounted by a bullfighter and bull (page *h*). This "sign" pictures what seems to be a bottle and the words "SAN BERNARDO." One wonders whether Eakins passed more than one evening in such a tavern, enjoying such wine, and built a happy reference to this local bar when he copied the bullfighting scene, as if it were graffiti on the wall behind Carmelita and Angelita.

Other sketches, unrelated to *A Street Scene in Seville,* appear in this sketchbook, although all seem to be from Spain and probably most are from Seville, because his stop in Madrid lasted only two days. The first sketches in the book, of bulls grazing, are unlike the cartoonlike graffiti drawing later, suggesting random sketching or work anticipating other, unrealized Spanish projects. As Eakins wrote to his father, "Then [after the street scene is finished] I will make a bull fighter picture & maybe a gypsy one." (DB/KF)

1. G 32 (MMA). TE to BE, 29 Nov. 1869 (Goodrich 1982, I: 54).
2. Goodrich 1933, 162.
3. Goodrich 1982, I: 55.
4. TE to BE, 26 Jan. 1870 (PMA transcript quoted in Goodrich 1982, I: 55–56).
5. TE to BE, 14 Mar. 1870, 29 Mar. 1870, 28 Apr. 1870 (PMA transcripts quoted in full in Goodrich 1982, I: 57, 59).
6. Goodrich 1982, I: 55.
7. TE to BE, 26 Jan. 1870 (PMA transcript quoted in Goodrich 1982, I: 56).

145a

Bull Grazing (r)

145a r

Bull from Rear (v)

145b

Five Bulls (r)

145b

145c

Harbor Scene (r)

145c

145d

"Street Scene in Seville": Compositional Sketch, Window at Upper Left (r)

"Street Scene in Seville": Compositional Sketch, Window at Center (v)

Fig. 52 (verso)

145d

145e

Bullfight (r)

Window Grille (v)

>Inscriptions (v): *10 Openings*

145f

Window Sketches (r)

Facade of a Building (v)

>Inscriptions (r) *9 open*
>
>Inscriptions (v): *no 25*

145f v

145g

Window Grilles (r)

Roof Line (v)

>Inscriptions (v): *35*

145g v

145h

"San Bernardo" Sign with Bullfight (r)

Cornice and Molding Profile (v)

>Inscriptions (v): (b.l.) *SANBL / San Bernardo;* (b.c.) *SAN BERNARDO*

The wine bottle forms at each end of the lettering may indicate that Eakins sketched this subject from a tavern sign. The bullfighter and bull seem to have provided him with a model for the graffiti that appears on the wall above the dancer in *A Street Scene in Seville.*

145h r

145i

Molding (r)

Architectural Detail [?] (v)

145j

Window Moldings (r)

Head, Bending Forward (v)

The position of this head parallels the pose of the drummer in *A Street Scene in Seville.*

145j v

145k

Sketch of a Head [?] (r)

Head [?] and Drapery (v)

145l

Head and Torso Sketch (r)

Half-length Figure: Waist to Feet (v)

Although the costume on the figure sketched on the verso resembles that of the musician in *A Street Scene in Seville*, both drawings may indicate variant poses for the dancer.

145l v

145m

Torso (r)

Foot (v)

The torso sketch suggests that Eakins found models in Seville who would pose nude. The body position shown here is that of the dancer in *Street Scene in Seville*. The sketch of a foot may relate to page *l* (verso).

145m r

145n

Head, Turned ¾ Left (r)

Head, Looking Right; Unidentified Sketch (v)

145o

Architectural Details (r)

Woman Seated, Playing Drum (v)

Inscriptions (r): *end of cornice*

The pilasters and arches sketched on this page were painted, in perspective, at the upper right of *A Street Scene in Seville*. The figure of the drummer takes a variant of the pose used in the painting.

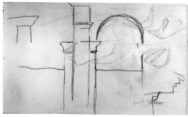

145o r

145o v

145p

Dancer; Architectural Detail (r)

Musician; Belt (v)

The two subjects on each page have been superimposed. The belt shown on the verso is seen on the dancer in *A Street Scene in Seville*.

145p r

145p v

145q

Hand of the Drummer (Twice) (r)

145r

Folds (v)

145s

Drapery Study: Woman's Kerchief [?] (r)

Unidentified Sketch (v)

The drawing on the verso may represent the shoulder of the woman at the window in *A Street Scene in Seville*.

145s r

145t

Arm (r)

Unidentified Sketch (v)

The sketch of a forearm may relate to the figures seen at the window in *A Street Scene in Seville*.

145u

Head of the Dancer (r)

Unidentified Sketches (v)

Eakins used a sheet of blue paper in the notebook to make a study of the cast shadow of the young dancer's hand on her face in *A Street Scene in Seville*.

145u r

145v

Both sides blank

Blue paper

145w

Unidentified Sketch (v)

Two pages have been removed between pages *w* and *x*.

145x

Palm Tree (r)

This tree appears at the upper right in *A Street Scene in Seville*.

145x

145y

Palm Foliage (r)

Head and Shoulders of a Figure (v)

The pose of this figure resembles that of the musician in *Street Scene in Seville*.

145y v

145z

Unidentified Sketches (r and v)

145aa

Foliage (r)

> On tan paper. One tan page is missing between *aa* and *bb*.

145bb

> Both sides blank
> Tan paper. One page is missing between *bb* and *cc*.

145cc

> Both sides blank

145dd

J. Ceballos (v)

> Inscriptions (v): *J. Ceballos / O, donell no. 24*

145ee

Roofline (v)

145ff

Standing Figure (r)

> On tan paper

145ff

145gg

Unidentified Sketch (v)

145hh

Unidentified Sketch (r)

145ii

Unidentified Sketch (v)

145jj

Andalaria Moe (r)

Regla Mermuda; Screw (v)

> Inscriptions (r): *Andalaria Moe / hermana. / misma. / la madre / vieja / La prima della / Senora Soledad / Alameda de Hercules*

> Inscriptions (v): *Regla Mermuda / Cencion [Concepcion?] Garcia / très belle / 17 años / 85 / Cuaquina Feligrano / cava nueva 69 / Rosa Flore / 80 Verbena / Pepa Flore / 80 Verbena / Juan de Flore / 80 Verbena / Feliciana Mohe / 46 Verbena*

145kk

Antonio Garcia (r)

Figure at a Window (v)

> Inscriptions (r): *Antonio Garcia / Cava nueva 77 / Maria Otin misma / casa / très vielle. / Saimene / Cava nueva 79 / [illegible] / Cavallero / Manuca Mermuda / 8 años / beau garáon / 77 cava nueva 79*

145kk

145ll

Calle Butron 14 (v)

> Inscriptions (v): *Calle Butron 14. / Sevilla Puerto Orsario / Petite fille 7 years. / Petit garcon. 9 ans. bien bâti / cava 105 antigua*

Inside rear cover

> Inscriptions (r): *Calle Linuner[?] / Salu Fernande / Calle Queso n. 8. / Andalaria Suna / Calle San Yulon[?] / en la Cava 7 no. / Calle de la Macarena / Bidal Bercera / Torero / Calle Cervantes / 16 / Antonion Butieri / El Paije / Huerta de Rozario. / no. 11*

Rowing Subjects

146

The Schreiber Brothers: Perspective Study of Rowers, c. 1874

Graphite on foolscap

14¹⁄₁₆ × 17¹⁄₁₆ in. (35.7 × 43.3 cm)

1985.68.7.5

Inscriptions: (TE in graphite, u.l.) *Picture 5 ft 72 ft figures / Horizon 6[?] ft / 60:5:72 in. / 90:5 / [?]″ / 120′*; (b.l. to b.r.) numbered grid, *1–8, 60–113*

Exhibitions: Yale 1996, no. 37.

Fig. 110

This drawing is an early draft for *The Schreiber Brothers* (also known as *The Oarsmen*) of 1874 (fig. 109, discussed in chap. 12). Similar in scale to the finished painting, this drawing shares the same viewing distance ("Picture 5 feet"), which puts the figures (at the same scale of one-twelfth life) at the same distance in space ("72 ft figures"). However, this drawing varies from the painting and two other preparatory drawings (cats. 147, 148) in having a much higher horizon line: seventy-two instead of forty-eight inches. The annotations at the upper left of the drawing are obscure on the subject of the eye level because Eakins superimposed at least two sets of numbers in his inscription (perhaps "6 ft" written over "72 in"?), but the horizon can be measured on the drawing itself: it is six inches from the vanishing point to the scale base line at sixty feet which—multiplied by twelve to get back to "life" size—equals seventy-two inches.[1]

Additional annotations at the upper right (*90, 120*) indicate that Eakins considered placing the figures much deeper in space, closer to the horizon line, and beyond the steep recession of the foreground. However, if the figures were to remain at one-twelfth scale, this would have entailed an uncomfortably long viewing distance (seven and a half or ten) and the odd "telescopic" foreshortening seen at such distances. Instead, Eakins avoided the steep foreground by lowering the eye level, as seen in cats. 148 and 149. (KF)

1. On the terms and procedures of Eakins' perspective drawings, see chap. 7.

147

The Schreiber Brothers: Perspective and Plan, 1874

Pen, black, red, and blue ink and graphite on off-white paper

28¼ × 47⅝ in. (71.8 × 121 cm)

Gift of Charles Bregler, 1948.19

Inscriptions: (TE in graphite, b.r.) *EAKINS 1874;* (u.l.) *horizon 4 ft / Tableau 5 ft / reflection angle of bridge 34–45*

/ Dog[?] *head 38–46 / Trees 40–60 / Billy's head 62½ + 83 /
Wave 4*[ft?] *× ¹⁄₁₆ in / slope of wave*[?] *102*[?]; (u.r. on
plan) numbered grid, *10–0–10, 59–92;* annotations by CB
in ink, and two photographs attached to the drawing,
were removed c. 1975 along with CB's cardboard back-
ing. These annotations read:

(CB, in ink, u.l.) *Perspective drawing by Thomas Eakins 1874
/ mounted on card board in Eakins studio / 1729 Mt. Ver-
non St Philadelphia. Pa / by Charles Bregler / Eakins used
this same system of perspective / in all of his rowing and
sailing pictures / making a mechanical drawing after accu-
rate / measurements of the boat. This enabled him / when
composing his picture, to place the boat / at any distance,
angle, or tilt of boat*[.] */ This is the drawing used for the
painting / of the Schreiber Brothers canvas 18 × 32 /
recorded in Goodrich book. / To avoid confusion Eakins used
in addition / to black, red and blue inks / They are now
faded but still perceptible.;* (u.c., next to photograph of
TE) *Thomas Eakins / age 35 1879 / The year he was ap-
pointed / Director of the schools / of the Pennsylvania Acad-
emy of Fine Arts;* (u.c., below photograph of painting)
Schreiber Brothers; (b.r.) *A boat is the hardest thing I know
of to put into perspective. / It is so much like the human
figure. / There is something alive about it. / It requires a
heap of thinking / and calculating to build a boat. / The
above is by Eakins / recorded by Bregler.*

References: Goodrich 1933, no. 67, p. 165; Hendricks 1974,
no. 209, p. 337; illus. p. 73.

Exhibitions: PAFA, *In This Academy* (1976), no. 220;
PAFA, *American Graphic Arts* (1986), no. 97; Yale 1996,
no. 39.

Fig. 111

Charles Bregler gave this drawing to the Pennsylvania
Academy in 1948, just after he established an annual student
prize in memory of Thomas and Susan Macdowell Eakins.[1]
Never published in its entirety, this drawing has been in-
cluded among the more recently received items from Bre-
gler's collection in order to integrate it once again with the
other *Schreiber Brothers* drawings, cats. 146–148, found in his
portfolios. Bregler's extensive annotations on the drawing,
cited above (although no longer visible), demonstrate the
generous didactic purpose in his gift, intended for art stu-
dents of a later day.

Indeed, this drawing can serve as an introduction to
Eakins' perspective method (see chaps. 7, 12). All the funda-
mentals of his system are present on this sheet. At the upper
right is a plan indicating the size and angle in space of the
two boats seen in *The Schreiber Brothers* of 1874 (fig. 109). To
save space, their actual relationship to each other in distance
has been condensed. The scale numbering on this plan, given
in feet along the upper right margin of the paper, does tell
the position of the Schreibers' shell, which sits between sixty
and ninety-two feet away, but the fisherman's boat has been
dropped into the empty grid nearby, even though it actually

rests about one hundred twenty feet from the viewer. From
the plan, which is drawn in half-inch squares representing
one foot in real space, we learn that the shell is about thirty-
six feet long, the fishing boat five feet across and twenty-one
feet long.[2] Using this same grid at a different scale, a tiny
sketch of the bridge pier and fishing boat was added at the
upper right.

The perspective drawing on the left side of the sheet is at
a larger scale (1 foot = 1 inch, or one-twelfth rather than one-
twenty-fourth life), identical to the scale of the finished
painting. The shell, the boat, the bridge pier, and the distant
shoreline are all set into space presuming a horizon line at "4
ft." and a spectator distance of "5 ft" from the picture. Lightly
ruled vertical lines at left and right mark the edges of the
canvas. Because the paper has been trimmed, the bottom of
the sheet now coincides with the lower edge of the actual
canvas; the upper edge occurs where the center line of the
composition intersects the uppermost line of the masonry
courses of the bridge pier. Other annotations reveal Eakins'
interest in calculating the correct lengths for the reflections
of the bridge, the trees, "Billy's head," and the dog (?), given
the wave pattern on the water.

Eakins made a small sketch at the bottom right of his
signature and the date, apparently planning to inscribe his
name in perspective. Eventually he signed the picture at the
right along the horizon line, as if on the wall of the bridge
pier, with no complexities of foreshortening. (KF)

1. See Foster and Leibold, 322. Bregler's annotations draw attention
 to his conservation of this drawing, probably between 1939 and
 1944. In the course of mounting the paper on cardboard he evi-
 dently trimmed about four inches off the top and bottom of the
 sheet, making the present dimensions smaller than the 32 × 48
 inches recorded by Goodrich in 1933.
2. This length tallies with the description of a standard "pair or dou-
 ble shell" given in *The American Rowing Almanac and Oarsman's
 Pocket Companion* (New York: Engelhardt and Bruce, 1875), 119.
 The "Table showing dimensions and prices" records such a shell as
 thirty-five feet long and fifteen inches in the beam, with twelve-
 foot oars.

148

"The Schreiber Brothers": Perspective Study of Bridge Pier and Water [1874]

Graphite on foolscap

13¹⁵⁄₁₆ × 17 in. (35.4 × 43.2 cm)

1985.68.7.4

Inscriptions (r): (TE in graphite, u.l.) *Tableau 5 pieds 60: 5:
48 / Lhorizon 4 pieds / Le bord lointain*[?] *700 pieds / 700:
5: 48 /* arithmetical notations; (b.c.) numbered grid, *1–8,
40–60;* (b.r., on pier) *pier;* (c.l., on pier) numbering of
courses of stone; pinholes throughout design

Inscriptions (v): (throughout) perspective grid with arithmetical notations

Exhibitions: Yale 1996, no. 38.

The pinholes throughout this drawing tell us that it was used to transfer Eakins' design to the canvas of *The Schreiber Brothers* (fig. 109). Although the sheet is slightly smaller than the actual painting, the drawing shows the scene at the same scale (one-twelfth life) with a few inches cropped on each side and about an inch to be imagined at the bottom.

Eakins' annotations recapitulate the terms of the perspective stated in cat. 147: using a notation shorthand seen elsewhere in his drawings, he summarizes these factors as *60:5:48*, where *60* equals the distance in feet to the line where a perfect one-twelfth scale (1 inch = 1 foot) obtains, *5* indicates the distance, in feet, from spectator to picture, and *48* announces the height of the horizon, in inches. A second formulation for "le bord lointain" tells us that the far shore of the Schuylkill is 700 feet away.

Although the number and width of the masonry courses seen in the preparatory drawings are carefully repeated in the painting, the sequence of verticals indicating different stone blocks is different in all three versions. Although important and insistent in these drawings, these verticals were much softened and diminished in the painting, perhaps to make the wall retire in space. (KF)

149

Oarsmen on the Schuylkill; Plan and Cross-section, c. 1874

Graphite and pen and ink on cream wove paper

47⅝ × 31⅝ in. (irr.) (121 × 80.3 cm)

1985.68.7.2

Inscriptions (r): (TE in graphite, u.l.) *The Biglin Shell / length 35 ft. / cockpit / amidships 15 in. / flare 19 in. / centre of boat to centre of outrigger 27 in. / outrigger 6¼ inches high above seat, / oars 12 ft long. / 3 ft 6 oar from end to the button.;* (throughout) numbered grids, *27–68, 11–0–16,* and arithmetical notations

Inscriptions (v): (b.r.) *4 oared shell Schmitt* [illeg] */ & pair oared the Biglons* [crossed out]

Exhibitions: Yale 1996, no. 43.

This drawing bears a plan and cross section of the four-oared shell seen in *Oarsmen on the Schuylkill* (fig. 115). The boat is superimposed on a grid of one-inch squares representing one foot in real space, so that the shell is drawn at one-twelfth scale. The axis of the boat is set at a 60-degree angle to the grid of the plan, corresponding to the direction it moves in space away from the horizontal baseline of the picture plane. The axis running from the lower left to the

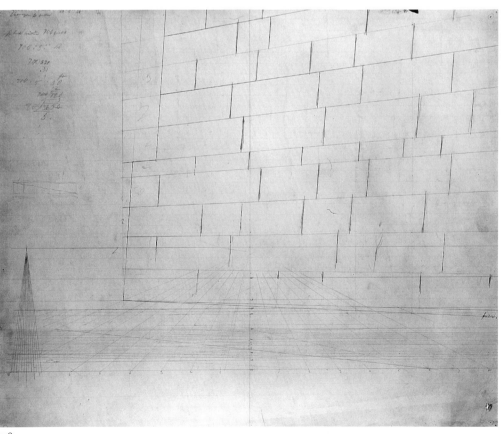

148

upper right of the sheet (numbered in feet, from 28 to 57) follows the line of sight from the viewer (standing at 0) to the vanishing point at the center distance of the picture. The center of the shell crosses this line about forty-four feet from the viewer; the rudder is about thirty feet away, and the tip of the bow sixty-eight feet distant. From this plan we can deduce that the shell is about forty-two feet long, a dimension close to the standard forty-one feet expected of a four-oared shell.[1] Eakins' annotations in the upper left corner, describing the "Biglin Shell," must be for another, shorter (thirty-five-foot) boat, surely the one owned by the Biglin brothers and seen in *The Pair-Oared Shell* (fig. 108) and much like the Schreiber brothers' boat, seen in cats. 148–150.

The plan also records two slightly different diagonals intersecting the shell from the lower right. The uppermost line, marked "angle of light," slopes at about 36 degrees from the picture plane; the lower line, marked "light ground plan," follows exactly the 45-degree diagonal of the squares on the grid. For simplicity in painting shadows Eakins may have established this more regular angle on the plan. From the shadows cast in the perspective drawing (cat. 150) it can also be estimated that the sun is very low, about 15 degrees above the horizon in the west, corresponding to Susan Eakins' description of this painting as a sunset scene.[2] At the lower right of the drawing is an inch scale, described in Eakins' drawing manual as a handy device to measure correctly to the thousandths of an inch and illustrated in cat. 113. (KF)

1. *American Rowing Almanac* (1874), "Table showing dimensions." This table also confirms the greater breadth (seventeen to twenty inches) and weight of a four-oared shell as well as the slightly longer oars (twelve feet, 3 inches) compared with those for a single shell. Eakins describes the Biglin's oars as twelve feet long, noting that they are "3 ft. 6 from end to the button," referring to the leather ring around the oar that kept it from slipping through the oarlock.

2. Theodor Siegl estimated the date and the time of day shown in *The Pair-Oared Shell* by figuring the angle of the sunlight in the painting (54–56). The location of the shell is much harder to map in this picture, however, and Eakins' possible manipulation of the sun's angle for convenience, suggested above, makes such calculations difficult.

149

150

Oarsmen on the Schuylkill: Perspective Study, c. 1874

Graphite, pen and ink, and watercolor on buff pulp paper

26¾ × 47⁹⁄₁₆ in. (67.9 × 120.8 cm)

1985.68.7.1

Inscriptions (r): (TE in ink over graphite, u.r.) *distance of picture 6 ft. / 7 becomes 1 / at the stroke. / eye 36 inches above water. /* [in graphite] *stroke 42 ft off / Seat 3 in high / 44;* (throughout) numbered grid, *23–3000;* pinholes throughout design

Inscriptions (v): (in graphite, b.l.) *4 oared shell / perspective of;* (c.r.) *Biglin / Brothers*

Exhibitions: Yale 1996, no. 44.

Fig. 114

Many tiny pinholes in this drawing, particularly around the oarlocks, on the contours of the shell and oars, and at the high points in the landscape, indicate that Eakins used this sheet to transfer his design to the canvas of *Oarsmen on the Schuylkill* (fig. 115). The sheet of drawing paper is slightly larger than the canvas, but the shell appears at the same scale—one-fourth life—in both versions.[1] The annotations and the evidence of the drawing confirm the conditions of this scale: the viewing distance is six feet and the horizon "36 inches above the water," or about level with the eyes of the oarsmen, seated on their "3 inch high seats." Eakins' note "7 becomes 1 at the stroke" most likely indicates that the one-fourth scale found along the foreground baseline (twenty-four feet distant) has diminished to one-seventh at the place of the first oarsman from the stern (who rows "stroke" position) at "42 feet off." Beyond the shell, Eakins' grid plots the space more than half a mile into the distance.

This drawing reveals the fastidiousness of Eakins' transfer, from the plan (cat. 149) into perspective, of the smallest and most complex parts of the shell.[2] Special attention is given to the oarlocks, outriggers, and oar cross sections, all of which are boxed or gridded for correct placement, just as he suggests in his drawing manual (cats. 105–108, 119, 120). In the foreground, small sketches of nuts and bolts preoccupied him, as they had in a preparatory drawing for *John Biglin in a Single Scull* (G 58, MFA, Boston), also from 1874. (KF)

1. The paper has been trimmed, probably by CB, from the standard 32 × 48 in. size of most of Eakins' large perspective drawings recorded by Goodrich in 1933.
2. Cooper misreads this drawing as "clearly" a pair-oared shell, though all four oars are visible, following the arrangement seen in the plan and section; see Yale 1996, 78.

151

Bridge Study, c. 1872–74

Graphite on foolscap

8¹⁄₁₆ × 5¹⁵⁄₁₆ in. (20.5 × 15.1 cm)

1985.68.11.2

Inscriptions: (TE in graphite, upside down b.l.) *W. S. W.;* (c.) *width straight / across / 9 yds;* (u.c.) *87 2 89 ft / 29 yds 2 ft*

Exhibitions: Yale 1996, no. 24

This drawing seems to show a section of the Reading Railroad Bridge just below the falls of the Schuylkill.[1] Although this bridge, with its characteristic rusticated voussoirs and stone posts, does not appear in any of Eakins' extant rowing pictures, he must have considered it as a background element for his racing scenes, if only because the start (and finish) line for the professional five-mile course stood just downstream. Amateur racers, following a shorter course that began at the next bridge south, would turn the stake at this point.[2] Eakins' measurements of the length between posts and the width of the bridge indicate his serious consideration of the form in space; the annotation *W. S. W.* follows a line indicating the compass-point orientation of the bridge axis in respect to the east bank of the river.

1. Kenneth Finkel, former curator of prints and photos at the Library Company of Philadelphia, has suggested this identification, based on a stereopticon photograph by James E. McClees, showing the bridge in 1859 (LCP). The Reading bridge is still extant, although overshadowed by the Roosevelt Expressway.
2. Johns 1983, fig. 28. This bridge must have been just beyond the frame to the right in *The Biglin Brothers About to Start the Race* (or *The Biglin Brothers Racing*), of c. 1873 (NGA).

151

152

Partant Pour la Chasse [Starting Out After Rail]:
Perspective Study, c. 1873–74

Pen and ink over graphite on foolscap

14¹⁄₁₆ × 17⅛ in. (35.7 × 43.5 cm)

1985.68.9

Inscriptions (r): (TE in graphite, u.l.) *l'horizon 84 Partant /
Tableau 10 pieds. / pour les sorce*[?]; (c.l.) numbered grid,
80–120

Inscriptions (v): (b.r.) *Partant pour la chasse.;* pinholes
throughout

Fig. 117

The notations on the recto, "Partant," and on the verso,
"Partant pour la chasse," identify this drawing as a study for
one—or all—of three similar paintings (two oils and a water-
color) variously known as *Starting Out After Rail* (fig. 116),
Sailing, and *Harry Young, of Moyamensing, and Sam Hel-
hower, 'The Pusher,' Going Rail Shooting* (also known as *Start-
ing Out After Rail,* fig. 65), all painted about 1873–74 (see
chap. 13).

Although this sheet of paper is smaller than the oil,
Starting Out After Rail and its watercolor twin, *Harry Young
. . .* , the section of the composition shown in this drawing,
from the horizon line to the scale baseline at eighty feet, is
identical in size and in all aspects of the perspective to both
finished pictures. Oil, watercolor, and drawing all have the
same horizon (eighty-four inches) given at the same scale
(one-eighth, at eighty feet) and from the same viewing dis-
tance (ten feet). Tiny pinholes throughout the sheet confirm
that the drawing was used to transfer the grid to the oil can-
vas, watercolor paper, or both.

Eakins' technique of "boxing" a yacht to calculate its
three tilts was repeated a decade later in his drawing manual
(see cats. 123, 124, and fig. 118). The lesson is murkier in this
drawing, because the "box" shown does not completely
confine the boat in the painting, and the grid coordinates
suggest a much longer boat than actually appears. The two
ruled ink lines define the extent of the boat on either side of
the center line (two feet to the left, four feet to the right) but
not the axis of the keel. At the upper right seems to be a
squared cross section of the bow of the boat. For other draw-
ings of this boat, see cats. 154 and 164–167. (KF)

153

Delaware River Skylines, c. 1874

Graphite on foolscap

9¾ × 7¹¹⁄₁₆ in. (24.8 × 19.5 cm)

1985.68.7.3

Inscriptions: (TE in graphite, u.c.) *60;* (b.l.) embossed stationer's stamp: H. P. CO.

The profiles at the top of the page are seen in the background of the three versions of *Starting Out After Rail* (see figs. 65, 116).

153

154

Figure Study: Man Holding Tiller [?]; Sailboat, 1873?

Graphite and pen and brown ink on foolscap

5 × 7¹¹⁄₁₆ in. (12.7 × 19.5 cm)

1985.68.10.7

Inscriptions (r): (TE in brown ink, c.r.) *Eakins;* (in graphite, c.) arithmetical notations

Inscriptions (v): *Gustavus Vasa restored the Independence of Sweden 1323* [repeated, to fill the page]; (b.l.) *28.;* (u.r.) [illegible blind stamp]

The small sketch of a sailboat at the right shows a Delaware ducker at the same scale and from the same vantage as one seen in the background of *Starting Out After Rail* (figs. 65, 116). Other drawings of this boat type appear in cats. 164–167. The helmsman, who bears a resemblance to Eakins' father, Benjamin, is studied in detail at the left. Although almost obscured by the sail, his bright red shirt, dark vest, and distinctive hat assert themselves in the oil version of this subject (fig. 116). Such mini portraits were common in Eakins' sporting pictures; he frequently included his own image as a spectator.

The signature at the right may have been a tentative plan for a decorative signature on this painting. Ultimately, the oil

was signed in block letters at the lower left; the watercolor has no visible signature in the design.

The penmanship exercises on the verso were probably not done by Eakins. Like similar repeated sentences on the verso of cat. 161 or Eakins' letter draft to Gérôme of 1874,[1] these exercises probably indicate "found paper" from his father's calligraphy classes. (KF)

1. PAFA Archives; see Foster and Leibold, p. 154, no. 56. On the text of this letter, see chap. 13.

154

155

Rail Shooting: Perspective Study and Plan (r), c. 1876

Sailboat (v)

Graphite on foolscap

13¹⁵⁄₁₆ × 17 in. (35.4 × 43.2 cm)

1985.68.8.2

Inscriptions (r): (TE in graphite, u.r.) *Rail shooting / Shuster* [sic] *& Wright;* (u.l.) *Distance 6 pieds. 72 / horizon 5 pieds / Dessin 1½* [superimposed on *18*] *pouces*[?]; (u.l. on plan) *middle;* (b.r.) numbered grid, *30–72,* arithmetical notations

Inscriptions (v): (u.l.) *Horiz 9 pieds / Tableau 4 pieds / Distance 1 pied /* arithmetical notations; (b.l. to b.r.) numbered grid, *48–200*

Fig. 124 (recto); fig. 128 (verso)

The inscription at the upper right of this drawing identifies it as a study for *Rail Shooting, Shuster and Wright,* offering a first piece of news about the identity of the pusher, who has been known simply as "Blackman" in the painting known as *Will Schuster and Blackman Going Shooting for Rail* (fig. 122) of 1876. Eakins exhibited this painting at the NAD in 1877 as *Rail Shooting on the Delaware* and the following year at PAFA as *Rail Bird Shooting;* the names of the hunters were never published in Eakins' lifetime. Only Schuster (or Shuster) was remembered by Susan Eakins, who supplied his name to Goodrich; evidently a white, middle-class, middle-aged man, he may have been a friend and hunting companion of the Eakinses. But the painting was unlocated when

Goodrich recorded it in 1930, and Susan Eakins may never have known the identity of the pusher, who posed for her husband before she knew him well. "Blackman" could well be a surname or a descriptive name, but Wright's mention in Eakins' inscription offers more positive identification. The full name, Dave Wright, with an address and the title *Rail Shooting with Shuster,* appears elsewhere in Eakins' notebooks from this period (see cat. 182 and the Spanish notebook), providing confirmation of his identity.[1]

The plan of the painting, drawn at the upper right in cat. 155, is given at the scale of one foot to one-quarter inch, or one-forty-eighth of life. It shows the boat set at a 45-degree angle to the picture plane, a second piece of surprising news because the composition gives the impression of very shallow recession, almost friezelike in its progression across the canvas. In fact, the trajectory of the boat in the painting is not actually as steep as this plan indicates. Even as modified, the foreshortening of the boat diminishes its length, which is revealed on the plan to be fifteen feet—a classic gunning skiff of the Delaware ducker type.[2] The scale on the plan tells us that the boat is between thirty-five and forty-six feet distant, and tiny footprints show the exact placement in space of Schuster and Wright.

The perspective drawing at the center of this sheet sets the plan in space under the terms noted in the upper right corner: the painting is to be viewed from six feet (seventy-two inches); the horizon is sixty inches high (at the eye level of Schuster). Using Eakins' law of perspective as pronounced in his drawing manual (see cat. 92), we know that the size of the figures will depend on the ratio of the viewing distance (six) to the actual distance to the figures (thirty-six, where Wright's footprints stand on the plan), or one-sixth of life. Indeed, on the actual painting the figures are at this scale: Wright, clearly a tall man, is about eleven and a half inches tall on the canvas, indicating a height of about 5 feet 9 with his knees bent. Schuster, although his feet are hidden from view, appears to be about 5 feet 6.[3] All these dimensions are reduced again in the drawing, which shows a viewing distance of one and a half feet and therefore a scale of one-twenty-fourth at the thirty-six-foot line (1.5/36). Vertical lines at each edge of the perspective grid indicate the edges of the canvas, while the thirty-foot line marks the lower edge.

The diagonal line seen on the grid is not the axis of the boat, although this line does begin, like the boat, at a point thirty-five feet away. However, the line slopes at a rate of 2:1 (or about 63 degrees on plan), twice as fast as the diagonal of the boat plan at upper right. In the perspective, this line creates the effect on the picture plane of a 12-degree angle from the baseline, steeper than the approximately 4-degree angle that would be translated on to the picture plane from the boat plan, or the slightly shallower angle (3 degrees) seen in the painting. Eakins may have considered this steeper recession at an earlier stage of his planning, or he may have drawn this diagonal to generate the more distant squares of his grid, a device explained in his perspective manual (see cat. 100).

The related figure sketch, cat. 156, has no spatial coordinates given, although a light grid of lines can be measured to discover the scale of one foot to one inch (one-twelfth life), midway between the perspective (one-twenty-fourth) and the actual painting (one-sixth). Eakins' purpose here seems to be the placement of the figures and their approximate poses.

On the verso of both cats. 155 and 156 are sketches of a yacht in perspective, perhaps in preparation for a painting that was never realized; see also cat. 169 and "The Yacht 'Vesper'" project, described in chap. 13. In cat. 155 the perspective is taken from on shore, with tiny figures shown on the beach in the foreground. The yacht sails diagonally toward us to the left, her bow about 60 feet distant, her stern 110 feet away. The horizon, according to Eakins' inscriptions, is high (nine feet), but the viewing distance is relatively short (four feet for the hypothetical painting, one foot for the drawing). Cat. 156 includes a plan at the upper right showing the placement of a similar boat between 180 and 110 feet distant, now sailing away from shore. Two perspective grids, each with a different horizon level, cover the rest of the sheet. The inscriptions indicate a nine-foot horizon, as in cat. 155, but a longer viewing distance (five feet), perhaps to account for the deeper placement in space of the yacht. (KF)

1. The title of this painting was suggested to Goodrich by the listing in Eakins' record book 1 (PMA), p. 14. In record book 2 (CBTE), p. 38, it is called simply *Rail Shooting,* probably a preferable title because it conforms to the annotations on this drawing and the title used in early exhibition entries. However, because both TE and SME contributed to these record books, it is not clear who was responsible for these titles. See Goodrich 1982, I: ix, 311. Goodrich also interviewed Addie Williams, who remembered a hunter resembling Blackman, who was the son of an escaped slave, living at "Cohansie" near her girlhood home (Goodrich notebooks, PMA). On the verso of cat. 182, Dave Wright is listed as living at 726 Edmund Street, an address (if it is in Philadelphia) near the river north of Bridesburg. A list of models, kept in the latter pages of his Spanish notebook (CBTE), also includes "Dave Wright—negro—'Rail Shooting with Shuster.'" In this entry (p. 57) he is listed at "Irving Street 3704," in West Philadelphia.

2. Eakins' boat types are discussed in chap. 13. Drawings of similar boats are seen in cats. 164–167.

3. Schuster's height is more difficult to estimate because he is about four feet deeper in space and therefore diminished in scale, compared with Wright. His height can be assumed to be about four or five inches taller than his eye level, with another inch or so added to account for his stance on the bottom of the boat, slightly below the water line.

156

Rail Shooting [Schuster and Wright]: Figure Sketches (r), c. 1876

Sailboats: Perspective Studies and Plan (v)

Charcoal and graphite on foolscap

13¹⁵⁄₁₆ × 17¹⁄₁₆ in. (35.4 × 43.3 cm)

1985.68.8.1

Inscriptions (r): (TE in graphite, b.r.) arithmetical notations

Inscriptions (v): (u.l.) *Horizon 9 pieds. / tableau 5 pied 60* [illeg.] / *Picture*[?] *15* [illeg.]; (u.r.) numbered grid, *30–0–30, 110–180;* (c.l.) numbered grid, *60–180;* (b.l.) numbered grid, *90–180;* verso printed with gray lines

See cat. 155 and discussion of the hunting subjects in chap. 13.

157

Pushing for Rail [?]: Ground Plans, c. 1873–74

Graphite on foolscap

8½ × 13¹⁵⁄₁₆ in. (21.6 × 35.4 cm)

1985.68.8.7

Inscriptions (TE in graphite, throughout) numbered grids, *20–40; 40–50; 0–12; 153–167; 20–44; 11–16*

Three sets of coordinates compete on this plan, which seems to map multiple schemes for the placement of at least four boats. The grid is made in one-eighth-inch squares,

156 r

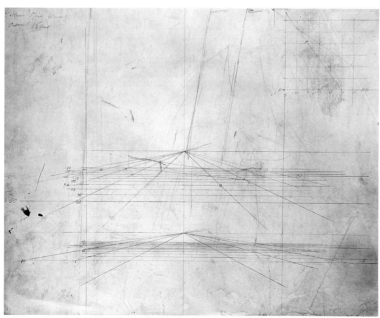

156 v

probably indicating square feet. At this scale, the short diagonal lines scattered throughout the drawing are about nine feet long, considerably shorter than the gunning skiffs depicted in Eakins' rail-shooting paintings. If boats, they are shown at 28, 36, 152, and 160 feet distant. Their varied positions suggest a tentative plan for one of the multiple boat compositions, such as *Pushing for Rail* (fig. 121), *The Artist and His Father Hunting Reed Birds in the Cohansey Marshes* (fig. 119; plate 10), or the lost *Rail Shooting* (cats. 158–163). No drawings for these paintings survive to record the spatial coordinates of all the boats shown, and the reeds usually hide the boats in the finished oils, making it hard to calculate the angle of recession. The longer diagonals, sloping 1:2 and 1:1 across the plan, may be reference lines for use when placing the "boats" in space. (KF)

157

of a boat. The words "La chasse" on the recto and verso, as well as the pair of figures holding what appear to be a rifle and a pusher's pole, link the drawing with the series of rail hunting pictures painted by Eakins between 1874 and 1876.

Among the known works from this group, *The Artist and His Father Hunting* (fig. 119; plate 10) has the most in common with *La Chasse*, particularly the diagonally oriented boat approaching the bottom edge of the composition, the second boat parallel to the picture plane in the left distance, and the light source from in front of the picture plane to the left, as indicated by a diagonal line inscribed "lumiere." A detailed preliminary drawing for *The Artist and His Father* (G 69, priv. coll.) varies from *La Chasse* on several important points, however. While *La Chasse* represents a distance of seven feet from the eye of the beholder to the picture plane ("Tableau 7 pieds distance"), G 69 is annotated "Distance of picture 4½ ft." The horizon line on *La Chasse* is five inches lower, the scale of figures smaller, and their placement in space more distant. If it is a study for *The Artist and His Father*, then it represents an incipient stage in the project's development, prior to drastic changes in all the coordinates of the pictorial space. Alternatively, *La Chasse* may be the only evidence of a project that Eakins never completed, of a lost oil, *Rail Shooting*, G 105, discussed in the context of other unidentified drawings (cats. 159–163) in chap. 13. (DS/KF)

158

La Chasse: Perspective Study for "Rail Shooting," c. 1873–76

Graphite on cream wove paper

14 × 17¹⁄₁₆ in. (35.6 × 43.3 cm)

1985.68.8.9

Inscriptions (r): (TE in graphite, u.l.) *Tableau 7 pieds distance / 56: 7: 58 / La Chasse / Chasseur 60 pieds presque*[?] *2 à droite / L'oiseau 30 pieds* [illeg.] *1e pied à gauche 2½ dessus l'horizon*, arithmetical notations, numbered grid, *22–16*; (u.r.) *68 fr. l'oiseau / Distance 9080 ft Trees 50 ft high / water level / at trees—level at edge of marsh / 6'*[?] *8 fr l'oiseau*; (b.l.) *lumiere*; (throughout drawing) numbered grid, *45–256; 1–4*

Inscriptions (v): (b.r.) *La chasse*; (b.l.) *La chasse*; pinholes throughout

Fig. 125

This sheet bears a perspective grid with numerous points of reference in the foreground, primarily for the construction

159

Rail Shooting [?]: Perspective Studies of Gunning Skiffs and Birds in Flight, c. 1873–76

Graphite on foolscap

13¹⁵⁄₁₆ × 16¹⁵⁄₁₆ in. (35.4 × 43 cm)

1985.68.8.8

Inscriptions (r): (TE in graphite, u.c.) *1 pied cubique / pour l'oiseau / Il a l'inclinaison / qu'il lui faut*

Inscriptions (v): (b.l.) numbered grid, *1–50*

Fig. 126

This drawing is one of six (cats. 157, 159–163) that were found pinned together, as if to suggest that they belonged to a single project. All six drawings show boats and birds, although none seem directly related to known rail hunting pictures. The perspective drawing *La Chasse* (cat. 158), also found with these sketches, may provide a framework for the rest, particularly cat. 159, which supplies the bird mentioned in the annotations of the larger drawing.

The boat seen in cat. 159 is a half-decked gunning skiff, much like the Delaware ducker depicted in *The Artist and His Father* (fig. 119; plate 10). A few slight strokes of the pencil at the right may indicate the figure of a pusher, who stands on the stern deck of the boat to the right. The scale of the boat (one-twentieth life) in this drawing, its angle of recession,

and its distance below the horizon are identical to the boat at the right middle distance in *La Chasse*. Likewise, the ducker at the lower left seems to be a study for the boat sketched roughly in the left-hand distance of *La Chasse*. The only inconsistency between the two drawings is the angle of light, which comes from the right in cat. 159, instead of from the left, as indicated by the line marked "lumiere" in cat. 158. From their long necks and dangling legs in flight, the birds (or one bird, sketched twice) must be rail, examined in greater detail from this same perspective in cats. 161 and 162. On the development of this project, probably the lost painting *Rail Shooting*, see chap. 13. (KF)

160

Perspective Study of Gunning Skiff, c. 1873–76

Graphite on foolscap

8½ × 13¹⁵⁄₁₆ in. (21.6 × 35.4 cm)

1985.68.8.6

This sketch shows a gunning skiff, probably a Delaware ducker much like the one in cat. 159 but with the deck at the left and a steeper angle of recession as the boat moves into the right distance. The only skiffs seen in this position elsewhere in Eakins' work are at the far left in *Pushing for Rail* (fig. 121) (where the boat is almost made invisible by the marsh grass) and at the left in *La Chasse* (see cats. 158, 159). Markings above and inside the boat may indicate the position and cast shadows of the legs of a hunter. (KF)

160

This drawing and the next two are devoted to studies of the same type of bird, probably the sora rail hunted with such enthusiasm in the marshes of the lower Delaware River in September and October.[1] Seen foreshortened, as if in flight, the rail in cat. 161 may be a study for the bird in *Rail Shooting* (cats. 158, 159). These drawings all seem to show the birds at life scale, about seven inches from beak to tail and with a wing span of about eleven inches, which would fit within the pied cubique outlined in cat. 159. In cat. 162 this same bird is seen as if transparent, with the wirelike armature of its skeleton seen in perspective. A cross section of the bird in flight (cat. 163) was prepared in anticipation of these studies, and it was squared for transfer into perspective. Applying principles of mechanical drawing explained in his drawing manual, Eakins also displays his anatomical understanding of the bird's construction in order to set it dramatically, and correctly, into space.

The penmanship exercises seen on the verso also appear on the verso of cat. 154 and Eakins' letter to Gérôme, both from about 1874. (KF)

1. The same birds appear on an oil sketch, *Game Birds*, G74, described by Goodrich as plover, painted about 1874. Hendricks published this sketch as *Plover*, c. 1872, although the birds are evidently too large and long-legged to be plover (1974, 79).

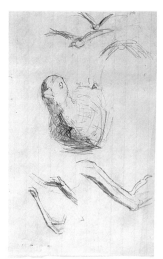

161

161

Rail Birds in Flight, c. 1873–76

Graphite on foolscap

7¹¹⁄₁₆ × 4¹⁵⁄₁₆ in. (19.5 × 12.5 cm)

1985.68.8.3

Inscription (v) (in brown ink, l. to r.) *Gustavus Vasa restored the Independence of Sweden* [repeated ten times, below] / *135*

162

Bird in Flight: Anatomical Study, Foreshortened, c. 1873–76

Pen and red and blue ink over graphite on foolscap

4¹⁵⁄₁₆ × 8¹⁄₁₆ in. (12.5 × 20.5 cm)

1985.68.8.4

See cat. 161.

162

163

Bird in Flight: Anatomical Study, Cross-section, c. 1873–76

Pen and red ink over graphite on foolscap

8½ × 13¹⁵⁄₁₆ in. (21.6 × 35.4 cm)

1985.68.8.5

Inscriptions: (TE in graphite, u.l. to u.r.) numbered grid, *1–10*

See cat. 161.

163

164

Measured Cross-section of a Gunning Skiff, c. 1873–76

Graphite on foolscap

5¹³⁄₁₆ × 6¾ in. (14.8 × 17.1 cm)

1985.68.10.1

Inscriptions: (TE in graphite u.r.) *rib is ½ in* [*wide,* crossed out] *deep / & ⅝ wide;* (b.l. to b.r.) *The skin is between ⅛ & ¼ in thick* [*bottom,* crossed out] *keel board 8¾ in wide*[?] */ probably ½ in. thick in middle;* (u.l. to c.r.) measurements of boards

Eakins' cross section of a Delaware ducker, perhaps "Harry Lewis's skiff" (see cats. 165, 166), reveals his intimate

knowledge of the boat type best seen in *Starting Out After Rail* (figs. 65, 116). Although not to scale, his drawing records the width of each one of the seven lapped boards that make up the lapstrake construction characteristic of this type. (KF)

164

165

Harry Lewis's Skiff: Rudder and Tiller, c. 1873–76

Graphite on foolscap

9¹⁵⁄₁₆ × 8 in. (25.2 × 20.3 cm)

1985.68.10.2

Inscriptions (r): (TE in graphite, u.l.) *Harry Lewis's Skiff / 48 in. wide;* (c.) *pulley for sheet 4 ft. 8 in from stern on a rib / or 4 ft 3 in;* (b.l.) arithmetical notations, measurements on diagram

Inscriptions (v): (u.l) *sheet 5 ft 6 in / from end of / boom;* (b.l.) *mast 12 ft 10 in high / boom 13 ft / spreet 10 ft 3 in / circumference / 5 in. / circumference of boom 4¾ / 10 ft 3 in spreet 3½ / shape of section of / spreet / spreet / sheet 5 ft 6 in / from end of / boom;* (u.r.) arithmetical notations; (u.c.) embossed stationer's stamp: Superior

Harry Lewis (1840–1909), printer and neighbor of the Eakins family, grew up with Tom and must have often joined him sailing and hunting. We can find him among the crew members "hiked out" over the edge of the boat at the far right in *Sailboats Racing* (PMA) of 1874 (fig. 62), his features familiar to us because of the larger portrait Eakins painted of him two years later.[1] Lewis's gunning skiff, a Delaware ducker, may have been the model used for the boat in *Starting Out After Rail* (figs. 65, 116). See also cats. 164, 166. (KF)

1. G 95; Siegl, 66–67.

165

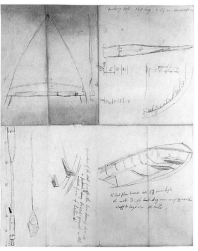

166 r

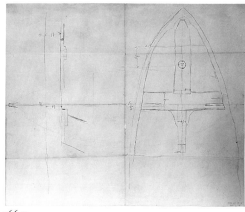

166 v

166

Measured Drawings of a Gunning Skiff, Oar and Pushing Pole (r and v), c. 1873–76

Graphite on foolscap

17¹⁄₁₆ × 14 in. (43.3 × 35.6 cm)

1985.68.10.4

Inscriptions (r): (TE in graphite, u.r.) *pushing pole 16 ft. long & 5½ in. circumference;* (c.r.) *17 in straight up to / level of gunwhale;* (b.r.) *the last floor board sets 5* [½ crossed out] *inches high / the next 3 the* [*last,* crossed out] *big one is of ¼ inch / stuff & logs on the ribs;* (b.l.) *perspective of the seat from off the bow showing how it / is* [*fastened* crossed out] [*strung* crossed out] *braced against a rib / secured*[?] *from* [*f* crossed out] *behind;* measurements throughout

Inscriptions (v): measurements throughout

Both sides of this sheet are covered with measured sketches of parts of a Delaware ducker, most likely "Harry Lewis's skiff," also seen in cat. 165. Many of the details in these drawings, such as the maststep, the stern deck, the lapstrake siding, and the ribbed floor of the boat are visible in *Starting Out After Rail* (fig. 65). The three-pronged end of the pushing pole is, however, a detail never revealed in the paintings. (KF)

167

Measured Drawings of a Gunning Skiff: Plan and Profile, c. 1873–76

Graphite on foolscap

14 × 17¹⁄₁₆ in. (35.6 × 43.3 cm)

1985.68.10.5

Inscriptions (r): (TE in graphite, u.c.) *When the sun is nearly down / & the whites are orange & equal in / tone to sky & flesh is deep red & yellow / in lights &* [illeg.] *gray in shadow / Make a view looking near north / or south;* (u.l., on diagram) *same width all the way;* (b.c.) *outside-strip;* arithmetical notations and measurements throughout

Inscriptions (v): (u.r. on diagram) letters *a–f*

Eakins' computations at the upper right reckon the total length of the measured sections of this skiff as 180 inches or 15 feet, standard for a Delaware ducker. His details document

the construction of the bow and the oarlock installation, each seen from two viewpoints. On the same paper as cat. 166 and, like it, displaying all the signs of having been folded in Eakins' pocket, this drawing probably describes the same boat: Harry Lewis's skiff (cat. 165). His idea for a picture, jotted at the upper margin, calls to mind the reddish tonality of sunset in *The Artist and His Father Hunting* (fig. 119; plate 10). (KF)

167

168

Measured Sketches of a Sailboat, c. 1872–76

> Graphite on foolscap
>
> 13¹⁵⁄₁₆ × 8½ in. (35.4 × 21.6 cm)
>
> 1985.68.10.3
>
> Inscriptions: (TE in graphite, u.c.) *bow at a;* throughout bottom half of sheet, measurements of skiff.

The square-sterned, fixed keel boat shown in this drawing is not related to the double-ended, drop-keel duckers seen in most of Eakins' hunting subjects. At twenty feet, the boat is also considerably larger than the ducker and related local sailboats of fifteen-foot length, the tuck-ups and hikers seen elsewhere in his paintings. A boat of this type may be the one used by the fishermen in *The Schreiber Brothers* (fig. 109). (KF)

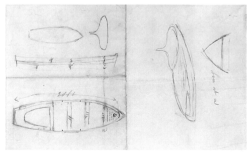

168

169

Sailboat [The "Vesper"?] Compositional Sketches and Plans, c. 1874

> Graphite on foolscap
>
> 13¹⁵⁄₁₆ × 16⅞ in. (35.4 × 42.9 cm)
>
> 1985.68.10.6
>
> Inscriptions (r): (TE in graphite, u.l.) *Horizon 9 ft / Distance tableau 18 in 1½ ft / 50: 3/2 :: 104 / 3•24 50 : 3/2 : 12 / 100 100•36;* (b.l. to b.r.) numbered grid, *0–20, 50–200*
>
> Inscriptions (v): (b.r.) *1st tape at bow sprit port / 2nd " " foremast / 3rd " fore end of cabin light / 4th aft end of cabin / 5th aft end of each[?] / level with rudder point / dimensions of boat*

Fig. 127

This drawing and perhaps the sketches on the versos of cats. 155 and 156 are the only material evidence of a plan that Eakins announced in 1874 to paint the yacht *Vesper*. The inscription at the upper right contains Eakins' usual formulation of the perspective conditions: 50:3/2:108, summarizing the foreground scale baseline (fifty feet, where, in this drawing, objects are one-thirty-third life size), the viewing distance of the spectator (one and a half feet from the picture) and the eye level or horizon (108 inches, or 9 feet). The odd scale fraction directs us to the more important and manageable scale line 150 feet distant, where the boat appears. Here the scale is a more convenient one-hundredth of life.

The plan at the upper right shows the boat's direction of sail in respect to the picture plane (a slope of 4:3). This plan is drawn in ten-foot squares, fifteen feet to the inch. From the plan we can deduce that the yacht is fifty-two feet long. (KF)

170

Sailboat Sketch

> Pen and black ink on cream paper
>
> 2⅜ × 4 in. (6 × 10.2 cm)
>
> 1985.68.10.8
>
> Inscriptions: (CB in graphite on mount, b.c.) *drawing by T. Eakins*

Eakins rarely sketched with pen and ink. The small size of this piece and its evidently rapid execution suggest a page torn from a sketchbook. Once folded, the paper was flattened and mounted on a piece of cardboard, probably by Bregler. Perhaps Eakins jotted down an idea for a sailing picture on such a small sheet and tucked it into his pocket. The relationship between this drawing and paintings from the mid-'70s to 1880s by Winslow Homer (*Breezing Up*) and Albert

Ryder (*With Sloping Mast and Dipping Prow*) is also worth remarking; like Eakins' small pen-and-ink sketch of Cabanel's *Birth of Venus*, cat. 189x, this may be a thumbnail drawing of another artist's work. (KF)

170

171

Cloud Studies, c. 1871–74

Graphite and orange crayon on foolscap

13¹⁵⁄₁₆ × 16¹⁵⁄₁₆ in. (35.4 × 43 cm)

1985.68.11.1

Inscriptions: (TE in graphite, u.l.) *sun wrong side looking West;* (c.l.) *These clouds very delicate / hard to see*

The faint cloud formations in this sketch do not appear in any of Eakins' finished oils. Evidently this is an outdoor study, perhaps made at the time of his other field sketches for his rowing and hunting subjects. (KF)

Baseball Players
Practicing, 1874–1875

172

Baseball Players Practicing: Perspective Study,
c. 1874–75

Graphite on foolscap

$13^{15}\!/_{16} \times 16^{15}\!/_{16}$ in. (35.4 × 43 cm)

1985.68.12.2

Inscriptions: (TE in graphite, u.l.) *Horizon 64 Base Ball. /
Tableau 4 pieds;* (u.r. and b.c.) arithmetical notations;
(b.c. to c.) numbered grid, *40–175,* pinholes on grid
points

Fig. 56

For a discussion of this drawing and the next one in re-
spect to the finished watercolor (plate 2), see chap. 7.

173

Baseball Players Practicing: Perspective Study with
Figures, c. 1874–75

Graphite on off-white wove paper

$13^{15}\!/_{16} \times 17$ in. (35.4 × 43.2 cm)

1985.68.12.1

Inscriptions (r): (TE in graphite, c.l. and b.l.) arithmetical
notations

Inscriptions (v): (b.l.) *slope 1:15 60;* (u.r.) arithmetical com-
putations

Fig. 57

Portrait of Dr. John
H. Brinton, 1876

174

Portrait of Dr. John H. Brinton: Ground Plan, 1876

Graphite and red ink on off-white wove paper

$17 \times 13\frac{7}{8}$ in. (43.2 × 35.2 cm)

1985.68.13.3

Inscriptions: (TE in graphite throughout) numbered grid,
0–27

Fig. 228

The three drawings for Eakins' portrait of the surgeon John H. Brinton (fig. 227) serve as an introduction to Eakins' portrait method, analyzed in chap. 19. From the annotations on cat. 175, we know that Eakins established his perspective of the space in the picture by assuming a spectator distance of sixteen feet and a horizon line of forty-eight inches, at Dr. Brinton's eye level. The perspective drawing was made, for convenience, much smaller than the life scale of the actual portrait. Although usually not so explicit, Eakins' notes record the scale of the drawing (one-eighth) and its viewing distance, which is one-eighth the length of the portrait's, or two feet. The scale on the plan, cat. 174, is slightly smaller (one-twelfth), no doubt because of the simplicity of measurements on a grid where one foot equals one inch. (KF)

175

Portrait of Dr. John H. Brinton: Perspective Study, 1876

Graphite, red and black inks on off-white wove paper

$17 \times 13\frac{7}{8}$ in. (43.2 × 35.2 cm)

1985.68.13.2

Inscriptions (r): (TE in graphite, u.l.) *Picture / Distance 16 ft Brinton / Drawing 2 ft / Horizon 48 in / Scale ⅛;* (b.l. to c.l.) numbered grid, *12–32;* (b.r.) *15 × 19 / 22 25½*

Inscriptions (v): (b.r.) *Brinton;* (c.r.) triangle with measurements

See cat. 174, fig. 229, and plate 20.

176

Portrait of Dr. John H. Brinton: Plan and Perspective Study of the Artist's Signature, 1876

Pen and ink over graphite on foolscap

$13\frac{7}{8} \times 17\frac{1}{16}$ in. (35.2 × 43.3 cm)

1985.68.13.1

Inscriptions (r): (TE in ink over graphite, u.l. to u.r.)

Eakins / 76; (b.l. to b.r.) *Eakins / 76.;* (in graphite, b.r.) *Brinton*

Inscriptions (v): (TE in graphite, u.r.) *Brinton*

Fig. 49

The signature and date at the top of this page were set into perspective in the lower part of the drawing. The slight reduction in scale indicates the placement of the signature in space thirteen feet from the viewer, just six inches beyond the picture plane. The signature appears at the same scale on the carpeted floor at the lower right corner of Eakins' portrait. Another perspective signature from twenty-five years later can be seen in cat. 213. (KF)

Eakins' painting of the American sculptor William Rush at work in his studio (fig. 129; plate 11) may have been conceived as early as 1875 and begun following the completion of *The Gross Clinic* late that year. Many studies in different media preceded the consummation of the painting in 1877. The coordinated use of preparatory drawings (cats. 177–189) and sculptures (cats. 253–257) is discussed in chap. 14.

William Rush Carving His Allegorical Figure of the Schuylkill River, 1876–1877

177

William Rush Carving: Study of Chippendale Chair (r and v), c. 1876–77

Graphite (r) and chalk (v) on foolscap

12⁷⁄₁₆ × 7¹³⁄₁₆ in. (31.6 × 19.8 cm)

1985.68.14.20

Inscriptions: (b.r.) embossed stationers' stamp: three turrets in an oval

Fig. 134

This drawing of a Chippendale side chair measures approximately the same as the chair at the lower right in the actual painting, about eight and a half inches high. It appears that Eakins first plotted out its cubic dimensions with the crosses, then constructed the chair within his perspective box. On the verso he copied the resulting outline of the chair with chalk and then, most likely, traced it from the paper onto the canvas. (MT/KF)

178

William Rush Carving: Study of Scrollwork, c. 1876–77

Graphite on tissue paper

30⅛ × 19⅞ in. (76.5 × 50.5 cm)

1985.68.14.19

Inscriptions: (TE in graphite, u.l.): *3 ft.*

178

179

William Rush Carving: Study of Scrollwork, Foreshortened, c. 1876–77

Pen with black and red inks over graphite on foolscap

12⁷⁄₁₆ × 7¹³⁄₁₆ in. (irr.) (31.6 × 19.8 cm)

1985.68.14.18

Inscriptions: (TE in black ink, c.) *finish* [or *finial*] *scroll / for S. Girard / Augst 13th*

The two drawings of scrolls (cats. 178–179) were probably copied from a sketchbook originally belonging to William Rush.[1] Shown in elevation in cat. 178, they are foreshortened in cat. 179, as they appear in *William Rush Carving His Allegorical Figure of the Schuylkill River*. The smaller scroll was transposed at the same scale on to the canvas; the larger scroll was reduced 25 percent and inverted for the painting. These sketches of scrolls are located on the right wall of William Rush's workshop above his workbench, below which one can see tools and various slabs and chips of wood, indicating work in progress. In the left foreground are two finished scrolls, one prominently highlighted, evidence of Rush's training as a carver, and his more routine work.

The sketches of scrolls on the wall are accompanied by the chalked inscription: "finish scroll / for S. Girard / Augst 13." One assumes then that the scrolls being prepared were intended for Stephen Girard, the great shipping magnate of the Revolutionary and early Republican eras. In fact, Girard had been Rush's most generous patron, commissioning at least one-fourth of his total production of figureheads.[2] It was this type of sculpture that had initially brought Rush fame.

The date 13 August may be related to a commission from Girard that Eakins discovered in Rush's notebook. Interestingly, the same date can also be found chalked onto a similar location—the right wall—in a photograph of Eakins, Samuel Murray, and William R. O'Donovan in their studio in 1892 (fig. 106). As in the William Rush painting of 1876–77, the chalked-in appointment time is also located above a workbench carrying tools and sculptures—in this case, a bust of Walt Whitman by O'Donovan. The three artists shared Eakins' studio on 1330 Chestnut Street in the early 1890s. The date 13 August is apparently an appointment with Weda Cook, who posed for Eakins in 1892.[3] Perhaps just a memorandum, it may also be an oblique reference to the importance of the live model (the principal theme in the William Rush painting) or an in-joke among Eakins and his friends, who surely knew the Rush painting, still in Eakins' possession. As these possibilities are weighed, it should be remembered that the photograph (probably made by Susan Eakins) was not a casual snapshot of the three artists enjoying each other's company, but a carefully staged rendition of the theme of the artist in the studio.[4]

If nothing else, this subtle and intriguing relationship between the William Rush painting and the later photograph gives us an indication of Eakins' lifelong preoccupation with the themes laid out in his 1876–77 painting. In a sense, the painting served as a basis for a profoundly significant personal iconography, made explicit in Eakins' revisions of the William Rush subject at the end of his career. (MT)

1. Another scroll drawing, perhaps from this same source, is in the Washington sketchbook; see cat. 189p. On Eakins' research, see Goodrich 1933, 171; Gordon Hendricks, "Eakins' *William Rush Carving His Allegorical Statue of the Schuylkill*," *Art Quarterly* (Winter 1968): 383–384.
2. Bantel, 10. Hendricks discussed a receipt for a scroll for Girard dated 1 Feb. 1807, but no other Girard documents from c. 1809 ("Eakins' *William Rush Carving*," 400).
3. Rosenzweig, 147.
4. On this theme, see Johns 1983, 91.

179

180

William Rush's "Allegory of the Waterworks": Rear View, c. 1876–77

Graphite on foolscap

6³⁄₁₆ × 4 in. (irr.) (15.7 × 10.2 cm)

1985.68.14.10

Inscriptions: (b.r.) embossed stationers' stamp: three turrets in an oval

This sketch and the next one are studies of William Rush's *Allegory of the Waterworks*, often mistakenly called *The Schuylkill Freed*, a figure carved in 1825 to decorate the portals of the millhouse of the Philadelphia waterworks.[1] Eakins could have seen these sculptures easily, although they were installed far overhead. Because the vantage in these drawings

seems to be high, Eakins must have viewed the sculpture from a distance, perhaps from the hillside of Fairmount.[2] Eakins modeled a small sculpture based on Rush's *Allegory* (see cat. 253), but the inclusion of certain details in the sketches indicates that these drawings were made from Rush's work and not his own. He evidently enjoyed the compact pyramidal form of Rush's piece when seen from the far left, as in cat. 180, but he placed the *Allegory* at the back of the studio in *William Rush Carving* (fig. 129; plate 11) in the more informative position shown in cat. 181. Siegl notes that Eakins may have known that Rush carved the *Allegory* sixteen years later than the *Nymph* but nevertheless included this figure (as well as other anachronisms, such as the *George Washington* of 1815) in Rush's workshop,[3] perhaps because it was familiar to Philadelphians and closely related to the theme of the *Nymph*. (KF)

1. Bantel, cat. 97. Since 1937 the *Allegory* has been on deposit at the PMA. Photos of the sculpture in situ can be seen in Bantel, 19, 173. Eakins' description of this piece is quoted in Goodrich 1933, 171.

2. Gordon Hendricks suggested that Eakins climbed on a nearby roof ("Eakins' *William Rush Carving His Allegorical Statue of the Schuylkill*," *Art Quarterly* [Winter 1968]: 393).

3. Siegl, 68.

180

181

William Rush's "Allegory of the Schuylkill": Side View, c. 1876–77

Graphite on foolscap

3¹³⁄₁₆ × 5¹³⁄₁₆ in. (9.7 × 14.8 cm)

1985.68.14.15

See cat. 180. Random marks in red ink appear at the bottom right. This drawing may have been cut from the sheet of

writing paper also used for cats. 184, 185, and 186. All four pieces were found mounted together on a single piece of paper, probably by CB. (CHV)

181

182

William Rush's "Water Nymph and Bittern": Studies of Figure, Arm, Claw, c. 1876–77

Graphite on cream wove paper

3⁹⁄₁₆ × 5¹⁄₁₆ in. (9 × 12.9 cm)

1985.68.14.11

Inscriptions (r): (TE in graphite, u.l.) *10½ 9¼ / 53 44½ / 45-x 40-x;* (u.r., below arm) *10½;* (c.) *45 around 4 or 5 for / draperies*

Inscriptions (v): *Dave Wright / 726 Edmund st / From Ridge Road to / Poplar*

Cat. 182 and the following five drawings are all sketches made from William Rush's sculpture *Water Nymph and Bittern* of 1809, fig. 135, known to Eakins as an "allegorical representation of the Schuylkill River." Originally made to decorate the garden of the pumphouse at Center Square in Philadelphia (fig. 130), the figure had been moved to the waterworks at Fairmount in about 1829. By 1872 the deterioration of the wooden sculpture caused concern, and—according to Eakins' account—the nymph was stripped of many layers of old paint and a mold was made in order to cast a replica in bronze. The original was repainted and replaced opposite the millhouse, while the bronze was installed in the center of a fountain nearby.[1] Eakins could have made these sketches from either source, although the detailed views of the head seen in the William Rush sketchbook (cats. 188e–h) would have been difficult to achieve from the fountain, and some of the chiaroscuro patterns in the drawings (e.g., cat. 187) suggest the white painted surface of the original wood rather than the dark and shiny patina of the bronze. How-

ever, the often painted and refinished surface of the original had lost much of its detail by 1877, as Eakins remarked, making the cast a superior record of the "elegance and beauty" of Rush's work. (KF)

1. The wooden original deteriorated and was removed in about 1902; its surviving fragment is now in the PAFA collection, 1990.8. The title, *Water Nymph and Bittern*, is modern; see Bantel, cat. 35 and photos on pp. 20, 116; Eakins' statement about the history and meaning of the figure is published in Goodrich 1933, 170–171; see also Siegl, 70–71.

184

182

183

William Rush's "Water Nymph and Bittern": Four Views, c. 1876–77

Graphite on heavy cream wove paper

3⁹⁄₁₆ × 5 in. (9 × 12.7 cm)

1985.68.14.12

Fig. 136

184

William Rush's "Water Nymph and Bittern": Facing Right, c. 1876–77

Graphite on foolscap

6³⁄₁₆ × 4 in. (15.7 × 10.2 cm)

1985.68.14.13

See cats. 181 and 182. All three pieces were probably from the same sheet of paper, later torn and separated by Bregler.

185

William Rush's "Water Nymph and Bittern": Rear View, 1876–77

Graphite on foolscap

6³⁄₁₆ × 3¹³⁄₁₆ in. (15.7 × 8.1 cm)

1985.68.14.14

Inscriptions: (TE in graphite, b.r.) *10 ft.;* (b.r.) embossed stationers' stamp: three turrets in an oval

Fig. 137

See cats. 181 and 182.

186

William Rush's "Water Nymph and Bittern": Facing Left, 1876–77

Graphite on foolscap

6⅛ × 3¼ in. (15.6 × 8.3 cm)

1985.68.14.16

See cats. 181 and 182.

187

William Rush's "Water Nymph and Bittern": Frontal View, 1876–77

Graphite on foolscap

14 × 8½ in. (35.6 × 21.6 cm)

1985.68.14.17

Inscriptions: (TE in graphite, u.l.) *Rush Sculptor;* blue lines printed on verso

Fig. 138

This is a larger and more detailed study of Rush's sculpture than seen in cats. 182–186. In this sketch Eakins seems concerned with conveying the folds of the drapery as they covered the midriff and legs of the statue. He also studied more carefully the effects of light and shade. His concern endows the sculpture with a vitality suggesting a live model rather than a wooden sculpture. (MT)

188

The William Rush Sketchbook, 1876–77

Graphite on seven sheets of lined machine-made paper, and one sheet of brown wove paper

c. 7⅜ × c. 4⅝ in. (18.7 × 11.8 cm) sheet size

Inscriptions: All by TE in graphite. Annotations and remarks are given for each page following the general commentary.

These eight pages, all on the same unevenly ruled notepaper, all bearing sketches relating to the William Rush project, come from a notebook that Charles Bregler divided in 1944. That year he sold six double-leaf "signatures" from this book (each signature with two pages connected by a fold) that ultimately came to the Hirshhorn Museum. Like the present pages, most of the Hirshhorn pages have a drawing on the verso and shorthand notations on the recto. Reunited, the two groups suggest a notebook of twenty-four pages plus a cover of plain pulp paper (cat. 188h). The notations are in Pitman shorthand, now rarely used; enough of the Hirshhorn notations could be translated to indicate that they record lecture notes on anatomy or dissection.[1]

Bregler selected the most elaborate sketches with the lengthiest annotations for sale, but the remaining pages in his collection can still be easily reintegrated with the Hirshhorn group. Three of the Hirshhorn sketches are studies of Rush's sculpture (*George Washington; The Allegory of the Schuylkill,* as in cats. 180, 181; and the *Water Nymph and Bittern,* seen in cats. 182–187 and on pages *e–h*). The others are costume studies from period sources, including Krimmel's *Fourth of July in Centre Square* (fig. 130), also used on page *a*. Similar studies of costume and sculpture appear in the Washington sketchbook, cat. 189. (KF)

1. Rosenzweig, 63–70. The tally includes two sheets of paper at PAFA with shorthand (on three sides) and no drawings, and indications of pages cut off (and now unlocated) from the fold of pages *a* and *d*. Hendricks noted that Eakins studied shorthand at Central High School (1974, 8).

188a

Costume Study: After John L. Krimmel's "Fourth of July in Centre Square"

1985.68.14.1

Inscriptions (r): *Krimmel / White Lace Shawl*

Inscriptions (v): shorthand notations with word squamous appearing at center and bottom center

Krimmel's painting of c. 1809–12 (fig. 130) was at PAFA in Eakins' day. This drawing is taken from the figure of a woman in pink at the right side of the canvas. Three figures standing next to her were sketched on another page of this sketchbook, now in the Hirshhorn Museum.[1] The word "squamous" within Eakins' shorthand notations on the verso suggests that he was taking notes during a lecture on the anatomy of the skull. (KF)

1. Rosenzweig, 70.

188a

188b

Costume Study: Francis McAllister

1985.68.14.2

Inscriptions (r): (u.l. to u.r.) *Frances McAllister 1806 Aged 60 / Dotted lace / cap. White / satin ribbon / Book muslin / shawl / 3 thick / white borders.*

Inscriptions (v): shorthand notations with word "rami" appearing b.l.

Evidently taken from a painting of 1806, this sketch has not yet been related to a particular source.

188b

188c

Furniture Study: Chair [?]

1985.68.14.3

Inscriptions (r): (u.l.) *25 inches high*

Inscriptions (v): shorthand notations

Although this appears to be a drawing of a small chair or stool, it does not appear in the painting of *William Rush Carving*.

188c

188d

Costume Study: After Rembrandt Peale's "William Rush"

1985.68.14.4

Inscriptions (r): (b.l. to b.r.) *Vest white looks like corduroy / William Rush, / White marseilles vest.*

Inscriptions (v): shorthand notations

Fig. 131

Eakins' study was taken from an undated portrait of William Rush attributed to Rembrandt Peale (1778–1860), fig. 132. This painting was once in C. W. Peale's museum.[1] Rush is seen in this costume in Eakins' *William Rush Carving* (fig. 129; plate 11). (KF)

 1. Bantel, 11.

188e

William Rush's "Water Nymph and Bittern": Head and Shoulders, Facing Left

1985.68.14.5

Inscriptions (v): shorthand notations

See cats. 182–187.

188e

188f

William Rush's "Water Nymph and Bittern": Torso, Facing Left

1985.68.14.6

Inscriptions (v): shorthand notations

See cats. 182–187.

188f

188g

William Rush's "Water Nymph and Bittern": Head and Shoulders, Front View

1985.68.14.7

Inscriptions (v): shorthand notations

See cats. 182–187.

188g

188h

William Rush's "Water Nymph and Bittern": Two Views (r)

Sketch of Bittern (v)

Graphite on brown wove paper

1985.68.14.8

Inscriptions (r): (u.l.) *Magie 1219 Arch St.*

Inscriptions (v): (u.l) *Kuhn / Fisher / Biddle / Cadwalladers / William Henry Rawle.;* (u.r.) *De Willing / Miss Susan Binney / Dallas' Daughter, / in the Mint*

Related in size and subject to the previous group of sketchbook pages, this discolored sheet may have been an endpaper. The list of names on the verso includes old Philadelphia families from Rush's day whose portraits provided Eakins with costume details. (KF)

See also cats. 182–187.

188h

189

Washington Sketchbook, 1876–78

Graphite on 25 sheets of blue-lined machine-made paper

4½ × 7½ in. (11.4 × 19.1 cm) sheet size

1985.68.14.9.*a–y*

Inscriptions: All in graphite by TE, except for page *x*. Remarks are given for each page in sequence following the general commentary.

The twenty-five extant sheets (plus seven blank leaves) in this sketchbook give evidence of a larger booklet that once held at least thirty-six pages. The cover, if any, has not survived. The copy-book paper sets it apart from another sketchbook of the same date and size in CB's collection—the William Rush sketchbook, cat. 188—because the printed blue lines run parallel to the long dimension of the page, at right angles to the spine. Eakins typically ignored these lines, even when writing. Most often he turned the sketchbook to put the spine at the top; rarely did he turn the page horizontally, and he never took advantage of a double-page spread. Such habits illustrate his prejudices as a figure painter most comfortable with vertical formats, as well as his inattentiveness to the paper surface, a trait seen elsewhere in his drawings (see chap. 7).

Three different projects dominate the pages in this book, allowing us to date its use from about the fall of 1876—at the earliest—through the spring of 1878, as shown by the letter to Schussele dated 22 March of that year (page *o*). Most plentiful are sketches related to his painting *William Rush Carving His Allegorical Figure of the Schuylkill River,* begun in 1876 and completed in 1877 (see fig. 129, plate 11, and chap. 14): eleven sides from ten different pages, *a, g, j, m, p, r, s, t, u, y.* Seven sides from five pages (*q, u, v, w, y*) may concern his portrait of Rutherford B. Hayes, painted for the Union League of Philadelphia in the fall of 1877 (and now lost; see chap. 19); and five sides from four pages (*a, r, t, u*) may relate

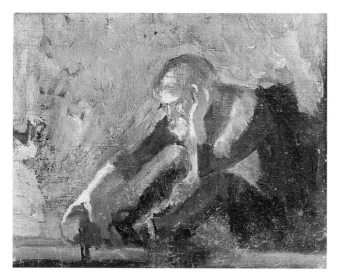

Columbus in Prison, c. 1876, oil on canvas, 5⅝ × 7⅜ in., Kennedy Galleries.

to a painting of Christopher Columbus that Eakins planned but never completed. Other pages are filled with notes and sketches that record thoughts and impressions at the Pennsylvania Academy (*b, g, o, x*) or abroad in Philadelphia, collecting the names of potential models (*b, e, g, q, u*) or studying horse anatomy (*d, e*). Apparently the last seven pages of the sketchbook were filled even farther afield, in Washington, D.C., where Eakins traveled in 1877 to paint President Hayes. To distinguish this sketchbook from the similar William Rush sketchbook, this novel section done in Washington has been used to characterize the entire booklet.

The visit to Washington was prompted by the commission to paint the president, but between sessions at the White House Eakins visited the Capitol and the Corcoran Gallery, turning his free time into costume research sessions for the "William Rush" project and another historical subject that was taking shape in his mind concerning Christopher Columbus. Only one small oil sketch, *Columbus in Prison* (see accompanying illustration), has survived to illustrate Eakins' intentions for this painting, which evidently was never developed beyond this stage. The notations in the Washington sketchbook, scattered amid items relating to *Rush* and *Hayes*, indicate that the Columbus theme was under consideration in 1877 and could even have been inspired by the sight of John Vanderlyn's mural and Randolph Rogers' door at the Capitol (pages *r, u*). Eakins' attention to Rogers' image of the explorer "in chains" may indicate a source for his own unusual concept of an aged, captive Columbus. However, Eakins' selective interest in costume in these sketches of Columbus, so like his focused attention on cravats, lapels, and bootstraps in his study of Stuart, Sully, Harding, and Houdon, may mean that the Columbus picture was already conceptually well formed and, like the Rush project, in need of background detail. Certainly the books he was consulting at this time (see page *a*) offered the kind of

technical information on Columbus' scientific context needed only after the pictorial concept was established. Because the oil sketch shows no signs of the costume details gleaned from Rogers and Vanderlyn in Washington, it probably precedes this trip. Perhaps, as McHenry and Goodrich have suggested, the sketch was made in 1876, at the time of the centennial celebration, when American beginnings were a popular topic of discussion.[1] Characteristically, Eakins did not choose to depict one of the more public, theatrical moments in Columbus' life, as did Vanderlyn and Rogers. Instead, his oil sketch shows Columbus alone in prison, chin in hand, considering a small sphere (chained to his leg) and musing over the events and ideas outlined in the books Eakins had seen. If McHenry is correct in linking the genesis of this sketch to the period when *The Gross Clinic* was excluded from the centennial art exhibition (only to be displayed among the medical equipment), Columbus' sad figure, beset by jealous, ungrateful, or misapprehending enemies, may be an oblique comment on the unjustly unappreciated men of science and vision of a latter day. Feeling victimized, Eakins was in a mood to consider compassionately other maligned "explorers." Structurally, his view of Columbus as misunderstood and constrained is analogous to his presentation of William Rush, brought to a successful realization in the same years.[2] Perhaps the Rush subject, so much closer to Eakins in time, space, and personal reference, and certainly much easier to imagine in detail, drew emotional energy away from the Columbus idea, which, as the Washington sketchbook shows, had only nineteenth-century visual sources to support it. The Columbus project came to nothing more than these sketches, and no documents concerning the scheme survive, so we may never know the special purpose or inspiration behind this idea, or why Eakins abandoned it.[3] (KF)

189a

Bibliographical Citations on Navigation History (r)

Costume Study: Man's Collar (v)

> Inscriptions (r): *Navigation. / History / Humboldt. (F. H. A. von) Progrès de l'astronomie nautique / aux 15e et 16e sièclen / Instruments / Chaucer G. Conclusyons of the / astrolabye. / [In Chaucer (G) Works 1542. / Gemma (R) De astrolabio / catholico libellus, / auctore Gemma Frisió / [In Apianus Cosmographia]*; written vertically at b.l. beside final entry: *(not seen)*; first two entries crossed out with graphite "x."

Inscriptions (v): *Miriam Dodge / Gardel / Whittle*

The books listed on the recto may have been consulted for information pertinent to Eakins' plans for a picture of Christopher Columbus (see also pages *r* and *u*). The first two titles have been crossed out, as if seen; the last is marked "not seen." Copies of Humboldt's study of 1809 can still be found at the Historical Society of Pennsylvania or the Library Company of Philadelphia, and Chaucer's *Works*, in the edi-

tion of 1542, are held by the University of Pennsylvania, although the acquisition dates of these books remains unknown. Gemma's much rarer treatise was held by no library in Philadelphia, which explains why it was not seen.

The verso image is the first of several early-nineteenth-century costume notes in this sketchbook, all evidently made in preparation for *William Rush Carving*. Eakins drew this information from period portraits, sometimes identified in his annotations. Here Eakins forgot to note his source, making even more obvious his interest in the lapels of the jacket, not the features of the sitter nor the artistic qualities of the painting. The inscriptions on this page seem to bear no relation to the sketch. "Gardel" may refer to Eakins' friend Bertrand Gardel, seen in *The Chess Players* of 1876. (KF)

189b

Mercury (r)

> Inscriptions (v): *40 Presbyterian Builders* [?] */ opposite Mint. / James Maurice / 540 Vincient St. / McClement / 752 S. Sixth St / 16 years old*

Eakins probably sketched the figure of *Mercury* in the main corridor of the Pennsylvania Academy, where a copy "after John of Bologna" (Giovanni da Bologna, 1529–1608) stood soon after the new building opened in 1876.[4] However, replicas of the original sculpture of 1564 in Florence were common; a small version stood on the newel post at the foot of the staircase in John Sartain's home, where Eakins was a frequent visitor.[5] Perhaps, in league with his friend and fellow painter Billy Sartain (John's son), Eakins added in jest an erect phallus to the figure. Such commentary would have been a flippant restatement of the theme of public sculpture and nude study in his William Rush project. Rush had also carved *Mercury* at least three times, although his versions were discreetly clad in Roman costume.[6] On the trail of Rush's sculptures, Eakins may have paused to consider a Mercury from a less prudish era. (KF)

189c

Anatomical [?] Sketch (r)

Tiny perforations bisect the page, interrupting the drawing as if another sheet of paper had once been laid across the page. The sketched form, with its suggestion of pelvic bones, is also seen on page *j;* the same perforations appear on page *m*, where half the page has been torn out along the line of holes. At least one page has been torn out of the sketchbook between pages *b* and *c*. (KF)

189d

Horse's Front Legs (v)

189d

189e

Horse's Rear (v)

> Inscriptions (v): (along right edge of drawing) *J. W. Barr Broad & Barclay*

A similar sketch, including a side view and measurements of a horse, appears on cat. 44.

189b

189e

189f

Two Cylinders; Shorthand Notations (r)

Inscribed overall with shorthand symbols, repeated as if in practice. These same shorthand notations appear on the verso of page *y* below and on many of the pages in the William Rush sketchbook; see cat. 188. The unexplained sketch next to these notations resembles nothing so much as a tin can telephone. (KF)

189f

189g

Man at Lectern, and Other Figure Sketches (r)

Trestles, for "William Rush Carving" (v)

> Inscriptions (r): *William Waters / 913 Callowhill St. / John Conner laborer / 2040 Winter St.*
>
> Inscriptions (v): measurements, e.g., *37 wide / whole tressel*

The bearded man in this sketch stands at a lectern that resembles the furniture designed by Frank Furness for the new Pennsylvania Academy building; he may be addressing an audience in the school's auditorium. Reviewing the list of special lectures at the Academy in this period, it is tempting to speculate that the speaker is Eakins' old friend and classmate at the Ecole in Paris, Earl Shinn, who spoke on "The History of Aesthetics" on 17 October 1876.[7] Eakins' familiarity with Shinn may explain the irreverent gestures of the figures in the audience, who slump in boredom or "cock a snook" at the speaker. On the verso are the drawings of the wooden trestles seen at the back of Rush's shop in Eakins' painting of *William Rush Carving* of 1877. The annotations on the recto are probably names of likely models. (KF)

189g r

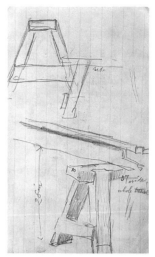

189g v

189h

Striding Figure; Cubes (r)

Boat Profiles [?] (v)

The exotic costume and accessories of this figure suggest that the sketch was made from a sculpture, for the man wears a flowing headdress and knee breeches and appears to be carrying a quiver attached to his back with a swirling sash. On the verso are three quick sketches that may be cross sections of boat hulls; see also the verso of page *l*. (KF)

189h

189i

Architectural Sketch: Measured Drawing of an Interior (r)

This sketch of a doorway, a fireplace, and the elaborate moldings of a room must have been taken from an actual interior. Considering the other projects represented in this sketchbook, it is possible to imagine this as the White House room where Eakins depicted President Hayes in 1877 (see chap. 19). No other painting from this period with this architectural background has been located; the Hayes portrait is lost. At least one page has been torn out of the sketchbook between pages *i* and *j*. (KF)

189i

189j

Anatomical [?] Sketch; Measurements of Rush's "Washington" (r)

Inscriptions (r): *chin to top of scroll / 23½ top of scroll / to foot* [line drawn through] *stand bottom / of left foot 40¼ / right foot raised 2 inches*

The unidentified form (pelvic bones?) in this sketch appears also on page *c*. The measurements were taken from William Rush's wooden sculpture, *George Washington*, of 1815 (Independence National Historic Park, Philadelphia) which Eakins also sketched and modeled in wax in preparation for his painting, *Rush Carving . . .* See cat. 257 and Rosenzweig, no. 26.1. (KF)

189j

189k

List of Names of Philadelphia Artists (r) (v)

Inscriptions (r): in two columns

Newbold H. Trotter	*Xanthus Smith*
Jeremy Wilson	*De Crano*
D.W.C. Boutelle.	*Fred James*
Peter Moran	*Charles V. Brown*
H. C. [crossed out]	*Alex Laurie*
Howard Helmick	*Howard Roberts*
Joseph W. John	*Faulkner*
R. Heber Reed.	*Mary Cassatt*
Thos. J. Fenimore	*Catharine Drinker*
T. Buchanan Reed.	*J. L. Krimmel, d. Acad*
Geo. B. Wood Jr.	[*or dead;* crossed out]
C.L. Fussell.	*Leslie*
A. C. Paquet Engraver.	*Edward May*
W. Van Bonfield	
G. Nicholson	
Leon S. Juillard	
Milne Ramsay.	
A.G. Heaton	
Ida Waugh	
Emily Sartain	

Inscriptions (v): in two columns

Benjamin West.	*Wm. Rush*
Gilbert Stuart	*Isaac. Broome*
Neagle	*J. A. Bailly, Sculptor*
Isaac Williams	*A. E. Harnisch (Rome)*
Wm. H. Willcox	*Edmund D. Lewis*
Wm. T. Richards	*Edward Moran*
P.F. Rothermel.	*Geo. C. Lambdin*
S. B. Waugh	*Wm. E. Winner*
Thomas Sully.	*Wm. E. Furness Junior*
(center square painter)	*Russell Smith*
Christian Schuessele.	*W. Sanford Mason*
James Hamilton	*F. Henry Smith*
George W. Holmes,	*Chas. F. Blauvelt*
Chas Wilson Peale.	*W. E. Cresson*
——— Peale	*Daniel R. Knight*
Rembrandt Peale	*W. H. Hewitt*
Chas L. Fussell	*W. Vandweld Bonfield*
J. Henry Brown.	*Stephen J. Ferris*
Abraham Woodside	*Paul Weber*

Conarroe [crossed out] *Edward Moran*

Pettit [crossed out] *E. D. Marchant*

Geo. W. Conarroe. *Robert Wylie*

Thos. Moran

Geo. F. Bensell

This list of seventy-five names (excluding repeats) makes an interesting roster of Eakins' Philadelphia peers past and present, for everyone here had a connection to the city. Eakins topped his lists with historical figures from the founding generation of the Pennsylvania Academy: Benjamin West and William Rush. As the list proceeds, more and more of Eakins' own contemporaries appear. The inspiration for this roster is not clear, although it is not a list of artists exhibiting at the Academy in about 1876–78. Two dozen of these artists did not show at the annual exhibitions during those years, while some PAFA exhibitors do not appear on Eakins' list (e.g., Thomas and William Birch, Henry Inman, and Bass Otis—all figures from the past—as well as many obscure contemporaries, probably students or amateurs). Neither was the list based on the artists enumerated in the 1876 Philadelphia city directory, which included 104 names, but not Eakins, Rothermel, Cassatt, and others. However, about 80 percent of these artists were alive in 1876, and while some were nonresidents, the total list gives a rich sense of the size of the professional art community according to Eakins: his most worthy ancestors, peers, critics, friends, and competitors in Philadelphia. Perhaps the retrospective of American art appearing at the Centennial Exhibition, or the related scholarship of his friend Earl Shinn (compare page *g*), who had recently published a history of Philadelphia's artists and a profile of the Pennsylvania Academy, inspired Eakins to consider the city's artistic lineage from William Rush to 1876.[8] Oddly, Eakins' best friend as an artist, William Sartain, and his father, John Sartain, are not mentioned. Perhaps this list was made in their company. (KF)

189l

Boat Profiles [?] (r)

Geometric Shapes and Arithmetical Notations (v)

On the verso and on parts of *m* and *n*, Eakins explores a right triangle, the squares projected from its sides, and its volume as a wedge. The recto image may relate to page *h*.

189l

189m

Geometric Shapes (r)

Floor Plan [?] (v)

This page has been torn along a line of perforations at the center, leaving the sheet half the size of the other sketchbook leaves. On the verso, the plan seems to mark intervals (feet?) from the dot to a gridded corner. Given the context of this sketchbook, with its many drawings for the painting *William Rush Carving*, it is logical to read Rush's studio into this plan: if the dot represents the location of the model, then the sketched circle indicates the base of the *Nymph* and the gridded corner represents the spot where Rush's sculpture of *George Washington* is to be set into space, about fourteen feet behind the model (see fig. 129, plate 11, and the earlier version, G III, Yale University Art Gallery). Similar plans, done with more care, exist for the rowing subjects and *The Fairman Rogers Four-in-Hand*; none is extant for *William Rush Carving*, although surely Eakins used such drawings to set the distant figures into proper perspective. (KF)

189m r 189m v

189n

Geometric Shapes

189n

189o

Copy of a letter to Christian Schussele from George Corliss, 22 March 1878 (r)

Copy of a letter from Corliss to Schussele, 15 May 1877 (v)

Inscriptions (r):

> *Penna Acad. of the Fine Arts*
> *Phila. March 22. 1878*
> *Prof. C. Schuessele—*
> *Dear Sir*
> *At a Special Meeting*
> *of the Board of Directors of the*
> *Academy held this day, it was*
> *resolved,* [line struck through]
> *Resolved*
> *That the resolution of*
> *May 14, 1877, instructing Prof*
> *Schuessele not to delegate his*
> *authority or duties to any other*
> *person as instructor be rescinded*
> *and that Prof Schuessele be authorized*
> *to avail himself of such assistance*
> *as he may consider desirable in*
> *any or all of the classes.*
> *Yours truly*
> *Geo Corliss*
> *Secretary*

Inscriptions (v):

> *Pennsylvania Academy of*
> *the Fine Arts.*
> *Philadelphia May 15th.*
> *1877*
> *Prof. C. Schussele.*
> *Dear Sir,*
> *At a stated meeting of*
> *the Board of Directors, held*
> *14 th. inst. it was* [illegible—crossed out] *resolved.*
> *That Prof. Schussele be*
> *instructed that he will, from*
> *this date, be expected not*
> *to delegate his authority or du-*
> *ties to any other person; and*
> *that his personal attention*
> *to the instruction of regularly*
> *established evening classes will*
> *hereafter be necessary.*
> *Yours respectfully*
> *Geo. Corliss. Actuary.*

Copies of the original letters that Eakins transcribed are in the PAFA Archives; Goodrich published all of the first letter of 1877 and portions of the letter of 1878 in his discus-

sion of Eakins' career as a teacher at the Academy.[9] The earlier letter was a slap at Eakins, who had been voluntarily supervising evening classes when Schussele's health made his regular attendance difficult. As Schussele's condition continued to deteriorate in 1878, the board realized Eakins' services were needed, and the earlier restriction was lifted. The significance of these two decisions, which first impeded and then opened his opportunities as a teacher, is underscored by Eakins' sense that they were worth copying for his own record. (KF)

189p

Scroll Study: Carved Wooden Ship's Finial, for "William Rush Carving" (r)

This is a variant that does not appear in the final painting. See also cats. 178 and 179.

189q

Address (r)

Floor Plan (v)

Inscriptions (r): *A. Dilwin / 1624 Afton St. S. of Ellsworth. / W. of 16th*

Inscriptions (v): measurements throughout

This rough sketch of a floor plan, with some internal measurements but no consistent scale, may relate to the measured elevation on page *i*. Because of its placement within this sketchbook, the drawing may be interpreted as a plan of President Hayes' office showing the position of figures and furniture within this space. (KF)

189q

189r

Costume Studies: Lapel of Man's Jacket (r)

Christopher Columbus (two views) (v)

Inscriptions (v): *Columbus / from bronze / door of capitol / shirt bound / round waist / with strap / & cloak / thrown over / shoulders.*

The recto image seems to have been done from an unidentified early-nineteenth-century portrait, like the sketches on pages *a, t, u,* and *y*.

The verso images were sketched in Washington, D.C., probably in late summer 1877, when Eakins was painting President Rutherford B. Hayes. Both figures were taken from the eight panels of the "Columbus Doors" by Randolph Rogers (1825–92), installed in 1858 on the central portico of the east front of the Capitol. The larger, central figure shows Columbus as he appears before the Council of Salamanca in panel number seven, the lowest panel on the left-hand door. The smaller sketch at the lower left of the sheet depicts "Columbus in Chains" from panel number six, second from the bottom on the right-hand door.[10] See also page *u*. (KF)

189r v

189s

Costume Studies: Bootstrap, from Houdon's Sculpture "George Washington" (r)

"George Clinton," from Sculpture by H. K. Brown (v)

Inscriptions (r): *Statue / Washington / given by / Virginia in / 18* [scratched out] *1788 / Bootstrap goes / on the lower / two buttons.*

Inscriptions (v): *George Clinton / H K Brown / Sculp / 1873.*

A copy of J.-A. Houdon's (1741–1828) sculpture of George Washington, completed in 1791, stood in the National Statuary Hall in the Capitol when Eakins visited Washington, D.C., in 1877. Created in 1864, this hall was filled with sculptures donated by the states, which were each invited to submit statues of two illustrious citizens. Virginia contributed a copy by William J. Hubard (1807–62) of Houdon's original statue, which stands in the Richmond capitol. Eakins, with the William Rush project on his mind, seems to have been interested only in the mechanics of Washington's bootstraps; in the painting of 1877, Rush wears similar boots (see fig. 129, plate 11). Henry Kirke Brown's (1814–66) statue of George Clinton, sketched on the verso of this page, also stood in the National Statuary Hall. As with *Washington*, Brown's figure drew Eakins' attention because

of its costume, especially the collar, waistcoat, and knee breeches. (KF)

189s

189t

Costume Study: after Gilbert Stuart's "Thomas Jefferson" (r)

Pediment of the Parthenon; Ships (v)

Inscriptions (r): *Thomas Jefferson Gilbert Stuart / White House*

Both the portrait of Jefferson and the parasol sketched below were done in search of period costume for *William Rush Carving*, perhaps while passing idle moments in the White House, awaiting opportunities to paint President Hayes. The sketch of the Parthenon may have been suggested by Eakins' visit to the Capitol; the boat studies may have been made as he considered the theme of Christopher Columbus, displayed on the doors of the Capitol (see page *r*). At least one page has been torn out between pages *s* and *t*. (KF)

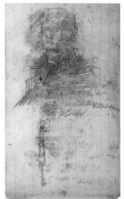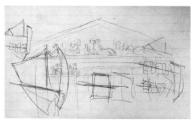

189t v

189t r

189u

Boat Studies [?] (r)

Costume Studies: after Thomas Sully's "James Madison"; after John Vanderlyn's "Columbus" (v)

Inscriptions (r): *James / Stony. 2d house of court. from / 15th. below Cherry.*

Inscriptions (v): (u.r. to l.) *gave me 10 minutes work. All I had / James Madison by / T. Sully / Corcoran's / gallery;* (c.r.) *yellow cloak / red vest & red / sleeves white / drawers & white* [crossed out] */ sle* [crossed out] *slashed & / white showing / through;* (b.r. to l.) *Tuesday 3.25 to 3.50 / Wednesday. 1.40 to 3.15.*

Fig. 51, verso

The original Corcoran Gallery opened in 1871 in a building on Pennsylvania Avenue just a block from the White House. Eakins' sketch of James Madison was taken from a full-length portrait of 1809 by Thomas Sully (1783–1872) that had been given in 1877 to the gallery by the painter Frederic E. Church. Although the portrait was done at full length, Eakins focused only on Madison's collar and necktie. Painted in the same year that William Rush sculpted his *Water Nymph and Bittern,* Sully's portrait offered details of period dress exactly contemporary with the scene depicted in Eakins' *William Rush Carving.*

Eakins traveled across town to the Capitol rotunda to sketch the other figure on this page from John Vanderlyn's (1805–76) mural, *The Landing of Columbus at the Island of Guanahani, West Indies, Oct. 12, 1492* of 1839–46. As with the Madison portrait, the details of costume seem to have motivated Eakins' interest; the drawing of the pose is careless, while the color notes are elaborate. See also page *r.* (KF)

189v

Portrait of a Man [Rutherford B. Hayes?]; Sketch of a Seated Man (v)

See page *w.*

189v

189w

Standing Man [Rutherford B. Hayes?] (r)

Washington Addresses and Train Times [?] (v)

Inscriptions (r): *Louvre*[?] */ 12 50 1.25 2½;* (c.r.) *Mora.*

Inscriptions (v): *16 l. 25 × 39 / F.D. Stuart 21st. below Penna. Avenue / above H. / 16 × 19 / Figure*[?] *14 / 425* [crossed out] */ 828 14th St. 5 o'clock / Cor 14th & I. / Pondexter / Penna. Avenue + / 15th St. / Top of Building / Big Hotel opposite Treasury. / Mr. Brandt. 1328 I. St. N.W. / 6.55 8.10 9.00 9.47* [crossed out] *7.20 9.46 Express. / F. St.* [illegible]

Fig. 226

See page *v* and general discussion above.

189x

Cabanel's "Venus" (r)

Inscriptions: (CB in ink, l.r.) *by Thomas Eakins*

This sketch was made from *The Birth of Venus* of 1863 by Alexander Cabanel (1823–89) in the collection of Henry C. Gibson of Philadelphia, who bequeathed the painting to the Pennsylvania Academy after his death in 1891. Eakins probably made this sketch at the Academy in the spring of 1877, when the painting was lent to the annual exhibition. Eakins' interest in this painting is paradoxical, given his often-quoted disdain for the naked "smiling smirking goddesses of waxy complexion" that populated the Salon paintings of his day. The affected posture, dewy idealism, and contrived mythological pretext for nudity in Cabanel's work would have been antithetical to Eakins' own philosophy of figure painting.[11]

The torn margin at the left shows that this page was once attached to page *g* in the sketchbook. The relatively clean margins also indicate that this page came in the middle of the page sequence, not at the end (where the pages are more soiled and damaged), but the loss of many other pages throughout the book makes it impossible to know its exact placement. (KF)

189x

189y

Costume Studies; after Chester Harding's "John Randolph" and Gilbert Stuart's "Edward Everett" (r)

Calendar of Sittings with Rutherford Hayes [?] (v)

Inscriptions (r): (u.r. to l.) *Chester Hardings portrait of / John Randolph Va.;* (c.r.) *Edward Everett / 19 years old / By Stuart / in 1812 / White neck / tie ends / hanging / down almost / covering plain shirt front;* (b.r. to b.l.) *Saturday 11–12.35 Judge Wood. / talk about fear & strikes. / Monday 2 to 3.15. All wet.* [?] / *old man to get cashiered army / officer reinstated. Read papers / most of the time. / Man from T* [illegible] *street fighting pistols.*

Inscriptions (v): (u.l. to b.r.) *Tuesday 50 minutes* [superimposed on ¾ hour] / *Wednesday 1 hr. 45 minutes. / Thursday 55 minutes / old man from N.C. / got nothing after the / first 10 minutes. / Friday 1 hour. Crazy spiritualist / Saturday 10.50 to 1 o'clock / Monday 2.20–3 30. Gen / Crook & Ohio politicians / Tuesday 2.15 to 3.30 / N.Y. Bankers. / Wednesday 2.15 to 3.15. / Bad posing / General Crook / Thursday 2.20. 3.33 / Indian Philanthropists. / Friday 2.10 3 10* [10 scratched out] *T Survey General from N* [torn] / *invitation to* [illegible, torn]; (along r. margin) miscellaneous shorthand symbols

Chester Harding's (1792–1866) portrait of *John Randolph of Roanoke,* painted in 1829–30, came into the collection of the Corcoran Gallery in 1875 (see page *u*). The sketch of Randolph and the jottings at the bottom of the page regarding Eakins' appointments with President Hayes suggest that the notes on Stuart's portrait of Edward Everett, also on this page, were also made in the Corcoran or in another Washington collection. Catalogues of Stuart's work indicate otherwise, although one of the two known portraits of Everett could have been in Washington temporarily, or a copy or misidentified "Stuart" or "Everett" seen instead.[12] Given Eakins' fixation on cravats, the identity of artist or sitter remains less important than Eakins' belief that he was consulting an authentic period source. (KF)

1. McHenry, 33; Goodrich 1933, 169. See also Parry and Chamberlin-Hellman, 22–23. SME's manuscript inventory notes that the Columbus sketch (G 103) was once slightly larger, about 9 × 10 in. (CBTE, Foster and Leibold, fiche series II 4/D/5).

2. On Eakins and his identification with William Rush, see Johns 1983, chap. 4.

3. Because *Columbus in Prison* was not catalogued by Marceau or Burroughs, Goodrich must have relied on Susan Eakins' identification of this sketch, which would have been made before she knew Eakins well. Hendricks asserted, without justification, that Eakins abandoned the Columbus project "in disgust," implying that, as with the *Hiawatha* paintings, Eakins found the subject "too poetical" (1974, 110).

4. PAFA, *Catalogue of the Property and Loan Exhibition* (Philadelphia, 1876), no. 267, p. 22, no size or medium given. The sculpture had been on view at the Academy since 1862; it is no longer in the collection.

5. PAFA's archivist, Cheryl Leibold, discovered a photograph of the Sartain home showing this sculpture in place (Sartain Family Papers, Historical Society of Pennsylvania; see AAA microfilm reel 3913, frame 250).

6. Bantel, cats. 99, 100, 101. It is not clear whether Rush's best-known *Mercury,* installed on top of the gazebo at Fairmount in 1828, was still in place in 1876. The connection between Rush and Giambologna was suggested to me by Michele Taylor.

7. "Special Lectures at the Pennsylvania Academy, 1876–1926; Printed Tickets," typescript, PAFA Archives. The next such public lecture was not until Dec. 1878. There would have been, of course, other less formal lectures in connection with the school curriculum.

8. See Earl Shinn, *A Century After: Glimpses of Philadelphia* (Philadelphia, 1875); and "The First American Art Academy," *Lippincott's Magazine* 9 (Feb. 1872): 143–153. Shinn's influence was suggested to me by Michele Taylor.

9. Goodrich 1982, I: 171–172 and nn., p. 327, which indicate that Goodrich learned of this correspondence first via Eakins' transcripts in this notebook.

10. See James M. Goode, *The Outdoor Sculpture of Washington, D.C.: A Comprehensive Historical Guide* (Washington, D.C.: Smithsonian Institution Press, 1974), 55–58.

11. Goodrich 1982, I: 28–29.

12. Lawrence Park, *Gilbert Stuart: An Illustrated Descriptive List of His Work* (New York, 1926); vol. 1 lists two versions from 1820: no. 286, still owned by Everett's family in New Jersey, and no. 287, given to the Massachusetts Historical Society in 1856. Park's catalogue reconfirms information known in Eakins' day; see George C. Mason, *The Life and Work of Gilbert Stuart* (New York, 1879), 114, which lists but does not reproduce the two Everett portraits and notes that they were not known to have been engraved. Eakins' confusion of dates (Everett was twenty-six years old when Stuart painted him in 1820, not "19 years old . . . in 1812") may be additional evidence that the painting was not by Stuart or not of Everett.

189y

The Courtship, c. 1878

190

The Courtship: Perspective Study of Chair and
Spinning Wheel, c. 1878

Graphite and pen with blue and red ink on foolscap

17 × 13⅞ in. (43.2 × 35.2 cm)

1985.68.15

Inscriptions (r): (TE in graphite, u.r.) *23½″*; (c.r.) arith-
metical notations

The first of Eakins' many paintings and sculptures on
the theme of knitting or spinning was *In Grandmother's Time*
of 1876, a subject probably provoked by the nostalgic mood of
the Centennial.[1] Eakins depicted an elderly woman, dressed
in the costume of the turn of the nineteenth century, seated
at a spinning wheel. According to William Dean Howells,
such a scene transpired at the Centennial exhibition, where a
"lovely old Quakeress" stepped forward from the crowd to
"take the wheel," providing "altogether the prettiest thing I
saw at the Centennial."[2] Eakins may also have been inspired
by his admiration for Velázquez' *Las Hilanderas,* which he
praised effusively when he saw it in the Prado in 1869.[3]

About two years later Eakins began on a more ambitious
and anecdotal treatment of the spinning theme. *The
Courtship* (see accompanying illustration) shows a young
woman spinning while a young man watches. Their early-
nineteenth-century costumes and the evocation of the narra-
tive in Henry Wadsworth Longfellow's popular poem of
1858, "The Courtship of Miles Standish," in which John
Alden courts Priscilla while she is spinning, place this subject
squarely in the realm of colonial revival themes.[4]

The spinners in *The Courtship* and *In Grandmother's
Time* sit in the same low chair and at the same spinning
wheel, which is placed at the same angle in space. However,
the larger size of *The Courtship* makes it possible to identify
Eakins' preparatory drawing, cat. 190, with this later work,
because the wheel is exactly the same size in both drawing
and painting. The vanishing point on this drawing is at the
left margin, above the spinner's chair, where it would be in
The Courtship. From this placement we might surmise that
another sheet of paper, representing the other half of the
composition, has been lost.[5] Although no perspective coordi-
nates were noted on this drawing, they can be deduced by
measuring. The chair straddles a line in space that must have
been Eakins' scale line, and the orthogonals cross this line
every three inches, suggesting a scale of one foot to three
inches, or one-fourth life. Measuring up from this line to the
horizon finds a distance of twelve inches, which (at one-
fourth life) indicates a "real" horizon of forty-eight inches, or
Eakins' eye level when seated. The viewing distance of the
painting can be calculated by using a rule of thumb (demon-
strated in cats. 100, 173) to discover a spectator position four
feet from the picture. Knowing this distance and the scale,
we can use Eakins' law of perspective (described in cat. 92) to

394

deduce that objects at one-fourth scale projected on a canvas four feet away must be sixteen feet distant in reality. The spinner and her beau are therefore sixteen feet from us; the lower edge of the canvas is probably the twelve-foot line.

Eakins made this drawing to plot the location of the chair and the spinning wheel in space. Most difficult and beautiful as a problem in perspective is the description of the wheel, which lies in a plane indicated by a diagonal line on the floor. The plane cuts through the center of the driving wheel where a groove holds the spun thread in place, not along the front or rear face of the wheel. The outline of the wheel itself is drawn in red and blue ink. Specific points on the wheel, its frame and linkages to the treadle, the placement of its feet on the floor, and the placement of the principal coordinates of the chair are marked with small circles and "x's" in both colors of ink and graphite. The outline of the chair is made in a firm but sketchy manner, with a pencil. The distaff arm appears in two different positions with an almost ghostly evocation of unspun flax, rendered in rubbed graphite. Eakins' pleasure in such a problem, and his techniques for measuring and drawing a wheel in space, clearly illustrate attitudes and principles that he would spell out in his drawing manual in the following decade (see cats. 118–120).

Eakins' working method for *The Courtship* corresponds to that of the rowing pictures he painted earlier in the decade. For both, perspective drawings of the mechanical elements are paired with oil studies for the figures who manipulate the machinery. The shifts from modern life to a nostalgic past, from man's sport to woman's work, from a landscape to a domestic interior, are shifts of subject but not of artistic purpose. If anything, the unromantic, factual tone is more obvious in *The Courtship* than in the rowing scenes.

The similarity of tone is due as much to the treatment of the setting as to the detached air of the figures in what could easily have become a sentimental painting. In most Colonial Revival pictures, a backdrop of architecture and decoration, often carefully researched, vies with the figures for our attention. None of Eakins' costume pieces have these crisply detailed interiors as settings. Instead, the lack of distinction of even wall from floor planes in *The Courtship* makes it imperative that Eakins position its furnishings carefully, as they are our only clue to the character of the painted space. Such austerity is in sharp contrast to the richly textured evocations of water, air, and foliage in the rowing scenes, but the effect parallels the single-minded focus on figure over ground in his watercolors of the late 1870s, and in many of the later portraits.

When Eakins is characterized as a painter of modern portraits, the costume pieces, including the spinning subjects, are seemingly anomalous. But they need to be considered an expression of their maker's artistic interests. Defining one of his favorite subjects as the juxtaposition of machinery, often in motion, with its human user helps create a more comfortable category for them, related to his larger engrossment with modernity. Few machines were associated with

better-off women, who were being relieved of such household labor as well as deprived of the pleasure in handwork. The disappearance of the spinning wheel from every kitchen made it as powerful a symbol of rapidly changing times as the factories that came in its place. (KJ/KF)

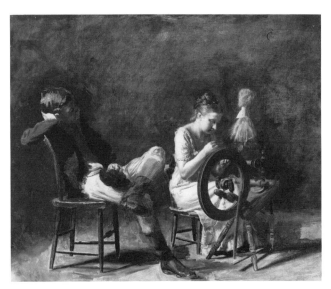

The Courtship, c. 1878, oil on canvas, 20 × 24 in., Fine Arts Museums of San Francisco, Museum Purchase by Exchange; Gift of Mrs. Herbert Fleishhacker, M. H. de Young, John McLaughlin, J. S. Morgan and Sons, and Miss Keith Wakeman.

1. G 106, oil on canvas, 16 × 12 in. (Smith College Museum of Art). Other spinning subjects are G 119–121, 144–147, 504; Hirshhorn cat. 122; and Hendricks 1974, 163. See also cats. 206–207, 243, 260–261.
2. Quoted in Sewell, 59.
3. Ellen Landau has noted this connection, as well as the assumption, in Eakins' day, that Velázquez' scene of spinners and tapestry weavers depicted a genre subject, not the more complex allegory understood in this subject today (Rosenzweig, 96). Eakins' admiration for Velázquez is recorded in his Spanish notebook; see Foster and Leibold, 60–61, 185.
4. See Christopher Monkhouse, "The Spinning Wheel as Artifact, Symbol, and Source of Design," in Kenneth Ames, ed., *Victorian Furniture: Essays from a Victorian Society Autumn Symposium* (Philadelphia, 1983), 153–172. See also Marc Simpson, "The Courtship," in *The American Canvas: Paintings from the Collection of the Fine Arts Museums of San Francisco* (New York: Hudson Hills, 1989), 144.
5. Eakins used two sheets of paper in this fashion for his perspective of *Negro Boy Dancing*, cat. 191.

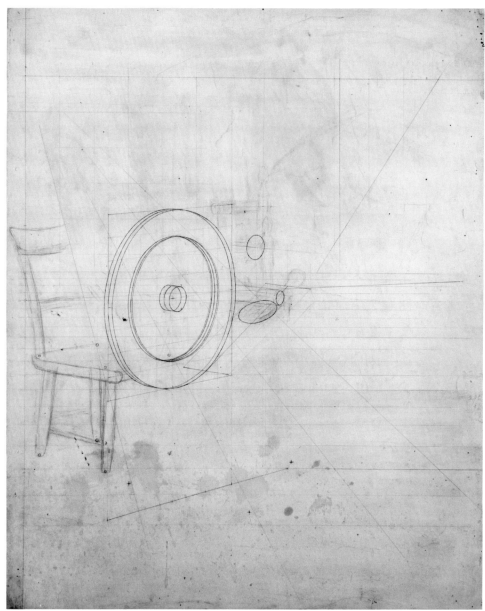

190

Negro Boy
Dancing, 1878

191

Negro Boy Dancing: Perspective Study, c. 1877–78

Pen and black, red, and blue ink over graphite on two
sheets of foolscap

Watermark: WESTON'S LINEN / 1876

17 × 14 in. each sheet (43.2 × 35.6 cm)

1985.68.16.1 and 2

Inscriptions (left sheet, r.): (TE in red ink over graphite,
u.l.) *Horizon 48 / Picture 4 ft.;* (in graphite, b.l. to c.l.)
numbered grid, *16–32;* (b.l. to b.r.) numbered grid, *4–1*

Inscriptions (left sheet, v.): (u.l.) *Study of negroes. / Water color.*

Inscriptions (right sheet): (b.l.) *67 in high old man / 47 boys head,*
arithmetical notations; (b.l. to b.r.) numbered grid, *1–4*

Fig. 69; plate 8

Two sheets together comprise a preparatory drawing for
Negro Boy Dancing (fig. 68; plate 7), also known as *The Negroes,
Study of Negroes,* or *The Dancing Lesson.* The drawing is at the
scale of the finished watercolor, and all three figures are seen in
their final poses, at the same depth, and in relation to one an-
other as in the watercolor. The annotations clearly state that the
horizon is forty-eight inches, the viewing distance four feet,
width of the scene eight feet, and that the standing man and
dancing boy are five feet, seven inches and three feet, eleven
inches tall, respectively. From this we can know that the scale
ranges between one-fourth (in the foreground, along the sixteen-
foot line) and one-fifth (for the standing man).

The banjo player at left is the most highly resolved of the
three figures in the drawing. He and the two chairs are drawn in
black ink over graphite. Somewhat more sketchy in appearance is
the man at center, who is drawn in graphite only, the absence of
ink suggesting that Eakins stopped one step short with this figure.
However, he is in another sense more complete, in that Eakins
began to work out the shadowing on the man's left side. Like the
old man, the drawing of the dancer is in graphite only. Perhaps
another step less complete, the complex configuration of the
dancing boy's head, hands, bare legs and feet appear, but his torso,
pelvis, and thighs remain invisible. As with the leaning man at the
center, Eakins also explored the fall of light upon the dancing boy.
Although more complete than some of Eakins' perspective draw-
ings, this view omits many aspects of the picture, including por-
tions of the dancer's body, and many details, such as the portrait of
Abraham Lincoln and son, the table at left, the hat and cane on
the chair at center, and the shadows on the floor and wall.

Eakins prepared for the watercolor *Negro Boy Dancing*
with oil studies of the figures (figs. 70, 71). The grids incised
in the surfaces of the images of the banjo player and the
dancing boy demonstrate that these are indeed oil studies,
not exhibition pieces. Most probably an oil study for the
standing man was also prepared, although it seems to have
been lost or overpainted before Eakins' death. The relation-
ship of these oil studies to the drawing and final watercolor is
discussed in chap. 9. (DS)

Late in 1878, Eakins was commissioned by Fairman Rogers, then chairman of the Committee on Instruction at the Pennsylvania Academy, to paint a "portrait" of his family and prized four-in-hand team in action with Rogers' gleaming new coach (fig. 140). The many compositional drawings in the Bregler collection show that this project underwent a major revision before assuming its present configuration. The meaning of this commission and the affiliated drawings, some of which may have been done twenty years later, is discussed in chap. 15. (KF)

The Fairman Rogers Four-in-Hand, or A May Morning in the Park, 1879–1880

192

The Fairman Rogers Four-In-Hand: Compositional Studies, with Boats, Horseman, and Locomotive, c. 1879

Graphite on foolscap

17 × 14¹⁄₁₆ in. (43.2 × 35.7 cm)

1985.68.17.3

Inscriptions (r): (TE in graphite, b.l. and b.r.) arithmetical notations

Inscriptions (v): (u.l. and b.l.) arithmetical notations

Fig. 145

Many diverse sketches fill this page. As outlined in chap. 15, they all may be related to the coach and four at the lower center. Presumably this is Fairman Rogers' outfit, which proceeds toward us as it does in the painting, but with the addition of a man and a dog walking along the road in the opposite direction. At the bottom right corner is an architectural sketch, perhaps depicting the base of an outdoor sculpture, suggesting that Eakins considered showing Rogers' coach as it passed near some monument. At the upper left are four small sketches: a sailboat, two figures in a skiff, a man pushing a boat forward with a pole, and a horseman—all spatially unrelated but all moving diagonally away from the picture plane to the right. Below these figures are two even smaller, fainter sketches of an antique locomotive (also seen in cats. 199, 200) and another similar machine, perhaps a more modern locomotive or a steam thresher. Upside down in the upper right corner appears another architectural sketch, including a church and a structure with round corner towers. This section is crossed with a grid of three-quarter-inch squares.

The numbers jotted in the right margin (161, 187, 26, and 6½, 5½R, and 12) probably relate to the plan and sketch seen in cat. 193, which must have followed this drawing. The most distant point of the carriage in that plan is 187 feet; the closest point of the team is 161 feet, leaving a space 26 feet deep occupied by the entire coach and four. The points 6½ and 5½ mark the extension of the axis of the rectangle enclosing the team and the coach to the left and right of the center line of

the plan. The numbers given at the lower left ("7 ft, 170 ft, and 24 24[?]") suggest a viewing distance and the scale (one-twenty-fourth) for figures 170 feet away, given a spectator seven feet from the painting. (KF)

193

The Fairman Rogers Four-in-Hand: Compositional Study and Plan, c. 1879

Graphite on brown paper

21⅜ × 16⁷⁄₁₆ in. (54.3 × 41.8 cm)

1985.68.17.4

Inscriptions (r): (TE in graphite, u.r.) numbered grid, *161–187*; (c.) numbered grid, *13–0–13*

Inscriptions (v): (u.l.) *Murray's Baldwin*

Fig. 146

The compositional idea put forth in cat. 192 is developed here, with the addition of a horseman in the foreground—much like the one sketched in the margin of the earlier drawing—two grooms in the rumble seat and a Conestoga wagon in the distance. The entire sketch is gridded with one-inch squares.

The plan at the top of the page maps distances thirteen feet to the left and right of the central axis (or viewer's line of sight). These one-fourth-inch squares, if they are meant to represent square feet, establish a scale of one-forty-eighth. The long rectangle set diagonally across the plan must be Rogers' coach and four, set in space between 161 and 187 feet away.

The coach in this sketch is about one-thirty-third life, the horseman one-twenty-fourth and the hiker at the lower right of the sketch is about one-twentieth life size. If the viewing distance noted on cat. 192 (perhaps) or 194 remains in force, he must be striding along at about 140 feet distant. This position would make sense of the calculations at the left margin (185/160/25 and 160/25/135) if they show that the same interval elapses between the rear of the coach and the front of the team (twenty-five feet) as between the front of the team and the hiker. (KF)

194

The Fairman Rogers Four-In-Hand: Squared Compositional Study, c. 1879

Graphite on buff wove paper

12⅛ × 18¾ in. (irr.) (30.8 × 47.6 cm)

1985.68.17.2

Inscriptions: (TE in graphite, u.r.) arithmetical notations /

Distance 87 in. / Horizon 80 in.; (c.) *Horizon*

Fig. 147

This drawing is the only one of the Fairman Rogers' group to specify the viewing distance (eighty-seven inches) and the horizon level (eighty inches, at the shoulders of the horseman). Eakins' notations at the right margin summarize the perspective in a formulaic fashion found elsewhere in his perspective drawings: 135 × 12:87:80. These numbers tell the baseline of the principal figures (the horseman and the hiker, now apparently on the same plane) at 135 feet distant,[1] a length translated into inches (135 × 12, or 1,620), followed by the distance of the spectator and the height of the horizon. Calculations on the next line (7168 ÷ 1620 = 4.42) may refer to the distance of the Conestoga wagon, some 7,168 inches away (nearly 600 feet), in respect to the distance of the horseman. According to Eakins' law of perspective, the wagon should be one-fourth the size of the rider if it is four times farther in space.

The horizon line established in this drawing and evidently in all the others, including the final painting, is mysterious, since it is two feet higher than a conventional eye height of sixty inches and more than a foot above Eakins' own eye level, but lower than the horseman or the passengers and driver of the coach. The viewing distance (eighty-seven inches) is even more perplexing, because it is an awkward fraction in feet (seven and one-quarter), difficult to work with and unusual in Eakins' work. Such an odd viewing distance suggests a scaled-down distance for the drawing, based on a larger canvas with a longer and more "even" viewing distance.[2] The calculations at the top of the page (18 × 12 = 216) may indicate a distance of eighteen feet, translated into inches. That distance is also the viewing distance used for the full-scale perspective drawing, cat. 195, and presumably the finished painting. In Eakins' marginal calculations this number, 216, is multiplied (for reasons I have yet to understand) by 121 and then divided by 3 to arrive at 87.12, a number jotted just above his annotation "Distance 87 in." From this we may speculate somewhat ignorantly that eighty-seven inches is a round number somehow derived from eighteen feet, reflecting a drawing about 40 percent the size of the finished oil. This conclusion is borne out in the scale of the coach and the overall dimensions of the sketch, which are approximately 40 percent of those in the painting and the full-scale drawing, cat. 195. Comparing this sketch to cat. 193, the scale is different again, as indicated by the larger (one-and-one-fourth-inch) squares on the grid that crosses the composition.

The unusual set of relationships between the drawings and the painting, signaled by these odd percentage enlargements or reductions (unlike the usual halving or quartering) can be understood better by establishing the scale of the coach itself in cat. 194. This can be measured on the drawing from the horizon line down to the "ground" below the front wheel to show a distance one-twenty-fourth of the "real" height of the viewer, eighty inches. This fraction, the only

"easy" one (based on feet and inch calculations) in the composition, appears to have generated the relative sizes and distances of every other part. Comparing this scale in the sketch with the scale of the painting (as in cat. 195), where the coach is one-tenth life size, the odd 40 percent relationship between drawing and painting can be redefined as a relationship between each image and the reality of the coach. Almost incidentally, this produces a proportion of 2.4:1 between painting and drawing, or 5:4 between cats. 194 and 193, although they were not actually derived from one another. Such separate calculations indicate that Eakins did not work from drawing to drawing but instead returned to refigure the basic spatial problem afresh in each new sketch. This habit makes it difficult to know which drawing came first in any sequence of related drawings. It also demonstrates the dominating power of his visual concept, apparently held fast in his mind, over the immediate suggestive potential of any given drawing. (KF)

1. See the annotation on cats. 196: "Rider 135 ft."
2. More often the drawing would be set up for a viewing distance of eighteen inches, anticipating a painting four times larger, seen from six feet away (e.g., cat. 155).

195

The Fairman Rogers Four-in-Hand: Perspective Study of Coach, c. 1879

Pen and black, blue, and red ink over graphite on cream wove paper

22⅛ × 30⅝ in. (irr.) (56.2 × 77.8 cm)

1985.68.17.1

Inscriptions: (TE in black ink, u.l.) *Distance 18 ft.;* (in graphite, u.l.) numbered grid, *0–11 / road 46 ft;* (c.l.) *peacock / front of hook / Chance's sternum;* (c.) *Williams' sternum / W's spine of ilium;* (b.l. to b.r.) numbered grid, *0–8, 144–224*

Of the many Fairman Rogers–related drawings, cat. 195 is the only one clearly related to the final painting (plate 12). Siegl noted pinholes in the canvas and concluded "that the drawing of the coach was transferred by mechanical means from a detailed perspective study."[1] Pinholes in this drawing confirm his conclusion, although the detail in this perspective is far less complex than Siegl might have imagined.

This drawing is at the scale of the painting but slightly smaller in overall dimensions, showing only the center of the composition and lacking an inch top and bottom, and three

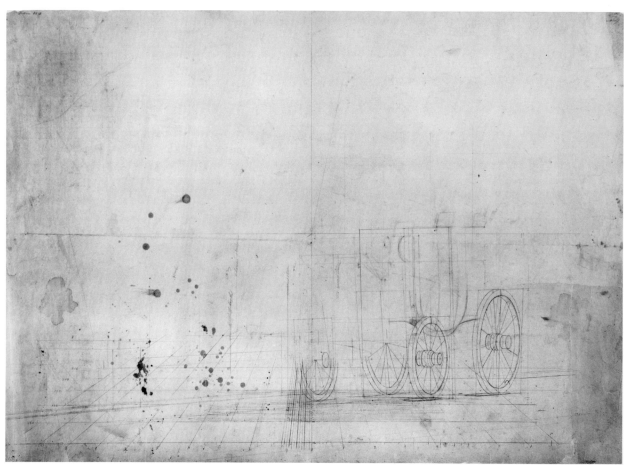

195

inches on each side. While much larger than the earlier stud-ies, cats. 192–194, the horizon is consistent at eighty inches with these other sketches. The scale here is one-eighth (or ten inches to the horizon) at the 144-foot line in the fore-ground, where one and a half inches represents one foot on the grid along the bottom of the page. The coach itself, with its left front wheel 180 feet away, appears at one-tenth life. Both of these distance and scale figures offer, by way of Eakins' "first law of perspective" (see cat. 92), a viewing dis-tance of eighteen feet.

No figures appear in this perspective, although pencil notations tell us the names and anatomical landmarks of three horses: Williams, the near-wheel (left-hand, to the coachman) horse, Chance, the off-wheeler (or right-hand), and Peacock, the off-leader. The near-leader, closest to us in the painting and beautifully gleaming in the sun, is not men-tioned in these annotations, perhaps because she needed no introduction: this was Rogers' favorite mare, Josephine, nearly "perfection in all her points."[2] (KF)

1. Siegl, 81.
2. Fairman Rogers, *A Manual of Coaching* (Philadelphia, 1899), 38.

196

The Fairman Rogers Four-In-Hand: Perspective Study of Wheels, c. 1879

Graphite on buff wove paper

11 × 18½ in. (irr.) (27.9 × 47 cm)

1985.68.17.5

Inscriptions: (TE in graphite, b.l.) *near hind near front;* (c.r.) *rider 135*

The annotations "near hind," "near front," and "rider 135" identify this drawing as a study for the wheels of Fair-man Rogers' coach, the latter inscription referring to the horseman who appears 135 feet distant in cat. 194. Similar demonstrations of gridding a circle and setting it into space appeared several years later in Eakins' manuscript on drawing techniques; see cats. 116, 117. (KF)

196

197

Baldwin. Boats: Perspective Study, c. 1879?

Graphite on foolscap

17¹/₁₆ × 14¹/₁₆ in. (irr.) (43.3 × 35.7 cm)

Inscriptions: (TE in graphite, u.l.) *175 in / Distance 87 in / Horizon* [crossed out: *80 in 15 ft. 180"*] / *20' = 240";* (u.c.) *Baldwin. Boats;* (u.r.) *Horizon;* (b.l. to c.l.) numbered grid, *150–260, 440;* (b.l. and b.r.) *5*

1985.68.18.1

Baldwin. Boats is one of four drawings (cats. 197, 198, 200, 202) found pinned together with cat. 196, a study easily identified with *The Fairman Rogers Four-in-Hand*. As in the related groups of Brinton drawings (cats. 174–175) and hunt-ing studies (cats. 155–163), this assembly hints at a coherence understood by the person—most likely Thomas or Susan Eakins—who pinned these items together. The relationship of these five items and another two (cats. 199, 201) found in the same portfolio remains elusive; the possible meanings of this assembly are discussed along with Fairman Rogers' proj-ect in chap. 15.

Key to all these drawings, but perplexingly mute, is the perspective study labeled "Baldwin. Boats." The viewing dis-tance is the same eccentric number seen in cat. 194: eighty-seven inches, or seven and a quarter feet. Again, we might assume that this odd fraction indicates a reduction, for the sake of a more manageable drawing, from a longer viewing distance imagined for a larger painting. The horizon nota-tion, once eighty inches (as in the Fairman Rogers' drawings) has been scratched out and changed to 15 feet (or 180 inches) and then changed again and tripled to 20 feet (or 240 inches), the most aerial of all Eakins' viewing positions. A long diag-onal drives from the lower left to the upper right, locating as it crosses the fan of orthogonals the horizontal grid lines every ten feet into space. More distant lines are charted by additional diagonals above.[1] Two shorter, shallower diago-nals intersect the center line of the grid 175 feet away. The steeper one follows the diagonals of the grid squares, linking dots 5 feet to the left and 5 feet to the right of center, from 170 to 180 feet in depth. The shallower diagonal begins at a dot 6 feet to the left and moves without interruption to the right margin on a path from 172 to 180 feet in depth. Both lines, in their length and distance from the viewer, are like the axis of the Rogers' coach and four, but not exactly. An-other equally mysterious diagonal slopes across the top of the grid, 440 feet distant. The plan of the space depicted in this drawing is mapped out in cat. 198. (KF)

1. See cat. 100 for a description of this device for laying out space in a perspective drawing.

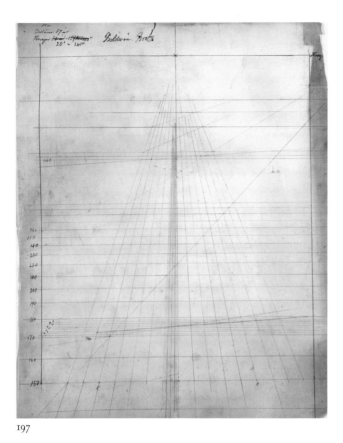

197

198

Perspective Study: Ground Plan, c. 1879?

Graphite on foolscap

17 × 14¹⁄₁₆ in. (43.2 × 35.7 cm)

1985.68.18.2

Inscriptions: (TE in graphite, c.l.) numbered grid, *150–190*

See cat. 197.

198

199

Locomotive: "Old Ironsides," c. 1899?

Graphite on cream laid paper

Watermark: SHAM[?]

7¹⁵⁄₁₆ × 4⅞ in. (20.2 × 12.4 cm)

1985.68.18.5

Inscriptions: (TE in graphite, c.l.) *22;* (c.r.) *9½*

This quick sketch with measurements depicts the historic locomotive Old Ironsides, built in 1832 by Matthias Baldwin, founder of the Baldwin Locomotive Works in Philadelphia. In service on the Germantown line for more than twenty years, this locomotive may have been retired to the Baldwin company's yards, several blocks south of Eakins' home, although it is not described as extant in any of the company's catalogues, first published in about 1880.[1] The engine, copied from Robert Stephenson's famous John Bull, imported to Camden in 1831, can be identified from its tall stack, its larger set of driving wheels behind the smaller carrying wheels at the front, and the frame placed outside the wheels. The same locomotive appears in greater detail, with its tender for fuel and water, in cat. 200. (KF)

1. Baldwin Locomotive Works, *Illustrated Catalogue of Locomotives,* 2nd ed. (Philadelphia: J. B. Lippincott, 1881), 6–10. An elevation of Old Ironsides appears on p. 7. This same mechanical drawing is republished in later editions of this booklet, even though photomechanical images are used elsewhere, suggesting that the locomotive was not extant. I have not discovered a perspective of this locomotive similar to Eakins' view in cats. 199 and 200, although its fame must have inspired other images.

199

200

Locomotives: "Old Ironsides" and Baldwin "Atlantic" Engine, c. 1899

Graphite on buff wove paper

8 × 12½ in. (20.3 × 31.8 cm)

1985.68.18.4

Fig. 151

The top of the page contains a drawing of Old Ironsides, the Baldwin Locomotive Company's first engine (see cat. 199). Below it is a late-nineteenth-century locomotive of the Atlantic type (with a 4–4–2 wheel pattern) developed by the Baldwin company after 1895. The engine can be precisely dated by its wheel configuration and the "camelback" placement of the cab, as well as the double cylinders mounted in front of the drive wheels. This feature identifies the "compound" engine invented by Samuel Vauclain of the Baldwin firm in 1889 and brought to a peak of speed and efficiency in the late 1890s. Eakins' drawing and another related version (cat. 201) seem to have been taken from a photomechanical engraving in one of the Baldwin company catalogues published after 1897, when this particular engine type was put into service on the Atlantic City line.[1] Small details, such as the headlight, chimney, bell, dome, cab, and tender profiles follow exactly the silhouette of this illustration. For a discussion of these locomotives, see chap. 15.

1. *History of the Baldwin Locomotive Works, 1831–1907* (Philadelphia: Edgell, 1907), 86. This book includes the earlier historical text cited in cat. 199, including the story of Old Ironsides, with supplementary chapters bringing the company's history up to date. Because these books functioned as sales catalogues they may have been reprinted annually; however, I have not been able to determine when after its debut in 1897 this Atlantic type was first illustrated.

201

Locomotive: Perspective Study, Baldwin "Atlantic" Engine, c. 1899

Graphite on foolscap

8¹¹⁄₁₆ × 14¹⁄₁₆ in. (22.1 × 35.7 cm)

1985.68.18.3

See cat. 200.

201

202

Perspective Scale, n.d.

Graphite on off-white laid paper

Watermark: DE[torn]

7¹³⁄₁₆ × 6¹⁵⁄₁₆ in. (35.1 × 17.6 cm)

1985.68.18.6

Inscriptions (v): (TE in graphite, u.r.) *Locomotive 8 in long / Ironsides 5 in long*

The scale drawn on the recto is like those found on many of Eakins' perspective drawings. The annotations on the verso may have been added at another time. The dimensions given correspond to the drawings of the two locomotives in cat. 200.

The Pathetic Song,
1881

The Pathetic Song: Perspective Study, c. 1881

Pen and red and blue ink over graphite on cream wove
paper

16¹⁵⁄₁₆ × 14 in. (43 × 35.6 cm)

1985.68.22

Inscriptions: (TE in blue ink, u.l.) *distance 2¼ ft. / Horizon
45 inches / Scale ¼;* (in graphite, u.l.) *new center ¼ inch to
right / ⅜ above;* (in blue ink over graphite, b.l.) num-
bered grid, *12–28;* (b.l. to b.r.) numbered grid, *3–O–3;*
(in graphite, b.l.) *1st position stool / + 2d position stool /*
numbered grid, *carp 1–carp 5;* (b.r.) numbered grid, *carp
1–carp 5;* (c.r.) *carp* [written repeatedly]

This perspective of the parlor seen in *The Pathetic Song*
varies slightly from the appearance of the painting, suggest-
ing intermediate steps between this drawing and the two
nearly identical final versions in oil (fig. 96; plate 9) and wa-
tercolor.[1] The drawing is marked to show a viewing distance
of two and a quarter feet and a horizon line forty-five inches
from the floor. Beneath these remarks is the annotation:
"Scale ¼." None of these inscriptions describe the actual con-
ditions of this perspective, the oil, or the watercolor. The
scale of this drawing is one-eighth along the line eighteen
feet distant, where the singer will stand; the scale of the
painting (using the thirty-three-inch image of the singer as a
yardstick) is one half life. The notation "1/4" refers, then, to
the relationship between the painting and this drawing,
which Eakins reduced to fit on a standard piece of paper.
The viewing distance of the painting must therefore be four
times longer than that of the drawing, or nine feet. The other
annotations on the drawing refer to the terms of the perspec-
tive grid, which were altered slightly for the painting. His in-
scriptions indicate that Eakins moved the stool of the cello
player to the right, and relocated the center point (the inter-
section of the horizon line with the line of sight of the
viewer, usually drawn as a vertical line down the middle of
the picture) three-eighths of an inch higher and one-fourth
inch to the right. This alteration, translated into "life" scale,
makes the new horizon line forty-eight inches—typical of
Eakins' eye level in a seated position, and slightly above the
eye level of the petite pianist (Susan Eakins) and the cellist.[2]
This adjustment of the eye level would have necessitated a
new perspective drawing, because every plane in the picture
would be seen differently as a result. The figures, still await-
ing placement in space, probably did not shift in relation to
the center line, although they would draw closer to the piano.
Eakins' oil sketch for this painting shows the same asymmet-
rical balance of figures seen in the oil, although they are all
pulled slightly apart in the final version.[3] In both sketch and
painting, the singer stands with all the sunlit forms of her
dress to the left of the center line, gently balanced against the
dark piano and pianist at the right.

Other differences between the drawing and the two paintings also indicate reconsideration of this composition midway through the planning process. The inked, ruled lines that frame a central portion of the perspective bracket a proportionately wider image, so that more of the mantel piece and piano at left and right are seen than appears in the final composition. The new borders rise from the two-foot mark at each side of the center line, and bracket—as usual for Eakins—an even number of feet across the pictorial space at the bottom of the picture (four) and from side to side along the base line of the principal figure (ten). Likewise, many notations of the word "carp" or "carpet lines" imply a larger carpet than the small prayer rug seen under the singer's feet in the painting. A figured floor pattern seen beneath this small rug in both paintings suggests the presence of wall-to-wall broadloom carpeting, like that seen in the Eakins' parlor in *The Chess Players* (fig. 9), but the pattern is not as the perspective drawing would prepare us to expect. However, the contours of the small rug are apparent in the drawing, too, showing that Eakins intended this layered floor texture at the outset.

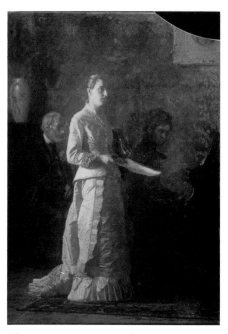

The Pathetic Song, c. 1881, oil on canvas, unfinished, in Eakins' studio, modern print from 4 × 5 in. dry-plate negative, PAFA inventory no. 87.26.52. Compare the finished picture, fig. 96 (plate 9).

Eakins did not use this drawing for the watercolor replica of *The Pathetic Song*, which copies the composition of the oil, not the format of the drawing. The watercolor also has a new scale, larger than this drawing but smaller than the oil (about one-third of all dimensions in the painting, or one-fourth life). These new dimensions signal a fresh calcu-

lation on the watercolor paper, perhaps based on another, intermediate perspective drawing—now lost—or the oil. Pinholes in the drawing must have been made by drafting tools, for changes in the scale and the perspective grid would have made it useless for transfer.

Two views of the painting in process appear in Eakins' own photographs, also discovered in the Bregler collection. The first (fig. 97) shows the canvas in Eakins' studio, with Margaret Harrison posing. Although the view of the canvas is cropped, it is evident that only her figure has been blocked in, and it remains half finished. A second photograph (see accompanying illustration) made prior to the addition of Eakins' signature, shows the painting before musical notations were suggested on her sheet of paper, and before completion of the picture frame at the upper right. The figure of Susan Macdowell was also substantially revised after this picture was made, although the basic pose was not altered. For additional discussion and illustration of the photographs made in conjunction with this painting, see chap. 11. (KF)

1. The oil is G 148; the watercolor, not catalogued by Goodrich, is in the MMA. This watercolor is on a sheet of paper 16¾ × 11⅜ in.; the image area is about 14¾ × 10½ in.
2. The center line is visible in the watercolor; the horizon may be a line seen running through the pianist's hair, across the singer's shoulders and above the head of the cellist.
3. The oil sketch, G 143, is fig. 59; see Rosenzweig, 93. Its size is slightly smaller than the area bounded by lines in the drawing, and its scale seems to be one-eighth.

An Arcadian, c. 1883

204

An Arcadian: Three Figure Studies, c. 1883

Graphite on foolscap

$4^{15}/_{16} \times 7^{11}/_{16}$ in. (12.5 × 19.5 cm)

1985.68.20

Inscriptions (r): (TE in graphite throughout) measurements and arithmetical notations

Inscriptions (v): arithmetical notations

Fig. 194

The figure at the far right is in the posture of the woman in *An Arcadian* of c. 1883 (fig. 191). All three studies seem to be based on Eakins' photographs; see cats. 251, 262, and chap. 17. (KF)

205

Landscape Study: Field with Trees, n.d.

Charcoal on cream laid paper

$12\frac{1}{2} \times 19$ in. (31.8 × 48.3 cm)

1985.68.19

This puzzling charcoal drawing is unique in Eakins' oeuvre. His landscape work is otherwise entirely in pencil (especially before 1870) or oil (after 1870), and his use of charcoal seems to have been restricted to his student years at the Academy or the Ecole. This drawing is unusual in its large size and excellent paper, given such a landscape subject, for most of his landscape sketches are small and broad, not so delicately worked, and such paper appears only in his student figure drawings. The materials alone would suggest the 1860s, then, but the style is most unlike his early landscape sketches, (cats. 1–4, 15). A date in the early '80s might be proposed, instead, in order to draw it close to the Arcadian subjects and Barbizon-style Gloucester landscapes of this decade. The topography also suggests his sister's farm at Avondale, where photographs and sketches for *Arcadia* were made. Anomalous in many ways, this drawing may be an experiment soon abandoned, or a relic of a larger group of works that did not survive. It may also be by someone else, although it was segregated by Bregler and placed in a portfolio containing only Eakins' drawings, and it does not resemble work by SME, CB, or any other artist whose work was found in the collection. (KF)

205

206

Spinning and Knitting: Architectural Plan, Interior Elevation, and Sketch of Three Relief Sculptures, c. 1882–83

Graphite on laid foolscap

15¼ × 12¼ in. (38.7 × 31.1 cm)

1985.68.21.1

Inscriptions: (TE in graphite, b.r.) *TE;* (b.l.) *1 ft. 10 in., 2 ft.;* (b.r.) mathematical notations

Fig. 82

Spinning and Knitting, c. 1882–1883

In about 1882, Eakins received a commission to make relief sculptures for the chimney breast of a new townhouse at 2032 Walnut Street in Philadelphia. The house, half of a double house later known as the John Wanamaker House, was designed in 1882 by Theophilus P. Chandler, Jr. (1845–1928). Chandler designed many prominent homes around Rittenhouse Square and founded the architecture school at the University of Pennsylvania. It was Chandler who proposed that Eakins make the sculptures; his client, James P. Scott, the original owner of the house, ultimately refused to accept the reliefs (cats. 260, 261).[1]

This drawing was once folded into sixteenths and was evidently stored for years folded into eighths. Printed with lines for use as letter paper, the sheet was probably folded in half even before Eakins drew on it. The first of the top four quadrants from the left contains perspective diagrams. All of the next and half of the following quadrant, the left one of which has been badly burned by exposure to light, show an architectural elevation. A plan occupies the final quadrant and a half. The bottom tier contains three oval sketches, the center one framed by a rectangle. Below the ovals are mathematical notations and, at the far right, Eakins' initials. Notations of size wrap around the top of the first oval.

The sheet may record Eakins' original notes about the project, and perhaps it was folded to fit into his breast pocket after a meeting with Chandler. Evidently he began by considering the plan of the house and the elevation of the interior wall. Two fireplaces seem to be indicated on the plan, one at the foot of a grand staircase, the other at the back of an adjoining room. Confusingly overlaid on this plan is the elevation of a room in perspective, hinting at a wall with a mantel piece (?) flanked by turned columns and surmounted by a round arch, all vaguely evocative of the eclectic historicism of Chandler's "French Renaissance" design. Because the interior of this house no longer exists, and no plans or photographs of it seem to have survived, this vague sketch may be the only clue to the placement Eakins intended for his sculptures, sketched as small ovals and rectangles above the mantel, "3 feet above the eye."[2]

Eakins surely took this vantage into account in planning the perspective framework for his reliefs, although the possibility that the sculptures could be also seen from the staircase

may have encouraged him to use a standard viewpoint equally coherent from both angles. Annotations on the sheet note a horizon at forty-two inches, lower than usual, probably to meet the eye level of the figures. According to his inscriptions, the ideal viewing position was four feet away. From this distance, and three feet below the sculptures, the reliefs are very legible, although a head-on viewpoint (from which they were constructed) remains the most comfortable and instructive.[3]

Two of the scenes sketched within ovals are familiar from Eakins' earlier work. The watercolor *Homespun* (MMA) seems to have been the model for the spinning subject on the left. Exhibited at the Academy in the spring of 1882, this watercolor may have caught the eye of Chandler or Scott, and the firmness of Eakins' sketch shows that he had it before him as he made this drawing. The much vaguer figure on the right may have been drawn from a memory of the knitting chaperone in *William Rush Carving* (plate 11). Ultimately, Eakins modeled the relief from life, based on a pose seen in the watercolor *Seventy Years Ago* (Princeton), in which the knitter faces the viewer. In relief, seen from below, this second pose was much more legible, but the sketch shows that Eakins' first scheme placed both spinner and knitter in mirrored poses, facing in and away from the viewer.

The central panel is an image not seen elsewhere in Eakins' work, depicting a man chopping down a tree while another figure in the distance seems to load a horse-drawn wagon. The integration of all three subjects may depend on a program stipulated by Chandler or Scott that we will never know. Perhaps Scott's business—reportedly in sugar or wool—had something to do with this scheme, although neither product explains the central panel.[4] Eakins may have wished to contrast men's work, outdoors and destructive, with women's creative work, by the hearth; they are gathered together by the fire, which is fed by the woodsman's labor. Other structural oppositions have been noted by Evan Turner: youth versus age, back versus front, motion versus stasis, simplicity versus elegance.[5] Like Eakins' other historical subjects, the figures tell a story of pre-industrial skill and intense absorption. In the athletic, shirtless pose of the woodchopper emerges, too, a suitable subject for an artist seeking semi-nude activities in American life, in the vein of *William Rush Carving* or the recent painting by Eakins' assistant Thomas Anshutz, *Iron Workers Noontime* of 1880 (Fine Arts Museum of San Francisco).

Knitting and *Spinning*, constructed from new modeling sessions, were well under way by spring 1883, when Eakins showed his clay or plaster reliefs to Scott. Evidently Scott was not impressed, and commented that the price ($400 each) "seemed high for a thing [he] might not even use." Appalled by the tenor of this remark, Eakins took pains to justify his charges, summarizing in a letter to Scott all the expenses up to that point, estimating the additional costs to be expected for the completion of the panels in stone and their

installation, and at the same time estimating the cost of the third panel, now described as "an old man reading."[6] By this time the woodcutter had been exchanged for a more sedentary figure, perhaps suggested by another painting, such as *The Writing Master*, a portrait of his father completed in 1882. Conceptually, a reading figure fit well between the two women, demonstrating a fireside occupation that better harmonized with the domestic environment than an energetic outdoor scene. But even this more tranquil subject was doomed by Scott's lack of interest. He refused to accept the two reliefs that were already done and did not pay the artist until June 1885, when E. H. Coates arbitrated a settlement that recovered Eakins' costs.[7]

While awaiting this settlement Eakins kept the plasters, painted them to simulate the surface of bronze, and exhibited them at the Academy's annual show in the fall of 1883; after they were cast in real bronze he sent the pair to the Society of American Artists' exhibition in the spring of 1887. At least, by this display, he was able to demonstrate his skill in relief as well as his participation in the Decorative Age, which likewise found Winslow Homer painting bopeeps on fireplace tiles in 1878 and John La Farge and Augustus Saint-Gaudens collaborating on a fireplace for Cornelius Vanderbilt II in 1882. The decorative, nostalgic, or allegorical imagination displayed in these contemporary projects illustrates a spirit shared with Eakins' mantel reliefs; the failure of the Scott panels, by contrast to the celebrity of the Vanderbilt project, also points out his awkwardness in this mode. Like Homer, Eakins essayed this type of work only once, when it was most fashionable.[8] Forced to curtail his ambitions midway through the project, his move toward greater simplicity may have been true to his strengths, showing (as in the Fairman Rogers project) the characteristic impact of life study and technical challenges on his imaginative flights. (KF/KJ)

1. Siegl, 99–101; and Theodor Siegl, "*Spinning* and *Knitting*, Two Sculptural Reliefs by Thomas Eakins," *Philadelphia Museum of Art Bulletin* 74 (June 1978): 1923; Rosenzweig, 97–99; Goodrich 1982, 213–219.

2. Scott's house is today known as the mansion of the merchant John Wanamaker, who purchased it in the 1890s. The house was damaged by fire in the twentieth century, and it remains only as a facade.

3. Virginia Naudé's conservation report on these plasters notes that the border of *Spinning* was enlarged to make it equal in size to *Knitting*, although the figure of the spinner "was intentionally rendered smaller than the image of the knitter because the viewer first encounters the reliefs at a point where *Spinning* would be nearer. Eakins wanted to compensate for the discrepancy in distance from the viewer's eyes" (*JAIC*, 59). This theory may be correct if the sketch plan on cat. 206 shows the actual configuration of the staircase and fireplace. This reading is contradicted by Evan Turner's account of the Chandler house, which "apparently" featured a "grand stair hall" with stairs and a long landing on the left wall, overlooking the fireplace on the opposite wall. From this layout, Turner presumed that *Knitting* was on the left. See "Thomas Eakins and the Quest for Truth," *Art Institute of Chicago Centennial*

Lectures: Museum Studies 10 (Chicago: Contemporary Books, 1983), 166.

4. Siegl's notes (PMA Archives) say that he was a wool merchant; an Atwater-Kent walking tour brochure of Rittenhouse Square describes Scott as a sugar merchant (*News and Notes,* April 1988).

5. Turner, "Thomas Eakins and the Quest for Truth," 188.

6. TE to James P. Scott, 11 July 1883 (CBTE, Foster and Leibold, no. 62, fiche series I 3/F/5–6); Goodrich 1982, I: 216.

7. Ibid. Coates later paid for a set of the bronzes for PAFA. Eakins' "interview with Coates" concerning these bronzes was recorded in SME's retrospective diary of important dates (CBTE) as 4 Apr. 1887. When Eakins exhibited the two panels at PAFA in 1883, he showed them along with *The Writing Master* (MMA).

8. Marc Simpson has proposed a similar decorative impulse in Eakins' three Arcadian reliefs (G 506–508). On the relationship of these sculptures to the *Spinning* and *Knitting* panels, see Simpson, 82–83, and the discussion of the Arcadian subjects in chap. 17.

207

Spinning and Knitting: Sketches for Sculptural Group (r)

Spinning Wheel Studies (v), c. 1882–83

Graphite and red ink on paper

12⅜ × 7⅝ in. (31.4 × 19.4 cm)

1985.68.21.2

Inscriptions: (TE in graphite, c.) *horizon 42 / picture 4 ft / panel 18;* (c.r.) mathematical notations

The two sides of this sheet show Eakins making a variety of notations for the Scott relief sculptures, also shown in cat. 205. On the recto are barely recognizable stick figures set into ovals, flanking a square central panel. The drawing is just clear enough to suggest that the subject of the center panel is still the woodsman; the knitter has gained her tilt-top table. The panels are shown over an equally loosely drawn fireplace. Annotations indicate that the side panels were to be eighteen inches high (as indeed they are), which would make the woodchopper scene approximately twenty-four inches square. This drawing was probably made to remind the artist of the ensemble once he had begun to compose the details, such as those studied on the verso.

The verso of the sheet is dominated by three studies of furniture details, a leg of the spinning wheel on the upper left, a wheel spoke on the upper right, and a stool leg in the lower left. Each form is shown in outline with the center line indicated, but without other modeling. In the center of the sheet is a circular form linked to a perspective grid, with a scale below marked in red ink. This may relate to the form of the wheel or the tilt-top table, or perhaps to the vanishing point of one of the reliefs. The construction of these circular forms in perspective was the principal challenge of each panel; Eakins would describe his procedure, using this proj-

ect to illustrate his points, in his own lectures on perspective (see cats. 133–138). At the bottom right and drawn perpendicularly to the other sketches is a thumbnail study for the *Knitting* relief, which shows the cat behind rather than under the chair.

The combination of details of turned furniture legs and spindles is exact enough to identify the wheel being described as more like the one used in the watercolors of Margaret Eakins than the one Nannie Williams posed at for *The Courtship* (cat. 190). However, all the turnings have been simplified in this drawing and in the actual relief, indicating that Eakins used another, similar spinning wheel for this relief, or else modified the profiles to make them less complex. If he did simplify the forms, then Saint-Gaudens' remark that the "excessive reality of the chair and wheel . . . demand an unattainable perfection in the figures" gains an ironic context, for evidently Eakins did accommodate the accessories to a more generalized level of detail.[1] (KJ/KF)

1. Goodrich 1982, I: 218–219.

207 r 207 v

208

Saddle: Top and Side View, c. 1887–92

Pen and ink on parchment paper

5¼ × 5⅞ in. (13.3 × 14.9 cm)

1985.68.24

Inscriptions: (TE? in ink, u.r.) *A, B, C, D, E, G, H;* (b.c.) *A. Saddle bag Stud / B. Pouches Stud / C. 2 Saddle bag Staples / D. 1 Carbine Strap Staple* [underlined:] *Right / E 2 Breast plate Staples / G 2 Packing Strap Staples / H 2 Pouch Strap Loops / I 2 Saddle bag Loops / K 1 Carbine pipe Loop* [underlined:] *Right*

Eakins bought two cow ponies in Dakota Territory in 1887, and he may have brought western saddles home to

Philadelphia along with the horses. This diagram of a saddle with all its specialized studs and staples may have been encountered in the west or brought home, although it is not apparently the same one used in *Cowboys in the Badlands* (fig. 210), his major oil resulting from this trip.

More likely, this is a military saddle, like the one shown on General Grant's horse, modeled by Eakins in 1892 for the Soldiers' and Sailors' Memorial Arch in Brooklyn. Eakins and W. R. O'Donovan, who modeled Grant's figure, traveled to West Point to photograph horses, and details of saddle could have been observed there. Much of the saddle in the finished sculpture was obscured by Grant's figure, although a photograph of the completed plaster of the horse alone, taken in Eakins' studio before it was shipped to New York for casting, shows a similar saddle, with the addition of saddle blankets, straps and saddlebags.[1] Most of the studs and staples shown in this drawing have been eliminated in the sculpture, however, perhaps because they were too difficult to cast, or were distractingly realistic, or because Eakins used another, slightly different saddle as his actual model. (KF)

1. See Goodrich 1982, II: 110–118. A large platinum print of Eakins' photograph is in CBTE.

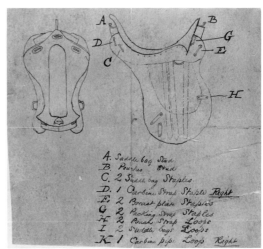

208

Portrait of John J.
Borie, c. 1896–1898

Portrait of John J. Borie: Perspective Study and
Ground Plan, c. 1896–98

Graphite and blue pencil on buff wove paper

35 × 14⅞ in. (88.9 × 37.8 cm)

1985.68.32

Inscriptions: (TE in graphite, c.l.) *John Borie / Horizon 5' /*
Picture 12½' / Drawing 3' 1½" = 37½" / Horizon; (b.c.)
Horizon 60 / Distance 12' 6"; (bottom half of sheet)
numbered grid, *12–24,* arithmetical notations; (in blue
pencil, u.c.) *Window / showing sky / window showing /*
building

Figs. 230, 231

According to Eakins' annotations and the evidence on
the drawing itself, Borie stands twelve and a half feet distant.
The perspective drawing, at one-fourth the scale of the
painting, has a viewing distance one-fourth as long, or thirty-
seven and a half inches. A different scale prevails in the plan
at the top of the page, where two-inch squares indicate one-
sixth scale. On this plan, Borie's footprints cross the twelve-
and-a-half-foot line, although his feet turn full front rather
than slightly to the right, as they appear in the painting. The
diagonal line of the drawing table that Borie leans against
runs faintly through the plan at an angle about 37 degrees
from the picture plane. The Borie portrait was never
finished; for a discussion of the method revealed in this ar-
rested work, see chap. 19. (KF)

Portrait of Stewart Culin: Perspective Study, c. 1899

> Blue, black, and red pen and ink over graphite on buff
> wove paper
>
> 34¹³⁄₁₆ × 22³⁄₁₆ in. (88.4 × 57.9 cm)
>
> 1985.68.25
>
> Inscriptions: (TE in graphite, u.l.) *Culen* [sic] / *Picture
> 14.75 / Drawing 3.6875 / Horizon 60.;* (u.r.) *5th division / 7
> × 3;* (b.r.) *12: 1475: 60* and other arithmetical notations;
> (c. to b.c.) numbered grid, *12–52*
>
> Fig. 233

Portrait of Stewart Culin, 1899

Although Eakins' portrait of Stewart Culin (1858–1929) is lost, much can be learned about it from this perspective drawing.[1] The basic conditions of the perspective are contained in Eakins' annotations, which tell us that the horizon (or eye level of the painter) is sixty inches and the viewing distance of the picture is fourteen and three-quarters feet. Because we know from earlier descriptions that the image of Culin was life size, the viewing distance of the picture must be the same as Culin's actual distance in space, and indeed his chair sits behind the table straddling a pencil line fourteen and three-quarters feet into the picture's space. The annotation "Drawing 3.6875" refers to the viewing distance of the drawing itself, which is one-fourth life size (showing a scale of 3 inches = 1 foot at the 14.75-foot line) and therefore has a viewing distance one-fourth as long as that of the painting. These terms are recapitulated in the inscriptions at the bottom of the sheet: "12:14.75:60," where 12 may note the first inked line in the foreground, perhaps once considered as the lower edge of the canvas. The notes at the upper right cannot be easily related to this drawing; they may represent Eakins' ideas about the division of the picture's surface or the proportionate relation of different parts.

The two overlapping grids in this drawing are distinguished by colors of ink or graphite. Following the method outlined in Eakins' drawing manuscript, the lattice of lines describing the perspective space is in blue ink ruled over graphite lines. These lines "vanish" at the central point, where the horizon line (the uppermost blue ink line) crosses the central vertical axis of the picture (also in blue). Horizontal blue lines cross this network of orthogonals indicating recession, in feet, from the bottom of the drawing (where a graphite line represents the important eleven-foot line, and where the scale is close to one-third) to sixteen feet distant, behind Culin's chair. The back wall of the room is not indicated. Over this perspective "net" is superimposed a grid of three-inch squares, probably representing one-foot intervals on the surface of the painting and, in contradictory fashion, on the plane that Culin inhabits, fourteen and three-quarters feet away.[2]

Two small square holes have been cut out of the paper on the vertical axis just below the vanishing point and at a

similar distance below the eleven-foot line. Such holes do not appear in other known perspective drawings by Eakins, and their purpose is not clear. Along with the many pinpricks in this drawing, they may have been made in the course of registering this drawing over other sketches. (KF)

1. G 483. On the background and iconography of this portrait, see chap. 19.
2. On the special perspective problems of full-length, life-size portraits, see chap. 19.

Portrait of His
Eminence Sebastiano
Cardinal Martinelli,
c. 1902

Portrait of His Eminence Sebastiano Cardinal Martinelli: Perspective Study and Ground Plans, c. 1902

Pen and black, red, and blue ink over graphite on buff
wove paper

27½ × 35¾ in. (69.9 × 90.8 cm)

1985.68.26

Inscriptions: (TE in graphite, u.l.) *Cardinal Martinelli /
Horizon 47″ picture 13′ / Drawing 13/6;* (u.c.) *18°———951:
309: 156: 50.69 to left*[?] *for diagnol / 18 + 45 63 /* [erased
word] / *Each 3 spaces 5½ inches,* arithmetical notations /
(u.r.) arithmetical notations; (b.l.) numbered grid, *0–19;*
(b.r.) numbered grid, *9–21*

Fig. 235

This perspective drawing and plan were made in prepa-
ration for Eakins' portrait of Sebastiano Martinelli (1848–
1918), completed in 1902 (fig. 234; plate 21). The relationship
of the drawing to the painting is discussed in chap. 19.

The perspective drawing, as Eakins' annotations
confirm, is one-sixth the scale of the life-size painting; the
viewing distance must therefore be one-sixth of thirteen feet,
which is the distance of the figure and the fictive picture
plane in the oil. The plan at the right is on a smaller scale of 1
inch = 1 foot, or one-twelfth life. (KF)

Portrait of Very Rev. John J. Fedigan: Perspective Study, c. 1902

Graphite with brown ink on gray-lined foolscap

17 × 14¹⁄₁₆ in. (43.2 × 35.7 cm)

1985.68.27

Inscriptions: (TE in graphite, u.l.) *Fedigon* [sic] / *Picture 16 ft / Drawing 16/6 / Horizon 46″*; (u.c.) *PROVI / IOAN-NIS / AEDIFICAVIT;* (b.l.) numbered grid, *14–25;* (b.r.) *16⅜ 12⅜*

Portrait of Very Reverend John J. Fedigan, 1902

Eakins gave his portrait of the Very Reverend John J. Fedigan, O. S. A. (1842–1908), to Villanova College, where president Fedigan had been the driving force behind the construction of new buildings for the college and the Augustinian convent of St. Thomas. In this perspective drawing the ghost of Fedigan's figure stands next to a drafting table that, in the finished painting, bears a perspective rendering of the new monastery.[1] His name and his role as builder are part of an inscription in Latin that Eakins lettered at the upper left corner of the drawing. Faint lines at the upper right indicate that Eakins may have considered adding something to the back wall, but then decided to leave it bare.

The drawing and its annotations confirm the horizon line at forty-six inches, following the top edge of the drawing board and the belt of Fedigan's habit. Because the painting is at life scale, this distance occurs without diminution on the canvas: forty-six inches from belt to floor. From such a viewpoint—evidently Eakins' eye level when seated—we must look up to this man who was Provincial of the Order of St. Augustine in the United States. We would probably look up to him anyway: the grid on Eakins' drawing tells us that the Irish-born Fedigan was a tall man—6 feet 1, according to the lines drawn emphatically above the contour of his head—but Eakins' lower vantage enhances the towering quality of the priest's figure.

The inscription on the drawing notes that the "picture" is sixteen feet distant, and Fedigan's left footprint indeed lies across the sixteen-foot line on Eakins' floor grid. Since "picture" and figure are seen at the same viewing distance, we could conclude that this drawing is a reduced plan for a full-size image, even if Fedigan's actual portrait had disappeared. The reduction of the drawing itself is explained in his annotation "16/6"—Eakins' idiosyncratic method of indicating one-sixth of sixteen—but it could be deduced by measuring: on the paper, the large twelve-inch squares on the surface of the canvas are represented as two inches on each side, or one-sixth scale in respect to life size. The viewing distance of the drawing is thirty-two inches, or one-sixth of sixteen feet.

The calculation for viewing distance is, as in all life-size portraits, a somewhat slippery matter, because the actual picture plane is situated, according to the drawing, two and a half feet forward of Fedigan, or about thirteen and a half feet

Portrait of Very Rev. John J. Fedigan, 1902, oil on canvas,
89½ × 52 in., on loan to Villanova University from the Province
of St. Thomas of Villanova, Villanova, Pennsylvania.

1. G 362, signed and dated 1902. An oil sketch for this portrait, once in Bregler's collection and now in the Hirshhorn, is G 363; see Rosenzweig, 181. Fedigan's pose recapitulates the stance of *The Architect,* J. J. Borie; see cat. 209. The difference in effect created by viewing height can be measured in the consideration of these two very similar paintings: *Borie,* evidently made by Eakins from a standing position, *Fedigan* while seated.

212

from the viewer. Again, as in cats. 174–176 and 209–225, discussed in chap. 19, this discrepancy (or simultaneity) of fictional and actual picture planes must be finessed in the presentation of full-length, life-sized figures. After preparing this drawing Eakins made a few subtle changes in the image, mostly by suppressing or eliminating the assertiveness of the back wall with its lettered architrave. He also reduced the recession of this wall, indicated by the slope of the baseboard, which rises from left to right more steeply in the drawing. Eakins may have felt that the inscription came too close to Fedigan's head and visually trapped him. The elimination of this molding and the shallower angle of the baseboard (which, in the painting, comes to rest on a course parallel with the plane of the drawing board) increased the airiness of the picture space and the stability of the image, befitting the contemplative builder who stands before us. (KF)

An Actress (Portrait of Suzanne Santje): Plan and Perspective Study of the Artist's Signature, 1903

Graphite on gray-lined foolscap

12⅛ × 14¹⁄₁₆ in. (30.8 × 35.7 cm)

1985.68.28

Inscriptions (r): (TE in graphite, u.c.) *Eakins / 1903;* (b.l. to b.r.) *Eakins / 1903*

Inscriptions (v): (TE in graphite, b.c.) *Miss Suzanne Santje / Roanoke / Va.*

An Actress (Portrait of Suzanne Santje), 1903

This signature appears in the lower left corner of the painting *An Actress (Portrait of Suzanne Santje).* The inscription on the verso of the drawing also appears in the painting, written across an envelope that lies on the floor just above Eakins' name.[1] Like the study of his signature for the Brinton portrait (cat. 176; fig. 49), this drawing shows a gridded plan of Eakins' signature set above a rendering of the same design in perspective, at a slightly different scale. In both paintings the signature occupies about a foot on the finished canvas. Here the plan sets the name and date on a diagonal, and the design is boxed within a grid, eight squares to a side, each square measuring eight-tenths of an inch. Below, the signature has been enlarged 50 percent to fill a grid of one-and-a-quarter-inch squares. At this scale the signature was transferred to the canvas.

Although no perspective drawings for the larger space of the picture survive, the fragmentary grid of the signature shows perspective diminution of less than 4 percent from the front to the back of signature box, very similar to the recession seen in the Brinton portrait. Suzanne Santje's portrait is almost exactly the same size as Brinton's, and both sitters occupy about the same amount of space in the picture, suggesting—along with the common pace of the recession—a similar long viewing distance (sixteen feet). The shared pose, including the inclination of the head, the angle of the body, and other structural similarities, such as the inclusion of Santje's father's portrait exactly where Brinton's ancestor portrait appears in the earlier picture, illustrate other continuities in Eakins' work during more than twenty-five years of portrait painting. (KF)

1. G 384, 79¾ × 59⅞ in. (PMA). See Siegl, 157–159. Siegl explains Santje's business connections in Roanoke; Goodrich also notes her friendship with Susan Eakins' relatives in the Reynolds and Macdowell families in that city (Goodrich, PMA notebooks).

213

trait: CHIEF ENGINEER JEANNETTE / EXPEDITION 1879–82, it reads in part.[3] Perhaps in working out the spacing of this inscription Eakins reached for a sheet of paper at hand this year, incidentally carrying the violin studies. Two neatly cut holes in the paper near this lettering remain unexplained. (KF/DS)

1. G 402 (Art Institute of Chicago). A sketch for this painting, also showing the violin, is in the PMA (see Siegl, 161); a related version is in the Hirshhorn (see Rosenzweig, 189–190). The squared shoulders of this instrument do make it resemble the instrument played by Hedda van den Beemt in all three versions.
2. G 444 (French Benevolent Society, Philadelphia).
3. G 408 (PMA); Siegl, 163.

214

Cello or Violin Parts, c. 1904

Graphite on gray-lined cream wove paper

Watermark: (b.l. to u.l.) WESTLOCK; (b.r. to u.r.) WESTLOCK

14 × 17 in. (irr.) (35.6 × 43.2 cm)

1985.68.29

Inscriptions: (TE in graphite, u.c.) arithmetical notations; (c.l.) *8.5 / 1.5;* (c.r.) *JE;* (b.r.) *JEANNETTE*

This drawing presents studies of the components of a bow and either a violin or a cello. Although no measurements or scale are given, the proportions and profiles suggest a violin. If the bow is drawn at the same scale as the other parts, then the instrument is probably a violin drawn at one-third scale. Across the bottom of the sheet Eakins drew a plan of the body of the instrument freehand within a grid. This device could guide a symmetrical rendering of the curved body and facilitate the transfer of the design to another context. Above this grid Eakins depicted a sequence of parts: a fingerboard whose tapering sides recede to a point, a tailpiece, and a scrolled neck, seen from two vantages. If the drawing represents the parts of a violin, then it may be a study for *Music* of 1904[1] or *Portrait of Manuel Waldteufel* of 1907.[2] Since Eakins had painted musical subjects earlier (e.g., *The Pathetic Song, The Cello Player, Mrs. Frishmuth*), it is remarkable that this is the only study drawing of this type to survive.

The name "Jeannette" inscribed toward the edge of the drawing does not seem to refer to anyone in Eakins' family or circle of students. The annotation may relate to the portrait of Rear Admiral George W. Melville, painted by Eakins the same year as *Music.* Melville was chief engineer on board the ill-fated *Jeannette,* a ship lost in the ice during an Arctic expedition twenty-five years earlier. Melville's fortitude on this expedition earned mention in the lengthy account of his accomplishments lettered by Eakins on the back of the por-

214

The following five drawings for Eakins' portrait of Monsignor Turner (fig. 236; plate 22), painted in about 1906, make up one of the largest suites of related drawings in the collection. This group demonstrates the thoroughness of Eakins' preparations even late in his career, as well as the extent of his manipulation of "reality" in the service of pictorial effect and meaning (see chap. 19).

Portrait of Monsignor James P. Turner, c. 1906

215

Portrait of Monsignor James P. Turner: Perspective Study and Ground Plan, c. 1906

Graphite with red and blue pen and ink on buff pulp paper

35$\frac{1}{16}$ × 33 in. (89.1 × 83.8 cm)

1985.68.30.3

Inscriptions (r): (TE in graphite, c.l.) *Monsigner* [sic] / *Turner / Distance / 14' / Drawing / 14' / 4 / Horizon / 28.5"*; (u.r.) *Wall*; (throughout) 2 numbered grids, *14–62, 1–64*, arithmetical notations

Inscriptions (v): (c.l.) *Turner*

Fig. 237

The inscriptions note that the figure and the viewing distance of the picture are both at fourteen feet, indicating life-size scale. The perspective drawing has been reduced to one-fourth this size with a commensurate reduction in the viewing distance. The eye level is twenty-eight and a half inches from the tile floor that Turner stands on. The plan at the right side of the drawing is at a smaller scale (one-twelfth life). (KF)

216

Portrait of Monsignor James P. Turner: Perspective Study of Tile Floor, c. 1906

Graphite and brown and red wash on buff pulp paper

35$\frac{7}{8}$ × 47$\frac{1}{4}$ in. (91.1 × 120 cm)

1985.68.30.4

Inscriptions (r): (TE in graphite throughout) numbered grid, *1–56*

Inscriptions (v): (c.l.) *Turner*

See cat. 215.

216

217

Portrait of Monsignor James P. Turner: Perspective Study of Tile Floor, c. 1906

Graphite, black and red wash, and chalk (?) on buff pulp paper

35⅞ × 42 in. (91.1 × 106.7 cm)

1985.68.30.1

Inscriptions (r): (TE in graphite throughout) numbered floor tiles and vertical axis, *1–56;* (c.l. and c.r.) *Wall;* (b.l. to b.r.) arithmetical notations

Inscriptions (v): (in graphite, b.r.) *Turner;* (throughout) numbered grid, *3–8,* arithmetical notations and punched holes

This drawing and the following one, cat. 218, were used to transfer the perspective of the floor pattern to the lower part of the canvas. Both are on sheets of paper as wide as the actual canvas. Vertically, the designs cover an area that extends from about two inches above the lower edge of the canvas to just above the horizon line.

See also cat. 215.

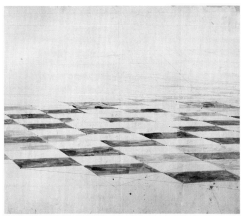

217

218

Portrait of Monsignor James P. Turner: Perspective Study of Tile Floor, c. 1906

Graphite, red and brown wash, and gouache on buff pulp paper

32½ × 42 in. (82.6 × 106.7 cm)

1985.68.30.2

Inscriptions: (TE in graphite throughout) numbered floor tiles and vertical axis, *1–60,* punched holes

Fig. 238

See cats. 215 and 217.

219

Portrait of Monsignor James P. Turner: Transfer Pattern, c. 1906

Graphite on buff wove paper

35 × 17½ in. (88.9 × 44.5 cm)

1985.68.33.7

Inscriptions: (CB in graphite, c.r.) *handle with care / paper torn;* (b.c. to b.r.) *This contains perspective drawing for 4 oared shell Eakins / picture in Brooklyn Museum;* (TE, left margin) numbered grid, *2–4½;* punched holes throughout

The area within the punched holes on this drawing corresponds, at 1:1 scale, to a section on the upper left of the portrait depicting a framed image of the Virgin Mary. A faint pencil outline of her head and shoulders appears within a smaller grid of lines at the upper left of the drawing. To transfer this grid, Eakins lay the left edge of this paper along the left margin of the canvas. The lowest line of the punched dots describes the upper edge of the frame or table beneath the picture. The annotation by Bregler along the right margin referred to other drawings kept in the same portfolio. (KF)

The six drawings (cats. 220–225) for Eakins' portrait of Dr. William Thomson (1833–1907) form the Bregler collection's largest group of related studies for a portrait. Two unidentified drawings (cats. 226–227) may also pertain to this project. On the relationship of these drawings to the finished painting (fig. 239), see chap. 19.

Portrait of Dr. William Thomson, 1907

220

Portrait of Dr. William Thomson: Perspective Study, c. 1907

> Pen and blue and red ink over graphite on buff wove paper
>
> 25⅞ × 19⅞ in. (65.7 × 50.5 cm)
>
> 1985.68.33.1
>
> Inscriptions: (TE in graphite, b.c. to c.) numbered grid, *9–18;* (b.l. and b.c.) arithmetical notations
>
> Fig. 240

221

Portrait of Dr. William Thomson: Ground Plan, c. 1907

> Pen and blue ink over graphite on buff wove paper
>
> 20⅛ × 18¹⁵⁄₁₆ in. (51.1 × 48.1 cm)
>
> 1985.68.33.3
>
> Inscriptions: (TE in graphite, u.c. to b.c.) numbered grid, *10–14*

The plan of the floor in Dr. Thomson's office is made in three-inch squares, each representing a square foot in space (or one-fourth scale). Thomson's footprint appears across the ten-foot line, and the table surface beside him is shown to be thirty-nine inches long. The placement of the lamp(?) on the table is precisely indicated along the thirteen-foot line. (KF)

221

222

Portrait of Dr. William Thomson: Transfer Pattern for Table, c. 1907

Graphite on buff wove paper, punched with holes

21 × 24⁵⁄₁₆ in. (53.3 × 61.8 cm)

1985.68.33.2

The S-curve shapes traced in the drawing define the corners of the table that Dr. Thomson leans on; the same curve appears in the floor plan of the table (cat. 221) and the perspective elevation (cat. 220). The other lines and punch holes plot the axis of some form, probably a lamp, that rests on the table behind Dr. Thomson. To transfer these points, the right margin of the paper seems to have been placed along the right margin of the canvas. (KF)

legs of Thomson's table straddle the rich, deeply colored pattern of the foreground carpet and the neutral tones of the midground, structuring a necessary visual progression into space from front to rear. Although constructed perspectivally, the progression these legs engender is not along perfectly rationalized "perspectival" lines. As the eye moves from Thomson's arm and table edge down through the table legs, there is an ambiguous transition to the middle depth of the canvas as one reaches the floor. The table legs are perspectival devices used not just for the sake of spatial clarity, since the spatial order they suggest is indeterminate, but for the sense of visual circulation they produce. They are the means of elision, or shift, which lend the work a dramatic spatiality, from the highlighted point of Thomson's well-waxed boot to the browned hues of the two-dimensional eye chart in the upper distance. (JCT)

222

223

Portrait of Dr. William Thomson: Transfer Pattern for Table Leg, c. 1907

Graphite and pen and ink on buff wove paper

26³⁄₁₆ × 25⁵⁄₈ in. (with 10¹⁄₁₆ × 1⁵⁄₈ in. appendage at right edge) (66.5 × 65.1 cm)

1985.68.31.3

Inscriptions (v): (CB? in graphite, u.r.) *Dr. Thompson* [sic] *Eakins*

This drawing is a perspectival study and transfer punch sheet for the pedestal base of a table on which Dr. Thomson leans his left forearm. The small paper appendage fastened to the right edge (so that the front table leg can be carried further down the paper) does not come into play in the finished version of the painting, as the right edge of the canvas stops at a point corresponding to the right edge of the larger piece of paper.

In the painting of Dr. Thomson the table legs play a critical but subtle compositional role, and it is not surprising that Eakins worked them out in detail. The front and rear

223

224

Portrait of Dr. William Thomson: Transfer Pattern for the Eye Chart, c. 1907

Graphite and pen and ink on buff wove paper

17 × 11⁷⁄₁₆ in. (irr.) (29.1 × 43.2 cm)

1985.68.31.2

Inscriptions: (TE in graphite, b.c.) *TES(I)*[?]

Fig. 242

This drawing depicts the eye test chart in the upper left corner of the final portrait. The punched holes and the texture of canvas imprinted in warm brown paint on the verso testify to its use as a transfer pattern. The radiating, clocklike

pattern at the top of the chart is designed to detect degrees of astigmatism. Its presence in the picture denotes not only the practice of the medicine of the eye, but, like the ophthalmoscope that Thomson holds, it also signals a degree of technical specificity and subspecialization within the larger field. As a marker of Thomson's special knowledge, it also becomes the symbol of his authority and stature.

On the eye chart sketch, seven full rows of letters are carefully inscribed beneath the semicircular diagram. The letter rows reduce in size as they move down the sheet in the typical fashion of a Snellen test chart, and on the sketch even the last row is clearly drawn and legible.[1] In its painted realization, however, the last four lines of letters are beyond view, lost to our sight in the dark tonalities of the background. In the passage from sketch to paint, Eakins has wittily located the conjunction of perspectival depth with the two-dimensional, symbolic space of perfect visual acuity—the eye chart. Indeed, to have transferred to canvas the final rows of small print as they were conceived in the sketch, would have granted the eye chart a visual parity with the foreground figure—someone who would have immediately grasped that optical slip of the brush.

Eakins in fact had lecture notes on this very point: "If you hold up your two forefingers in front of your eye one at arm's length and the other half a bar, the eye cannot see them both sharp at the same time. If you sharpen your eye on the near one the distant one blurs. . . . The character of depth is incompatible with that of sharpness especially as you go out sideways from the point of sight and one or the other characteristics must be sacrificed in a picture."[2] (JCT)

1. The combination of the astigmatism chart and the Snellen Scale makes a very unorthodox artifact; see the discussion in chap. 19.
2. Sewell, 72, from Eakins' Lecture Manuscripts and Notes, at PMA, c. 1884.

225

Portrait of Dr. William Thomson: Perspectival Transfer Pattern, 1907

Graphite and pen and ink on buff wove paper

$47^{7}/_{16} \times 22^{11}/_{16}$ in. (irr.) (120.5 × 57.6 cm)

1985.68.31.1

Inscriptions: (CB? in graphite, u.c.) *Dr. William Thompson* [sic] / numerical notations; (TE in graphite, u.l.) *Dr. Thomson* / arithmetical notations; (c.l.) numbered grid, *15–18* / arithmetical notations; (c.r.) *7*; punched holes throughout

Inscriptions (v): (TE in graphite throughout) grid and numerical notations

This sheet contains a large perspectival grid with small punched holes at several intersections apparently for use in

transfer to the canvas of the finished Thomson portrait. The upper left corner of the grid is further subdivided, as if to facilitate the placement of a more detailed passage—perhaps the lamp (?) on the table or the foot of Dr. Thomson. The verso is also gridded off, but the hole-punch patterns clearly relate to the recto. The identification of this drawing has been confused by the use of the paper for other unrelated and unidentified perspective studies. Only CB's annotation and the emergence of this drawing in the company of other Thomson drawings make the attribution to this project possible. (JCT/KF)

226

Perspective Study: Floor Boards, Room Corner, c. 1907?

Graphite, black ink, and watercolor on buff wove paper

$26 \times 32^{11}/_{16}$ in. (irr.) (66 × 83 cm)

1985.68.33.4

Inscriptions: (TE in graphite c.) *floor line;* (c.l.) *floor line;* (throughout in graphite and ink) numbered grid, *1–19*

This perspective drawing and the following plan, cat. 227, seem to be for a portrait subject. The perspective shows the corner of a room with painted floorboards or a striped carpet on the floor. The horizon line is low, about forty-five inches above the twelve-foot-line in the foreground, suggesting the eye level of a seated figure painted from a sitting position. Annotations on the verso of the plan refer to a "Horizon 44 inchs [sic]" and to "top of head" and "top of chair," confirming this sense of a seated figure. From the plan and a slight diagonal in the foreground of the perspective, the axis of the figure seems to be turned slightly to the left, across the twelve-foot-line in space. Beyond, the room extends to seventeen feet distant. A diagonal black ink line at the left may indicate the edge of a table or carpet. The space and pose suggest the *Portrait of Dr. William Thomson* (cats. 220–225), and these drawings may be drafts for the background of the unfinished first version, in which no eye chart or rug appear.[1]

The drawing is at one-third the scale of life; this may or may not be the scale of the actual painting. Vertical lines at left and right in the perspective drawing bracket a space forty inches across the floor along the twelve-foot-line, where the figure sits. Following Eakins' typical practice with life-size portraits, this dimension would be carried forward to the actual lower edge of the canvas. Although the paper is badly broken along the top of the sheet and no strong horizontal line can be found to mark the top edge of the canvas, the ink line of the rear corner may suggest the height of the canvas: from the eleven-foot-line in the foreground to the tip of this line would be no less than sixty-three inches, if painted at life scale. These dimensions again compare with the first Thom-

son portrait (68 × 45 in.). Reduced, as in the drawing, the dimensions would be proportionately smaller.

Annotations on the verso of cat. 227 ("Picture 2 ft. from eye / 8 [ft] off") do not clarify matters. These conditions suggest a painting or drawing with a scale of one-fourth life—smaller than the perspective drawing on the recto. If eight feet is taken to be the viewing length of the painting, the image on the recto would be translated into two-thirds life scale along the twelve-foot-line, much larger than the drawing but an unusual scale for Eakins' portraits. This annotation probably refers to another project pursued at about the same time. The plan on the recto is not helpful in this search, for it is drawn in an even odder scale, where one-foot squares on the floor are represented by squares two and three-fourths inches to a side (4/11 scale). These eccentricities make it impossible to predict the size of the canvas Eakins planned. More useful in identifying this subject, if it is ever found, will be the detailed record of stripes in the floor covering that Eakins so patiently laid down in watercolor. (KF)

1. Both drawings are on paper similar to the other late perspective drawings (such as those for the Turner and Thomson portraits) and were found with these sheets.

226

227

Perspective Study: Ground Plan with Floor Pattern, c. 1907?

Graphite and watercolor on buff wove paper

26⅛ × 32¹¹⁄₁₆ in. (66.4 × 83 cm)

1985.68.33.5

Inscriptions (r): (TE in graphite, u.l.) *Floor line;* (left and right margins) numbered grid, *0–17;* (b.l. to b.r.) *2 1 0 1 2 3;* (TE? in brown ink, r.c.) *Thos*[?]

Inscriptions (v): (TE in graphite, u.c.) *Horizon 44 inchs* [sic]/ *Picture 2 ft. from eye / 8 "[ft.] off;* (c.l.) *top of head / top of chair top of chair*

227

228

Alphabet, n.d.

Black ink over brown ink on gray-lined foolscap

14 × 8⁹⁄16 in. (35.6 × 21.8 cm)

1985.68.36

Inscriptions: (TE in ink, top half of sheet) *A–Z*

229

Miscellaneous Drawings

Thomas Eakins or his circle

Chair and Stool (r), n.d.

Table (v)

Graphite on foolscap

5¹⁵⁄16 × 8⁵⁄16 in. (15.1 × 21.1 cm)

1985.68.37.3

Inscriptions: (TE in graphite, u.c. in diagram) *P / I G*

These forms cannot be related to a painting by TE. They may have been drawn as perspective exercises by CB. This drawing was discovered in a portfolio containing other perspective drawings by Eakins, however, carefully segregated from Bregler's work. (KF)

230

Thomas Eakins or his circle

Sketch of Rocking Chair on Grid

Graphite on buff wove paper

4⁵⁄8 × 3¹¹⁄16 in. (11.8 × 9.4 cm)

1985.68.37.1

This drawing and the next one, of cats, were found among manuscripts by TE, SME, and CB.

231

Thomas Eakins or Susan Macdowell Eakins

Sketches of Cats (r and v)

Graphite on gray-lined foolscap

Watermark: WESTLOCK

8½ × 14¹⁄16 in. (21.6 × 35.7 cm)

1985.68.37.2

The Eakins household was full of cats, and Susan's di-

aries contain many references to the birth and death of their
favorites. Cats appear in many of Eakins' paintings (*Kathrin,
The Chess Players*) and in his relief sculpture (*Knitting,* cat.
260), but these sketches seem to be life studies, not prepara-
tions for a particular painting. (KF)

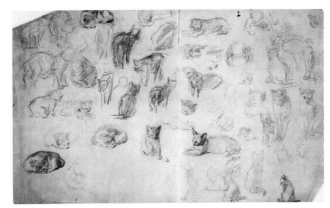

231 r

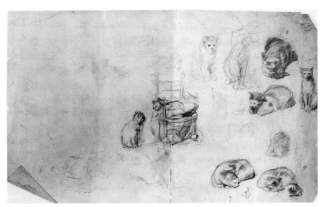

231 v

Oil Sketches

232

The Artist and His Father Hunting Reed Birds: Marsh Landscape Sketch, c. 1873

Oil on canvas

5½ × 8⁷⁄₁₆ in. (14 × 21.4 cm)

1985.68.38.20

Inscriptions (r): (CB, incised into paint, b.l.) *Thomas Eakins*

Inscriptions (verso of cardboard mount): (CB, in black ink on paper label, c.) *Study of Landscape / Painted by / Thomas Eakins / Listed in Goodrich book 172 / rebacked by and property / of Charles Bregler*

Provenance: CB Estate Inventory 1958, 11, *Study of Landscape.*

Exhibitions: Knoedler 1944, no. 28, *Landscape (Sketch)* "painted probably in the '80s. Unsigned."

References: Goodrich 1933, no. 172; Foster 1990, 75.

Fig. 120

This sketch must have been painted in the Cohansey marshes south of Philadelphia in the fall of 1873, just before Eakins contracted malaria while hunting and sketching in the same area. According to his letter the following spring to his teacher, J.-L. Gérôme, Eakins had to rely on such sketches more than he might have wished, for after his recovery his doctor forbade further expeditions to the marsh. The larger paintings that he had planned or half completed in the fall of 1873 had to be executed from extant sketches such as this, or from memory. The two trees in this sketch were transferred at the same scale to the background of *The Artist and His Father Hunting Reed Birds in the Cohansey Marshes* (fig. 119; plate 10). This painting, and Eakins' correspondence with Gérôme, are discussed above in chap. 13.

Although the rapid brushwork and small size of this sketch suggest work done on the spot, further evidence of plein air study could have been found on this canvas before it was cut down. All four edges of the image have been cropped, and the canvas has been mounted on cardboard, evidently just before Lloyd Goodrich recorded this sketch in 1933. The present dimensions of the canvas are slightly larger than those given in his catalogue (5 × 7½ in.), probably because Goodrich measured the sight dimensions of the picture within a frame. But record drawings in Goodrich's notebook indicate that he had seen the canvas when it included another landscape sketch.[1] The marsh sketch was once at the upper left corner of an approximately 10 × 13 in. canvas; the bottom was covered by another, inverted view that was later catalogued as G 173: "Water in foreground, high shore beyond, and sky . . . 4½ × 10⅜."[2]

Goodrich assumed that most of Eakins' small unsigned, undated landscape sketches were made near Gloucester in the early 1880s. Now, by association with the hunting sub-

jects, both of these landscapes may be dated to c. 1873. The shoreline mirrored in the water of the lower sketch resembles the Schuylkill River landscape in the background of *Oarsmen on the Schuylkill* (fig. 115), also from about 1874. If it is a study for that rowing painting, it would confirm a late date for that canvas rather than the earlier date (1871) suggested by Siegl; see cats. 149–150 and chap. 12. (KF)

1. The painting was discovered in a small gold-painted frame in 1984. Creases in the paint film, revealed during conservation, indicate that the canvas was for a time unstretched. It seems from his notes that Goodrich saw the canvas both before and after it was divided, although SME could have advised him of its earlier appearance. In either event, his reports tell us that someone—perhaps Bregler—had begun to divide and mount such sketches during SME's lifetime. Some time after 1933 and before the Knoedler exhibition of 1944, Bregler added the "signature" at the lower left.
2. After 1933 this sketch came to Seymour Adelman, perhaps by way of Bregler; see Avondale/Dietrich, cat. 2, *Landscape Sketch*.

233

Ships and Sailboats on the Delaware: Study [1874]

Oil on canvas

7⅛ × 10½ in. (irr.) (18.1 × 26.7 cm)

1985.68.38.16

Inscriptions: (verso of cardboard mount) (CB, in black ink on white paper label, u.c.) *Study for the picture / Ships and Sailboats on the / Delaware River / painted by / Thomas Eakins / Listed in Goodrich book #81 / property of Charles Bregler;* (encircled, u.r.) *40* [torn]; (in orange pencil, u.l.) *26*

Provenance: CB Estate Inventory 1958, 11, *Study for Picture / "Ships and Sailboats on the Delaware"*

Exhibitions: Knoedler 1944, no. 9.

References: Goodrich 1933, no. 81; Gordon Hendricks, "On the Delaware," *Bulletin of the Wadsworth Atheneum* 4 (Spring–Fall 1968): 41–42; Hendricks notes that it was once in the collection of Charles Bregler, "now unlocated."

Eakins loved to sail, and he often attended the races on the Delaware. He wrote to his fiancée, Kathrin Crowell, on 19 August 1874 that he had been painting in south Jersey the previous Monday "and when we were done we got up to Gloucester in time to see the largest race ever seen on the Delaware & which I had forgotten all about. I think there must have been upwards of two hundred sail boats."[1] The experience may have suggested the idea of a sailboat picture and, with his painting gear on board that day, he may have seized the opportunity to sketch from his own boat as the race began. His description of the oil, *Ships and Sailboats on the Delaware*[2] (or, *On the Delaware*) of 1874 (see accompany-

ing illustration), later developed from this sketch, explains the circumstances he tried to record: "It is a still August morning 11 o'clock. The race has started down from Tony Brown's at Gloucester on the ebb tide. What wind there is from time to time is astern and big sails flop out some one side and some the other. You can see a least little breeze this side of the vessels at anchor. It turns up the water enough to reflect the blue sky of the zenith. The row boats and clumsy sail boats in the foreground are not the racers but starters and lookers on."[3]

The small size and broad handling of the sketch may indicate that it was indeed painted on the scene. Seemingly empty and simple, the sketch served several purposes, recording the color values of the sky and water, the placement of the larger boats, and—most difficult of all—the effect of wind. The oncoming breeze is represented by a change of texture in the clouds and by a long blue smudge across the water. Boats on each side of this band of color also make visible the presence of wind: a small boat at the right edge of this zone catches the breeze and fills its white sail, while the schooner stands becalmed on the far side, its sails limply flopping. The contrast between the bright, moving sailboat and the dark "clumsy" ships increased in the finished oil, which is twice as large and much more detailed. In this expanded version, Eakins added a fleet of raceboats to the sunny distance and a pair of dark rowboats to the group of anchored onlookers. He also took more time to show the wind-ruffled water as dull, the calm water as reflective. However, the "story" of the breeze is told less dramatically now, as the schooner's sail appears taut and the path of the wind is rendered by color and texture only, without value contrast.

Later in 1874, Eakins reworked the composition for a similar canvas, *Ships and Sailboats on the Delaware* (see accompanying illustration), where the group of larger boats was shifted to the left.[4] Perhaps, as Siegl has suggested, Eakins was dissatisfied with the static effect of the first composition and felt that an asymmetrical arrangement would add a sense of movement and distance to the right side of the picture. Evidently pleased with this new composition, he copied it in a watercolor of the same size, which he exhibited at the American Watercolor Society's exhibition in February 1875 as *No Wind—Race Boats Drifting*.[5] Once the watercolor was finished he reconsidered the margins—as he had for *Baseball Players Practicing* (fig. 55; plate 2)—cropping the image to increase its horizontality.[6] This last version must have been Eakins' favorite, for he exhibited it often. The shift into watercolor enlisted a medium that could, as Siegl remarked, "properly capture the luminosity of the scene." Indeed, the delicacy and suggestiveness of Eakins' final version make the broad effects of the initial sketch seem, as Goodrich noted, "hardly more than color notes"[7] by comparison. But the watercolor draws upon these first observations by returning to the strong pattern of light and dark banding seen only in the sketch. An alternate title for the watercolor—*Waiting for a Breeze*—confirms Eakins' recollection of the challenge con-

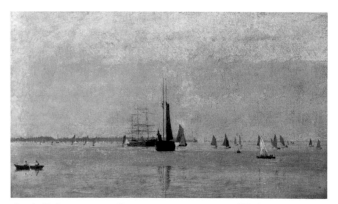

On the Delaware, 1874, oil on canvas, 10⅛ × 17⅛ in., Wadsworth Atheneum, Hartford, Gift of Henry Schnakenberg.

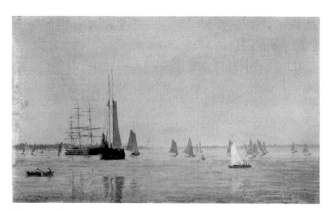

Ships and Sailboats on the Delaware, 1874, oil on canvas, 10¼ × 17¼, Philadelphia Museum of Art, Given by Mrs. Thomas Eakins and Miss Mary Adeline Williams.

fronted in the original sketch: the depiction of the presence and absence of wind. (KF)

1. CBTE, Foster and Leibold, no. 57, fiche series I 3/D/6–7.
2. G 80. Bregler's label on the verso of his sketch confused this painting with the second version, G 82, discussed below. The Wadsworth Atheneum's painting has also been known as *Becalmed* and *Sailboats on the Delaware;* see Hendricks, "On the Delaware," 39–48, and Sewell, 29, 31.
3. Eakins to Earl Shinn, 30 Jan. 1875, quoted in Siegl, 58–59.
4. G 82; Siegl, 58–59. As Hendricks has noted, this second version is slightly cooler in tone and looser in handling than the Wadsworth Atheneum's painting.
5. G 83 (coll. Thomas S. Pratt), also known as *Drifting* and *Waiting for a Breeze* (AWS 1875, no. 208). See Hoopes, 34, and plates 7, 8, and Foster 1982, 216–217.
6. Eakins began the watercolor on a sheet of paper the same size as

the PMA oil, but he cropped the image on all four sides with light pencil rulings to tighten his composition. As with *Baseball* (fig. 55), this secondary moment of decision-making is confirmed by the placement of his signature within these new borders. Also interesting is his choice of a mat, indicated in his letter to Earl Shinn of 30 Jan. 1875: "The mat I think is too blue but I cannot tell till I see where it is hung. The color was very true but the mat may be exaggerated" (Ackerman 1969, 241).

7. Siegl, 59; Goodrich's notes (PMA) indicate that he found this sketch in Eakins' "fourth floor studio—unframed." His records for these four sailboat paintings show that the oil sketch and the Wadsworth Atheneum painting were never exhibited; the PMA oil was sent to Paris and forwarded by Gérôme to Goupil's gallery in London, where it was shown in 1875. The watercolor was shown three times between 1875 and 1879 before being donated to a benefit auction for Christian Schussele's family in 1880.

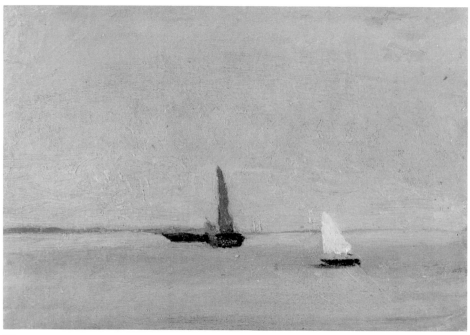

233

234

Sailboats Racing: Study of the Delaware River [1874]

Oil on heavy paper

6¾ × 12 in. (17.1 × 30.5 cm)

1985.68.38.17

Inscriptions (r): (CB, incised b.r.) *Thomas Eakins*

Inscriptions (v): (CB, in ink on paper label, u.c.) *Study of Delaware river / Painted by / Thomas Eakins / Property of / Charles Bregler / 39* [encircled] *Listed in Goodrich book 170*

Provenance: CB Estate Inventory 1958, 10, "Study of Delaware River / By Thomas Eakins / Listed Goodrich no. 17 / Wood panel 39, Framed."

Exhibitions: Possibly Knoedler 1944, no. 27; possibly Carnegie 1945, no. 67.

References: Possibly Goodrich 1933, no. 170, "Three sketches of shore, fields and trees, in oil on one sheet of heavy paper, 10⅝ × 13¼."

Fig. 61

This river view appears in the right-hand distance of *Sailboats Racing*, also known as *Sailboats (Hikers) Racing on the Delaware* of 1874 (fig. 62).[1] Although the dimensions of this sketch are only a quarter of those of the final oil, the spit of land seen at the right appears at the same scale in *Sailboats Racing*. When he transposed the sketch Eakins doubled the height and width of the tree at the far right so that it would bulk larger in the finished oil, and he eliminated the boat at left by overlapping it with a larger foreground sail. Probably painted on the spot to record color and value, the sketch uses the palette seen in *Sailboats Racing* as well as certain subtle observations of light, such as the lighter blue-gray water along the shore of the island, where the shallowness and wave action reflect the blue of the sky. Because of the briskness of the breeze, indicated by whitecaps along the shore, the rest of the river's surface is rough, displaying its own muddy color rather than reflecting the sky.

An earlier oil sketch beneath the surface of the river view disrupts the brush pattern at the bottom right and, at the bottom center, glints through with orange, tan, and white color notes. These marks form no identifiable shape, even in X-ray photography (see fig. 248), and may be impossible to read because the sheet of paper has been trimmed on all sides, probably by Bregler, who mounted the brittle paper on a reinforcing sheet of cardboard after 1944.[2]

Bregler's label on the cardboard mount describes this sketch as "listed in Goodrich book 170," a number also ascribed to cats. 235 and 236. Goodrich's entry in 1933 recorded a larger, single sheet of heavy paper, 10⅝ × 13¼ in., containing "three sketches of shore, fields and trees." A thumbnail record drawing of this page made by Goodrich in his notebooks confirms the location and general character of the two

smaller sketches, 235 and 236, at the upper left and right of this sheet of "badly torn" paper.[3] However, his sketch shows that the lower portion of the page was taken up by a landscape of a field and trees—not a river scene. Moreover, the remaining area on the sheet, once the two smaller sketches are accounted for, would not be large enough to contain the river view for *Sailboats Racing*. All three sketches are indeed on the same kind of paper, remarkable for its brittleness and the presence of a commercially applied white ground containing gritty particles, so it remains possible that Goodrich's notes and measurements were incorrect. Since no sketch fitting the size and description of this lower fragment of G 170 has survived, it is also possible that it was too badly torn to be saved, and Bregler, in confusion or perhaps in search of tidiness, inserted the *Sailboats Racing* sketch into its place in Goodrich's listing.[4] Oddly, given the size and indisputable authenticity of this sketch, not even fully recognized by Goodrich and Bregler, it appears nowhere in Goodrich's notes. Although he was generally careful about recording verso images, Goodrich may have overlooked it on the back of another sheet; more likely, this sketch, like many of Eakins' preparatory pieces, was "lost" to both Goodrich and Susan Eakins when he inventoried her collection in 1930–32. (KF)

1. G 76; Siegl, 57–58.
2. See appendix.
3. Goodrich, PMA notebooks.
4. Bregler had four items in his collection labeled G 170, according to his estate inventory; two of these listings can be securely related to cats. 234 and 235. Cat. 236 (see provenance record for this item) must be one of the two remaining listings; the fourth piece, perhaps the landscape sketch described by Goodrich, was not found in his widow's possession in 1984. All four pieces conceivably could have come from the recto and verso of a single board, which Bregler delaminated but did not reline before 1930, although the fragility of the paper would seem to make this procedure unlikely. Since the three extant sketches have all been mounted on cardboard, their versos can no longer be examined.

235

Landscape Study: Shoreline with Trees, c. 1874

Oil on heavy paper

6⅞ × 7 in. (irr.) (17.5 × 17.8 cm)

1985.68.38.18

Inscriptions (r): (CB, incised b.l.) *EAKINS*

Inscriptions (v of cardboard mount): (CB in ink on paper label, c.) *Study by / Thomas Eakins / given to Charles Bregler / by Mrs. Eakins / Goodrich book #170*; (u.r.) *36* [partly circled]

Provenance: CB Estate Inventory 1958, 10, "Small Oil Painting on Cardboard / Study By Thomas Eakins,

(#36), / Registered in Goodrich's Book #170."

Exhibitions: Knoedler 1944, no. 27; Carnegie 1945, no. 67.

References: Goodrich 1933, no. 170, "Three sketches of shore, fields and trees, in oil on one sheet of heavy paper, 10⅝ × 13¼."

This small sketch and cats. 234 and 236 were labeled by Bregler as fragments of a single sheet of paper catalogued by Goodrich as no. 170 (see cat. 234). This view of a beach bordered by trees was in the upper left corner of the page, according to Goodrich's record sketch, made in about 1930.[1] Although all four edges were cut and the upper left corner reconstructed and overpainted by Bregler,[2] traces of brushwork unrelated to the scene described carry over into the image of cat. 236, confirming their earlier side-by-side arrangement. Although there are problems in affiliating cat. 234 with this group, Bregler claimed that they were all parts of the same sheet, and indeed they are all on the same unusual paper, which has been coated with a gritty white ground, probably a commercial preparation to make the paper suitable for oil sketching. Their common materials offer a clue to a date close to 1874, when the sketch for *Sailboats Racing* (cat. 234) was made.[3] All of Eakins' small landscape sketches were catalogued together by Goodrich as "probably" from the early 1880s, and only the discovery of a clear connection to an earlier painting (as in cats. 232–234) has allowed the creation of a new category of work: landscape sketches from the early 1870s. (KF)

1. Goodrich, PMA notebooks.
2. See Mark Bockrath, *JAIC*, 55, and his appendix below.
3. Eakins rarely painted in oil on paper, or else few such sketches have survived. The extant paper sketches all seem to be from the mid-'70s. See chap. 8 and cat. 237.

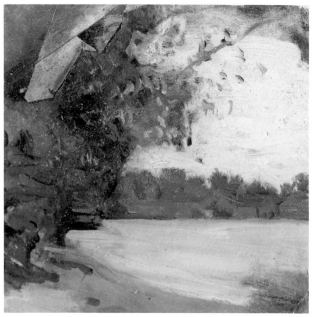

235

236

Landscape Study: Cultivated Field and Tree, c. 1874

Oil on heavy paper

4¹¹⁄₁₆ × 4¹¹⁄₁₆ in. (11.9 × 11.9 cm)

1985.68.38.19

Inscriptions (r): (CB, incised b.l.) *TE*

Inscriptions (v): (CB, in ink on paper label, u.c.) *Study by 42 / Thomas Eakins / given to Charles Bregler / by Mrs Eakins / Goodrich book #170*

Provenance: CB Estate Inventory 1958, 7, "Gilt Framed Oil Painting / by Thomas Eakins, Study for Landscape / Which is Listed, Goodrich #170, Signed / "Thomas Eakins"; or 11, "Study Landscape By Thomas Eakins / Goodrich #170." [The present sketch was found framed, so it may be the item on p. 7.]

Exhibitions: Knoedler 1944, no. 27; Carnegie 1945, no. 67.

References: Goodrich 1933, no. 170

Fig. 63

See cats. 234 and 235.

237

Head of a Man [Rutherford B. Hayes?], 1877?

Oil on paper fragment, mounted on cardboard

4⅝ × 2¾ in. (irr.) paper (11.8 × 7 cm); 7 × 5¼ in. mount

1985.68.38.2

Inscriptions (r): (CB, b.l.) *T. E.* [removed in conservation] (incised, b.c.) *S / S*

Inscriptions (v of mount): (CB, in ink, c.) *a study by / Thomas Eakins / given to / Charles Bregler / by Mrs. Eakins / Sept. 18. 1930;* (in ink on label, u.l.) *25*

Provenance: SME to CB, 1930 (per verso inscription); CB Estate Inventory 1958, 4, *Study of a Man's Head.*

Fig. 224

This thumbnail sketch, evidently done very quickly from life, demonstrates Eakins' portrait method at its most spontaneous. The style, scale, and tonality of this work recollect Eakins' preparations for his small interior genre subjects of the mid-1870s, such as *The Chess Players* (fig. 9) or *The Gross Clinic* (fig. 88), where many individualized faces were studied for inclusion in the background.[1] Because Eakins rarely painted in oil on paper, the materials used for this sketch also suggest impromptu work done outside the studio.[2]

The sitter resembles President Rutherford B. Hayes (1822–93), whom Eakins painted at the White House in September and October 1877, although the small size of this sketch and its broad handling, as well as the loss of the final

portrait, make a positive identification impossible. However, the survival of this tiny study (unlike most of the audience sketches for *The Gross Clinic*) may reflect on the importance of the sitter, and it is likewise odd that no other finished portrait or genre scene has been located that incorporates the pose and appearance of the man in this sketch. For discussion of this project, see chap. 19.

Bregler rescued *Head of a Man* and mounted it on a larger piece of cardboard, overpainting the edges extensively to re-create a sense of background. The actual scrap of extant paper hardly extends beyond the figure, although an abrupt change in color (to reddish brown) below the sitter's white shirtfront may indicate the existence of other studies once adjacent on a larger sheet of paper. Another page of various oil sketches on paper, already very brittle and much damaged by 1930–32 when it was examined by Lloyd Goodrich, received similar treatment from Bregler, who broke the sketches apart and mounted them separately (see cats. 234–236). Unfortunately, this small sketch eluded Goodrich's attention in the 1930s, so we have no record of its size or appearance prior to Bregler's conservation, which erased any additional information available from the original paper. (KF)

1. The sketch technique here most resembles *Bertrand Gardel (Study for "The Chess Players")* of 1876 (G 98, PMA; Siegl, 66) and *Robert C. V. Meyers* of 1875 (G 93; Avondale/Dietrich, cat. 4), the only extant portrait sketch for *The Gross Clinic*. Both of these small portrait sketches are also in oil on paper.

2. Most of Eakins' preliminary portrait studies are in oil on canvas, wood, or cardboard. Other than the two sketches mentioned above, only two other such sketches were recorded by Goodrich: *Sketches of Benjamin Eakins*, G 184, and *Head in Right Profile*, G 186, both undated and unlocated. Goodrich lists no oil on paper sketches after 1882.

238

Figure Study: Masked Nude Woman, c. 1875–85

Oil on cardboard

14 × 8 in. (35.6 × 20.3 cm)

1985.68.38.4

On the recto: (CB) incised lines around the figure, enclosing a rectangle 12¹¹⁄₁₆ × 6¹⁵⁄₁₆ in. These lines were made after the application of twentieth-century varnish.

On the verso: vestiges of two overlaid oil studies (a seated figure, painted over a portrait study), both scraped out

Provenance: CB Estate Inventory 1958, 10, "Feminine Nude Study Attributed to Eakins" may refer to this item or cat. 240.

Plate 4

Three life studies from nude women were found in Bregler's collection (cats. 238–240). The special purposes, quali-

ties, and problems uniting this unusual group are discussed in chap. 8. The mask worn by the model in cat. 238 indicates this study—unlike the other two—may have been made in a life class. Given Eakins' frequent representation of the back of a model during the mid-1870s and early 1880s, it appears likely that he set the pose of the model and painted this sketch in a class under his instruction.[1] The famous charcoal drawing of a model with a wide cloth tied around her head (fig. 30), probably from about 1866, when Eakins attended the PAFA life class, has made the masked model a commonplace in the literature on the artist. Goodrich explained the mask's use as a practical expedient to keep the model anonymous, but other interpretations of this practice might be explored.[2] Mask wearing would have declared to beholder and beheld alike their fallen state. In addition, by preventing direct visual contact the mask may have been thought to reduce "contagion" from immoral models, some of whom were prostitutes. Such a proposal also has implications for Eakins' use of models depicted from behind, since such a point of view prevents reciprocal eye contact and mental engagement.

In his letter of January 1877 to the Committee on Instruction concerning his proposed advertisement for female models, Eakins wrote that "the privilege of wearing a mask might also be conceded & advertised."[3] Eakins' language indicates his lack of enthusiasm for the practice, perhaps echoed in the skimpy mask used by the model in this sketch. One may imagine that Eakins reduced the surface area of the mask to a minimum in his classes because masks not only made it impossible to perceive the whole figure, but they also would have emblematized the disputed association of shame with beholding the nude figure and displaying one's body.

In this classroom sketch Eakins' concern with pedagogy and his attitude toward the "grand construction" of a figure in oil paint intersect. "The first things to attend to in painting the model are the movement and the general color," he said. "The figure must balance, appear solid and of the right weight. The movement once understood, every detail of the action will be an integral part of the main continuous action; and every detail of color auxiliary to the main system of light and shade. The student should learn to block up his figure rapidly, and then give to any part of it the highest finish without injuring its unity."[4] Consistent with his use of the words "movement" and "action" to describe qualities of the figure upon its initial realization in paint, the present sketch shows that Eakins strived to render this figure as a single volume, subordinating anatomical parts to unifying sweeps of light and dark. This aspect appears most clearly at the center of the sketch, where Eakins used a single brushstroke to define the model's lower back. Perhaps this is the approach to figure construction to which Eakins referred when he said, "Get life into the middle line. If you get life into that, the rest will be easy to put on."[5] Not only does one derive from this stroke a sense of the movement of Eakins' brush, but also of the model's body as a series of dynamic movements counterpoised in equilibrium.

The sketch also illustrates his insistence that the "least important . . . thing to catch about a figure is the outline."[6] The left side of the figure has no unified profile, only a series of contiguous strokes with which he modeled the left shoulder blade, waist, and buttock. After establishing the arm at the left side of the figure, Eakins defined its contour as an afterthought, treating the background with a single stroke that carried along wet paint from the arm itself.

Although this sketch may be just an exercise, Eakins could have produced it as a demonstration piece for his students, since it illustrates his philosophy and practice so clearly. Picking up a used panel, he may have produced this sketch as an example to students who looked on while he painted, or examined it after he had finished, although the sources on Eakins as a teacher mention no such practice.[7] However, the hole pierced through the composition board at top suggests that it was hung directly on a wall. The rectangle incised around the figure, added after the sketch had been varnished, represents a more formal attitude to display; probably this is Bregler's work. (DS)

1. Given the standards of modesty in this period, it is no coincidence that most of Eakins' nudes are seen from the back. Gérôme's work offered many such poses, as in *King Candaules* of 1859, echoed in Eakins' *William Rush Carving His Allegorical Figure of the Schuylkill* (fig. 129; plate 11) and its many studies.
2. Goodrich 1982, I: 10.
3. This letter is quoted in Goodrich 1982, I: 169–170. In his article "Memories of Thomas Eakins," *Harper's Bazaar* 81 (7) (Aug. 1947): 147, Adam Emory Albright stated that models continued to wear masks at the Academy until at least the mid 1880s (quoted in Siegl, 60).
4. Recorded in Brownell and quoted in Goodrich 1982, I: 175.
5. Recorded by Bregler, quoted in Goodrich 1982, I: 185.
6. Quoted in Goodrich 1982, I: 175.
7. The figure was painted over an earlier sketch, evidently another interior scene. Eakins inverted the panel and coated the image with dark brown paint before beginning the nude. A layering of images also occurs on the verso (a portrait, under a figure study), where both layers have been severely scraped. The ghost of the portrait resembles Susan Eakins' late work; occasionally she reused her husband's panels. Goodrich recorded several objects with work on the verso "not by Eakins"; Mrs. Eakins, with characteristic modesty, may have identified these studies, asked for anonymity, and scraped her own work off (see fig. 246).

ing a rectangle 8⅜ × 6¾ in. These lines were made after the application of twentieth-century varnish.

Inscriptions (v): (CB in ink on paper label, u.c.) *Study of nude woman / painted by / Thomas Eakins / property of / Charles Bregler;* vestiges of a figure study (?) remain on the verso, although the image has been largely scraped out.

Provenance: CB Estate Inventory 1958, 10, "Study of a Nude Woman / By Thomas Eakins / Paper Panel."

The seated women painted in cats. 239 and 240 may be the same model in the same chair but seen in variant poses. See chap. 8, and cat. 238.

239

239

Figure Study: Nude Woman, Seated, with Arms Raised, c. 1875–85

Oil on heavy cardboard
13³⁄₁₆ × 10¾ in. (33.5 × 27.3 cm)
1985.68.38.3
On the recto: (CB) Incised lines around the figure, form-

240

Figure Study: Nude Woman, Seated, with Arms Lowered (r), c. 1875–85

Four Sketches: Seated Man, Sleeping Dog, Two Vases [?] (v)

Oil on heavy cardboard
13¾ × 10¾ in. (34.9 × 27.3 cm)

1985.68.38.5

Provenance: CB Estate Inventory (1958), 10, "Feminine
Nude Study Attributed to Eakins," may be this study or
cat. 239. This also may have been inventoried on p. 12 as
"Oil Study / "Feminine Nude Seated," By S. M.
Eakins, / Unframed."

On the verso of this composition board appear oil
sketches of spherical objects, a dog, and a seated boy. The
spheres, perhaps Oriental vases or balls of yarn, recall studies
of spheres and wooden eggs produced by Eakins in about
1884, the year he established a still life class at PAFA.[1] The
dog in the sketch may be the setter Harry (1879–94), inher-
ited by Eakins on the death of his sister Margaret in 1882. In
addition to Harry's cameo appearance in three finished works
from around that time, Eakins painted at least four informal
studies of the dog.[2]

Although the recto and verso images could be from dif-
ferent years, perhaps the figure of the nude woman on the
recto also relates to a work by Eakins dating to the early
1880s, *The Artist's Wife and His Setter Dog,* begun in 1884, in
which a slumping seated woman faces left, accompanied by
the sleeping Harry.[3] Although the woman in this sketch does
not resemble Susan Eakins in coloring or build, Eakins may
have been experimenting with the pose of this portrait from a
nude model, or his wife's portrait may have been suggested
by such a sketch. Another element linking the two composi-
tions is the gaze of the model toward the artist. Such ocular
and mental contact with a nude figure is unique in Eakins'
work. It represents the antithesis of the relationship between
artist and model in a public class where the model wears a
mask and poses with her back turned (cat. 239). Eakins was
embroiled in scandal in 1886, in part for using his own stu-
dents as models in his studio, and the direct gaze of this
woman may indicate the informal and confident mood of
these private sessions.[4] (DS)

1. See *Two Cylinders and a Ball* and *Object Study,* both c. 1884 (Joslyn
 Art Museum, Omaha) (Siegl, 174, and Hendricks 1974, 330). These
 two sketches were given by CB to George Barker in about 1944.
 Eakins' 1883 request that a still life class be instituted suggests that
 1884 was the first year of this program. See Goodrich 1982, I: 182.
 On the exercises assigned and the skills acquired, see Siegl, 109.
2. Siegl, 156–157. Other sketches of Harry are on the verso of G 349
 (Siegl, 156–157) and G 183 and 193, Avondale/Dietrich, cats. 3 and 8;
 see also cat. 243. The three finished works that include Harry all
 date from the first half of the 1880s: *Shad Fishing at Gloucester* (fig.
 155), *Swimming* (fig. 181), and *The Artist's Wife and His Setter Dog* of
 c. 1884 (G 213, MMA). *In the Studio* of 1884 (G 208, Hyde Collec-
 tion), an oil study for an unfinished watercolor (G 209, PMA), also
 includes Harry. Other setters belonged to the Macdowell family,
 including another named Harry (d. 1885), according to SME's ret-
 rospective diary, CBTE.
3. See Spassky, 613–619.
4. Foster and Leibold, 69–90, 109.

240 r

240 v

241

Fifty Years Ago (Young Girl Meditating): Study, c. 1877

Oil on canvas

12½ × 7⅝ in. (31.8 × 19.4 cm)

1985.68.38.7

Inscriptions: (CB, in ink on paper label, u.c.) *Title Young
Girl meditating / painted by Thomas Eakins / study for his
water color now in the / Metropolitan Museum N.Y.C. /
Listed in Goodrich book #116 / This painting in oil on can-
vas listed 117 / Rebacked and property of Charles Bregler;*
(in ink on gold gummed label, u.r.) *10*

Provenance: CB's manuscript inventory of SME's estate
1939, PAFA Archives, no. 40, *Girl Looking at Plant,* 7½
× 12½; CB Estate Inventory 1958, 7, "Framed oil paint-
ing / By Thomas Eakins / "Young Girl Meditating." /
Goodrich #117, Study for Water Color / Goodrich
#116."

Exhibitions: Milch Galleries 1933, no. 18, *Girl with Plant.*

References: Burroughs 1924, 329, *Girl Looking at a Plant,*
1877, 8 × 4; Goodrich 1933, no. 117, *Sketch* (for the pre-
ceding watercolor, G 116, *Young Girl Meditating,* 1877),
12¾ × 7½; Foster 1986, 1229.

Plate 5 and fig. 252

This oil sketch was made in preparation for a watercolor,
Young Girl Meditating (fig. 66; plate 6), exhibited by Eakins
with the titles *Fifty Years Ago* and *Reminiscence.*[1] It was once
part of a canvasboard panel with sketches on both sides; Bre-
gler divided the panel in about 1943, remounting and labeling
both halves carefully. The other side (fig. 67) carried a
smaller study that Bregler apparently cropped before mount-
ing.[2] The role of these sketches in Eakins' watercolor method
is discussed above in chap. 9. (KF)

1. G 116. Goodrich's notebooks (PMA) record that this sketch was
 found unframed in the fourth-floor studio. On the title, see chap. 9
 above, n. 38.

2. This sketch, labeled G 117A in Goodrich's notebooks, is inscribed on its verso by CB: "This is one of two oil studies / painted by Thomas Eakins in / 1877 for his water color painting / now in the Metropolitan Museum N.Y. / This one was on the back of / the other study listed 117 / in the Goodrich book life of Eakins / Charles Bregler pupil of Eakins / and life long friend, and Author / of "Eakins as a Teacher" / removed it from the back of / the one listed 117/ and rebacked it on a wood / panel. / Title. Young girl meditating / Eakins always made a oil study / for all of his watercolors." In a letter to Goodrich of 22 Mar. 1943, CB described this sketch as covered in paint, which he removed in the process of his treatment. This sketch remained in Bregler's possession until his death; it was listed in his estate inventory on p. 14. A related study is underneath the surface of cat. 242; see fig. 249.

242

"Thar's a New Game Down in Frisco": Study for the Central Standing Figure [1878]

Oil on canvas

13⅞ × 9⅞ in. (35.2 × 25.1 cm)

1985.68.38.8

Inscriptions (r): (CB, incised, u.r.) *Study by / THOMAS EAKINS*

Inscriptions (v): (CB, in ink on white label, u.c.) *This is a study for the / central figure in the illustration / on page 38 of Scribners Magazine / November 1878 / It is a poem by Bret Hart / The spelling Bee at Angels / The title under the illustration reads, "Thar's a new game / down in Frisco" / Painting by Thomas Eakins / Goodrich book #128;* (in blue ink, u.r.) *47;* (b.l.) *2* [encircled]; scored line from u.r. to b.r., 2⅜ in. from r. edge; scored line from u.r. to u.l., 3 in. from upper edge.

Provenance: CB Estate Inventory 1958, 10.

References: *Scribner's Monthly* 17 (1) (Nov. 1878): 38; Ellwood C. Parry III and Maria Chamberlin-Hellman, "Thomas Eakins as an Illustrator," *The American Art Journal* 5 (May 1973): 25.

This oil sketch was made in preparation for the first of two wood-engraved illustrations accompanying Bret Harte's poem "The Spelling Bee at Angel's" (see accompanying illustration), which appeared in *Scribner's Monthly* in Nov. 1878. The commission from *Scribner's* produced the first illustrations to be published from Eakins' designs and earned the artist $40. The two paintings that he sold to *Scribner's* have not survived, making this sketch the only extant record of Eakins' own hand in this project.[1]

The two engravings made from his designs illustrate the cozy opening scene of the poem and its deadly denouement. According to Parry and Chamberlin-Hellman, the first moment illustrated comes from the opening scene, when Smith of Shooters' Bend describes to his fellow miners a "new game

down in Frisco." As reported by Truthful James, Harte's narrative voice, Smith of Shooters' Bend, "got up, permiskiss-like, and this remark he hove: 'Thar's a new game down in Frisco thet, ez fer ez I kin see, Beats euchre, poker and vantoon, they calls the "Spellin' Bee."'"[2]

However, the gesture of the central standing figure, forcefully drawn in cat. 242, would seem to indicate that this illustration emerges from slightly further along the narrative sequence. The figure's hand is outstretched, with thumb and forefinger dramatically extended as if counting out the letters of a word: The new game is in progress. The pendant illustration shows Truthful James, "The only Gent that lived to tell about that Spellin' Bee." Truthful James' sharp wit and fast action stood him in good stead in the face of such challenging and violence-provoking words as "phthisis" and "gneiss."

The final illustrations submitted to *Scribner's* were probably in ink and gouache, like Eakins' drawing for *Thar's Such a Thing as Calls in this World,* published by *Scribner's* the following year. That illustration was preceded by a full-size (14 × 17 in.) perspective drawing, and no doubt Eakins prepared a similar drawing to organize the complex figure composition of *The Spelling Bee.* Single figure studies in oil were also made for *Thar's Such a Thing as Calls,* analogous to this sketch of "Smith" or the oil studies of the figures in the watercolor *Negro Boy Dancing* (figs. 68–70).[3] As with these projects, the oil sketch of Smith was probably larger than the finished composition, which was again reduced in the wood engraving. Smith is about one-quarter life size in this oil sketch; in the wood engraving, which measures 3⅜ × 4⅞, his figure has been reduced to two inches high. The vertical and horizontal lines scored across the design when the paint was still wet may have been used to coordinate this image with the grid of a perspective drawing, or the surface of the final image. An X-radiograph of the canvas (fig. 252) reveals that this study was painted over a study for *Fifty Years Ago;* see cat. 241. (JCT/KF)

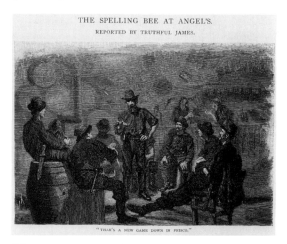

"Thar's a new game down in Frisco," from Bret Harte, "The Spelling Bee at Angel's," wood engraving, 3⅜ × 4⅞ in., *Scribner's Monthly* 17 (1) (Nov. 1878): 38.

1. "As far as I knew, no other study of the work exists," wrote CB to Lloyd Goodrich on 30 Apr. 1942. "It was mounted on wood by me, size 10 × 14. It was signed by me on upper right corner 'Study by Thomas Eakins,' and further data on the back." CB found it "on a scrap of unmounted canvas" in Eakins' studio (19 May 1942; both letters from Goodrich notebooks, PMA). Upon receipt of Bregler's information, Goodrich designated this sketch G 127A, following his entry for the illustration, G 127.

2. Quoted in Parry and Chamberlin-Hellman, 24.

3. The illustration, G 129, is in the Brooklyn Museum; the perspective drawing is in the Hirshhorn, cat. 139; the oil study, G 130, is in the New Britain Museum. See Parry and Chamberlin-Hellman, 30–31.

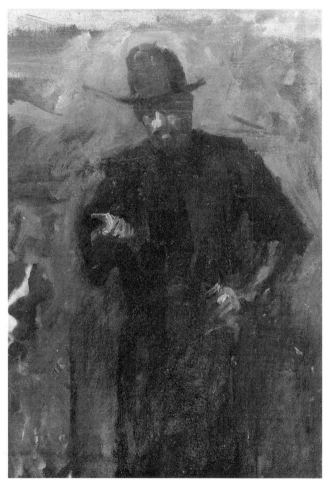

242

243

Spinning: Sketch, c. 1881

Oil on wooden panel

14⅛ × 10⅜ in. (35.9 × 26.4 cm)

1985.68.38.6

Inscriptions (r): (CB, incised, u.l.) *original / sketch / for Spinning / by Thomas Eakins*

Inscriptions (v): (CB, in ink on paper label, u.l.) *Study for Spinning / Painted by / Thomas Eakins / property of / Charles Bregler / Listed in Goodrich book 145;* (circled, u.r.) *17;* (u.l.) *Screw;* (b.r.) *Sc*[torn]

Provenance: CB's draft of SME's estate inventory 1939 lists this work as [G] *145 sketch*, among other items given to him by Mrs. Eakins; CB Estate Inventory 1958, 5, "Study for Spinning."

Exhibitions: Knoedler 1944, no. 22, *Spinning (Sketch)*, 14½ × 10¼.

References: Goodrich 1933, no. 145, *Sketch* [for preceding watercolor, no. 144, *Spinning*, 1881]; Foster 1986, 1232.

Plate 3 and figs. 253 and 256

In 1881 Eakins painted two watercolors of his sister Margaret spinning. Like Nannie Williams in *The Courtship* (cat. 190), Margaret wears a neoclassical white dress with a high waist in both of these pictures, *Spinning* (fig. 60) and *Homespun*. However, she sits on a stool rather than in a chair, and she uses a different wheel within an environment that has been more carefully defined. Although still far short of the detailed settings provided by other contemporary painters of early American scenes, the wooden furniture nonetheless establishes a kitchen-like context.

The watercolor *Spinning* shows Margaret facing her brother, although she looks attentively at her work and not at the viewer. The oil sketch in the Bregler collection was made from a related angle. This sketch may be the earliest surviving work related to the watercolors. It was probably abandoned in favor of the view chosen for *Spinning* because Eakins could not find a suitable location for the unspun flax, here shown as separated from the wheel by Margaret's figure. He also had trouble finding legible positions for the legs of the figure. The oil is also distinguished from the finished watercolor by the inclusion in the lower right of the head of Harry, Margaret's dog. This study is discussed in relation to Eakins' oil sketching technique in chap. 8.

On the verso, inverted, is a three-quarter-length study of a standing man. Dressed in a black three-piece suit and sporting a wing collar and a mustache, he is posed with one hand tucked in the waistband of his trousers and the other placed behind his back. The image has been deliberately scraped so that the figure barely emerges from the darkness of the ground. This sketch may be by Eakins or Susan Macdowell Eakins; the remaining vestiges are insufficient to identify the subject firmly, although Jeanette Toohey has suggested that it is a portrait study of Eakins by his wife. (KJ)

244

The Fairman Rogers Four-in-Hand: Study of a Horse's Leg, c. 1879

Oil on wood panel

10⁵⁄₁₆ × 3⁷⁄₁₆ in. (26.2 × 8.7 cm)

1985.68.38.21

Inscriptions (r): (CB, incised into paint, b.l.) *Painted by / Thomas Eakins / owned by / Charles Bregler*

Provenance: CB Estate Inventory 1958, 11, *Horses Hind Leg.*

References: Goodrich 1933, no. 201: "*Study* [for *An Arcadian*]. Sketch of the seated figure, in sunlight. On the same side of the panel, and on the back, sketches of parts of a horse, for the *Fairman Rogers Four-in-Hand* (no. 133). Wood, 10¼ × 14½. Unsigned. Owned by Mrs. Eakins."

Fig. 143

Goodrich's notes and record sketches from 1931–32 indicate that this sketch of a horse's leg was once the left-hand margin of a larger panel, 10¼ × 14½ in. in size. The other portion contained a sketch of a woman seated on the ground (fig. 192), as seen in the painting *An Arcadian* (fig. 191). Some time before 1944, when the sketch of the woman appeared "alone" in the Knoedler exhibition, Bregler divided the panel, splitting the front from the back and cutting the verso image into two parts; all three pieces were then mounted on Masonite. The Arcadian woman and the horse sketches eventually came to the Hirshhorn, and the horse's leg "disappeared" into Bregler's collection.[1]

The leg study relates to the sketches once on the verso of the panel showing Josephine, the near-lead horse in *The Fairman Rogers Four-in-Hand* (fig. 140; plate 12), and to similar studies of Rogers' team.[2] The position of the leg most resembles the right rear leg of the near-wheeler, Williams, although the pattern of light and shade is not as seen in the finished painting, indicating that it must have been done as a separate study, probably outdoors, as the painting was taking shape. The Rogers project is discussed in chap. 15, *An Arcadian* in chap. 17; also see cats. 192–196, 203, and 206. (KF)

1. Rosenzweig, 82, 106. CB's label on the verso of the Arcadian woman, Hirshhorn no. 48, notes that "painting of horse[s] that were on back / were transferred to another panel / by Charles Bregler." In a letter to Goodrich dated 22 Mar. 1943, Bregler wrote, "You no doubt recall the studies of the horses for the coaching picture. and that there were paintings on both sides of the wood panels. Those I have were sawed in half. This was [a] tedious difficult job. but it was successfully accomplished. and all the studie[s] were then perman[en]tly fasten[ed] to white pine weldwood panels" (Goodrich, PMA).

2. G 137, 165, 181, 182, and 199; see Siegl, 73–81; Sewell, 68–69; Rosenzweig, 80–83.

245

The Fairman Rogers Four-in-Hand: Landscape Study of Fairmount Park, c. 1879

Oil on wood panel

5 × 6½ in. (12.7 × 16.5 cm)

1985.68.38.11

Inscriptions (v): (CB, in ink on paper label, c.) *Study of landscape for the / Fairman Rogers coaching picture / painted by Thomas Eakins / this study was taken from / the panel #135 listed in / Goodrich book and rebacked / by Charles Bregler;* (b.l.) *35* [encircled]

Provenance: CB Estate Inventory 1958, 10, "Study of Landscape for Rogers / Coaching Pictures By Thomas Eakins, / listed #125 [*sic*] in Goodrich's."

Exhibitions: PMA 1944, no. 39: "The Fairman Rogers Four-in-Hand, 1879, G. nos. 134–137 incl."; Knoedler 1944, no. 18: "Study for the Landscape, Fairman Rogers Four-in-Hand, G 135."

References: Burroughs 1924, 329: "*Fairmount Park, (Sketch for the Fairman Rogers Four-in-Hand),* panel, about 9 × 13—Mrs. Eakins," could refer to this sketch or to G 136; Goodrich 1933, no. 135: "*Sketch for the Landscape [Fairman Rogers Four-in-Hand].*"

Plate 13 and fig. 144

The landscape on this panel appears in *The Fairman Rogers Four-in-Hand* of 1879–80 (fig. 140; plate 12), discussed above in relation to Eakins' method and the many studies found in the Bregler collection (see chap. 15 and cats. 192–196, 244). This small landscape study was used almost exactly, enlarged about twenty-five times, to become the background of the final painting. In transferring his observations to the larger canvas, Eakins cropped the foreground, diminished the shadow on the drive, and softened the brightness of the road seen through the trees in the distance. He also pulled the trees at the right into a closer group and drew a flanking tree at the left (studied in more detail in another small oil in the PMA), closer to the parapet, to act as a framing device.[1] Bregler evidently incised mat lines around the composition and cropped the panel to the edge of Eakins' image.

This image was once on the recto of a panel that was split into five or six pieces by Charles Bregler some time after 1944, when the whole panel was exhibited at Knoedler's gallery in New York. When Goodrich catalogued this panel in 1933, he gave its dimensions as 10⅜ × 14½ in.—typical of Eakins' wooden sketching panels. According to his notes and a quick record sketch, the Fairmount Park view was alone on the recto, and the verso held three different subjects: a long Delaware River scene stretching from side to side along the top of the panel (cut by Bregler into two parts and now reunited as cat. 247); a study of a woman's head turned side-

ways on the panel in the lower left corner (cat. 246); and, turned in the opposite direction, the head and shoulders of the fisherman seen third from the left in *Mending the Net* (fig. 164; plate 17).[2] A sixth fragment (cat. 248), showing the river and a pier, was labeled by Bregler as derived from this panel, although the present sketches leave no unaccounted space on the verso, and Goodrich recorded no such view on the recto. With or without the problematic last fragment, the reassembled panel (see fig. 247) expresses Eakins' economical use of materials, with sketches from three different oils, made across a three-year period, all sharing space on one of the panels kept in his portable sketching box. (KF)

1. Siegl, cat. 34.
2. This sketch was retained by Mrs. Bregler and now remains with her heirs.

246

Shad Fishing at Gloucester on the Delaware River: Study of a Woman's Head, c. 1881

Oil on wood panel

8⅞ × 6 in. (irr) (22.5 × 15.2 cm)

1985.68.38.10

Inscriptions (r): (CB, incised into paint, b.l.) *Sketches by / Thomas Eakins;* (on printed label [Knoedler's 1944], b.l. [now removed]) *18*

Inscriptions (v): (CB, in brown ink on paper-tape label) *Study painted by / Thomas Eakins / from panel 135 / Rebacked by / Charles Bregler;* (in black ink on same label, b.l.) *Sister of Eakins in picture #152;* (u.r.) *49* [encircled]

Provenance: CB Estate Inventory 1958, 11: "Study of Sister / Shad Fishing on the Delaware / C.F. #152 Goodrich. Signed. Framed."

Exhibitions: PMA 1944, no. 39: "The Fairman Rogers Four-in-Hand, 1879, G. nos. 134–137 incl."; Knoedler 1944, no. 18: "Study for the Landscape, Fairman Rogers Four-in-Hand, G 135."

References: Burroughs 1924, 329: "*Fairmount Park (Sketch for the Fairman Rogers Four-in-Hand),* panel, about 9 × 13—Mrs. Eakins" could refer to this sketch or to G 136; Goodrich 1933, no. 135: "On the back is a sketch of a river bank, and a sketch of a man, and one of a woman, both outdoors"; Foster 1990, 77–81.

This study is a preliminary sketch for the second figure from the left in the foreground group of *Shad Fishing at Gloucester on the Delaware River,* c. 1881 (fig. 155). In 1932, Lloyd Goodrich learned from Susan Eakins that "the figures were Benjamin and a daughter, but [she] did not say which daughter or identify the two other women. It seems probable that the two young women at the left were Margaret and

Caroline, who were living at home in 1881. Caroline later became estranged from TE, which could have caused SME not to mention her."[1] Bregler, perhaps taking his information from Mrs. Eakins as well, identified this figure in the sketch only as "Sister of Eakins."

The identities of these women become slightly clearer in the two photographs of the group also found in Bregler's collection (figs. 158, 159). The figure at the far right, in the dark dress, seems to be Margaret; Caroline may hold the parasol, at the left, while the young woman in the center may be Frances Eakins, Susan Macdowell, or another family friend. This central woman was studied again in this oil sketch; no similar sketches of the other figures in the group have survived. In the actual oil, this figure was reduced to one-eighth its size in this sketch, which may explain the breadth of treatment in this study. For a discussion of Eakins' use of photographs and oil sketches in this project, see chap. 16.

The head study is one of five or six fragments apparently cut by Bregler from a single wooden panel catalogued by Goodrich in 1933 as G 135 (reassembled in fig. 247). The original outer edges of the panel are at the top and left margins of this sketch. Five of these pieces remain in the Bregler collection: see the description of the entire panel in cat. 245, and also cats. 247 and 248. (AW/KF)

1. Goodrich 1982, I: 329.

246

247

Delaware Riverscape, from Gloucester, c. 1881

Oil on wood panel (two pieces joined together)

4½ × 14½ in. (11.4 × 36.8 cm)

1966.14, Gift of Mrs. Charles Bregler (left side)

1985.68.38.12 (right side)

Inscriptions (left side, r): (CB, incised into paint, b.l.) *T. EAKINS*

Inscriptions (left side, v): (CB, in ink on paper label, c.) *Study of Delaware River / Painted by / Thomas Eakins / from panel #135 listed / in Goodrich book / Property of C. Bregler*

Inscriptions (right side, r): (CB, incised, b.l.) *Thomas Eakins* [no longer visible after conservation]

Inscriptions (right side, v): (CB, in ink on brown paper-tape label, u.c.) *Study painted by / Thomas Eakins / from panel listed in / Goodrich book #135 / rebacked by / Charles Bregler*

Provenance: (left side) CB Estate Inventory 1958, 12: "Study of Delaware River / by Thomas Eakins, From Panel. / (#135 Listed in Goodrich Book), / Signed Unframed."

Provenance: (right side) CB Estate Inventory 1958, 12: "Study Painted by Thomas Eakins / From a Panel, listed in Goodrich Book, #135 / Rebacked By Charles Bregler, Signed."

Exhibitions: PMA 1944, no. 39: "The Fairman Rogers Four-in-Hand, 1879, G. nos. 134–137 incl."; Knoedler 1944, no. 18, "Study for the Landscape, Fairman Rogers Four-in-Hand," G 135 (left side only) PAFA, *In This Academy* (1976): no. 230: *Delaware River Study.*

References: Burroughs 1924, 329: "*Fairmount Park (Sketch for the Fairman Rogers Four-in-Hand)*, panel, about 9 × 13—Mrs. Eakins" could refer to this sketch or to G 136; Goodrich 1933, no. 135: "On the back is a sketch of river bank, and a sketch of a man, and one of a woman, both outdoors"; (left side only) Hendricks 1974, no. 222; (both sections, rejoined) Foster 1990, 85–87.

Plate 14

The tiny but panoramic *Delaware Riverscape, from Gloucester* was once part of a larger panel containing at least three other sketches; a description of this panel and its subsequent division appears in the discussion of cat. 245. In the course of creating five or six small pictures out of this panel, Charles Bregler divided the river view into two separate sketches. Both were still in Bregler's collection when he died. In 1966 his widow gave one half (the left side, then known as *Delaware River Study*) to PAFA. Fortunately, the acquisition of the rest of Bregler's collection twenty years later reunited the two halves of the view, now reconsolidated into a single image by the Academy's conservator, Mark Bockrath (see figs. 247, 257).[1]

The rejoining of the pieces allows us to identify the view of the Pennsylvania shore of the Delaware River seen from the New Jersey side, just south of the Gloucester ferry slip, which appears at the far right. From this vantage, looking almost due north, the steeples and industrial buildings of Philadelphia appear along the skyline. On perhaps the same day, Eakins took photographs of a similar view (see figs. 161, 162). The post in the foreground appears in none of these photographs of shad fishermen, although it may be a piece of a dismantled windlass used to haul loaded nets on to the beach. In this scene the description of its function is less important than its use as a visual marker on the beach, around which the entire composition revolves. Likewise, the rusty brown brushwork in the foreground may represent fishing nets strung along the beach, providing color cues for the painter's later reference rather than descriptive detail for an imagined audience. Eakins incorporated much of this information into the background and tonality of *Shad Fishing at Gloucester on the Delaware* of 1881 (fig. 155), although the viewpoint of that painting is higher. On his use of such sketches and photographs in the preparation of the Gloucester landscapes, see chap. 16. (KF)

1. See Bockrath, in *JAIC*, 56, and appendix below.

248

Shad Fishing at Gloucester on the Delaware: Delaware River and Gloucester Pier, c. 1881

Oil on wood panel

5½ × 4⅛ in. (14 × 10.5 cm)

1985.68.38.13

Inscriptions (v): (CB, in ink on paper label, on Masonite backing, u.c.) *Study of Delaware river / painted by / Thomas Eakins / This is from panel listed in / Goodrich book #135. / and was rebacked by / Charles Bregler*

Provenance: CB Estate Inventory 1958, 12: "Study of Delaware River / By Thomas Eakins, C. F. Goodrich #135, Gilt Frame."

References: Goodrich 1933, no. 135, perhaps (see cat. 245); Foster 1990, 85–86.

Fig. 163

Like many of the small oil studies in Bregler's collection, this image has been cut down from a larger board. The upper and right margins are the original edges of the panel; the lower and left hand sides were cut, probably by Charles Bregler in the 1940s. Bregler's label indicates that this fragment was once part of panel G 135, now sundered into five or—if this piece is included—six small panels. (The story of this panel is retailed in cat. 245; other fragments in this collection include cats. 246–247.) However, if Goodrich's account of this panel prior to its division is correct, this scene was not part of the original assembly. Perhaps it was on the recto of the image, alongside the Fairmount Park landscape (cat. 245) and Goodrich failed to note it, or it may have come from the verso of another panel, also unrecorded.

Whether Bregler misidentified this piece or Goodrich

overlooked it, the authenticity of the work cannot be questioned in terms of materials, style, or content.[1] The scene shows the same ferry slip sketched in cat. 247, from a very similar viewpoint on the beach at Gloucester, New Jersey. Eakins' photographs on the scene, taken in the spring of 1881 (figs. 161, 162) record the two trees at the end of the ferry quay, the steeple and white sheds (?) on the far shore, and the timbers on the beach at the far right, which served as a retaining wall for the base of a horse-powered windlass. Eakins transposed this sketch at the identical scale to the right-hand distance of his painting, *Shad Fishing at Gloucester on the Delaware* of 1881 (fig. 160). On the allied use of sketches and photographs in this work, see chap. 16.

Unusual in this sketch is the addition of graphite lines to the wet paint surface, to indicate the masts of the ship tied up at the pier beyond. At such a small scale, Eakins had to pick up a pencil to get a sufficiently crisp line for these details. Incised into the surface of the panel beneath the paint layers, one-quarter inch from the bottom edge, a ruled line may indicate the establishment of a perspective base line, although this line slopes slightly. Another incised line a half-inch from the bottom was made after the paint layers had dried; most likely it was drawn by Bregler to indicate the edge of a mat or frame. (KF)

1. Like the fragments of G 135, this sketch is on a poplar panel similar to those used for furniture. Beveled slightly, so that the upper edge is half as thick as the lower, this panel was probably not commercially prepared for painting. Unfortunately, Bregler's division of the panel obscures all of its original dimensions. I am grateful to Mark Bockrath for his analysis of these materials; see also his appendix in this volume on the conservation of these sketches.

249

Shoreline of the Delaware River, with Fishing Nets (r)

Mending the Net: Study of a Fisherman (v), c. 1881–82

Oil on tan cardboard

4 × 5¾ in. (10.2 × 14.6 cm)

1985.68.38.14

Inscriptions (r): (CB, incised into paint, b.r.) *originl study / by Thomas Eakins*

Inscriptions (v): (in yellow paint, b.l.) *33;* (in graphite, b.r.) *33;* (CB, in ink on white paper label) *Painted by / Thomas Eakins / Recorded in L. Goodrich book 156 / The man on back is one of the / fisherman in picture "Mending the Net."* [label removed in conservation]

Provenance: CB Estate Inventory 1958, 12: "Oil Sketch "Seashore" / Painted on Back with Oil study / "Fisherman Mending the Nets," Goodrich #156."

Exhibitions: Knoedler 1944, no. 24

References: Goodrich 1933, no. 156: "*A Fisherman*. Sketch of the head and shoulders of the fifth fisherman from the left [in *Mending the Net*, G 155]. On the back, a sketch of a beach and water, with a sailboat"; Foster 1990, 81–82.

Fig. 171 (verso); plate 15 (recto)

The odd size and cardboard makeup of this panel place it among a number of similar sketches cut by Eakins to fit into a small carrying case that he made himself. This box had grooves on the interior to keep two or three freshly painted panels secure but separate; the lid, engraved with Eakins' name in block letters, also slid out of the box to serve as a palette.[1] The six extant sketches that fit into this box all contain images relating to the Gloucester shad-fishing paintings of 1881–82 or *Swimming*, begun in 1884. Sometimes combined or overlaid on the same panel, these little outdoor sketches manifest Eakins' interest in plein air painting during these years just as they bracket the relatively limited duration of his enthusiasm for such small studies.[2]

The portability of this box may have added to its appeal on outings when he was already lugging along camera equipment, for all the oil sketches fitted to this box were made in tandem with camera studies at the same site, probably on the same day. The beach scene corresponds to two photographs discovered in Bregler's collection (fig. 172), evidently taken from the same spot.[3] These photos provide a link that ties this oil sketch to Eakins' watercolor *Mending the Net* of 1882 (fig. 173). The verso sketch of a fisherman (the fifth man from the left in *Mending the Net*, fig. 164) repeats the pose of the same man in a photograph (fig. 169) that includes another figure who also appears in the painting. As with all of Eakins' oil-sketch/photograph pairs, the images in each medium pursued different goals. The fisherman was evidently painted from life, not from the photograph, for the pattern of sunlight and shadow is slightly different. Knowing that the detail of the man's costume and pose would be held by the photograph, Eakins focused his own attention on the qualities of color and value created by outdoor light. The interplay of media in the finished Gloucester paintings is discussed in chap. 16. (KF)

1. Eakins "had a small sketch box that held this size of sketch," wrote Bregler to Carroll Meeks at Yale University on 26 June 1940, probably referring to a small boxing sketch (G 313) in his collection; "this box made by him is also in my collection" (PAFA Archives, CBTE). The box, which is now in the Amon Carter Museum, is engraved EAKINS / PENNA.ACAD.FINE ARTS on the lid. It was given to the Fort Worth Art Museum in about 1945–50 through Bill Davidson of Knoedler & Company, which was probably acting as the agent of Charles Bregler. The box was directed to Fort Worth because it contained a panel (G 194) with sketches for *Swimming*, purchased by the Fort Worth Art Association twenty years earlier. A second panel found in the box had been primed with gray-green ground but not otherwise painted. I am grateful to James Fisher, at the FWAM, for his description of the box, its history, and its contents. See Bolger and Cash, plates 14–16. Four

other sketches of the same size (4 × 5¾ in.) and cardboard can be gathered from Goodrich's listing; all came through Bregler's collection in the 1940s: G 195, bearing a sketch for the landscape in *Swimming*, with a study on the verso of the hand of a fisherman in *Mending the Net* (Dietrich Collection; see Avondale/Dietrich, cat. 9, given, perhaps erroneously, as 10⅝ × 14½); G 175, *Shore Scene* (Dietrich Collection; see Avondale/Dietrich, cat. 5), perhaps from Gloucester and numbered "34" (by CB? compare. "33" on cat. 249); G 180, *Girl Beneath Tree* (Joslyn Art Museum), with two tiny beach scenes on the verso, similar to the composition of cat. 249, G 175, and *Shad Fishing* (fig. 155; PMA); and G 313, *Sketch [for "Between Rounds"]*, c. 1899, unlocated, with a "landscape" on the verso.

2. Gray, red-brown, and tan strokes, the vestiges of another, darker sketch beneath the recto image, can be seen at the upper right corner of the panel.

3. A variant, blurrier dry-plate image is 1985.68.2.927.

250

Delaware River Scene, 1881–82

Oil on canvas

1985.68.38.15

6½ × 9¼ in. (16.5 × 23.5 cm)

Inscriptions (r): (CB, incised into paint, b.l.) *Thomas Eakins / 31*

Inscriptions (v): (CB, in ink on paper label, u.r.) *Delaware River / Painted by / Thomas Eakins / Listed in Goodrich book 167 / rebacked by and property / of Charles Bregler;* (in blue ink, b.r.) *14;* (in type, b.l.) *Charles Bregler / 4935 N. 11th Street / Philadelphia, 41, Pa. / 2-15-49*

Provenance: CB Estate Inventory 1958, 13: "Delaware River," By Thomas Eakins, / listed in Goodrich Book #167."

Exhibitions: Knoedler 1944, no. 26: "*Landscape (sketch)*, 6½ × 9¼, G 167."

References: Goodrich 1933, no. 167: "River scene; beach in foreground, river with long boat at left, shore beyond, with house and factories at right. Strong sunlight reflected in water at left. Canvas mounted on cardboard, 6½ × 9¼"; Foster 1990, 86–87.

Plate 16

This view of the Delaware River, probably from the beach at Gloucester, New Jersey, must have been painted in about 1881–82, when Eakins' other paintings of the shad fisheries were made. The long prow of a shad fishing boat, seen frequently in Eakins' newly discovered photographs made near this spot, protrudes into the picture at the left.[1] Like many of Eakins' landscape sketches, it was painted over another, unidentified study that asserts brush patterns at odds with the surface pattern of the visible sketch and occasionally glints of inappropriate colors. Unusual, however, is

the retention of the white ground on the canvas, which contributes to the overall high value of this sketch, compared with the landscape studies of the 1870s. For a discussion of this sketch in the context of Eakins' Gloucester landscapes, see chap. 16.

Like many other sketches in the collection, this image was cut down from a larger support, probably by Charles Bregler. Although it had assumed its present dimensions by 1933, when Goodrich recorded this sketch in his catalogue, the picture was on a 10½ × 13½ in. canvasboard panel when first examined in about 1930. Goodrich's small record sketch shows that the image was close to the upper-left-hand corner of the canvas rectangle, with four inches of bare margin or illegible color notes below and to the right.[2] Bregler may have been responsible for trimming these margins, perhaps at Mrs. Eakins' suggestion. He also added the "signature" at the lower left and the number "31," perhaps as an inventory number or as a reference to the year his work was done (compare cat. 249). (KF)

1. See dry-plate negatives, PAFA 1985.68.2.886–.909.
2. Goodrich, PMA.

251

Arcadia: Sketch, c. 1883

Oil on wood panel

5¾ × 7¾ in. (14.6 × 19.7 cm)

1985.68.38.9

Inscriptions (v): (CB, incised in paint, b.r.) *T.E.;* (SME in ink on brown tape, u.c.) *Loaned to Penna. Museum of Art. / Sketch "Arcadian Scene" / Eakins;* (in graphite) *Board 5⅝ in 7⅞ inch;* (in brown ink) *9;* (in ink on torn gold label) *19;* (CB, in ink on white paper label, c.) *"Arcadia" / painted by / Thomas Eakins / Listed in Goodrich book #197. / Property of Charles Bregler;* (in brown ink on cloth label, for PMA exhibition 1930) *25–1930–1*

Provenance: CB's draft of SME Estate Inventory 1939, no. 43, *Arcadian Scene;* CB Estate Inventory 1958, 8, *Sketch, "Arcadia."*

Exhibitions: PMA 1930, per label on verso, although not starred (to indicate inclusion in the exhibition) in Marceau checklist 1930, no. 194; Art Club 1936, possibly no. 15, *Sketch for Arcadian Picture;* Knoedler 1944, no. 33: *Arcadia (Sketch).*

References: Marceau 1930, no. 194, *Arcadian Scene*, 5⅝ × 7¾; Goodrich 1933, no. 197; Spassky, 610; Foster 1986, 1234.

Plate 19

This small study is one of a series of paintings, photographs, and sculptures on Arcadian themes made by

Eakins in about 1883; see cats. 203 and 262, figs. 184–194, and plate 18, and the discussion in chap. 17. The panel was cut down on all four sides prior to Marceau's checklist in 1930, and since it has no exhibition record prior to its appearance in the PMA's exhibition that year, we can speculate that Mrs. Eakins asked Bregler to trim the panel at about this time so that it would fit the elaborate nineteenth-century frame it now inhabits. The back of the panel has also been primed in tan and very broadly painted in greens and browns, but the cropping of the panel to a quarter, perhaps, of its original size (if Eakins' typical 10½ × 14½ board was used) has made identification of the verso subject impossible. (KF)

252

Girl with a Fan; Portrait of Miss Gutierrez, c. 1902–08

Oil on canvas, mounted on panel

20 × 16 in. (50.8 × 40.6 cm)

1985.68.38.1

Inscriptions: (CB, on paper label in ink, u.l.) *Rebacked on a wood panel / by a special process / making the painting safe / for all time / by Charles Bregler;* (on gold gummed label in black ink, u.c.) *4;* (on label in ink, u.l.) *Woman with a fan / Miss Gutierrez / Painted by Thomas Eakins 1902 / Goodrich book 370, owned by / Charles Bregler, Phila, Pa. / Charles Bregler Goodrich / Phila. Pa book # 370.;* (on label attached to side of stretcher, u.l.) *No. 3722 / PICTURE;* (on paper label in ink, u.l. attached to side of stretcher): *Title / Woman with a fan.*

Provenance: SME Estate Inventory 1939, no. 68, *Woman with Fan;* CB's notes elsewhere record it as *Girl with Fan*, G 370, a gift to him from SME; CB Estate Inventory 1958, 7, *Girl with Fan.*

Exhibitions: Knoedler 1944, no. 63, *Girl with a Fan (Miss Gutierrez),* "signed on the back: T.E."

References: Burroughs 1924, 332, as "1903? — *Portrait of a Girl* — 20 × 16 — Mrs. Eakins"; Marceau 1930, no. 209, as *Young Girl with a Fan*, 20 × 16, "not signed or dated," owned by Mrs. Thomas Eakins; Goodrich 1933, no. 370, with the present title, "signed on the back: T.E."

Fig. 220

Nothing is known of Miss Gutierrez; perhaps she was related to Joseph Gutierrez, a cigarmaker listed in Gopsill's *Philadelphia City Directory* in 1901, or Ramon Gutierrez, listed in 1903. Her Spanish name makes us look again at her fan and bright earring, although little ethnic glamour resides in this image.[1] But Eakins was drawn to Mediterranean culture of all kinds: he spoke Latin, French, Spanish, and Italian, revered Spanish painting (both old and new), remembered his own student sojourn in Spain with warmth, and enjoyed visiting immigrant friends such as Signor and Sig-

nora Gomez D'Arza in South Philadelphia. He painted Signora D'Arza, an Italian actress, in 1902, about the same time as Miss Gutierrez; both are shown in a three-quarters right pose, strongly lit from the left, with one glittering earring and one expressive hand—the right—caught by the light.[2] *Signora D'Arza* is the larger, more finished and compelling portrait, her alert, almost fierce features looming out of the shadow and conveying strength and self-command. *Miss Gutierrez* is less incisive, dreamier; the modeling strokes on her face remain unfused; her right shoulder and chest are summarily sketched. The sense of incompleteness—especially around the eyes—gives her face a flat, unfocused expression that fails to meet the expectations created by the unusually small canvas, with its close-up, tightly framed image and the exceptionally fine resolution of her right hand and fan.[3] Her graceful grip on the fan, its complex half-opened twist, and the light falling across her fingers and through the fabric of the fan are captured masterfully, while Miss Gutierrez herself retreats behind its folds.

Eakins' characteristic attention to telling gestures and accessories lends importance to his focus on the hand and fan, even if it highlights the incompleteness of the rest of the painting. Like an ethnographer, he enjoyed documenting modern clothing—especially women's fancy dress—and spared no pains to get the details right.[4] Fans occupied him on several occasions, beginning with his portrait of his fiancée-to-be Kathrin Crowell in 1872, and again in several portraits around 1890 of Amelia Van Buren, Letitia Wilson Jordan Bacon, and Mrs. Talcott Williams. After 1900 he included fans in images of Beatrice Fenton and Mrs. Joseph W. Drexel, who was an important collector of fans. In all these portraits save the first the fan is held low, usually furled in the lap or in front of the body, as a decorative, feminine attribute, occasionally suggesting the woman's psychological closure or inaccessibility. Miss Gutierrez is the only woman who holds the fan to her face and actually covers herself. The gesture seems half-conscious and pensive rather than flirtatious or deliberately modest. Perhaps the relationship of woman and fan tells us something about Miss Gutierrez's tentativeness—as a person or as a sitter—or Eakins' perception of her as a retiring soul.

Eakins apparently intended to work further on the painting, or perhaps he at least enjoyed considering it daily, for a photograph of his studio from about 1912–13 shows this canvas resting at eye level against the east wall (fig. 222). The prominence of this portrait in his studio ten years after the date Goodrich assigned to it seems remarkable. Either the portrait was completed about the time the photograph was taken, putting it among the last of Eakins' portraits, or Eakins was still, after a decade, tantalized by the irresolution of the painting and hoping for the return of the evasive Miss Gutierrez. (KF)

1. Fans appear occasionally in Eakins' portraits of women, apparently with no ethnic connotation, but earrings are rare. The sitter's name and the estimated date of the portrait were established by Goodrich

in SME's lifetime, so she must have supplied (or concurred with) these facts. The vagueness of the identification indicates that the sitter was not a close friend. However, since Gutierrez is also an old Southern name, this young woman may have come from the circle of SME's family in Roanoke, Virginia. Eakins never had a student by this name, nor was there a Gutierrez enrolled at PAFA about this time, although (given SME's inconsistent spellings) it may be worth remarking the presence of Miss Godfriede Gutherz, of Washington, D.C., in the Academy's day life drawing classes in 1912–13. Carl Gutherz (1844–1907), an exact contemporary of Eakins who studied in Paris and Rome, painted murals in the House of Representatives in Washington.

2. G 360, MMA: See Goodrich 1982, II: 10–11, 55, 210. Eakins' reverence for Spanish art has often been discussed; see chap. 6 above. His continuing interest in Spain after 1890 may be illustrated by the many pages of albumen photographs, mostly of Seville, in the Bregler collection album. According to CB's annotations, these photos were taken (in the 1890s?) by Edmund Quinn, Eakins' student at the Art Students' League.

3. On the incidence of this small canvas in Eakins' work after 1902, see chap. 19, n. 2.

4. See Goodrich 1982, II: 69–70.

Sculpture

All the sculpture in the Pennsylvania Academy's collection has been catalogued as part of a project begun before the Bregler collection was acquired. This catalogue (see PAFA, *American Sculpture*) integrates the ten sculptures by Eakins found in Bregler's holdings into the larger related group of plaster casts and bronzes in the Academy's permanent collection. To avoid duplication with this concurrent volume, the catalogue listings here are brief; fuller consideration of these pieces, with related bibliographic references and analysis based on conservation records, can be found in the sculpture catalogue, which also includes the sculpture in the Bregler collection by Charles Bregler, Samuel Murray, William R. O'Donovan, Edmund Austin Stewardson, and Leonard Wells Volk.

Eakins' sources in French academic practice, and the role of sculpture within his method, are considered above in chaps. 5 and 10.

253

Allegory of the Waterworks: Study After William Rush, 1876–77

Plaster

4⅝ × 8⅜ × 2¾ in. (11.8 × 21.3 × 7 cm)

1985.68.1.1.1

Inscriptions: (CB, incised in backdrop, recto) *EAKIN* [sic]

Provenance: Gift of SME to CB, c. 1932, cf. CB to Murray, n.d. (c. July 1939); CB Estate Inventory (1958), 5.

References: Goodrich 1933, no. 498; Siegl, 67–69.

Cast in 1931 from wax original, now in the PMA. See cats. 180–181, and chap. 14.

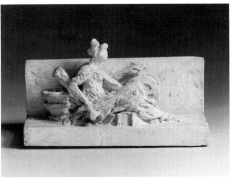

253

254

Head of William Rush: Study After Rush's "Self Portrait," 1876–77

Plaster

7⅛ × 4¼ × 5 in. (18.1 × 10.8 × 12.7 cm)

1985.68.1.1.2

Inscriptions: (CB, incised underneath base) *1;* (CB, incised in base, recto) *EAKINS*

Provenance: Gift of SME to CB, c. 1932, cf. CB to Murray (c. July 1939); CB Estate Inventory 1958, 5.

References: Goodrich 1933, no. 498; Siegl, 67–69.

Cast in 1931 from wax original in the PMA. See chap. 14.

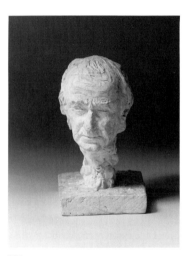

254

255

Water Nymph and Bittern: Study After William Rush's "Allegory of the Schuylkill River," 1876–77

Plaster

9½ × 4¼ × 2⅝ in. (24.1 × 10.8 × 6.7 cm)

1985.68.1.1.3

Provenance: Gift of SME to CB, c. 1932, cf. CB to Murray (c. July 1939); CB Estate Inventory 1958, 9.

References: Goodrich 1933, no. 498. Siegl, 67–69. William H. Gerdts, "Additions to the Museum's Collections . . . ," *The Newark Museum,* n.s. 13 (1961): 22, 40.

Fig. 139

Cast in 1931 from wax original in the PMA. See chap. 14 and cats. 182–188.

256

Head of the Water Nymph: Study After William Rush, 1876–77

Plaster

7⅜ × 4½ × 3½ in. (18.7 × 11.4 × 8.9 cm)

1985.68.1.1.4

Inscriptions: (CB, incised underneath base) *IV;* (CB, incised underneath base) *EAKINS*

Provenance: Gift of SME to CB, c. 1932, cf. CB to Murray (c. July 1939); CB Estate Inventory 1958, 5.

References: Goodrich 1933, no. 498; Siegl, 67–69.

Cast in 1931 from wax original now in PMA. See chap. 14 and cats. 182–188.

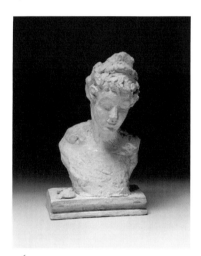

256

257

George Washington: Study After William Rush, 1876–77

Plaster

1985.68.1.1.5

8⅛ × 4⅛ × 2⅝ in. (20.6 × 10.5 × 6.7 cm)

Inscriptions: (CB, incised underneath base) *IV*

Provenance: Gift of SME to CB, c. 1932, cf. CB to Murray (c. July 1939); CB Estate Inventory 1958, 5.

References: Goodrich 1933, no. 498; Siegl, 67–69.

Fig. 79

Cast in 1931 from wax original now in PMA. See chap. 14.

258

Anatomical Cast of Front of Neck and Part of Shoulder, c. 1877

Plaster, painted dark red

8¾ × 15⅝ × 5 in. (22.2 × 39.7 × 12.7 cm)

1985.68.1.2

Inscriptions (v): anatomical notations in yellow painted block letters throughout

Inscriptions (in top cutoff): (TE, in yellow paint) *T.E.;* (CB, incised) *CAST / b*[y] */ EAKINS;* (in bottom cutoff) (TE, in black paint) *Eakins*

Provenance: CB Estate Inventory 1958, 9.

Related Works: *Front of Neck and Part of Shoulder,* 1930, bronze. SME to R. Sturgis Ingersoll to Perry Benson, Jr., to PMA in 1944.

References: Siegl, 83, 87.

Fig. 76

See also cats. 37–38.

259

Anatomical Cast of Left Foot, c. 1877

Plaster

6 × 3½ × 10 in. (15.2 × 8.9 × 25.4 cm)

1985.68.1.3

Provenance: CB Estate Inventory 1958, 16.

Related Works: *Cast of Left Foot,* 1930, bronze. SME to R. Sturgis Ingersoll to Perry Benson, Jr., to PMA in 1986.

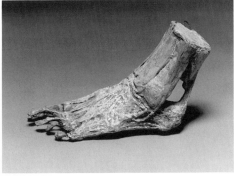

259

260

Knitting, 1882–83

Plaster, painted brown

20¾ × 17¼ × 4½ in. (52.7 × 43.8 × 11.4 cm)

1985.68.1.5

Inscriptions (v): (TE in ink on paper label fragment) *Knitting / by Thomas Eakins. / 1330 Chestnut St. / Philadelphia.;* (in ink on same label in another hand) *Return / [torn] as Bros / [torn] Bway*

Provenance: CB Estate Inventory 1958, 15.

References: Goodrich 1933, no. 505; Siegl, 101; Naude, in *JAIC,* 57–60.

Exhibitions: PAFA 1883, no. 415.

Related Works: (plaster) Corcoran Gallery of Art, Art Institute of Chicago, priv. colls.; (bronze) PAFA (cast 1886), PMA (cast 1930)

Fig. 81

See cats. 205 and 206; Eakins' photographs of *Knitting* survive in glass negatives in the Bregler collection, 88.13.a, b, c, d, and 96.3.d, showing small differences in the head and hands of the figure.

261

Spinning, 1882–83

Plaster, painted brown

21 × 17⅜ × 4¼ in. (53.3 × 44.1 × 10.8 cm)

1985.68.1.6

Inscriptions (v): (TE in ink on paper label fragment) *by Th[omas Eakins] / 1330* [Che]*st*[nut] *Street / Philadelphi*[a]; (in ink on same label in another hand) *1[8]7 Broadway / N.Y.;* (in red pencil, c.r.) *18[03] / 245*

Provenance: CB Estate Inventory 1958, 15.

References: Goodrich 1933, no. 504; Siegl, 99–100; Naude, in *JAIC,* 57–60.

Exhibitions: PAFA 1883, no. 414.

Related Works: (plaster) PMA, Art Institute of Chicago, priv. coll.; (bronze) PAFA (cast 1886), PMA (cast 1930).

Fig. 80

See cats. 205, 206, 243, and 260. Eakins' photographs of this relief prior to casting survive in glass negatives in the Bregler collection, 87.26.23 and 96.3.e. They indicate an earlier appearance of the distaff and flax bundle in the background.

262

An Arcadian, c. 1883

Plaster painted dark green

8 × 5¼ × ¾ in. (20.3 × 13.3 × 1.9 cm)

1985.68.1.4

Provenance: CB Estate Inventory 1958, 11, *Draped Classic Feminine Nude.*

Exhibitions: PAFA, *Sculpture at the PAFA,* 1986–87.

References: Goodrich 1933, no. 507; Siegl, 106; Foster 1986, 1236; Simpson, 83.

Related works: (bronze) Fine Arts Museum of San Francisco (cast c. 1930).

Fig. 197

See chap. 17.

Memorabilia

The many manuscripts and related printed materials from Eakins' house, rescued by Bregler in 1939, have been catalogued and reproduced on microfiche in Foster and Leibold, *Writing About Eakins* (1989). In addition to this material, which includes several notebooks and Eakins' "wallet" (or card case), other studio artifacts were found in Bregler's collection. His most prized bits of memorabilia, such as Eakins' buckskin cowboy clothes, his palette, his camera equipment, and drafting tools, were sold in 1944 and subsequently came to the Hirshhorn Museum; see Rosenzweig, cats. 125–132. Bregler (or Susan Eakins) may also have given similar items to Seymour Adelman, who sold them to the Dietrichs: a palette and brushes, a crayon box, a penknife; see Avondale/Dietrich, cats. 78–80. The artist's materials that remained in Bregler's collection and are now at PAFA— brushes, drafting tools, palettes, and palette knives—may have been Bregler's own or may have once belonged to Susan or Thomas Eakins. The following items are distinctive, however, and must have been Eakins' own property. (KF)

263

Upholstered Jacobean Revival Armchair, c. 1860

Fig. 10

At least a dozen sitters posed for Eakins in this chair, beginning with Kathrin Crowell in 1872 (fig. 8). By the end of his life, this chair had become a fixture in the "new" fourth-floor studio (fig. 222), which may explain why it appears in so many late portraits. Bregler and Seymour Adelman sentimentally purchased it at the Freeman & Company auction on 26 July 1939, hoping that it would become part of a house-museum or memorial collection.[1] Bregler took the chair home and probably replaced the reddish-brown upholstery seen in Eakins' paintings; the present brown velveteen fabric is from the twentieth century. The casters now on the chair may date the piece to the 1860s, when rollaway furniture became popular; these casters are clearly seen in *Elizabeth Crowell and Her Dog*. The chair also appears in *Professor Benjamin Howard Rand* (G 85, 1874); *The Zither Player* (G 94, 1876); *Mrs. John H. Brinton* (G 126, 1878); *Sewing* (G 132, c. 1879); *Dr. Leidy* (G 252, 1890); *Amelia Van Buren* (fig. 219); *Signora Gomez D'Arza* (G 360, 1902); *Ruth* (G 383, 1903); *Suzanne Santje* (G 384), 1903; *Mrs. Edith Mahon* (G 407, 1904); and *The Old-Fashioned Dress* (G 457, c. 1908).[2] Eakins seems to have preferred using this chair for his women sitters, finding its warmly colored, curved, and fuzzy surfaces appropriately feminine. For a small person, such as Kathrin Crowell or Amelia Van Buren, the chair created a decorative backdrop as well as a supportive spatial box, useful in establishing space around the figure and defending or protecting the body within. "Draw the chair first and put the figure in the chair," he told his students. "It will be a guide to the figure."[3]

In keeping with the claim that Eakins aged his sitters and emphasized their worn and wrinkled qualities, it might be said that he likewise aged this chair in his paintings, flattering its mid-Victorian character in the process. (KF)

1. Foster and Leibold, pp. 24–25, no. 21, and letters between the two men now at the Bryn Mawr College Library. Bregler's papers indicate that he lent the chair to the Knoedler exhibition of 1944.
2. Goodrich 1982, II: 64 and n. 323.
3. Bregler II, 383.

264

Watercolor Box, English, c. 1850–80

Inscriptions: (CB, in black ink, on paper label, lid, verso, u.c.) *water color box of / Thomas Eakins*

The contents of this wooden box, including seven brushes and an assortment of new and used hard cakes of watercolor pigment by various manufacturers, has been analyzed by PAFA's conservator, Mark Bockrath, in the appendix below. The original box and set of twelve colors was packaged by the London firm Waring and Dimes, 91 Great Russell Street, Bloomsbury, according to a label inside the lid. Such boxes would have been readily available in the United States, and although the hard cake pigments were already seen as "old-fashioned" by 1850, the conservative nature of many manufacturers and artists kept them commonplace throughout Eakins' career.[1] McHenry, who visited Bregler's collection in the 1940s, noted that he owned "the little oblong painting box of wood Eakins had used as a boy,"[2] perhaps referring to this kit or confusing it with the boxed drafting tools, also owned by Bregler, that are clearly labeled as from his school days.[3] However, Eakins surely must have owned watercolors when he produced such items as cat. 1, and this may be his boyhood set. Eakins' accounts from Paris also record the purchase of watercolors in 1868; such a box would also have been readily available in France.[4] The addition of pigment cakes by various other manufacturers—Winsor & Newton, Ackermann, Newman—indicates that Eakins continued to resupply this box for years. (KF)

1. Marjorie B. Cohn, *Wash and Gouache: A Study of the Development of the Materials of Watercolor* (Cambridge, Mass.: Fogg Art Museum, 1977), 55. Although replaced in favor with many artists by "moist" colors, the dry cakes remained popular with those interested in the purest, most brilliant washes, or "engineering and architectural draughtsmen" who were concerned with the transparency of their drawings (ibid.) Such factors may have guided Eakins in the 1850s, when his principal use of wash occurred in his mechanical and perspective drawings; compare cats. 5–9, 13–14.
2. McHenry, 55.
3. Hirshhorn; see Rosenzweig, 223.
4. See TE to BE, 17 Mar. 1868. CBTE; see Foster and Leibold, no. 39. The expense incurred, 5.50f, indicates a modest set.

265

Porte-crayon, brass (?), c. 1875

Inscriptions: (engraved on side) *Thomas Eakins / from his Pupils / 1875*

"In 1873, in the absence of any regular classes of the Academy, the [Philadelphia] Sketch Club formed schools for study of the living model, open to members and non-members. . . . They also gave lessons in anatomy, and secured the services of Thomas Eakins, who gave gratuitous instruction until the completion of the present Academy building, when the classes were discontinued."[1] Grateful for his guidance, the members gave this porte-crayon to Eakins. As its name implies, it holds a stick of pigment—usually a crayon or chalk—for drawing. (KF)

1. Clement and Hutton, xxxiv.

266

Eakins' School Bell

This bell, identified by Bregler's label as "Eakins' School Bell," was apparently used by Eakins in his fourth-floor studio to summon assistance.

267

The Fairman Rogers Four-in-Hand, engraved plate, c. 1899.

Fairman Rogers asked Eakins to prepare a black and white replica of his painting (fig. 140) for use by the engravers preparing a frontispiece for his *Manual of Coaching*, first published in 1899. The grisaille oil, made at the same scale as the original painting, is in the St. Louis Art Museum. The engraved block, much reduced from the original image, must have been given to Eakins by Rogers. (KF)

268

Silver door plate, engraved "B. Eakins"

According to Bregler, this plate from the doorway of the house at 1729 Mount Vernon Street was taken by Samuel Murray shortly before the house was sold in 1939.[1] The plate may have been given to Bregler by Mrs. Murray after Murray's death in 1941. (KF)

1. See CB, "Diary of Visits to 1729 Mt. Vernon St.," 29 June 1939; Foster and Leibold, fiche series IV 12/A/1.

A long gap opened between 1878, when Eakins received his first exhibition prize (a silver medal for his watercolors, cat. 269), and 1900, when his work at the Exposition Universelle in Paris won an honorable mention. Disdainful of such awards "from committees who did not know a good picture from a bad one" (see cat. 270), Eakins did not take good care of these certificates, but he did not throw them away, either. (KF)

Certificates of Awards

269

Stephen A. Schoff (1818–1904) after H. (Hammatt) Billings (1816–74)
Diploma for Massachusetts Charitable Mechanics' Association, 1878

> Etching and engraving with ink additions on cream wove paper
>
> 17³/₁₆ × 22½ in. (43.7 × 57.2 cm)
>
> 1985.68.43.10
>
> Inscriptions: (in plate, b.l.) *ENGRAVED BY S. A. SCHOFF; DESIGNED BY H. BILLINGS;* (b.r.) *Printed by J. H. Daniels;* (top to bottom) [text of diploma] / *SEPT. 1878;* (in ink, b.c.) *WITH SILVER MEDAL / TO THOMAS EAKINS FOR Water-color Painting;* (in graphite, u.r.) *72;* (c.r.) *Eakins;* (blind stamp, b.c.) figure of classical woman

Eakins exhibited three watercolors at this exhibition in Boston: *Study of Negroes* (fig. 68), *Young Lady Looking at a Flower* (fig. 66), and *Turning the Stake* (now unlocated). This was his first exhibition prize.

270

Adrien Didier (1838–1924) after Camille Boignard (n.d.)

Certificate for Honorable Mention from Exposition Universelle Paris, 1900

> Engraving on cream wove paper
>
> Watermark: Perigot Masure 1900 Arches
>
> 22⅞ × 29¾ in. (58.1 × 75.6 cm)
>
> 1985.68.43.11
>
> Inscriptions: (in plate, b.r.) *ADRIEN DIDIER SC.;* (b.l.) *CAMILLE BOIGNARD INV.;* (b.c.) *1900 / IMP. A PORCABEUF—PARIS*
>
> Inscriptions: (v): (TE in graphite, c.l.) *Diplomas from committees who did not know a good picture from a bad one*

Eakins exhibited *The Cello Player* (fig. 250) and *Salutat* at the Exposition.

271

Raphael Beck (fl. 1888–c. 1900)

Pan American Exposition Gold Medal Certificate, 1900

Lithotint (?) and lithography on buff wove paper
Watermark: NATIONAL LINEN LEDGER
15 × 18⁹⁄₁₆ in. (38.1 × 47.2 cm)
1985.68.43.12
Inscriptions: (on stone, b.r.) *THE COURIER CO. LITHO. DEPT BUFFALO, N.Y. U.S.A.*; (b.l.) *RAPHAEL BECK, DEL. / COPYRIGHT, 1900, BY THE PAN-AMERICAN EXPOSITION CO.*; (top to bottom) text of certificate; (inscribed in ink, b.l.) [to] *Thomas Eakins* / [for] *Oil Paintings*; (b.c.) gold seal over blind stamp, head of Columbia

Eakins exhibited *Mending the Net* (fig. 164), *Portrait of Louis N. Kenton [The Thinker]* (fig. 232), and *Professor Barker of the University of Pennsylvania* at this exposition in Buffalo, New York.

272

Will H. Low (1853–1932)

Commemorative Diploma from Saint Louis Universal Exposition, 1904

Photo-lithograph (?) on cream wove paper
21½ × 25⅝ in. (54.6 × 65.1 cm)
1985.68.43.13
Inscriptions: (on stone, b.r.) *GILBO AND COMPANY, BROOKLYN, NEW YORK CITY*; (b.l.) *WILL H. LOW 1904 / WILL H. LOW INV. ET DELT.*; (u.l.) *Copyrighted by Louisiana Purchase Exposition Company 1904*; (u.r.) *II*; (b.c.) text of certificate, vignette of allegorical figure of Columbia seated between figure of royalty and Mercury.

Eakins exhibited seven paintings at the Louisiana Purchase Exposition: *Cardinal Martinelli* (fig. 234); *The Cello Player* (fig. 250); *Louis Kenton [The Thinker]* (fig. 232); *Dextra Victrice, Conclamantes Salutat*; *The Gross Clinic*; *The Agnew Clinic*; and *The Crucifixion*. He was awarded this diploma and the gold medal certificate below.

273

Will H. Low (1853–1932)

Certificate of Gold Medal from Saint Louis Universal Exposition, 1904

Photo-lithograph(?) on cream wove paper
21⁹⁄₁₆ × 25⅝ in. (54.8 × 65.1 cm)
1985.68.43.14
Inscriptions: (on stone, b.r.) *GILBO AND COMPANY, BROOKLYN, NEW YORK CITY*; (b.l.) *WILL H. LOW 1904 / WILL H. LOW INV. ET DELT.*; (u.l.) *Copyrighted by Louisiana Purchase Exposition Company 1904*; (u.r.) *II*; (b.c.) text of certificate, vignette of allegorical figure of Columbia seated between figure of royalty and Mercury.

See also cats. 272 and 274.

274

E. H. Schmidt (fl. c. 1903)

Louisiana Purchase Exposition Certificate Appointing Thomas Eakins to Advisory Committee, 1903–4

Transfer lithograph (?) or engraving with ink additions on cream wove paper
18¹⁄₁₆ × 23 in. (45.9 × 58.4 cm)
1985.68.43.15
Inscriptions: (printed under vignette, b.c.) *COPYRIGHTED 1903 BY E.H. SCHMIDT*; (b.l.) *WOODWARD & TIERNAN PRT'G CO. ST. LOUIS*; (top to bottom) text of certificate / under vignette *THE CHRISTENING OF LOUISIANA*; (b.l.) Expo. gold seal with colored ribbons affixed

See also cats. 272 and 273.

Appendix The Conservation
of the Paintings

Mark Bockrath

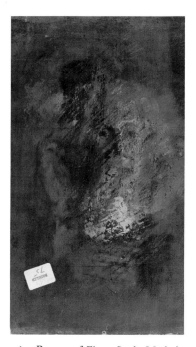

246. Reverse of *Figure Study: Masked
Nude Woman* (cat. 238), showing
scraped sketches.

"These Simple Studies": Eakins'
Oil Sketching Technique

Although numerous drawings in charcoal, ink, and graphite attest to his skill as a draftsman, Thomas Eakins discouraged students from making overly finished drawings, preferring that they sketch with oil paints and so learn to model in color. "The brush was a better and more powerful instrument to draw with—if you are going to be a painter to work with paint," he told Charles Bregler. "I cannot urge you too much to paint little simple studies," he said. "These simple studies make a strong painter."[1]

Such studies were used by Eakins to make compositional decisions and to note the true color and tone of the elements in the design. All of the oil sketches in the Bregler collection appear to have been rapidly executed in a wet-into-wet technique, with no later reworking. They were intended as working sketches by Eakins, who often reused the surface several times, overpainting old studies with new ones or scraping them down for repainting—as in the verso of cat. 238 (fig. 246), in which two layers of work (a face and an unrelated seated figure) were both vigorously scraped away by the artist. Eakins often painted several adjoining sketches on the same support, such as the piece of wood that was separated by Bregler into two Delaware River scenes (cat. 247), a study of the back of a woman's head (cat. 246) made for the painting *Shad Fishing at Gloucester on the Delaware* (1881), and a study of a man's head for the painting *Mending the Net* (1881). Reassembled (fig. 247), the pieces show how Eakins turned the panel before producing each sketch. Sometimes Eakins painted over thickly textured sketches that had not been scraped down, and the thick brushmarkings of such a previous sketch show clearly in the surface of *Sailboats Racing: Study of the Delaware River* (cat. 234). An X-radiograph of the painting suggests that the present sketch covers part of a larger composition that is not comprehensible as an image (fig. 248).

The X-radiograph of *"Thar's a New Game Down in Frisco"* (fig. 249; see cat. 242) does show a comprehensible image when it is inverted. Eakins clearly painted this sketch over a study for *Fifty Years Ago* (fig. 66). The figure of the young girl visible in the X-radiograph is slightly larger than the one in the Bregler collection's study for this painting (cat. 241; plate 3). This X-radiograph also shows an image of the piece of wood to which Bregler mounted the canvas support of the sketch, subsequently painting the rough reverse surface of the wood.

Eakins frequently transferred designs from his preparatory sketches to larger paintings by means of transfer grids. This "squaring up" process involved drawing a pattern of squares on the small drawing or oil sketch and then enlarging the design onto a bigger painting by use of a corresponding pattern of larger squares. After executing the small oil sketch Eakins would incise the grid pattern into the wet paint of all or part of the sketch with a sharp pencil or stylus. The direct correspondence of such a pattern from the sketch to the large

247. Reassembled sketches (cats. 246, 247), and *Mending the Net, Study of a Man's Head* (estate of Mary Bregler).

248. X-radiograph of *Sailboats Racing: Delaware River Study,* cat. 234

finished work can be seen by comparing *The Cello Player* of 1896 (PAFA) with its preparatory sketch (figs. 250, 251). The lines appear in the same parts of the figure and background in both works, with the lines in the sketch about three inches apart and the lines in the painting at about one-foot intervals. Infrared examination of the large painting reveals the grid in thinly painted areas of the background, and examination of the lines with low-power magnification shows that they were drawn in graphite pencil on the white ground.

Eakins also frequently made oil sketches for his watercolors, an unusual practice when compared with that of his contemporaries, who generally did not see in the dark, rich colors of oil paint a suitable medium for working out ideas for a sparkling, transparent watercolor. However, many of the designs for Eakins' finely rendered and complex watercolors, whose tonal ranges frequently approach those of oil paintings, were first sketched by the artist in oil, the medium with which he was most adept and comfortable. In the case of *Fifty Years Ago* of 1877, the oil sketch was made in preparation for a smaller watercolor, and the squaring process was used to reduce the image size. The figure in the oil sketch is gridded for transfer in one-inch squares, while more complex passages, such as the face and hands, are divided into quarter-inch grids (fig. 252).

Eakins' oil sketches were painted on a variety of supports, including a thin paper with a pebbly textured priming, plain weave and twill fabrics, and cardboard and wood panels (probably poplar). Siegl states that Eakins used wooden panels frequently from 1879 to 1883, carrying them in his paint box for outdoor sketches.[2] The panels were generally about 11 × 14 inches, although some were cut down by Bregler. The Bregler collection sketches on wood date from about 1877 to 1882. Fabric and cardboard supports appear throughout Eakins' career. The cardboard supports (as in cats. 238–240) all show regular, rounded, manufactured edges, indicating that their present sizes are their original sizes.

Ground colors and application vary from sketch to

249. X-radiograph of *"Thar's a New Game Down in Frisco,"* cat. 242, inverted to show study for *Fifty Years Ago.*

sketch. The sketches on fabric all showed commercially prepared white lead oil grounds. In the cases of *"Thar's a New Game Down in Frisco"* (cat. 242) and *The Artist and His Father Hunting Reed Birds: Marsh Landscape Sketch* (cat. 232; fig. 120; plate 10), this white ground was coated with a thin yellow-brown imprimatura before the sketch was done. A thin brown imprimatura was also brushed onto the pebbly white oil grounds of the paintings on thin paper supports. Paintings done on wooden supports cut from larger panels by Bregler all bore dark tan oil grounds applied with a brush. In the case of the sketch *Study of a Horse's Leg* (cat. 244; fig. 143), this tan ground was then recoated with a brown ground. The sketches of nudes on cardboard, cats. 238–240, show brown

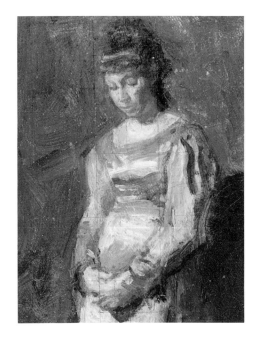

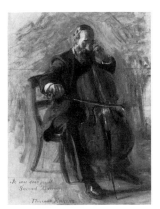

250. *The Cello Player*, 1896, oil on canvas, 64¼ × 48¼ in., Pennsylvania Academy of the Fine Arts, Temple Fund Purchase.

251. Bottom left, *The Cello Player*, 1896, oil on canvas, 17½ × 14 in., collection of the Heckscher Museum, Huntington, New York. Museum Purchase: Heckscher Trust Fund, Stebbins Family, Priscilla de Forest Williams, George Wilhelm and Acquisition Fund.

252. Top right, Detail of *Fifty Years Ago* (cat. 241).

253. Bottom right, X-radiograph of *Spinning: Sketch* (cat. 243).

grounds applied by the artist with a palette knife. The brown ground on the sketch for *Spinning: Sketch* (cat. 243; plate 3) was applied with a palette knife as well, and the thick ridges of paint thus formed show well in the X-radiograph of the painting (fig. 253). The grounds on *Spinning* and on the sketches on cardboard are loosely applied with colors that are not well mixed, suggesting that Eakins used leftover paint scraped from his palette. The small two-sided sketch *Mending the Net: Study of a Fisherman* and *Shoreline of the Delaware River, with Fishing Nets* (cat. 249) shows multiple grounds. The recto shows a brush-applied tan ground under a yellow-ochre colored ground that was at least partially applied with a knife. The *Shoreline* on the verso (plate 15) shows layers of gray, brown, and tan below the present design, indicating either reuse of the panel with painted designs or application of several ground layers.[3]

The Finished Painting

Eakins' technique in his finished paintings was quite consistent throughout his career in terms of his materials. Although his supports for sketching varied, Eakins' larger finished works were invariably on stretched fabrics with smooth, commercially prepared lead white oil grounds. He used both plain- and twill-weave fabric, generally linen, though the former was used more frequently. Bregler noted one instance in which Eakins painted on jute.[4] Eakins' most frequent supplier of canvases was the Philadelphia firm F. Weber & Company, as evidenced by numerous labels on the stretcher bars.[5]

Eakins' method of beginning a painting is evident in such unfinished works as *Jennie Dean Kershaw* (fig. 221), *Mrs. Joseph W. Drexel* of 1900 (Hirshhorn), and *The Young Man (Portrait of Kern Dodge)*, c. 1902 (PMA), in which broad

washes of local color are used to establish the major forms and tonal relations in the composition. There is no evidence of a developed underpainting of brown washes commonly used by many other artists of this period to establish tones and compositional elements before the local colors were applied. Eakins often sketched the composition with thin lines of dark paint or graphite pencil. Graphite pencil lines are visible in *The Young Man* and in the thinly painted portions of *The Cello Player,* loosely indicating placement of forms under the washes of paint.[6] Eakins sometimes used thin imprimaturas of tan, brown, red-brown, or warm gray paint to tone the white ground as an initial step in his painting process.

After the initial laying in of the work, Eakins applied multiple layers of paint, slowly building form and perfecting details. Eakins occasionally used painting knives in addition to brushes to apply paint. The knives were particularly useful for roughly textured highlight areas, as can be seen in the skies of *Sailing (Starting Out After Rail)* of 1873 (PMA) and *The Crucifixion* of 1880 (PMA), and in the sunlit road in *The Fairman Rogers Four-in-Hand* of 1879 (fig. 140; plate 12).

Eakins' paintings today tend to be in good condition, attesting to his sound craftsmanship and permanent palette. Occasionally his paintings show traction cracks from problems with different drying rates for multiple paint layers, but these are unusual. For the most part, Eakins' technical skill and conservative approach have allowed us to see his paintings today much as they originally appeared.

Eakins' Palette

Crushed pigment samples from Eakins' palette in the oil sketches were examined and identified with a polarized microscope. A variety of colors were sampled in an effort to determine typical mixtures for areas such as flesh tones, foliage, skies, and so forth. Thirty-two samples from fourteen paintings were analyzed.

The pigments identified included lead white, vermilion, red, yellow, and brown earth colors (raw and burnt umbers, raw and burnt siennas, yellow ochre), ultramarine blue, viridian green, chrome yellow, organic red lake, and bone (ivory) black. This palette of generally stable pigments, with its emphasis on warm colors, corroborates Bregler's statement about Eakins' palette: "His palette was arranged with white at either end, one for mixing with the light colors, and the other for the dark. The colors used were the permanent earth pigments with the addition of cadmium yellow. . . . The brilliant but fugitive colors derived from coal tar, etc., were never considered or used by him."[7] Eakins' student and longtime friend Samuel Murray also stated, "Eakins used mostly all earth colors. One white would be to the right, down rather near the thumb, the other all the way over to the left. The center would be saved for the tones that made the flesh, and across the top of the palette reading from right to left would be the following colors: cadmium yellow and orange, vermilion, light red, burnt sienna, permanent blue, Van Dyke brown and black; Eakins didn't use bitumen, which is fatal to pictures meant to last; and he never used lakes or other fancy colors that run and are not permanent—those synthetic, made from anilines."[8] The permanent blue mentioned by Murray is ultramarine blue, and the light red is an opaque, light, warm iron-oxide red, similar to Venetian red.[9] Although a deep transparent organic red lake such as alizarin or rose madder lake is found in several samples, no coal tar dyes were found. These coal tar derivatives now include many colors of good permanence, but they were notoriously impermanent in Eakins' time.

Colors on a palette owned by Eakins, now in the collection of the Hirshhorn Museum and Sculpture Garden, were identified as follows: "cadmium yellow, ultramarine (permanent blue), three shades of cinnabar (vermilion), and the earth colors. The white is lead white."[10] The mention of cadmium yellow in the written accounts and on the Hirshhorn palette is an anomaly between these examples and PAFA's samples, which contained chrome yellow, a pigment similar in appearance to cadmium yellow. Viridian is also not mentioned in the accounts. However, chrome yellow was identified on paint samples taken by conservator Theodor Siegl from Eakins' paintings at PMA.[11]

Some typical pigment mixtures for the frequently used colors in the sketches are illustrated in the following examples: Foliage was painted with mixtures of viridian, bone black, ultramarine blue, chrome yellow, and yellow and brown earth colors. Skies contained bone black, lead white, and yellow earth, resulting in a warm gray rather than a cool blue. The primary constituents of the flesh tones were lead white, vermilion, yellow, red, and brown earth colors, and organic red lake. The darker earth colors were used in the shadows of the flesh, with organic red lake and bone black in the deepest shadows, as in the lip shadows in *Girl with a Fan: Portrait of Miss Gutierrez* (cat. 252; fig. 220). In this portrait, a touch of pure chrome yellow was found in the highlight of the sitter's earring.

Eakins' palette, containing primarily warm earth colors, is rather restricted in selection when one considers the variety of bright blues, greens, reds, violets, and yellows available at the time. It is the palette of a realist painter interested in contrasts of tone, not of an Impressionist interested in intense chromatic contrasts. It is a palette whose overall warmth results in the predominance of brown, yellow, red, olive, and gray colors so frequently seen in Eakins' paintings.

Eakins' Watercolor Box

Thomas Eakins produced about thirty watercolor paintings in the 1870s and 1880s. His watercolor box (cat. 264; fig. 254), with its numerous colors, brushes, and other implements, forms one of the most interesting parts of the Bregler collection's wealth of artists' materials. The box is labeled by Bregler as belonging to Thomas Eakins, although it may have been used and replenished by Susan Macdowell Eakins, herself a capable watercolorist. The set of colors began with a small mahogany box from the English manufacturer Waring

254. Watercolor box (cat. 264).

and Dimes. The lidded box contains a removable shelf with labeled compartments for the original colors: vermilion, gamboge, light red, yellow ochre, burnt umber, burnt sienna, raw sienna, crimson lake, indigo, Prussian blue, Cologne earth, and Van Dyke brown. Other colors were added from paints made by Winsor and Newton, Newman, and MacPherson's Tints by Ackermann, all English manufacturers; there also were a few of unknown origin. English watercolor materials were prized by Europeans and Americans alike in the nineteenth century, and their appearance in Eakins' box is not surprising.[12] The colors are all hard cakes, most in the form of embossed tablets bearing the name of the color on one side and the name and address of the manufacturer on the other. A few stray colors in porcelain tubs are also present. The box contains sable and camel hair brushes with both wooden and goose quill handles, a tablet of sumi ink, glass dishes for mixing colors, and what appears to be a small sponge. The wooden handles of some brushes are sharpened to points, probably for scratching into or dabbing paint. Eakins presumably added colors as he needed them to replace used ones or to supplement the rather sparse original Waring and Dimes set.

Many colors can be identified from their embossed labels, but fragments of cakes, worn cakes, and the porcelain tubs bear no recognizable labels. The colors in this latter group were identified by polarized light microscopy from crushed pigment samples. The pigments identified include aureolin (cobalt yellow), Naples yellow, a barium-strontium chromate yellow, and chrome yellow; red, yellow, and brown earth colors, such as ochres, siennas, and umbers, Van Dyke brown, and Cologne earth; vermilion, organic red lake, and a possible violet lake; emerald green; cobalt blue, indigo, and Prussian blue; and zinc white, bone black, and lamp black. Several mixed colors are also present in the set, including MacPherson's Deep Blue Permanent, comprising Prussian

blue, red lake, and bone black, as well as some duplicate colors. All colors were in use during the period of Eakins' watercolor production.

Charles Bregler as a Restorer

Charles Bregler's involvement with the preservation of the collection evolved from his work with Susan Eakins in caring for the materials that Thomas Eakins left in his studio when he died in 1916. Susan Eakins eventually came to regard Bregler as the restorer of the collection, entrusting him with cleaning and mounting the paintings. After Susan Eakins died in 1938 Bregler cleaned and catalogued works from her estate for sale and distribution to her heirs. Therefore, many paintings and drawings, in addition to items in his own collection, show the marks of Bregler's handiwork.

Bregler's efforts at restoration and cataloguing express his desire to preserve and authenticate all materials belonging to his beloved teacher. To this end, Bregler wrote sometimes lengthy inscriptions on labels on the reverse of the mounted sketches, supplying anecdotal information on the sketch's origin, identifying if possible the painting for which the sketch was made, and declaring his possession of it, as in the label on the reverse of *Ships and Sailboats on the Delaware: Study* (cat. 233), which reads: "Study for the picture / Ships and Sailboats on the / Delaware River / painted by / Thomas Eakins / Listed in Goodrich book #81 / Property of Charles Bregler." On the reverse of the mount of *Shad Fishing at Gloucester on the Delaware River: Study of a Woman's Head* (cat. 246) Bregler wrote: "Study painted by / Thomas Eakins / from panel 135 / Rebacked by / Charles Bregler / Sister of Eakins in picture #152."

In many instances Bregler incised inscriptions into the paint of the sketch itself in order to further ensure its identification. *Study for the Swimming Hole* of 1883 (Hirshhorn) bears such an incised inscription: "Original sketch for the / Swimming Hole / by Thomas Eakins." This sketch also had an explanatory label on its reverse, which notes that the sketch was "rebacked by Charles Bregler / and signed by him on lower right hand corner / to insure its authenticity should these labels / be lost or destroyed."[13] Many of the sketches at PAFA bear similar incised inscriptions on their faces, such as "Painted by / Thomas Eakins" on the left edge of *Study of a Horse's Leg* (cat. 244).

Bregler's labels sometimes tell us about his restoration methods and his reasons for choosing certain mounts. On the reverse of *Girl with a Fan* (cat. 252), which was painted on fabric and mounted by Bregler to a plywood panel with an attached stretcher using a lead white adhesive, is the following inscription: "Rebacked on a wood panel / by a special process / making the painting safe / for all time / by Charles Bregler." Bregler said that he chose the adhesive because "the process I use is my own. No moisture is used. The common practice and a bad one is that the old canvas is glued to a new one. The moisture gets into the old canvas and oft times loosens the paint film."[14]

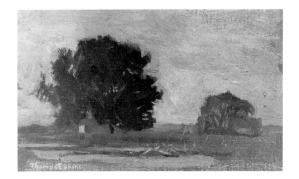

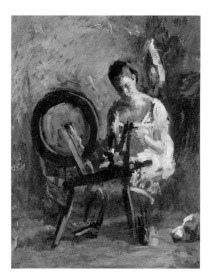

255. *The Artist and His Father Hunting Reed Birds: Marsh Landscape Sketch* (cat. 232), before treatment.

256. *Spinning: Sketch* (cat. 243) before treatment.

In a letter to Samuel Murray of c. 1941, Bregler discusses his treatment of Eakins' portrait of Murray (1889, coll. Mr. and Mrs. John Russell Mitchell) with a similar mounting technique: "Your portrait is now safely and securely on a / wood panel. And there is not the slightest possibility / of it again being injured. / I shall do nothing to destroy the soft tone it has / acquired by age. I want to wait until the end of the week / so the adhesive has thoroughly hardened."[15] This note also states that Bregler varnished the portrait with mastic, a natural resin varnish. The yellowing and solubility parameters of the varnish on PAFA's sketches suggest that they, too, were coated with mastic varnish by Bregler.

In addition to Bregler's intentions to preserve the paintings in his restorations, there often appears to be an attempt on his part to turn the sketches into more "finished" paintings. Bregler frequently repainted the backgrounds of figure studies or covered areas of exposed ground with thick oil paint in order to continue the sky or foreground to the edges of a rectangular format in landscape sketches. *The Artist and His Father Hunting Reed Birds: Marsh Landscape Sketch,* like many of Eakins' sketches, was never intended to fill a rectangular space, and its foreground and sky were loosely indicated, leaving large sections of the priming exposed (compare fig. 255 before conservation and fig. 120 after). Bregler added some sky to the upper right corner of the design and added a scumble of gray paint along the bottom edge of the foreground field. The background of *Spinning* was also overpainted by Bregler to make it into a smooth brown tone. The original background, revealed after cleaning (compare fig. 256 and plate 3), shows Eakins' roughly textured, mottled background, applied with a painting knife.

The *Marsh Landscape Sketch,* like others, was cut by Bregler to make a composition of his own choice before repainting. Bregler sometimes incised outlines around parts of a sketch as a guide for framing, as in *Figure Study: Nude Woman, Seated, with Arms Raised* (cat. 239), as an alternative method of selecting a composition. Pieces of paper similar in

texture and appearance to Eakins' original paper supports were added by Bregler to the missing corners of two sketches on paper, *Sailboats Racing: Study of the Delaware River* (cat. 234) and *Landscape Study: Shoreline with Trees* (cat. 235). The added corners were then overpainted by Bregler to complete the compositions. Bregler also repainted creases in fabric supports and repaired paint losses in many sketches, and he repainted areas where Eakins' reuse of a sketch produced irregular surfaces or left exposed underlayers that did not relate to the upper design, as in *Sailboats Racing.*

Bregler often cut wooden panels bearing multiple sketches into individual compositions; see, for example, fig. 247. He then split this panel with a saw to separate the recto and verso (which held a landscape study, cat. 245); tool marks are visible on the reverse of the individual panels. All the sketches split in this fashion were then mounted to Masonite boards with lead white adhesive and nails around their perimeters. Several studies on wood in the Bregler collection show this treatment. The cut edges of many of the Masonite mounted wooden panels as well as the scrapes in the lead white adhesive on the edges of the panel indicate that the panels were mounted before they were sawn by Bregler.

Bregler used a variety of mounting methods to flatten and mount other sketches, including gluing thin paper and small canvas supports to cardboard with animal-skin glues, mounting larger canvas supports to plywood with lead white adhesive, as in *Girl with a Fan* and *Fifty Years Ago. "Thar's a New Game Down in Frisco,"* on a fabric support, was glued to a solid piece of wood. The mounting of the paper with glue involved heat that resulted in blistering of paint. Thicker cardboard supports, which were painted on both sides, were not split or mounted by Bregler. Some wooden panels, such as *Spinning,* also painted on both sides, were not split by Bregler, perhaps because both sides were not finished enough for individual presentation. Some mounted works were taped or nailed to frames.

Bregler's treatments, though they would be considered

257. *Delaware Riverscape, from Gloucester* (cat. 247) before treatment (plate 14).

largely irreversible by today's conservation standards, were not unusual for his time, and they included many of the practices employed by unschooled restorers of his time. It was in the extent to which Bregler repainted and mounted sketches to present them as finished works of art that his efforts seem most overzealous. The attempt to separate Bregler's restorations from Eakins' work proved difficult when the sketches were received for treatment at the painting conservation laboratory at PAFA. Scholars, collectors, and conservators encountering other items once owned or treated by Bregler can recognize his practices by considering the work now in PAFA.

Conservation of the Oil Sketches

The goal of conservation was to stabilize the paintings and return them as closely as possible to their original appearance. This required undoing most of Bregler's restorations. Yellowed varnish and overpaint were removed whenever possible. Overpaint that proved too resistant to remove was reduced in thickness and inpainted to a satisfactory appearance. All paintings were then revarnished with a nonyellowing synthetic resin. Paint losses were filled to level and inpainted to match surrounding paint with reversible synthetic colors. Bregler's incised inscriptions were not generally filled or inpainted, as they did not appear disturbing in most instances. When Bregler's addition of paper to an original support was revealed by the removal of overpaint, the attachment was left in place to add structural support to the painting. Such additions were not inpainted, however, so as to clearly identify them as nonoriginal materials.

In instances where wooden panels were being held in tension by their nailed mounts, or where the nails had split the wood, the nails, Masonite backing, and lead white adhesive were removed. If the mounted panel appeared stable, no structural treatment was performed.

Delaware Riverscape, from Gloucester (cat. 247; plate 14) had been cut in half (fig. 257) by Bregler from a panel that he had divided into at least five pieces, including the verso (see fig. 247). The landscape was rejoined into one composition during treatment, forming a panoramic shore scene. The left side of the painting had been given to PAFA by Mrs. Bregler

twenty years earlier. Its deteriorated surface and missing right side made it barely comprehensible as a design. Fortunately, when both sides were cleaned and rejoined, their colors and surface contours matched well and made a satisfying composition.

This is a revision of a text originally titled "The Paintings of Thomas Eakins," in "Thomas Eakins: Painter, Sculptor, Photographer," *Journal of the American Institute for Conservation* 31 (1992): 52–56. Reprinted with the permission of the American Institute for Conservation of Historic and Artistic Works, 1400 Sixteenth Street N.W., Suite 340, Washington, D.C. 20036.

I thankfully acknowledge treatment work performed on the Bregler collection by conservators Thomas Wollbrinck, James Vallano, and Paul A. Cooper, assistance with microscopy by conservator Nancy Pollak, research, manuscript preparation, and storage of the collection by Robin Beckett, photography by Rick Echelmeyer, and the opportunity to view files and paintings given by the curatorial and conservation staffs of the Hirshhorn Museum and Sculpture Garden and the Philadelphia Museum of Art.

Notes

1. Bregler I, 380–383.
2. Siegl, 73.
3. A summary table of Eakins' supports and the ground preparations used for paintings in CBTE is given in *JAIC*, 53.
4. Charles Bregler to Samuel Murray, n.d., CBTE. See chap. 8 above.
5. Unpublished technical notes by Theodor Siegl, PMA Archives.
6. Siegl, 146.
7. Charles Bregler, "The Readers Comment," *Art Digest* 15 (15 Nov. 1940): 4.
8. McHenry, 102–103.
9. Rutherford J. Gettens and George L. Stout, *Painting Materials: A Short Encyclopaedia* (New York: Dover, 1966), 124.
10. Rosenzweig, 227.
11. Unpublished technical notes by Theodor Siegl, PMA Archives.
12. Marjorie B. Cohn, *Wash and Gouache* (Cambridge, Mass.: Center for Conservation and Technical Studies, Fogg Art Museum, 1977), 12–13.
13. Rosenzweig, 100.
14. Charles Bregler to Seymour Adelman, n.d., CBTE.
15. Rosenzweig, 221.

References

Ackerman 1969 Gerald M. Ackerman, "Thomas Eakins and His Parisian Masters Gérôme and Bonnat," *Gazette des Beaux-Arts* 73 (Apr. 1969): 235–256.

Ackerman 1972 Gerald M. Ackerman, Introduction and catalogue commentaries, *Jean-Léon Gérôme (1824–1904)*, exh. cat. (Dayton: Dayton Art Institute, 1972).

Ackerman 1986 Gerald M. Ackerman, *The Life and Works of Jean-Léon Gérôme, with a Catalogue Raisonnée* (London: Sotheby's, 1986).

Art Club Art Club Gallery, Philadelphia, "Exhibition Presented by Mrs. Thomas Eakins," 17 Oct.–15 Nov. 1936. Group exh. of the work of TE, SME, CB, EMK, C. L. Fussell, and D. W. Jordan.

Avondale/Dietrich William Innes Homer, ed., *Eakins at Avondale, and Thomas Eakins: A Personal Collection* [Dietrich Collection], exh. cat. (Chadds Ford, Pa.: University of Delaware and the Brandywine River Museum, 1980).

Bantel Linda Bantel et al., *William Rush, American Sculptor*, exh. cat. (Philadelphia: PAFA, 1982).

Boime 1971 Albert Boime, *The Academy and French Painting in the Nineteenth Century* (London: Phaidon Press, 1971; rpt., New Haven: Yale University Press, 1986).

Boime 1974 Albert Boime, "Curriculum Vitae: The Course of Life in the Nineteenth Century," in *Strictly Academic: Life Drawing in the Nineteenth Century*, exh. cat. (Binghamton: University Art Gallery, State University of New York, 1974), 5–15.

Bolger and Cash Doreen Bolger and Sarah Cash, eds., *Thomas Eakins and the Swimming Picture*, exh. cat. (Fort Worth: Amon Carter Museum, 1996). With contributions by the editors and Claire Barry, Richard Brettell, Kathleen A. Foster, Milan R. Hughston, Elizabeth Johns, and Marc Simpson.

Bregler I Charles Bregler, "Thomas Eakins as a Teacher," *The Arts* 17 (Mar. 1931): 376–386.

Bregler II Charles Bregler, "Thomas Eakins as a Teacher: Second Article," *The Arts* 18 (Oct. 1931): 27–42.

Brownell W. H. Brownell, "The Art Schools of Philadelphia," *Scribner's Monthly* 18 (5) (Sept. 1879): 737–750.

Burroughs Alan Burroughs, "Catalogue of Works by Thomas Eakins (1848–1916)," *The Arts* 5 (6) (June 1924): 328–333.

Carnegie, *Eakins* 1945 Carnegie Institute, Pittsburgh, *Thomas Eakins Centennial Exhibition, 1844–1944*, exh. cat., 26 Apr.–1 June 1945.

Casteras Susan M. Casteras, *Susan Macdowell Eakins, 1851–1938*, exh. cat. (Philadelphia: PAFA, 1973).

Chamberlin-Hellman Maria Chamberlin-Hellman, "Thomas Eakins as a Teacher" (Ph.D. diss., Columbia University, 1981).

Clement and Hutton Clara Erskine Clement and Laurence Hutton, *Artists of the Nineteenth Century and Their Works* (Boston: Houghton-Mifflin, 1879; rev. ed., 1907).

Danly and Leibold Susan Danly and Cheryl Leibold, *Thomas Eakins and the Photograph: Works by Thomas Eakins and His Circle in the Collection of the Pennsylvania Academy of the Fine Arts* (Washington, D.C.: Smithsonian Institution Press for the Pennsylvania Academy of the Fine Arts, 1994). With essays by Elizabeth Johns, Anne McCauley, and Mary Panzer.

Domit Moussa M. Domit, *The Sculpture of Thomas Eakins*, exh. cat. (Washington, D.C.: Corcoran Gallery of Art, 1969).

Foster 1972 Kathleen A. Foster, "Paris and Philadelphia: Thomas Eakins and the Beaux-Arts" (Master's thesis, Yale University, 1972).

Foster 1982 Kathleen A. Foster, "Makers of the American Watercolor Movement, 1860–1890" (Ph.D. diss., Yale University, 1982).

Foster 1986 Kathleen A. Foster, "An Important Eakins Collection," *Magazine Antiques* 130 (6) (Dec. 1986): 228–237.

Foster 1990 Kathleen A. Foster, "Realism or Impressionism? The Landscapes of Thomas Eakins," *Studies in the History of Art* 37 (1990): 69–91.

Foster and Leibold Kathleen A. Foster and Cheryl Leibold, *Writing About Eakins: Manuscripts in Charles Bregler's Thomas Eakins Collection* (Philadelphia: University of Pennsylvania Press, 1989).

Fried Michael Fried, *Realism, Writing, Disfiguration: On Thomas Eakins and Stephen Crane* (Chicago: University of Chicago Press, 1987).

Gerdts and Yarnall William H. Gerdts and James Yarnall, *Index to American Art Exhibition Catalogues from the Beginning through the 1876 Centennial Year* (Boston: G. K. Hall, 1986).

Goodrich 1933 Lloyd Goodrich, *Thomas Eakins: His Life and Work* (New York: Whitney Museum of American Art, 1933).

Goodrich, 1982 Lloyd Goodrich, *Thomas Eakins*, 2 vols. (Cambridge: Harvard University Press for the National Gallery of Art, 1982).

Goodrich, PMA Lloyd Goodrich and Edith Havens Goodrich, Whitney Museum of Art, Record of Works by Thomas Eakins at PMA, Department of American Art.

Gray, *Anatomy* Henry Gray, *Anatomy, Descriptive and Surgical* (Philadelphia: Lea Brothers, 1887).

Hendricks 1965 Gordon Hendricks, "A May Morning in the Park," *Philadelphia Museum of Art Bulletin* 60 (Spring 1965):48–64.

Hendricks 1969 Gordon Hendricks, *Thomas Eakins: His Photographic Works*, exh. cat. (Philadelphia: PAFA, 1969).

Hendricks 1972 Gordon Hendricks, *The Photographs of Thomas Eakins* (New York: Grossman, 1972).

Hendricks 1974 Gordon Hendricks, *The Life and Work of Thomas Eakins* (New York: Grossman, 1974).

Homer and Talbot W. I. Homer and John Talbot, "Eakins, Muybridge and the Motion Picture Process," *Art Quarterly* 26 (2) (Summer 1963): 194–216.

Hoopes Donelson F. Hoopes, *Eakins Watercolors* (New York: Watson-Guptill, 1971).

JAIC Mark Bockrath, Virginia Naudé, and Debbie Hess Norris, "Thomas Eakins, Painter, Sculptor, Photographer: Examination, Technical Analysis and Treatment of His Works in the Charles Bregler Collection of the PAFA," *Journal of the American Institute for Conservation* 31 (1992): 51–64.

Johns 1980 Elizabeth Johns, "Drawing Instruction at Central High School and Its Impact on Thomas Eakins," *Winterthur Portfolio* 15 (2) (Summer 1980): 139–149.

Johns 1983 Elizabeth Johns, *Thomas Eakins: The Heroism of Modern Life* (Princeton, N.J.: Princeton University Press, 1983).

Knoedler 1944 Knoedler and Company, New York, *A Loan Exhibition of the Works of Thomas Eakins*, exh. cat. (New York, 1944).

Leibold 1988 Cheryl Leibold, "Thomas Eakins in the Badlands," *Archives of American Art Journal* 28 (2) (1988).

Leibold 1991 Cheryl Leibold, "The Many Faces of Thomas Eakins," *Pennsylvania Heritage* 17 (2) (Spring 1991).

McHenry Margaret McHenry, *Thomas Eakins, Who Painted* (Oreland, Pa.: Privately printed, 1946).

Marceau Henry Marceau, "Catalogue of Works of Thomas Eakins," *Philadelphia Museum of Art Bulletin* 25 (133) (March 1930): 17–33.

Milroy 1986 Elizabeth L. C. Milroy, "Thomas Eakins' Artistic Training, 1860–70" (Ph.D. diss., University of Pennsylvania, 1986).

Milroy, *Lifetime Exhibition Record* Elizabeth L. C. Milroy, *Guide to the Thomas Eakins Research Collection, with a Lifetime Exhibition Record and Bibliography* (typescript, PMA, 1984). Typescript was edited, with contributions by Douglass Paschall, and published by PMA in 1996.

Milroy, "Goodrich" Elizabeth L. C. Milroy. "Transcript of Interview with Lloyd Goodrich: 23 March, 1983" (typescript, Thomas Eakins Archive, PMA).

MMA, *Eakins* (1917) Metropolitan Museum of Art, New York, *A Loan Exhibition of the Works of Thomas Eakins*, exh. cat., 5 Nov.–3 Dec. 1917.

Olympia 1976 *Olympia Galleries Collection of Thomas Eakins Photographs*, sale catalogue (Philadelphia, 1976).

Olympia 1977 [Olympia Galleries Collection], Sotheby Parke-Bernet, Inc., catalogue no. 40448, New York, 10 Nov. 1977.

Olympia 1979 Seymour Adelman, *Thomas Eakins: 21 Photographs* (Atlanta: Olympia Galleries, 1979).

Olympia 1981 Ellwood C. Parry III and Robert Stubbs, *Photographer Thomas Eakins* (Philadelphia: Olympia Galleries and ACA Galleries, 1981).

Onorato 1976 Ronald J. Onorato, "Photography and Teaching: Eakins at the Academy," *American Art Review* 3 (July–Aug. 1976): 127–140.

Onorato 1977 Ronald J. Onorato, "The Pennsylvania Academy of the Fine Arts and the Development of an Academic Curriculum in the Nineteenth Century" (Ph.D. diss., Brown University, 1977).

Onorato 1979 Ronald J. Onorato, "The Context of the Pennsylvania Academy: Thomas Eakins' Assistantship to Christian Schuessele," *Arts Magazine* 53 (May 1979): 121–129.

PAFA, *American Sculpture* *American Sculpture at the Museum of American Art of the Pennsylvania Academy of the Fine Arts* (Philadelphia: PAFA, 1997). With contributions by Susan James-Gadzinski, Mary Mullen Cunningham, and Linda Bantel.

PAFA, *Drawing Toward Building* James F. O'Gorman et al., *Drawing Toward Building: Philadelphia Architectural Graphics, 1732–1986*, exh. cat. (Philadelphia: University of Pennsylvania Press for PAFA, 1986).

PAFA, *Eakins* (1917) *Memorial Exhibition of the Works of the Late Thomas Eakins*, exh. cat., 23 Dec. 1917–13 Jan. 1918.

PAFA, *Pictorial Photography* William I. Homer et al., *Pictorial Photography in Philadelphia: The Pennsylvania Academy's Salons, 1898–1901*, exh. cat. (Philadelphia: PAFA, 1984).

Parry Ellwood C. Parry III, "Thomas Eakins' 'Naked Series' Reconsidered: Another Look at the Standing Nude Photographs Made for the Use of Eakins's Students," *American Art Journal* 20 (2) (1988): 53–77.

Parry and Chamberlin-Hellman Ellwood C. Parry III and Maria Chamberlin-Hellman, "Thomas Eakins as an Illustrator," *The American Art Journal* 5 (1) (May 1973): 23.

PMA 1944 "Thomas Eakins Centennial Exhibition," *Philadelphia Museum of Art Bulletin* 39 (201) (May 1944).

PMA, *Three Centuries* Philadelphia Museum of Art, *Philadelphia: Three Centuries of American Art*, exh. cat. (Philadelphia: PMA, 1976).

Roanoke *Thomas Eakins, Susan Macdowell Eakins, Elizabeth Macdowell Kenton*, exh. cat. (Roanoke, Va.: North Cross School, 1977). With contribution by David Sellin, "Eakins and the Macdowells and the Academy."

Rogers "The Schools of the Pennsylvania Academy of the Fine Arts," *Penn Monthly* 12 (June 1881): 453–462. Reprinted as a brochure by PAFA (1881).

Rosenzweig Phyllis D. Rosenzweig, *The Thomas Eakins Collection of*

the Hirshhorn Museum and Sculpture Garden (Washington, D.C.: Smithsonian Institution Press, 1977).

Rutledge/Falk Anna Wells Rutledge, *The Annual Exhibition Record of the Pennsylvania Academy of the Fine Arts, 1807–1870* (1955; rpt., Madison, Conn.: Sound View Press, 1988, with revisions and additions by Peter Falk, ed.).

Schendler Sylvan Schendler, *Eakins* (Boston: Little, Brown, 1967).

Sellin David Sellin, *The First Pose* (New York: Norton, 1976).

Sewell Darrel Sewell, *Thomas Eakins: Artist of Philadelphia,* exh. cat. (Philadelphia: PMA, 1982).

Siegl *The Thomas Eakins Collection* (Philadelphia: PMA, 1978). With an introduction by Evan H. Turner.

Simpson Marc Simpson, "Thomas Eakins and His Arcadian Works," *Smithsonian Studies in American Art* 1 (2) (Fall 1987).

SME, Retrospective diary Susan Macdowell Eakins, retrospective diary of important dates, CBTE, Foster and Leibold, fiche series II 5/E/12–7/B/9.

Spassky Natalie Spassky, *American Paintings in the Metropolitan Museum of Art*, vol. 2: *A Catalogue of Works by Artists Born between 1816 and 1845* (New York: MMA, 1985).

Stebbins Theodore E. Stebbins, Jr., et al., *American Master Drawings and Watercolors* (New York: Harper and Row, 1976).

TE, PMA typescript Thomas Eakins, Manuscript of a drawing book, PMA. Pagination refers to the typed transcript by Theodor Siegl.

TE, Spanish notebook Eakins' pocket notebook, kept in Europe from c. 1868–70, with later additions through c. 1880. CBTE, Foster and Leibold, fiche series I 9/E/4–10/A/8.

TE, record books 1, 2 Thomas Eakins with SME and Margaret Eakins (?). Pocket notebooks with exhibition records, 1874–1916. 1: PMA Eakins Archive; 2: CBTE, Foster and Leibold, fiche series I 10/A/9–10/D/7.

Weinberg 1984 H. Barbara Weinberg, *The American Pupils of Jean-Leon Gérôme* (Fort Worth, Texas: Amon Carter Museum, 1984).

Weinberg 1991 H. Barbara Weinberg, *The Lure of Paris: American Artists at the Ecole des Beaux Arts* (New York: Abbeville, 1991).

Wilmerding John Wilmerding et al., *Thomas Eakins (1844–1916) and the Heart of American Life,* exh. cat. (London: National Portrait Gallery, 1993).

Yale 1996 Helen Cooper et al., *Thomas Eakins: The Rowing Pictures* (New Haven: Yale University Art Gallery, 1996). With contributions by Martin A. Berger, Christina Currie, and Amy B. Werbel.

The texts cited most frequently in this book appear on the list of references above; additional sources are given below, although not all of the items consulted for this book or cited in the endnotes are listed here. In his 1982 monograph Goodrich assembled most of the literature on Eakins before that date; since then, Johns (1983) has published a useful bibliographic essay drawing attention to topics in the culture of Eakins' period, and Homer (1992) and Wilmerding (1993) and his contributing authors have listed many supplementary references. There are superb bibliographies in Spassky's catalogue of the Metropolitan Museum of Art's collection and in Milan R. Hughston and Sarah Cash's thorough record for *Swimming* (Bolger and Cash 1996). Milroy's *Lifetime Exhibition Record* of 1984, edited and expanded by Douglass Paschall for publication in 1996, contains all known references published before Eakins' death in 1917. I have listed below several period newspaper and journal reviews unknown to Milroy and Paschall, although others may be found in the notes.

My own text was written in 1990–92, and my research informed the exhibition *Thomas Eakins Rediscovered*, at PAFA in 1991–92. Following the public debut of this material I shared sections of my text with many colleagues whose work on Eakins has appeared in advance of this book. I have included these titles (by Bolger and Cash, Homer 1992, McClintock, Weinberg 1994–95, Werbel, Wilmerding, and Yale 1996) for their use to the reader, although they actually build on aspects of this present text. In the same spirit of inclusion, I have listed several publications that have appeared since the completion of this manuscript, and a few worthwhile items that have eluded earlier bibliographers.

Ackerman, Gerald M. "Thomas Eakins 1844-1916," in Katherine Harper Mead, ed., *The Preston Morton Collection of American Art* (Santa Barbara: Santa Barbara Museum of Art, 1981): 164.

Ackerman, Gerald M., et al. *Gérôme: Jean-Léon Gérôme 1824-1904*, exh. cat. (Vesoul, France: Musée de Vesoul, 1981).

Adelman, Seymour. "Introduction," in *Twenty-one Photographs* (Atlanta: Olympia Galleries, 1979).

———. "Thomas Eakins: Mount Vernon Street Memories," in *The Moving Pageant: A Selection of Essays* (Lititz, Pa.: Sutter House, 1977).

Albright, Adam Emory. "Memories of Thomas Eakins," *Harper's Bazaar* (Aug. 1947): 138–139, 184.

"The Annual Exhibition of the Photographic Society of Philadelphia." *Philadelphia Photographer* 20 (May 1883).

"Art in Philadelphia." *New York Daily Tribune* (Nov. 25, 1881).

"Art Notes: New York: The American Water-Color Society." *Art Journal* 8 (1882): 93–95.

Axelrod, Allen, ed. *The Colonial Revival in America* (Winterthur, Del.: Winterthur Books, 1985).

Barsotti, Roberta. "Thomas Eakins 1866 to 1877: An American in Paris." Master's thesis, Courtauld Institute of Art, 1987.

Berkovitz, Julia S. "Professor Benjamin Howard Rand," *Journal of the American Medical Association* 264 (15 August 1990): 787.

Blaugrund, Annette. *Paris 1889: American Artists at the Universal Exposition* (Philadelphia: PAFA, 1989).

Boime, Albert. "American Culture and the Revival of the French Academic Tradition," *Arts Magazine* 56 (May 1982): 95–101.

Bolger, Doreen, and Claire M. Barry. "Thomas Eakins's 'Swimming Hole,'" *Antiques Magazine* 145 (March 1994): 408–411.

Boulton, Kenyon C. III, Peter Huenicik, Earl A. Powell III, Harry Z. Rand, and Nanette Sexton. *American Art at Harvard*, exh. cat. (Cambridge, Mass.: Fogg Art Museum, 1972).

Bowman, Ruth. "Nature, The Photograph and Thomas Eakins," *Art Journal* 33 (Fall 1973): 32–40.

Boyle, Richard J., Frank H. Goodyear, Jr., et al. *In This Academy: The Pennsylvania Academy of the Fine Arts, 1805–1976*, exh. cat. (Philadelphia: PAFA, 1976).

Boyanoski, Christine. *Sympathetic Realism: George A. Reid and the Academic Tradition* (Toronto: Art Gallery of Ontario, 1986).

Bregler, Charles. "Photos by Thomas Eakins: How the Famous Painter Anticipated the Modern Movie Camera," *American Magazine of Art* 36 (Jan. 1943): 28–29.

Buki, Zoltan, and Suzanne Corlette, eds. *The Trenton Battle Monument: Eakins Bronzes* (Trenton: New Jersey State Museum, 1973).

Burroughs, Alan. "Thomas Eakins," *Arts* 3 (March 1923): 185–189.

———. "Thomas Eakins, the Man." *Arts* 4 (Dec. 1923): 302–303.

Canaday, J. "Familiar Truths in Clear and Beautiful Language," *Horizon* 6 (Autumn 1964): 88–105.

Chamberlin-Hellman, Maria. "Samuel Murray, Thomas Eakins, and the Witherspoon Prophets," *Arts Magazine* 53 (May 1979): 134–139.

Clark, William J. "The Iconography of Gender in Thomas Eakins's Portraiture," *American Studies* 32 (Fall 1991): 5–28.

Coke, Van Deren. *The Painter and the Photograph from Delacroix to Warhol* (Albuquerque: University of New Mexico Press, 1972).

Corn, Wanda M. *The Color of Mood*, exh. cat. (San Francisco: M. H. de Young Memorial Museum and California Palace of the Legion of Honor, 1972).

Couture, Thomas. *Conversations on Art Methods [Methode et entretiens d'atelier]*, S. E. Stewart, trans. (New York: G. P. Putnam's, 1879).

Danly, Susan. *Telling Tales*, exh. cat. (Philadelphia: PAFA, 1991.)

Danto, Arthur C. "Men Bathing, 1883: Eakins and Seurat," *Art News* 94 (March 1995): 95–96.

Davis, Anne. "Seekers After Reality: Thomas Eakins and George Reid," in *A Distant Harmony* (Winnipeg: Winnipeg Art Gallery, 1982).

Davis, Whitney. "Erotic Revision in Thomas Eakins's Narratives of Male Nudity," *Art History* 17 (Sept. 1994): 301–341.

Dinnerstein, L. "Thomas Eakins' 'Crucifixion' as Perceived by Mariana Griswold van Rensselaer," *Arts Magazine* 53 (May 1979): 140–145.

Ferber, Linda S. "'My Dear Friend': A Letter from Thomas Eakins to William T. Richards," *Archives of American Art Journal* 34 (1994): 15–21.

Ferber, Linda S., William H. Gerdts, et al. *The New Path: Ruskin and the American Pre-Raphaelites* (Brooklyn: Brooklyn Museum, 1985).

Fifer, Valerie J. *American Progress: The Growth of the Transport, Tourist, and Information Industries in the Nineteenth-Century West, Seen through the Life and Times of George A. Crofutt, Pioneer and Publicist of the Transcontinental Age* (Chester, Conn.: Globe Pequot Press, 1988).

"The Fine Arts." *Philadelphia Evening Telegraph* (Oct. 17, 1881).

"The Fine Arts: The American Water-Color Society." *Independent* (Feb. 16, 1882): 8.

Fink, Lois Marie. *American Art at the Nineteenth-Century Paris Salons* (Washington, D.C.: National Museum of American Art, Smithsonian Institution, and Cambridge University Press, 1990).

Fink, Lois Marie, and Joshua C. Taylor. *Academy: The Academic Tradition in American Art* (Washington, D.C.: National Collection of Fine Arts, 1975).

Fraser, Toney. "Whitman, Eakins, and the Athletic Figure in American Art," *Aethlon: The Journal of Sport Literature* 6 (Spring 1989): 79–89.

Fried, Michael. "Realism, Writing, and Disfiguration in Thomas Eakins's Gross Clinic," *Representations* 9 (Winter 1985): 33–104.

Fryer, Judith. "'The Body in Pain' in Thomas Eakins' *Agnew Clinic*," *Michigan Quarterly Review* (Winter 1991): 191–209.

Gerdts, William H. *The Great American Nude: A History in Art* (New York: Praeger, 1974).

———. "Thomas Eakins and the Episcopal Portrait: Archbishop William Henry Elder," *Arts Magazine* 53 (May 1979): 154–157.

———. *The Art of Healing: Medicine and Science in American Art*, exh. cat. (Birmingham, Ala.: Birmingham Museum of Art, 1981).

Glassie, Henry. "Meaningful Things and Appropriate Myths: The Artifact's Place in American Studies," *Prospects* 3 (1977): 1–49.

———. *The Spirit of Folk Art* (New York: Abrams, 1989).

Goodbody, Bridget L. "The Present Opprobrium of Surgery: The 'Agnew Clinic' and Nineteenth-Century Representations of Cancerous Female Breasts," *American Art* 8 (Winter 1994): 32–51.

Goodrich, Lloyd. *Sixth Loan Exhibition: Winslow Homer, Albert P. Ryder, Thomas Eakins,* exh. cat. (New York: Museum of Modern Art, 1930).

———. *Thomas Eakins: A Retrospective Exhibition,* exh. cat. (Washington, D.C.: National Gallery of Art, 1961).

———. *Thomas Eakins Retrospective Exhibition,* exh. cat. (New York: Whitney Museum of American Art, 1970).

———. "' . . . About a man who did not wish to be written about': Portraits in Friendship of Thomas Eakins," *Arts Magazine* 53 (May 1979): 96–99.

Goodyear, Frank H., Jr. "The Thomas Eakins Collection of the Philadelphia Museum of Art," *Arts Magazine* 53 (May 1979): 158–159.

Gopnik, Adam. "The Art World: Eakins in the Wilderness," *New Yorker* (Dec. 26, 1994–Jan. 2, 1995): 78–91.

Griffin, Randall C. "Thomas Anshutz's *The Ironworkers' Noontime,*" *Smithsonian Studies in American Art* 4 (Summer–Fall 1990): 129–143.

———. *Thomas Anshutz, Artist and Teacher* (Huntington, N.Y.: Hecksher Museum and the University of Washington Press, 1994).

Hardin, Jennifer. "Thomas Eakins and the Nude," *Antiques* 144 (Nov. 1993): 708–715.

Hartmann, Sadakichi. *A History of American Art,* 2 vols. (Boston: L. C. Page, 1902).

Hatt, Michael. "The Male Body in Another Frame: Thomas Eakins' *The Swimming Hole* as an Erotic Image," *Journal of Philosophy and the Visual Arts* (1993): 8–21.

Heard, Sandra Denny. *Thomas P. Anshutz, 1851–1912* (Philadelphia: PAFA, 1973).

Hendricks, Gordon. "Eakins's William Rush Carving His Allegorical Statue of the Schuylkill," *Art Quarterly* 31 (Winter 1968): 382–404.

———. "Ships and Sailboats on the Delaware," *Wadsworth Athenaeum Bulletin* 4 (Spring–Fall 1968): 39–48.

———. "Thomas Eakins's Gross Clinic," *Art Bulletin* 51 (March 1969): 57–64.

———. "The Eakins Portrait of Rutherford B. Hayes," *American Art Journal* 1 (Spring 1969): 104–114.

———. *A Family Album: Photographs by Thomas Eakins* (New York: Coe Kerr Gallery, 1976).

Homer, William Innes. "Who Took Eakins' Photographs," *Art News* (May 1983): 112–119.

———. "New Documentation on Eakins and Walt Whitman in Camden," *Mickle Street Review* 12 (1990): 74–82.

———. "New Light on Thomas Eakins and Walt Whitman in Camden," in Geoffry M. Sill and Roberta K. Tarbell, eds., *Walt Whitman and the Visual Arts,* (New Brunswick, N.J.: Rutgers University Press, 1992).

———. *Thomas Eakins: His Life and Art* (New York: Abbeville, 1992).

Huber, Christine Jones. *The Pennsylvania Academy and Its Women 1850–1920* (Philadelphia: PAFA, 1973).

Johns, Elizabeth. "Thomas Eakins: A Case for Reassessment," *Arts Magazine* 53 (May 1979): 131–133.

———. "I, a Painter: Thomas Eakins at the Academy of Natural Sciences," *Frontiers* (annual of the Academy of Natural Sciences of Philadelphia) 3 (1981–82): 43–51.

———. "Thomas Eakins and 'Pure Art' Education," *Archives of American Art Journal* 23 (1983): 71–76.

———. "Body and Soul," *Art and Antiques* 7 (Sept. 1984): 73–79.

Kimmerle, Constance. "Thomas Eakins' Exploration of the Mechanism and Laws of Human Expression and Understanding in Themes of Mental Effort and Creative Activity," Ph.D. diss., University of Pennsylvania, 1989.

Leahy, Mary S. "Susan Macdowell Eakins and the Adelman Family," in *Seymour Adelman, 1906–1985: A Keepsake* (Bryn Mawr, Pa.: Bryn Mawr College Library, 1985): 17–41.

Leibold, Cheryl. "Thomas Eakins in the Badlands," *Archives of American Art Journal* 28 (1988): 2–15.

———. "Photographic High Jinks at the Pennsylvania Academy of the Fine Arts," *Nineteenth Century* 12 (1993): 2–7.

Lifton, Norma. "Thomas Eakins and S. Weir Mitchell: Images and Cures in Nineteenth Century Philadelphia," in Mary Gedo, ed., *Psychoanalytic Perspectives on Art* 2 (1987): 247–274.

Lubin, David. *Act of Portrayal: Eakins, Sargent, James* (New Haven: Yale University Press, 1985).

Marceau, Henri. "The Fairman Rogers Four-in-Hand," *Pennsylvania Museum Bulletin* 26 (Jan. 1931): 21–25.

Marling, Karal Ann. *George Washington Slept Here: Colonial Revivals and American Culture* (Cambridge, Mass.: Harvard University Press, 1988).

Marzio, Peter. *The Art Crusade: An Analysis of American Drawing Manuals, 1820–1860* (Washington, D.C.: Smithsonian Institution Press, 1976).

Matthiesen, Frank O. *American Renaissance: Art and Expression in the Age of Emerson and Whitman* (New York: Oxford University Press, 1941).

McCaughey, Patrick. "Thomas Eakins and the Power of Seeing," *Artforum* 9 (Dec. 1970): 56–61.

McClintock, Elizabeth R. "Thomas Eakins, 'On the Delaware (Becalmed),'" in Elizabeth Mankin Kornhauser, *American Paintings Before 1945 in the Wadsworth Atheneum,* vol. 1 (Hartford: Wadsworth Antheneum and Yale University Press, 1996), cat. 183.

McElroy, Guy C. *Facing History: The Black Image in American Art 1710–1940,* exh. cat. (Washington, D.C.: Corcoran Gallery of Art, 1990).

May, Stephen. "Two Geniuses [Eakins and Rowland] and a Paintbrush," *Down East* (Aug. 1994): 67, 69, 87–88.

Milroy, Elizabeth. "'Consummatum est': A Reassessment of Thomas Eakins' Crucifixion of 1880," *Art Bulletin* 71 (June 1989): 269–284.

———. "Thomas Eakins, Robert Harris, and the Art of Léon Bonnat," *Journal of Canadian Art History* 10 (1987): 84–102.

Moffett, Cleveland. "Grant and Lincoln in Bronze," *McClure's Magazine* 5 (Oct. 1895): 419–432.

Mosby, Dewey F., and Darrel Sewell. *Henry Ossawa Tanner*, exh. cat. (Philadelphia: Philadelphia Museum of Art, 1991).

Novak, Barbara. *American Painting of the Nineteenth Century: Realism, Idealism, and the American Experience* (New York: Praeger, 1969).

[PAFA Exhibition Review]. *Philadelphia Evening Press* (Dec. 2, 1881).

Panhorst, Michael W. *Samuel Murray: The Hirshhorn Museum and Sculpture Garden Collection, Smithsonian Institution* (Washington, D.C.: Smithsonian Institution Press, 1982).

Panzer, Mary. *Philadelphia Naturalistic Photography, 1865–1906* (New Haven: Yale University Art Gallery, 1982).

Parry, Ellwood C. III. "The Gross Clinic as Anatomy Lesson and Memorial Portrait," *Art Quarterly* 32 (Winter 1969): 373–391.

———. *The Image of the Indian and the Black Man in American Art, 1590–1900* (New York: Braziller, 1974).

———. "Thomas Eakins and the Everpresence of Photography," *Arts Magazine* 51 (June 1977): 111–115.

———. "Thomas Eakins and the Gross Clinic," *Jefferson Medical College Alumni Bulletin* 16 (Summer 1967): 2–12.

———. "The Thomas Eakins Portrait of Sue and Harry; or, When Did the Artist Change His Mind?" *Arts Magazine* 53 (May 1979): 146–153.

Peale, Rembrandt. *Graphics: A Manual of Drawing and Writing* (New York: 1834, and 19 later editions).

Peck, Robert McCracken. "Thomas Eakins and Photography: The Means to an End," *Arts Magazine* 53 (May 1979): 113–117.

Philadelphia Museum of Art. *Eakins in Perspective: Works by Eakins and his Contemporaries, in Addition to Memorabilia*, exh. cat. (Philadelphia: PMA, 1962).

Porter, Fairfield. *Thomas Eakins* (New York: Braziller, 1959).

Prown, Jules David. *American Painting from Its Beginnings to the Armory Show* (New York: Skira, 1969).

———. "Thomas Eakins' Baby at Play," *Studies in the History of Art* 18 (1985): 121–127.

Rosenberg, Pierre, Theodore E. Stebbins, Jr., Barbara Weinberg et al. *A New World: Masterpieces of American Painting, 1760–1910*, exh. cat. (Boston: Museum of Fine Arts, 1983).

Rosenheim, Jeff L. "Thomas Eakins, Artist Photographer, in the Metropolitan Museum of Art," *Metropolitan Museum of Art Bulletin* (Winter 1994–95): 45–51.

Rosenzweig, Phyllis. "Problems and Resources in Thomas Eakins Research: The Hirshhorn Museum's Thomas Eakins Collection," *Arts Magazine* 53 (May 1979): 118–120.

Sandweiss, Martha, ed. *Photography in Nineteenth Century America* (Fort Worth: Amon Carter Museum, 1991).

Schendler, Sylvan. *Eakins* (Boston: Little, Brown, 1967).

Smith, M. S. "The Agnew Clinic: 'Not Cheerful for Ladies to Look at,'" *Prospects* 11 (1987): 161–183.

Steinberg, Leo. "Art/Work," *Art News* 70 (Feb. 1972), 34–35.

Strazdes, Diana. "Thomas Eakins at the Carnegie: Private Vision, Public Enigma," *Carnegie Magazine* 59 (1988): 22–29.

Terhune, Ann Gregory, et al. *Thomas Hovenden (1840–1895), American Painter of Hearth and Homeland* (Philadelphia: Woodmere Art Museum, 1995).

Terry, James S. "Artistic Anatomy and Taboo: The Case of Thomas Anshutz," *Art Journal* 44 (Summer 1984): 149–152.

Tomko, George. *Catalog of the Roland P. Murdock Collection* (Wichita: Wichita Art Museum, 1972).

Torchia, Robert Wilson. "*The Chess Players* by Thomas Eakins," *Winterthur Portfolio* 26 (1991): 267–276.

Treuttner, William. "Dressing the Part: Thomas Eakins's Portrait of Frank Hamilton Cushing," *American Art Journal* 17 (Spring 1985): 49–72.

Turner, Evan H. [Eakins exhibition at St. Charles Borromeo Seminary, Overbrook, Pa.], untitled brochure (April 1970).

———. "Thomas Eakins at Overbrook," *Records of the American Catholic Historical Society of Philadelphia* 81 (Dec. 1970): 195–198.

———. "Thomas Eakins: The Earle Galleries' Exhibition of 1896," *Arts Magazine* 53 (May 1979): 100–107.

Van Rensselaer, Mariana Griswold. *The Book of American Figure Painters* (Philadelphia: Lippincott, 1886).

Weinberg, Ephraim. "The Art School of the Pennsylvania Academy," *Antiques* 121 (March 1982): 690–693.

Weinberg, H. Barbara. "Nineteenth-Century American Painters at the Ecole des Beaux-Arts," *American Art Journal* 13 (Autumn 1981): 66–84.

———. "Thomas Eakins and the Metropolitan Museum of Art," *Metropolitan Museum of Art Bulletin* 52 (Winter 1994–95), 4–42.

Weinberg, H. Barbara, Doreen Bolger, and David Park Curry. *American Impressionism and Realism: The Painting of Modern Life, 1885–1915*, exh. cat. (New York: Metropolitan Museum of Art and Harry N. Abrams, 1994).

Weiss, J. A. W. "Clarence Cook: His Critical Writings," Ph.D. diss., Johns Hopkins University, Baltimore, 1976.

Werbel, Amy, "Perspective in the Life and Art of Thomas Eakins," Ph.D. diss., Yale University, 1996.

Williams, Hermann Warner. *Mirror to the American Past: A Survey of American Genre Painting 1750–1900* (Greenwich, Conn.: New York Graphic Society, 1973).

Wilmerding, John, *American Art* (Harmondsworth, England: Pelican Books, 1976).

———. "Thomas Eakins' Late Portraits," *Arts Magazine* 53 (May 1979): 108–112.

Wilmerding, John, et al. *American Light: The Luminist Movement, 1850–1875*, exh. cat. (New York: Harper and Row, for the National Gallery of Art, 1980).

Index

Page numbers in **bold** type refer to illustrations.